FUNDAMENTALS OF GRAPHICS COMMUNICATION

D1305332

FUNDAMENTALS OF GRAPHICS COMMUNICATION

Gary R. Bertoline
Purdue University

Eric N. Wiebe
*North Carolina State
University*

Craig L. Miller
Purdue University

Leonard O. Nasman
*Microcomputer
Education Systems*

IRWIN

Chicago • Bogotá • Boston • Buenos Aires • Caracas
London • Madrid • Mexico City • Sydney • Toronto

THE IRWIN GRAPHICS SERIES

Titles in the Irwin Graphics Series include:

Engineering Graphics Communication

Bertoline, Wiebe, Miller, and Nasman, 1995

Technical Graphics Communication

Bertoline, Wiebe, Miller, and Nasman, 1995

Fundamentals of Graphics Communication

Bertoline, Wiebe, Miller, and Nasman, 1996

Problems for Engineering Graphics Communication and Technical Graphics Communication Workbook #1, 1995

Problems for Engineering Graphics Communication and Technical Graphics Communication Workbook #2, 1995

AutoCAD Instructor Release 12

James A. Leach, 1995

AutoCAD Companion Release 12

James A. Leach, 1995

AutoCAD 13 Instructor

James A. Leach, 1996

AutoCAD 13 Companion

James A. Leach, 1996

CADKEY Companion

John Cherng, 1996

Hands-On CADKEY: A Guide to Versions 5, 6, and 7

Timothy J. Sexton, 1996

Modeling with AutoCAD Designer

Dobek and Ranschaert, 1996

Engineering Design and Visualization Workbook

Dennis Stevenson, 1995

Providing you with the highest quality textbooks that meet your changing needs requires feedback, improvement, and revision. The team of authors and Richard D. Irwin are committed to this effort. We invite you to become part of our team by offering your wishes, suggestions, and comments for future editions and new products and texts.

Please mail or fax your comments to:

Gary Bertoline
c/o Richard D. Irwin
1333 Burr Ridge Parkway
Burr Ridge, IL 60521
fax: 708-789-6946

© Richard D. Irwin, a Times Mirror Higher Education Group, Inc., company, 1996

All rights reserved. No part of this publication may be reproduced, stored in a retrieval system, or transmitted, in any form or by any means, electronic, mechanical, photocopying, recording, or otherwise, without the prior written permission of the publisher.

Irwin Book Team

Publisher: *Tom Casson*

Senior sponsoring editor: *Elizabeth A. Jones*

Senior developmental editor: *Kelley Butcher*

Marketing manager: *Brian Kibby*

Project editor: *Gladys True*

Production supervisor: *Bob Lange*

Designer: *Laurie J. Entringer*

Cover photographer: *Michael Furman*

Cover illustrator: *James Mohler*

Assistant manager, graphics: *Charlene R. Breedon*

Manager, graphics and desktop services: *Kim Meriwether*

Compositor: *Wm. C. Brown Communications, Inc.*

Typeface: *10/12 Times Roman*

Printer: *Von Hoffmann Press, Inc.*

Library of Congress Cataloging-in-Publication Data

Fundamentals of graphics communication / Gary R. Bertoline . . . [et al.]

p. cm.—(Irwin graphics series)

Includes index.

ISBN 0-256-12402-7

1. Engineering graphics. I. Bertoline, Gary R. II. Series.

T353.F976 1996

95-37183

604.2—dc20

Printed in the United States of America
2 3 + 5 6 7 8 9 0 VH 9 8 7 6

“If I have seen further . . . it is by standing upon the shoulders of Giants.” Isaac Newton

This book is dedicated to the pioneers in graphics, and our teachers, colleagues, family, and students from whom we have learned so much and owe our gratitude.

ABOUT THE AUTHORS

Gary R. Bertoline

focused on the integration of CAD into engineering graphics and visualization. He has 20 years experience teaching graphics at all levels from elementary school to senior citizens. Gary taught junior high and high school graphics at St. Henry High School, St. Henry, Ohio, drafting/design technology at Wright State University, Lake Campus, in Celina, Ohio, and engineering graphics at The Ohio State University, Columbus, Ohio.

Gary authored numerous publications, authored or co-authored 7 textbooks and workbooks, and made over 50 presentations throughout the world. He has won the Frank Oppenheimer Award three times for best paper at the Engineering Design Graphics Division Mid-year Meeting. He has developed many graphics courses, including CAD, solid modeling, multimedia, and integrated many modern topics into traditional engineering graphics courses, such as modeling, animation, and visualization. Gary has conducted research in cognitive visualization and was the co-author for a curriculum study in engineering graphics funded by SIGGRAPH. Gary is on the editorial board for the *Engineering Design Graphics Journal* and is the Irwin Graphics Series Editor. He is a member of American Society for Engineering Education, National Computer Graphics Association, Epsilon Pi Tau, and National Association of Industrial Technology. He is a certified Industrial Technologist

Gary R. Bertoline is Professor and Department Head of Technical Graphics at Purdue University. He earned his B. S. Degree in Industrial Technology at Northern Michigan University in 1974 and M.Ed. in Industrial Technology at Miami University in 1979 and Ph.D. at Ohio State University in Industrial Technology in 1987. His graduate work

and recipient of the Orthogonal Medal for outstanding contributions to the advancement of Graphic Science by North Carolina State University in 1992. Gary is a consultant for industry and is founder and president of Spectrum Multimedia Services, Inc.

Eric N. Wiebe

Eric N. Wiebe has been teaching in the Graphic Communications Program at North Carolina State University since 1989. He earned his B. A. degree in Chemistry from Duke University in 1982 and an M. A. in Industrial Design at North Carolina State in 1987. Before going to graduate school, Mr. Wiebe worked as a chemist and in the A/E/C industry. His graduate work in Industrial Design focused on the role of computer graphics and CAD in the design process. After completing his Master's, Mr. Wiebe helped develop a photorealistic rendering and modeling system for architectural and design professionals and worked as a private consultant. Since coming to teach at North Carolina State, Mr. Wiebe has developed and taught a 3-D solids modeling course for 5 years. In addition, he coordinated the introduction of CAD into the introductory engineering graphics course. Mr. Wiebe has also developed a course on scientific visualization, which looks at the graphic representation of technical and scientific data. Since coming to N. C. State, Mr. Wiebe has continued to work as a consultant to industry and has been active at the university level on the integration of computing in academics. He has authored numerous publications and the CAD workbook: *The Student Edition of Generic CADD*. In addition to being on the editorial review board of the *Engineering Design Graphics Journal*, he

is a member of the American Society for Engineering Education, the American Design Drafting Association, and the Human Factors and Ergonomics Society.

Craig L. Miller

ing Graphics at The Ohio State University. He has also taught as a graduate teaching assistant in the College of Technology at Bowling Green State University, at the high school level and adult education in a vocational school. Craig was honored twice as the recipient of the Purdue University School of Technology's Outstanding Non-tenured Faculty Award in 1992 and 1993. Professor Miller's business experience includes serving as a computer-based training specialist and consultant to Arthur Andersen & Company, Nationwide Insurance Company and Vice President of Spectrum Multimedia Services, Inc. Dr. Miller is very active in the ASEE, having served as session chairperson and on various committees. Craig has been honored with the Frank Oppenheimer Award for best paper at the EDGD Mid-year Meeting. He is an active member of Epsilon Pi Tau, National Association of Industrial Technology (NAIT), American Society for Engineering Education (ASEE), ASEE-Engineering Design Graphics Division (EDGD), and the National Society for Performance Instruction (NSPI). Craig has presented over 15 papers at professional conferences in North America and Australia. He has authored papers in journals on engineering and technical graphics,

CADD, and visualization research. His research interests are in measuring and advancing students' spatial abilities and historical research. He was also involved in an international curriculum development with the Royal Melbourne Institute of Technology.

Leonard O. Nasman

Len Nasman is currently President of Microcomputer Education Systems, Inc. a company primarily involved in developing instructional books and video tapes for teaching CAD. The company has also developed computer assisted instruction software, and interactive videodisc systems. Len has an extensive and varied background in engineering graphics and education. He started his career as a drafter at Bell Telephone Laboratories and, after completing his bachelor's degree, worked for a number of years as a Design Engineer in the aerospace industry. He taught Drafting and Design Technology at Trinidad State Community College in Colorado and received his Master's and Ph.D. degrees in Vocational Technical Teacher Education from Colorado State University. Len taught drafting part-time at Larimer County Vo-Tech Center while working on his Ph.D. After nine years in Vocational Technical Teacher Education in Colorado and Texas, Len moved to the National Center for Research in Vocational Education at The Ohio State University. In 1982, he returned to his roots by accepting an assignment in the Engineering Graphics Department at Ohio State where he remained until taking a leave to establish Microcomputer Education Systems as a leading developer of CAD books and video tapes. Len has also won the Frank Oppenheimer Award for the best paper at the EDGP Mid-year Meeting.

To the authors of this text, teaching graphics is not a job, it is a “life mission.” We feel that teaching is an important profession, and that the education of our engineers is critical to the future of our country. Further, we believe that technical graphics is an essential, fundamental part of a technologist’s education. We also believe that many topics in graphics and the visualization process can be very difficult for some students to understand and learn. For these and other reasons, we have developed this text, which addresses both traditional and modern elements of technical graphics, using what we believe to be an interesting and straightforward approach.

In Chapter 1 you will learn about the “team” concept for solving design problems. The authors of this text used this concept, putting together a team of authors, reviewers, industry representatives, focus group, and illustrators, and combining that team with the publishing expertise at Richard D. Irwin to develop a modern approach to the teaching of technical graphics.

Engineering and technical graphics have gone through significant changes in the last decade, due to the use of computers and CAD software. It seems as if some new hardware or software development that impacts technical graphics is occurring every year. Although these changes are important to the subject of technical graphics, there is much about the curriculum that has not changed. Engineers and technologists still find it necessary to communicate and interpret designs, using graphics methods such as drawings or computer models. As powerful as today’s computers and CAD software have become, they are of little use to engineers and technologists who do not fully understand fundamental graphics principles and 3-D modeling strategies, or do not possess a high-level visualization ability.

This new-generation graphics text is therefore based on the premise that there must be some fundamental changes in the content and process of graphics instruction. Although many graphics concepts remain the same, the fields of engineering and technical

graphics are in a transition phase from hand tools to the computer, and the emphasis of instruction is changing from drafter to 3-D geometric modeler, using computers instead of paper and pencil. Much of this text is still dedicated to the instruction of graphics using hand tools, but the instruction is generic, so that either hand tools or computers can be used.

The content and instructional approach used in this text is a direct result of two curriculum studies conducted early in this decade. The National Science Foundation (NSF) study, conducted at the University of Texas by Davor Jurisic and Ron Barr, concluded that 3-D modeling should be the core of technical graphics instruction. A study sponsored by SIGGRAPH and conducted by Gary Bertoline and Mary Sadowski, Purdue University, Del Bowers, Arizona State University, Mike Pleck, University of Illinois, Mike McGrath, Colorado School of Mines, and a Delphi group of more than 30 educational and industrial leaders determined, among other findings, that graphics instruction has a common knowledge base, and that visualization instruction is an important part of the graphics curriculum. This text has made an effort to embrace the findings of both of these studies.

The primary goal of this text is to help the engineering and technology student learn the techniques and standard practices of technical graphics, so that design ideas can be adequately communicated and produced. The text concentrates on the concepts and skills necessary to use both hand tools and 2-D or 3-D CAD. The primary goals of the text are to show how to:

1. Clearly represent and control mental images.
2. Graphically represent technical designs, using accepted standard practices.
3. Use plane and solid geometric forms to create and communicate design solutions.
4. Analyze graphics models, using descriptive and spatial geometry.
5. Solve technical design problems, using traditional tools or CAD.

6. Communicate graphically, using sketches, traditional tools, and CAD.
7. Apply technical graphics principles to many engineering disciplines.

IMPORTANT FEATURES OF THIS BOOK

Much thought has gone into designing a *complete* instructional approach to teaching and learning of technical graphics. The instructor is provided with a number of tools to assist in the instruction aspects, and the student is provided with tools to assist in the learning process.

This text was specifically written using techniques which will prepare students to use technical graphics to solve design problems and communicate graphically. Our goal was to provide to the students a text-book that was clear, interesting, and relevant.

Some of the important features of this text include:

1. **Integration of CAD**—CAD concepts and practices have been integrated through all the chapters, when they are relevant to the topic. They are not simply “tacked onto” the end of a chapter.
2. **CAD references**—The CAD references direct the student and instructor to a specific CAD activity that should be done. The references are keyed directly to *The AutoCAD Companion* and *AutoCAD Instructor*, written by James Leach, and *The CADKEY Companion*, written by John Cherng. These texts are comprehensive CAD manuals that, when combined with this text, provide a complete instructional package for engineering design graphics.
3. **Four-color illustrations**—Color is used to enhance the instruction process and to show the student how powerful a medium graphics can be in every engineering discipline. The use of four-color illustrations is a first for a technical graphics text.
4. **Practice exercises**—Integrated throughout the text are *Practice Exercises*, which will give students real experience in learning the concepts being presented.
5. **Industry application boxes**—Most chapters have an *Industry Application* box that summarizes an article showing how graphics and design are being used in industry today.
6. **Chapter objectives**—Every chapter starts with a list of objectives, so that students will know what they will be learning in that chapter.
7. **Chapter introduction and summary**—The introduction prepares the student for what is in the chapter. The summary at the end of the chapter emphasizes the important elements presented.
8. **Key terms**—This list of terms located at the end of each chapter highlights the important terms that appear in boldface throughout the chapter.
9. **Glossary**—A glossary at the end of the text contains the definitions of all key terms.
10. **Further reading**—Each chapter contains a list of books and articles that are relevant to the material covered in the chapter.
11. **Questions for review**—At the end of each chapter is a list of questions covering the important concepts and information that the students should have learned in the chapter.
12. **Problems**—Numerous problems are included at the end of each chapter, so that students can apply the concepts and knowledge just learned, and instructors can gage the progress of the students.
13. **Integration of sketching**—Sketching activities are integrated throughout the text and are included in the end-of-chapter problems.
14. **Step-by-step illustrated procedures**—Most chapters include many drawing examples that use step-by-step procedures with illustrations to demonstrate how to create graphics elements. These step-by-step procedures show the student in simple terms how a drawing is produced.
15. **Highlighting**—Important words and phrases are italicized to highlight important information.
16. **Visualization**—Part of Chapter 2 is devoted exclusively to visualization to assist the student in understanding the concepts and importance of visualization, and offers techniques for reading and visualizing engineering drawings.
17. **Coverage of engineering geometry**—The text contains extensive coverage of engineering

geometry, including the geometry that can be created with surface and solid modeling software, which is so important when using 3-D CAD.

18. **Quality**—Every effort was made to provide a quality text containing accurate, up-to-date information. Accuracy is a continual process, emphasized throughout the project. The figures and other graphics contained in the text were meticulously designed and developed using the latest computer graphics technology. The graphics were reviewed by the editors and authors, tested in the classroom, and checked by technical graphics instructors.

19. **Irwin Graphics Series**—This text is part of a series of texts, workbooks, and related curriculum material that is being developed for engineering and technical graphics. The series will provide the user with a complete assortment of instructional material, ranging from traditional texts to CAD workbooks to many nontraditional materials, such as grading programs and computer animations.

SUPPLEMENTS

A number of supplements have been developed to assist in the instruction of technical graphics. Most of these supplements are contained in the *Graphics Instructional Library (GIL)*, which is available to those who adopt this text. The GIL contains the following items:

Instructor's Manual

This supplement is available in hard copy and it contains:

Chapter outlines.
Teaching tips.
Test questions.

CD-ROM

Many figures from the text will be available on CD-ROM for instructional use. In addition animations and grading programs are on the CD-ROM.

An MS/Windows-based grading program, which can be used to analyze student scores statistically and graphically, has been developed. For those that adopt both this text and James Leach's *AutoCAD Companion*, a program is available that permits on-screen

grading of AutoCAD drawing problems and automatically enters the grade into an MS/Excel spreadsheet.

In addition, supplemental Autolisp programs, such as a command for making a parabola with AutoCAD, are available on disk. Demonstration versions of some software are also on disk, such as a program that automatically creates a development from a 3-D model. Finally, there is a Hypercard-based visualization test that automatically scores responses and prints the results.

Solutions Manual

This solutions guide contains answers to the end-of-chapter questions, as well as many of the end-of-chapter drawing problems.

Workbooks

Three traditional workbooks with additional problems are available. These three workbooks, *Problems for Engineering Graphics Communication and Technical Graphics Communication Series 1 and 2*, have been developed by the faculty at Purdue University and have been subjected to over 30 years of classroom testing. In addition, another workbook, *Engineering Design and Visualization Workbook*, has been created by Dennis Stevenson at the University of Wisconsin-Parkside. This workbook has many traditional and nontraditional types of problems that are useful for visualization exercises and 3-D modeling.

Software

Contained in the GIL is additional software useful for teaching technical graphics. CADKEY, Inc., has a special version of their software for use in the classroom.

How the Graphics Were Produced

Taking a page from our own book, the authors produced 3-D models for nearly every illustration created for this book. The models were created with AutoCAD and Form-Z software, using MS-DOS-based and Macintosh hardware. After the models were created, the necessary views were extracted and imported into FreeHand, 3-D Studio, StrataVision, or PhotoShop illustration software for final rendering. Some of the models were also used to create animations, using 3-D

Studio and Animator Pro for the video that is in the Graphics Instructional Library. Some images were scanned and modified using PhotoShop and FreeHand. File translations between different file formats and computer platforms were accomplished using HiJack Pro, DOS Mounter, Mac-in-DOS, and Debabilizer. Large files were compressed using PK Zip and StuffIt Deluxe. DeltaGraph and MS Excel were used to create most of the graphs in the text. Some of the sketches were created using Squiggle. Many of the end-of-chapter illustrations were created by modeling real parts, using industry blueprints or reverse engineering of real products. Screen grabs of computer images were created using HiJack Pro.

ACKNOWLEDGMENTS

The authors wish to thank the reviewers, focus groups, and industrial advisory board members for their contribution to the content, organization, and quality of this book and its supplements.

Reviewers

John G. Nee
Central Michigan University

Rebecca Rosenbauer
Lafayette College

Douglas W. Smith
Austin Community College

Leroy Crist
Southeastern Community College

Richard W. Carter
Western Illinois University

Lowell P. Stanlake
University of North Dakota

James C. Shahan
Iowa State University

Gerald L. Bacza
Fairmont State College

James Merrigan
Brookdale Community College

Mark A. Curtis
Ferris State University

Robert P. Kaiser
ITT Technical Institute

Basavapatna S. Sridhara
Middle Tennessee State University

Daniel H. Suchora
Youngstown State University

William F. Eichfeld
Southern Illinois University–Carbondale

James F. Bebee
San Francisco State University

William E. Gavin
Mississippi State University

Focus Group

A focus group was held at the 1993 Engineering Design Graphics Mid-year Meeting in San Francisco, California. The authors are especially grateful to the following individuals, who spent many hours reviewing and discussing the manuscript:

Robert Chin
East Carolina State University

John B. Crittenden
Virginia Polytechnic Institute

Thomas Sweeney
Hutchinson Technical College

Doug Frampton
The University of Akron

Robert Raudebaugh
Western Washington State University

Ed Nagle
Tri-State University

Murari Shah
Purdue University

Industrial Advisory Board

The industrial advisory board served the authors in a number of different ways, such as providing illustrations, reviewing material, providing plant tours and interviews, and proffering their advice.

Lynn Smith, Manager, Imaging Services
Intergraph Corporation

Steve Zucker, Manager, Marketing Communications
McDonnell Douglas

Bruce Pilgrim, Publication Director
SDRC

Tony DeJoseph, Supervisor of Design Technology
Corning Inc.

Bill Abramson
Grumman Aerospace Corporation

Robert D. Olmstead, Director, Product Engineering
Stanley Bostitch

Steve Johnston, Manager of Design Drafting
Westinghouse Electric-Electro/Mechanical Division

Roger Volk, Group Leader, Computer-Aided
Engineering
Monsanto Chemical Company

Ken Victor, Manager of Configuration & Integration
Northrop Corporation

Rae Todd
Platte River Power Authority

Michael E. Moncell, 3600 Current Product Manager
Caterpillar Inc.

Ron Gordy, Tool Design
Caterpillar Inc.

Jim Rau, Vice President of Engineering
TRW Ross Gear Division

Kenton Meland
Newport News Shipbuilding & Drydock Co.

M. Joseph Marvin, Chief Design Engineer
Buehler Products, Inc.

Mark Kimbrough, Design Director
Design Edge, Inc.

Mark F. Huston, Manager, Standard Products
Division
Kennametal, Inc.

Pat Lalonde
Algor, Inc.

Jim Piotrowski
Alvin & Company

Rich Seibel
Staedtler, Inc.

Steve J. Schroff, Executive Vice President
Schroff Development Corporation

Jim Meloy
Autodesk, Inc.

Neele Johnston
Autodesk, Inc.

Paul Mailhot and Pete Mancini
CADKEY, Inc.

Gloria Lawrence and Marvel O'Connor
Hewlett-Packard Company

Norm Williams
Fairfield Manufacturing Inc.

William G. Daniel, President
William G. Daniel & Associates

Ray Idaszak, Steve Thorpe, and Dave Bock
*North Carolina Supercomputing Center, a division of
MCNC*

David W. Easter
Virtus Corp.

Linda Houseman
*University of North Carolina, Department of
Computer Science*

Thomas C. Palmer
Computational Engineering International

Illustrators

A text of this type would be useless without good, accurate graphics. We have had the good fortune to have some of the best young illustrators in the country work on this text. Joe Mack and James Mohler led a team of illustrators that worked many months on the illustrations. The authors are indebted to these two individuals, both of whom have enormous talent. Joe Mack has since moved on to a very successful career in multimedia software development, and James Mohler has started his own multimedia company. In addition, the authors would like to thank the other illustrators on the team: Rob Cumberland, Jonathan Combs, Doug Acheson, Doug Bailen, Aaron Cox, Brad Johnson, Steve Adduci, Clark Cory, Trent Mohr, Keith Higgins, Dale Jackson, Jonathan Humphries, Sue Miller, Andy Mikesell, and the illustrators from Wm. C. Brown Communications, Inc.

OTHER CONTRIBUTORS

We would like to thank Tom Sweeney, an expert in GDT from Hutchinson Technical College, for his input into Dimensioning and Tolerancing Practices; William A. Ross, Purdue University, for his numerous ideas on designing the text and end-of-chapter problems; Terry Burton for his review and input into the sketching chapter; and H. J. de Garcia, Jr., University of Missouri-St. Louis, for contributing problems used in this book. Accuracy checking of end-of-chapter problems was done by Ted Branoff, North Carolina State University, Ed Nagle, Tri-State University, Jim Hardell, Virginia Polytechnic Institute, and Murari Shah, Purdue University. Special thanks to Peter Booker for the use of historical figures found in his text, *A History of Engineering Drawing*.

The authors would also like to thank the publisher, Richard D. Irwin, for its support of this project. This has been an expensive and time-consuming process for the authors and the publisher. Few publishers are willing to make the investment necessary to produce a comprehensive, modern graphics text from scratch. The technical graphics profession is indebted to Richard D. Irwin for taking the risk of defining a discipline in transition. The authors would like to thank: Tom Casson, for his support and encouragement throughout the project; Bill Stenquist, for the many hours he spent with the authors designing the contents and the strategy necessary to complete a project of this size and complexity; Brian Kibby, for his creative marketing and willingness to work with the authors to see that instructors would understand the features of this text; and Kelley Butcher for all the work she put into this project. She is simply the best development editor with whom the authors have ever worked. In the short time Betsy Jones has been on the project, she has given us the support and direction

needed to complete the project and stay focused at a time when everything needed to be done "yesterday." Our thanks also to the production staff at Irwin, especially Bob Lange, Laurie Entringer, Charlie Hess, Charlene Breeden, Gladys True, and Kim Meriwether, who pulled the graphics and text together into a beautifully designed and easy-to-use textbook; and the production staff at Wm. C. Brown Communications, Inc., who assisted in the illustrations and produced the bound text. There are many others at Irwin who assisted on this project and we are grateful for all they have done to make this text a success.

Gary Bertoline would like to especially thank his wife, Ada, and his children, Bryan, Kevin, and Carolyn, for the sacrifices they made so that he might fulfill this important mission in his life. His thanks also go to Caroline and Robert Bertoline, who encouraged him to pursue his studies. He would also like to thank all his colleagues, especially those at Purdue University, his instructors at Northern Michigan University who inspired him to pursue graphics as a discipline, and Wallace Rigotti who taught him the basics.

Finally, we would like to know if this book fulfills your needs. We have assembled a "team" of authors and curriculum specialists to develop graphics instructional material. As a user of this textbook, you are a part of this "team" and we value your comments and suggestions. Please let us know if there are any misstatements, which we can then correct, or if you have any ideas for improving the material presented. Write in care of the publisher, Richard D. Irwin or call Gary R. Bertoline at 317-497-3018, or E-mail at bertolin@tech.purdue.edu, or Compuserve at 70400,475.

*Gary R. Bertoline
Eric N. Wiebe
Craig L. Miller
Leonard O. Nasman*

BRIEF CONTENTS

- 1** Introduction to Graphics Communications, *I*
- 2** Sketching, Text, and Visualization, *55*
- 3** Engineering Geometry and Construction, *139*
- 4** Multiview Drawings, *205*
- 5** Pictorial Drawings, *281*
- 6** Auxiliary Views, *333*
- 7** Section Views, *357*
- 8** Dimensioning and Tolerancing Practices, *393*
- 9** Reading and Constructing Working Drawings, *463*
- 10** Integrated Design and Modeling with CAD, *565*

Appendices, *A-1*

Index, *I-1*

CONTENTS

1 Introduction to Graphics Communications, 1

Objectives, 1

- 1.1 Introduction, 2
- 1.2 The Importance of Technical Graphics, 5
- 1.3 The Design Process, 6
- 1.4 Changes in the Engineering Design Process, 8
- 1.5 Standards and Conventions, 9
- 1.6 What You Will Learn, 10
 - INDUSTRY APPLICATION:** Custom Athletic Shoes Using CAD, 11
- 1.7 Specialists and Technical Drawings, 11
- 1.8 Technical Drawing Tools, 11
- 1.9 Computer-Aided Drawing Tools, 12
 - 1.9.1 Display Devices, 12
 - 1.9.2 Input Devices, 12
 - 1.9.3 Output Devices, 15
- 1.10 Traditional Tools, 16
 - 1.10.1 Straightedges, 16
 - 1.10.2 Protractors, 17
 - 1.10.3 Pencils, 17
 - INDUSTRY APPLICATION:** Virtual Reality Changes the Face of Design, 18
- 1.10.4 Drawing Paper, 18
- 1.10.5 Triangles, 19
- 1.11 Alphabet of Lines, 20
- 1.12 Line Drawing Techniques, 22
 - 1.12.1 Erasing, 23
 - 1.12.2 Drawing a Line through Two Points, 24
 - 1.12.3 Drawing Parallel Lines, 24
 - 1.12.4 Drawing Perpendicular Lines, 25
 - 1.12.5 Drawing Lines at Angles Relative to a Given Line, 26
 - 1.12.6 Drawing Irregular Curves, 26
- 1.13 Scales, 28
 - 1.13.1 Architect's Scale, 29
 - 1.13.2 Civil Engineer's Scale, 30
 - 1.13.3 Mechanical Engineer's Scale, 31
 - 1.13.4 Metric Scale, 35
- 1.14 Drawing Instrument Set, 36
 - 1.14.1 Compass, 36
 - 1.14.2 Dividers, 37
- 1.15 Templates, 38
- 1.16 Technique for Drawing Using Traditional Tools, 39
- 1.17 Summary, 40

Key Terms, 41

Questions for Review, 41

Further Reading, 42

Problems, 42

2 Sketching, Text, and Visualization, 55

Objectives, 55

- 2.1 Technical Sketching, 56
 - 2.1.1 Freehand Sketching Tools, 58
 - INDUSTRY APPLICATION:** Sketch Modeling with CAD, 59
- 2.2 Sketching Technique, 61
 - 2.2.1 Straight Lines, 61
 - 2.2.2 Curved Lines, 63
- 2.3 Proportions and Construction Lines, 64
- 2.4 Introduction to Projections, 68
 - 2.4.1 Isometric Pictorials, 70
 - 2.4.2 Isometric Ellipses, 72
 - 2.4.3 Isometric Grid Paper, 75
 - 2.4.4 Oblique Pictorials, 76
 - 2.4.5 Multiview Projections, 77
- 2.5 Multiview Sketching Technique, 82
 - 2.5.1 Precedence of Lines, 82
 - 2.5.2 Conventional Practices for Circles and Arcs, 83
- 2.6 Multiview Sketches, 83
 - 2.6.1 One-View Sketches, 83
 - 2.6.2 Two-View Sketches, 83
 - 2.6.3 Three-View Sketches, 85
- 2.7 Lettering, 86
 - 2.7.1 Lettering Standards, 87
 - 2.7.2 Hand Lettering, 87
 - 2.7.3 Alternate Text Styles, 88
 - 2.7.4 Computer Lettering Technique, 90
- 2.8 Text on Drawings, 93
- 2.9 Visualization for Design, 94
 - 2.9.1 Problem Solving, 96
- 2.10 Solid Object Features, 97
- 2.11 General Visualization Techniques, 98
 - 2.11.1 Solid Object Combinations and Negative Solids, 98
 - 2.11.2 Planar Surfaces, 101
- 2.12 Visualization Techniques for Engineering Drawings, 107
 - 2.12.1 Image Planes, 107

2.12.2	Object-Image Plane Orientation, 107	3.12.2	Ruled Surfaces, 192
2.12.3	Multiple Image Planes, 109	3.12.3	Fractal Curves and Surfaces, 197
2.12.4	Choosing a View to Describe an Object, 111	3.13	Summary, 198 <i>Key Terms</i> , 198 <i>Questions for Review</i> , 198 <i>Further Reading</i> , 199 <i>Problems</i> , 199
2.13	Future Directions, 112	4	Multiview Drawings, 205
2.14	Summary, 113 <i>Key Terms</i> , 114 <i>Questions for Review</i> , 114 <i>Further Reading</i> , 115 <i>Problems</i> , 115	Objectives, 205	
3	Engineering Geometry and Construction, 139	4.1	Projection Theory, 206 4.1.1 Line of Sight (LOS), 206 4.1.2 Plane of Projection, 206 4.1.3 Parallel versus Perspective Projection, 206
	Objectives, 139	4.2	Multiview Projection Planes, 210 4.2.1 Frontal Plane of Projection, 210 4.2.2 Horizontal Plane of Projection, 210 INDUSTRY APPLICATION: CAD and Stereolithography Speed Solenoid Design, 211 4.2.3 Profile Plane of Projection, 212 4.2.4 Orientation of Views from Projection Planes, 212
3.1	Engineering Geometry, 140	4.3	Advantages of Multiview Drawings, 213
3.2	Shape Description, 140	4.4	The Six Principal Views, 214 4.4.1 Conventional View Placement, 217 4.4.2 First- and Third-Angle Projection, 217 4.4.3 Adjacent Views, 220 4.4.4 Related Views, 220 4.4.5 Central View, 220 4.4.6 Line Conventions, 220 4.4.7 Multiviews from 3-D CAD Models, 227
3.3	Coordinate Space, 140 3.3.1 Right-Hand Rule, 143 3.3.2 Polar Coordinates, 143 3.3.3 Cylindrical Coordinates, 144 3.3.4 Spherical Coordinates, 145 3.3.5 Absolute and Relative Coordinates, 145 3.3.6 World and Local Coordinate Systems, 146	4.5	Views Selection, 231
3.4	Geometric Elements, 147	4.6	Fundamental Views of Edges and Planes, 233 4.6.1 Edges (Lines), 234 4.6.2 Principal Planes, 234 4.6.3 Inclined Planes, 236 4.6.4 Oblique Planes, 238
3.5	Points, Lines, Circles, and Arcs, 147 3.5.1 Points, 147 3.5.2 Lines, 149 3.5.3 Tangencies, 154 3.5.4 Circles, 161 3.5.5 Ogee Curves, 164 3.5.6 Irregular Curves of Arcs, 165 3.5.7 Rectified Arcs, 165 INDUSTRY APPLICATION: Computer Design of a New Generation of Amtrak Seats, 166	4.7	Multiview Representations, 238 4.7.1 Points, 238 4.7.2 Planes, 238 4.7.3 Change of Planes (Corners), 240 4.7.4 Angles, 241 4.7.5 Curved Surfaces, 241 4.7.6 Holes, 243 4.7.7 Fillets, Rounds, Finished Surfaces, and Chamfers, 243 4.7.8 Runouts, 246 4.7.9 Elliptical Surfaces, 247 4.7.10 Irregular or Space Curves, 249 4.7.11 Intersecting Cylinders, 249 4.7.12 Cylinders Intersecting Prisms and Holes, 250
3.6	Conic Curves, 166 3.6.1 Parabolas, 166 3.6.2 Hyperbolas, 169 3.6.3 Ellipses, 171		
3.7	Roulettes, 175 3.7.1 Spirals, 176 3.7.2 Cycloids, 177 3.7.3 Involutes, 178		
3.8	Double-Curved Lines, Including Helixes, 178		
3.9	Freeform Curves, 179 3.9.1 Spline Curves, 179		
3.10	Angles, 180 3.10.1 Bisecting an Angle, 181 3.10.2 Transferring an Angle, 181		
3.11	Planes, 182		
3.12	Surfaces, 183 3.12.1 Two-Dimensional Surfaces, 185		

- 4.8 Multiview Drawings Visualization, 250
 - 4.8.1 Projection Studies, 251
 - 4.8.2 Physical Model Construction, 251
 - 4.8.3 Adjacent Areas, 253
 - 4.8.4 Similar Shapes, 254
 - 4.8.5 Surface Labeling, 255
 - 4.8.6 Missing Lines, 255
 - 4.8.7 Vertex Labeling, 256
 - 4.8.8 Analysis by Solids, 256
 - 4.8.9 Analysis by Surfaces, 258
- 4.9 ANSI Standards for Multiview Drawings, 259
 - 4.9.1 Partial Views, 259
 - 4.9.2 Revolution Conventions, 260
 - 4.9.3 Removed Views, 261
- 4.10 Summary, 261
 - Key Terms*, 262
 - Questions for Review*, 262
 - Problems*, 262

5 Pictorial Drawings, 281

- Objectives, 281
- 5.1 Axonometric Drawings, 282
- 5.2 Isometric Axonometric Projections, 282
 - 5.2.1 Isometric Axonometric Drawings, 286
- INDUSTRY APPLICATION: Hong Kong Airport Uses CAD and Pictorial Views in Its Design, 303
- 5.3 Oblique Drawings, 306
 - 5.3.1 Oblique Projection Theory, 306
 - 5.3.2 Oblique Drawing Classifications, 308
 - 5.3.3 Object Orientation Rules, 308
 - 5.3.4 Oblique Drawing Construction, 309
 - 5.3.5 Standards for Dimensions, 313
- 5.4 Perspective Drawings, 313
- 5.5 Perspective Drawing Terminology, 315
- 5.6 Perspective Drawing Classifications, 317
- 5.7 Perspective Drawing Variables Selection, 319
- 5.8 One-Point Perspectives, 319
 - 5.8.1 Plan View Method, 319
 - 5.8.2 Measuring Line Method, 321
 - 5.8.3 Circular Features, 323
- 5.9 CAD Perspective Drawings, 323
- 5.10 Summary, 323
 - Key Terms*, 325
 - Questions for Review*, 325
 - Further Reading*, 326
 - Problems*, 326

6 Auxiliary Views, 333

- Objectives, 333
- 6.1 Auxiliary View Projection Theory, 334
 - 6.1.1 Fold-Line Method, 334
 - 6.1.2 Reference Plane Method, 335

- 6.2 Auxiliary View Classifications, 337
 - 6.2.1 Fold-Line Labeling Conventions, 338
 - 6.2.2 Depth Auxiliary View, 338
 - 6.2.3 Height Auxiliary View, 338
 - 6.2.4 Width Auxiliary View, 341
 - 6.2.5 Partial Auxiliary Views, 342
 - 6.2.6 Half Auxiliary Views, 342
 - 6.2.7 Curves, 342
 - 6.2.8 Auxiliary Views Using CAD, 343
- INDUSTRY APPLICATION: Design for the Environment (DFE), 344
- 6.3 Auxiliary View Applications, 344
 - 6.3.1 Reverse Construction, 344
 - 6.3.2 View in a Specified Direction: Point View of a Line, 345
 - 6.3.3 Dihedral Angles, 345
 - 6.3.4 Successive Auxiliary Views: True Size of Oblique Surfaces, 345
- 6.4 Summary, 349
 - Key Terms*, 349
 - Questions for Review*, 349
 - Problems*, 349

7 Section Views, 357

- Objectives, 357
- 7.1 Sectioning Basics, 358
 - 7.1.1 CAD Technique, 362
 - 7.1.2 Visualization of Section Views, 362
- 7.2 Cutting Plane Lines, 365
 - 7.2.1 Placement of Cutting Plane Lines, 365
- 7.3 Section Line Practices, 366
 - 7.3.1 Material Symbols, 367
 - 7.3.2 Drawing Techniques, 367
 - 7.3.3 Outline Sections, 369
 - 7.3.4 Thin Wall Sections, 370
- 7.4 Section View Types, 370
 - 7.4.1 Full Sections, 371
 - 7.4.2 Half Sections, 371
 - 7.4.3 Broken-Out Sections, 372
 - 7.4.4 Revolved Sections, 372
 - 7.4.5 Removed Sections, 373
 - 7.4.6 Offset Sections, 376
 - 7.4.7 Assembly Sections, 376
- INDUSTRY APPLICATION: Adjustable Mountain Bike Suspension, 379
- 7.4.8 Auxiliary Sections, 380
- 7.5 Special Sectioning Conventions, 380
 - 7.5.1 Ribs, Webs, and Other Thin Features, 380
 - 7.5.2 Aligned Sections, 380
 - 7.5.3 Conventional Breaks, 382
- 7.6 3-D CAD Techniques, 383

7.7 Summary, 384
Key Terms, 386
Questions for Review, 386
Problems, 386

8 Dimensioning and Tolerancing Practices, 393

Objectives, 393

8.1 Dimensioning, 394
 8.2 Size and Location Dimensions, 395
 8.2.1 Units of Measure, 395
 8.2.2 Terminology, 396
 8.2.3 Basic Concepts, 398
 8.2.4 Size Dimensions, 398
 8.2.5 Location and Orientation Dimensions, 399
 8.2.6 Coordinate Dimensions, 399
 8.2.7 Standard Practices, 400

8.3 Detail Dimensioning, 403
 8.3.1 Diameter versus Radius, 406
 8.3.2 Holes and Blind Holes, 406
 8.3.3 Counterbored Holes, 407
 8.3.4 Spotfaces, 408
 8.3.5 Countersinks, 408
 8.3.6 Screw Threads, 408
 8.3.7 Grooves, 408
 8.3.8 Manufacturers' Gages, 408

INDUSTRY APPLICATION: Global Design Teams Using Computers to Communicate and Exchange Data, 410

8.4 Dimensioning Techniques, 410
 8.4.1 The Dimensioning Process, 411
 8.4.2 Dimensioning Guidelines, 412
 8.4.3 ANSI Standard Dimensioning Rules, 414

8.5 Tolerancing, 416
 8.5.1 Tolerance Theory, 416
 8.5.2 Interchangeability, 416

8.6 Tolerance Representation, 417
 8.6.1 General Tolerances, 417
 8.6.2 Limit Dimensions, 418
 8.6.3 Plus and Minus Dimensions, 418
 8.6.4 Single Limit Dimension, 418
 8.6.5 Important Terms, 418
 8.6.6 Fit Types, 419
 8.6.7 Fit Type Determination, 421
 8.6.8 Tolerance Costs, 421
 8.6.9 Functional Dimensioning, 422
 8.6.10 Tolerance Stack-Up, 422
 8.6.11 Metric Limits and Fits, 425
 8.6.12 Standard Precision Fits: English Units, 429

8.7 Tolerances in CAD, 434
 8.7.1 Geometric Accuracy, 435
 8.7.2 Associative Dimensioning, 435

8.8 Geometric Dimensioning and Tolerancing, 435
 8.9 GDT Symbols, 436
 8.10 GDT Rule #1, 436
 8.11 Maximum Material Condition, 438
 8.11.1 Material Condition Symbols, 438
 8.11.2 Departure from MMC, 439
 8.11.3 Perfect Form at MMC, 439
 8.11.4 Separation of Control Types, 439

8.12 Datums and Datum Features, 440
 8.12.1 Datum Uses, 440
 8.12.2 Datums and Assembly, 440
 8.12.3 Datum Feature Control, 441
 8.12.4 Datum Reference Frame, 441
 8.12.5 Primary Datum, 441
 8.12.6 Secondary and Tertiary Datums, 441
 8.12.7 Datum Feature Identifiers, 442

8.13 Geometric Controls, 442
 8.13.1 Perfection, 442
 8.13.2 Tolerance Zones, 442
 8.13.3 Virtual Condition, 442
 8.13.4 Form Controls, 442
 8.13.5 Orientation Controls, 445
 8.13.6 Position Controls, 447

8.14 Design Applications, 448
 8.14.1 Five-Step GDT Process, 448
 8.14.2 Application Example, 449

8.15 Summary, 451
Key Terms, 456
Questions for Review, 456
Problems, 457

9 Reading and Constructing Working Drawings, 463

Objectives, 463

9.1 Basic Concepts, 464
 9.2 Working Drawings, 465
 9.2.1 Detail Drawings, 465
 9.2.2 Assembly Drawings, 468
 9.2.3 Part Numbers, 470
 9.2.4 Drawing Numbers, 470
 9.2.5 Title Blocks, 473
 9.2.6 Parts Lists, 474
 9.2.7 Part Identification, 476
 9.2.8 Revision Block, 476
 9.2.9 Scale Specifications, 476
 9.2.10 Tolerance Specifications, 477
 9.2.11 Zones, 477
 9.2.12 Tabular Drawings, 478

INDUSTRY APPLICATION: Concurrent Engineering and 3-D CAD Produce New Car in Record Time, 480

9.2.13 Working Assembly Drawing, 480
 9.3 Threaded Fasteners, 480
 9.3.1 Applications, 481

9.3.2	Thread Terminology, 482	10.3.5	3-D Viewing Techniques, 581
9.3.3	Thread Specifications: English System, 482	10.3.6	Object Modification, 584
9.3.4	Thread Specifications: Metric System, 486	10.4	3-D Modeling and the Design Process, 587
9.3.5	Thread Drawings, 487	10.5	Ideation, 587
INDUSTRY APPLICATION: Design for Manufacturability (DFM) Reduces Number of Fasteners, 488		10.5.1	Problem Identification, 587
9.4	Standard Bolts, Studs, and Screws, 492	10.5.2	Preliminary Ideas Statement, 589
9.4.1	Standard Bolts, 492	10.5.3	Preliminary Design, 590
9.4.2	Standard Nuts, 493	10.6	Refinement, 590
9.4.3	Standard Screws, 493	10.6.1	Modeling, 592
9.4.4	Locking Devices, 495	10.6.2	Computer Simulation and Animation, 594
9.4.5	Templates, 495	10.6.3	Design Analysis, 595
9.4.6	CAD Techniques, 495	10.7	Design Visualization, 599
9.5	Nonthreaded Fasteners, 496	10.7.1	Data Visualization Elements, 600
9.5.1	Standard Washers, 496	10.7.2	Visualizations for One Independent Variable, 603
9.5.2	Pins, 497	10.7.3	Visualizations for Two Independent Variables, 605
9.5.3	Keys, 497	10.8	Implementation, 607
9.5.4	Rivets, 498	10.8.1	Planning, 607
9.6	Springs, 499	INDUSTRY APPLICATION: Using AutoCAD Solid Modeling for New Product Development, 609	
9.7	Mechanisms, 500	10.8.2	Production, 610
9.7.1	Gears, 500	10.8.3	Marketing, 611
9.7.2	Cams, 502	10.8.4	Finance, 612
9.7.3	Linkages, 505	10.8.5	Management, 613
9.7.4	Bearings, 507	10.8.6	Service, 614
9.8	Piping, 508	10.8.7	Documentation, 614
9.8.1	Piping Components, 509	10.9	Summary, 619
9.8.2	Pipe Drawings, 510	INDUSTRY APPLICATION: Design for Manufacturability (DFM), 620	
9.9	Welding, 512	Key Terms, 621	
9.9.1	Welding Processes, 515	Questions for Review, 622	
9.9.2	Welded Joint Types, 515	Further Reading, 623	
9.9.3	Weld Symbols, 516	Problems, 623	
9.9.4	Weld Types, 518		
9.10	Reprographics, 519	APPENDICES, A-1	
9.10.1	Reproduction Techniques, 520	1	Metric Equivalents, A-3
9.10.2	Digital Technologies, 521	2	Trigonometry Functions, A-4
9.11	Summary, 522	3	ANSI Running and Sliding Fits (RC), A-5
	<i>Key Terms, 522</i>	4	ANSI Clearance Locational Fits (LC), A-6
	<i>Questions for Review, 523</i>	5	ANSI Transition Locational Fits (LT), A-7
	<i>Further Reading, 524</i>	6	ANSI Interference Locational Fits (LN), A-8
	<i>Problems, 524</i>	7	ANSI Force and Shrink Fits (FN), A-9
10	Integrated Design and Modeling with CAD, 565	8	Description of Preferred Metric Fits, A-10
10.1	Design, 566	9	ANSI Preferred Hole Basis Metric Clearance Fits, A-11
10.2	The Engineering Design Process, 568	10	ANSI Preferred Hole Basis Transition and Interference Fits, A-12
	10.2.1 Traditional Engineering Design, 568	11	ANSI Preferred Shaft Basis Metric Clearance Fits, A-13
	10.2.2 Concurrent Engineering Design, 568		
10.3	3-D Modeling, 570		
	10.3.1 Wireframe Modeling, 570		
	10.3.2 Surface Modeling, 572		
	10.3.3 Solid Modeling, 573		
	10.3.4 3-D Construction Techniques, 577		

12 ANSI Preferred Shaft Basis Metric Transition and Interference Fits, *A-14*
13 Unified Standard Screw Thread Series, *A-15*
14 Thread Sizes and Dimensions, *A-16*
15 Tap Drill Sizes for American National Thread Forms, *A-17*
16 Hex Cap Screws (Finished Hex Bolts), *A-17*
17 Socket Head Cap Screws (1960 Series), *A-18*
18 Square Head Bolts, *A-19*
19 Hex Nuts and Hex Jam Nuts, *A-20*
20 Square Nuts, *A-21*
21 ANSI Metric Hex Jam Nuts and Heavy Hex Nuts, *A-22*
22 ANSI Metric Hex Nuts, Styles 1 and 2, *A-22*
23 ANSI Metric Slotted Hex Nuts and Hex Flange Nuts, *A-23*
24 ANSI Square and Hexagon Machine Screw Nuts and Flat Head Machine Screws, *A-24*
25 ANSI Slotted Flat Countersunk Head Cap Screws, *A-25*
26 ANSI Slotted Round and Fillester Head Cap Screws, *A-25*
27 Drill and Counterbore Sizes for Socket Head Cap Screws, *A-26*
28 ANSI Hexagon and Spline Socket Head Cap Screws, *A-26*
29 ANSI Hexagon Socket Head Shoulder Screws, *A-27*
30 Drill and Counterbore Sizes for Metric Socket Head Cap Screws, *A-27*
31 ANSI Socket Head Cap Screws—Metric Series, *A-28*
32 ANSI Metric Hex Bolts, *A-28*
33 ANSI Metric Hex Cap Screws, *A-29*
34 ANSI Hex and Hex Flange Head Metric Machine Screws, *A-30*
35 ANSI Slotted Flat Head Metric Machine Screws, *A-31*
36 ANSI Slotted Headless Set Screws, *A-32*
37 ANSI Hexagon and Spline Socket Set Screws, *A-32*
38 ANSI Hexagon and Spline Socket Set Screw Optional Cup Points, *A-33*
39 ANSI Square Head Set Screws, *A-34*
40 ANSI Taper Pipe Threads (NPT), *A-35*
41 ANSI Metric Plain Washers, *A-36*
42 ANSI Type A Plain Washers—Preferred Sizes, *A-37*
43 ANSI Type A Plain Washers—Additional Selected Sizes, *A-37*
44 ANSI Type B Plain Washers, *A-38*
45 ANSI Helical Spring Lock Washers, *A-39*
46 ANSI Internal and External Tooth Lock Washers, *A-40*
47 ANSI Keyseat Dimensions for Woodruff Keys, *A-41*
48 ANSI Standard Woodruff Keys, *A-42*
49 Key Size versus Shaft Diameter—Key Size and Keyway Depth, *A-43*
50 ANSI Standard Plain and Gib Head Keys, *A-43*
51 ANSI Chamfered, Square End, and Taper Pins, *A-44*
52 British Standard Parallel Steel Dowel Pins—Metric Series, *A-45*
53 ANSI Cotter and Clevis Pins, *A-46*
54 Welding Symbols, *A-47*
55 Geometric Symbols, Definitions, and Characteristics, *A-51*
56 CAD References for *AutoCAD 13 Companion*, Leach, *A-54*
57 CAD References for *AutoCAD 12 Companion*, Leach, *A-56*
58 CAD References for *CADKEY Companion*, Cherng, *A-58*

INDEX, *I-1*

CHAPTER 1

Introduction to Graphics Communications

A drawing acts as the reflection of the visual mind. On its surface we can probe, test, and develop the workings of our peculiar vision.

Edward Hill

OBJECTIVES

After completing this chapter, you will be able to:

1. Describe why technical drawings are an effective communications system for technical ideas about designs and products.
2. Define important terms related to graphics communications for technology.
3. Define standards and conventions as applied to technical drawings.
4. Describe the design process.
5. Identify the important parts of a CAD system used to create technical drawings.
6. Identify the important traditional tools used to create technical drawings.
7. Define the important terms related to traditional tools.
8. Use traditional tools and CAD to draw lines, circles, arcs, and curves.
9. Use scales, dividers, and CAD to measure and scale drawings.
10. Identify standard metric, U.S., and architectural drawing sheet sizes.
11. Identify the types and thicknesses of the various lines in the alphabet of lines.

Chapter 1 is an introduction to the graphics language and tools of the engineer and technologist. The chapter explains why technical drawing is an effective way to communicate engineering concepts, relating past developments to modern practices, and examines current industry trends, showing why engineers and technologists today have an even greater need to master graphics communications. Concepts and terms important to understanding technical drawing are explained and defined, and an overview of the tools, underlying principles, standards, and conventions of engineering graphics is included.

- Technical drawings are created using a variety of instruments, ranging from traditional tools, such as pencils, compass, and triangles, to the computer. Drawing tools are used to make accurate and legible drawings and models. Traditional drawing instruments are still important, especially for sketching; today, however, the computer can be used for most drawing and modeling requirements. This chapter is an introduction to: computer-aided design/drafting (CAD) systems, including the related hardware, software, and peripheral devices; and the traditional equipment normally used by engineers and technologists to create technical drawings and models.

1.1 INTRODUCTION

What is graphics communications? For one thing, it is an effective means of communicating technical ideas and problem solutions.

Look at what happens in engineering design. The process starts with the ability to visualize, to see the problem and the possible solutions. Then, sketches are made to record initial ideas. Next, geometric models are created from those sketches and are used for analysis. Finally, detail drawings or 3-D models are made to record the precise data needed for the production process. Visualizing, sketching, modeling, and detailing are how engineers and technologists communicate as they design new products and structures for our technological world.

Actually, graphics communications using engineering drawings and models is a language, a clear, precise language with definite rules that must be mastered if you are to be successful in engineering design. Once you know the language of graphics communications, it will influence the way you think, the way you approach problems. Why? Because humans tend to think using the languages they know. Thinking in the language of technical graphics, you will visualize problems more clearly and will use graphic images to find solutions with greater ease.

31%	Drafting and Documentation
17%	Manufacturing Engineering
7.5%	Functional Design
11%	Engineering Analysis
19.5%	Design Modeling
14%	Other

Figure 1.1 A Total View of Engineering Divided into Its Major Activities

Graphics plays a very important role in all areas of engineering, for documentation, communications, design, analysis, and modeling. Each of the activities listed is so heavily slanted toward graphics communications that engineering is 92 percent graphically based. (Information from Dataquest, Inc. CAD/CAM/CAE/GIS Industry Service.)

Figure 1.2

This jet aircraft would be impossible to create without computer graphics models and drawings. Drawings are the road maps which show how to manufacture or build products and structures.

In engineering, 92 percent of the design process is graphically based. The other 8 percent is divided between mathematics, and written and verbal communications. Why? Because graphics serves as the primary means of communication for the design process. Figure 1.1 shows a breakdown of how engineers spend their time. Drafting and documentation, along with design modeling, comprise over 50 percent of the engineer's time and are purely visual and graphical activities. Engineering analysis depends largely on reading technical graphics, and manufacturing engineering and functional design also require the production and reading of graphics.

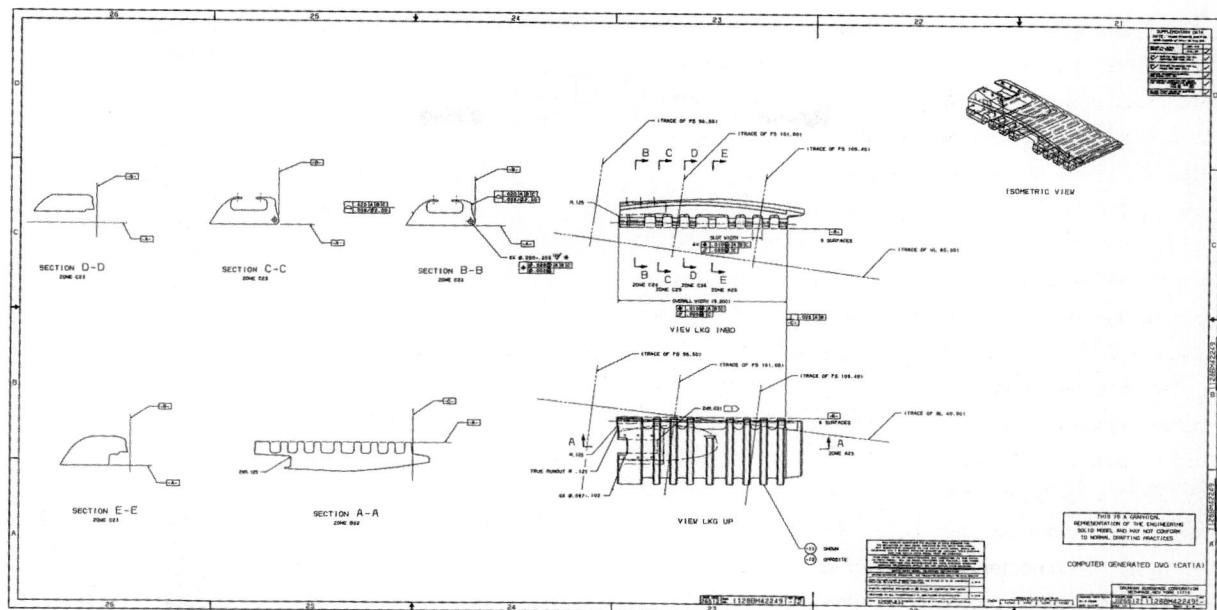

Figure 1.3 Engineering Drawing

Engineering drawings and computer models such as these were needed to produce an aircraft. The 3-D model is used to design and visualize the aircraft. The engineering drawings are used to communicate and document the design process. (Courtesy of Grumman Aerospace Corporation.)

Why do graphics come into every phase of the engineer's job? To illustrate, look at the jet aircraft in Figure 1.2. Like any new product, it was designed for a specific task and within specified parameters; however, before it could be manufactured, a three-dimensional (3-D) model and engineering drawings like those shown in Figure 1.3 had to be produced. Just imagine trying to communicate all the necessary details verbally or in writing. It would be impossible!

A designer has to think about the many features of an object that cannot be communicated with verbal descriptions. (Figure 1.4) These thoughts are dealt with in the mind of the designer using a visual, non-verbal process. This "visual image in the mind" can be reviewed and modified to test different solutions before it is ever communicated to someone else. As the designer draws a line on paper or creates a solid cylinder image with a computer, he or she is translating the mental picture into a drawing or model that will produce a similar picture in the mind of anyone who sees the drawing. This drawing or graphic representation is the medium through which visual images in the mind of the designer are converted into the real object.

Technical graphics can also communicate solutions to technical problems. Such technical graphics are

Figure 1.4 Technical Drawings Used for Communications

Technical drawings are a nonverbal method of communicating information. Descriptions of complex products or structures must be communicated with drawings. A designer uses a visual, nonverbal process. A visual image is formed in the mind, reviewed, modified, and is ultimately communicated to someone else, all using visual and graphics processes.

Figure 1.5 Users of Graphics

Users of engineering and technical graphics in industry include technical and nontechnical personnel.

produced according to certain standards and conventions so they can be read and accurately interpreted by anyone who has learned those standards and conventions.

The precision of technical graphics is aided by tools; some are thousands of years old and still in use today, and others are as new and rapidly changing as computer-aided design/drafting (CAD). This book will introduce you to the standards, conventions, techniques, and tools of technical graphics and will help you develop your technical skills so that your design ideas become a reality.

Engineers are creative people who use technical means to solve problems. They design products, systems, devices, and structures to improve our living conditions. Although problem solutions begin with thoughts or images in the mind of the designer, presentation devices and computer graphics hardware and software are powerful tools for communicating those images to others. They can also aid the visualization process in the mind of the designer. As computer graphics have a greater impact in the field of engineering, engineers will need an ever-growing understanding of and facility in graphics communications.

Technologists assist engineers and are concerned with the practical aspects of engineering in planning and production. Technologists must be able to communicate quickly and accurately using graphics, by sketching design problems and solutions, analyzing design solutions, and specifying production procedures.

Both engineers and technologists are finding that sharing technical information through graphical means is becoming more important as more nontechnical people become involved in the design/manufacturing process. As Figure 1.5 illustrates, the circle of people requiring technical information is rapidly widening, and engineering and technical information must be effectively communicated to many other people who are not engineers or technologists, such as marketing, sales, and service personnel. Computer graphics can assist in the process. It can be the tool used to draw together many individuals with a wide range of visual needs and abilities.

Practice Exercise 1.1

1. Attempt to describe the aircraft part shown in Figure 1.3 using written instructions. The instructions must be of such detail that another person can make a sketch of the part.
2. Now try verbally describing the part to another person. Have the person make a sketch from your instructions.

These two examples will help you appreciate the difficulty in trying to use written or verbal means to describe even simple mechanical parts. Refer to Figure 1.6 and others in this text to get an idea of how complicated some parts are compared to this example. It is also important to note that air and water craft have thousands of parts. For example, the nuclear powered *Sea Wolf* class submarine has over two million parts. Try using verbal or written instructions to describe that!

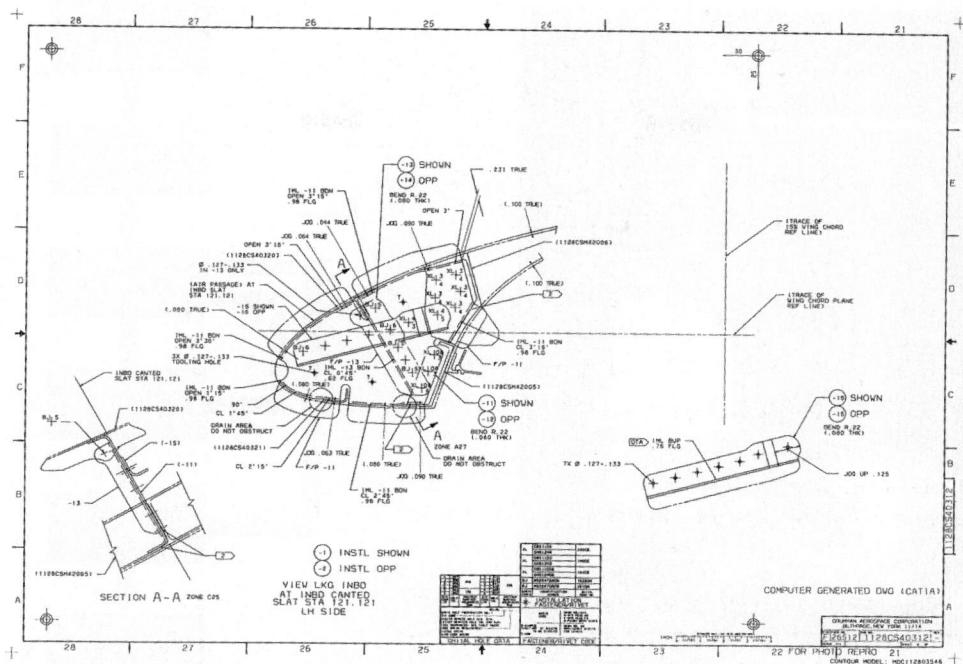

Figure 1.6 Multiview Drawing of an Aircraft Part

Only experienced users of technical drawings can interpret the various lines, arcs, and circles sufficiently to get a clear mental picture of what this part looks like three-dimensionally. (Courtesy of Grumman Aerospace Corporation.)

1.2 THE IMPORTANCE OF TECHNICAL GRAPHICS

Technical graphics is a real and complete language used in the design process for:

1. Communicating.
2. Solving problems.
3. Quickly and accurately visualizing objects.
4. Conducting analyses.

A **drawing** is a graphical representation of objects and structures and is done using freehand, mechanical, or computer methods. A drawing serves as a graphic model or representation of a real object or idea. Drawings may be abstract, such as the multiview drawings shown in Figure 1.6, or more concrete, such as the very sophisticated computer model shown in Figure 1.7. Even though drawings may take many forms, the graphics method of communication is universal and timeless.

It may seem to be a very simple task to pick up a pencil and start drawing three-dimensional images on two-dimensional paper. However, it takes special

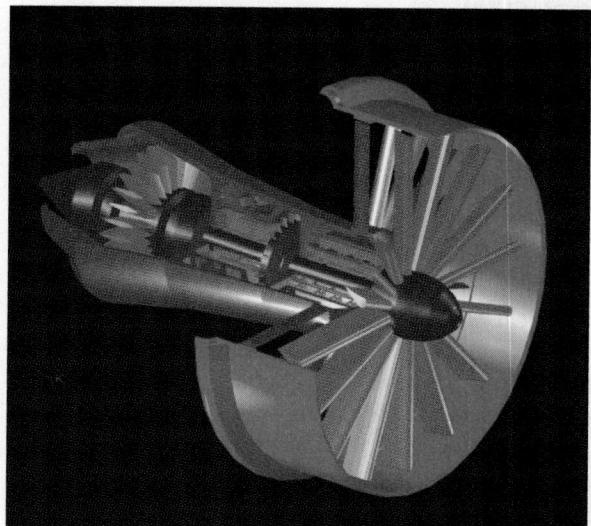

Figure 1.7 3-D Computer Model of a Turbocharger

This computer rendering of a 3-D computer model is more easily understood because more detail is given through the use of colors, lights, and shades and shadows. (Courtesy of Autodesk, Inc.)

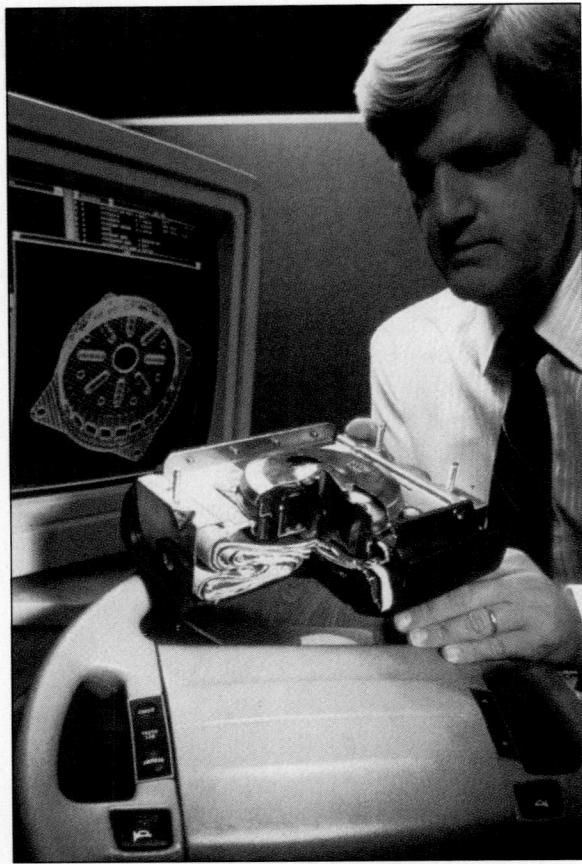

Figure 1.8

Technical drawings are used to communicate complex technical information, such as the design of an automobile airbag safety system. (Courtesy of McDonnell Douglas.)

knowledge and skill to be able to represent complex technical ideas with sufficient precision for the product to be mass-produced and the parts to be easily interchanged. (Figure 1.8) This special knowledge is called **technical drawing**.

The projection techniques used to represent 3-D images on 2-D paper or flat computer screens took many years to develop. Actually, it has taken millennia for the techniques needed for graphics communications to evolve into the complex and orderly systems we have today. The volumes of standards developed by the American National Standards Institute (ANSI) will quickly convince you that technical drawing is a precise, formal language.

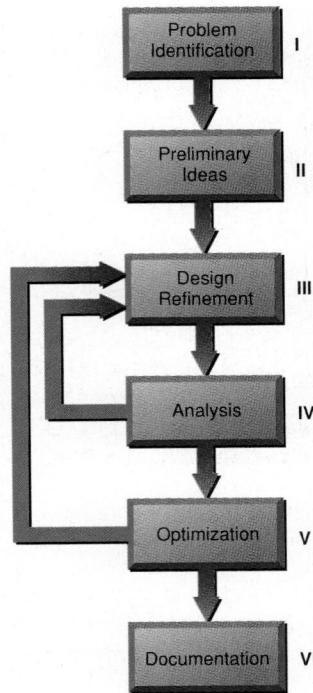

Figure 1.9 Traditional Engineering Design Sequence

The traditional design process is a sequential process that can be grouped into six major activities, beginning with identification of the problem and ending with documentation of the design. Technical graphics are used throughout this process to document design solutions.

1.3 THE DESIGN PROCESS

The **design process** involves organizing the creative and analytical processes used to satisfy a need or solve a problem. Sketches, drawings, computer models, and presentation graphics are all linked to the design and production processes.

Traditionally, the design process is a linear activity consisting of six major phases, as shown in Figure 1.9. In the design process, the problem is identified in Stage 1 and concepts and ideas are collected in Stage 2. These original thoughts are recorded as rough sketches, on paper or on the computer, using graphics. Such sketches record fleeting images in the mind and communicate initial ideas to others. This phase of engineering design is sometimes called **ideation** and the communications medium is computer models or sketches.

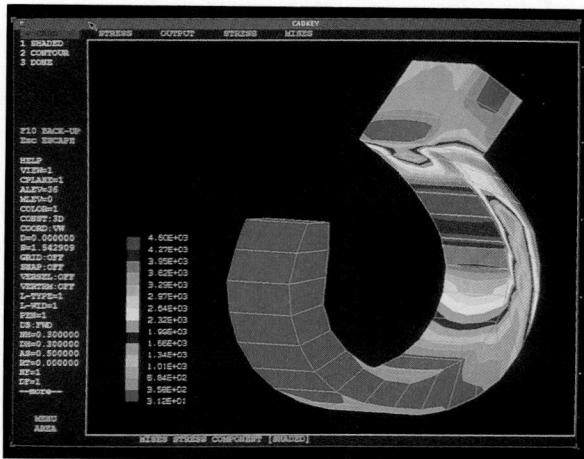

Figure 1.10 Design Refinement

This finite element model of a crane hook is used in the analysis of a part to determine where maximum stress and strain occur when a part is put under varying load conditions. Areas colored in red indicate the most highly stressed regions. This three-dimensional graphics model is typically used in Stage 4 of the design process. (Courtesy of CADKEY, Inc.)

In Stage 3, Design Refinement, a compromise solution(s) is selected from the collection of rough sketches. In this phase, as a solution to the problem becomes more clear, the initial design sketches or models are refined. The results are refined sketches or computer models that can be analyzed. The finite element model shown in Figure 1.10 is such a model. Stage 4, Analysis, and Stage 5, Optimization, are interactive steps that may be repeated many times before the final design is chosen.

After the final design solution is chosen, it must be documented or recorded (Stage 6) in sufficient detail for the product to be manufactured or constructed. The design solution is then archived for referencing or changes. (Figure 1.11) Rough sketches cannot be used in this stage of engineering design if the product is to be mass produced. Mass production requires precise drawings or computer models that follow a standard communication format. Again, from the rough sketches of Stage 1 to the precise models of Stage 6, an engineer or technologist cannot be effective without being fluent in the language of graphics communications.

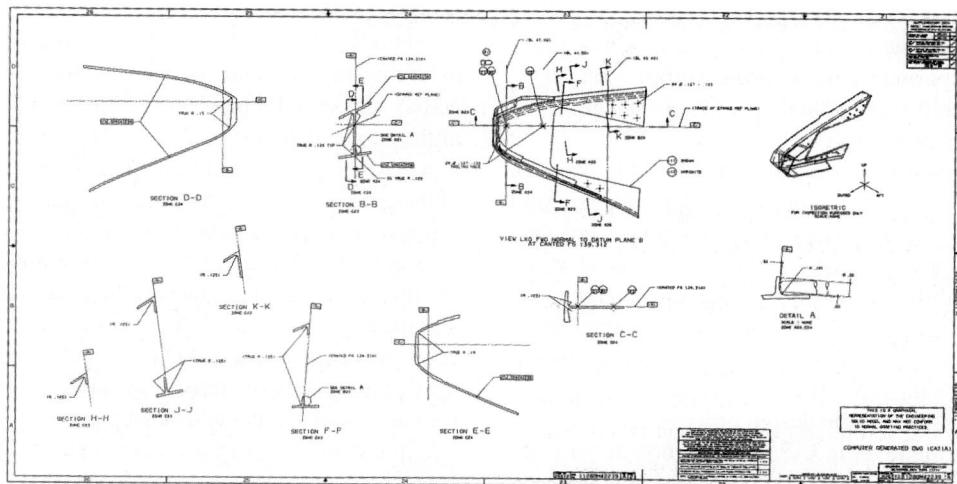

Figure 1.11 Documentation

This is a typical engineering drawing used for documentation. Drawings of this type are used in manufacturing, for planning, fabrication, and assembly. This technical drawing is part of the documentation process and is stored in a safe place for use later. (Courtesy of Grumman Aerospace Corporation.)

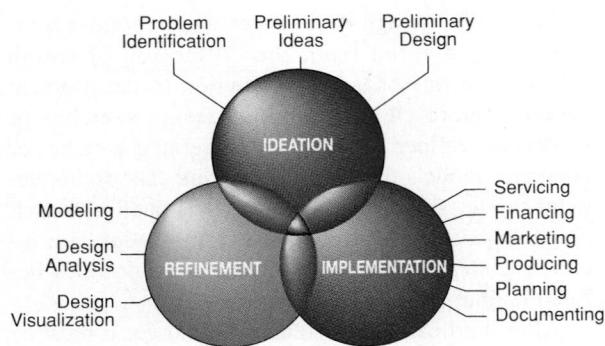

Figure 1.12 Concurrent Design Process

An alternative approach to the linear design process is called concurrent engineering. Concurrent engineering gets everyone involved in the design process, including the customer. The overlapping circles indicate that designing concurrently is an integrated activity involving many people.

1.4 CHANGES IN THE ENGINEERING DESIGN PROCESS

Modern design, analysis, and communications techniques are changing the traditional role of engineers. The design process in U.S. industry is shifting from a linear, segmented activity to a team activity, involving all areas of business and using computers as the prominent tool. This new way of designing, with its integrated team approach, is called **concurrent engineering**. Concurrent engineering (Figure 1.12) involves coordination of the technical and nontechnical functions of design and manufacturing within a business. This design shift has resulted in a major change in the way engineers do their jobs.

Engineers and technologists must be able to work in teams. They must be able to design, analyze, and communicate using powerful CAD systems, and they must possess a well-developed ability to visualize, as well as the ability to communicate those visions to nontechnical personnel. Typically, design engineers in many industries today work in teams to create conceptual designs, with rapid-fire communication back and forth at every stage of the design process.

Moreover, the trend in U.S. industry now is for engineers to be expert geometric modelers using computers. **Geometric modeling** is the process of creating computer graphics to communicate, document, analyze, and visualize the design process. Engineers use sketches and computer models for visualization, and then do minimal documentation for production. Documentation may be in the

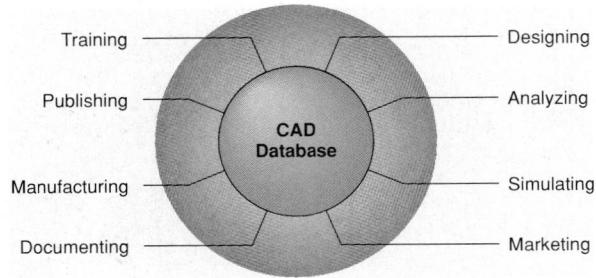

Figure 1.13 CAD Database Applications

The CAD database, which is represented as graphics, provides technical information not only to the engineers on the design team, but also to the manufacturing, marketing and sales, and training departments.

form of 3-D computer models sent directly to production to generate the *computer numerical control (CNC)* code for machining. Two-dimensional drawings are extracted from the 3-D model, with critical dimensions added for *coordinate measuring machine (CMM)* checking for quality control.

With the shift in design to concurrent engineering, widely diverse groups of people—engineers, scientists, managers, and technologists—all share a pressing need for a better understanding of the principles of visual communication. More than ever before, they all need to be able to read and interpret graphics representations of technical information, quickly, efficiently, and accurately.

Actually, the credit goes to computer graphics, with its ability to communicate many kinds of quantitative, verbal, and visual information. Figure 1.13 shows some of the applications for a CAD database in the production of a product, using concurrent engineering practices. All of these activities, from analysis and simulation to publications and training, depend on the graphical display of information. Figure 1.13 shows how many different groups, technical and nontechnical, share information in a graphic format. It also shows how the technologist or engineer working with CAD must understand the graphics display needs of marketing, sales, and training, as well as design and manufacturing.

Thus, computer graphics draws together many individuals with a range of visual needs and abilities, allowing large, diverse groups to communicate faster and more efficiently. In other words, the numerous new devices, methods, and media are driving the need for broader visual communications skills that were seldom necessary for the engineers and technologists of the past.

Practice Exercise 1.2

1. Look ahead to the engineering drawing shown in Figure 1.15.
2. From the drawing, mentally visualize the 3-D form of the object.
3. Try to sketch your mental image of the 3-D object.

Are you having difficulty making the transition from the 2-D drawing to the 3-D object? Being able to make the mental transition from 2-D to 3-D is part of what you will learn. Visualization is a very important part of technical graphics, because engineers and technologists must be able to make the transition quickly from 2-D to 3-D and from 3-D to 2-D.

1.5 STANDARDS AND CONVENTIONS

The language of graphics has been used for thousands of years; however, its effectiveness in modern times is due to the establishment of standards. There is no effective communication without an agreed upon standard of signs or symbols. The letters of the alphabet are the signs used for writing, and grammar forms the science which underlies word language. Standards and conventions are the “alphabet” of technical drawings, and plane, solid, and descriptive geometry are the science which underlies the graphics language.

The English language has many similarities to the graphics language. Following the standard rules of English makes the communication of thoughts between people easier. If the words in a sentence were presented in a random order, it would be very difficult for anyone to understand what was being said.

The graphics language must also follow a set of standards and conventions in order to make communication using technical graphics effective. However, these standards and conventions are not timeless, unchanging truths. Just as English gradually changes and we no longer speak in the manner of 16th-century Shakespeare, the standards and conventions of the graphics language have evolved over the years and are still changing as new technologies affect how technical drawings are produced.

Conventions are commonly accepted practices, rules, or methods. In technical drawing, an example of a convention is the use of dashed lines on multiview drawings to designate a feature hidden from the current viewpoint. (Figure 1.14)

Standards are sets of rules that govern how technical drawings are represented. For example, mechanical

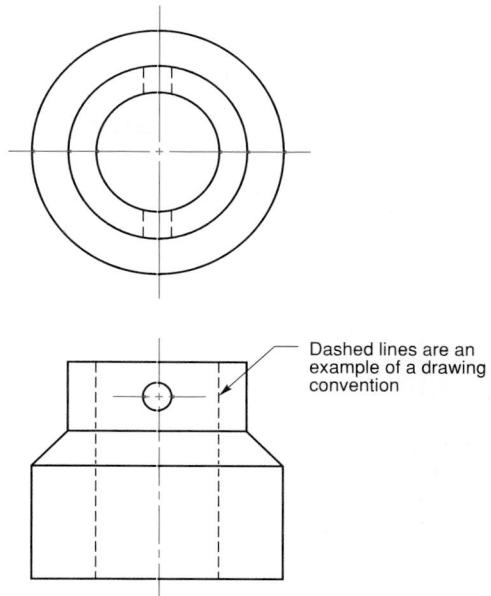

Figure 1.14 Drawing Conventions

Dashed lines used to represent hidden features on an engineering drawing are an example of a drawing convention. In this case the drawing convention, hidden lines, is used to represent the location of the drilled hole's diameter, in a view where the hole cannot be seen directly. Following such conventions means that your technical drawing can be accurately interpreted by anyone who reads it.

drawings are dimensioned using an accepted set of standards, such as placing the dimension text such that it is read from the bottom of the sheet. (Figure 1.15) Standards allow for the clear communication of technical ideas. In the United States, the **American National Standards Institute (ANSI)** is the governing body that sets the standards used for engineering and technical drawings. ANSI standards are periodically revised to reflect the changing needs of industry and technology. The Y series of ANSI standards are the ones most important for technical drawing. Some important ANSI standards used in technical drawings are:

- ANSI Y14.1-1980(R1987), Drawing Sheet Size and Format.
- ANSI Y14.2M-1979(R1987), Line Conventions and Lettering.
- ANSI Y 14.3-1975(R1987), Multiview and Sectional View Drawings.
- ANSI Y14.5M-1982(R1988), Dimensioning and Tolerancing.

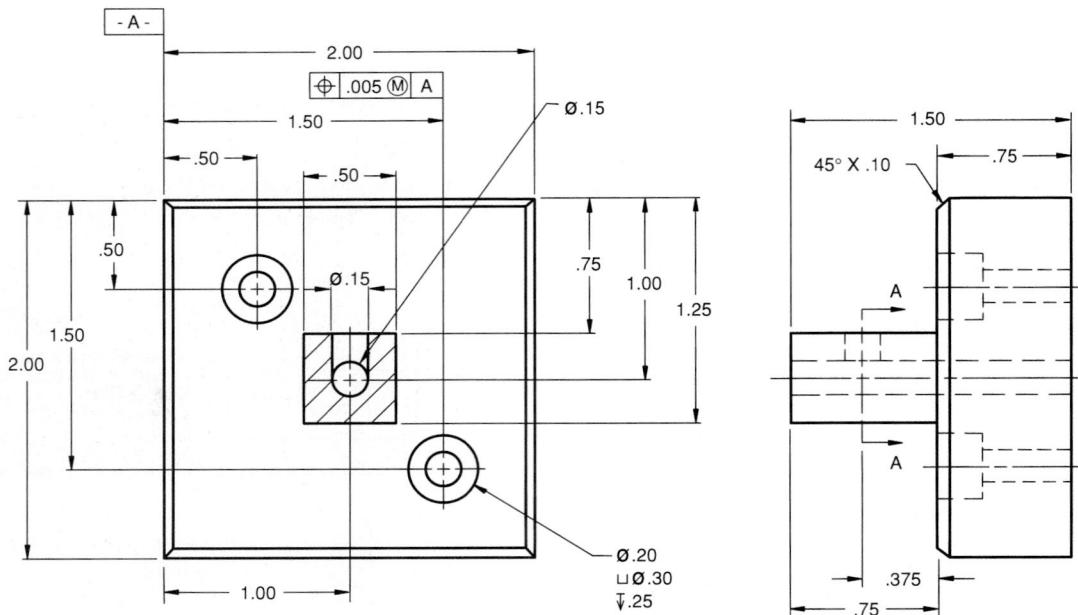

Figure 1.15 Dimensioned Mechanical Drawing Using ANSI Standards

The dimension type, placement, size, and other factors are examples of standard drawing conventions. For example, one ANSI standard dimensioning rule states that all diametral dimensions should be preceded by a phi (ϕ) symbol.

ANSI Y14.6-1978(R1987), Screw Thread Representation.

ANSI Y14.6aM-1981(R1987), Screw Thread Representation (Metric Supplement).

ANSI Y14.7.1-1971(R1988), Gear Drawing Standards, Part 1.

ANSI Y14.7.2-1978(R1989), Gear Drawing Standards, Part 2.

Other standards are: International Standards Organization (ISO), Japanese Standards (JIS), Department of Defense (DOD), and the U.S. Military (MIL).

Standards are used so that drawings convey the same meaning to everyone who reads them. For example, Figure 1.15 is a detail drawing which reflects many of the ANSI standards for dimensioning mechanical drawings. It is quite common in American industry to have parts of an assembly produced in many different locations. Having a standard graphics language is the only way this can be accomplished effectively.

Practice Exercise 1.3

Figure 1.15 is a typical technical drawing used in industry to document the design of a product and to aid in manufacturing the product. Carefully read the technical drawing and try to answer the following questions:

1. What do the thin, short-dashed lines represent?
2. What do the thick, short-dashed lines with arrows at the ends, labeled A-A, represent?
3. What do the areas with closely spaced thin lines drawn at a 45-degree angle represent?
4. What do the numbers and symbols located inside the long, horizontal rectangles represent?
5. What do the thin alternating long- and short-dashed lines represent?

Standards and conventions provide the design detail necessary to manufacture a product to precision. A person with a technical drawing background should be able to easily answer all of the questions listed above. Can you?

1.6 WHAT YOU WILL LEARN

In this text, you will learn the six important areas in technical graphics:

Visualization—the ability to mentally control visual information.

Graphics theory—geometry and projection techniques.

Standards—sets of rules that govern how parts are made and technical drawings are represented.

Industry Application Custom Athletic Shoes Using CAD

Micro Engineering Solutions, Inc., filled some big shoe orders for world-class runners in the 1992 Summer Olympic Games in Barcelona, Spain. ASICS, a Japan-based athletic shoe company, used Solution 3000 CAD/CAM [computer-aided design/computer-aided manufacturing] software to design and custom-build running shoes for world-class athletes, such as sprinter Leroy Burrell of the United States and marathoners Rosa Mota of Portugal and Taniguchi-San of Japan.

The ASICS custom-build shoe system is a four-stage process. First the athlete's feet are measured by ASICS using a laser/digital measuring device, made by Mitsubishi, to record 60,000 to 70,000 coordinates on each foot. The X, Y, and Z measurement data is then read into the Solution 3000, where free-form surfaces are created to precisely replicate the contours of the athlete's feet.

The surface model is then edited on a CAD/CAM system to prepare the data for specific manufacturing techniques. A wooden pattern of the athlete's feet is created using the Solution 3000 automatic surface roughing functions. In the last step, three-axis section

cuts are made over the surfaces to generate the ultimate shape to build the shoe.

In a few years, you may be able to buy custom-made shoes from a local retail outlet using the technology described.

Reprinted from *Design Management*, May 1992, © 1992 by Argus, Inc., Atlanta, GA, U.S.A.

Conventions—commonly accepted practices and methods used for technical drawings.

Tools—devices used to create engineering drawings and models, including both hand-held and computer tools.

Applications—the various uses for technical graphics in engineering design, such as mechanical, electrical, and architectural.

Each chapter in the text will explain the graphics theory important for a topic, integrate the visualization practices, explain the relevant standards and conventions, demonstrate the tools used to create drawings, and apply the topic to engineering design.

1.7 SPECIALISTS AND TECHNICAL DRAWINGS

Drawings are used throughout the design process to develop and document the design solution. Over the years specialized fields of engineering design have developed to meet the needs of industry. For example, military and civil engineering were the first types of

engineering specialties. From these two areas others developed, such as mechanical, electrical, chemical, aerospace, industrial, and many others. Special types of technical drawings, such as gears and cams, welding, riveting, electrical components and circuits, piping, structures, mapping and topography, also evolved to support the specialized fields of engineering.

1.8 TECHNICAL DRAWING TOOLS

Just as the graphics language has evolved over the years into a sophisticated set of standards and conventions, so have the tools used to graphically communicate technical ideas. Tools are used to produce three basic types of drawings: freehand sketches, instrument drawings, and computer drawings and models. The tools have evolved from pencils, triangles, scales, and compasses to **computer-aided design/drafting (CAD)** systems. **CAD** is computer software and related computer hardware that supplements or replaces traditional hand tools in creating models and technical drawings. (Figure 1.16)

Figure 1.16 CAD Workstations

Typical CAD workstations used in industry have large color monitors. The CPU itself is housed in the rectangular box located below or on the side of the monitor, or on the floor. (Courtesy of Hewlett-Packard Company.)

Since many industries have not fully integrated CAD into their design offices, it is necessary to learn both traditional and computer design methods. Also, traditional tools are used for sketching, which is one of the most effective methods available to represent design ideas quickly.

1.9 COMPUTER-AIDED DRAWING TOOLS

Traditional tools will continue to be useful for sketching and rough layout work; however, good CAD software can create virtually any type of technical drawing. Circle commands replace the compass, line commands replace the T-square and triangles, and editing commands replace the dividers and erasing shield.

Figure 1.17 shows how engineers use computer-aided design/computer-aided manufacturing (CAD/CAM) in the design and production processes. A CAD system consists of hardware devices used in combination with specific software. The **hardware** for a CAD system consists of the physical devices used to support the CAD software. There are many different hardware manufacturers and types of hardware devices, all of which are

used to create, store, or output technical drawings and models. It is not uncommon in industry to have multiple input, storage, and output devices for a CAD system.

1.9.1 Display Devices

There is a wide range of display devices, or monitors, available for computers. A **display device** is a type of output device, that is, a device through which information flows from the computer “out” to the user.

Display devices are classified by their type, resolution, size, and color capabilities. Monitor sizes range from 9 to 25 inches, measured diagonally.

In a CAD system, the display device can be thought of as the drawing paper or medium upon which technical drawings and models are produced. A CAD system can have a single display device, as shown in Figure 1.18, or a dual display device. Figure 1.19 shows a screen from a CAD program. The CAD software commands are located on the left side of the screen. Movement of a screen cursor is controlled by an **input device**, such as a keyboard, tablet, or a mouse, through which information flows from the user “in” to the computer. The cursor is used to select a command by moving the cursor to that command on the screen and highlighting it.

1.9.2 Input Devices

Input devices are used to interact with software programs, including CAD. The computer keyboard is one type of input device and is used to enter alphanumeric data. Other input devices include the mouse, tablet, and scanner. These devices and their application to CAD systems are described in the following sections, as are some very specialized devices developed specifically for CAD use.

A **tablet** is an input device used to control cursor movement and select menu items. (Figure 1.20) For a CAD program, the tablet is covered with a thin plastic overlay that contains the menu options. (Figure 1.21) Attached to the tablet is the cursor control device, which may be a puck or a stylus. A puck has a set of crosshairs, and a menu item is selected by moving the crosshairs over that item and pressing one of the buttons located on the surface of the puck.

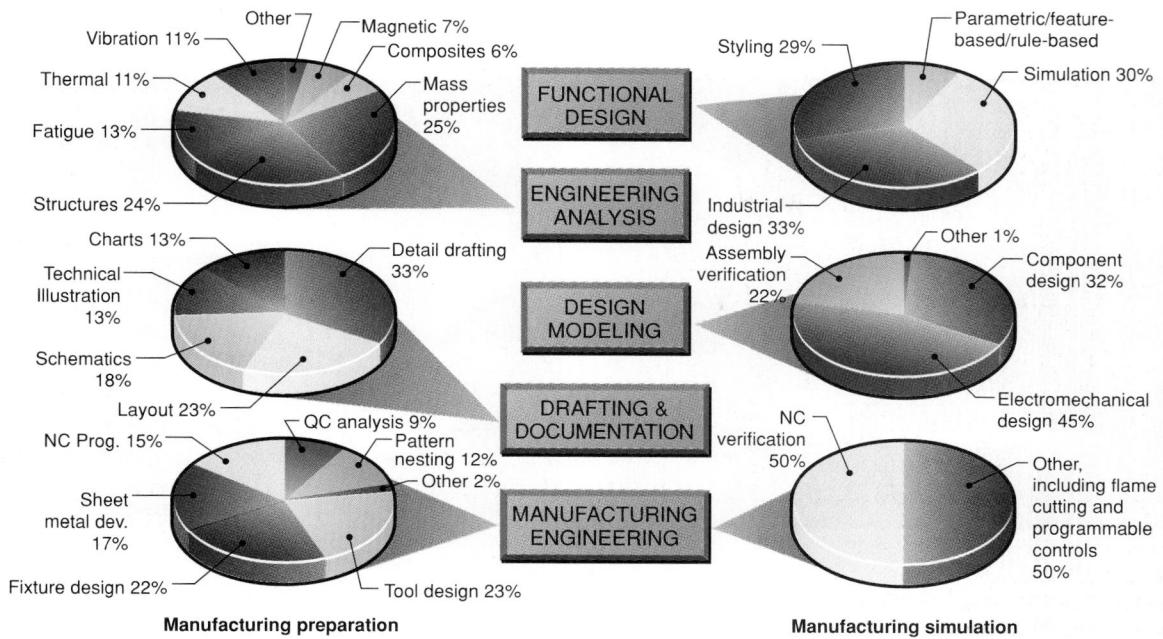

Figure 1.17

Engineers and technologists use CAD throughout the design process for a variety of applications. (Information from Dataquest, Inc. CAD/CAM/CAE/GIS Industry Service.)

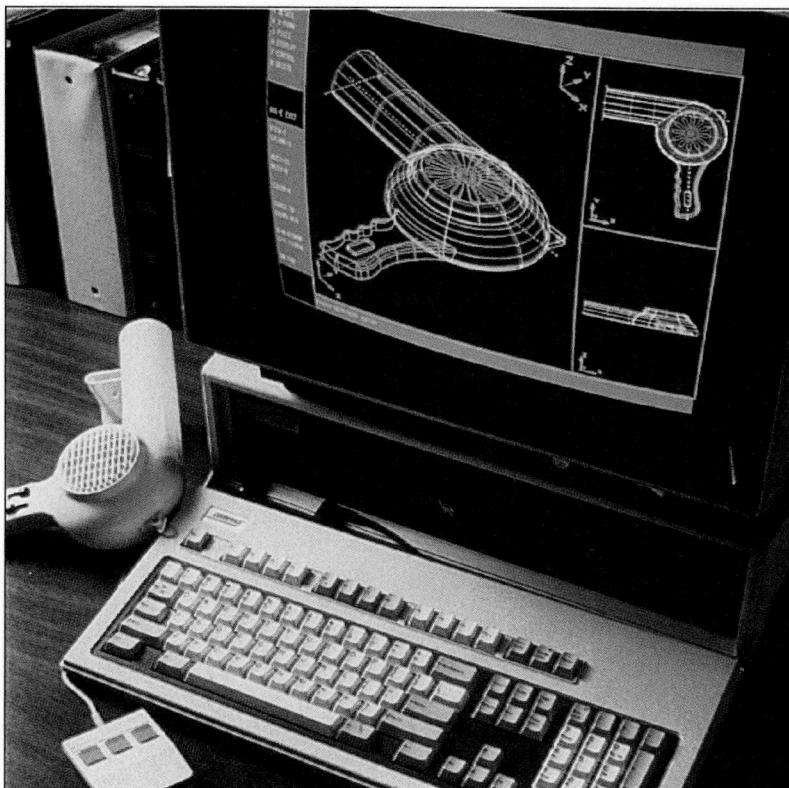

Figure 1.18 Display Device

Display devices are used to display graphic images and text for CAD work. (Courtesy of CADKEY, Inc.)

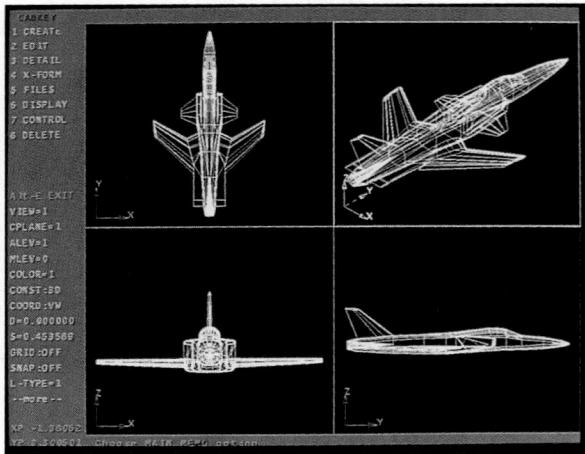

Figure 1.19 CAD Display

The screen display of a CAD program has a menu area and an area for drawing. (Courtesy of CADKEY, Inc.)

Figure 1.20 Tablets

Tablets are input devices used to interact with the CAD software. (Courtesy of CalComp.)

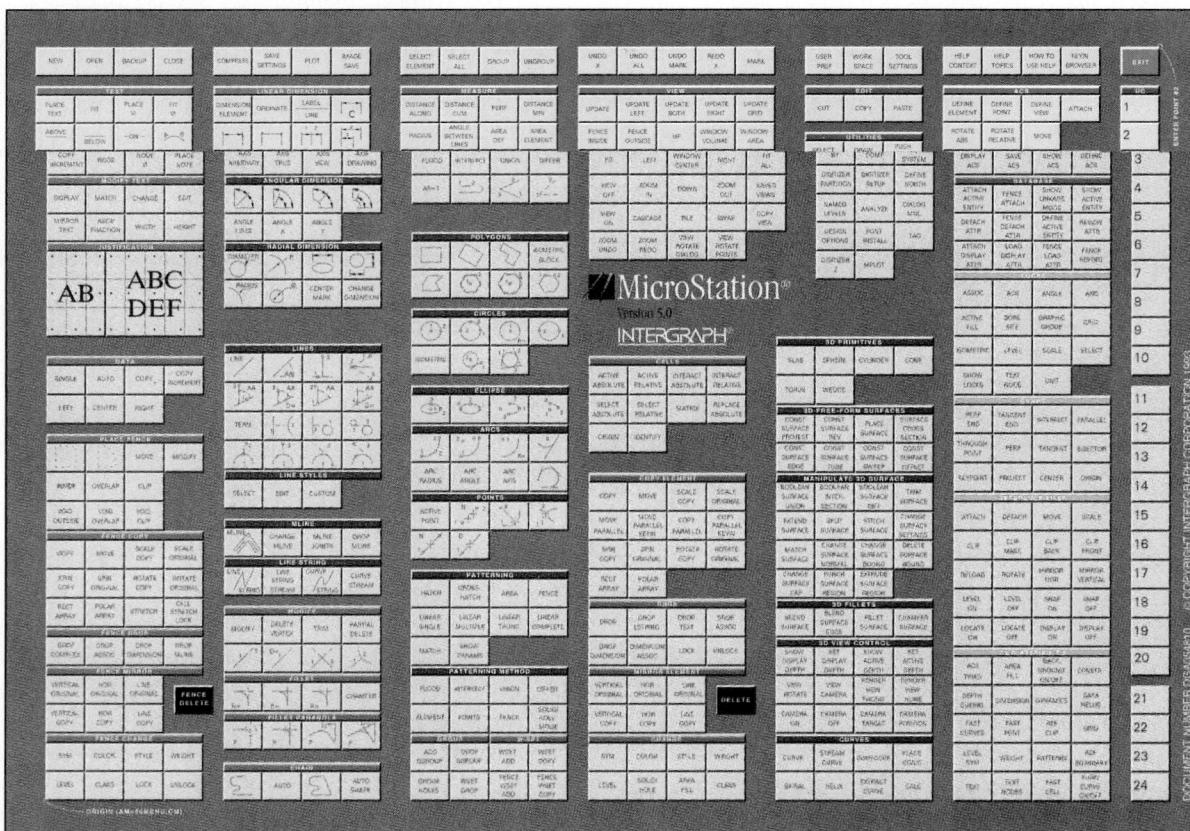

Figure 1.21 CAD Menu

A menu for a CAD software program is overlaid on the surface of the tablet. (Courtesy of Intergraph Corporation.)

Figure 1.22 A Mechanical Mouse Used to Control the Cursor and Make Menu Selections on a CAD System

The **mouse** is an input device used to control cursor movement and to make menu selections. A mouse can be mechanical, optical, or infrared. A mechanical mouse has a small ball that rolls across a surface. (Figure 1.22)

Drawing a Line Using a Mouse

Step 1. To draw a line using a mouse, select the appropriate command, such as LINE, from the on-screen menu by using the mouse to move the screen cursor over the command to highlight it.

Step 2. While the command is highlighted, press the button located on the top left of the mouse to select the LINE command.

Step 3. With the mouse, move the cursor to the starting point on the screen, and then press the same mouse button.

Step 4. With the mouse, move the cursor to the location for the endpoint of the line, and then press the same mouse button.

The mouse can be thought of as the replacement for the pencil when creating technical drawings and models.

© CAD Reference 1.1

1.9.3 Output Devices

The **output devices** used to make hard copies of the drawings created on screen are categorized as: printers, plotters, or film recorders. These devices can be used to make quick, rough check plots, production plots, presentation plots, or a combination of these.

Figure 1.23 Desktop Plotter

A- and B-size desktop plotters are used to make multicolored plots on small-size paper. (Courtesy of Hewlett-Packard Company.)

Figure 1.24 Inkjet Plotters

D- and E-size inkjet plotters spray ink onto paper, using narrow nozzles, to create colored plots of CAD drawings. (Courtesy of Hewlett-Packard Company.)

Pen plotters use a variety of pens and media to create hard copy of CAD drawings. (Figure 1.23) There are three types of pen plotters: desktop, flatbed, and paper-mover. These devices have excellent resolution and accuracy, but are slower and do not produce shaded, rendered, or solid filled output.

Inkjet printers use narrow nozzles to spray ink onto the paper. (Figure 1.24) The technology uses special paper and ink cartridges to produce color output. The resolution is not as high as that of an electrostatic plotter, but inkjet printers are fast and can be used for color shading, renderings, and solid filled output. Inkjet

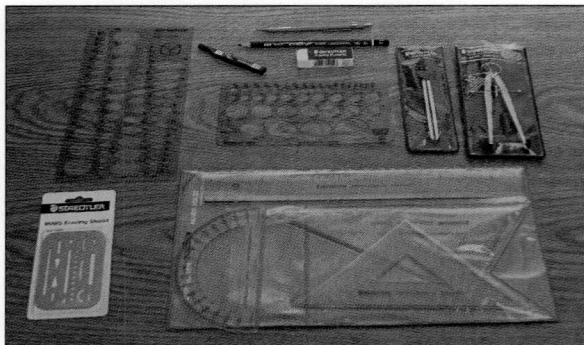

Figure 1.25 Traditional Tools

These are some of the many traditional mechanical drawing tools used for engineering drawings.

printers are measured by the pages per minute (ppm) that can be printed, and the resolution, expressed as dpi. A typical color inkjet printer will print 4 ppm with a resolution of 300 dpi.

1.10 TRADITIONAL TOOLS

The traditional tools used to create technical drawings have evolved over time. Many tools were originally used in ancient Greece to study and develop geometry. Although computers may someday replace the need for some traditional tools, they are still useful today for drawing, and more importantly, for sketching. **Traditional tools** are devices used to assist the human hand in making technical drawings. The assistance includes drawing lines straighter, making circles more circular, and increasing the speed with which drawings are made. The tools typically used to create mechanical drawings or sketches (Figure 1.25) consist of:

1. Wood and mechanical pencils.
2. Instrument set, including compass and dividers.
3. 45 and 30/60 degree triangles.
4. Scales.
5. Irregular curves.
6. Protractors.
7. Erasers and erasing shields.
8. Drawing paper.
9. Circle templates.
10. Isometric templates.

Figure 1.26 Parallel Edge

A parallel edge is used as a straightedge for drawing lines. (Courtesy of Staedtler, Inc.)

Figure 1.27 Drafting Machine

A drafting machine is used to create lines on technical drawings. The head is adjustable to create angled lines.

1.10.1 Straightedges

Mechanical drawings are started by taping the drawing paper to the working surface. A **straightedge**, such as a T-square, parallel edge (Figure 1.26), or drafting machine (Figure 1.27), is used to draw horizontal lines. They are also used as guides for triangles, which are used to create vertical and inclined lines. (Figure 1.28) **Drafting machines** are devices that supplement the T-square, triangles, protractors, and scales. The **parallel edge** is used to replace the T-square on wide drawing surfaces, to increase the accuracy and ease of making large-format drawings.

Figure 1.28 Drawing Vertical and Inclined Lines

A drafting machine is used to support triangles for vertical and inclined lines.

1.10.2 Protractors

When lines must be drawn at angles different from the 15-degree intervals available using triangles, either a protractor, the protractor head of a drafting machine, or an adjustable triangle is required. The **protractor** is a semicircular device whose center is placed at the start point of the line. The angle is then marked (Figure 1.29), and a straightedge is used to create the measured line.

Using a Protractor to Measure an Angle

Step 1. Place the protractor's center at one end of the line. (see Figure 1.29)

Step 2. Read the angle of the line by viewing where the line passes below a mark on the protractor's semicircular edge.

1.10.3 Pencils

Mechanical pencils are more commonly used in drawing than are wood pencils. (Figure 1.30) Mechanical pencils use either drafting leads or thin leads. Drafting leads are thicker and must be sharpened using lead pointers or abrasive paper. **Thin-lead pencils** use leads of specific diameters that do not need to be sharpened. These lead diameters correspond to ANSI standard line thicknesses, such as 0.7 mm or 0.35 mm. A thin-lead pencil can only be used for a single lead diameter; therefore, several thin-lead pencils are required for technical drawings, one for each of the different line thicknesses required.

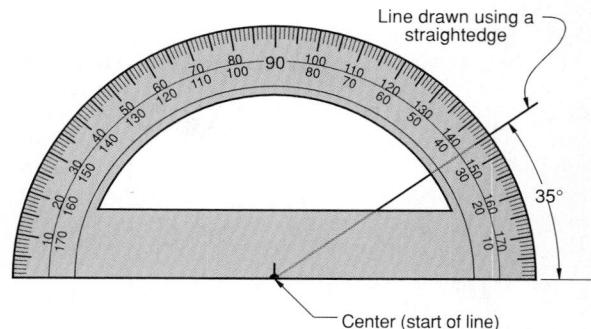

Figure 1.29 Protractor

The protractor is used to measure and mark angles on a technical drawing.

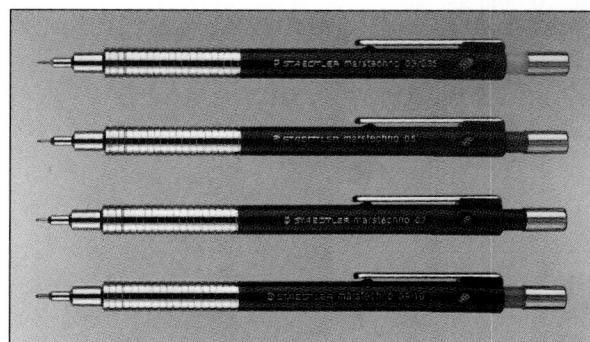

Figure 1.30 Thin Lead Mechanical Pencils

Mechanical pencils used for technical drawing come in different lead sizes for drawing the different thicknesses of lines required. (Courtesy of Staedtler, Inc.)

Wood pencils have to be sharpened, using pencil pointers or abrasive paper, to create the various line thicknesses used in technical drawings. (NOTE: Never sharpen a pencil *over* a drawing, and always keep the pencil point conical in shape to get good quality lines.) Hand-drawn lines must be of uniform weight and thickness, and must be correctly spaced so they can be legibly reproduced, such as for blueprinting.

Line weight refers to the relative darkness of the line. For example, the line drawn to represent the center of a circle is drawn black using a soft lead. The thickness of the center line is approximately 0.35 mm. Uniform thickness means that the line should not vary. (Figure 1.31) Thin-lead pencils are the easiest tool for drawing lines of uniform weight and thickness.

Industry Application

Virtual Reality Changes the Face of Design

Sitting in a chair, an engineer uses a helmet connected to a supercomputer to simulate sitting in the cab of a recently designed vehicle. The computer system and headset convert 3-D CAD models into images that mimic the real world. This technology is called virtual reality and is changing the way some industries do design.

A virtual reality system lets the designer experience a design in a realistic 3-D world. Designers can sit in the seat of a new vehicle, or walk through a new building, viewing the ceiling, floor, what's ahead and what's behind, by simply turning their heads. The designer can become immersed in this virtual world, and this can produce better designs.

Virtual reality is being applied to aircraft, architectural, vehicle, acoustic, city planning, and home design.

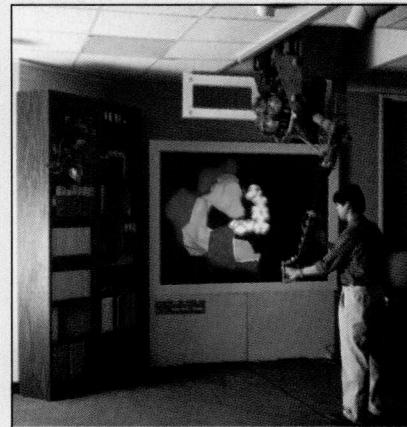

Virtual Reality System Used to Enhance the Visualization of New Designs (Courtesy of University of North Carolina, Chapel Hill, Department of Computer Science.)

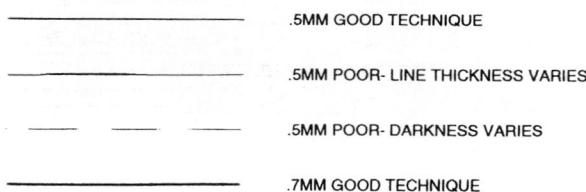

Figure 1.31 Line Weight

Uniform lines do not vary in thickness or darkness.

Mechanical and wood pencil leads are graded to distinguish their hardness. (Figure 1.32) Hard grades range from 4H to 9H: the higher the number, the harder the lead. Hard leads are used for construction lines, with 4H being the one used most often. Medium grade leads are 3H, 2H, H, F, HB, and B. These leads are used for general purpose work, such as visible lines, dimensions, sections, and center lines. The softer grades, such as HB and B, are commonly used for sketching. Soft leads range from 2B to 7B, with the larger number representing a softer grade. This type of lead is not commonly used in engineering or technical drawing, but rather for artwork and architectural renderings.

1.10.4 Drawing Paper

Media are the surfaces upon which an engineer or technologist communicates graphical information. The media used for technical drawings are different types or grades of paper, such as tracing paper, vellum, and polyester film. Tracing paper is a thin, translucent paper used for detail drawings. Vellum is a tracing paper chemically treated to improve translucency. Polyester film, or its trade name Mylar, is transparent, waterproof, and difficult to tear. Mylar can be used for lead pencil, plastic-lead pencil, or ink drawings. Mylar is an excellent drawing surface that leaves no trace of erasure.

Special papers have also been developed for CAD plotters. For example, plotter paper used for fiber-tipped pens has a smooth or glossy surface to enhance line definition and minimize skipping. Often, the paper comes with a preprinted border, title block, and parts list. (Figure 1.33)

ANSI has established standard sheet sizes for the media used for technical drawings. Each paper size is designated by a letter, as shown in Table 1.1.

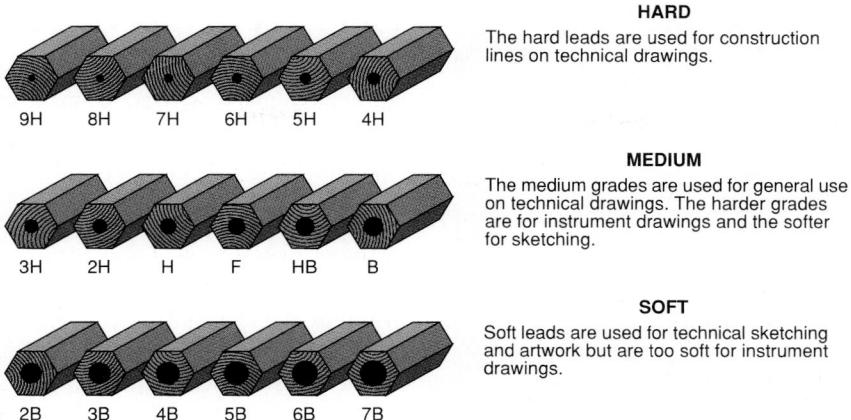

Figure 1.32 Pencil Grades

Pencils are graded by lead hardness, from 9H to 7B: 9H is the hardest and 7B is the softest.

Table 1.1 ANSI Standard Sheet Sizes

Metric (mm)	U.S. Standard	Architectural
A4 210 × 297	A-Size 8.5" × 11"	9" × 12"
A3 297 × 412	B-Size 11" × 17"	12" × 18"
A2 420 × 524	C-Size 17" × 22"	18" × 24"
A1 594 × 841	D-Size 22" × 34"	24" × 36"
A0 841 × 1189	E-Size 34" × 44"	36" × 48"

Keeping Drawings Clean

Keeping your drawing surface clean is an important part of technical drawing. Drawings become dirty primarily from the graphite from the pencils. To keep a drawing clean, follow these guidelines:

- Never sharpen pencils over your drawing.
- Clean your pencil point with a soft cloth after sharpening.
- Keep your drawing instruments clean.
- Rest your hands on the drawing instruments as much as possible, to avoid smearing the graphite on the drawing.
- When darkening lines, try to work from the top of the drawing to the bottom, and from left to right across the drawing. Work from right to left across the drawing if you are left-handed.
- Use a brush to remove erasure particles. Never use your hands.

HARD
The hard leads are used for construction lines on technical drawings.

MEDIUM
The medium grades are used for general use on technical drawings. The harder grades are for instrument drawings and the softer for sketching.

SOFT
Soft leads are used for technical sketching and artwork but are too soft for instrument drawings.

Custom Printed Engineering & Drafting Decal Appliques

Have the convenience of placing your logo, title blocks, etc., wherever you want them on your drawings or documents. Working from your camera-ready artwork, we can custom print decal appliques that let you position these elements as you see fit. Minimum order: packet of 100 appliques. For information and pricing, please contact the Contract and Bid Department at Alvin & Company headquarters in Connecticut.

Figure 1.33 Preprinted Title Blocks

Preprinted standard borders and title blocks on drafting paper are commonly used in industry. (Courtesy of Alvin & Company.)

1.10.5 Triangles

Vertical and inclined lines are drawn with **triangles** guided by a T-square or a parallel edge. Some triangles are thinner around the perimeter so they can be used for inking. Triangles come standard as 45 degrees and 30 × 60 (30/60) degrees. Triangles come in various sizes, such as 6, 8, and 10 inch, and are made of clear plastic. (Figure 1.34) By combining the 30/60-degree triangle and the 45-degree triangle, it is possible to draw angles at 15-degree intervals. (Figure 1.35)

Figure 1.34 Drafting Triangles

Drafting triangles are either 30/60- or 45-degree triangles and come in various sizes. (Courtesy of Alvin & Company.)

1.11 ALPHABET OF LINES

The **alphabet of lines** is a set of standard linetypes established by the American National Standards Institute (ANSI) for technical drawing. Figure 1.36 shows the alphabet of lines, and the approximate dimensions used to create different linetypes, which are referred to as **linestyles** when used with CAD. ANSI Y14.2M-1979 (R1987) has established these linetypes as the standard for technical drawings. Two line weights are sufficient to follow the standards, a 0.7 mm (0.032") and a 0.5 mm (.019") or 0.35 mm (0.016"). Thick lines are drawn using soft lead, such as F or HB. Thin lines are drawn using a harder lead, such as H or 2H. Construction lines are very light and are drawn using 4H or 6H lead. A good rule of thumb for creating construction lines is to draw them so that they are difficult to see if your drawing is held at arm's length.

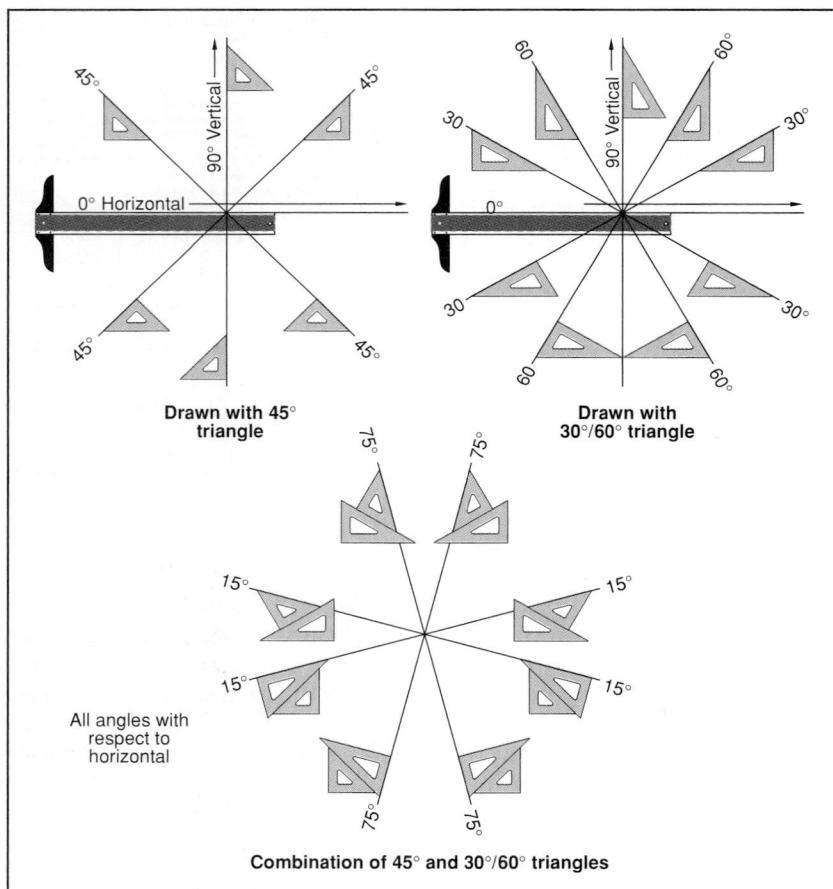

Figure 1.35

By combining the straightedge with the 45-, and 30/60-degree triangles, you can draw lines at any 15-degree increment.

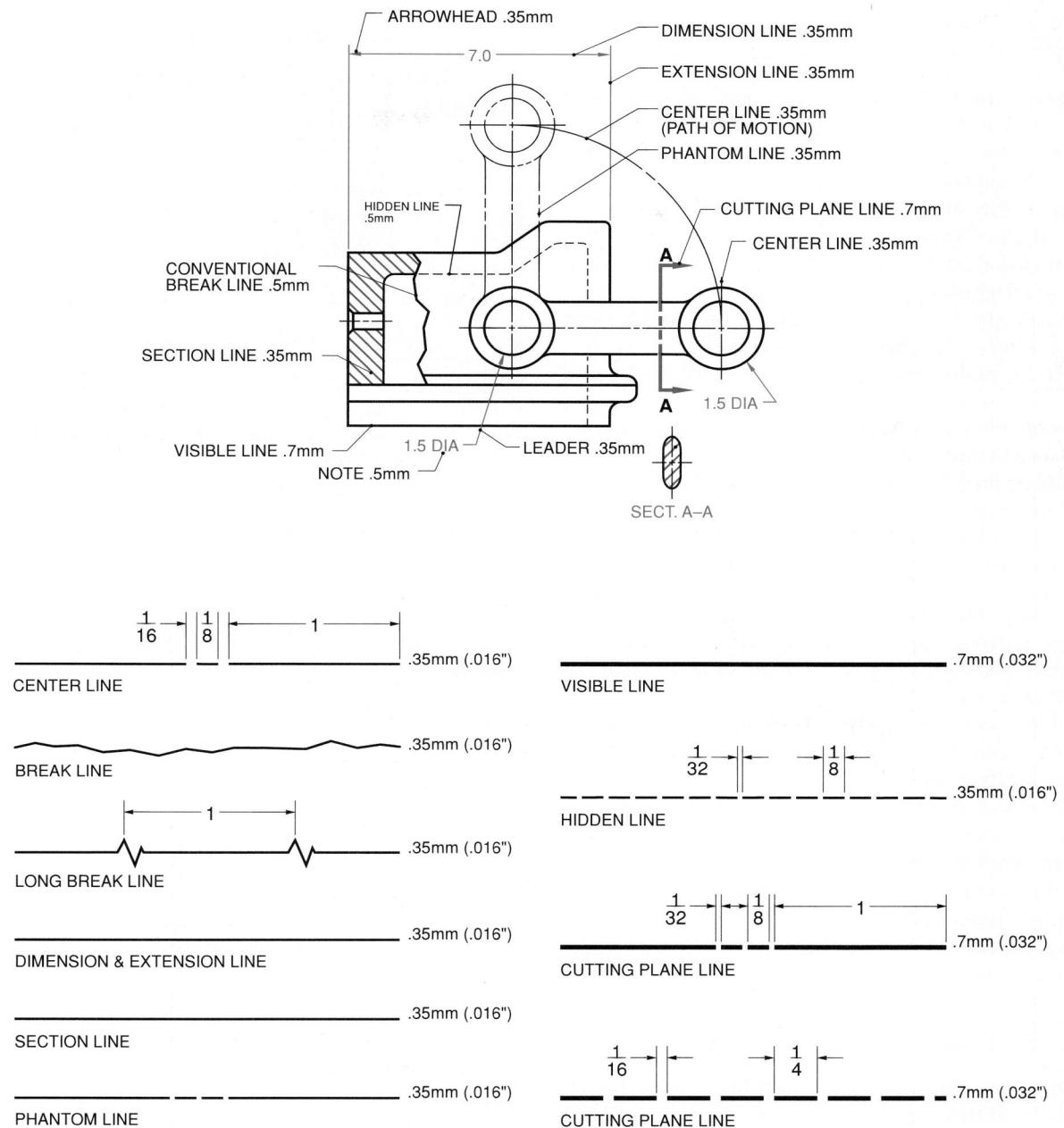

Figure 1.36 The Alphabet of Lines

The alphabet of lines is a set of ANSI standard linetypes used on technical drawings. The approximate dimensions shown on some linetypes are used as guides for drawing them with traditional tools. The technical drawing shows how different linetypes are used in a drawing.

Listed below are the standard linetypes and their applications in technical drawings:

Center lines are used to represent symmetry and paths of motion, and to mark the centers of circles and the axes of symmetrical parts, such as cylinders and bolts.

Break lines are freehand lines used to show where an object is “broken” to reveal interior features.

Dimension and extension lines are used to indicate the sizes of features on a drawing.

Section lines are used in section views to represent surfaces of an object cut by a cutting plane.

Cutting plane lines are used in section drawings to show the locations of cutting planes.

Visible lines are used to represent features that can be seen in the current view.

Hidden lines are used to represent features that cannot be seen in the current view.

Phantom lines are used to represent a moveable feature in its different positions.

It is important that you understand and remember these different linetypes and their definitions and uses, because they are referred to routinely throughout the rest of this book.

CAD software provides different linestyles for creating standard technical drawings. Figure 1.37 shows the linestyle menu for a typical CAD system. The thicknesses of lines on a CAD drawing are controlled by two different means: (1) controlling the thickness of the lines drawn on the display screen; and, (2) controlling the plotted output of lines on pen plotters by using different pen numbers for different linestyles, where different pen numbers have different thicknesses, such as a 0.7 mm and a 0.3 mm.

1.12 LINE DRAWING TECHNIQUES

Horizontal, vertical, and inclined lines are drawn by hand with traditional tools, such as a straightedge and triangles. If a drafting machine is used, the blades serve as guides for drawing the lines. By adjusting the head of the drafting machine, you can create inclined lines.

Drawing Horizontal Lines

A horizontal line is drawn using the top edge of the blade of the T-square, drafting machine, or parallel edge.

Step 1. Hold the pencil in your right (or left) hand in a position similar to that used for writing.

Figure 1.37 AutoCAD’s Linestyle Menu Showing Some of the Linetypes Available

Step 2. Hold the straightedge firmly with your left hand as you pull the pencil from left to right across the paper. If you are left-handed, hold the straightedge with your right hand and pull the pencil from right to left.

Step 3. Rest your right (or left) hand lightly on top of the straightedge.

Step 4. Use the top edge of the straightedge as a guide for the pencil, position the pencil at approximately 60 degrees to the paper, and slowly rotate the pencil as the line is being drawn. (Figure 1.38)

Horizontal lines are drawn with CAD in a variety of ways. Each endpoint of the line can be defined using X-Y coordinate positions, such as 0,0 for one end and 4,0 for the other, which defines a horizontal line 4 units long. Another method would be to use a rectangular grid and snap to the grid points. (Snapping is a technique used by CAD systems to accurately place endpoints of lines at equally spaced points called a grid.) 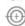 **CAD Reference 1.2**

Drawing Vertical Lines

Step 1. Draw a vertical line by placing one edge of either the 45- or 30/60-degree triangle on the top edge of the straightedge. The vertical blade of the drafting machine could also be used.

Step 2. Rest the right hand on the bottom of the triangle. (Figure 1.39) Hold both the triangle and straightedge in position with the left hand.

Step 3. With the right hand, pull the pencil from the bottom to the top of the paper, holding the pencil at an angle of 60 degrees to the paper and slowly rotating the pencil as you draw. Left-handers hold the triangle with the right hand and draw with the left.

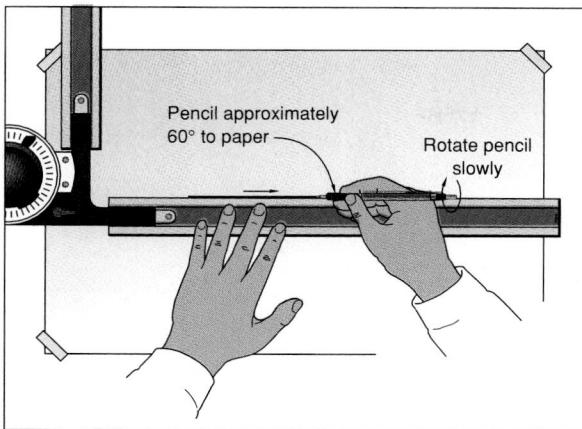

Figure 1.38 Drawing a Horizontal Line

A horizontal line is drawn by holding the pencil at a 60-degree angle to the paper and rotating the pencil as it is pulled across the paper. The blade of the drafting machine is used as a guide for the pencil point as it is pulled across the paper. By applying even pressure and slowly rotating the pencil, you can produce lines of uniform weight and thickness.

Vertical lines are drawn with CAD using procedures similar to those for drawing horizontal lines. Coordinate endpoints could be specified, such as 0,0 for one end and 0,4 for the other, making a vertical line 4 units long. The rectangular snap and grid could also be used to create vertical lines. © CAD Reference 1.3

Drawing Inclined Lines

The 45- and 30/60-degree triangles can be combined or used separately, along with a straightedge, to draw lines at 15-degree intervals, as shown in Figure 1.35. Lines at other than 15-degree intervals are drawn using either the protractor head on a drafting machine (Figure 1.40), a hand-held protractor, or an adjustable triangle.

Step 1. Mark the desired angle using the protractor, as described earlier. If the angle to be drawn is at any 15-degree increment, triangles can be used as the guide, as shown in Figure 1.35.

Step 2. Align the triangle with the marks for the line to be drawn.

Step 3. Use the edge of the triangle as a guide to draw the inclined line.

Inclined lines are created with CAD by using rectangular or polar coordinates. For example, the first endpoint for the line could be located at 0,0, and the second point could be defined by giving the length and the angle relative to the first point, such as 4 units long and 45 degrees. This would result in an inclined line. © CAD Reference 1.4

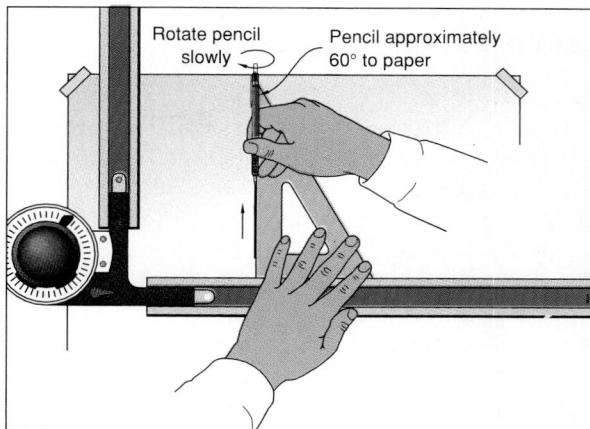

Figure 1.39 Drawing Vertical Lines

Vertical lines are drawn by pulling the pencil along the edge of a triangle or the vertical blade of the drafting machine, slowly rotating the pencil as it is pulled.

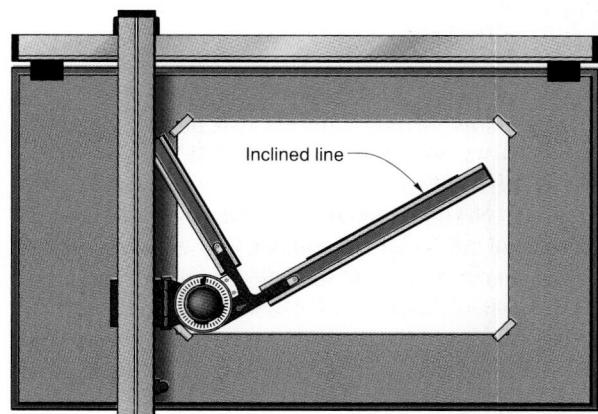

Figure 1.40 Drawing Inclined Lines

Drawing inclined lines using a drafting machine requires setting the protractor head to the desired angle and locking the head in place. The pencil is then pulled along the blade at a 60-degree angle to the paper and is slowly rotated as it is pulled.

1.12.1 Erasing

Lines are erased using a soft eraser, or the ERASE command when using CAD. To erase in small areas, or protect areas not to be erased, use an erasing shield. (Figure 1.41) An **erasing shield** is a thin piece of metal with various sizes and shapes of holes cut in it. The part of the drawing to be erased is exposed through a hole in the erasing shield and the surrounding area is shielded. A CAD system uses a TRIM command, which has a function similar to that of an erasing shield. © CAD Reference 1.5

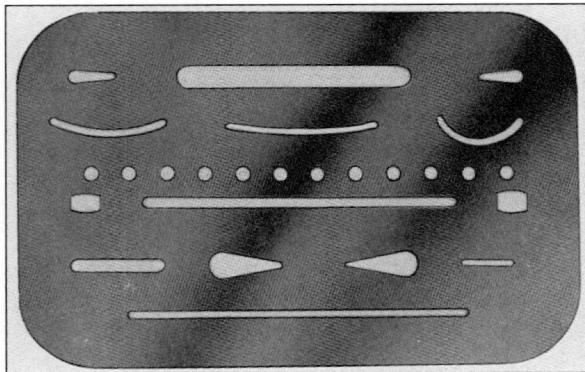

Figure 1.41 Erasing Shield

An erasing shield is used to erase parts of a drawing. The part of the drawing to be erased is exposed to an open area in the shield. Areas of the drawing that are not to be erased are protected by the shield. (Courtesy of Alvin & Company.)

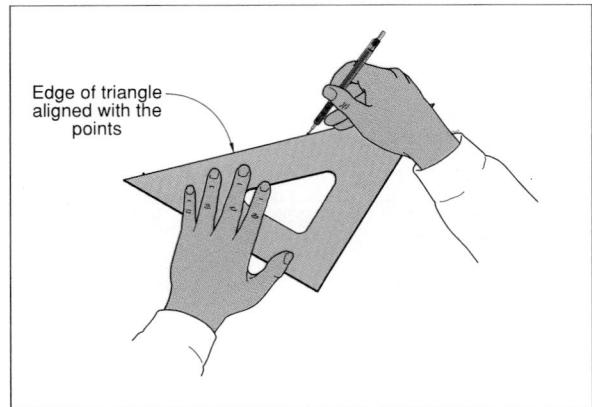

Figure 1.42 Drawing a Line through Two Points

To draw a line through two points, align the edge of a triangle to the two points and then pull the pencil along the edge of the triangle.

1.12.2 Drawing a Line through Two Points

A line is drawn through two points by aligning one side of a straightedge with the two points, then connecting them with a line. (Figure 1.42) With CAD, a line is drawn through two points by “picking” each endpoint. Normally an existing point is picked using some type of “snap” command. For example, if the two points that must be picked are the endpoints of existing lines, then the SNAP command must be set to “endpoints.” The CAD software will then accurately connect the endpoints of the new line.

A CAD system provides the user with many options for picking existing entities, such as midpoints, centers, and intersections. Snapping to existing entities is an important CAD technique used to assure the accuracy of drawings and models. © CAD Reference 1.6

1.12.3 Drawing Parallel Lines

The procedure to follow when drawing a line parallel to a given line varies depending on the tools being used.

Drawing Parallel Lines

Drafting machine

Step 1. If using a drafting machine, adjust the protractor head to align one blade or straightedge with the given line.

Step 2. Lock the protractor head, then move the drafting machine to the new position and draw the parallel line. (Figure 1.43)

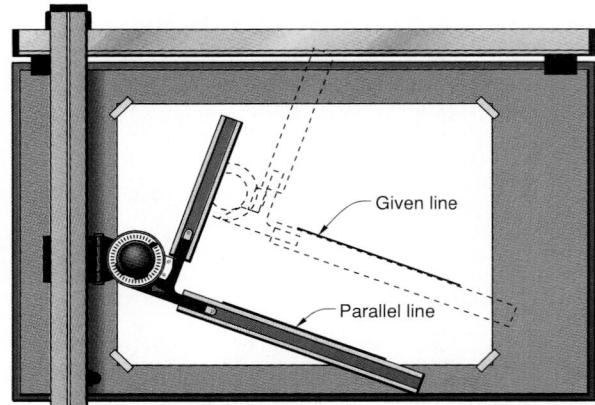

Figure 1.43 Drawing Parallel Lines

To draw a line parallel to a given line using a drafting machine, align one blade with the given line by adjusting the protractor head and locking it in place. Then move the drafting machine to the new position and draw the line along the parallel blade.

Two triangles

Step 1. If using two triangles, adjust the two triangles until one edge of one triangle is aligned with the given line, while the other triangle serves as a straightedge and is held stationary.

Step 2. Slide the aligned triangle along the edge of the stationary triangle.

Step 3. After the moving triangle is in the new position, draw the line along the same edge that was aligned with the given line. (Figure 1.44)

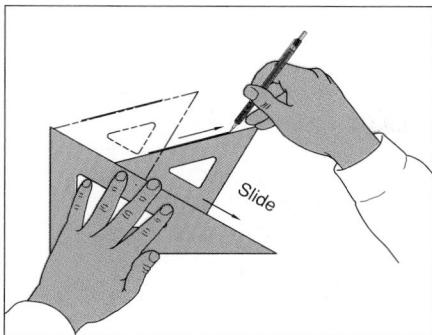

Figure 1.44 Drawing Parallel Lines Using Triangles

To use two triangles to draw parallel lines, set up one of the triangles so that one edge aligns along the given line. Use the other triangle as a guide or base for the first triangle. Hold the base triangle stationary and slide the other triangle along the edge of the base triangle to the new position, where the line is drawn.

Adjustable triangle

Step 1. Adjust one edge of the triangle to align with the given line.

Step 2. Then move the triangle along the straightedge.

With CAD, there are a number of techniques used to create parallel lines. For example, there may be a PARALLEL command that will automatically draw lines parallel to a given line. The given line is picked, then a point is selected where the parallel line is drawn. 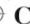 **CAD Reference 1.7**

1.12.4 Drawing Perpendicular Lines

A line is drawn perpendicular to another line using two triangles, a triangle and a straightedge, or a drafting machine. The drafting machine is used to draw a line perpendicular to a given line by aligning one blade with the given line, then using the other blade as a guide to draw the perpendicular line. The adjustable protractor head is used to align the first blade. (Figure 1.45)

Drawing Perpendicular Lines

Step 1. If two triangles are used, align the edge of one of the triangles with the given line. Do not use the hypotenuse (long edge) of the triangle. Use the other triangle as a straightedge and hold it stationary. (Figure 1.46)

Step 2. Slide the aligned triangle along the edge of the stationary triangle.

Step 3. After the moving triangle is in the new position, draw the line, using its perpendicular edge.

With CAD, drawing a line perpendicular to a given line is done using a PERPENDICULAR command or snap

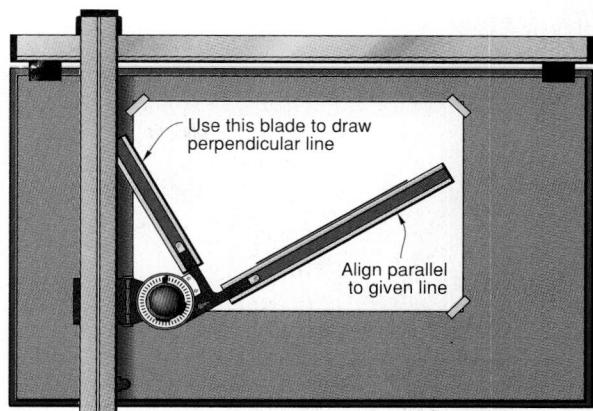

Figure 1.45 Drawing Perpendicular Lines

To draw a line perpendicular to a given line using a drafting machine, align one blade with the given line by adjusting the protractor head, and then lock the head in place. Move the drafting machine head to the new position and draw the line along the perpendicular blade.

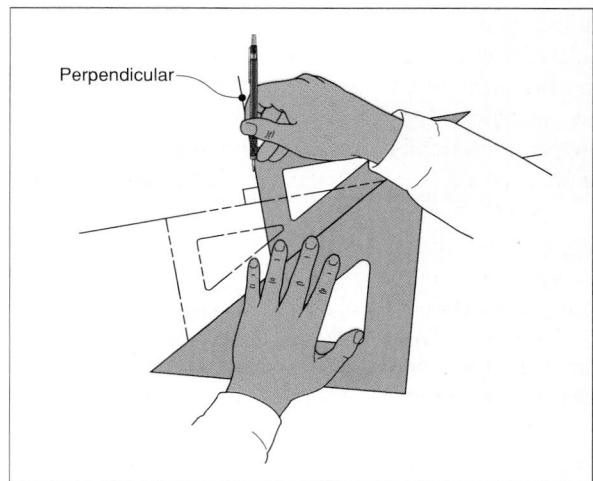

Figure 1.46 Drawing Perpendicular Lines Using Two Triangles

To use two triangles to draw perpendicular lines, align one of the triangles so that one edge (not the hypotenuse) is parallel to the given line. Use the other triangle as a guide or base. Hold the base triangle stationary and slide the other triangle along the edge of the base triangle to the new position; draw the line using the perpendicular edge of the triangle that was moved.

option. The endpoint of the new line is picked, then the existing line is selected. The new line is automatically drawn from the picked endpoint perpendicular to the picked line. **CAD Reference 1.8**

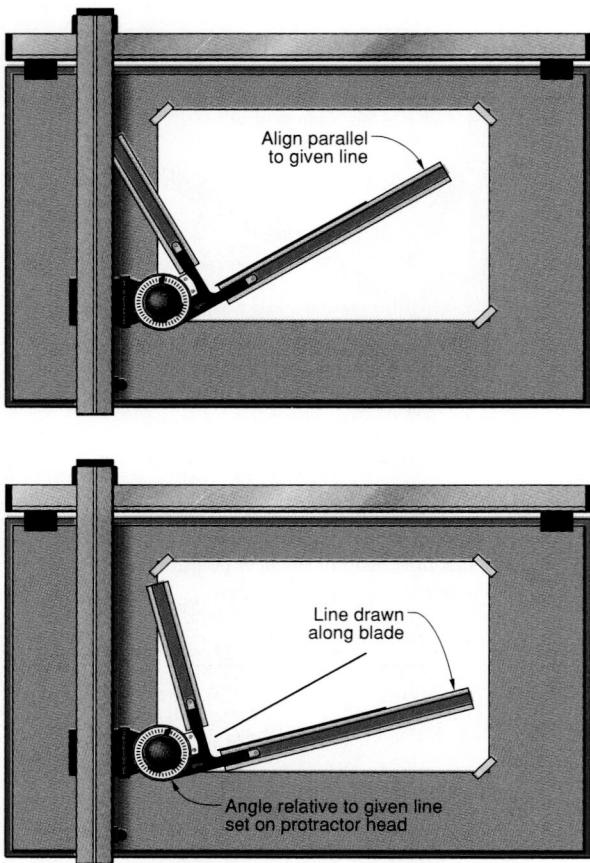

Figure 1.47 Drawing a Line at an Angle

To draw a line at an angle to a given line using a drafting machine, align one blade with the given line by adjusting the protractor head, and then read its angle. Adjust the drafting machine head to the new angle, lock it in place, and then draw the line along the blade.

1.12.5 Drawing Lines at Angles Relative to a Given Line

A drafting machine, a protractor and straightedge, or triangles are used to draw lines at an angle to a given line. The protractor head of the drafting machine is adjusted to align with the given line, making that position the zero setting. (Figure 1.47) The protractor head is then adjusted to the desired angle and the line is drawn.

Drawing a Line at a Given Angle

Figure 1.48 shows how two triangles, one of which is a 30/60-degree triangle, can be used to create a line at 30 degrees to a given line.

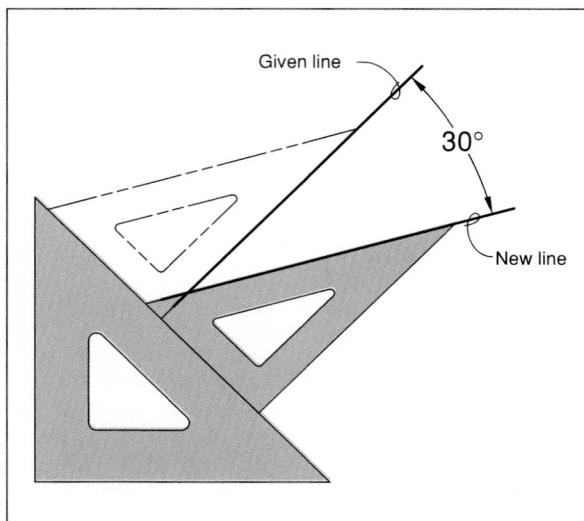

Figure 1.48 Drawing a Line at an Angle Using Two Triangles

Two triangles can be used to draw a line at an angle to a given line by using one triangle as a guide or base and aligning the other triangle so that one edge is parallel to the given line. Hold the base triangle stationary and slide the other triangle along the edge of the base triangle to the new position, where the line is drawn.

Step 1. Using one triangle as a straightedge, slide the 30/60-degree triangle into position so that the leg adjacent to the 30-degree angle is parallel with the given line.

Step 2. Hold the triangle used as a straightedge stationary, slide the 30/60-degree triangle to the new position, and draw the new line.

With CAD, a line can be drawn at an angle to a given line by using polar coordinate inputs, or rotating the snap and grid to align with the given line. **CAD Reference 1.9**

1.12.6 Drawing Irregular Curves

Irregular or French curves are used to draw curves which are not circles or arcs, examples of which are parabolas, hyperbolas, ellipses, and involutes. (Figure 1.49) To draw long, irregular curves, a long, flexible device called a **spline** is used. (Figure 1.50) A CAD system can draw an irregular curve by using the **SPLINE** command. **CAD Reference 1.10**

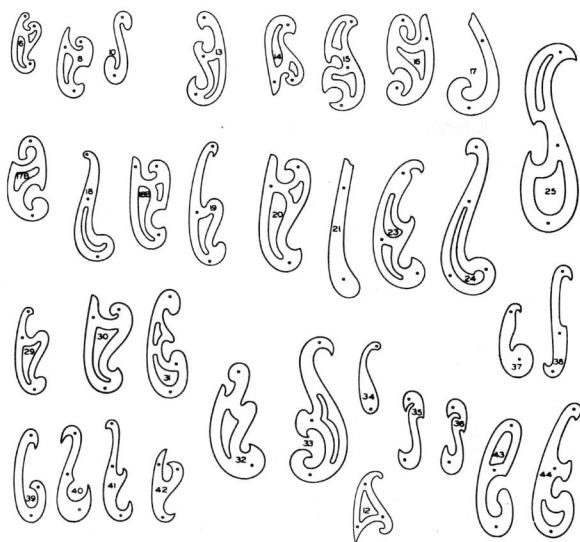

Figure 1.49 Irregular Curves

Irregular or French curves come in many shapes and sizes and are used to draw irregular curves. (Courtesy of Alvin & Company.)

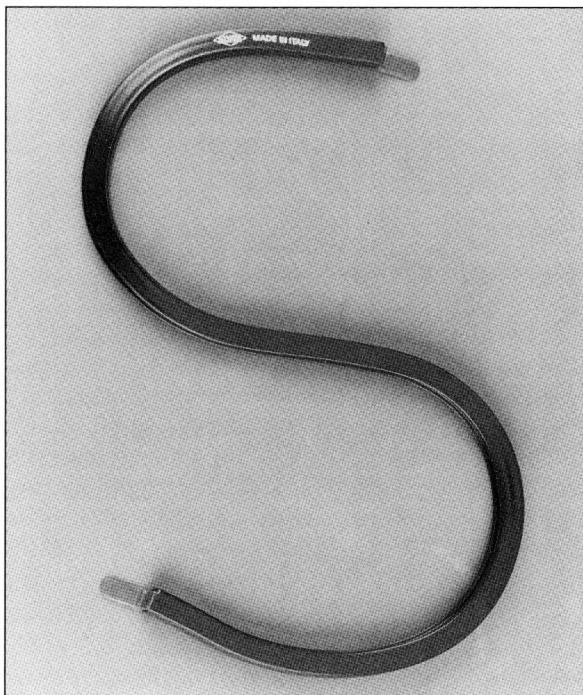

Figure 1.50 Spline

A spline is a flexible device used to draw long, irregular curves through a series of points. (Courtesy of Alvin & Company.)

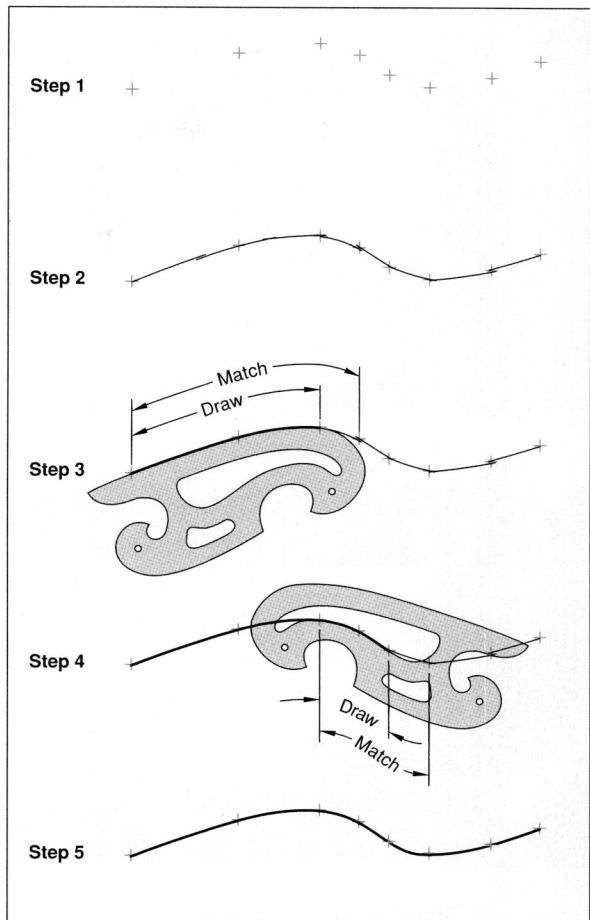

Figure 1.51 Steps in Drawing an Irregular Curve through a Series of Points

Drawing an Irregular Curve

Step 1. A series of points is used to locate the curve. (Figure 1.51)

Step 2. For best results, sketch a curve through the points.

Step 3. Align the irregular curve with only two or three points, then draw the curve only through these points. The curve segment drawn through the last of these points should be aimed in the general direction of the next point.

Step 4. Adjust the irregular curve to go through the next two or three points.

Step 5. Repeat these steps to complete the curve.

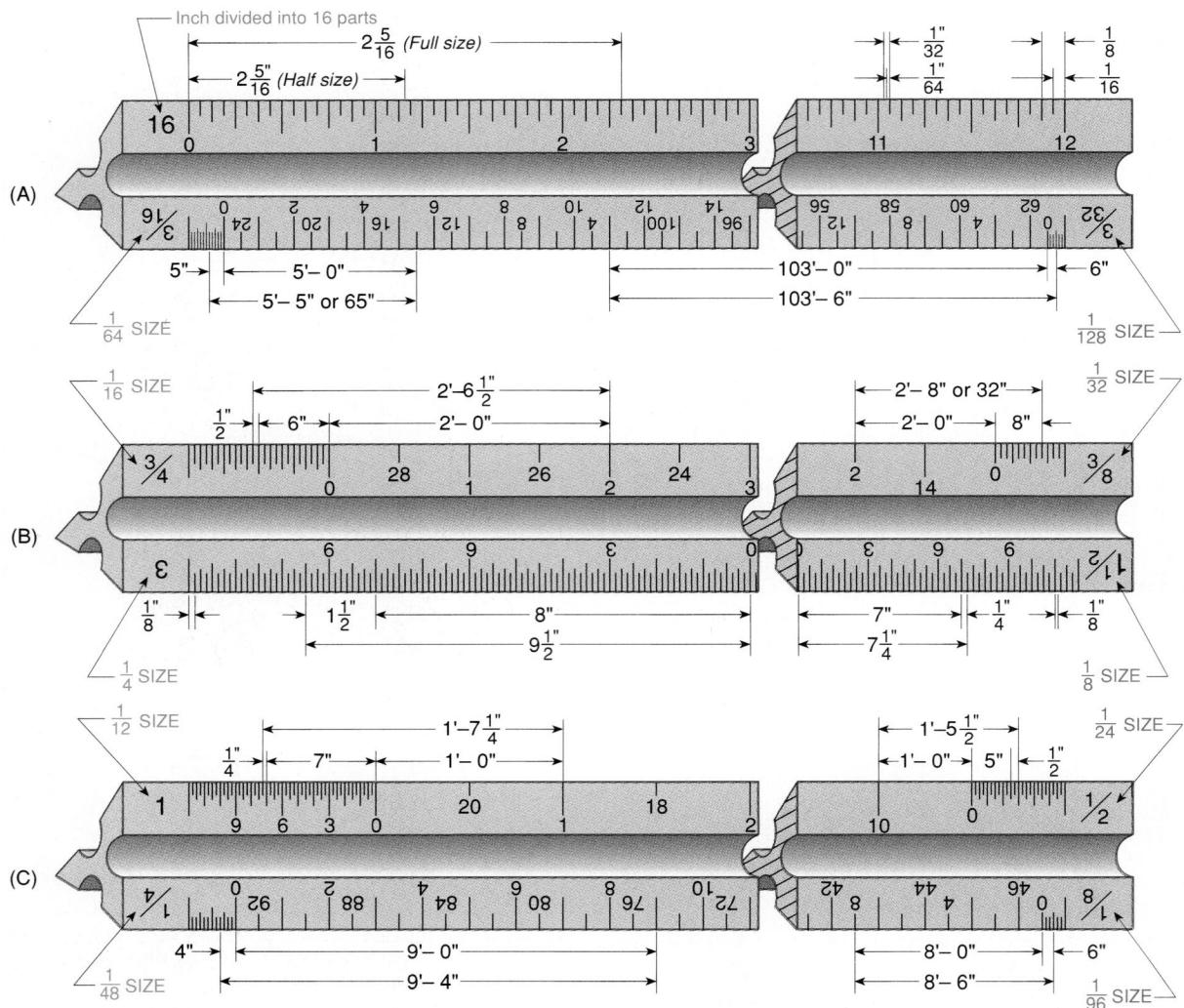

Figure 1.52 Architect's Scale

The architect's scale has 11 scales with which to measure distances accurately on architectural drawings.

1.13 SCALES

Scales are used to measure distances on technical drawings. Scales are usually 6 or 12 inches long and are made of wood, plastic, or metal. Triangular scales are commonly used in technical drawing because they offer the user a combination of several scales on each side. (Figure 1.52) The most common types of scales used in technical drawing are: mechanical engineer's, civil engineer's, metric, and architectural scales. A **combination scale** is one that has engineering, metric, and architectural components on a single scale.

The scale chosen to create the drawing must be clearly marked in the title block. For example, a drawing that is done full size is labeled as FULL SIZE, or as a ratio of 1:1. A half-size drawing is marked as HALF SIZE, or 1:2. Other reduced scales are 1:4 (quarter size), 1:8 (eighth size), 1:16 (sixteenth size), and so on. Enlarged scales are 2:1 (double size), 3:1, 4:1, 10:1, 100:1, and so on. When a metric drawing is created, the word METRIC or SI is prominently marked on the drawing.

Normally, CAD drawings are created full size. Only the plotted drawing is scaled to fit the paper. When starting a CAD drawing, set the units desired

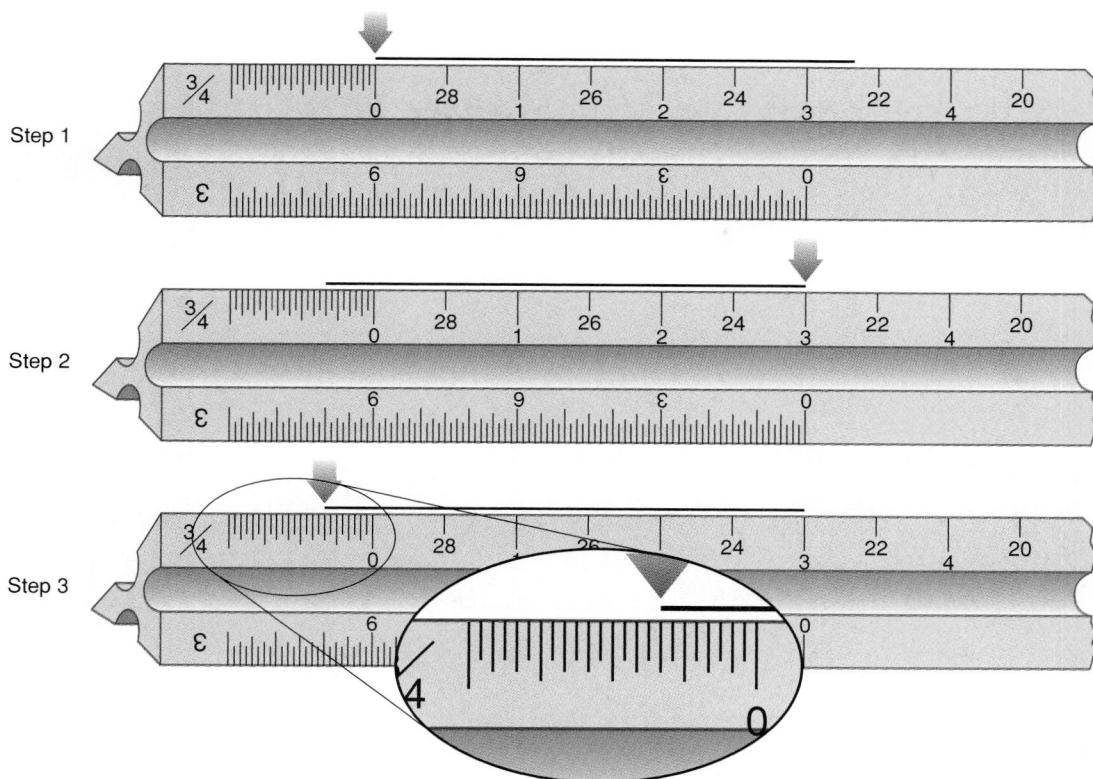

Figure 1.53 Steps in Reading an Architect's Scale, 3'-4"

and draw full size. When ready to choose the paper size, determine the longest horizontal and vertical dimensions on the drawing, then calculate the size paper needed to place the full-size drawing on the sheet. For plots, decide the size of the paper to be used and then calculate the plotting scale that will make the drawing fit the sheet. 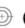 **CAD Reference 1.11**

1.13.1 Architect's Scale

An **architect's scale** is used to create drawings of structures, such as a building or a factory floor layout. Because architects work in feet and inches, each scale is divided into a section for feet and a subsection for inches, and it is called an open divided scale. The scale is used by first finding the distance in feet and then adding the number of inches. (Figure 1.53) The combination architect's scale has 11 different scales. Some sides have more than one scale superimposed on each other. Notice in Figure 1.52 that the $\frac{1}{4}$ and $\frac{1}{8}$ scales are on the same side; the $\frac{1}{4}$ scale is read from the left, and the $\frac{1}{8}$ scale is read from the right.

Reading an Architect's Scale

For this example, use the $\frac{1}{4}$ " per foot scale. (Figure 1.53) This scale has a $\frac{1}{4}$ " marked at the end. The feet are read to the right of the zero mark. Fractions of a foot are measured to the left of zero. The large numbers (28, 26, 24...) near the left end of the scale represent two things: (1) the number of feet for the $\frac{3}{8}$ scale, which starts from the right end, and (2) the 6" marks for the $\frac{1}{4}$ scale.

Step 1. Align the zero mark on the scale with the start point of the line to be measured.

Step 2. Adjust the scale so that the other end of the line is aligned with the smaller of the two foot mark values, which for this example is 3.

Step 3. The fractions of a foot are read to the left of the zero mark. To determine how many parts a foot has been divided into on this scale, count the number of both short and long marks to the left of zero. For this scale, there are 24 marks to the left of zero, meaning that a foot is divided into 24 equal parts, each equal to $\frac{1}{24}$ ". The longer marks represent inches. Determine which mark to the left of zero aligns closest to the left end of the line. For this example, the closest mark is the 8, which is read as 4". So the line is measured as 3' 4".

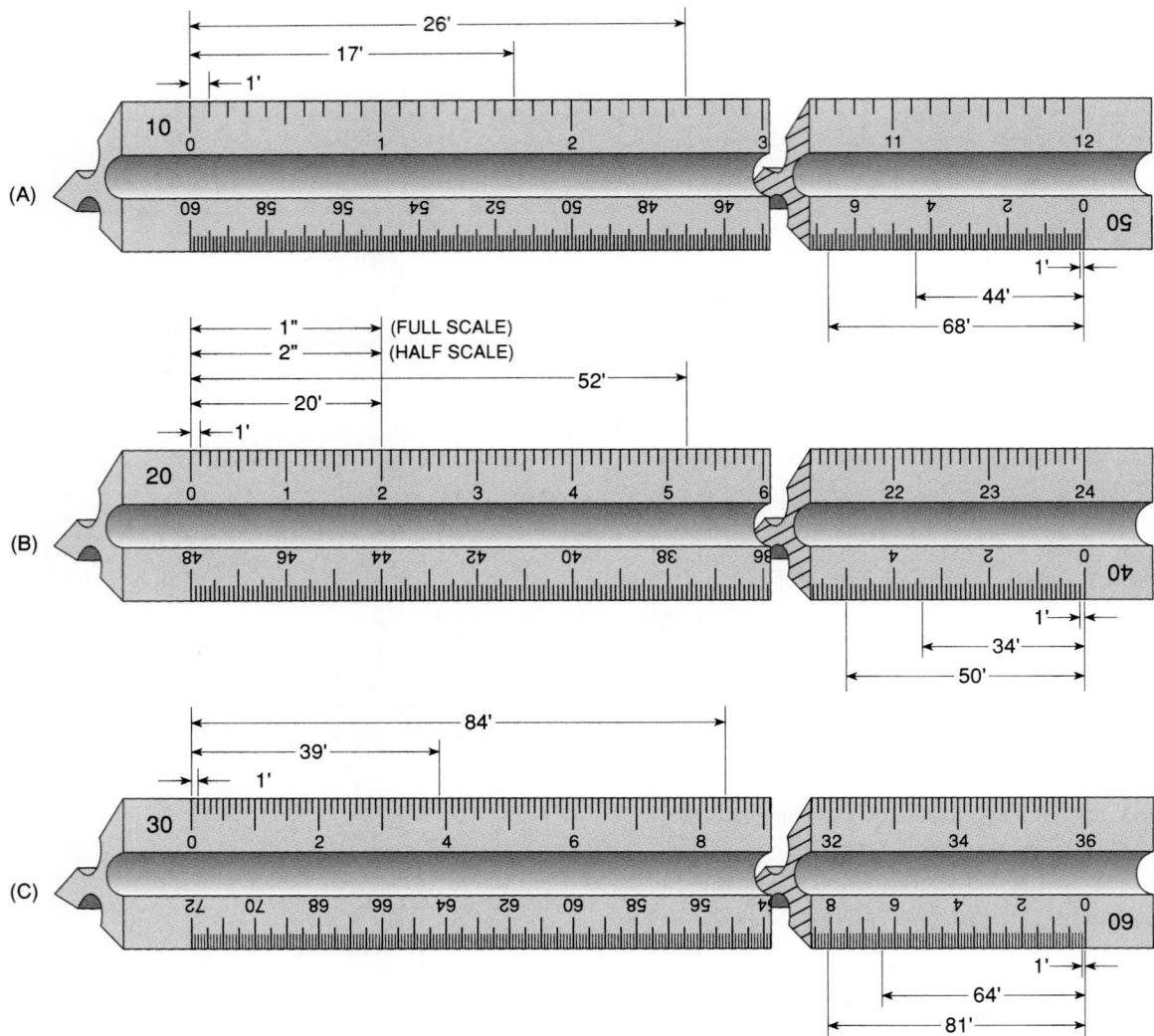

Figure 1.54 The Civil Engineer's Scale

1.13.2 Civil Engineer's Scale

The **civil engineer's scale** is a decimal scale divided into multiple units of 10, and it is called a fully divided scale. (Figure 1.54) This scale is commonly used to draw large structures and maps, where one inch on the map or drawing represents some number of feet or miles. Each end of the scale is labeled 10, 20, 30, 40, 50, or 60, which specifies the number of

units per inch. For example, the 30 scale has 30 units per inch. Many different scales can be created by simply moving the decimal place, as follows:

10 scale: 1=10', 1=100', 1=1000'

The 20, 30, 40, 50, and 60 scales work in a similar manner. (Figure 1.55A)

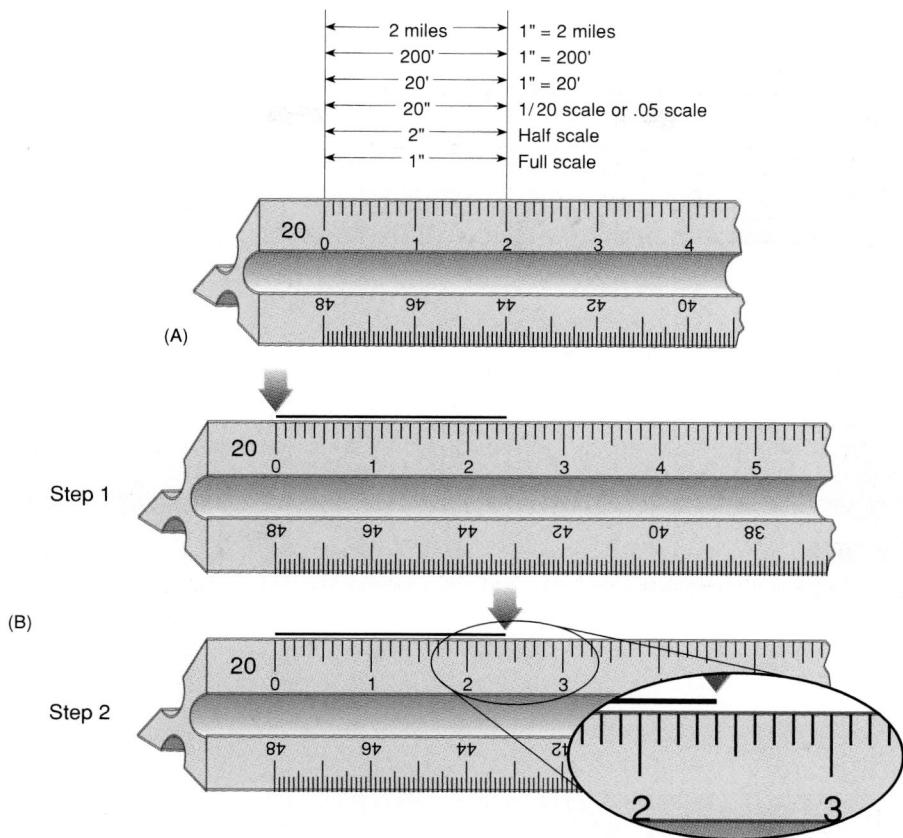

Figure 1.55 Steps in Reading a Civil Engineer's Scale, 24'

Reading a Civil Engineer's Scale

For this example, the 20 scale is used. (Figure 1.55B) The 20 scale has twenty marks per inch; therefore, each mark equals $1/20$ of an inch if the scale is used full size. However, the scale can also be conveniently used for half-size scale and others.

Step 1. Align the zero mark on the 20 scale with the left end of the line to be measured.

Step 2. Determine the closest mark on the 20 scale that corresponds to the right end of the line. For this example, assume a line that ends at the fourth mark past the number 2 on the scale. If this were a full-size drawing, the length of the line would be $24/20$ or $1.2"$. On a half-scale drawing, the line would be $2.4"$. If the scale were 1 inch equals 20 feet ($1"=20'$), then the line would be read as $24'$.

1.13.3 Mechanical Engineer's Scale

The **mechanical engineer's scale** is used to draw mechanical parts and is either fractionally divided into $1/16$ or $1/32$, or decimalized into 0.1 or 0.02. (Figure 1.56) Typically, the other sides of the scale are half size ($1/2"=1"$), quarter size ($1/4"=1"$), and eighth size ($1/8"=1"$). (Figure 1.56) For scales smaller than $1/8$, use the architect's scale.

Reading a Mechanical Engineer's Scale

Full-size 16 scale

The 16 scale represents an inch divided into 16 equal parts; therefore, each mark is $1/16"$, every other mark is $2/16"$ or $1/8"$, every fourth mark is $4/16"$ or $1/4"$, and every eighth mark is $8/16"$ or $1/2"$. (Figure 1.57)

Figure 1.56 The Combination Mechanical Engineer's Scale

Step 1. To measure a line, align the zero mark with the left end of the line.

Step 2. Determine which point on the scale is closest to the right end of the line. For this example, assume a line for which the right end is aligned exactly with the ninth mark past 1". The length of this line is read as 1-9/16".

Full-size 50 scale

The 50 scale is commonly used for full-size mechanical engineering drawings, because it provides two-decimal-place accuracy. (Figure 1.58) The ANSI standard calls for such accuracy on all nontoleranced dimensions, making the 50 scale the logical choice. The 50 scale divides

an inch into 50 parts, meaning each mark equals 1/50 or 0.02". The numbers between the longest marks on the scale, such as 2, mean 20/50.

Step 1. To measure a line, align the zero mark with the left end of the line.

Step 2. Determine which point on the scale is closest to the right end of the line. For this example, assume a line for which the right end is aligned three marks to the left of the small number 12.

Step 3. The length of the line is read as 2.46".

Half-size scale

The half-size scale is labeled $\frac{1}{2}$ at the end. To the right of zero, each mark represents a full inch; to the left of zero,

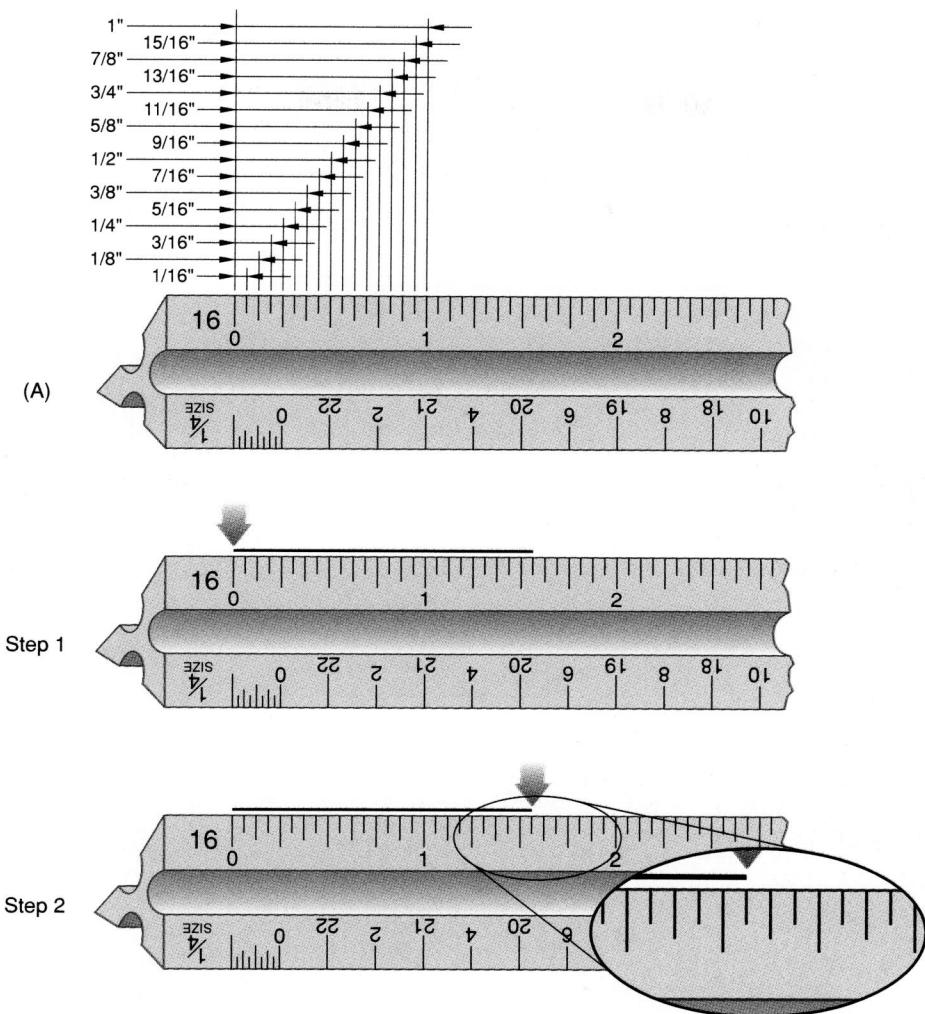

Figure 1.57 Steps in Reading the Mechanical Engineer's Scale, 1-9/16"

there is only one inch and it is marked off in fractions. (Figure 1.59) There are 16 marks in the inch to the left of zero, which means that each mark represents $1/16"$. The longer marks represent $1/8"$, $1/4"$, and $1/2"$ increments.

Step 1. To measure a line, position the scale such that the left end of the line is to the left of zero and is within the inch that is marked off. (The exact position is not critical in this step.)

Step 2. While making sure that the left end of the line stays within the marked-off inch to the left of zero, ad-

just the scale so that the right end of the line is exactly aligned with the closest full inch mark to the right of zero.

Step 3. Read the full inch mark first; then read the mark to the left of zero that most closely aligns with the left end of the line. As an example, assume a line that is between 3" and 4" long. The right end of that line would be at the 3" mark to the right of zero. The left end of the line would be at one of the marks to the left of zero, such as the fifth mark, which would be $5/16"$. The sample line, then, would measure $3-5/16"$.

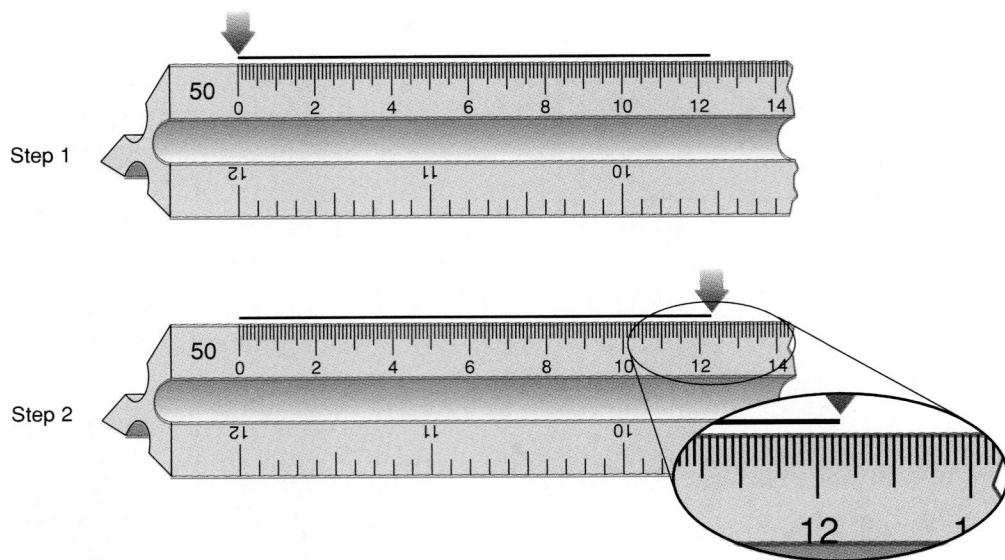

Figure 1.58 Reading a 50 Scale, 2.46"

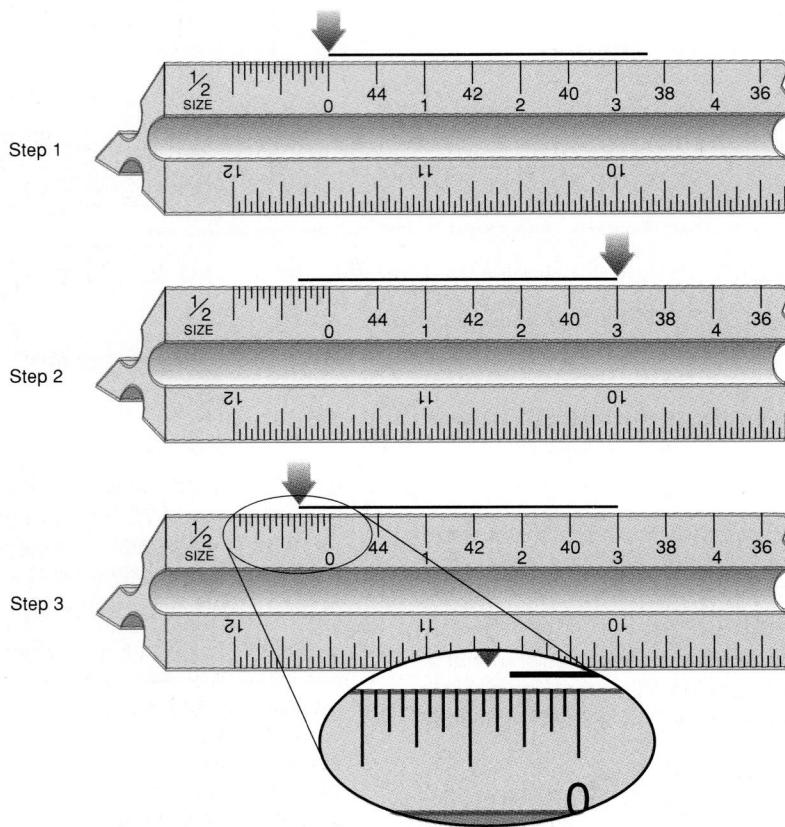

Figure 1.59 Reading a Half-Size Scale, 3-5/16"

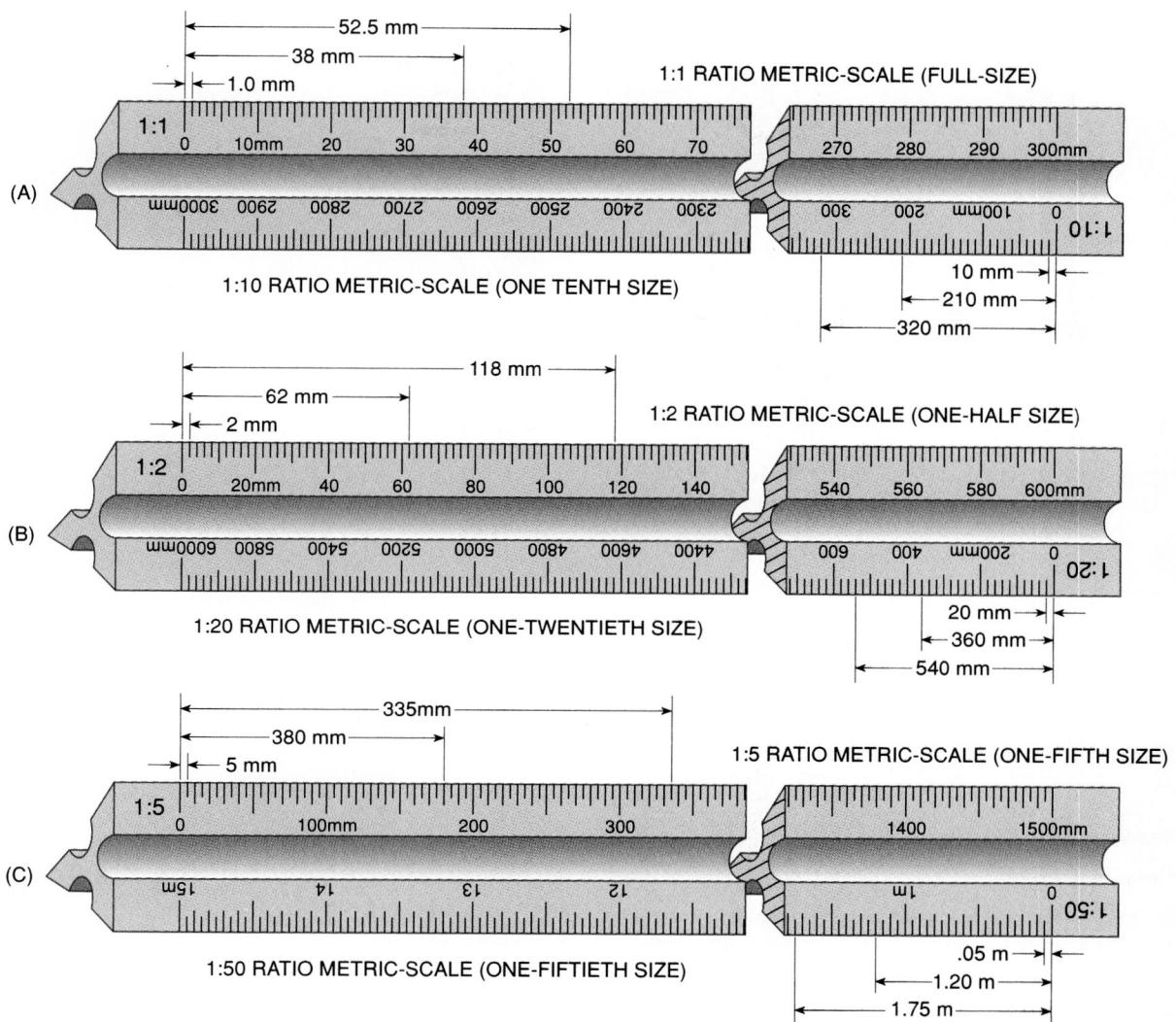

Figure 1.60 The Metric Scale for Using SI Units

1.13.4 Metric Scale

The international organization that established the metric standard is the **International Standards Organization (ISO)**. The system is called the **International System of Units**, or *Système Internationale*, abbreviated **SI**. The **metric scale** is used to create scaled technical drawings using SI units, (Figure 1.60) for which the millimeter (mm), meter (m), and kilometer (km) are the most common units of measure. The meter is the base unit, with the millimeter equal to 1/1000 of a meter and the kilometer equal to 1000 meters. The conversion factor between millimeters and inches is the ratio $1''=25.4$ mm. For example, to

change 68 mm to inches, divide 68 by 25.4 to get $2.68''$. To change $3.75''$ to millimeters, multiply 3.75 by 25.4 to get 95.25 mm. Conversion tables are found on the inside front cover of this text.

Figure 1.60 shows the different sides of a triangular metric scale and includes examples of how they are read. Each side of the triangular scale has a different metric scale, as follows:

- 1:1 Full size
- 1:2 Half size
- 1:5 Fifth size
- 1:10 Tenth size
- 1:20 Twentieth size
- 1:50 Fiftieth size

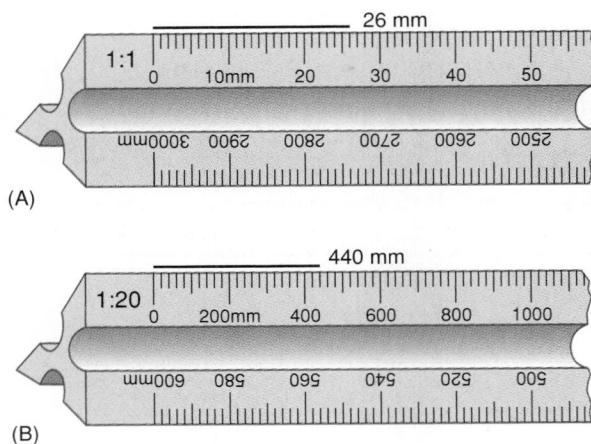

Figure 1.61 Reading the Full and 1:20 Metric Scale

These ratios can be reduced or enlarged by multiplying or dividing by a factor of 10. For example, the 1:20 scale can be reduced to a 1:200 scale by multiplying by 10.

Reading a Metric Scale

Full-size 1:1 ratio

On the 1:1 metric scale, each mark represents 1 mm and every tenth mark represents 10 mm, or 1 cm. (Figure 1.61A)

Step 1. To measure a line, align the zero mark with the left end of the line and read the mark on the scale aligned closest to the right end of the line. For this example, assume a line for which the right end is closest to the sixth mark past the number 20. The length of this line would be read as 26 mm, or 2.6 cm.

Twentieth-size 1:20 ratio

For this scale, each mark represents 20 mm and every tenth mark is 200 mm. (Figure 1.61B) Multiplying this scale by a factor of 10 would make it 1:200, where each mark would represent 200 mm and every tenth mark 2000 mm.

Step 1. To measure a line, align the zero mark with the left end of the line and read which mark on the scale is aligned closest to the right end of the line. For this example, assume a line for which the right end is closest to the second mark past the number 400. The length of the line is 440 mm.

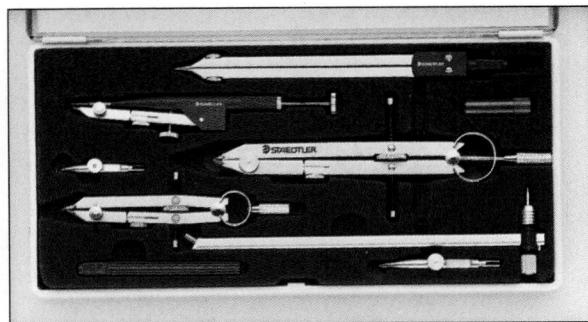

Figure 1.62 Drawing Instrument Set Commonly Used for Technical Drawings

This set contains two compasses, a divider, a beam attachment for large circles and arcs, inking points, and a tube with extra parts. (Courtesy of Staedtler, Inc.)

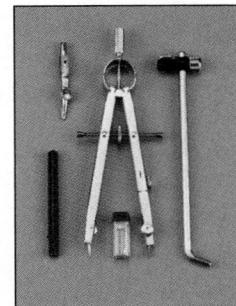

Figure 1.63 A Bow Compass and Extension Bar Used to Draw Circles and Arcs

(Courtesy of Staedtler, Inc.)

1.14 DRAWING INSTRUMENT SET

A **drawing instrument set** typically consists of one large and one small bow compass and a set of dividers, as shown in Figure 1.62. These instruments can be purchased separately or in a set. Some sets contain a small box to hold extra points and lead, and an extension bar for the compass, for making larger circles and arcs. Adapters are available for ink pens or for thin-lead mechanical pencils.

1.14.1 Compass

The **compass** is used to draw circles and arcs of varying diameters. (Figure 1.63) The lead is sharpened to a bevel using sandpaper. (Figure 1.64) The extension bar is used to draw large circles by extending the

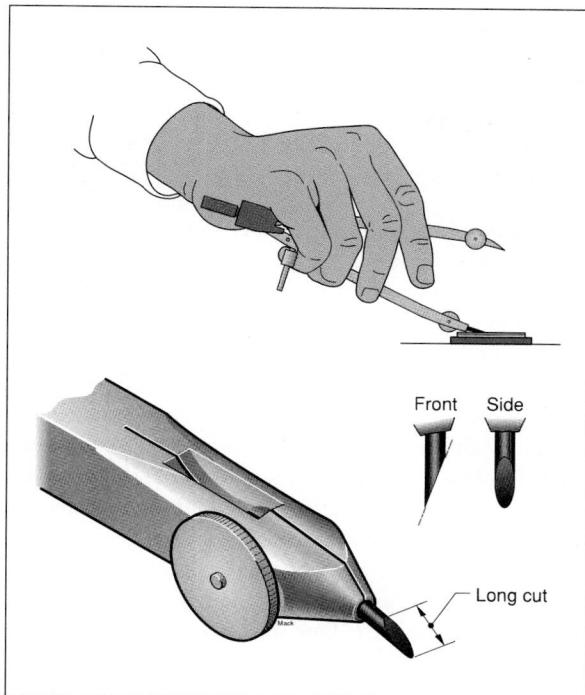

Figure 1.64 Sharpening Compass Lead

The lead in a compass is sharpened to a bevel using sandpaper.

range of the large bow compass. A beam compass is used for even larger circles. (Figure 1.65) With CAD, the CIRCLE and ARC commands are used to create all sizes of circles and arcs.

Drawing a Circle or Arc

Step 1. Draw two perpendicular lines to mark the center point of the circle or arc, and use the scale to mark the radius along one of these center lines. (Figure 1.66)

Step 2. Set the compass point at the intersection of the center lines; then set the compass to the radius by aligning the pencil point of the compass with the mark on the center line.

Step 3. Draw the circle or arc by leaning the compass in the direction that the circle is being drawn, putting most of the pressure on the pencil point. The compass can be moved either clockwise or counter-clockwise.

1.14.2 Dividers

A **divider** is similar to a compass except that it has needle points in both ends. There are two types of dividers: center wheel bow, and friction. (Figure 1.67)

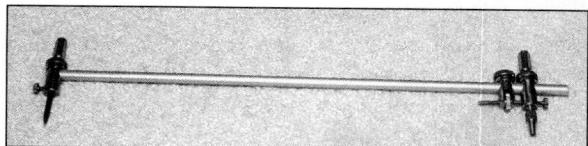

Figure 1.65 Beam Compass

A beam is a special attachment to a regular compass and is used to draw large circles and arcs.

Figure 1.66 Steps Used to Draw a Circle with a Compass

The divider is used to transfer measurements on a drawing, or divide a line into equal parts by trial and error.

To transfer a measurement, open the dividers to the desired distance; then pick up and move the dividers to the new position and mark the paper by lightly pushing the points of the dividers into the paper. This will leave two small marks that are the same distance apart as the original measurement.

To divide a line into equal parts, such as three, open the dividers to a distance you believe to be about one-third the length of the line. Then, begin at one end of the line and step off the distance three times. If the last space falls short or goes beyond the other end of the line, reset the divider by a distance equal to one-third of the shortfall or excess and re-step the line. Repeat these steps, using trial and error, until the line is equally divided.

With CAD, the DIVIDE or a similar command is used to mark equally spaced points on a line. © CAD Reference 1.13

Figure 1.67 Divider

A divider is used to transfer measurements.
(Courtesy of Staedtler, Inc.)

1.15 TEMPLATES

Templates are devices used to assist in the drawing of repetitive features, such as circles, ellipses, threaded fasteners, and architectural symbols. (Figure 1.68) The circle template is used to draw circles, arcs, and fillets and rounds, and is quicker than using a compass. The circle template has perpendicular center line marks, which are used to align the template to the perpendicular center lines on the drawing. An ellipse template works in a similar manner to create ellipses. Templates are also available for other common shapes, such as electronic or architectural symbols, and threaded fasteners. (Figure 1.69)

CAD software can be used to make templates of virtually anything drawn. Once an electronic template is created for a part, such as a fastener or an electronic or architectural symbol, the template can be scaled, rotated, and placed into an existing drawing. TEMPLATE, SYMBOL, BLOCK, and PATTERN are common CAD commands synonymous with using templates. One advantage of using CAD is that anything drawn has the potential of becoming a template and nothing need be drawn twice. Software products available as add-ons to a CAD program include symbol or template libraries, so the user does not have to draw the symbols from scratch.

© CAD Reference 1.14

Figure 1.68 Circle Template

A circle template is used to draw circles and arcs by aligning marks on the template with center lines on the drawing, then using a pencil to trace the outline of the hole cut in the template. (Courtesy of Staedtler, Inc.)

Figure 1.69 Symbol Template

This template is used to draw architectural symbols, such as door swings and appliances. (Courtesy of Staedtler, Inc.)

1.16 TECHNIQUE FOR DRAWING USING TRADITIONAL TOOLS

Engineering and technical drawings are used to communicate technical information. In order to communicate the technical idea clearly, the drawing must be neat and must have consistent lines. Through practice and hard work, you will be able to create neat drawings that are easy to read and understand. The following are important guidelines that should be followed when making technical drawings using traditional tools:

1. All lines except construction lines should be black, crisp, and consistent. (Figure 1.70) Black lines are created by using a soft lead and putting pressure on the pencil as the line is being drawn. Crisp lines do not have fuzzy edges. A consistent line does not change in thickness from one end to the other.

2. Corners should be sharp and without overlap.
3. Different linetypes vary in thickness, and the drawing should reflect these variances. For example, a visible line is thick (0.7 mm) and a hidden line is thin (0.35 mm). There should be a clear difference between these two lines when drawn.
4. Dashes, such as hidden, center, and phantom linetypes, should have consistent spacing, with definite endpoints.
5. Arcs intersecting lines should have smooth points of tangency.
6. Construction lines should be very light and should be drawn with a hard-grade lead. A good rule of thumb when creating construction lines is that, when the drawing is held at arm's length, the construction lines should be difficult to see.

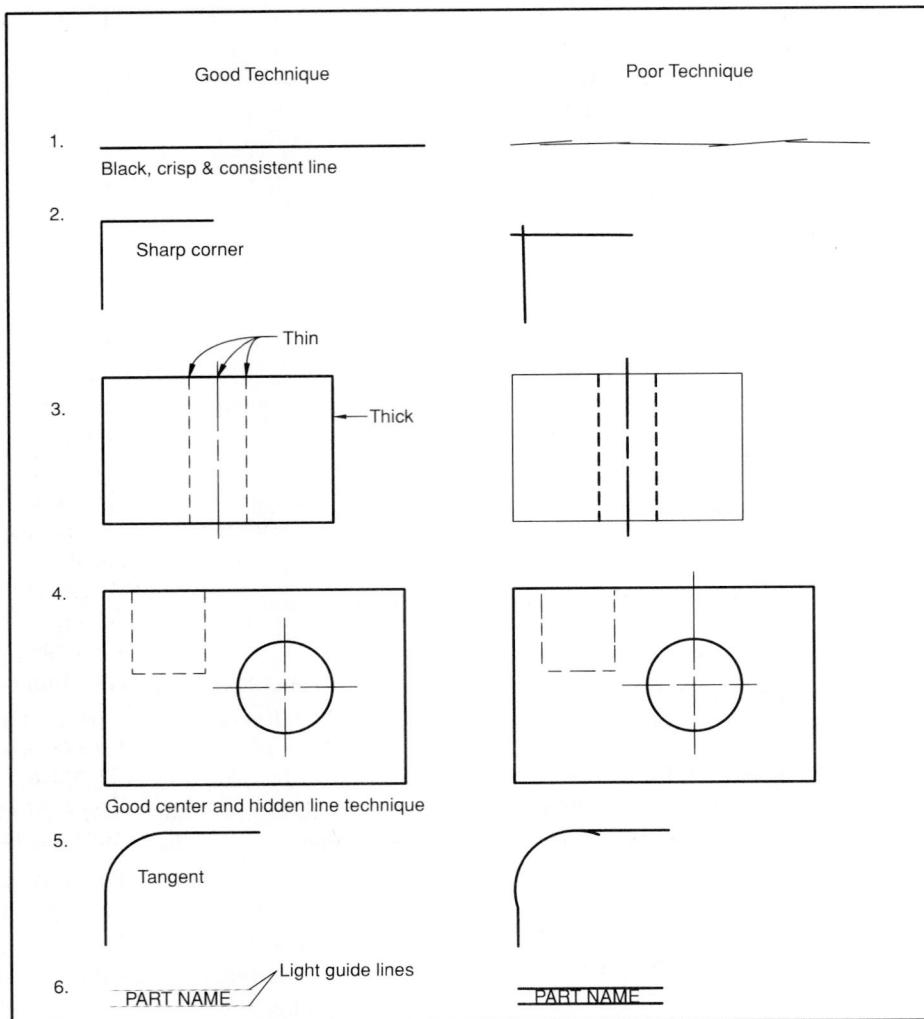

Figure 1.70 Examples of Good and Poor Drawing Technique for Lines and Arcs, Using Traditional Tools
Lines should be black, crisp, consistent, and the proper thickness.

1.17 SUMMARY

As a student of technical graphics, you will study and learn to apply the tools used to create engineering drawings and models. Even more important, you will learn the underlying principles and concepts of technical graphics, such as descriptive geometry. You will also learn the standards and conventions that will enable you to create drawings and models that can be read and accurately interpreted by engineers or technologists anywhere.

The tools used for technical drawing include traditional ones, such as the triangle and the compass,

and CAD. Traditional tools are used to make technical drawings by hand, and it takes practice and repetition to become proficient in their use. Although with CAD there is less emphasis on developing good technique, it still requires practice and repetition to attain proficiency.

The ability to draw is a powerful skill. It gives a person's thoughts visible form. Engineering drawings can communicate complex ideas both efficiently and effectively, and it takes special training to be able to produce these complex images. If drawings are "windows to our imaginations," then engineering drawings are specialized windows that give expression to the most complex, technical visions our minds can imagine.

Engineering drawing does more than communicate. Like any language, it can actually influence how we think. Knowing how to draw allows you to think of and deal with many problems that others may not. A

knowledge of technical graphics helps you more easily envision technical problems, as well as their solutions. In short, technical graphics is a necessity for every engineer and technologist.

KEY TERMS

Adjustable triangle	Dimension lines	International Standards Organization (ISO)	Pen plotter
Alphabet of lines	Divider	International System of Units (SI)	Phantom lines
American National Standards Institute (ANSI)	Drafter/Designer	Irregular (French) curve	Protractor
Applications	Drafting machine	Line weight	Scales
Architect's scale	Drawing	Linestyles	Scanner
Break lines	Drawing instrument set	Manufacturing engineering technology	Section lines
Center lines	Electrical engineering technology	Mechanical engineer's scale	Spline
Civil engineer's scale	Engineering graphics	Mechanical engineering technology	Standards
Combination scale	Engineers	Mechanical pencil	Straightedge
Compass	Erasing shield	Media	Tablet
Computer-aided design/drafting (CAD)	Extension lines	Metric scale	Technical drawing
Concurrent engineering	Geometric modeling	Mouse	Technologists
Construction engineering technology	Graphics theory	Output device	Templates
Conventions	Hardware	Parallel edge	Thin-lead pencil
Cutting plane lines	Hidden lines		Tools
Design process	Ideation		Traditional tools
	Industrial technology		Triangles
	Input device		Visible lines
			Visualization

QUESTIONS FOR REVIEW

1. Define the following terms: drawing, engineering drawing, and technical drawing. What are the distinctions among these terms?
2. What are ideation drawings used for?
3. What is the purpose of document drawings?
4. Why are technical drawings an important form of communication for engineers and technologists?
5. How might graphics be used in your area of study or work?
6. Define standards.
7. Define conventions.
8. List three examples of how graphics are used in engineering design.
9. Sketch and label the concurrent engineering model in Figure 1.12.
10. Define CAD.
11. Name the primary parts of a CAD system.
12. List the typical hand tools used to create a drawing.
13. What are templates used for? Give an example of one.
14. Describe how pencils are graded.
15. List the standard paper sizes used for technical drawings.
16. What is the shape of a sharpened compass lead?
17. What grade pencil is used to create construction lines on technical drawings?
18. List five recommended drawing techniques for creating good technical drawings.
19. How are metric drawings clearly identified on the drawing sheet?

FURTHER READING

Booker, P. *The History of Engineering Drawing*. London: Chatto & Windus, 1962.

Ferguson, E. S. "The Mind's Eye: Nonverbal Thought in Technology." *Science* 197, no. 4306 (August 26, 1977), pp. 827–36.

Land, M. H. "Historical Developments of Graphics." *Engineering Design Graphics Journal* 40, no. 2 (Spring 1976), pp. 28–33.

Higbee, F. G. "The Development of Graphical Representations." In *Proceedings of the Summer School for Drawing Teachers*. eds. R. P. Hoelscher, J. Rising. New York: McGraw Hill Company, Inc., 1949, pp. 9–26.

Reynolds, T. S. "Gaspard Monge and the Origins of Descriptive Geometry." *Engineering Design Graphics Journal* 40, no. 2 (Spring 1976), pp. 14–19.

PROBLEMS

The following problems introduce you to the tools of technical drawing. To solve these problems, you must use either traditional tools or a CAD system. By doing the drawing problems, you will learn how traditional tools, such as the straightedge, triangles, compass, dividers, scales, protractors, paper, eraser, and pencils, are used. If solving the problems using CAD, you will learn how to draw and erase lines, circles, arcs, and curves.

To convert the problems to metric, use 25.4 mm per inch and round the value to the nearest whole millimeter. Use capital letters (caps) for all text.

- 1.1 Research and report on an important historical figure in engineering design, such as Henry Ford, Thomas Edison, the Wright brothers, or Alexander Graham Bell.
- 1.2 Identify at least five other individuals who worked as engineers and had an impact on society.
- 1.3 Research and report on an important historical engineering achievement, such as airplanes, space flight, computers, or television.

- 1.4 Identify three new products that have appeared on the market in the last five years.
- 1.5 Research and report on an important historical figure in graphics, such as Gaspard Monge, M. C. Escher, Thomas Alva Edison, Leonardo da Vinci, Albrecht Durer, or Frank Lloyd Wright.
- 1.6 To demonstrate the effectiveness of graphics communications, write a description of the object shown in Figure 1.71. Test your written description by having someone attempt to make a sketch from your description.
- 1.7 Make a sketch of a common device, such as a telephone, automobile, computer mouse, or coffee cup.
- 1.8 Get a clear mental picture of a television, then sketch what you see in your mind. Is this mental image 2-D or 3-D? Try to put words to each feature of the TV you are drawing. In this problem you will experience the difficulty in trying to verbally describe an object with enough detail for it to be manufactured.

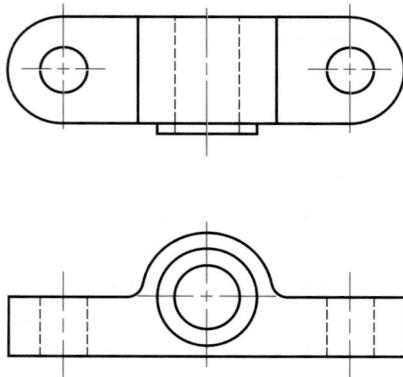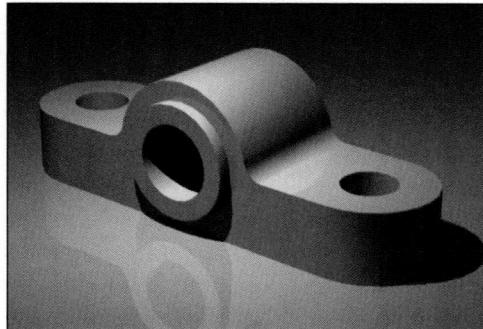

Figure 1.71 Problem 1.6 Bearing Block to Be Described Verbally

Figure 1.72 Problem 1.11 A-Size Drawing Sheet Divided into Six Equal Parts

- 1.9 Interview a practicing engineer or technologist and ask how graphics is used in his or her daily work.
- 1.10 Ask the practicing engineer or technologist what changes are taking place in his or her profession.
- 1.11 Using traditional tools or CAD, draw the border for an A-size (8 1/2" x 11") sheet, using the dimensions shown in Figure 1.72. Divide the drawing area into six equal parts and label each, beginning with the letter A. Do not include the

Figure 1.73 Problem 1.12 A4 Metric Drawing Sheet Divided into Six Equal Parts

dimensions. Text is $1/8''$ high, all caps, and centered vertically in the space, using light construction guidelines if using traditional tools.

- 1.12 Using traditional tools or CAD, draw the border for an A4 metric sheet, using the dimensions shown in Figure 1.73. Divide the drawing area into six equal parts and label each, beginning with the letter A. Text is 3 mm high, all caps, and centered vertically in the space, using light construction guidelines, if using traditional tools.

Figure 1.74 Problem 1.13 Line Exercise

1.13 See Figure 1.74. Using either the A or A4 sheet created in Problems 1.11 and 1.12, do the following in the given space:

- a.* Draw six equally spaced horizontal lines.
- b.* Draw six equally spaced vertical lines.

- c.* Draw eight equally spaced 45-degree lines.
- d.* Draw eight equally spaced 30-degree lines.
- e.* Draw eight equally spaced 15-degree lines.
- f.* Draw eight equally spaced 75-degree lines.

1.14 See Figure 1.75. Determine the measurements shown, on the metric scales.

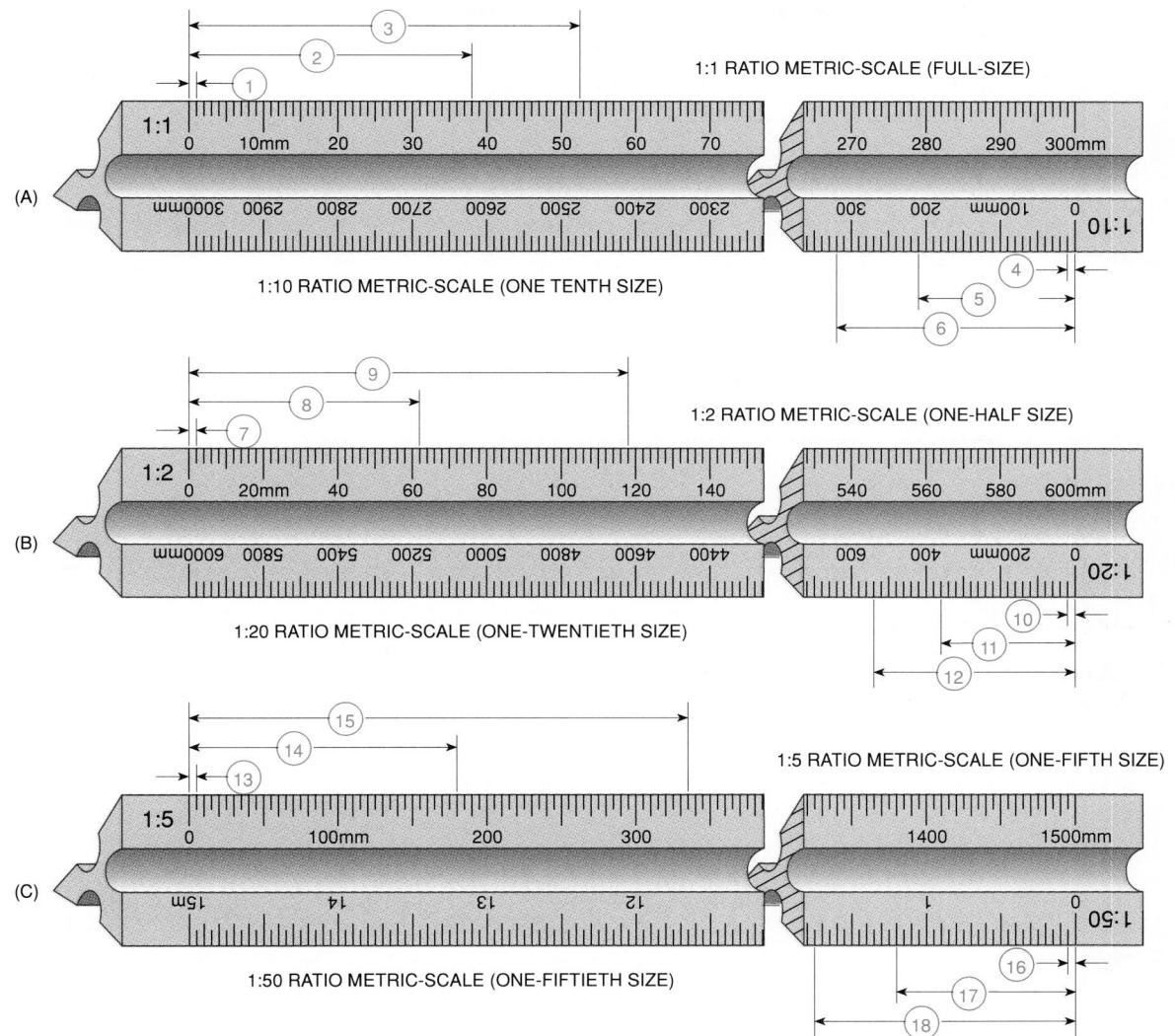

Figure 1.75 Problem 1.14 Reading Metric Scales

1.15 See Figure 1.76. Determine the measurements shown, on the civil engineer's scales.

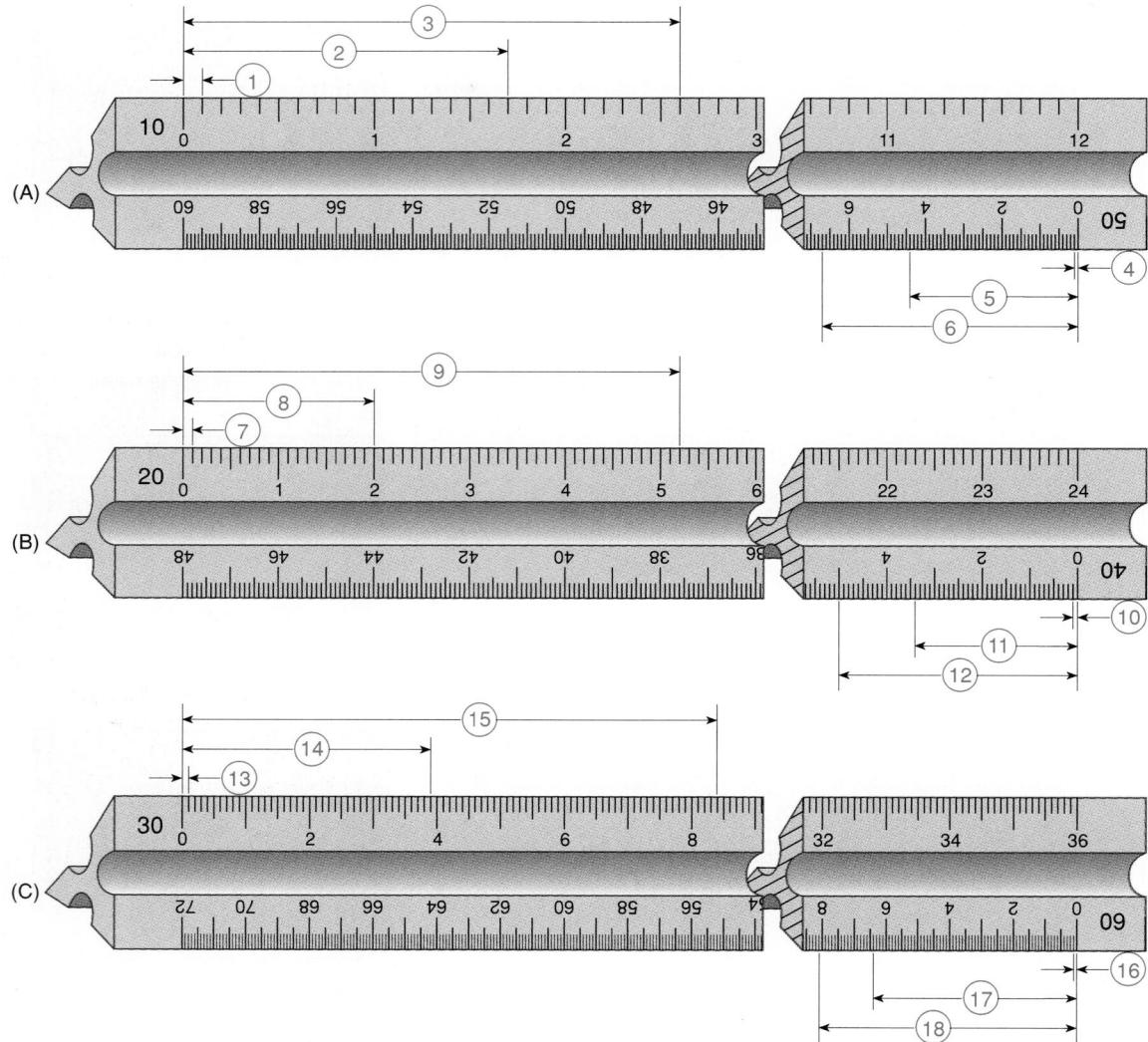

Figure 1.76 Problem 1.15 Reading Civil Engineer's Scales

1.16 See Figure 1.77. Determine the measurements shown, on the architectural engineer's scales.

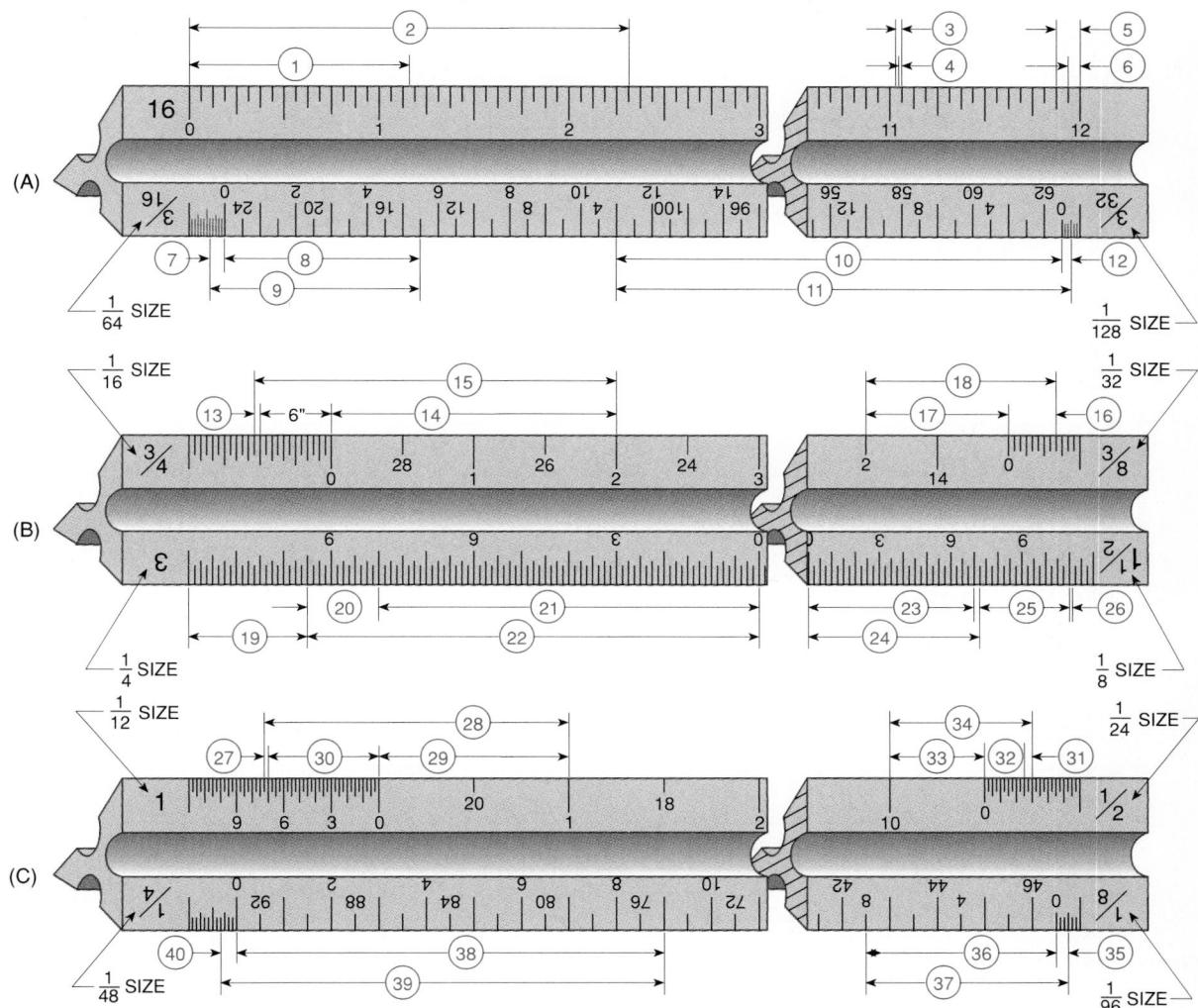

Figure 1.77 Problem 1.16 Reading Architectural Engineer's Scales

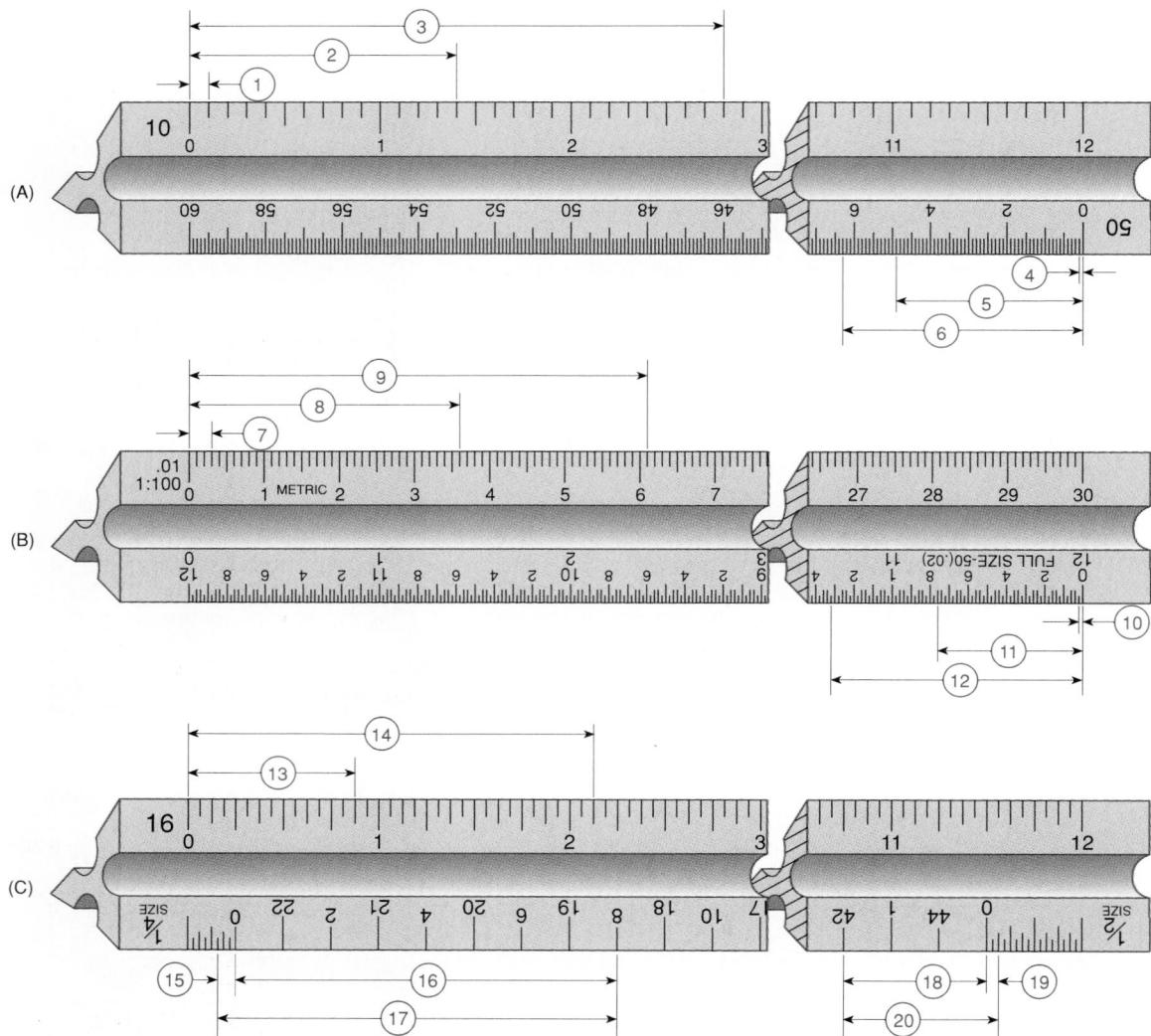

Figure 1.78 Problem 1.17 Reading Combination Scales

1.17 See Figure 1.78. Determine the measurements shown, on the combination scales.

1.18 See Figure 1.79. Draw the border lines and title blocks for the ANSI and ISO drawing sheets, using the dimensions shown. Add text as shown, using $1/8''$ (3 mm) all caps text.

Figure 1.79 Problem 1.18
ANSI Standard Title Blocks
and Border Lines

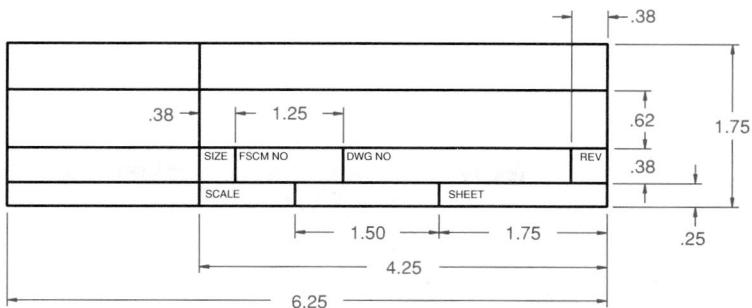

Title Block for A, B, C.

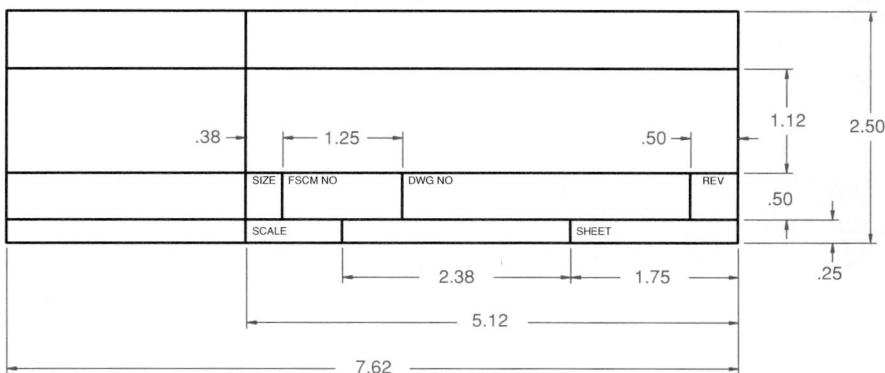

Title Block for D and E.

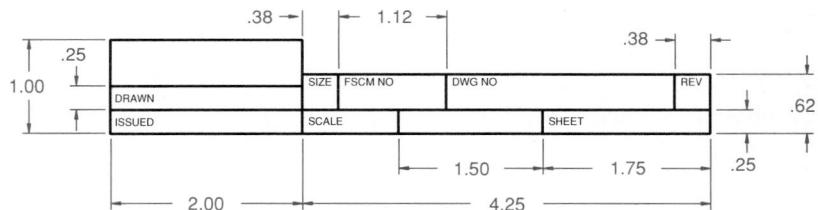

Continuation Sheet Title Block for A, B, C.

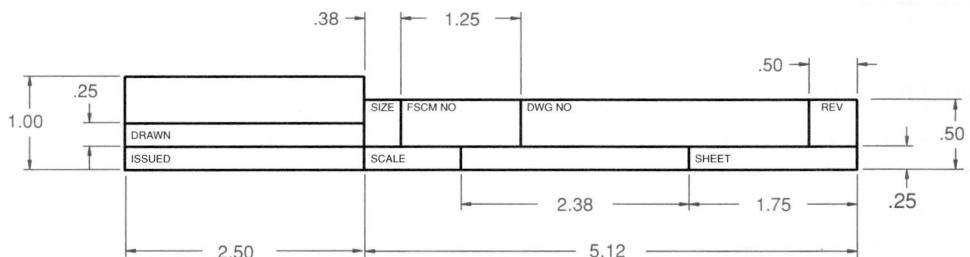

Continuation Sheet Title Block for D and E.

Size Designation	Width (Vertical)	Length (Horizontal)	Margin		International Designation	Width		Length	
			Vertical	Horizontal		mm	In.	mm	In.
A (Horiz)	8.5	11.0	0.38	0.25	A4	210	8.27	297	11.69
A (Vert)	11.0	8.5	0.25	0.38	—	—	—	—	—
B	11.0	17.0	0.38	0.62	A3	297	11.69	420	16.54
C	17.0	22.0	0.75	0.50	A2	420	16.54	594	23.39
D	22.0	34.0	0.50	1.00	A1	594	23.39	841	33.11
E	34.0	44.0	1.00	0.50	A0	841	33.11	1189	46.11

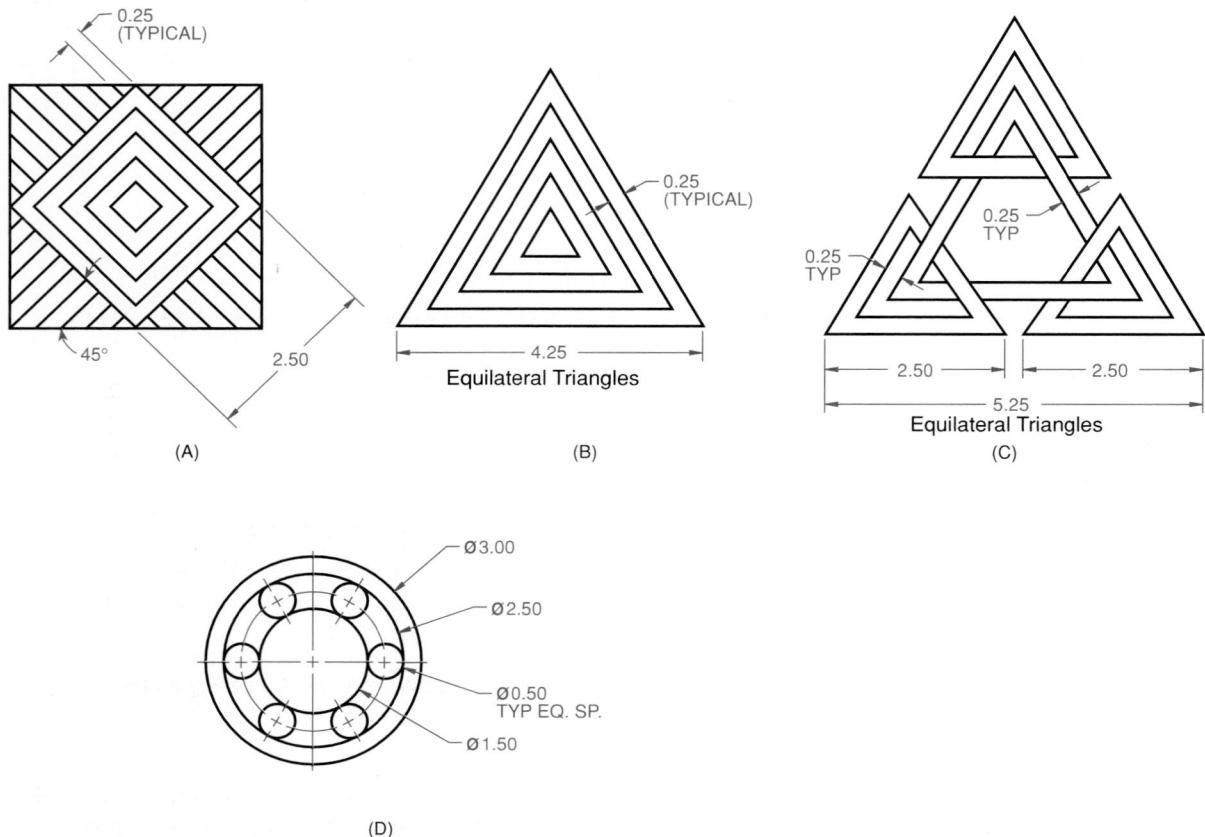

Figure 1.80 Problem 1.19 Shape Construction

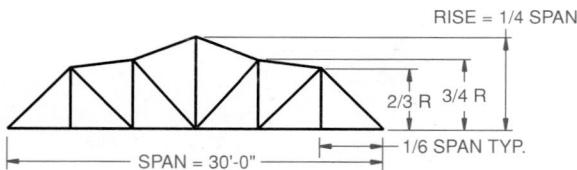

Figure 1.81 Problem 1.20 Centering Plate

1.19 See Figure 1.80. Do the problems assigned by your instructor, using the appropriate size drawing sheet. Do not dimension. Whenever you see TYPICAL or TYP on the drawings, it means that similar features are the same size; \varnothing means diameter of the circle.

1.20 See Figure 1.81. Using a scale of $1/8'' = 1'-0''$, draw the truss shown in the figure. The rise (R) is one-fourth the span of the truss.

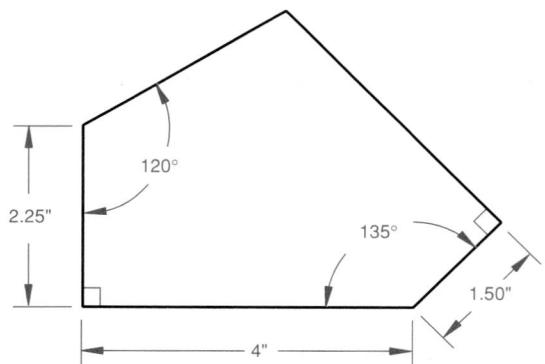

Figure 1.82 Problem 1.21 Angle Polygon

1.21 See Figure 1.82. Construct the irregular polygon shown in the figure, using the given dimensions, on an A- or A4-size sheet. Do not dimension.

1.22 See Figure 1.83. Construct the irregular polygon shown in the figure, using the given dimensions, on an A- or A4-size sheet. Do not dimension.

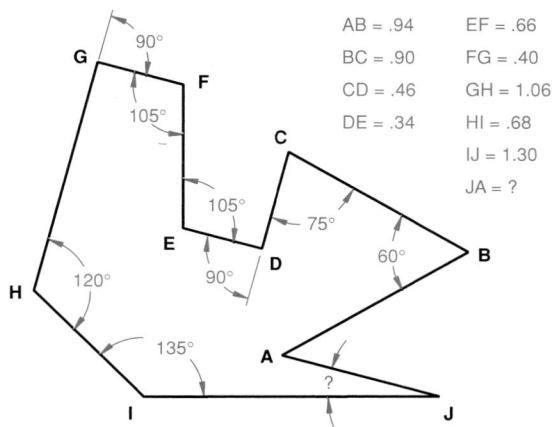

Figure 1.83 Problem 1.22 Irregular Polygon

1.23 See Figure 1.84. Construct the centering plate, using the given dimensions. All of the angles are proportional to angle A. Place the drawing on an A- or A4-size sheet. Do not dimension.

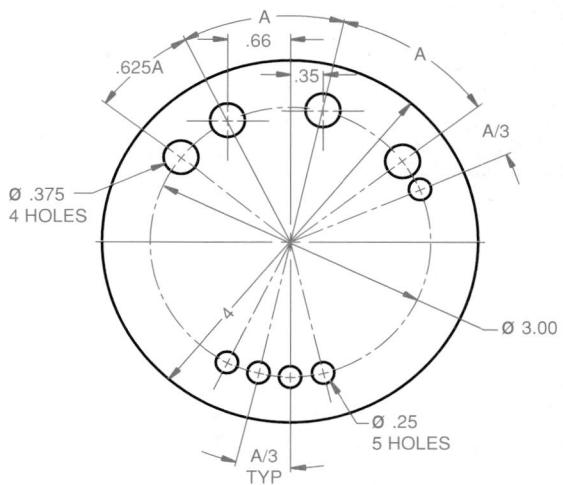

Figure 1.84 Problem 1.23 Centering Plate

1.24 See Figure 1.85. Construct the V-spacer shown in the figure. The letter R in the dimensions means the radius of the arc. Use an A-size sheet.

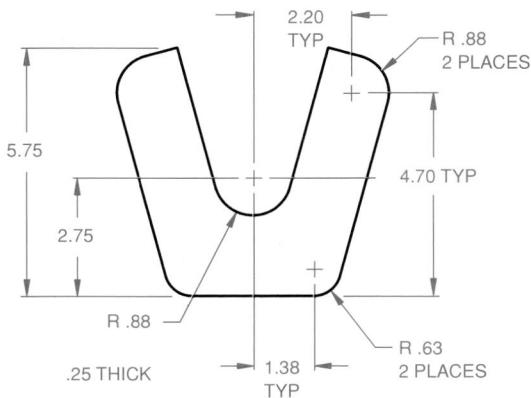

Figure 1.85 Problem 1.24 V-Spacer

1.25 See Figure 1.86. Construct the pump gasket shown in the figure, using an A-size sheet.

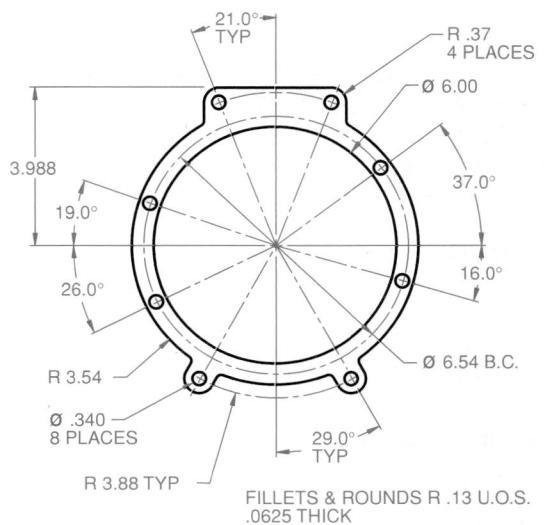

Figure 1.86 Problem 1.25 Pump Gasket

1.26 See Figure 1.87. Construct the open support shown in the figure, using an A-size sheet.

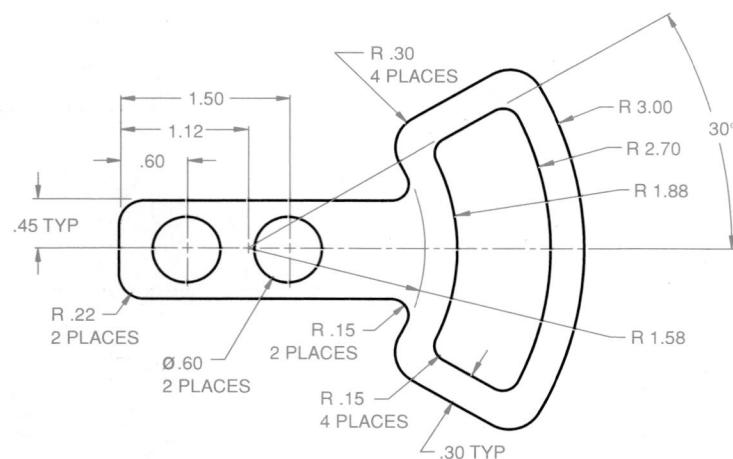

Figure 1.87 Problem 1.26 Open Support

1.27 See Figure 1.88. Construct the angle bracket shown in the figure, using a B-size sheet.

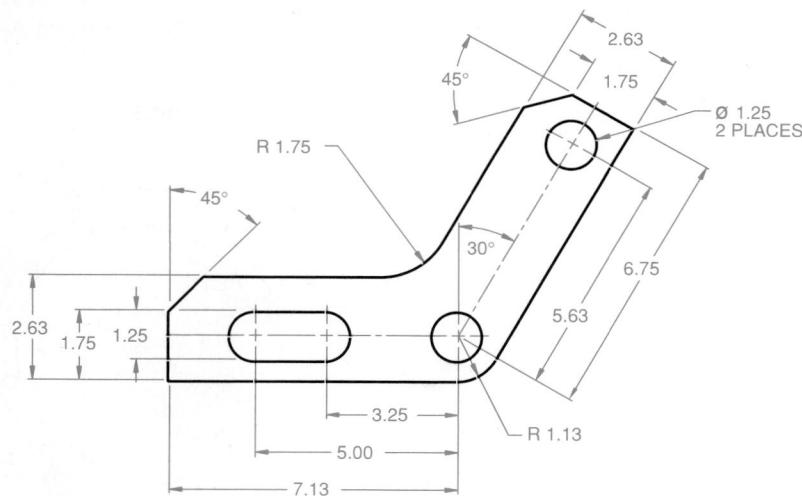

Figure 1.88 Problem 1.27 Angle Bracket

1.28 See Figure 1.89 A through F. Using the scale assigned by your instructor, measure and then construct the parts.

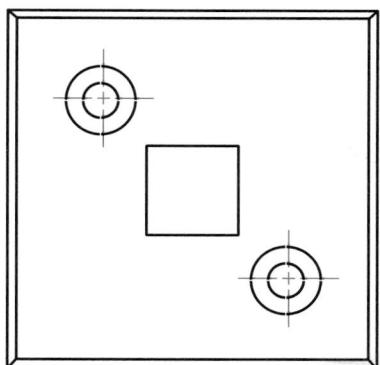

(A)

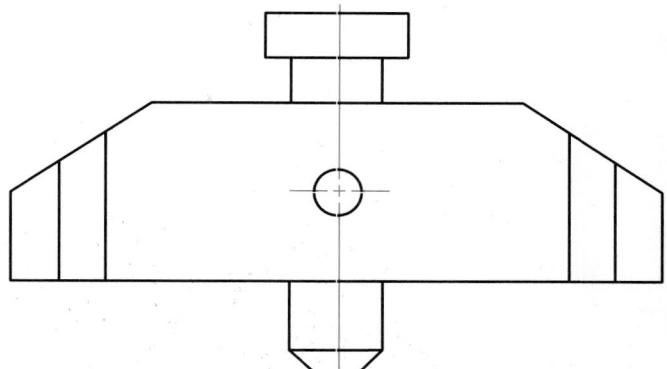

(B)

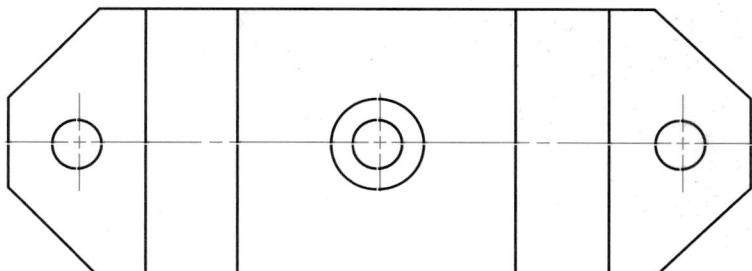

(C)

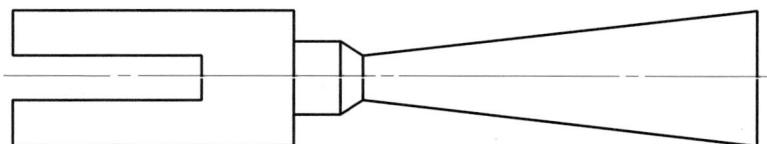

(D)

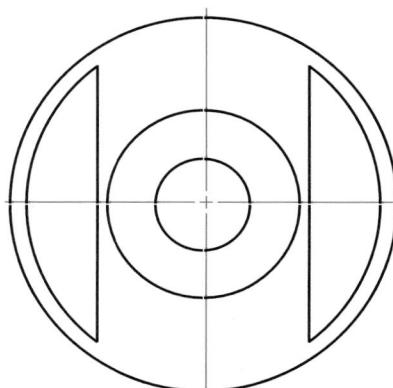

(E)

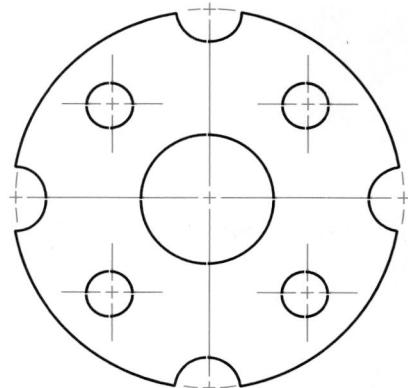

(F)

Figure 1.89 Problem 1.28
Scaled Drawings

CHAPTER 2

Sketching, Text, and Visualization

It adds a precious seeing to the eye.

William Shakespeare

OBJECTIVES

After completing this chapter, you will be able to:

1. Define technical sketching.
2. Understand how sketching integrates into the design process.
3. Identify and define two types of sketches.
4. Create a design sketch using pencil or computer.
5. Identify and use sketching tools.
6. Use grid paper to create sketches.
7. Lay out a sketch using proportions.
8. Understand the difference between pictorial and multiview projection.
9. Create an isometric sketch.
10. Create an oblique sketch.
11. Create a multiview sketch.
12. Identify the types and precedence of lines.
13. Follow good hand-lettering practice.
14. Identify important practices when using CAD for lettering.
15. Recognize the need for visualization.
16. Use the manipulation of solid primitives as a technique for visualizing 3-D objects.
17. Use the technique of a 3-D object interacting with 2-D surfaces for visualization.
18. Apply the concepts of image planes and projection to visualize 3-D objects.
19. Appreciate the role that future technology might play in visualization.

Sketching is an important method of quickly communicating design ideas; therefore, learning to sketch is necessary for any person working in a technical field. Sketching is as much a way of thinking as it is a method of recording ideas and communicating to others. Most new designs are first recorded using design sketches.

- This chapter introduces you to sketching techniques. The next chapter uses these techniques to help you visualize the forms of objects in your mind. Later chapters show you how to take your sketched design ideas and formalize them in models or drawings that can be used in analysis and manufacturing.
- Lettering is part of sketching and drawing. Before CAD, lettering had much more emphasis in engineering and technical graphics. Now it is no longer necessary to spend hours working on lettering technique. CAD systems offer the user many different typestyles that can be varied in a number of ways.
- Visualization is the mental understanding of visual information. For students in engineering and technology, visualization skills can be crucial in understanding the fundamental concepts of technical graphics. The ability to visualize also greatly enhances the speed and accuracy with which drawings can be done, using traditional drafting techniques or the computer. Visualization skills can assist you in building and manipulating a 3-D design in the virtual world of the computer. Sketching techniques will be the primary vehicle through which you will develop and use visualization skills.

2.1 TECHNICAL SKETCHING

There are three methods of creating technical drawings: freehand, mechanical, and electronic, as shown in Figure 2.1. **Technical sketching** is the process of producing a rough, preliminary drawing representing the main features of a product or structure. Such sketches have traditionally been done freehand; today, CAD systems can also be used. A technical sketch is generally less finished, less structured or restricted, and it takes less time than other types of freehand illustrations. (Figure 2.2) Also, a technical sketch may communicate only selected details of an object, using lines; whole parts of an object may be ignored, or shown with less emphasis, while other features may be shown in great detail.

Technical sketches can take many different forms, depending on the clarity needed and the purpose of the sketch, both of which depend on the audience for which the sketch is intended. For example, a sketch made quickly to record a fleeting design idea may be very

Figure 2.1

Technical drawings are created using freehand, mechanical, or electronic means. Freehand drawings are known as sketches and are an important communications tool that engineers use frequently when designing.

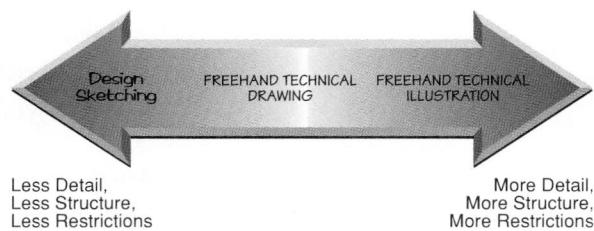

Figure 2.2

Freehand drawings are grouped by the level of detail, structure, and restrictions used to create the sketch.

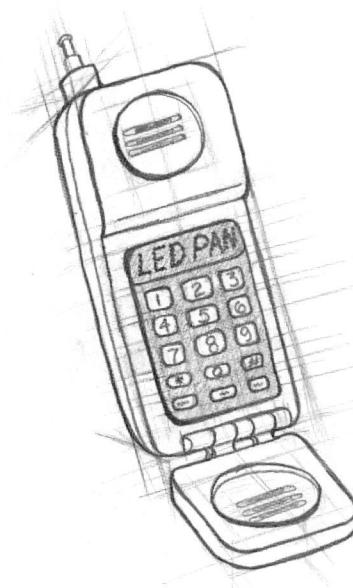

Figure 2.3 Technical Sketch

A rough technical sketch can be made to capture a design idea quickly.

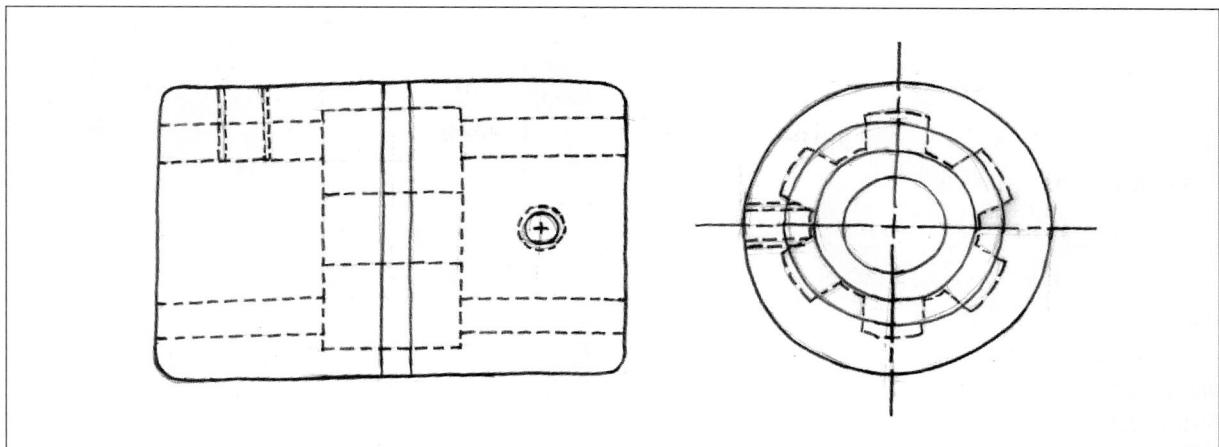

Figure 2.4 Multiview Sketch of a Mechanical Part, Used by the Engineer to Communicate Technical Information about the Design to Others

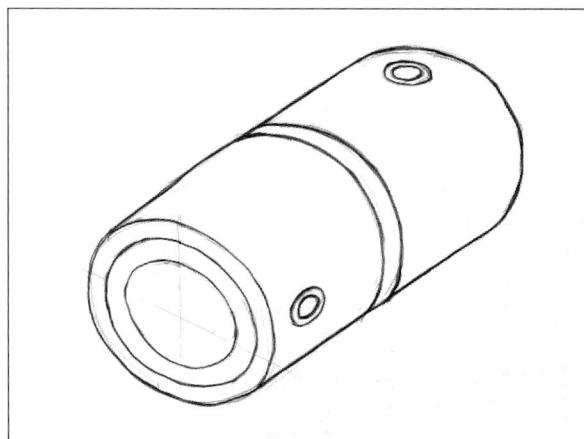

Figure 2.5 Pictorial Sketch

Pictorial sketches are used to communicate technical information in a form that is easy to visualize.

rough. (Figure 2.3) This type of sketch is for personal use and is not meant to be understood by anyone but the individual who produced it. A sketch may also use the format of a more formal, multiview drawing intended to be used by someone who understands technical drawings. (Figure 2.4) However, this type of sketch would not be appropriate for a nontechnical person. Pictorial sketches would be used to further clarify the design idea and to communicate that idea to nontechnical individuals. (Figure 2.5) Shading can be used to further enhance and clarify a technical sketch. (Figure 2.6)

Technical sketches are used extensively in the first (ideation) stage of the design process and are an

Figure 2.6 Shaded Sketch

This rendered sketch is an example of the amount of detail that can be used when creating sketches. This type of sketch is more appropriate for technical illustrations than for design communications. (Irwin drawing contest winner Tim Brummett, Purdue University.)

informal tool used by everyone involved in the design and manufacture of a product. (Figure 2.7) For example, an industrial technologist might make several sketches of a layout for a factory floor.

Many designers find that sketching becomes part of their creative thinking process. Through the process of *ideation*, as explained in Chapter 10, “Integrated Design and Modeling with CAD,” sketching can be used

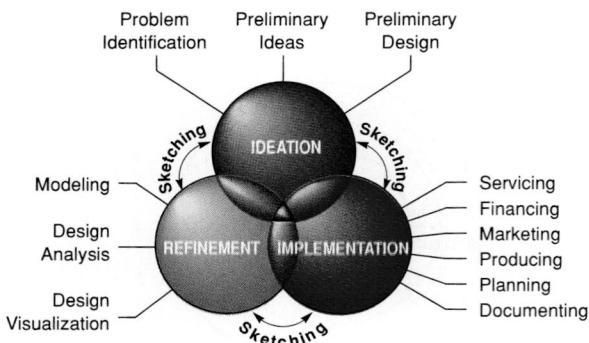**Figure 2.7**

Sketching is used throughout the design process to communicate information.

to explore and solidify design ideas that form in the *mind's eye*, ideas that are often graphic in nature. Sketching helps capture these mental images in a permanent form. Each sketch is used as a stepping stone to the next sketch or drawing, where ideas are refined, detail is added, and new ideas are formed.

On a large project, hundreds of sketches are created, detailing both the successful and the unsuccessful approaches considered for solving the design problem. Since all but the smallest of design projects are a collaborative effort, sketches become an important tool for communicating with other members of the design team.

At the early stages of the design process, highly refined, detailed drawings can actually impede the exploration of alternative ideas. What is needed are informal, nonrestrictive sketches that can communicate both geometric and nongeometric information, and can be produced quickly and changed easily. Technical sketching, being fast and less restrictive, can convey ideas at a level of detail that communicates the design intent and, at the same time, allows the viewers to imagine for themselves how different solutions might further the design. Sketches as a communications tool encourage collaborative contributions from other members of the design team.

Traditionally, a sketch would be defined as a freehand drawing; that is, a drawing produced without instruments. A more modern definition of sketching would include CAD-based tools. (Figure 2.8) With some newer graphics software employing flexible, unrestrictive tools, the user can quickly rough out 2-D and 3-D designs. These drawings can later be refined for use by more traditional CAD software tools. Even though a

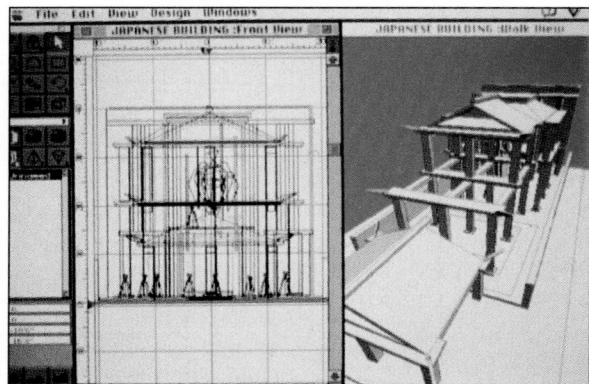**Figure 2.8 CAD Sketch**

Sketches can be created using CAD software. This software allows you to model architectural structures quickly. (Courtesy of Virtus, Corp.)

computer can be used for sketching, there will still be many times when it is preferable to use paper and pencil, because of convenience, speed, and ease of use.

2.1.1 Freehand Sketching Tools

Normally, tools used for sketching should be readily available and usable anywhere: pencil, paper, and eraser. Though variations on these tools are numerous and sophisticated, the goal of technical sketching is simplification. Just a couple of pencils, an eraser, and a few sheets of paper should be all that is needed. Many a great design idea was born on the back of a napkin with a No. 2 wooden pencil! Though there may be a temptation to use straightedges, such as T-squares and triangles, a minimum amount of practice should allow you to draw lines good enough for sketches without these aids. Mechanically drawn lines can slow you down, add a level of accuracy not needed in the early stages of a design, and restrict the types of forms explored.

Pencils The lead used in pencils comes in many different hardnesses (see Chapter 1); the harder the lead, the lighter and crisper the line. For general purpose sketching, leads in the H and HB range will give you acceptable lines. If the lead is much harder, the lines will be too light and hard to see. In addition, hard lead has a tendency to puncture and tear some of the lighter weight papers used in sketching. On the other hand, if the lead is too soft, too much graphite is deposited on the paper and can be smudged easily. Leads in the middle range allow for a dark, relatively crisp line.

Industry Application

Sketch Modeling with CAD

Precise 3-D models of newly designed buildings are important when the design has been finalized. However, many architects need to work with simpler, less precise models early in the design phase, when they are evaluating hundreds of different variables, such as economic, social, environmental, and functional elements. It is during this stage that architects have traditionally used rough, hand sketches. Sketch modeling is a technique

in which rough 3-D computer models are created by the architect and easily modified. The technique provides the visual feedback necessary for schematic architectural design. Ease of use, the ability to think in 3-D, the ability to work with irregular shapes and forms, access to solar projections for lighting studies, and the ability to create fuzzy interpretations are the key elements of sketch modelers.

New campus buildings for the University of California at Davis were computer modeled by architects Backen, Arrigoni, and Ross. After the sun and shadows were projected, the designers softened the image with freehand effects produced by a computer program. (Courtesy of Backen, Arrigoni, and Ross Architects.)

Adapted from B.-J. Novitski, "Sketch Modeling," *Computer Graphics World*, May 1993.

With any weight of lead, you can vary the darkness of the line to some degree. With wooden pencils, lighter lines can be drawn by dulling the point of the lead. With a thin-lead mechanical pencil, the lead is essentially always sharp. Lighter lines can be drawn by easing the pressure on the mechanical pencil as you draw.

Though traditional wooden pencils can be used for sketching, it is more common to use mechanical pencils. If only a single mechanical pencil is used, one with a 0.5 mm lead size is probably the best.

However, if you want to emphasize a group of lines by drawing them thicker, you may want to work with a set of pencils, each with a different lead thickness. The alternative is to draw over the lines a number of times. This is less desirable since it is impossible to draw freehand exactly along the same path twice; each time you draw over a line, you widen or slightly change its path. Also, it is useful to have one pencil with a somewhat harder lead, such as 2H or 4H, to produce a slightly lighter line for preliminary construction lines.

(A)

(B)

Figure 2.9 Square (A) and Isometric (B) Grids Used for Sketching

The grid lines are used as an aid in proportioning the drawing and sketching straight lines freehand.

Eraser Erasing should only be used to correct mistakes in a line, not to make changes in a design. Such changes should be recorded on a separate sketch, and the original sketch should be preserved. Still, most people find that a small amount of erasing is helpful. Usually, the eraser on the end of the pencil is sufficient. However, if you are going to do a lot of sketching, you may need a separate eraser, and one of any size or shape will do. You might consider a gum eraser, since it leaves less residue when used.

Paper There is a wide range of paper choices for sketching (including a napkin you could draw on during lunch). The most accessible and easiest to use is notebook size (8½" × 11") paper. Because of the difficulty of drawing long lines freehand, paper much larger than that is normally not useful for a single sketch. On the other hand, larger paper is useful for drawing multiple sketches that should be visually grouped together.

Plain bond paper with no lines offers the highest degree of flexibility; lined paper tends to lock you in visually to drawing along the lines. However, when you want the guidance of existing lines on the paper, it is most useful to have the lines running along both dimensions, forming a grid. Two of the most common **grid papers** used in sketching are: **square grid** (Figure 2.9A), and **isometric grid** (Figure 2.9B) for use in certain types of pictorial sketch. Common grid densities run from 4 to 10 lines per inch.

Often, it would be useful to have grid lines for the sketch, but not for the final drawing. One way this can be achieved is to sketch on thin, plain, semitransparent **tracing paper** laid over the grid paper and taped down so that the grid lines show through. When the sketch is done, it is untaped from the grid paper and viewed without the grid lines behind it. This technique is also a money saver, because grid paper is more expensive than tracing paper (often called trash paper), which can be bought in bulk on rolls. The other advantage to tracing paper is that it can be laid over other sketches, photos, or finished technical drawings. A light table can be used to improve the tracing process. Tracing is a fast, accurate method for refining a design idea in progress, or for using an existing design as the starting point for a new one.

2.1.2 CAD Sketching Tools

With a CAD system, a scanner can be used to scan an existing image into the computer. Scanned images enter the computer as raster images; that is, a tight grid of dots of varying color. This type of image is not directly usable in most CAD systems and must be transformed to vector (line) information. The scanned raster image, then, is used by the CAD operator as the template for tracing to create vectors. This technique is comparable to the way tracing paper is laid over an existing drawing.

Figure 2.10 A Comparison of Mechanically Drawn and Sketched Lines

Most CAD systems can be used to produce sketches. Through the use of grids and the snap function, it is possible to produce rough sketches quickly. Some CAD systems also have a sketch mode that will produce rough lines drawn “freehand” using a mouse or other input device. © CAD Reference 2.1

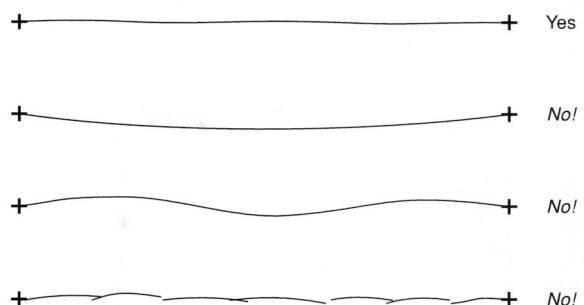

Figure 2.11 Examples of Good and Bad Straight Line Technique

Sketched lines should be straight and dark, and should have a consistent thickness.

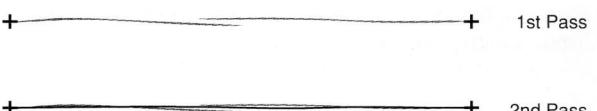

Figure 2.12 Sketching Lines

The sequential drawing of a straight line is done by first drawing a very light line, using short strokes. The light line is then drawn over and darkened.

2.2 SKETCHING TECHNIQUE

It takes practice and patience to produce sketches that are both legible and quickly made. The following sections describe common techniques used to produce good sketches quickly. The discussions cover the tools and the techniques for creating straight lines, curves (such as circles and arcs), and proportioned views. With patience and practice, it is possible for you to become good at making quick, clear sketches, regardless of your experience and natural drawing ability.

2.2.1 Straight Lines

All sketches are made up of a series of lines. Lines created for sketches differ from mechanically produced lines in that they are not constrained or guided by instruments, such as a T-square, template, or compass. Instead, the lines are guided strictly by the eye and hand. Such lines have a different aesthetic quality than mechanical lines. (Figure 2.10) At a micro level, sketched straight lines are uneven; at a macro level, they should appear to follow a straight path without any interruptions. (Figure 2.11)

One of the easiest guides to use for sketched lines is grid paper. Lines drawn right on the grid are the easiest to produce, and even those lines that are offset but parallel to a grid line are fairly easy to produce. The idea is to keep your sketched line a uniform (but not necessarily equal) distance between two existing grid lines.

Curved lines, straight lines not parallel to a grid line, and lines drawn without the aid of a grid are

more difficult. In all of these cases, the lines are drawn as interpolations between two or more points. The points are typically marked on an engineering drawing as two intersecting lines, one horizontal and one vertical, and each approximately $\frac{3}{16}$ " long. Your eye should take a “global” view of all the points to be connected and should guide your hand as it goes from point to point.

Quite often, the sketched line is built up from a sequence of two or three passes with the pencil. (Figure 2.12) The first pass is drawn light, using a hard lead, such as a 4H, sharpened to a point, and may not be as straight as your final line will be; however, it should provide a path on top of which the final, even, darker line is drawn. For particularly long lines, the initial line may be drawn in segments, coming from the two endpoints and meeting in the middle; however, the final line should be drawn in one single pass to avoid choppiness. If necessary, another pass can be used to darken or thicken the line.

Long lines are difficult to control, even for someone with a lot of experience. If you cannot choose a drawing scale that reduces the size of the sketch, use grid

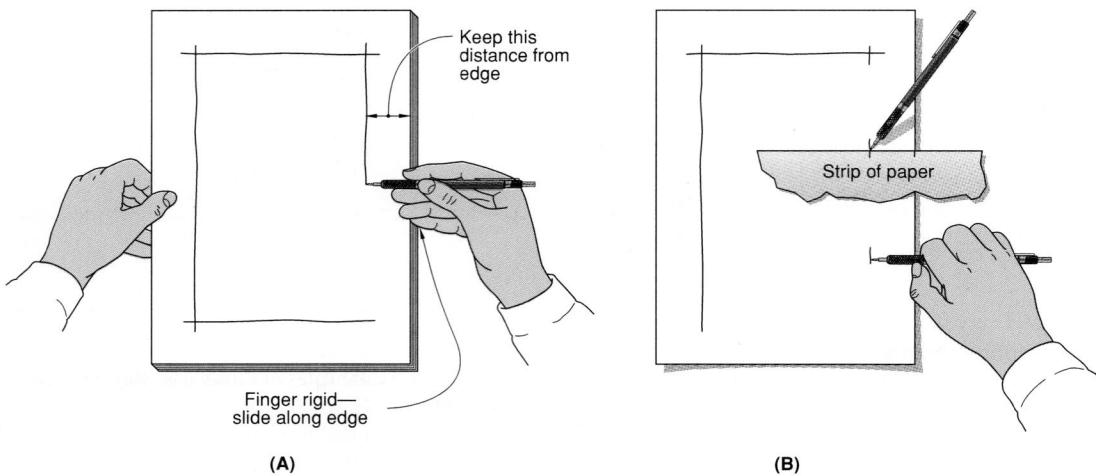

Figure 2.13 Sketching Long Lines

Very long lines can sometimes be more difficult to draw. One technique is to use the edge of the paper as a guide for your hand. Another technique is to mark equal distances from the edge of the paper using a marked scrap of paper as a guide. The marks are then used as a guide to produce the line.

paper as a guide, drawing either directly on the grid paper or on tracing paper placed on top of the grid paper. If the line is parallel and relatively close to the edge of the paper, you can rest a finger or a portion of your palm along the edge of the paper to stabilize your drawing hand. (Figure 2.13) If necessary, you can use a ruler or a scrap of paper to mark a series of points on the sketch, but this will slow you down a bit.

Another technique that helps when drawing lines of any length is changing the orientation of the paper. Sketching paper should not be fixed to your drawing surface. Instead, you should be able to rotate the paper freely, orienting it in the direction that is most comfortable. Practice will determine which orientation is best for you. Many people find that drawing the lines by moving away from or toward the body, rather than from left to right, produces the quickest, straightest lines; others find it most comfortable if the paper is angled slightly away from the body. Again, the longer the line, the more important it is that the paper be positioned comfortably for you.

To sketch quickly, accurately, and without fatigue, your hand and the rest of your body should be relaxed. Paper orientation should allow your whole forearm to be in a comfortable position. Your hand must also be relaxed and comfortable. Students learning to sketch often believe that sketched lines must be as rigid as mechanically drawn lines, and they assume that the tighter they grip the pencil, the more control they will

have over the line. In fact, the opposite is true. A more relaxed grip (though not relaxed enough to let the pencil float in your hand) will allow the eye and mind to control the pencil more directly, making almost subconscious corrections to keep it on track.

With experience, although you will be conscious of where you are drawing from and to, the actual drawing of the line will be virtually automatic. The idea is to find the right balance between relaxed, comfortable drawing and sloppy, loose drawing. Though not drawn with instruments, sketched lines should still be crisp, and straight lines should be easily distinguishable from those that are supposed to be curved.

The following summarizes the techniques used to sketch straight lines:

- Orient the paper to a comfortable position. Do not fix the paper to the surface.
- Mark the endpoints of the lines to be sketched.
- Determine the most comfortable method of creating lines, such as drawing from left to right, or drawing either away from or toward your body.
- Relax your hand and the rest of your body.
- Use the edge of the paper as a guide for making straight lines.
- Draw long lines by sketching a series of connected short lines.
- If necessary, draw on grid paper or on tracing paper that is overlaid on grid paper.

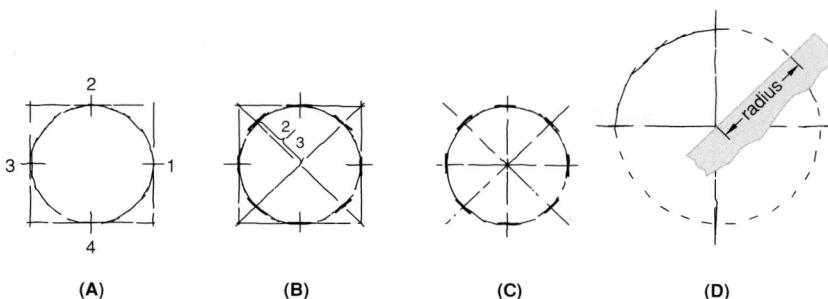

Figure 2.14 Sketching a Circle

Sketching a circle is easier using one of the techniques shown. For small circles, use a square or multiple center lines to guide the construction process. For large circles, use a scrap of paper with the radius marked on it as a guide.

Sketching Straight Lines

In this exercise, you are to create a series of 5" long parallel lines equally spaced at 0.5". Refer to Figures 2.11 and 2.12.

Step 1. Lightly mark the endpoints of the lines to be sketched on 8-½" by 11" paper.

Step 2. Orient the paper in a comfortable position for sketching.

Step 3. Comfortably and in a relaxed manner, position your hand so that the pencil is close to one of the marked endpoints of the first line to be sketched. Sketch the top line first, to avoid smearing newly sketched lines with your hand.

Step 4. Quickly scan the two endpoints of the first line, to determine the general direction in which you will be sketching.

Step 5. Lightly sketch a short line, approximately 1" long, by moving your hand and the pencil in the general direction of the other end of the line.

Step 6. Repeat Steps 4 and 5 until the other end of the line is reached.

Step 7. Return to the starting point of the line and over-draw the line segments with a slightly longer, heavier stroke, to produce a thick, dark, more continuous straight line.

Step 8. Repeat Steps 3 through 7 to sketch the remaining straight lines.

2.2.2 Curved Lines

Curved lines need multiple guide points. The most common curve is a circle or circular arc. Though very small circles and arcs can be drawn in one or two strokes and with no guide points, larger circles need some preliminary points. The minimum number of points for a circle is four, marked on the perimeter at equal 90-degree intervals. For an arc, use at least one guide point for every 90 degrees and one at each end.

There are a number of ways to lay out the guide points for circular curves quickly. One way is to draw a square box whose sides are equal to the diameter of the circle. (Figure 2.14A) The midpoints on each side of the square mark the points where the circle will touch the square. These points are called points of tangency. More guide points can be added by drawing the two diagonals across the square. The center of the circle being sketched is the point where the diagonals cross. (Figure 2.14B) Mark the guide points on each diagonal approximately two-thirds the distance from the center of the circle to the corner of the square. This distance is the approximate radius of the circle. (Figure 2.14C)

As with longer straight lines, large arcs and circles are harder to draw and may need guide points marked at more frequent intervals. To do this, it is handy to use a scrap of paper with the radius marked on it. (Figure 2.14D)

Circular arcs are drawn the same way as circles, adjusting the number of points to suit the degree of curvature (i.e., the length) of the arc. Noncircular arcs, however, can be more difficult. Since these lines are only to be sketched, calculating the points that the curve should pass through is too involved and is not recommended. Simply use the eye to estimate guide points and then gradually draw a curve to pass through those points. (Ellipses and curves in multiview drawings are two special cases treated later in this chapter.)

As with straight lines, positioning the paper and using a relaxed grip are important for helping you create good curves. Unlike straight lines, curves are usually best drawn in a series of arcs of not more than 90 degrees. After each arc is drawn, rotate the paper for the next segment of arc. With practice you may be able to eliminate rotating the paper for smaller arcs, but will probably still have to do so for larger ones.

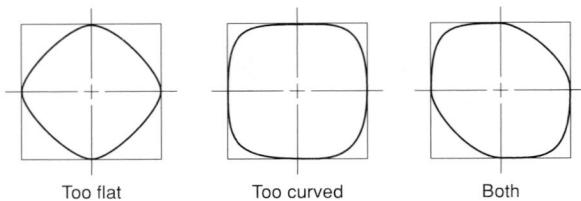

Figure 2.15 Poorly Drawn Circles Will Have Flat Areas and Sharp Curves

A common pitfall when drawing circles is not properly estimating the degree of curvature. This leads to arcs that are too flat, too curved, or both. (Figure 2.15) Until you get better, more points along the arc will help guide you.

Sketching a Circle or Arc

The following steps demonstrate how to sketch a circle or arc. Refer to Figures 2.14 and 2.15 as a guide.

Step 1. Orient the paper in a comfortable position and relax your grip on the pencil. Lightly mark the corners of a square with sides equal in length to the diameter of the circle or arc to be sketched.

Step 2. Lightly sketch the square, using short strokes to create the straight lines.

Step 3. Mark the midpoints of the four sides of the square. This gives you four marks on the perimeter of the circle.

Step 4. Sketch diagonals across the corners of the square. Where the diagonals cross is the center of the circle.

Step 5. Mark the diagonals at two-thirds the distance from the center of the circle to the corner of the square. This gives you four more marks on the circle's perimeter.

Step 6. Sketch the circle by creating eight short arcs, each between two adjacent marks on the perimeter. Start at any mark and sketch an arc to the next mark (on either side of the first one, whichever is most comfortable for you).

Step 7. Rotate the paper and sketch the next arc from the last mark you touched to the next mark on the perimeter. Repeat this step until all eight arc segments have been sketched. For smoother sketches, rotate the paper in the opposite direction from the one you used to draw the arc.

Step 8. Overdraw the arcs with a thick, black, more continuous line to complete the sketched circle.

Sketching Ellipses for Multiview Drawings

Lines, arcs, circles, and ellipses are common features sketched in multiview drawings. Sketching lines, arcs,

and circles was explained earlier in this chapter. Occasionally, it is necessary to sketch an ellipse on a multiview drawing. Smaller ellipses can be sketched inside a rectangular bounding box whose dimensions equal the major and minor axes of the ellipse. (Figure 2.16A)

For larger ellipses, the trammel method, explained below, may be needed. (Figure 2.16B)

Step 1. Mark half the length of the major axis of the ellipse on a piece of scrap paper and label the endpoints A and C, as shown in Figure 2.16B, Step 1. The scrap paper is the **trammel**.

Step 2. Mark half the length of the minor axis of the ellipse on the piece of scrap paper, starting from point A, and label the endpoint as B.

Step 3. Sketch the major and minor axes and use the trammel to mark points along the ellipse. This is done by placing point C anywhere on the minor axis and point B on the major axis and then placing a mark at point A. Repeat the process by moving the trammel, until you have a series of points marked.

Step 4. Connect the points to complete the ellipse.

2.3 PROPORTIONS AND CONSTRUCTION LINES

Frequently, in the sketch of an object, the relative proportions of its primary dimensions—width, height, and depth—are more important than their actual physical sizes. A **proportion** is the ratio between any two dimensions of an object. These proportions are represented in the sketch by a series of preliminary lines, which are drawn light and fast, and which may or may not represent the locations of the final lines in the sketch. Their purpose is to form a backbone, a structure inside which the final linework can be drawn.

The first step in a sketch involves drawing the construction lines, which guide a sketch's overall shape and proportion. **Construction lines** are very light, thin lines used to roughly lay out some of the details of sketches or drawings. Do not try to draw the construction lines to exact lengths, since lengths are marked later, either by intersecting lines or short tick marks.

Construction lines have two primary features: the lines themselves, and the intersections created where two lines cross. For example, the construction lines become the paths for the final straight lines. Points marked by the intersections of construction lines guide the drawing of circles. Usually, both of these features are used in creating sketches. Since all the dimensions of a sketch are estimated, groups of construction lines forming boxes and other shapes

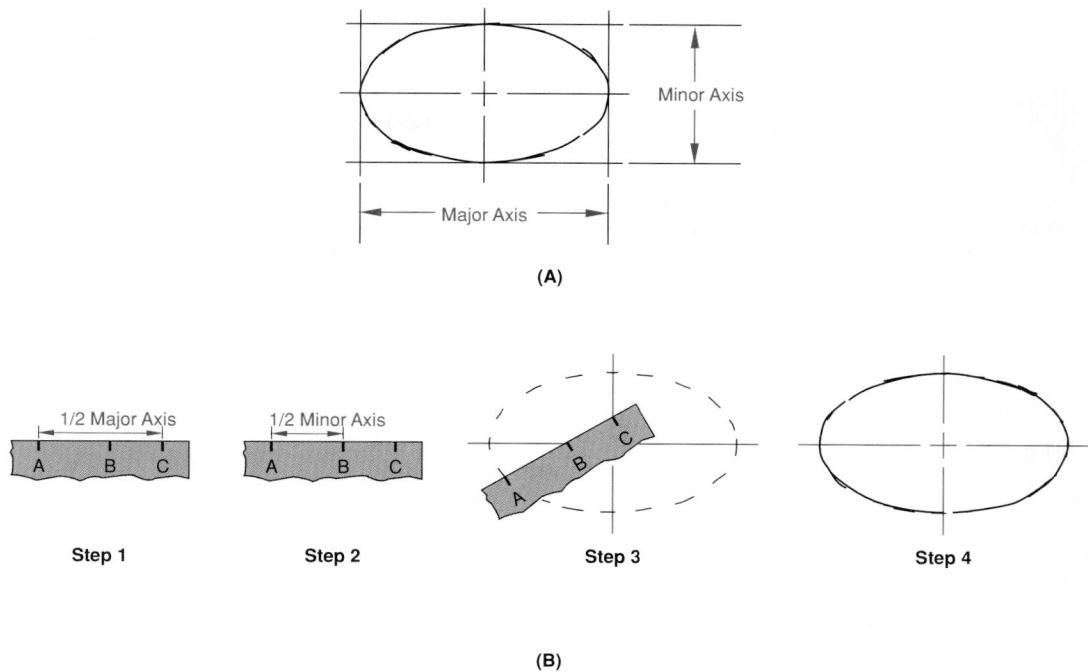

Figure 2.16 Sketching Ellipses

An ellipse is created by sketching the major and minor axes, then sketching a rectangle whose sides are equal to the axes. A scrap of paper can be used to create an ellipse, using the trammel method.

are an important tool for preserving the shape and proportion of the object and its features as the sketch is developed.

Grid paper can be used as a guide in creating construction lines, but should not be thought of as a substitute, since the grid does not directly represent the proportions of the object, and there are many more grid lines than there are features on the object. The goal is to draw construction lines on top of the grid to reveal the form of the object. With experience, you may be able to make do with fewer construction lines, but while you are learning how to create properly proportioned sketches, you should use more, rather than less, construction lines to guide you.

The level of detail in many objects can be daunting for beginners. The best strategy—even if you are an experienced artist—is to draw the object in stages. Before beginning a sketch, look at the object carefully and identify its various features. One feature could be the entire object. Other features may be holes, notches, rounded corners, etc. On more complex objects, groups of features can be combined to form larger features.

Each feature has a proportion that can be represented by a series of construction lines. The following steps describe how to proportion a drawing by breaking it down into its component features.

Creating a Proportioned Sketch

Step 1. Refer to Figure 2.17. Gage the proportion of the overall size of the object. For the first sketch, use two overall dimensions of the object: width and height. Lightly sketch a box that represents the ratio of these two dimensions. (Figure 2.17, Step 1) This box is called a **bounding box** because it represents the outer dimensional limits of the feature being drawn. If the object is rectangular in shape, the final linework will follow the perimeter of the bounding box. In most cases, however, the final linework will only touch on a portion of the box's edges.

Step 2. Inside the first bounding box, draw other boxes to represent the larger features of the object, and within those boxes draw still others to represent the smaller features of the object. Often, a construction line can be used for more than one box. The final boxes each show the proportions of one feature of the object.

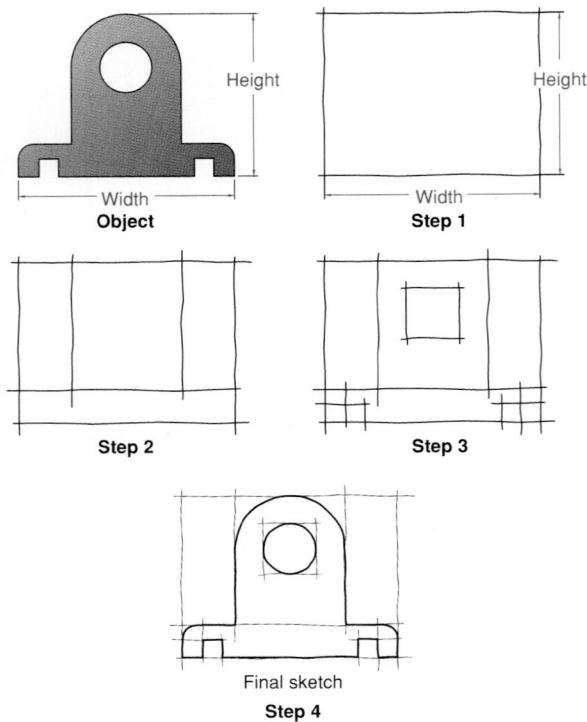

Figure 2.17 Creating a Proportioned Sketch

To create a well-proportioned sketch, use multiple steps to create lightly sketched boxes that are then used as guides for the final sketch.

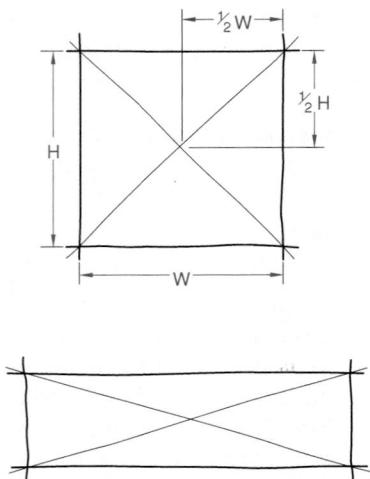

Figure 2.18 Locating the Center of Squares and Rectangles

Construction lines are used to draw diagonals marking the center of a square or rectangle.

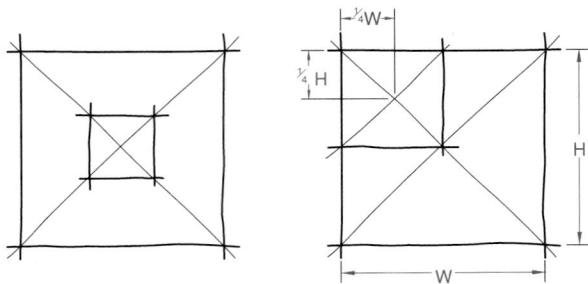

Figure 2.19 Constructing Proportioned Squares

Construction lines are used to draw diagonals that can be used to construct new squares or rectangles.

Step 3. Continue to draw bounding boxes until the smallest features of the object have been represented. As you gain experience, you may find that some of these smaller features need not be boxed; instead, their final lines can be sketched directly.

Step 4. When all of the features of the object have been boxed, begin sketching the final linework, which is done significantly darker than the construction lines.

The goal is, if you hold the drawing at arm's length, the construction lines are hard to see, and the final linework is clear and sharp. If there is not enough contrast between the construction lines and the final linework, then the construction lines become a distraction. Make the final lines darker, or the construction lines lighter, or both; however, do not erase your construction lines.

Some construction lines are not part of a bounding box. These lines are used to create intersections to mark important points. For example, diagonals inside a bounding box can be used to mark its center. (Figure 2.18) This holds true whether the box is square or rectangular. This centerpoint could then mark either the center of the feature to be drawn, or the corner for another, smaller bounding box. (Figure 2.19)

Sketching Identically Proportioned Squares

Figure 2.20 demonstrates how to create a series of identically proportioned squares.

Step 1. In the square that you want to duplicate, draw a pair of diagonal lines to locate its center. Through this center point, draw lines to the midpoints of each of its sides. (Figure 2.20, Step 1)

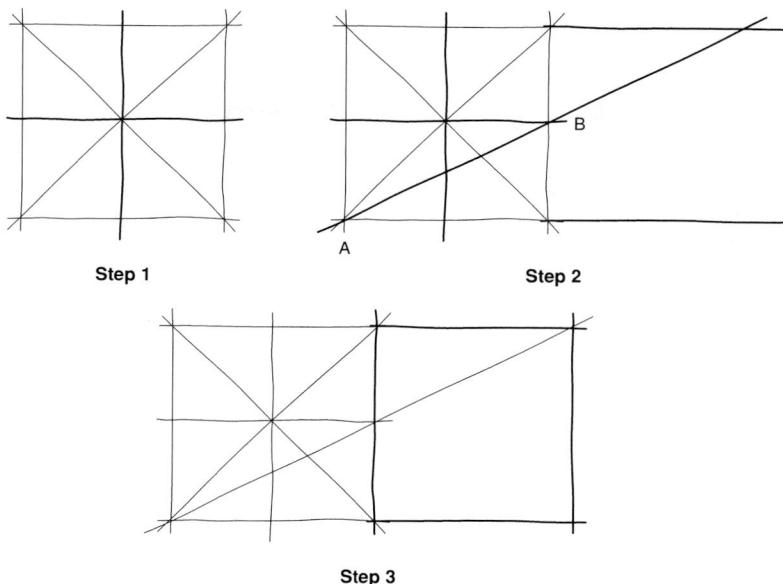

Figure 2.20 Sketching Identically Proportioned Squares

An identically proportioned square is created by extending both top and bottom horizontal lines and constructing diagonals across the existing box.

Step 2. Extend out to one side the top and bottom horizontal lines of the bounding box. Draw a diagonal line toward one of the horizontal lines, starting from one corner (marked A) and going through the midpoint of the adjacent perpendicular side (marked B).

Step 3. Where the diagonal line crosses the upper horizontal line, mark the corner of the new box. Sketch a vertical line from this point to complete the new square.

The proportioned square method is especially useful when grid paper is not used and you need to create a larger object out of a series of identically proportioned smaller boxes. As shown in Figure 2.20, this method can be adapted to squares of any size.

One of the most difficult sketching techniques to learn is making a sketch look well proportioned. For example, Figure 2.21 shows a well proportioned and a poorly proportioned sketch of a computer monitor. Proportioning skills will improve with practice. A good rule of thumb is, if the drawing does not look or feel right, it probably is not. In the poorly proportioned monitor in Figure 2.21, the ratio of the height to the width is incorrect.

Whether you are copying another drawing or sketching a real object, the temptation is to accurately

Well Proportioned

Poorly Proportioned

Figure 2.21 Good and Poor Proportions

One well and one poorly proportioned sketch of a computer monitor. The poorly proportioned monitor looks too wide.

measure all the features. This defeats the purpose of doing just a sketch. If you are copying a drawing, the fastest approach is simply to trace over it. If you must enlarge (or reduce) the sketch, use grid paper and multiply (or divide) the number of grids enclosed in a feature, or use a grid of a different size. (Figure 2.22) If you are sketching a real object, roughly measure the overall dimensions with a scale, or mark the measurements on any convenient material. If you are going to sketch a larger object, stand at a distance from the object, face it, and hold a pencil at arm's

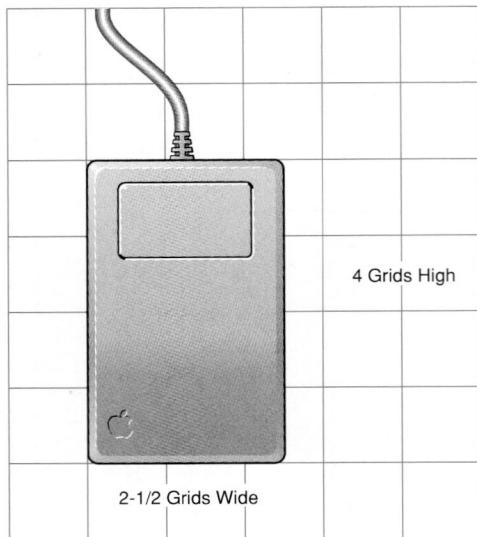

Figure 2.22 Grid Paper Is Used to Scale an Object

The scale can be changed by enlarging or reducing the values. For example, to double the size of the sketch, multiply 2- $\frac{1}{2}$ and 4 by 2, and sketch the mouse on a grid using 5 and 8 as the width and height.

length in front of you. (Figure 2.23) Align the end of the pencil with one edge of a feature, as sighted along your outstretched arm. Make a mark on the pencil to represent the opposite edge of that feature. Translate this pencil length to the sketch, and repeat the process for other features and their dimensions. Be sure to stand in the same place every time!

In all cases, a progressive refinement of the construction lines from the largest feature to the smallest will allow you to compare your sketch regularly with the object and the proportions being sketched.

Sketching Objects

Step 1. Collect magazine photographs or clippings that show 2-D images or patterns. These can range from pictures of faces, to company logos, to fronts of buildings, etc. Stick with images that look *flat*; that is, images that don't show a depth dimension.

Step 2. Lay tracing paper over the image and tape the paper down.

Step 3. Lightly sketch an overall bounding box of the object. Look at the image contained in the bounding box. Mentally identify as many features on the object as you can. The features may be small and self-contained or a collection of several smaller features.

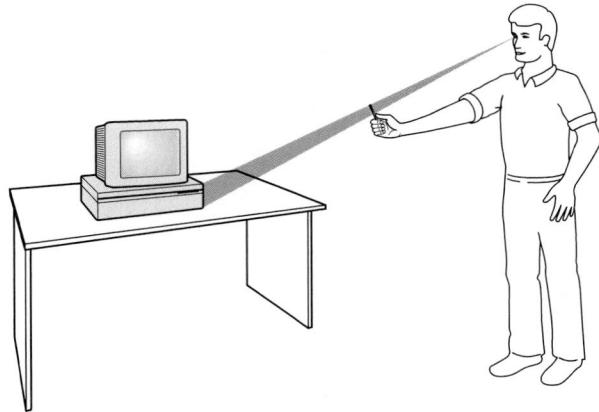

Figure 2.23 Estimating Dimensions of Larger Objects with a Pencil Held at Arm's Length

Step 4. Refine the drawing by sketching a series of progressively smaller bounding boxes. Start with the larger features and work downwards.

Step 5. If desired, you can then darken some of the lines representing the image, to highlight the most important lines of a feature. What are the most important lines of a feature? Experiment with different lines to see which are more critical than others in representing the form of the image.

HINT: Buy a roll of tracing paper from your local blueprint or art supply store. It's cheaper than individual sheets and you won't run out as often.

2.4 INTRODUCTION TO PROJECTIONS

Both ideation and document sketches can represent the objects being designed in a number of different ways. We live in a three-dimensional (3-D) world, and representing that world for artistic or technical purposes is largely done on two-dimensional (2-D) media. Although a sheet of paper is technically three-dimensional, the thickness of the paper (the third dimension) is useless to us. It should be noted that the computer screen is a form of two-dimensional media, and images projected on it are governed by the same limitations as projections on paper. Modern techniques, such as holograms, stereograms, and virtual reality devices, are attempts to communicate three-dimensional ideas as three-dimensional forms. However, drawings are still the primary tool used for representing 3-D objects.

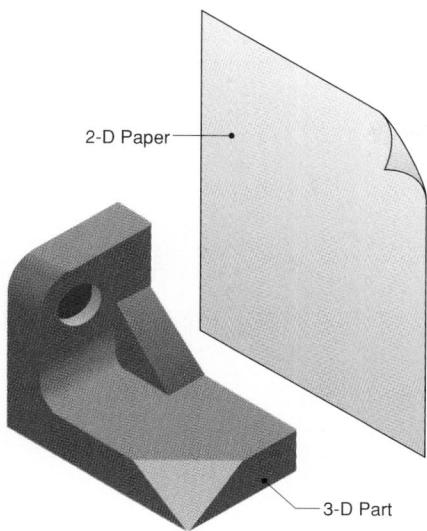

Figure 2.24 3-D Object on 2-D Medium

For centuries, graphicians have struggled with representing 3-D objects on 2-D paper. Various projection techniques have evolved to solve this problem.

Most projection methods were developed to address the problem of trying to represent 3-D images on 2-D media. (Figure 2.24) Projection theory and methods have taken hundreds of years to evolve, and engineering and technical graphics is heavily dependent on projection theory.

The most common types of projection used in sketching are *multiview*, *isometric* (one type of axonometric), *oblique*, and *perspective*, as shown in Figure 2.25. (See also Table 1, Chapter 4 “Multiview Drawings.”) These four types of projection can be placed in two major categories: multiview sketches, and pictorial sketches. **Multiview sketches** present the object in a series of projections, each one showing only two of the object’s three dimensions. The other three types of projection, grouped as **pictorial sketches**, present the object in a single, pictorial view, with all three dimensions represented. There are always trade-offs when using any type of projection; some are more realistic, some are easier to draw, and some are easier to interpret by nontechnical people.

Mechanically drawn pictorials can often be as hard to draw as multiviews. Various 2-D CAD-based tools have eased the process of creating pictorials. Probably the easiest way of creating such views is to use a 3-D CAD package to create a

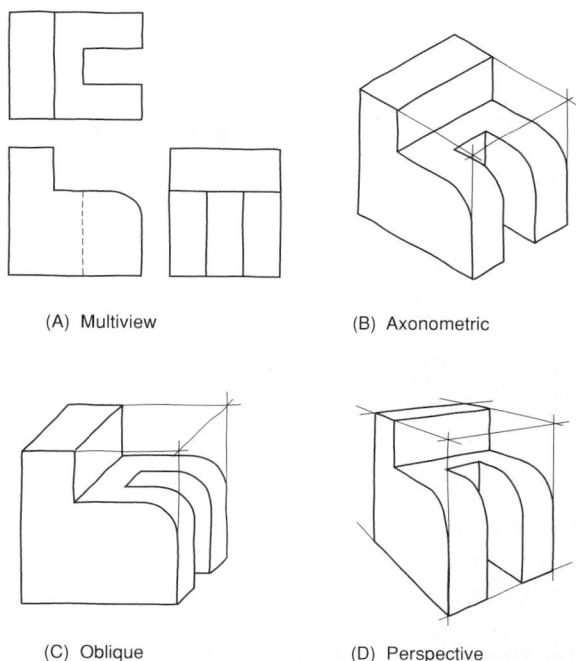

Figure 2.25 Classification of Sketches

Various projection techniques are used to create four basic types of sketches: multiview, axonometric, oblique, and perspective. The sketches shown in B, C, and D are called **pictorial**, because they represent the object as a 3-D form. The multiview sketch uses multiple flat views of the 3-D object to accurately represent its form on 2-D paper.

model. This model can easily represent pictorial views and can also generate views for a multiview drawing. 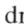 **CAD Reference 2.2**

Another way of classifying projections relates to whether they use **parallel projection** or **perspective projection**. Multiview, isometric, and oblique multiview projections use parallel projection, which preserves the true relationships of an object’s features and edges. This type of projection is the basis of most engineering and technical graphics. Perspective projection distorts the object so that it more closely matches how you perceive it visually.

Since it is much easier to lay out a sketch in parallel rather than in perspective projection, you will probably find yourself doing a majority of your sketching using parallel projection, even though it is less realistic. Only when the object spans a large distance—such as a house or bridge—will it be useful to represent the distortion your eyes perceive as the object recedes from view.

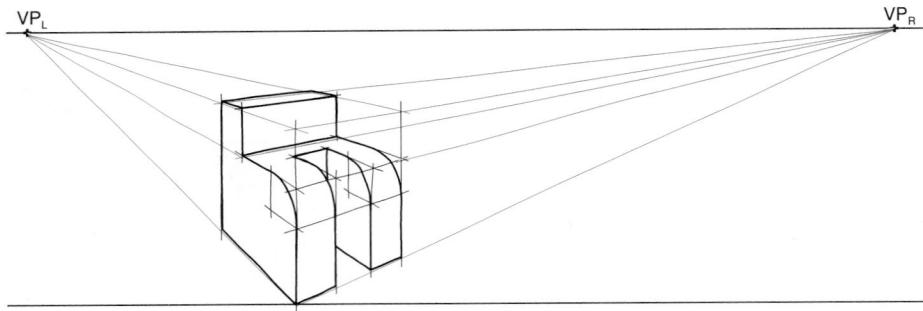

Figure 2.26 Perspective Sketch

For perspective projection, the width and depth dimensions converge on vanishing points.

2.4.1 Isometric Pictorials

An **isometric pictorial** sketch is a type of parallel projection that represents all three dimensions in a single image. Though there are a number of ways of orienting an object to represent all three dimensions, isometric pictorials have a standard orientation that makes them particularly easy to sketch. Start by looking at the two-point perspective in Figure 2.26. Then, instead of having the width and depth construction lines converge on vanishing points, have them project parallel to each other at a 30-degree angle above the baseline. (Figure 2.27) A more complete treatment of constructing isometric pictorials is presented in Chapter 5, “Pictorial Drawings.”

Many CAD systems will automatically produce an isometric view of a 3-D model when the viewing angle is specified. Some CAD systems have predefined views, such as isometric, which are automatically created after selection. 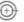 **CAD Reference 2.3**

Making an Isometric Sketch

Make an isometric sketch of the object shown in Figure 2.28.

Sketching the isometric axis

Step 1. Isometric sketches begin with defining an **isometric axis**, which is made of three lines, one vertical and two drawn at 30 degrees from the horizontal. These three lines of the isometric axis represent the three primary dimensions of the object: width, height, and depth. Though they are sketched at an angle of only 60 degrees to each other, they represent mutually perpendicular lines in 3-D space.

Step 2. Begin the sketch by extending the isometric axes shown in Step 1, Figure 2.28. Sketch a horizontal

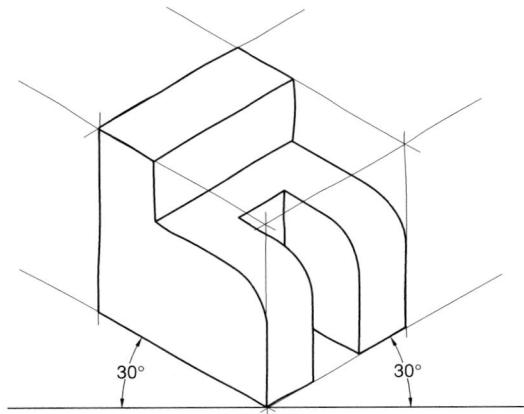

Figure 2.27 Isometric Sketch

For this isometric sketch, the width and depth dimensions are sketched 30 degrees above the horizontal.

construction line through the bottom of the vertical line. Sketch a line from the base of the vertical line to the right, at an approximate angle of 30 degrees above the horizontal construction line. Sketch a line from the base of the vertical line to the left, at an approximate angle of 30 degrees above the horizontal construction line.

The corner of the axis is labeled point 1; the end of the width line is labeled point 2; the end of the depth line is labeled point 4; and the top of the height line is labeled point 3. The lengths of these lines are not important, since they will be treated as construction lines, but they should be more than long enough to represent the overall dimensions of the object. Estimate the overall width, height, and depth of the object using the estimating techniques described earlier in this chapter. Use these dimensions to sketch a block that would completely enclose the object.

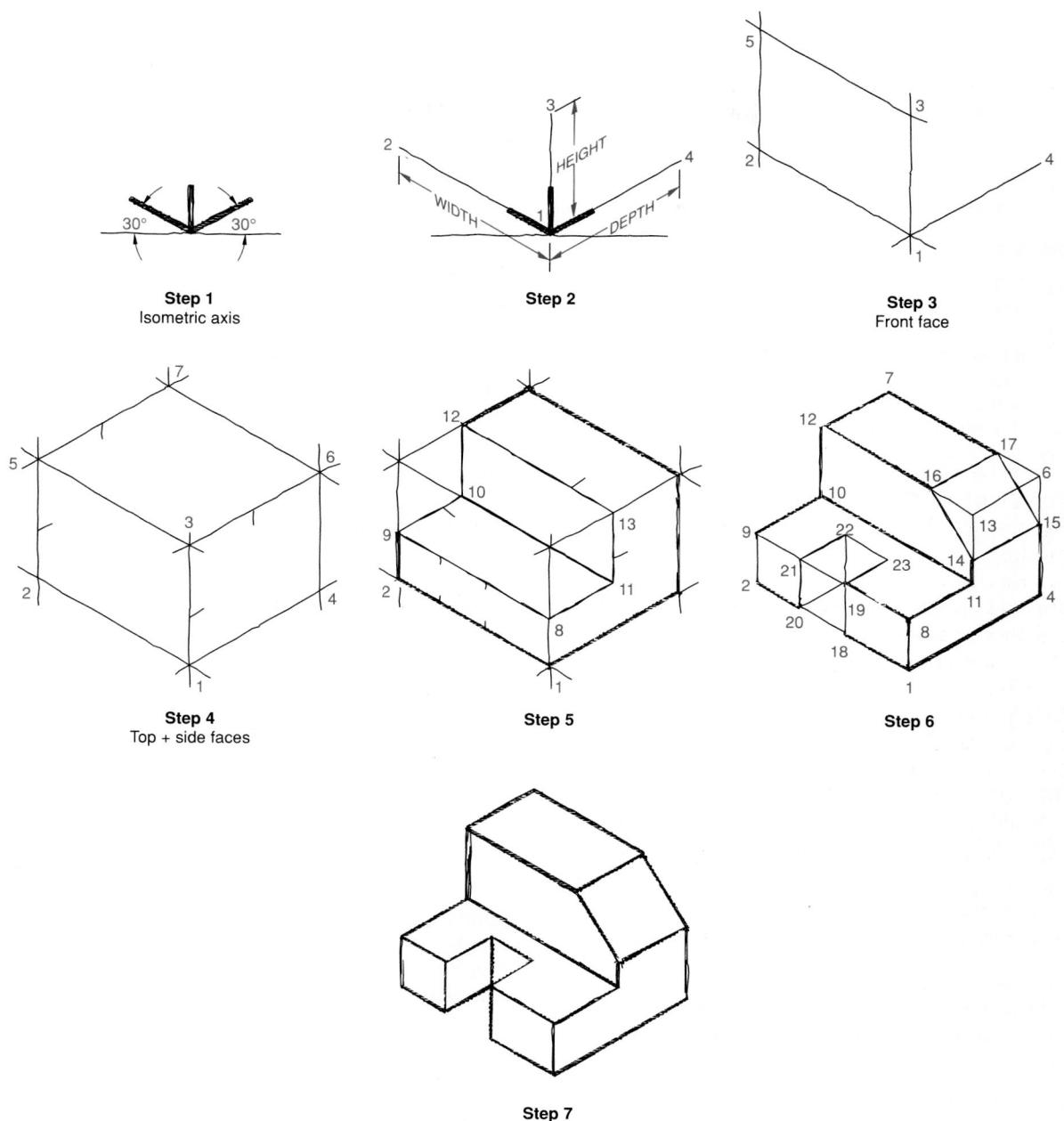

Figure 2.28 The Basic Steps Used to Create an Isometric Sketch of an Object

Blocking in the object

Step 3. Sketch in the front face of the object by sketching a line parallel to and equal in length to the width dimension, passing the new line through point 3.

Sketch a line parallel to and equal in length to the vertical line (1-3), through points 5-2. The front face of the object is complete.

Step 4. From point 3, block in the top face of the object by sketching a line parallel to and equal in length to line 1-4. This line is labeled 3-6. Sketch a line parallel

to and equal in length to line 3–5, from point 6. This line is labeled 6–7. Sketch a line from point 5 to point 7. This line should be parallel to and equal in length to line 3–6. Block in the right side face by sketching a line from point 6 to point 4, which is parallel to line 1–3. The bounding box of the object, sketched as construction lines, is now finished. The box serves the same purpose as the one drawn in Figure 2.17, but it represents all three dimensions of the object instead of just two.

Adding details to the isometric block

Step 5. Begin by estimating the dimensions to cut out the upper front corner of the block, and mark these points as shown in Step 4. Sketch the height along the front face by creating a line parallel to line 1–2; label it 8–9. Sketch 30-degree lines from points 8 and 9 and label these lines 9–10 and 8–11. Now sketch a line from point 10 to point 11. Sketch vertical lines from points 10 and 11 and label the new lines 10–12 and 11–13. Sketch a line from point 12 to point 13, to complete the front cutout of the block.

With a simple sketch, you can often lay out all of your construction lines before having to darken in your final linework. With more complicated sketches, the sheer number of construction lines can often cause confusion as to which line belongs to which feature. The confusion can be worse in an isometric sketch, where the lines represent three dimensions rather than two. Therefore, after the marks are made for the last two features in Step 5, you can begin darkening in some of the lines representing the final form.

Step 6. Estimate the distances to create the angled surface of the block and mark these points, as shown in Step 5. From the marked point on line 11–13, sketch a 30-degree line to the rear of the block on line 4–6. Label this new line 14–15. From the marked point on line 12–13, sketch a 30-degree line to the rear of the block on line 6–7. Label this new line 16–17. Sketch a line from point 14 to point 16 and from point 15 to point 17, to complete the sketching of the angled surface. Lines 14–16 and 15–17 are referred to as **nonisometric lines** because they are not parallel to the isometric axis.

Estimate the distances for the notch taken out of the front of the block and mark these points, as shown in Step 5. Draw vertical lines from the marked points on line 1–2 and line 8–9. Label these lines 18–19 and 20–21, as shown in Step 6. Sketch 30-degree lines from points 19, 20, and 21 to the estimated depth of the notch. Along the top surface of the notch, connect the endpoints of the 30-degree lines and label this new line 22–23. The 30-degree line extending back from point 20 is stopped when it intersects line 18–19, as shown in Step 6. To complete the back portion of the notch, drop a vertical line from point 22, as shown in Step 6. Stop this new line at the intersection point of line 19–23. The rough isometric sketch of the block is complete.

Note that we have not mentioned hidden features representing details behind the visible surfaces. The drawing convention for isometric sketches calls for disregarding hidden features unless they are absolutely necessary to describe the object.

Step 7. Darken all visible lines to complete the isometric sketch. Since the construction lines are drawn light, there is no need to lighten them in the completed sketch.

2.4.2 Isometric Ellipses

Isometric ellipses are a special type of ellipse used to represent holes and ends of cylinders in isometric drawings. In an isometric drawing, the object is viewed at an angle, which makes circles appear as ellipses. When sketching an isometric ellipse, it is very important to place the major and minor axes in the proper positions. Figure 2.29 is an isometric cube with ellipses drawn on the three visible surfaces: top, profile, and front. Remember Figure 2.29A, because those are the three positions of isometric ellipses found on most isometric sketches and drawings. The following are the key features of the isometric ellipse on each plane:

- The major and minor axes are always perpendicular to each other.
- On the top plane, the major axis is horizontal and the minor axis is vertical.
- On the front and profile planes, the major axes are measured 60 degrees to the horizontal.
- The major axis is always perpendicular to the axis running through the center of the hole or cylinder.

Sketching an Isometric Ellipse

Figure 2.30 shows the steps for creating an isometric ellipse. Notice that the steps are almost identical to those for sketching a circle as explained earlier in this chapter. The difference is in the orientation and proportion of the primary axes.

Step 1. This isometric ellipse will be drawn on the front plane. Begin by sketching an isometric square whose sides are equal to the diameter of the circle.

Step 2. Add construction lines across the diagonals of the square. The long diagonal is the **major axis** and the short diagonal is the **minor axis** of the ellipse. The two diagonals intersect at the center of the square, which is also the center of the isometric ellipse.

Step 3. Sketch construction lines from the midpoints of the sides of the square through the center point. These lines represent the center lines for the isometric ellipse. The midpoints of the sides of the isometric square will be tangent points for the ellipse and are labeled points A, B, C, and D.

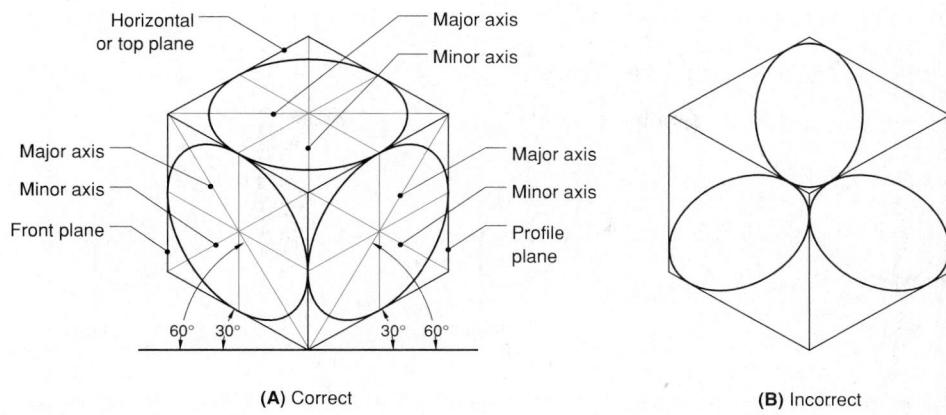

Figure 2.29 Isometric Representation of Circles

Circular features appear as ellipses in isometric sketches. The orientation of the ellipse is set according to the face on which the circle lies. The correct orientation is shown in (A) and examples of incorrect orientations are shown in (B).

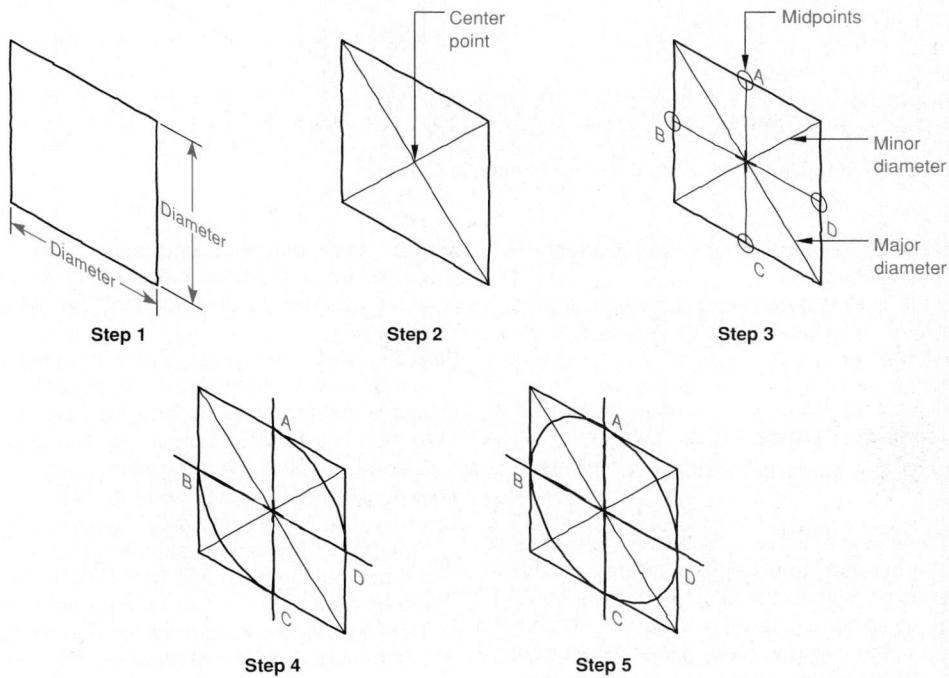

Figure 2.30 Sketching an Isometric Ellipse

The steps used to create a sketch of an isometric ellipse begin with constructing an isometric box whose sides are equal to the diameter of the circle. The center of the box and the midpoints of the sides are found, and arcs are then drawn to create the ellipse.

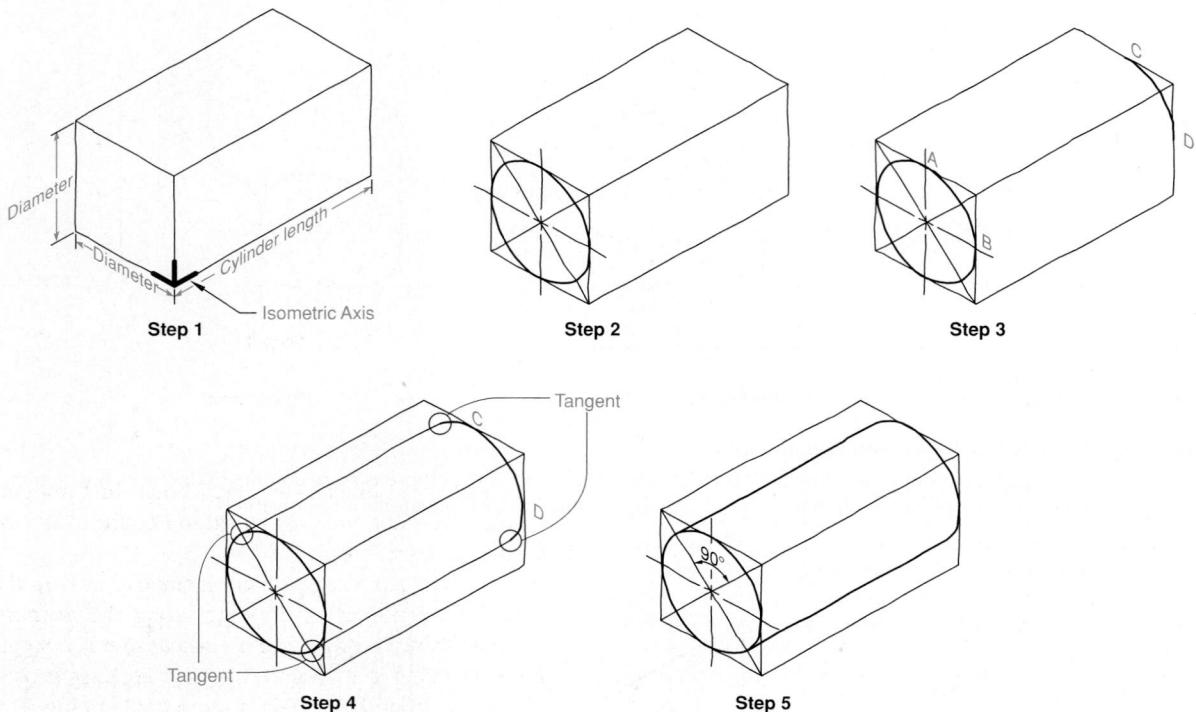

Figure 2.31 Steps Used to Construct a Sketch of an Isometric Cylinder

Step 4. Sketch short, elliptical arcs between points B and C, and points D and A.

Step 5. Finish the sketch by drawing the elliptical arcs between points C and D, and points A and B, completing the ellipse.

Sketching an Isometric Cylinder

Figure 2.31 shows the steps for creating an isometric view of a cylinder.

Step 1. Sketch the isometric axis. To sketch the bounding box for the cylinder, begin on one 30-degree axis line and sketch an isometric square with sides equal to the diameter of the cylinder. This square will become the end of the cylinder. Next, mark the length of the cylinder on the other 30-degree axis line, and sketch the profile and top rectangles of the bounding box. For the profile rectangle, the length represents the length of the cylinder and the height represents the diameter of the cylinder. For the top rectangle, again the length represents the length of the cylinder, but the width represents the diameter of the cylinder. Note that only three long edges of the bounding box are drawn (the hidden one is not), and only two lines for the back end of the bounding box are drawn (the two hidden ones are not).

Step 2. Draw diagonals and center lines on the isometric square, and sketch in the ellipse, to create the end of the cylinder, as described in “Sketching an Isometric Ellipse.”

Step 3. Where the center lines intersect with the top and front sides of the isometric square, mark points A and B. Sketch construction lines from points A and B to the back end of the bounding box and mark points C and D. Sketch an arc between points C and D.

Step 4. On the isometric square, locate the two points where the long diagonal intersects with the ellipse. From those two points, sketch two 30-degree lines to the back of the bounding box. (These 30-degree lines are tangent to the ellipse on the front of the cylinder.) Then, sketch short elliptical arcs from points C and D to the tangent lines, as shown in the figure. The cylinder should now be visible in the boundary box.

Step 5. Darken all visible lines to complete the cylinder. Note that the major axis of the ellipse is perpendicular to the axis running through the center of the cylinder, and the minor axis is coincident to it.

Sketching Semi-Ellipses

Figure 2.32 shows how to sketch a semi-ellipse.

Step 1. This isometric ellipse will be drawn on the profile plane. Begin by sketching an isometric square whose sides are equal to the diameter of the arc. Add

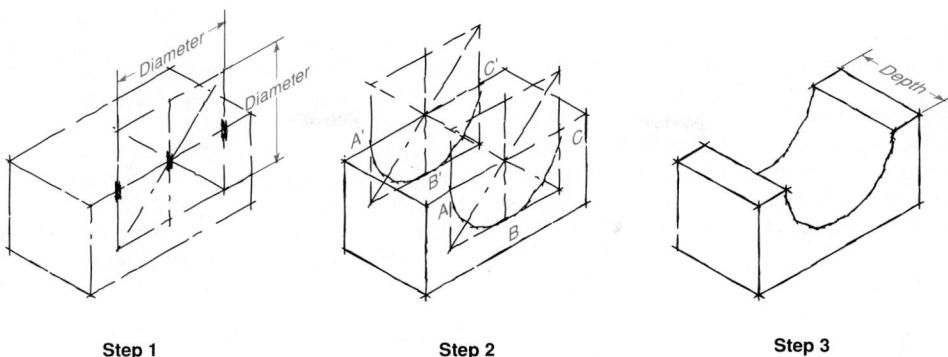

Figure 2.32 Steps Used to Construct a Sketch of a Semi-Ellipse

construction lines across the diagonals of the square. The two diagonals intersect at the center of the square, which is also the center of the isometric ellipse. Sketch construction lines from the midpoints of the sides of the square through the center point. These lines represent the center lines for the isometric ellipse.

Step 2. The midpoints of the sides of the isometric square will be tangent points for the ellipse and are labeled points A, B, and C. The long diagonal is the major axis and the short diagonal is the minor axis. Sketch short, elliptical arcs between points B and C and points B and A, which creates the elliptical arc on the near side of the object. The back part of the semi-ellipse can be sketched by constructing 30-degree parallel lines that are equal in length to the depth of the part, from points A, B, and C. This locates points A', B', and C' on the back side of the object. Add the back ellipse by sketching an arc between points B' and C' and points B' and A'.

Step 3. Finish by darkening the final lines and lightening the construction lines.

2.4.3 Isometric Grid Paper

The use of isometric grid paper can improve your technique and decrease the time necessary to create an isometric sketch. Isometric grid paper is made of vertical and 30-degree grid lines, as shown in Figure 2.9B. There are two primary advantages to using isometric grid paper. First, there is the advantage obtained by using any kind of grid paper. Proportions of the object's features can be translated into certain numbers of blocks on the grid. This can be especially useful when transferring the dimensions of a feature from one end of the object to the other. Unlike square grid paper, each intersection on an isometric grid has three lines passing through it, one for each of the primary axis lines. This can create some confusion when

counting out grid blocks for proportions. Just remember which axis line you are using and count every intersection as a grid block.

The second advantage of the isometric grid is the assistance it provides in drawing along the primary axis lines. Though estimating a vertical line is not difficult, estimating a 30-degree line and keeping it consistent throughout the sketch is more challenging. Remember that the only dimensions that can be transferred directly to an isometric sketch are the three primary dimensions. These dimensions will follow the lines of the grid paper. When blocking in an isometric sketch, lay out the dimensions on construction lines that run parallel to the grid lines. Angled surfaces are created using construction lines that are nonisometric; that is, they do not run parallel to any of the grid lines and are drawn indirectly by connecting points marked on isometric construction lines.

If there is a disadvantage to using isometric grid paper, it is the distraction of having the grid in the finished drawing. As with square grid paper, this problem can be solved in a number of ways. You could use tracing paper over the grid paper, allowing the grid paper to be used over and over. You could work out a rough sketch on grid paper and then trace over it. You could also use grid paper with grid lines printed in a special color that does not reproduce in photocopies. Grid paper with a very dark grid can be flipped over and the sketch can be made on the back side. You can see the grid through the paper, but it won't reproduce on the photocopier.

CAD systems will display isometric grids on screen and the user can use them as an aid in creating isometric drawings. In addition, a special ELLIPSE command is used to create isometric ellipses of any size and orientation. **© CAD Reference 2.4**

Practice Exercise 2.1

Using isometric grid paper, sketch common, everyday objects. Some examples are given in Figure 2.33. Sketch objects with a variety of features. Some should require sketching isometric ellipses, while others should have angled surfaces that require nonisometric lines. Start with simpler forms that only contain isometric lines and work toward more complex forms. Another approach is simply to leave

out some of the details. You can capture the essence of the form by representing just its primary features. This is a common approach in creating ideation sketches.

The cost and availability of isometric grid paper can be a discouraging factor in using it to create lots of sketches. You can minimize the expense by using roll tracing paper over a sheet of grid paper. The two sheets can be held together with low-tack tape, or put in a clipboard. With practice, you will find that grid paper is not needed and you can create sketches on the tracing paper alone.

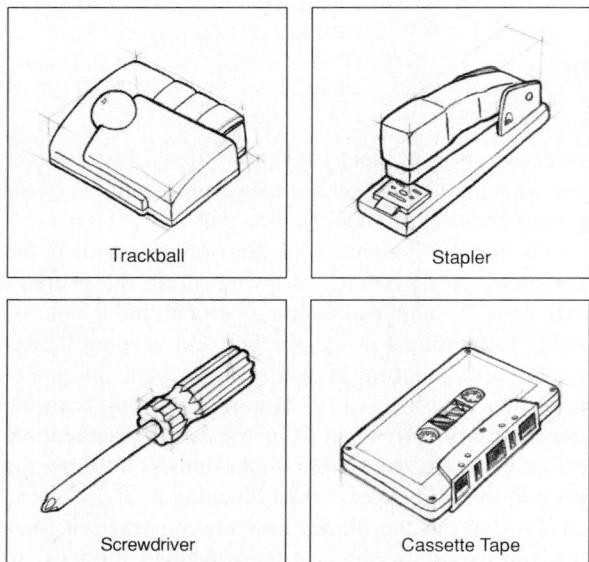

Figure 2.33 Isometric Sketches of Common Objects

2.4.4 Oblique Pictorials

Oblique pictorials are another method of creating a pictorial sketch of an object. Oblique sketching attempts to combine the ease of sketching in two dimensions with the need to represent the third dimension. In an oblique sketch, the front face is seen in its true shape and is square with the paper, and only the depth axis is drawn at an angle. (Figure 2.34) As with an isometric pictorial, the lines of projection are parallel to each other.

Because of the ease with which the front face is drawn, oblique sketching is useful when the majority of the features are on the front face of the object. Many types of furniture are conveniently drawn in oblique, especially cabinets with a lot of detailing on the front. On the other hand, oblique sketching should not be used if the object has many features (especially, circular ones) on faces other than the front.

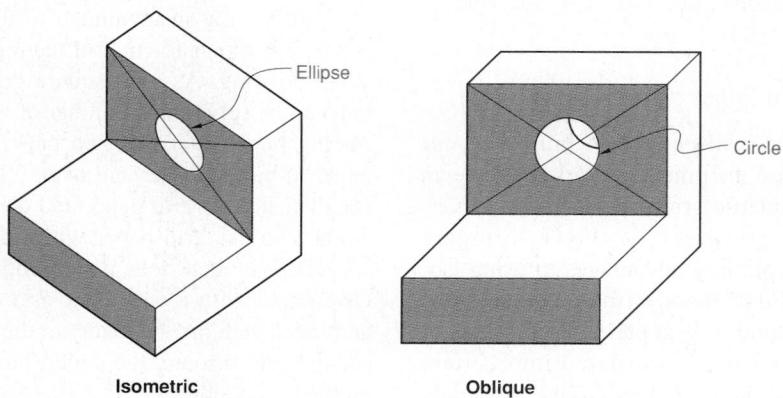

Figure 2.34 Isometric versus Oblique Sketches

In oblique sketching, the front face of the object (showing the height and width dimensions) is squared with the paper, and the depth dimension is drawn at an angle to the horizontal. This is different than an isometric sketch, where no faces are squared with the paper.

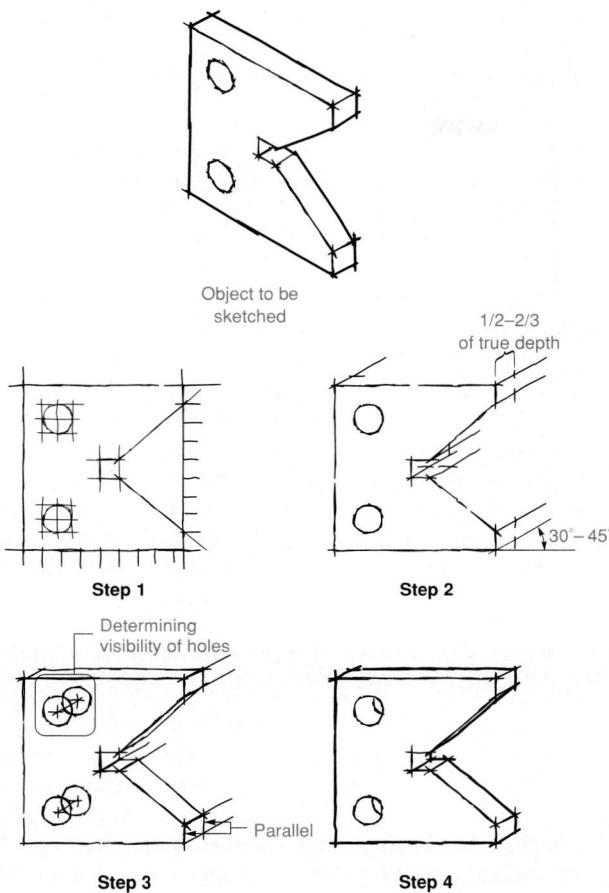

Figure 2.35

The construction of an oblique sketch is a multistep process that begins by boxing in the front view, adding details, and then boxing in the depth dimension.

As with isometric sketches, hidden features are not shown on most oblique sketches, unless absolutely necessary to describe the object. Because of the difference in how the depth dimension is drawn, scaling the depth to half or two-thirds its actual size helps the visual proportions of the sketch.

Creating an Oblique Sketch

Figure 2.35 shows the steps used to create an oblique sketch. The object is oriented so that most of the details are represented in the front view.

Step 1. Begin the sketch by boxing in the front face of the object as if you were creating a front view. Estimate distances and box in features to create a proportional sketch.

Step 2. To view the object from the right and above, sketch depth construction lines at an angle of 30 to 45 degrees above the horizontal and to the right of the front face. (Figure 2.35, Step 2) To view the object from below, sketch the depth lines below the horizontal. To view the object from the left side, sketch the depth lines to the left of the front face. Sketch only corners that will be visible.

Estimate the distance for the depth along the sketched lines. Full-length depth lines may make the object look out of proportion. Two-thirds or one-half size depth lines will create a better proportioned sketch. If full-size depth dimensions are used, the sketch is called a **cavalier oblique**. If the depth is one-half size, the sketch is called a **cabinet oblique**. For the example in Figure 2.35, one-half size depth is marked along each depth line.

Step 3. Draw a line between each depth mark to create the back edge of the object. These lines are parallel to the edges of the front view. The next step is to determine if any part of the hole on the rear of the object can be seen from the front. This is done by marking the locations of the centers of the holes on the front and sketching depth lines from those center points. The depth is marked on the depth lines, the marks are used as centers for the back holes, and circles equal in diameter to the front circles are sketched.

Step 4. If any part of a back circle is inside a front circle, that part will be visible in the oblique drawing and is darkened along with the other visible lines.

2.4.5 Multiview Projections

Multiview drawings are based on parallel projection techniques and are used when there is a need to represent the features of an object more accurately than is possible with a single (pictorial) view. A multiview drawing is a collection of *flat* 2-D drawings that work together to give you an accurate representation of the overall object. With a pictorial drawing, all three dimensions of the object are represented in a single view. The disadvantage of this approach is that not all the features in all three dimensions can be shown with optimal clarity. In a multiview projection, however, each view concentrates on only two dimensions of the object, so particular features can be shown with a minimum of distortion. (Figure 2.36) Enough views are generated to capture all the important features of the object.

Given their advantages, why are multiview drawings not always used? For one thing, there are the multiple views, rather than a single view, to be drawn. These views must be coordinated with one another to represent the object properly. You have to

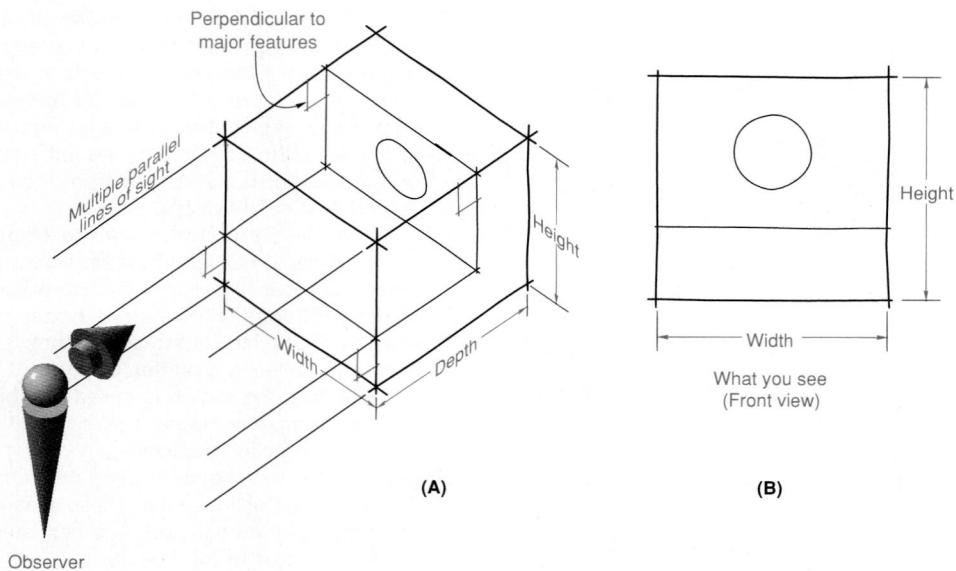

Figure 2.36 Multiview Drawings

Multiview drawings are classified as a parallel projection, because the lines of sight used to view the object are parallel. This method of viewing an object results in a single view, with only two of the three dimensions represented. Therefore, it takes multiple views to show all three dimensions.

carefully visualize the views as you sketch them, and so does the person viewing them. Without training and experience, you might find it hard to interpret multiview drawings. The choice between multiviews and pictorials is often one of exact representation of features versus ease of sketching and viewing.

Orienting and Selecting the Front View When creating a multiview drawing of a design, the selection and orientation of the front view is an important first step. The front view is chosen as the most descriptive of the object; for example, what would normally be thought of as the side of the car is chosen as the front view because it is the most descriptive. (Figure 2.37A) In addition, the object must be properly oriented in the view. The orientation of the object is based on its

function. For example, for an automobile, the normal or operating position is on its wheels, rather than on its roof or bumpers. (Figure 2.37B)

Choosing the Views for a Multiview Drawing

Another way to understand the views of an object is to pick it up and turn it around. This may be hard to imagine with something like a car, but many of the objects you will be sketching are considerably smaller and can be held in the hand. Imagine picking up the object shown in Figure 2.38 and holding it so that you are looking at the front. Now, rotate the object so that you are looking at its top. Rotate it back to where you started and then rotate it so you are looking at its right side. There are an infinite number of intermediate views of the object between the points of rotation at which you

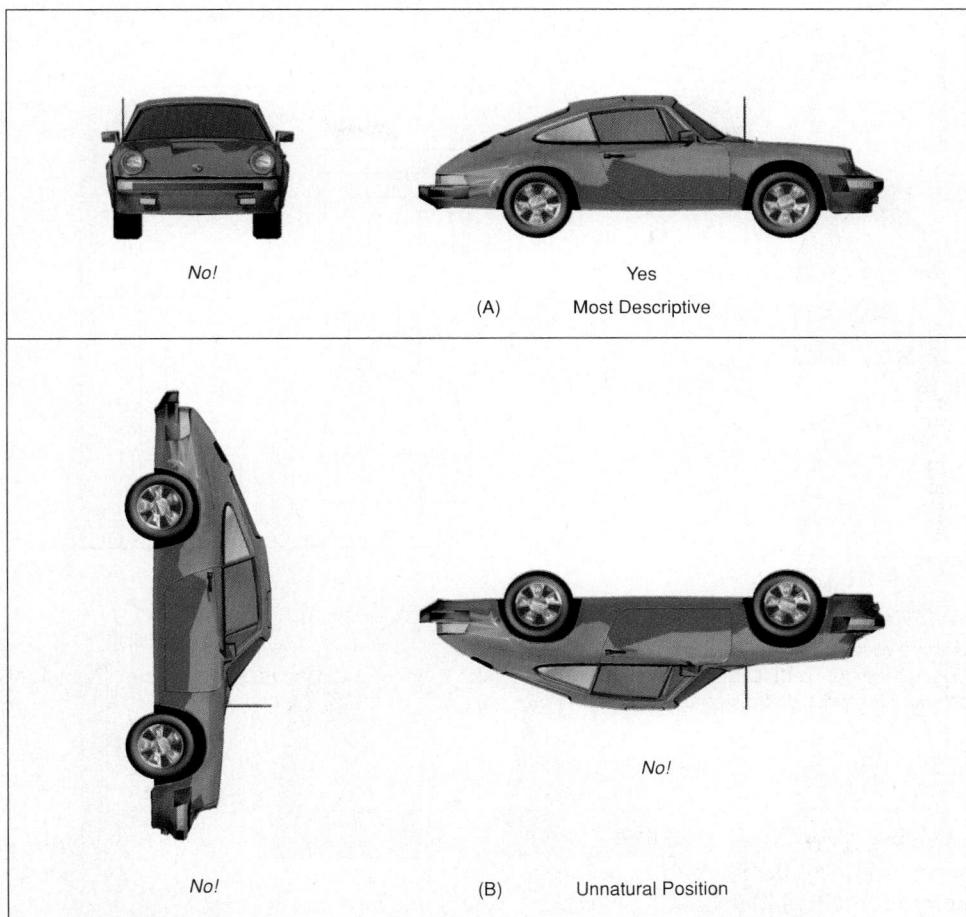

Figure 2.37 Most Descriptive View

Proper orientation and the most descriptive features of an object are important when establishing the front view for a multiview sketch. Objects should be positioned in their natural orientation; for this car, that position is on its wheels.

stopped; for right now, however, consider only those views that are rotated 90 degrees from each other. These are considered *regular* or *principal views* and each represents two primary dimensions of the object. If you continue rotating the object in 90-degree increments, you will see as many as six regular views. (Figure 2.39)

A multiview drawing should have the minimum number of views necessary to describe an object completely. Normally, three views are all that are needed; however, the three views chosen must be the most descriptive ones. The most descriptive views are those that reveal the most information about the design, with the fewest features hidden from view.

For example, Figure 2.39 shows one isometric view and six orthographic views of a simple object.

Of the six orthographic views, which are the most descriptive? Although all the views given reveal much about the size and shape of the object, some are more descriptive than others. The choice of views is determined as follows:

1. Identify the most descriptive or important features of the object.
2. Determine the views that best represent those features.

After deciding the most descriptive features of the part, choose the views which show these features. Part of this selection will involve determining which views do the best job of neither obscuring nor hiding other

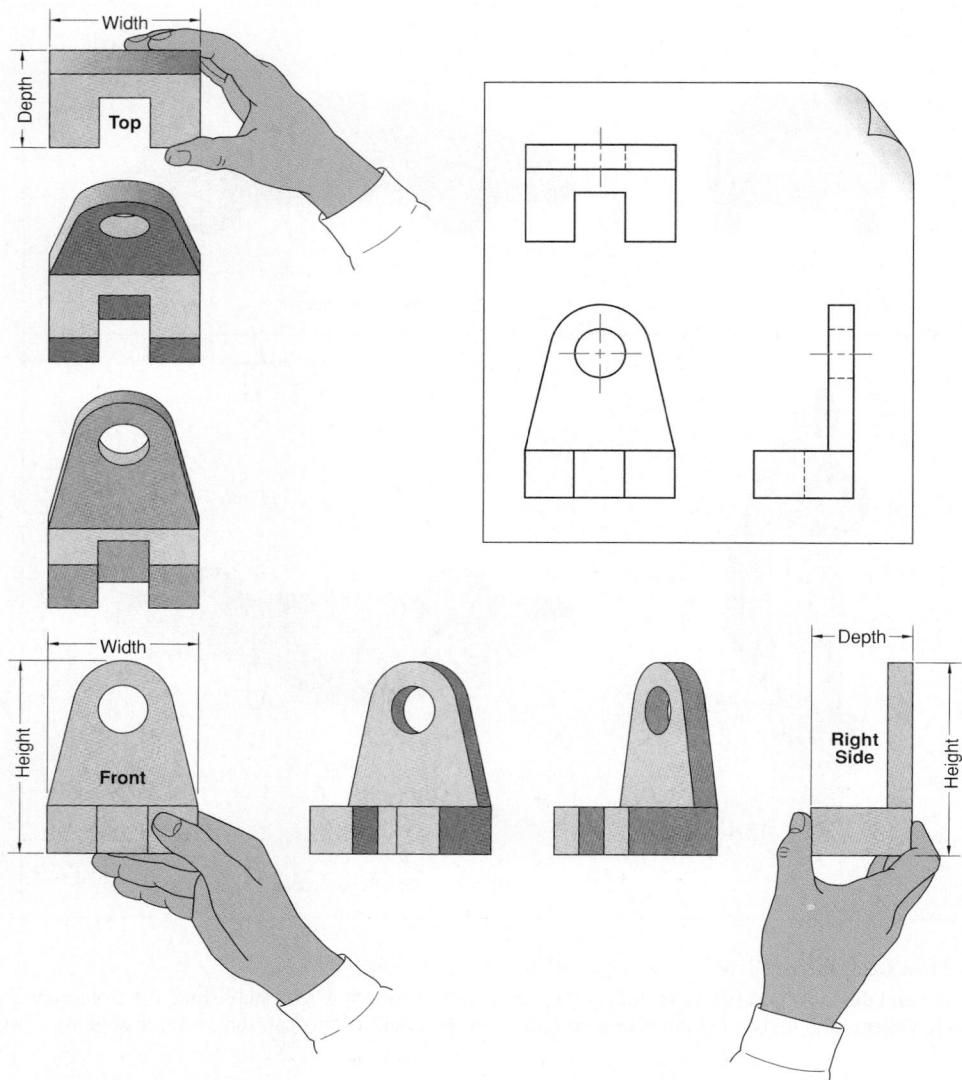

Figure 2.38 Visualizing a Multiview Drawing

By rotating a real object in your hand, you can simulate how a multiview drawing is created. A different principal view of the object is produced for every 90 degrees of rotation.

features. For example, the object in Figure 2.39 has four important features: the hole, the rounded top, the L-shaped profile, and the slot cut out of the base in front. There are only two views that show the hole and rounded top: the front and rear. Although both views show these features equally well, the front view is chosen over the rear view because it does not hide the slot cut in the base. The L-shaped profile is shown

equally well in both the right and left side views, and they have an equal number of hidden features. Although either view can be used, convention favors choosing the right side view. The slot in the base is shown in both the top and bottom views. However, the top view has fewer hidden lines, so it is preferred over the bottom view for the sketch. For this object, then, the preferred views are the front, top, and right side views.

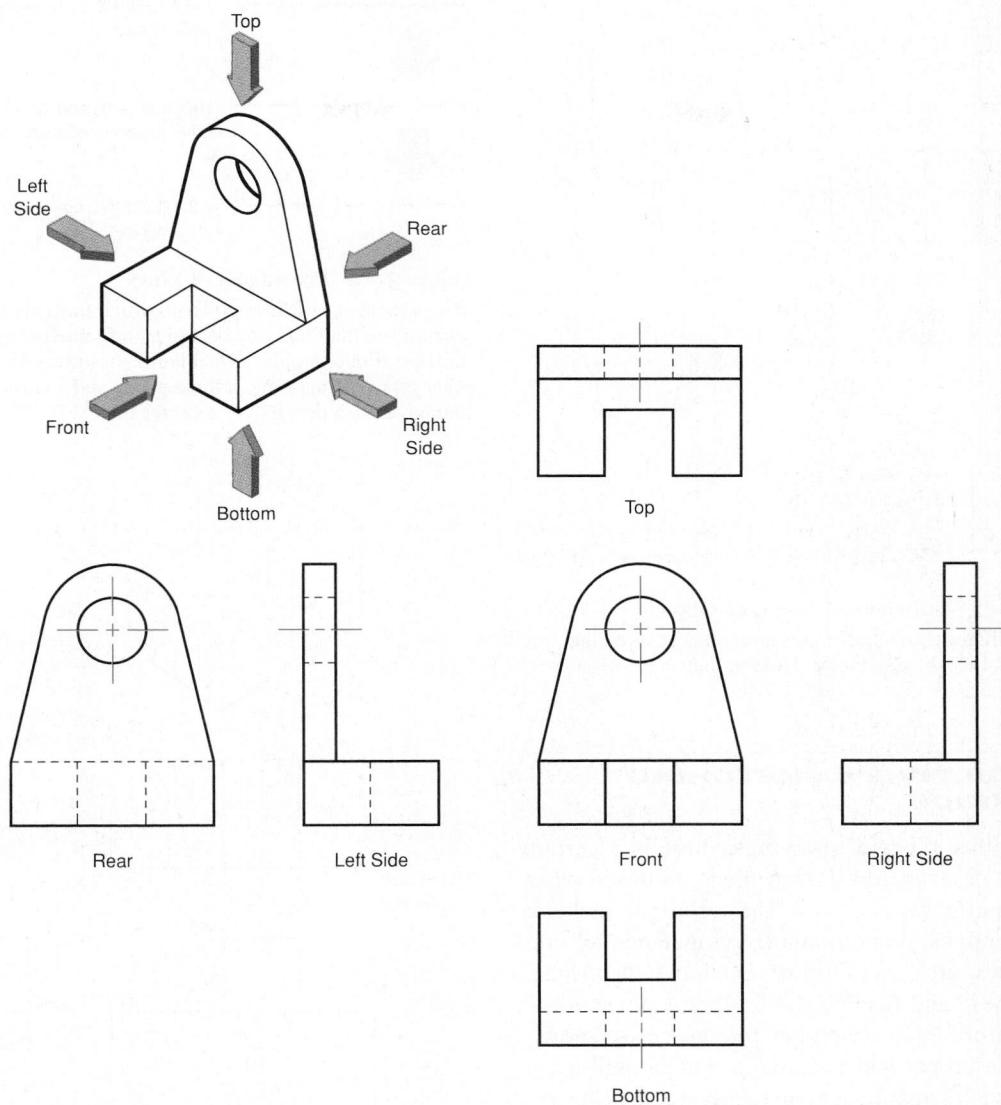

Figure 2.39 Six Principal Views

A multiview drawing of an object will produce six views, called regular or principal views. The object is viewed from six mutually perpendicular viewpoints. The six views are called front, top, bottom, rear, right side, and left side.

Practice Exercise 2.2

Find a number of small objects that can be picked up in your hand and rotated. Look at them carefully and identify their important features. Orient each object so that the most important features are seen. Make this view the front view. Before rotating them, try to imagine what the top and right side views will look like. Now rotate them and see if that is how they look. Do all of the important features show up in these three

views? If not, what other front view can you select that would result in seeing all of the important features in the three views?

Next, look at some larger items you cannot pick up. For each object, move around it and look at it from different viewpoints. Try to imagine picking it up and rotating it. Is there any difference in how the object looks if you pick it up and rotate it rather than walk around it?

Figure 2.40 shows some common objects represented in multiview drawings.

Figure 2.40 Multiviews of Common Objects

These multiview drawings of common objects show the front, top, and right side views. Hidden lines have been omitted for clarity.

2.5 MULTIVIEW SKETCHING TECHNIQUE

As with other types of drawings, there is a certain technique, or standard set of methods, followed when creating multiview sketches. The technique includes line conventions, proportioning, and methods for creating circles, arcs, and ellipses. Section 1.11 “Alphabet of Lines” and Section 4.4.6 “Line Conventions” contain information on proper line usage. A knowledge of the proper and effective technique will assist the beginner in creating legible multiview sketches.

2.5.1 Precedence of Lines

It is fairly common in technical drawings to have two lines in a view coincide. When this happens, the conventional practice called the **precedence of lines** dictates the linetype to draw when two or more lines in a view overlap. (Figure 2.41)

For example, in Figure 2.42A a visible line in the top view coincides with the hidden lines for the hole. The precedence of lines requires that the visible lines be drawn and the hidden lines not be shown in the top view. Figure 2.42B shows an example of a hidden line

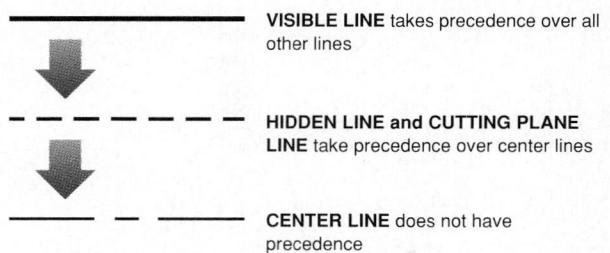

Figure 2.41 Precedence of Lines

The precedence of lines governs which lines are drawn when more than one line occupies the same position on a drawing. For example, a visible line has precedence over all other types of lines, and a hidden line and a cutting plane line have precedence over a center line.

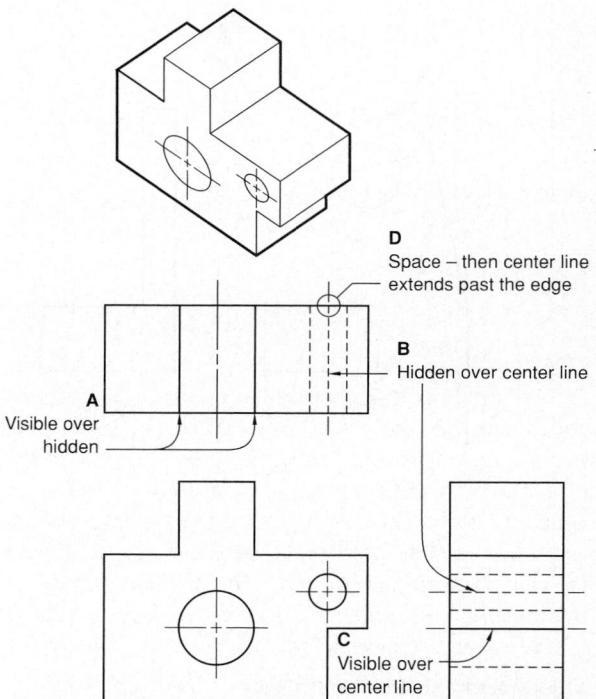

Figure 2.42 An Engineering Drawing Showing How the Precedence of Lines Is Applied

that has precedence over a center line. Figure 2.42C is an example of a visible line having precedence over a center line. Notice that whenever a hidden or visible line has precedence over a center line, the center line is still drawn in the view by leaving a space and then extending it beyond the edge. (Figure 2.42D)

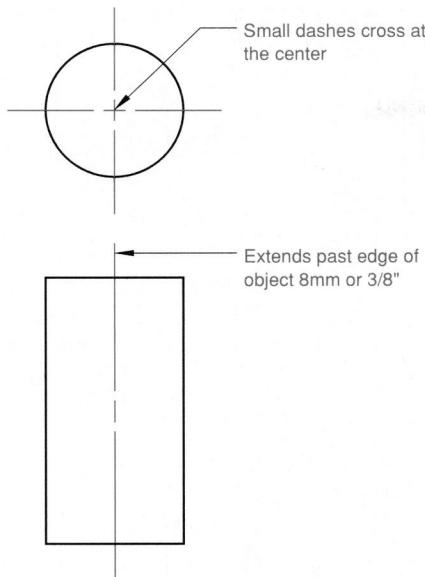

Figure 2.43 An Engineering Drawing of a Cylinder, Showing the Application of Center Lines

2.5.2 Conventional Practices for Circles and Arcs

Circles are used to represent holes and the bases of cones and cylinders. Arcs are used to represent portions of these elements, as well as rounded corners on objects. Whenever representing a hole, cylinder, or cone on a technical drawing, the conventional practice is to draw center lines, which are used to: (a) locate the centers of circles and arcs; (b) represent the axis of cylinders, cones, and other curved surfaces; and, (c) represent lines of symmetry.

Figure 2.43 is a multiview drawing of a cylinder. In the top view, horizontal and vertical center lines are drawn to locate the center of the circle. In the front view, a very thin center line (.035 mm) is drawn to show the location of the cylinder's axis. The small dashes that cross at the center of the circle extend approximately 8 mm or $\frac{3}{8}$ " from the edges of the object. The short segment of the center line is approximately 3 mm or $\frac{1}{8}$ " long. The long segment can be from 20 mm to 40 mm, or $\frac{3}{4}$ " to 1- $\frac{1}{2}$ " long. For very long cylinders, the center line is drawn as a series of long and short segments. Section 4.4.6 "Line Conventions" contains more information on the use of centerlines.

2.6 MULTIVIEW SKETCHES

Multiview drawings can have from one to three or more views of an object. However, multiview sketches rarely have more than three views.

Multiview sketches are important in that they provide more accurate geometric information than a pictorial sketch, without requiring the time that a formal multiview drawing would take. If dimensions are provided, they are usually only for a particular feature(s) and are often only approximations, since these sketches are used early in the design process before final specifications have been made.

As is the goal with all sketches, multiview sketches should be done quickly and clearly. Straightedges, such as triangles and T-squares, should be avoided since they will only slow you down and will compel you toward a level of finish that is inappropriate in sketches. In addition, you should draw only as many views as are necessary to show the features accurately. An initial analysis of the features should tell you if one, two, or three views are needed to clearly show the elements of interest.

2.6.1 One-View Sketches

The simplest multiview sketch represents just the front view of an object. Though not truly a *multiview*, it is still meant to represent only two dimensions of the object, which is the basic concept of multiview drawings. This sketch can be produced using the techniques shown in Figure 2.17.

2.6.2 Two-View Sketches

Occasionally, an object can be completely described using only two views. As an example, Figure 2.44 shows a symmetrical part that can be described using two views. If the front view is as shown in the pictorial, the top and side views would be the same. Nothing would be gained by drawing both the top and side views, so only one of these views is sketched.

Creating a Two-View Sketch

Figure 2.44 and the following steps describe how to create a two-view sketch.

Step 1. In the front view, block in the squares with sides equal to the diameters of the circles. Since both the front and right side views show the height dimension,

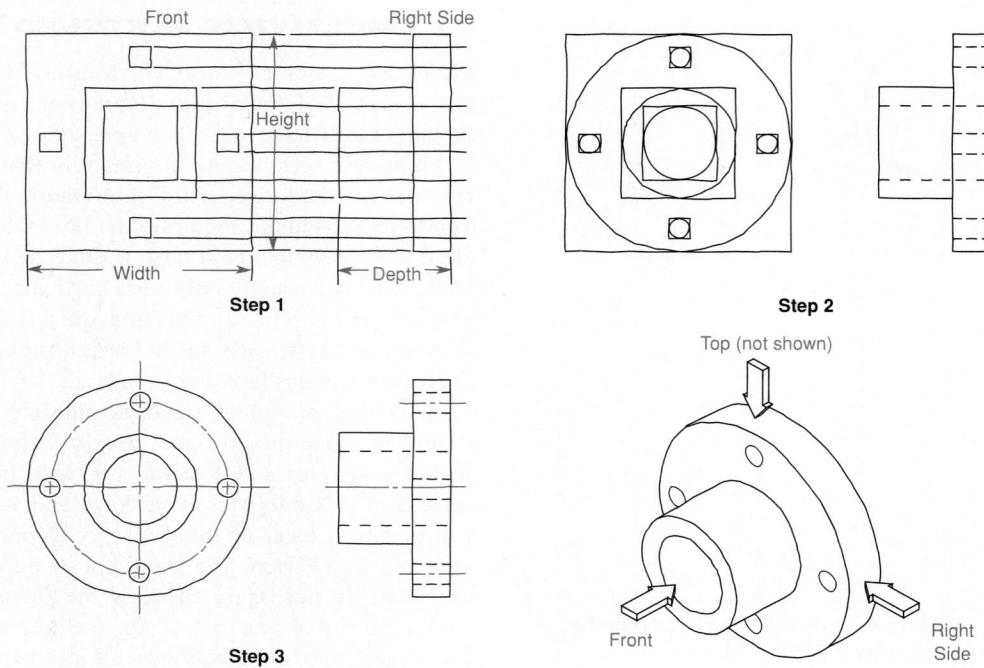

Figure 2.44 Creating a Two-View Sketch

A two-view sketch is created by blocking in the details, then adding center lines, circles, arcs, and hidden lines.

construction lines can be used to project the height of the squares onto the right side view. Block in the rectangles representing the details for the side view.

Step 2. Using the squares and center lines as guides, sketch the circles for each hole and the cylinder, in the front view. Using the construction lines as guides, sketch the hidden lines for the holes, in the side view.

Step 3. Darken all visible, center, and hidden lines.

Scale and locate the views on the drawing so that there is approximately equal spacing between the two views and between each view and the edge of the paper. (Figure 2.45) Normally, if the front and right side views are used, the paper is oriented so that the long dimension runs horizontally; if the front and top views are used, the long dimension of the paper runs vertically. There are exceptions to this if the object has particularly extreme proportions. Remember that the top view is *always* aligned with and placed above the front view, and the right side view is *always* aligned with and placed to the right of the front view. *Do not* rearrange the views just to fit them on the paper.

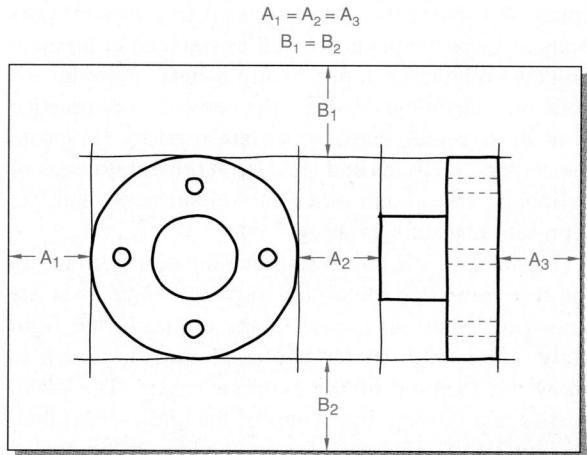

Figure 2.45 Centering a Two-View Sketch

A two-view sketch is centered on a sheet of paper by equally dividing the areas between and around the views.

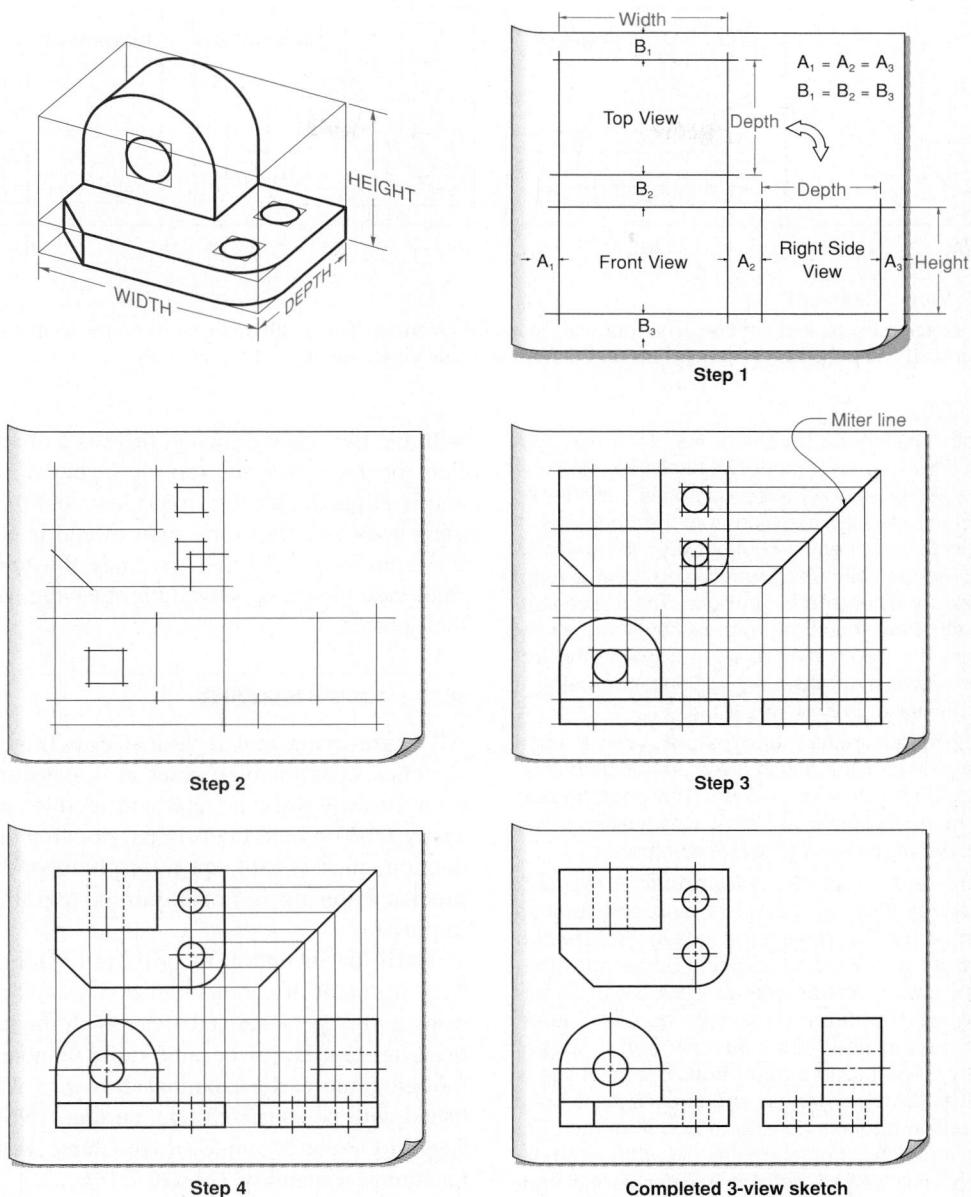

Figure 2.46 Creating a Three-View Sketch

A three-view sketch is created by blocking in the overall width, height, and depth dimensions for each view, then blocking in the details, using a miter line to transfer depth dimensions between the top and side views, and then, adding the final details, such as circles, arcs, center lines, and hidden lines.

2.6.3 Three-View Sketches

When an object is more complex, three views are needed. The object used in Figure 2.46 was chosen because it has many of the most common features you will be sketching, such as holes, arcs, lines, and planes.

Creating a Three-View Sketch

Figure 2.46 and the following steps show how to create a three-view sketch.

Step 1. Begin by blocking in the front, top, and right side views of the object, using the overall width, height,

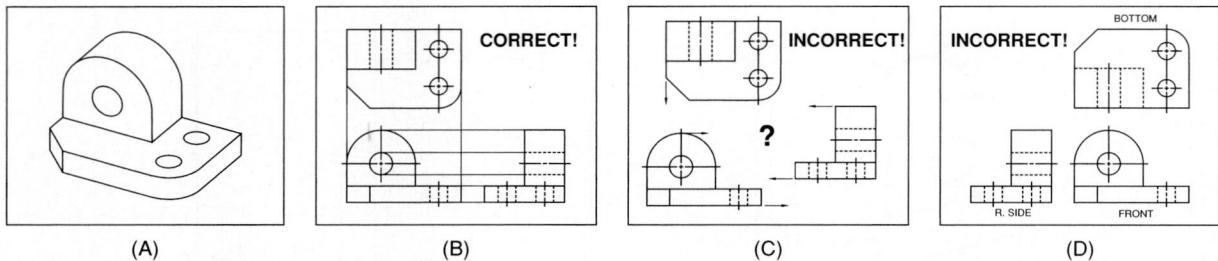

Figure 2.47 View Alignment

A three-view sketch must be laid out properly, following standard practices. The width dimensions on the front and top views are aligned vertically, and the height dimensions on the front and side views are aligned horizontally.

and depth. Sketch the front view first, then use construction lines to project the width dimension from the front view to the top view. Also, use construction lines to project the height dimension from the front view to the right side view. Leave room between the views so the sketch does not look crowded, and there is room to add text for notes and dimensions. The spaces between each view should be approximately the same. Make sure the depth dimension is equal in the top and side views by measuring the distance using a scale or dividers.

Step 2. Lightly block in the major features seen in each view. For example, the drilled holes are blocked in on the views where they look round. The angled edge and the rounded corner are most clearly seen in the top view. Begin darkening these major features.

Step 3. Quite often, features will appear in two and sometimes all three of the views, and construction lines can be used to project the location or size of a feature from one view to another. Remember that each view always shares one dimension with an adjoining view. The depth dimension can be shared between the top and right side view with a special construction line called a **miter line**. The miter line is drawn at a 45-degree angle and is used as a point of intersection for lines coming to and from the right side and top views. For example, the width of a hole in the top view can be projected down to the front view. Then the location of the hole can be passed across the miter line to the right side view.

Step 4. Finish adding the rest of the final lines. Be careful to do all hidden lines and center lines for the holes. Darken all final lines.

As with the two-view drawing, there are conventional practices that must be followed when arranging the three views on the paper. (Figure 2.47) Make sure that all three views stay aligned with their neighboring views. (Figure 2.47A) If they do not, they will not be able to share dimensions via projection lines. As

with the two-view drawing, there is a strict organization for the views: the top view goes directly above and is aligned with the front view, and the right side view goes directly to the right of and is aligned with the front view. Do not rearrange the top, front, or right side views, or substitute other regular views in their places.

2.7 LETTERING

All engineering and technical drawings, including sketches, contain some notes or dimensions. All text on a drawing must be neat and legible, so it can be easily read on both the original drawing and a reproduction, such as a blueprint or photocopy. Although precise lettering is not required, legibility is very important.

Until the invention of printing by Johann Gutenberg in the 15th century, all text was hand lettered, using a very personalized style. With the invention of printing, text styles became more standardized. Although some early technical drawings were embellished with personalized text, current ANSI standards suggest the use of single-stroke Gothic characters, for maximum readability. (Figure 2.48)

The tools used to add text to engineering and technical drawings have evolved over the years from quill pens to the computer. Pencils are still a common tool, but their use is declining as more drawings are being produced with CAD software. Mechanical lettering guides, such as the **lettering template** in Figure 2.49, the lettering machine, and press-on type, were developed in the years before CAD.

In a modern engineering or technical graphics office, it is more important to have good typing skills than it is to have or practice hand-lettering skills. The keyboard has all but eliminated the need

Figure 2.48 An Example of Hand-Lettered Gothic Text Style Commonly Used in Engineering Drawing

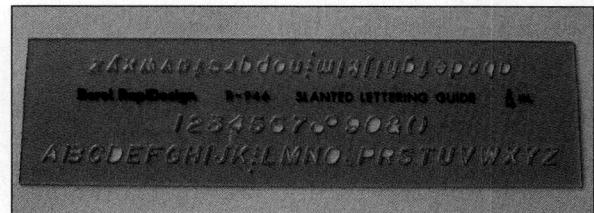

Figure 2.49 A Mechanical Lettering Template Used to Assist in the Drawing of Text on Engineering Drawings

to do hand lettering on final drawings. One of the greatest productivity advantages of CAD over traditional tools is the speed with which text can be added to a drawing. The use of computers to create engineering and technical drawings has resulted in the choice of many different text styles and placement options for engineering and technical drawings. © **CAD Reference 2.5**

2.7.1 Lettering Standards

ANSI has developed a set of standard practices for adding text to a drawing. In this book, other techniques have been added to those standards to help you create legible text using hand lettering or computer tools. These standards and techniques are:

- Use a Gothic text style, either inclined or vertical.
- Use all capital letters.
- Use $\frac{1}{8}$ " (3 mm) for most text height.
- Use $\frac{1}{4}$ " (6 mm) for the height of fractions.
- Determine the minimum space between lines of text by taking the text height and dividing it by 2.

Figure 2.50 shows examples of these standards.

2.7.2 Hand Lettering

Though hand lettering is used less and less, you must still be able to produce clear, legible, hand-lettered words and numbers that conform to a standard style.

Whenever lettering by hand, you should use guide lines. **Guide lines** are very thin, very light construction lines used as a guide to create uniform letters on engineering and technical drawings. Guide lines are constructed using a very sharp, hard pencil, such as a 4H, 5H, or 6H. One method of creating guide lines is to measure the distances between them using a scale, or a piece of scrap paper with the distances marked on the edge. (Figure 2.51) In addition to horizontal

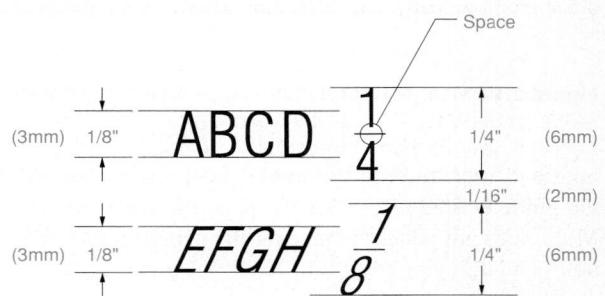

Figure 2.50 Recommended Text Heights

The recommended heights for text on technical drawings are $\frac{1}{8}$ " or 3 mm high for letters and $\frac{1}{4}$ " or 6 mm for fractions.

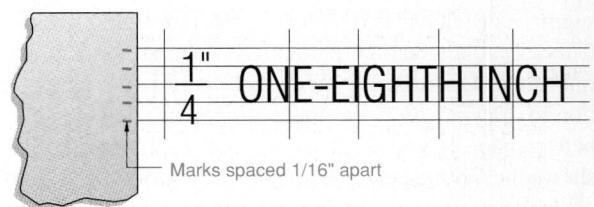

Figure 2.51 Placing Marks for Guide Lines

A ruler or scrap of paper can be used to place marks on technical drawings in order to draw guide lines that are spaced $\frac{1}{16}$ " or 1.5 mm apart. Vertical guide lines can also be used to assist in forming letters.

guide lines, beginners often find vertical guide lines to be useful. Vertical guide lines are placed every fourth or fifth letter to help keep the letters vertical and aligned.

Lettering guides can also be used to make guide lines, as shown in Figure 2.52. The lettering guides are a convenient method for laying out various distances for text, as well as the angle used to create inclined text. These lettering guides are used against a straight edge, such as a T-square, and a pencil is inserted into a

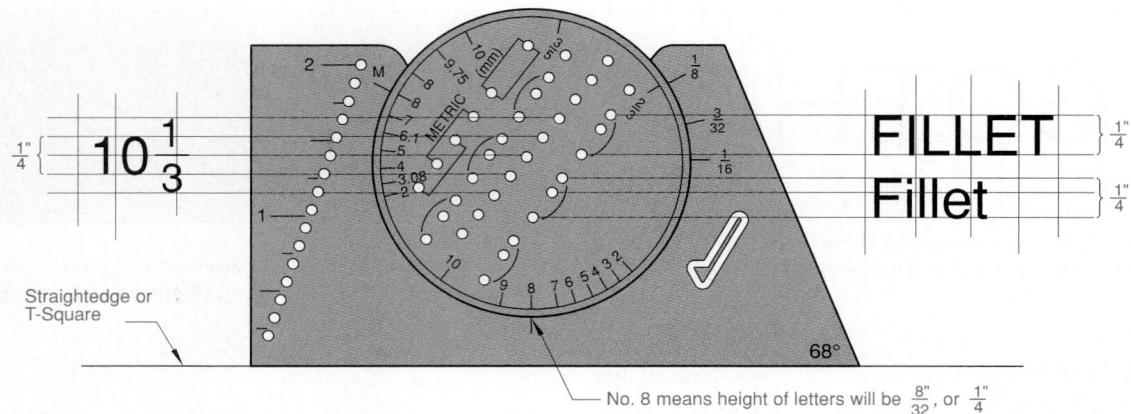

Figure 2.52 An Adjustable Lettering Guide Used for Hand Lettering on Drawings

hole and used to drag the guide across the paper. As the guide is dragged across the paper, a line is drawn. More lines are added by placing the pencil in different holes and dragging the guide across the paper again.

Within these guide lines, the individual letters are drawn. There is a particular style to each letter. Figure 2.53A shows examples of each letter in its vertical format. Notice that all of the letters are in capitals. In general, lower-case letters are never used. In Figure 2.53A, a recommended stroke sequence is given. Each straight segment of a letter is drawn as a separate single stroke. Curved strokes that are particularly long are broken up into multiple strokes. Even though there is the temptation to draw an "O" in a single stroke, you will create a better shape if you do it in two halves. Figure 2.53B shows the Gothic design in the inclined format.

There are many pitfalls in hand lettering. Most of them are correctable with a little bit of practice and attention to your work. Whenever lettering a drawing by hand, follow the format illustrated in the top line in Figure 2.54. Take particular note of the uniformity of spacing between letters. Do not have equal spacing between letters. Instead, look at the volume of background area in and around each letter. This volume is what should be uniform.

2.7.3 Alternate Text Styles

Until CAD became popular for creating engineering and technical drawings, the text style was standardized by ANSI as single-stroke Gothic. Although Gothic is still the standard set by ANSI, the user of a CAD system has many other choices. **© CAD Reference 2.6**

CAD text is classified and grouped by its characteristics. The size and style of a type define its **font**.

Figure 2.55 shows the three main text groups: Gothic, computer, and stylized. Computer text (line 2) has no curved lines and is made up of a series of short, straight lines. Look at the letter "S" in the word "Standard" in the second line in Figure 2.55. Notice that the "S" is made up of short, straight lines and no curves. This style is popular with CAD systems because the text is plotted more quickly than other typestyles. The Gothic text (line 1) is the same style as specified by the ANSI standard and is used when hand lettering. Stylized text is a large group of computer text styles that vary between CAD systems. Examples from Figure 2.55 are bold, italics, and sans serif.

Text can also be varied by using bold or italic versions. Boldface is a heavyweight version of a typeface. An italic typeface is slanted and is generally lighter in weight.

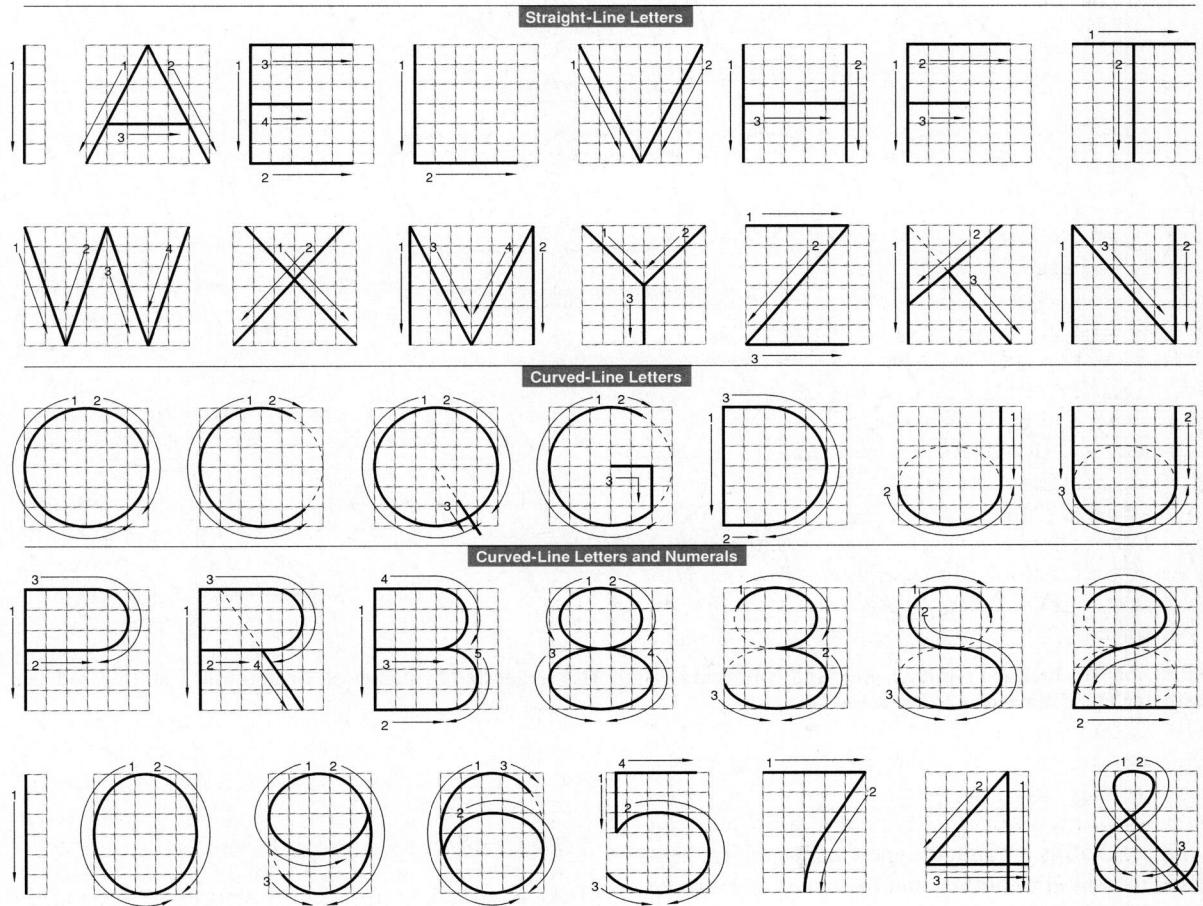

Figure 2.53A Vertical Gothic Letter and Numeral Design, with Suggested Sequence of Strokes that Can Be Used as a Guide for Hand Lettering a Technical Drawing

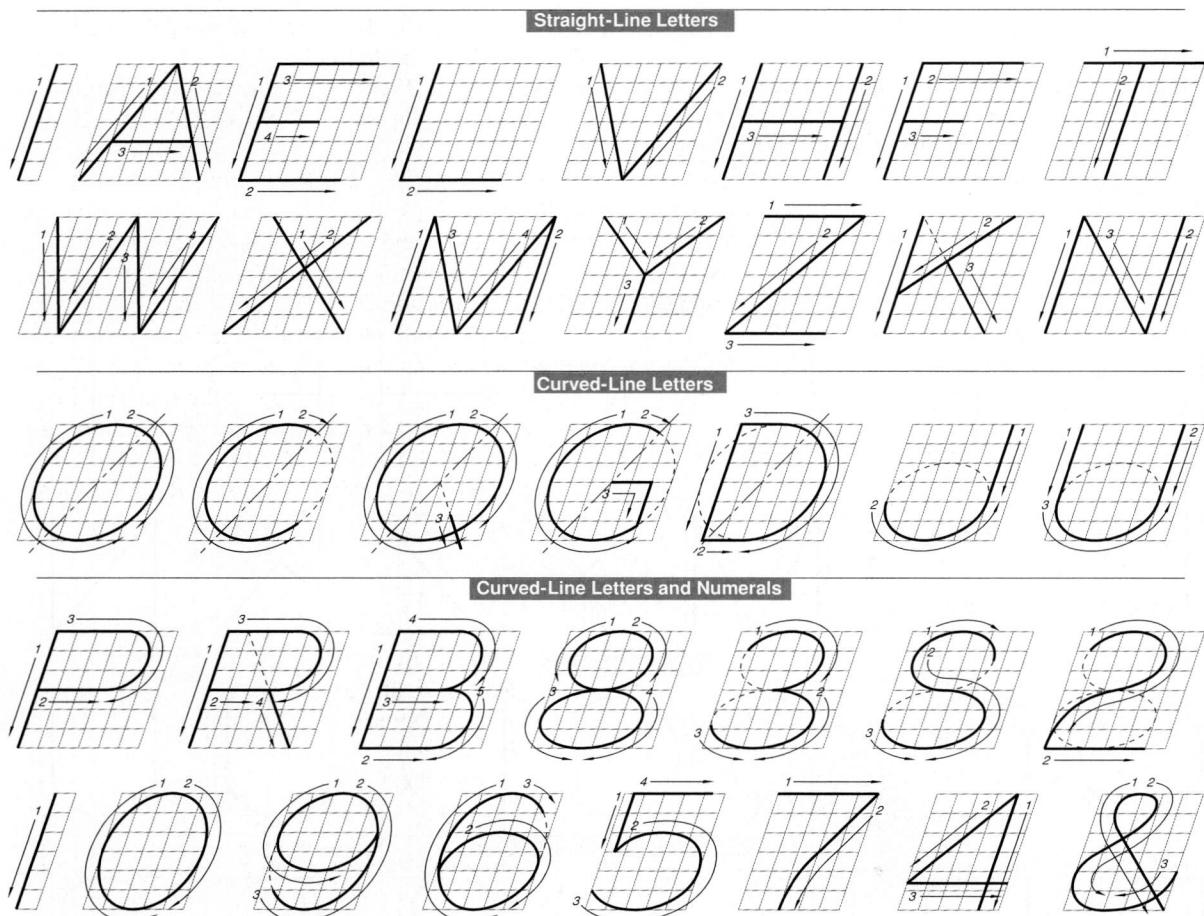

Figure 2.53B Inclined Gothic Letter and Numeral Design, with Suggested Sequence of Strokes that Can Be Used as a Guide for Hand Lettering a Technical Drawing

Figure 2.56 is a guide to type characteristics. Type size is measured in **points**, and there are 72 points per vertical inch. So 36-point type is about $\frac{1}{2}$ inch high, where the height is measured from the top of the letter to a fixed depth below the letter. The ascender is the portion of a lowercase character that extends above the letter height. The descender is the portion of a lowercase letter that extends below the baseline. A serif is a small finishing stroke perpendicular to the main character stroke. A sans serif typeface is one without serifs. Gothic is a sans serif typeface.

2.7.4 Computer Lettering Technique

Text is added to a CAD drawing by selecting the TEXT command, entering the letters and numerals with the keyboard, and then picking a point on the drawing where the text is to be placed. Before adding text to a drawing, many variables must be set. Some of the more common computer text variables are height, font, alignment, aspect ratio, slant, and rotation. Although some CAD software makes it easy to use different fonts, technical drawings that adhere to ANSI standards should always use the block Gothic style, for maximum clarity when reproducing technical drawings.

Text Height The height of the text is controlled by entering a numerical value. Think of this as setting your guide lines for the text. The advantage of CAD is that it is easy to create virtually any size text for a drawing. One important consideration is the scale to be used for the drawing itself. For example, suppose you were a drafter/designer and had to create a drawing of a new section of interstate highway. The section of the road you are to draw is approximately 1000 feet long and the text height is set at $\frac{1}{8}$ ". Obviously you cannot plot the drawing full scale, so a scale of $1'' = 25'-0''$ is chosen to fit the drawing on a D-size sheet. This will

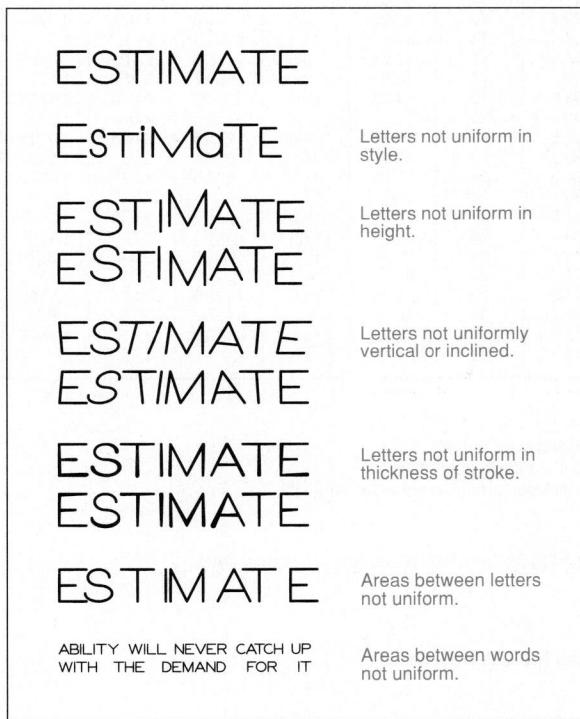

Figure 2.54 Examples of Poor Hand Lettering Technique

plot the drawing at 1/300 scale. If the $\frac{1}{8}$ " text is also plotted at 1/300 scale, it would be reduced to a series of dots, at best. Figure 2.57 provides text heights for some common plot scales. [© CAD Reference 2.7](#)

Text Alignment **Text alignment** controls the justification of a line of CAD text. Typical alignments are: center, left, and right. [© CAD Reference 2.8](#)

Center justification centers the text about a selected point, which is indicated by the X in Figure 2.58A. Left justification places the text flush left with a margin and results in a ragged right margin. (Figure 2.58B) Right justification places the text flush right with a margin and results in a ragged left margin. (Figure 2.58C) Some CAD systems provide even more precision in placing text, using the following:

- Top center
- Top left
- Top right
- Middle center
- Middle left
- Middle right
- Bottom center
- Bottom left
- Bottom right

HAND LETTERED GOTHIC
STANDARD CAD TEXT STYLE.
STYLIZED BOLD
STYLIZED ITALICS
STYLIZED SANS SERIF

Figure 2.55 Comparison of Hand-Lettered Text with Some of the Different Text Styles Available with CAD

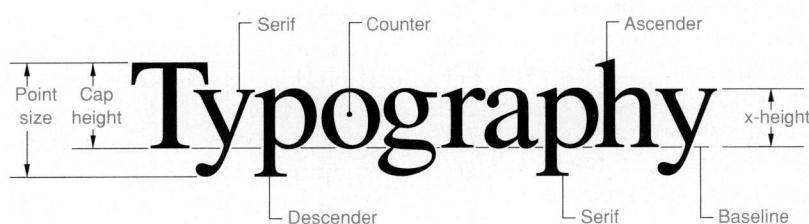

Figure 2.56 Important Terms Associated with Text
This information is useful when using CAD for lettering.

Text Size and Plot Scale Reference Table												
Scale	1/8" Text Height	Plotted Drawing Scale										
		Desired Text Size (On paper)	1:128 3/32" = 1'	1:96 1/8" = 1'	1:48 1/4" = 1'	1:32 3/8" = 1'	1:24 1/2" = 1'	1:16 3/4" = 1'	1:12 1" = 1'	1:4 3" = 1'	1:2 6" = 1'	
1/32" = 1'	48	1/32"	0.03125"	4	3	1.5	1	0.75	0.5	0.375	0.125	0.0625
1/16" = 1'	24	1/16"	0.0625"	8	6	3	2	1.5	1	0.75	0.25	0.125
3/32" = 1'	12	3/32"	0.09375"	12	9	4.5	3	2.25	1.5	1.125	0.375	0.1875
1/8" = 1'	6	1/8"	0.125"	16	12	6	4	3	2	1.5	0.5	0.25
1/4" = 1'	3	5/32"	0.15625"	20	15	7.5	5	3.75	2.5	1.875	0.625	0.3125
1/2" = 1'	1.5	3/16"	0.1875"	24	18	9	6	4.5	3	2.25	0.75	0.375
1/4 size	.5	7/32"	0.21875"	28	21	10.5	7	5.25	3.5	2.625	0.875	0.4375
1/2 size	.25	1/4"	0.25"	32	24	12	8	6	4	3	1	0.5
Full size	.125	9/32"	0.28125"	36	27	13.5	9	6.75	4.5	3.375	1.125	0.5625
2/1	.0625	5/16"	0.3125"	40	30	15	10	7.5	5	3.75	1.25	0.625
3/1	.0416	11/32"	0.34375"	44	33	16.5	11	8.25	5.5	4.125	1.375	0.6875
4/1	.0312	3/8"	0.375"	48	36	18	12	9	6	4.5	1.5	0.75
5/1	.0250	13/32"	0.40625"	52	39	19.5	13	9.75	6.5	4.875	1.625	0.8125
10/1	.0125	7/16"	0.4375"	56	42	21	14	10.5	7	5.25	1.75	0.875
100/1	.00125	15/32"	0.46875"	60	45	22.5	15	11.25	7.5	5.625	1.875	0.9375
1000/1	.000125	1/2"	0.5"	64	48	24	16	12	8	6	2	1
1" = 1000'	1500	17/32"	0.53125"	68	51	25.5	17	12.75	8.5	6.375	2.125	1.0625
1" = 500'	750	9/16"	0.5625"	72	54	27	18	13.5	9	6.75	2.25	1.125
1" = 100'	150	19/32"	0.59375"	76	57	28.5	19	14.25	9.5	7.125	2.375	1.1875
1" = 10'	15	5/8"	0.625"	80	60	30	20	15	10	7.5	2.5	1.25
21/32"	0.65625"	84	63	31.5	21	15.75	10.5	7.875	5.625	3.625	1.3125	
11/16"	0.6875"	88	66	33	22	16.5	11	8.25	5.625	3.625	1.375	
23/32"	0.71875"	92	69	34.5	23	17.25	11.5	8.625	5.625	3.625	1.4375	
3/4"	0.75"	96	72	36	24	18	12	9	3	1.5	0.75	
25/32"	0.78125"	100	75	37.5	25	18.75	12.5	9.375	6.25	4.125	1.5625	
13/16"	0.8125"	104	78	39	26	19.5	13	9.75	6.25	4.125	1.625	
27/32"	0.84375"	108	81	40.5	27	20.25	13.5	10.125	6.875	4.5	1.6875	
7/8"	0.875"	112	84	42	28	21	14	10.5	7.5	5	1.75	
29/32"	0.90625"	116	87	43.5	29	21.75	14.5	10.875	7.5	5	1.8125	
15/16"	0.9375"	120	90	45	30	22.5	15	11.25	7.5	5	1.875	
31/32"	0.96875"	124	93	46.5	31	23.25	15.5	11.625	8.75	5.625	1.9375	
1"	1"	128	96	48	32	24	16	12	4	2	2	

Instructions:

- 1) Find the plotted text size you want in the column on the left.
- 2) Read across until you reach the correct plotting scale column.
- 3) The value shown is the size of text (in inches) you create in your CAD drawing.

Example:

Desired text size is 9/16", and drawing is plotted at 3/8" = 1' - 0". Make text 18" high in CAD.

$$\text{Calculated as: } \frac{9}{16} \times \left(\frac{12}{3/8} \right) = 18$$

Figure 2.57 Recommended Text Height and Plot Scale Settings for CAD Drawings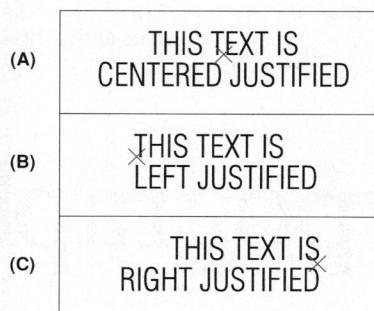**Figure 2.58**

Most CAD systems allow text to be justified about a given point.

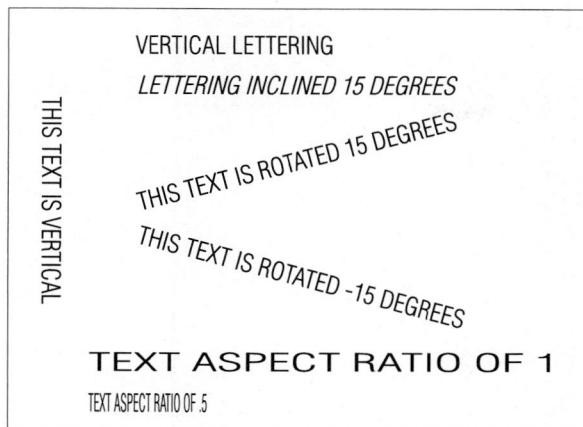

Figure 2.59 Examples of CAD Text Slant, Incline, and Aspect Ratios

Other CAD Text Variables Depending on the type of CAD system, there are many other text variables that can be controlled. Text slant is used to create individual text characters at an angle away from vertical. (Figure 2.59) Text rotation is the angle, measured from horizontal, used to create entire lines of text at an angle. Text aspect ratio is the numerical ratio of the width versus the height of individual characters. Text aspect ratio can be controlled to create letters that range from narrow to wide. For example, a text ratio of 1 produces characters that are equally wide and high. A text ratio of 0.5 produces characters that are twice as high as they are wide. Ratios greater than one create extended letters; ratios less than one create compressed letters. Some CAD systems even allow text to be drawn upside down, backwards, and vertically.

Occasionally, special text characters not found on a standard computer keyboard must be added to technical drawings. Examples are the degree, plus-minus, and diameter symbols. By entering a special string of text (a code), it is possible to create such symbols. Using one particular CAD software product, entering %%D results in the degree symbol being created on the drawing. Another CAD software may have a different code for creating the degree symbol.

© CAD Reference 2.9

2.8 TEXT ON DRAWINGS

Without text it would be nearly impossible to describe engineering designs completely. Text on engineering and technical drawings is used:

- To communicate nongraphic information.
- As a substitute for graphic information, in those instances where text can communicate the needed information more clearly and quickly. (Examples: the name of a part or assembly, the number of parts needed, the dimensions of a part.)

The use of text on drawings should be kept to a minimum and the text should be short and concise.

Although text can be placed anywhere on a drawing, there are a few areas where text is more commonly found. These areas are described in the following paragraphs. (Figure 2.60)

Title Block Text is used in **title blocks** to identify the drawing name and its relationship to other drawings. Other important information also found in a title block includes the scale, date drawn, company, name of the person who made the drawing, name of the person who checked the drawing, etc.

Revision Block A **revision block** is located adjacent to the title block and lists the revisions made to a drawing.

Bill of Materials Text is used in a **bill of materials** to identify part numbers and names, part materials, quantities needed for the assembly, dimensional sizes, and other information.

General Notes Text can be used to provide general information that cannot otherwise be effectively or quickly communicated. Sometimes, part names and numbers are placed near the orthographic views when more than one part of an assembly is drawn on a single sheet. Special manufacturing information may also be noted.

Dimensions Text is used on dimensions to identify the measurements necessary to make the product or structure. Most dimension text is numerals $\frac{1}{8}''$ or 3 mm high.

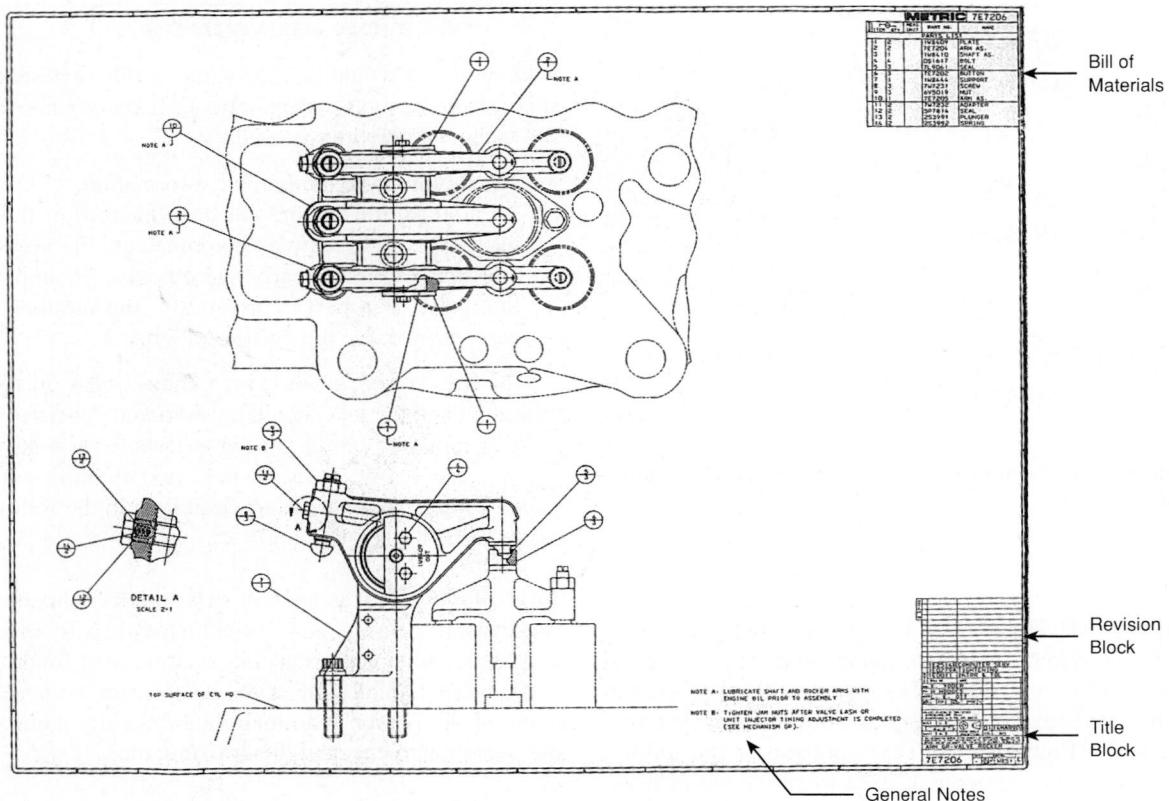

Figure 2.60 Examples of a Title Block, General Notes, a Revision Block, and Bill of Materials on a Technical Drawing

2.9 VISUALIZATION FOR DESIGN

The brain has an amazing ability to process visual information. Unconsciously, your brain is managing the navigation as you walk through the house or drive down the street. (Figure 2.61) Your brain's desire to organize the visual information around you allows you to look at the clouds or the stars and see the shapes of animals, objects, or people. This natural visualization ability can be put to work in more structured ways by engineers, scientists, and technologists, to solve problems.

Nikola Tesla, one of the great inventors in electronics, was said to be able to design exclusively with images in his head. Leonardo da Vinci, a great inventor of an earlier generation, used drawings as an integral part of his design process. (Figure 2.62) The famous scientist Albert Einstein used visual imagery to solve complex

Figure 2.61

Your sight allows you to successfully navigate your environment.

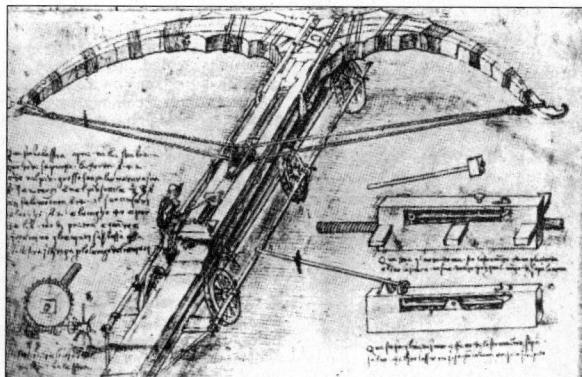

Figure 2.62

Leonardo da Vinci used drawing as a means of visualizing his designs.

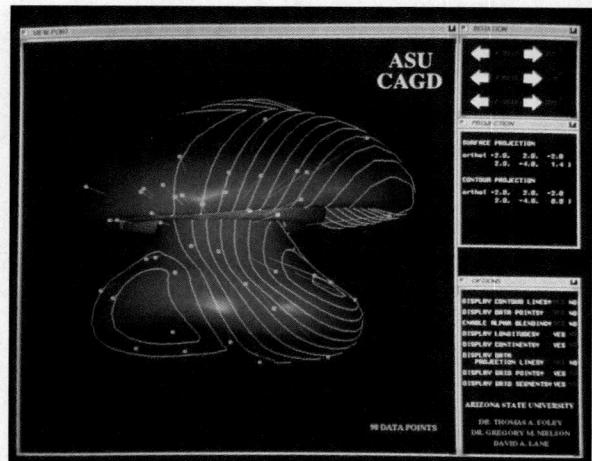

Figure 2.63 Computer-Generated Scientific Visualization

Figure 2.64 Hand/Eye Connection

The hand/eye connection is important when sketching.

problems in physics. Einstein once said: “The words or the language, as they are written or spoken, do not seem to play any role in my mechanism of thought. The psychical entities which serve as elements of thought are certain signs and more or less clear images which can be voluntarily reproduced and combined.”

We all have the ability to use imagery to solve problems that are spatial in nature. What you may not have is Tesla’s ability to do complete designs from beginning to end in your head. You will find, however, that transforming your ideas into tangible graphic images serves both as a permanent record of those ideas and as a means of encouraging further creative thinking. Though sketching is a primary method for visualization, the cur-

rent computer graphics hardware and software systems are a great equalizer for those who do not have a natural ability to express their ideas visually. (Figure 2.63)

To effectively use graphics as a vehicle for visualizing design ideas, you must understand that the two-dimensional graphics you draw—whether on paper or a computer screen—are a *representation* of information existing in another form. Exercises at the end of this chapter focus on drawing exactly what you see, as though there was a direct connection between your hand and the object being drawn. (Figure 2.64) In fact, the mind and the information it receives visually play a critical role in guiding what the pencil draws on the paper. (Figure 2.65)

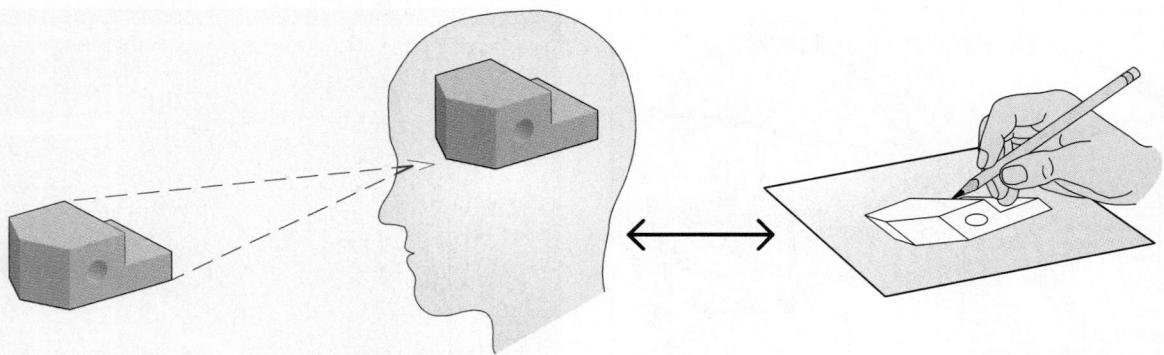

Figure 2.65 Hand/Eye/Mind Connection

The hand/eye/mind connection more accurately describes the processes used to make sketches. The mind forms a mental picture of existing or nonexisting objects, which can then be sketched. The feedback loop between the mind and the hand is so powerful that the object need not exist.

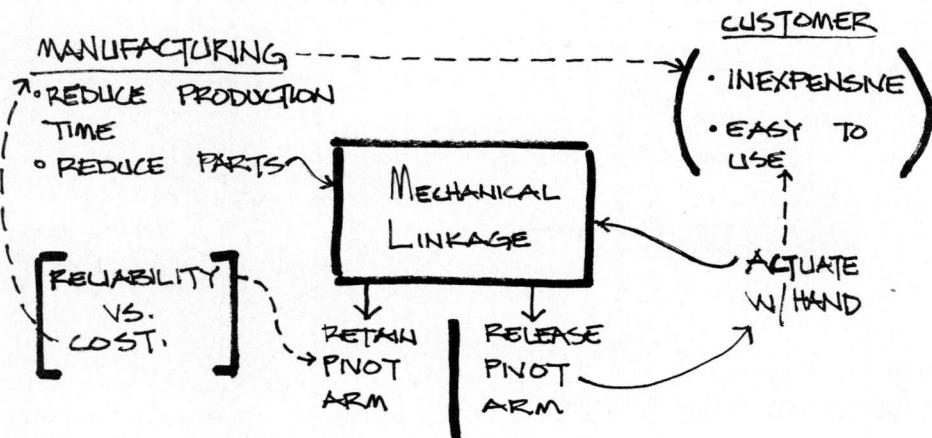

Figure 2.66 Flow Chart

This flow chart is used to identify requirements of the design.

2.9.1 Problem Solving

Visualization is important and integral to the engineering design process. Using either the computer or the drafting board, engineers and technologists must have the ability to document their completed designs, based on well-defined technical graphics standards. They must also have the ability to understand, at a deeper level, the three-dimensional forms they are documenting.

The ability to visualize forms in your mind enhances your ability to understand both existing objects and objects that may not yet have been manufactured. Visualizing three-dimensional forms allows you to play *what-if games* in the early stages of the design

process, before there are physical models. The ability to visualize also allows you to spatially analyze more detailed problems later on.

As an engineer or technologist, much of what you will do professionally will involve solving problems. The problem drawing may start out as a flow chart (Figure 2.66), but should soon evolve into an image of an object. (Figure 2.67)

Now you can begin the what-if games: "What-if I move this part over to the other side?" "What-if I lower the height by half and make it a bit deeper?" You may perform some of these what-if games as mental images, but eventually there will be too much detail and/or too many variations of the design to keep in your head. Put them down on paper as *ideation sketches*.

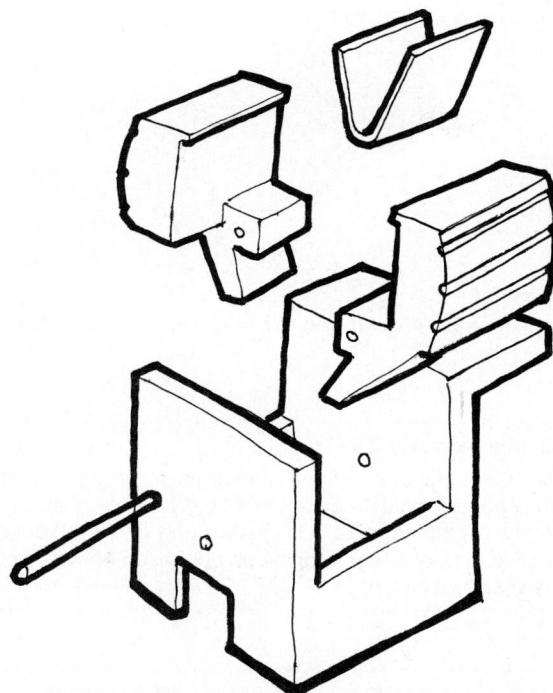

Figure 2.67 Ideation Sketch

An exploded assembly sketch is used to visualize a possible design solution.

Eventually you will use your sketching abilities to create problem-solving ideation sketches; at first, however, you will use those abilities to understand a 3-D object as it exists. Before you can evolve a design, you must first understand fully how it exists initially. By reviewing what you know about an image of an object, mentally building and synthesizing that information, and drawing the results of this mental effort, you can visualize a 3-D object and its future possibilities. (Figure 2.65) However, the process does not stop there; what you have drawn becomes a graphics image for starting the whole process all over again.

2.10 SOLID OBJECT FEATURES

The first visualization technique treats objects as you would normally see and feel them. A closer look at a solid object reveals features, or attributes, which help you visualize the object's current form. These attributes are also useful for transforming the object into something new, either on paper or in your mind. Figure 2.68 contains two simple, primitive objects, one a

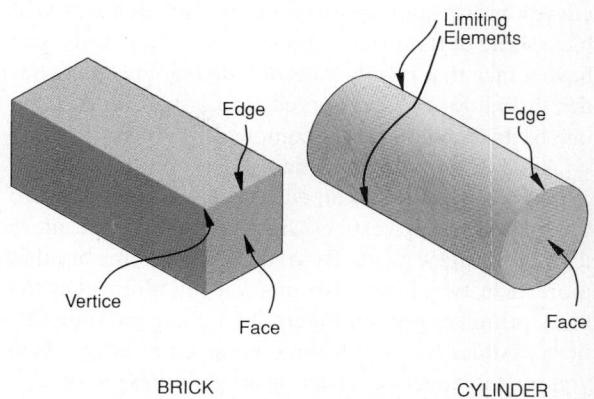

Figure 2.68 Solid Object Features

These brick and cylinder primitives show important features: edge, face, vertice, and limiting element.

brick or rectangular prism, and the other a *cylinder*. These two primitives clearly demonstrate several important characteristics, or attributes, of objects.

Practice Exercise 2.3

Put various objects under a strong, directed light. Identify the edges on the object by looking at them, and then feel them with your hand. Does the gradation of light on various parts of the object correspond to the "sharpness" of the corners?

Edges are the lines that represent the boundary between two faces of an object. On real objects, edges exist at a sharp break in light or dark levels on a surface. (see Figure 2.68) **Faces** are areas of uniform or gradually changing lightness and are always bounded by edges. This is an important rule! Both edges and faces can be curved. For instance, as you follow around the curved face of the cylinder, there is gradual change in the lightness of the surface. Only when you go to the front of the cylinder is there an abrupt change in lightness, signaling an edge.

Another important attribute demonstrated by the cylinder is the limiting element. A **limiting element** is a line that represents the farthest outside feature of the curved surface. It is the last visible part of the curved surface as it drops away from your line of sight. Even though it is not a boundary between faces, a line is used to represent the limiting element. The line is tangent to the curved edge at each end of the cylinder. If you examine the cylinder, you will note that, even with an ideal viewing position, a curved face that

curves more than approximately 180 degrees will have some of its surface obscured; in other words, you have a face that is only partially visible. For the cylinder in Figure 2.68, its curved face is half hidden and one of its circular faces is completely hidden.

Another important attribute, found on the brick, is corners, or **vertices**. If an edge is the place where two faces meet, then vertices are the place where more than two edges meet. By extension, this means that more than two faces also meet at this point. On the brick primitive seen in Figure 2.68, there are four vertices visible, each with three connecting edges. Can you see three faces connecting at all of these vertices?

Going back to the cylinder, does it have any vertices? The answer is no, because there is no point at which three edges or three faces come together.

© CAD Reference 2.10

Practice Exercise 2.4

Based on the brick (prism) and cylinder developments found at the end of this chapter, construct the brick and cylinder, using tape or glue to hold the paper forms together. After constructing the two primitive shapes, identify and label:

- The faces, edges, and vertices of the brick (prism).
- The faces and edges of the cylinder.

Hold the cylinder at arms length and identify the limiting elements on each side of the curved surface. Change the position of the cylinder and notice: (a) the limiting elements change with the cylinder; and (b) you can never view more than 180 degrees of the 360-degree curved surface of the cylinder.

The basic rules of geometry that apply to 2-D shapes also apply to 3-D objects. Since faces are attached to each other at common edges, the **shape** of one face influences both the number of faces attached to it and the shapes of those other faces. For the brick primitive in Figure 2.67, all of the faces are either rectangles or squares, and the adjacent edges on each face are at 90 degrees to each other.

The shapes of 2-D faces can be used to interpret how a 3-D object is shaped. The square end-face on the brick has four edges, which means there are four other faces attached to it. If the end-face were a hexagon instead of a square, (Figure 2.69) how many faces would be attached to it? What if the end-face had one edge instead of four? Since one shape that has a single edge is a circle, the brick would become a cylinder and the end-face would have only one curved face attached to it.

Figure 2.69

This hexagonal prism has an end face attached to six other faces.

Practice Exercise 2.5

Have someone put various objects in a paper or cloth bag. Feel the objects without looking at them. Can you identify: (a) the edges, (b) the faces, and (c) the objects? Try sketching or describing the object based on what you feel when touching it.

2.11 GENERAL VISUALIZATION TECHNIQUES

2.11.1 Solid Object Combinations and Negative Solids

Solid objects can be combined as if they were building blocks. (Figures 2.70A and 2.70B) To be considered a true combination, a flat face of one object must join a flat face of the other object. This *face-to-face rule* guides the number of possible combinations you can make from two solid objects. A combination such as that shown in Figure 2.70C is not a true combination. For example, “a tire on a road” is thought of as two separate objects, not one.

Practice Exercise 2.6

Based on the cube development found at the end of this chapter, construct the cube, using tape or glue to hold the paper form together. Using either sketches or physical blocks shaped like those shown in Figure 2.70, explore all the possible combinations of these two objects. Are all of them unique?

Suppose, for example, that the cylinder is pushed through the cube and cube material comes out ahead of the cylinder, like a plug from a hole. The plug of removed cube material perfectly matches the *void* left

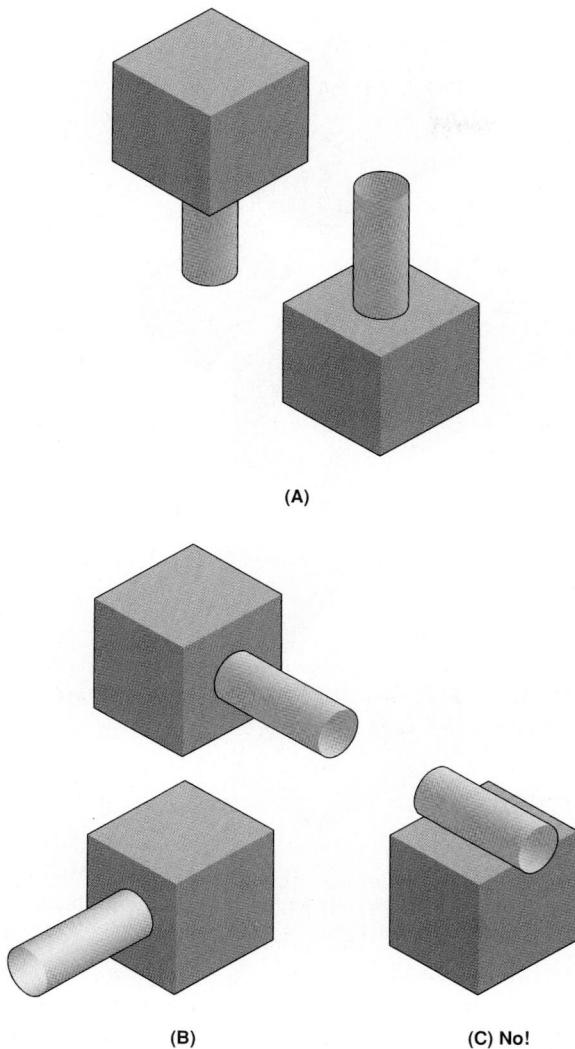

Figure 2.70 Combining Solid Objects

Additive combinations of primitives can be used to create new forms. This example shows acceptable (A and B) and unacceptable (C) ways a cylinder could be added to a cube to form a new object.

in the cube. (Figure 2.71) It is also a replica of the cylinder. There is a perfect negative/positive relationship between the void in the cube and the removed cylindrical plug. The plug can be thought of as a **negative solid**. If the plug is put back in the hole, it will fill the void perfectly, recreating the original cube.

If a smaller brick is removed instead of a cylindrical plug, (Figure 2.72A), the effect would be similar, except the hole would have four straight sides, to match the four sides of the removed brick plug. (Figure 2.72B)

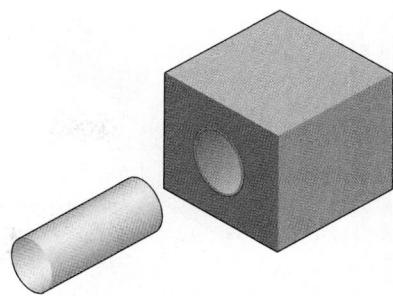

Figure 2.71

The cylinder subtracted from the cube is equal in volume and shape to the hole left in the cube.

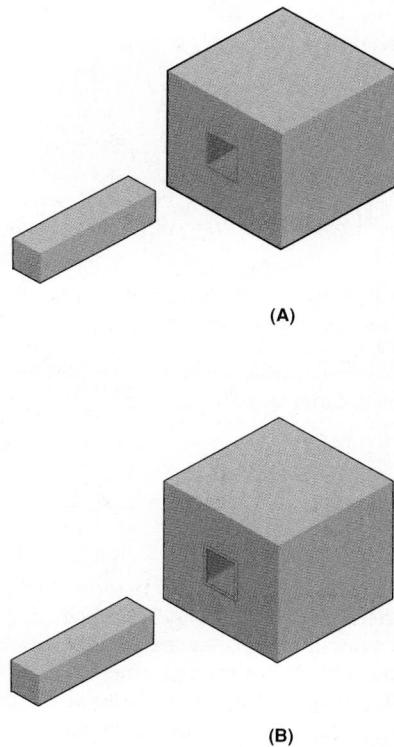

Figure 2.72

When a square prism is subtracted from the cube, the edges of the hole match the end face of the square prism.

Negative solids can also be taken off the corners, rather than from the middle. This *notching* produces several possibilities (Figure 2.73), especially when you expand beyond cylinders and bricks to wedges (Figure 2.74) and pyramids. (Figure 2.75)

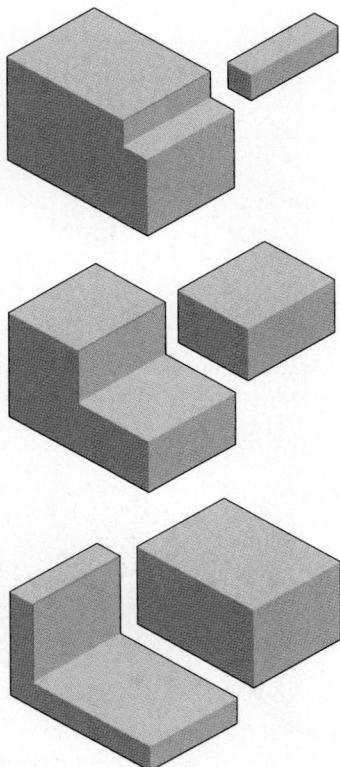**Figure 2.73**

Subtraction of progressively larger prisms from the brick creates entirely different geometric forms.

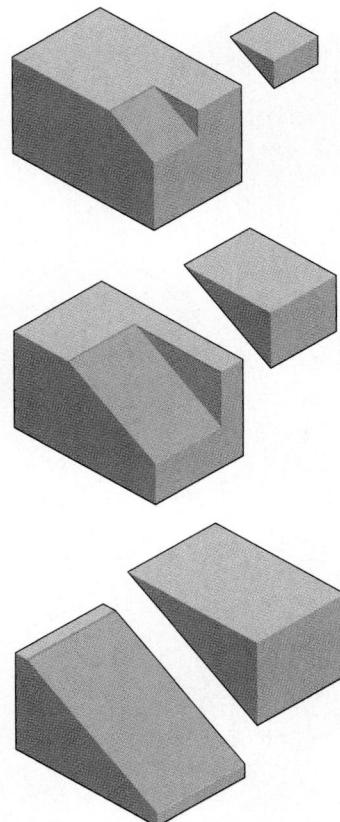**Figure 2.74**

Subtraction of progressively larger wedges from the brick creates new geometric forms.

Practice Exercise 2.7

Using clay or Styrofoam®, form a number of blocks approximating the brick primitive. Using a knife, remove various shaped primitives from your original brick, saving what you have cut off. The easiest shapes to remove are the ones coming off the corners. The difficult shapes to remove are the plugs from the middle of the brick. Observe that the new faces created on the original brick correspond to faces on the removed shapes. The other faces on the removed shapes should form seamless surfaces with faces on the original brick when the shapes are put back. Pictorially sketch some of the new geometric forms you have created.

Instead of a physical model, use a 3-D CAD program that has primitives and Boolean operations. Create the brick as the base model, then subtract various primitive shapes, such as cubes, cylinders, and wedges, to create new geometric forms. Print pictorial views of some of the new forms.

To summarize, there are two fundamental techniques for combining solids: (1) the **additive** technique, in which one object is added to another to increase its volume; and (2) the **subtractive** technique, in which one object is removed from the other.

Used together, the two techniques for combining objects become a powerful tool for visualizing solids and creating complex geometric forms using a CAD solid modeling program. Complex objects (Figure 2.76A) can be “decomposed” into a combination of solid primitives. Starting with an initial primitive, new primitives can be either added or subtracted. (Figure 2.76B)

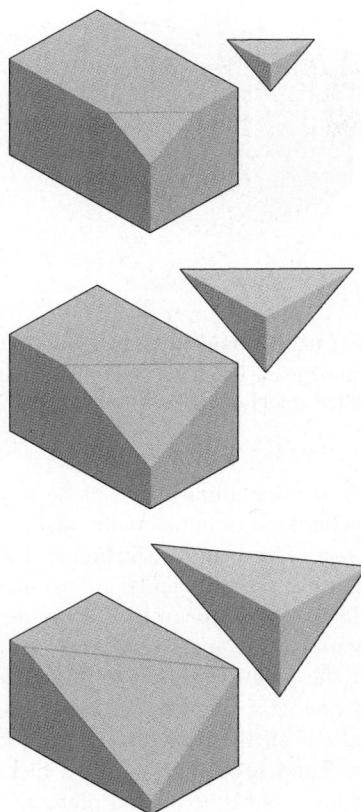**Figure 2.75**

Subtraction of progressively larger pyramids from the brick creates new geometric forms.

2.11.2 Planar Surfaces

Another tool that can be used for visualizing objects is planar surfaces. Such surfaces can interact with a solid object, or can be used to represent the object itself.

Cutting Planes One planar surface that will be introduced later in this chapter is the **cutting plane**. For our purposes here, a cutting plane is *like a blade* that is flat, razor thin, and infinitely large. Two pieces of the object can be left together, instead of being separated, and the cutting plane can be thought of as having created a new surface inside the object. (Figure 2.77)

In essence, the cutting plane is a 2-D plane that exists in a 3-D world. Now instead of combining two 3-D solids together, you can combine a 3-D solid with a

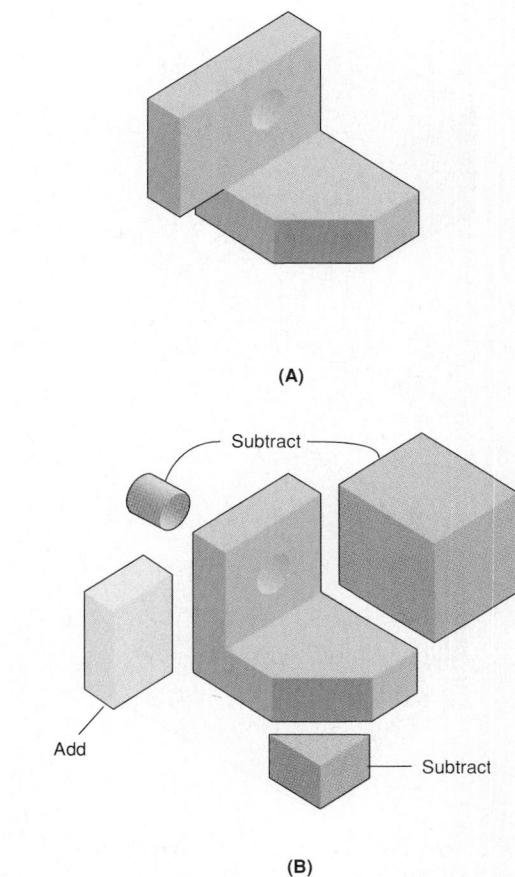**Figure 2.76**

Additive and subtractive techniques can be used to make a solid geometric form.

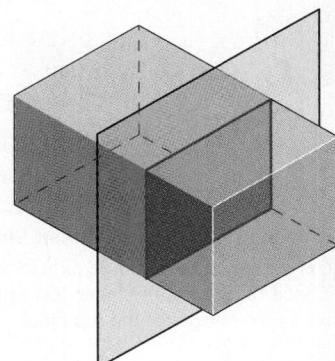**Figure 2.77 Normal Cutting Plane**

A normal cutting plane in the brick will create a new surface called a normal face. This new surface is exactly the same as the end face.

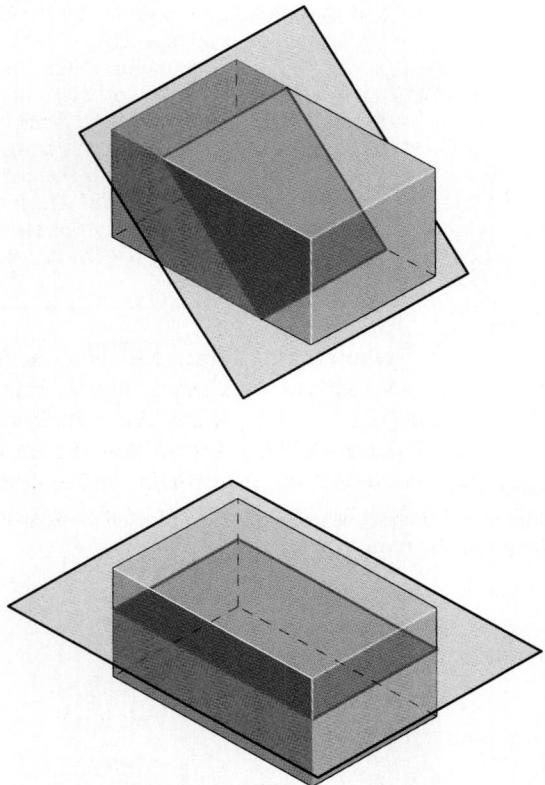

Figure 2.78 Cutting Plane Rotated about Single Axis

A cutting plane is rotated about a single axis in the brick. This creates inclined faces until the plane has rotated 90 degrees, creating a face normal to the top face.

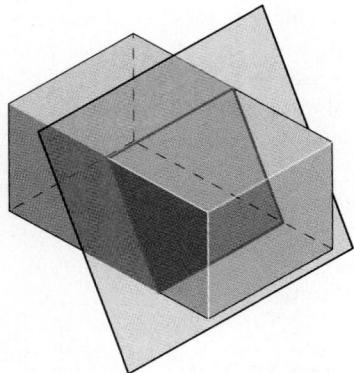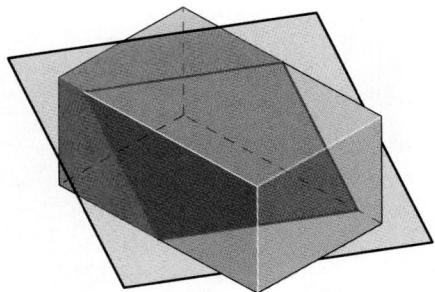

Figure 2.79 Cutting Plane Rotated about Two Axes

Rotating a cutting plane about two axes in the brick creates a new face called an **oblique face**.

2-D plane. The orientation of the plane to the object determines what kind of cut is made; that is, the shape of the new face. For example, in Figure 2.77 the cutting plane is either perpendicular or parallel to all of the major faces on the primitive. This new face is called a **normal face**, and is an exact replica of the end face of the primitive. If you rotate the cutting plane about one axis (Figure 2.78) (but less than 90 degrees) and cut all the way through the object, you create an **inclined face**. The inclined faces become longer and longer until the cutting plane is rotated 90 degrees. At this point, the plane is parallel to the top face of the object, and mirrors the shape of that face perfectly; the cutting plane has again become a normal face. If you rotate the cutting plane so that it is neither parallel nor perpendicular to any of the faces of the object, the face created by the cutting plane is called an **oblique face**. (Figure 2.79)

When you rotate the cutting plane, the inclined face only lengthens along one of its two dimensions. This effect can be seen in both the brick primitive and the cylinder. (Figure 2.80) In the cylinder, when the cutting plane is parallel to the end face, a normal face in the shape of a perfect circle is generated. As the plane rotates around the axis marked A, the dimension along axis A does not change; it stays the diameter of the circle. However, the dimension along axis B, which is perpendicular to axis A, gets longer and longer and the face becomes an *ellipse*.

Next, visualize the cutting plane actually cutting the object like a knife and making multiple slices along the long dimension. For a cylinder (Figure 2.81A) all of the slices are the same diameter. For a cone, however, (Figure 2.81B) the edges along the long dimension are not parallel to each other, and the

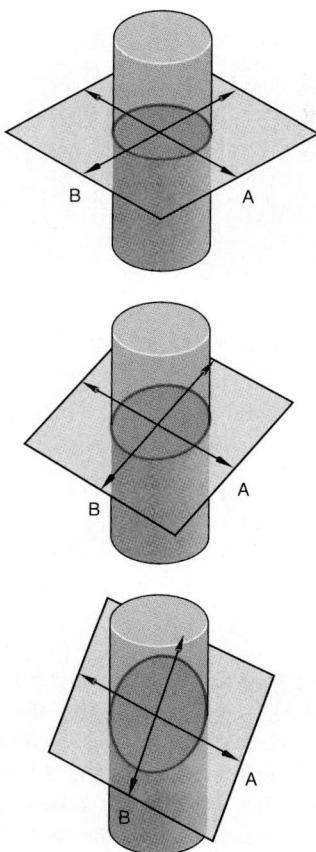

Figure 2.80

Rotating a cutting plane in a cylinder creates circular and elliptical faces.

slices from the point to the base of the cone get larger and larger, until the last slice equals the diameter of the base. For a sphere (Figure 2.81C), all of the edges are curved, and the size of the slices are largest at the middle rather than at one end. These examples demonstrate that, on simpler objects, those edges running parallel to the cutting plane dictate the *shape* of the slices; those edges running in the direction that the cutting plane moves dictate the *size* of the slices.

© CAD Reference 2.11

Practice Exercise 2.8

Using clay or Styrofoam, form a number of blocks approximating various primitive objects, such as cones, cylinders, spheres, cubes, bricks, etc. Use a knife to cut each object into normal slices of uniform thickness. Lay the slices out in the order they came off the object. Compare their sizes and shapes and put them back together again, reforming each solid. What happens if you cut the slices at an incline to the end face of the solid? Do they differ from the normal slices? Do they vary from each other the same way the normal slices do? Do the *end* inclined slices differ from the others? Why?

Symmetry **Symmetry** describes the relationship between the two halves of a solid object. For a symmetrical object, both halves are identical. If you rotate the cylinder 180 degrees so that the other circular face is toward you, the cylinder will look the same, because both halves of the cylinder are identical.

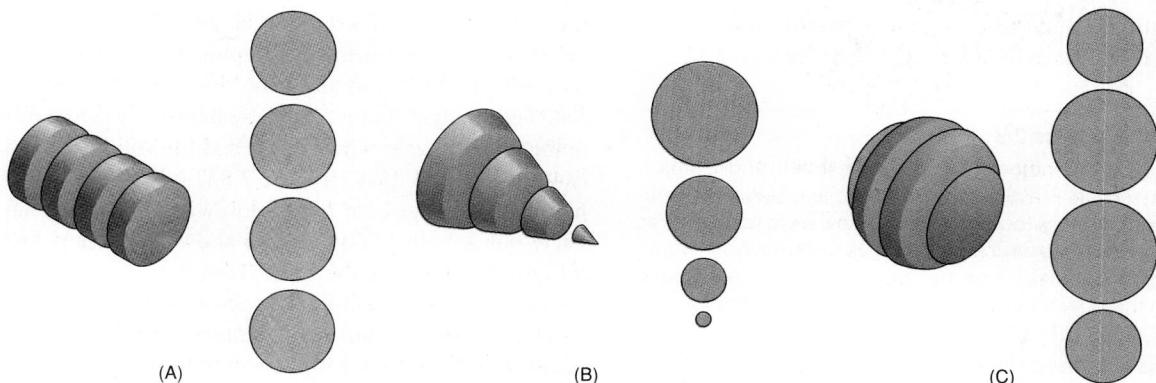

Figure 2.81 **Progressive Slicing of a Cylinder, Cone, and Sphere**

This creates different sized progressions of circular faces for the three primitives.

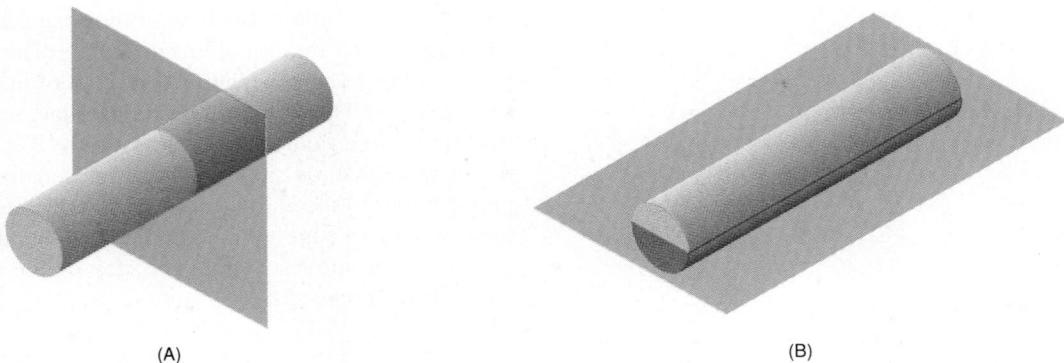

Figure 2.82 Planes of Symmetry

Planes of symmetry for a cylinder are created by passing a plane through the midpoint of the cylinder (A), or by passing the plane through the centers of the circular ends (B).

One way to evaluate two halves of an object without rotating it is to bisect the object with a thin sheet, or cutting plane. (Figure 2.82) If the plane acts as a mirror and the mirror reflection of one half looks identical to that of the other half, the halves are symmetrical. Objects can have more than one plane of symmetry. For example, the cylinder can be cut in half by a plane that goes through the center of the circular ends. (Figure 2.82B)

Mentally rotating an object is one way to imagine planes of symmetry. For example, if you imagine rolling the cylinder like you would a log, you will see that it does not look any different when you roll it 90 degrees, or even 180 degrees. This demonstrates there are multiple planes of symmetry passing through the long axis of the cylinder. **© CAD Reference 2.12**

Practice Exercise 2.9

Using physical objects, such as the brick and cylinder constructed in Practice Exercise 2.4, try rotating the objects so that they look as though they were in the same position as they were before. Determine how many planes of symmetry can be identified in these objects. Sketch the objects and show the planes of symmetry.

Surface Models (Developments) Place the cutting plane on a surface of the object. (Figure 2.83A) The face on the cutting plane would be the same as the

object's face. If you put a cutting plane on every surface of the object (Figure 2.83B), the collection of cutting planes would form a wrap, or *skin*, around the object. Visualizing this skin is another way to visualize the solid object. The skin is flexible and conforms to the exact shape of the faces of the object. It wraps around curved surfaces and creases wherever there is an edge. To determine what the primitive would look like, “remove” the skin by cutting it at the edges, not on any of the faces, and then flatten the skin out. (Figure 2.84)

The flattened skin, called the **development**, clearly shows all of the object's faces, in their true size and shape. It also provides information concerning how those faces are connected. In some cases, the edges are still connected in the development. In other cases, they are cut in order to allow the skin to unfold and lay flat. Those edges that would be reattached if the development were again wrapped around the solid are indicated by dashed lines. (Figure 2.85) It is important to note that the edges cut to unfold the development can vary. For example, Figure 2.86 shows another possibility for developing the brick. However, do not completely cut a face free from the rest of the development.

Developments can also be made for objects that have curved surfaces, and the nature of the curved surface directly affects the ease with which the development is made. A **single-curved surface** is a surface

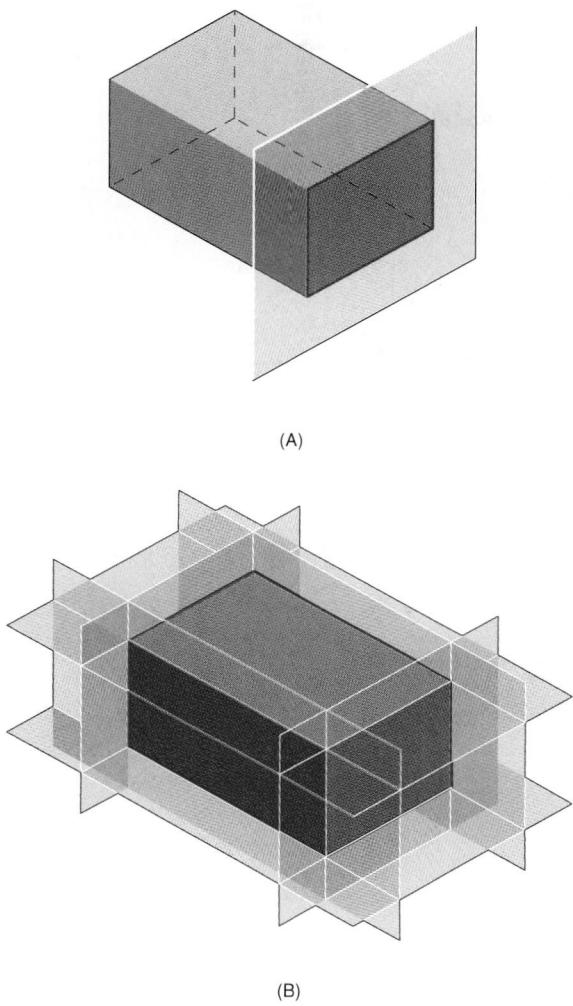

Figure 2.83

Cutting planes can be used to cover the surface of the brick.

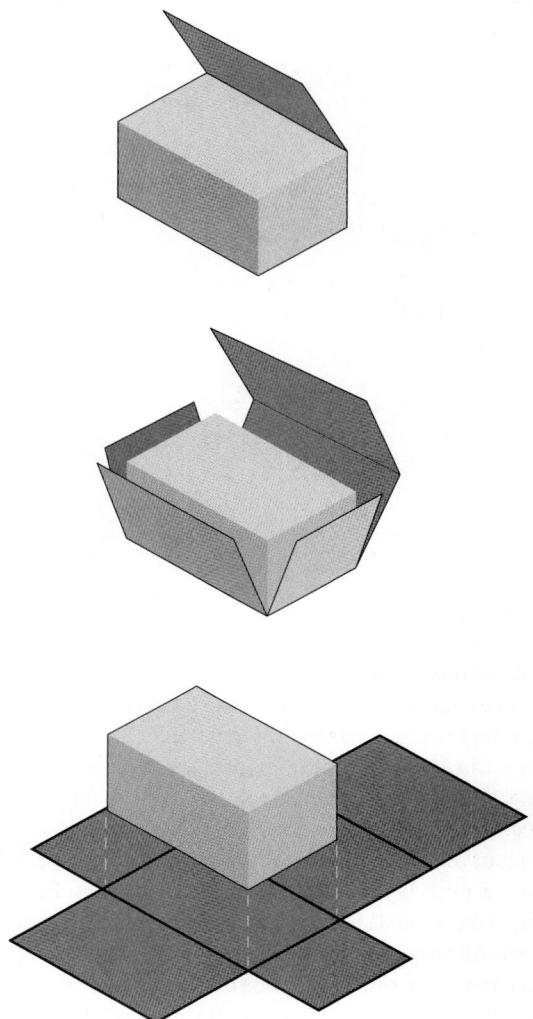

Figure 2.84 Development

Development of the brick is accomplished by cutting the skin of the brick along some of the edges, then unfolding the skin and flattening it.

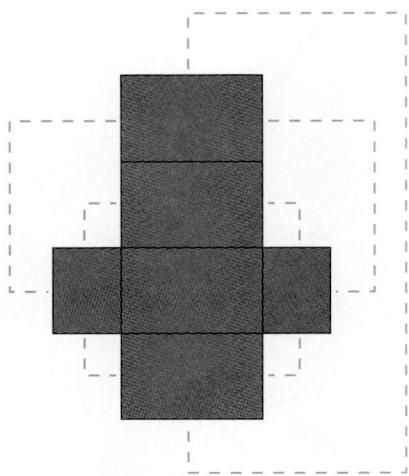**Figure 2.85**

Brick edges that are attached to form the brick skin are indicated by dashed lines.

that only curves in one dimension (such as a cylinder). A development for this type of curved face can be made without many cuts. (Figure 2.87A) A sphere, on the other hand, is a **double-curved surface**, that is, one which curves in two dimensions. (Figure 2.87B) This surface can only be approximated in a development, and only after the face is cut in a number of places. © CAD Reference 2.13

Visualization techniques are specific to certain types of objects and manufacturing processes. For example, the visualization with solids technique would be helpful to a machining operation that removes material from an object. In contrast, the development technique would be indispensable in sheet metal and package design work. For technical drawings, cutting planes are useful in creating sectional views of complicated parts or structures such as buildings.

Practice Exercise 2.10

Using some of the primitive objects you have made, create developments by wrapping the objects in paper. Start by placing the paper on the object. Fold the paper around a few of the edges, creasing the paper lightly as you go. As you proceed, trim the paper and cut the edges at the creases. For the rectilinear forms, such as the cube or the brick, make more than one development and cut different edges. Make developments of cylinders, cones, and other objects with single-curved surfaces. Try making a development of a sphere. Can you wrap the paper around it without wrinkling the paper? With a sphere, how many separate surfaces are you actually developing?

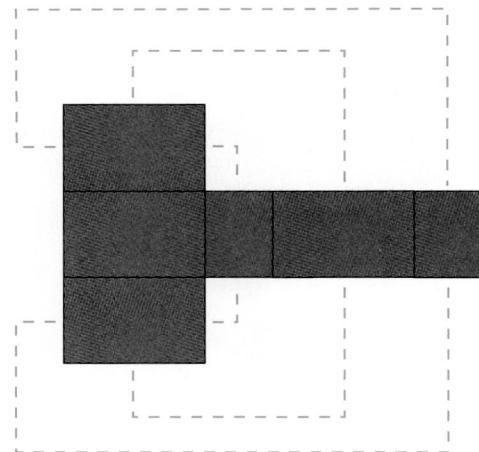**Figure 2.86**

There are many alternate methods of creating the development for the brick, such as the one shown here.

(A)

(B)

Figure 2.87

The difference between developing a single-curved surface (a cylinder), and a double-curved surface (a sphere).

2.12 VISUALIZATION TECHNIQUES FOR ENGINEERING DRAWINGS

Another technique for combining 2-D planes and 3-D solids is introduced in the following sections. This technique using image planes is designed specifically to help in the creation of 2-D multiview engineering drawings and 3-D computer models.

2.12.1 Image Planes

Imagine placing a 2-D plane between you and the object you wish to visualize. (Figure 2.88) The 2-D plane is now called an **image plane** (or picture plane or projection plane): what is imaged by your eyes is also imaged on the plane. Think of the image plane as being transparent, like the viewfinder is on a camera: what you see is registered on the film. This analogy will be used in other chapters of this text, such as Chapter 4, "Multiview Drawings."

Practice Exercise 2.11

Two ways to demonstrate an image plane are as follows:

(1) Using a camera, take pictures of simple objects under good light. (If you use an instant camera, the exercise can be done immediately.) Look at the object from exactly the same viewpoint as that used when the picture was taken. Make sure the lighting is also the same. On the photograph, highlight the contours of the object, using water-based markers. Identify different faces of the object by using different colors. Study the results, then use a damp cloth to wipe the picture clean, to be used again.

(2) Alternatively, place a 12" x 12" sheet of rigid clear plastic or a cardboard frame with a transparency acetate between you and a well-lit object. Brace the plastic so that you don't have to hold it, and draw the contours of the object, using water-based markers. When done, study the results, then use a damp cloth to wipe the plastic clean.

Using each of these techniques, look at the objects from a number of different viewpoints, either by moving yourself or by rotating the object. From which viewpoints can you see the most number of contours? Which viewpoints afford the fewest number of contours? What happens when you get closer or farther away?

The three variables involved in the use of image planes are:

1. The object being viewed.
2. The image plane.
3. The eye of the viewer.

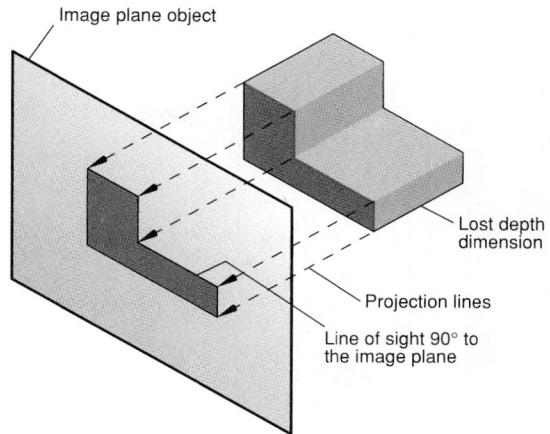

Figure 2.88 Image Plane

The image on the plane represents what you would see if you were looking at the object through a semitransparent plane.

Assume the image plane is always between the viewer and the object. In addition, assume the line of sight of the viewer is always perpendicular (at 90 degrees) to the image plane. (Figure 2.88)

In Practice Exercise 2.11, you drew lines on the image plane wherever you saw edges on the object. Conceptually, you were visualizing *projection lines* from the object to the image plane. The relationships between the eye, image plane, and object determine the angle between projection lines. If the viewer is infinitely far away from the object, all of the projection lines will appear to be parallel to the line of sight and therefore perpendicular to the image plane. This is called *parallel projection*, and is the type of projection most commonly used in engineering drawings.

Practice Exercise 2.12

Use the same setup of object and image plane as you used in the previous exercise. However, instead of drawing directly on the plastic sheet, use it to "frame" your view of the object and draw what you see on a piece of paper. (If you do not have a sheet of clear plastic, make a cardboard frame.) Instead of drawing the edges in perspective, as you see them, draw them in parallel projection (i.e., all edges that are parallel on the object are parallel in the sketch).

2.12.2 Object–Image Plane Orientation

There are three **primary axes** about which you can rotate the object relative to the image plane. The three axes are *horizontal*, *vertical*, and *depth* in coordinate

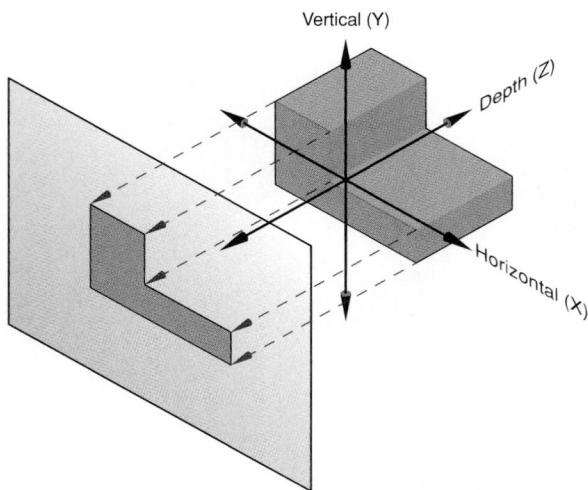

Figure 2.89 The Relationship of the Image Plane to the Standard, Mutually Perpendicular Viewing Axes

space. (Figure 2.89) You need only rotate the object about two of these axes to see all sides of the object. Rotation about the horizontal and vertical axes tends to provide the most information.

Practice Exercise 2.13

Place a 12" x 12" sheet of rigid, clear plastic between you and the object. Rotate the object 360 degrees about each of the three axes. Which faces are revealed by each rotation? Are faces always seen in their true size and shape?

To determine if a face is shown in its true size and shape, examine the orientation of the face with respect to the image plane. If the face of an object is parallel to the image plane (i.e., is a *normal face*), the face shown on the image plane will not be distorted. Another way of imagining this is to move the object toward the image plane. The normal face will lay perfectly flat on the image plane. (Figure 2.90A) This projection is identical to Figure 2.88.

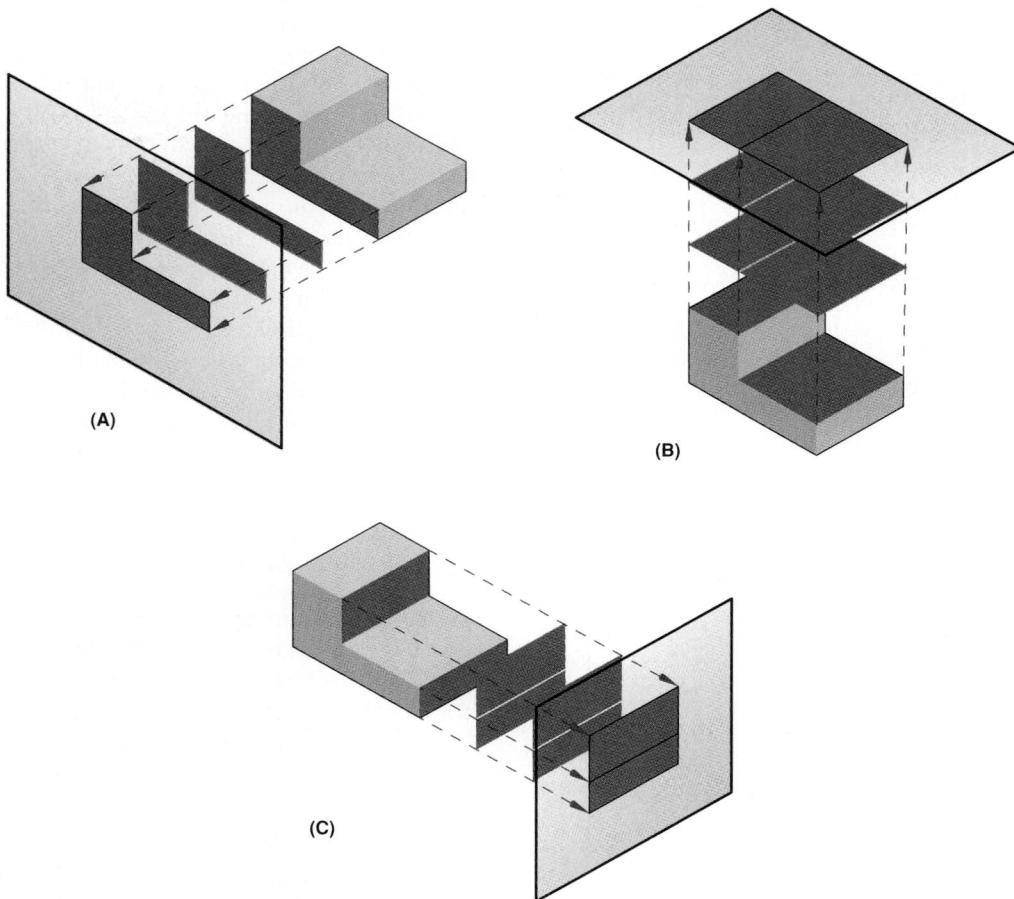

Figure 2.90 Projection of Normal Faces onto the Image Plane

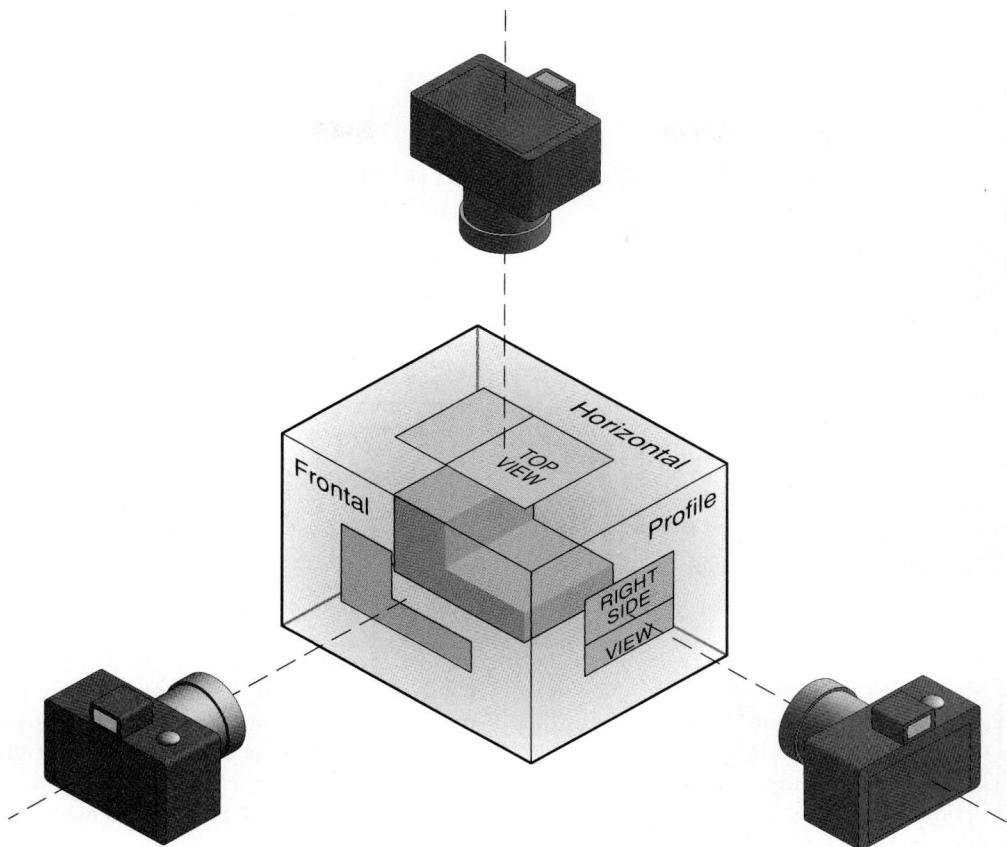

Figure 2.91 Camera Metaphor

The metaphor of cameras can be used to describe capturing three principal views of the object—front, top, and right side—through the three image planes.

Other faces of this object can also be normal to the image plane. (Figures 2.90B and C) By rotating the object (or the image plane) 90 degrees about either the vertical or horizontal axes, other faces will become parallel to the image plane. The 2-D image plane always compresses one of the dimensions of the 3-D object, and that dimension is always the one perpendicular to the image plane: i.e., the depth axis. The result is that two faces sitting at different depths on the object sit side by side on the image plane. One of the challenges of visualization is to reconstruct this third dimension when viewing a projection. © CAD Reference 2.14

2.12.3 Multiple Image Planes

A more traditional way of generating multiple views of an object is to hold the object stationary and create a separate image plane for each view. In Figure 2.91, three separate image planes are used to produce the three projections previously shown in Figure 2.90. These three image planes, traditionally named *frontal*, *horizontal*, and *profile*, generate the three standard views, *front*, *top*, and *right side*, respectively. Taken together, these three views comprise a standard multiview drawing. (See Chapter 4, “Multiview Drawings.”)

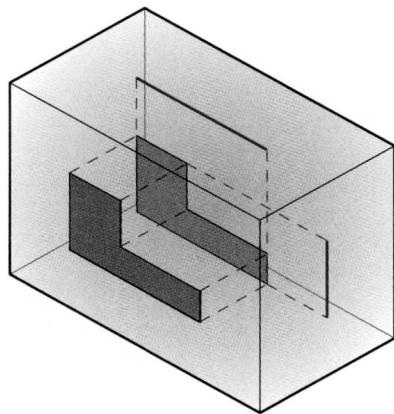

Figure 2.92 Normal Face Projection

A normal face projects on all three principal image planes. On one image plane, the face appears true size and shape. In the other two, the face appears on edge and is represented as a line.

The three planes are *mutually perpendicular*; that is, each is 90 degrees from the other two. Imagine a face as being completely separate from the rest of the solid object, just a 2-D surface in space. (Figure 2.92) This face is parallel to the image plane and perpendicular to the adjoining planes. The result is that, if in one plane you are seeing a face in its true size and shape, in the other planes you will see the face as an edge. Since faces that touch each other share edges, in the multiview projection, the edge views of one face become part of the outlines or contours of faces seen in other views. (Figure 2.93)

There are other faces that have a different relationship to the three principal planes. One is an *inclined face*, which is not *parallel to any of the principal image planes*. This face is rotated about either the vertical or horizontal axis, but not both. (Figure 2.94A) The face is visible in two of the views, but *not* in true size and shape. The face has depth in both views, but it is compressed or *foreshortened* onto the image plane. (Figures 2.94B and C) In Figure 2.94D, the inclined face is projected as an edge on the perpendicular plane, just as a normal face would be. Inclined faces can, of course, be combined with normal faces in an object. (Figure 2.95)

Whereas an inclined face is created by rotating a normal face about either the vertical or horizontal axes, an *oblique face* is created by rotation about both axes. (Figure 2.96A). An oblique face is seen foreshortened

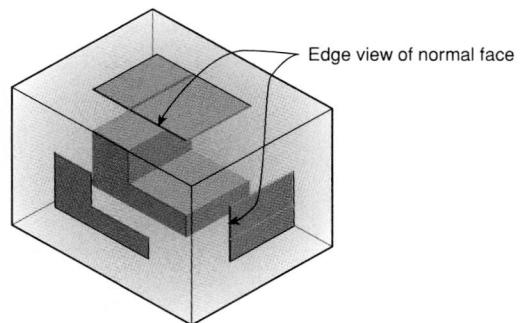

Figure 2.93 Edge Views of Normal Face

In a multiview projection, edge views of a normal face become the outlines of another face.

in all three views, since it is neither parallel nor perpendicular to any of the principal image planes. (Figure 2.96B) Unlike normal and inclined faces, oblique faces are not seen as an edge in any of the standard views. Chapter 6, “Auxiliary Views,” goes into detail on how image planes that are oriented parallel to inclined and oblique surfaces are used to see those surfaces in true size and shape. © CAD Reference 2.15

Practice Exercise 2.14

Replace the object on the other side of your image plane with a stiff sheet of cardboard representing a single face of an object. Align the cardboard sheet so that it is parallel to the image plane. Ask a second person to hold the cardboard sheet, if necessary. Change your viewing direction, but don't move the cardboard sheet, and look at the sheet as an edge view. Do the same by holding the image plane still and rotating the cardboard sheet. Rotate the cardboard less than 90 degrees about either the horizontal or vertical axis, to create an inclined face. Move the image plane around until you can identify the two standard views where the inclined face is visible. Find the view where the face is seen as an edge. How does the amount of rotation affect the size of the projection seen in the image plane? Rotate the cardboard so that it is almost normal to the image plane. How does it look from the three principal views? Do the same tests with the cardboard sheet rotated about both the vertical and horizontal axes, creating an oblique face.

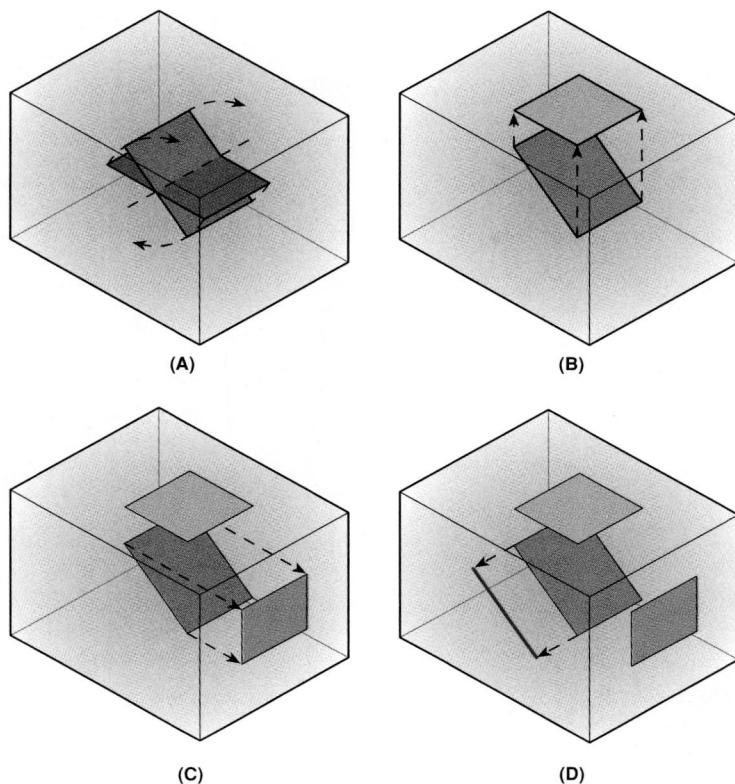

Figure 2.94 Inclined Face Projection

An inclined face is oriented such that it is not parallel to any of the principal image planes. The inclined face is foreshortened in two views and is an edge in one view.

2.12.4 Choosing a View to Describe an Object

In the past, certain projections were chosen more often because they were the easiest to draw. Today, 3-D computer modeling systems and CAD software can generate any projection with equal ease. You can choose the views which most clearly and succinctly show the object being visualized. However, do not produce so many views that you unnecessarily duplicate information and confuse the viewer. Visualize the object, identify the features you need to show, and generate clear concise images that show them. Use sketches as an aid in visualizing the form and deciding on the views required. The pencil and computer together form a powerful tool for visualizing objects.

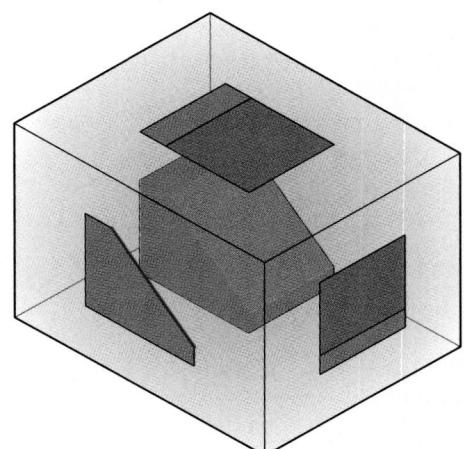

Figure 2.95 Projection of an Object that Has Both Inclined and Normal Faces onto the Three Image Planes

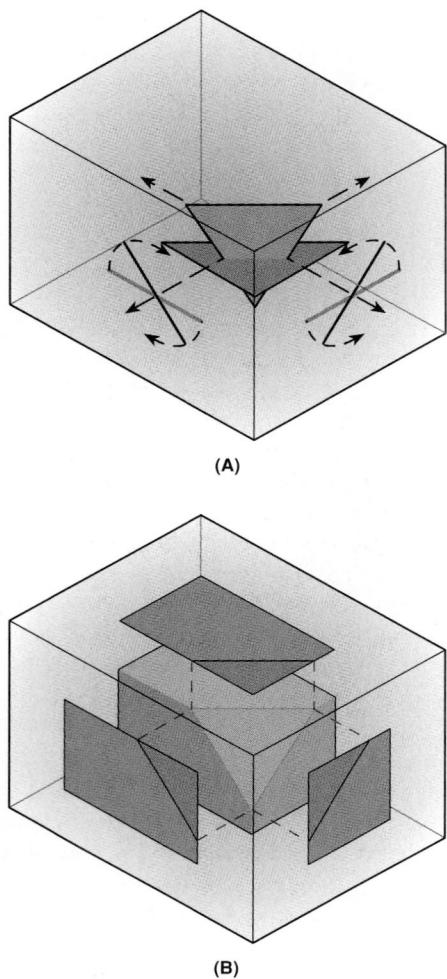

Figure 2.96 Oblique Face Projection

The projection of an oblique face is foreshortened in all three principal image planes.

2.13 FUTURE DIRECTIONS

The advanced visualization techniques described in the preceding sections are not limited just to the engineering professions. Researchers in the pharmaceutical industry are using sophisticated computer systems to model molecules for new drugs. (Figure 2.97) The sheer complexity of potential molecules means that every visualization technique available has been put to work. Visualizing such molecules is hampered by several factors. For instance, they are so small that no one

Figure 2.97 Modeling Molecules

A representation of a large molecule on a ball and stick computer system that provides tactile feedback. The colored surfaces represent the dynamic forces between the atoms.

(Tom Palmer and Dave Bock at the North Carolina Supercomputing Center, a division of MCNC.)

has ever seen a molecule directly. You can only theorize indirectly what one might look like, or how it might react to the forces of other molecules nearby.

One advanced technique being used for visualizing complex molecules is **stereoscopic displays**. Two images of the molecule, reflecting what the two eyes would normally see, are generated by the computer and shown to each eye individually. This can be done by using either one screen and a shutter device that controls what each eye sees, or a pair of miniature screens mounted inside goggles that show one screen to each eye. (Figure 2.98) The realism with which molecules are manipulated is further enhanced by additional feedback concerning energy forces being generated by the molecules. Rather than simply seeing representations of the energy forces, you can actually feel them. For example, a hand controller can be used to manipulate two molecules together. When energy forces of the two molecules indicate opposition to this movement, feedback is received through the controller. The effect is like arm wrestling, and important information is obtained regarding whether the two molecules are likely to go together in real life.

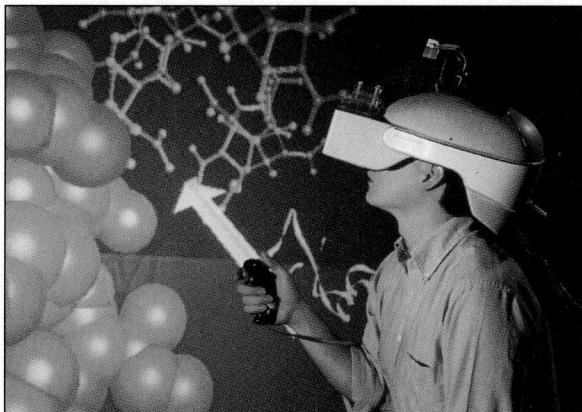

Figure 2.98 Virtual Reality Molecular Modeler that Gives the User a Realistic Three-Dimensional View

(Courtesy of University of North Carolina, Chapel Hill, Department of Computer Science.)

2.14 SUMMARY

Sketching is an important tool for quickly and efficiently communicating design ideas. It is a particularly useful tool early in the design process, when several ideas are being explored. One of the appealing characteristics of sketches is the minimal amount of equipment needed for their creation. A pencil, eraser, and paper are the only tools really necessary for creating a sketch. Increasingly, software being developed to run on low-cost computer systems has many of the same attributes as hand sketching. This new software has the potential of allowing a more direct translation of sketched designs into final, refined models that can be used in manufacturing and construction.

Whether a sketch is created by hand or on the computer, there is a basic set of techniques that should be used. Sketches are meant to be quickly created approximations of geometric forms. Therefore, exact measurements are usually not used in sketching. Instead, construction line techniques are used to preserve the proportions of different features of the object.

The process of transferring the features of a 3-D object onto a 2-D sheet of paper is called projection. One way of defining the projection relates to whether the lines projecting the features of the object are all parallel to each other. The types of projection include: isometric pictorial, oblique pictorial, and multiview. These projections constitute the most popular methods used in engineering and technical graphics. Another type of projection, perspective, more closely matches how you perceive objects in the real world. This type of projection is less commonly used, in part because of the difficulty in laying out the sketch, and also because of the distortions it creates in the features of the object drawn.

The graphical methods used in creating a sketch communicate considerable information. At times, however, words are more effective for providing information on a drawing. The use of a standard method of lettering ensures that text in a drawing will be clear and legible. Computers are used extensively for generating text. This is due in part to the flexibility with which text can be generated and modified to meet specialized needs. Later chapters in this book will go into more detail as to the proper use and placement of text in engineering and technical graphics.

The mind uses many visualization tools, working in concert, to interpret the 3-D world. The mind engages in constant problem solving in the interpretation process. Part of this problem-solving process is automatic. However, you can develop numerous sketching and modeling techniques that will help. With a better understanding of how the mind interprets what it receives, you can use conscious mental power to assist in this process. You can also learn to bring physical processes into play. For example, you may be able to pick up an object and rotate it, to gain a better understanding of the object. More importantly, you may be able to create a sketch which will help you in the visual problem-solving process.

KEY TERMS

Additive	Ground's eye view	Minor axis	Single-curved surface
Bill of materials	Guide lines	Miter line	Square grid
Bird's eye view	Hidden line conventions	Multiview drawings	Stereoscopic displays
Bounding box	Horizon line	Multiview sketch	Subtractive
Cabinet oblique	Human's eye view	Negative solid	Symmetry
Cavalier oblique	Ideation sketches	Nonisometric lines	Technical sketching
Construction lines	Image plane	Normal face	Text alignment
Cutting plane	Inclined face	Oblique face	Title block
Development	Isometric axis	Oblique pictorial	Tracing paper
Document sketches	Isometric ellipses	Parallel projection	Trammel
Double-curved surface	Isometric grid	Perspective projection	Vanishing point
Edges	Isometric pictorial	Pictorial sketch	Vertices
Faces	Lettering guides	Point	Worm's eye view
Font	Lettering template	Precedence of lines	
Grid paper	Limiting element	Proportion	
Ground line	Major axis	Revision block	

QUESTIONS FOR REVIEW

1. Define and describe the uses for technical sketching.
2. Define an ideation sketch and explain how it differs from a document sketch.
3. List the four types of sketches, grouped by projection methods. Sketch an example of each type.
4. Describe the major differences between parallel and perspective projection.
5. Define multiview drawing and make a sketch of one.
6. Define principal view.
7. Describe the precedence of lines.
8. List the two important uses for text on a drawing.
9. Define font.
10. Define text alignment and sketch an example.
11. Define text aspect ratio and give examples.
12. Why is visualization important in engineering and technical graphics? Is it useful in any other fields? Are you born with the ability to visualize, or is it learned?
13. Explain the relationship between seeing real objects, seeing in the mind's eye, and drawing on paper or with the computer.
14. What role do ideation sketches play in the design process? Do they use new or existing graphic information?
15. What is the relationship between faces and edges in the visualization of an object?
16. Do planar and curved surfaces reveal themselves differently on an object?
17. Explain the different visual results of additive and subtractive combinations of two solids. Are there ways of arranging additive or subtractive combinations such that the resulting object doesn't look any different?
18. What are the differences in the way normal, inclined, and oblique faces are visualized? How are cutting planes used to generate these faces?
19. Can cutting planes create circular or elliptical faces?
20. Define a development. How is it used in visualization?

FURTHER READING

Biederman, I. "Recognition-by-Components: A Theory of Human Image Understanding." *Psychological Review* 94 (1987), pp. 115–147.

Coren, S., and L. Ward. *Sensation and Perception*. 3rd ed. New York: Harcourt Brace Jovanovich, 1989.

Edwards, B. *Drawing on the Right Side of the Brain*. New York: St. Martin's Press, 1979.

Edwards, B. *Drawing on the Right Side of the Brain: A Course in Enhancing Creativity and Artistic Confidence*. Boston, MA: Houghton Mifflin, 1979.

Friedhoff, R. M., and W. Benzon. *Visualization: The Second Computer Revolution*. New York, N.Y.: Harry N. Abrams, 1989.

Goldstein, E. B. *Sensation and Perception*. 3rd ed. Belmont, CA: Wadsworth, 1989.

Hanks, K.; L. Belliston; and D. Edwards. *Design Yourself!* Los Altos, CA: William Kaufmann, Inc., 1978.

Hanks, K., and L. Belliston. *Draw!* Los Altos, CA: William Kaufmann, Inc., 1977.

Hanks, K., and L. Belliston. *Draw! A Visual Approach to Thinking, Learning and Communicating*. Los Altos, CA: William Kaufmann, 1977.

Knowlton, K. W. *Technical Freehand Drawing and Sketching*. New York: McGraw-Hill, 1977.

Martin, L. C. *Design Graphics*. New York: Macmillan, 1968.

McKim R. H. *Experiences in Visual Thinking*. 2nd ed. Boston, MA: PWS Engineering, 1981.

Mitchell, W. J., and M. McCullough. *Digital Design Media*. New York, N.Y.: Van Nostrand Reinhold, 1991.

Rodriguez, W. *The Modeling of Design Ideas: Graphics and Visualization Techniques for Engineers*. New York: McGraw-Hill, 1992.

Taylor, D. L. *Computer-Aided Design*. Reading, MA: Addison-Wesley, 1992.

Wyman, J. D., and S. F. Gordon. *Primer of Perception*. New York: Reinhold, 1967.

PROBLEMS

Hints for Isometric Sketching

- Identify the major features and overall dimensions of the object.
- Use clean, crisp strokes.
- Do not use straightedges or scales when sketching.
- Start by drawing a bounding box, using construction lines.
- Only measure dimensions along the primary axes.
- Do not directly transfer angles from a multiview to a pictorial.
- Use light construction lines to locate vertices and edges.
- Sketch faces roughly in this order:
 - Normal faces on the perimeter of the bounding box.
 - Normal faces in the interior of the bounding box.
 - Inclined faces.
 - Oblique faces.
- Darken all object lines.

Hints for Multiview Sketching

- Identify the major features and overall dimensions of the object.
- Use clean, crisp strokes.
- Do not use straightedges or scales when sketching.

- Start by drawing bounding boxes and a miter line, using construction lines.
- Align the views.
- Use light construction lines to locate vertices and edges.
- Only measure dimensions along the primary axes.
- Map inclined and oblique faces between all three views.
- Follow the precedence of lines.
- Doublecheck to make sure there are no missing hidden or center lines.
- Darken all visible, hidden, and center lines.

2.1 Using visible, center, and hidden line styles, practice sketching the following types of lines/features using size A or A4 plain or grid paper:

- Straight lines
- 90- and 180-degree arcs
- Circles
- Ellipses

2.2 Refer to Figure 2.99, Multiview Sketching Problems. Sketch (freehand) the necessary views, using size A or A4 plain or grid paper. Divide the long dimension of the paper with a thick dark line. A multiview drawing can fit on either half of the paper. Add a border line and title block.

(1)

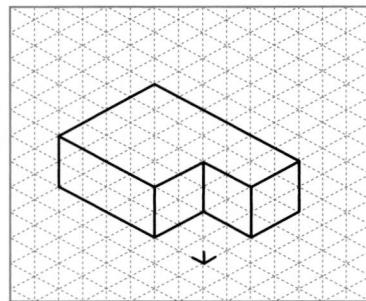

(2)

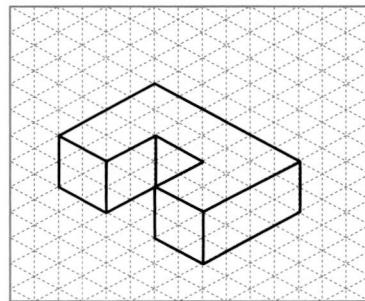

(3)

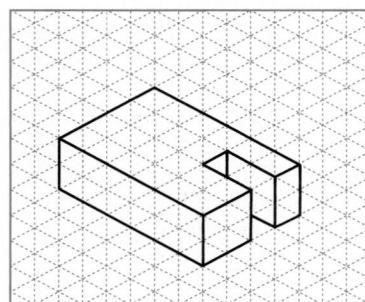

(4)

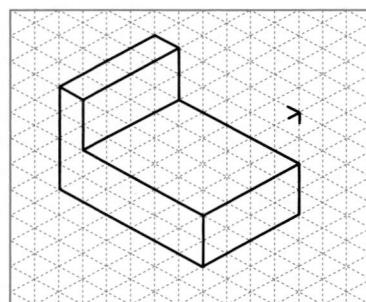

(5)

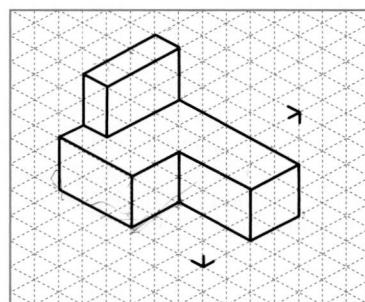

(6)

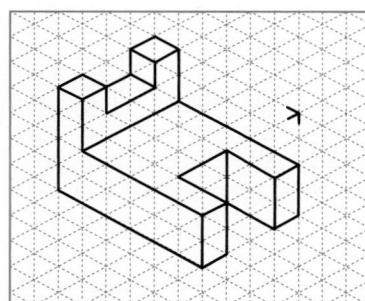

(7)

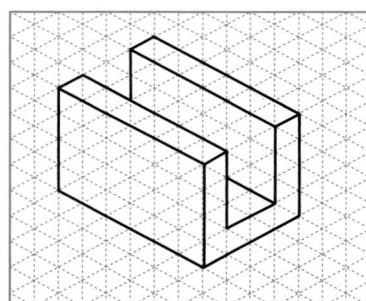

(8)

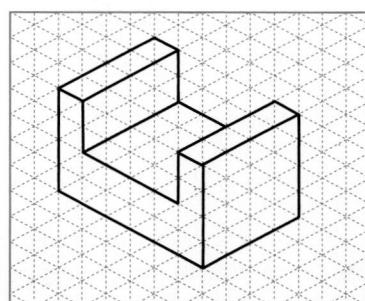

(9)

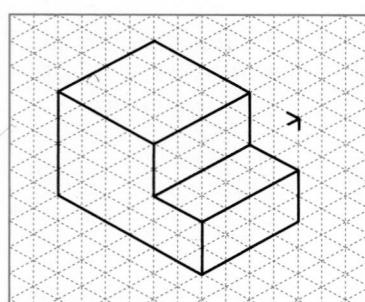

(10)

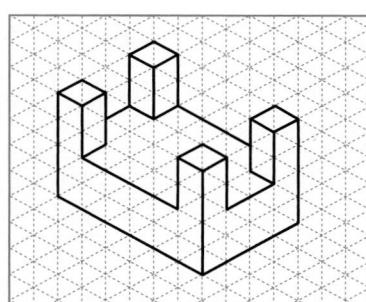

(11)

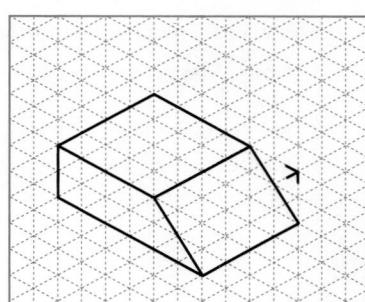

(12)

Figure 2.99A Problem 2.2 Multiview Sketching Problems

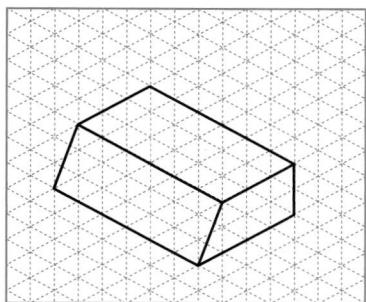

(13)

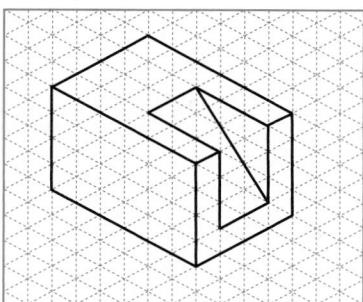

(14)

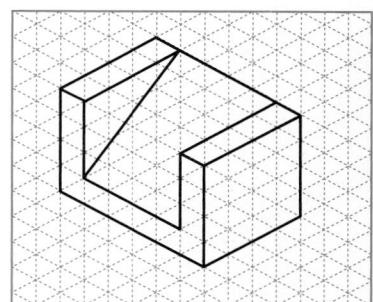

(15)

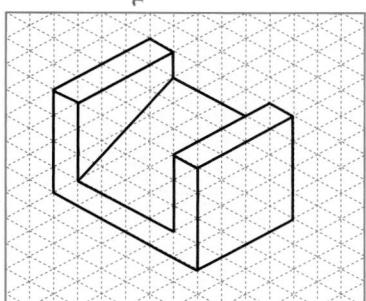

(16)

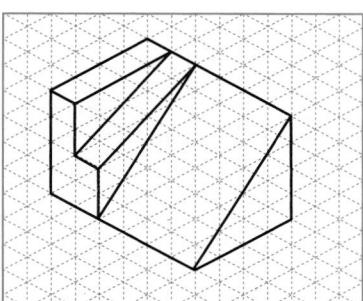

(17)

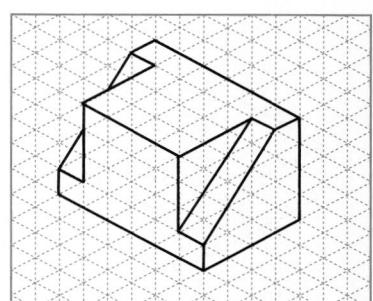

(18)

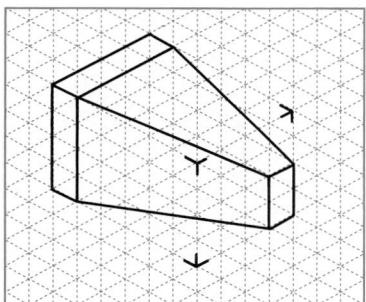

(19)

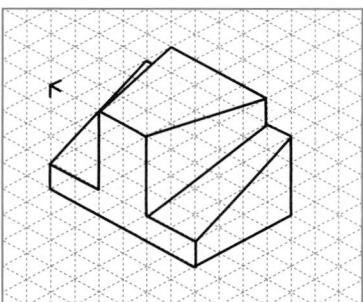

(20)

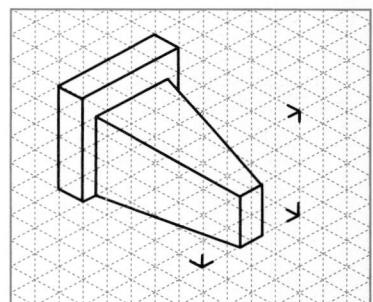

(21)

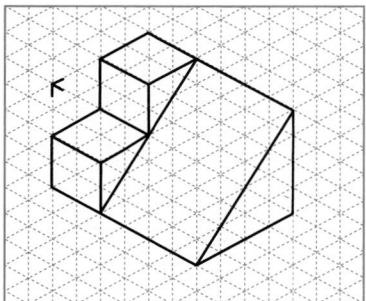

(22)

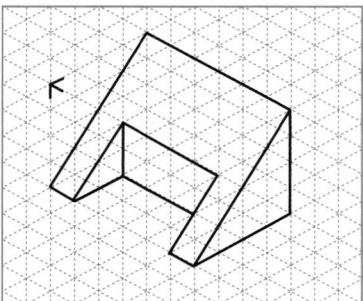

(23)

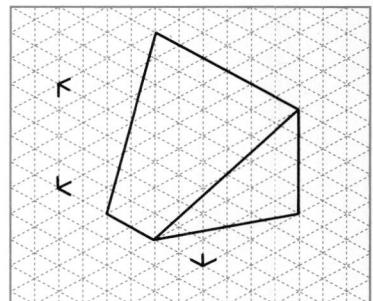

(24)

Figure 2.99B Problem 2.2 Multiview Sketching Problems

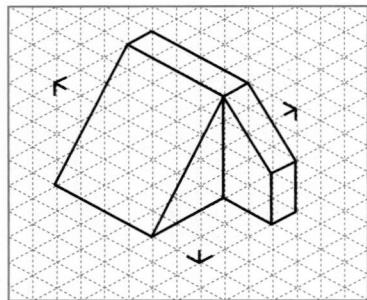

(25)

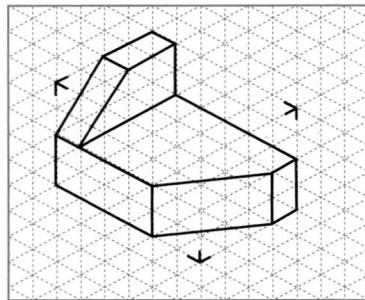

(26)

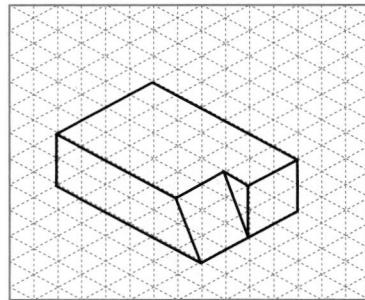

(27)

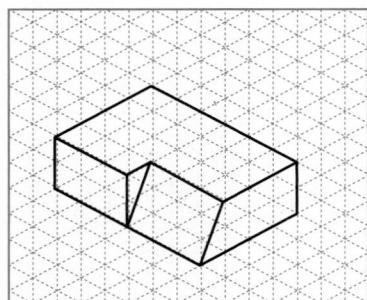

(28)

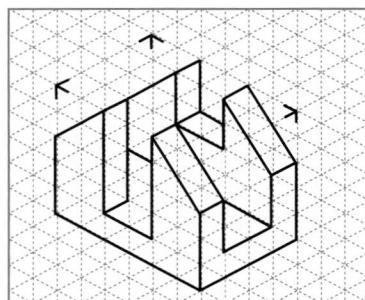

(29)

(30)

(31)

(32)

(33)

(34)

(35)

(36)

Figure 2.99C Problem 2.2 Multiview Sketching Problems

(37)

(38)

(39)

(40)

(41)

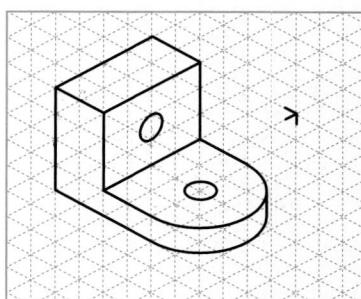

(42)

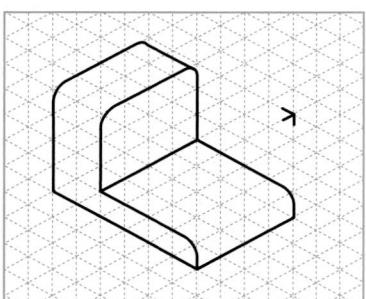

(43)

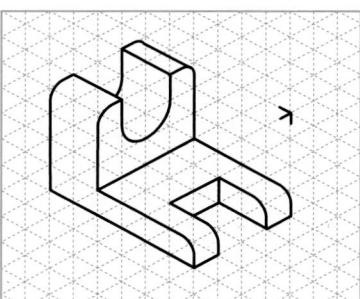

(44)

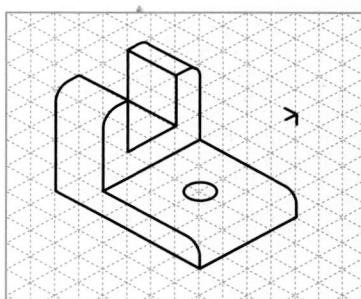

(45)

(46)

(47)

(48)

Figure 2.99D Problem 2.2 Multiview Sketching Problems

Assume all holes to be through.

(49)

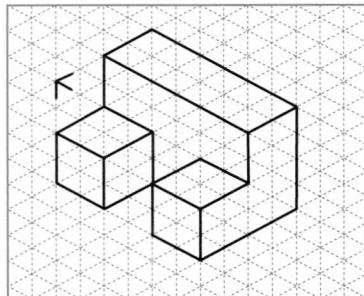

(50)

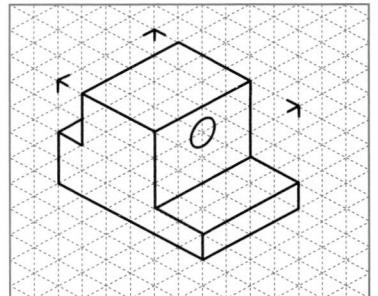

(51)

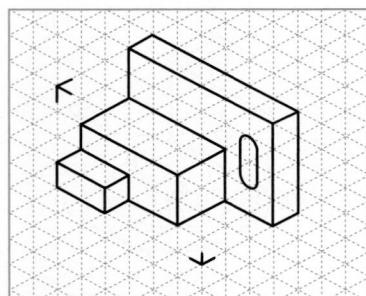

(52)

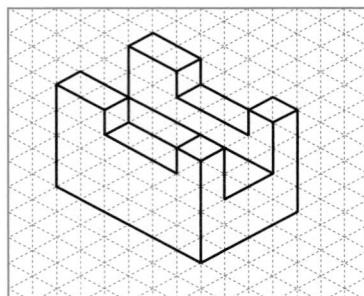

(53)

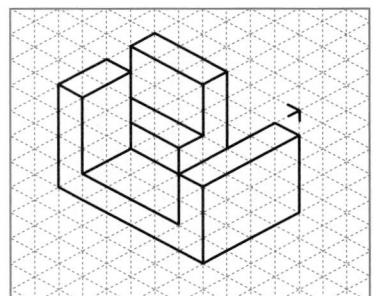

(54)

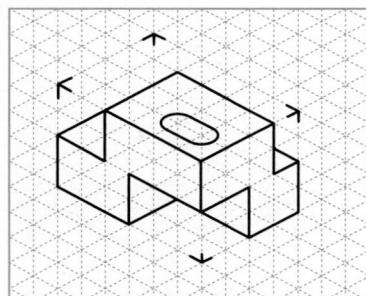

(55)

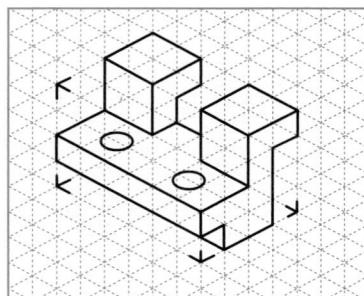

(56)

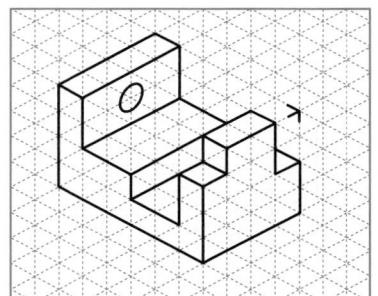

(57)

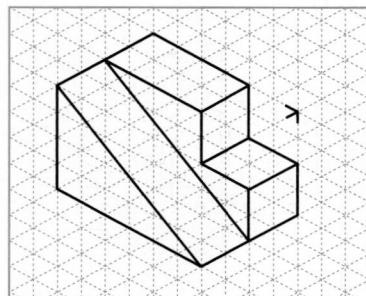

(58)

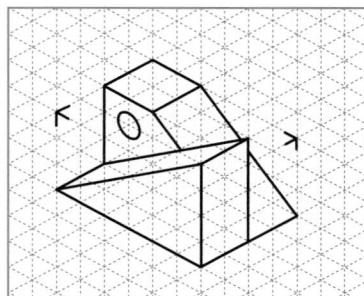

(59)

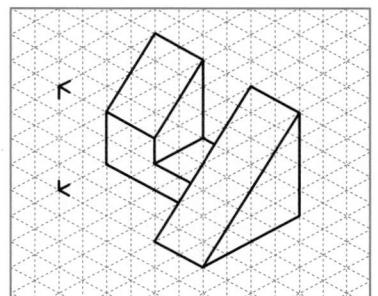

(60)

Figure 2.99E Problem 2.2 Multiview Sketching Problems

Assume all holes to be through.

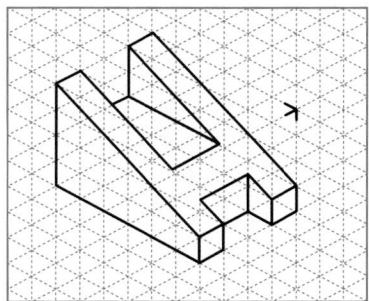

(61)

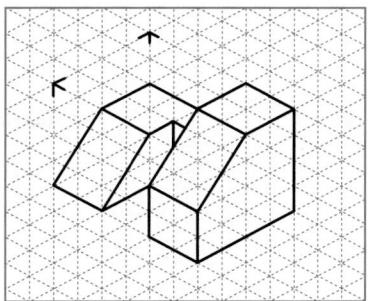

(62)

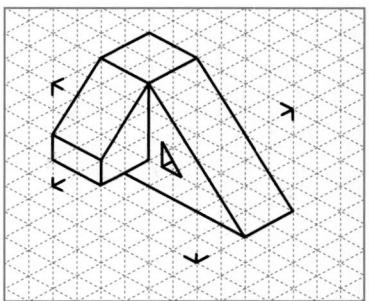

(63)

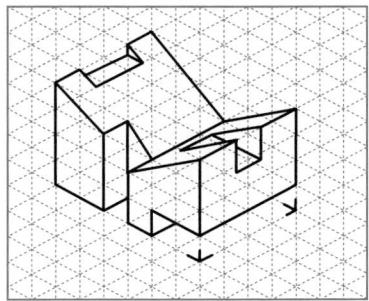

(64)

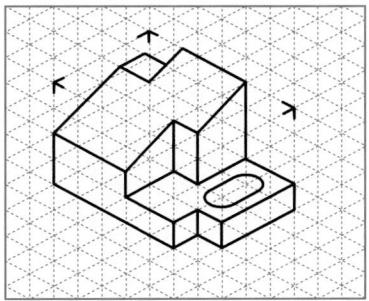

(65)

(66)

(67)

(68)

(69)

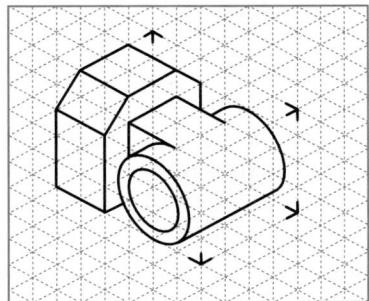

(70)

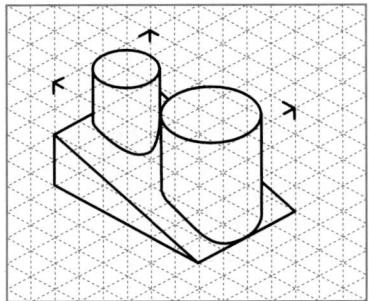

(71)

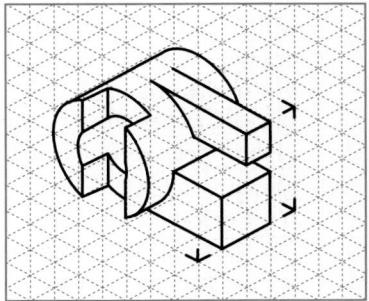

(72)

Figure 2.99F Problem 2.2 Multiview Sketching Problems

Assume all holes to be through.

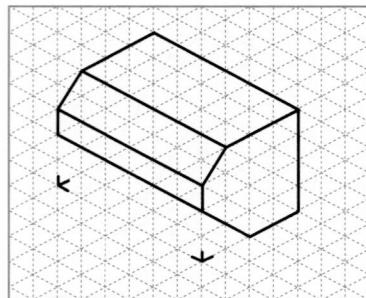

(73)

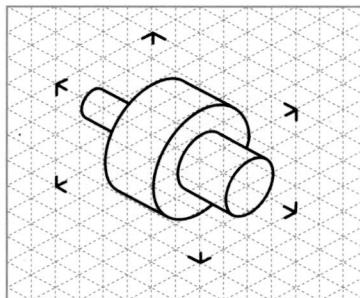

(74)

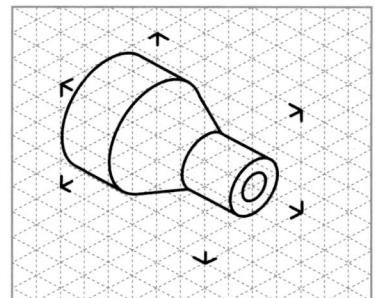

(75)

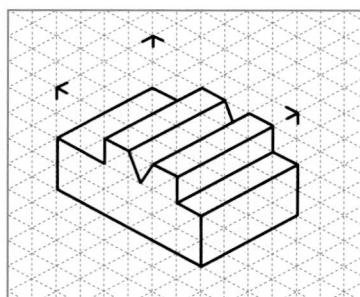

(76)

Figure 2.99G Problem 2.2 Multiview Sketching Problems

- 2.3 Refer to Figure 2.100, Pictorial Sketching Problems. Sketch (freehand) pictorials, using size A or A4 plain or grid paper. Pictorials can be perspective, isometric, or oblique. Divide the long dimension of the paper with a thick dark line. A pictorial drawing can fit on either half of the paper. Add a border line and title block.
- 2.4 Draw a pictorial sketch of one of the multiviews in Problem 2.3. Pass the pictorial sketch to another student in the class, but do not specify which multiview you used. Have that student draw a multiview from your sketch. Compare that to the original multiview. Do they look the same? Reverse the process by starting with one of the objects in Problem 2.2.
- 2.5 Create 2-D CAD drawings or 3-D CAD models from the sketches drawn in Problems 2.2 and 2.3. Compare the time taken and the strategy used to that of sketching.
- 2.6 Using one object from either Problem 2.2 or 2.3, sketch and compare the following pictorials on size A or A4 plain or grid paper:
 - a. One-, two-, and three-point perspective.
 - b. One-point perspective and oblique.
 - c. Two-point perspective and isometric.
- 2.7 Using one object from either Problem 2.2 or 2.3, sketch isometric pictorials from three different viewpoints, on size A or A4 plain or grid paper.
- 2.8 Using one object from Problem 2.2, sketch different multiviews using three different front views as a starting point, on size A or A4 plain or grid paper. Which views are identical?
- 2.9 Using one object from Problem 2.2, sketch all six standard views (front, top, right side, left side, bottom, back) on size A or A4 plain or grid paper. Which views are identical?
- 2.10 Using sketches made from either Problem 2.2 or 2.3, identify the following features, with color pencils or markers: edges, faces, and voids (negative space).

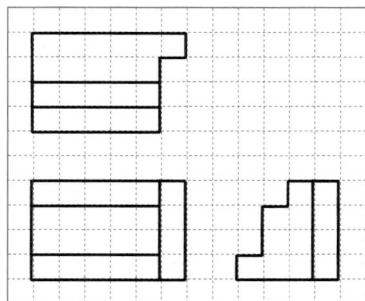

(1)

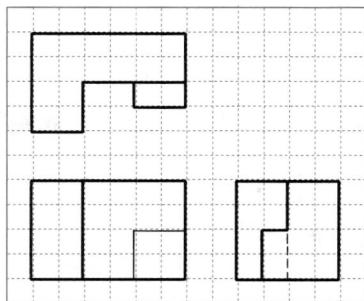

(2)

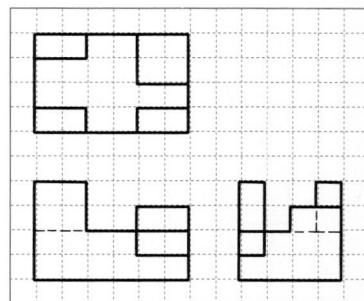

(3)

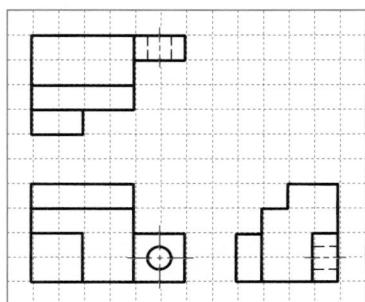

(4)

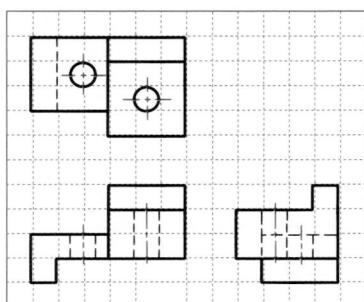

(5)

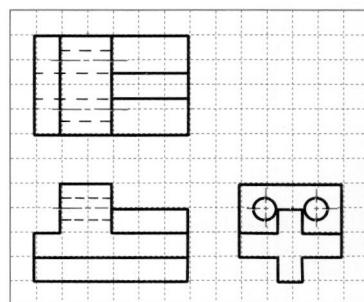

(6)

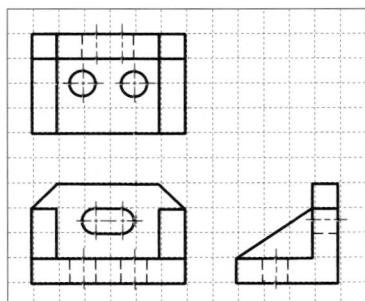

(7)

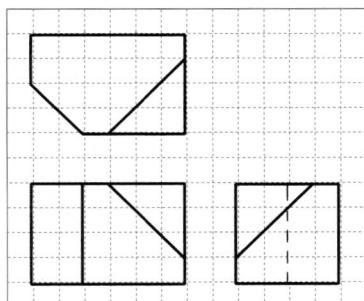

(8)

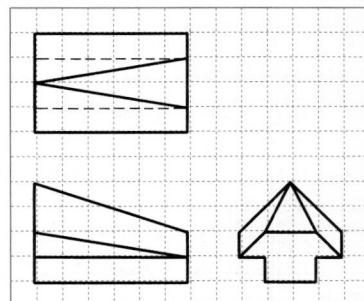

(9)

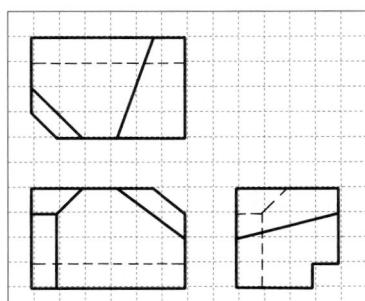

(10)

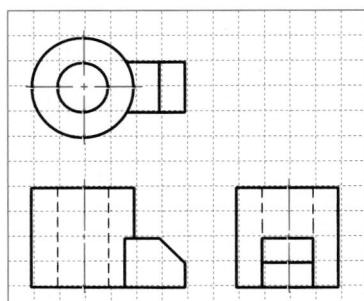

(11)

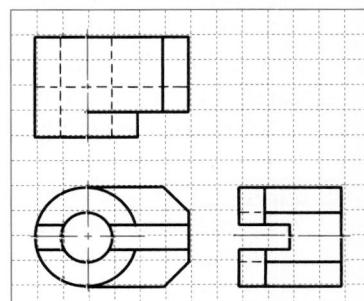

(12)

Figure 2.100A Problem 2.3 Pictorial Sketching Problems

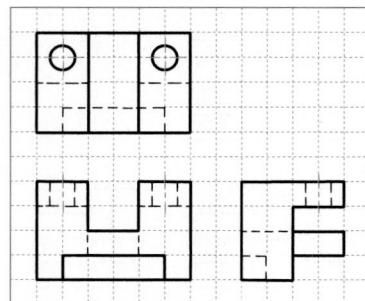

(13)

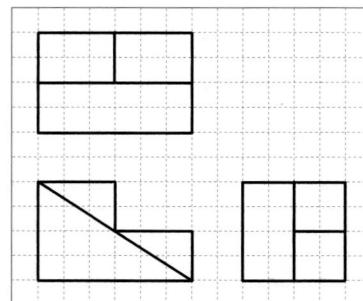

(14)

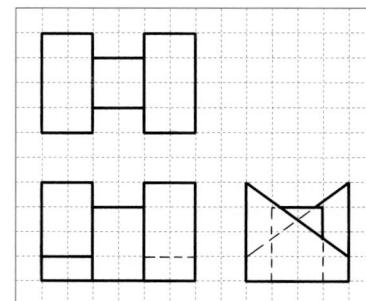

(15)

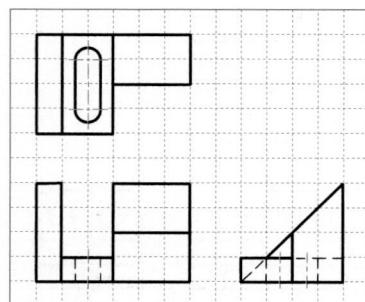

(16)

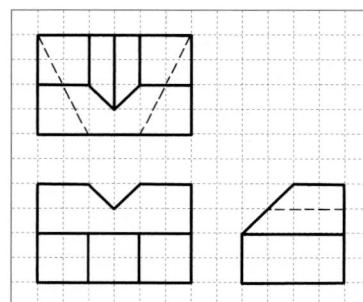

(17)

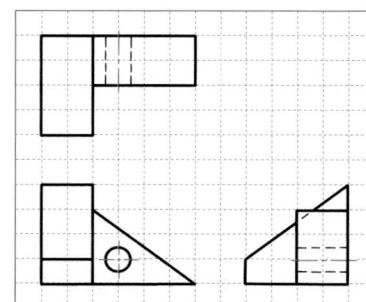

(18)

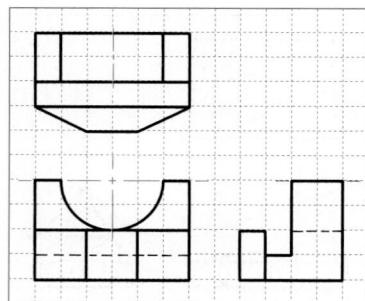

(19)

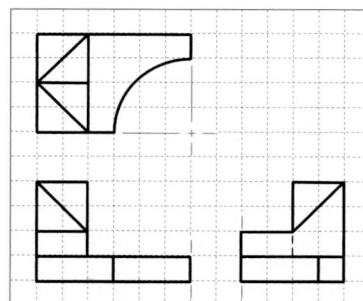

(20)

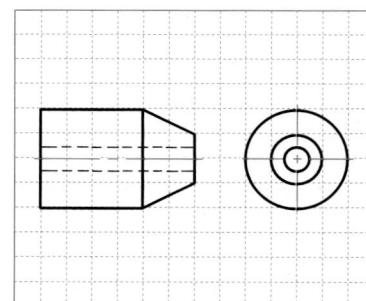

(21)

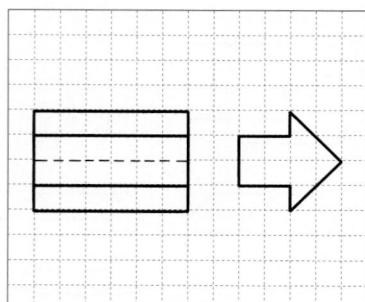

(22)

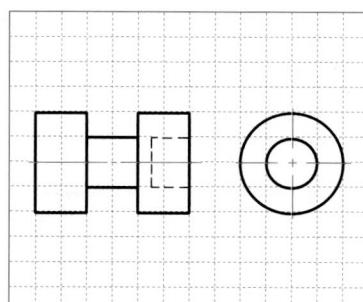

(23)

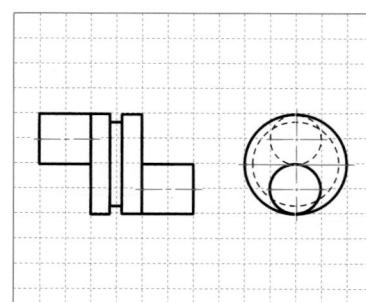

(24)

Figure 2.100B Problem 2.3 Pictorial Sketching Problems

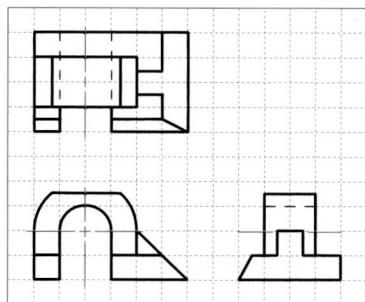

(25)

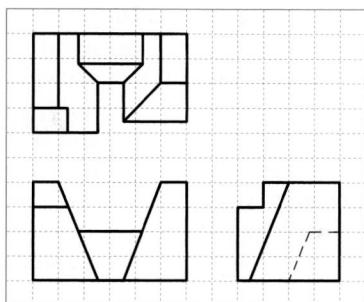

(26)

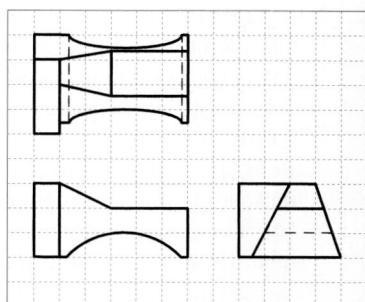

(27)

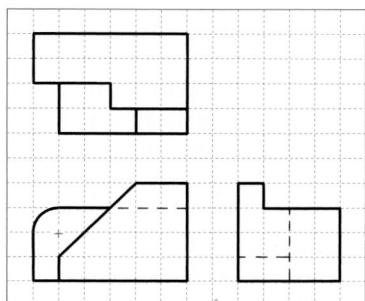

(28)

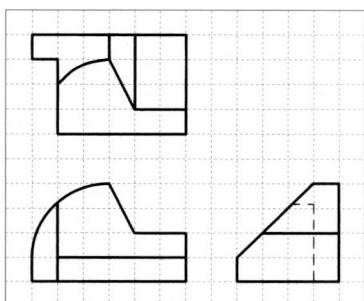

(29)

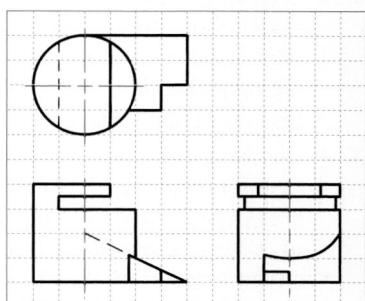

(30)

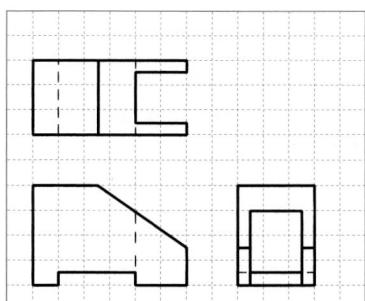

(31)

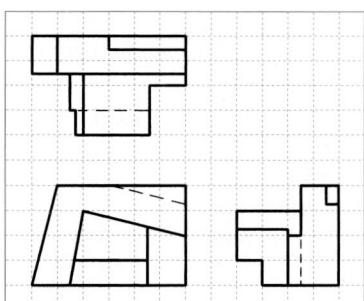

(32)

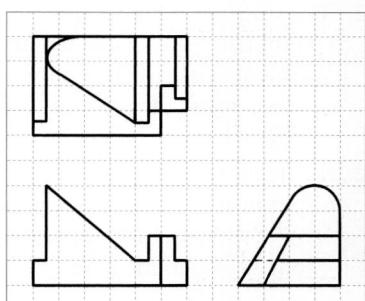

(33)

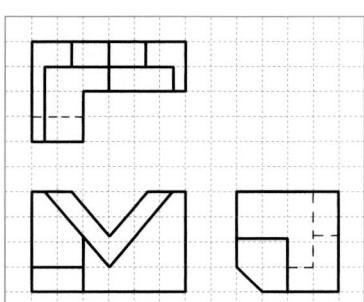

(34)

Figure 2.100C Problem 2.3 Pictorial Sketching Problems

2.11 Gather real examples, photographs, or magazine pictures of common objects. Have the objects vary in complexity of form. Some should have only simple, planar features, while others should be curved, sculpted surfaces. Some ideas are motor vehicles, farm equipment, household appliances, aircraft and nautical vessels, computer equipment, audio/visual equipment, furniture, lighting fixtures, sports and exercise equipment, hand tools, and stationary and hand-held power tools

2.12 Choosing one of the objects from Problem 2.11, sketch isometric pictorials or multiview drawings, using either plain or grid paper. Identify the major features of the object and choose the best viewpoint to begin the sketch.

2.13 Choosing from one of the larger objects identified in Problem 2.11, sketch a multiview of it on grid paper using the ‘finger-on-pencil’ method of judging proportions (see Section 2.3). Then create a pictorial sketch of the object on grid paper, but at twice the scale. Use the grid blocks to adjust the scale of the drawing.

2.14 Using one photograph from those gathered in Problem 2.11, create ten alternate designs of the object with tracing paper. With each sketch, trace most of the features as they are in the photo, but change some to create a new design.

2.15 Create ten designs as you did in Problem 2.13, but instead of developing each new design from the original photograph, evolve the design from one sketch to the next.

2.16 Evolve a design through three stages of refinement. First, generate 10 rough, ideation sketches, showing different design ideas. Use techniques outlined in Problems 2.14 and 2.15, and sketch on plain or grid paper. Spend about three minutes on each ideation sketch. Pick the three best designs and refine them, spending about 10 minutes on each sketch. Finally, pick the best design and spend about 30 minutes creating a detailed pictorial sketch. The final sketch may combine ideas from all three of the previously sketched designs.

2.17 Sketch one of the objects or photographs gathered in Problem 2.11, in two different ways: (1) as a pictorial; and (2) as a functional diagram. The functional diagram depicts the functions and actions of the object, and how they interrelate.

2.18 Draw each letter of the alphabet and all nine numerals four times, using guide lines, the proper style, and the proper stroke sequence (see Figures 2.53A and 2.53B). Do both vertical and inclined style lettering.

2.19 Letter the name of the linetype under three examples of each type in Problem 2.1.

2.20 Letter the names of each of the standard views in the sketch done in Problem 2.9.

2.21 Letter the names of the major components of the final design in Problem 2.16.

2.22 Using a CAD system, create example sentences of text, using a mix of the following variables:

- Height
- Font
- Alignment
- Aspect ratio
- Slant
- Rotation

Some example sentences:

ALL LETTERS SHOULD BE UPPER CASE.
SINGLE-STROKE GOTHIC IS THE ANSI STANDARD.

AVOID RAMBLING SENTENCES.

USE ANSI STANDARD ABBREVIATIONS.

EXPLAIN IN A NOTE WHAT CANNOT BE DRAWN.

USE PROPER SPACING BETWEEN LINES.

2.23 Gather real examples and/or magazine photographs of both single and multiple objects. The objects should vary in complexity of form. Some should have only simple planar features, while others should have curved, sculpted surfaces. Larger objects or scenes around school or home can simply be identified. These objects, photographs, and scenes will be used in the rest of the exercises in this chapter. Some ideas are:

- Motor vehicles.
- Farm equipment.
- Household appliances.
- Aircraft and nautical vessels.
- Computer equipment.
- Audio/visual equipment.
- Furniture.
- Lighting fixtures.
- Sports and exercise equipment.
- Hand tools.
- Stationary and hand-held power tools.

2.24 Using a photograph of a single, complex object, create a tracing, showing a single contour line around the object. Then, create another tracing and add two more contours outlining what you consider to be the two most important features on the object. Repeat the process until you have five or six sketches, each time adding two or more contours to the sketch. At what point can you identify the object in the sketch without looking at the photograph?

As an alternative to photographs, use a complex object from Figure 2.101A and B.

2.25 Using real scenes and photographs showing multiple items, or using objects created from the developments in Figures 2.102 through 2.107, create sketches using contour lines to identify the boundaries between the elements. First, use photographs, and then real-world scenes or objects. Trace the contour lines, and then create more sketches of the same scenes, objects, or photographs, drawing contour lines that divide the scenes into different groupings.

2.26 Choose a photograph of a complex scene showing familiar objects and/or people and sketch it without tracing. Now, sketch the same scene with the photograph upside down. Do not try to identify the objects in the photograph. Concentrate on the individual contours and their relationships to each other.

2.27 Choose either four objects representing basic geometric forms (e.g., a book, a rolling pin, a pencil, etc.), or primitive objects made from the developments in Figures 2.102 through 2.107. The lighter their color, the better. Place the objects in a strong light coming from behind you, over your shoulder (or equivalent).

- Sketch the contours of the object.
- Shade the surfaces of the object to show the darkness as it appears.
- Move to a new location and sketch them again.
- Move the light source to a new position.
- Repeat *c* and *d*, but this time imagine the movement in your mind rather than actually moving the object. Create the sketches from what you imagine they would look like.

(A)

(B)

(C)

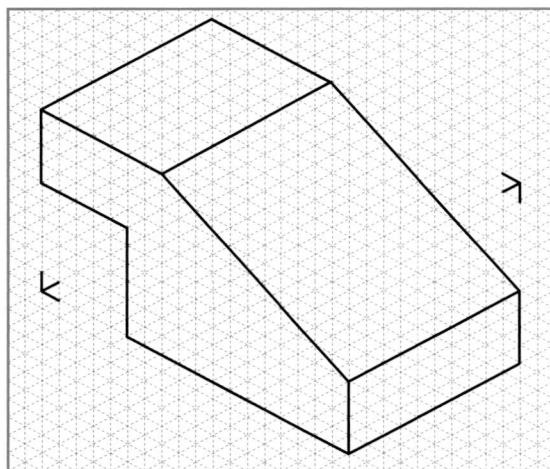

(D)

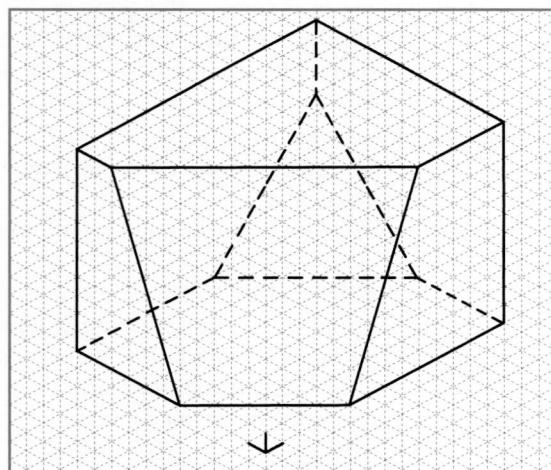

(E)

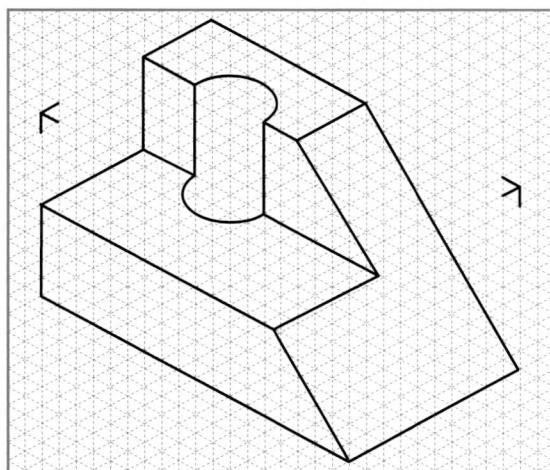

(F)

Figure 2.101A Isometric Drawings of Cut Blocks to Be Used in the Problem Exercises in This Chapter
Assume all holes to be through.

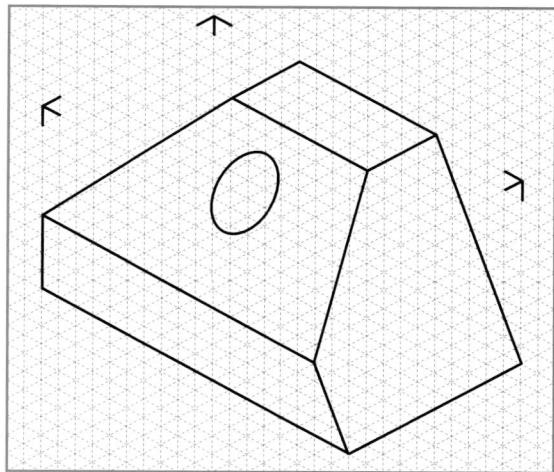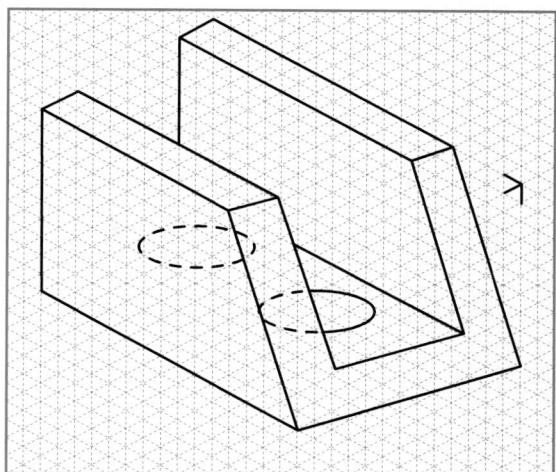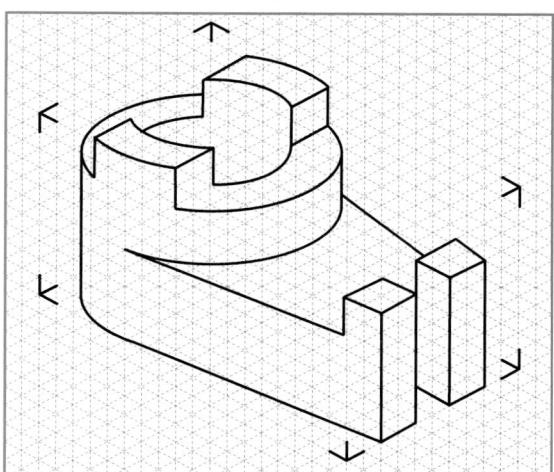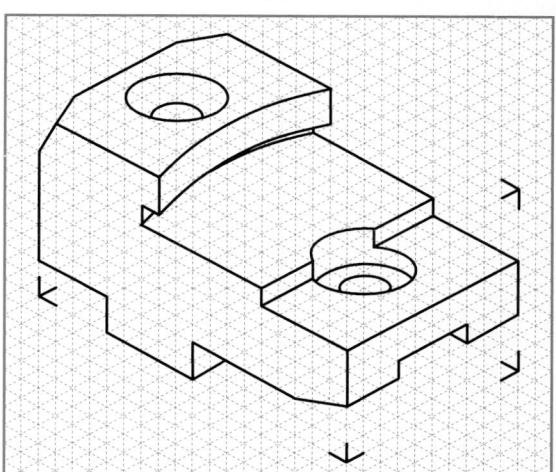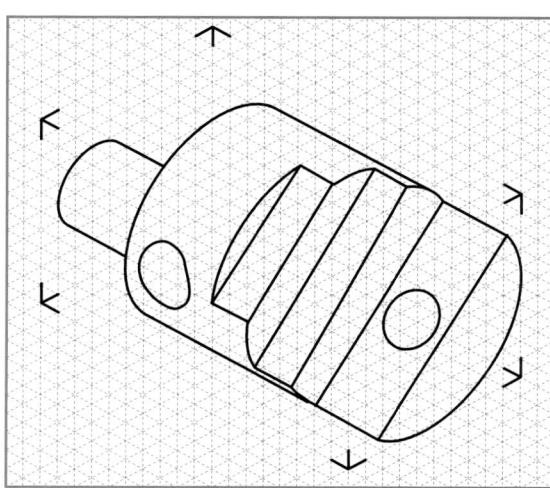

Figure 2.101B Isometric Drawings of Cut Blocks to Be Used in the Problem Exercises in This Chapter
Assume all holes to be through.

Figure 2.102 Development of a Cube to Be Made into Three-Dimensional Form

NOTE: Dashed lines represent where the paper is to be folded, and solid lines are where the paper is cut. Use glue and/or tape to create the objects.

Figure 2.103 Development of a Prism (Brick) to Be Made into Three-Dimensional Form

Figure 2.104 Development of a Wedge to Be Made into Three-Dimensional Form

Figure 2.105 Development of a Cylinder to Be Made into Three-Dimensional Form

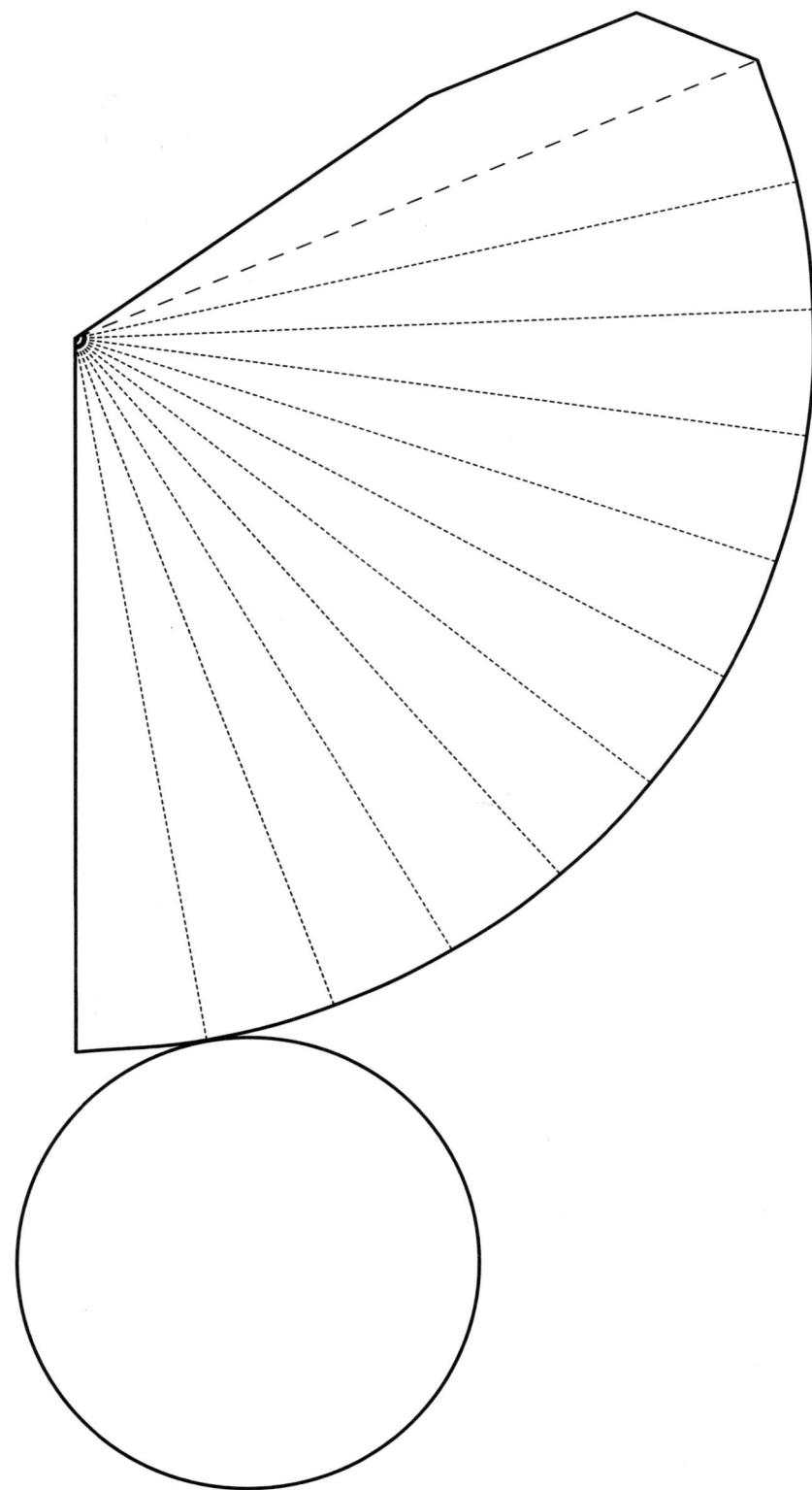

Figure 2.106 Development of a Cone to Be Made into Three-Dimensional Form

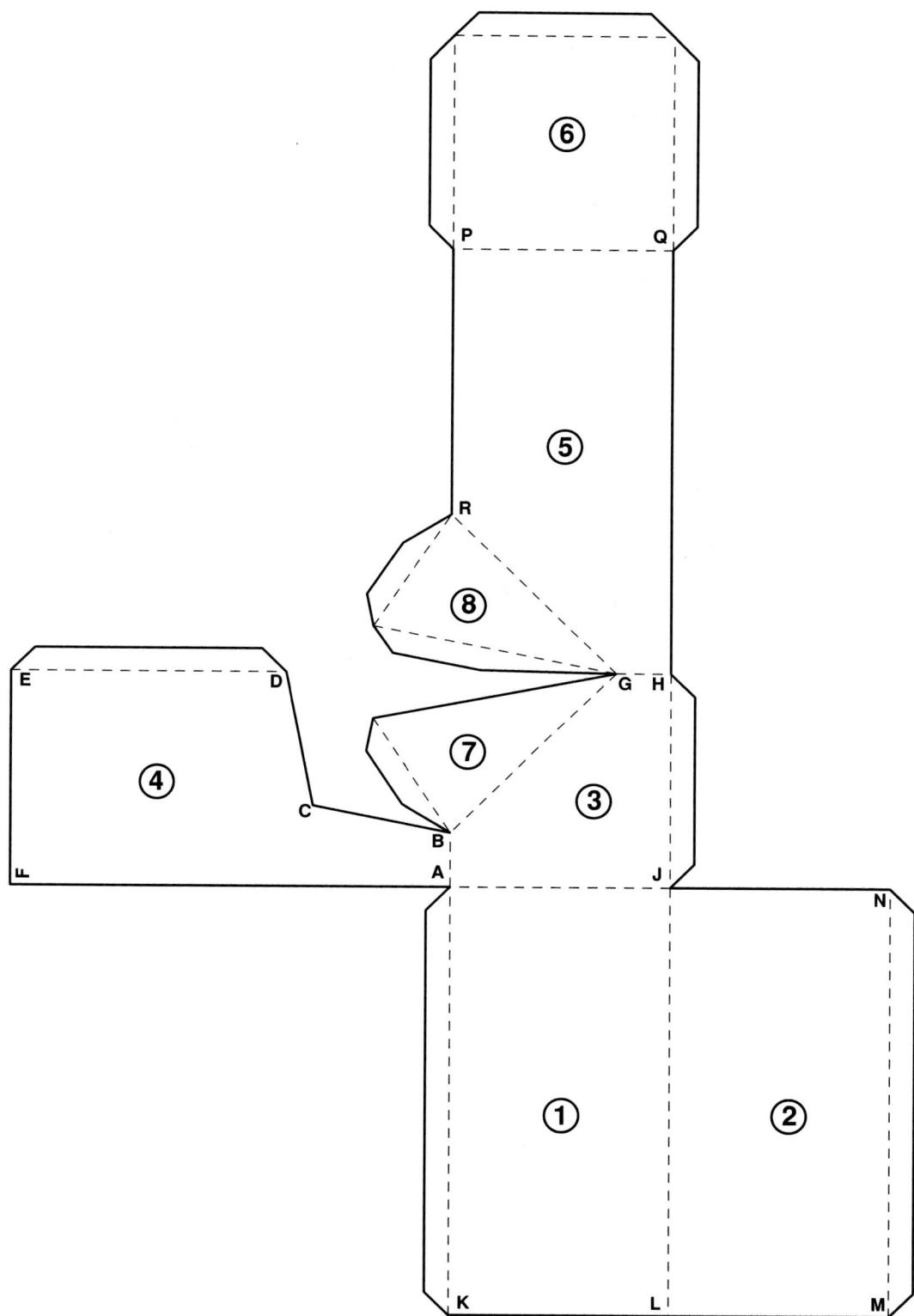

Figure 2.107 Development of an Oblique Block to Be Made into Three-Dimensional Form

2.28 Using the objects and setup from Problem 2.27, create the following series of contour and shaded sketches:

- Systematically move the object in 90-degree increments about all three axes.
- Systematically move the object in 5-degree increments through 90 degrees.
- Repeat *a* and *b* with a different object, but do the rotations in your mind.
- Make photocopies of the 5-degree increment sketches. Pick one face of the object and shade it in all of the sketches. How does it change shape?

2.29 Repeat Problem 2.28*a* through *c*, with two or three objects in the scene. Rotate the objects around a common imaginary axis. Try setting them on a lazy susan. Make photocopies of the 5-degree increments and darken in the contours that divide one object from another. Do their locations on the background stay the same in the different sketches?

2.30 Figures 2.108 and 2.109. Match objects with target shapes.

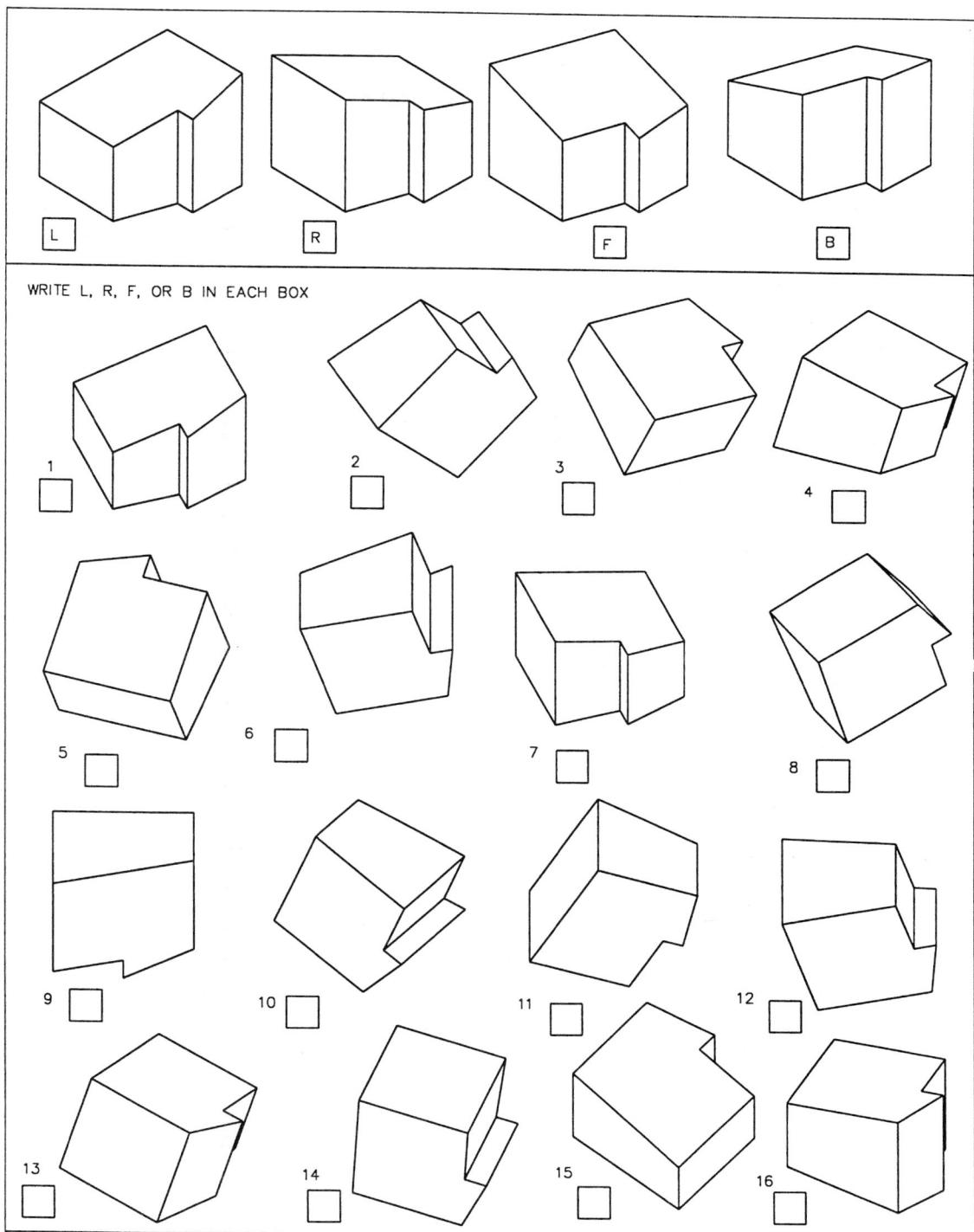**Figure 2.108**

Match objects with target shapes.

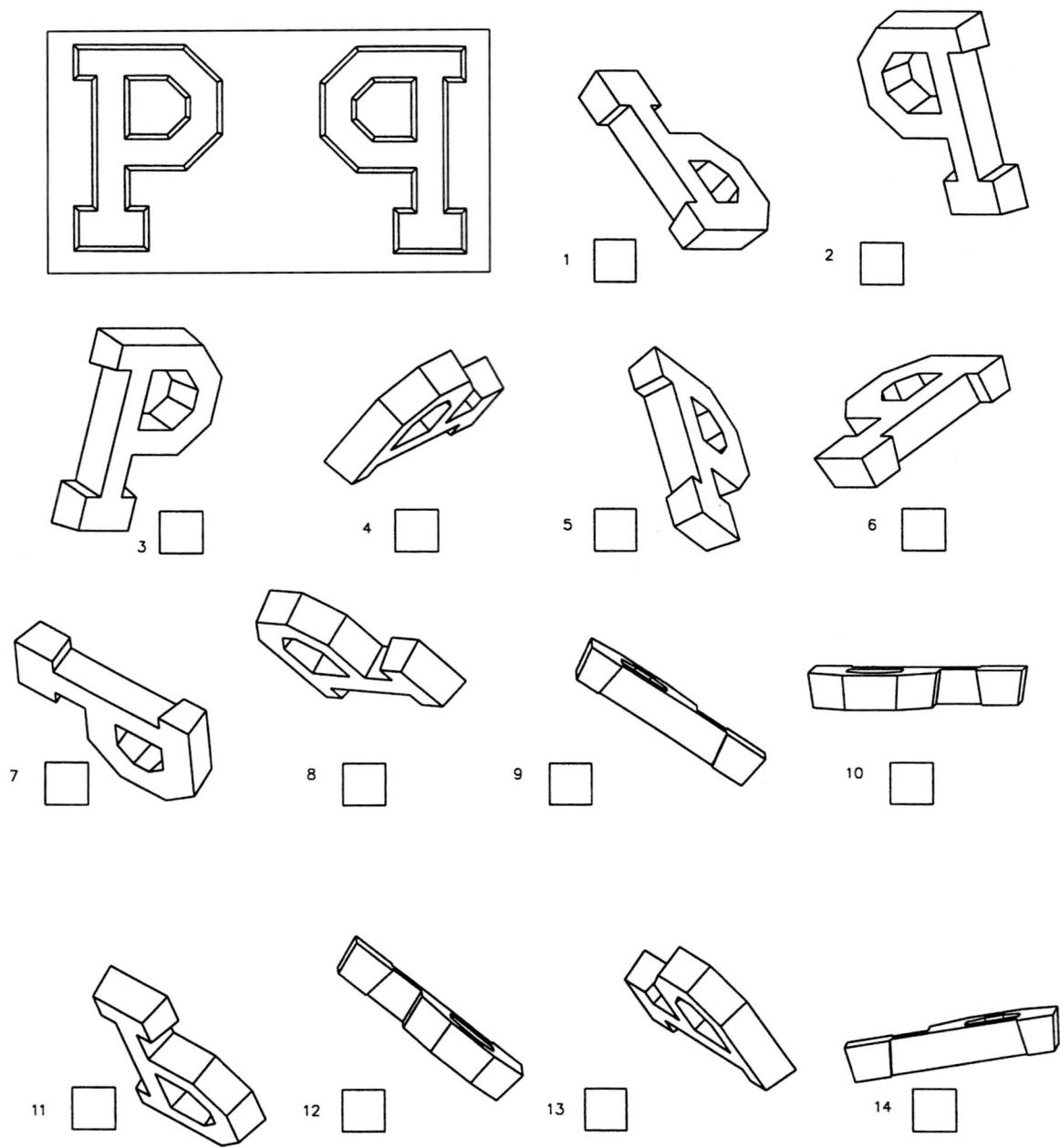**Figure 2.109**

Match objects with target shapes. Write the letter p or q in the square below the rotated letter.

CHAPTER 3

Engineering Geometry and Construction

The senses delight in what is truly proportional.

Thomas Aquinas

OBJECTIVES

After completing this chapter, you will be able to:

1. Describe the importance of engineering geometry in the design process.
2. Describe coordinate geometry and coordinate systems and apply them to CAD.
3. Explain the right-hand rule.
4. List the major categories of geometric entities.
5. Explain and construct the geometric conditions that occur between lines.
6. Construct points, lines, curves, polygons, and planes.
7. Explain and construct tangent conditions between lines and curves.
8. Explain and construct conic sections, roulettes, double-curved lines, and freeform curves.
9. List and describe surface geometric forms.
10. Describe engineering applications of geometry.

Graphics is used to represent complex objects and structures that are created from simple geometric elements, such as lines, circles, and planes. Current 3-D CAD programs use these simple geometric forms to create more complex ones, through such processes as extrusion, sweeping, and Boolean solid modeling operations. To fully exploit the use of CAD, you must understand geometry and be able to construct 2-D and 3-D geometric forms. • This chapter introduces the geometric forms useful in engineering design, from the simple to the complex. The chapter defines four engineering geometry categories, from simple 2-D elements to complex 3-D forms. The geometric elements and forms that are the basic components of engineering geometry are defined and illustrated, along with the application of these elements to engineering design. In addition, geometric conditions are defined and illustrated, and geometric construction techniques that are useful for engineering design are described. • The chapter is divided into two major sections: geometric construction and engineering geometry. Many of the geometric construction techniques described apply only to hand tools, because many CAD systems have commands that perform some of the steps automatically. However, the construction techniques are still valuable because the terminology and the descriptions of the various geometric forms are applicable to CAD. CAD systems become even more powerful in the hands of someone who understands 2-D and 3-D geometric forms.

3.1 ENGINEERING GEOMETRY

Geometry provides the *building blocks* for the engineering design process. **Engineering geometry** is the basic geometric elements and forms used in engineering design.

In this chapter, traditional and CAD-based geometric construction techniques are introduced, along with the primitive geometric forms that serve as the building blocks for more complicated geometric shapes commonly found in engineering design. Some of the more advanced surface geometry topics covered in this chapter introduce geometric forms that can be created by 3-D surface modeling CAD programs.

3.2 SHAPE DESCRIPTION

Engineering and technical graphics are concerned with the descriptions of shape, size, and operation of engineered products. The **shape description** of an object relates to the positions of its component geometric elements in space. To be able to describe the shape of an object, you must understand all of the geometric forms, as well as how they are graphically produced.

Shape description is based on the primitive forms, points, lines, and planes, which are combined to create more complex forms, such as that shown in Figure 3.1. A shape description is developed through orthographic, pictorial, or other projection techniques.

3.3 COORDINATE SPACE

In order to locate points, lines, planes, or other geometric forms, their positions must first be referenced to some known position, called a **reference point** or origin of measurement. The **Cartesian coordinate system**, commonly used in mathematics and graphics, locates the positions of geometric forms in 2-D and 3-D space. This system was first introduced in 1637 by the French mathematician René Descartes (1596–1650). The coordinate geometry based on this system theorizes that, for every point in space, a set of real numbers can be assigned, and for each set of real numbers, there is a unique point in space.

A 2-D coordinate system establishes an **origin** at the intersection of two mutually perpendicular axes, labeled X (horizontal) and Y (vertical). (Figure 3.2) The origin is assigned the coordinate values of 0,0. Values to the right of the origin are considered positive, and those to the left are negative. Similarly, values above the origin are positive, and those below are negative. Using this convention, you can locate any point in 2-D space by assigning a unique set of numbers to that point. The numbers assigned to each point are called **coordinates**, where the first number is the X coordinate and the second number is the Y coordinate. For example, the coordinates 3,5 would locate a point in the upper right quadrant of the 2-D coordinate system, as shown in Figure 3.2. Coordinates of -3,5 would locate a point in the upper left quadrant; coordinates of -3,-5 would locate a point in the lower left quadrant; and coordinates of 3,-5 would locate a point in the lower right quadrant. By connecting these points with lines, you create a rectangle in fixed coordinate space. (Figure 3.3)

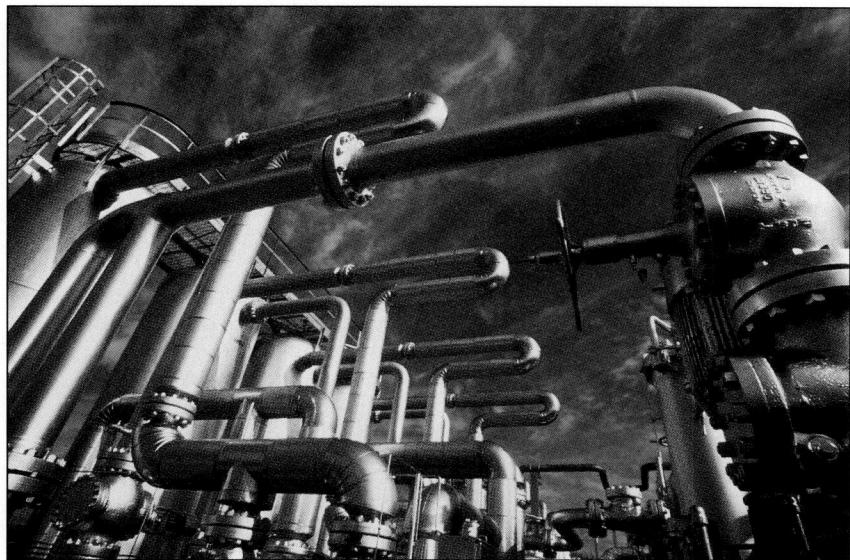**Figure 3.1**

Complex engineering geometry is found in many engineered products, structures, and systems.

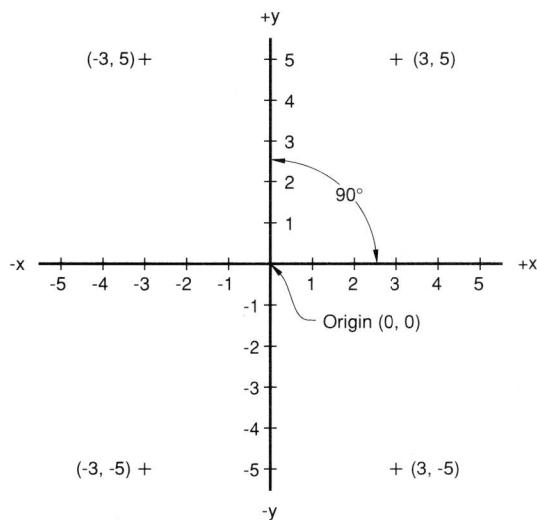**Figure 3.2 2-D Cartesian Coordinate System**

The 2-D Cartesian coordinate system was developed by René Descartes to locate the positions of geometric forms in space.

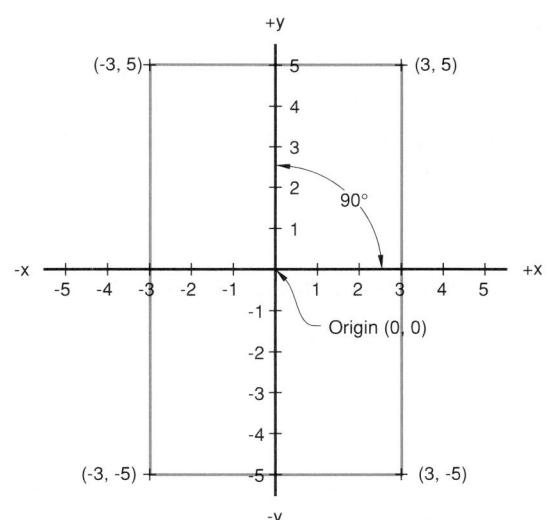**Figure 3.3**

A rectangle is created by using coordinate values for each corner and then drawing the connecting lines.

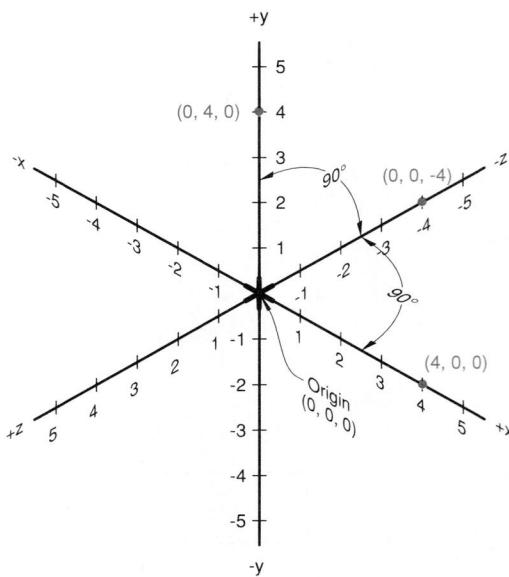

Figure 3.4 3-D Coordinate System

The 3-D coordinate axes consist of three mutually perpendicular axes. The red numbers in parentheses are example coordinate values at the marked locations.

In a 3-D coordinate system, the origin is established at the point where three mutually perpendicular axes (X, Y, and Z) meet. (Figure 3.4) The origin is assigned the coordinate values of 0,0,0. By convention, values to the right of the origin are positive, and those to the left are negative; values above the origin are positive, and those below are negative; and values in front of the origin are positive, and those behind are negative.

Using this convention, you can assign a unique triplet of ordered numbers to any point in 3-D space. The first number represents the X distance, the second number the Y distance, and the third number the Z distance. Figure 3.5 shows a rectangular prism located in 3-D coordinate space, with the following values for the corners. Notice in Figure 3.5 the coordinate triplets in parentheses given for each of the corners of the rectangular prism.

This coordinate system is used in multiview drawings and 3-D modeling, using both traditional tools and CAD. Figure 3.6 is a multiview drawing of an object, with coordinate axes displayed in each viewport. The front viewport shows the X and Y axes, with Z as a point; the top viewport shows the X and Z axes, with Y as a point; and the profile viewport shows the Y and Z axes, with X as a point. By “placing” the lower left-front corner of the block on the origin, you can then

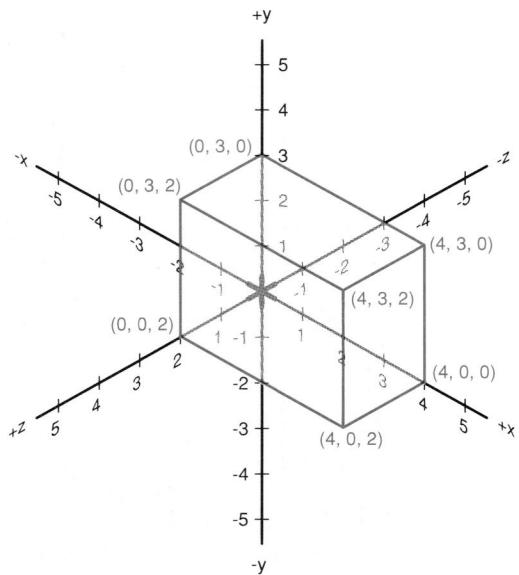

Figure 3.5

A rectangular prism is created using the 3-D coordinate system by establishing coordinate values for each corner.

locate all other points on the block by their coordinates. For example, point A in the figure is located at coordinates 3,3,-1.

CAD systems provide a method for displaying the cursor's current position in coordinate space. Normally, there is some type of toggle switch or command that turns on the coordinate tracking, which is then displayed at the top or bottom of the screen. (Figure 3.7) To create 3-D models, most CAD systems use 2-D input devices, such as mice and digitizers, and then require keyboard entry of the Z value to define the third dimension. © CAD Reference 3.1

Practice Exercise 3.1

Take three sheets of square grid paper and lay out X-Y, Y-Z, and X-Z axes on each one. Label the axes. Using the coordinates given in Figure 3.5, map the points on the grid paper, minus the coordinate not represented. Photocopy all three sheets. Using the photocopy, cut out and glue together the three rectangles defined by the points, in their appropriate orientations. For the missing sides of the solid, make a second photocopy of your sheets, cut them out and glue them in place. They represent exact duplicates of the opposite faces in terms of size and shape. What is different about them? Do the coordinates on the photocopies correctly reflect where the second set of faces is in space?

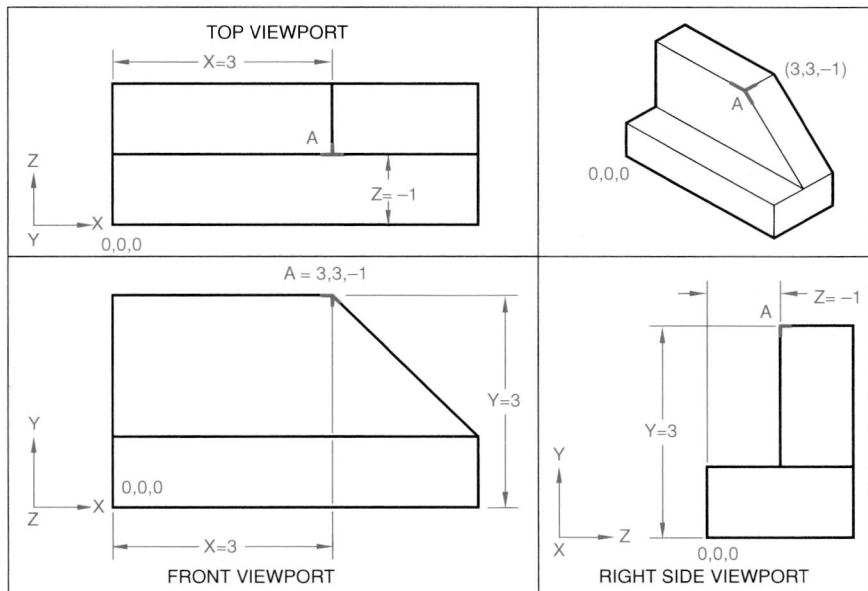

Figure 3.6 Display of Coordinate Axes in a Multiview CAD Drawing

Only two of the three coordinates can be seen in each view.

Figure 3.7 Display of Coordinate Position of Cursor on a CAD Screen

3.3.1 Right-Hand Rule

The **right-hand rule** is used to determine the positive direction of the axes. To visualize the right-hand rule, make a fist with your right hand, with your thumb pointing outward. (Figure 3.8A) The direction your thumb is pointing indicates the positive direction on the X axis. Straighten your index finger so that it is

pointing straight up, at 90 degrees to your thumb. (Figure 3.8B) The direction your index finger is pointing indicates the positive direction on the Y axis. Straighten your middle finger so that it is pointing forward, at 90 degrees to your index finger. (Figure 3.8C) The direction your middle finger is pointing indicates the positive direction of the Z axis.

The right-hand rule is also used to specify the direction of positive rotation about each axis. Imagine that the fingers of your right hand are made into a fist and are wrapped around one of the axes, with the thumb pointing in the positive direction of that axis. The direction that your fingers curl to make the fist identifies the direction of positive rotation for the axis. (Figure 3.8D) This technique applies to all three axes.

The right-hand rule is used in both traditional drawing and CAD.

3.3.2 Polar Coordinates

Polar coordinates are used to locate points in the X-Y plane. Polar coordinates specify a distance and an angle from the origin (0,0). Figure 3.9 shows a line in the X-Y plane, 4.5 units long and at an angle of 30 degrees from the X axis. Polar coordinates are commonly used by CAD systems to locate points. © CAD Reference 3.2

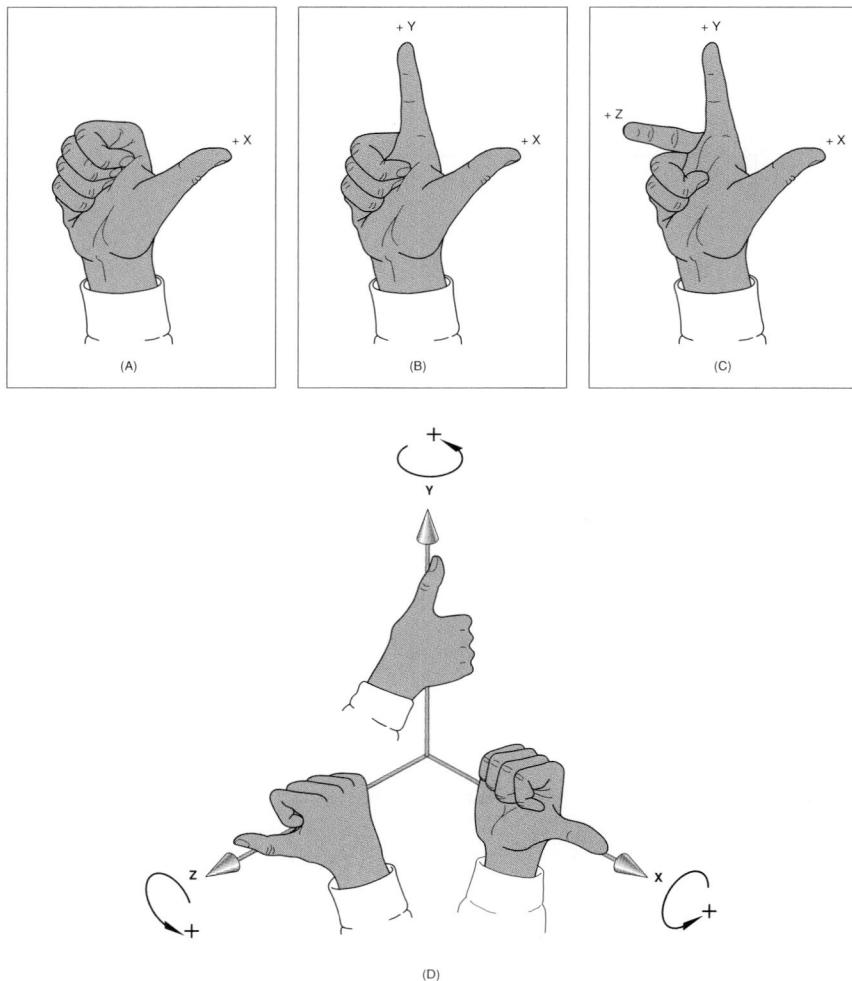

Figure 3.8 Right-Hand Rule for Axes Directions

The right-hand rule defines the X, Y, and Z axes, as well as the positive and negative directions of rotation on each axis.

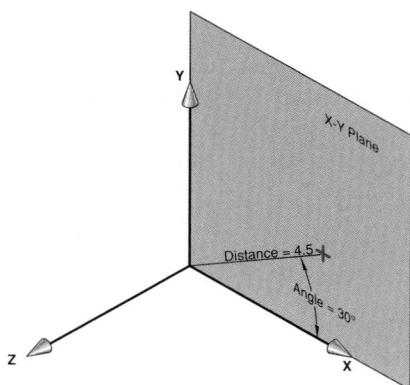

Figure 3.9 Polar Coordinates

Polar coordinates use a distance in the X-Y plane and an angle from the X axis to locate a point.

3.3.3 Cylindrical Coordinates

Cylindrical coordinates involve one angle and two distances. Cylindrical coordinates specify a distance from the origin, an angle from the X axis in the X-Y plane, and a distance in the Z direction. To illustrate, in Figure 3.10, point A is 7 units in the Z direction, and is 4.5 units from the origin as measured on a line that is at 60 degrees from the X axis in the X-Y plane. Because of the way it is located, point A is on the surface of a cylinder that has a radius of 4.5 units and a length of 7 units; hence the name *cylindrical coordinates*.

Cylindrical coordinates are used in designing circular shapes and in geographic applications. To change

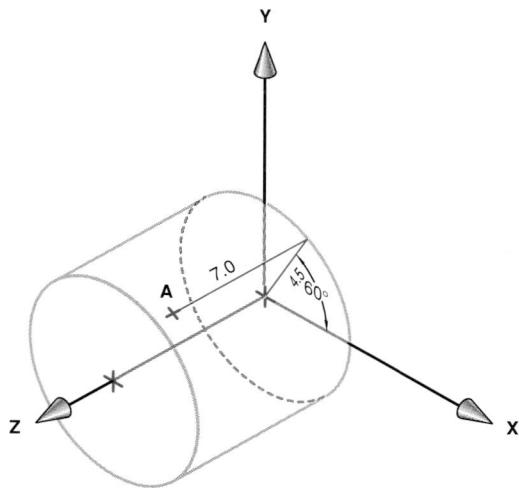

Figure 3.10 Cylindrical Coordinates

Cylindrical coordinates locate a point on the surface of a cylinder by specifying a distance and an angle in the X–Y plane, and a distance in the Z direction.

to convert cylindrical coordinates to Cartesian coordinates, use the following equations:

$$\begin{aligned} x &= r \cos \theta \\ y &= r \sin \theta \\ z &= z \end{aligned}$$

For example, the Cartesian coordinates for point A in Figure 3.10 are 2.25, 3.90, 7, determined as follows: use the equations shown above and substitute the values $r = 4.5$ and angle $\theta = 60$ degrees:

$$\begin{aligned} x &= 4.5 \cos 60 = 2.25 \\ y &= 4.5 \sin 60 = 3.90 \\ z &= 7 \end{aligned}$$

© CAD Reference 3.3

3.3.4 Spherical Coordinates

Spherical coordinates are used to locate points on a spherical surface by specifying two angles and one distance. (Figure 3.11) Spherical coordinates specify a distance from the origin on a line that is at an angle from the X axis in the X–Y plane, and then an angle away from the X–Y plane. In Figure 3.11, the distance in the X–Y plane is 3 (which defines the radius of the sphere), the angle in the X–Y plane is 20 degrees, locating a point from which an angle of 60 degrees is drawn away from the X–Y plane along the surface of the sphere. © CAD Reference 3.4

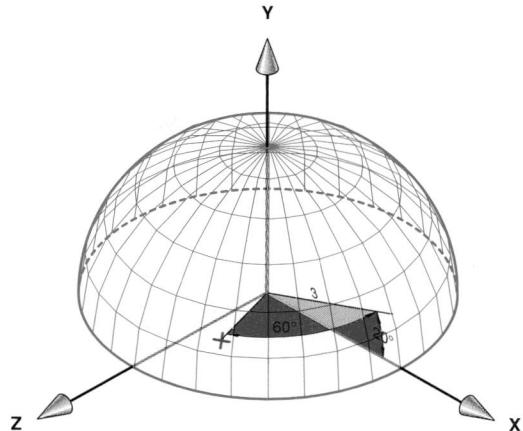

Figure 3.11 Spherical Coordinates

Spherical coordinates locate a point on the surface of a sphere by specifying an angle in one plane, an angle in another plane, and one length.

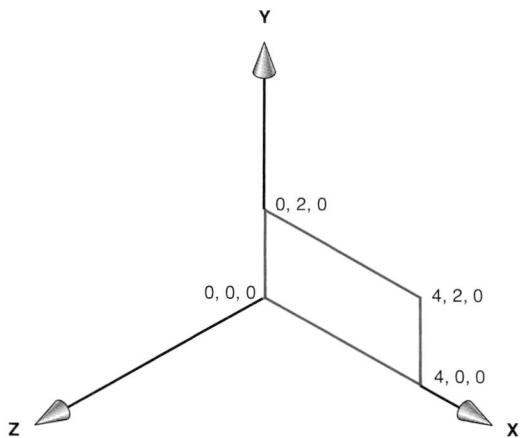

Figure 3.12 Absolute Coordinates

Absolute coordinate values are referenced to the fixed origin.

3.3.5 Absolute and Relative Coordinates

Absolute coordinates are always referenced to the origin (0,0,0). In Figure 3.12, the rectangle is defined by corners that have absolute coordinate values of:

0,0,0
4,0,0
4,2,0
0,2,0

Relative coordinates are always referenced to a previously defined location and are sometimes referred to as *delta coordinates*, meaning changed coordinates.

Figure 3.13 shows the same rectangle as in Figure 3.12, but constructed using relative coordinates starting with point A, then locating points B, C, and D. Point A has values 4,0,0; B is referenced from A and has relative values 0,2,0; C is referenced from B and has relative values -4,0,0; and D is referenced from C and has relative values 0,-2,0. © CAD Reference 3.5

Practice Exercise 3.2

Using the coordinates given in the text, build a wireframe model out of wire. Create three coordinate planes (X-Y, Y-Z, and X-Z) on square grid paper. Glue them onto a cardboard backing and tape them together to form a grid box with the grid facing inward. Place the wireframe in the box so that the corners correspond to the correct absolute coordinates. Count off the number of grids to get from one corner of the object to another. Use a corner other than 0,0,0 as a reference point and move the wireframe model to a different location in the grid box. Do the absolute coordinates of the corners change? Count the number of grids from one corner to another. Do the delta coordinates change?

Do the same exercise with 3-D models on the computer. Use either coordinate readouts in the status area, or 3-D grid planes to help visualize the results.

3.3.6 World and Local Coordinate Systems

CAD systems normally use two types of coordinate systems: world, and user or local systems. Both of these are based on Cartesian coordinates. The **world coordinate system** is the stationary or reference system where the geometry is defined and stored. The world coordinate system uses a set of three numbers (x,y,z) located on three mutually perpendicular axes and measured from the origin (0,0,0). (Figure 3.14) The **local coordinate system** is a moving system that can be positioned anywhere in 3-D space by the user, to assist in the construction of geometry. In Figure 3.14, axes X and Y of the local coordinate system are aligned with the inclined plane, resulting in local coordinate values that are

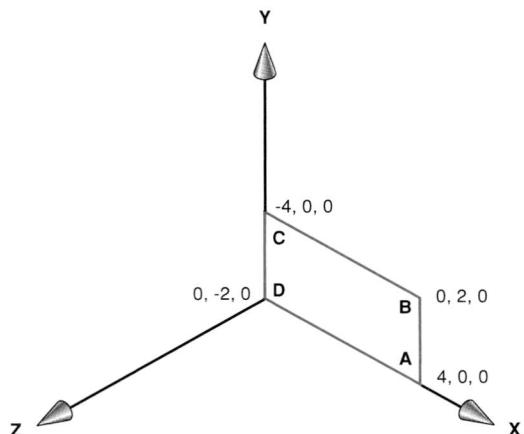

Figure 3.13 Relative Coordinates

Relative coordinate values are referenced to the previous specified point.

different from the world coordinate values. Locating a point on the inclined surface will be easier using the local coordinate system because the X-Y plane of the local coordinate system is parallel to the inclined surface. For example, the point A has world coordinates of 1,4,-3 and local coordinates of 3,3.5,0. © CAD Reference 3.6

Practice Exercise 3.3

Create a workplane of either stiffened grid paper or clear plastic, with two axes on it. The third axis can be represented sticking out of the plane, if desired. Place the plane on various surfaces of objects (including inclined and oblique surfaces). Calculate the local coordinate locations of various features on the object. Compare them to the world coordinates of the features, using the grid box from the previous exercise as the world coordinate reference.

Do the same exercise using 3-D models on a computer. Use locally defined workplanes, and compare the local coordinate readouts to world coordinate values. The exercise can be done with 2-D CAD systems and locally (user) defined coordinate systems.

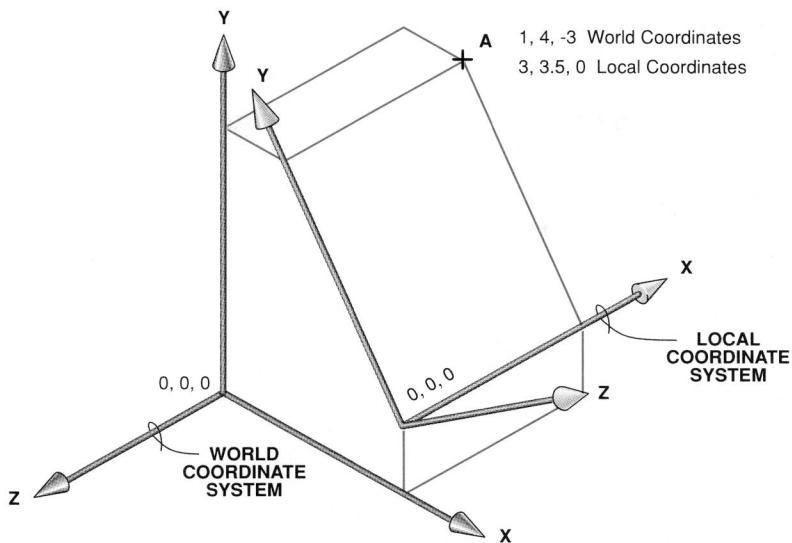

Figure 3.14 World and Local Coordinates

This object in 3-D coordinate space shows the difference between the world coordinate system and a local coordinate system. World and local coordinate systems are commonly used with CAD to construct 3-D objects. Point A has different coordinate values, depending on whether the local or world coordinate system is used.

3.4 GEOMETRIC ELEMENTS

Different systems can be used to categorize geometric elements. In this text, geometric elements are categorized as points, lines, surfaces, or solids. Lines, surfaces, and solids also have many subcategories. Figure 3.15 lists each category and many of the geometric elements in each category. The remainder of this chapter will define, illustrate, construct, and apply many of the geometric elements listed in Figure 3.15.

3.5 POINTS, LINES, CIRCLES, AND ARCS

Points, lines, circles, and arcs are the basic 2-D geometric primitives, or generators, from which other, more complex geometric forms can be derived or mathematically produced. For example, by taking a straight line and moving it in a certain way through a

circular path, you can create a cylinder. This section defines, illustrates, and describes how to create points, lines, circles, and arcs.

3.5.1 Points

A **point** is a theoretical location that has neither width, height, nor depth. Points describe an exact location in space. Normally, a point is represented in technical drawings as a small cross made of dashes that are approximately $\frac{1}{8}$ " long. (Figure 3.16A) With CAD, it is possible to extrude (i.e., string out) a point to create a line, or to extrude several points to create more complicated forms. (Figure 3.16B) A point is found at the intersection of two lines or at the end of a finite line. In computer graphics, it is common to use the word **node** to mean a point. (Figures 3.16C, E, F, and G) For example, the intersection of geometric entities, and specific locations along arcs, circles, and splines, are called nodes.

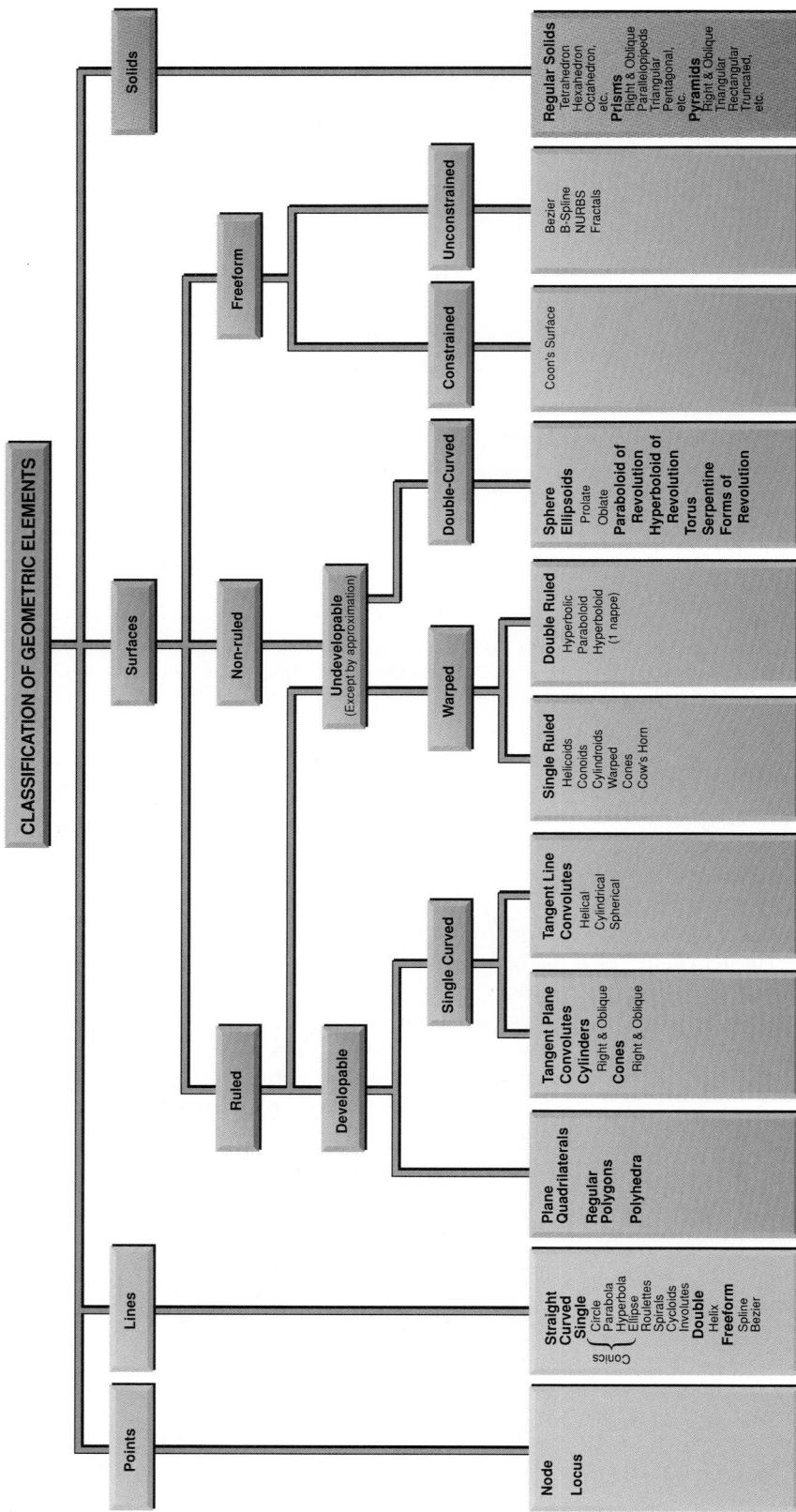

Figure 3.15 Classification of Geometric Elements

Geometric elements are divided into four main categories: points, lines, surfaces, and solids. Each category contains subcategories in which most geometric elements are found.

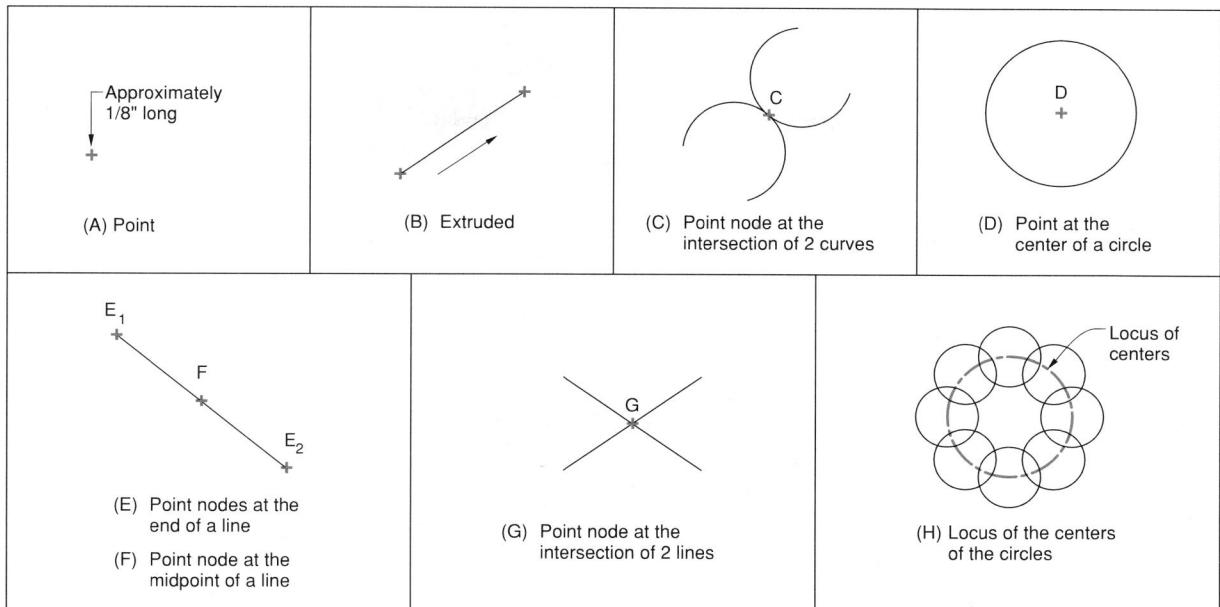

Figure 3.16 Examples and Representation of Points

A point is used to mark the locations of centers and loci, and the intersections, ends, and middles of entities.

Analysis of a problem may indicate that a certain unknown point must be located at a fixed distance from some given point, line, or arc. The location of this unknown point is called a locus. A **locus** represents all possible positions of a point. The locus of a point may be drawn as a line, circle, or arc. For example, the center of each circle shown in Figure 3.16H forms a locus of centers.

Nodes are very important when constructing geometric forms with CAD. CAD systems normally allow the user to locate exactly such important geometric elements as endpoints, centers, and intersections. These nodes can be used to construct geometric forms more accurately. For example, a line can be accurately drawn from the midpoint of an existing line, because the CAD system stores the exact location as a node.

© CAD Reference 3.7

3.5.2 Lines

A **line** is a geometric primitive that has length and direction, but not thickness. A line may be straight, curved, or a combination of these. As with points, it is possible to create more complex geometric forms from lines by using CAD extrusion or sweeping operations,

as shown in Figure 3.17A. Lines also have important relationships or *conditions*, such as parallel, intersecting, and tangent.

Straight Lines A straight line is generated by a point moving in a constant direction. (Figure 3.17B) Straight lines can either be finite or infinite in length. A straight finite line is a line of *specific length*. (Figure 3.17C) A straight infinite line is a line of *nonspecific length*. (Figure 3.17D)

A **ray** is a straight infinite line that extends into infinity from a specified point. (Figure 3.17E) Ray is a common term used in computer graphics to describe the path of a light ray, and is important when a scene is being rendered.

The relationship of one line to another results in a condition, such as parallel or perpendicular. A **parallel line** condition occurs when two or more lines on a plane are a constant distance apart. (Figure 3.18A) A **nonparallel line** condition occurs when two or more lines on one or more planes are spaced unevenly apart. (Figure 3.18B) A **perpendicular line** condition, sometimes called a *normal*, occurs when two or more lines on a plane intersect each other at right angles (90 degrees). (Figure 3.18C) An **intersecting line** condition occurs

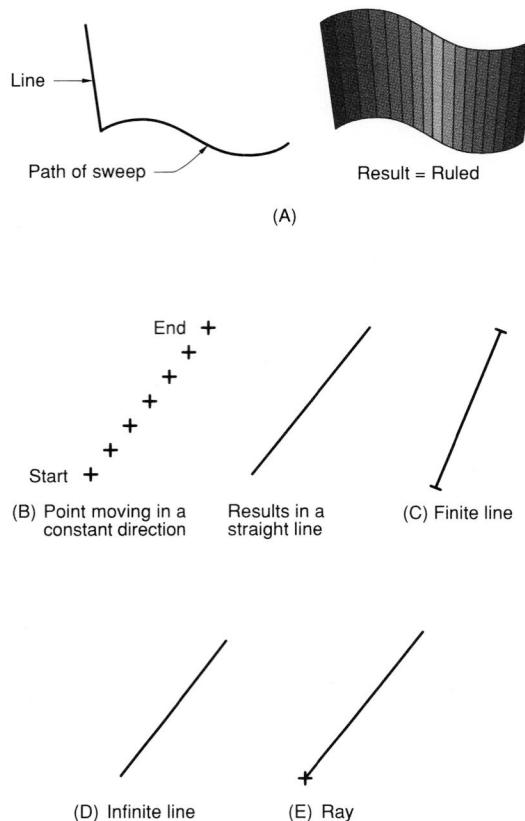

Figure 3.17 Examples and Representation of Lines

Lines can be used to construct other geometric forms, such as a ruled surface. Lines are either finite or infinite, and are called rays in computer graphics.

when two or more lines cross each other at a common point. (Figure 3.18D) A **tangent** condition exists when a straight line is in contact with a curve at a single point. (Figure 3.18E)

In technical drawing, lines are used to represent the intersections of nonparallel planes, and the intersections are called *edges*. (Figure 3.18F)

Straight lines are drawn using triangles and a straightedge, or the LINE command in a CAD system. The straightedge can be a triangle, T-square, parallel bar, or drafting machine. Although the illustrations in this section primarily use triangles for the straightedge, the same basic procedures can be used with the other types of straightedges, except where otherwise noted.

Practice Exercise 3.4

Create a line in 3-D space, either with a wire or on a computer. Hold the line fixed along any primary axis and view it from the directions of the three primary axes. In which views does it look like a line? In which views does it look its full length? In which views does it look like a point? Move the line so that it does not align with any of the primary axes. Repeat the viewing/analyzing process and make multiview sketches of the line.

To construct horizontal, vertical, inclined, parallel, and perpendicular lines, refer to Chapter 1.

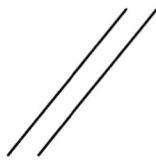

(A) Parallel Line Condition

(B) Nonparallel Line Condition

(C) Perpendicular Line Condition

(D) Intersecting Lines

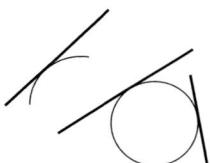

(E) Tangent Condition

(F) Line at the Intersection of Two Planes (Edge)

Figure 3.18 Line Relationships***A Line Parallel to a Given Line at a Given Distance***

To draw a line parallel to a given line AB and at a distance XY from the given line, use the following procedure. (Figure 3.19)

Drawing a Line Parallel to a Given Line at a Given Distance

Step 1. Set the compass to distance XY. Draw two arcs from any two points on the given line. (Points E and F are shown in the figure.) The farther apart the two points, the greater the accuracy of the final line. From the two points E and F, draw lines perpendicular to the given line and intersecting the two arcs.

Step 2. Mark the places where the perpendicular lines intersect the arcs (points G and H). Then draw a line through those two points. This line will be parallel to the given line at the desired distance from that line.

Dividing a Line into Equal Parts If you have a line that is difficult to measure accurately, use the following procedure to divide that line into equal parts. (Figure 3.20) (For our example, the line is divided into three equal parts.)

Dividing a Line into Equal Parts

Step 1. Draw a line at any angle and distance from point M, creating line MO.

Step 2. Place the zero mark of a scale onto point M and parallel to line MO. Mark three points equally spaced along the line.

Step 3. Draw a line from points N and O.

Step 4. Draw lines parallel to line NO through the two remaining points on line MO. The intersection of these lines with line MN will divide the line into three equal parts.

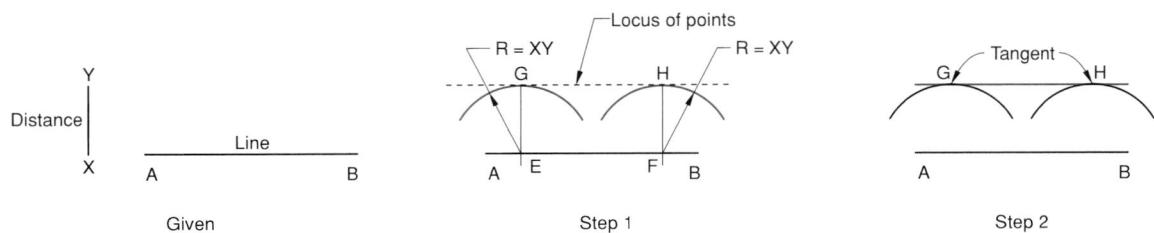

Figure 3.19 Drawing a Line Parallel to a Given Line at a Given Distance

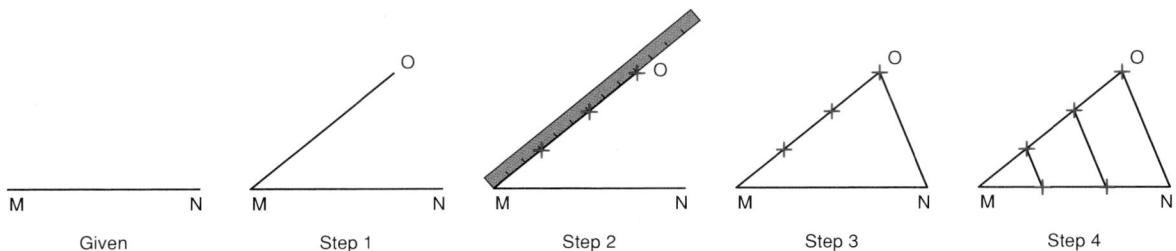

Figure 3.20 Dividing a Line into Equal Parts

CAD software has a special command that will automatically divide a selected line into the number of parts specified by the user. © CAD Reference 3.8

Dividing a Line into Proportional Parts If you have a given line that is difficult to measure accurately, and you wish to divide that line into proportional parts, such as 1:2:3, use the same procedure as described for dividing a line into equal parts, except that the scale measurement in Step 2 should be easily divisible into the proportions desired. © CAD Reference 3.9

Bisecting a Line To **bisect** means to divide in half. The intersection of a **bisector** and a line locates the **midpoint** of the line. Bisect a line using one of the following construction techniques. (Figure 3.21)

Bisecting a Line: Compass Method

Step 1. To bisect a line using a compass, set the compass to a distance that is *greater than half* the length of the given line.

Step 2. Set the point of the compass at one end of the line and draw an arc across the line.

Step 3. Set the point of the compass at the other end of the line and draw another arc across the line.

Step 4. Use a straightedge and draw a line connecting the intersection points of the two arcs. The new line is the perpendicular bisector and locates the midpoint of the line.

To bisect a line using dividers, open the dividers to a distance estimated to be half the length of the given line. Step off the distance along the line. If the dividers are set correctly, the pointer will exactly meet the endpoint of the line on the second step. If the dividers are not set correctly, adjust them (i.e., make the setting smaller if the second step went beyond the endpoint of the line; larger if the second step did not reach the endpoint of the line), and repeat the step off procedure. Continue this process until the dividers are as close as you can make them. Mark the midpoint of the line after the first step off. Since this process is less accurate and more time consuming, it is not recommended unless you have limited access to drawing tools. © CAD Reference 3.10

Curved Lines A **curved line** is the path generated by a point moving in a constantly changing direction, or is the line of intersection between a 3-D curved surface and a plane. (Figure 3.22) Curved lines are classed as single-curved or double-curved. On a **single-curved line**, all points of the line are in a plane. Examples of single-curved lines are a circle, ellipse, parabola, hyperbola, spiral, spline, involute, and cycloid. On a **double-curved line**, no four consecutive points are in the same plane. Examples of double-curved lines are the cylindrical helix, the conical helix, and the general form created at the line of intersection between two curved surfaces.

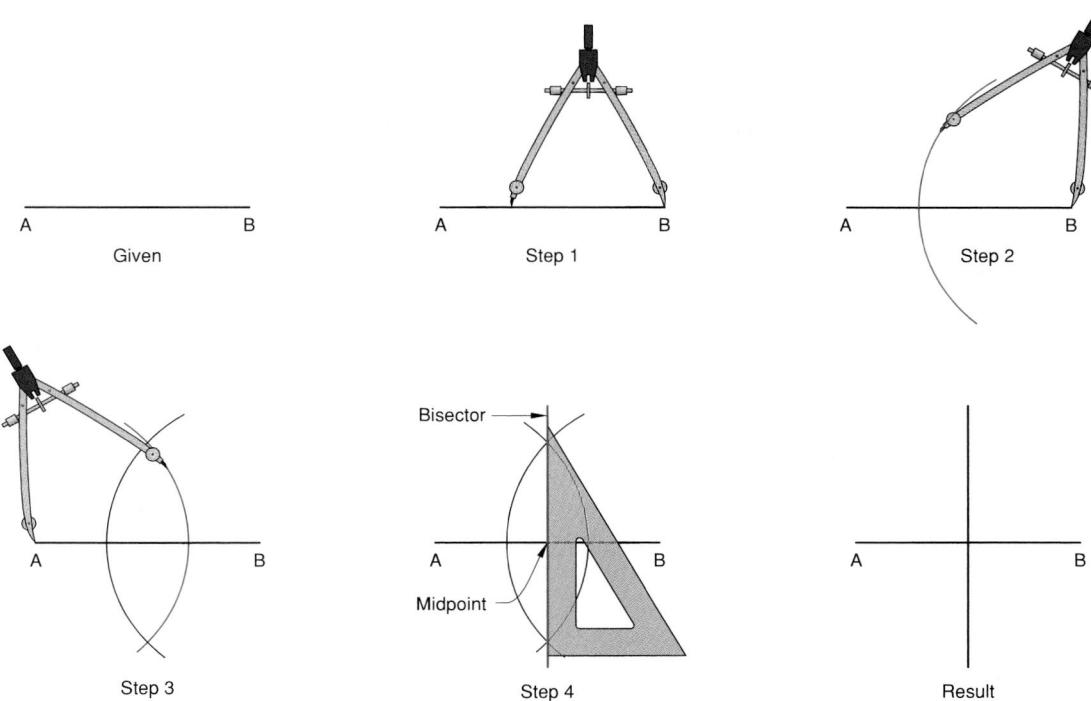

Figure 3.21 Bisecting a Line, Using a Compass and Triangle

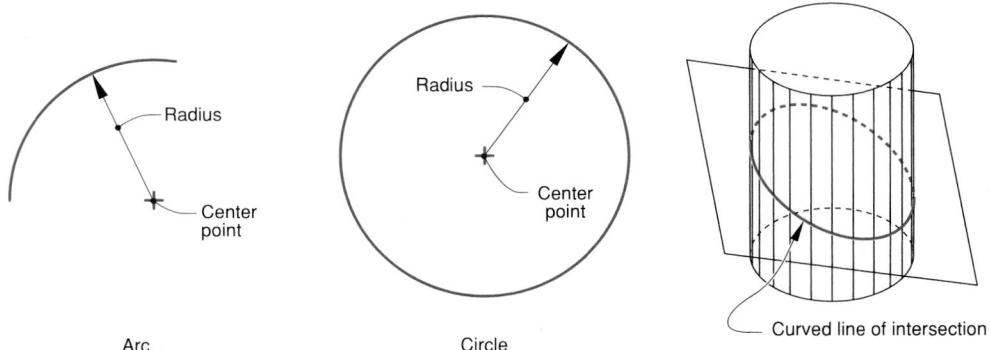

Figure 3.22 Curved Lines

Regular curves are bent lines of constant radius. Regular curves include arcs, circles, and curved lines of intersection on cylinders.

Practice Exercise 3.5

Create a single-curved line in 3-D space, either with a wire or on a computer. Align the line along a primary axis and view it along the three primary axes. In which views does it look like a straight line? a curved line? In which views does it look its full length? Move the line so that it does not align with any of the primary axes. Repeat the viewing/analyzing process. Can you lay a plane up against the curved line? Try it.

Repeat the above exercise with a double-curved line.

A **regular curve** is a constant-radius arc or circle generated around a single center point. The line of intersection between a circular cylinder or sphere and a plane perpendicular to the axis is also a regular curve. Regular curves are drawn using a compass or circle template, or with the CIRCLE and ARC commands in CAD. To use a compass or circle template to draw a regular curve, first determine the location of the center and the length of the radius.

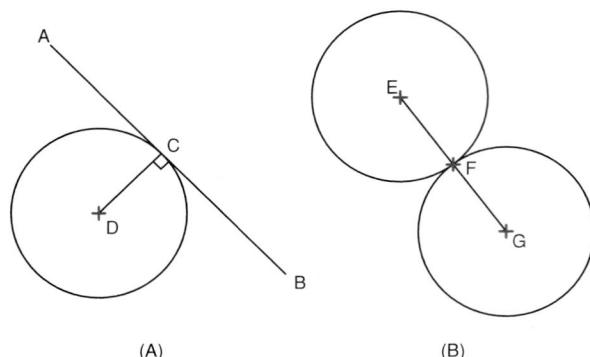**Figure 3.23 Planar Tangents**

Planar tangent conditions exist when two geometric forms meet at a single point and do not intersect.

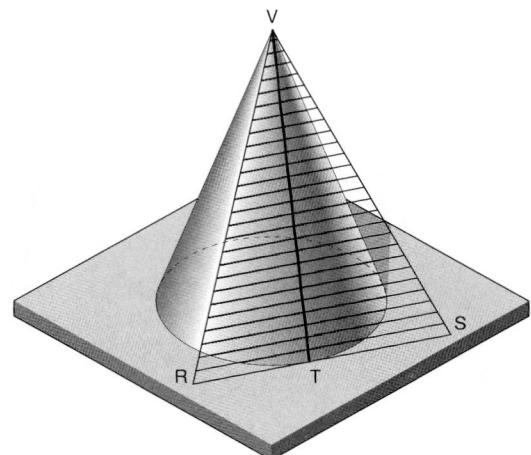**Figure 3.24 Tangent Plane**

Plane RVS is tangent to the cone at line VT.

CAD systems provide the user with many CIRCLE and ARC command options to construct regular curves.

Irregular curves, such as parabolas, hyperbolas, and splines, are defined and methods for their construction are described later in this chapter.

3.5.3 Tangencies

In planar geometry, a tangent condition exists when a straight line is in contact with a curve at a single point; that is, *a line is tangent to a circle if it touches the circle at one and only one point*. At the exact point of tangency, a radius makes a right angle to the tangent line. In Figure 3.23A, the tangent point between the line and the circle is point C.

Two curves are tangent to each other if they touch in one and only one place. When two arcs or circles are tangent, a line drawn to connect the centers of the two arcs or circles locates the point of tangency. In Figure 3.23B, the tangent point between the two circles is located at point F.

In 3-D geometry, a tangent condition exists when a plane touches but does not intersect another surface at one or more consecutive points. (Figure 3.24) Another tangent condition exists where there is a smooth transition between two geometric entities. (Figure 3.25A) However, a corner between two geometric entities indicates a nontangent condition. (Figure 3.25B) A line is tangent to a surface if the line touches the surface at a single point. (Figure 3.26)

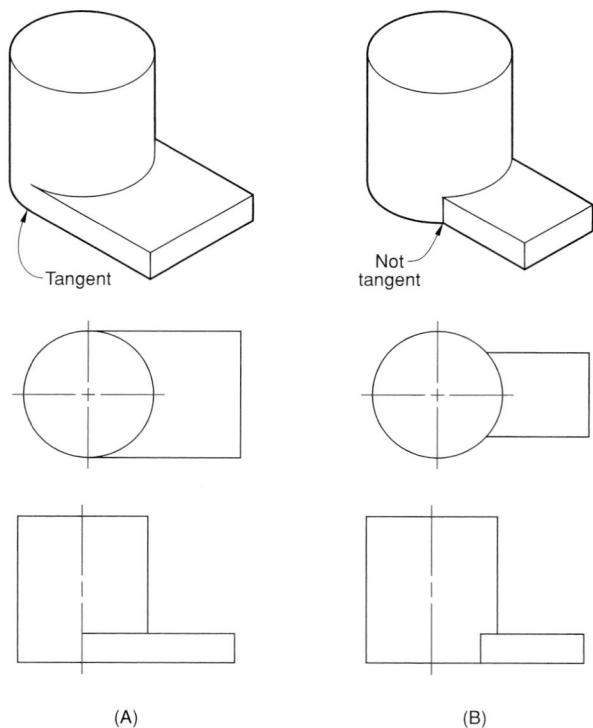**Figure 3.25 Tangent and Nontangent Conditions in 3-D Geometry**

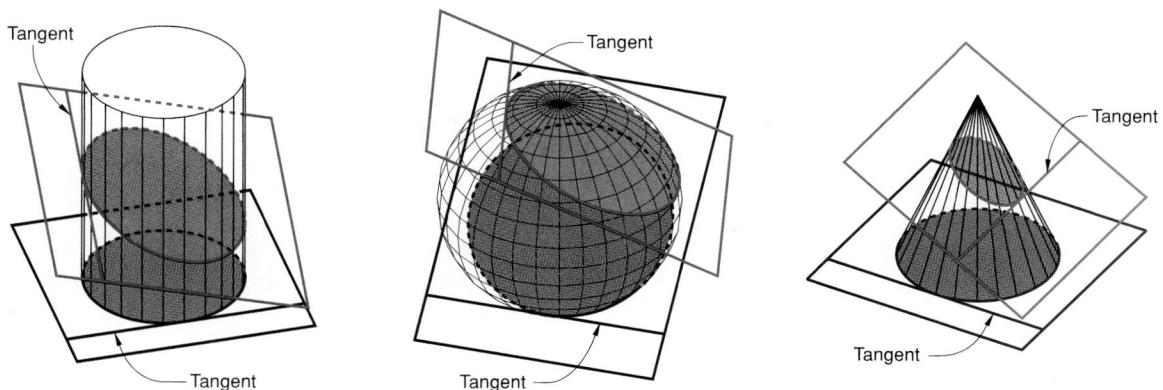

Figure 3.26 Tangent Lines

The lines of intersection between each plane and each solid are tangent conditions, as are lines that touch a surface at a single point.

Practice Exercise 3.6

Using physical models of spheres, cylinders, cones, and planes, create points/lines of tangencies.

Using 2-D and 3-D computer models, use transformation commands (MOVE, ROTATE, and OBJECT SNAP) to position objects so that they make contact. Will all conditions of two objects touching at a single point/line result in a tangency? What if there is overlap and they touch at more than one point/line? Use 2-D/3-D Boolean intersect commands to evaluate both tangent and nontangent relationships.

Tangent construction is an important part of technical drawing. With traditional tools, tangencies are constructed using triangles and a compass. With CAD, tangent construction is performed automatically, using TANGENT point snap commands.

Locating the Point of Tangency between a Circle or Arc and a Line The point of tangency between a circle or arc and a line is determined by drawing a line through the center of the circle or arc and perpendicular to the tangent line. (Figure 3.27A) A CAD system automatically determines points of tangency, which are represented as nodes in the database. 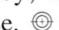

Locating the Point of Tangency between Two Circles The point of tangency between two circles or arcs is located by drawing a line between the two centers of the circles or arcs; where the line intersects the circles is the point of tangency. (Figure 3.27B) With CAD, the point of tangency is found by using the INTERSECTION option to snap onto the tangent point.

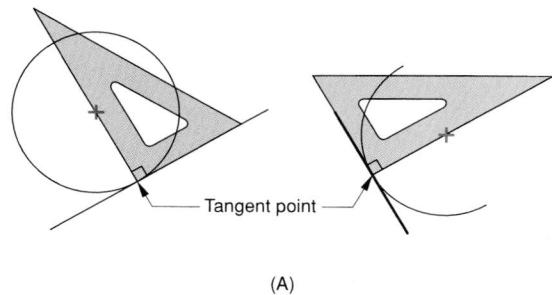

(A)

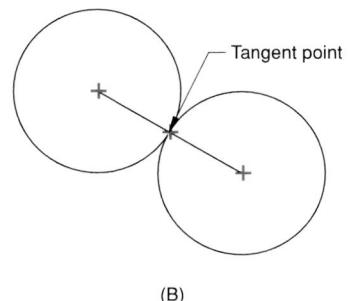

(B)

Figure 3.27 Locating Tangent Points on Circles and Arcs

Drawing an Arc Tangent to a Line at a Given Point on that Line An arc can be drawn tangent to a given line at a point on that line by constructing a perpendicular to the line through the point, marking the radius of the arc on the perpendicular line (i.e., locating the center of the arc), and using a compass to draw the arc. (Figure 3.28)

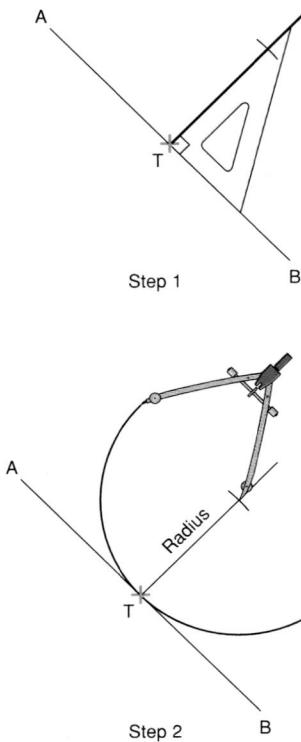

Figure 3.28 Drawing an Arc Tangent to a Line at a Given Point on the Line

Constructing an Arc Tangent to a Line at a Given Point on that Line

Step 1. Given line AB and tangent point T, construct a line perpendicular to line AB and through point T.

Step 2. Locate the center of the arc by marking the radius on the perpendicular line. Put the point of a compass at the center of the arc, set the compass for the radius of the arc, and draw the arc, which will be tangent to the line through the point T.

Drawing an Arc Tangent to Two Lines To draw an arc tangent to two lines that form a right angle, use the following steps. (Figure 3.29A)

Constructing an Arc Tangent to Two Lines at a Right Angle

Step 1. Set the compass to the desired radius, place the compass point at the intersection of the two given lines, and draw an arc. The intersections of the arc with the lines are labeled A and B.

Step 2. Using the same radius, set the compass point at A and draw an arc, and do the same at point B. The intersection of these two arcs is the center C of the tangent arc.

Step 3. Again using the same radius, set the compass point at C and draw an arc tangent to each line, at points A and B.

To draw an arc tangent to two lines that form an obtuse or acute angle, use the following steps. (Figure 3.29B and C)

Constructing an Arc Tangent to Two Lines Forming an Obtuse or Acute Angle

Step 1. Draw lines parallel to the two given lines at a distance equal to the radius of the arc. Where the two parallel lines intersect locates the center C of the arc.

Step 2. Draw lines from the center C perpendicular to the given lines. This locates the points of tangency A and B.

Step 3. With C as the center and the compass set at the given radius, draw an arc tangent to each line, at points A and B.

Most CAD systems have a method that automatically locates the tangent points when creating an arc tangent to two given lines. © CAD Reference 3.14

Drawing an Arc Tangent to a Line and an Arc If you have a given line and a given arc that cannot intersect, you can draw a defined-radius arc tangent to both the given line and given arc, using the following procedure. (Figure 3.30A)

Constructing an Arc Tangent to a Line and an Arc

Step 1. Draw a line parallel to the given line at a distance equal to the defined radius of the tangent arc. For our example, the defined radius of the tangent arc is 0.75", the given line is AB, and the given arc has its center at C.

Step 2. Draw a construction arc from center C. The radius of the construction arc is equal to the sum of the defined radius of the tangent arc plus the radius of the given arc.

Step 3. The intersection point between the construction arc and the parallel line is the center N for the tangent arc. Draw the tangent arc with the defined radius and the center N. To locate the point of tangency between the given arc and the tangent arc, draw a line connecting the centers of the two arcs; the intersection of this line with the two arcs is the point of tangency T2. To locate the point of tangency between the given line and the tangent arc, draw a line perpendicular to line AB and through the center N of the tangent arc; the intersection of this perpendicular line with the given line is the point of tangency T1.

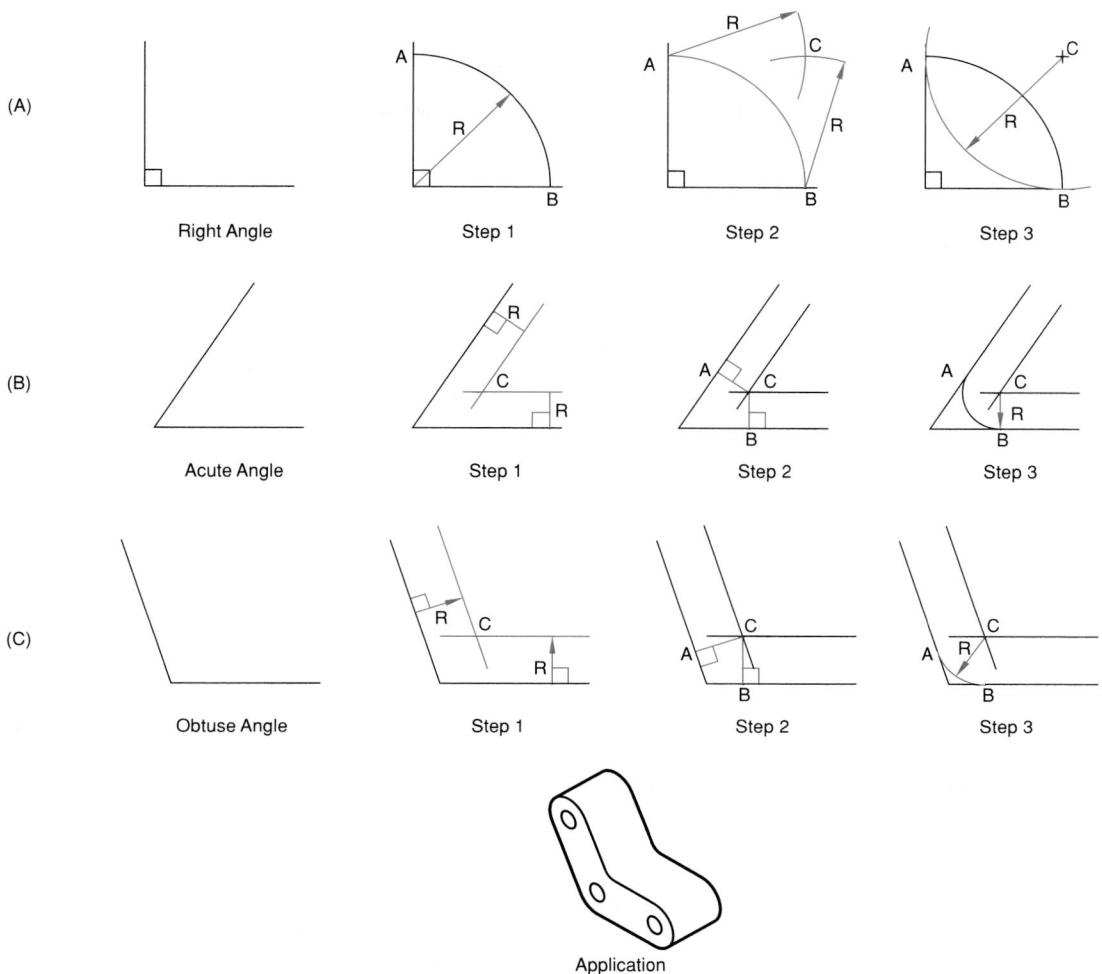

Figure 3.29 Constructing Arcs Tangent to Two Lines

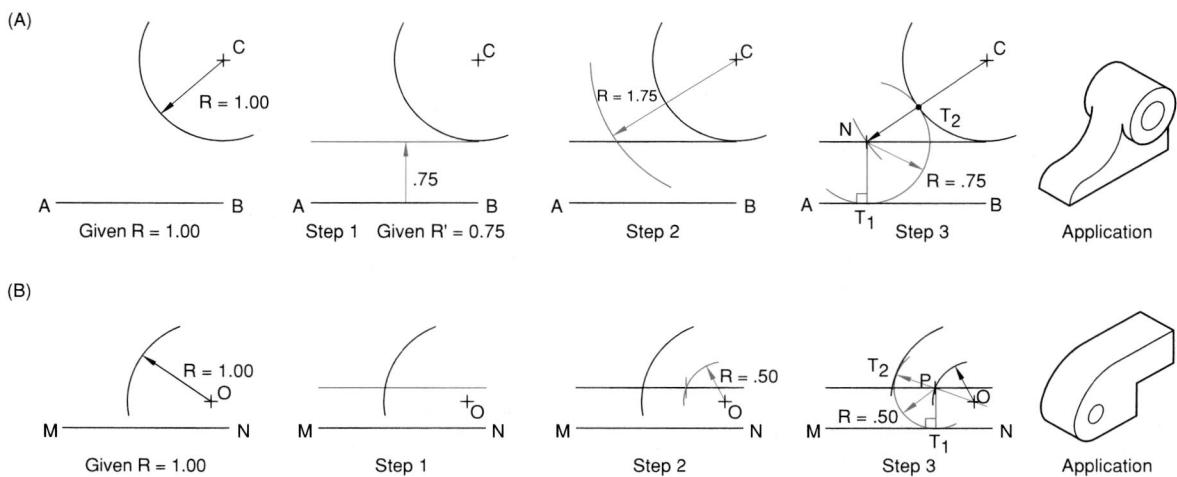

Figure 3.30 Constructing an Arc Tangent to a Line and Another Arc

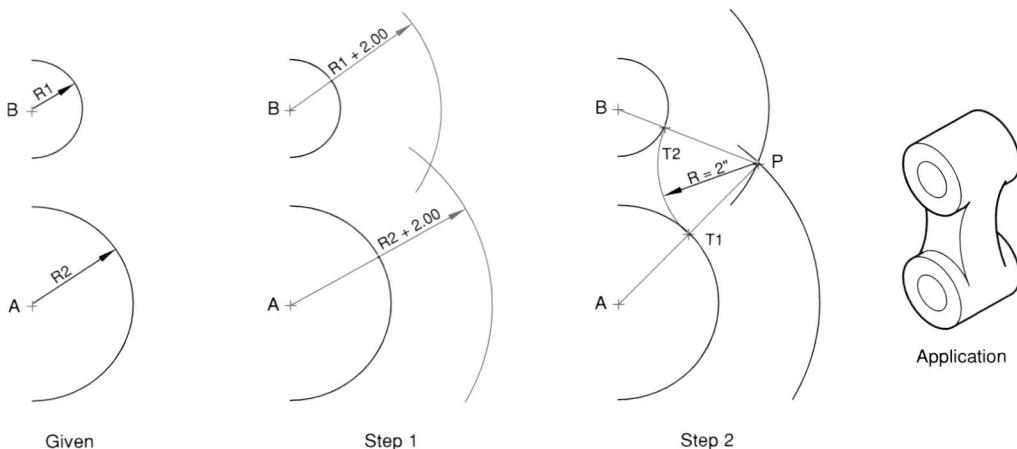**Figure 3.31**

Construct an arc tangent to two given arcs or circles by locating the center of the tangent arc, then drawing the tangent arc.

If you have a given line and a given arc that can intersect, you can draw a defined-radius arc tangent to both, using the following procedure. Note: The defined radius of the tangent arc must be less than the radius of the given arc. (Figure 3.30B) © CAD Reference 3.15

Constructing an Arc Tangent to a Line and an Arc that Intersect

Step 1. Draw a line parallel to the given line at a distance equal to the defined radius of the tangent arc. For our example, the given line is MN, the center of the given arc is O and its radius is R, and the defined radius of the tangent arc is 0.5".

Step 2. Draw a construction arc from center O. The radius of the construction arc is equal to the radius R of the given arc minus the radius 0.5" of the tangent arc.

Step 3. The intersection point between the construction arc and the parallel line is the center point P of the tangent arc. Draw an arc using center point P and radius 0.50" between the given arc and line. To locate the tangent point between the given arc and the tangent arc, draw a line connecting their centers O and P; the point where this connecting line intersects the two arcs is the point of tangency T2. To locate the tangent point between the given line and the tangent arc, draw a line perpendicular to the given line and through the center P of the tangent arc; the point where this perpendicular line intersects the given line is the point of tangency.

Drawing an Arc Tangent to Two Arcs If you have two given arcs that cannot intersect, you can draw a defined-radius arc tangent to both given arcs, using the following procedure. (Figure 3.31) For our example,

one given arc has a radius of R1 and a center A, the second given arc has a radius R2 and a center B, and the tangent arc has a defined radius of 2".

Drawing an Arc Tangent to Two Arcs that Cannot Intersect

Step 1. Using a radius equal to 2" plus R1, draw a construction arc from center A. Using a radius equal to 2" plus R2, draw a second construction arc from center B.

Step 2. The intersection point of the two construction arcs is the center P of the tangent arc. Using the defined radius of 2", draw the tangent arc from center P. Draw a line from center B to P and from center N to P, to locate the points of tangency with the two given arcs.

If you have two given arcs that can intersect, you can draw a defined-radius arc tangent to both given arcs, using the following procedure. (Figure 3.32) For our example, one given arc has a radius of R1 and a center M, the other given arc has a radius R2 and a center N, and the tangent arc has a defined radius of 0.5". © CAD Reference 3.16

Drawing an Arc Tangent to Two Arcs that Can Intersect

Step 1. Using a radius equal to R1 minus 0.5", draw a construction arc from center M. Using a radius equal to 0.5" plus R2, draw a construction arc from center N. The intersection point of the two construction arcs is the center P of the tangent arc.

Step 2. Using the defined radius of 0.5" draw the tangent arc from center P. Draw lines from center M to P and from center N to P, to locate the tangent points T1 and T2.

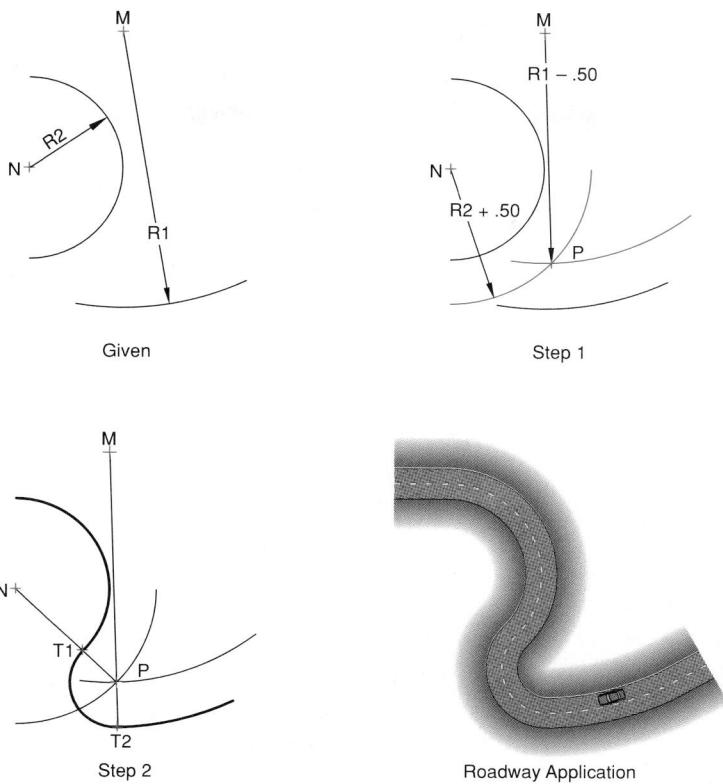**Figure 3.32**

Construct an arc tangent to two given arcs by locating the centers of the given arcs, then drawing the tangent arc.

Figure 3.33 shows two other examples of arcs constructed tangent to given arcs. In Figure 3.33A, the radius AB of the tangent arc to be drawn is subtracted from the radius of given arc M . Using the center of arc M , construct an arc opposite the side of the tangent arc. The second construction arc is drawn by using the center of given arc N and a radius equal to AB minus the radius of arc N . Draw the tangent arc using radius AB with the center O located at the intersection of the construction arcs. To construct tangent points T_1 and T_2 , draw a line from center O through the centers of the given arcs.

Figure 3.33B shows the construction necessary for a special case. The steps are nearly identical to those in Figure 3.33A, except the radius of the smaller arc C is added to the radius of the tangent arc EF to find the center point P .

Drawing Lines Tangent to Two Circles To draw lines tangent to two circles that do not intersect, use

the following procedure. (Figure 3.34) Note that the tangent lines can cross each other. Note also that this is partially a trial and error method.

Drawing Lines Tangent to Two Circles

Step 1. Construct lines tangent to the circles using a T-square and triangle or two triangles. The tangent lines are created by aligning one side of the triangle between the two circles so that it is tangent to both circles. Slide the triangle so that the other edge passes through the center of one of the circles, and mark the point of tangency on the circumference of the circle. Then slide the triangle until the side aligns with the center of the other circle, and mark the point of tangency along the circumference of the circle. Slide the triangle so that it aligns with the points of tangency and draw the line. Draw the second line using the same steps.

Step 2. After the tangent line is drawn, the tangent points are labeled by drawing a line from the centers of the circles perpendicular to the tangent lines, as shown in Figure 3.34.

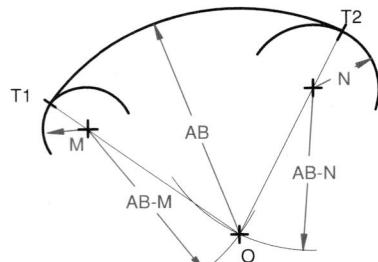

(A)

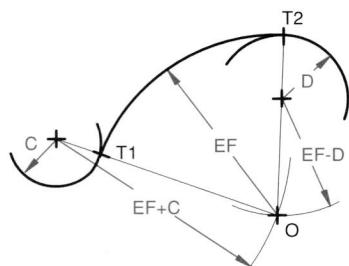

(B)

Figure 3.33 Construction of an Arc Tangent to a Given Arc

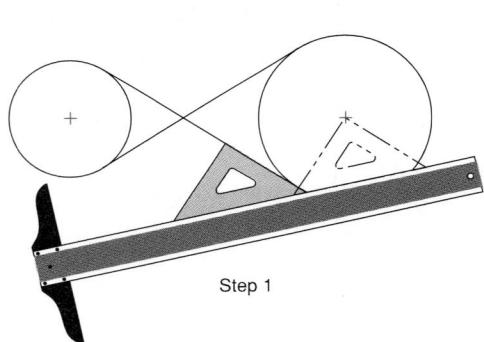

Step 1

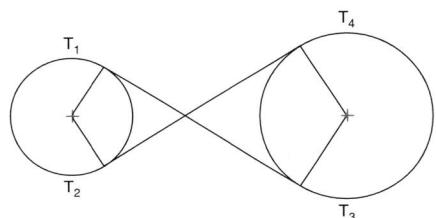

Step 2

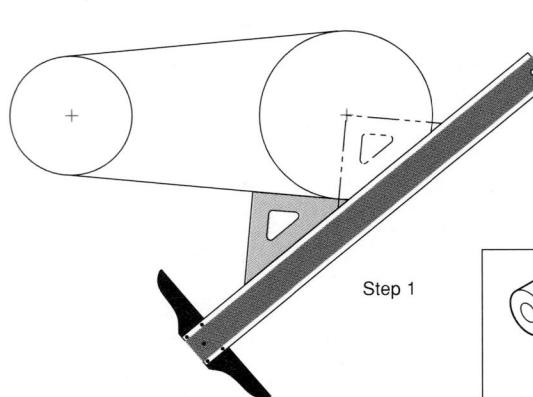

Step 1

Application

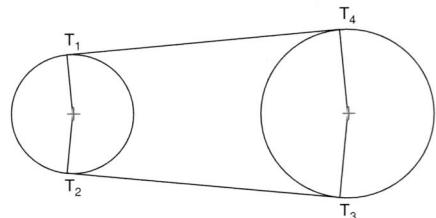

Step 2

Figure 3.34 Constructing Lines Tangent to Two Circles or Arcs, Using a Straightedge

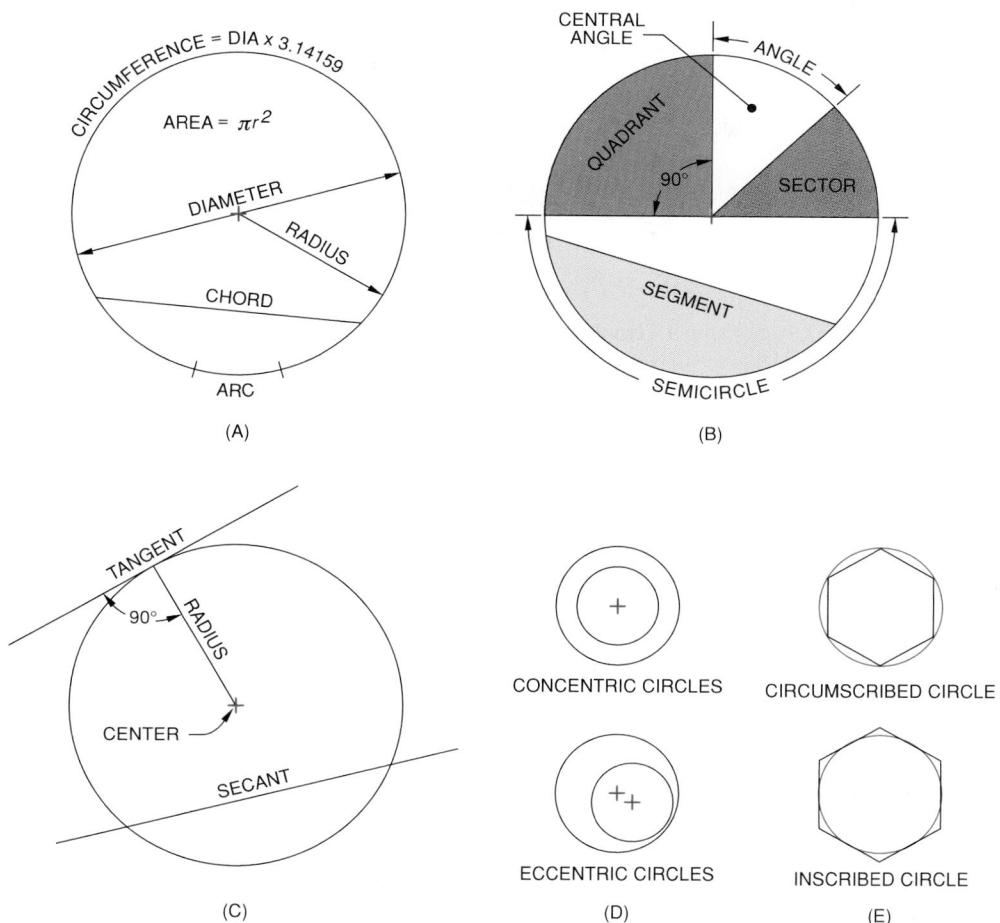

Figure 3.35 Circle Definitions

A circle is a single-curved plane with all points at an equal distance from a point called the center. The important features of a circle are shown.

CAD systems draw lines tangent to two circles using the LINE command and a TANGENT snap feature that automatically determines the points of tangency when the circles are selected. **CAD Reference 3.17**

3.5.4 Circles

A **circle** is a single-curved-surface primitive, all points of which are equidistant from one point, the center. A circle is also created when a plane passes through a right circular cone or cylinder and is perpendicular to the axis of the cone.

The elements of a circle are as follows (Figure 3.35):

Center. The midpoint of the circle.

Circumference. The distance all the way around the circle.

Radius. A line joining the center to any point on the circumference.

Chord. A straight line joining any two points on the circumference.

Diameter. A chord that passes through the center. The diameter is equal to twice the radius.

Secant. A straight line that goes through a circle but not through the center.

Arc. A continuous segment of the circle.

Semicircle. An arc measuring one-half the circumference of the circle.

Minor arc. An arc that is less than a semicircle.

Major arc. An arc that is greater than a semicircle.

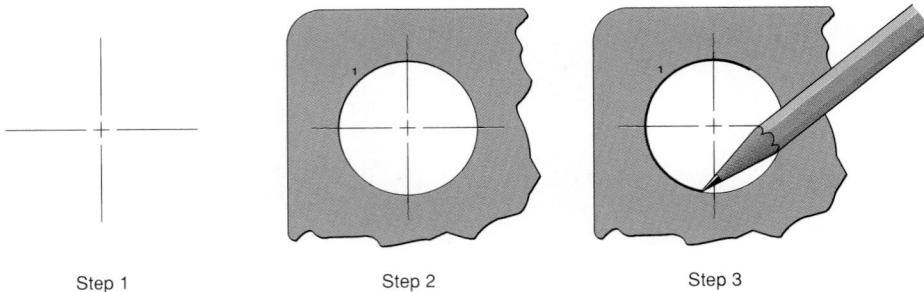

Figure 3.36 Constructing a Circle Using a Template

A circle template can be used instead of a compass to draw circles. The template comes in a series of standard sizes. To construct a circle using a template, align the marks on the template with the center lines for the circle.

Central angle. An angle formed by two radii.

Sector. An area bounded by two radii and an arc, usually a minor arc.

Quadrant. A sector equal to one-fourth the area of the circle. The radii bounding a quadrant are at right angles to each other.

Segment. An area bounded by a chord and a minor arc. The chord does not go through the center.

Tangent. A line that touches the circle at one and only one point.

Concentric circles. Circles of unequal radii that have the same center point.

Eccentric circles. Circles of unequal radii that have different centers, and one circle is inside the other.

Circumscribed circle. A circle drawn outside of a polygon such that each vertex of the polygon is a point on the circle.

Inscribed circle. A circle drawn inside a polygon such that all sides of the polygon are tangent to the circle.

To construct a circle using a compass, refer to Chapter 1.

Drawing a Circle Using a Template Templates are often used to construct circles for technical drawings. The template is made of plastic with multiple holes of various diameters. Each hole is of a specific diameter that is marked on the template, along with guidelines to align the hole with the center lines for the circle to be drawn. (Figure 3.36) The following steps describe how to use a circle template to draw a 1" diameter circle.

Constructing a Circle Using a Template

Step 1. Locate the center of the circle by drawing center lines. (Figure 3.36)

Step 2. Place the circle template over the drawing and align the template so that the 1" circle is over the center lines. Adjust the template so that the center lines align with the marks on the template.

Step 3. Using a pencil, draw the circle by tracing around the hole in the template.

Drawing a Circle through Three Points To draw a circle through three points A, B, and C (Figure 3.37), use the following procedure. **© CAD Reference 3.18**

Drawing a Circle through Three Points

Step 1. Draw lines AB and BC.

Step 2. Draw perpendicular bisectors through lines AB and BC.

Step 3. The center of the circle is the point D where the perpendicular bisectors intersect. Set the compass point at the center D and set the radius to AD, then draw the circle. The circle will pass through the three points A, B, and C.

Locating the Center of a Circle The center of a circle can be located using either of the following procedures.

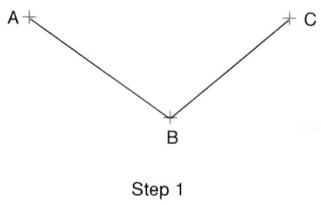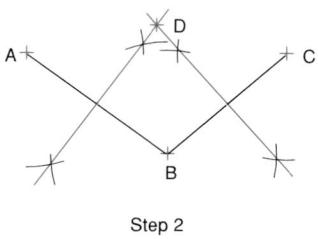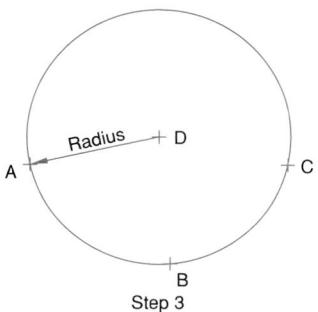

Figure 3.37 Drawing a Circle through Three Points

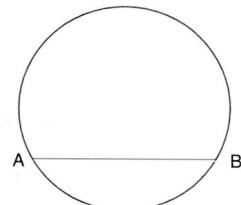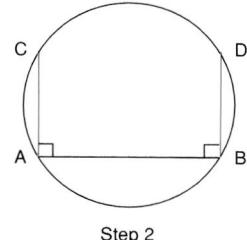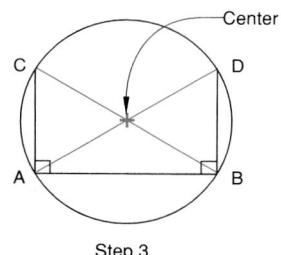

Figure 3.38 Locating the Center of a Circle: Right Triangle Method

Locating the Center of a Circle: Right Triangle Method

Step 1. Draw a chord of any length AB. (Figure 3.38)
Step 2. Construct perpendiculars AC and BD from the ends of the chord.
Step 3. Construct diagonals from CB and DA. The intersection of the diagonals locates the center of the circle.

Locating the Center of a Circle: Chord Method

Step 1. Draw two chords AB and CD anywhere inside the circle. (Figure 3.39)
Step 2. Bisect the two chords and draw the perpendicular bisectors so that they intersect inside the circle. The intersection point between the two perpendicular bisectors is the center of the circle.

CAD systems provide a CENTER snap option that will automatically locate the center of a circle.
 © CAD Reference 3.19

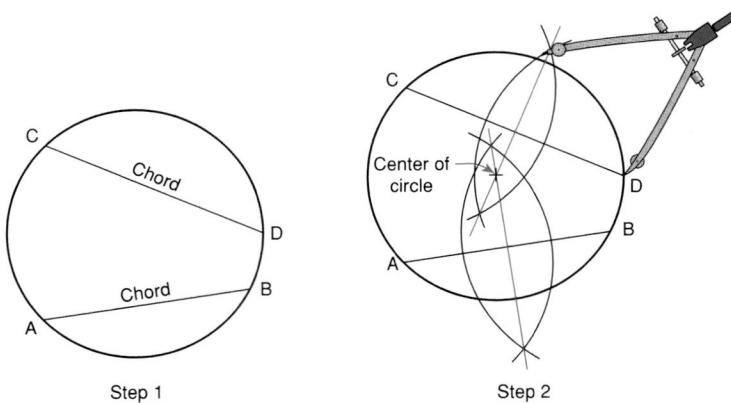

Figure 3.39 Locating the Center of a Circle: Chord Method

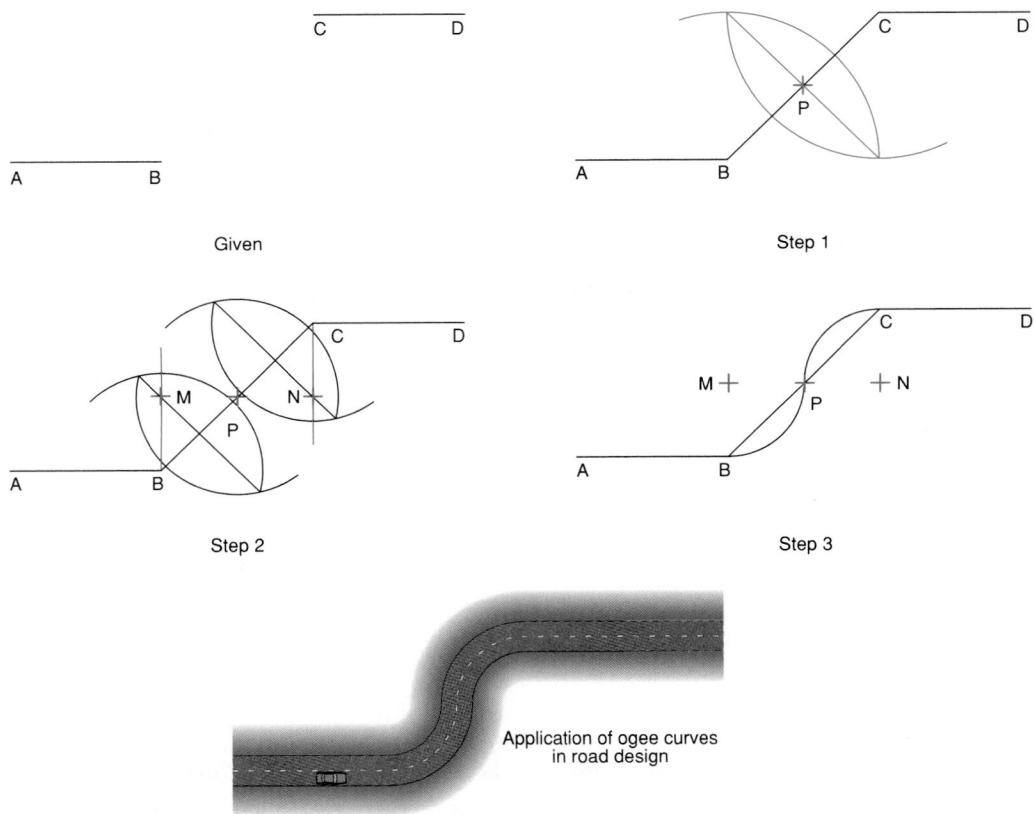

Figure 3.40 Constructing an Ogee Curve between Two Parallel Lines

3.5.5 Ogee Curves

An **ogee curve** is an “S” curve that connects two lines with two arcs to form a smooth curve. If the lines are *parallel*, construct an ogee curve using two equal arcs, as follows. (Figure 3.40)

Constructing an Ogee Curve between Two Parallel Lines

Step 1. Given parallel lines AB and CD, offset from each other, draw line BC and bisect it to find the midpoint P.

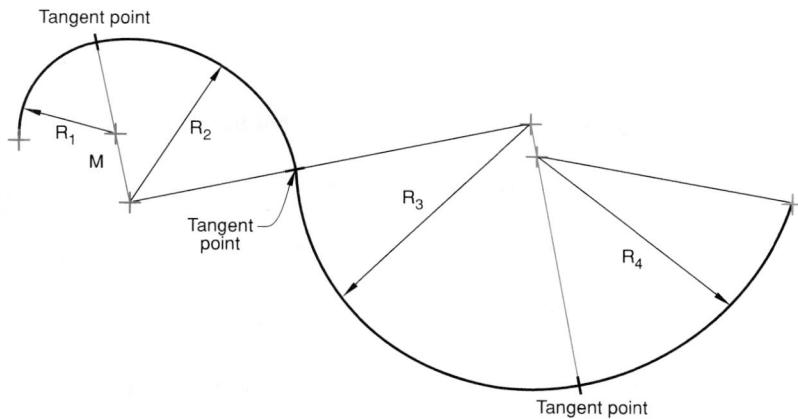

Figure 3.41 Constructing Irregular Curves of Arcs by Drawing a Series of Tangent Arcs

Step 2. Bisect line segments BP and CP. Construct a line perpendicular to line AB through point B, and another line perpendicular to line CD through point C. Make the perpendicular lines long enough to intersect the bisectors of BP and CP; label these intersection points M and N. These are the centers of the two arcs.

Step 3. Draw arcs from centers M and N using radius BM or CN. (They're the same!)

To construct an ogee curve using two arcs of different radii, divide line BC proportionally instead of in half, and use the same procedure as described here.

© CAD Reference 3.20

3.5.6 Irregular Curves of Arcs

An irregular curve can be constructed by drawing a series of tangent arcs. Begin by sketching a series of arcs through the points. By trial and error, draw an arc of radius R_1 and center at M that will closely match the desired curve. The successive centers of the arcs will be on lines through the points of tangency. (Figure 3.41)

3.5.7 Rectified Arcs

Rectifying an arc determines its approximate length along a straight line. (Figure 3.42) Divide the arc into a number of equal parts, using triangles or a protractor. This creates a number of equal chordal distances.

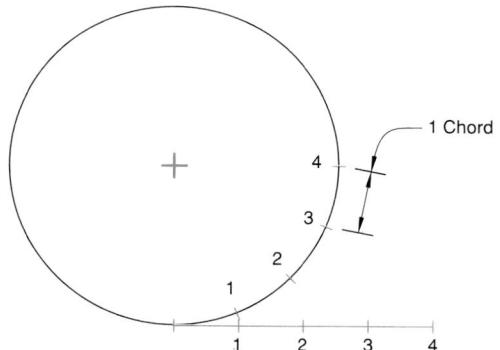

Figure 3.42 Rectifying an Arc by Laying Out Chordal Distances along a Tangent Line

Since the arcs' curves and the chords are not exactly equal in length, each chord is only an approximation of the length of that segment of the arc. Construct a tangent to the arc at one end of the arc. Lay out the chordal distances along the tangent line to approximate the length of the arc.

The mathematical approach would be to find the circumference (c) of the circle from its diameter (d) ($c = \pi d$), determine what part of the circle is the arc, then find the length. For example, an arc of 60 degrees is one-sixth of the full circle (360° divided by 60°). If the circumference of the circle is 6, then the arc length is 1. © CAD Reference 3.21

Industry Application

Computer Design of a New Generation of Amtrak Seats

In 1992 Amtrak installed the first prototypes of a new generation of seats, which had dramatic improvements over previous ones. New features included retractable personalized food tray, adjustable leg and foot rests, adjustable lumbar and headrest cushion assemblies, and capabilities for audio and video service. Development of the complex new design was made easier by creating 3-D solid models of the new seat.

Stress and mechanism kinematic analyses were done using the solid model for the input geometry. This allowed the designers to identify, from the computer model, interferences, pinch points, and small gaps in between the cushions and frame. In the past, getting a perfect fit between the cushions and the frame normally took several prototype stages.

A finite element model was also created from the 3-D geometric model. This analysis made it possible to reduce the weight and materials by 10 to 15 percent relative to traditional designs. Through the use of a computer to model the new seat design, the seats were designed in only four months, compared to an estimate of more than a year using conventional tools.

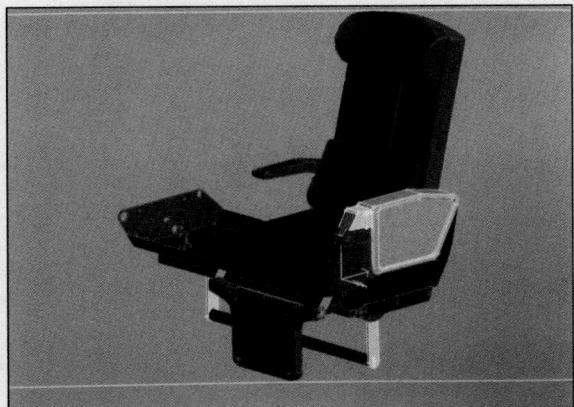

A Solid Model Prototype of the New Generation of Amtrak Seats (Courtesy of Coach and Car Equipment Corp. and the MacNeal-Schwendler Corp.)

Adapted from "Aries Aids Design of New Generation of Amtrak Seats," *ViewPort*, no. 7 (Summer 1992), p. 6.

3.6 CONIC CURVES

Conic curves, or conics, are special case single-curved lines that can be described in several ways: as sections of a cone; as algebraic equations; and as the loci of points. For our purposes, **conics** are the curves formed by the intersection of a plane with a right circular cone, and they include the ellipse, parabola, and hyperbola. (The circle is a special case ellipse.) A right circular cone is a cone that has a circular base and an axis that passes at 90 degrees through the center of the circular base.

Conics are often used in engineering design and in science to describe physical phenomena. No other curves have as many useful properties and practical applications.

3.6.1 Parabolas

A **parabola** is the curve created when a plane intersects a right circular cone parallel to the side of the cone. (Figure 3.43). A parabola is a single-curved-surface primitive. Mathematically, a parabola is defined as the set of points in a plane that are equidistant from a given fixed point, called a *focus*, and a fixed line, called a *directrix*. (Figure 3.43)

Construction of Parabolas A number of different techniques can be used to construct parabolas. Each technique involves locating points along the parabolic path and connecting those points using an irregular curve. In this section, the three methods described for constructing parabolas are mathematical, tangent, and parallelogram.

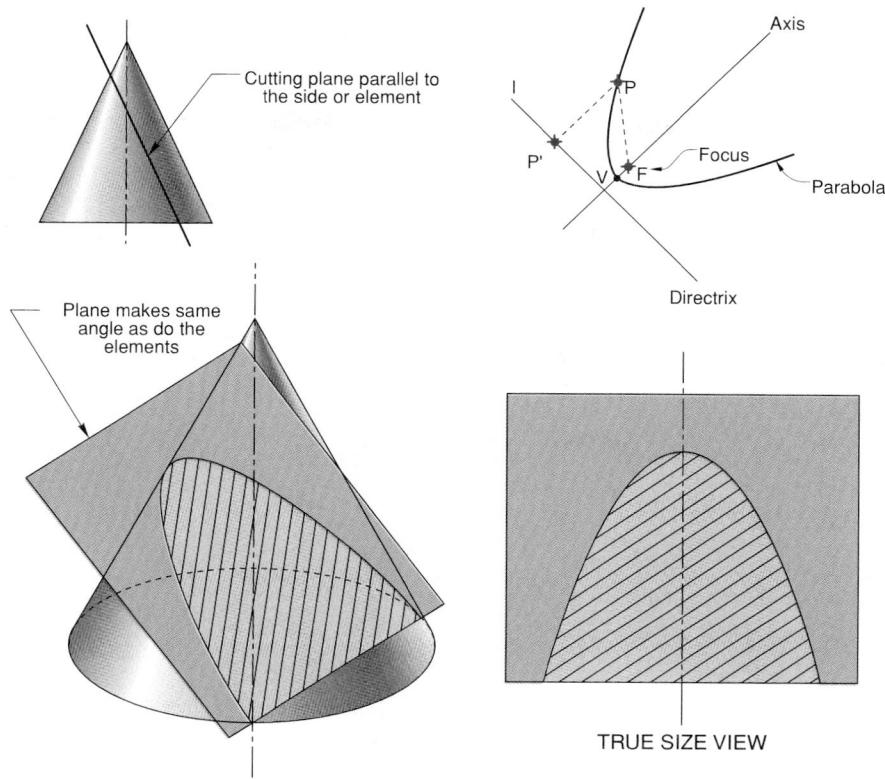

Figure 3.43 Parabola

A parabolic curve is created by passing a plane through a cone, with the plane parallel to the side of the cone. A parabolic curve is defined mathematically as a set of points that are equidistant from a focus point and a directrix.

Constructing a Parabola: Parallelogram Method

Step 1. Draw a rectangle or parallelogram to contain the parabola. Locate its axis parallel to the sides and at the midpoint of the base. Label this midpoint as O. (Figure 3.44)

Step 2. Divide the sides into equal parts, divide the base into twice that number of parts, and number the parts. Connect the points on the vertical sides with point O.

Step 3. Through the parts marked on the base, construct lines that intersect the lines drawn in Step 2 and are parallel to the sides.

Step 4. Using an irregular curve, construct a curve through the points of intersection. Repeat Steps 1 through 4 to complete the other side of the parabola.

Some CAD systems can automatically produce a parabola, once the directrix is defined, the focus is located, and the endpoints of the parabola are located. If

the parabola cannot be generated given the conditions defined by the user, an error message will be displayed. If the CAD system does not have a PARABOLA command, the construction techniques described in this section can be used to create points that can then be connected using a SPLINE command.

© CAD Reference 3.22

Engineering Applications of Parabolas Parabolas have a unique reflective property, as shown in Figure 3.45. Rays originating at a parabola's **focus** are reflected out of the parabola parallel to the axis, and rays coming into the parabola parallel to the axis are reflected to the focus. Parabolas are used in the design of mirrors for telescopes, reflective mirrors for lights, such as automobile headlights, cams for uniform acceleration, weightless flight trajectories, antennae for radar systems, arches for bridges, and field microphones commonly seen on the sidelines of football games.

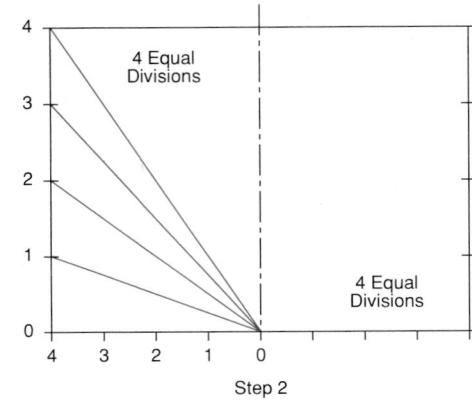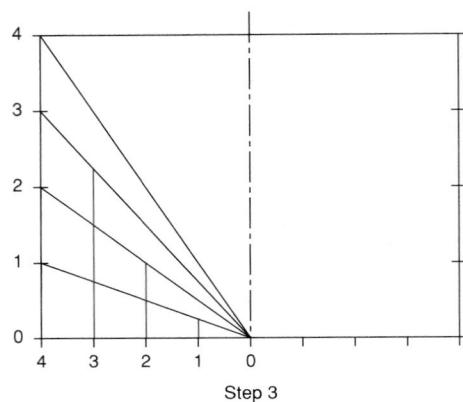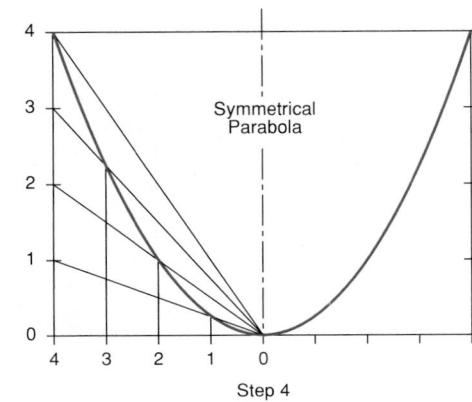

Figure 3.44 Parallelogram Method of Drawing a Parabola

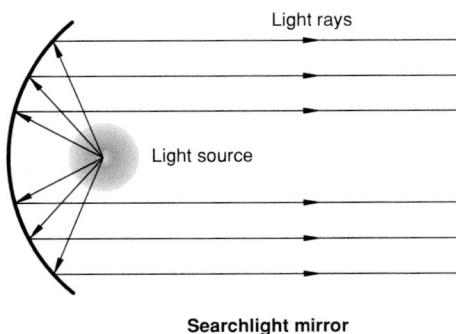

Searchlight mirror

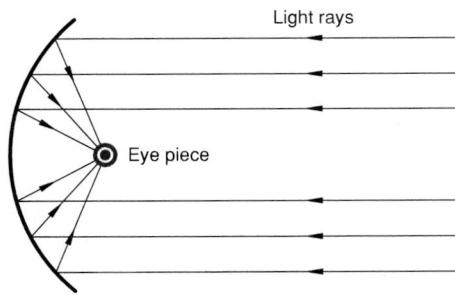

Telescope mirror

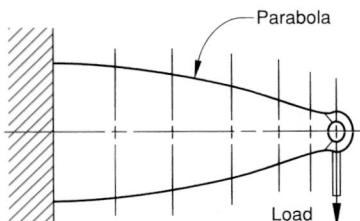

Beam of uniform strength

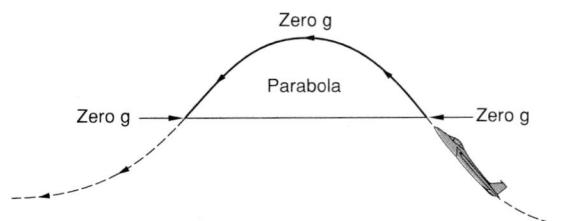

Weightless flight trajectory

Figure 3.45 Engineering Applications for a Parabola

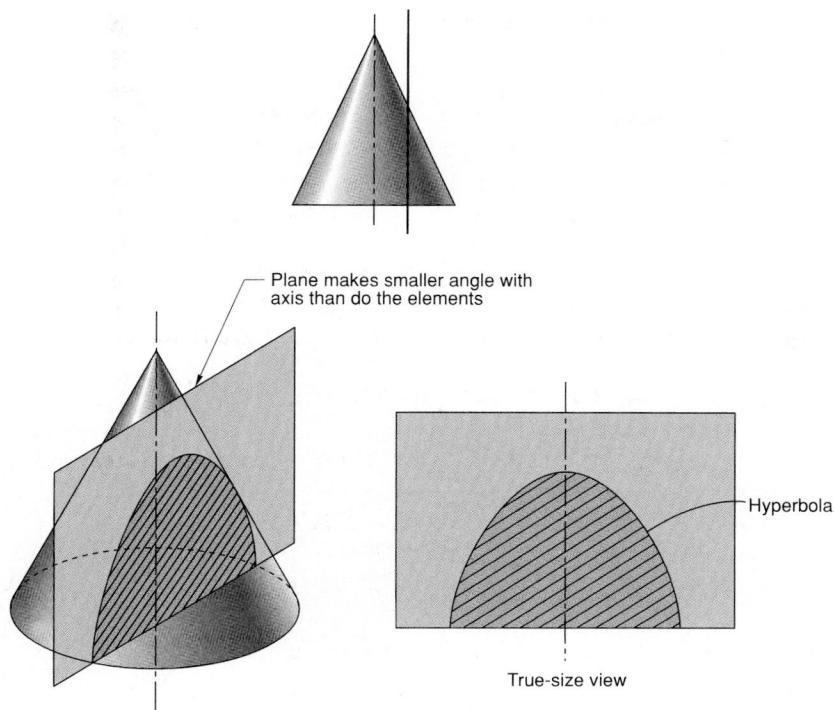

Figure 3.46 Hyperbola

A hyperbola is created by passing a plane through a cone at a smaller angle with the axis than that made by the elements.

A parabola revolved about its axis generates a 3-D ruled surface called a **paraboloid**. An auditorium ceiling in the shape of a paraboloid reduces reverberations if the speaker is standing near the focus.

3.6.2 Hyperbolas

A **hyperbola** is the curve of intersection created when a plane intersects a right circular cone and makes a smaller angle with the axis than do the elements. (Figure 3.46) A hyperbola is a single-curved-

surface primitive. Mathematically, a hyperbola is defined as the set of points in a plane whose distances from two fixed points, called the *foci*, in the plane have a constant difference. (Figure 3.47)

Construction of Hyperbolas A hyperbola is constructed by locating points along its path, then connecting those points using an irregular curve. Two methods of constructing hyperbolas are the mathematical method and the equilateral hyperbola method.

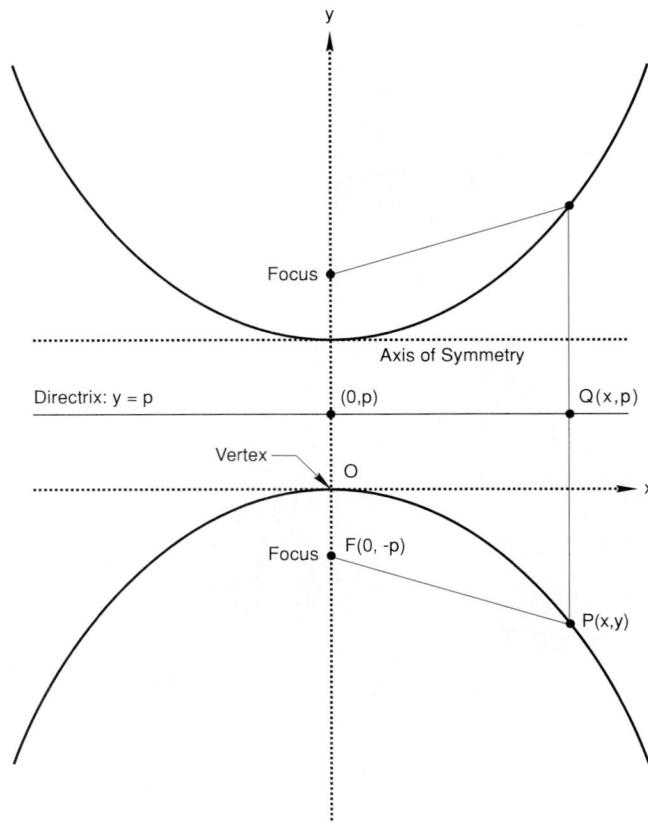

Figure 3.47 Mathematical Definition of a Hyperbola

Constructing a Hyperbola: Mathematical Method

One way of constructing a hyperbola is to use the mathematical definition. (Figure 3.48)

Step 1. Draw the axis, called the *axis of symmetry*, and construct a perpendicular through the axis. Locate focal points F equidistant from the perpendicular and on either side of it. Locate points A and B on the axis equidistant from the perpendicular. These points will be on the curve.

Step 2. Select radius $R1$, use the focal points as the centers, and draw the arcs. Then add $R1$ and AB , use the result as the radius, and draw a second set of arcs, using the focal points as centers. The intersections of the two arcs on each side of the perpendicular are points along the path of the hyperbola.

Step 3. Select a new radius $R2$ and repeat Step 2. Continue this process until several points on the hyperbola are marked.

Step 4. Using an irregular curve, draw a smooth curve through the points, to create the hyperbola.

Some CAD systems have a command that will automatically construct a hyperbola after the given parameters are entered. If there is not such a command, the construction techniques described here can be used. Locate points and use a SPLINE command to connect the points. 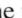 **CAD Reference 3.23**

Engineering and Science Applications of Hyperbolas Hyperbolic paths form the basis for the Long Range Navigation (LORAN) radio navigation system. Hyperbolas are also important in physics, as Einstein discovered in his theory of relativity. Ernest Rutherford discovered that when alpha particles are shot towards the nucleus of an atom, they are repulsed away from the nucleus along hyperbolic paths. In astronomy, a comet that does not return to the sun follows a hyperbolic path.

Reflecting telescopes use elliptical, hyperbolic, and paraboloid mirrors, as shown in Figure 3.49. Light

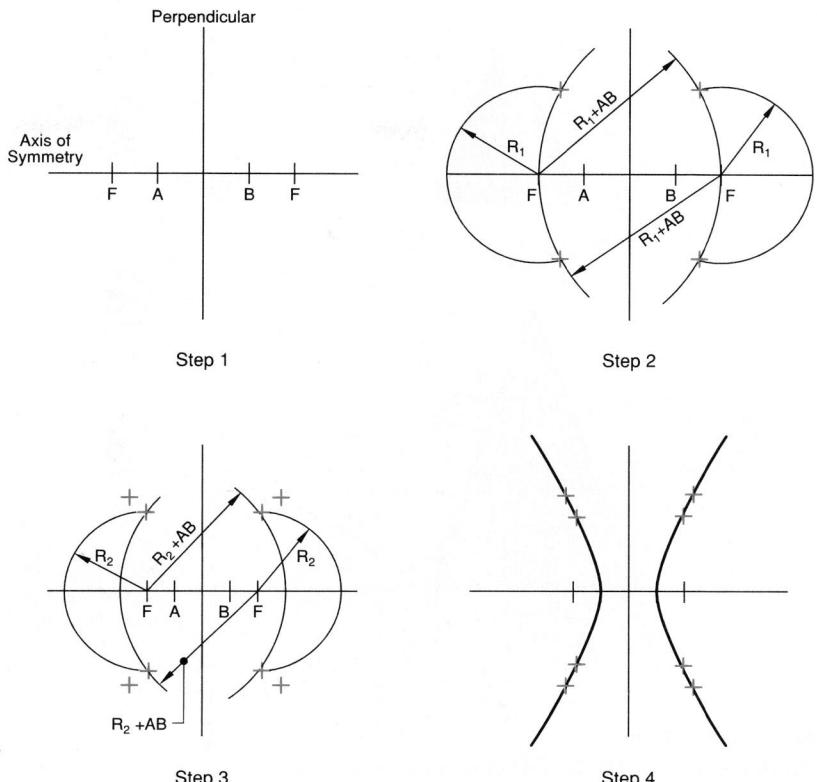

Figure 3.48 Mathematical Method of Constructing a Hyperbola

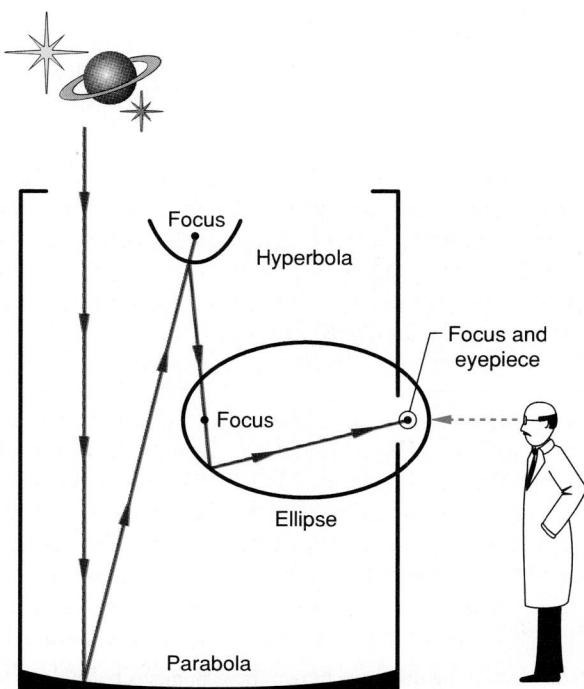

Figure 3.49 Schematic Representation of a Telescope that Uses Hyperbolic, Parabolic, and Elliptical Mirrors

from a celestial body reflects off a primary parabolic mirror at the base of the telescope and heads to the focus of the parabola. A hyperbolic mirror is positioned such that the focus of the parabola and one focus of the hyperbola are in the same plane. The light reflecting from the parabolic mirror reflects off the hyperbolic mirror and goes through the second focus of the hyperbola. This focus is shared with the focus of a partial elliptical mirror. The light is then reflected through the other focus of the ellipse, which is where the eyepiece of the telescope is located.

3.6.3 Ellipses

An **ellipse** is a single-curved-surface primitive and is created when a plane passes through a right circular cone at an angle to the axis that is greater than the angle between the axis and the sides. (Figure 3.50) Also, a circle, when viewed at an angle, appears as an ellipse. (Figure 3.51) Mathematically, an ellipse is the set of all points in a plane for which the sum of the distances from two fixed points (the foci) in the plane is constant. (Figure 3.52) The **major diameter** (major axis) of an ellipse is the longest straight-line

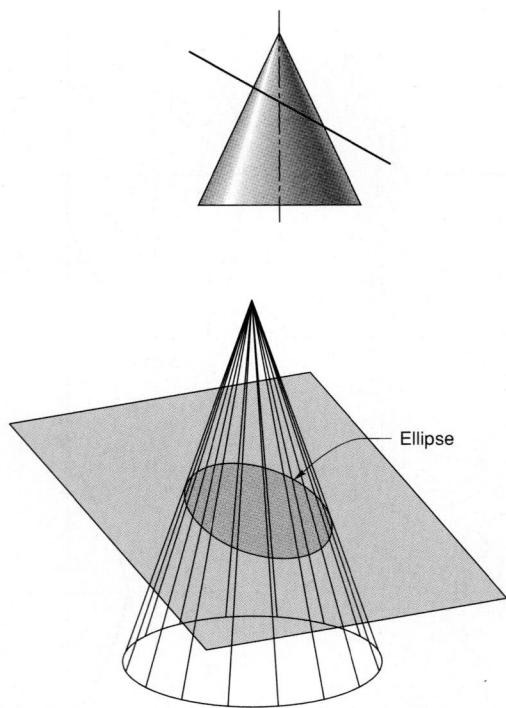

Figure 3.50 Ellipse

An ellipse is formed by the line of intersection between an inclined plane and a cone.

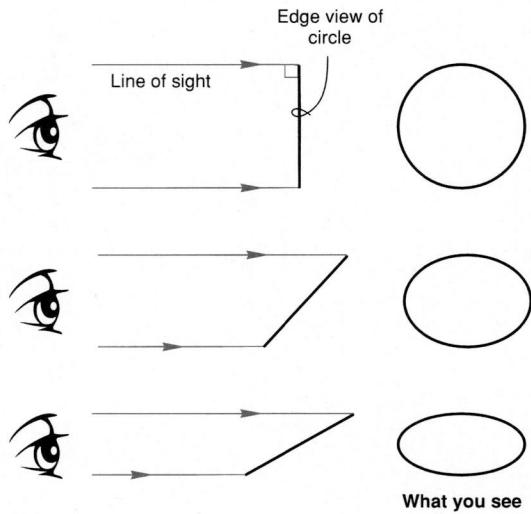

Figure 3.51 Line of Sight to Create Ellipses

A line of sight other than 90 degrees changes the appearance of a circle to an ellipse.

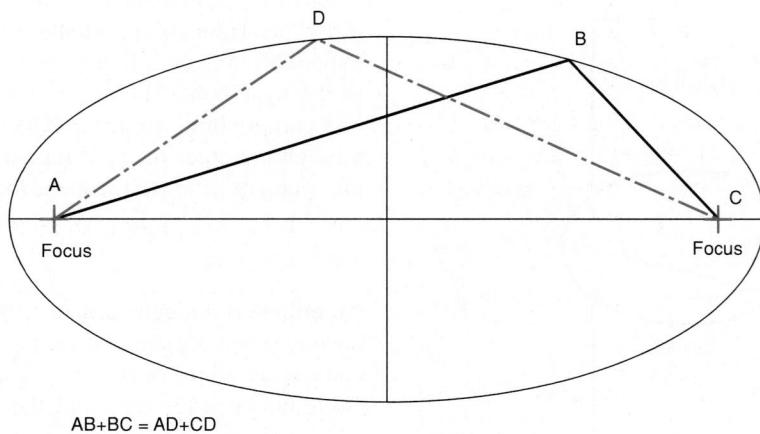

Figure 3.52 Mathematical Definition of an Ellipse

An ellipse is mathematically defined as the set of points for which the sum of the distances to two focus points is constant.

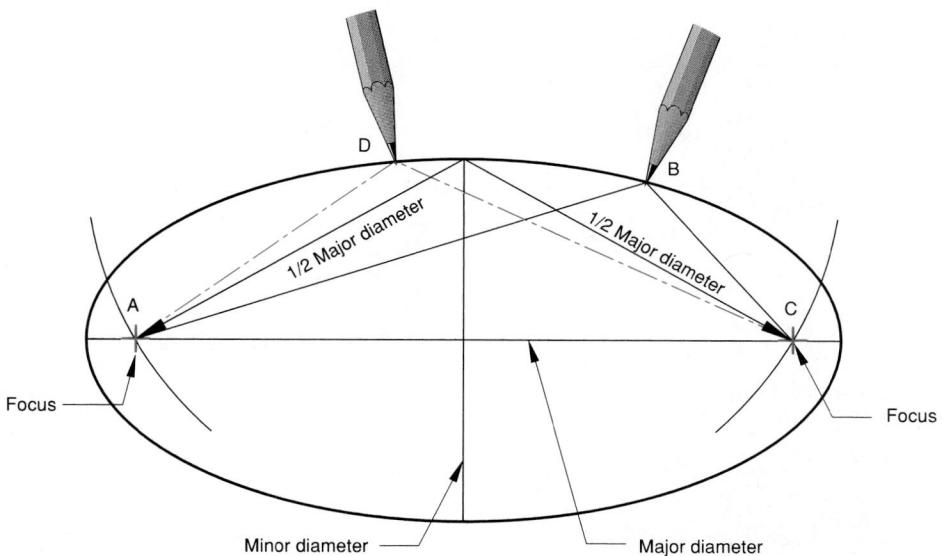

Figure 3.53 Ellipse Construction

An ellipse can be constructed using a pencil and a string fixed at the focus points.

distance between the sides and is through both foci. The **minor diameter** (minor axis) is the shortest straight-line distance between the sides and is through the bisector of the major axis. The foci are the two points used to construct the perimeter and are on the major axis.

Construction of Ellipses A number of techniques can be used to construct ellipses. Some are more accurate than others. The construction techniques described here include the mathematical, foci, trammel, concentric circle, approximate, and template methods.

An ellipse can be constructed using the mathematical definition by placing a looped string around the two foci and using a pencil to draw the ellipse. (Figure 3.53)

Constructing a Foci Ellipse

Define AB as the major diameter and CD as the minor diameter of an ellipse. (Figure 3.54)

Step 1. To locate the foci, set a compass to half the major diameter, position the compass point at one end of the minor diameter (C or D), and draw an arc that intersects the major diameter. Repeat for the other end of the minor diameter. The foci X and Y are located where the constructed arcs intersect the major diameter.

Step 2. Mark a number of points along line segment XY. A greater number of points will increase the accuracy of the constructed ellipse. (The points do not have to be equidistant from each other.)

Step 3. Set the compass to radius B1, then draw two arcs using Y as the center. Set the compass to radius A1, then draw two arcs using X as the center. The two arcs will intersect in the upper-left and lower-left quadrants and the intersections are points on the ellipse. Repeat this step for all the remaining points.

Step 4. Use an irregular curve to connect the points, thus drawing the ellipse.

Section 2.2.2 “Curved Lines,” describes how to sketch an ellipse using a trammel. To draw, rather than just sketch, the ellipse, use an irregular curve to connect the points identified by the trammel.

Constructing an Approximate Ellipse

Step 1. Define axes AB and CD and draw line AC. (Figure 3.55)

Step 2. Use point P as the center and AP as the radius, and draw an arc AX with a compass.

Step 3. Use point C as the center and CX as the radius, and draw the arc XY with a compass.

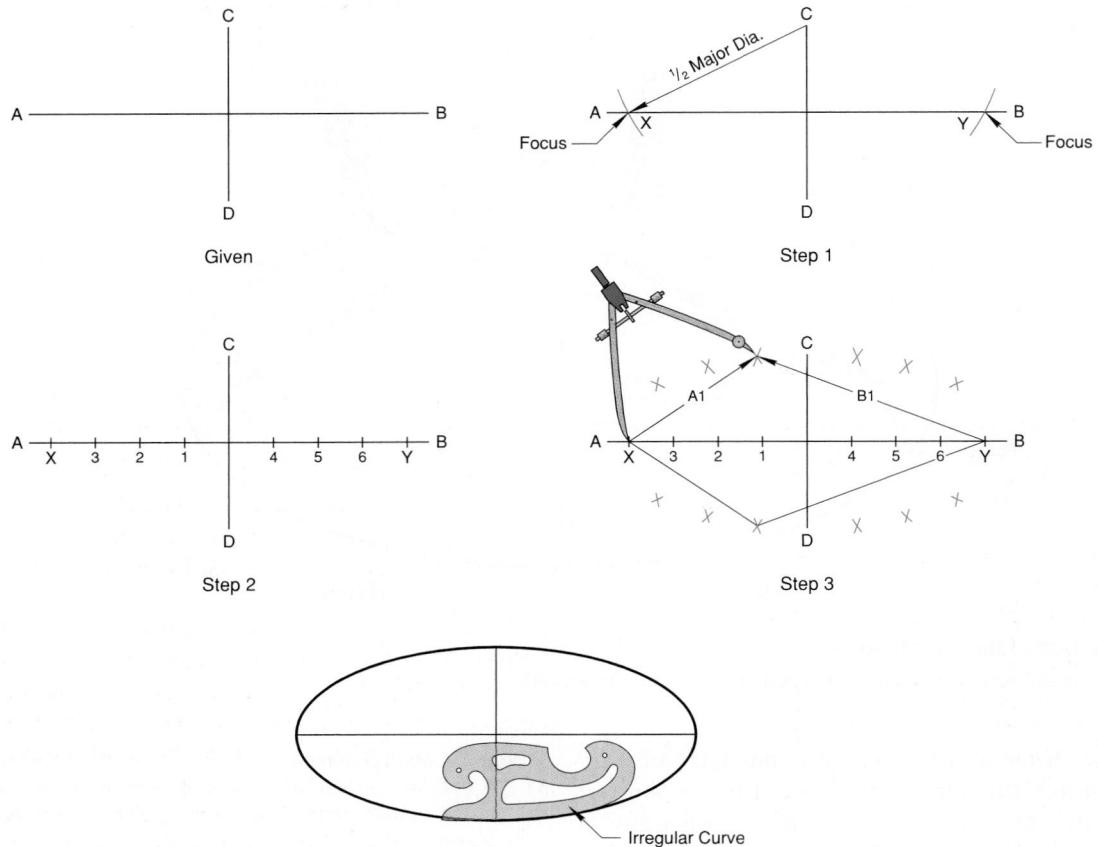

Figure 3.54 Constructing a Foci Ellipse

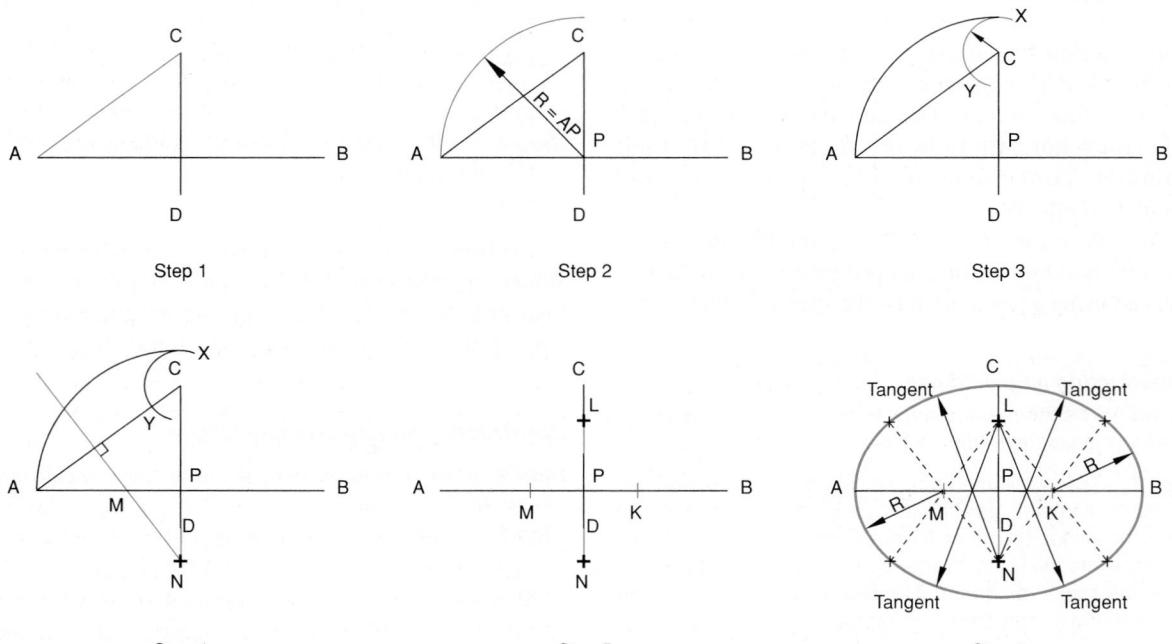

Figure 3.55 Constructing an Approximate Ellipse

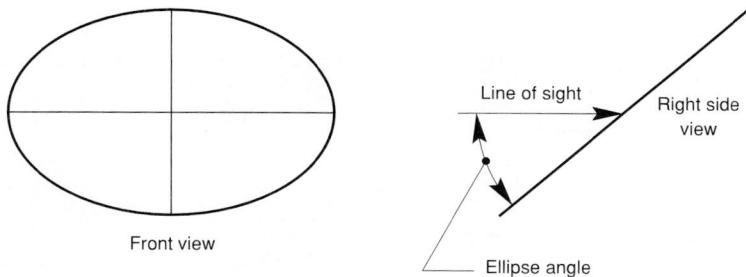

Figure 3.56 Viewing Angle Determines Ellipse Angle

The viewing angle relative to the circle determines the ellipse template to be used. The circle is seen as an inclined edge in the right side view and foreshortened (as an ellipse) in the front view. The major diameter is equal to the diameter of the circle.

Step 4. Construct the perpendicular bisector of line AY, and extend the bisector until it intersects the major diameter at M and the minor diameter (extended) at N.

Step 5. Locate K on the major diameter by setting distance MP equal to KP. Locate L on the minor diameter (extended) by setting NP equal to LP. Points M, N, K, and L are centers of arcs used to create the approximate ellipse.

Step 6. From point M, draw an arc with a radius of MA; from point K, draw an arc with a radius of KB (which is the same as MA); from point N, draw an arc with a radius of NC; from point L, draw an arc with a radius of NC. Draw construction lines from the centers M, N, K, and L, through the arcs drawn from those centers, to locate points of tangency.

Ellipse templates come in intervals of 5 degrees, such as 20, 25, and 30. The viewing angle relative to the circle determines the ellipse template to be used. (Figure 3.56) Each ellipse has a set of center lines marked on the plastic to align with the major and minor diameters drawn on the paper.

Constructing an Ellipse Using a Template

Step 1. To draw an ellipse using a template, draw the major and minor diameters for the ellipse. (Figure 3.57) Determine the angle and find the applicable ellipse template. Determine which ellipse on the template most closely matches the major and minor diameters.

Step 2. Line the template ellipse marks along the major and minor diameters and draw the ellipse, using the template as a guide.

A CAD system will automatically create an ellipse once the major and minor diameters are specified and the location of the center point (the intersection of the

major and minor diameters) is picked. Most CAD systems will provide more than one type of ellipse, such as isometric ellipses. 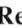 **CAD Reference 3.24**

Engineering and Science Applications of Ellipses
The ellipse has a reflective property similar to that of a parabola. Light or sound emanating through one focus is reflected to the other, and this is useful in the design of some types of optical equipment. *Whispering galleries*, such as the Rotunda in the Capitol Building in Washington, D.C., (Figure 3.58) and the Mormon Tabernacle in Salt Lake City, Utah, are designed using elliptical ceilings. In a whispering gallery, sound emanating from one focus is easily heard at the other focus.

Ellipses are also useful in astronomy. Kepler's first law states that the orbit of each planet in the solar system is an ellipse, with the sun at one focus. In addition, satellites sent into Earth orbit travel in elliptical orbits about the Earth.

3.7 ROULETTES

Roulettes are curves generated by the rolling contact of one curve or line on another curve or line. Any point attached to the rolling curve or line will describe the roulette curve. The moving point is called the *generating point*. The roulette is constructed by moving the rolling curve or line to a number of new positions, marking the corresponding positions of the generating point, and drawing a curve connecting those points. There are an infinite variety of roulettes, some of which are more important than others in engineering design, such as in the design of machine elements, instruments, and mechanical devices. The most common types of roulettes used in engineering are spirals, cycloids, and involutes.

Figure 3.57 Drawing an Ellipse Using a Template

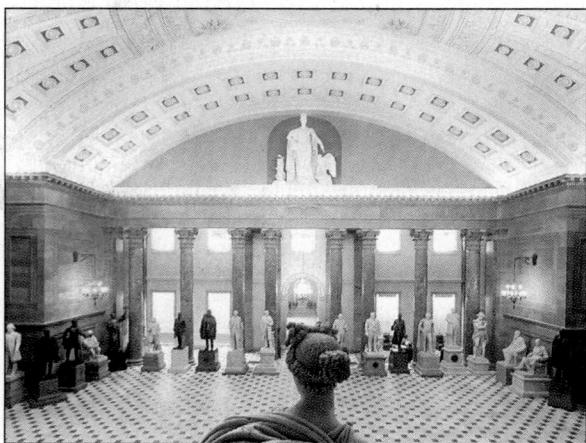

Figure 3.58 Ellipse Application

The Rotunda in the Capitol Building in Washington, D.C., has an elliptical ceiling.

3.7.1 Spirals

A **spiral** is a single-curved surface that begins at a point called a *pole* and becomes larger as it travels in a plane around the origin. A spiral is sometimes referred to as a *spiral of Archimedes*, which is the curve on a heart cam that converts uniform rotary motion into uniform reciprocal motion. To draw a spiral of Archimedes, use the following procedure. (Figure 3.59) © CAD Reference 3.25

Drawing a Spiral of Archimedes

Step 1. Draw a circle and divide it into a number of equal segments, such as six. Label the intersections between each radius and the circle as points 1 through 6. Divide radius 0-6 into the same number of equal parts (i.e., six). Mark the points on the radius as 1', 2', etc.

Figure 3.59 Drawing a Spiral of Archimedes

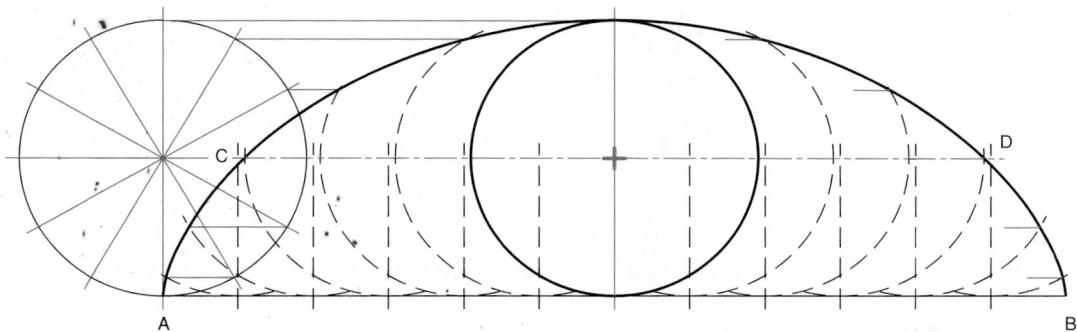

Figure 3.60 Generation of a Cycloid

A cycloid is generated by the motion of a point on the circumference of a circle that is rolled along a straight line.

Step 2. Draw an arc of radius 0-1', with 0 as the center and the arc going from radius 0-6 to radius 0-1. Mark the point of intersection of the arc with radius 0-1. Then draw an arc of radius 0-2', with 0 as the center and the arc going from radius 0-6 to radius 0-2. Mark the point of intersection of the arc with radius 0-2. Repeat this process until arcs have been drawn from all the points on radius 0-6. (Notice that the last "arc," if drawn from point 6', would be the circle itself.)

Step 3. Using an irregular curve, connect the intersection points in the order that they were marked; that is, the point on the 0-1 radius with the point on the 0-2 radius, then the point on the 0-2 radius with the point on the 0-3 radius, and so forth. To complete the spiral, connect the center 0 with the intersection point on the 0-1 radius.

3.7.2 Cycloids

A **cycloid** is the curve generated by the motion of a point on the circumference of a circle as the circle is

rolled along a straight line in a plane. (Figure 3.60) The length of the cycloid curve is defined as exactly equal to four diameters of the rolling circle, and the area between the cycloid and the baseline AB equals three times the area of the rolling circle.

An *epicycloid* is formed when the circle is rolled on the outside of another circle. A *hypocycloid* is formed when the circle is rolled on the inside of another circle. A *trochoid* is the curve formed by a point on the radial spoke of a circle as the circle rolls along tangent to a straight line. 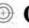 **CAD Reference 3.26**

Practice Exercise 3.7

Make a circular cardboard disk with a hole punched near its perimeter. With a pencil in the hole, run the circle along a straightedge to create a cycloid. Do the same but run the circle along the internal (epicycloid) and external (hypocycloid) perimeter of another circle. (Similar effects can be created using a Spirograph™.)

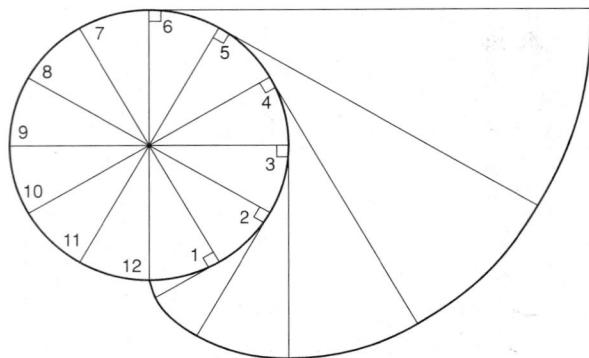

Figure 3.61 Constructing the Involute of a Circle

Cycloid curves are commonly used in kinematics (motion studies) and in mechanisms that work with rolling contact. Epicycloids and hypocycloids are often used in rotary pumps, blowers, and superchargers.

3.7.3 Involutes

An **involute** is the spiral path of a point on a string unwinding from a line, circle, or polygon. Involutes of circles are used in the design of spur gears. (Figure 3.61) The contact surfaces between gear teeth are designed as involutes. The involutes permit motion to be transmitted smoothly and at a constant velocity, which is important in mechanisms using gears. Figure 3.62 is an involute gear tooth profile constructed by the method shown in Figure 3.61. The curve on the profile of the gear tooth is the involute.

Constructing the Involute of a Circle

Step 1. Divide the circle into a number of equal segments and label the intersection points between the radii and the circle, as shown in Figure 3.61. Draw a tangent line at each point of intersection.

Step 2. With point 1 as the center, draw an arc equal in radius to the chord 1-12 and intersecting the tangent drawn from point 1. With point 2 as the center, draw an arc equal in radius to the chord 2-12 and intersecting the tangent drawn from point 2. Continue this process until intersection arcs have been drawn for all of the tangent lines.

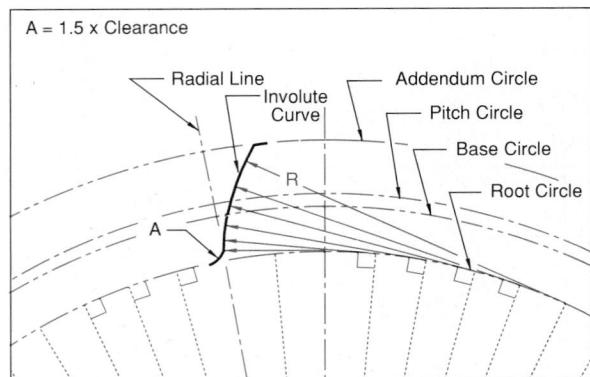

Figure 3.62 Part of the Gear Tooth Profile Is an Involute

Practice Exercise 3.8

Wrap a string around a coffee can. Attach a pencil to the free end of the string. Place the can on a piece of paper and, holding the string tight, draw while unwrapping the string. Change diameters of the can to create different involutes.

3.8 DOUBLE-CURVED LINES, INCLUDING HELICES

A *double-curved line* is a curve generated by a point moving uniformly at both an angular and a linear rate around a cylinder or cone. The line of intersection between two curved solids forms a double-curved line. Cylindrical and conical helixes are examples of double-curved lines.

A **helix** is the curve formed by a point moving uniformly at both an angular and a linear rate around a cylinder or cone. Because of the uniform angular rate, a helix is a curve of constant slope, called the *helix angle*. A *cylindrical helix* is the curve formed by a point moving uniformly at both an angular and a linear rate around a cylinder. The distance that the point moves parallel to the axis during one revolution is called the *lead* or *pitch*. A screw thread is a common application of a cylindrical helix, as are spiral staircases, worm gears, drill bits, spiral milling cutters, springs, and conveyors. (Figure 3.63) A *conical helix* is the curve formed by a point moving uniformly at both an angular and a linear rate around a cone.

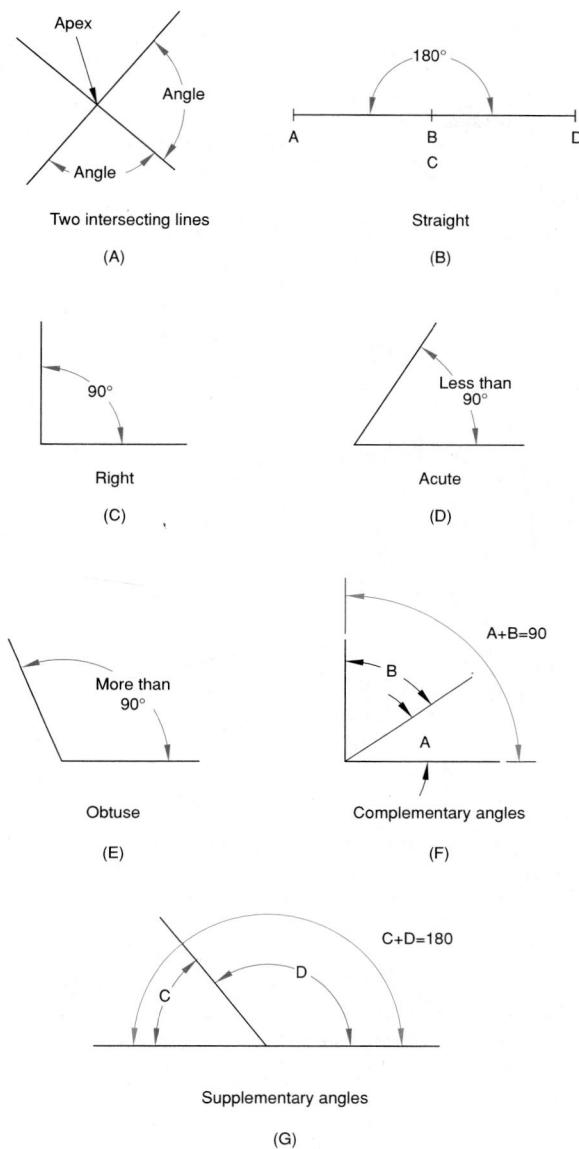

Figure 3.68 Classification of Angles

3.10.1 Bisecting an Angle

Angles are drawn with the following traditional tools: triangles, straightedges and a protractor, adjustable triangles, and drafting machines. CAD systems can draw lines at specified angles using a LINE command and specifying the angle to be drawn and either the locations of the endpoints of the line or a line length.

© CAD Reference 3.28

Bisecting an Angle

Step 1. Given angle ABC, set the compass to any distance, use B as the center, and draw an arc that intersects both sides of the angle. (Figure 3.69)

Step 2. Set the compass point at the intersection of this first arc and one of the sides of the angle and draw a second arc. Then, set the compass point at the intersection of the first arc and the other side of the angle, and draw a third arc such that it intersects the second arc.

Step 3. Draw a line from point B through the intersections of the second and third arcs constructed in Step 2. This line bisects the angle and is called the bisector.

3.10.2 Transferring an Angle

At times, it is necessary to transfer an existing angle to a new location, without measuring the angle. One method of doing so involves the use of a compass, as described in the following procedure. (Figure 3.70)

© CAD Reference 3.29

Transferring an Angle Using a Compass

Step 1. Given the angle BAC and the new location A'B' for one of the sides, open the compass to any convenient radius, set the compass point at the apex A, and draw an arc across the given angle. The arc should intersect the sides at E and F.

Step 2. Use the same radius, set the compass point at the new apex A', and draw an arc. This arc should intersect A'B' at E'.

Step 3. Set the compass equal to the chord measured from E to F on the given angle. Move the compass to the new location, place the compass point at E', and draw another arc. This arc will intersect the other arc drawn from A', at point F'. Draw a line from the intersection (F') of the two construction arcs to the new apex A', to form an angle equal to the given angle.

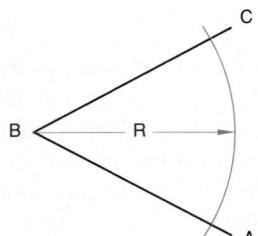

Step 1

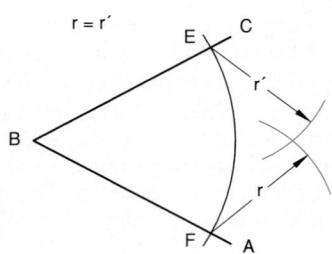

Step 2

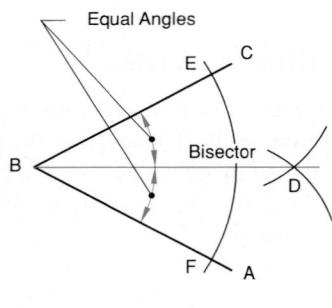

Step 3

Figure 3.69 Bisecting an Angle Using a Compass

3.11 PLANES

A **plane** is a two-dimensional surface that wholly contains every straight line joining any two points lying on that surface. Although many drawings are created from simple geometric primitives, such as lines and curves, many real-world designs are made of *planar surfaces*. Theoretically, a plane has width and length but no thickness. In practice, planar surfaces have some thickness.

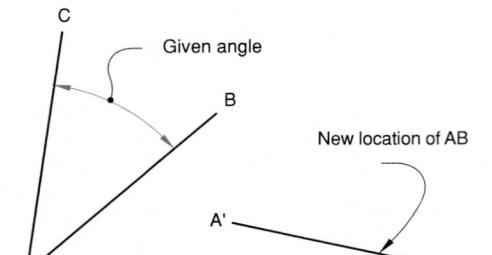

Step 1

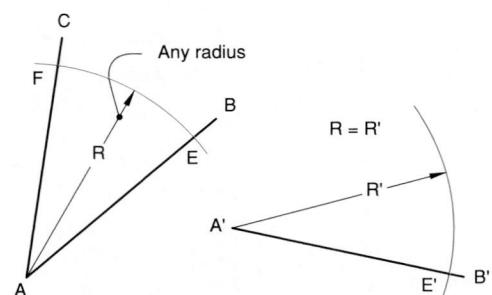

Step 2

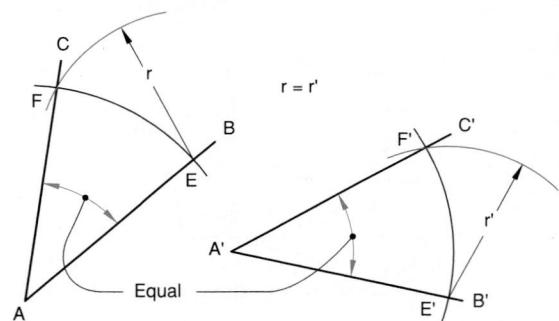

Step 3

Figure 3.70 Transferring an Angle Using a Compass

An *infinite plane* is an unbounded two-dimensional surface that extends without a perimeter in all directions. A *finite plane* is a bounded two-dimensional surface that extends to a perimeter in all directions. A plane can be defined by three points not in a straight line; two parallel lines; a line plus a point that is not on the line or its extension; or two intersecting lines. (Figure 3.71)

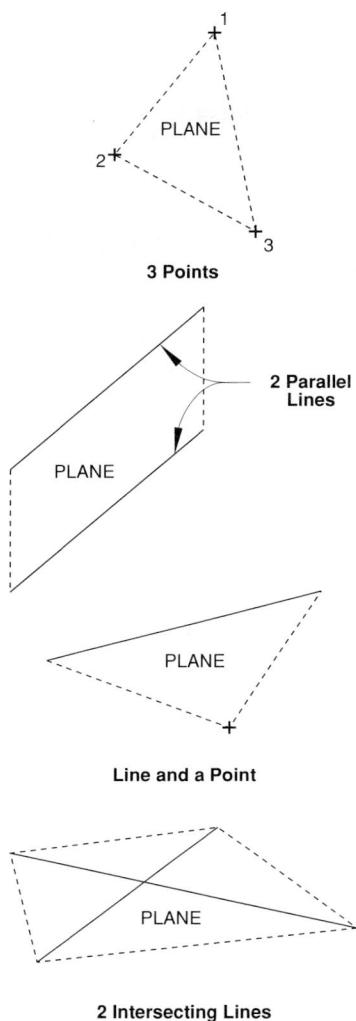

Figure 3.71 Planes

Planes are formed by three points, two parallel lines, a line and a point, or two intersecting lines.

3.12 SURFACES

A **surface** is a finite portion of a plane, or the outer face of an object bounded by an identifiable perimeter. The fender of an automobile and the airplane wing are examples of complex 3-D surfaces. (Figure 3.72) Just as a line represents the path of a moving point, a surface represents the path of a moving line, called a **generatrix**. A generatrix can be a straight or curved line. The path that the generatrix travels is called the **directrix**. A directrix can be a point, a straight line, or a curved line. (Figure 3.73F)

Figure 3.72

An airplane wing is a good example of a complex 3-D surface.

The shape of a surface is determined by the constraints placed on the moving line used to generate the surface. Surfaces are generally classed as planar, single-curved, double-curved, warped, and freeform.

A **planar surface** is a flat, two-dimensional bounded surface. (Figure 3.73A) A planar surface can be defined as the motion of a straight-line generatrix that is always in contact with either two parallel straight lines, two intersecting lines, or a line and a point not on the line.

A **single-curved surface** is the simple-curved bounded face of an object produced by a straight-line generatrix revolved around an axis directrix (yielding a cylinder) or a vertex directrix (yielding a cone). (Figure 3.73B)

A **double-curved surface** contains no straight lines and is the compound-curved bounded face of an object produced by an open or closed curved-line generatrix revolved around an axis directrix (yielding a sphere or ellipsoid), a center directrix (yielding a torus), or a vertex directrix (yielding a paraboloid or a hyperboloid). (Figure 3.73C)

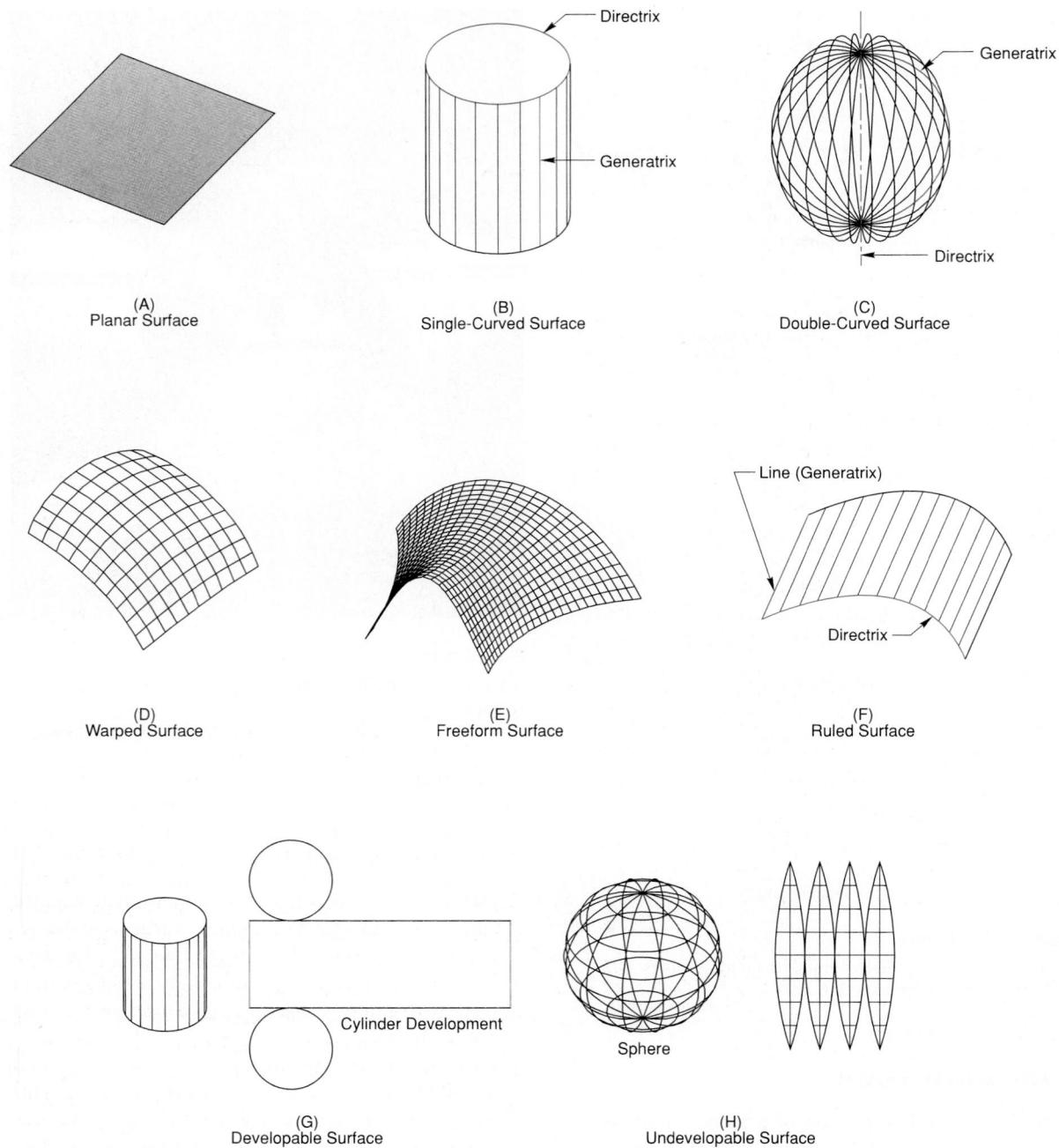

Figure 3.73 Examples of Surfaces Commonly Used in Engineering Design

A **warped surface** is a single- and double-curved transitional surface (cylindroid, conoid, helicoid, hyperbolic paraboloid), often approximated by triangulated surface sections that may join other surfaces or entities together. (Figure 3.73D)

A **freeform surface** follows no set pattern and requires more sophisticated underlying mathematics. (Figure 3.73E)

Surfaces can also be classified as ruled, developable, or undevelopable, as follows:

A **ruled surface** is produced by the movement of a straight-line generatrix controlled by a directrix to form a planar, single-curved, or warped surface. (Figure 3.73F)

A **developable surface** can be unfolded or unrolled onto a plane without distortion. Single-curved surfaces, such as cylinders and cones, are developable. (Figure 3.73G)

An **undevelopable surface** cannot be unfolded or unrolled onto a plane without distortion. Warped and double-curved surfaces, such as a sphere or an ellipsoid, cannot be developed except by approximation. (Figure 3.73H) For example, the Earth is nearly a sphere, and representing its land forms on flat paper has taken cartographers centuries to develop. On some types of maps, the land forms near the poles are drawn much larger than they really are, to compensate for the curvature that can't be shown.

The advancement of computer graphics has resulted in the development of special types of surfaces that are mathematically generated to approximate complex freeform surfaces. These complex surfaces are created by a series of patches, where a **patch** is a collection of points bounded by curves and is the simplest mathematical element that can be used to model the surface. Some of the more common computer-generated freeform surfaces are:

- Fractal
- B-spline
- Coons'
- Bezier
- Nonuniform Rational B-spline (NURBS)

These names reflect the underlying geometry used to generate the curves. For example, B-spline curves are used to generate a B-spline surface patch.

Traditionally, orthographic views are used to represent surfaces. With CAD, it is possible to create mathematical models of very complex surfaces that would

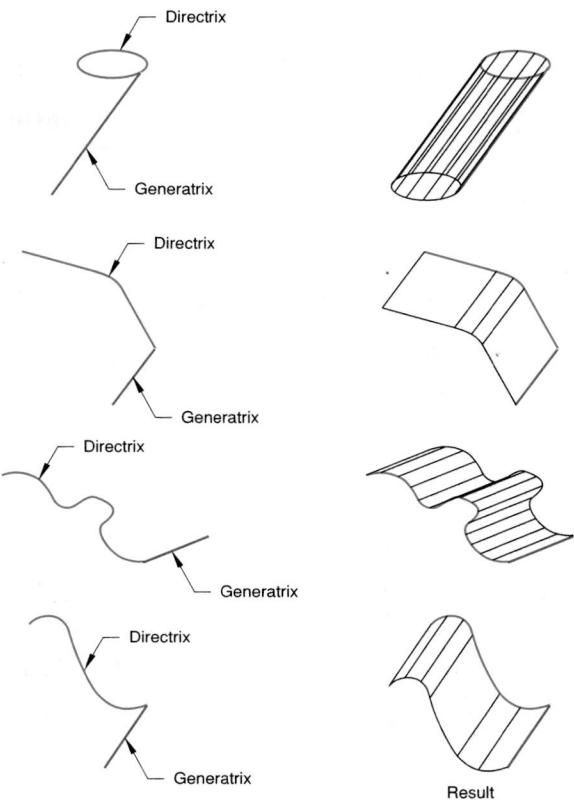

Figure 3.74 Generating Swept Surfaces by Sweeping Generator Entities along Director Entities

be impossible to represent using traditional tools. The computer model can be used to determine surface characteristics such as area. One such surface, called a **surface of revolution**, is created by revolving a curve (generatrix) in a circular path (directrix) about an axis. These types of surfaces are used on any part that requires surfaces with arc or circular cross sections. Another method of creating surfaces with CAD is to sweep generator entities, such as circles, arcs, and lines, along director entities, as shown in Figure 3.74. This method of creating surfaces is called **swept surfaces**. Swept surfaces are often used for product and tooling design. **CAD Reference 3.30**

3.12.1 Two-Dimensional Surfaces

Two-dimensional surfaces are simple ruled surfaces and include closed curves, quadrilaterals, triangles, and regular polygons. (see Figure 3.15) These geometric

Figure 3.75 Classification of Quadrilaterals

primitives are the building blocks for more complex surfaces and solids. For example, CAD creates more complicated 3-D forms through extrusion and sweeping operations, such as creating a rectangular prism by extruding a rectangular surface.

Quadrilaterals **Quadrilaterals** are four-sided plane figures of any shape. The sum of the angles inside a quadrilateral will always equal 360 degrees. If opposite sides of the quadrilaterals are parallel to each other, the shape is called a **parallelogram**. The square, rectangle, rhombus, and rhomboid are parallelograms. Quadrilaterals are classified by the characteristics of their sides. (Figure 3.75)

Square. Opposite sides parallel, all four sides equal in length, all angles equal.

Rectangle. Opposite sides parallel and equal in length, all angles equal.

Rhombus. Opposite sides parallel, four sides equal in length, opposite angles equal.

Rhomboid. Opposite sides parallel and equal in length, opposite angles equal.

Regular trapezoid. Two sides parallel and unequal in length, two sides nonparallel but equal in length, base angles equal, vertex angles equal.

Irregular trapezoid. Two sides parallel, no sides equal in length, no angles equal.

Trapezium. No sides parallel or equal in length, no angles equal.

Quadrilaterals are constructed using straightedges, triangles, and a compass to create parallel lines and to measure equal angles. As an example, several techniques for constructing a square are as follows.

Constructing a Square

Step 1. Given side AB, use a triangle with a 45-degree angle. Position the triangle so that the 45-degree angle is at A, and draw a line. Do the same at B. (Figure 3.76) The lines will cross at the center of the square.

Step 2. Draw lines perpendicular to the endpoints of line AB until they intersect the 45-degree construction lines at points C and D.

Step 3. Draw a line from C to D to complete the square.

To construct a square inside a circle (i.e., an inscribed square), use the following procedure. (Figure 3.77)

Constructing an Inscribed Square

Step 1. Construct a circle equal in diameter to the side of the square.

Step 2. Draw two diameters of the circle, at right angles to each other.

Step 3. The intersections of these diameters with the circumference of the circle are the vertices of the inscribed square.

To draw a square whose sides are tangent to a circle (i.e., a circumscribed square), use the following procedure. (Figure 3.78) © CAD Reference 3.31

Constructing a Circumscribed Square

Step 1. Construct a circle equal in diameter to the side of the square.

Step 2. Draw two diameters of the circle, at right angles to each other.

Step 3. The intersections of these diameters are used as the points of tangency. Construct lines perpendicular to the diagonals. These lines are tangent to the circle and are the sides of the square.

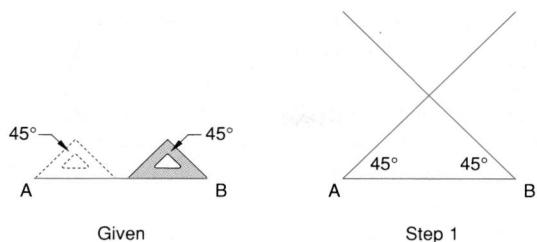

Figure 3.76 Constructing a Square by Drawing the Diagonals

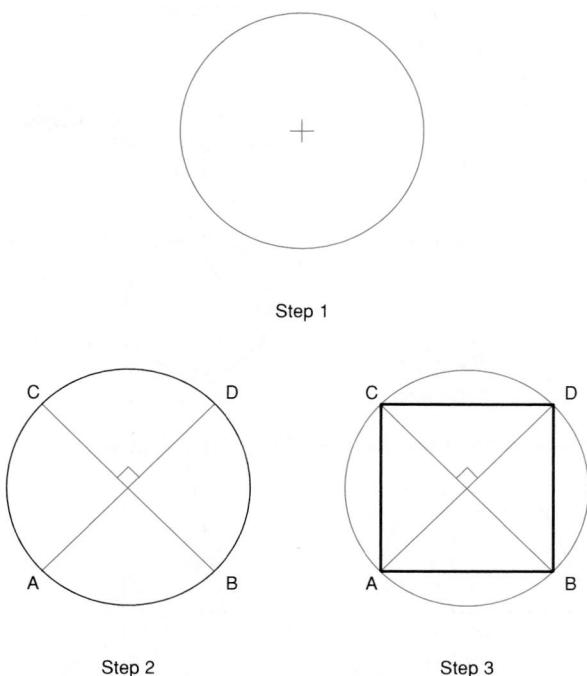

Figure 3.77 Constructing an Inscribed Square

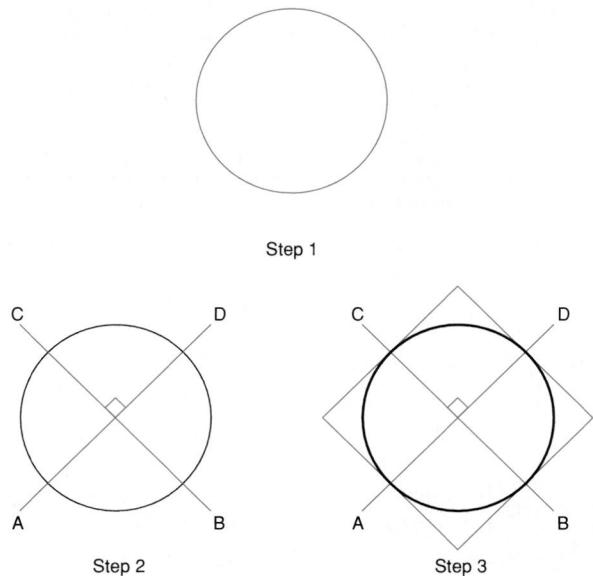

Figure 3.78 Constructing a Circumscribed Square

Regular Polygons A **polygon** is a multisided plane of any number of sides. If the sides of the polygon are equal in length, the polygon is called a **regular polygon**. Regular polygons can be inscribed in circles. To determine the angle inside a polygon, use the equation $S = (n - 2) \times 180$ degrees, where n equals the number of sides. Regular polygons are grouped by the number of sides. (Figure 3.79)

Triangle (equilateral). Three equal sides and angles.
Square. Four equal sides and angles.

Pentagon. Five equal sides and angles.

Hexagon. Six equal sides and angles.

Heptagon. Seven equal sides and angles.

Octagon. Eight equal sides and angles.

Nonagon. Nine equal sides and angles.

Decagon. Ten equal sides and angles.

Dodecagon. Twelve equal sides and angles.

Icosagon. Twenty equal sides and angles.

Triangles A **triangle** is a polygon with three sides. The sum of the interior angles equals 180 degrees. The **vertex** is the point at which two of the sides meet. Triangles are named according to their angles (right, obtuse, acute) or the number of equal sides. (Figure 3.80)

Equilateral triangle. Three equal sides and three equal interior angles of 60 degrees.

Isosceles triangle. At least two equal sides.

Scalene triangle. No equal sides or angles.

Right triangle. Two sides that form a right angle (90 degrees), and the square of the hypotenuse is equal to the sum of the squares of the two sides (Pythagoras Theorem).

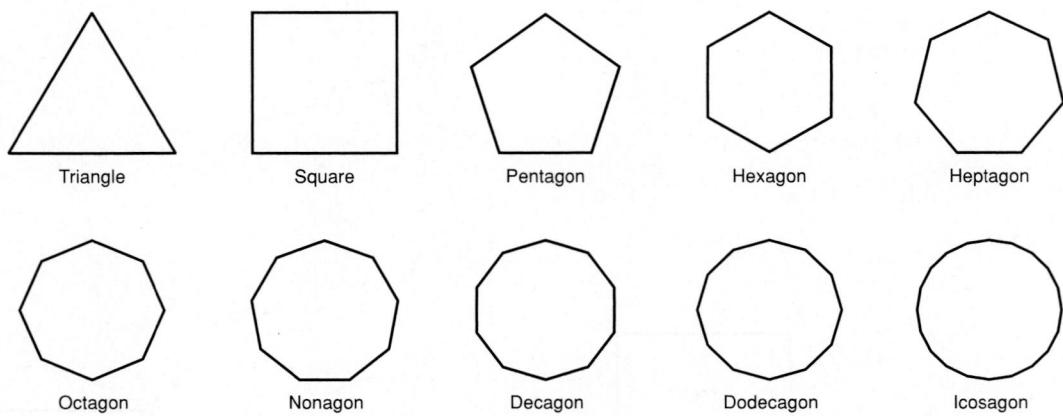

Figure 3.79 Classification of Regular Polygons

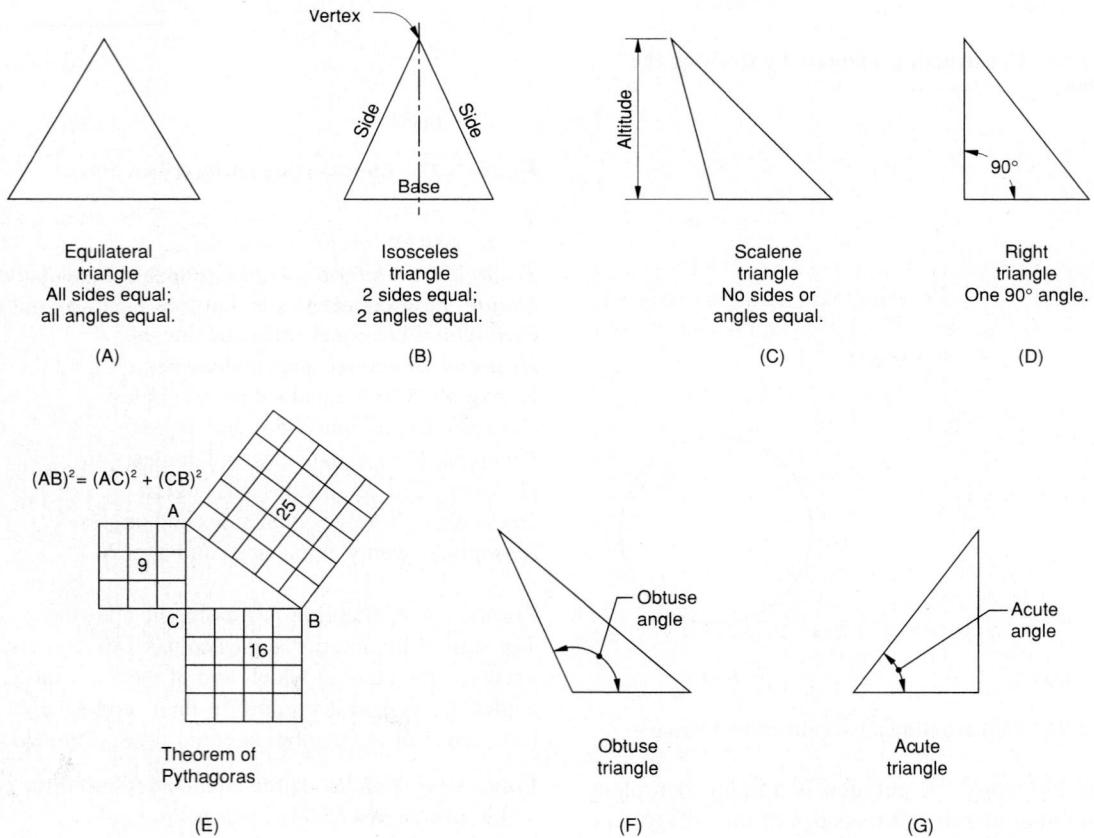

Figure 3.80 Classification of Triangles

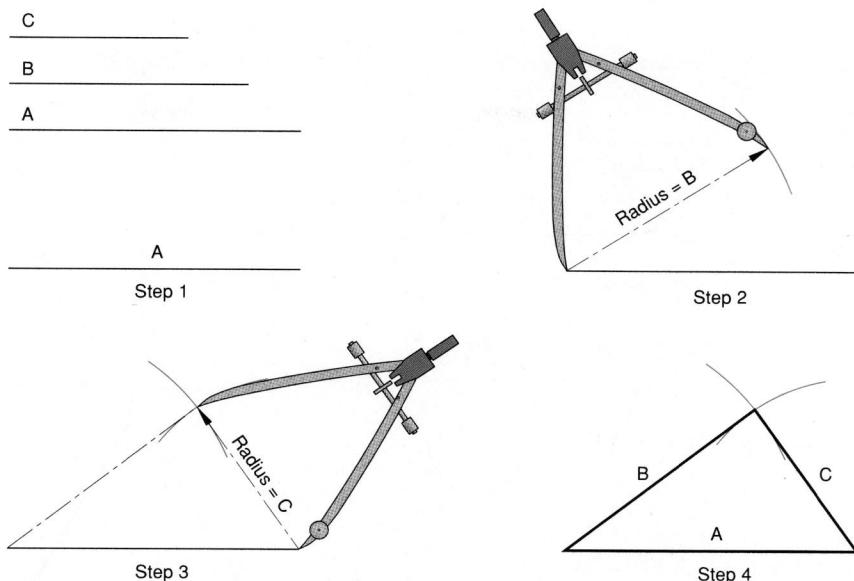

Figure 3.81 Constructing a Triangle, Given the Length of Its Sides

Obtuse triangle. One obtuse angle (greater than 90 degrees).

Acute triangle. No angle larger than 90 degrees.

Right triangles are acute triangles. A right triangle can be either isosceles triangles, where the other two angles are 45 degrees, or a 30/60 triangle, where one angle is 30 degrees and the other is 60 degrees.

To construct a triangle with traditional tools, use the following procedure.

Constructing a Triangle

Step 1. If you are given the length of A and C, but not the internal angles, draw sides, such as A. (Figure 3.81)

Step 2. Draw an arc with a radius equal to B, using one end of line A as the center.

Step 3. From the other end of line A, draw an arc with a radius equal to the length of C.

Step 4. Draw sides B and C from the ends of line A to the point of intersection of the two arcs.

To construct an equilateral triangle, use the following procedure. (Figure 3.82A)

Constructing an Equilateral Triangle

Step 1. If you are given the length of the side D, set the compass equal to the length of D.

Step 2. Draw an arc from one endpoint of one side D.

Step 3. Draw another arc from the other endpoint of side D.

Step 4. Draw lines from the ends of side D to the intersection of the two arcs.

The alternate method of constructing an equilateral triangle would be to use the 60-degree angle 30/60-degree triangle to construct lines as shown in Figure 3.82B.

With CAD, triangles can be created by using the ARC or CIRCLE commands to create the construction arcs, then using OBJECT snap commands to draw the lines by grabbing the endpoints of the lines and the intersection of the arcs. Equilateral triangles are created more easily by using the POLYGON command, specifying the number of sides and the length of the sides, and locating the vertices. **CAD Reference 3.32**

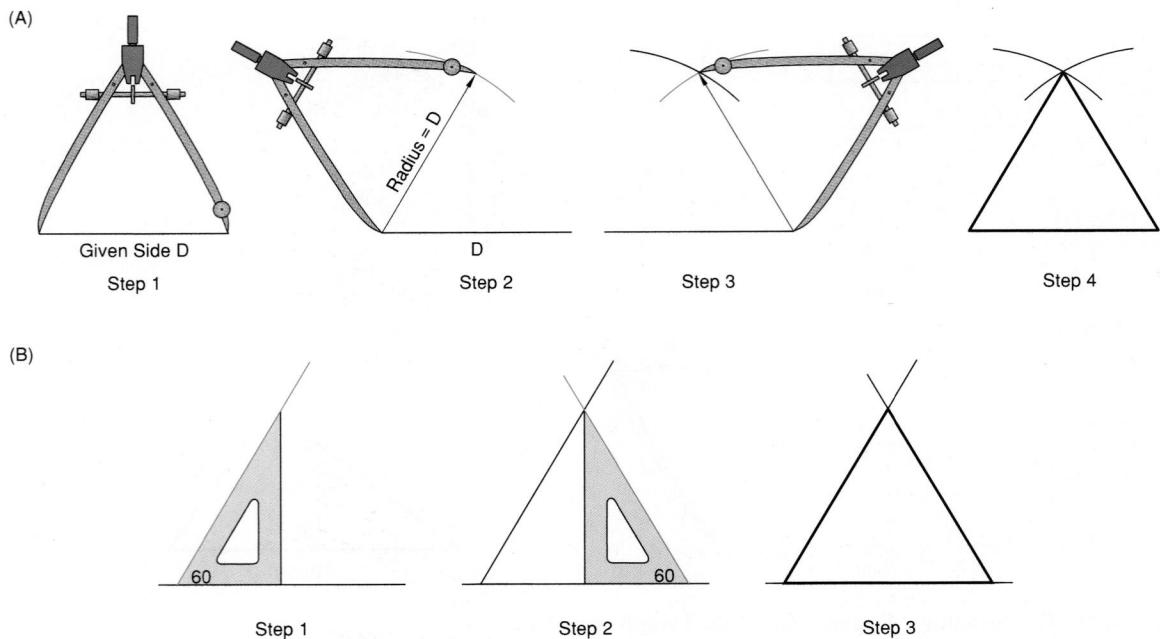

Figure 3.82 Constructing an Equilateral Triangle

Pentagons A pentagon has five equal sides and angles. A pentagon is constructed by dividing a circle into five equal parts, using a compass or dividers, as shown in Figure 3.83. 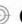 **CAD Reference 3.33**

Hexagons A hexagon has six equal sides and angles. Hexagons are constructed by using a 30/60-degree triangle and a straightedge to construct either circumscribed or inscribed hexagons around or in a given circle.

The construction techniques described are useful for drawing the heads of hexagonal nuts and bolts. Nuts and bolts are designated by the distance across the flats. For example, for a 1" hexagonal bolt head, draw a 1" diameter circle, then circumscribe a hexagon around the circle. For more detailed information on drawing such fasteners, see Chapter 9.

Constructing a Circumscribed Hexagon

Step 1. To construct a circumscribed hexagon in a given circle that has a center at point A, draw horizontal and vertical center lines at 90 degrees to each other. Using a 30/60-degree triangle, draw diagonal lines through the center point and at 30 degrees to the horizontal center line. (Figure 3.84)

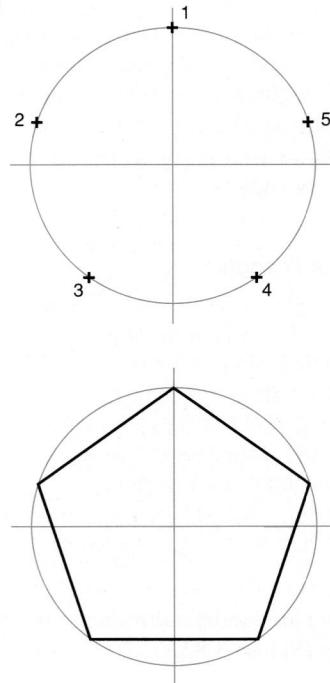

Figure 3.83 Constructing a Pentagon by Stepping Off Five Equal Distances on the Circumference of the Circle

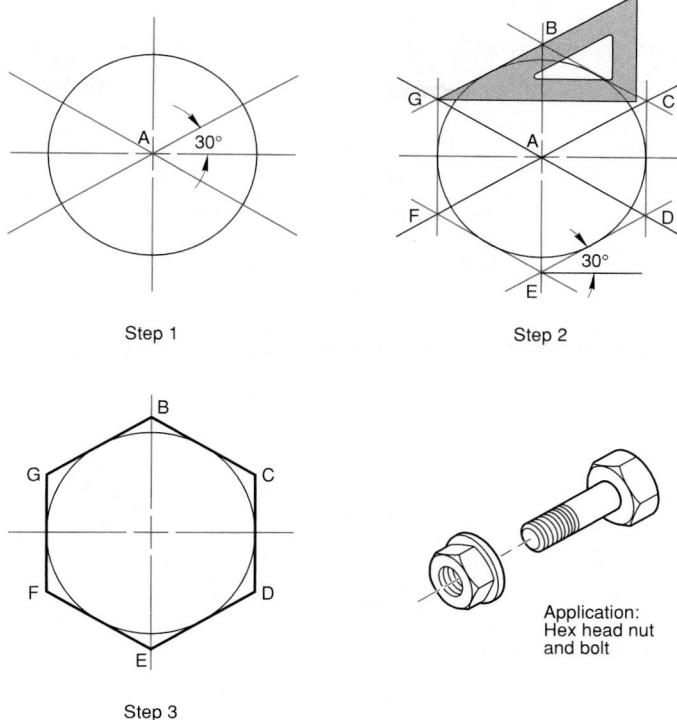

Figure 3.84 Constructing a Circumscribed Hexagon, Given the Distance across the Flats

Step 2. Construct tangent lines at the two points where the horizontal center line intersects the circle. These tangent lines are parallel to the vertical center line, and they intersect the two diagonal lines at points C, D, F, and G. Using a 30/60-degree triangle, draw lines from the four points, at 30 degrees to the horizontal. These 30-degree lines are tangent to the circle and intersect the vertical center line at points B and E.

Step 3. Connect points B through G to form the circumscribed hexagon.

A circumscribed hexagon can also be constructed with 60-degree diagonals, using the same procedure as above, but measuring from the vertical center line instead of the horizontal center line. Normally, a circumscribed hexagon is used when the distance *across the flats* of the hexagon is given, and the inscribed method is used when the distance *across the corners* is given.

Constructing an Inscribed Hexagon

Step 1. To construct a hexagon inscribed in a given circle that has a center point at A, draw a horizontal center line. Mark the points where the horizontal center line intersects the circle as points B and C (Figure 3.85).

Step 2. Draw two diagonals through the 60 degrees to the horizontal. Mark where the diagonals intersect the circle as points D and G.

Step 3. Connect the intersecting diagonals to form the inscribed hexagon.

An inscribed hexagon is a special polygon with 60-degree diagonals, such as the one shown in Figure 3.86. As described above, an inscribed hexagon exists, the center line, with a CAD system.

Most CAD systems have a command for drawing a hexagon. Some systems have a command for drawing a hexagon.

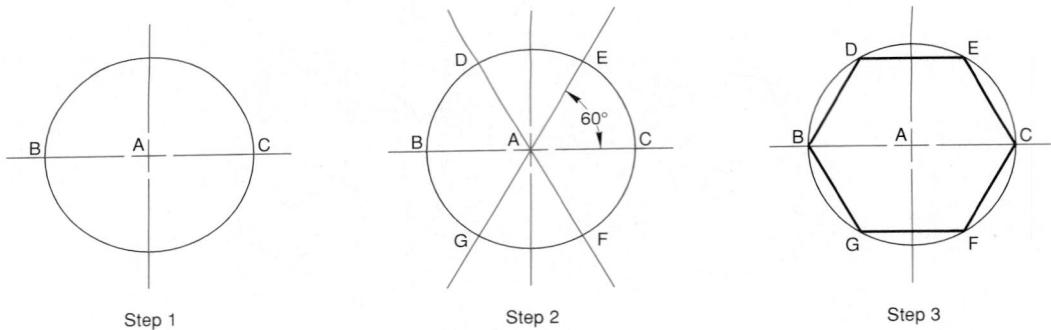

Figure 3.85 Constructing an Inscribed Hexagon, Given the Distance across the Corners

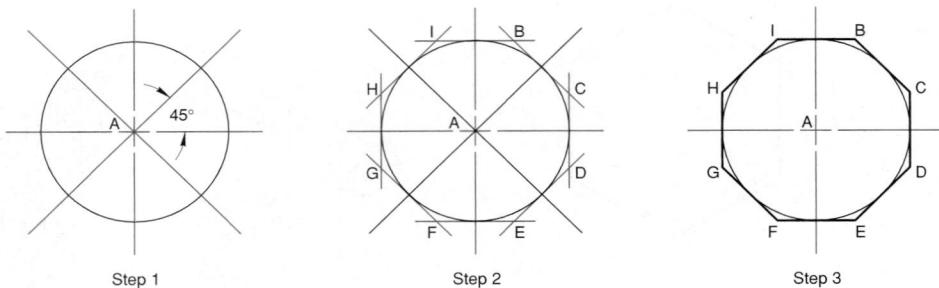

Figure 3.86 Constructing a Circumscribed Octagon, Given the Distance across the Flats

octagon has eight equal sides and angles. Circumscribed and inscribed octagons are constructed using the same 45-degree triangle and the same center lines as are used for circumscribed and inscribed hexagons.

Step 2. Using a 45-degree triangle, construct two more center lines that are 45 degrees from the horizontal. Where the center lines intersect the circle, label the points D, G, F, and I.

Step 3. Connect each point on the circumference of the circle to form the inscribed octagon.

3.12.2 Ruled Surfaces

Polyhedra, single-curved surfaces, and warped surfaces are classified as ruled surfaces. (Figure 3.73) All ruled surfaces, except for warped surfaces, are developable.

With traditional tools, simple plane surfaces are drawn using triangles and straightedges.

Some CAD systems have surface modeling programs that can be used to create simple plane surfaces and more complicated ruled surfaces. © CAD Reference 3.35

Single-Curved Surfaces Single-curved surfaces are generated by moving a straight line along a curved path such that any two consecutive positions of the

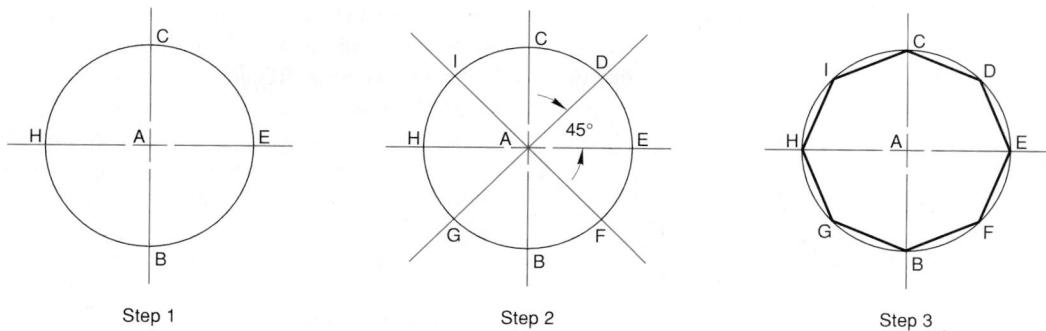

Figure 3.87 Constructing an Inscribed Octagon, Given the Distance across Corners

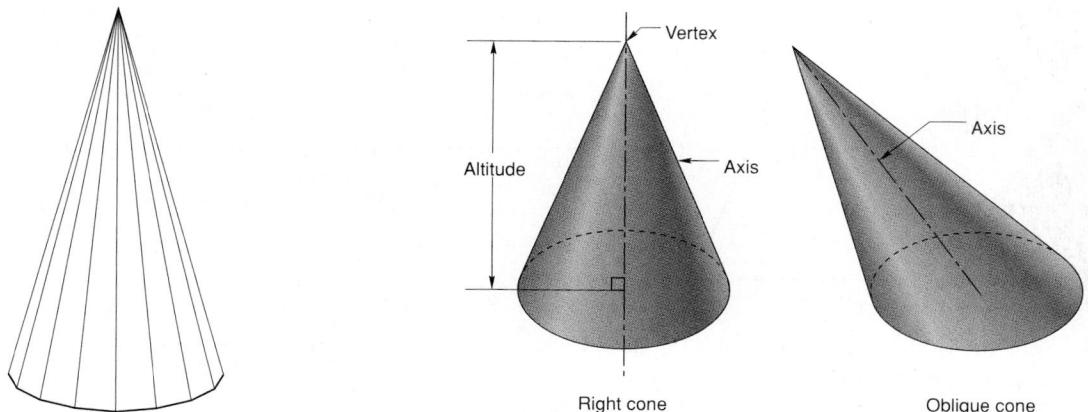

Figure 3.88 Faceted Representation of a Cone

The computer display of a single curved surface, such as a cone, will often show the surface as elements or tessellation lines.

generatrix are either parallel (cylinder), intersecting (cone), or tangent to a double-curved line (convolute). (These surfaces can also be generated by sweeping a curved generatrix along a straight-line directrix.) The cone, cylinder, and convolute are the only types of surfaces in this class and they all are developable. Most CAD systems will display a single-curved surface with a series of *elements*, *facets*, or *tessellations*, and some can automatically develop the surface. (Figure 3.88)

Cones There are three basic classifications of **cones**. (Figure 3.89) If the axis is perpendicular to the base, the axis is called the *altitude* and the cone is called a *right cone*. If the axis is not perpendicular to the base, the cone is called an *oblique cone*. If the tip of the cone is cut off, it is called a *truncated cone* or a *frustum* of a cone.

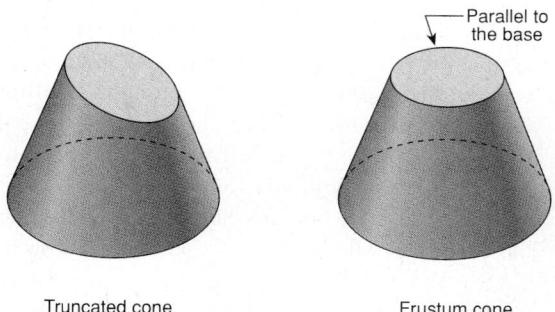

Figure 3.89 Classification of Cones

There are many applications for cones in engineering design, including the *nose cone* of rockets; transition pieces for heating, ventilating, and air-conditioning systems; conical roof sections; and *construction cones* used to alert people to construction areas. Cones are represented in multiview drawings by drawing the base curve, vertex, axis, and limiting elements in each view. (Figure 3.90)

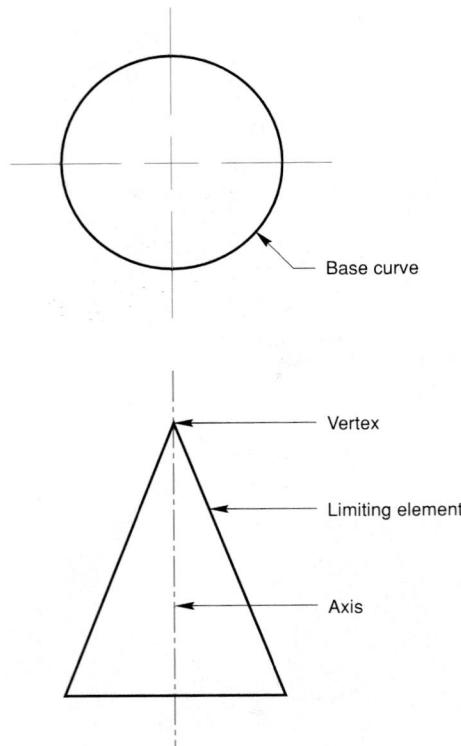

Figure 3.90 Multiview Drawing of a Cone

The multiview representation of a right circular cone is a circle in the top view and a triangle in the front view.

The directrix for a cone may be either a single or double curve. The directrix may also assume any irregular shape, but is normally circular or elliptical. Cones are therefore further classified by the path of the generatrix: circular, elliptical, nephroidal, deltoidal, astroidal, cardioidal, and free curve.

Most 3-D CAD systems can easily produce many of the cones described in this section. One approach with CAD uses the 3-D primitive geometry commands. For example, to create a circular cone, the primitive command CONE is used to define the location and circumference of the base and the location of the vertex. A noncircular cone is created by constructing the noncircular base, then extruding that form along a defined axis to a vertex point. **© CAD Reference 3.36**

Cylinders A **cylinder** is a single-curved ruled surface formed by a vertical, finite, straight-line element (generatrix) revolved parallel to a vertical or oblique axis directrix and tangent to a horizontal circular or

elliptical directrix. The line that connects the center of the base and the top of a cylinder is called the *axis*. If the axis is perpendicular to the base, the cylinder is a *right cylinder*. If the axis is not perpendicular to the base, the cylinder is an *oblique cylinder*. A multiview drawing of a right circular cylinder shows the base curve (a circle), the extreme elements, and the axis. (Figure 3.91)

If the base curve is a circle, the cylinder is circular. If the base curve is an ellipse, the cylinder is elliptical.

© CAD Reference 3.37

Practice Exercise 3.9

Take four clay or foam right-angle cones and cut them at angles appropriate to make circular, elliptical, parabolic, and hyperbolic sections. Look at the cut sections from a perpendicular viewpoint and along the major axis of the cone. Viewing along the major axis of the cone, which sections look circular? Which look like a line? Which have other shapes?

Take four clay, foam, or paper cylinders of the same altitude and base diameter as the cones, and cut them at identical angles. Compare the resulting sections (side-by-side and face-to-face). Are any the same size? Are any the same shape? View these new sections along a normal axis and along the major axis.

Repeat the above exercise with 3-D computer models. Use Boolean subtraction operations or a SECTION command.

Convolutes A **convolute** is a single-curved surface generated by a straight line moving such that it is always tangent to a double-curved line. Figure 3.92 shows the generation of a convolute using a helix curve (the double-curved line) as the directrix, which results in a helical convolute. **© CAD Reference 3.38**

Polyhedra A **polyhedron** is a symmetrical or asymmetrical 3-D geometric surface or solid object with multiple polygonal sides. The sides are plane ruled surfaces (Figure 3.93) and are called *faces*, and the lines of intersection of the faces are called the *edges*. **Regular polyhedra** have regular polygons for faces. There are five regular polyhedrons: tetrahedron, hexahedron, octahedron, dodecahedron, and icosahedron. As solids, these are known as the *five platonic solids*. Some polyhedra, such as the tetrahedron, pyramid, and hexahedron, are easily produced with 3-D CAD programs by using extrusion techniques. **© CAD Reference 3.39**

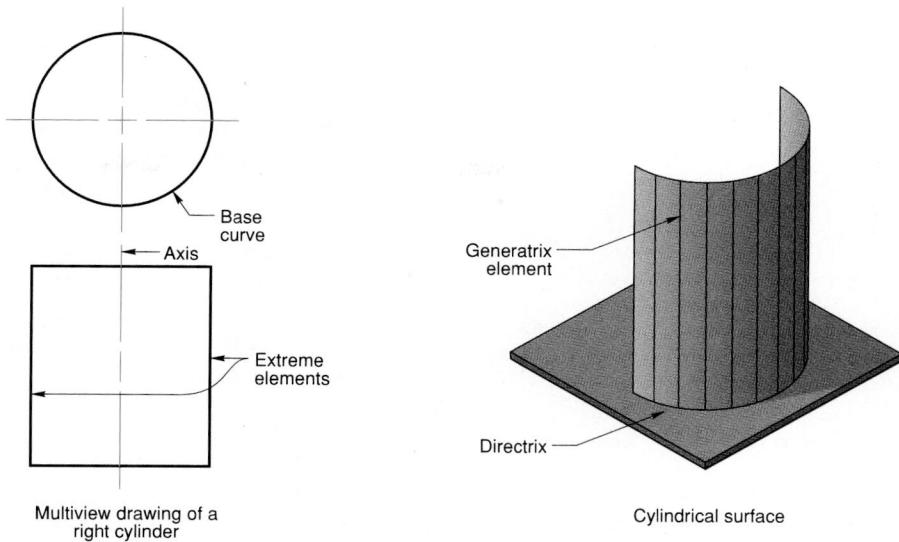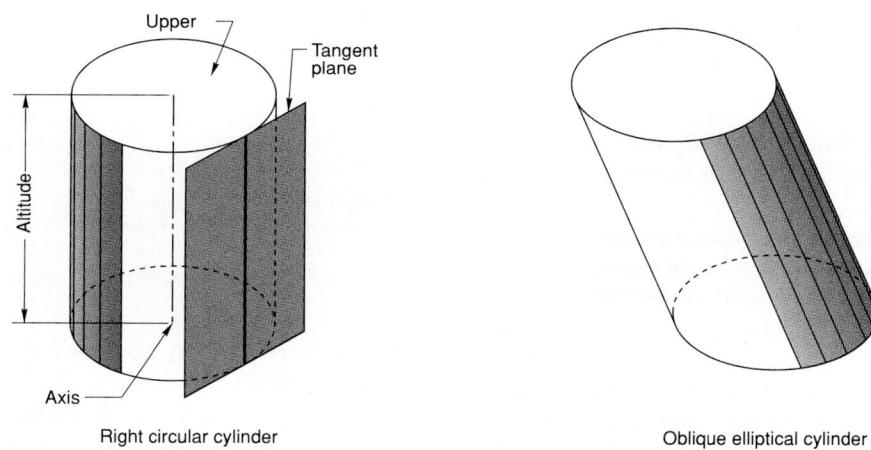

Figure 3.91 Cylinder Classifications

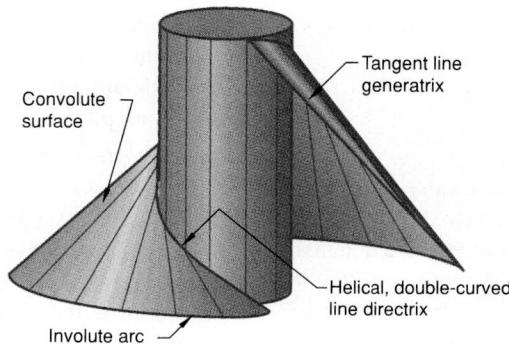

Figure 3.92 Helical Convolute

A convolute surface is formed by the sweep of a straight line tangent to a double-curved line. A helical convolute is a special case formed by the sweep of a line tangent to a helix curve.

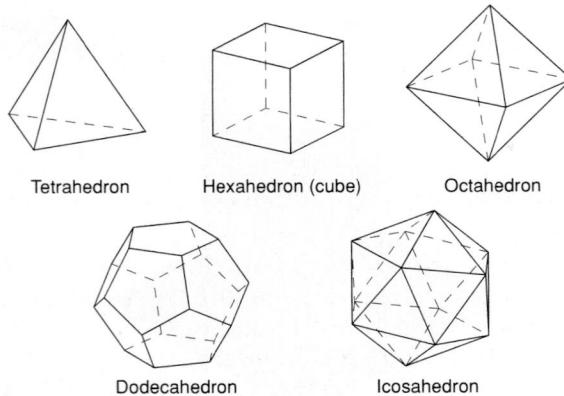**Figure 3.93 Regular Polyhedra**

Regular polyhedra are solids formed by plane surfaces that are regular polygonal shapes.

Regular polyhedra are classified by the shape and number of faces, as follows.

Tetrahedron. A symmetrical or asymmetrical 3-D surface or solid object with *four* equilateral triangular sides.

Hexahedron. A symmetrical or asymmetrical 3-D surface or solid object with *six* quadrilateral sides.

Octahedron. A symmetrical or asymmetrical 3-D surface or solid object with *eight* equilateral triangular sides.

Dodecahedron. A symmetrical or asymmetrical 3-D surface or solid object with *twelve* pentagonal sides.

Icosahedron. A symmetrical or asymmetrical 3-D surface or solid object with *twenty* equilateral triangular sides.

Practice Exercise 3.10

Create real models of polyhedra using the developments found at the end of Chapter 2. Make real models of the Cube, Prism, and Tetrahedron. Sketch the multi-views and pictorials of each real model created from the developments.

Using a CAD solid modeler with primitive commands, create solid models of regular polyhedra. View the polyhedra from various viewpoints, with hidden lines shown and then removed.

Polygonal Prisms A **polygonal prism** is a polyhedron that has two equal parallel faces, called its *bases*, and lateral faces that are parallelograms. (Figure 3.94)

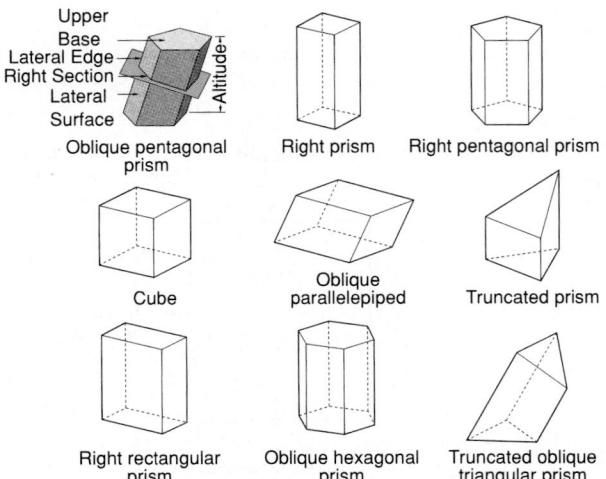**Figure 3.94 Classification of Prisms**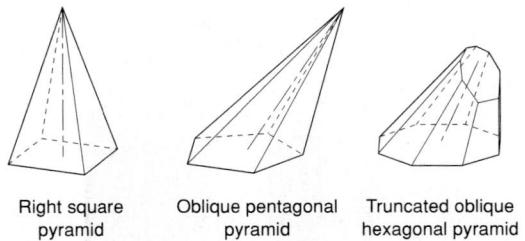**Figure 3.95 Classification of Pyramids**

The parallel bases may be of any shape and are connected by parallelogram sides. A line connecting the centers of the two bases is called the *axis*. If the axis is perpendicular to the bases, the axis is called the *altitude* and the prism is a *right prism*. If the axis is not perpendicular to the bases, the prism is an *oblique prism*. A *truncated prism* is one that has been cut off at one end, forming a base that is not parallel to the other base. A **parallelepiped** is a prism with a rectangle or parallelogram as a base. Polygonal prisms are easily produced with 3-D CAD programs by using extrusion techniques.

Pyramids A **pyramid** is a polyhedron that has a polygon for a base and lateral faces that have a common intersection point, called a *vertex*. The *axis* of a pyramid is the straight line connecting the center of the base to the vertex. If the axis is perpendicular to the base, the pyramid is a *right pyramid*; otherwise, it is an *oblique pyramid*. (Figure 3.95) A *truncated* or *frustum* pyramid is formed when a plane cuts off the vertex. The *altitude* of a pyramid is the perpendicular distance from the vertex to the center of the base plane.

Warped Surfaces A *warped surface* is a double-curved ruled 3-D surface generated by a straight line moving such that any two consecutive positions of the line are *skewed* (not in the same plane). Warped surfaces are not developable. Figure 3.96 illustrates an example of a warped surface. Lines MN and OP are neither

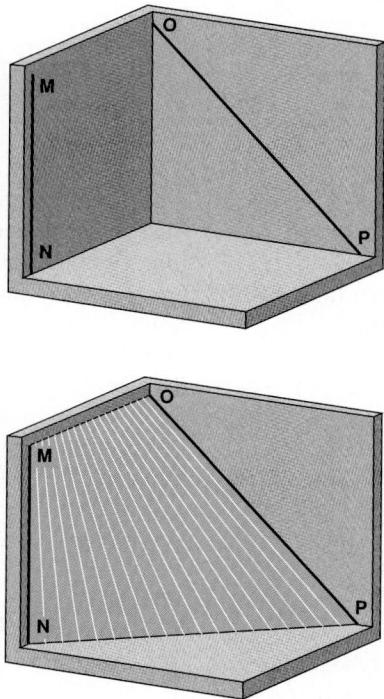

Figure 3.96 Generating a Warped Surface by Moving a Straight Line So that Any Two Consecutive Positions Are Skewed

parallel nor intersecting. To connect them with a smooth surface, to form a sheetmetal panel for an automobile, for example, a warped surface must be used.

3.12.3 Fractal Curves and Surfaces

Benoit Mandelbrot of the IBM Research Center pioneered an investigation into the nature of *self similarity*, which is the condition where a figure is repeated or mimicked by smaller versions of itself. Well-known occurrences of self similarity are coastlines, mountain ranges, landscapes, clouds, galaxy structures, radio noise, and stock market fluctuations. For example, a coastline viewed from orbit will have a certain level of ruggedness, caused by bays, peninsulas, and inlets. The same coastline viewed from an aircraft will show further detail, and the detail will mimic the ruggedness, with smaller bays, peninsulas, and inlets.

Mandelbrot developed the geometry of **fractals**, which is short for fractional dimensional, to define such repetition mathematically. Fractal geometry has led to the development of computer-based fractal design tools that can produce very complex random patterns. The term fractal is used to describe graphics of randomly generated curves and surfaces that exhibit a degree of self similarity. These fractal curves and surfaces emerge in the form of images that are much more visually realistic than can be produced with conventional geometric forms. (Figure 3.97) In addition, fractal image compression techniques can be used to solve storage problems associated with large graphical image files on computers. © CAD Reference 3.40

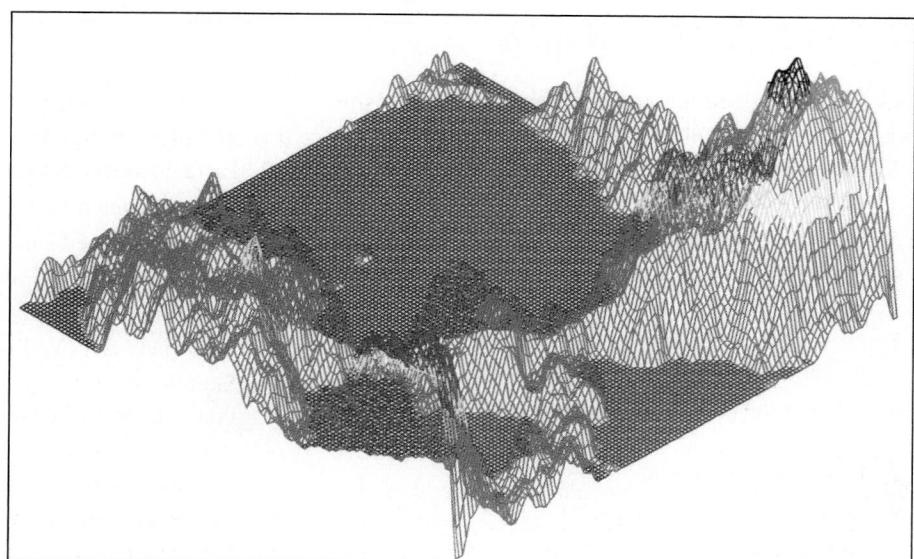

Figure 3.97 Mountain Terrain Based on Fractal Surfaces

3.13 SUMMARY

This chapter introduces you to the geometry commonly used in engineering design graphics. Since surface modeling is an important part of modern engineering design, modern techniques and geometric forms used with CAD systems are described. In

addition, geometric construction techniques useful in creating some types of 2-D engineering geometry are included. Because geometry provides the building blocks for creating and representing more complex products and structures, the information presented in this chapter will be used throughout the remaining chapters in this text.

KEY TERMS

Absolute coordinates	Focus	Parabola	Roulette
Angle	Fractal	Paraboloid	Ruled surface
Bezier curve	Freeform curves	Parallel line	Shape description
Bisector	Freeform surface	Parallelepiped	Single-curved line
B-spline curve	Generatrix	Parallelogram	Single-curved surface
Cartesian coordinate system	Helix	Perpendicular lines	Spherical coordinates
Circle	Hyperbola	Planar surface	Spiral
Cone	Intersecting lines	Plane	Spline curve
Conics	Involute	Point	Surface
Coordinates	Irregular curves	Polar coordinates	Surface of revolution
Curved line	Line	Polyhedron	Swept surfaces
Cycloid	Local coordinate system	Polygonal prism	Tangent
Cylinder	Locus	Polygon	Triangle
Cylindrical coordinates	Major diameter	Pyramid	Undevelopable surface
Developable surface	Midpoint	Quadrilaterals	Vertex
Directrix	Minor diameter	Reference point	Warped surface
Double-curved line	Node	Regular curve	World coordinate system
Double-curved surface	Nonparallel line	Regular polyhedra	
Ellipse	Ogee curve	Regular polygon	
Engineering geometry	Origin	Relative coordinates	
	Patch	Right-hand rule	

QUESTIONS FOR REVIEW

1. Define engineering geometry and describe its importance to engineering design.
2. Describe how coordinate space relates to engineering design.
3. Explain the right-hand rule, using sketches.
4. How is a curved line different from a straight line?
5. Describe an engineering application for a parabola and for a hyperbola.
6. What is the difference between a plane and a surface?
7. List six quadrilaterals.
8. Define concentric circles.
9. Define a tangent.
10. Describe an engineering application for an ellipse.
11. List and sketch four conic sections.
12. List and sketch four regular polyhedrons.
13. List and sketch four polygonal prisms.
14. Define a warped surface.
15. List the major categories of geometric forms.
16. Sketch and label the various conditions that can occur between two lines.
17. Sketch and label the various tangent conditions that can occur between lines and curves and between two curves.
18. Sketch a circle and label the important parts.
19. List and define freeform curves.
20. Describe fractals.

FURTHER READING

Anand, V. B. *Computer Graphics and Geometric Modeling for Engineers*. New York: John Wiley & Sons, 1993.

Barnsley, M. *Fractals Everywhere*. Boston, MA: Academic Press Inc., 1988.

DeJong, P. E.; J. S. Rising; and M. W. Almfeldt. *Engineering Graphics Communications, Analysis, Creative Design*. 6th ed. Dubuque, IA: Kendall/Hunt Publishing Company, 1983.

Foley, J. D.; A. VanDamm; S. K. Feiner; and J. K. Hughes. *Computer Graphics Principles and Practices*. 2nd ed. Reading, MA: Addison-Wesley, 1991.

Mandlebrot, B. *The Fractal Geometry of Nature*. New York: Freeman, 1983.

Mortenson, M. E. *Geometric Modeling*. New York: John Wiley & Sons, 1985.

Nothing But Zooms, Video animations of the Mandelbrot set available from ART MATRIX, P.O. Box 880, Ithaca, NY 14851-0880. Phone 607-277-0959.

Rogers, D. F., and J. A. Adams. *Mathematical Elements for Computer Graphics*. 2nd ed. New York: McGraw-Hill, 1990.

Wellman, B. L. *Technical Descriptive Geometry*. 2nd ed. New York: McGraw-Hill, 1987.

Whitt, L. "The Standup Conic Presents: The Parabola and Applications." *The UMAP Journal* 3 no. 3 (1982), pp. 285-313.

Whitt, L. "The Standup Conic Presents: The Hyperbola and Applications." *The UMAP Journal* 5 no. 1 (1984).

PROBLEMS

3.1 Using rectangular graph paper, draw or sketch the X and Y axes for the Cartesian coordinate system, then locate point A at 2,3; point B at -2,5; point C at -3,-2; and point D at 4,-1.

3.2 Using the same axes constructed in Problem 3.1, construct line AB using endpoints -1,-2 and -3,-4.

3.3 Add to the axes in Problem 3.1 a line MN with the first endpoint at 1,1 and the second endpoint at 45 degrees and 1" from the first endpoint.

3.4 Using rectangular graph paper, construct the X and Y axes, then draw a figure, using the following absolute coordinate values:

0,0
3,0
3,2
0,2
0,0

3.5 Using rectangular graph paper, construct the X and Y axes, then draw a figure, using the following relative coordinate values:

0,0
4,0
0,3
-4,0
0,-3

3.6 Using isometric grid paper, construct the X, Y, and Z axes. Reference Figure 3.4. Using the right-hand rule, place points at the following locations:

1. 0,0,0
2. 4,0,0
3. 4,2,0
4. 0,2,0
5. 0,0,2
6. 4,0,2
7. 4,2,2
8. 0,2,2

Connect points 1-2, 2-3, 3-4, 4-1.

Connect points 5-6, 6-7, 7-8, 8-5.

Connect points 4-8, 3-7, 6-7, 5-7.

What geometric solid is produced?

3.7 Use the A-size sheet drawn in Chapter 1, or create a new one; then do the following:

- Draw a 1.75" horizontal line AB, then bisect it.
- Draw a 2.25" inclined line CD, then divide CD into five equal parts.
- Draw a 1.5" vertical line EF, then proportionally divide it into three parts.
- Draw a 2" vertical line GH, then draw a line perpendicular to GH, through a point 0.5" from one end.
- Draw a 2" horizontal line JK, then draw another line parallel to JK and 0.5" from it.
- Draw a 1" diameter circle, then draw a line tangent to the circle.

3.8 Create a new drawing sheet as for Problem 3.7, then do the following:

- Draw a 1" radius arc, then construct a line tangent to it. Locate and label the point of tangency.
- Draw a 0.75" diameter circle, then construct another circle tangent to the first one.
- Draw two lines at right angles to each other, then construct an arc tangent to both lines.
- Draw two lines at 45 degrees to each other, then construct an arc tangent to both lines.
- Construct a circle and a line separate from the circle, then construct an arc tangent to both the circle and the line.
- Construct nonintersecting 1" diameter circles, then construct an arc tangent to both circles.

3.9 Create a sheet as in Problem 3.7, then do the following:

- Mark three points on the sheet, then construct a circle through the three points.
- Draw two parallel lines spaced 1.5" apart, then construct an ogee curve between the two lines.
- Draw a 0.75" radius arc, then rectify its length.
- Construct two lines at any angle, then construct a parabola, using the tangent method.
- Draw two lines at right angles, then construct a hyperbola, using the equilateral method.
- Draw a 2" horizontal line. Locate two foci by constructing a short perpendicular line 0.5" from each end of the horizontal line. Construct an ellipse using any technique.

3.10 Create a sheet as in Problem 3.7, then do the following:

- Construct a spiral of Archimedes.
- Draw a 1" diameter circle, then construct an involute of the circle.
- Draw two intersecting lines not at right angles to each other, then bisect one of the acute angles.
- Draw two intersecting lines.
- Transfer one of the acute angles constructed in *d* to another position.
- Construct a square with 1.25" sides.

3.11 Create a sheet as in Problem 3.7, then do the following:

- Draw a 2" diameter circle, then inscribe a square.
- Draw a 1.75" diameter circle, then circumscribe a square.
- Given sides $A = 1.375"$, $B = 1.00"$, and $C = 2.00"$, construct a triangle.
- Construct an equilateral triangle with sides 1.375".
- Draw a 1.5" diameter circle, then inscribe a pentagon.
- Draw a 1.5" diameter circle, then circumscribe a hexagon.

3.12 Create a sheet as in Problem 3.7, then do the following:

- Draw a 1.5" diameter circle, then inscribe a hexagon.
- Draw a 1.5" diameter circle, then circumscribe an octagon.
- Draw a 1.5" diameter circle, then inscribe an octagon.
- Construct a cycloid.
- Construct an epicycloid.
- Construct a hypocycloid.

3.13 (Figure 3.98) Draw the ratchet and detent, using the given dimensions.

3.14 (Figure 3.99) A Geneva stop mechanism has a driving wheel that turns at a constant speed and a driven wheel that turns intermittently. The driven wheel rotates one-fourth turn every time the drive pin enters and leaves a slot. Begin the drawing by constructing triangle ABC, then locate point P and center line CP. After the drawing is complete, measure angle X.

3.15 (Figure 3.100) The piston is driven by the connecting rod, which rotates on the crankshaft. As point A moves in a circular path from A0 to A12, the piston pin B moves in a straight line from points B0 to B12. Create a displacement curve by dividing the semicircles into 12 equal parts, then locate point B at each of the 12 intervals, and finally transfer that displacement to the diagram.

3.16 Create an A-size drawing sheet, then construct a helix from a right circular cylinder that has a 2" diameter base and is 4" high.

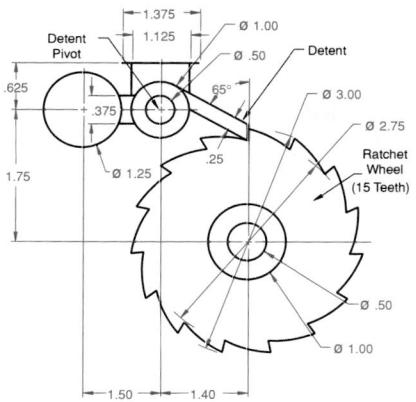

Figure 3.98 Ratchet and Detent

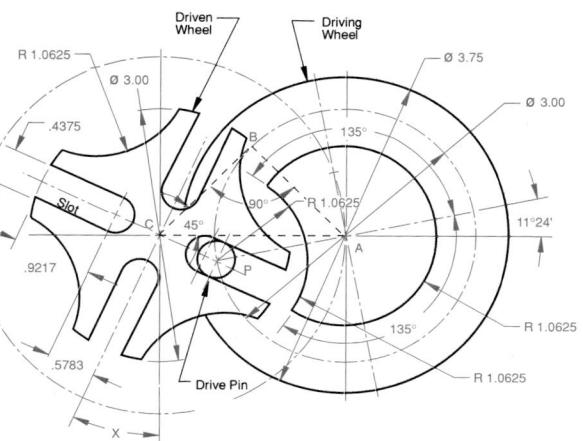

Figure 3.99 Geneva Stop Mechanism

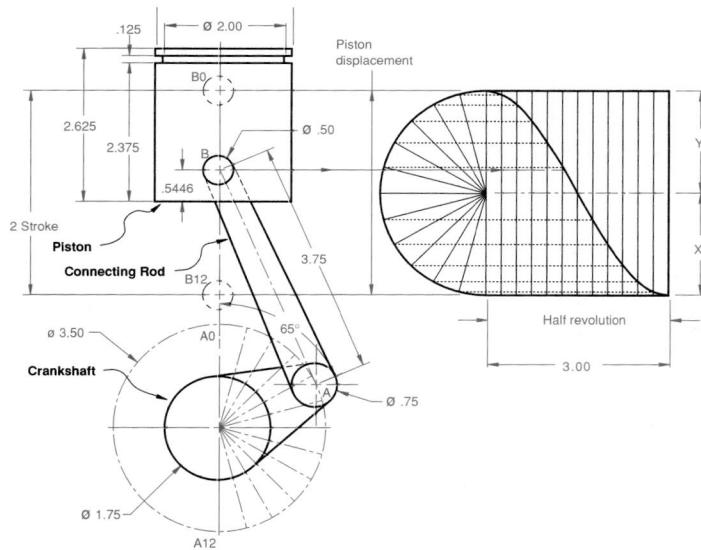

Figure 3.100 Piston, Connecting Rod, Crankshaft, and Displacement Curve

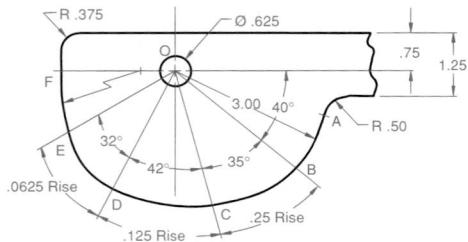

Figure 3.101 Cam Arm

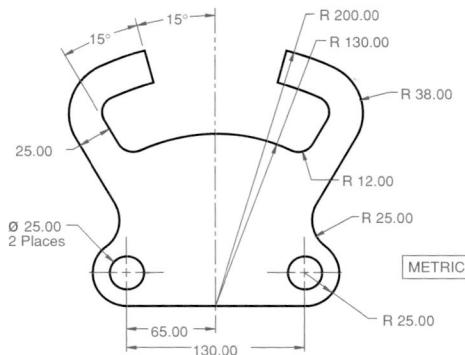

Figure 3.103 Split Guide

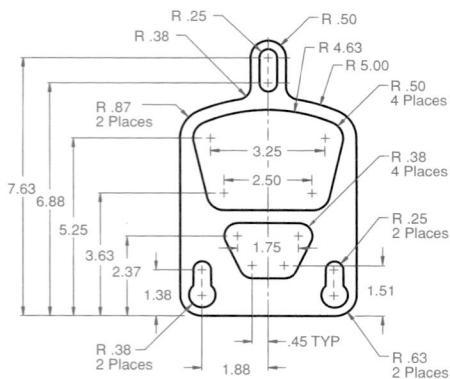

Figure 3.102 Slip Cover

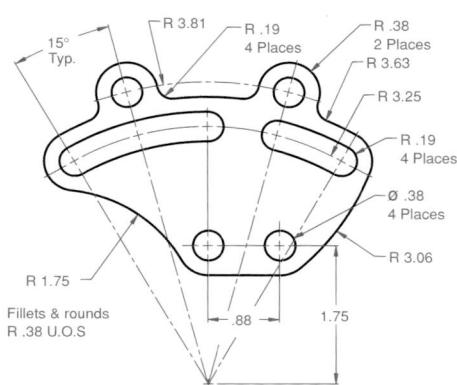

Figure 3.104 Arched Follower

3.17 Create an A-size drawing sheet, then construct a helix from a right circular cone that has a 2" diameter base and is 4" high.

3.18 (Figure 3.101) Draw the cam arm, using the given dimensions and calculating the missing ones. The curve is made of five tangent circular arcs. The rise is the change in distance from the center of the hole in the cam arm.

3.19 (Figure 3.102) Draw the slip cover, using the given dimensions.

3.20 (Figures 3.103 through 3.112) Draw the part, using the given dimensions.

3.21 A circular arc passes through three points labeled A, B, and C. Point A is 3" to the left of B, and point C is 4" to the right of B and 1" below line AB. Draw the arc and show your construction.

3.22 Draw a triangle with sides 3", 2.25", and 1.875". Inscribe a circle in the triangle.

3.23 Draw a regular hexagon with 1" sides.

3.24 Inscribe a regular hexagon in a 2" diameter circle.

3.25 Draw a regular octagon with 1.5" sides.

3.26 Inscribe a regular octagon in a 1.75" diameter circle.

3.27 Draw an ellipse with a major diameter of 3" and a minor diameter of 1.875".

3.28 Draw an ellipse with a major diameter of 40 mm and a minor diameter of 28 mm.

3.29 Draw an angle and bisect it, then transfer the angle to a new position.

3.30 Draw a triangle and circumscribe a circle.

3.31 Draw a line 6.5" long, and proportionally divide it into three parts of 3, 5, and 9.

3.32 Draw an equilateral triangle and bisect all the angles.

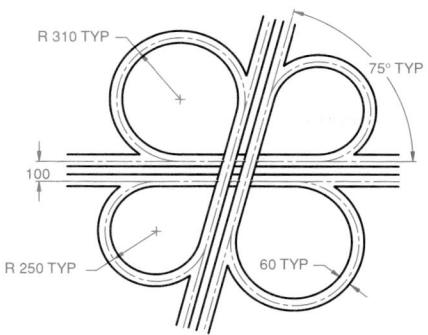

Figure 3.105 Highway Interchange

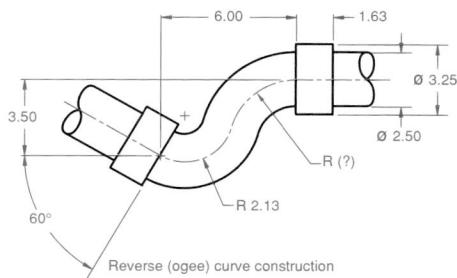

Figure 3.106 Offset Pipe

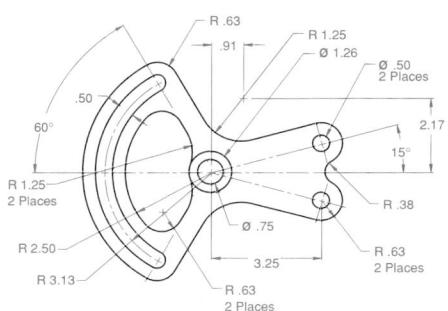

Figure 3.107 Butterfly Spacer

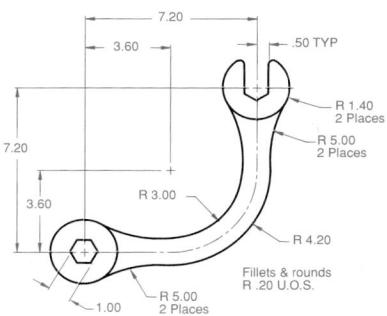

Figure 3.108 Offset Wrench

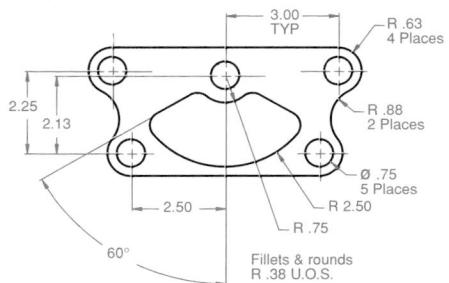

Figure 3.109 Centering Plate

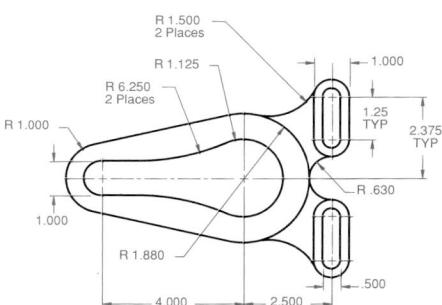

Figure 3.110 Harness Guide

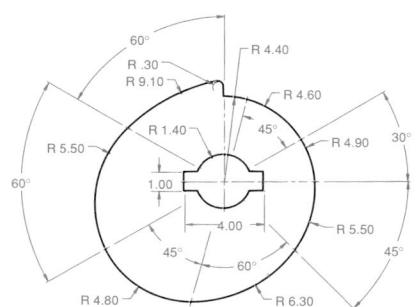

Figure 3.111 Variable Guide

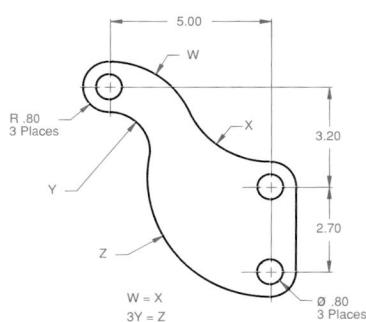

Figure 3.112 Transition

CHAPTER 4

Multiview Drawings

As lines, so loves oblique, may well
Themselves in every angle greet;
But ours, so truly parallel,
Though infinite, can never meet.

Andrew Marvell

OBJECTIVES

After completing this chapter, you will be able to:

1. Explain orthographic and multiview projection.
2. Identify frontal, horizontal, and profile planes.
3. Identify the six principal views and the three space dimensions.
4. Apply standard line practices to multiview drawings.
5. Create a multiview drawing using hand tools or CAD.
6. Identify normal, inclined, and oblique planes in multiview drawings.
7. Represent lines, curves, surfaces, holes, fillets, rounds, chamfers, runouts, and ellipses in multiview drawings.
8. Apply visualization by solids and surfaces to multiview drawings.
9. Explain the importance of multiview drawings.
10. Identify limiting elements, hidden features, and intersections of two planes in multiview drawings.

Chapter 4 introduces the theory, techniques, and standards of multiview drawings, which are a standard method for representing engineering designs. The chapter describes how to create one-, two-, and three-view drawings with traditional tools and CAD. Also described are standard practices for representing edges, curves, holes, tangencies, and fillets and rounds. The foundation of multiview drawings is orthographic projection, based on parallel lines of sight and mutually perpendicular views.

4.1 PROJECTION THEORY

Engineering and technical graphics are dependent on projection methods. The two projection methods primarily used are perspective and parallel. (Figure 4.1) Both methods are based on projection theory, which has taken many years to evolve the rules used today.

Projection theory comprises the principles used to represent graphically 3-D objects and structures on 2-D media. An example of one of the methods developed to accomplish this task is shown in Figure 4.2, which is a pictorial drawing with shades and shadows to give the impression of three dimensions.

All projection theory is based on two variables: line of sight, and plane of projection. These variables are described briefly in the following paragraphs.

4.1.1 Line of Sight (LOS)

Drawing more than one face of an object by rotating the object relative to your *line of sight* helps in understanding the 3-D form. (Figure 4.3) A **line of sight (LOS)** is an imaginary ray of light between an observer's eye and an object. In perspective projection, all lines of sight start at a single point (Figure 4.4); in parallel projection, all lines of sight are parallel (Figure 4.5).

4.1.2 Plane of Projection

A **plane of projection** (i.e., an image or picture plane) is an imaginary flat plane upon which the image created by the lines of sight is projected. The image is produced by connecting the points where the lines of sight pierce the projection plane. (See Figure 4.5) In effect, the 3-D object is transformed into a 2-D representation (also called a projection). The paper or computer screen on which a sketch or drawing is created is a plane of projection.

4.1.3 Parallel versus Perspective Projection

If the distance from the observer to the object is infinite (or essentially so), then the *projectors* (i.e., projection lines) are parallel and the drawing is classified as a parallel projection. (see Figure 4.5) **Parallel projection** requires that the object be positioned at infinity and viewed from multiple points on an imaginary line parallel to the object. If the distance from the observer to the object is finite, then the projectors are not parallel and the drawing is classified as a perspective projection. (See Figure 4.4) **Perspective projection** requires that the object be positioned at a finite distance and viewed from a single point (station point).

Perspective projections mimic what the human eye sees; however, perspective drawings are difficult to create. Parallel projections are less realistic, but they are easier to draw. This chapter will focus on parallel projection. Perspective drawings are covered in Chapter 5 “Pictorial Drawings.”

Orthographic projection is a parallel projection technique in which the plane of projection is positioned between the observer and the object and is perpendicular to the parallel lines of sight. The orthographic projection technique can produce either pictorial drawings that show all three dimensions of an object in one view, or multiviews that show only two dimensions of an object in a single view. (Figure 4.6)

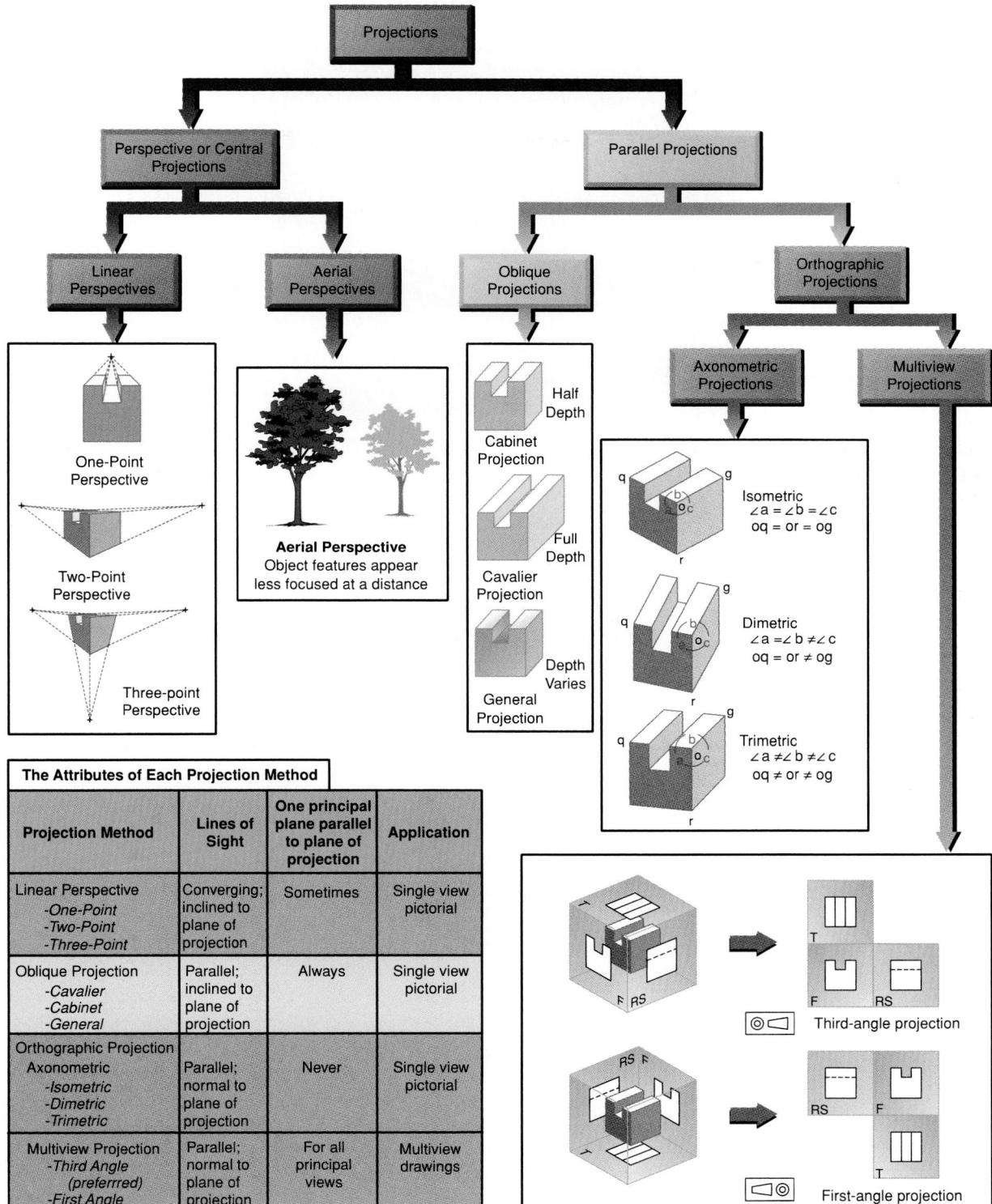

Figure 4.1 Projection Methods

Projection techniques developed along two lines: parallel and perspective.

Figure 4.2 Pictorial Illustration

This is a computer-generated pictorial illustration with shades and shadows. These rendering techniques help enhance the 3-D quality of the image. (Courtesy of CADKEY, Inc.)

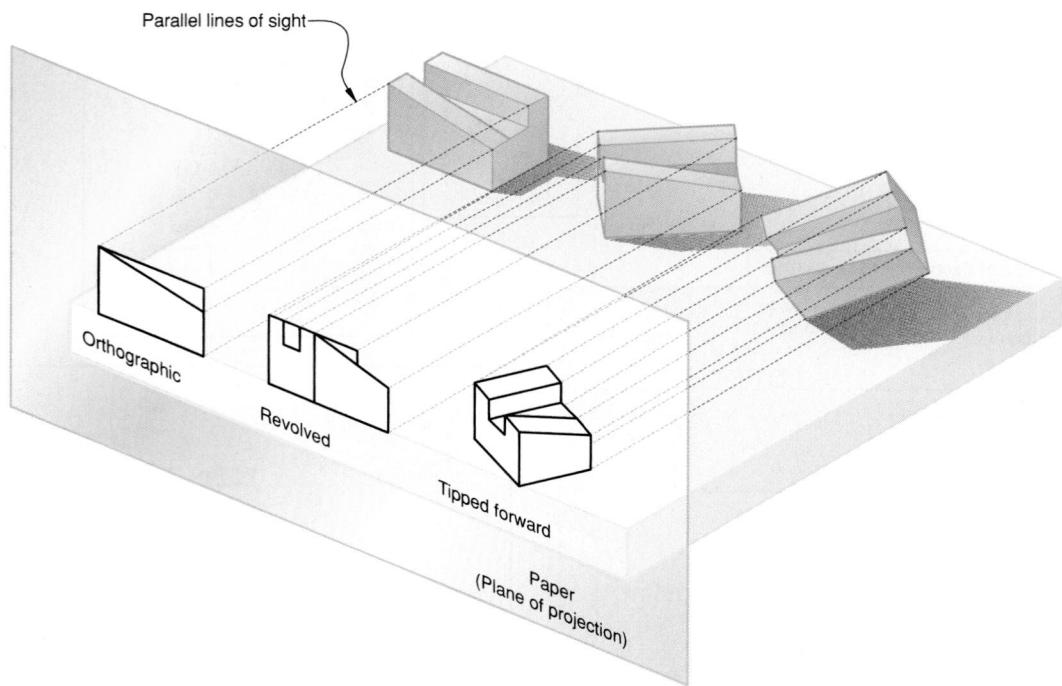

Figure 4.3 Changing Viewpoint

Changing the position of the object relative to the line of sight creates different views of the same object.

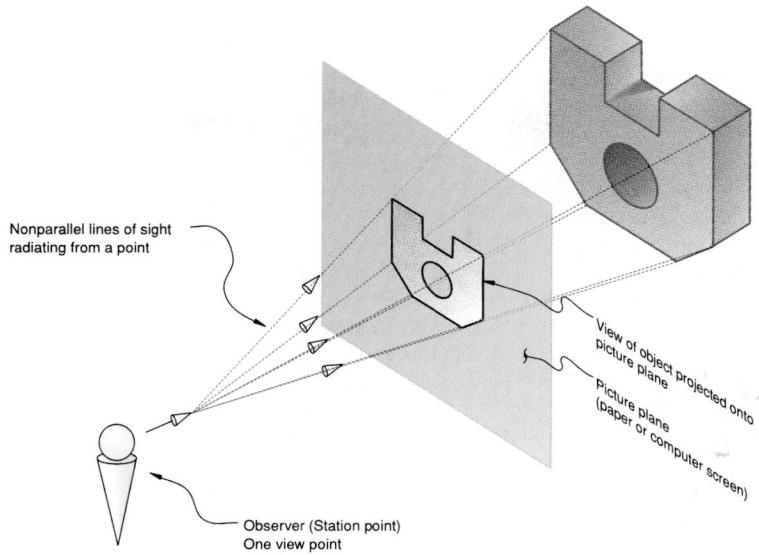

Figure 4.4 Perspective Projection

Radiating lines of sight produce a perspective projection.

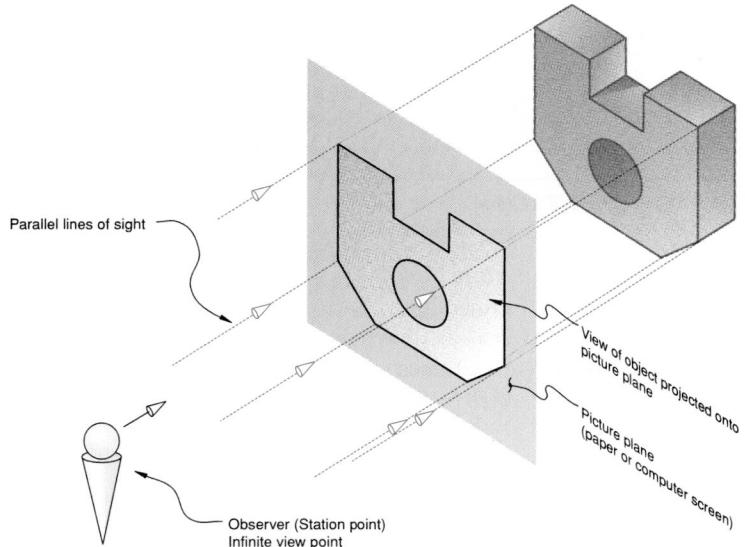

Figure 4.5 Parallel Projection

Parallel lines of sight produce a parallel projection.

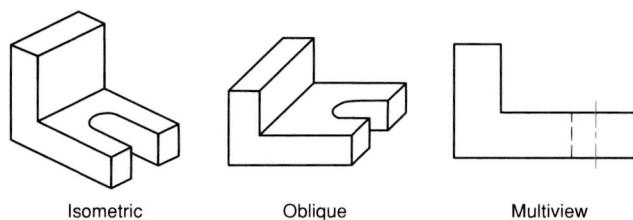

Figure 4.6 Parallel Projection

Parallel projection techniques can be used to create multiview or pictorial drawings.

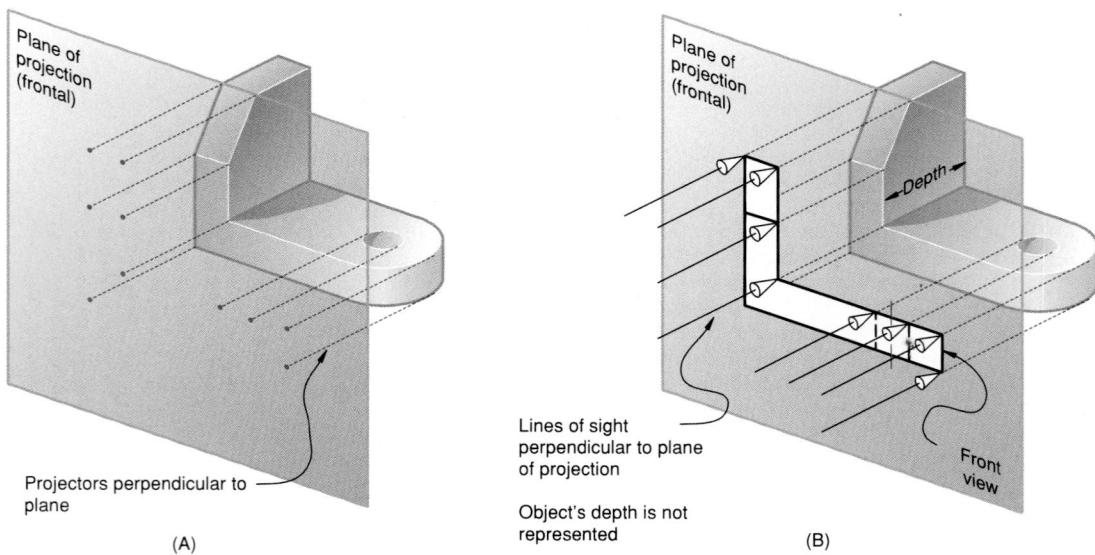

Figure 4.7 Orthographic Projection

Orthographic projection is used to create this front multiview drawing by projecting details onto a projection plane that is parallel to the view of the object selected as the front.

4.2 MULTIVIEW PROJECTION PLANES

Multiview projection is an orthographic projection for which the object is behind the plane of projection, and the object is oriented such that only two of its dimensions are shown. (Figure 4.7) As the parallel lines of sight pierce the projection plane, the features of the part are outlined.

Multiview drawings employ multiview projection techniques. In multiview drawings, generally three views of an object are drawn, and the features and dimensions in each view accurately represent those of the object. Each view is a 2-D flat image, as shown in Figure 4.8. The views are defined according to the positions of the planes of projection with respect to the object.

4.2.1 Frontal Plane of Projection

The *front view* of an object shows the *width* and *height* dimensions. The views in Figures 4.7 and 4.8 are front views. The **frontal plane of projection** is the plane onto which the front view of a multiview drawing is projected.

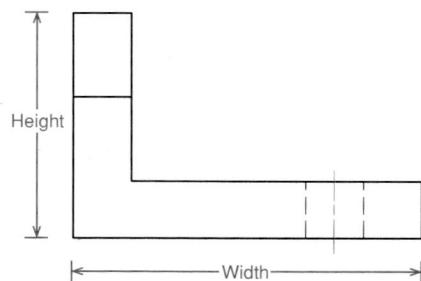

Figure 4.8 Single View

A single view, in this case the front view, drawn on paper or computer screen makes the 3-D object appear 2-D; one dimension, in this case the depth dimension, cannot be represented since it is perpendicular to the paper.

4.2.2 Horizontal Plane of Projection

The *top view* of an object shows the *width* and *depth* dimensions. (Figure 4.9) The top view is projected onto the **horizontal plane of projection**, which is a plane suspended above and parallel to the top of the object.

Industry Application

CAD and Stereolithography Speed Solenoid Design

When Peter Paul Electronics faced the need to quickly redesign a humidifier solenoid valve, Senior Design Engineer Thomas J. Pellegatto naturally turned his CAD-KEY-based system loose on the physical parameters of the new valve. But that wasn't enough. The design required lower-cost manufacturing technology as well as dimensional and mechanical design changes.

Existing valves from the company feature an all-steel sleeve, consisting of a flange nut, tube, and end stop, all of which are staked together for welding. A weld bead secures the end stop to the tube at the top edge and joins the tube and threaded portion of the flange nut at the bottom. Alignment of these components becomes critical, because the sleeve sits inside the coil,

which is the heart of the solenoid valve. In addition, a plunger that causes air or fluid to flow in the valve rises inside the sleeve.

According to Pellegatto, the simplest method for reducing cost and complexity of the critical sleeve assembly was to use the coil's bobbin to replace the sleeve and house the plunger. Working directly with engineers at DuPont, designers selected a thermoplastic named Rynite to eliminate misalignment and the need for welding the new assembly. The CAD system fed Peter Paul's internal model shop with the data to develop bobbin prototypes from the thermoplastic. In addition, designers decided to mold the formerly metallic mounting bracket as part of the plastic housing.

Once designs were finalized, Pellegatto sent the CAD file to a local stereolithography shop, which built demonstration models using a 3D Systems unit. Two copies each of three molded components—the bobbin, valve body, and overmolded housing—were produced for about \$3,000. Finally, after sample parts were approved by the customer, hard tooling was developed using revised CAD files. This venture into "desk-top manufacturing" saved enormous amounts of design cycle time, according to Pellegatto.

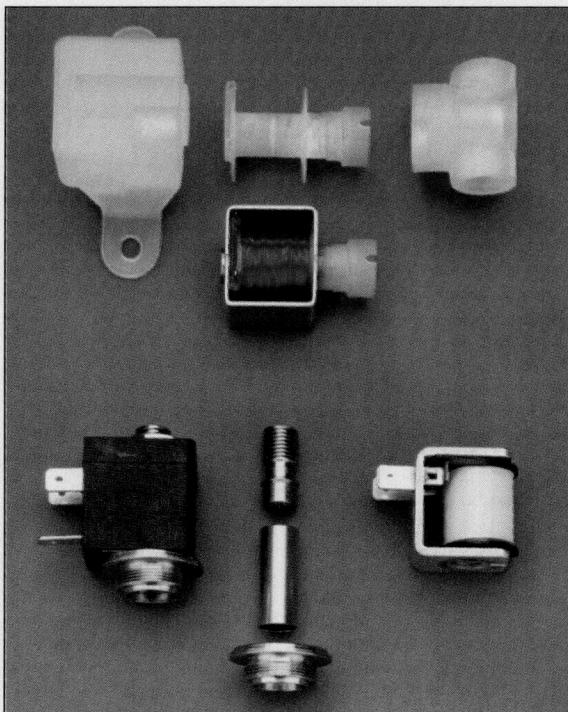

Redesign and simplification of the solenoid valve coil and sleeve assembly (left) is easily compared with the coil-on-bobbin assembly. The extended and molded one-piece bobbin eliminates the use of two machined parts, two welds, and one quality operation while providing an improved magnetic circuit, reduced weight, and lower cost.

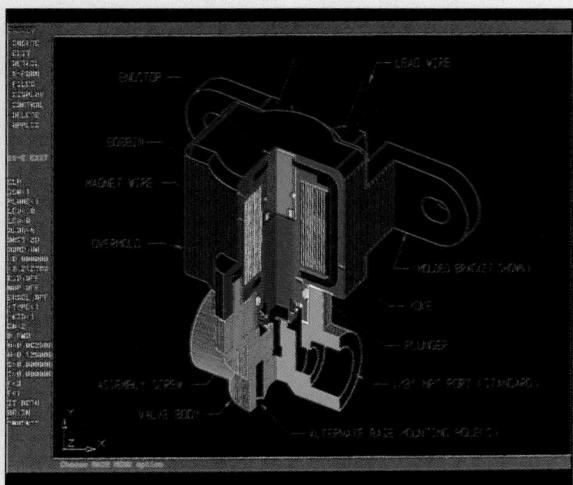

The three components created in plastic include the overmolded valve housing with integral bracket (red), the bobbin on which the coil is wound, and the valve body with which the solenoid valve is connected (blue).

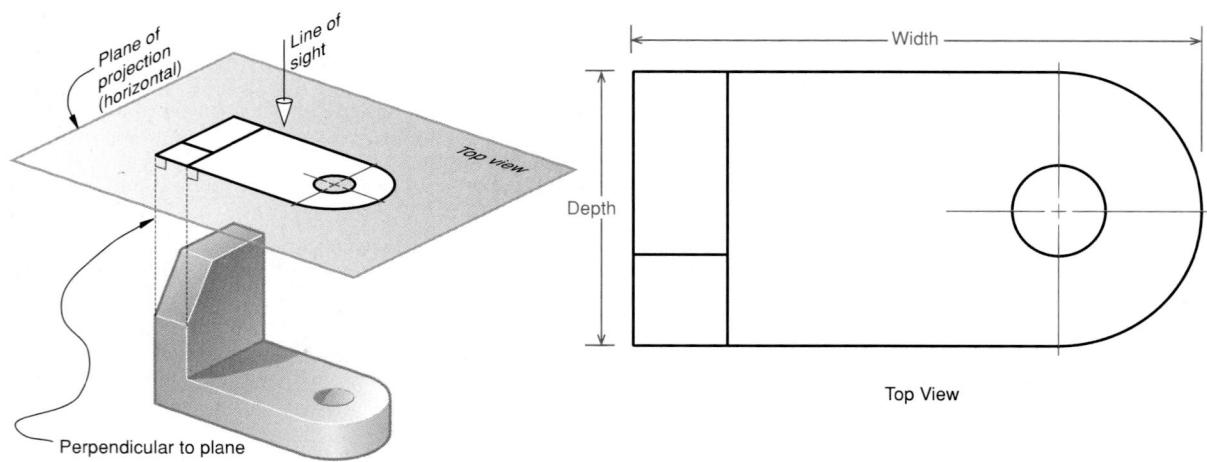

Figure 4.9 Top View

A top view of the object is created by projecting onto the horizontal plane of projection.

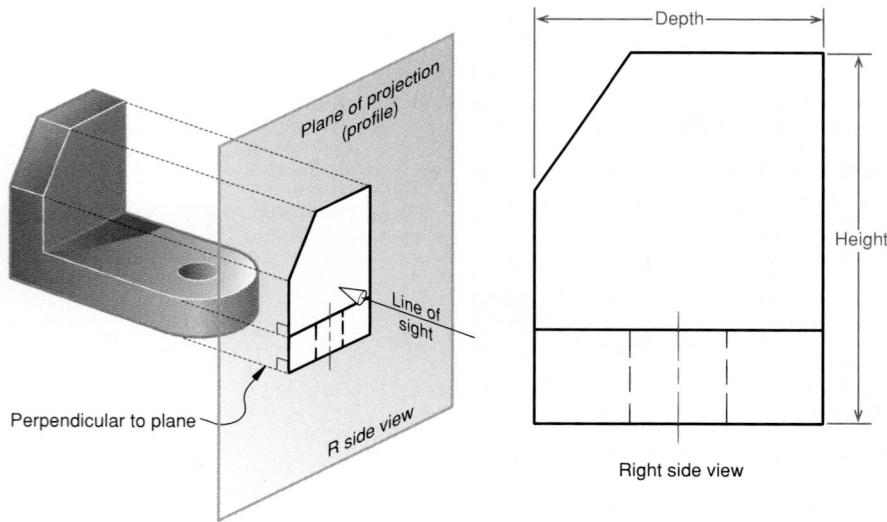

Figure 4.10 Profile View

A right side view of the object is created by projecting onto the profile plane of projection.

4.2.3 Profile Plane of Projection

The *side view* of an object shows the *depth* and *height* dimensions. In multiview drawings, the right side view is the standard side view used. The right side view is projected onto the **profile plane of projection**, which is a plane that is parallel to the right side of the object. (Figure 4.10)

4.2.4 Orientation of Views from Projection Planes

The views projected onto the three planes are shown together in Figure 4.11. The top view is always positioned above and aligned with the front view, and the right side view is always positioned to the right of and aligned with the front view, as shown in the figure.

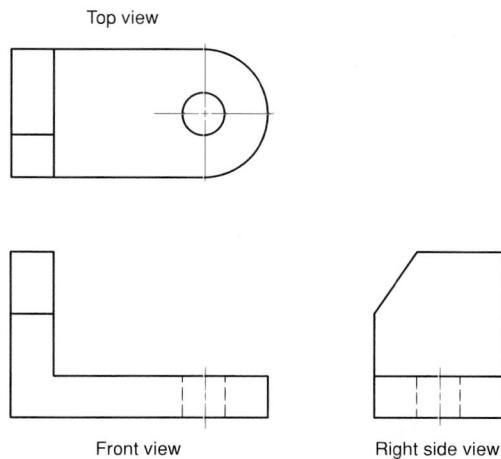

Figure 4.11 Multiview Drawing of an Object

For this object three views are created: front, top, and right side. The views are aligned so that common dimensions are shared between views.

4.3 ADVANTAGES OF MULTIVIEW DRAWINGS

In order to produce a new product, it is necessary to know its true dimensions, and true dimensions are not adequately represented in most pictorial drawings. To illustrate, the photograph in Figure 4.12 is a pictorial perspective image. The image distorts true distances, which are essential in manufacturing and construction. Figure 4.13 demonstrates how a perspective projection distorts measurements. Note that the two width dimensions in the front view of the block appear different in length; equal distances do not appear equal on a perspective drawing.

In the pictorial drawings in Figure 4.14, angles are also distorted. In the isometric view, right angles are not shown as 90 degrees. In the oblique view, only the front surfaces show true right angles. In isometric drawings, circular holes appear as ellipses; in oblique drawings, circles also appear as ellipses, except on the front plane. Changing the position of the object will minimize the distortion of some surfaces, but not all.

Since engineering and technology depend on exact size and shape descriptions for designs, the best approach is to use the parallel projection technique called orthographic projection to create views that show only two of the three dimensions (width, height, depth). If the object is correctly positioned relative to

Figure 4.12 Perspective Image

The photograph shows the road in perspective, which is how cameras capture images. Notice how the telephone poles appear shorter and closer together off in the distance. (Photo courtesy of Anna Anderson.)

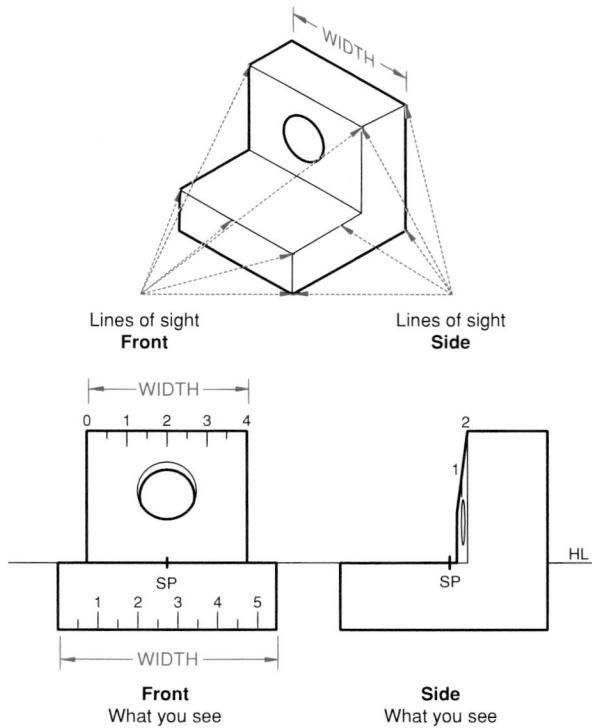

Figure 4.13 Distorted Dimensions

Perspective drawings distort true dimensions.

the projection planes, the dimensions of features will be represented in true size in one or more of the views. (Figure 4.15) Multiview drawings provide the most accurate description of three-dimensional objects and structures for engineering, manufacturing, and construction requirements.

In the computer world, 3-D models replace the multiview drawing. These models are interpreted directly from the database, without the use of dimensioned drawings. (Figure 4.16)

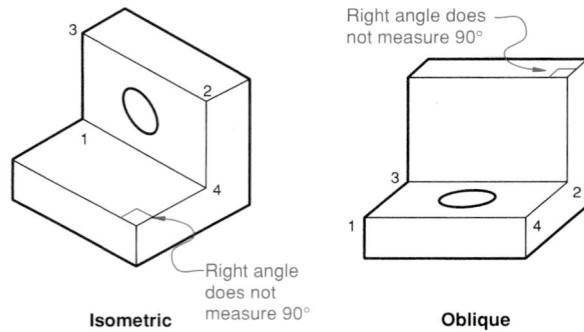

Figure 4.14 Distorted Angles

Angular dimensions are distorted on pictorial drawings.

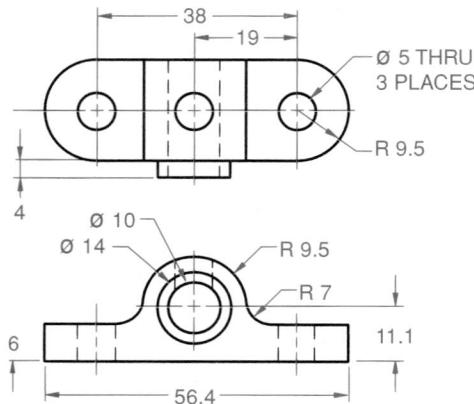

Figure 4.15 Multiview Drawing

Multiview drawings produce true-size features, which can be used for dimensionally accurate representations.

4.4 THE SIX PRINCIPAL VIEWS

The plane of projection can be oriented to produce an infinite number of views of an object. However, some views are more important than others. These **principal views** are the six mutually perpendicular views that are produced by six mutually perpendicular planes of projection. If you imagine suspending an object in a glass box with major surfaces of the object positioned so that they are parallel to the sides of the box, the six sides of the box become

Figure 4.16 CAD Data Used Directly by Machine Tool

This computer-numeric-control (CNC) machine tool can interpret and process 3-D CAD data for use in manufacturing, to create dimensionally accurate parts. (Courtesy of Intergraph Corporation.)

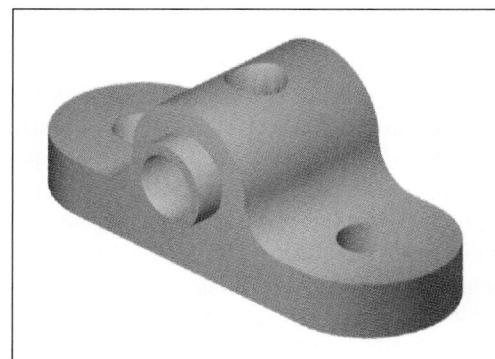

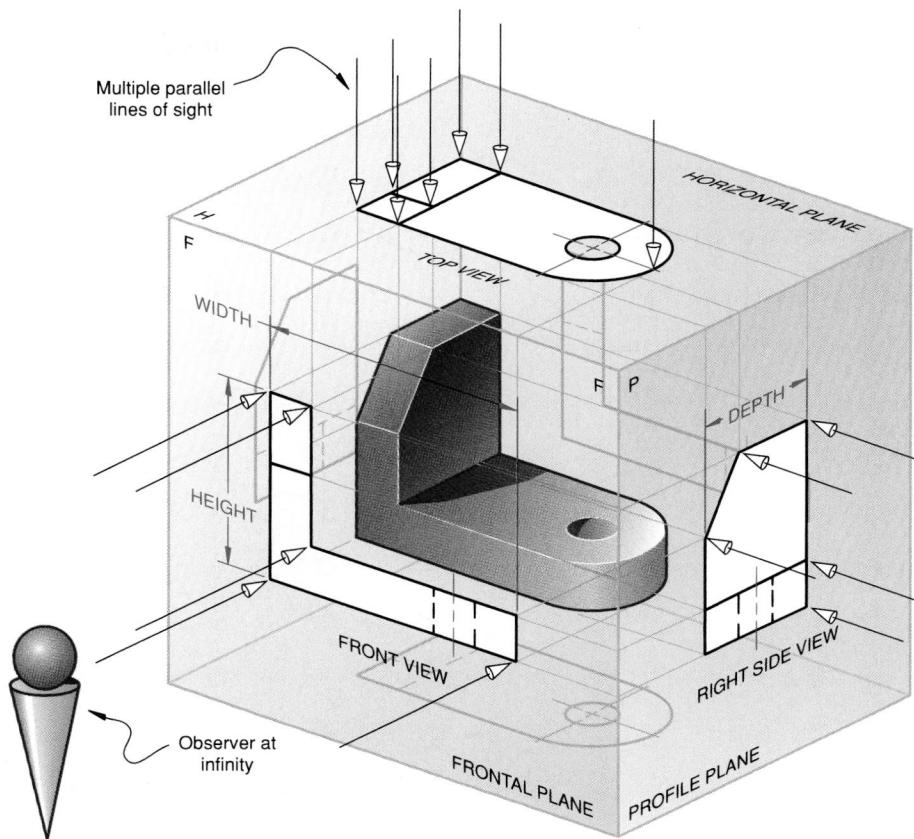

Figure 4.17 Object Suspended in a Glass Box, Producing the Six Principal Views

Each view is perpendicular to and aligned with the adjacent views.

projection planes showing the six views. (Figure 4.17) The six principal views are front, top, left side, right side, bottom, and rear. To draw these views on 2-D media, that is, a piece of paper or a computer monitor, imagine putting hinges on both sides of the front glass plane and on one edge of the profile plane. Then cut along all the other corners, and flatten out the box to create a six-view drawing, as shown in Figure 4.18.

The following descriptions are based on the X, Y, and Z coordinate system. In CAD, *width* can be assigned the X axis, *height* assigned the Y axis, and *depth* assigned the Z axis. This is not universally true for all CAD systems but is used as a standard in this text. © CAD Reference 4.1

The **front view** is the one that shows the most features or characteristics. All other views are based on the orientation chosen for the front view. Also, all other views, except the rear view, are formed by

rotating the lines of sight 90 degrees in an appropriate direction from the front view. With CAD, the front view is the one created by looking down the Z axis (in the negative Z viewing direction), perpendicular to the X and Y axes.

The **top view** shows what becomes the top of the object once the position of the front view is established. With CAD, the top view is created by looking down the Y axis (in the negative Y viewing direction), perpendicular to the Z and X axes.

The **right side view** shows what becomes the right side of the object once the position of the front view is established. With CAD, the right side view is created by looking down the X axis from the right (in the negative X viewing direction), perpendicular to the Z and Y axes.

The **left side view** shows what becomes the left side of the object once the position of the front view is established. The left side view is a mirror image of the

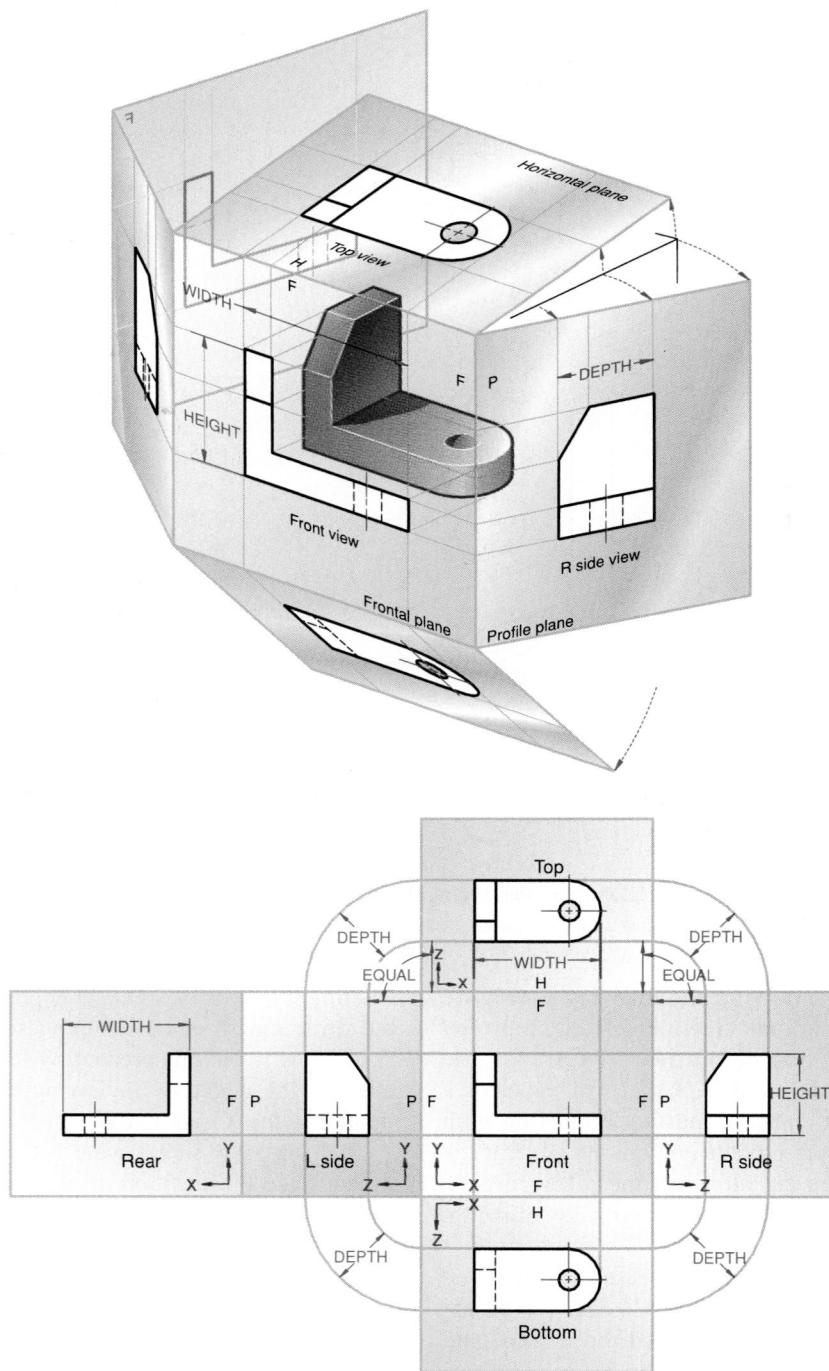

Figure 4.18 Unfolding the Glass Box to Produce a Six-View Drawing

right side view, except that hidden lines may be different. With CAD, the left side view is created by looking down the X axis from the left (in the positive X viewing direction), perpendicular to the Z and X axes.

The **rear view** shows what becomes the rear of the object once the front view is established. The rear view is at 90 degrees to the left side view and is a mirror image of the front view, except that hidden lines may be different. With CAD, the rear view is created by looking down the Z axis from behind the object (in the positive Z viewing direction), perpendicular to the Y and X axes.

The **bottom view** shows what becomes the bottom of the object once the front view is established. The bottom view is a mirror image of the top view, except that hidden lines may be different. With CAD, the bottom view is created by looking down the Y axis from below the object (positive Y viewing direction), perpendicular to the Z and X axes.

The concept of laying the views flat by “unfolding the glass box,” as shown in Figure 4.18, forms the basis for two important multiview drawing standards:

1. Alignment of views.
2. Fold lines.

The top, front, and bottom views are all aligned vertically and share the same width dimension. The rear, left side, front, and right side views are all aligned horizontally and share the same height dimension.

Fold lines are the imaginary hinged edges of the glass box. The fold line between the top and front views is labeled *H/F*, for horizontal/frontal projection planes; and the fold line between the front and each profile view is labeled *F/P*, for frontal/horizontal projection planes. The distance from a point in a side view to the *F/P* fold line is the same as the distance from the corresponding point in the top view to the *H/F* fold line. Conceptually, then, the fold lines are edge-on views of reference planes. Normally, fold lines or reference planes are not shown in engineering drawings. However, they are very important for auxiliary views and spatial geometry construction. © CAD Reference 4.2

Practice Exercise 4.1

Hold an object at arm's length or lay it on a flat surface. Close one eye, then view the object such that your line of sight is perpendicular to a major feature, such as a flat side. Concentrate on the outside edges of the object and sketch what you see. Move your line of sight 90 degrees, or rotate the object 90 degrees, and sketch what you see. This process will show you the basic procedure necessary to create the six principal views.

4.4.1 Conventional View Placement

The three-view multiview drawing is the standard used in engineering and technology, because many times the other three principal views are mirror images and do not add to the knowledge about the object. The standard views used in a three-view drawing are the *top*, *front*, and *right side* views, arranged as shown in Figure 4.19. The width dimensions are aligned between the front and top views, using vertical projection lines. The height dimensions are aligned between the front and profile views, using horizontal projection lines. Because of the relative positioning of the three views, the depth dimension cannot be aligned using projection lines. Instead, the depth dimension is measured in either the top or right side view and transferred to the other view, using either a scale, miter line, compass, or dividers. (Figure 4.20)

The arrangement of the views may only vary as shown in Figure 4.21. The right side view can be placed adjacent to the top view because both views share the depth dimension. Note that the side view is rotated so that the depth dimension in the two views is aligned.

4.4.2 First- and Third-Angle Projection

Figure 4.22A shows the standard arrangement of all six views of an object, as practiced in the United States and Canada. The ANSI standard third-angle symbol shown in the figure commonly appears on technical drawings to denote that the drawing was done following **third-angle projection** conventions. Europe uses the **first-angle projection** and a different

symbol, as shown in Figure 4.22B. To understand the difference between first- and third-angle projection, refer to Figure 4.23, which shows the *orthogonal planes*. Orthographic projection can be described using these planes. If the first quadrant is used for a multiview drawing, the results will be very different

from those of the third quadrant. (Figure 4.24) Familiarity with both first- and third-angle projection is valuable because of the global nature of business in our era. As an example, Figure 4.25 shows an engineering drawing produced in the United States for a German-owned company, using first-angle projection.

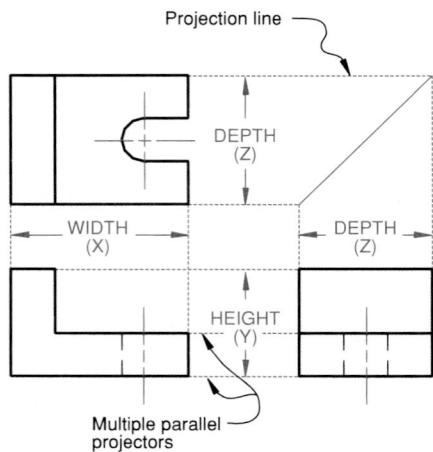

Figure 4.19 Three Space Dimensions

The three space dimensions are width, height, and depth. A single view on a multiview drawing will only reveal two of the three space dimensions. The 3-D CAD systems use X, Y, and Z to represent the three dimensions.

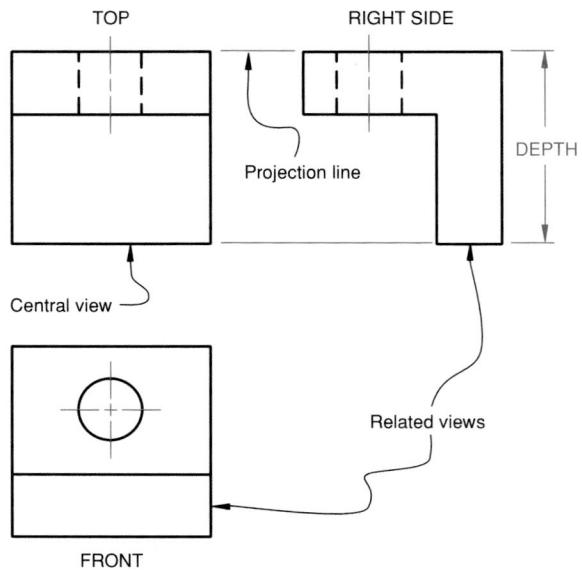

Figure 4.21 Alternate View Arrangement

In this view arrangement, the top view is considered the central view.

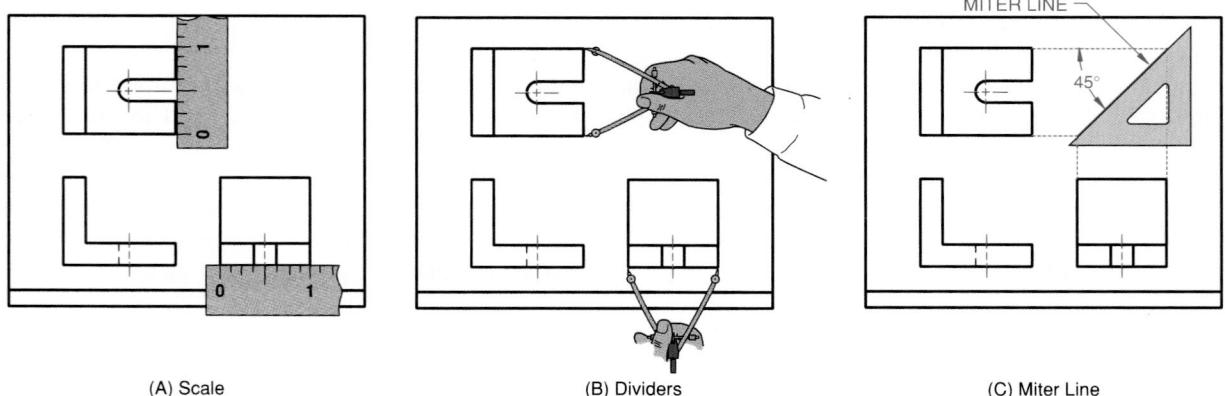

Figure 4.20 Transferring Depth Dimensions from the Top View to the Right Side View, Using Dividers, a Scale, or a 45-Degree Triangle and a Miter Line

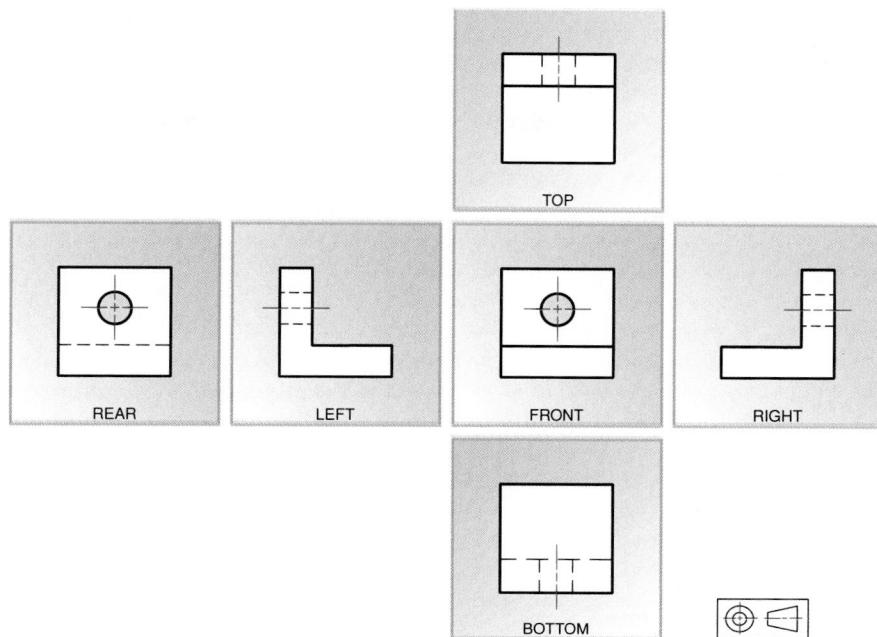

(A) U.S. Standard

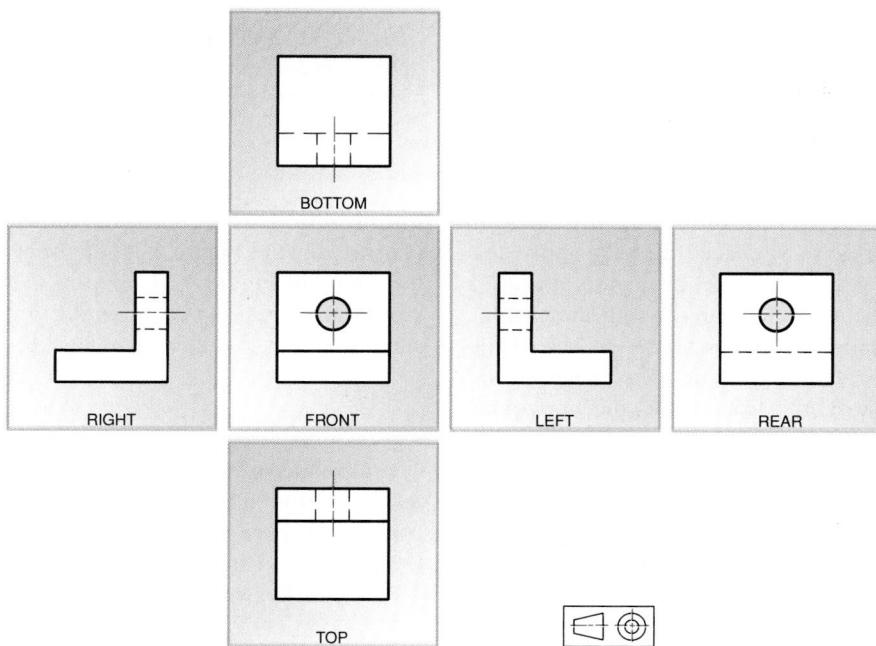

(B) European Standard

Figure 4.22 Standard Arrangement of the Six Principal Views for Third- and First-Angle Projection

Third- and first-angle drawings are designated by the standard symbol shown in the lower right corner of parts (A) and (B). The symbol represents how the front and right-side views of a truncated cone would appear in each standard.

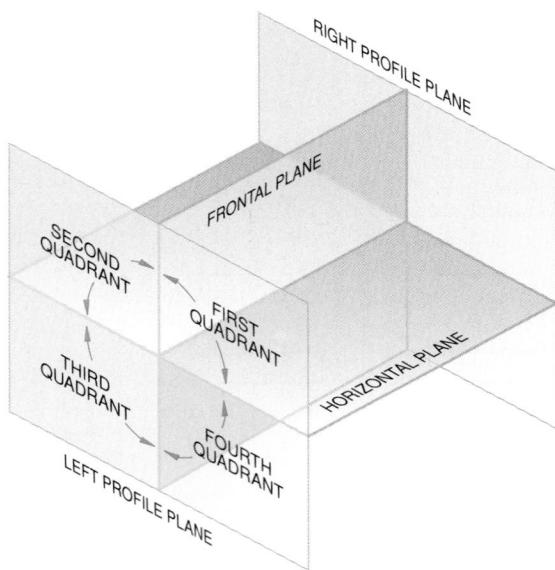

Figure 4.23 The Principal Projection Planes and Quadrants Used to Create First- and Third-Angle Projection Drawings

These planes are used to create the six principal views of first- and third-angle projection drawings.

4.4.3 Adjacent Views

Adjacent views are two orthographic views placed next to each other such that the dimension they share in common is aligned, using parallel projectors. The top and front views share the width dimension; therefore, the top view is placed directly above the front view, and vertical parallel projectors are used to ensure alignment of the shared width dimension. The right side and front views share the height dimension; therefore, the right side view is placed directly to the right of the front view, and horizontal parallel projectors are used to ensure alignment of the shared height dimension.

The manner in which adjacent views are positioned illustrates the first rule of orthographic projection: Every point or feature in one view must be aligned on a parallel projector in any adjacent view.

In Figure 4.26, the hole in the block is an example of a feature shown in one view and aligned on parallel projectors in the adjacent view.

*Principles of Orthographic Projection Rule 1:
Alignment of Features*

Every point or feature in one view must be aligned on a parallel projector in any adjacent view.

The distance *between* the views is not fixed, and it can vary according to the space available on the paper and the number of dimensions to be shown.

4.4.4 Related Views

Two views that are adjacent to the same view are called **related views**; in related views, distances between common features are equal. In Figure 4.26, for example, the distance between surface 1 and surface 2 is the same in the top view as it is in the right side view; therefore, the top and right side views are related views. The front and right side views in the figure are also related views, relative to the top view.

*Principles of Orthographic Projection Rule 2:
Distances in Related Views*

Distances between any two points of a feature in related views must be equal.

4.4.5 Central View

The view from which adjacent views are aligned is the **central view**. In Figure 4.26, the front view is the central view. In Figure 4.21, the top view is the central view. Distances and features are projected or measured from the central view to the adjacent views.

4.4.6 Line Conventions

The **alphabet of lines** is discussed in detail in Chapter 1, Section 1.11 “Alphabet of Lines,” and illustrated in Figure 4.27. The techniques for drawing lines are described in detail in Chapter 1, Section 1.12 “Line Drawing Techniques.”

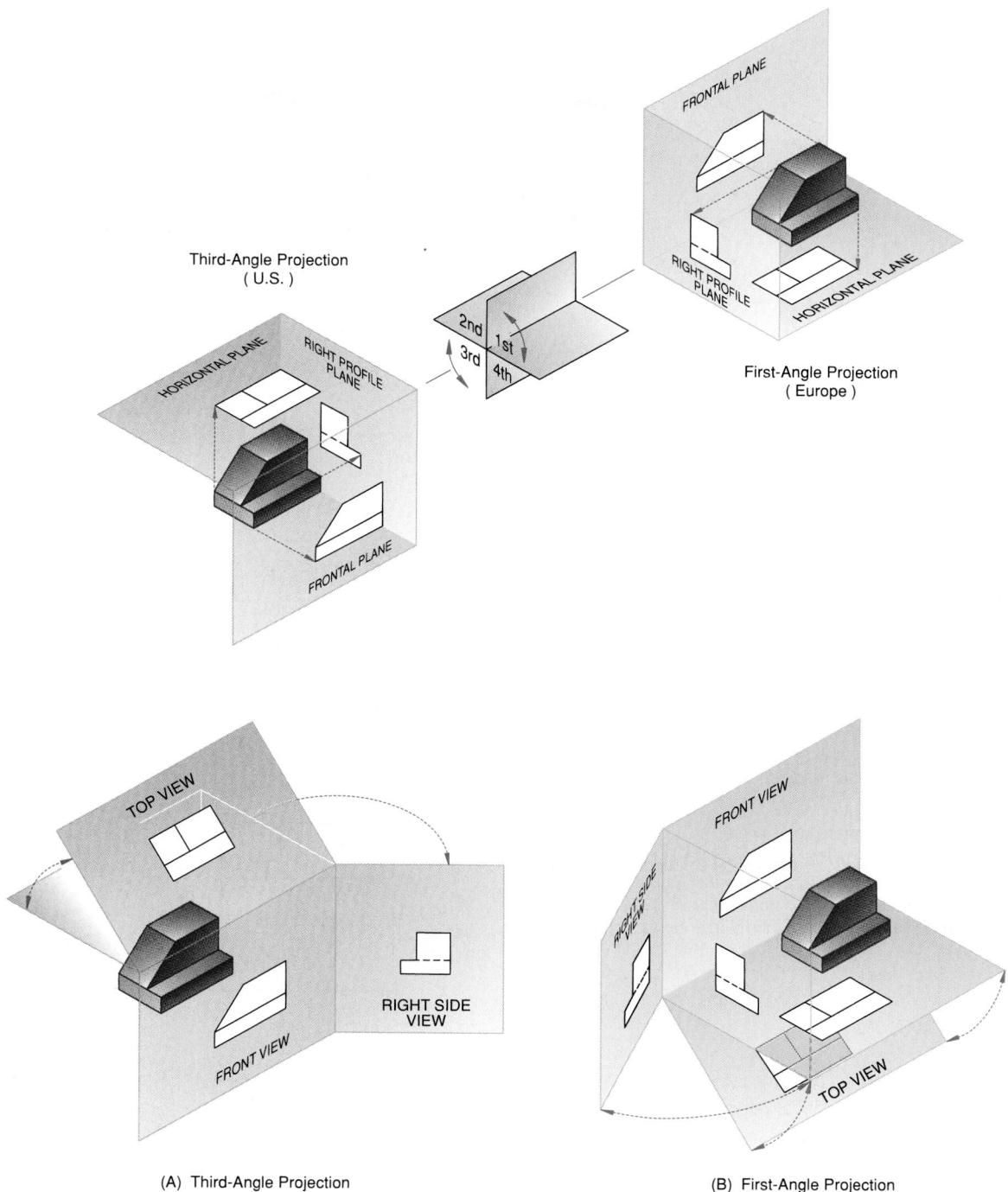

Figure 4.24 Pictorial Comparison between First- and Third-Angle Projection Techniques

Placing the object in the third quadrant puts the projection planes between the viewer and the object. When placed in the first quadrant, the object is between the viewer and the projection planes.

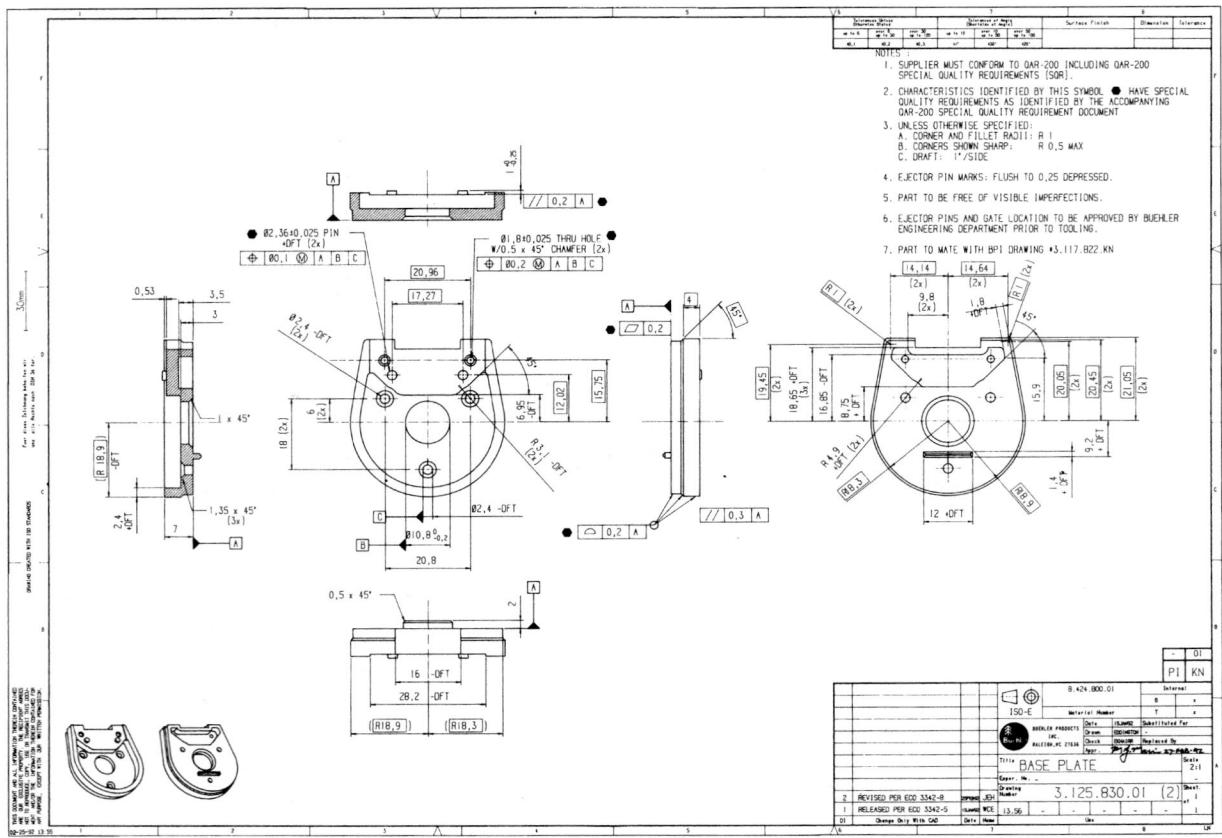

Figure 4.25 First-Angle Projection Engineering Drawing Produced in the United States for a European Company
(Courtesy of Buehler Products, Inc.)

Figure 4.26 Alignment of Views

Three-view drawings are aligned horizontally and vertically on engineering drawings. In this view arrangement, the front view is the central view. Also notice that surfaces 1 and 2 are the same distance apart in the related views: top and right side.

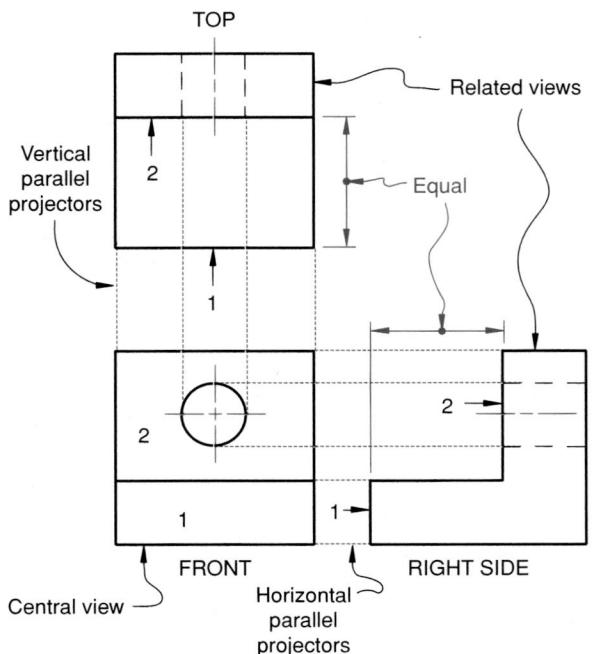

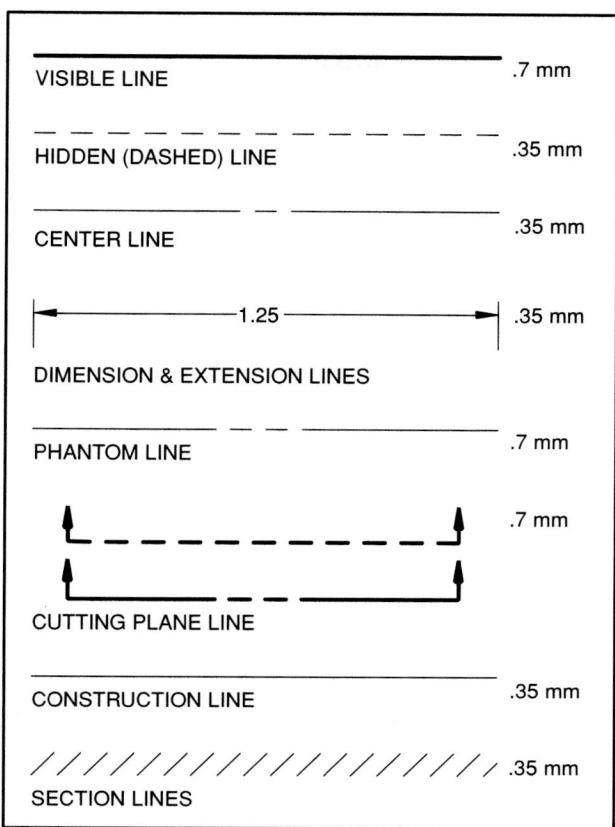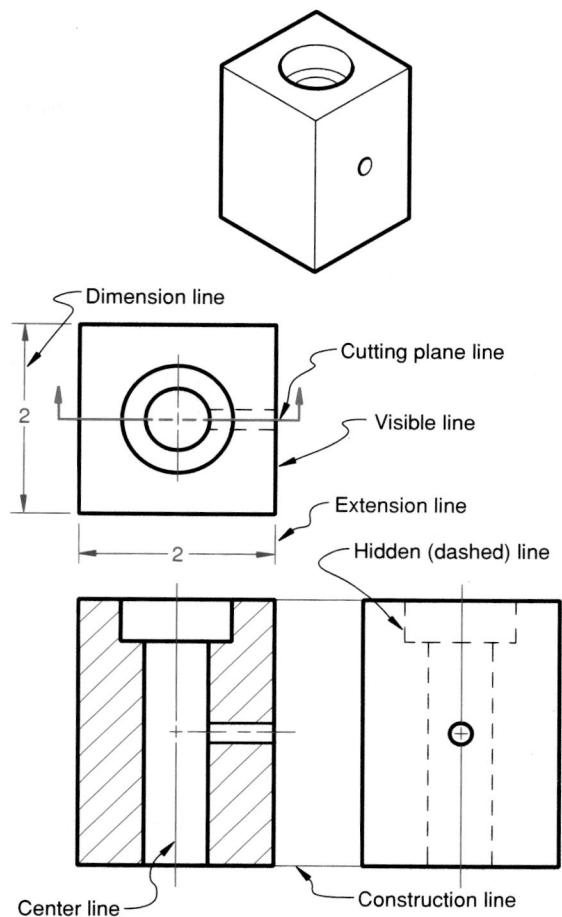

Figure 4.27 Alphabet of Lines

ANSI standard lines used on technical drawings are of a specific type and thickness.

Because hidden lines and center lines are critical elements in multiview drawings, they are briefly discussed again in the following sections. **CAD Reference 4.3**

Hidden Lines In multiview drawings, hidden features are represented as dashed lines, using ANSI standard line types. (See Figure 4.27)

Dashed lines are used to represent such hidden features as:

Holes—to locate the limiting elements.

Surfaces—to locate the edge view of the surface.

Change of planes—to locate the position of the change of plane or corner.

For example, Figure 4.28 shows dashed lines representing hidden features in the front and top views. The dashed parallel lines in the top and front views represent the limiting elements of the hole drilled through the object but not visible in these views. The hole is visible in the right side view. The single vertical dashed line in the front view represents the hidden edge view of surface C. Surface C is visible in the side view and is on edge in the top and front views.

Most CAD systems do not follow a standard practice for representing hidden lines. The user must decide if the drawn hidden lines effectively communicate the desired information. **CAD Reference 4.4**

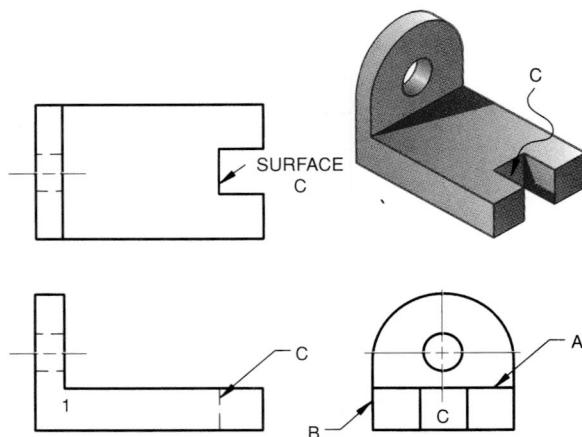

Figure 4.28 Hidden Features

The dashed lines on this drawing indicate hidden features. The vertical dashed line in the front view shows the location of plane C. The horizontal dashed lines in the front and top views show the location of the hole.

Center Lines Center lines are alternating long and short thin dashes and are used for the axes of symmetrical parts and features, such as cylinders and drilled holes (Figure 4.29), for bolt circles (Figure 4.30D), and for paths of motion (Figure 4.30E). Center lines should not terminate at another line or extend between views (Figure 4.30C). Very short, unbroken center lines may be used to represent the axes of very small holes (Figure 4.30C).

Some CAD systems have difficulty representing center lines using standard practices. This is especially true of the center lines for circles. Other CAD systems automatically draw the center lines to standards. **© CAD Reference 4.5**

One- and Two-View Drawings Some objects can be adequately described with only one view. (Figure 4.31) A sphere can be drawn with one view because all views will be a circle. A cylinder or cube can be described with one view if a note is added to describe the missing feature or dimension. Other applications include a thin gasket, or a printed circuit board. One-view drawings are used in electrical, civil, and construction engineering. **© CAD Reference 4.6**

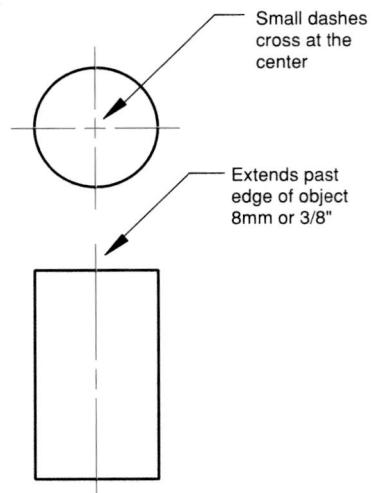

Figure 4.29 Center Lines

Center lines are used for symmetrical objects, such as cylinders. Center lines should extend past the edge of the object by 8 mm or $\frac{3}{8}$ ".

Other objects can be adequately described with two views. Cylindrical, conical, and pyramidal shapes are examples of such objects. For example, a cone can be described with a front and a top view. A profile view would be the same as the front view. (Figure 4.32) **© CAD Reference 4.7**

Three-View Drawings The majority of objects require three views to completely describe the objects. The following steps describe the basics for setting up and developing a three-view multiview drawing of a simple part.

Creating a Three-View Drawing

Step 1. In Figure 4.33, the isometric view of the part represents the part in its natural position; it appears to be resting on its largest surface area. The front, right side, and top views are selected such that the fewest hidden lines would appear on the views.

Step 2. The spacing of the views is determined by the total width, height, and depth of the object. Views are carefully spaced to center the drawing within the working area of the drawing sheet. Also, the distances between views can vary, but enough space should be left so that dimensions can be placed in between the views. A good rule of thumb is to allow

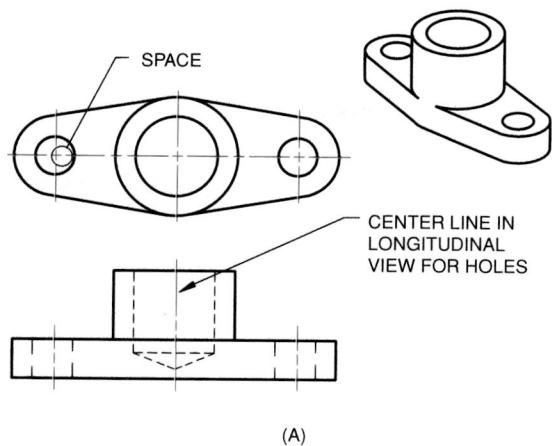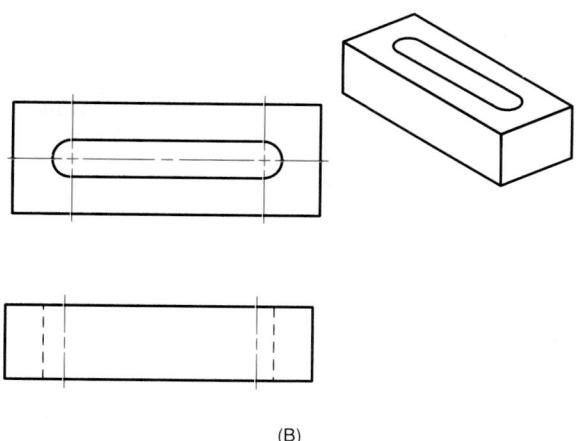

(A)

(B)

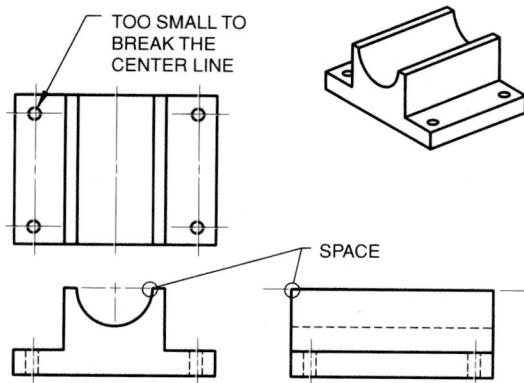

(C)

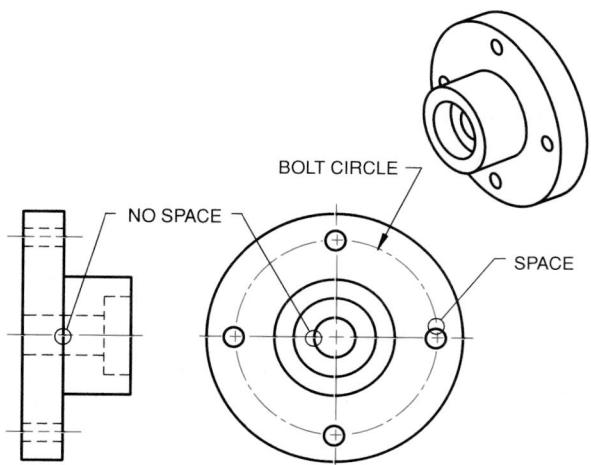

(D)

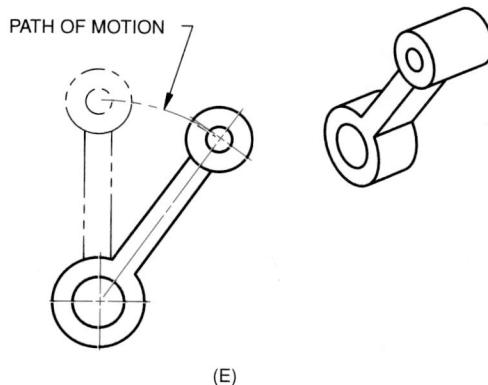

(E)

Figure 4.30 Standard Center Line Drawing Practices for Various Applications

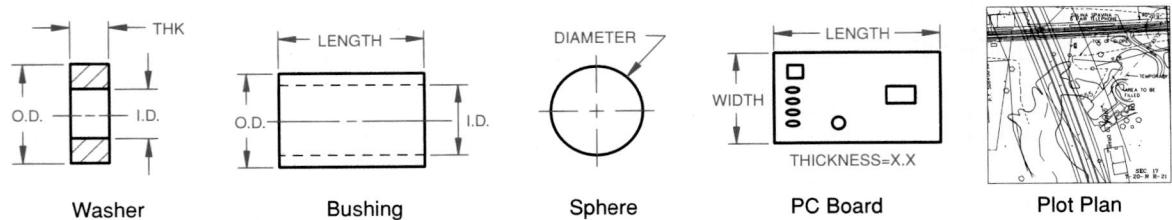

Figure 4.31 One-View Drawings

Applications for one-view drawings include some simple cylindrical shapes, spheres, thin parts, and map drawings.

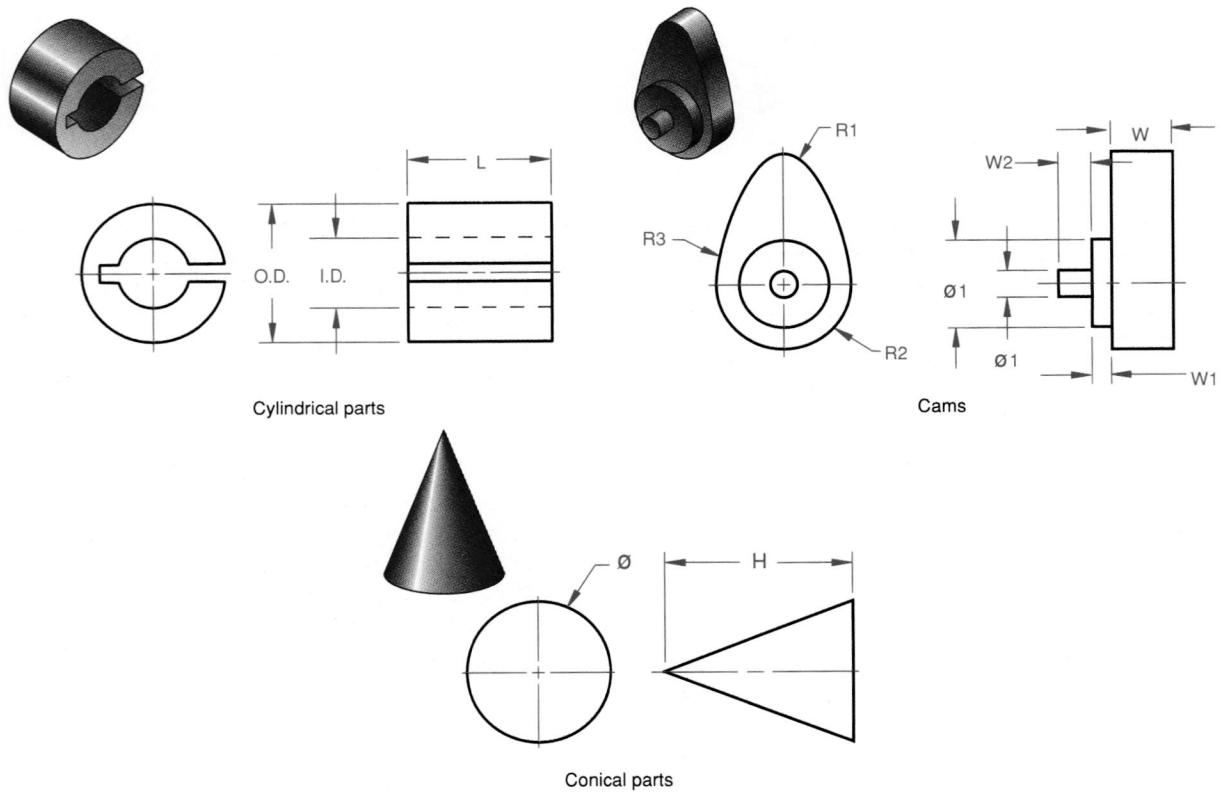

Figure 4.32 Two-View Drawings

Applications for two-view drawings include cylindrical and conical shapes.

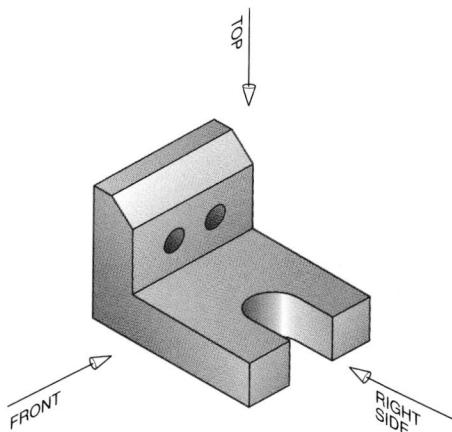

Figure 4.33 Selecting the Views for a Multiview Drawing

The object should be oriented in its natural position, and views chosen should best describe the features.

about 1.5" (36 mm) between views. To determine the total amount of space necessary to draw the front and side views in alignment, add the width (4") of the front view and the depth (3") of the side view. Then add 1.5" to give 8.5" as the total amount of space needed for the front and side views and the space between. If the horizontal space on the paper is 10", subtract 8.5" to get 1.5"; divide the result by 2 to get 0.75", which is the space left on either side of the two views together. These distances are marked across the paper, as shown in Figure 4.34A.

In a similar manner, the vertical positioning is determined by adding the height of the front view (3") to the depth of the top view (3"), and then adding 1.5" for the space between the views. The result is 7.5". The 7.5" is subtracted from the working area of 9", the result is divided by 2 to get 0.75", which is the distance across the top and bottom of the sheet. (Figure 4.34B)

Step 3. Using techniques described previously in this text, locate the center lines in each view and lightly draw the arc and circles. (Figure 4.34C)

Step 4. Locate other details and lightly draw horizontal, vertical, and inclined lines in each view. Normally, the

front view is constructed first because it has the most details. These details are then projected to the other views using construction lines. Details that cannot be projected directly must be measured and transferred, or projected using a miter line. For example, dividers can be used to measure and transfer details from the top view to the right side view. (Figure 4.34D) A miter line can also be constructed by drawing a 45-degree line from the intersection of the top and side view and drawing the projection lines as shown in Figure 4.34C.

Step 5. Locate and lightly draw hidden lines in each view. For this example, hidden lines are used to represent the limiting elements of the holes.

Step 6. Following the alphabet of lines, darken all object lines by doing all horizontal, then all vertical, and finally all inclined lines, in that order. Darken all hidden and center lines. Lighten or erase any construction lines that can be easily seen when the drawing is held at arm's length. The same basic procedures can be used with 2-D CAD. However, construction lines do not have to be erased. Instead, they can be placed on a separate layer, then turned off. © CAD Reference 4.8

4.4.7 Multiviews from 3-D CAD Models

The computer screen can be used as a projection plane displaying the 2-D image of a 3-D CAD model. The user can control the line of sight and the type of projection (parallel or perspective). Most 3-D CAD software programs have automated the task of creating multiview drawings from 3-D models. With these CAD systems, the 3-D model of the object is created first. (See Figure 4.33) Most CAD programs have pre-defined viewpoints that correspond to the six principal views. (Figure 4.35) The views that will best represent the object in multiview are selected, the viewpoint is changed, a CAD command converts the projection of the 3-D model into a 2-D drawing, and the first view is created. (Figure 4.36) This view is then saved as a block or symbol. The second view is created by changing the viewpoint again and then converting the new projection to a 2-D drawing of the object. (Figure 4.37) These steps are repeated for as many views as are necessary for the multiview drawing.

(A)

(B)

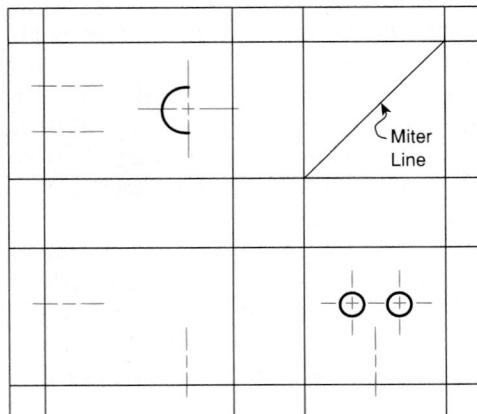

(C)

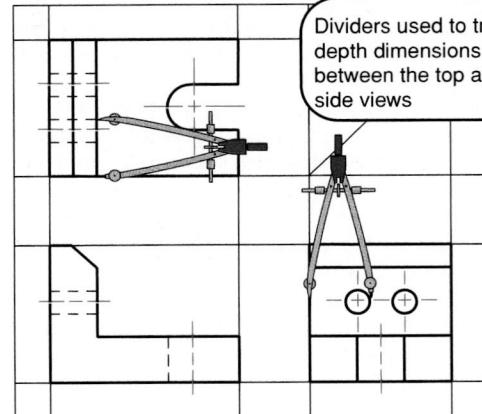

(D)

Figure 4.34 Steps to Center and Create a Three-View Multiview Drawing on an A-Size Sheet

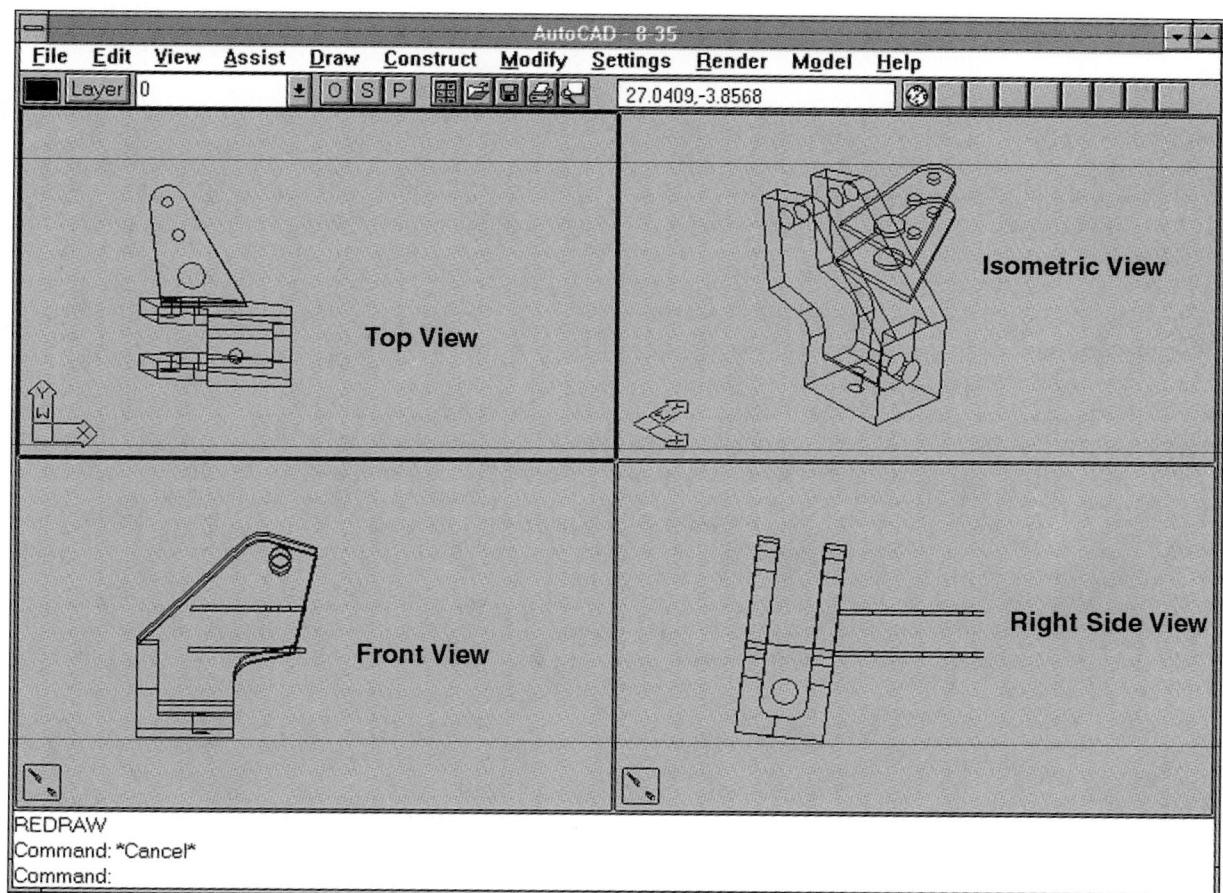

Figure 4.35 Predefined Multiviews on a CAD System

Figure 4.36 Changing the Viewpoint on a 3-D CAD Model to Create a Front View

This view is captured, then placed in a title block and border line.

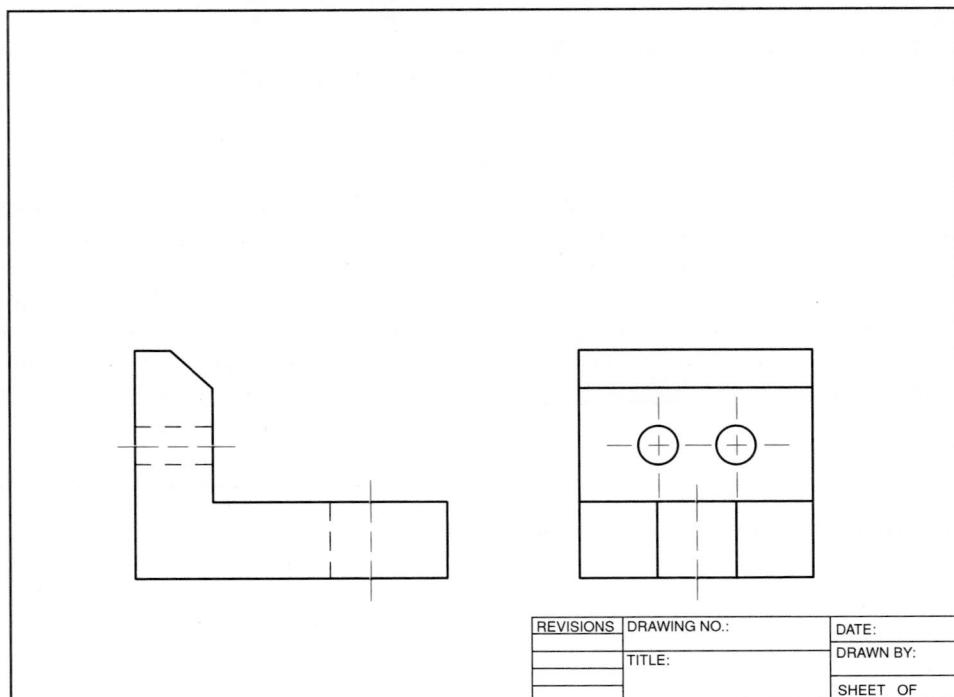

Figure 4.37 Changing the Viewpoint on the 3-D Model to Create a Right Side View

This view is captured, then placed in a title block and border line.

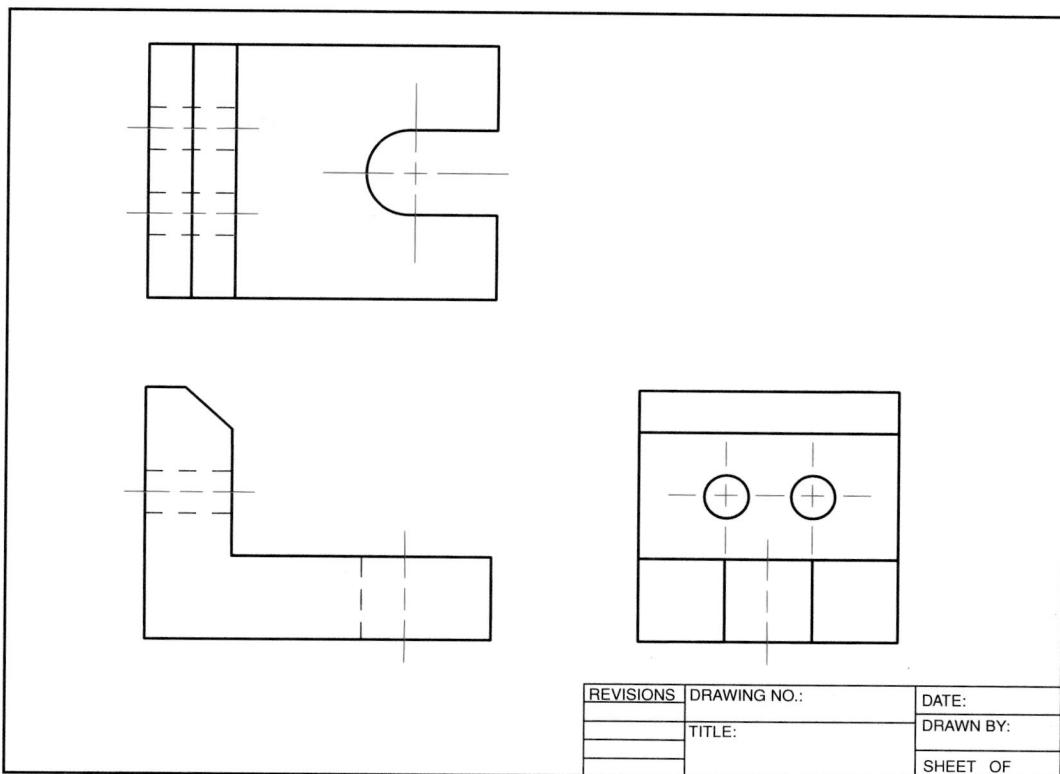

Figure 4.38 Creating a Multiview Drawing of the 3-D Model

The previously captured views are brought together with a standard border and title block to create the final drawing.

After the required number of 2-D views are created, the views are arranged on a new drawing by retrieving the blocks or symbols created earlier. Care must be taken to bring the views in at the proper scale and correct alignment. The views must then be edited to change solid lines to hidden lines and to add center lines. Other changes may be required so that the views are drawn to accepted standards. (Figure 4.38) © CAD Reference 4.9

4.5 VIEW SELECTION

Before a multiview drawing is created, the views must be selected. Four basic decisions must be made to determine the best views.

1. Determine the best position of the object. The object must be positioned within the imaginary glass box such that the surfaces of major features

are either perpendicular or parallel to the glass planes. (Figure 4.39) This will create views with a minimum number of hidden lines. Figure 4.40 shows an example of poor positioning; the surfaces of the object are not parallel to the glass planes, resulting in many more hidden lines.

2. Define the front view. The front view should show the object in its natural or assembled state. (Figure 4.41) For example, the front view of an automobile would show the automobile in its natural position, on its wheels.
3. Determine the minimum number of views needed to completely describe the object so it can be produced. For our example, three views are required to completely describe the object. (Figure 4.42)

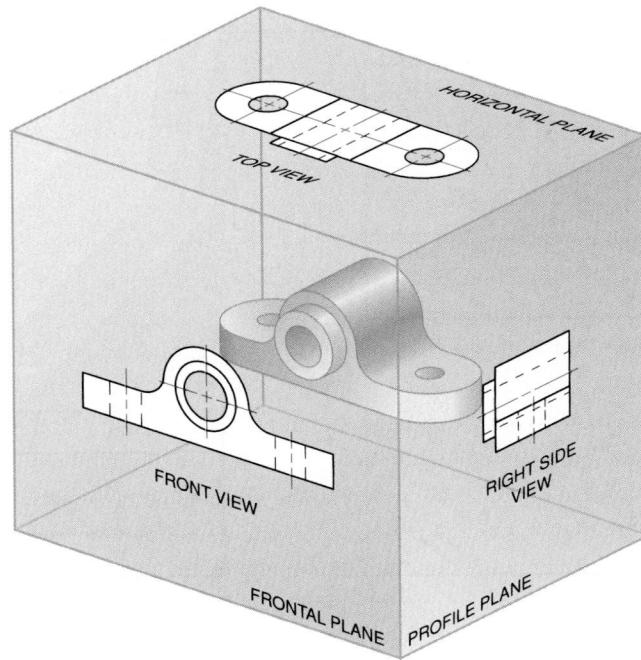

Figure 4.39 Good Orientation

Suspend the object in the glass box such that major surfaces are parallel or perpendicular to the sides of the box (projection planes).

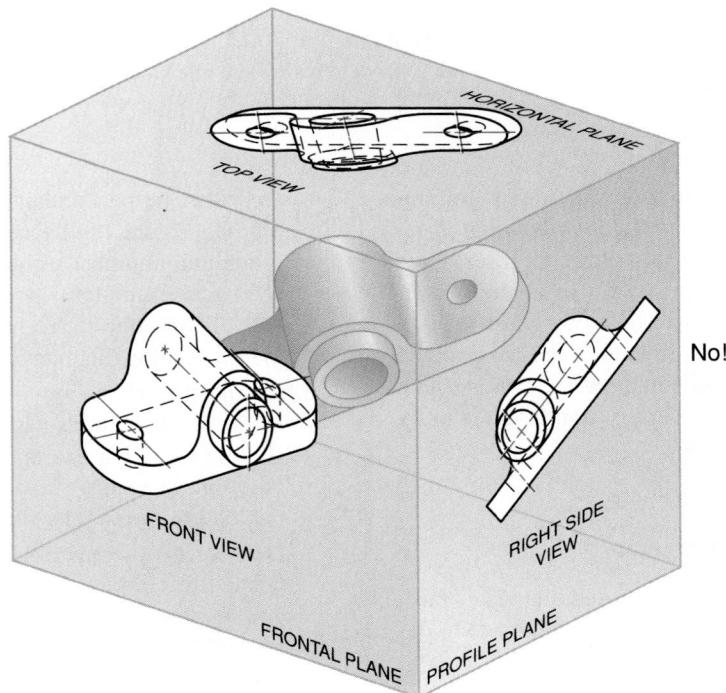

Figure 4.40 Poor Orientation

Suspending the object in the glass box such that surfaces are not parallel to the sides produces views with many hidden lines.

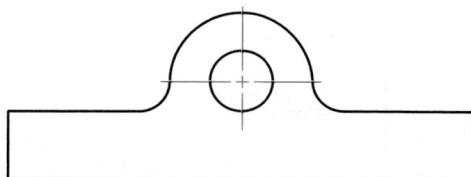

Natural Position

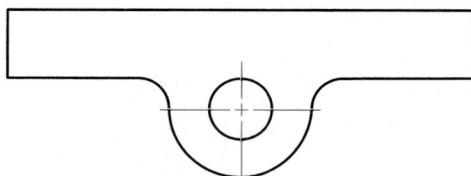Unnatural Position
No!**Figure 4.41 Natural Position**

Always attempt to draw objects in their natural position.

- Once the front view is selected, determine which other views will have the fewest number of hidden lines. In Figure 4.43, the right side view is selected over the left side view because it has fewer hidden lines.

Practice Exercise 4.2

Using any of the objects in Figure 4.93 in the back of this chapter, generate three multiview sketches. Each sketch should use a different view of the object as the front view. What features of the object become hidden or visible as you change the front view?

**4.6 FUNDAMENTAL VIEWS
OF EDGES AND PLANES**

In multiview drawings, there are *fundamental views* for edges and planes. These fundamental views show the edges or planes in true size, not foreshortened, so that true measurements of distances, angles, and areas can be made.

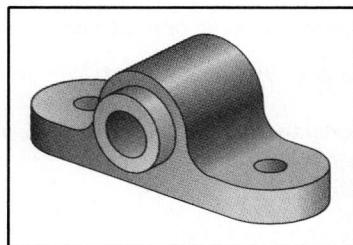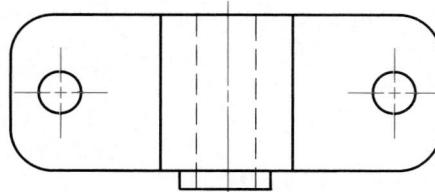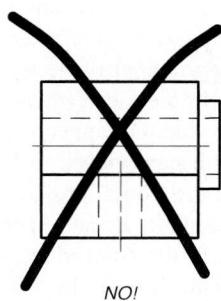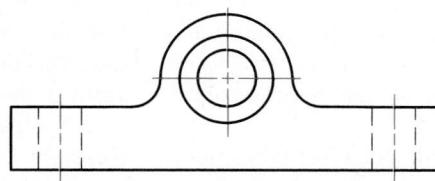**Figure 4.42 Minimum Number of Views**

Select the minimum number of views needed to completely describe an object. Eliminate views that are mirror images of other views.

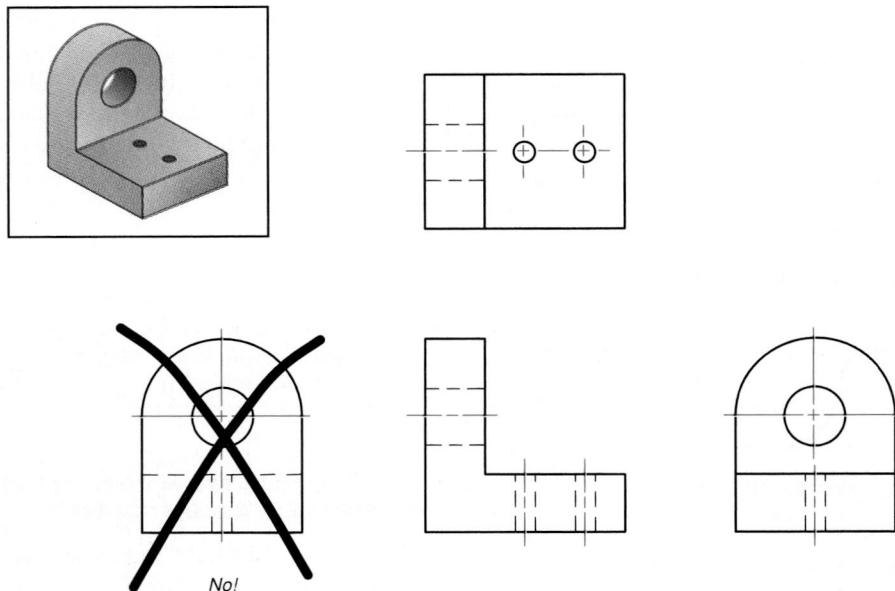

Figure 4.43 Most Descriptive Views

Select those views which are the most descriptive and have the fewest hidden lines. In this example, the right side view has fewer hidden lines than the left side view.

4.6.1 Edges (Lines)

An **edge**, or *corner*, is the intersection of two planes, and is represented as a line on multiview drawings. A **normal line**, or **true-length line**, is an edge that is parallel to a plane of projection and thus perpendicular to the line of sight. In Figure 4.44, edge 1–2 in the top and right side views is a normal edge.

*Principles of Orthographic Projection Rule 3:
True Length and Size
Features are true length or true size when the lines of sight are perpendicular to the feature.*

An edge appears as a point in a plane of projection to which it is perpendicular. Edge 1–2 is a point in the front view of Figure 4.44. The edge appears as a point because it is parallel to the line of sight used to create the front view.

An **inclined line** is parallel to a plane of projection, but inclined to the adjacent planes, and it appears foreshortened in the adjacent planes. In Figure 4.44, line 3–4 is inclined and foreshortened in the top and right side view, but true length in the front view, because it is parallel to the frontal plane of projection.

An **oblique line** is not parallel to any principal plane of projection; therefore, it never appears as a point or in true length in any of the six principal

views. Instead, an oblique edge will be foreshortened in every view and will always appear as an inclined line. Line 1–2 in Figure 4.45 is an oblique edge.

*Principles of Orthographic Projection Rule 4:
Foreshortening*

Features are foreshortened when the lines of sight are not perpendicular to the feature.

4.6.2 Principal Planes

A **principal plane** is parallel to one of the principal planes of projection, and is therefore perpendicular to the line of sight. A principal plane or surface will be true size and shape in the view where it is parallel to the projection plane, and will appear as a horizontal or vertical line in the adjacent views. In Figure 4.46, surface A is parallel to the frontal projection plane and is therefore a principal plane. Because surface A appears true size and shape in the front view, it is sometimes referred to as a **normal plane**. In this figure, surface A appears as a horizontal edge in the top view and as a vertical edge in the right side view. This edge representation is an important characteristic in multiview drawings. Principal planes are categorized by the view in which the plane appears true size and shape: frontal, horizontal, or profile.

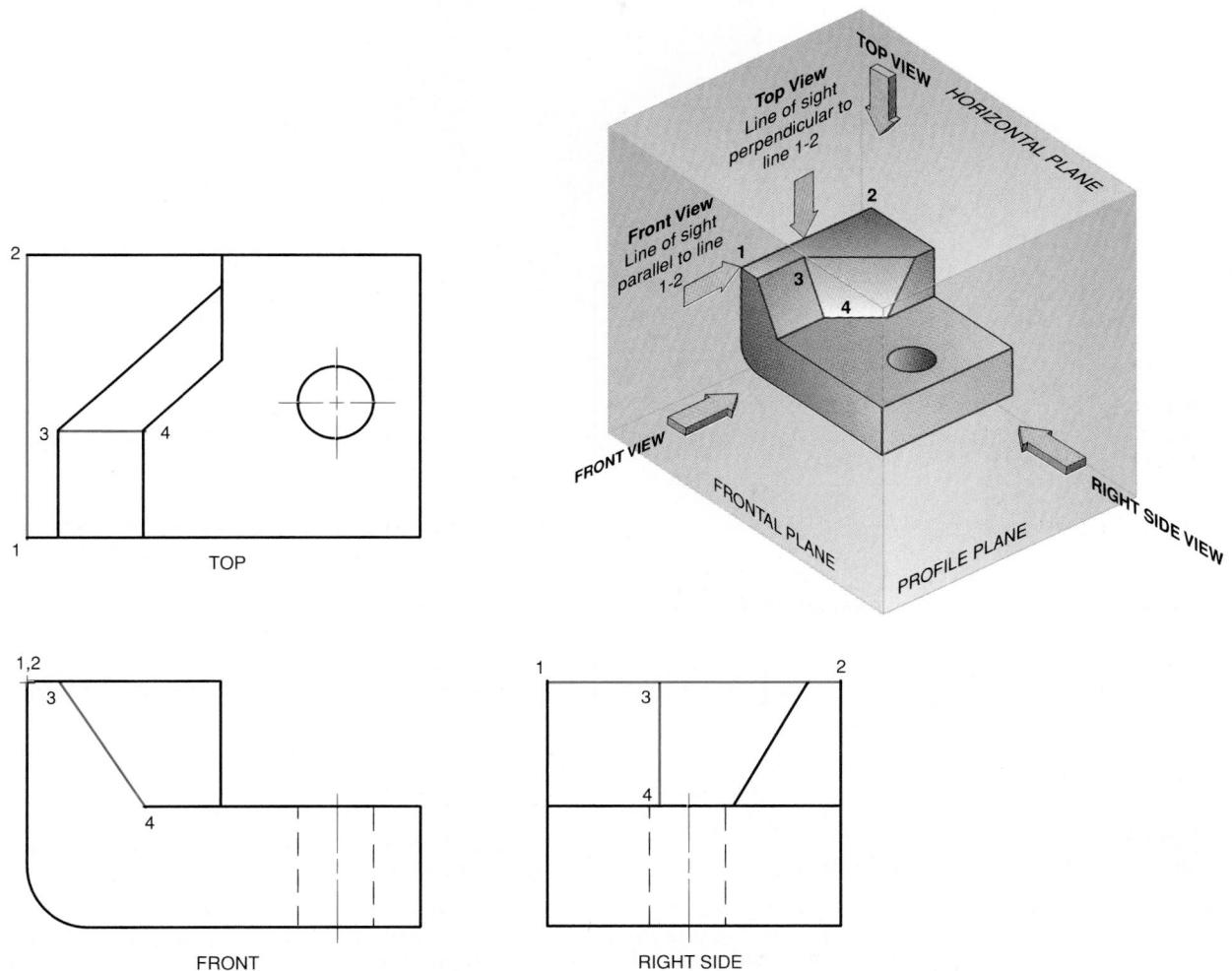

Figure 4.44 Fundamental Views of Edges

Determine the fundamental views of edges on a multiview drawing by the position of the object relative to the current line of sight and the relationship of the object to the planes of the glass box.

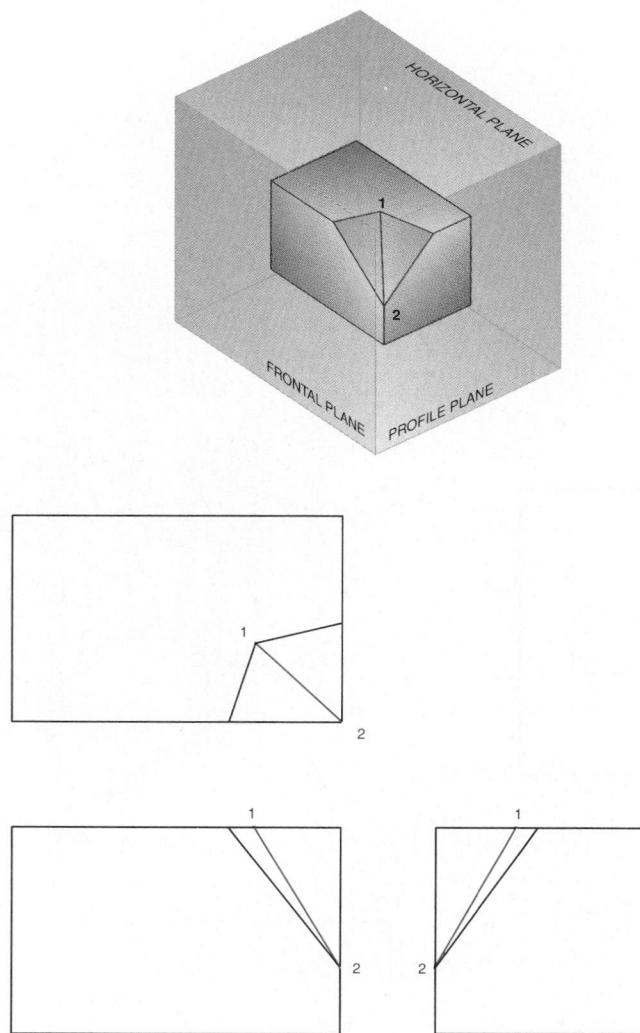

Figure 4.45 Oblique Line

Oblique line 1–2 is not parallel to any of the principal planes of projection of the glass box.

A **frontal plane** is parallel to the front plane of projection and is true size and shape in the front view. A frontal plane appears as a horizontal edge in the top view and a vertical edge in the profile views. In Figure 4.46, surface A is a frontal plane.

A **horizontal plane** is parallel to the horizontal planes of projection and is true size and shape in the top (and bottom) view. A horizontal plane appears as a horizontal edge in the front and side views. In Figure 4.46, surface B is a horizontal plane.

A **profile plane** is parallel to the profile (right or left side) planes of projection and is true size and

shape in the profile views. A profile plane appears as a vertical edge in the front and top views. In Figure 4.46, surface C is a profile plane.

4.6.3 Inclined Planes

An **inclined plane** is perpendicular to one plane of projection and inclined to adjacent planes, and cannot be viewed in true size and shape in any of the principal views. An inclined plane appears as an edge in the view where it is perpendicular to the projection plane, and as a foreshortened surface in

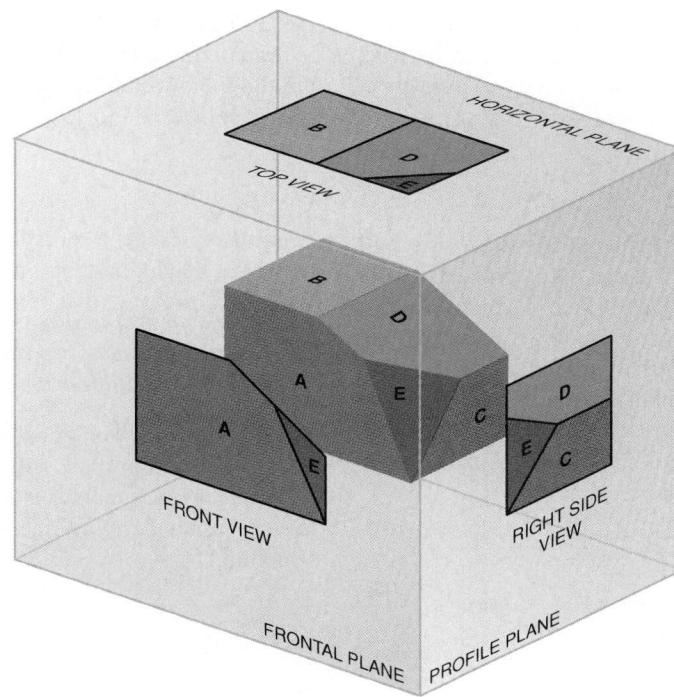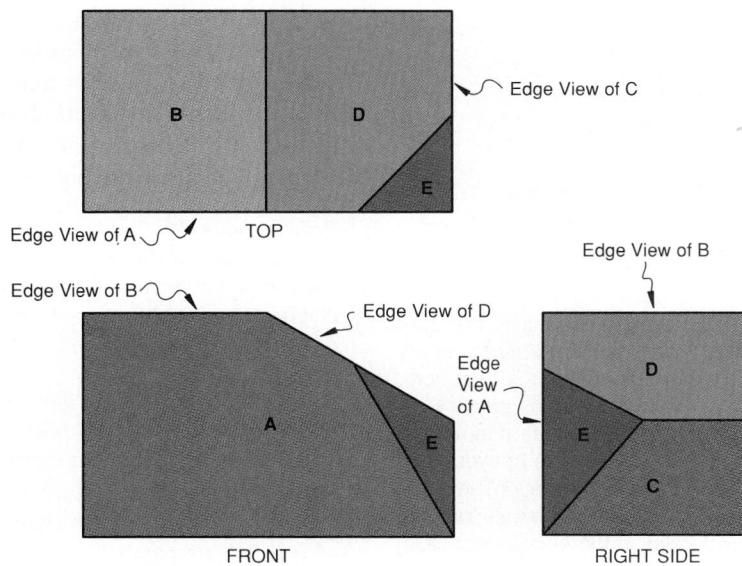

Figure 4.46 Fundamental Views of Surfaces

Surface A is parallel to the frontal plane of projection. Surface B is parallel to the horizontal plane of projection. Surface C is parallel to the profile plane of projection. Surface D is an inclined plane and is on edge in one of the principal views (the front view). Surface E is an oblique plane and is neither parallel nor on edge in any of the principal planes of projection.

the adjacent views. In Figure 4.46, plane D is an inclined surface. To view an inclined plane in its true size and shape, create an auxiliary view, as described in Chapter 6, “Auxiliary Views.”

4.6.4 Oblique Planes

An **oblique plane** is oblique to all the principal planes of projection. In Figure 4.46, plane E is an oblique surface. An oblique surface does not appear in its true size and shape, or as an edge, in any of the principal views; instead, an oblique plane always appears as a foreshortened plane in the principal views. A secondary auxiliary view must be constructed, or the object must be rotated, in order to create a normal view of an oblique plane.

Practice Exercise 4.3

Using stiff cardboard, cut out the following shapes:

- Rectangle.
- Circle.
- Trapezoid.
- Irregular shape with at least six sides, at least two of which are parallel to each other.

Sketch the following multiviews of each shape:

- The line of sight perpendicular to the face.
- Rotated 45 degrees about the vertical axis.
- Rotated 90 degrees about the vertical axis.
- Rotated 45 degrees about the horizontal axis.
- Rotated 90 degrees about the horizontal axis.
- Rotated 45 degrees about both the vertical and horizontal axes.

Which views represent true-size projections of the surface? In what views is the surface inclined, oblique, or on edge? What is the shape of a circle when it is foreshortened? For the inclined projections, how many primary dimensions of the surface appear smaller than they are in true-size projection? What is the relationship between the foreshortened dimension and the axis of rotation? Identify the parallel edges of the surface in the true-size projection. Do these edges stay parallel in the other views? Are these edges always seen in true length?

4.7 MULTIVIEW REPRESENTATIONS

Three-dimensional solid objects are represented on 2-D media as points, line, and planes. The solid geometric primitives are transformed into 2-D geometric primitives. Being able to identify 2-D primitives and

the 3-D primitive solids they represent is important in visualizing and creating multiview drawings. Figure 4.47 shows multiview drawings of common geometric solids.

4.7.1 Points

A **point** represents a specific position in space and has no width, height, or depth. A point can represent:

- The end view of a line.*
- The intersection of two lines.*
- A specific position in space.*

Even though a point does not have width, height, or depth, its position must still be marked. On technical drawings, a point marker is a small symmetrical cross. (See Chapter 3, “Engineering Geometry and Construction.”)

4.7.2 Planes

A **plane** can be viewed from an infinite number of vantage points. A plane surface will always project as either a line or an area. Areas are represented in either true size or foreshortened, and will always be similar in configuration (same number of vertices and edges) from one view to another, unless viewed as an edge. For example, surface B in Figure 4.48 is always an irregular four-sided polygon with two parallel sides (a trapezoid), in all the principal views.

Principles of Orthographic Projection Rule 5:

Configuration of Planes

Areas that are the same feature will always be similar in configuration from one view to the next, unless viewed on edge.

In contrast, area C in Figure 4.48 is similar in shape in two of the orthographic views and is on edge in the third. Surface C is a regular rectangle, with parallel sides labeled 3, 4, 5, and 6. Sides 3–6 and 4–5 are parallel in both the top view and the right side view. Also, lines 3–4 and 5–6 are parallel in both views. Parallel features will always be parallel, regardless of the viewpoint.

Principles of Orthographic Projection Rule 6:

Parallel Features

Parallel features will always appear parallel in all views.

A plane appears as an **edge view** or **line** when it is parallel to the line of sight in the current view. In the front view of Figure 4.48, surfaces A and D are shown as edges.

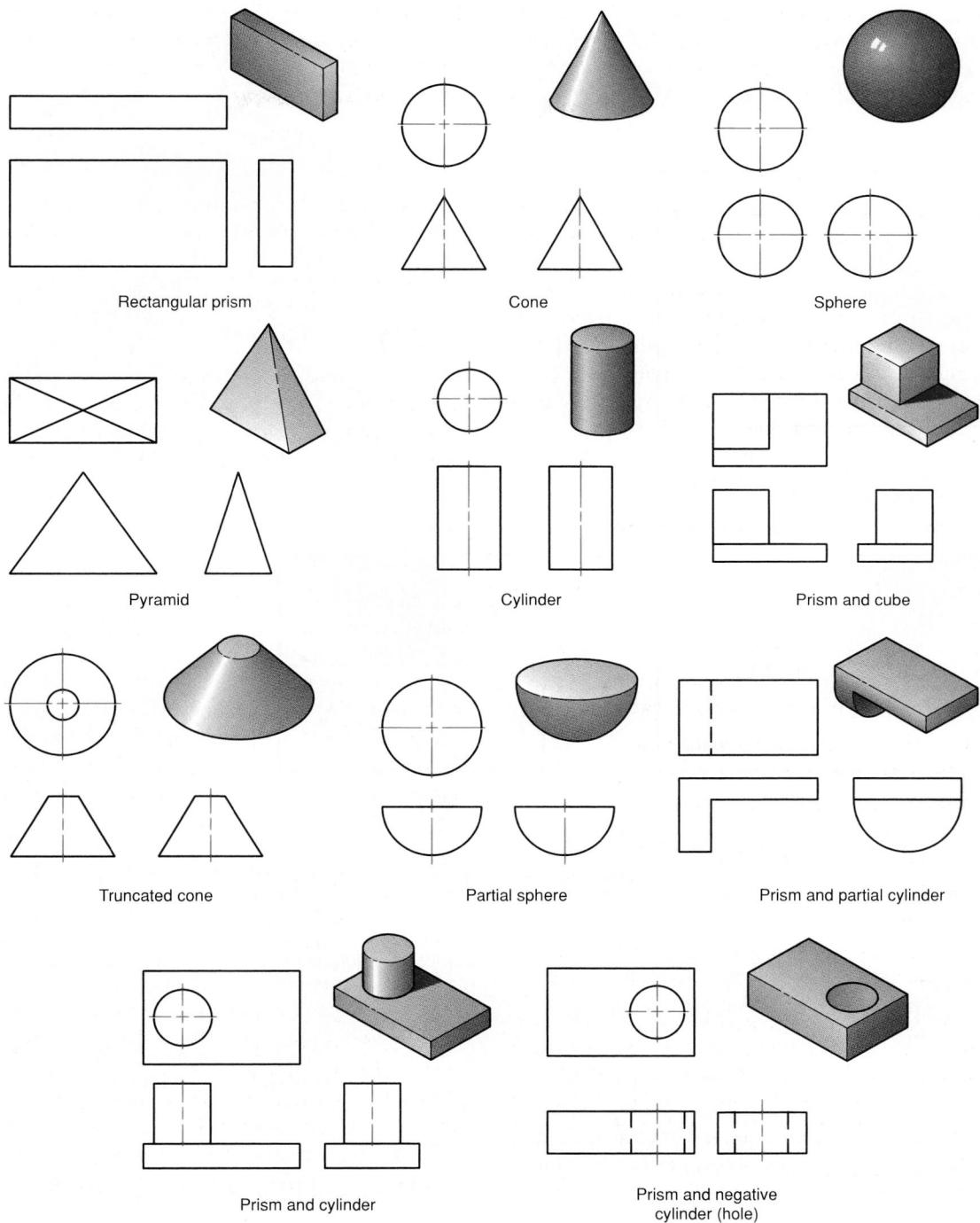

Figure 4.47 Multiview Drawings of Solid Primitive Shapes

Understanding and recognizing these shapes will help you to understand their application in technical drawings. Notice that the cone, sphere, and cylinder are adequately represented with fewer than three views.

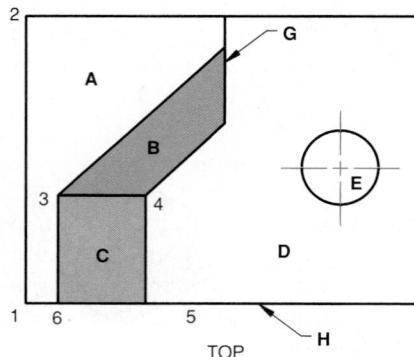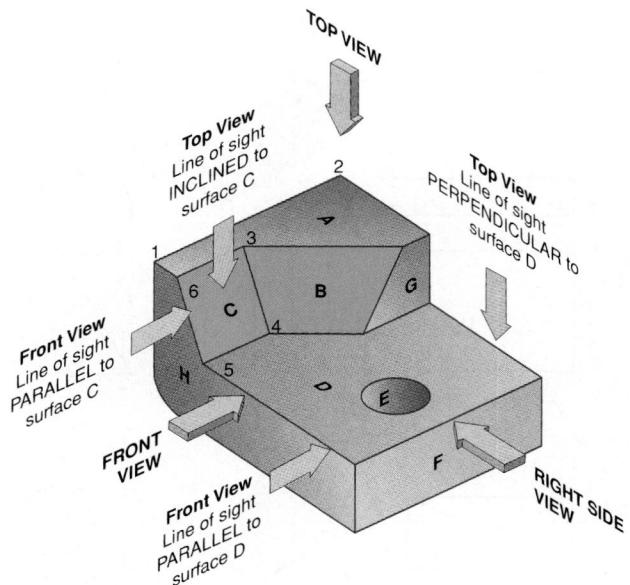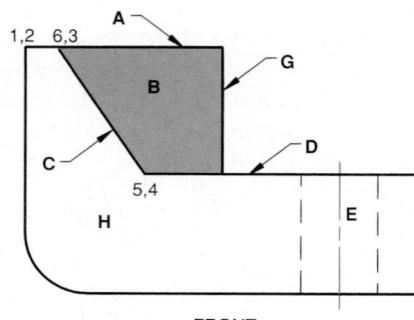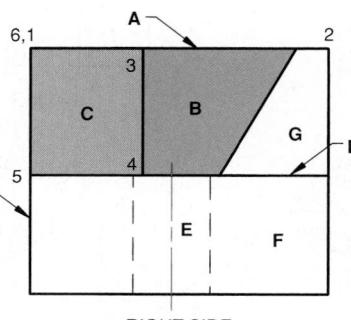

Figure 4.48 Rule of Configuration of Planes

Surface B is an example of the Rule of Configuration of Planes. The edges of surface C, 3–4 and 5–6, are examples of the Rule of Parallel Features.

Principles of Orthographic Projection Rule 7: Edge Views

Surfaces that are parallel to the lines of sight will appear as lines or edge views.

A **foreshortened plane** is neither parallel nor perpendicular to the line of sight. There are two types of foreshortened planes, oblique and inclined, as described in Sections 4.6.3 and 4.6.4. Surface B is foreshortened in all views of Figure 4.48.

Practice Exercise 4.4

Hold an object that has at least one flat surface (plane) at arm's length. Close one eye and rotate the object so that your line of sight is perpendicular to the flat surface. What you see is a true-size view of the plane. Slowly rotate the

object while focusing on the flat plane. Notice that the flat plane begins to foreshorten. As you continue to rotate the object slowly, the plane will become more foreshortened until it disappears from your line of sight and appears as a line or edge. This exercise demonstrates how a flat plane can be represented on paper in true size, foreshortened, or as a line.

4.7.3 Change of Planes (Corners)

A **change of planes, or corner**, occurs when two non-parallel surfaces meet, forming a corner or edge. (Figure 4.48, Line 3–4) Whenever there is a change in plane, a line must be drawn to represent that change. The lines are drawn as solid or continuous if visible in the current view, or dashed if they are hidden.

4.7.4 Angles

An angle is represented in true size when it is in a normal plane. If an angle is not in a normal plane, then the angle will appear either larger or smaller

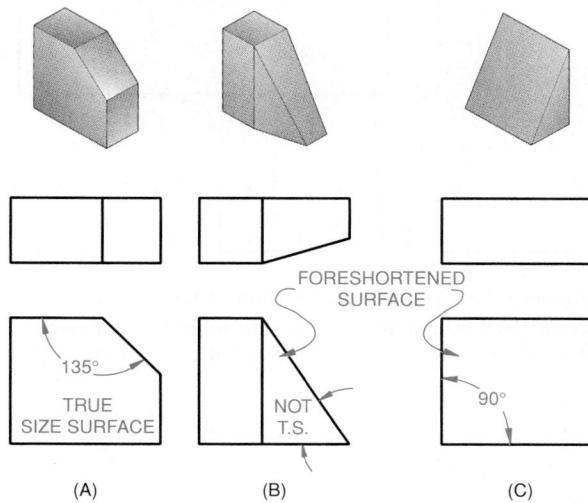

Figure 4.49 Angles

Angles other than 90 degrees can only be measured in views where the surface that contains the angle is perpendicular to the line of sight. A 90-degree angle can be measured in a foreshortened surface if one edge is true length.

than true size. For example, in Figure 4.49A, the 135-degree angle is measured as 135 degrees in the front view, which is parallel to the plane containing the angle. In Figure 4.49B, the angle is measured as less than true size in the front view because the plane containing the angle is not parallel to the frontal plane and is foreshortened. Right angles can be measured as 90 degrees in a foreshortened plane if one line is true length. (Figure 4.49C)

4.7.5 Curved Surfaces

Curved surfaces are used to round the ends of parts and to show drilled holes and cylindrical features. Cones, cylinders, and spheres are examples of geometric primitives that are represented as curved surfaces on technical drawings.

Only the far outside boundary, or limiting element, of a curved surface is represented in multiview drawings. For example, the curved surfaces of the cone and cylinder in Figure 4.50 are represented as lines in the front and side views. Note that the bases of the cone and cylinder are represented as circles when they are positioned perpendicular to the line of sight.

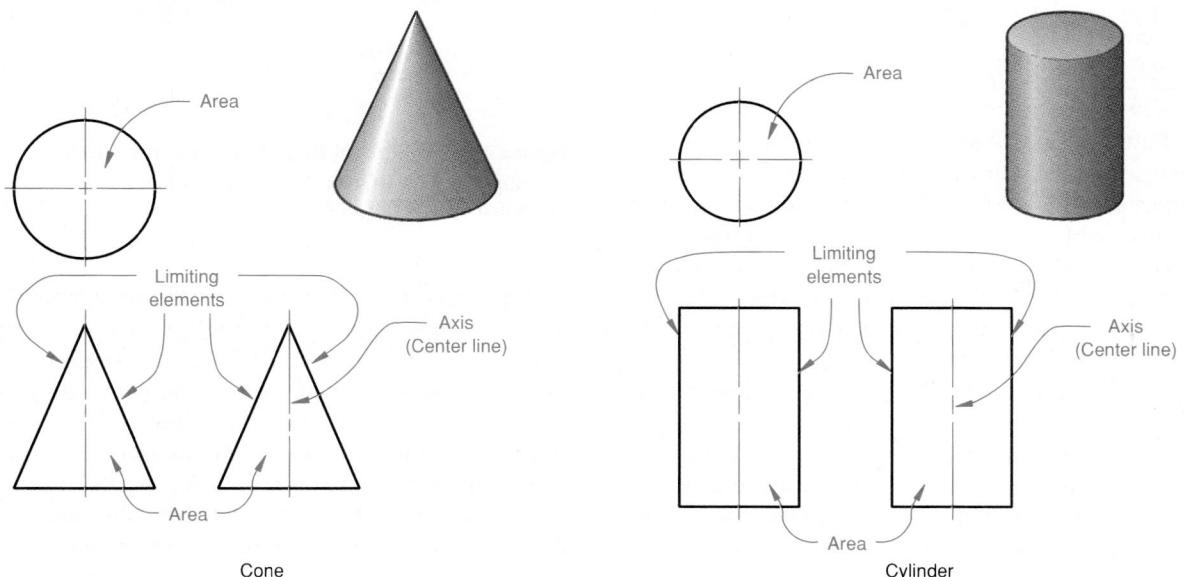

Figure 4.50 Limiting Elements

In technical drawings, a cone is represented as a circle in one view and a triangle in the other. The sides of the triangle represent limiting elements of the cone. A cylinder is represented as a circle in one view and a rectangle in the other.

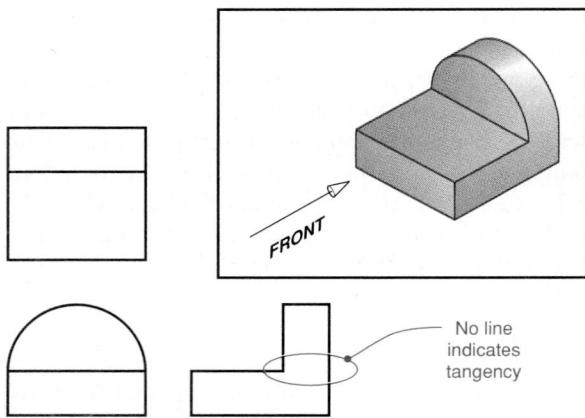

Figure 4.51 Tangent Partial Cylinder

A rounded end, or partial cylinder, is represented as an arc when the line of sight is parallel to the axis of the partial cylinder. No line is drawn at the place where the partial cylinder becomes tangent to another feature, such as the vertical face of the side.

Practice Exercise 4.5

Hold a 12-ounce can of soda at arm's length so that your line of sight is perpendicular to the axis of the can. Close one eye; the outline of the view should be a rectangle. The two short sides are edge views of the circles representing the top and bottom of the can. The two long sides represent the limiting elements of the curved surface. Hold the can at arm's length such that your line of sight is perpendicular to the top or bottom. Close one eye; the outline should look like a circle.

Partial cylinders result in other types of multiview representations. For example, the rounded end of the object in Figure 4.51 is represented as an arc in the front view. In the adjacent views, it is a rectangle, because the curve is tangent to the sides of the object. If the curve were not tangent to the sides, then a line representing a change of planes would be needed in the profile and top views. (Figure 4.52)

An ellipse is used to represent a hole or circular feature that is viewed at an angle other than perpendicular or parallel. Such features include handles, wheels, clock faces, and ends of cans and bottles. Figure 4.53 shows the end of a cylinder, viewed first with a perpendicular line of sight and then with a

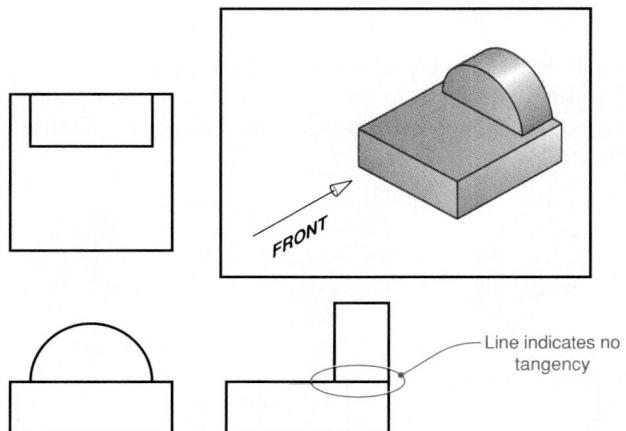

Figure 4.52 Non-Tangent Partial Cylinder

When the transition of a rounded end to another feature is not tangent, a line is used at the point of intersection.

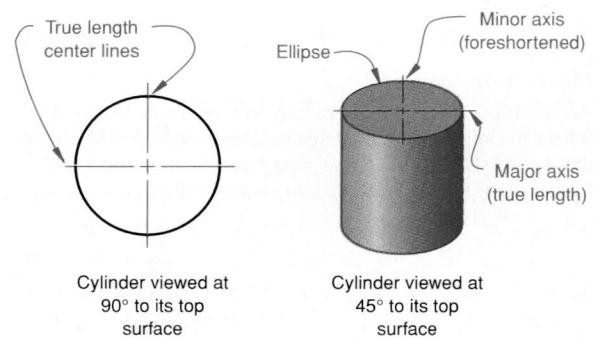

Figure 4.53 Elliptical Representation of a Circle

An elliptical view of a circle is created when the circle is viewed at an oblique angle.

line of sight at 45 degrees. For the perpendicular view, the center lines are true length, and the figure is represented as a circle. (Figure 4.54) However, when the view is tilted, one of the center lines is foreshortened and becomes the minor axis of an ellipse. The center line that remains true length becomes the major axis of the ellipse. As the viewing angle relative to the circle increases, the length of the minor axis is further foreshortened. (Figure 4.54)

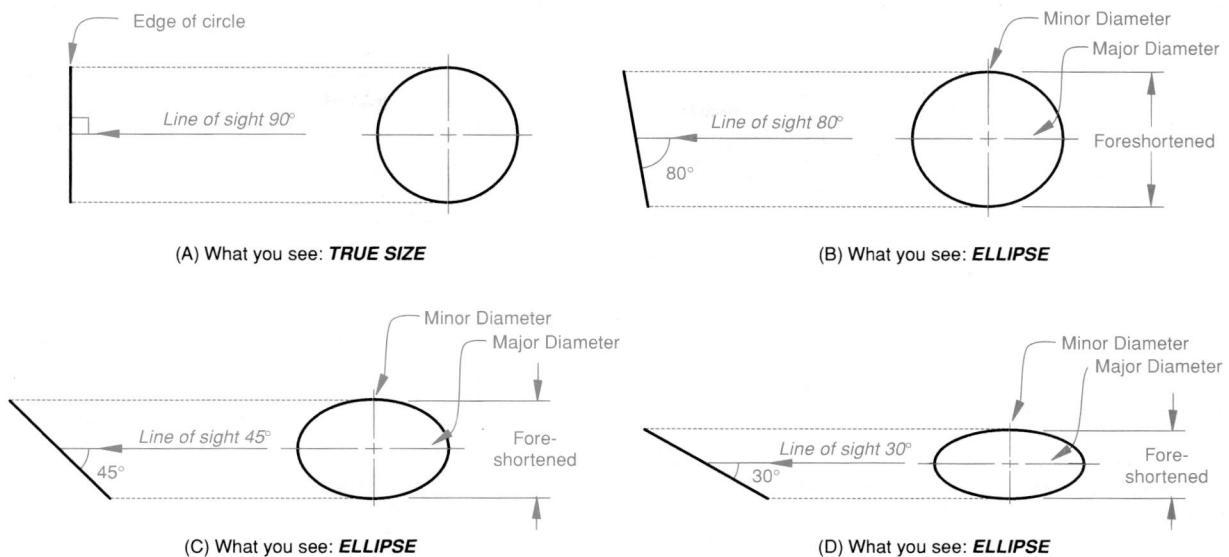

Figure 4.54 Viewing Angles for Ellipses

The size or exposure of an ellipse is determined by the angle of the line of sight relative to the circle.

4.7.6 Holes

Figure 4.55 shows how to represent most types of machined holes. A **through hole**, that is, a hole that goes all the way through an object, is represented in one view as two parallel hidden lines for the limiting elements, and is shown as a circle in the adjacent view. (Figure 4.55A) A **blind hole**, that is, one that is not drilled all the way through the material, is represented as shown in Figure 4.55B. The bottom of a drilled hole is pointed, because all drills used to make such holes are pointed. The depth of the blind hole is measured to the flat, as shown, then 30-degree lines are added to represent the drill tip.

A drilled and counterbored hole is shown in Figure 4.55C. **Counterbored holes** are used to allow the heads of bolts to be flush with or below the surface of the part. A drilled and **countersunk hole** is shown in Figure 4.55D. Countersunk holes are commonly used for flat-head fasteners. Normally, the countersink is represented by drawing 45-degree lines. A **spotfaced hole** is shown in Figure 4.55E. A spotfaced hole provides a place for the heads of fasteners to rest, to create a smooth surface on cast parts. For countersunk, counterbored, and spotfaced holes, a line must be drawn to represent the change of planes that occurs between the large diameter and the small diameter of the hole. Figure 4.55F shows a threaded hole, with two hidden lines in the front view and a solid and a hidden line in the top view.

4.7.7 Fillets, Rounds, Finished Surfaces, and Chamfers

A **fillet** is a rounded *interior* corner, normally found on cast, forged, or plastic parts. A **round** is a rounded *exterior* corner, normally found on cast, forged, or plastic parts. A fillet or round can indicate that both intersecting surfaces are not machine finished. (Figure 4.56) A fillet or round is shown as a small arc.

With CAD, corners are initially drawn square, then fillets and rounds are added using a FILLET command. 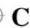 **CAD Reference 4.10**

Fillets and rounds eliminate sharp corners on objects; therefore, there is no true change of planes at these places on the object. However, on technical drawings, only corners, edge views of planes, and limiting elements are represented. Therefore, at times it is necessary to add lines to represent rounded corners, for a clearer representation of an object. (Figure 4.57) In adjacent views, lines are added to the filleted and rounded corners by projecting from the place where the two surfaces would intersect if the fillets or rounds were not used. (Figure 4.58) This is a conventional practice used to give more realistic representation of the object in a multiview drawing.

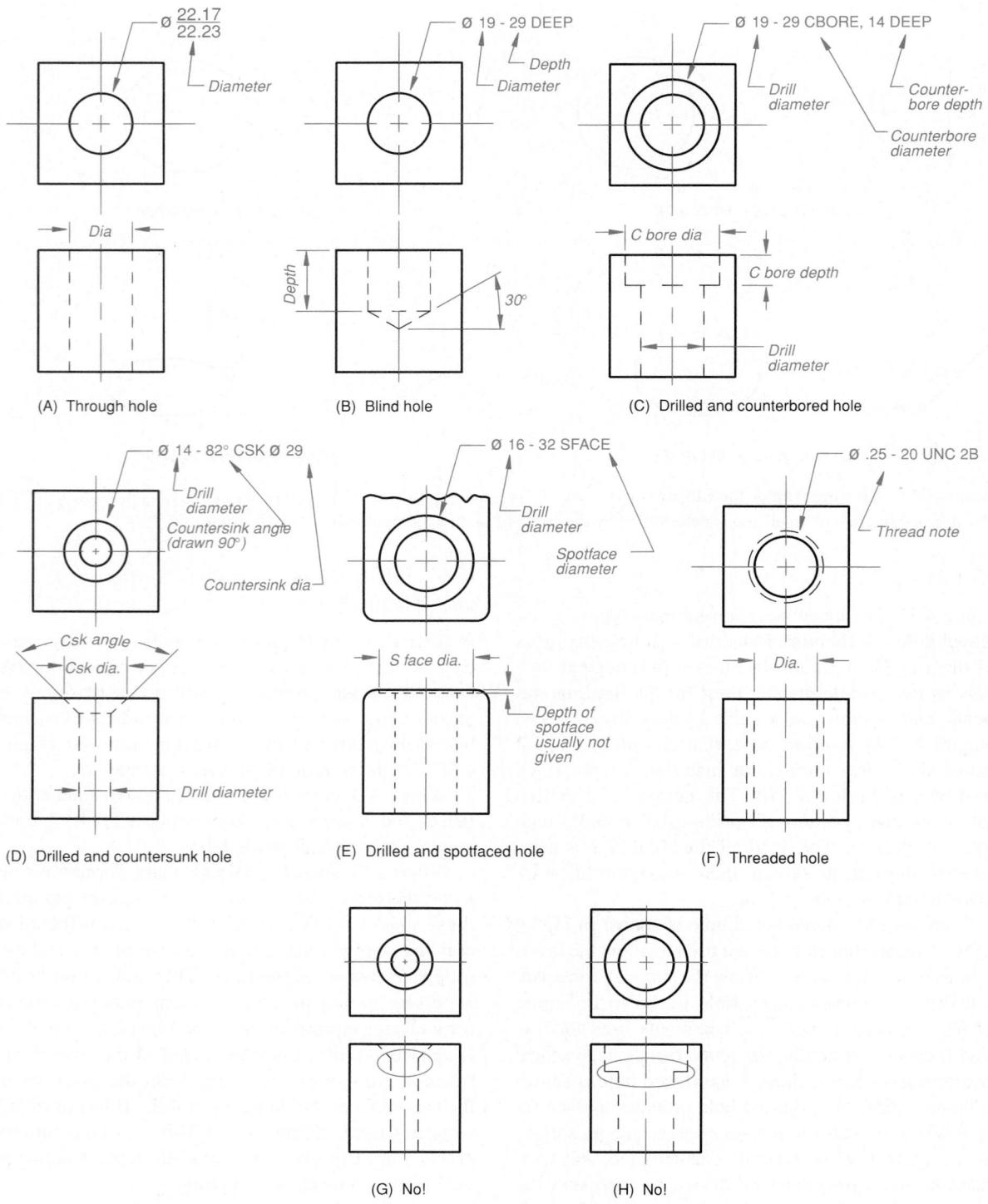

Figure 4.55 Representation of Various Types of Machined Holes

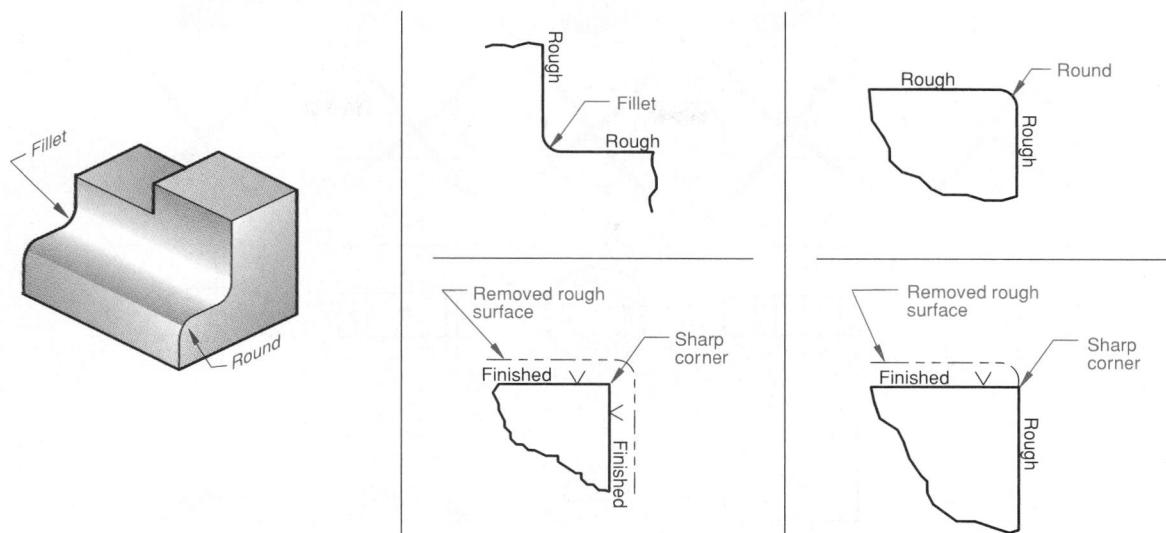

Figure 4.56 Representation of Fillets and Rounds

Fillets and rounds indicate that surfaces of metal objects have not been machine finished; therefore, there are rounded corners.

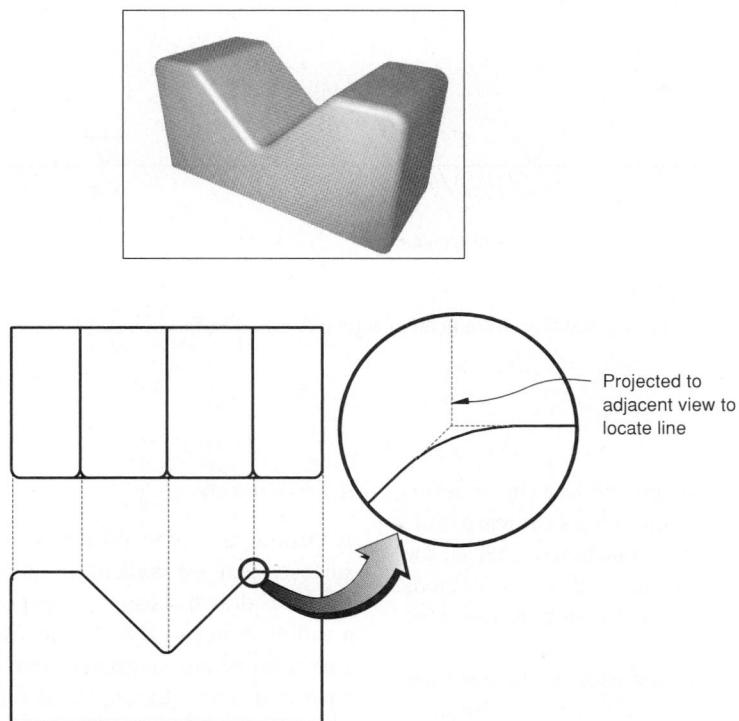

Figure 4.57 Representing Fillet and Rounded Corners

Lines tangent to a fillet or round are constructed and then extended, to create a sharp corner. The location of the sharp corner is projected to the adjacent view, to determine where to place representative lines indicating a change of planes.

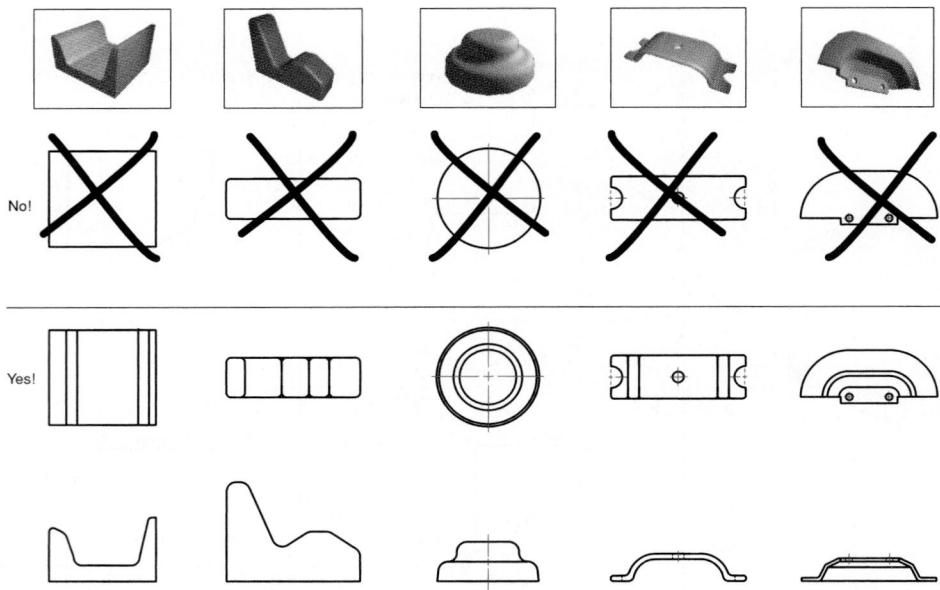

Figure 4.58 Examples of Representing Filleted and Rounded Corners

Lines are added to parts with fillets and rounds, for clarity. Lines are used in the top views of these parts to represent changes of planes that have fillets or rounds at the corners.

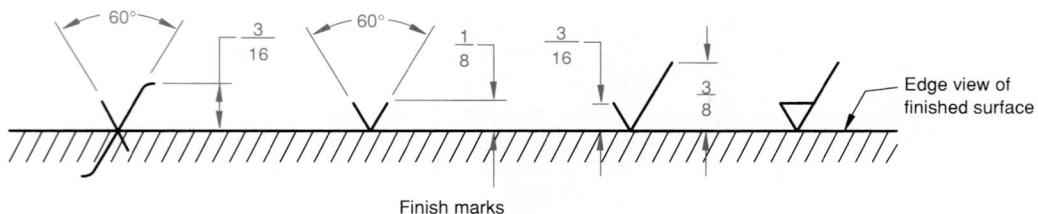

Figure 4.59 Finish Mark Symbols

Finish marks are placed on engineering drawings to indicate machine finished surfaces.

When a surface is to be machined to a finish, a **finish mark** in the form of a small v is drawn on the edge view of the surface to be machined, that is, the *finished surface*. Figure 4.59 shows different methods of representing finish marks and the dimensions used to draw them.

A **chamfer** is a beveled corner used on the openings of holes and the ends of cylindrical parts, to eliminate sharp corners. (Figure 4.60) Chamfers are represented as lines or circles to show the change of plane. Chamfers can be internal or external, and are specified by a linear and an angular dimension. With CAD, chamfers are added automatically to square corners using a CHAMFER command. © CAD Reference 4.11

4.7.8 Runouts

A **runout** is a special method of representing filleted surfaces that are tangent to cylinders. (Figure 4.61) A runout is drawn starting at the point of tangency, using a radius equal to that of the filleted surface, with a curvature of approximately one-eighth the circumference of a circle. Examples of runout uses in technical drawings are shown in Figure 4.62. If a very small round intersects a cylindrical surface, the runouts curve *away* from each other. (Figure 4.62A) If a large round intersects a cylindrical surface, the runouts curve *toward* each other. (Figure 4.62C) © CAD Reference 4.12

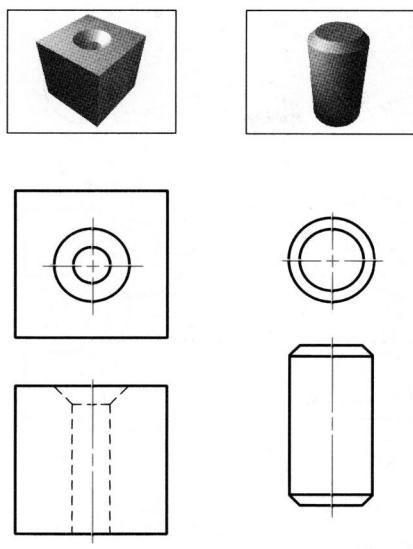

Figure 4.60 Examples of Internal and External Chamfers

Chamfers are used to break sharp corners on ends of cylinders and holes.

4.7.9 Elliptical Surfaces

If a right circular cylinder is cut at an acute angle to the axis, an ellipse is created in one of the multiviews. (Figure 4.63) The major and minor diameters can be projected into the view that shows the top of the cylinder as an ellipse. The ellipse can then be constructed using the methods described in Section 3.63, “Ellipses.” (Figure 4.64)

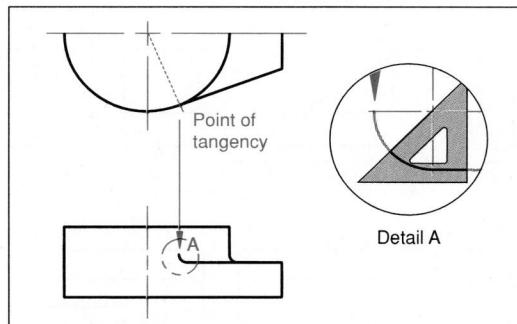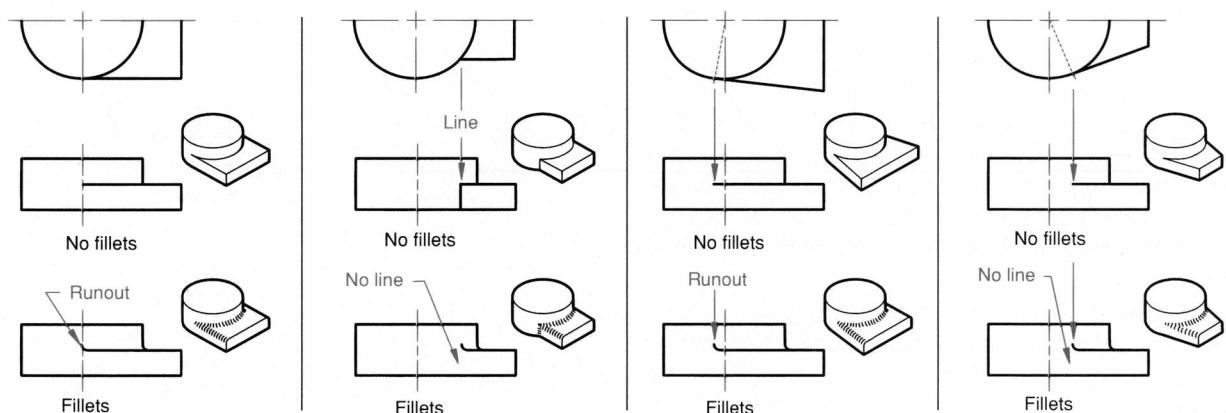

Figure 4.61 Runouts

Runouts are used to represent corners with fillets that intersect cylinders. Notice the difference in the point of tangency with and without the fillets.

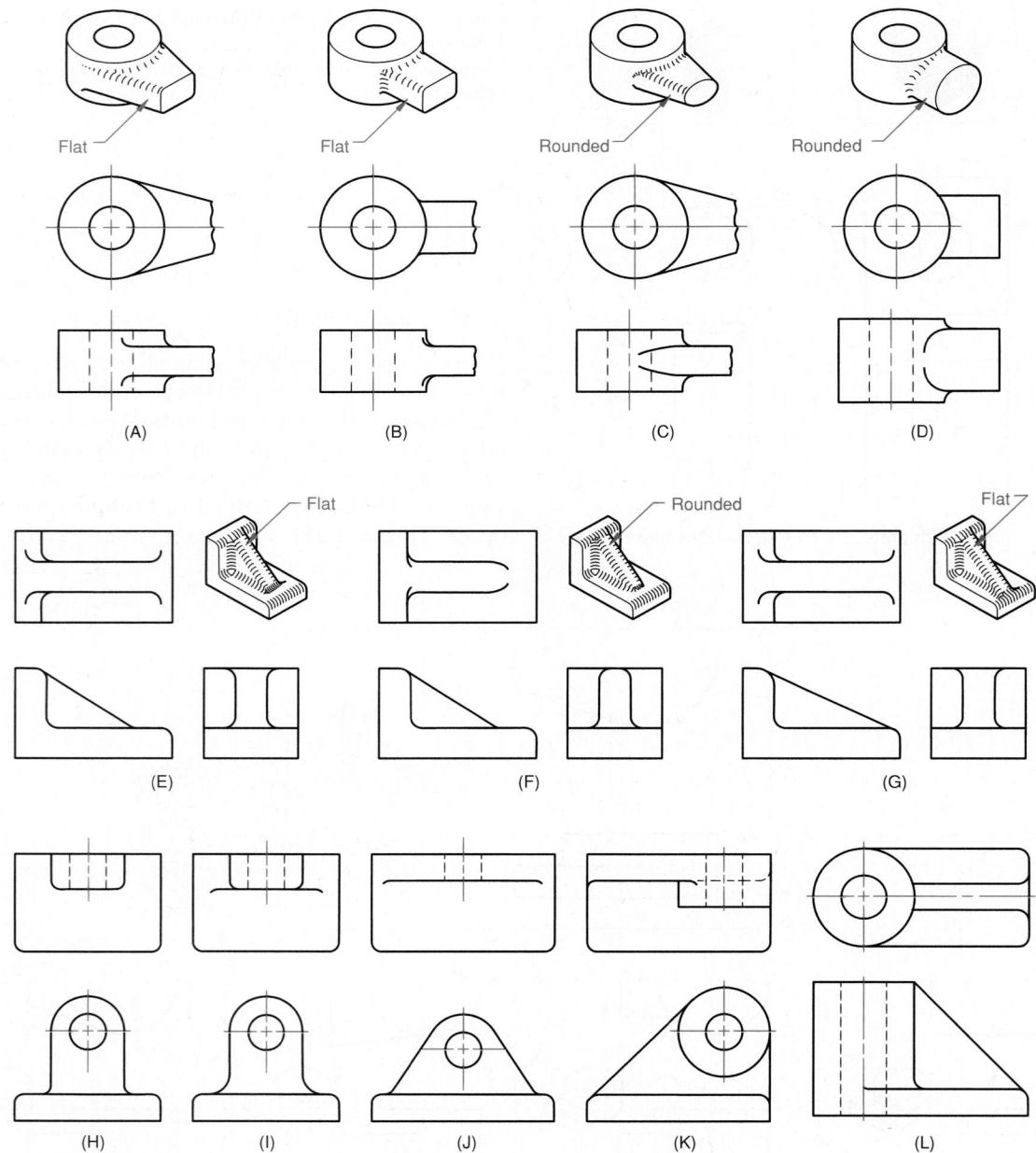

Figure 4.62 Examples of Runouts in Multiview Drawings

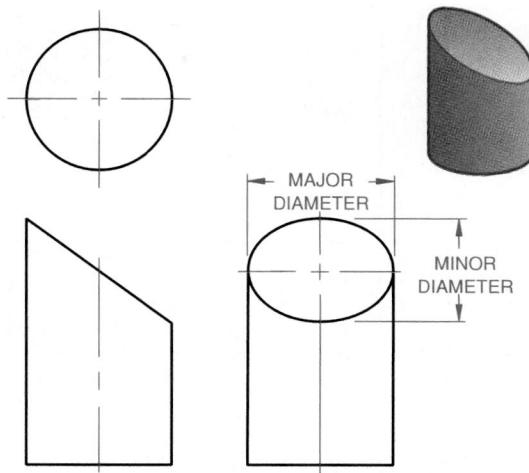

Figure 4.63 Right Circular Cylinder Cut to Create an Ellipse

An ellipse is created when a cylinder is cut at an acute angle to the axis.

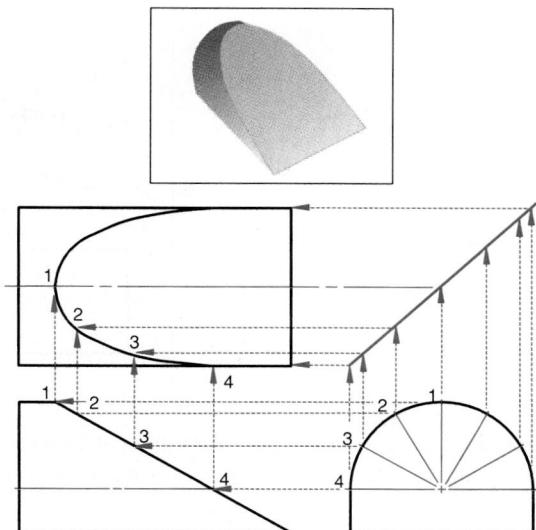

Figure 4.64 Creating an Ellipse by Plotting Points

One method of drawing an ellipse is to plot points on the curve and transfer those points to the adjacent views.

4.7.10 Irregular or Space Curves

Irregular or space curves are drawn by plotting points along the curve in one view, and then transferring or projecting those points to the adjacent views. (Figure 4.65) The intersections of projected points locate the path of the space curve, which is drawn using an irregular curve. With CAD, a SPLINE command is used to draw the curve.

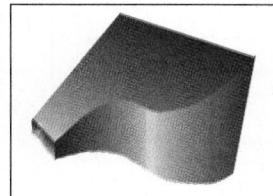

4.7.11 Intersecting Cylinders

When two dissimilar shapes meet, a line of intersection usually results. The conventional practices for representing intersecting surfaces on multiview drawings are demonstrated in Figure 4.66, which shows two cylinders intersecting. When one of the intersecting cylinders is small, true projection is disregarded. (Figure 4.66A) When one cylinder is slightly smaller than the other, some construction is required. (Figure 4.66B) When both cylinders are of the same diameter, the intersecting surface is drawn as straight lines. (Figure 4.66C)

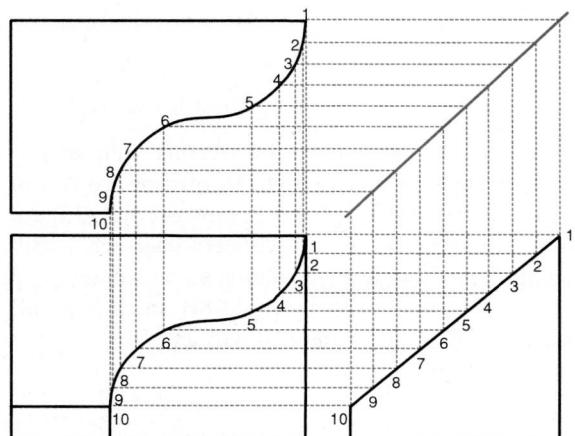

Figure 4.65 Plotting Points to Create a Space Curve

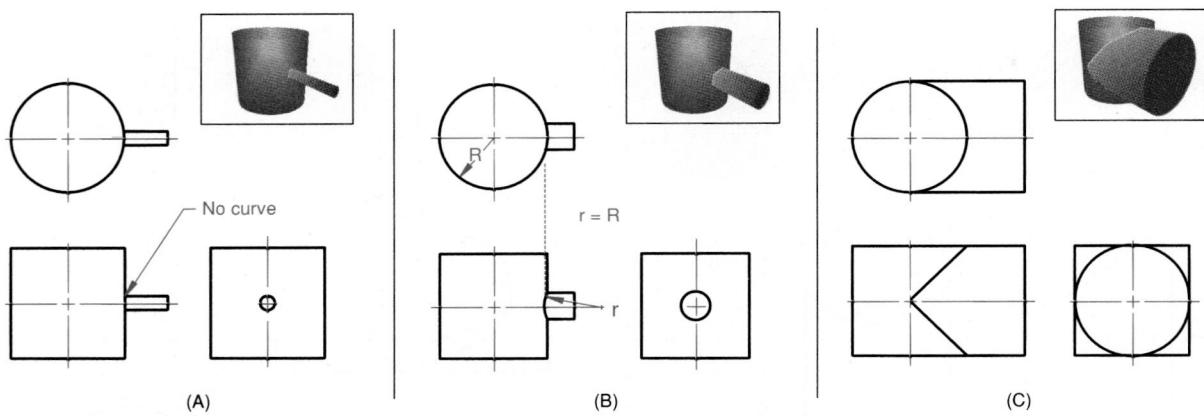

Figure 4.66 Representing the Intersection of Two Cylinders

Representation of the intersection of two cylinders varies according to the relative sizes of the cylinders.

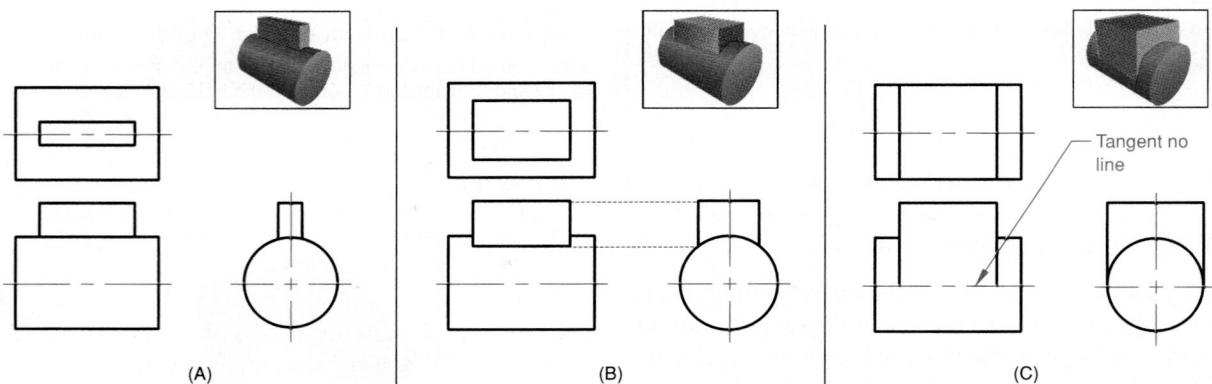

Figure 4.67 Representing the Intersection between a Cylinder and a Prism

Representation of the intersection between a cylinder and a prism depends on the size of the prism relative to the cylinder.

4.7.12 Cylinders Intersecting Prisms and Holes

Figure 4.67 shows cylinders intersecting with prisms. Large prisms are represented using true projection (Figure 4.67B and C); small prisms are not (Figure 4.67A). Figure 4.68 shows cylinders intersected with piercing holes. Large holes and slots are represented using true projection (Figure 4.68B and D); small holes and slots are not (Figure 4.68A and C).

4.8 MULTIVIEW DRAWINGS VISUALIZATION

With sufficient practice, it is possible to learn to *read* 2-D engineering drawings, such as the multiview drawings in Figure 4.69, and to develop mental 3-D images of the objects. Reading a drawing means being able to look at a two- or three-view multiview drawing and form a clear mental image of the three-dimensional object. A corollary skill is the ability to create a multiview drawing from a pictorial view of an object. Going from pictorial to multiview and multiview to pictorial is an important process performed every day by technologists. The following sections describe various techniques for improving

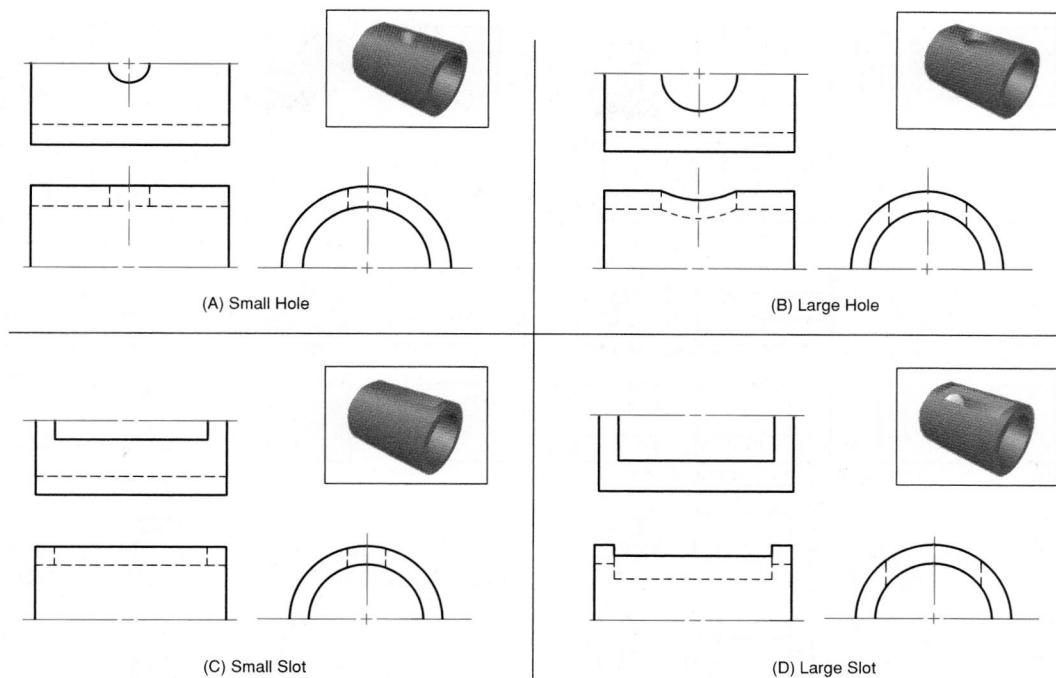

Figure 4.68 Representing the Intersection between a Cylinder and a Hole

Representation of the intersection between a cylinder and a hole or slot depends on the size of the hole or slot relative to the cylinder.

your ability to visualize multiview drawings. Additional information on visualizing 3-D objects is found in Chapter 2.

4.8.1 Projection Studies

One technique that will improve multiview drawing visualization skills is the study of completed multiviews of various objects, such as those in Figure 4.69. Study each object for orientation, view selection, projection of visible and hidden features, tangent features, holes and rounded surfaces, inclined and oblique surfaces, and dashed line usage.

4.8.2 Physical Model Construction

The creation of physical models can be useful in learning to visualize objects in multiview drawings. Typically, these models are created from modeling clay, wax, or Styrofoam. The two basic techniques for creating these models are cutting the 3-D form out of a rectangular shape (Figure 4.70) and using analysis of

solids (Figure 4.71) to divide the object into its basic geometric primitives and then combining these shapes. (See Section 4.8.8 for more information on analysis of solids.)

Practice Exercise 4.6

Figure 4.70 shows the steps for creating a physical model from a rectangular block of modeling clay, based on a multiview drawing.

Step 1. Create a rectangular piece of clay that is proportional to the width, height, and depth dimensions shown on the multiview drawing.

Step 2. Score the surface of the clay with the point of the knife to indicate the positions of the features.

Step 3. Remove the amount of clay necessary to leave the required L-shape shown in the side view.

Step 4. Cut along the angled line to remove the last piece of clay.

Step 5. Sketch a multiview drawing of the piece of clay. Repeat these steps to create other 3-D geometric forms.

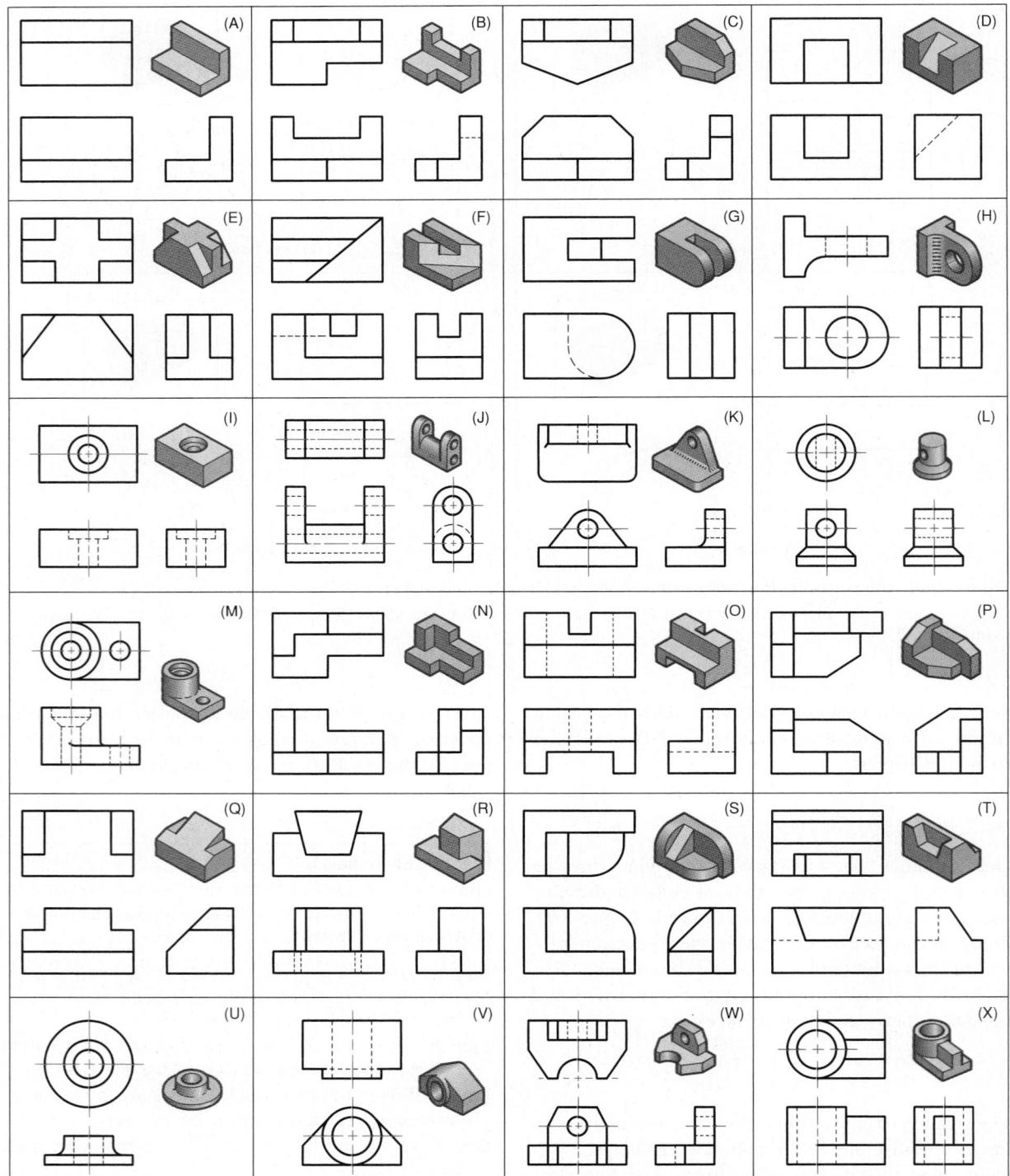

Figure 4.69 Examples of the Standard Representations of Various Geometric Forms

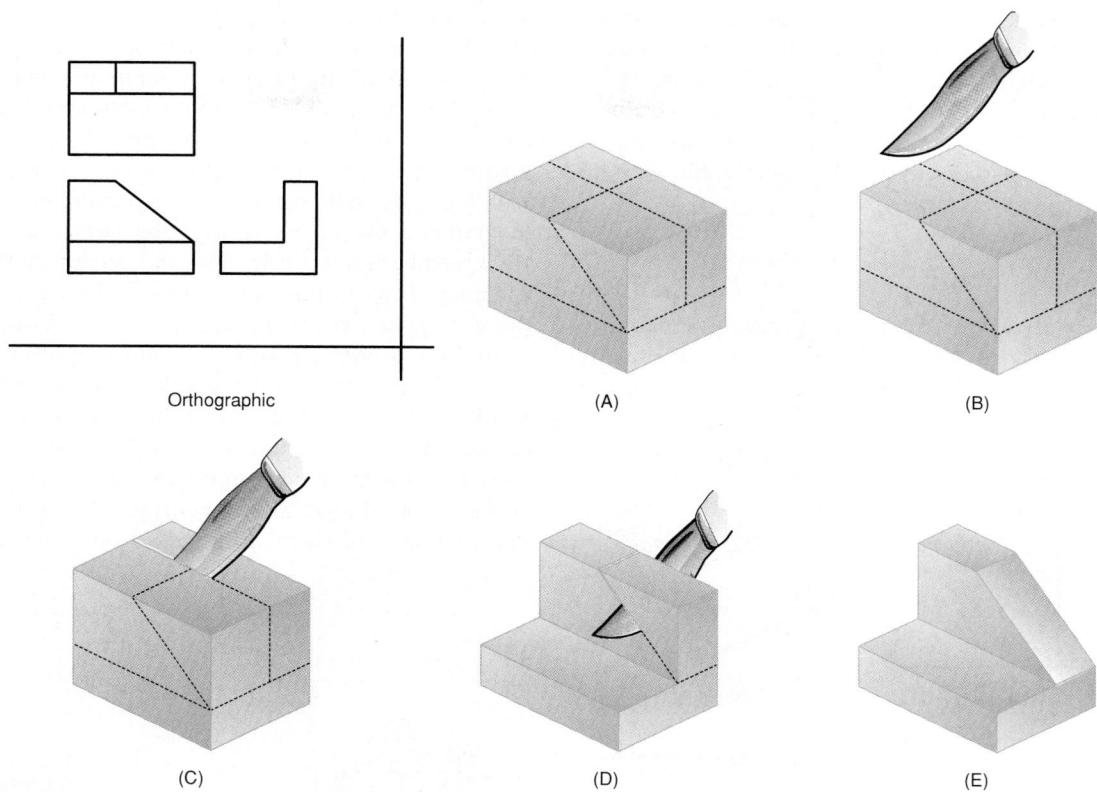

Figure 4.70 Creating a Real Model

Using Styrofoam or modeling clay and a knife, model simple 3-D objects to aid the visualization process.

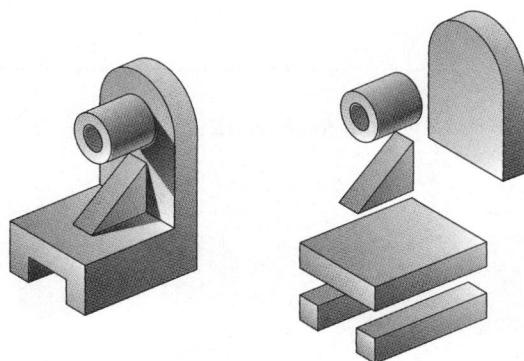

Figure 4.71 Analysis of Solids

A complex object can be visualized by decomposing it into simpler geometric forms.

4.8.3 Adjacent Areas

Given the top view of an object, as shown in Figure 4.72, sketch isometric views of several possible 3-D forms. Figure 4.73 shows just four of the solutions possible, and demonstrates the importance of understanding adjacent areas when reading multiview drawings. **Adjacent areas** are surfaces which reside next to each other. The boundary between the surfaces is represented as a line indicating a *change in planes*. No two adjacent areas can lie in the same plane. Adjacent areas represent either:

1. Surfaces at different levels.
2. Inclined or oblique surfaces.
3. Cylindrical surfaces.
4. A combination of the above.

Going back to Figure 4.72, the lines separating surfaces A, B, and C represent three different surfaces at different heights. Surface A may be higher or lower than surfaces B and C; surface A may also be inclined or cylindrical. This ambiguity emphasizes the importance of using more than one orthographic view to represent an object clearly.

4.8.4 Similar Shapes

One visualization technique involves identifying those views in which a surface has a similar configuration and number of sides. (See Section

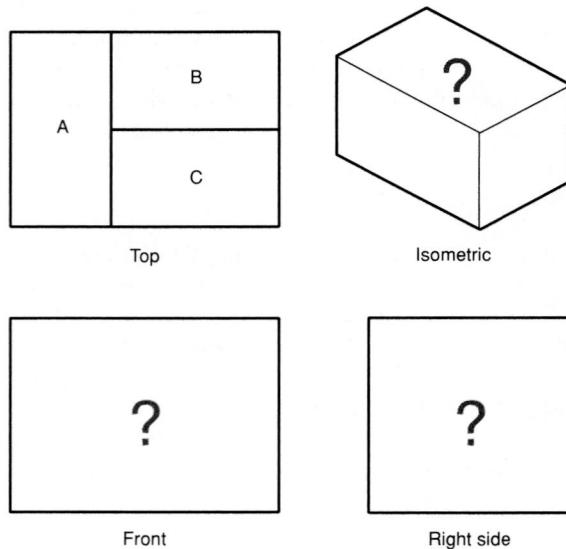

Figure 4.72 Adjacent Areas

Given the top view, make isometric sketches of possible 3-D objects.

4.7.2, Rule 5, “Configuration of Planes,” and Rule 6, “Parallel Features.”) Similar shape or configuration is useful in visualizing or creating multiview drawings of objects with inclined or oblique surfaces. For example, if an inclined surface has four edges with opposite edges parallel, then that surface will appear with four sides with opposite edges parallel in any orthographic view, unless viewing the surface on edge. By remembering this rule you can visually check the accuracy of an orthographic drawing by comparing the configuration and number of sides of surfaces from view to view. Figure 4.74 shows objects with shaded surfaces that can be described by their shapes. In Figure 4.74A, the shaded surface is L-shaped and appears similar in the top and right side views, but is an edge in the front view. In Figure 4.74B, the shaded surface is U-shaped and is configured similarly in the front and top views. In Figure 4.74C, the shaded

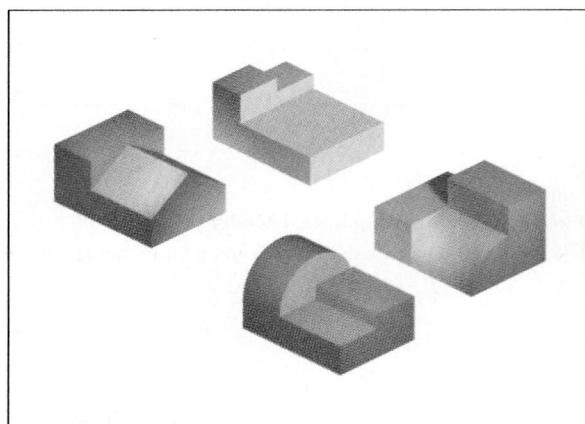

Figure 4.73 Possible Solutions to Figure 4.72

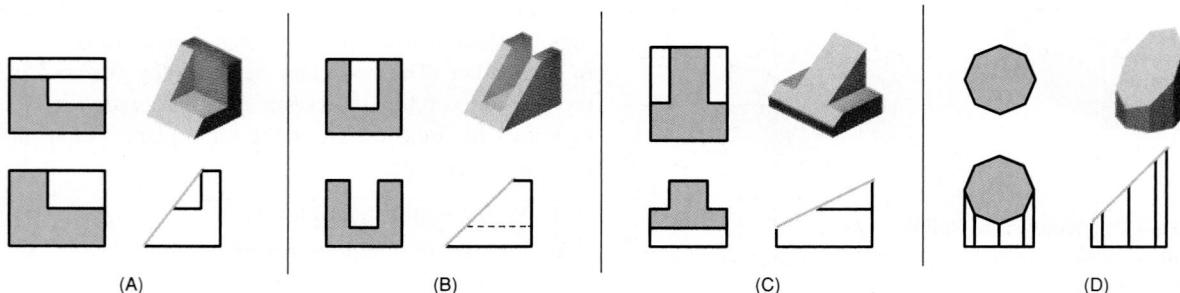

Figure 4.74 Similar-Shaped Surfaces

Similar-shaped surfaces will retain their basic configuration in all views, unless viewed on edge. Notice that the number of edges of a face remains constant in all the views and that edges parallel in one view will remain parallel in other views.

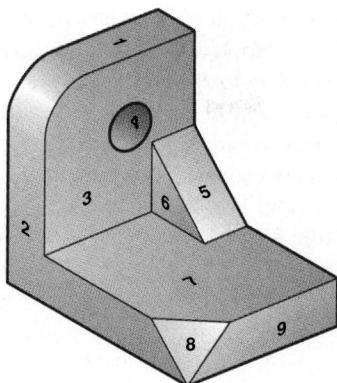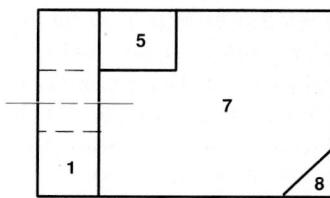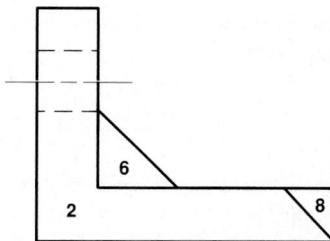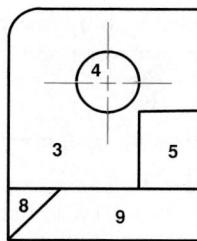

Figure 4.75 Surface Labeling

To check the accuracy of multiview drawings, surfaces can be labeled and compared to those in the pictorial view.

surface is T-shaped in the top and front views. In Figure 4.74D, the shaded surface has eight sides in both the front and top views.

4.8.5 Surface Labeling

When multiview drawings are created from a given pictorial view, surfaces are labeled to check the accuracy of the solution. The surfaces are labeled in the pictorial view and then in each multiview, using the pictorial view as a guide. Figure 4.75 is the pictorial view of an object, with the visible surfaces labeled with a number; for example, the inclined surface is number 5, the oblique surface is number 8, and the hole is number 4. The multiview drawing is then created, the visible surfaces in each view are labeled, and the results are checked against the pictorial. Notice that inclined surface 5 is labeled in the top and right side views, but not in the front view, because it is an edge in that view.

4.8.6 Missing Lines

Another way of becoming more proficient at reading and drawing multiviews is by solving missing-line problems. Figure 4.76 is a multiview drawing with at least one line missing. Study each view, then add any missing lines to the incomplete views. Lines may be missing in more than one of the views. It may be helpful to create a rough isometric sketch of the object when trying to determine the location of missing lines.

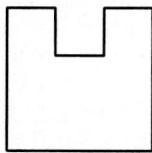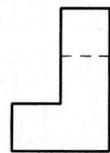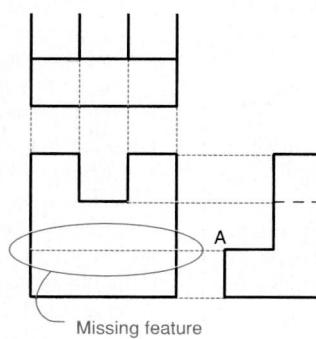

Missing feature

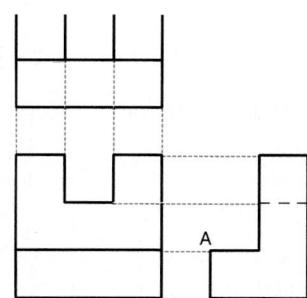

Completed multiview

Figure 4.76 Missing Line Problems

One way to improve your proficiency is to solve missing-line problems. A combination of holistic visualization skills and systematic analysis is used to identify missing features.

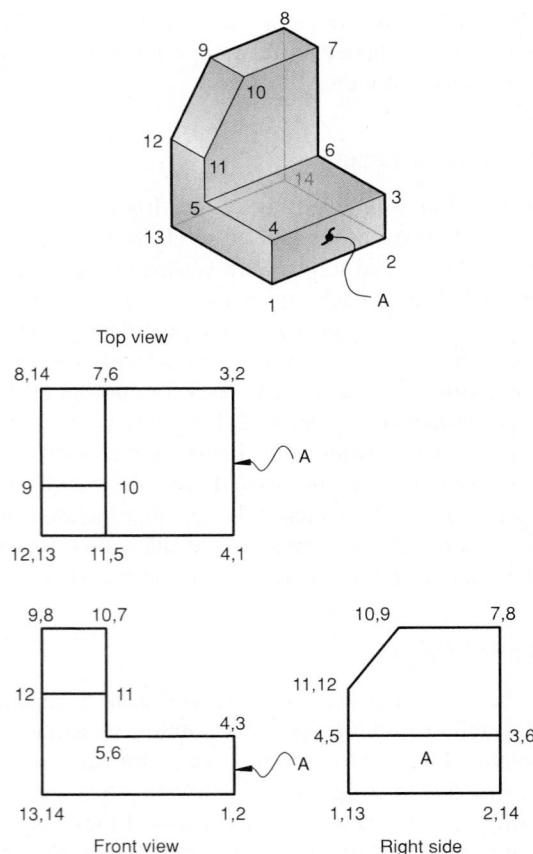

Figure 4.77 Numbering the Isometric Pictorial and the Multiviews to Help Visualize an Object

Locating Missing Lines in an Incomplete Multiview Drawing

Step 1. Study the three given views in Figure 4.76.

Step 2. Use analysis by solids or analysis by surfaces, as described earlier in this text, to create a mental image of the 3-D form.

Step 3. If necessary, create a rough isometric sketch of the object to determine the missing lines.

Step 4. From every corner of the object, sketch construction lines between the views. Because each projected corner should align with a feature in the adjacent view, this technique may reveal missing details. For the figure, corner A in the right side view does not align with any feature in the front view, thus revealing the location of the missing line.

4.8.7 Vertex Labeling

It is often helpful to label the vertices of the isometric view as a check for the multiview drawing. In the

isometric view in Figure 4.77, the vertices, including hidden ones, are labeled with numbers, then the corresponding vertices in the multiviews are numbered. In the multiviews, hidden vertices are lettered to the right of the numbered visible vertices. For example, the vertices of surface A are numbered 1, 2, 3, and 4. In the front view, surface A appears on edge, and vertices 1 and 4 are in front of vertices 3 and 2. Therefore, in the front view, the vertices of surface A are labeled 4, 3 and 1, 2.

4.8.8 Analysis by Solids

A common technique for analyzing multiview drawings is **analysis by solids**, in which objects are decomposed into solid geometric primitives, such as cylinders, negative cylinders (holes), square and rectangular prisms, cones, spheres, etc. These primitives are shown in Figure 4.47 earlier in this chapter. Their importance in the understanding and visualization of multiview drawings cannot be overemphasized.

Figure 4.78 is a multiview drawing of a 3-D object. Important features are labeled in each view. Planes are labeled with a P subscript, holes (negative cylinders) with an H subscript, and cylinders (positive) with a C subscript.

Analysis by Solids

Step 1. Examine all three views as a whole and then each view in detail. In the top view is a rectangular shape labeled A_p and three circles labeled G_h , H_c , and I_h . On the left end of the rectangular area are dashed lines representing hidden features. These hidden features are labeled D_p , E_c , and F_h .

Step 2. In the front view is an L-shaped feature labeled B_p . At opposite ends of the L-shaped area are dashed lines representing hidden features and labeled G_h and F_h . On top of the L-shaped area is a rectangular feature with dashed lines representing more hidden features. The rectangular feature is labeled H_c and the hidden feature is labeled I_h .

Step 3. In the right side view are two rectangular areas, and a U-shaped area with a circular feature. The rectangular feature adjacent to and above the U-shaped area is labeled C_p and has hidden lines labeled G_h . The rectangular feature above C_p is labeled H_c and contains dashed lines labeled I_h . The U-shaped area is labeled D_p and the arc is labeled E_c . The circular feature in the U-shaped area is labeled F_h .

This general examination of the views reveals some important information about the 3-D form of the object. Adjacent views are compared to each other and parallel projectors are drawn between adjacent views to help further analysis of the object.

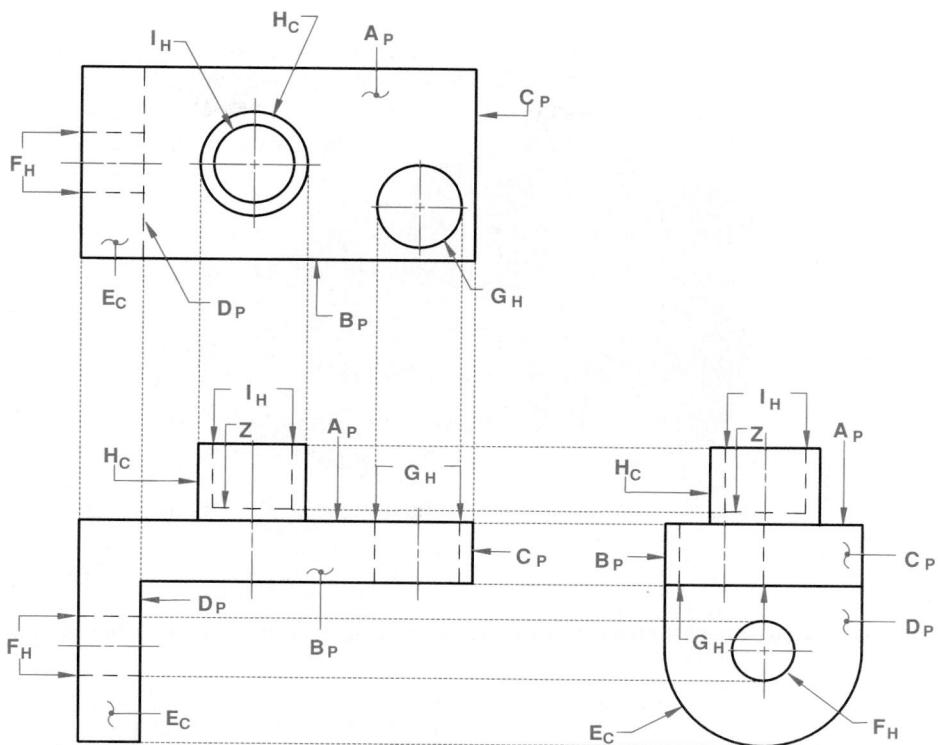

Figure 4.78 Visualizing a Multiview Drawing Using Analysis by Solids

Step 4. In the top view, rectangular area A_p extends the full width of the drawing, can only be aligned with area B_p in the front view, and appears as an edge in the front and right side views. Area B_p in the front view is aligned with area C_p in the right side view. B_p appears as a vertical edge in the right side view and a horizontal edge in the top view. The conclusion is that areas A_p , B_p , and C_p are top, front, and right side views, respectively, of a rectangular prism, which is the main body of the part.

Step 5. Circular area G_h in the top view is aligned with the hidden lines labeled G_h in the front view. Because these hidden lines go from top to bottom in the front view, it is concluded that the circle represents a hole. This can be verified by the dashed lines G_h in the right side view.

Step 6. In the front view, rectangular area H_c projects above the main body of the part; therefore, it should be visible in the top view. This rectangular area is in alignment with circular area H_c in the top view, and with rectangular area H_c in the right side view. The conclusion is that area H_c is a cylinder, because it appears as a circle in one view and as a rectangle in the other two views.

Step 7. The circle I_h in the top view is aligned with dashed lines I_h in the front view and is inside cylinder H_c . This indicates that circle I_h in the top view is a negative cylinder (hole) centered within cylinder H_c . The dashed line labeled Z in the front and right side views shows the depth of the negative cylinder I_h .

Step 8. In the top view, the dashed lines at the left end of rectangular area A_p represent one or more feature(s) below the main body of the part. Hidden line D_p in the top view is aligned with visible line D_p in the front view, and dashed lines F_h in the top view are directly above dashed lines F_h in the front view. Area E_c in the top view is aligned with area E_c in the front view. So the features hidden in the top view must be D_p and E_c in the front view.

D_p and E_c in the front view are aligned with D_p and E_c in the right side view. The right side view appears to be the most descriptive view of these features. In this view, area E_c is a partial cylinder represented by arc E_c . The side view also reveals that dashed lines F_h in the top and front views represent the diameter of hole F_h . Therefore, area D_p and partial cylinder E_c are a U-shaped feature with a hole whose width is revealed in the front and top views.

Analysis by solids should result in a clear mental image of the 3-D form represented in a 2-D multiview drawing. Figure 4.79 is a pictorial view of the object in the multiview drawing, and it should be similar to the mental image created after following the preceding eight steps.

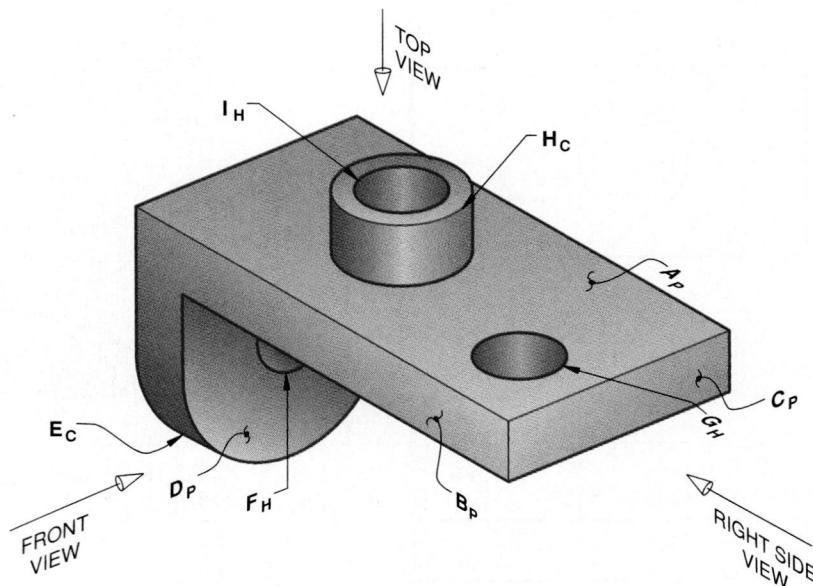

Figure 4.79 A Pictorial View of the Multiview Drawing in Figure 4.78, Revealing Its Three-Dimensional Form

4.8.9 Analysis by Surfaces

Figure 4.79 lends itself to analysis by solids because there are no inclined or oblique surfaces. With inclined and oblique surfaces, such as those shown in Figure 4.80, **analysis by surfaces** may be more useful.

Analysis by Surfaces

Step 1. Examine all three views in Figure 4.80. There are no circular or elliptical features; therefore, all the areas must be bounded by planar surfaces. In the top view, areas A and B are separated by lines; therefore, they are not in the same plane. The same is true for areas C and D in the front view, and areas E and F in the right side view. The reason for this is that no two contiguous (adjacent) areas can lie in the same plane. If they were in the same plane, a line would not be drawn to separate them. This is an example of Rule 8.

Step 2. The lines of projection between the top and front views indicate that area B corresponds to area D. Areas B and D are also similar in shape in that they both have six sides, thus reinforcing the possibility that areas B and D are the same feature. Similarly, areas A and C are aligned and are similar in shape, so they could be the same feature. However, before accepting these two possibilities, the side view must be considered.

Step 3. Area D aligns with area F, but they are not similar in shape; area F is three-sided and area D is

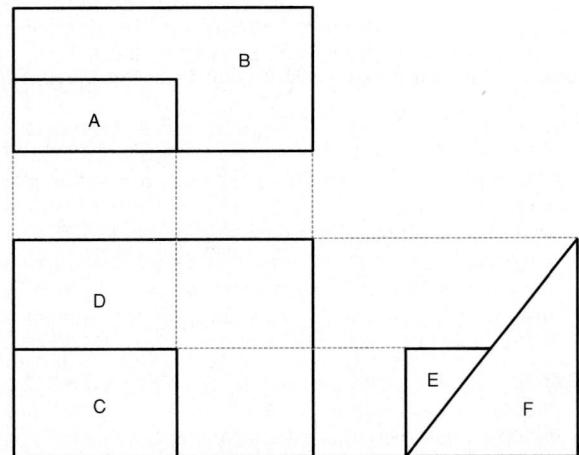

Figure 4.80 Visualizing a Multiview Drawing Using Analysis by Surfaces

six-sided. Therefore, areas D and F are not the same feature. In the right side view, area D must be represented as an edge view separating areas E and F; therefore, area D is the inclined plane in the right side view. Area C aligns with area E, but they are not similar in shape; area C is four-sided and area E is three-sided. In the right side view, area C must be represented as an edge view and is the vertical line on the left side of the view.

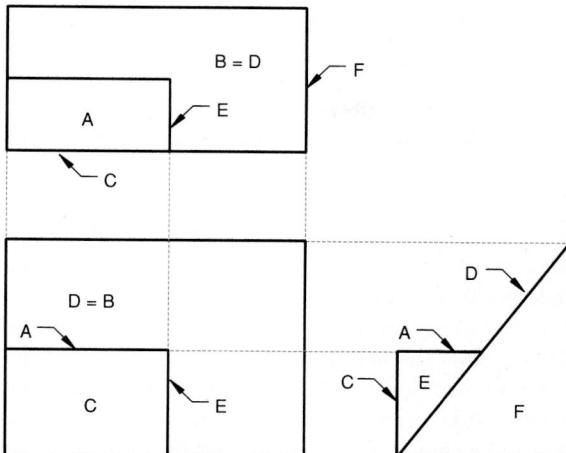

Figure 4.81 Conclusions Drawn about Figure 4.80

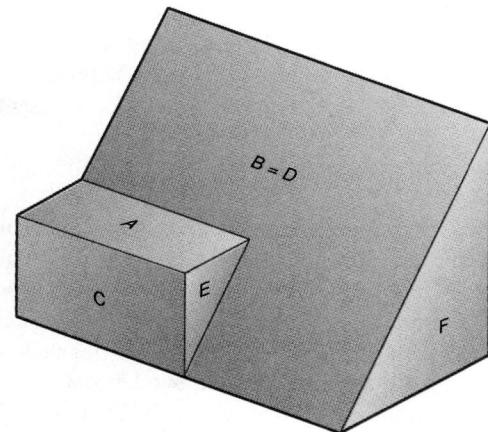

Figure 4.82 A Pictorial View of Figure 4.80, Revealing Its Three-Dimensional Form

Step 4. Areas E and F are not represented in the top or front views; therefore, areas E and F are edge views in the front and top views. (Figure 4.81) Because areas E and F are visible in the right side view, they are at the right end of the front and top views. Therefore, they must be located at the right end of the object.

Step 5. Based on alignment and similarity of shape, surfaces B and D must be the same surface.

Step 6. Area A in the top view is an edge view represented as a horizontal line in the front and side views. Area C in the front view is a horizontal edge view in the top view and a vertical edge view in the right side view. Areas A and C are therefore not the same.

Figure 4.82 is a pictorial view of the object. Areas B and D are the same inclined plane, area A is a horizontal plane, and areas C, E, and F are vertical planes.

*Principles of Orthographic Projection Rule 8:
Contiguous Areas
No two contiguous areas can lie in the same plane.*

4.9 ANSI STANDARDS FOR MULTIVIEW DRAWINGS

Standards form the common language used by engineers and technologists for communicating information. The standard view representations developed by ANSI for multiview drawings are described in the following paragraphs.

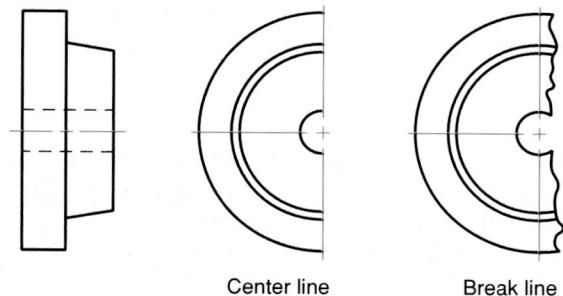

Figure 4.83 A Partial View Used on a Symmetrical Object

The partial view is created along a center line or a break line.

4.9.1 Partial Views

A **partial view** shows only what is necessary to completely describe the object. Partial views are used for symmetrical objects, for some types of auxiliary views, and for saving time when creating some types of multiview drawings. A break line (shown as a jagged line) or center line for symmetrical objects may be used to limit the partial view. (Figure 4.83) If a break line is used, it is placed where it will not coincide with a visible or hidden line.

Partial views are used to eliminate excessive hidden lines that would make reading and visualizing a drawing difficult. At times it may be necessary to supplement a

partial view with another view. For example, in Figure 4.84, two partial profile views are used to describe the object better. What has been left off in the profile views are details located behind the views.

4.9.2 Revolution Conventions

At times, a normal multiview drawing will result in views that are difficult to visualize and read. This is especially true of objects with ribs, arms, or holes that are not aligned with horizontal and vertical center lines. Figure 4.85 shows an object with ribs and holes that are equally spaced, with the two bottom holes not aligned with the center line of the object. True projection produces an awkward profile view that is difficult to draw because all but one rib are foreshortened. (Figure 4.85A) ANSI standard **revolution conventions** allow the profile view to be drawn as shown in Figure 4.85B. You must visualize the object as if the ribs are revolved into alignment with the vertical center line in the front view. This will produce a profile view that is easier to visualize and draw.

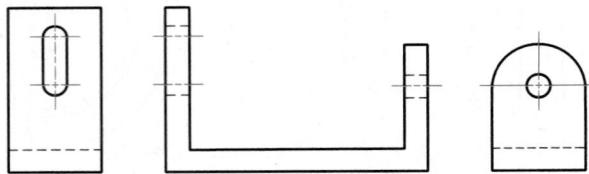

Figure 4.84 Use of Two Partial Profile Views to Describe an Object and Eliminate Hidden Lines

Revolution conventions can also be used on parts that have *bolt circles*. Figure 4.86 shows the true projection of a plate with a bolt circle. Notice that the profile view becomes difficult to read because of so many hidden lines. As shown in Figure 4.86, revolution conventions dictate that only two of the bolt circle holes must be represented in the profile view. These two bolt circle holes are aligned with the vertical center line in the front view and are then represented in that position in the profile view.

Figure 4.87 shows another example of revolution conventions. The inclined arms in the figure result in a foreshortened profile view, which is difficult and time consuming to draw. Revolution conventions allow the arms to be shown in alignment with the vertical center line of the front view, to create the profile view shown in the figure.

Objects similar to those described in the preceding paragraphs are frequently represented as section views. When revolution techniques are used with section views, the drawings are called *aligned sections*. (See Chapter 7, “Section Views.”)

Revolution conventions were developed before CAD. With the advent of 3-D CAD and the ability to extract views automatically, it is possible to create a true-projection view, like that shown in Figure 4.87, quickly and easily. You are cautioned that, even though a view can be automatically produced by a CAD system, this does not necessarily mean that the view will be easy to visualize by the user.

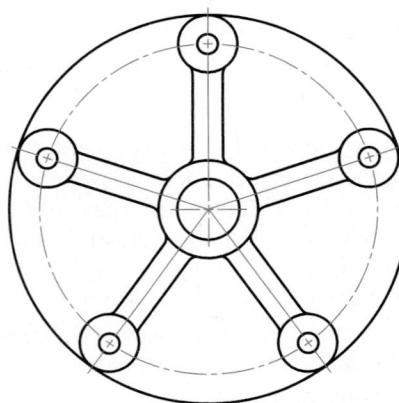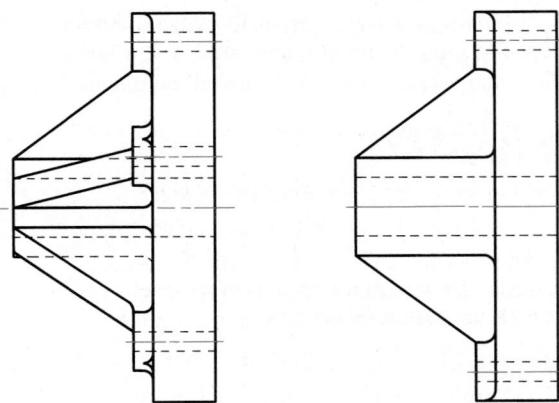

(A) True projection

(B) Preferred

Figure 4.85 Revolution Convention Used to Simplify the Representation of Ribs and Webs

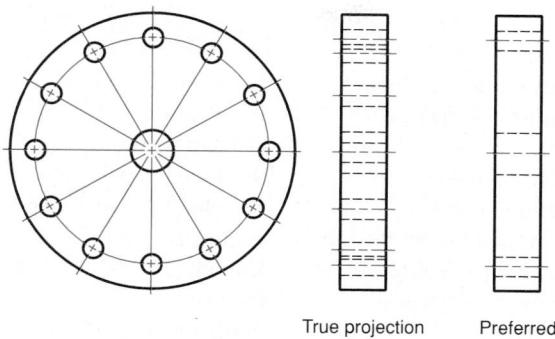

Figure 4.86 Revolution Convention Used on Objects with Bolt Circles, to Eliminate Hidden Lines and Improve Visualization

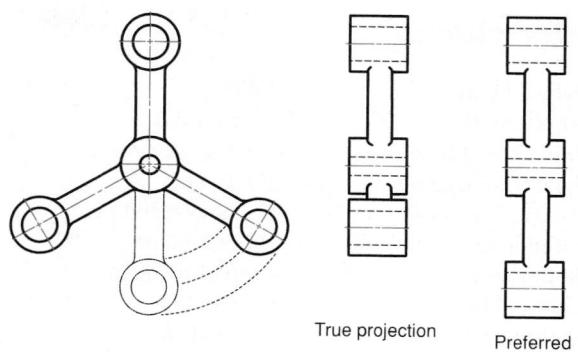

Figure 4.87 Revolution Convention Used to Simplify the Representation of Arms

Practice Exercise 4.7

In Figures 4.85–87, a new revolved view was created to replace a true projection in the profile view. This was done in order to represent the features of the object more clearly. Sketch new front views as if the new profile views represented true projections.

4.9.3 Removed Views

At times, it is important to highlight or enlarge part of a multiview. A new view is drawn that is not in alignment with one of the principal views, but is removed and placed at a convenient location on the drawing sheet. A **removed view** is a complete or partial orthographic view that shows some details more clearly. A new viewing plane is used to define the line of sight used to create the removed view, and both the viewing plane and the removed view are labeled, as shown in Figure 4.88.

4.10 SUMMARY

Multiview drawings are an important part of technical graphics. Creating multiview drawings takes a high degree of visualization skill and considerable practice. Multiview drawings are created by closely following orthographic projection techniques and ANSI standards. The rules of orthographic projection are listed here for your reference.

Rule 1: Every point or feature in one view must be aligned on a parallel projector in any adjacent view.

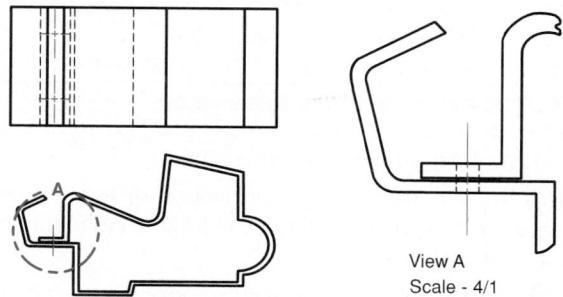

Figure 4.88 A Scaled Removed View (View A)

Rule 2: Distances between any two points of a feature in related views must be equal.

Rule 3: Features are true length or true size when the lines of sight are perpendicular to the feature.

Rule 4: Features are foreshortened when the lines of sight are not perpendicular to the feature.

Rule 5: Areas that are the same feature will always be similar in configuration from one view to the next, unless viewed as an edge.

Rule 6: Parallel features will always appear parallel in all views.

Rule 7: Surfaces that are parallel to the lines of sight will appear as lines or edge views.

Rule 8: No two contiguous areas can lie in the same plane.

KEY TERMS

Adjacent areas	Fillet	Multiview drawing	Projection theory
Adjacent views	Finish mark	Multiview projection	Rear view
Alphabet of lines	First-angle projection	Normal line	Related views
Analysis by solids	Fold lines	Normal plane	Removed view
Analysis by surfaces	Foreshortened plane	Oblique plane	Revolution conventions
Blind hole	Frontal plane	Orthographic projection	Right side view
Bottom view	Frontal plane of projection	Parallel projection	Round
Central view	Front view	Plane of projection	Runout
Chamfer	Horizontal plane	Partial view	Spotfaced hole
Change of planes	Horizontal plane of projection	Perspective projection	Standards
Corner	Inclined plane	Point	Third-angle projection
Counterbored hole	Left side view	Principal plane	Through hole
Countersunk hole	Line of sight (LOS)	Principal views	Top view
Edge		Profile plane	True-length line
Edge view		Profile plane of projection	

QUESTIONS FOR REVIEW

1. Define orthographic projection.
2. How is orthographic projection different from perspective projection? Use a sketch to highlight the differences.
3. Define multiview drawings. Make a simple multiview sketch of an object.
4. Define frontal, horizontal, and profile planes.
5. List the six principal views.
6. Define fold lines.
7. List the space dimensions found on a front view, top view, and profile view.
8. Define a normal plane.
9. Define an inclined plane.
10. Define an oblique plane.
11. List the eight rules of orthographic projection.

PROBLEMS

4.1 (Figure 4.89) Draw or sketch the front, top, and right side views of the object shown in the pictorial. Number each visible surface in each of the multiviews to correspond to the numbers given in the pictorial view.

4.2 (Figure 4.90) Given the front view shown in the figure, design at least six different solutions. Sketch your solutions in pictorial and in front and side views.

4.3 (Figure 4.91) Given the two views of a multiview drawing of an object, sketch or draw the given views, freehand or using instruments or CAD, and then add the missing view. As an additional exercise, create a pictorial sketch of the object.

4.4 (Figure 4.92) Given three incomplete views of a multiview drawing of an object, sketch or draw the given views, freehand or using instruments or CAD, and then add the missing line or lines. As an additional exercise, create a pictorial sketch of the object.

4.5 (Figure 4.93) Sketch, or draw with instruments or CAD, multiviews of the objects shown in the pictorials.

4.6 (Figures 4.94 through 4.145) Sketch, draw with instruments or CAD, or create 3-D CAD models for the parts shown.

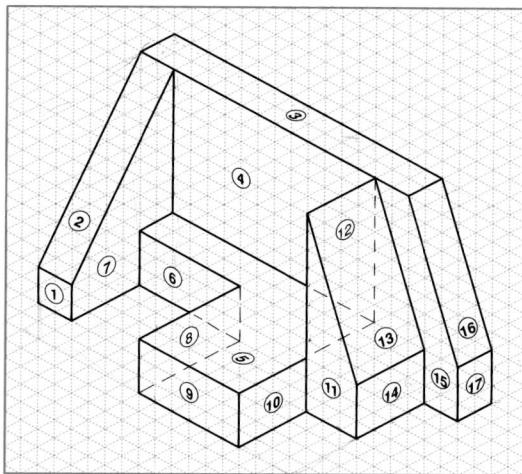

Figure 4.89 Solid Object for Problem 4.1

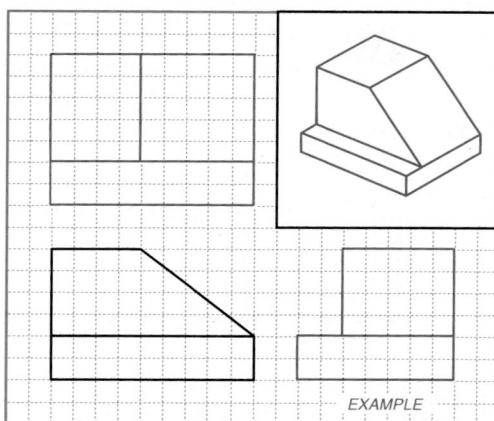

Figure 4.90 Front View for Problem 4.2

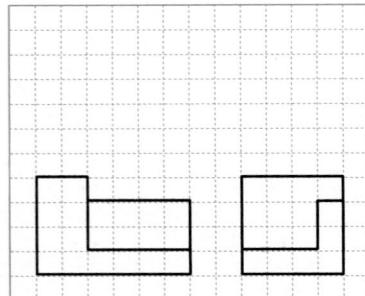

(1)

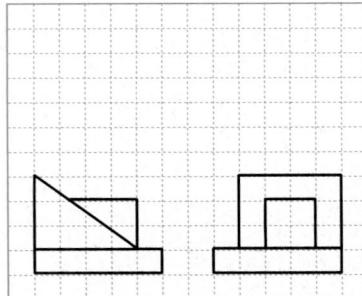

(2)

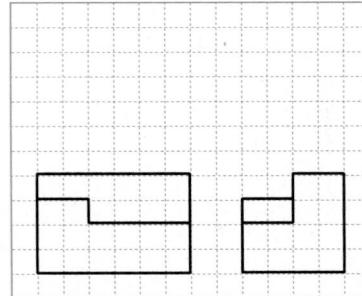

(3)

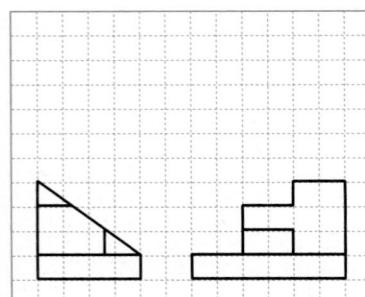

(4)

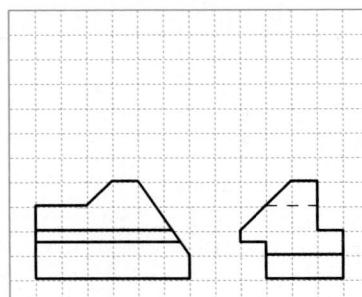

(5)

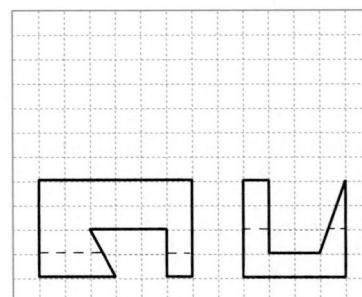

(6)

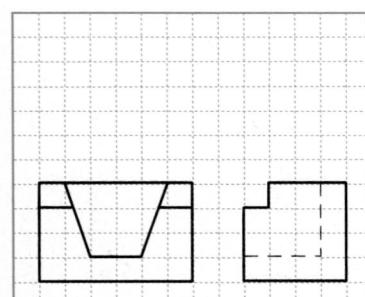

(7)

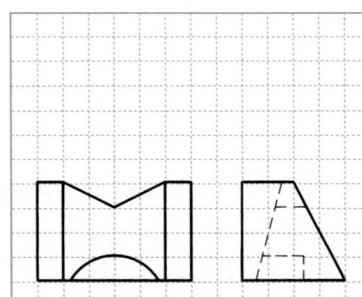

(8)

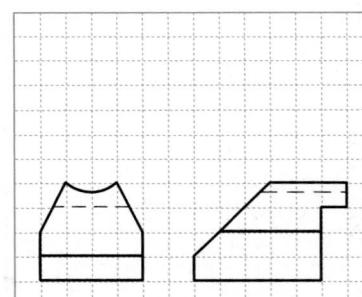

(9)

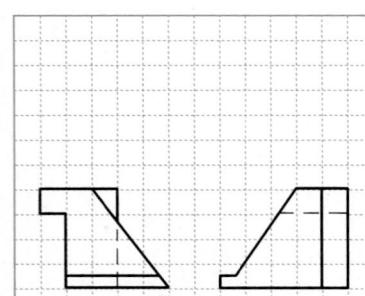

(10)

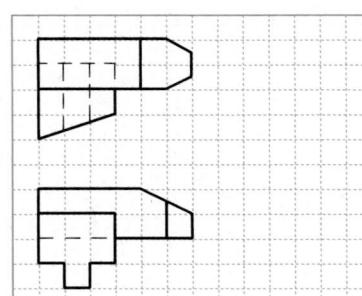

(11)

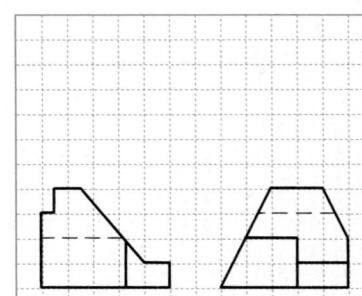

(12)

Figure 4.91 Two-View Drawings of Several Objects, for Problem 4.3

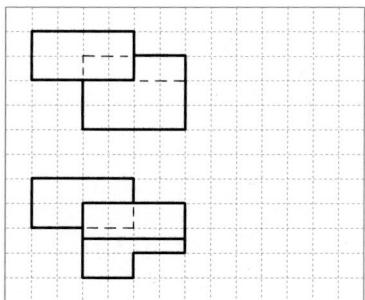

(13)

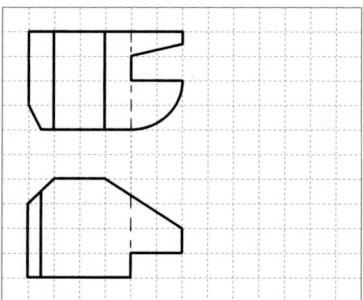

(14)

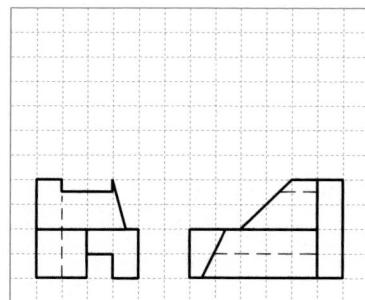

(15)

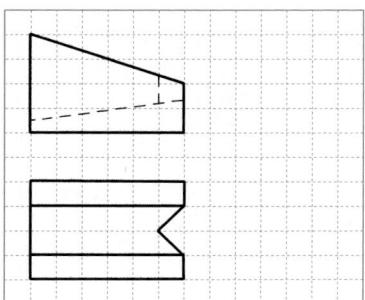

(16)

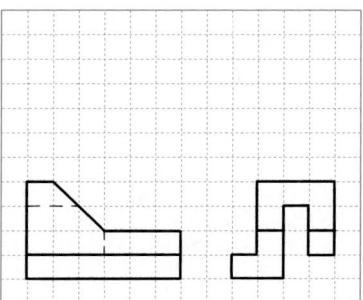

(17)

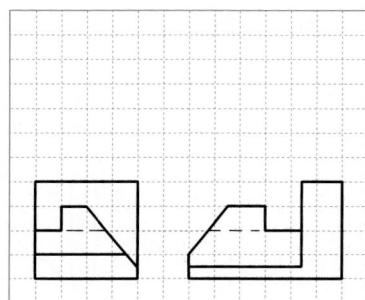

(18)

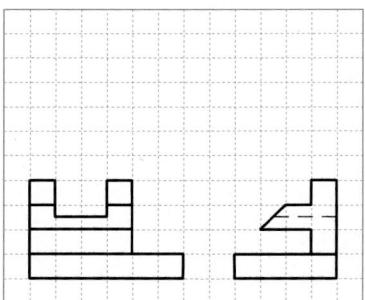

(19)

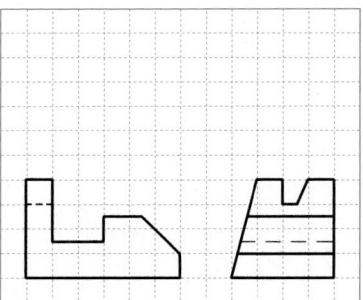

(20)

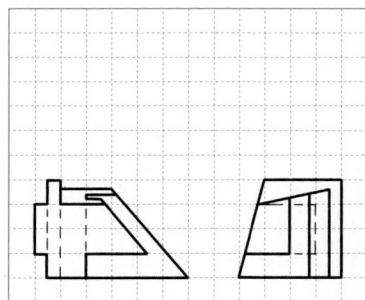

(21)

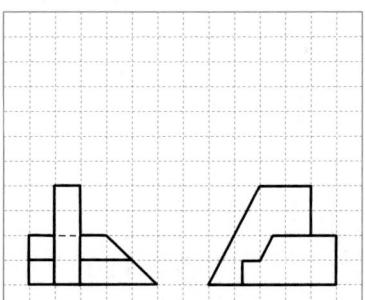

(22)

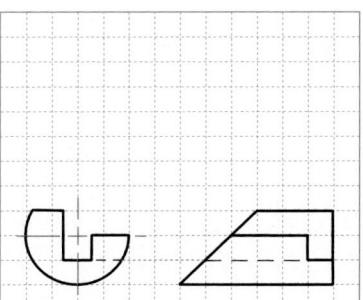

(23)

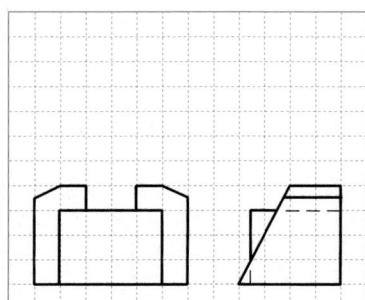

(24)

Figure 4.91 Continued

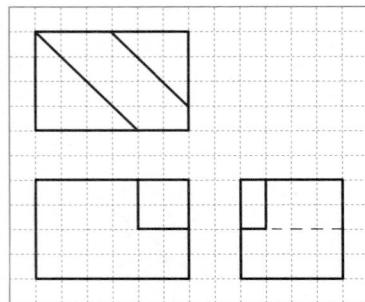

(1)

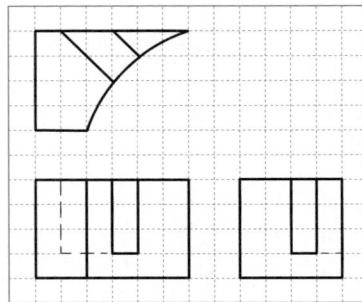

(2)

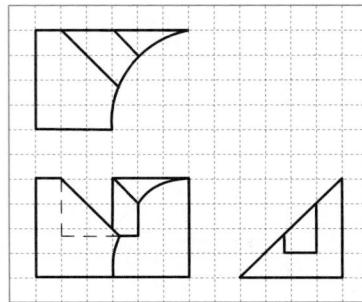

(3)

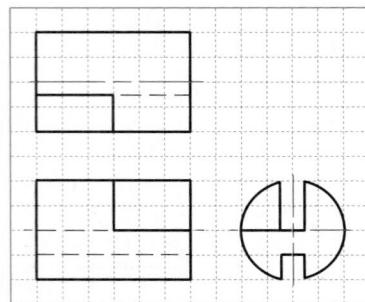

(4)

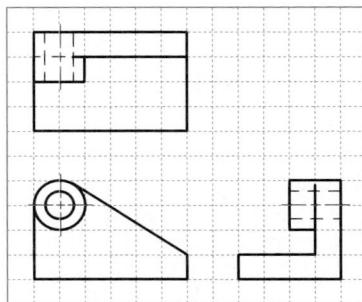

(5)

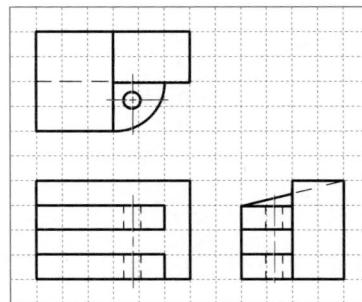

(6)

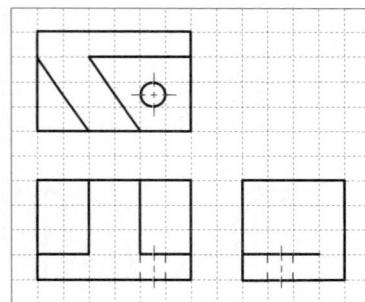

(7)

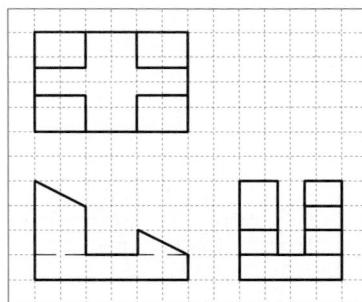

(8)

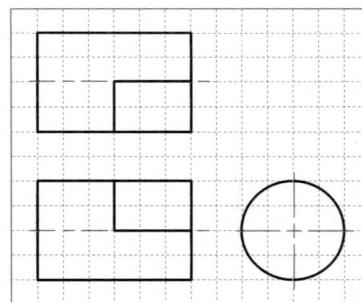

(9)

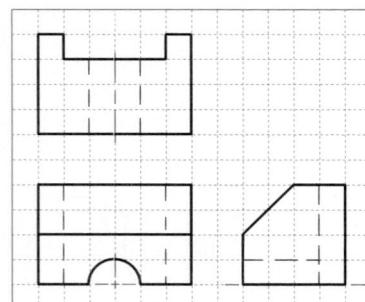

(10)

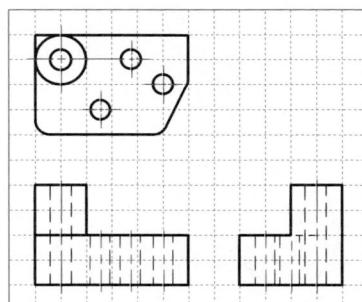

(11)

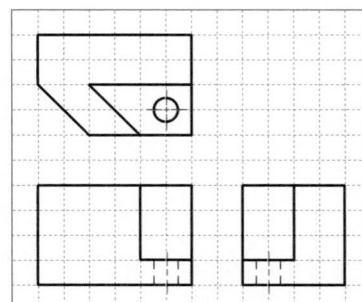

(12)

Figure 4.92 Three Incomplete Views of a Multiview Drawing of an Object, for Problem 4.4

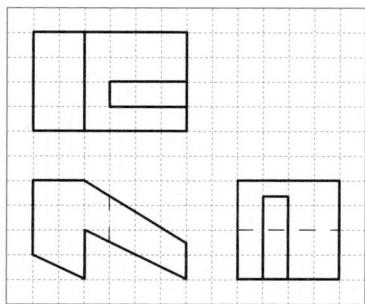

(13)

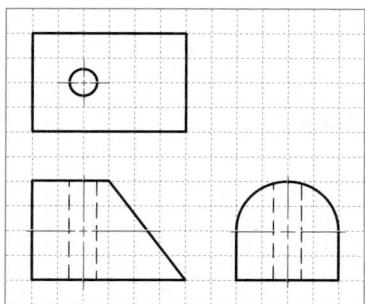

(14)

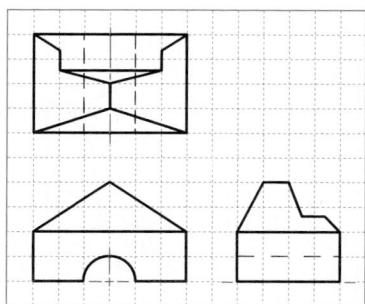

(15)

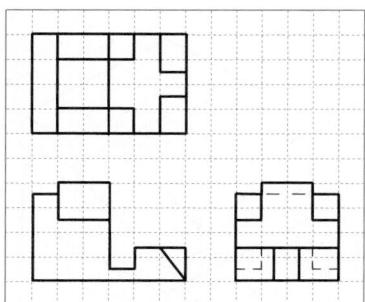

(16)

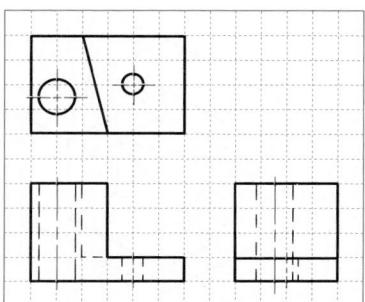

(17)

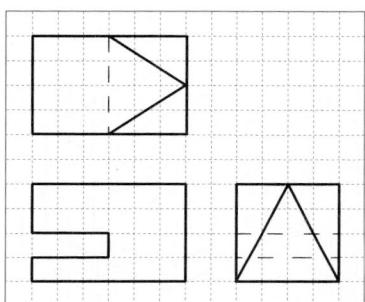

(18)

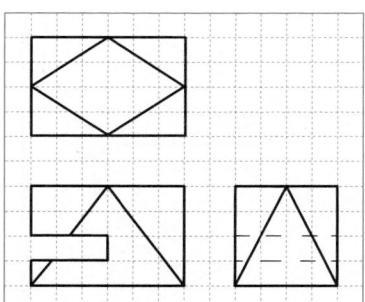

(19)

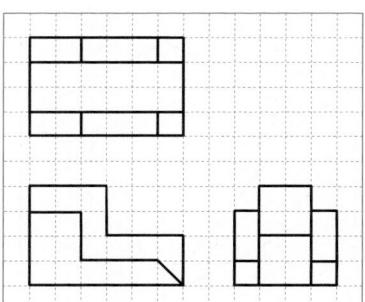

(20)

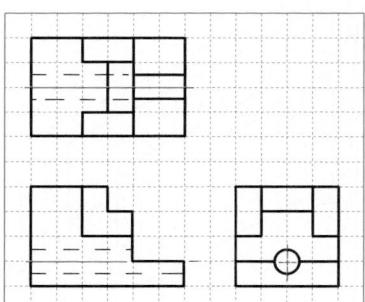

(21)

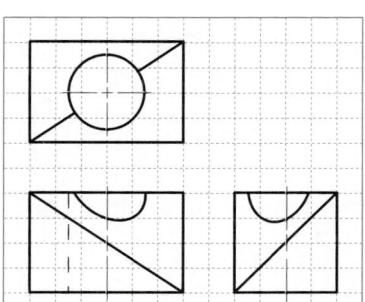

(22)

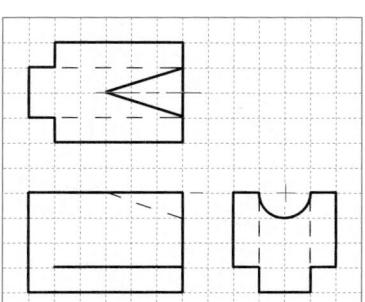

(23)

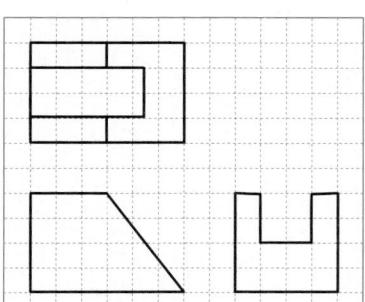

(24)

Figure 4.92 Continued

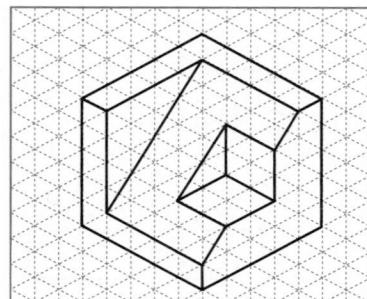

(1)

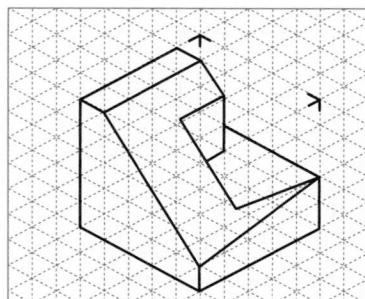

(2)

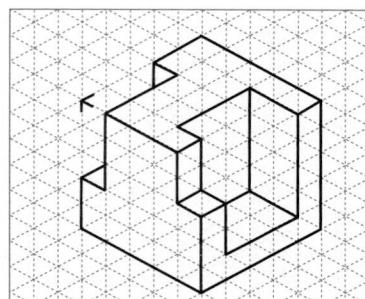

(3)

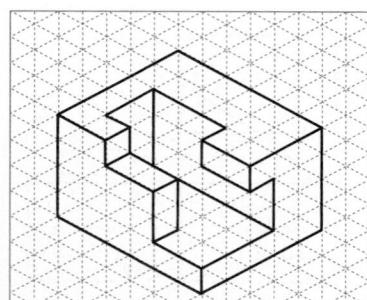

(4)

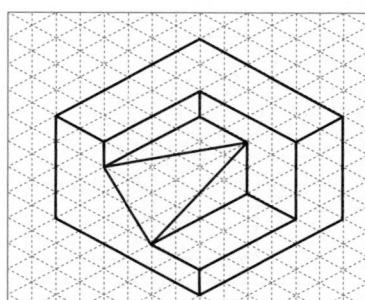

(5)

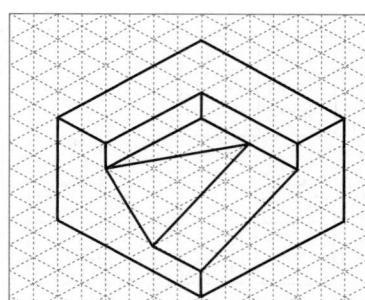

(6)

(7)

(8)

(9)

(10)

(11)

(12)

Figure 4.93 Pictorials of Several Objects, for Problem 4.5

(13)

(14)

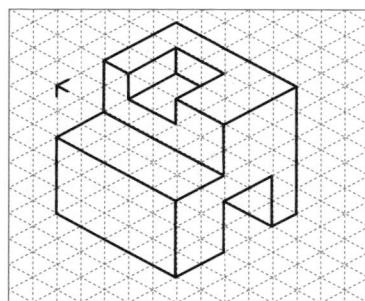

(15)

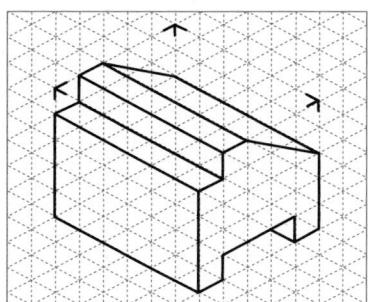

(16)

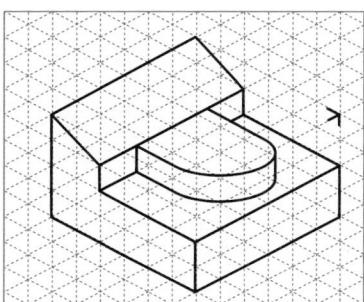

(17)

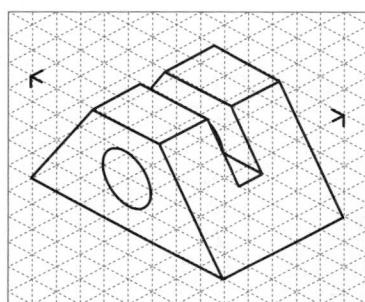

(18)

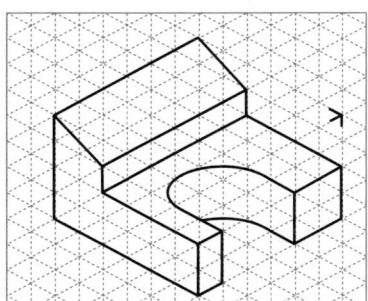

(19)

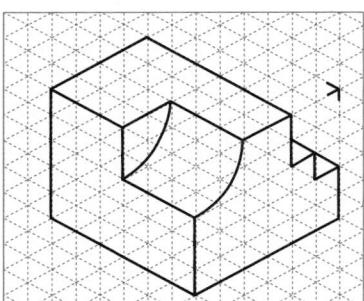

(20)

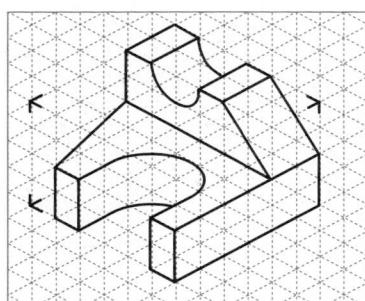

(21)

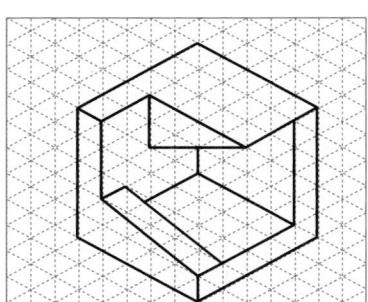

(22)

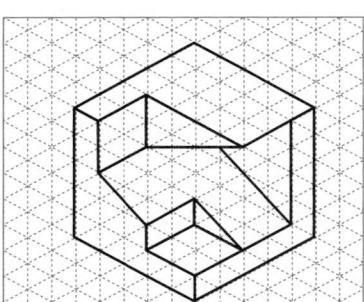

(23)

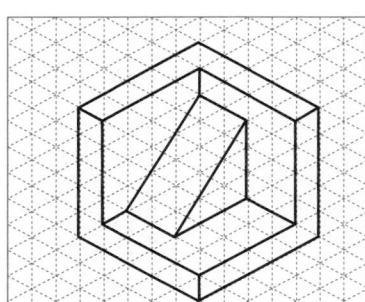

(24)

Figure 4.93 Continued

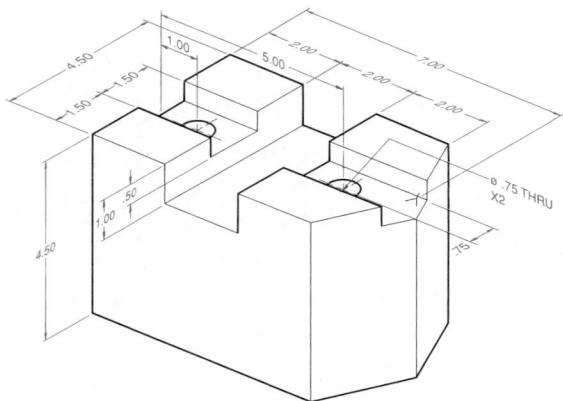

Figure 4.94 Tool Block

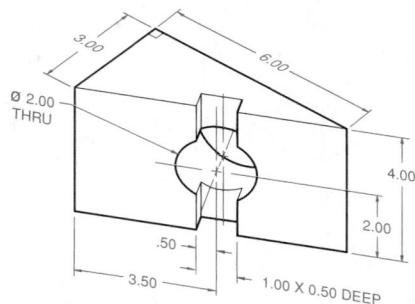

Figure 4.95 Wedge Support

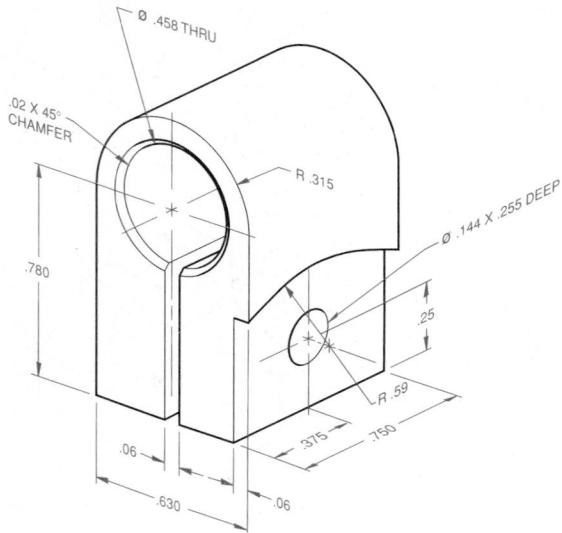

Figure 4.96 Coupling

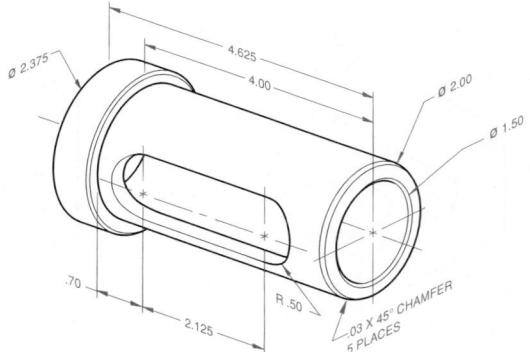

Figure 4.97 Retainer

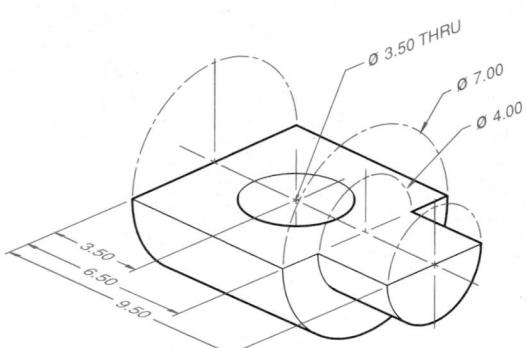

Figure 4.98 Half Pin

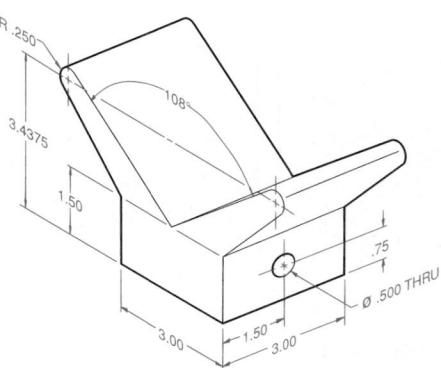

Figure 4.99 Snubber

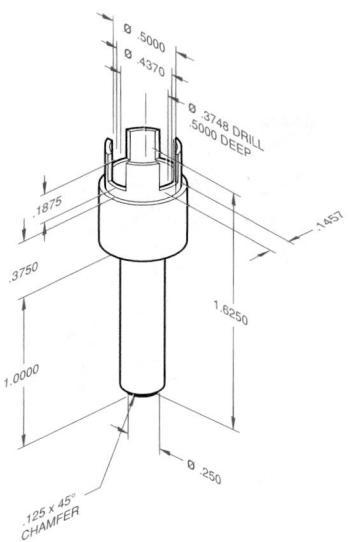

Figure 4.100 Dial Extension

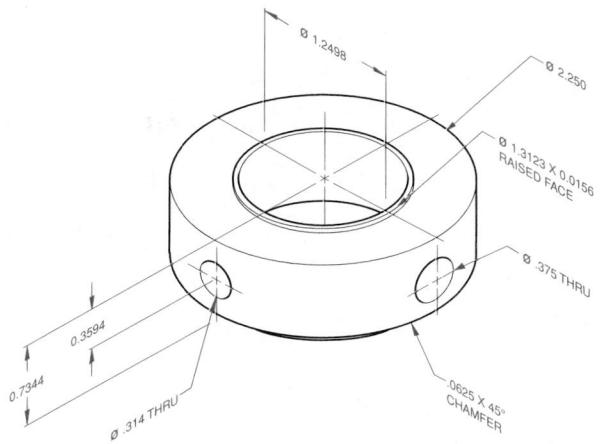

Figure 4.101 Spacer

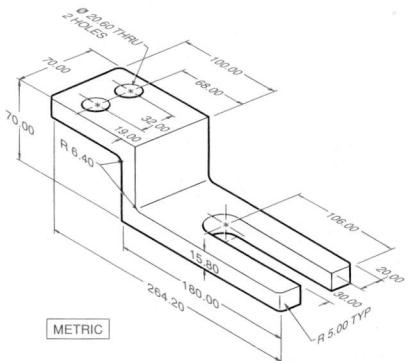

Figure 4.102 Motor Plate

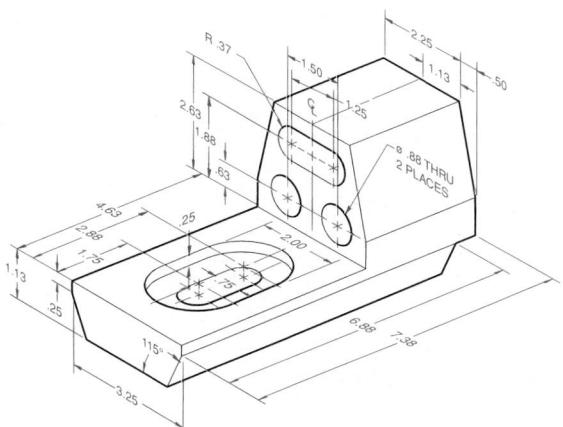

Figure 4.103 Seat

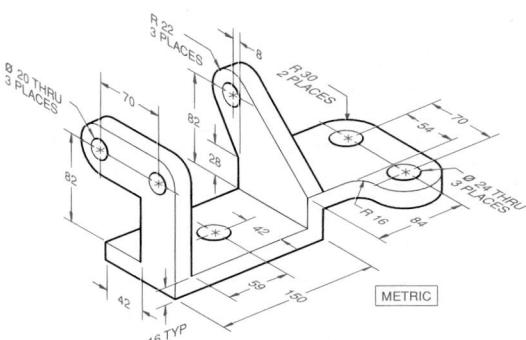

Figure 4.104 Cutoff

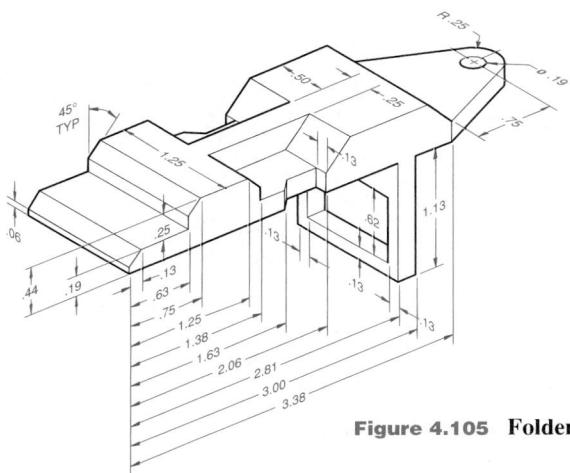

Figure 4.105 Folder

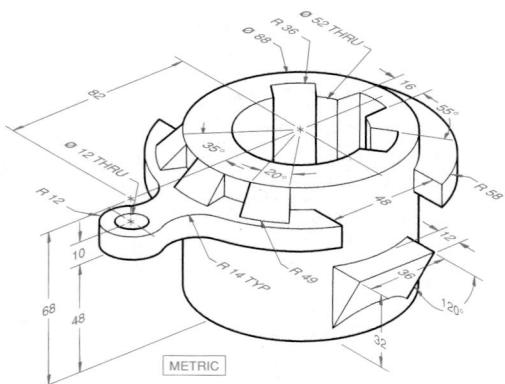

Figure 4.106 Spline Pilot

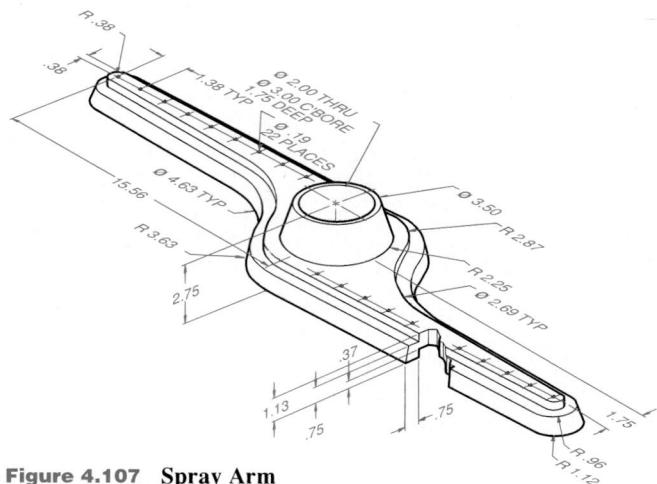

Figure 4.107 Spray Arm

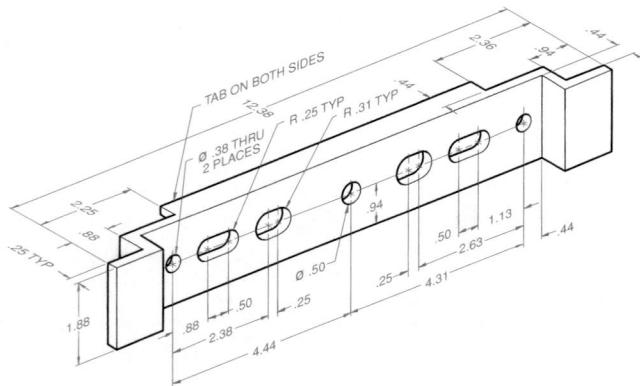

Figure 4.108 Control Back

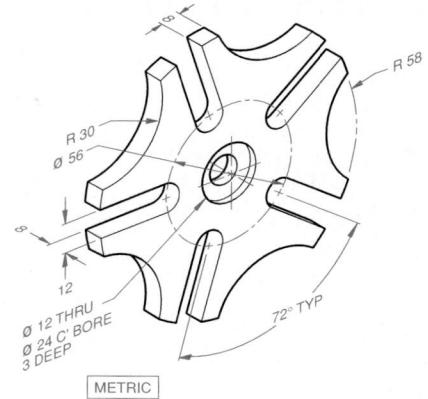

Figure 4.109 Gear Index

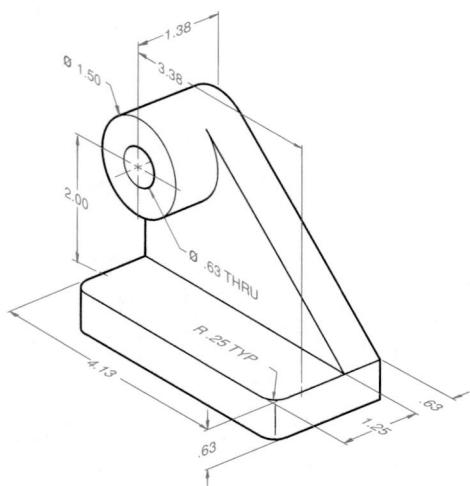

Figure 4.110 Shaft Support

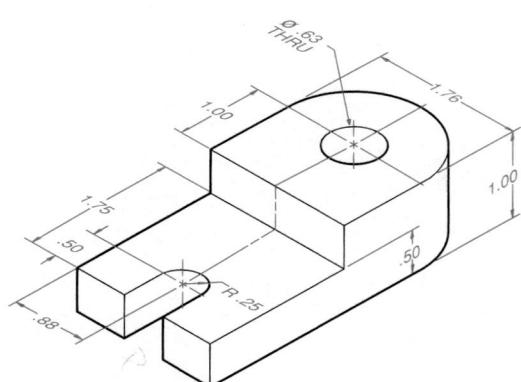

Figure 4.111 Stop Base

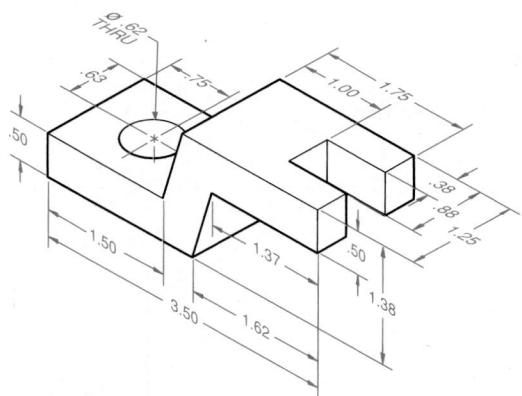

Figure 4.112 Tool Holder

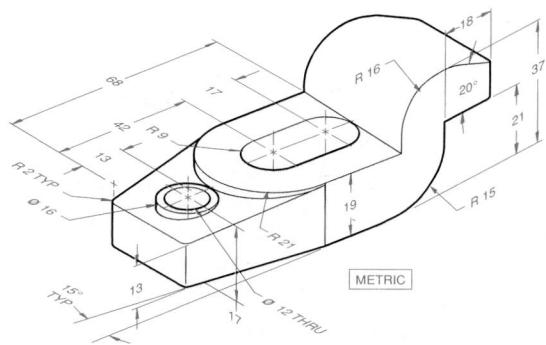

Figure 4.113 CNC Clamp

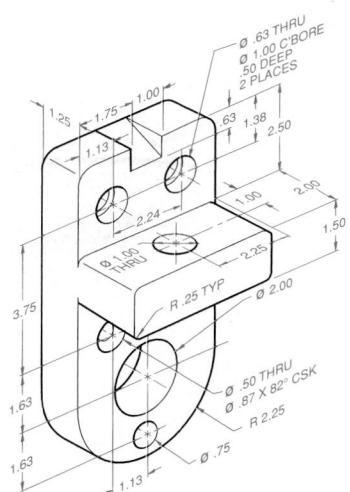

Figure 4.114 Locating Block

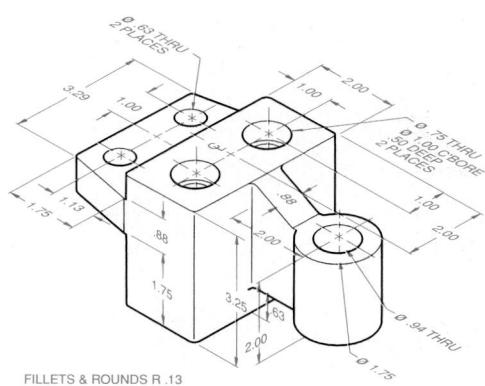

Figure 4.115 Cover Guide

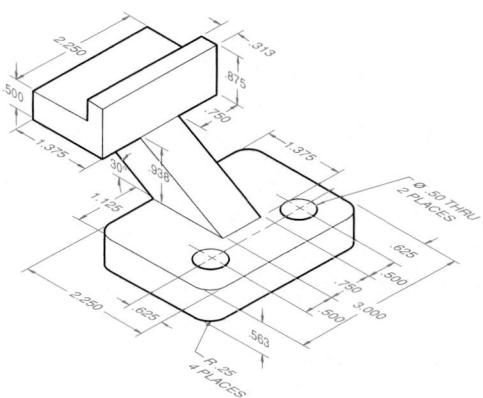

Figure 4.116 Dial Bracket

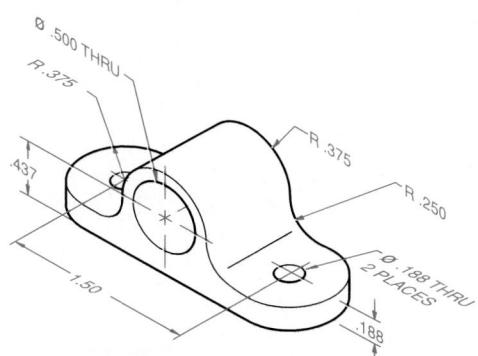

Figure 4.117 Bearing Block

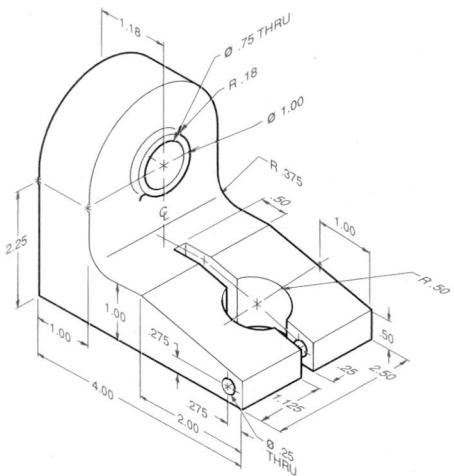

Figure 4.118 Adjustable Guide

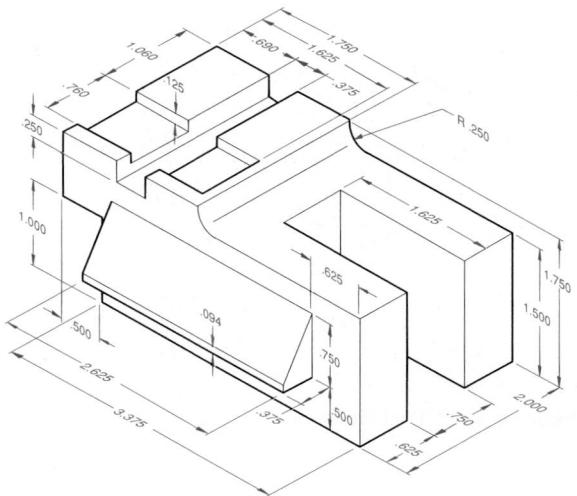

Figure 4.119 Pump Base

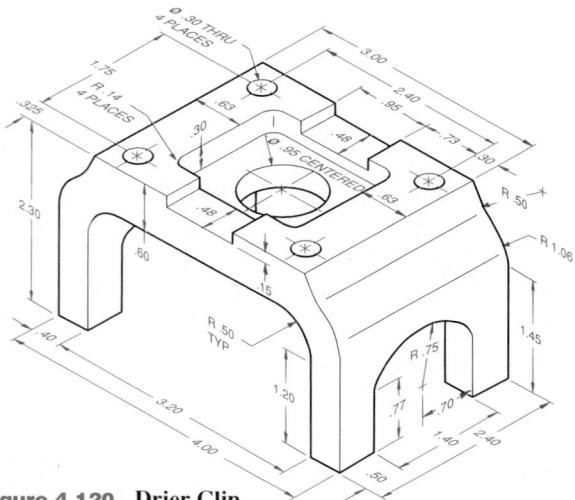

Figure 4.120 Drier Clip

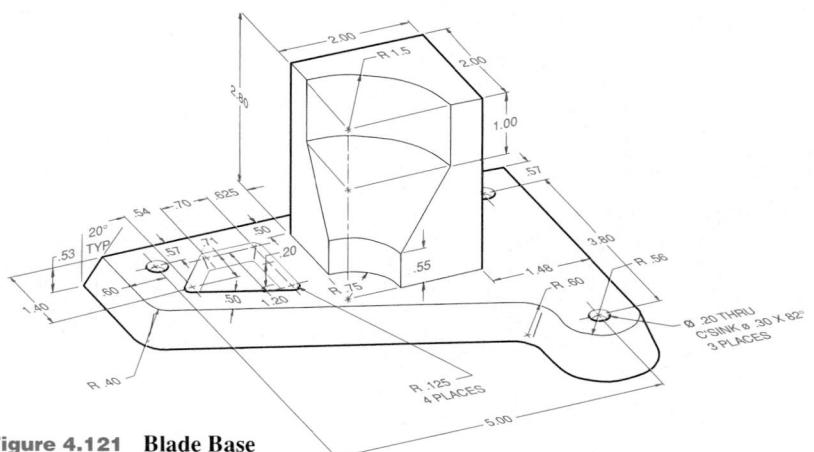

Figure 4.121 Blade Base

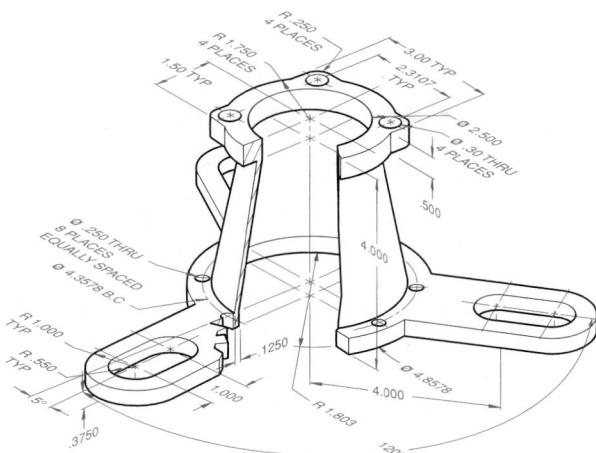

Figure 4.122 Dryer Tube

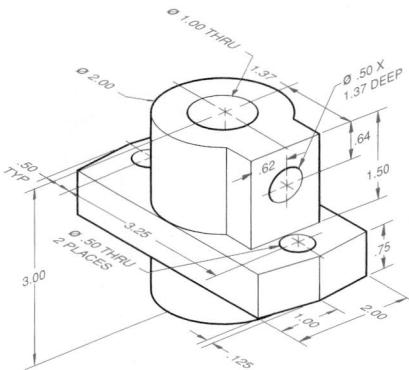

Figure 4.124 Locating Block

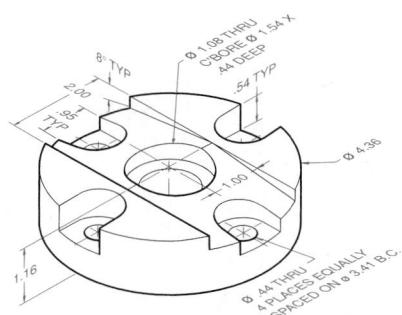

Figure 4.123 Retaining Cap

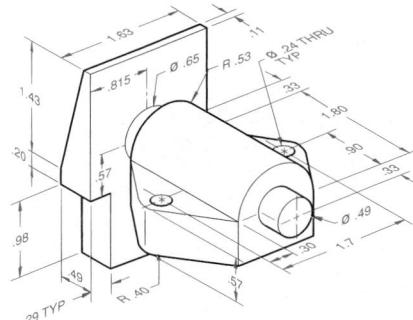

Figure 4.125 Tool Pad

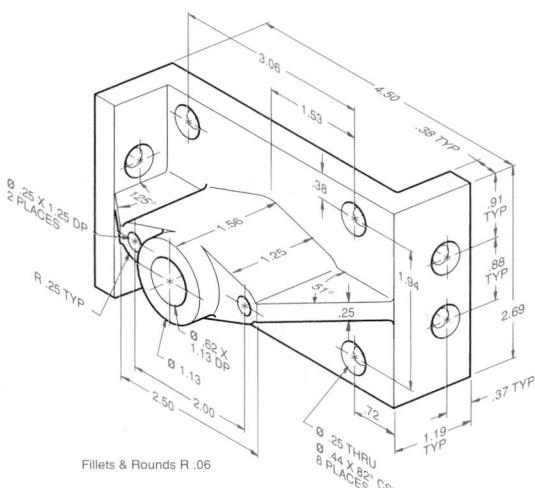

Figure 4.126 Locating Base

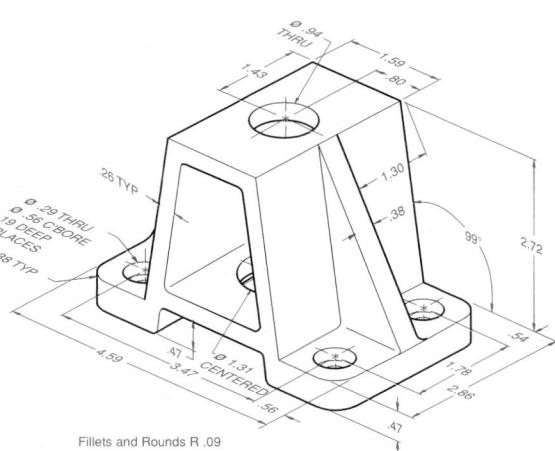

Figure 4.127 Anchor Base

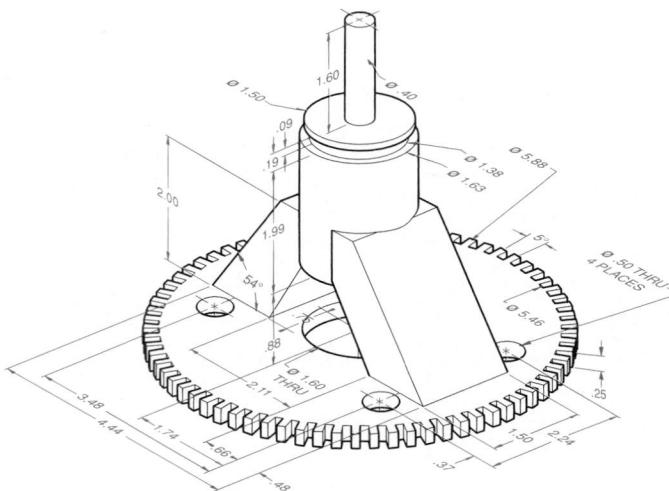

Figure 4.128 Dryer Gear

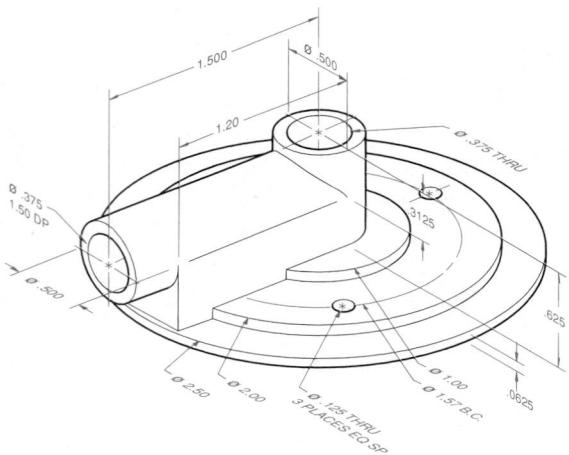

Figure 4.130 Clip Release

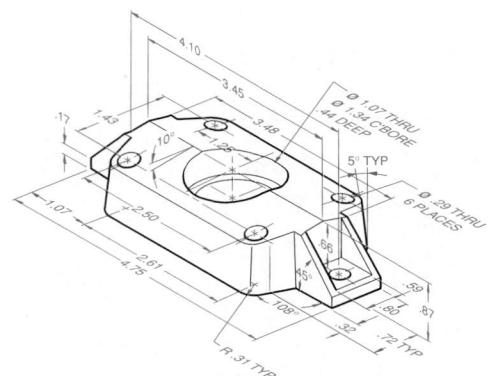

Figure 4.129 Heater Clip

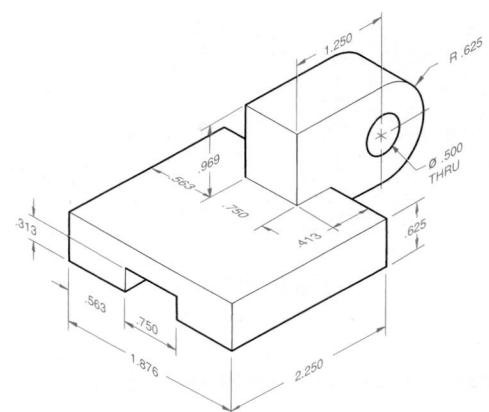

Figure 4.131 Slide Base

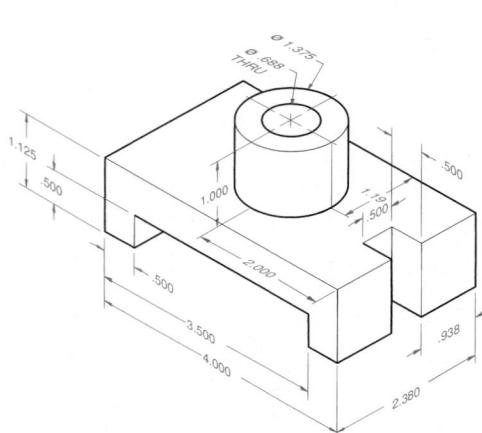

Figure 4.132 Retainer Clip

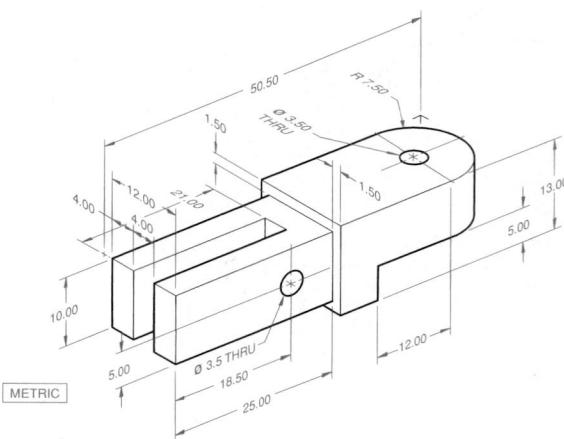

Figure 4.133 Strike Arm

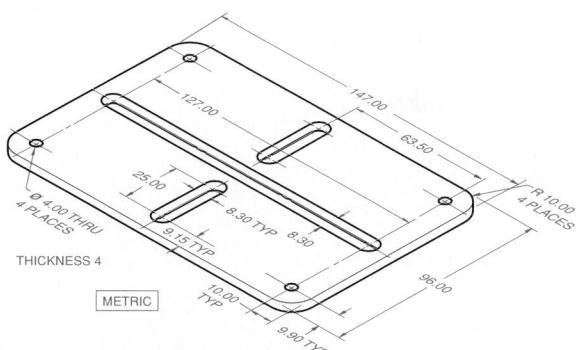

Figure 4.134 Offset Plate

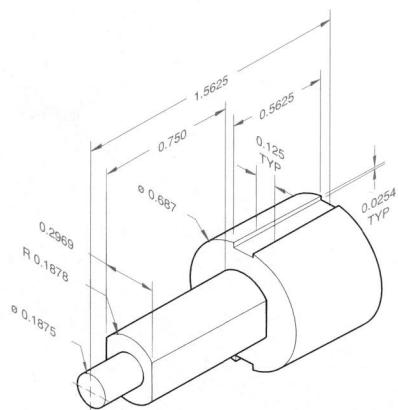

Figure 4.135 Shelf Stud

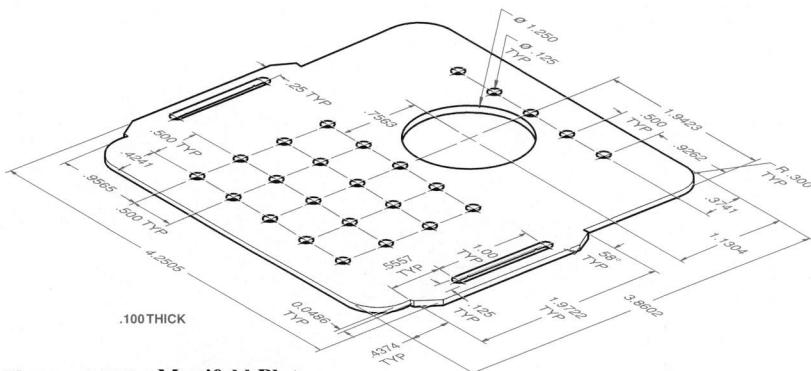

Figure 4.136 Manifold Plate

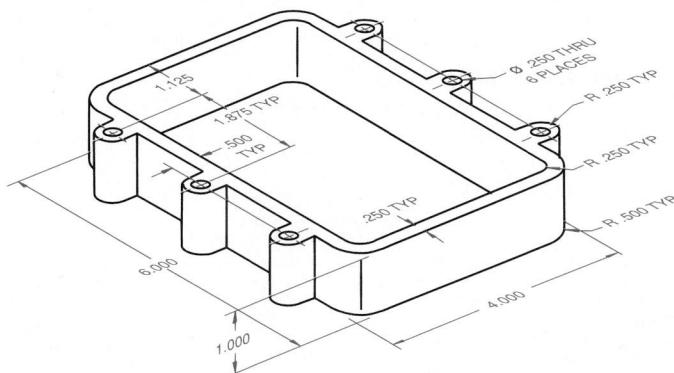

Figure 4.137 Protector

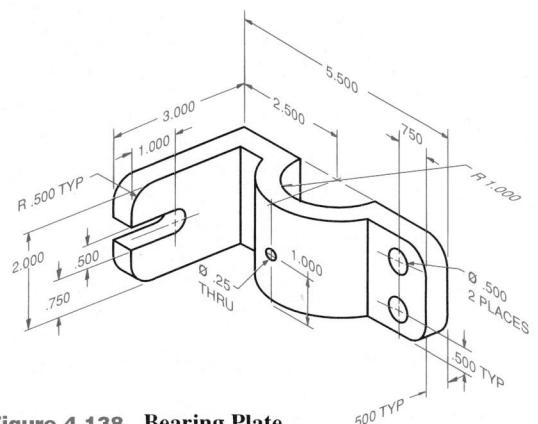

Figure 4.138 Bearing Plate

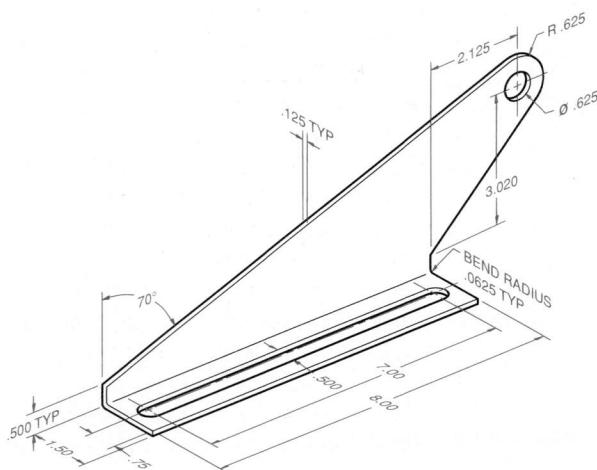

Figure 4.139 Angled Support

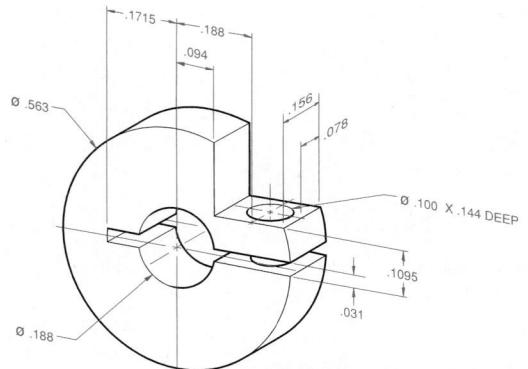

Figure 4.140 Drive Collar

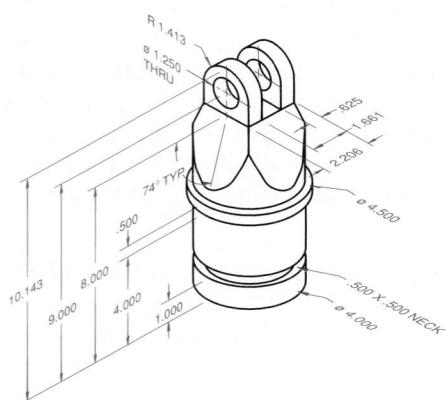

Figure 4.141 Pump Base

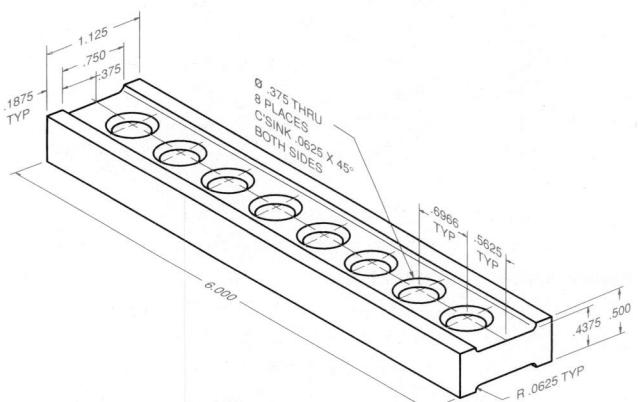

Figure 4.142 Burner Cap

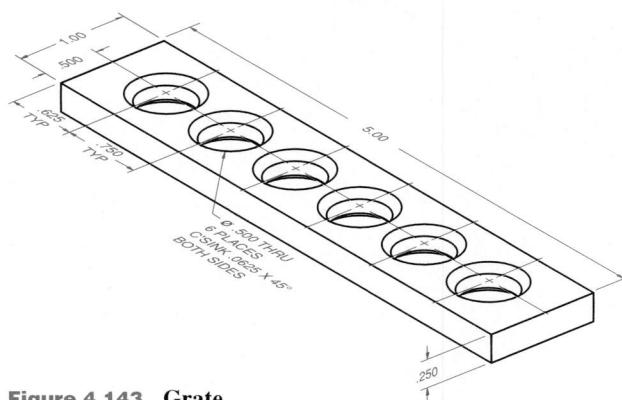

Figure 4.143 Grate

4.7 On square grid paper, sketch a series of multiviews of a cube, at least eight squares on a side. Visualize the following modifications to the cube and draw the resulting multiviews:

- a. Looking at the front view, drill a hole 3 squares in diameter and parallel to the line of sight.
- b. Take the result of (a) and drill another hole 2 squares in diameter to the right of the first hole.
- c. Take the result of (a) and drill another hole 3 squares in diameter above the first hole.
- d. Take the result of (a) and drill a hole 5 squares in diameter in the same location as the first hole, but only half-way through the cube.
- e. Instead of drilling a 3-square diameter hole through the object, create a cylinder projecting 2 squares out of the cube and parallel to the line of sight of the front view. Compare this to the views in (a).
- f. Same as (e), except raise the cylinder along the line of sight of the top view.
- g. Same as (a), except remove a square feature, rather than a round hole. Compare this to the views in (a).
- h. Same as (a), except place the center 2 squares to the right. Enlarge the drill to a diameter of 5 squares; 7 squares; 9 squares.
- i. Find the midpoints of the top and right side edges of the front view. Draw a line connecting these points and project it along the line of sight for the front view, to create a cutting plane. Remove this corner of the cube.

j. Same as (i), except rotate the cutting plane to be 15° , 30° , 60° , and 75° to the horizontal. Compare the dimensions of the inclined surface projections at each of these angles (including the original 45° angle).

k. Same as (i), except move the cutting plane toward the lower left corner of the front view, in 2-square increments. When is the inclined surface the largest?

l. Same as (i), except the cutting plane is defined by the midpoints of the top and right side edges of the front view and the midpoint of the top edge of the right side view.

m. Same as (l), except move the cutting plane in 2-square increments toward the opposite corner of the cube.

4.8 Same as 4.7 (a–k), except use a cylinder 8 squares in diameter, 8 squares deep, and seen in its circular form in the front view.

4.9 Using any of the objects shown in the exercises in the back of this chapter, decompose the objects into primitive geometric shapes. Color code these shapes to show whether they represent positive material added to the object or negative material removed from it. This can be done by:

- Drawing isometric pictorial sketches of the objects.
- Overdrawing on top of photocopies of the drawings.
- Tracing over the drawings.

CHAPTER 5

Pictorial Drawings

A picture shows me at a glance what it takes dozens of pages of a book to expound.

Ivan S. Turgenev, *Fathers and Sons*, 1862

OBJECTIVES

After completing this chapter, you will be able to:

1. Define axonometric, isometric, dimetric, and trimetric projection.
2. Explain the difference between an isometric projection and an isometric drawing.
3. Create an isometric drawing.
4. Use the true ellipse, four-center, and ellipse template methods to draw a circle in an isometric drawing.
5. Apply the theory of oblique projection to create oblique drawings and sketches.
6. Create a one-point perspective drawing.
7. Create a two-point perspective drawing.
8. Describe one-, two-, and three-point perspective projection theory.
9. Define horizon line, station point, picture plane, vanishing point, and ground line.
10. Describe and draw bird's eye, human's eye, ground's eye, and worm's eye views.
11. Describe the four perspective variables that are determined before creating a perspective drawing.
12. Create a one-point perspective drawing.
13. Represent circular features in a one-point perspective.
14. Represent circles and arcs in perspective drawings.

Pictorial drawings are a type of technical illustration that shows several faces of an object at once. Such drawings are used by any industry that designs, sells, manufactures, repairs, installs, or maintains a product. Axonometric and oblique pictorial drawings use a parallel projection technique and are frequently used in technical documents, sales literature, maintenance manuals, and documentation supplements in technical drawings. Perspective pictorial drawings use a converging projection technique and are more commonly found in architectural drawings. • Perspective drawings are the most realistic types of drawings used in engineering and technology. A perspective drawing creates a pictorial view of an object that resembles what you see. It is the best method for representing an object in three dimensions. • Pictorial drawings do not have the limitation of multiview drawings, which show only two dimensions of the object in each view and must be mentally combined to form a 3-D image of the object. This chapter explains the projection theory and standard practices used to create axonometric, oblique, and perspective drawings.

5.1 AXONOMETRIC DRAWINGS

The Greek word *axon* means axis and *metric* means to measure. **Axonometric projection** is a parallel projection technique used to create a pictorial drawing of an object by rotating the object on an axis relative to a *projection*, or *picture plane*. (Figure 5.1) Axonometric projection is one of the four principal projection techniques: multiview, axonometric, oblique, and perspective. (Figure 5.2) In multiview, axonometric, and oblique projection, the observer is theoretically infinitely far away from the projection plane. In addition, for multiviews and axonometric projections, the lines of sight are perpendicular to the plane of projection; therefore, both are considered *orthographic projections*. The differences between a multiview drawing and an axonometric drawing are that in a multiview, only two dimensions of an object are visible in each view and more than one view is required to define the object; whereas in an axonometric drawing, the object is rotated about an axis to display all three dimensions, and only one view is required. The axonometric projection is produced by multiple parallel lines of sight perpendicular to the plane of projection, with the observer at infinity and the object rotated about an axis to produce a pictorial view. (Figure 5.2B)

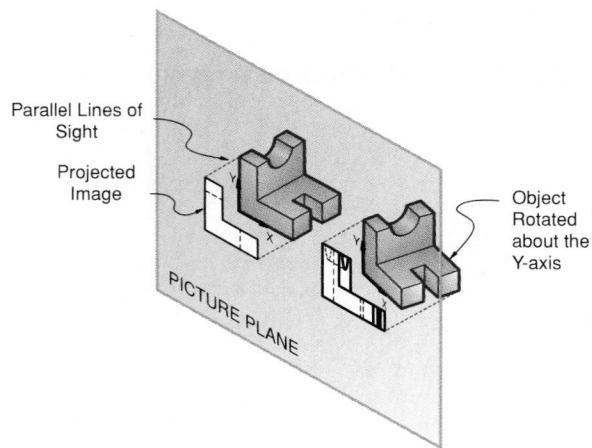

Figure 5.1 Axonometric Projection

An axonometric view is created by rotating the object about one or more axes.

5.1.1 Axonometric Drawing Classifications

Axonometric drawings are classified by the angles between the lines comprising the axonometric axes. The **axonometric axes** are axes that meet to form the corner of the object that is nearest to the observer. Figure 5.3 shows the axonometric axes on an object and contains three different axonometric views of that object. Although there are an infinite number of positions that can be used to create such a drawing (Figure 5.4), only a few of them are useful.

When all three angles are unequal, the drawing is classified as a **trimetric projection**. Trimetric drawings are the most pleasing to the eye, and are also the most difficult to produce. When two of the three angles are equal, the drawing is classified as a **dimetric projection**. Dimetric drawings are less pleasing to the eye, but are easier to produce than trimetric drawings. When all three angles are equal, the drawing is classified as an **isometric (equal measure) projection**. The isometric is the least pleasing to the eye, but is the easiest to draw and dimension, and is therefore the one that will be described in the following sections.

5.2 ISOMETRIC AXONOMETRIC PROJECTIONS

An isometric projection is a true representation of the isometric view of an object. An isometric view of an object is created by rotating the object 45 degrees about a vertical axis, then tilting the object (in this case, a cube) forward until the body diagonal (AB) appears as

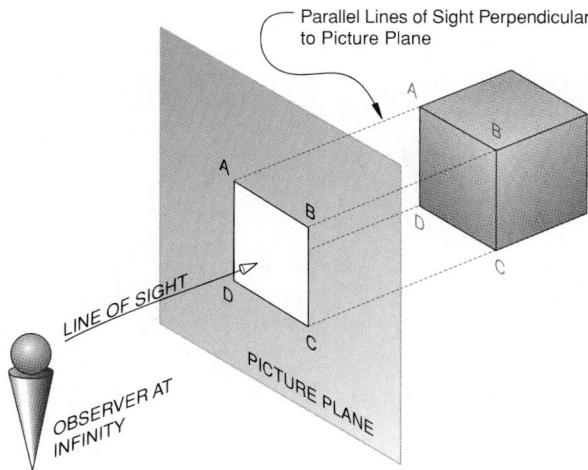

(A) Multiview Projection

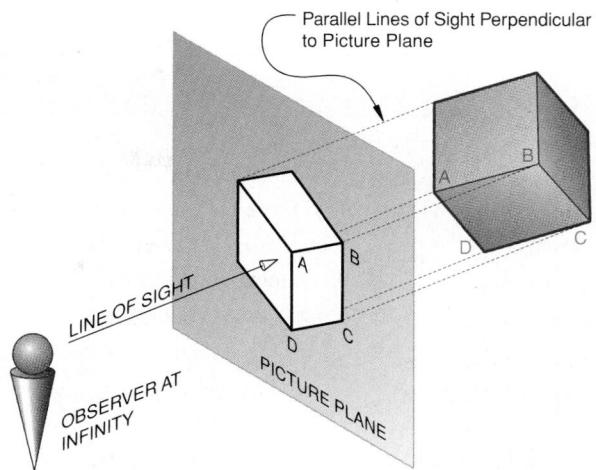

(B) Axonometric Projection

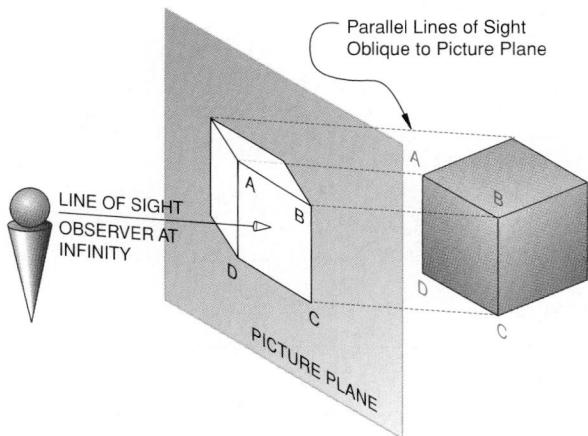

(C) Oblique Projection

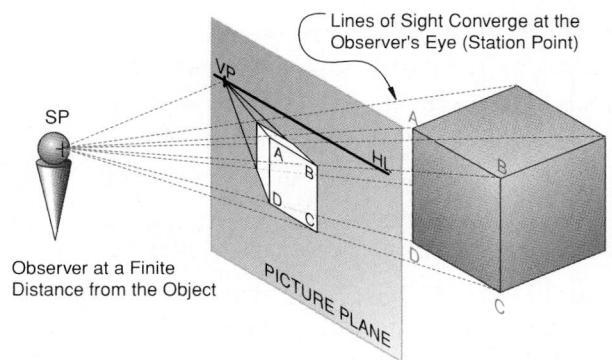

(D) Perspective Projection

Figure 5.2 Projection Techniques: Multiview, Axonometric, Oblique, and Perspective

Perspective is the only technique that does not use parallel lines of sight.

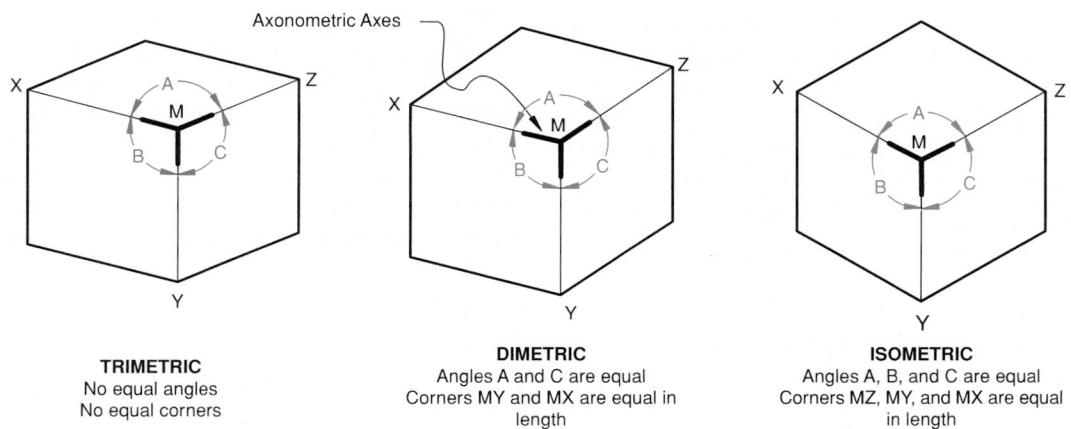

Figure 5.3 Angles that Determine the Type of Axonometric Drawing Produced

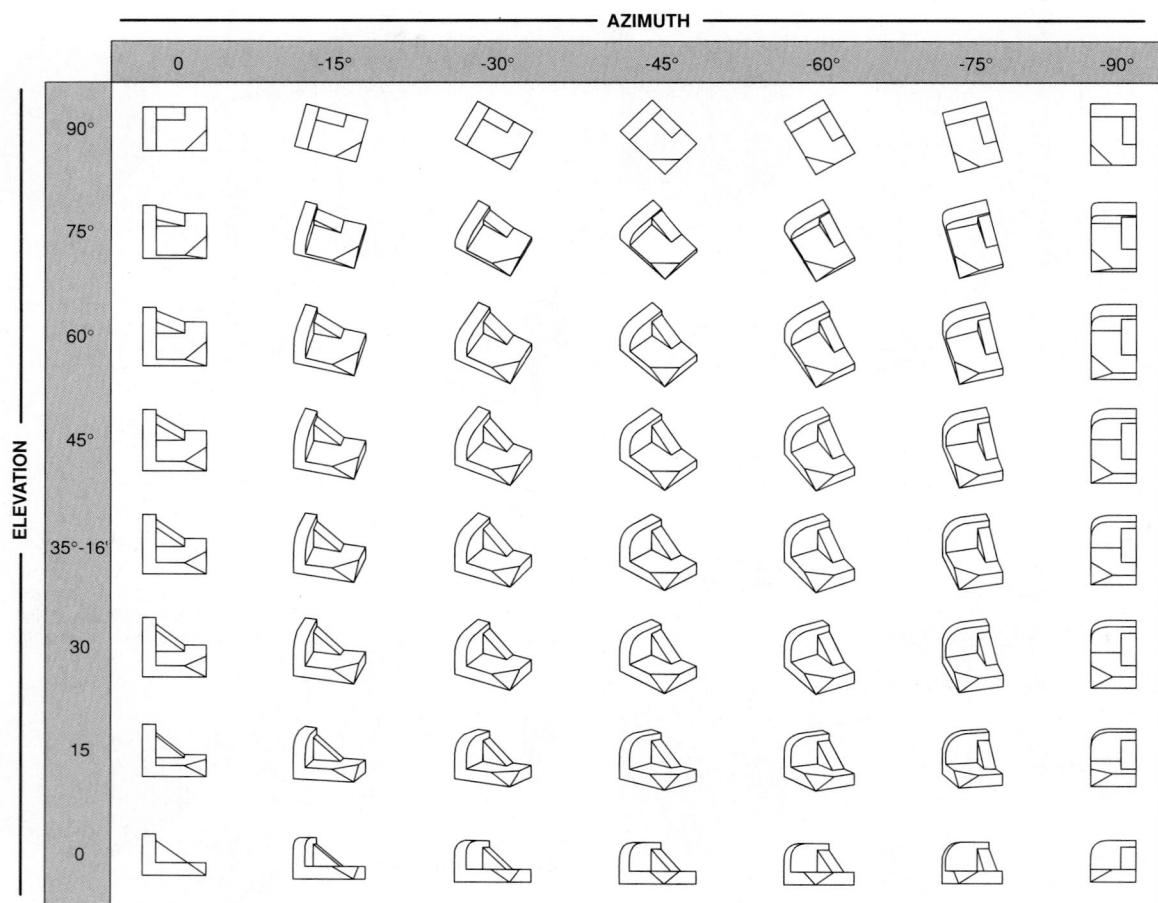

Figure 5.4 An Axonograph of a Part, Showing Some of the Views that Can Be Created by Rotating about Two of the Axes

a point in the front view. (Figure 5.5) The angle the cube is tilted forward is 35 degrees 16 minutes. The three axes that meet at A,B form equal angles of 120 degrees and are called the **isometric axes**. Each edge of the cube is parallel to one of the isometric axes. Any line that is parallel to one of the legs of the isometric axis is an **isometric line**. The planes of the cube faces and all planes parallel to them are **isometric planes**.

The forward tilt of the cube causes the edges and planes of the cube to become foreshortened as it is

projected onto the picture plane. The lengths of the projected lines are equal to the cosine of 35 degrees 16 minutes, or 0.81647 times the true length. In other words, the projected lengths are approximately 80 percent of the true lengths. A drawing produced using a scale of 0.816 is called an *isometric projection* and is a true representation of the object. However, if the drawing is produced using full scale, it is called an **isometric drawing**, which is the same proportion as an isometric projection, but is larger by a factor of

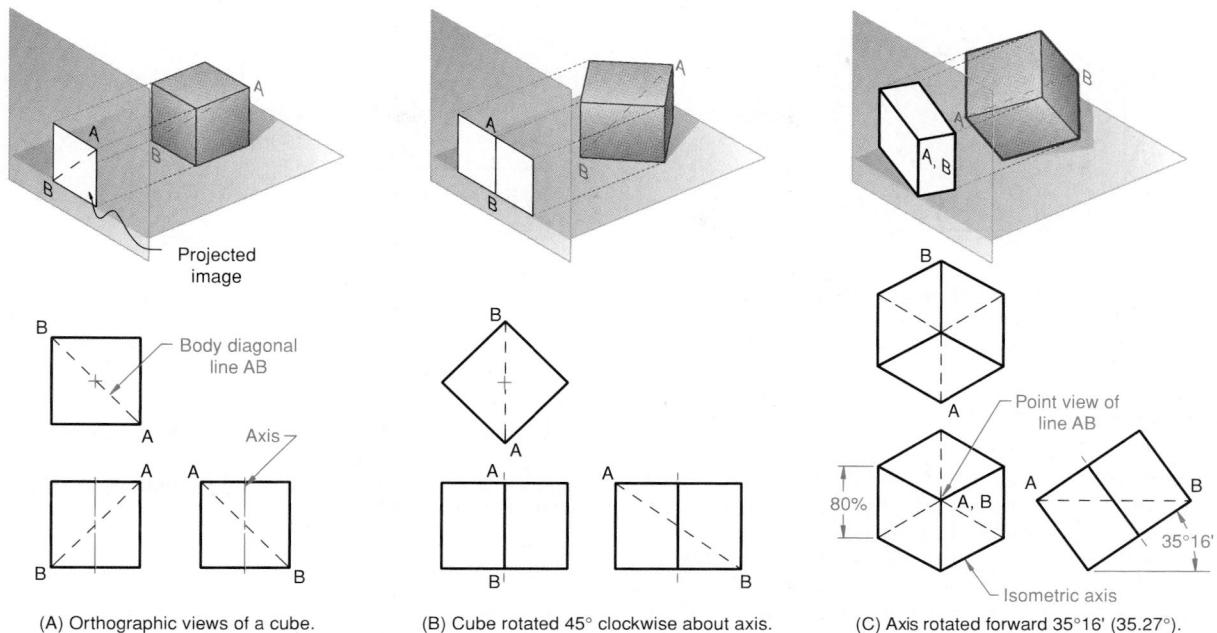

Figure 5.5 Theory of Isometric Projection

The object is rotated 45 degrees about one axis and 35 degrees 16 minutes on another axis.

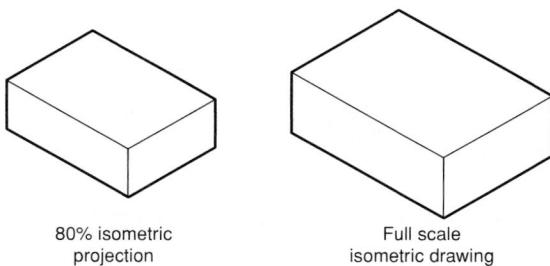

Figure 5.6 The Different Scales of an Isometric Projection and an Isometric Drawing

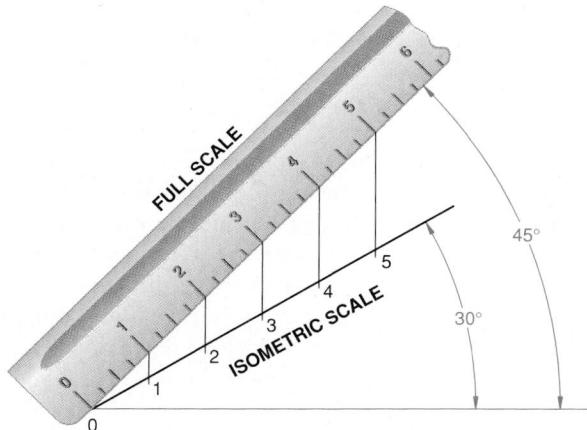

Figure 5.7 Creating an Isometric Scale

1.23 to 1. (Figure 5.6) Isometric drawings are almost always preferred over isometric projection for technical drawings, because they are easier to produce.

Figure 5.7 shows an isometric scale produced by positioning a regular scale at 45 degrees to the horizontal and projecting lines vertically to a 30-degree line. This foreshortens the true distances, creating an isometric scale along the 30-degree line, which can

then be used to create a true isometric projection of an object. A $\frac{3}{4}$ scale can also be used to approximate an isometric scale.

With CAD, isometric views of a 3-D model can be created automatically by using the angular rotations of 45 degrees on one axis and 35 degrees 16 minutes on another axis to change the viewpoint. © CAD Reference 5.1

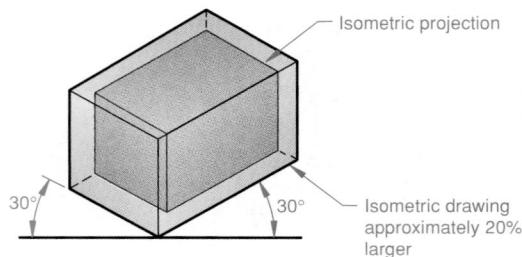

Figure 5.8 Size Comparison of Isometric Drawing and True Isometric Projection

Practice Exercise 5.1

Place a 12" x 12" sheet of clear, rigid plastic or glass between you and a cube. Brace the glass against a desk or other piece of furniture. Position the cube such that one of the faces is parallel with the glass. Draw the contour of the cube on the glass, using a water-based marker. Move the cube a few inches to the left or right, rotate it 45 degrees about a vertical axis, then tilt it forward approximately 30 degrees, using your 30/60 triangle as a guide. Brace the cube in its new position and draw the contour of the cube on the glass. This new view is an *isometric projection* of the cube on the glass. Compare the measurements of the vertical lines in the isometric projection with the original projection. The isometric projection should be slightly smaller than the original (multiview) projection.

5.2.1 Isometric Axonometric Drawings

As previously defined, an *isometric drawing* is an axonometric pictorial drawing for which the angle between axes equals 120 degrees and the scale used is full scale. (Figure 5.8) Isometric axes can be positioned in a number of ways to create different views of the same object. Figure 5.9A is a **regular isometric**, in which the viewpoint is looking down on the top of the object. In a regular isometric, the axes at 30 degrees to the horizontal are drawn upward from the horizontal. The regular isometric is the most common type of isometric drawing.

For the **reversed axis isometric**, shown in Figure 5.9B, the viewpoint is looking up on the bottom of the object, and the 30-degree axes are drawn downward from the horizontal. For the **long axis isometric**, the viewpoint is looking from the right (Figure 5.9C) or from the left (Figure 5.9D) of the object, and one axis is drawn at 60 degrees to the horizontal.

In an isometric drawing, true-length distances can only be measured along isometric lines, that is, lines that run parallel to any of the isometric axes. Any line

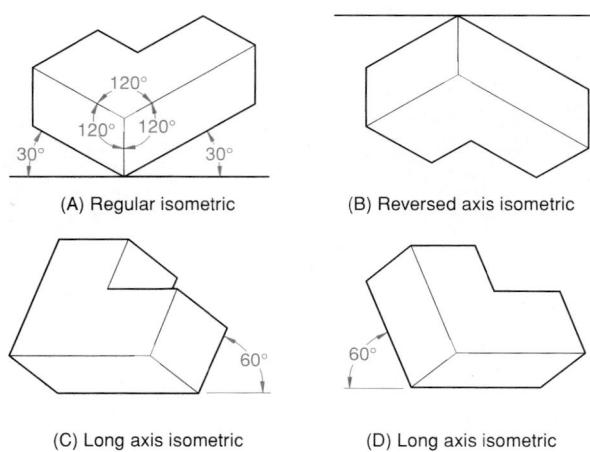

Figure 5.9 Positions of Isometric Axes and Their Effect on the View Created

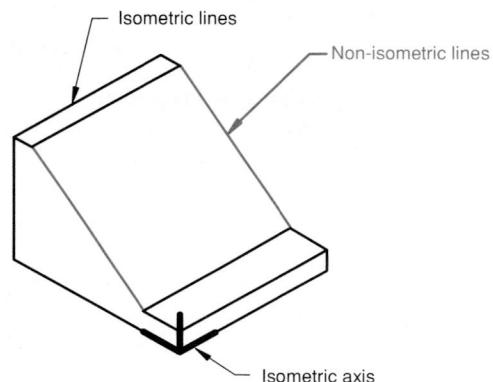

Figure 5.10 Isometric and Nonisometric Lines

that does not run parallel to an isometric axis is called a **nonisometric line**. (Figure 5.10) Nonisometric lines include inclined and oblique lines and cannot be measured directly. Instead, they must be created by locating two endpoints.

Figure 5.11 is an isometric drawing of a cube. As previously defined, the three faces of the isometric cube are isometric planes, because they are parallel to the isometric surfaces formed by any two adjacent isometric axes. Planes that are not parallel to any isometric plane are called **nonisometric planes**. (Figure 5.12)

Standards for Hidden Lines, Center Lines, and Dimensions In isometric drawings, hidden lines are omitted unless they are absolutely necessary to completely describe the object. Most isometric drawings

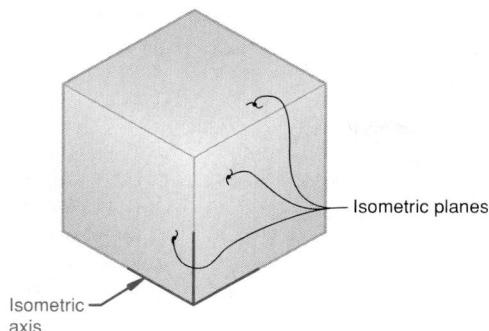

Figure 5.11 Isometric Planes Relative to Isometric Axes

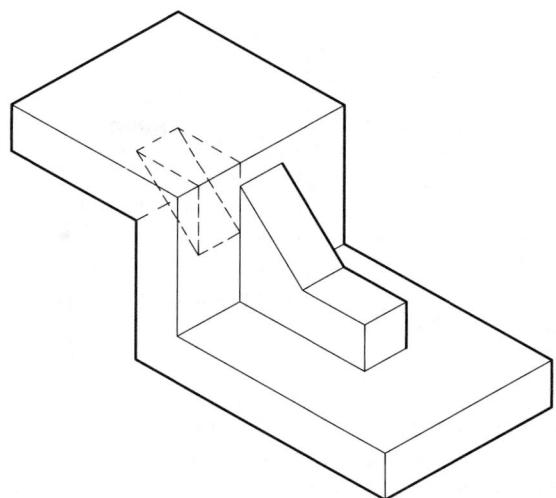

Figure 5.13 An Isometric Drawing with Hidden Lines for Details Not Otherwise Clearly Shown

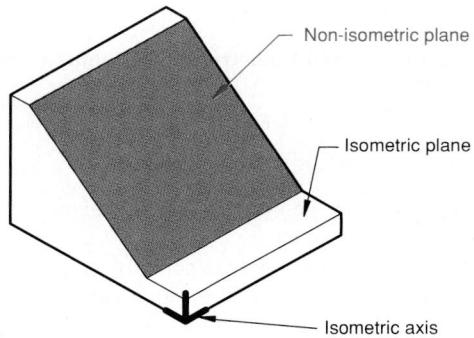

Figure 5.12 Nonisometric Plane

will not have hidden lines. To avoid using hidden lines, choose the most descriptive viewpoint. However, if an isometric viewpoint cannot be found that clearly depicts all the major features, hidden lines may be used. (Figure 5.13)

Center lines are drawn only for showing symmetry or for dimensioning. Normally, center lines are not shown, because many isometric drawings are used to communicate to nontechnical people and not for engineering purposes. (Figure 5.14)

Dimensioned isometric drawings used for *production* purposes must conform to ANSI Y14.4M-1989 standards. (Figure 5.15) These standards state that:

1. Dimensions and tolerances shall be per ANSI Y14.4M standards.
2. Dimension lines, extension lines, and lines being dimensioned shall lie in the same plane.
3. All dimensions and notes should be unidirectional, reading from the bottom of the drawing

Figure 5.14 Center Lines Used for Dimensioning

upward, and should be located outside the view whenever possible. The text is read from the bottom, using horizontal guide lines.

Dimensioned drawings used for *illustration* purposes may use the aligned method. (Figure 5.16) Extension lines, dimension lines, and lettering are all drawn in the plane of one of the faces of the object. In the aligned system, text takes on more of a pictorial look. Many of the illustrations at the end of Chapters 8 and 19 are examples of isometric dimensioning practices. See Chapter 8, “Dimensioning and Tolerancing Practices,” for more information. © CAD Reference 5.2

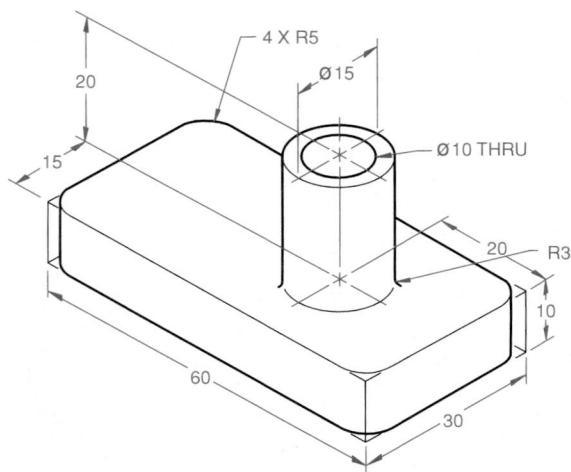

Figure 5.15 ANSI Standard Unidirectional Isometric Dimensioning

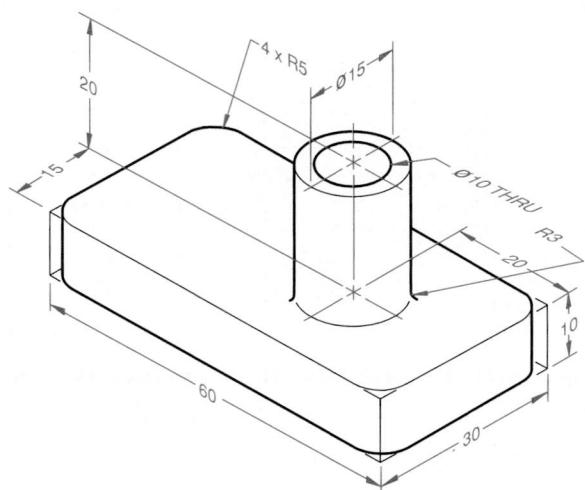

Figure 5.16 Aligned Isometric Dimensioning Used for Illustrations

The Boxing-In Method for Creating Isometric Drawings The four basic steps for creating an isometric drawing are:

1. Determine the isometric viewpoint that clearly depicts the features of the object, then draw the isometric axes which will produce that viewpoint.
2. Construct isometric planes, using the overall width (W), height (H), and depth (D) of the object, such that the object will be totally enclosed in a box.
3. Locate details on the isometric planes.
4. Darken all visible lines, and eliminate hidden lines unless absolutely necessary to describe the object.

These steps describe the boxing-in method, which is especially useful for irregularly shaped objects.

Constructing an Isometric Drawing Using the Boxing-In Method

Figure 5.17 shows a dimensioned multiview drawing and the steps used to create an isometric drawing of the object, using the boxing-in method.

Step 1. Determine the desired view of the object, then draw the isometric axes. For this example, it is determined that the object will be viewed from

above (regular isometric), and the axes shown in Figure 5.9A are used.

Step 2. Construct the front isometric plane using the W and H dimensions. Width dimensions are drawn along 30-degree lines from the horizontal. Height dimensions are drawn as vertical lines.

Step 3. Construct the top isometric plane using the W and D dimensions. Both the W and D dimensions are drawn along 30-degree lines from the horizontal.

Step 4. Construct the right side isometric plane using the D and H dimensions. Depth dimensions are drawn along 30-degree lines and height dimensions are drawn as vertical lines.

Step 5. Transfer some distances for the various features from the multiview drawing to the isometric lines that make up the isometric rectangle. For example, distance A is measured in the multiview drawing, then transferred to a width line in the front plane of the isometric rectangle. Begin drawing details of the block by drawing isometric lines between the points transferred from the multiview drawing. For example, a notch is taken out of the block by locating its position on the front and top planes of the isometric box.

Step 6. Transfer the remaining features from the multiview drawing to the isometric drawing. Block in the details by connecting the endpoints of the measurements taken from the multiview drawing.

Step 7. Darken all visible lines and erase or lighten the construction lines to complete the isometric drawing of the object.

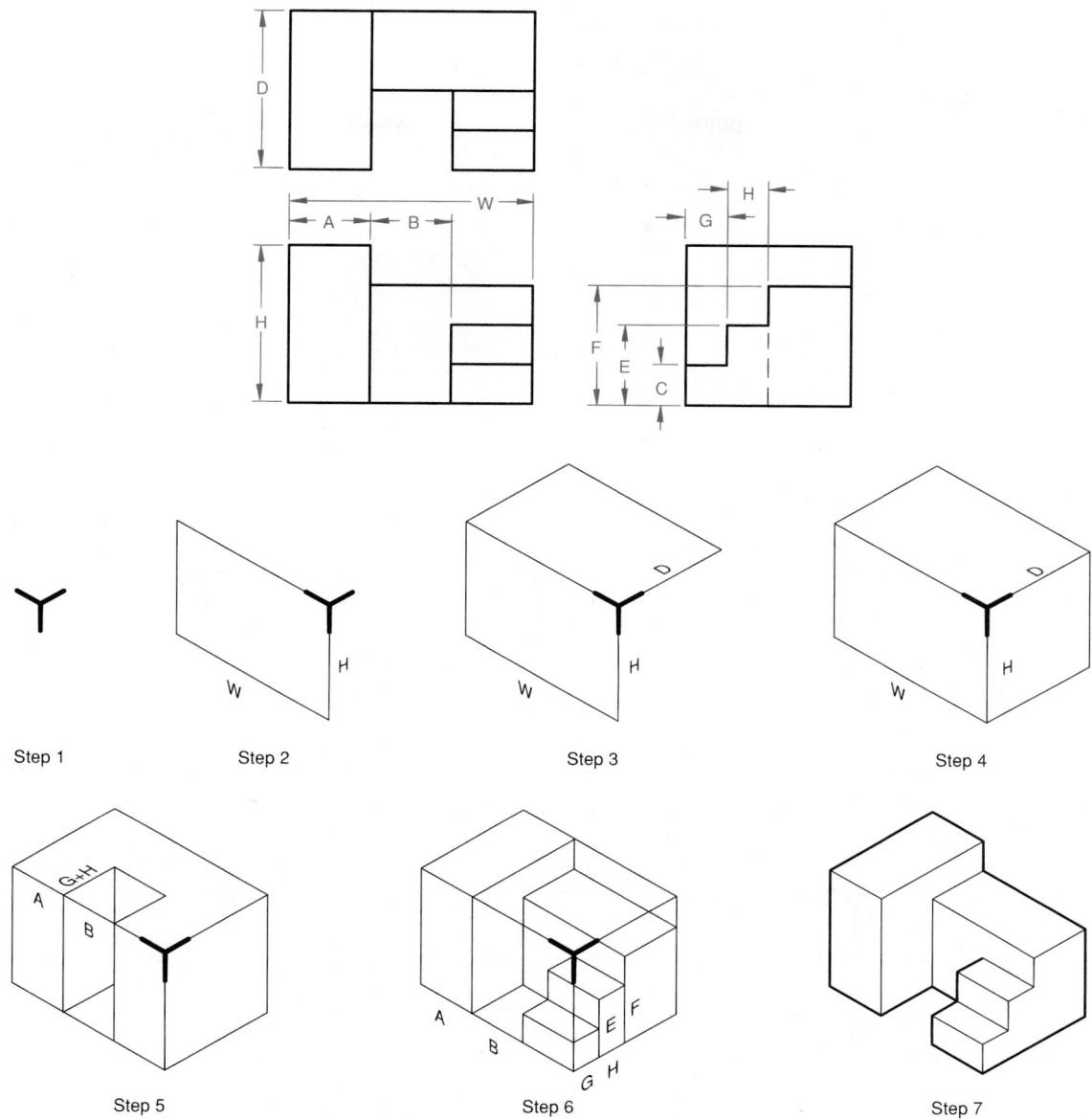

Figure 5.17 Constructing an Isometric Drawing Using the Boxing-In Method

Nonisometric Lines Normally, nonisometric lines will be the edges of inclined or oblique planes of an object as represented in a multiview drawing. It is not possible to measure the length or angle of an inclined or oblique line in a multiview drawing and then use that measurement to draw the line in an isometric drawing. Instead, nonisometric lines must be drawn

by locating the two endpoints, then connecting the endpoints with a line. The process used is called **offset measurement**, which is a method of locating one point by projecting another point.

To create an isometric drawing of an object with nonisometric lines, use the following procedure. (Figure 5.18)

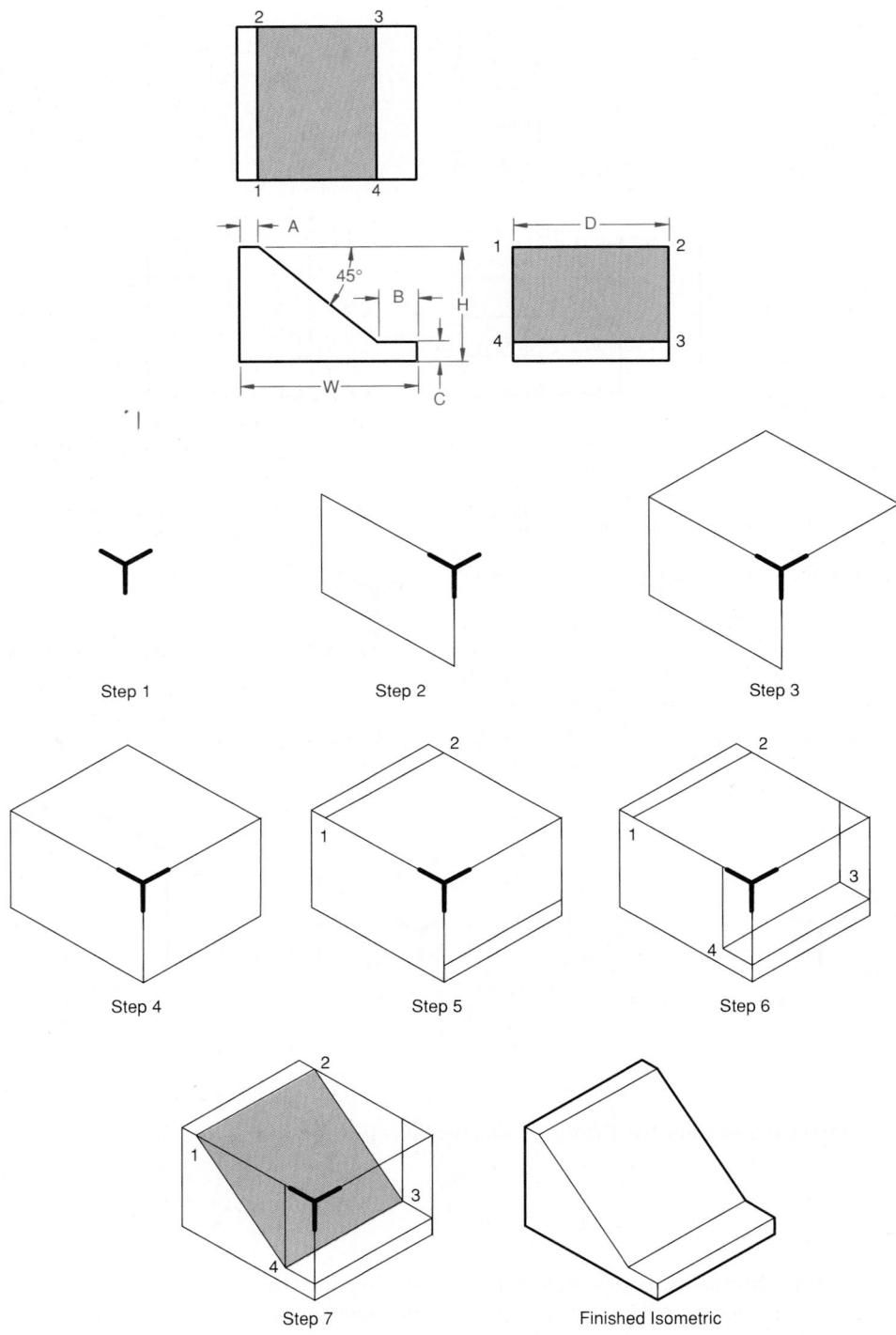

Figure 5.18 Constructing an Isometric Drawing Having Nonisometric Lines

Constructing Nonisometric Lines

Step 1. Determine the desired view of the object, then draw the isometric axes. For this example, it is determined that the object will be viewed from above, and the axes shown in Figure 5.9A are used.

Step 2. Construct the front isometric plane using the W and H dimensions.

Step 3. Construct the top isometric plane using the W and D dimensions.

Step 4. Construct the right side isometric plane using the D and H dimensions.

Step 5. Transfer the distances for C and A from the multiview drawing to the top and right side isometric rectangles. Draw line 1-2 across the top face of the isometric box. Draw an isometric construction line from the endpoint marked for distance C. This in effect projects distance C along the width of the box.

Step 6. Along these isometric construction lines, mark off the distance B, thus locating points 4 and 3. Connect points 4-3.

Step 7. Connect points 1-4 and 2-3 to draw the non-isometric lines.

Figure 5.19 is another example of how to locate points to make an isometric drawing of an irregular object. Determine dimensions A and B in the multiview drawing. Construct an isometric box equal to

dimensions W, H, and D, as measured in the multiview drawing. Locate dimensions A and B along the base of the isometric box, then project them along the faces to the edges of the top face, using vertical lines. Project the points of intersection across the top face, using isometric lines. Point V is located at the intersection of these last two projections. Locate the remaining points around the base and draw the figure.

Oblique Planes The initial steps used to create an isometric drawing of an object with an oblique plane are the same as the steps used to create any isometric view. The sides of the oblique plane will be non-isometric lines, which means that their endpoints will be located by projections along isometric lines. After each endpoint is located, the oblique plane is drawn by connecting the endpoints.

The following steps describe how to create an isometric view of the multiview drawing with an oblique plane shown in Figure 5.20.

Constructing Oblique Planes in an Isometric Drawing

Step 1. Determine the desired view of the object, then draw the isometric axes. For this example, it is determined that the object will be viewed from above, and the axes shown in Figure 5.9A are used.

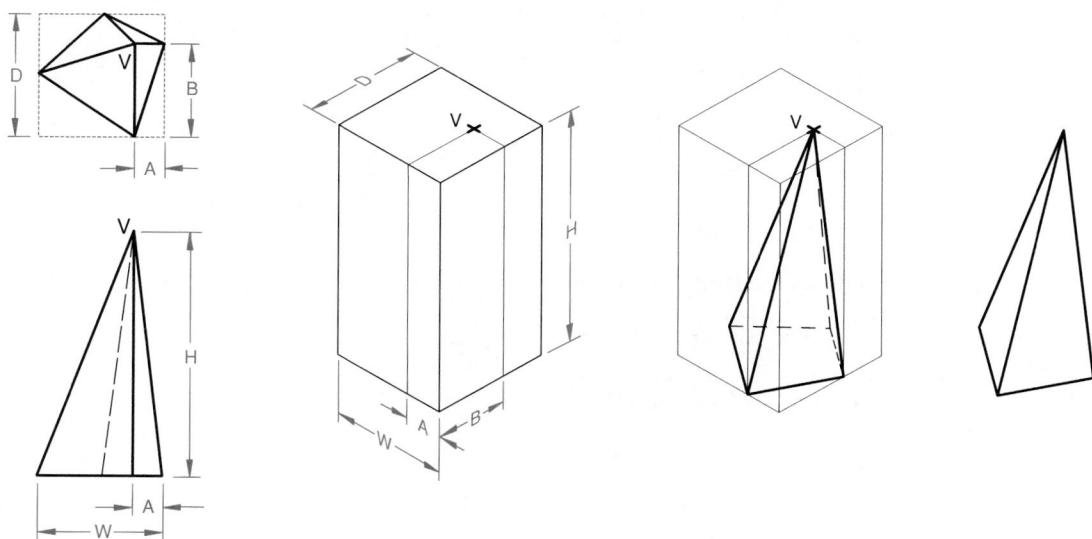

Figure 5.19 Locating Points to Create an Isometric Drawing of an Irregular Object

In this example, point V is located by boxing in the object, then measuring distances on the sides of the box.

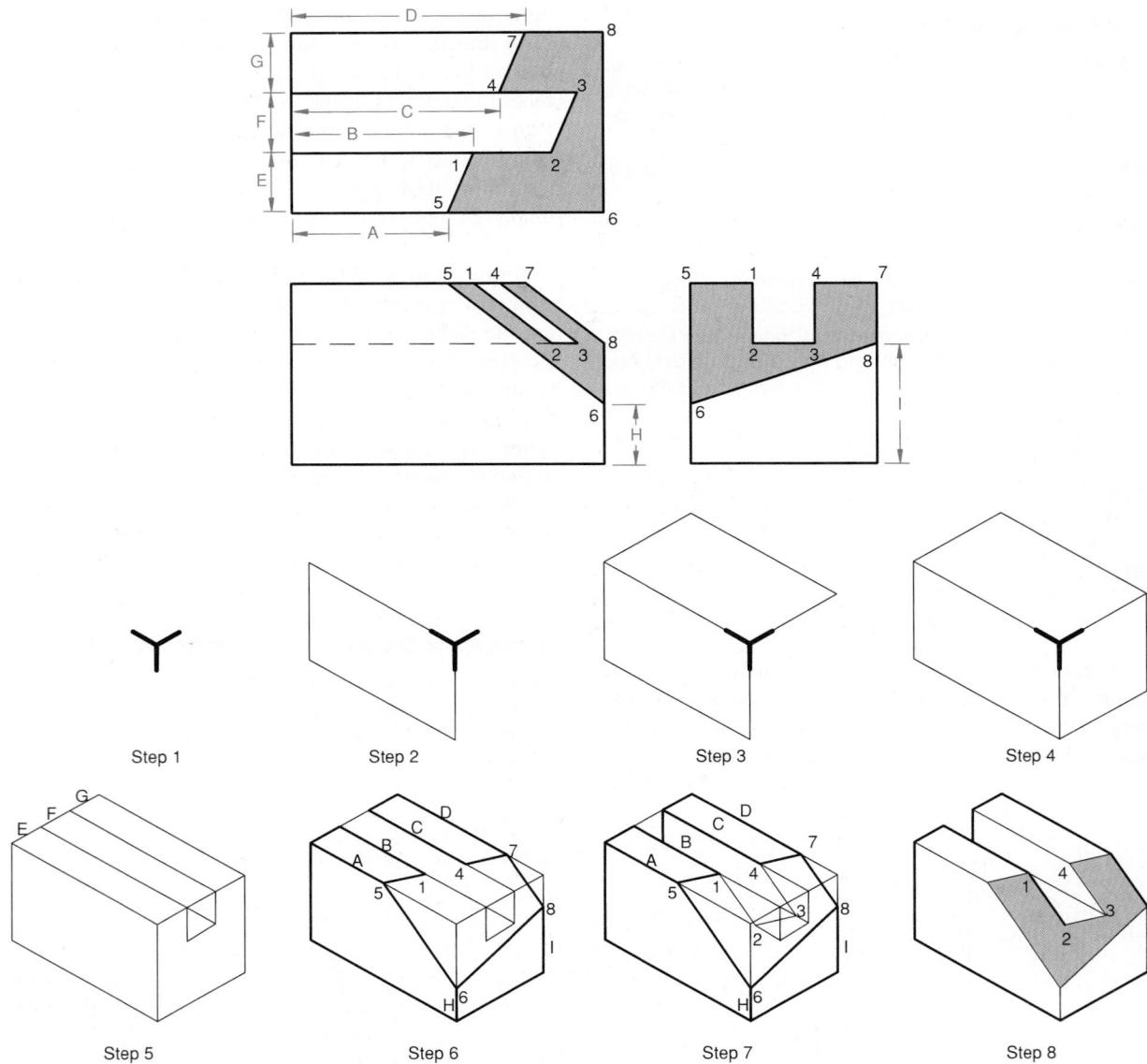

Figure 5.20 Constructing an Isometric Drawing Having an Oblique Surface

Step 2. Construct the front isometric plane using the W and H dimensions.

Step 3. Construct the top isometric plane using the W and D dimensions.

Step 4. Construct the right side isometric plane using the D and H dimensions.

Step 5. Locate the slot across the top plane by measuring distances E, F, and G along isometric lines.

Step 6. Locate the endpoints of the oblique plane in the top plane by locating distances A, B, C, and D along the lines created for the slot in Step 5. Label the endpoint of line A as 5, line B as 1, line C as 4, and line D

as 7. Locate distance H along the vertical isometric line in the front plane of the isometric box and label the endpoint 6. Then locate distance I along the isometric line in the profile isometric plane and label the endpoint 8. Connect endpoints 5–7 and endpoints 6–8. Connect points 5–6 and 7–8.

Step 7. Draw a line from point 4 parallel to line 7–8. This new line should intersect at point 3. Locate point 2 by drawing a line from point 3 parallel to line 4–7 and equal in length to the distance between points 1 and 4. Draw a line from point 1 parallel to line 5–6. This new line should intersect point 2.

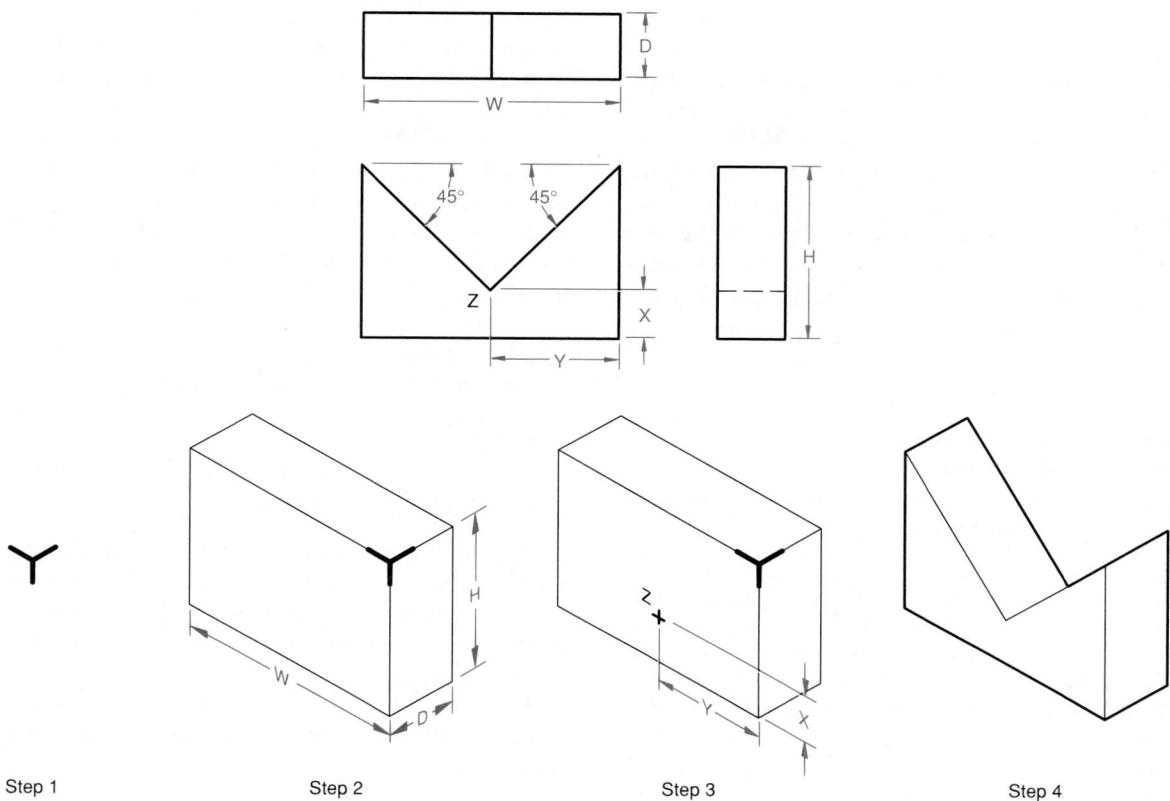

Figure 5.21 Constructing Angles in an Isometric Drawing

Step 8. Darken lines 4–3, 3–2, and 2–1 to complete the isometric view of the object.

The shaded surface in Step 8 has the same configuration as the shaded surface in the multiview drawing. Lines 5–6 and 7–8 are parallel lines that lie on the parallel front and rear plane. Also, lines 5–7 and 6–8 are not parallel; they lie on nonparallel faces of the isometric box. Two principles of orthographic projection are thus demonstrated: (1) Rule 5, configuration of planes, and (2) Rule 6, parallel features. See Chapter 4, “Multiview Drawings,” for a more complete explanation of these and other principles of orthographic projection. 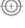 **CAD Reference 5.4**

Angles Angles can only be drawn true size when they are perpendicular to the line of sight. In isometric drawings, this is usually not possible; therefore, angles cannot be measured directly in isometric drawings. To draw an angle in an isometric drawing, locate the endpoints of the lines that form the angle and draw the lines between the endpoints.

Figure 5.21 and the following steps demonstrate the method for drawing an isometric angle.

Constructing Angles in an Isometric Drawing

Step 1. Determine the desired view of the object, then draw the isometric axes.

Step 2. Construct the front isometric plane using the W and H dimensions. Construct the top isometric plane using the W and D dimensions. Construct the right side isometric plane using the D and H dimensions.

Step 3. Determine dimensions X and Y from the front view and transfer them to the front face of the isometric drawing. Project distance X along an isometric line parallel to the W line. Project distance Y along an isometric line parallel to the H line. Point Z will be located where the projectors for X and Y intersect.

Step 4. Draw lines from point Z to the upper corners of the front face. Project point Z to the back plane of the box on an isometric line parallel and equal in length to the D line. Draw lines to the upper corner of the back plane to complete the isometric drawing of the object.

Notice that the 45-degree angles do not measure 45 degrees in the isometric view. This is an example of why no angular measures are taken from a multiview to construct an isometric drawing.

Irregular Curves Irregular curves are drawn in isometric by constructing points along the curve in the multiview drawing, locating those points in the isometric view, and then connecting the points using a drawing instrument such as a French curve. The multiview drawing of the curve is divided into a number of segments by creating a grid of lines and reconstructing the grid in the isometric drawing. The more segments chosen, the longer the curve takes to draw, but the curve will be more accurately represented in the isometric view.

Constructing Irregular Curves in an Isometric Drawing

Figure 5.22 and the following steps describe how to create an irregular isometric curve.

Step 1. On the front view of the multiview drawing of the curve, construct parallel lines and label the points 1–12. Project these lines into the top view until they intersect the curve. Label these points of intersection 13–18, as shown in Figure 5.22. Draw horizontal lines through each point of intersection, to create a grid of lines.

Step 2. Use the W, H, and D dimensions from the multiview drawing to create the isometric box for the curve. Along the front face of the isometric box, transfer dimension A to locate and draw lines 1–2, 3–4, 5–6, 7–8, 9–10, and 11–12.

Step 3. From points 2, 4, 6, 8, 10, and 12, draw isometric lines on the top face parallel to the D line. Then, measure the horizontal spacing between each of the grid lines in the top multiview as shown for dimension B, and transfer those distances along isometric lines parallel to the W line. The intersections of the lines will locate points 13–18.

Step 4. Draw the curve through points 13–18, using an irregular curve. From points 13–18, drop vertical isometric lines equal to dimension H. From points 1, 3, 5, 7, 9, and 11, construct isometric lines across the bottom face to intersect with the vertical lines dropped from the top face, to locate points 19–24. Connect points 19–24 with an irregular curve.

Step 5. Erase or lighten all construction lines to complete the view.

Circular Features A circular feature will appear elliptical if the line of sight is neither perpendicular nor parallel to the circular face. Circles that lie on any face of an

isometric cube will appear as ellipses with a 35°–16' exposure, as shown in Figure 5.23. In Figure 5.24, the center lines for a circle, the axis of a cylinder, and the major and minor axes of an ellipse are drawn for the front, right side, and top planes in an isometric drawing. Note that the minor diameter of the ellipse always coincides with the axis of the cylinder, and the major diameter of the ellipse is always at right angles to the minor diameter. Also, the center lines for the circle never coincide with the major or minor axis of the ellipse.

Ellipses Isometric ellipses representing circular features are drawn using one of three methods:

1. True ellipse construction.
2. Approximate four-center ellipse construction.
3. Isometric ellipse templates.

A true ellipse is constructed by drawing multiple randomly spaced, parallel and perpendicular lines across the circle in the multiview drawing. The lines form a grid similar to the one created for drawing an irregular curve in isometric.

Figure 5.25 and the following steps demonstrate using true ellipse construction to draw a short isometric cylinder.

Constructing a True Isometric Ellipse

Step 1. Construct multiple randomly spaced lines parallel to the vertical center line of the circle in the multiview drawing. Construct horizontal lines through the points of intersection on the circumference of the circle. Label all the points of intersection on the circle 1–12.

Step 2. Draw the isometric box, using the diameter of the circle as the sides and distance D as the depth dimension. Transfer the measurements from the multiview drawing to the isometric drawing. Construct isometric lines through the points to create a grid and locate points at the intersections. These points lie along the ellipse.

Step 3. Connect the points with an irregular curve to create a true isometric ellipse.

Step 4. Draw isometric lines equal to distance D from each point, to create that part of the ellipse which can be seen in the isometric drawing. Use an irregular curve to connect the points and draw tangent lines to represent the limiting elements of the cylinder.

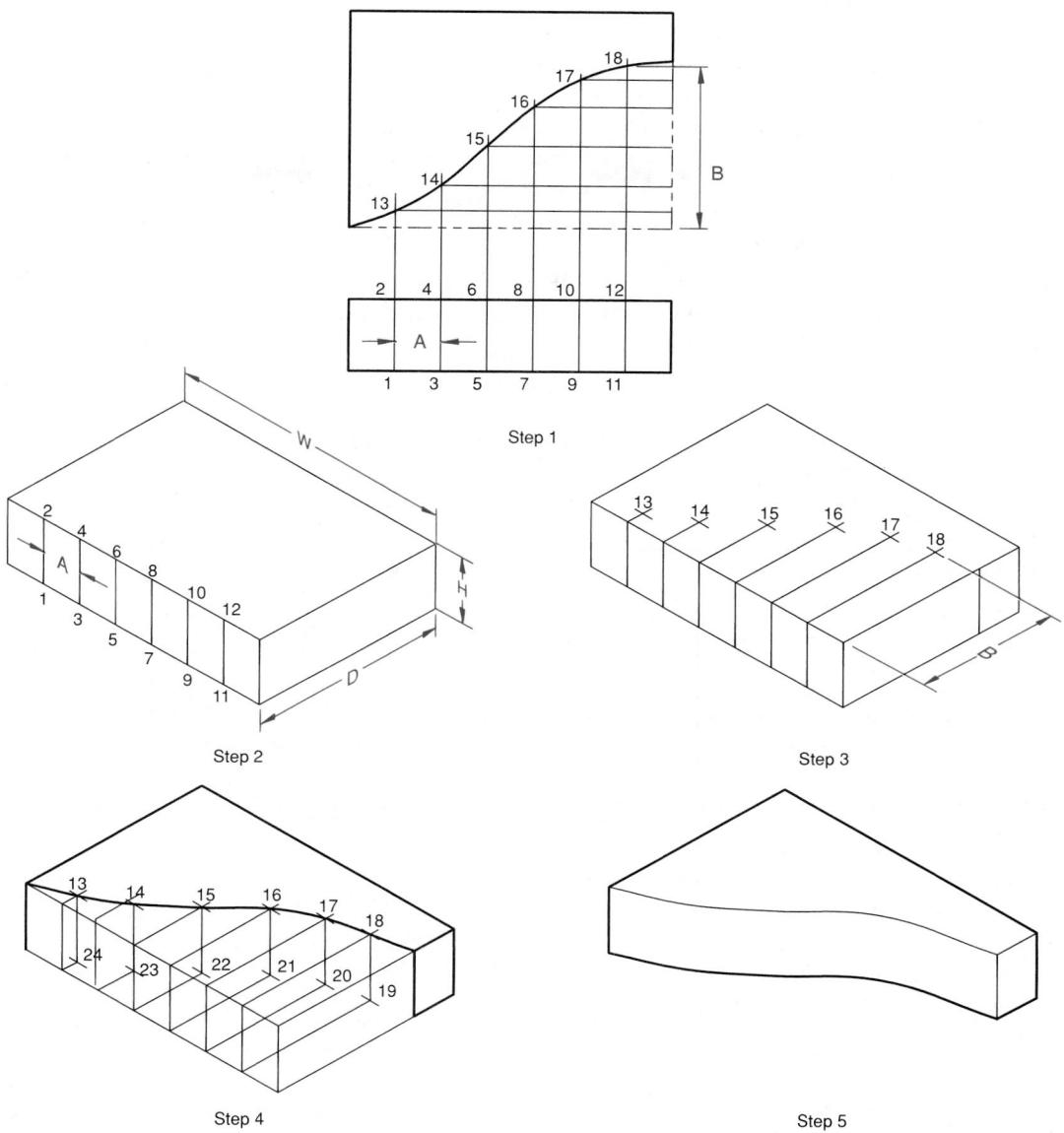

Figure 5.22 Constructing Irregular Curves in an Isometric Drawing

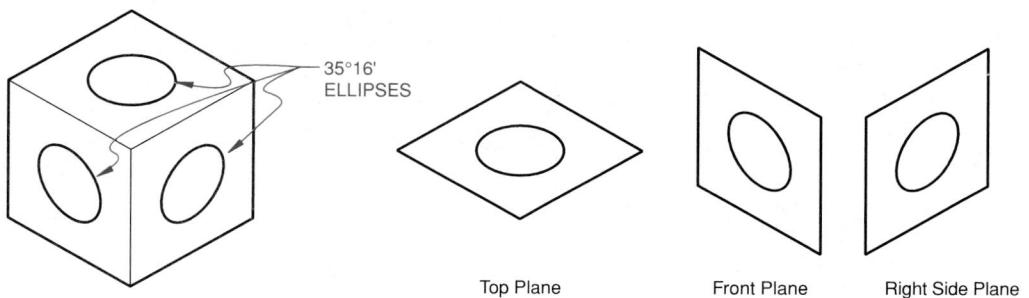

Figure 5.23 Representing Circular Features in an Isometric Drawing
Circles appear as ellipses with a 35°-16' exposure on all three isometric planes.

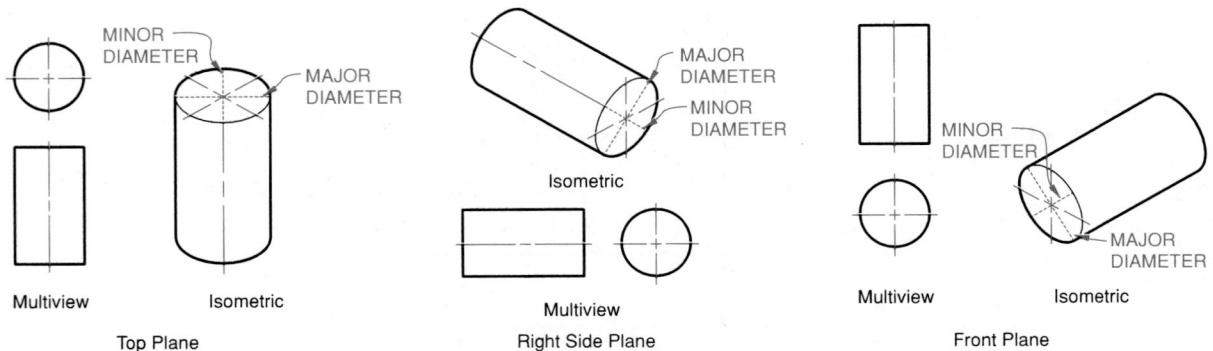

Figure 5.24 Location of Center Lines and the Major and Minor Axes of Isometric Ellipses

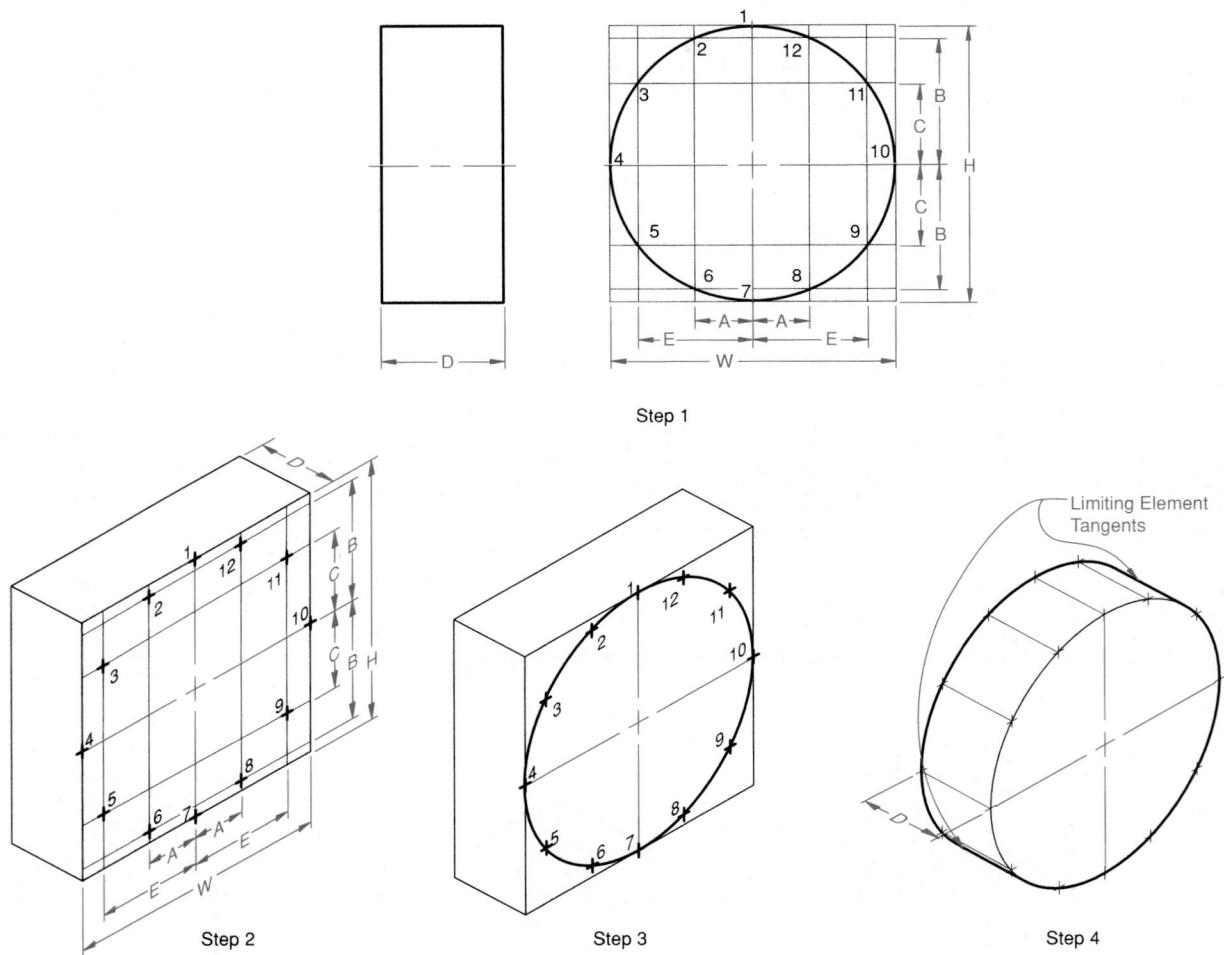

Figure 5.25 Drawing a True Ellipse

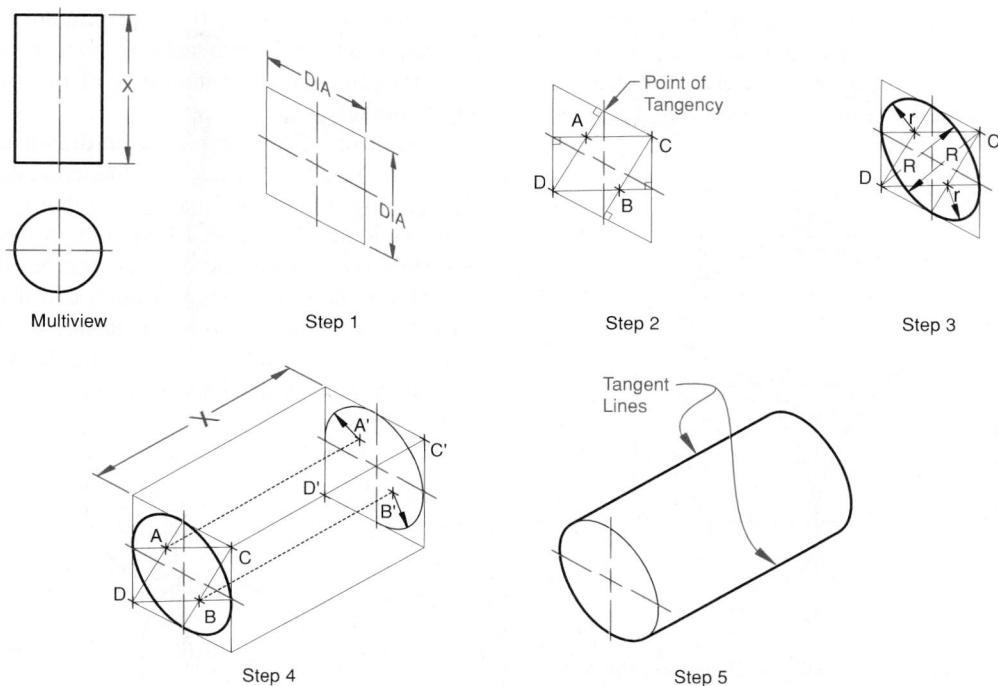

Figure 5.26 Constructing an Ellipse Using the Four-Center Method

The four-center construction technique creates an approximate isometric ellipse by creating four center points from which arcs are drawn to complete the ellipse. This method is sufficiently accurate for most isometric drawings.

Constructing an Ellipse Using the Four-Center Method

Figure 5.26 demonstrates the four-center ellipse construction method to construct an isometric cylinder.

Step 1. On the front plane, construct an isometric equilateral parallelogram whose sides are equal to the diameter of the circle.

Step 2. Find the midpoint of each side of the parallelogram. From the midpoint of each side, draw a line to the closest endpoint of the opposite side. These lines are perpendicular to the sides and they intersect at two points, which are the centers for two arcs used to create the approximate ellipse. The perpendicular bisect points are points of tangency for the ellipse.

Step 3. Draw two small arcs with radius r and centers located at points A and B. Draw two large arcs with radius R , using the two corners C and D as the centers.

Step 4. To complete the cylinder, draw the isometric box. Project arc center points A', B', and D' by drawing isometric lines equal to length X .

Step 5. Using radius R with point D' and radius r with points A' and B', construct the isometric ellipse on the rear face. Add tangent limiting element lines to complete the cylinder.

Figure 5.27 shows the construction needed to create a four-center ellipse on any of the isometric planes. All surfaces use perpendicular bisectors from the sides of the parallelogram to the closest corners to locate the center points for two of the four arcs. Figure 5.28 shows that the four-center ellipse is not the same as a true isometric ellipse, but it is close enough for use on most drawings.

However, whenever isometric circles are tangent or are intersecting, the four-center technique is not recommended. This is demonstrated by Figure 5.29, which shows the pitch diameters of a train of gears in

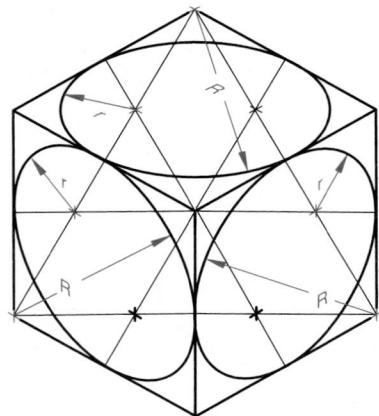

Figure 5.27 Four-Center Ellipses Drawn on the Three Faces of an Isometric Cube

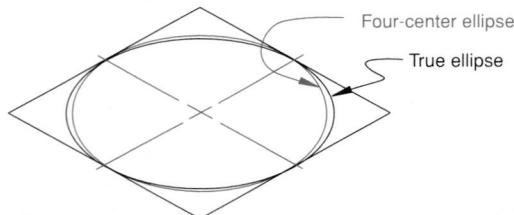

Figure 5.28 Difference between a True Ellipse and a Four-Center Ellipse

isometric, drawn using the approximate four-center technique. The pitch diameters of the gears do not appear tangent, but they should be if the gears are to mesh properly.

Isometric ellipses can also be drawn using templates. (Figure 5.30) Make sure the template is an isometric ellipse template, that is, one that has an *exposure angle of 35 degrees 16 minutes*. Although many different sized isometric ellipses can be drawn with templates, not every size isometric ellipse can be found on a template. However, it may be possible to approximate a smaller size by leaning the pencil in the ellipse template when drawing the ellipse.

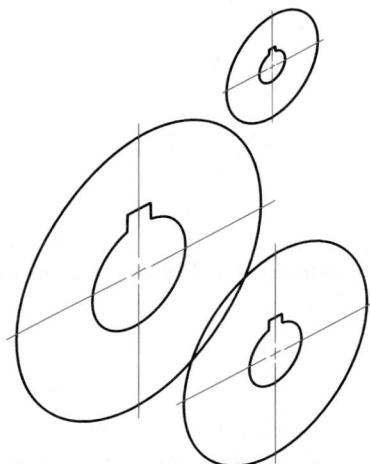

Figure 5.29 Application for which Four-Center Technique Is Not Used

In this example, the ellipses should be tangent, but they are not because the four-center technique is not accurate.

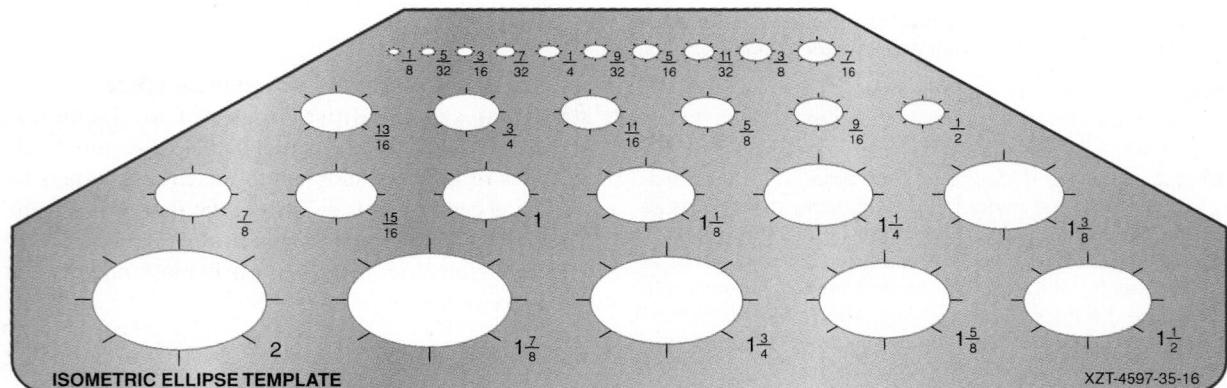

Figure 5.30 An Isometric Ellipse Template Has an Exposure Angle of $35^\circ-16'$

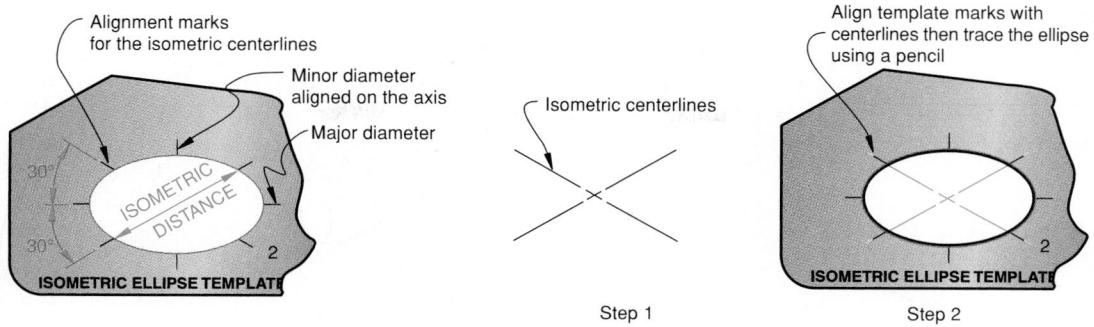

Figure 5.31 Constructing an Ellipse Using a Template

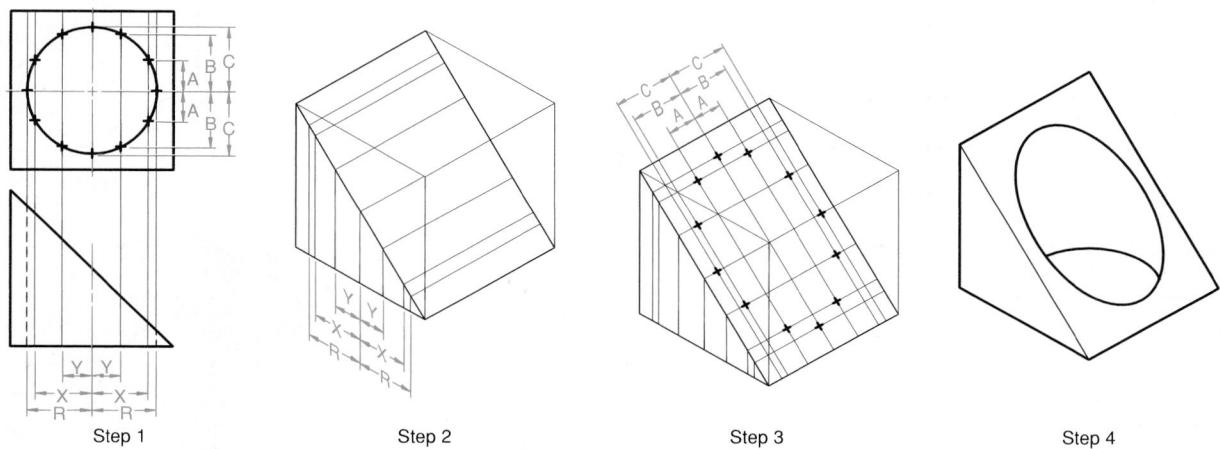

Figure 5.32 Constructing an Ellipse on an Inclined Plane

Constructing an Ellipse Using a Template

The steps used to draw an isometric ellipse using a template are as follows.

Step 1. The ellipse templates have markings which are used for alignment with the isometric center lines on the drawing. (Figure 5.31) Do not align the ellipse template with the major or minor diameter markings. Locate the center of the circle, then draw the isometric center lines.

Step 2. Find the correct isometric ellipse on the template. Align the isometric distance markings on the ellipse with the center lines, and use a pencil to trace around the elliptical cut in the template.

Inclined Plane Ellipse An ellipse can be drawn on an inclined plane by constructing a grid of lines on the ellipse in the multiviews and plotting points on this grid. (Figure 5.32) The points are then transferred to the isometric drawing, using isometric grid lines. The

grid lines produce a series of intersections that are points on the ellipse. These points are then connected with an irregular curve to create an ellipse on the inclined surface. Do not attempt to use an isometric ellipse template, as the exposure angle for this type of ellipse is not 35 degrees 16 minutes.

Constructing an Ellipse on an Inclined Plane

The following steps describe how to draw an ellipse on an inclined plane. (Figure 5.32)

Step 1. Draw randomly spaced lines parallel to the center line in the front view of the multiview drawing. Project those lines into the top view. Mark the intersections with the circumference of the circle. In the top view, draw lines parallel to the horizontal center line and through the intersections of the projected lines with the circumference of the circle. You may find it helpful to label the lines, intersection points, and distances between horizontal parallel lines (such as A, B, C) and vertical parallel lines (such as X, Y, R).

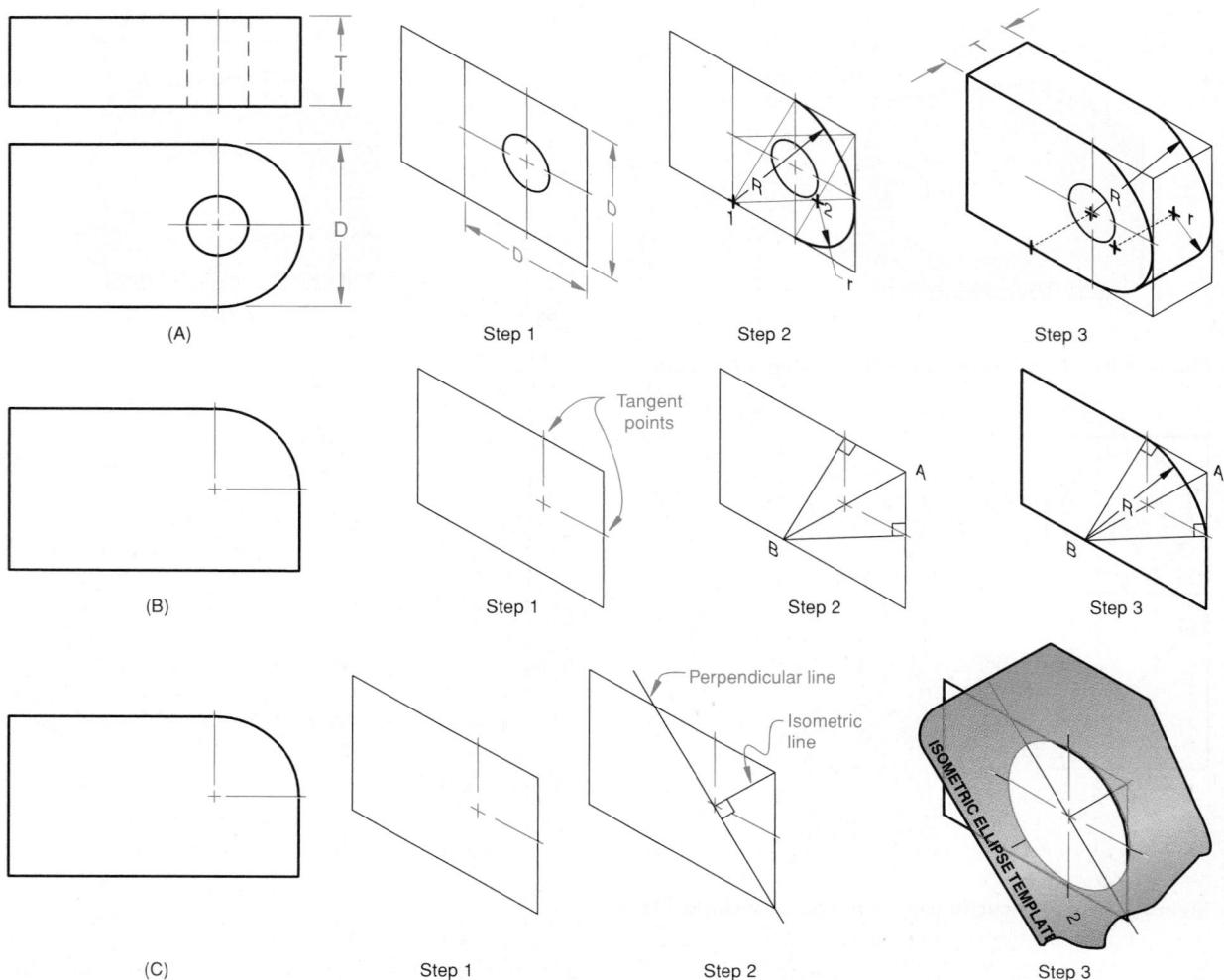

Figure 5.33 Constructing Arcs in Isometric Drawings

Step 2. Construct the isometric box, then draw the inclined plane in the box. Using distances X , Y , and R , construct isometric lines on the front face of the box. From their intersections with the inclined edge, draw isometric lines across the inclined plane.

Step 3. Transfer distances A , B , and C to the top edge of the inclined plane and project them across the inclined plane, using nonisometric lines that are parallel to the edges of the inclined plane. The intersections of the two sets of lines on the inclined plane are points on the ellipse.

Step 4. Use an irregular curve to draw the ellipse through the intersection.

Arches Since arcs are partial circles, they appear in isometric drawings as partial isometric ellipses.

Therefore, isometric arcs are constructed using any of the three techniques described for drawing ellipses: true ellipse, four-center, or template.

Constructing Arcs in Isometric Drawings

The four-center ellipse technique is used in Figure 5.33A.

Step 1. Construct the isometric box, then draw the isometric parallelogram with the sides equal to the diameter (D) of the arc.

Step 2. Construct the perpendicular bisectors in the isometric parallelogram. Construct the isometric half-circle using radii R and r from centers 1 and 2.

Step 3. Project center points 1 and 2 along isometric lines a distance equal to the thickness (T) of the object. Using the same radii R and r, construct arcs to create the partial isometric ellipse on the back plane.

The true ellipse technique is used in Figure 5.33B.

Step 1. Given the radius, locate the center lines for the arc, then draw a line (AB) which is extended from the corner through the center point of the arc.

Step 2. Draw lines perpendicular to the points of tangency of the arc, to intersect the line AB.

Step 3. The point of intersection is the center point for the arc. Use radius R to construct the partial isometric ellipse.

Figure 5.33C shows how to create an arc using an ellipse template.

Step 1. Given the radius, draw the center lines for the arc.

Step 2. Draw an isometric line through the center point, then construct another line perpendicular to the isometric line at the center point.

Step 3. Use these two lines to align the ellipse template to draw the ellipse.

Curved Intersections Curved intersections can be formed by such features as a hole drilled in an oblique surface or two cylinders intersecting. For a hole drilled in an oblique surface, the isometric drawing of the feature is created by developing a grid in the multiview, transferring that grid to the isometric view, and developing the oblique ellipse. The steps are as follows (Figure 5.34A).

Constructing an Ellipse on an Oblique Surface

Step 1. Using the technique demonstrated in Figure 5.32, construct a series of grid lines on the oblique surface in the multiview drawing, marking the intersection points representing the hole.

Step 2. Transfer the grid lines to the oblique surface in the isometric drawing.

Step 3. Mark the intersection points of the grid lines and use an irregular curve to connect these points, creating the curved intersection between the hole and the oblique plane.

To create the isometric elliptical intersection between two cylinders, refer to Figure 5.34B and use the following steps. (It is assumed that the two cylinders have already been constructed, using methods described in this chapter, and that only the intersection remains to be constructed.)

Constructing a Curved Intersection

Step 1. Draw a series of randomly spaced cutting planes, parallel to the axis of the large cylinder and through both the large and small cylinders. Mark where these planes intersect the outside edge of the top face of the small cylinder and the outside edge of the right side face of the large cylinder.

Step 2. Add the cutting plane lines to the cylinders in the isometric view. From the intersection points on the top face of the small cylinder, project vertical lines downward. From the intersection points on the right side face of the large cylinder, project isometric lines parallel to the axis of the cylinder.

Step 3. Mark the points of intersection between the vertical projection lines and the isometric projection lines.

Step 4. These intersection points are on the ellipse that forms the intersection between the two cylinders. Use an irregular curve to connect the intersection points.

Spheres The true isometric *projection* of a sphere is the actual diameter of the circle. The isometric *drawing* of a sphere is $1\frac{1}{4}$ times the actual diameter of the sphere.

Constructing an Isometric Drawing of a Sphere

Figure 5.35 demonstrates the development of an isometric drawing of a sphere.

Step 1. Construct a square around the front view of the sphere in the multiview drawing. Construct a diagonal across the face of the square, locate the intersection points between the diagonal and the sphere, and mark distances A and B.

Step 2. Construct an isometric cube, using the diameter of the sphere for the sides. Mark the midpoints of the top and bottom edges of the front face.

Step 3. Draw an isometric plane through these midpoints and draw the long diagonal of the isometric plane. Measure distances A and B on the diagonal. Determine radius R, which is the distance from the center of the isometric plane to point A or B. Using radius R, draw a circle which represents the isometric drawing of the sphere.

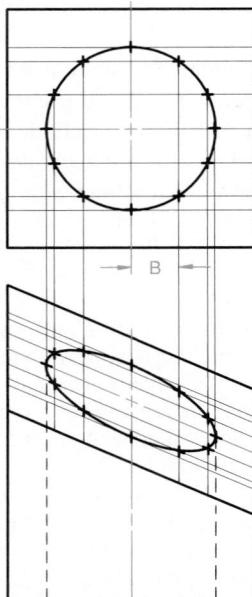

(A) Step 1

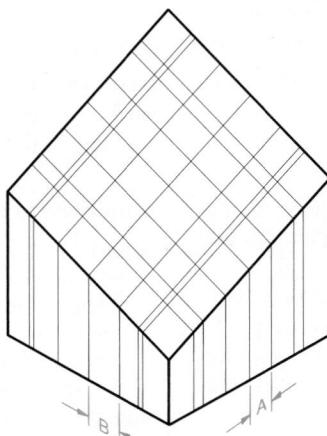

Step 2

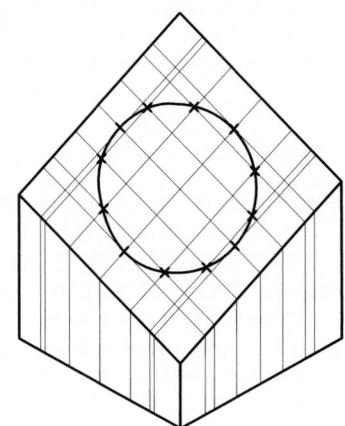

Step 3

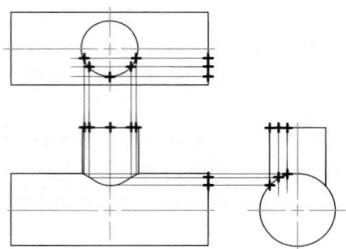

(B) Step 1

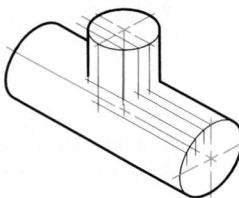

Step 2

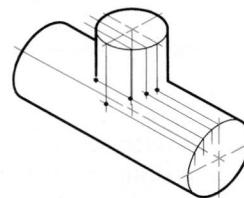

Step 3

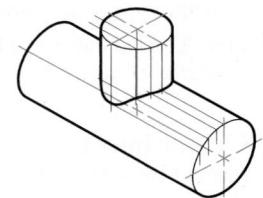

Step 4

Figure 5.34 Constructing Ellipses on an Oblique Surface and Constructing the Curved Intersection of Two Cylinders

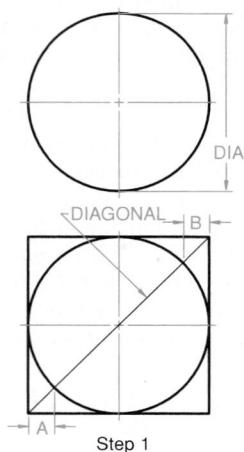

Step 1

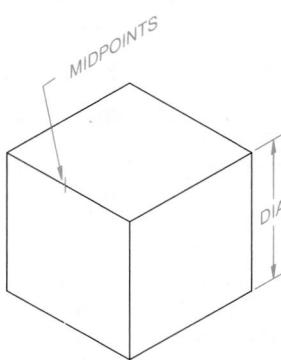

Step 2

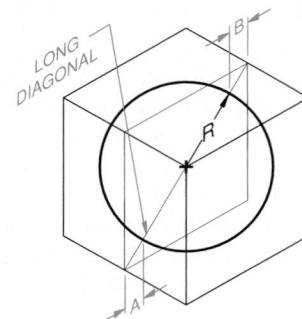

Step 3

Figure 5.35 Constructing an Isometric Drawing of a Sphere

Industry Application

Hong Kong Airport Uses CAD and Pictorial Views in Its Design

Hong Kong's new airport is being constructed on a 3.75-by 1.6-mile platform reclaimed from the sea. It is linked to the city by a combined expressway and railway line running across the world's second largest expansion bridge. Alongside the airport will be a new town for airport employees. The new airport will handle 87 million passengers a year. The terminal building is a $\frac{1}{4}$ -mile-long structure with provisions for the docking of 60 planes.

CAD is used to create the geometry of the runways and taxiways and relate that geometry to the possible

flight paths, taking into account local topology, urban development, and prevalent winds. The creation of the theoretical surfaces in the airspace has been a major design consideration, which was done manually in the past.

The designs of the airport, city, and bridge are being done with CAD and then integrated so that each engineering discipline has access to the latest design data. The airport is expected to begin operation in 1997.

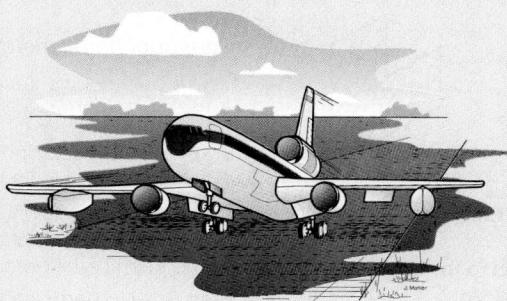

A Jumbo Jet on the Proposed Airport Runway

Adapted from: "Flying High," *Computer Graphics World* 16 no. 2 (February 1993), pp. 45-50.

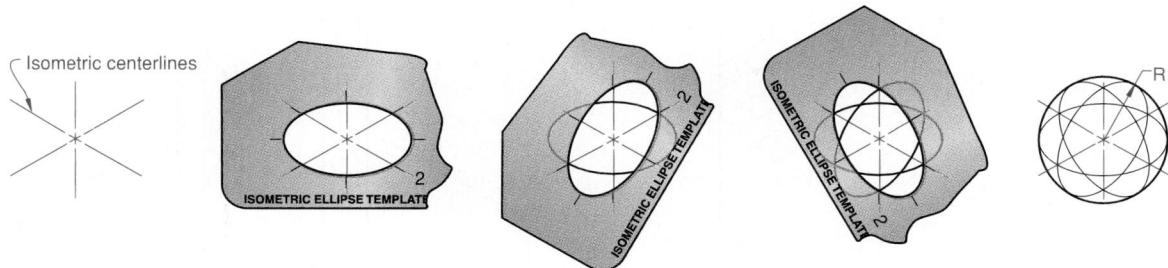

Figure 5.36 Constructing an Isometric Drawing of a Sphere Using a Template

An alternate method of developing the isometric drawing of a sphere involves constructing the isometric axes, using an isometric template to draw frontal, horizontal, and profile isometric ellipses, and using a compass to draw a circle tangent to the three ellipses. (Figure 5.36)

Section Views Section views are used to reveal the interior features of parts and structures. (See Chapter 7, "Section Views.") Isometric drawings of sections

use isometric cutting planes to reveal interior features. Section lines are normally drawn in the direction that gives the best effect, which is usually in the direction of the long diagonal of a square drawn on the section surface. (Figure 5.37)

To draw a full-section isometric view, first construct the sectioned surface. (Figure 5.38) Then add the portion of the object that lies behind the sectioned surface.

To draw a half-section isometric view, construct the whole object. (Figure 5.39) Add the cut surfaces to the drawing, then erase the portion that is to be removed. Darken all features, then add section lines to

Figure 5.37 Constructing Section Lines on the Right Side, Top, and Front Surfaces

Section lines are usually drawn parallel to the long diagonal of a square drawn on the isometric surface.

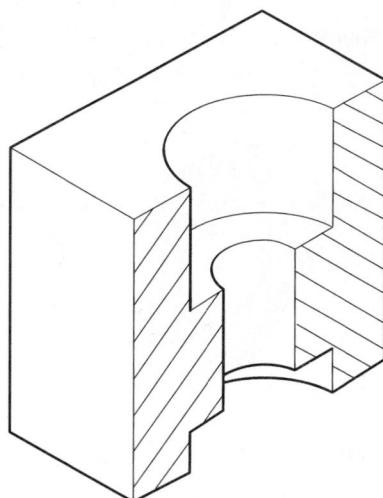

Figure 5.38 Full-Section Isometric Drawing

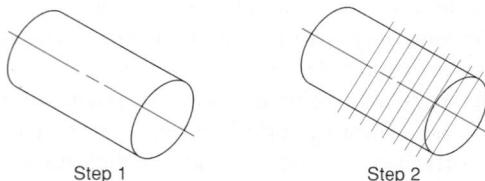

Figure 5.40 Constructing Isometric Screw Threads

complete the section view. Half sections are used more often than full sections because they show more of the outside features, making it easier to visualize the whole object.

Screw Threads, Fillets, and Rounds Screw threads are represented by a series of equally spaced isometric ellipses whose major diameter is equal to the diameter of the screw. The isometric ellipses are most easily drawn using a template, but the four-center technique can also be used. It is important that the threads be carefully and evenly spaced. Even a slight variation in spacing can destroy the look of the screw.

Constructing Isometric Screw Threads

Figure 5.40 shows the construction of an isometric drawing of a screw thread.

Step 1. Draw a cylinder equal in diameter to the diameter of the screw. Include the axis of the cylinder.

Step 2. Draw equally spaced lines perpendicular to the axis of the cylinder. These lines need not be equal to the pitch of the screw thread.

Step 3. With an isometric ellipse template, draw a series of ellipses using the perpendicular lines and the axis of the cylinder for alignment. Use a smaller isometric ellipse to represent the chamfered end of the thread.

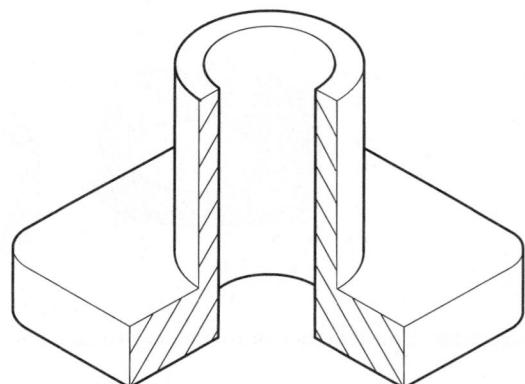

Figure 5.39 Half-Section Isometric Drawing

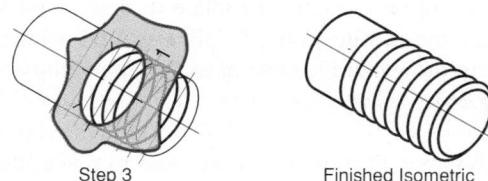

Finished Isometric

Figure 5.41 Marking of Fillets and Rounds in Isometric Drawings

Figure 5.42 Creating Isometric Fillets and Rounds

Figure 5.41 shows how fillets and rounds are represented in isometric drawings. The techniques shown are intended to add more realism to the drawing. The methods used to create fillets and rounds are shown in Figure 5.42. Arcs are drawn equal in length to the radius of the fillet or round. An isometric ellipse template is used to draw the arcs, or they are drawn free-hand. Alternatively, randomly broken lines are drawn parallel to or concentric with the axial direction of the fillet or round.

Assembly Drawings Isometric assembly drawings are classified as either assembled or exploded. (Figures 5.43 and 5.44) Such drawings are included in the instruction manuals that come with many household items and children's toys. Isometric assembly drawings used for production purposes normally have circles, called *balloons*, that contain numbers and are attached to leader lines pointing to the various parts. The numbers correspond to numbers in a parts list. (Figure 5.44) See Chapter 9, "Reading and Constructing Working Drawings," for more information.

Figure 5.43 3-D Model Isometric Assembly Drawing

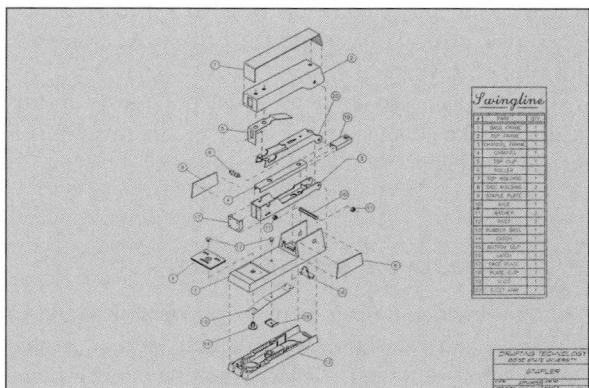

Figure 5.44 Exploded Isometric Assembly Drawing and Parts List

(Kevin Maus, Boise State University, Irwin student drawing contest winner.)

Isometric assembly drawings can also be created using 3-D CAD. Animation software can show the parts assembled, then coming apart, to create an exploded assembly drawing. Cutting planes can also be passed through the assembly, to create sectioned assembly views. © CAD Reference 5.6

Isometric Grids An **isometric grid** is a grid paper set up using the isometric axes with vertical and diagonal lines. Figure 5.45 shows an orthographic grid with a multiview drawing of an object and an isometric grid with the object drawn on it. The distance between grid points is normally 0.25 inches. Any size scale can be assigned to the grid before drawing the object.

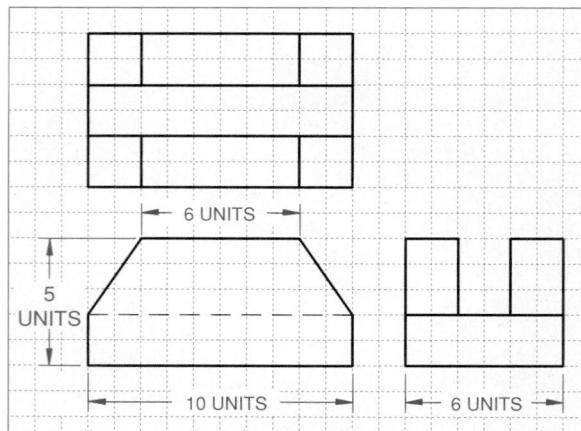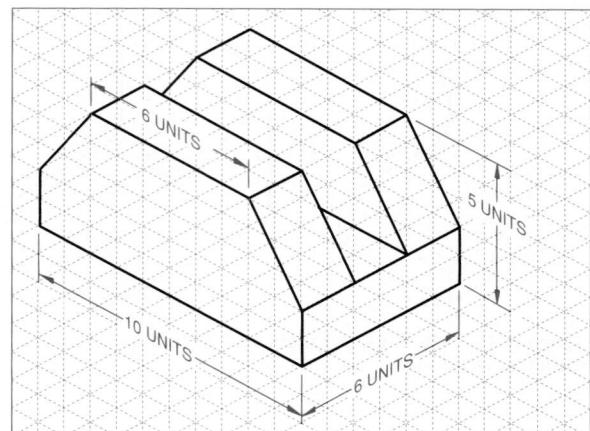

Figure 5.45 Using an Isometric Grid to Create an Isometric Drawing

In Figure 5.45, the number of grid marks for each feature were counted and that number was used on the isometric grid. This created a full-scale isometric drawing of the part.

Use the same basic steps given previously in this chapter to create an isometric view of a part using isometric grid paper. **CAD Reference 5.7**

5.3 OBLIQUE DRAWINGS

Oblique drawings are a form of pictorial drawing in which the most descriptive or natural view is treated as the front view and is placed parallel to the plane of projection. For example, oblique drawing is the pictorial method favored by the furniture manufacturing and cabinetmaking industry. (Figure 5.46) However, because of the excessive distortion that occurs, oblique drawings are not used as commonly as other types of pictorials.

5.3.1 Oblique Projection Theory

Oblique projection is the basis for oblique drawing and sketching. Oblique projection is a form of parallel projection in which the projectors are parallel to each other but are not perpendicular to the projection plane. The actual angle that the projectors make with the plane of projection is not fixed; thus, different angles can be used. (Figure 5.47)

Figure 5.46 Typical Furniture Industry Oblique Drawing

However, angles of between 30 degrees and 60 degrees are preferable, because they result in minimum distortion of the object.

If the principal view of the object is placed parallel to the projection plane and the line of sight is something other than perpendicular to the projection plane, the resulting projection is an oblique pictorial. The path of the projectors follows the receding edges of the object. A comparison of orthographic projection and oblique projection is illustrated in Figures 5.48 and 5.49.

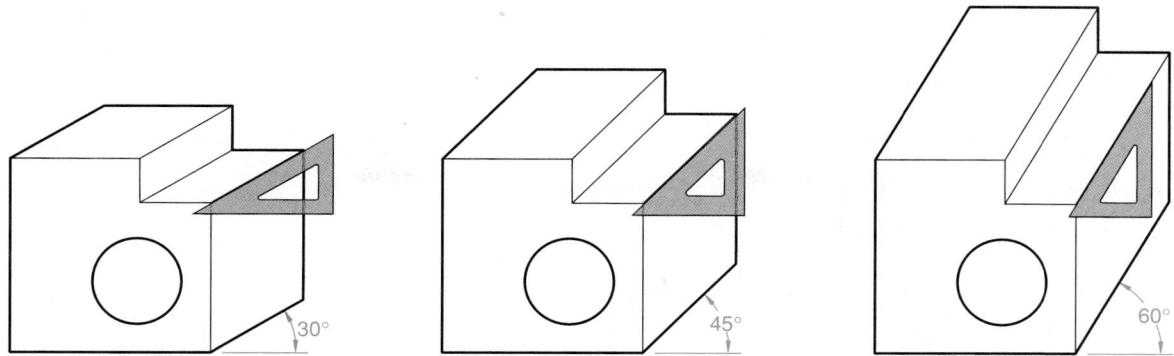

Figure 5.47 Oblique Drawing Angles

Typical oblique drawing angles used are 30, 45, or 60 degrees from the horizontal.

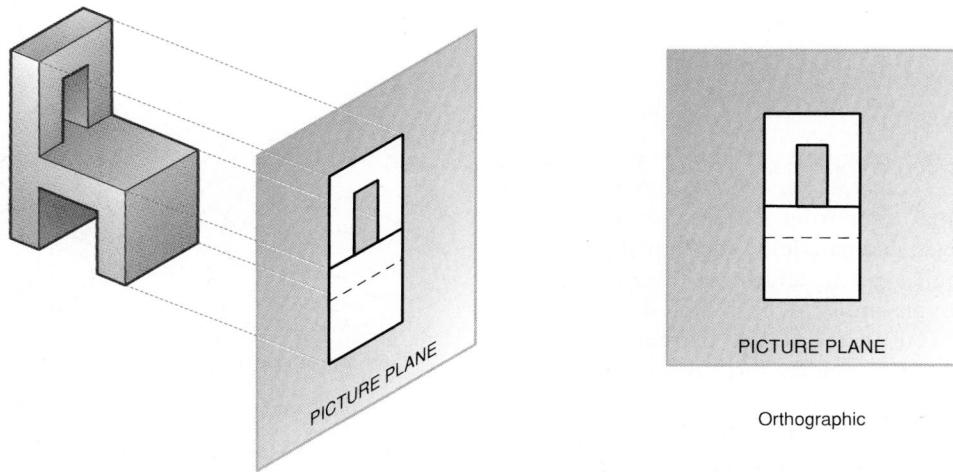

Figure 5.48 Orthographic Projection

In orthographic projection, the projectors are perpendicular to the projection plane.

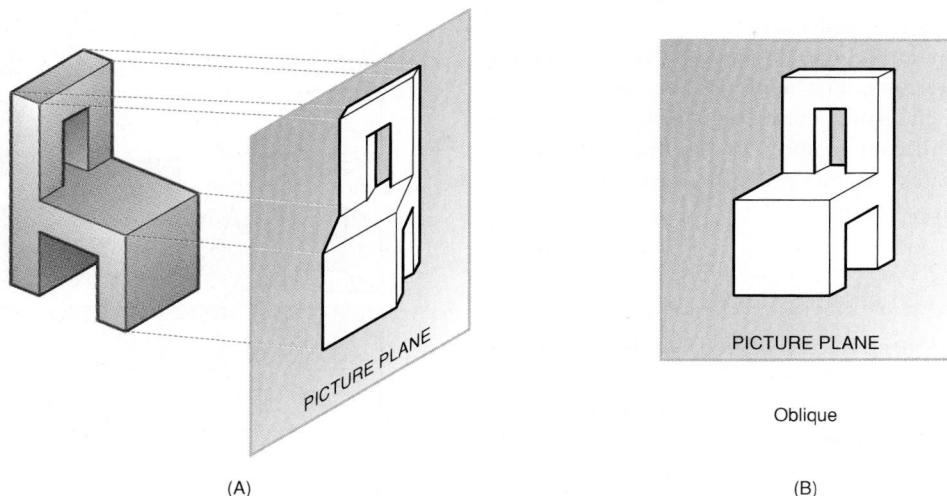

Figure 5.49 Oblique Projection

In oblique projection, the projectors are never perpendicular to the projection plane.

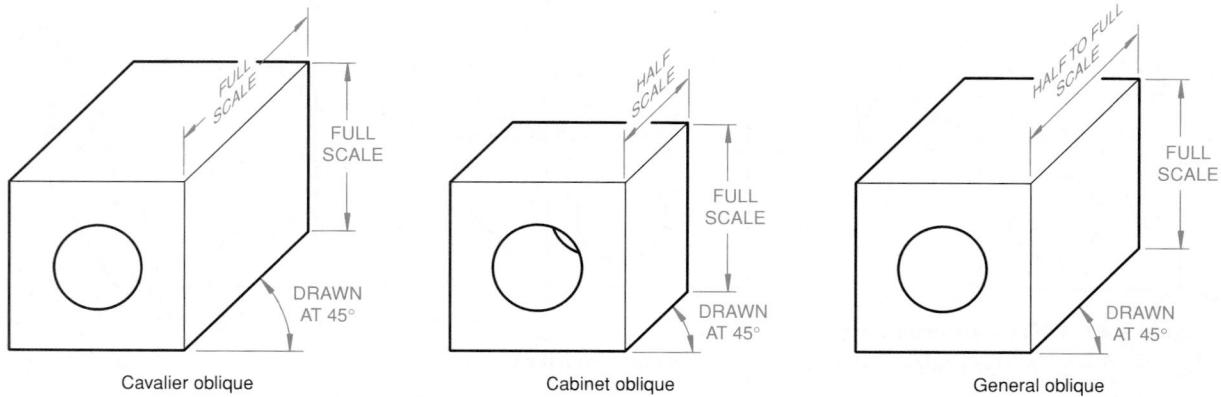

Figure 5.50 Types of Oblique Drawings

5.3.2 Oblique Drawing Classifications

There are three basic types of oblique drawings: (1) *cavalier*, (2) *cabinet*, (3) *general*. All three types are similar in that their front surfaces are drawn true size and shape, and parallel to the frontal plane. The receding angles can be anywhere from 0 to 90 degrees, although angles of less than 45 degrees or greater than 60 degrees cause extreme distortion. The difference between the three types relates to the measurements made along the receding axis. The **cavalier oblique** is drawn true length along the receding axis. The **cabinet oblique** is drawn half the true length along the receding axis. The **general oblique** can be drawn anywhere from full to half length along the receding axis. (Figure 5.50) The half-size receding axis on the cabinet oblique reduces the amount of distortion (Figure 5.51); therefore, the cabinet oblique drawing is the one used for most illustrations. The angle of the receding axis can also be changed to reduce distortion and to emphasize significant features of the drawing. Figure 5.52 illustrates various receding axis angles for a cavalier oblique drawing.

5.3.3 Object Orientation Rules

In oblique projection, the object face that is placed parallel to the frontal plane will be drawn true size and shape. Thus, the first rule in creating an oblique drawing is to place complex features, such as arcs, holes, or irregular surfaces, parallel to the frontal plane. (Figure 5.53) This allows these features to be drawn more easily and without distortion.

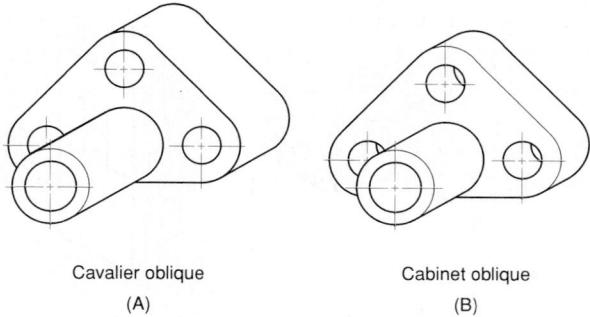

Figure 5.51 Comparison of Distortion for Cavalier versus Cabinet Oblique Drawings

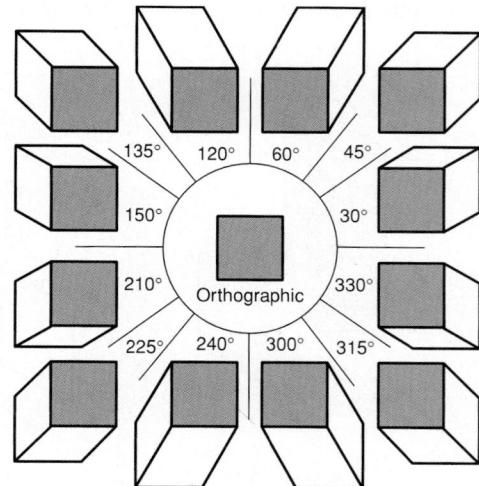

Figure 5.52 Receding Axis Angles

An object can be drawn with a variety of angles, to emphasize different features.

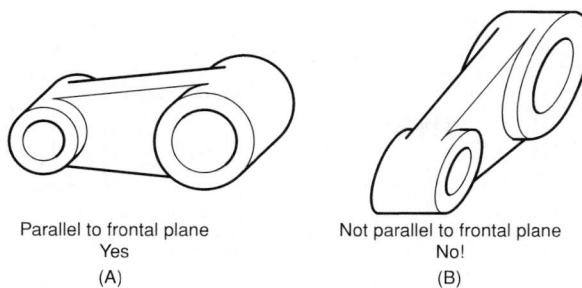**Figure 5.53 Object Orientation**

Place holes and arcs parallel to the frontal plane whenever possible, to avoid distortion and minimize having to draw circles as ellipses.

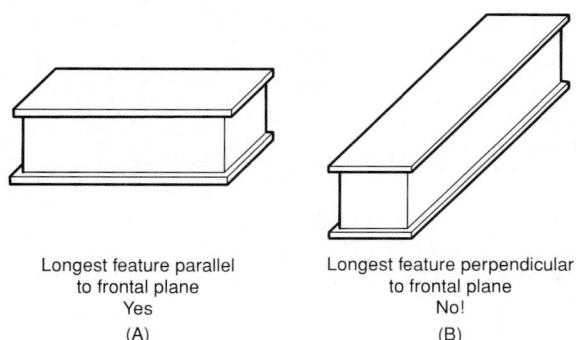**Figure 5.54 Long Dimension Orientation**

Place the longest dimension of the object parallel to the frontal plane, to avoid distortion.

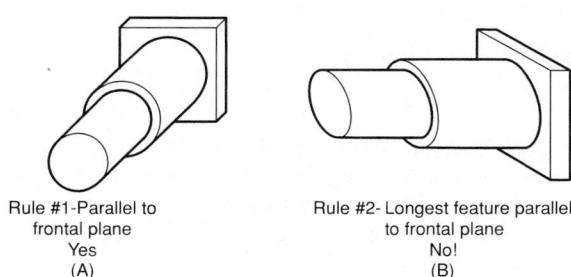**Figure 5.55 Cylinder Rule**

The cylinder rule overrides the longest-dimension rule when creating an oblique drawing.

The second rule in developing oblique drawings is that the longest dimension of an object should be parallel to the frontal plane. (Figure 5.54) If there is a conflict between these two rules, the first rule takes precedence, because representing complex geometry without distortion is more advantageous. (Figure 5.55)

5.5.4 Oblique Drawing Construction

To develop an oblique drawing that consists mostly of prisms, use the box construction technique. (Figure 5.56)

Constructing an Oblique Drawing Using the Box Technique

Determine from the given multiviews the best view for the front face of the oblique drawing. Decide what type of oblique to draw and define the angle for the receding lines. For this example, the front view of the object will be the front face, the cavalier oblique will be used, and the receding angle will be 45 degrees.

Step 1. Determine the overall height, width, and depth dimensions and begin to create the construction box. Draw the receding axes at 45 degrees and lay out the depth dimensions (in true length).

Step 2. Draw the front view, which is identical to the orthographic front view, using dimensions M, N, O, and P. Note that the front surface with the two holes is drawn in the frontal plane of the oblique construction box. The other parts of the front must be drawn at a distance P behind the frontal plane of the construction box. Distance P is measured along one of the 45-degree receding lines. Other details are added to the drawing to complete the construction.

Step 3. Darken or trim the lines to complete the drawing.

If the object is composed mostly of full or partial cylindrical shapes, place these shapes in the frontal plane so that they will be drawn true size and shape. (Figure 5.57)

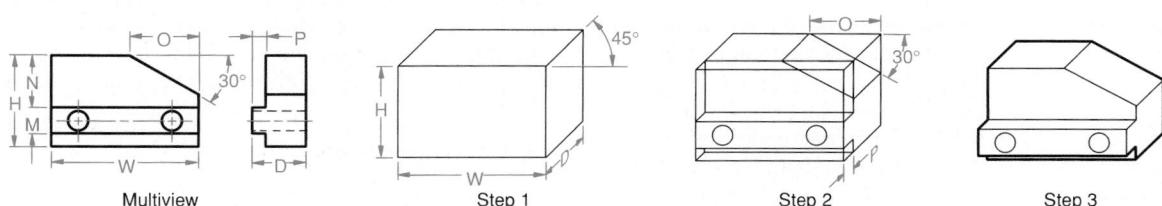**Figure 5.56 Constructing an Oblique Drawing Using the Boxing-In Method**

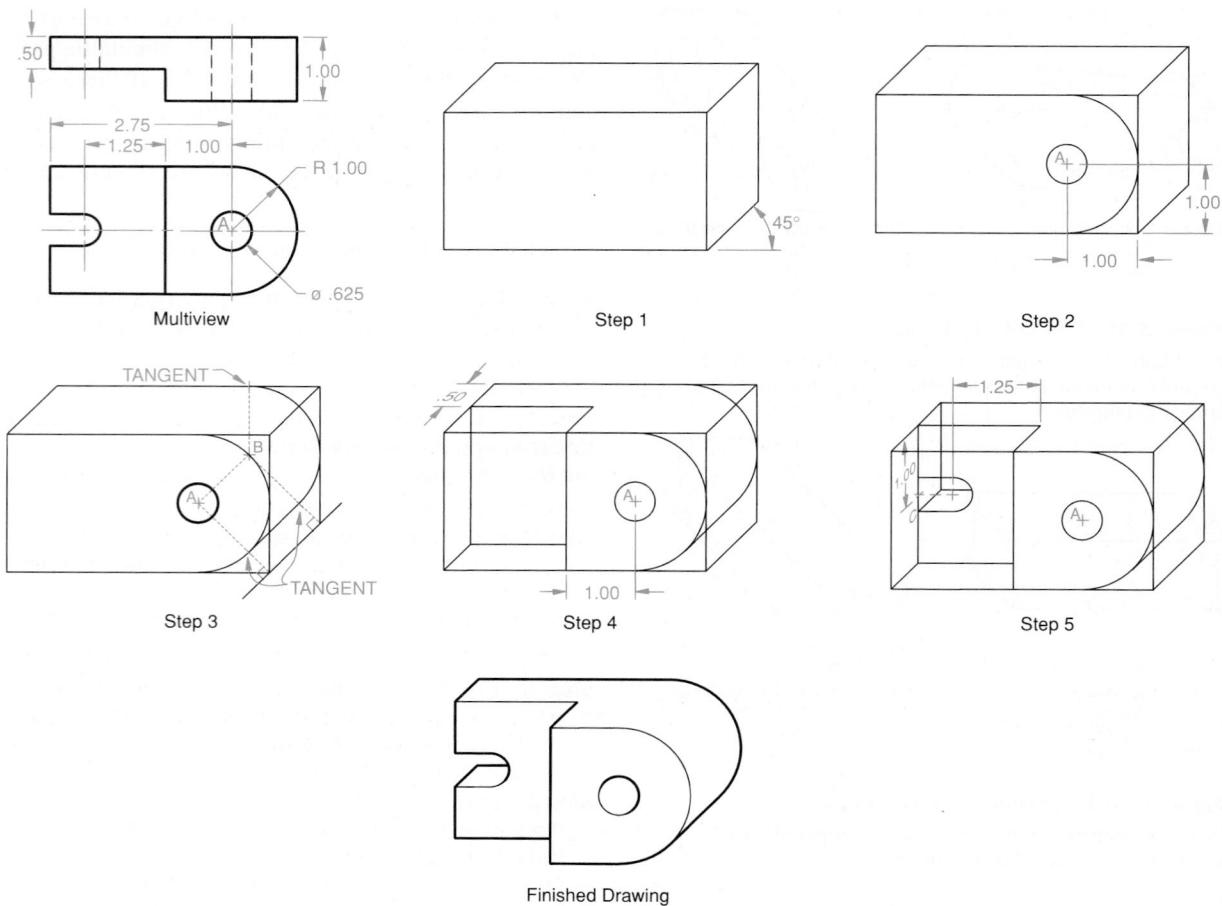

Figure 5.57 Constructing an Oblique Drawing of an Object with Circular Features

Constructing an Oblique Drawing of an Object with Circular Features

From the given multiviews, determine the best view for the front face of the oblique drawing. Decide what type of oblique to draw and define the angle for the receding lines. For this example, the front view of the object will be the front face, the cavalier oblique will be used, and the receding angle will be 45 degrees. Again, depth dimensions are drawn full scale on the receding lines.

Step 1. Block in the overall width, height, and depth dimensions, and use 45 degrees for the receding lines.

Step 2. On the front face, locate the center A of the 1" radius arc and 0.625 diameter hole. Draw the arc and the hole on the front face of the oblique drawing.

Step 3. Locate center B of the 1" arc and the hole in the back plane of the oblique drawing by projecting point A along a line at a 45-degree angle and 1" long (the depth dimension). Draw another 1" radius arc using

point B as the center. Determine points of tangency by constructing vertical lines from the centers to the top edges and other lines perpendicular to the receding line that is the bottom edge of the right side of the construction box.

Step 4. Mark the notch dimensions on the front face and mark the depth of the notch along the top left receding line. Draw the notch using the dimensions marked on the edges of the box.

Step 5. Locate the center of the 0.25" radius arc and mark the location of the slot. Draw the arc and then the slot, and project point C back at a 45-degree angle and 0.5" long. Draw the back part of the slot that is visible.

© CAD Reference 5.8

Circles It is not always feasible to position an object such that all of its cylindrical features are parallel to

the frontal plane. (Figure 5.58) In oblique drawing, an *alternate four-center ellipse method* can be used to draw circles not in the frontal plane. However, this method can only be used in cavalier oblique drawings, because the receding axes are drawn full scale; thus, the parallelogram used to develop the ellipse is an equilateral parallelogram.

The regular four-center method used in isometric drawing will only work with oblique drawings that have receding axes at 30 degrees (the same axis angle

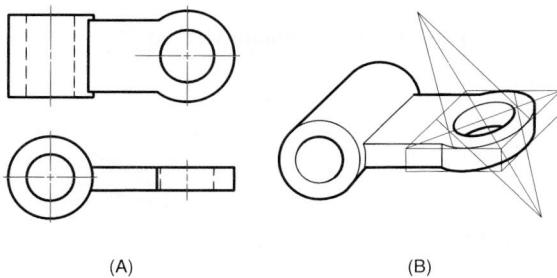

Figure 5.58 Four-Center Ellipse Construction

When it is not possible to place a circular feature parallel to the projection plane, create the circle as an ellipse using the four-center method.

used in isometric drawings). Any other receding axis angles call for using the alternate four-center ellipse method described in the following steps. (Figure 5.59)

Constructing Oblique Ellipses Using the Alternate Four-Center Method

Step 1. On the surface that is not parallel to the frontal plane, locate the center of the circle and draw the center lines.

Step 2. From the center point, draw a construction circle that is equal to the diameter of the circle that is being constructed. This construction circle will intersect the center lines at four points, A, B, C, and D.

Step 3. From points A and C, construct lines that are perpendicular to center line BD.

Step 4. From points B and D, construct lines that are perpendicular to center line AC.

Step 5. From the intersections of the perpendicular construction lines, draw four circular arcs using the radii marked.

Curved Surfaces Cylinders, circles, arcs, and other curved or irregular features can be drawn point-by-point using the **offset coordinate method**. (Figure 5.60) The offset coordinate method of drawing curves

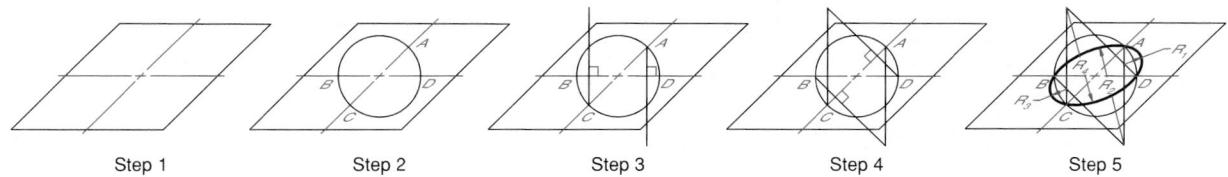

Figure 5.59 Constructing Oblique Ellipses Using the Alternate Four-Center Method

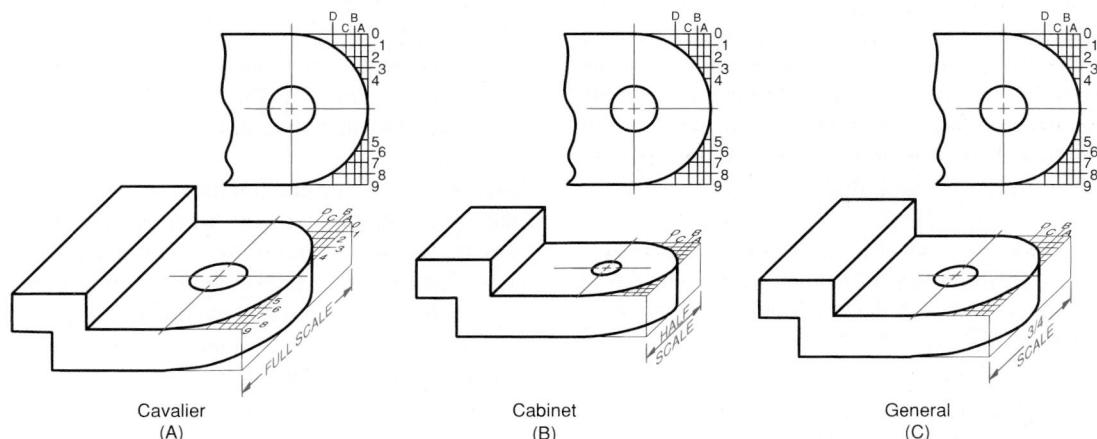

Figure 5.60 Constructing Oblique Curved Surfaces Using Offset Coordinates

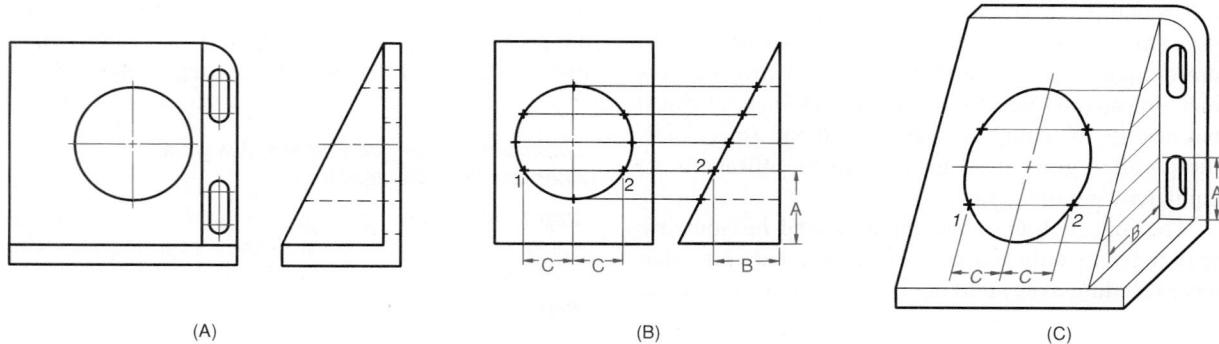

Figure 5.61 Constructing an Ellipse Inclined to the Frontal Plane Using the Offset Coordinate Method

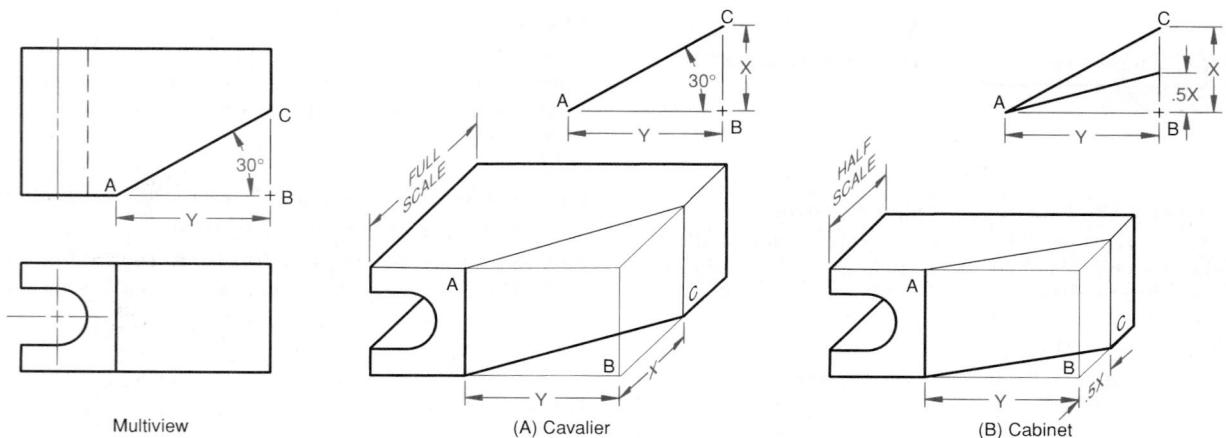

Figure 5.62 Constructing Oblique Angles

is a technique that uses a grid of equally spaced lines on the multiview to divide the curve into parts so that points along the curve can be located and transferred to the oblique view for construction of the oblique curve. The offset coordinate grid is first drawn on the orthographic view of the object, and the coordinate points delineating the curve are marked as shown in Figure 5.60A. The grid and coordinate points are then transferred to the oblique drawing and the curve is drawn with an irregular curve. If the oblique drawing is a cabinet or general oblique, the offset measurements from the multiview drawing must be transferred at the required reduced scale on the receding axis. (Figure 5.60B and C)

The alternate four-center ellipse method cannot be used with oblique drawings that are not full scale; therefore, circular features in these oblique drawings must be constructed using the offset coordinate method. This

method is also used to construct an ellipse in a plane that is inclined to the frontal plane of the oblique drawing. (Figure 5.61) Horizontal cutting planes are used to locate coordinate points, as shown in Figure 5.61B. The cutting planes and coordinate points are then transferred to the oblique drawing (Figure 5.61) and an irregular curve is used to draw the curved surface.

Angles True angular measurements can only be made in an oblique drawing when the plane that contains the angle is parallel to the frontal plane. If the angle lies in one of the oblique receding planes, the angle must be developed by linear measurements. (Figure 5.62A) The measurements are then transferred to the oblique drawing. If the drawing is a cabinet oblique, then all the receding dimensions must first be reduced to half size before being transferred to the oblique drawing, as shown in Figure 5.62B.

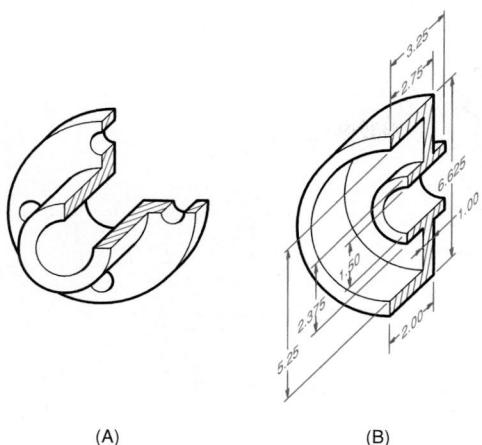

Figure 5.63 Oblique Section Views

Oblique section views use the same conventional practices as multiview section views.

Oblique Sections The same conventions used to develop different section views in isometric drawing are used in oblique drawing. (Figure 5.63) Full-section oblique drawings are seldom used, except for symmetrical parts, because too little outside detail is left, making visualization difficult. (Figure 5.63B) In an oblique section view, section lines should not be placed parallel or perpendicular to object lines. In a half-section view, section lines are drawn such that the lines would appear to coincide if the cut surfaces were to be folded together about the center line of the object. Refer to Chapter 7, “Section Views,” for more details on section conventions and practices.

Screw Threads Threads must be equally spaced along the center line of the thread, but the spacing need not be equal to the actual pitch. Use a distance that is pleasing to the eye, that is, not too crowded or too far apart. Only the crests of the screw thread are represented, using partial circles or ellipses. (Figure 5.64) If a cabinet oblique is drawn, the alternate four-center ellipse method or an ellipse template can be used to draw the threads.

5.3.5 Standards for Dimensions

Oblique drawings are dimensioned in a manner similar to that used for isometric drawings. All pictorial dimensioning conventions of ASME Y14.4M must be followed. Dimensions and notes must lie in the plane

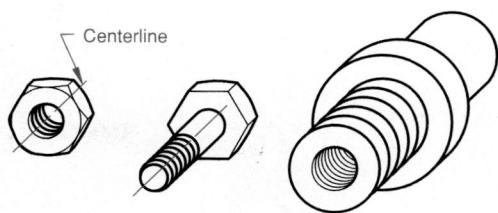

Figure 5.64 Oblique Screw Threads

With oblique screw threads, only the crests are drawn.

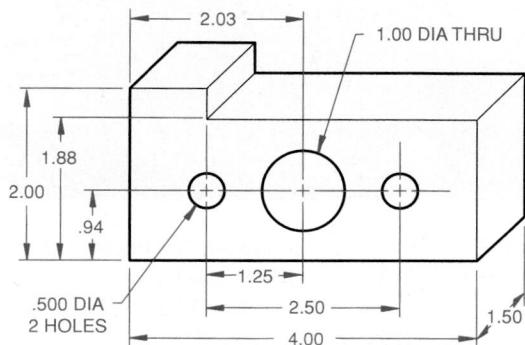

Figure 5.65 Dimensions on an Oblique Drawing

In oblique drawings, dimensions lie in the plane of the surface to which they apply, and unidirectional text placement is used.

of the surface to which they apply and unidirectional dimensioning practices should be followed. Vertical lettering should be used, and the dimensions should always be placed outside of the figure, unless it is clearer to place the dimensions on the figure. (Figure 5.65) Refer to Chapter 8, “Dimensioning and Tolerancing Practices,” for more information.

5.4 PERSPECTIVE DRAWINGS

Perspective drawings are a type of pictorial drawing used to represent 3-D forms on 2-D media. Such drawings create the most realistic representations of objects because the human visual system creates images that closely resemble perspective drawings. To prove this, find a long hall in a building or stand in the middle of a long, flat road. Look at the edges of the road or the points where the ceiling intersects the walls, and follow those lines into the horizon. You will see that the lines appear to converge at a common

Figure 5.66 Convergence as Seen in a Photograph

This photograph shows parallel railroad lines receding to a point on the horizon. (Courtesy of Anna Anderson.)

point on the horizon. (Figure 5.66) Obviously, the edges of the road and the ceiling do not actually converge at a single point. Yet, the human optical system receives the light from an environment and creates an image in our mind that portrays them doing so; that is, shows these edges in perspective.

Perspective projection techniques developed in the 14th and 15th centuries in Europe. Paolo Uccello (1397–1474), Albrecht Dürer, Leonardo da Vinci, and Leon Alberti are credited with developing the theory and techniques. Alberti's book, *On Painting*, published in 1436, laid out the basics of a system for creating a drawing that assumes one viewer and one viewpoint. Perspective drawings and modern photography are constructed as if the viewer has only one eye. Binocular-view images are called stereograms and require special viewing devices.

Leonardo da Vinci used perspective techniques for many of his sketches. (Figure 5.67) Albrecht Dürer perfected a technique to create perspective projections using a grid of wires in a frame that was placed between the subject and the artist. (Figure 5.68) The frame of wires created a grid pattern, which overlaid the subject. The grid pattern was drawn, then used as a guide to create the subject behind the grid. This device assisted in the creation of a perspective drawing.

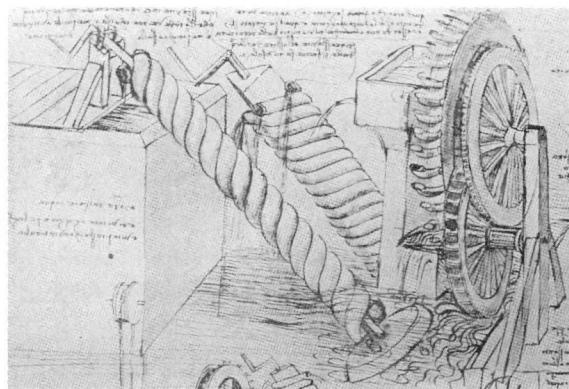

Figure 5.67 Da Vinci Sketch Drawn in Perspective

(By permission of Art Resource, NY.)

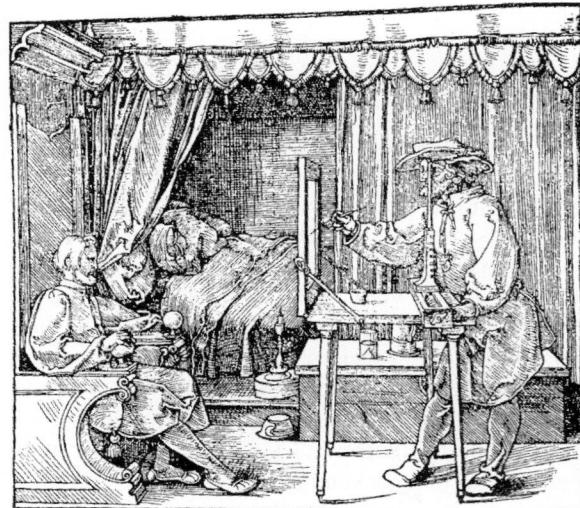

Figure 5.68 Perspective Projection Device

Albrecht Dürer used a projection device to create perspective drawings. (From *A History of Engineering Drawing*, P. J. Booker.)

Practice Exercise 5.2

You can test both Albrecht Dürer's method and the human perspective vision system by placing a piece of clear plastic between yourself and a small object. Position yourself about a foot away from the plastic and, on the plastic, use a marker to sketch the object as you see it. The sketch will be in perspective, proving that humans view the environment in perspective. Change your line of sight and sketch another view of the object to see how moving left, right, up, and down affects the perspective view created.

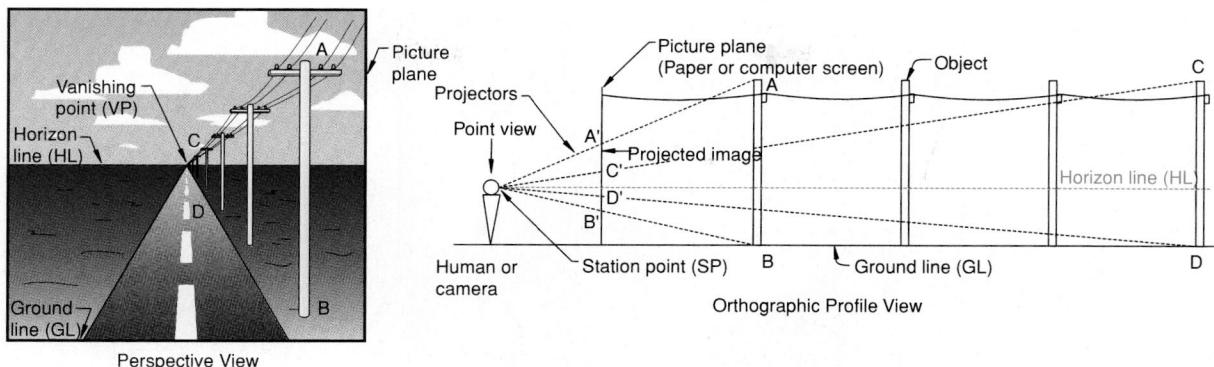

Figure 5.69 Perspective and Orthographic Profile Views of a Scene

5.5 PERSPECTIVE DRAWING TERMINOLOGY

Analyzing a perspective scene will reveal the important components and terms used in perspective drawing. Figure 5.69 shows a perspective drawing of a road, as well as the orthographic side view of the same road. In the perspective view, the sky meets the ground at a line called the *horizon* or *eye level*. The position of the horizon also represents the observer's eye level, which is shown in the orthographic side view. The **horizon line** is the position that represents the eye level of the observer, or the station point; that is, the **station point** in a perspective drawing is the eye of the observer. The station point is shown in the orthographic side view.

The plane upon which the object is projected is called the **picture plane**, where lines of sight from the object form an outline of the object. In the perspective view of Figure 5.69, the picture plane is the sheet of paper on which the scene is drawn. In the orthographic side view, the picture plane's position relative to the observer determines the size of the object drawn.

In Figure 5.69, telephone pole AB is projected onto the picture plane and appears foreshortened as A'B'. Likewise, telephone pole CD is projected onto the picture plane and appears foreshortened as C'D'. Object distance relative to the picture plane can be summarized as follows:

1. As objects move further behind the picture plane, they are projected as smaller images.

2. As objects move further in front of the picture plane, they are projected as larger images.

3. Objects positioned *in* the picture plane are shown true size. (Figure 5.70)

All parallel lines that are *not* parallel to the picture plane, such as the edges of the road in Figure 5.69, converge at the vanishing point. All parallel lines that *are* parallel to the picture plane, such as the telephone poles in Figure 5.69, remain parallel and do not recede to a vanishing point.

An object positioned at an infinite distance from the picture plane appears as a point, called the vanishing point. A **vanishing point** is the position on the horizon where lines of projection converge. Placing the vanishing point directly behind the object, as shown in Figures 5.69 and 5.71B, creates a view looking straight at the object. Placing the vanishing point to the right of the object, as shown in Figure 5.71A, produces a view showing the right side. Similarly, placing the vanishing point to the left of the object produces a view showing the left side, as shown in Figure 5.71C.

Practice Exercise 5.3

Cover Figure 5.72 with a sheet of tracing paper and, using a triangle, begin to extend the converging ends of the long vertical lines of the building. After extending five or six, you will notice that all the lines converge at a single point, called the vanishing point.

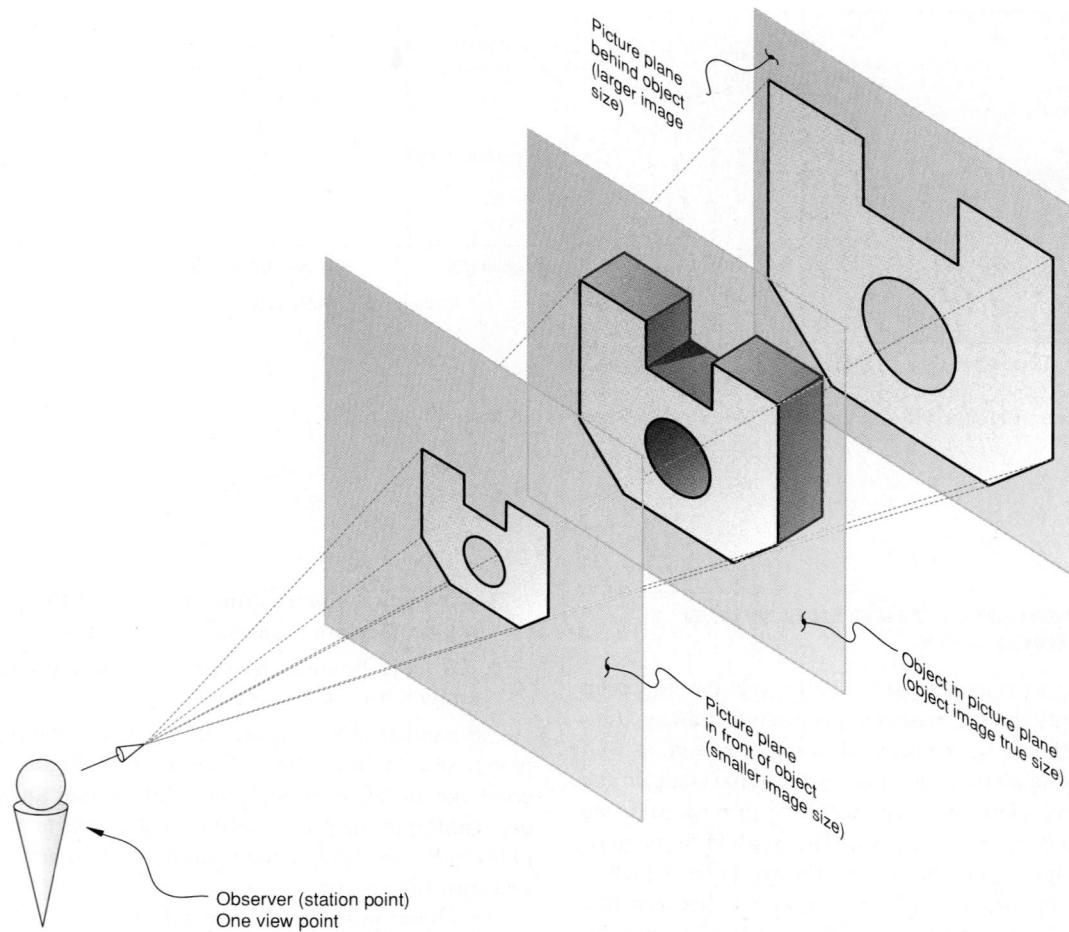

Figure 5.70 Object's Position

Changing the object's position relative to the picture plane determines the size of the object drawn.

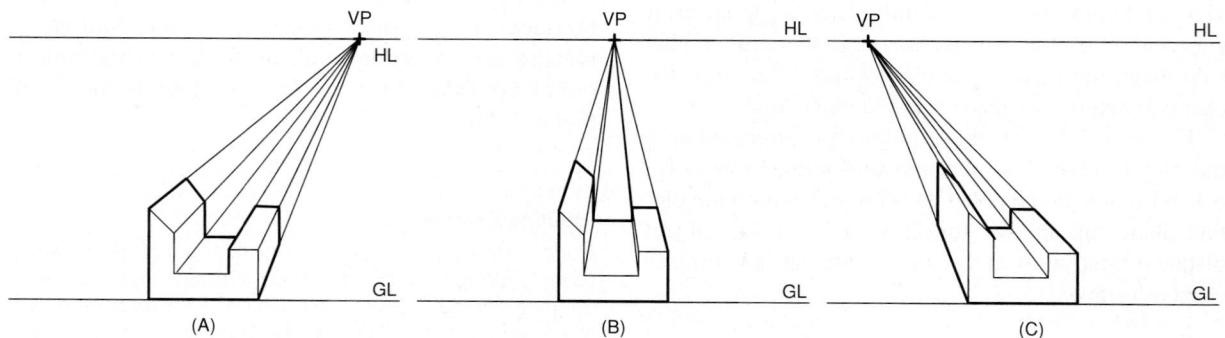

Figure 5.71 Vanishing Point Position

Changing the vanishing point changes the perspective view.

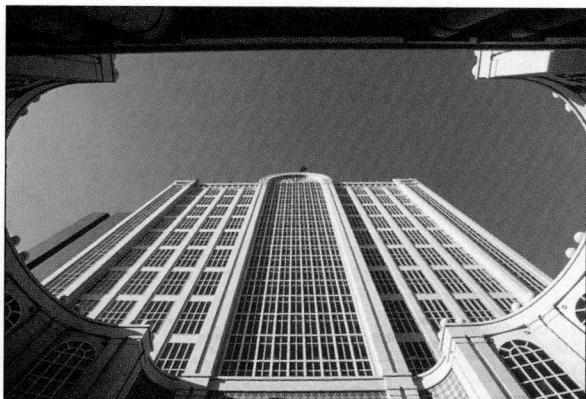

Figure 5.72

Trace this photograph onto tracing paper to determine the vanishing point.

The **ground line** shown in Figure 5.70 represents the plane on which the object rests. The type of perspective view created depends on the position of the ground line relative to the horizon line. Figure 5.73 shows the different types of views created by raising or lowering the ground line. A **bird's eye view** shows the object from above by placing the horizon line above the ground line. A **human's eye view** shows the object from a human adult's perspective by placing the horizon line approximately 6 feet above the ground line. This is commonly used in scaled architectural drawings. The **ground's eye view** shows the object as if the observer were lying on the ground; that is, the horizon and ground lines are in the same position. A **worm's eye view** shows the object from below by placing the ground line above the horizon line.

5.6 PERSPECTIVE DRAWING CLASSIFICATIONS

Perspective views are classified according to the number of vanishing points used to create the drawing. Figure 5.74 shows *one-, two-, and three-point perspective drawings*. A one-point perspective drawing, sometimes referred to as a *parallel perspective*, is created when one face of the object is parallel to the plane of projection. A two-point perspective drawing, sometimes referred to as an *angular perspective*, is created when the object is positioned at

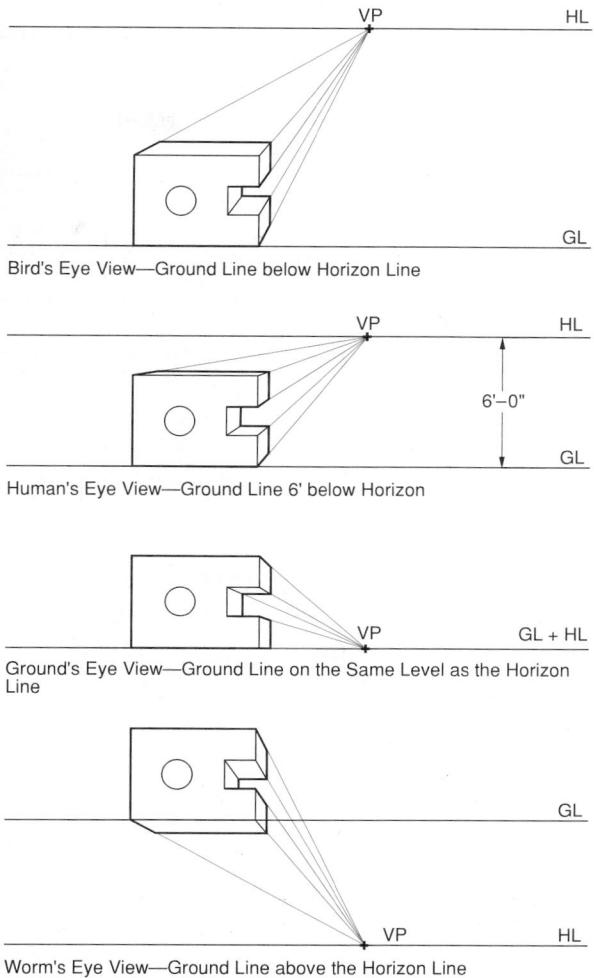

Figure 5.73 Ground Line Position

Changing the ground line relative to the horizon line changes the perspective view created.

an angle to the plane of projection and the vertical edges are parallel. In a three-point perspective drawing, no edges of the object are parallel to the plane of projection.

By varying the number of vanishing points, the positions of the vanishing points, and the position of the ground line relative to the horizon line, you can create virtually any perspective viewpoint of an object. (Figure 5.75) There are two basic systems for creating perspective drawings using hand tools:

1. The plan view method.
2. The measuring line method.

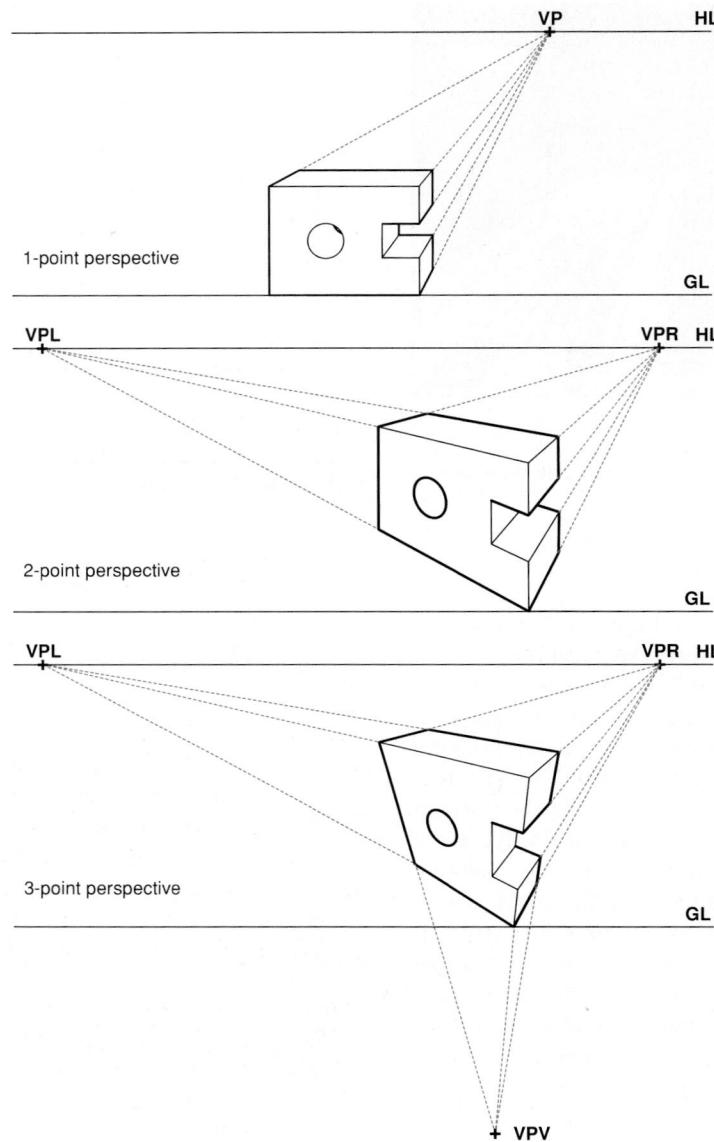

Figure 5.74 Classification of Perspective Drawings

Perspective views are classified by the number of vanishing points.

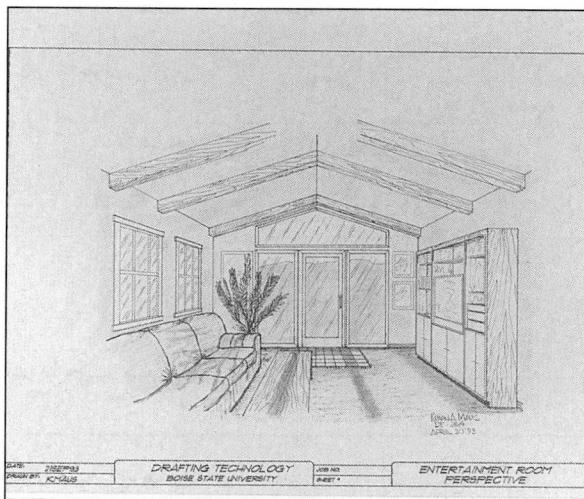

Figure 5.75 Two-Point Perspective Drawing

(Irwin drawing contest winner, K. Maus, Boise State University.)

5.7 PERSPECTIVE DRAWING VARIABLES SELECTION

Before starting on any type of perspective drawing, you must first visualize the desired view, then set the variables that will produce that view. The variables in perspective drawings are:

1. *Distance of object from picture plane.* Normally, you would like the object to be drawn without distortion, so the object is positioned on or very near the picture plane. As object distance behind the picture plane increases, object size gets smaller. As object distance in front of the picture plane increases, object size gets larger. (See Figure 5.70)
2. *Position for station point.* Normally, you would want the station point directed toward the center of the object, sometimes called the *center of interest*. The station point is usually positioned slightly above and to the left or right of the object, at a distance that produces a cone of vision of approximately 30 degrees. (Figure 5.76)
3. *Position of ground line relative to horizon.* Ground lines placed above the horizon will produce a view from below the object. Ground lines placed below the horizon will produce a view from above the object. (See Figure 5.73)
4. *Number of vanishing points.* To create a one-, two-, or three-point perspective, you would select one, two, or three vanishing points, respectively.

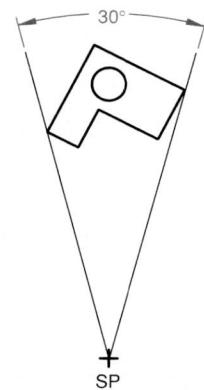

Figure 5.76 30° Cone of Vision

The cone of vision for most perspective drawings should be approximately 30 degrees.

5.8 ONE-POINT PERSPECTIVES

5.8.1 Plan View Method

In the plan view method, the depth dimensions are determined by projecting lines from the top view (i.e., the plan view) to the station point. Plan view is the common term used in architectural drawing. The following steps demonstrate how to create a one-point perspective drawing using the plan view method. (Figure 5.77) The perspective view to be created will be slightly above and to the right, near full scale, with a cone of vision of approximately 30 degrees.

Creating a One-Point Perspective Drawing, Plan View Method

Step 1. To establish the locations of the picture plane, horizon line, and ground line, first draw a long, horizontal line across the center of the work area (draw all lines as construction lines). This will be the horizon line (HL). Then, draw the picture plane (PP) line horizontally near the top of the work area. Finally, draw the ground line (GL) horizontally near the bottom of the work area, to produce a view of the object from above. Label all lines as shown in Figure 5.77.

Step 2. Draw the plan view (i.e., the top view) of the object on the picture plane line. This will produce a perspective view that will be near full size. Draw the right side or profile view near the right edge of the work area, with the base on the ground line. Locate the station point (SP) by measuring down from the picture plane line by a distance of two or three times the width of the object and slightly to the right of center.

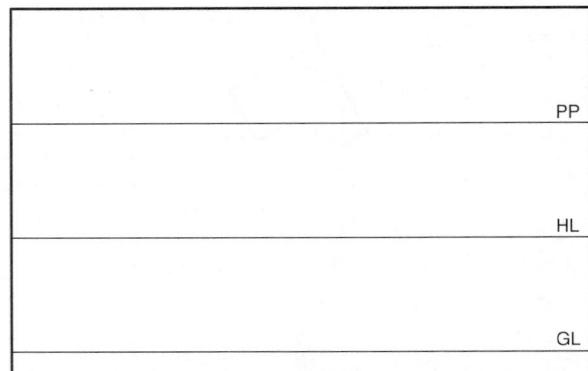

Step 1

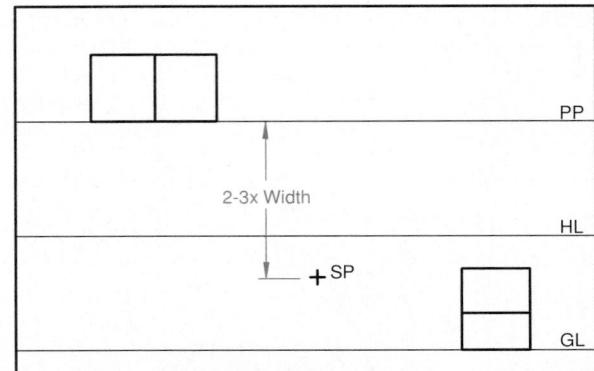

Step 2

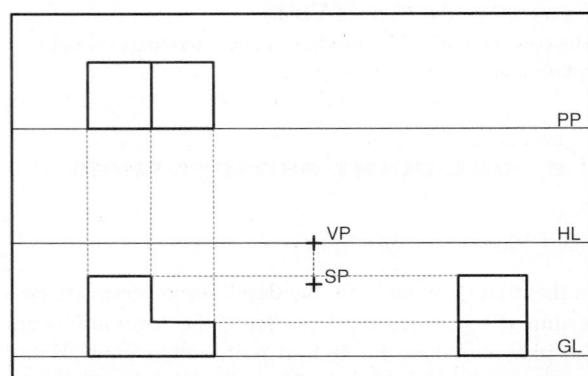

Step 3

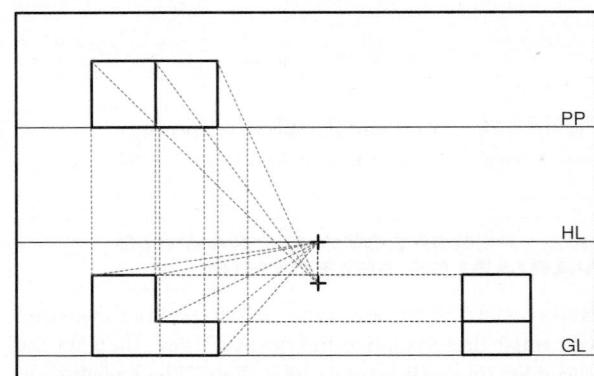

Step 4

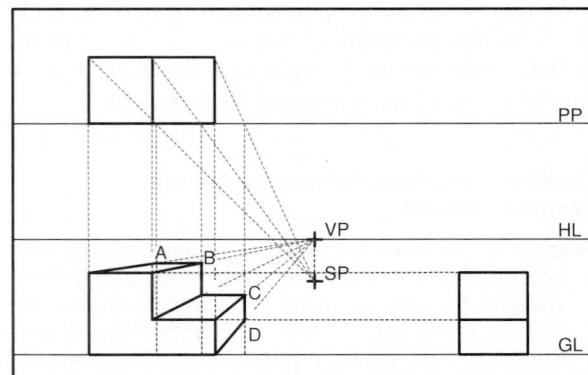

Step 5

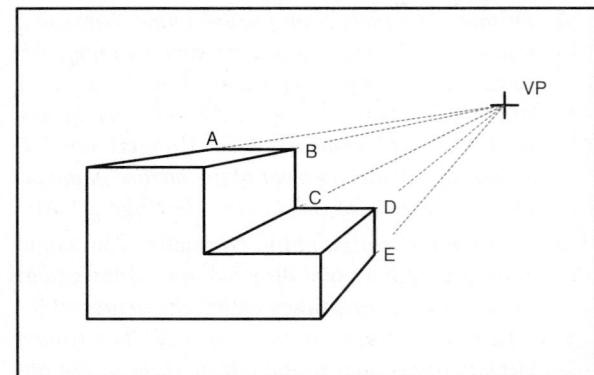

Finished Perspective

Figure 5.77 Steps in Making a Plan View One-Point Perspective Drawing

Step 3. Draw the front face of the perspective view by first projecting the width of the object from the plan view vertically down to the ground line. Then, project the height dimensions horizontally across from the right side view. The front plane of the object is parallel to the picture plane, so it is true size and can be drawn using the width dimensions projected from the plan view. Project a vertical line from the station point up to the horizon line to determine the location of the vanishing point (VP).

Step 4. This step will help establish the depth distances in the perspective view. From the plan view, project all of the back corners of the object to the station point. From the points where these projectors cross the picture plane line, drop vertical lines down to the ground line. From the front view, draw lines from the corners of the object to the vanishing point on the horizon line. The front view will be part of the perspective drawing.

Step 5. The vertical projectors from the picture plane line intersect the projectors from the front view to the vanishing point. These intersections establish the depth points for the perspective drawing. Draw a line between points A and B, B and C, C and D, and D and E, to create that part of the back plane of the object that can be seen. Draw lines from the front corners to the rear corners of the object along the projectors to the vanishing point, to complete the one-point perspective drawing of the object. *Do not include dashed lines for hidden features unless absolutely necessary for visualization.*

5.8.2 Measuring Line Method

The measuring line method does not need a plan view to create the perspective. Depth distances are established along the measuring line and are projected to a measuring point on the horizon line. Figure 5.78 and the following steps describe how to create a one-point perspective drawing using the measuring line method.

Creating a One-Point Perspective Drawing, Measuring Line Method

Step 1. Establish the locations for the ground line (GL), picture plane (PP), and horizon line (HL). For this example, the ground line is located above the horizon line to create a view from below the object. Locate the station point (SP) to the right of center on the ground line. Locate the vanishing point (VP) by projecting a vertical line from the station point down to the horizon line.

Step 2. Establish a point A' of the object anywhere on the picture plane, although near the midpoint works best. This point represents one of the corners of the object. Project point A' vertically down to the ground line, to establish point A. Measure the width of the object along the ground line by starting at point A and measuring to the left, establishing point B.

Step 3. Establish the height of the front view along line A'-A by locating point D. Draw the true-size front face of the object (A, B, C, and D).

Step 4. From point A' on the picture plane, project a vertical line up to the top border. From point A', measure the depth of the object along the vertical line just constructed, to establish point X. Using point A' as the center point and line A'-X as the radius, revolve line A'-X into the picture plane, to establish point Y. Draw a line from X to Y. Draw a line parallel to line X-Y from the station point to the picture plane, establishing intersection point Z. Drop a vertical line from point Z to the horizon line, to establish the measuring point (MP).

Step 5. Distance A'-X (the object depth) is marked along the ground line to the right of point A on the front face of the object, establishing point G. Draw a line from point G to the measuring point (MP), establishing the measuring line. Draw a line from point A to the vanishing point. At the point where this line intersects the measuring line (O), the depth of the object is located.

Step 6. Project the remaining corners of the object to the vanishing point. Draw a vertical and a horizontal line from point O, to establish the back of the object. Darken all lines to complete the one-point perspective of the object.

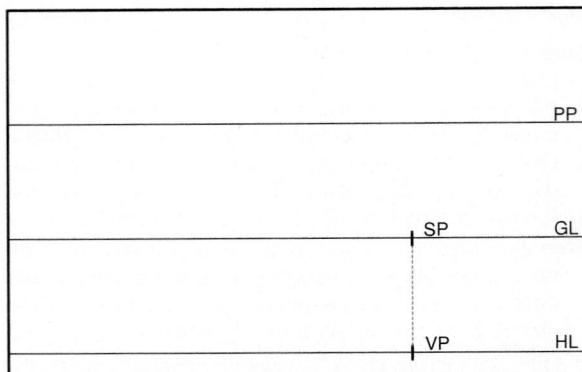

Step 1

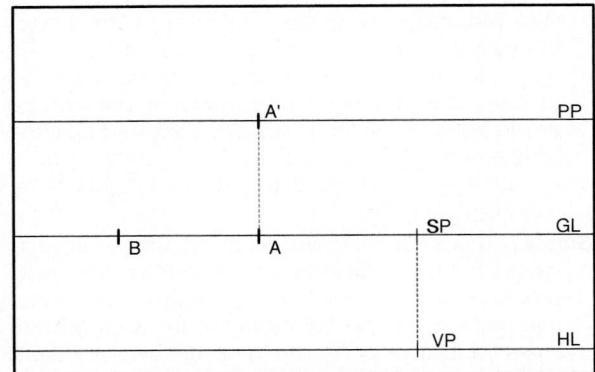

Step 2

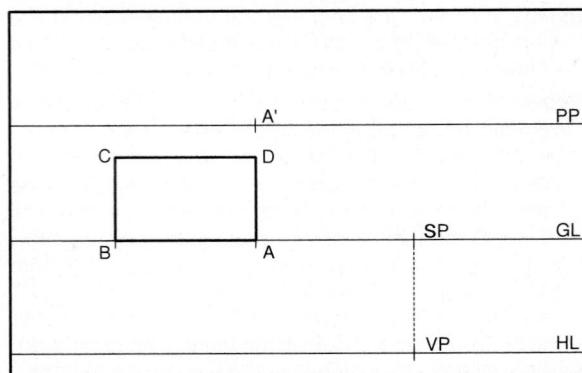

Step 3

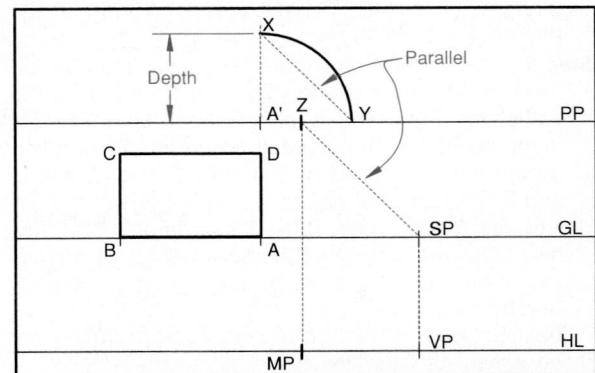

Step 4

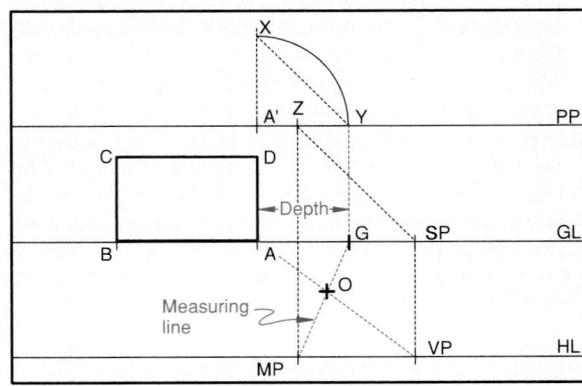

Step 5

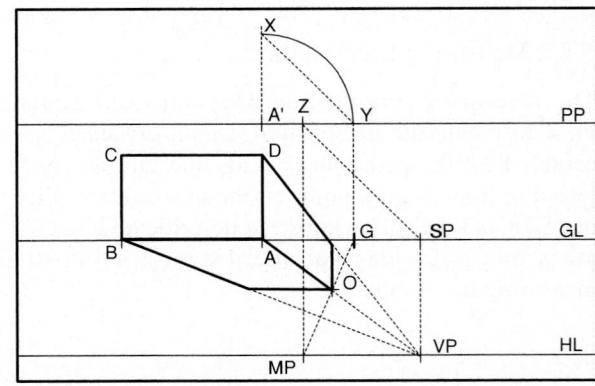

Step 6

Figure 5.78 Steps in Making a Measuring Line One-Point Perspective Drawing

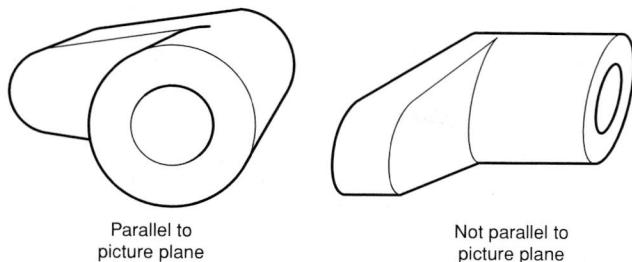

Figure 5.79 Representing Circular Features in One-Point Perspective

5.8.3 Circular Features

If circles and arcs are part of the object to be drawn using a one-point perspective, it is easier to draw these features if they are parallel with the picture plane. Circular shapes parallel to the picture plane are projected and drawn as circles and arcs in the perspective. (Figure 5.79) If the circular feature is not parallel to the picture plane, then the feature must be drawn as an ellipse.

A fourth method of creating a perspective drawing with CAD is with an integrated or add-on illustration software program. The illustration software reads the CAD 3-D model file for editing. The model is assigned material properties, colors, light types and sources, and other variables. Once the material and light properties are assigned, the model is processed and then displayed on screen. Using this method, photorealistic perspective renderings can be produced, as shown in Figure 5.82. 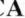 **CAD Reference 5.10**

5.9 CAD PERSPECTIVE DRAWINGS

CAD software can be used in four ways to create perspective drawings. The first method involves constructing a perspective view using the same techniques described earlier, using the CAD software to replace the traditional tools. To construct the perspective ellipses, use the ELLIPSE option by drawing a perspective square and locating the ellipse through three points.

In the second method, use a CAD program that has a perspective grid option. The grid is used to construct a perspective pictorial of the part. (Figure 5.80)

The third method creates a 3-D model using a CAD program that automatically creates perspective views. The perspective view shown in Figure 5.81 was created automatically, using a display option.

5.10 SUMMARY

The three classifications of pictorial drawings are axonometric, oblique, and perspective. Isometric drawings are the most popular among the various axonometric drawings, because they are the easiest to create. Both axonometric and oblique drawings use parallel projection. As the axis angles and view locations are varied, different pictorial views of an object can be produced.

There are three types of perspective drawings: one-, two-, and three-point. Each type refers to the number of vanishing points used to construct the drawings. Three-point perspectives are the most difficult to construct but are the most realistic. Other variables, such as position of the ground line in relation to the horizon line, can be controlled to produce virtually any view of an object.

Figure 5.80 A CAD Perspective Pictorial Constructed Using a Perspective Grid

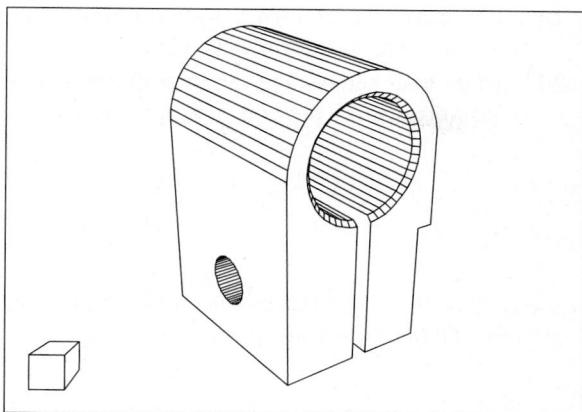

Figure 5.81 A CAD 3-D Model Displayed in Perspective View

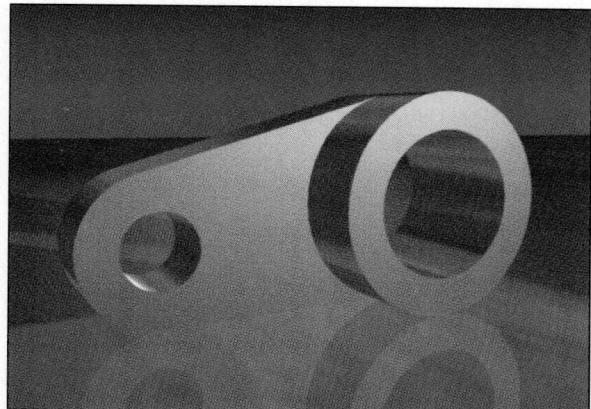

Figure 5.82 Rendered Perspective Illustration of a CAD 3-D Model

KEY TERMS

Axonometric projection
 Axonometric axes
 Bird's eye view
 Cavalier oblique
 Cabinet oblique
 Center of interest
 Dimetric drawing
 Dimetric projection
 General oblique

Ground's eye view
 Ground line
 Horizon line
 Human's eye view
 Isometric axes
 Isometric drawing
 Isometric grid
 Isometric line
 Isometric plane

Isometric projection
 Long axis isometric
 Nonisometric line
 Nonisometric plane
 Oblique projection
 Offset coordinate method
 Offset measurement
 Picture plane
 Regular isometric

Reversed axis isometric
 Station point
 Trimetric drawing
 Trimetric projection
 Vanishing point
 Worm's eye view

QUESTIONS FOR REVIEW

1. Define oblique projection.
2. List and describe the differences between the three different types of oblique drawing.
3. List the steps in developing an ellipse using the alternate four-center ellipse method.
4. Describe how irregular curved surfaces are developed in oblique drawings.
5. Describe how angles are determined in oblique drawings.
6. Describe how dimensions are placed on oblique drawings.
7. Describe how screw threads are represented in oblique drawings.
8. Define axonometric.
9. Define isometric, dimetric, and trimetric drawings.
10. Explain the difference between an isometric projection and an isometric drawing. Which would be drawn larger?
11. Sketch the axes used for an isometric drawing.
12. Sketch the axes used for regular, reversed, and long axis isometric drawings.
13. What is the general rule for hidden lines in isometric drawings?
14. Give examples of pictorial drawings used in industry.
15. Sketch an isometric cube, then show how isometric ellipses would be drawn on each face of the cube. Add center lines to the ellipses.
16. What are the three angular measurements of isometric drawing axes?

17. Describe perspective projection theory. Use sketches if necessary.
18. Identify the horizon line, station point, picture plane, vanishing point, and ground line in Figure 5.83.
19. Sketch and label bird's eye, human's eye, ground's eye, and worm's eye views.
20. List the four perspective variables that should be considered before drawing a perspective view

FURTHER READING

Helms, M. *Perspective Drawing*. Englewood Cliffs, NJ: Prentice Hall, Inc., 1990.

Thomas, T. A. *Technical Illustration*. 3rd ed. New York: McGraw-Hill Book Company, 1978.

PROBLEMS

Hints for Solving the Pictorial Drawing or Sketching Problems

- Identify the types of surfaces (i.e., normal, inclined, oblique, and curved) on the object in the multiview.
- Focus initially on the normal surfaces, evaluating their sizes, shapes, and locations.
- After sketching the bounding box, sketch those normal surfaces that lie in the same planes as the bounding box sides. These surfaces, when seen in their edge views in the multiview, should form the perimeter of the views.
- Next, sketch the normal surfaces inside the bounding box. Calculate their locations in the box by evaluating the locations of their edge views in the multiview.
- Since the angles of inclined and oblique surface edges cannot be calculated directly from the multiviews, identify the edges they share with normal faces in the multiview and in the pictorial, then connect vertices with edges not yet completed in the pictorial.
- Locate the center lines of holes and cylinders in the multiview and transfer them to the pictorial. Create bounding boxes of the appropriate sizes and sketch the ellipses.
- Double-check the completeness of the pictorial by comparing the pictorial to the multiview, surface-by-surface. For the more complex surfaces, count the number of sides and make sure those edges that are parallel in the multiview are also parallel in the pictorial.

5.1 Given the orthographic views in Figure 5.84, use traditional tools or CAD to create isometric or oblique drawings or sketches of those objects assigned by your instructor.

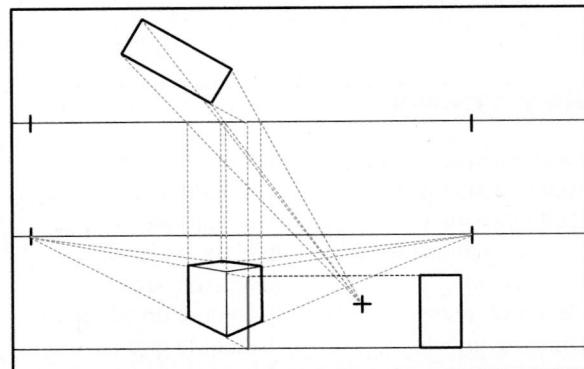

Figure 5.83

Identify important parts of a perspective drawing.

5.2 Using any of the objects you have sketched as an isometric pictorial, create new sketches that are:

- a. Reverse axis isometric.
- b. Long axis isometric, looking from the right.
- c. Long axis isometric, looking from the left.

Compare the sketches and answer the following questions:

- Have the angles of the isometric axes on the paper changed? Color code the three primary dimension axes in each of the sketches and compare them.
- Compare the isometric axes with each other in each of the pictorials. Do they all still subtend 120 degrees to each other?

- Color code or label identical surfaces in each of the pictorials (not all of the surfaces will be seen in all of the views). For surfaces that are seen in multiple pictorials, do they have the same number of edges? Are edges that are parallel in one pictorial parallel in the other? Do the surfaces have the same orientation? Do they have the same shape?

5.3 With a sheet of clear plastic as a projection plane, use a water-based marker to draw objects in the projection plane. Try to capture a pictorial view of the object.

- a. With a large object (such as a building), draw the projection, including the convergence of edges. Only draw the major features of the object. With a different color pen, overdraw the same view in parallel projection by “straightening out” the convergence.
- b. Repeat with a smaller object. Why is convergence not nearly as noticeable on the small object?

5.4 Use a sheet of clear plastic as a projection plane and draw an object about the size of your projection plane. Stand about 3 to 4 feet away from the object. Then, repeat the sketch in a different color marker, but with the projection plane up against the object. What has changed? What if you sketched the object from across the room?

5.5 Create a one-point perspective sketch and an oblique sketch receding in the same direction. How do they compare?

5.6 Using a picture representing a relatively small object, sketch four one-point perspective pictorials, using different combinations of vanishing point and horizon line. Make sure each of the horizon lines is used at least once.

Vanishing Point	Horizon Line
To the right of the object	Bird's eye view
Behind the object	Human's eye view
To the left of the object	Ground's eye view

Using the same combinations, sketch a larger object about the size of a car and another one the size of a building. Which horizon line seems most appropriate for each of the objects? How do these horizon lines relate to how we view these objects in the real world?

5.7 Sketch a series of six one-point perspectives (human's eye view), incrementing the station point from the left of the object to the right of it. Sketch another series of six one-point perspectives with the same object, holding the station point behind the object, but incrementally rotating the object 90° counterclockwise. Are both sets of sketches representing the same relative movement of the viewer and object? How do the sketches differ? How are they the same?

5.8 On B-size or A3 drawing sheets, use instruments or CAD to create one-point perspective drawings of the objects shown in Figures 5.85 through 5.92.

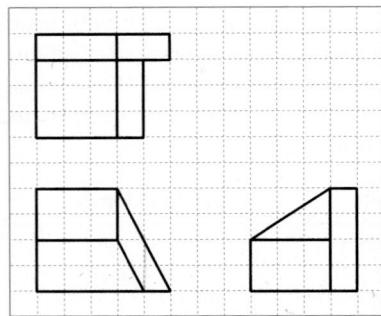

(1)

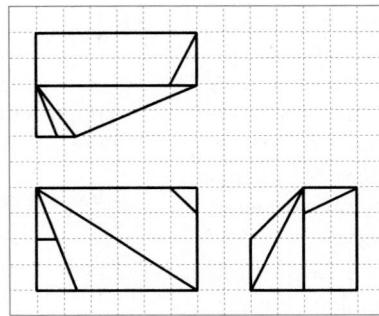

(2)

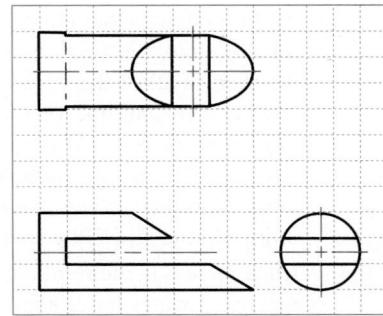

(3)

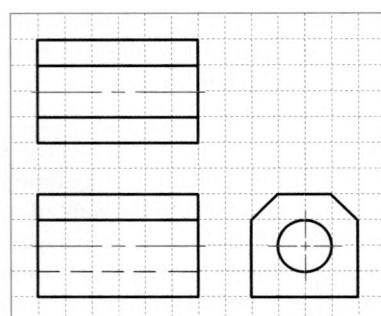

(4)

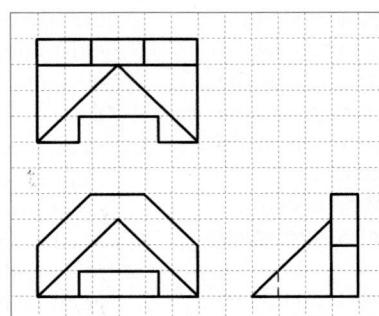

(5)

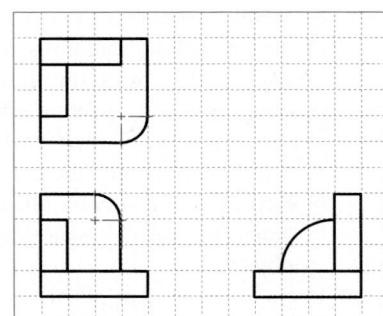

(6)

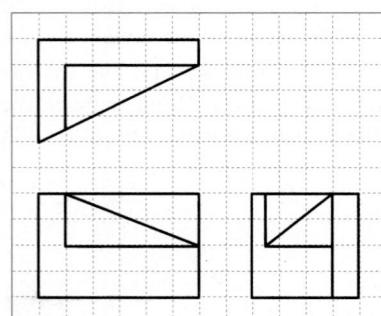

(7)

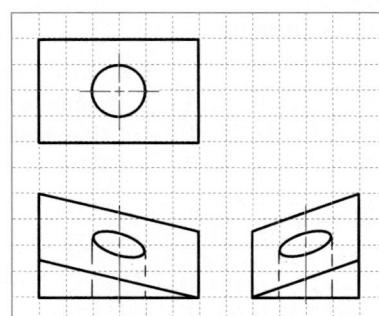

(8)

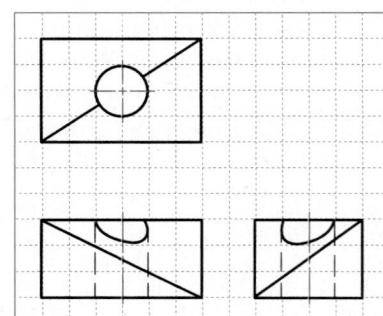

(9)

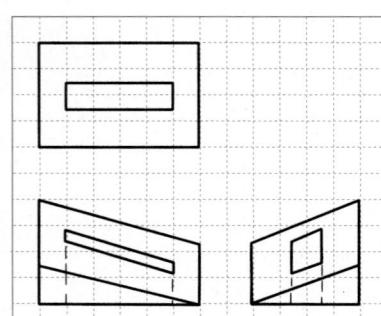

(10)

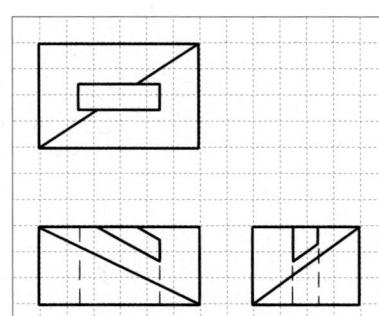

(11)

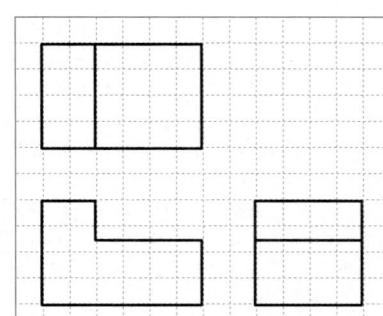

(12)

Figure 5.84 Orthographic Views for Problem 5.1

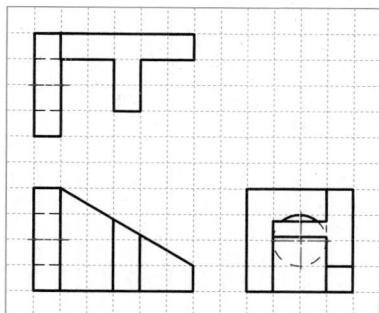

(13)

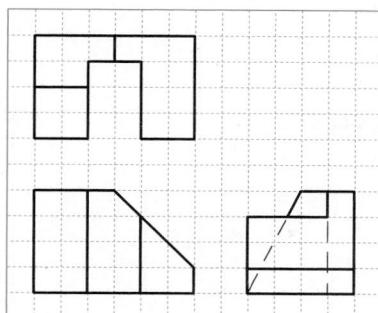

(14)

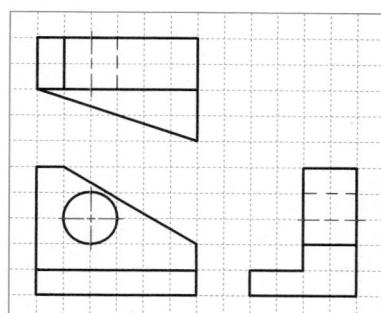

(15)

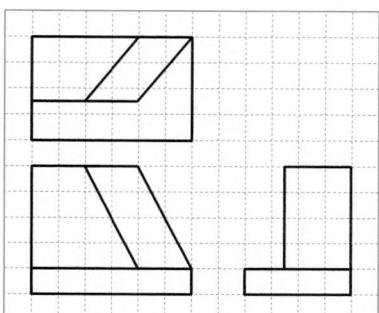

(16)

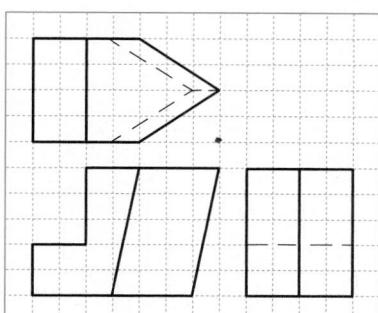

(17)

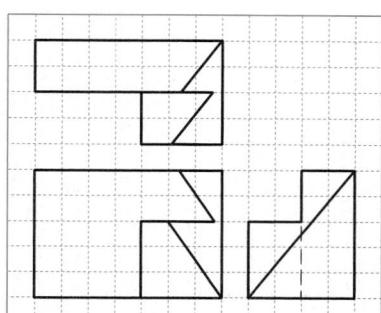

(18)

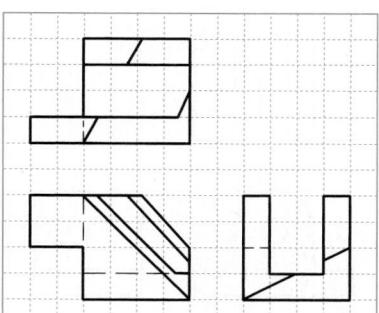

(19)

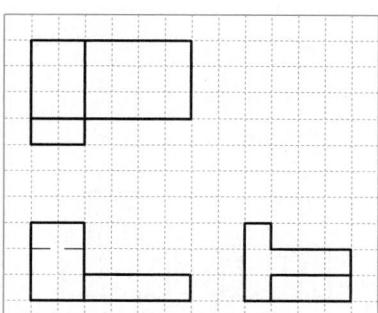

(20)

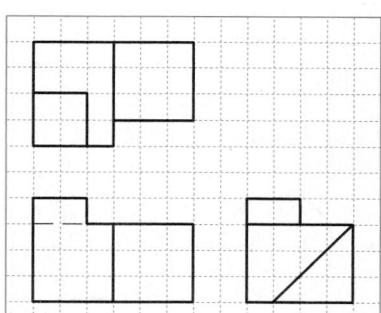

(21)

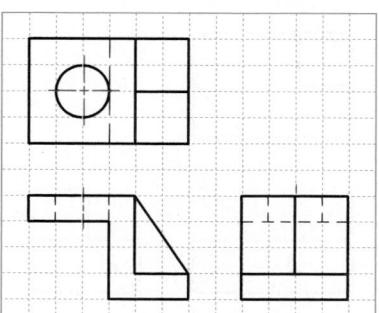

(22)

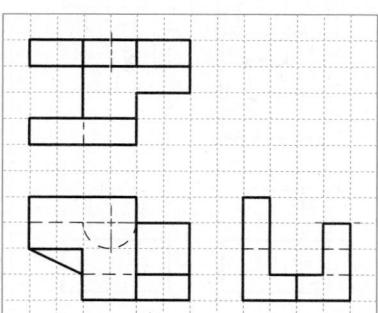

(23)

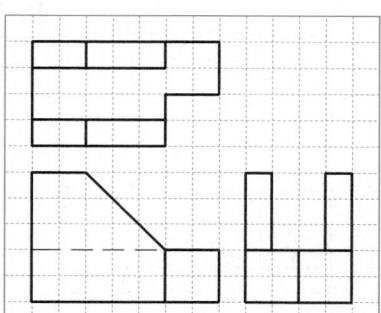

(24)

Figure 5.84 Continued

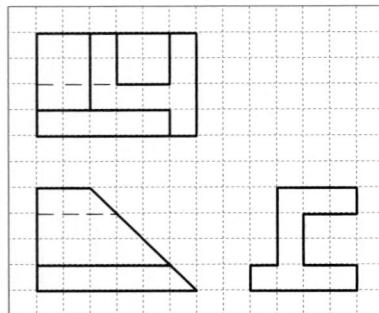

(25)

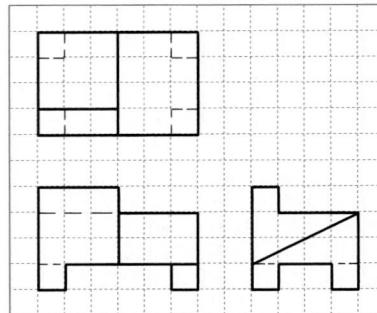

(26)

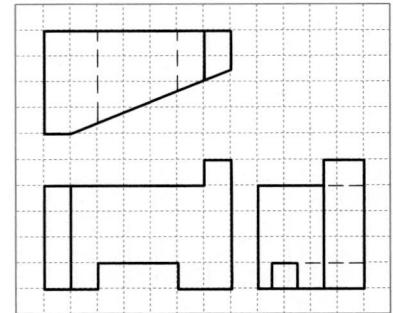

(27)

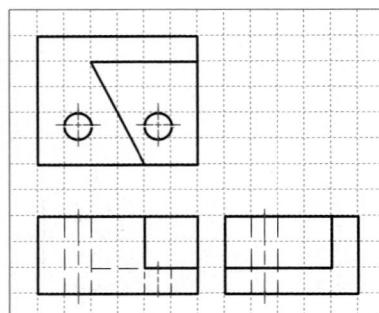

(28)

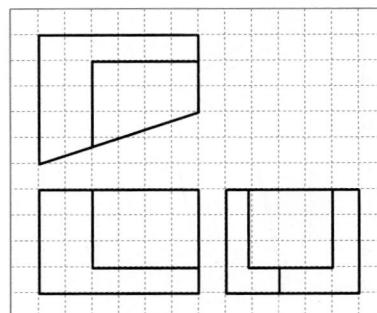

(29)

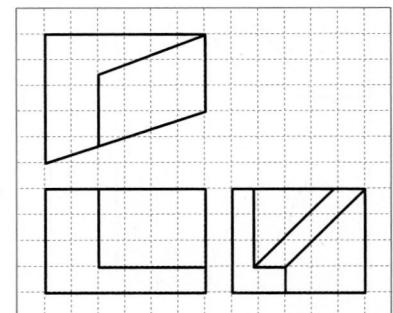

(30)

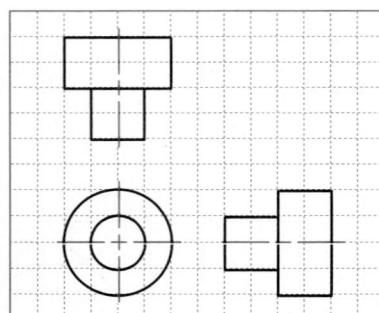

(31)

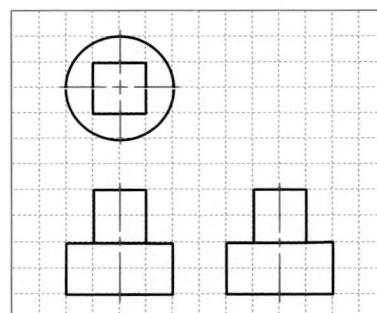

(32)

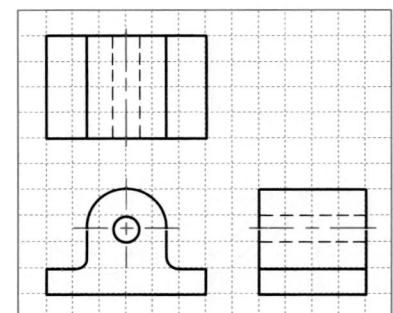

(33)

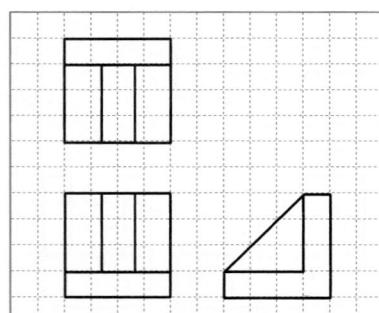

(34)

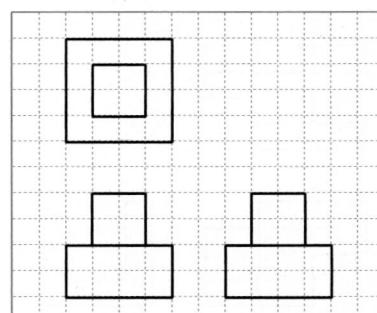

(35)

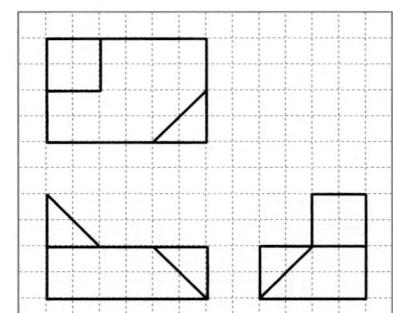

(36)

Figure 5.84 Continued

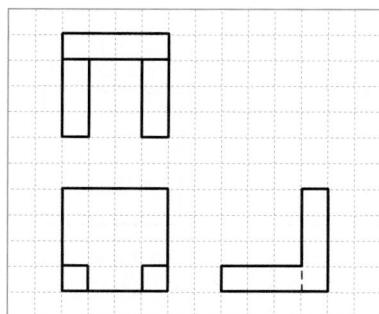

(37)

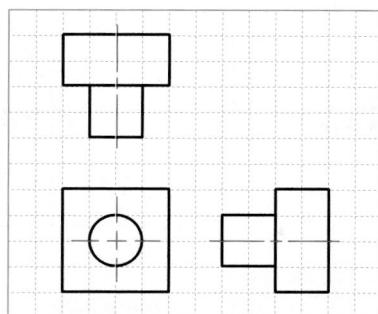

(38)

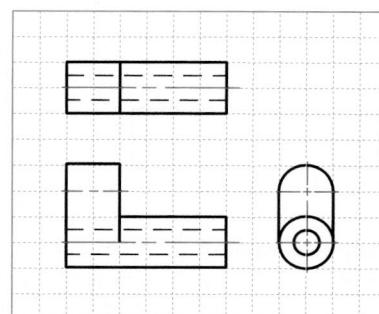

(39)

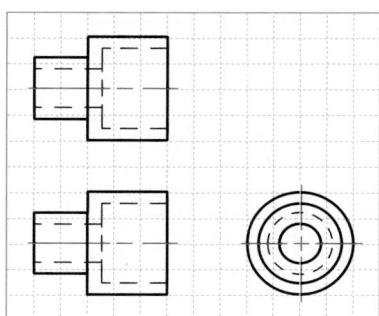

(40)

(41)

(42)

(43)

(44)

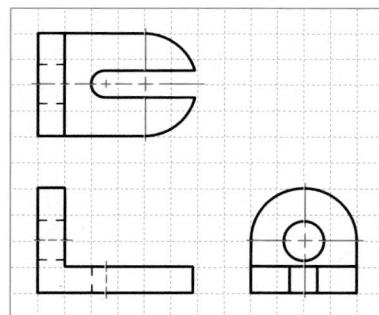

(45)

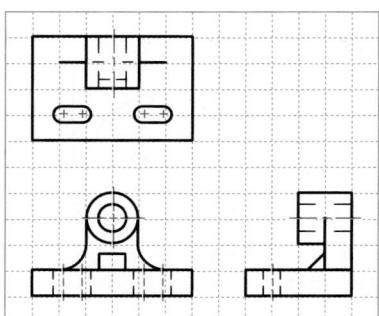

(46)

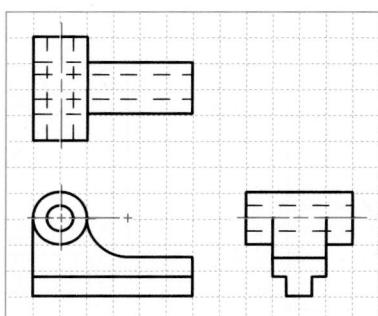

(47)

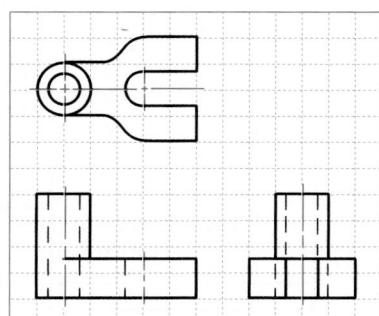

(48)

Figure 5.84 Continued

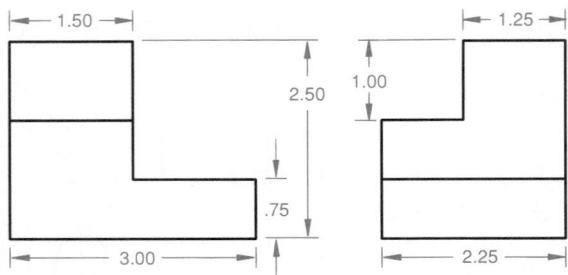

Figures 5.85–5.92

Create one-, two-, or three-point perspective drawings of the objects shown in the figures, using a B-size or A3-size sheet.

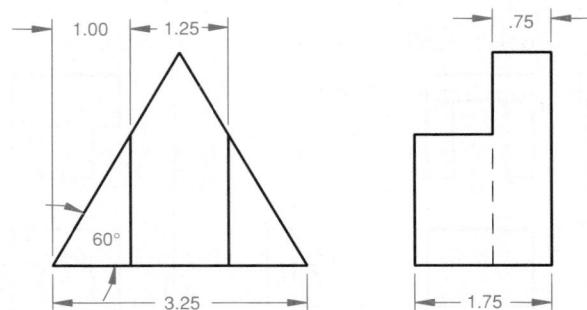

Figure 5.86

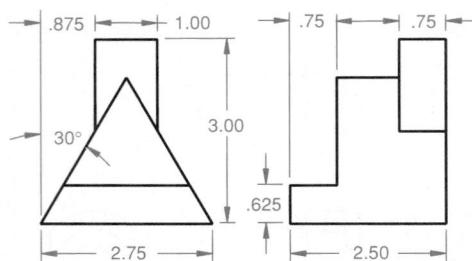

Figure 5.87

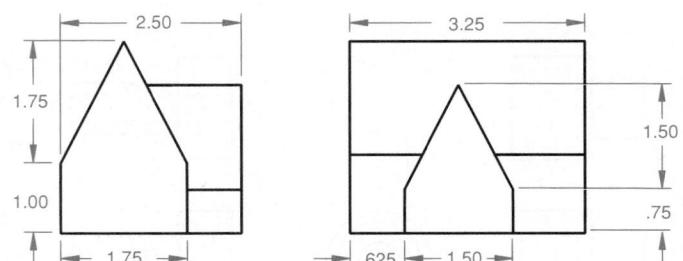

Figure 5.88

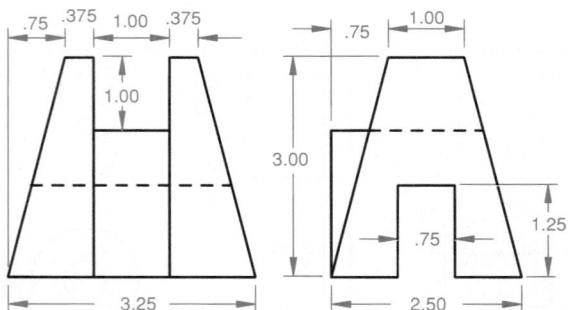

Figure 5.89

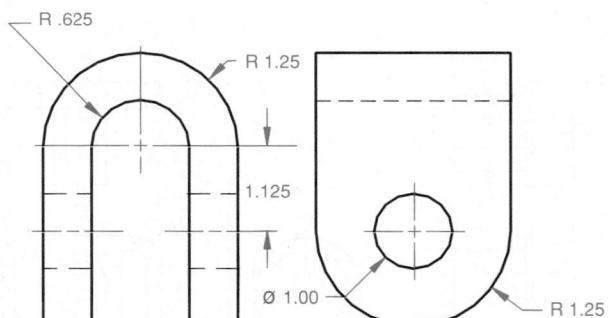

Figure 5.90

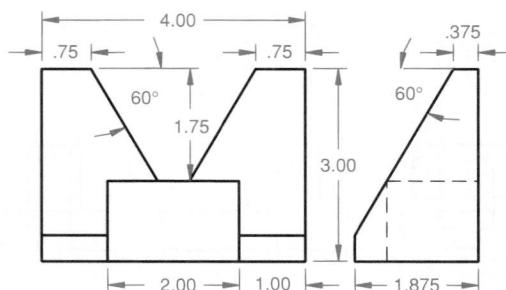

Figure 5.91

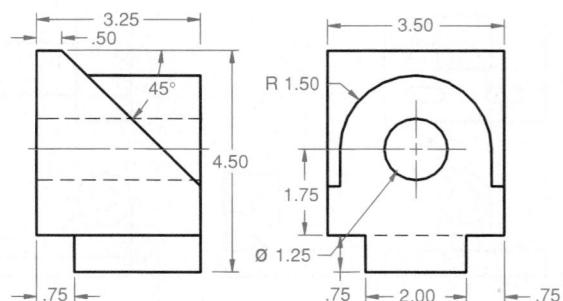

Figure 5.92

CHAPTER 6

Auxiliary Views

For the vision of one man lends not its wings to another man.

Kahlil Gibran

OBJECTIVES

After completing this chapter, you will be able to:

1. Create auxiliary views of inclined planes.
2. Use reference planes and fold lines when creating auxiliary views.
3. Explain auxiliary view projection theory.
4. Define primary, secondary, and tertiary auxiliary views.
5. Define width, height, and depth auxiliary views.
6. Create successive auxiliary views.
7. Solve dihedral angle problems.
8. Create a partial auxiliary view.
9. Plot curves in auxiliary views.
10. Use auxiliary views for reverse construction.
11. Create a view in a specified direction using auxiliary views.
12. Understand the difference between 2-D methods and 3-D CAD in creating auxiliary views.

There are times when one of the six principal views will not completely describe an object. This is especially true when there are inclined or oblique planes or features on an object. For these cases, a special orthographic view called an auxiliary view can be created. This chapter describes how to create auxiliary views for objects that cannot be clearly represented by the six principal views. Also described is the use of auxiliary views to solve spatial geometry problems, such as the point and true-length views of lines and edges, and the true-size views of planes.

6.1 AUXILIARY VIEW PROJECTION THEORY

An **auxiliary view** is an orthographic view that is projected onto any plane other than the frontal, horizontal, or profile plane. An auxiliary view is not one of the six principal views. Figure 6.1A shows three principal views of an object. Surface ABCD is in an inclined plane and is therefore never seen in true size or shape in any of these views. In a multiview drawing, a true size and shape plane is shown only when the *line of sight (LOS)* used to create the view is perpendicular to the projection plane. To show the true size and shape of surface ABCD, an auxiliary view can be created by positioning a line of sight perpendicular to the inclined

plane, then constructing the new view. (Figure 6.1B) Two methods of creating auxiliary views are the *fold-line method* and the *reference plane method*. These are discussed in the following sections.

Practice Exercise 6.1

On a flat surface, place a small object that has an inclined plane, such as the part shown in Figure 6.1. Determine the principal views for this object for a three-view multiview drawing. Position a rigid, clear plastic sheet in front of and parallel to a principal view such that the inclined plane appears foreshortened. Using a water-soluble color marker, trace the outline of the inclined surface on the clear plastic sheet. Then, position the clear plastic sheet in front of and parallel to the inclined surface. Trace the outline of the inclined surface on the clear plastic sheet. Use a ruler to measure the perimeters of the two views of the inclined surface. Explain why the distances are not equal.

6.1.1 Fold-Line Method

In Figure 6.2, the object is suspended in a glass box to show the six principal views, created by projecting the object onto the planes of the box. The box is then unfolded, resulting in the six principal views. However, when the six views are created, surface ABCD never appears true size and shape; it always appears either foreshortened or on edge.

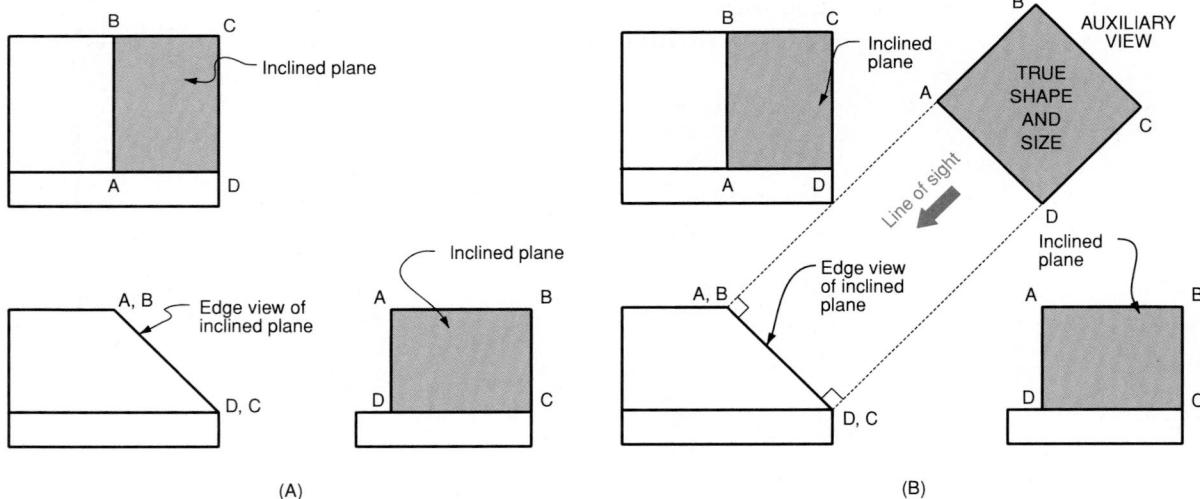

Figure 6.1 Auxiliary View

An auxiliary view of an inclined plane is not one of the principal views.

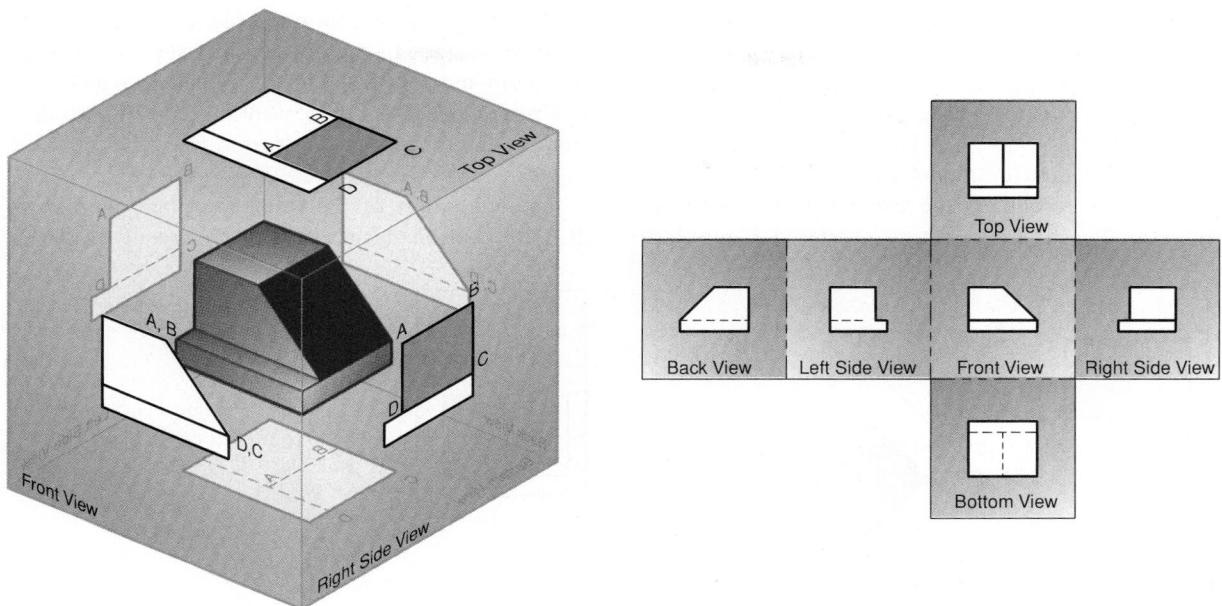

Figure 6.2 Object in Glass Box, and Resulting Six Views When the Box Is Unfolded

Figure 6.3 shows the object suspended inside a glass box, which has a special or *auxiliary plane* that is parallel to inclined surface ABCD. The line of sight required to create the auxiliary view is perpendicular to the new projection plane and to surface ABCD. The auxiliary plane is perpendicular to and hinged to the frontal plane, creating a *fold line* between the front view and the new auxiliary view.

In Figure 6.4, the auxiliary glass box is unfolded, with the fold lines between the views shown as phantom lines. In the auxiliary view, surface ABCD is shown true size and shape and is located at distance M from the fold line. The line AB in the top view is also located at distance M from its fold line. Changing the position of the object, such as moving it closer to the frontal plane, changes distance M. (Figure 6.5)

6.1.2 Reference Plane Method

The reference plane method of creating an auxiliary view is simply a variation of the fold-line method. In Figures 6.3 and 6.4 the frontal plane of projection is the frontal fold line in the multiview drawing that is used to construct the auxiliary view. This fold line

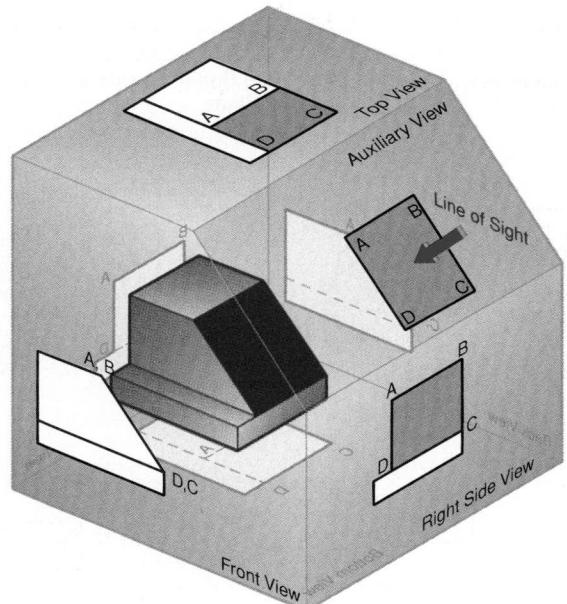

Figure 6.3 Object in Glass Box with Special Auxiliary Plane

is used as a *reference plane* for transferring distances from the top view to the auxiliary view. The reference plane method is a technique that locates a plane relative to the object, instead of suspending the object in a glass box. This single plane is then used to take measurements to create the auxiliary view. The reference plane can be positioned anywhere relative to the object, as shown in Figure 6.6.

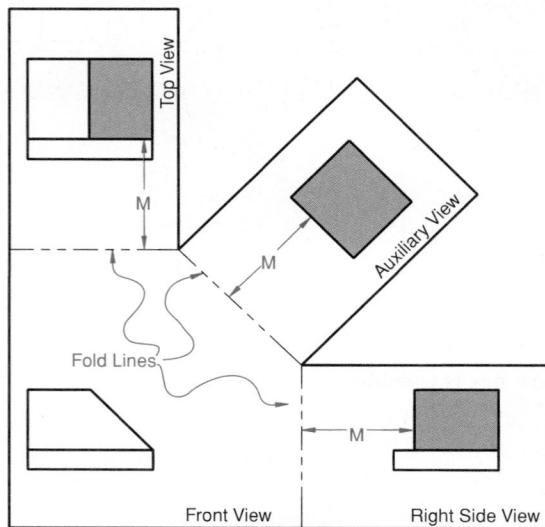

Figure 6.4 Unfolding the Glass Box to Create an Auxiliary View of the Inclined Plane

In Figure 6.6A, the reference plane coincides with the front surface of the object, so it appears on edge in the top and auxiliary views and is drawn as a line. The reference line is then used as a fold line to take measurements that are transferred from the top view and transfer to the auxiliary view.

The advantage of the reference plane method is that, if positioned correctly, it can result in fewer

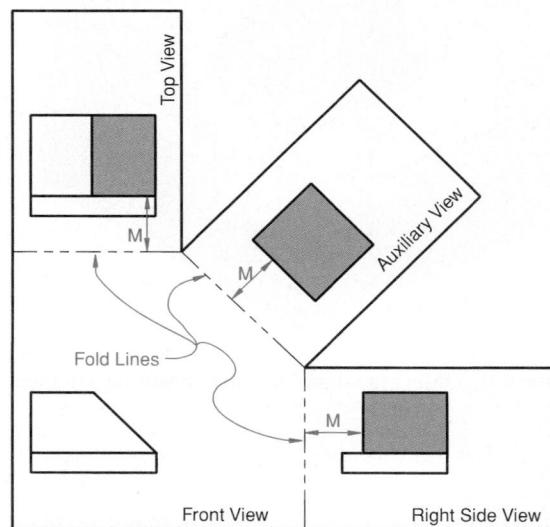

Figure 6.5 Object Distance from Fold Line

Object distance from the frontal plane determines the distance from the fold lines in the right side, auxiliary, and top views.

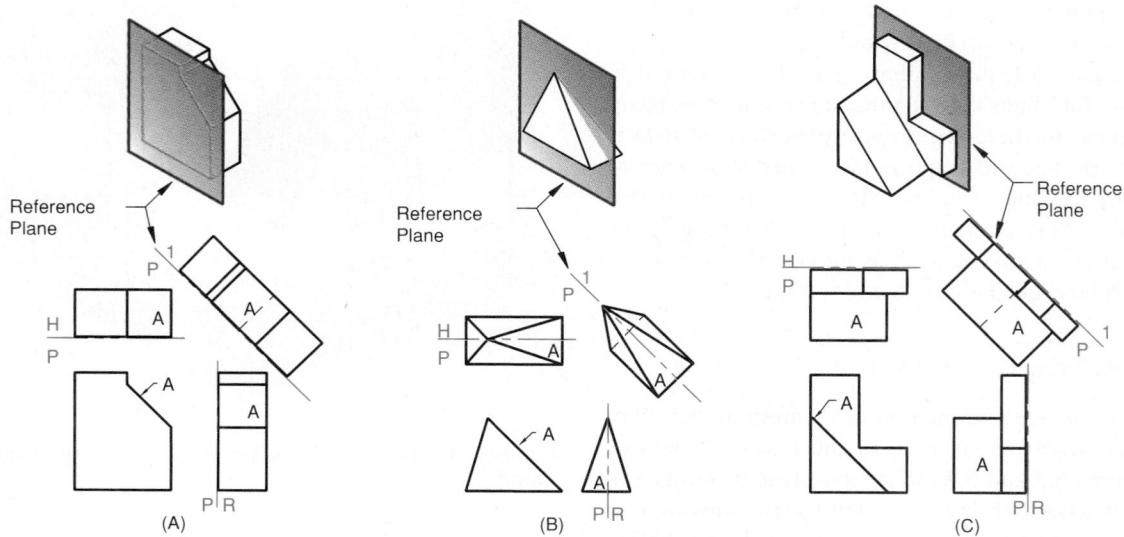

Figure 6.6

Reference planes can be positioned anywhere relative to the object.

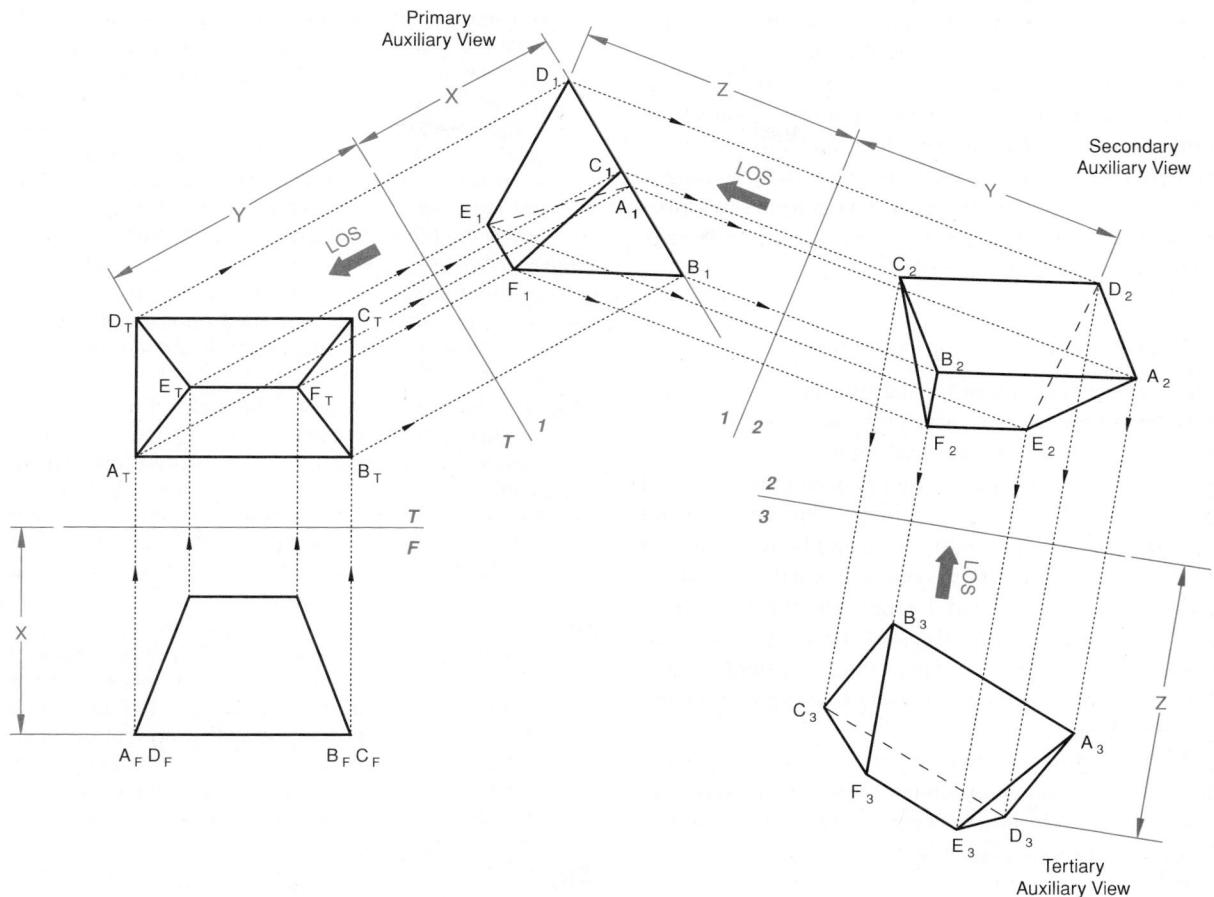

Figure 6.7 Primary, Secondary, and Tertiary Auxiliary Views

The line of sight (LOS) determines the direction of the projection lines used in each auxiliary view.

measurements when constructing auxiliary views. When using reference planes or fold lines always remember the following:

1. Reference or fold lines are always drawn perpendicular to the projection lines between the views.
2. Transfer measurements are always taken parallel to the projection lines and perpendicular to the reference or fold lines.
3. Reference planes always appear on edge as a line in the views adjacent to the central view but never in two adjacent views.
4. Distances from the object to the reference or fold lines in the auxiliary view and the measuring view are the same.

6.2 AUXILIARY VIEW CLASSIFICATIONS

Auxiliary views are created by positioning a new line of sight relative to the object. It is possible to create any number of auxiliary views, including a new auxiliary view from an existing auxiliary view. Therefore, auxiliary views are first classified as primary, secondary, or tertiary. (Figure 6.7)

A **primary auxiliary view** is a single view projected from one of the six principal views.

A **secondary auxiliary view** is a single view projected from a primary auxiliary view.

A **tertiary auxiliary view** is a single view projected from a secondary or another tertiary auxiliary view.

Auxiliary views are also classified by the space dimension shown in true size in the primary auxiliary view. For example, the auxiliary view shown in Figure 6.5 is classified as a *depth* auxiliary, because the depth dimension is shown true length. Auxiliary views projected from the top view are classified as *height* auxiliary views. (Figure 6.7) Auxiliary views projected from a profile view are classified as *width* auxiliary views. (see Figure 6.10)

6.2.1 Fold-Line Labeling Conventions

The labeling convention for the fold lines in auxiliary view construction can vary. However, the labels are normally descriptive in nature. For the example in Figure 6.7, the fold line located between the front and top views is labeled T–F, where the F means *front* and the T means *top*. The fold line located between the top and the primary auxiliary view is labeled T–1, where T is for the *top view* and 1 represents the *first auxiliary view*. Alternatively, the fold lines can be labeled by the projection planes. Since the *horizontal* projection plane contains the top view, the alternate labeling would be H–F and H–1.

The fold line located between the primary (i.e., first) and secondary auxiliary views is labeled 1–2. Similarly, the fold line between the secondary and tertiary auxiliary views is labeled 2–3.

6.2.2 Depth Auxiliary View

A **depth auxiliary** view is projected from the front view, and the depth dimension is shown true length. Figure 6.8 shows an auxiliary view that is projected from the front view of an object, using the fold-line method. Since plane ABCD is an inclined plane in the principal views, an auxiliary view is needed to create a true-size view of that plane. A depth auxiliary view is created as described in the following steps.

Constructing a Depth Auxiliary View

Step 1. Given the front, top, and right side views, draw fold line F–1 using a phantom line parallel to the edge view of the inclined surface. Place line F–1 at any convenient distance from the front view.

Step 2. Draw fold line F–H between the front and top views. Line F–H should be perpendicular to the

projectors between the views and at a distance X from the rear edge of the top view. Draw fold line F–P between the front and right side views, perpendicular to the projectors between the two views and at the distance X from the rear edge of the right side view. The distance from fold line F–H to the top view must be equal to the distance from fold line F–P to the right side view. Draw parallel projectors between the principal views, using construction lines.

Step 3. Project the length of the inclined surface from the front view to the auxiliary view, using construction lines. The projectors are *perpendicular* to the edge view and projected well into the auxiliary view from corners A,B and D,C.

Step 4. Transfer the depth of the inclined surface from the top view to the auxiliary view by first measuring the *perpendicular* distance from fold line H–F to point C at the rear of the top view. This is distance X. Measure this same distance on the projectors in the auxiliary view, measuring from fold line F–1. The measurement used to locate point C could have been taken from the profile view.

Step 5. From point C in the auxiliary view, draw a line perpendicular to the projectors. Depth dimension Y is transferred from the top view by measuring the *perpendicular* distance from fold line H–F to point A (or D) in the top view and transferring that distance to the auxiliary view along the projectors *perpendicular* to fold line F–1. Draw a line at the transferred point A (or D) in the auxiliary view, perpendicular to the projectors.

Step 6. To complete the auxiliary view of the inclined surface, darken lines AB and DC.

Only the inclined plane has been drawn in the auxiliary view; the rest of the object is not represented. When only the feature of interest is drawn in an auxiliary view and not the whole object, the view is called a partial auxiliary view. Most auxiliary views will be partial. Also, hidden features are not shown unless absolutely necessary. 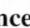 **CAD Reference 6.1**

6.2.3 Height Auxiliary View

A **height auxiliary** view is an auxiliary view projected from the top view, and the height dimension is shown true length. Figure 6.9 shows an auxiliary view that is projected from the top view of an object, using the fold-line method. Since surface ABCD is an inclined plane in the principal views, an auxiliary view is needed to

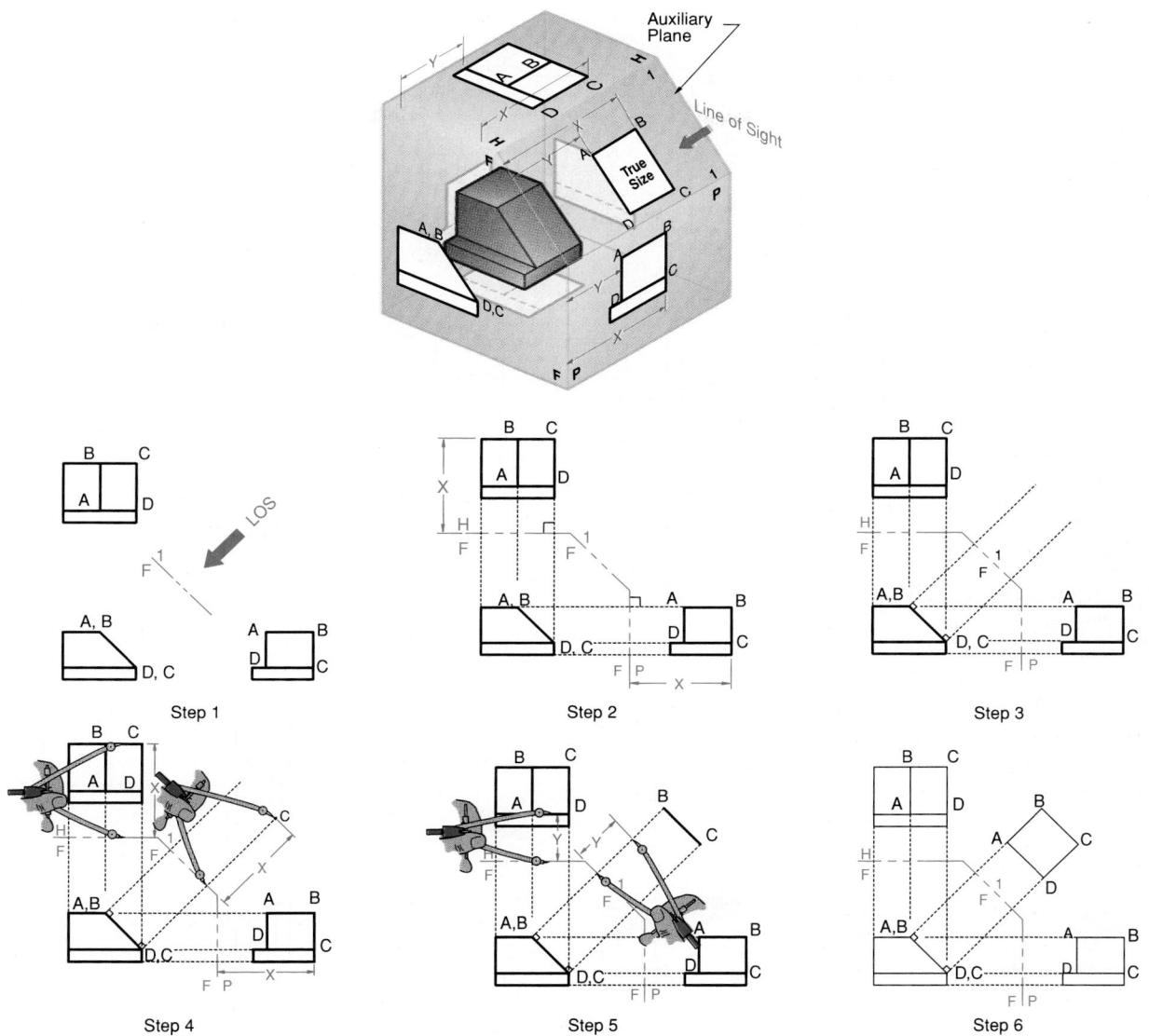

Figure 6.8 Constructing a Depth Auxiliary View to Determine the True Size and Shape of the Inclined Surface

create a true-size view of that surface. A height auxiliary view is created as described in the following steps.

Constructing a Height Auxiliary View

Step 1. Given the front, top, and right side views, draw fold line H-1 using a phantom line parallel to the edge view of the inclined surface. Place the line at any convenient distance from the top view.

Step 2. Draw fold line H-F between the front and top views, perpendicular to the projectors between the views and at a distance X from the bottom edge of

the front view. Draw fold line H-P between the top and right side views, perpendicular to the projectors between the views and at the same distance X from the rear edge of the right side view. The distance of fold line H-F to the front view must equal the distance from fold line H-P to the right side view. Draw parallel projectors between each principal view, using construction lines.

Step 3. Project the length of the inclined surface from the top view to the auxiliary view, using construction lines. The projectors are *perpendicular* to the edge view and projected well into the auxiliary view from corners A, B and D, C.

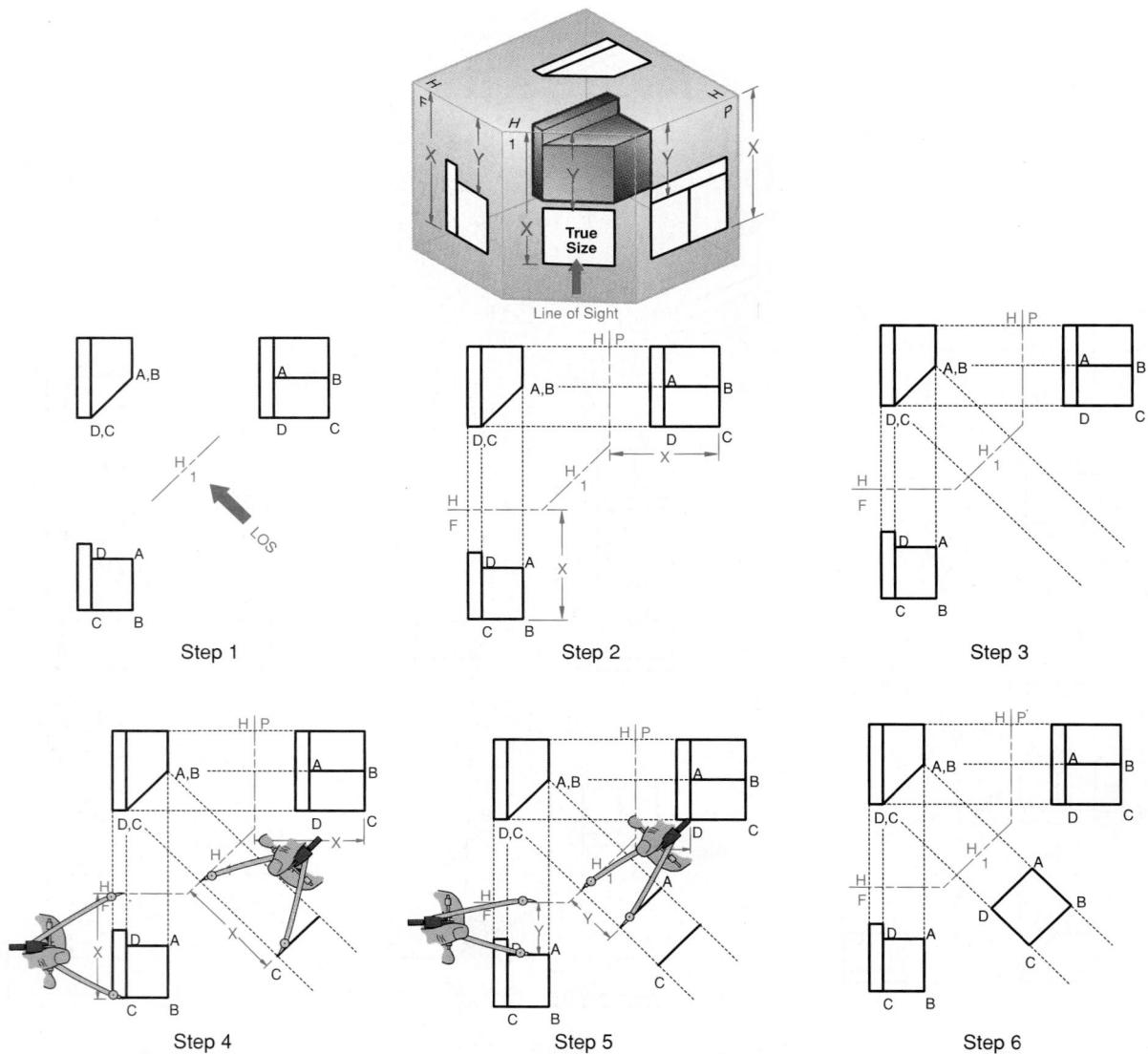

Figure 6.9 Constructing a Partial Height Auxiliary View of an Inclined Surface

Step 4. Transfer the height of the inclined surface from the front view to the auxiliary view by first measuring the *perpendicular* distance from fold line H-F, to the bottom edge of the front view. For this example, point C is measured at distance X from fold line H-F, and distance X is then measured along the projectors *perpendicular* to fold line H-1. From point C in the auxiliary view, draw a line perpendicular to the projectors.

Step 5. Height dimension Y is then transferred from the front view in a similar manner, measuring the

perpendicular distance from fold line H-F to point A (or D) of the front view and transferring this distance to the auxiliary view, measuring along the projectors *perpendicular* to fold line H-1. From the transferred point A in the auxiliary view, draw a line perpendicular to the projectors.

Step 6. Darken lines AB and DC to show the true size of the inclined surface and to complete the partial auxiliary view.

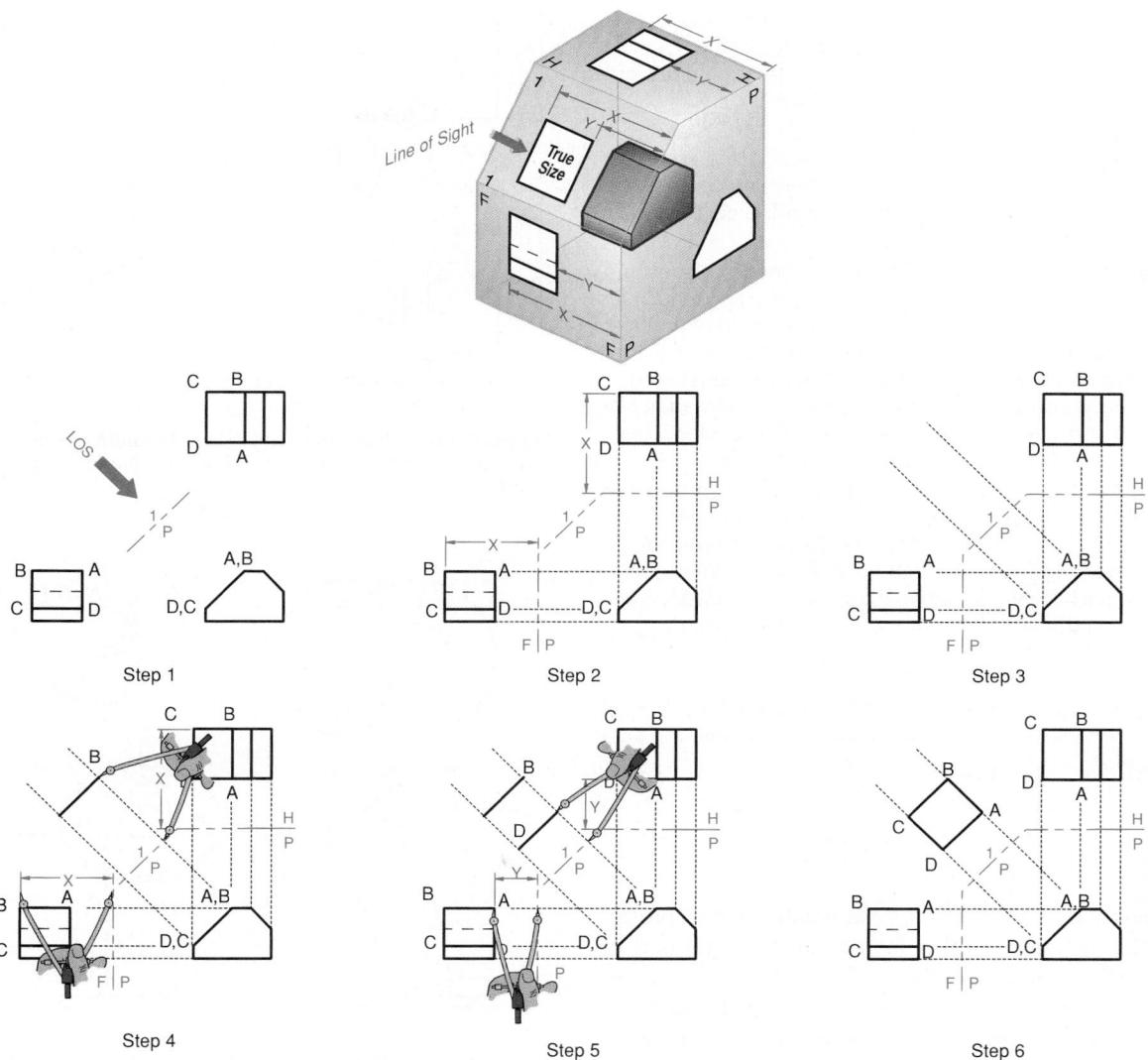

Figure 6.10 Constructing a Partial Width Auxiliary View of an Inclined Surface

6.2.4 Width Auxiliary View

A **width auxiliary view** is an auxiliary view projected from the profile view, and the width dimension is shown true length. Figure 6.10 shows an auxiliary view that is projected from the top view of an object, using the fold-line method. Since plane ABCD is an inclined plane in the principal views, an auxiliary view is needed to create a true-size view of the plane. A width auxiliary view is created as described in the following steps.

Constructing a Width Auxiliary View

Step 1. Given the front, top, and right side views, draw fold line P-1 using a phantom line parallel to the edge view of the inclined surface. Place the line at any convenient distance from the profile view.

Step 2. Draw fold line F-P between the front and profile views, perpendicular to the projectors between the views and at a distance X from the left edge of the front view. Draw fold line H-P between the top and profile views, perpendicular to the projectors between the views, and at a distance X from the rear

edge of the top view. The distance from fold line H-P to the top view must equal the distance from fold line F-P to the front view. Draw parallel projectors between each view, using construction lines.

Step 3. Project the length of the inclined surface from the profile view to the auxiliary view, using construction lines. The projectors are *perpendicular* to the edge view and projected well into the auxiliary view from corners A,B and D,C.

Step 4. Transfer the width of the inclined surface from the front view by first measuring the *perpendicular* distance from fold line P-F to the left side of the front view. For this example, point B is measured at distance X from fold line P-F and is then transferred to the auxiliary view along the projectors *perpendicular* to fold line P-1. From point B in the auxiliary view, draw a line perpendicular to the projectors.

Step 5. Width dimension Y is then transferred from the front view in a similar manner, measuring the *perpendicular* distance from fold line P-F to point A (or D) of the front view and transferring this distance to the auxiliary view along the projectors *perpendicular* to fold line P-1. From the transferred point A in the auxiliary view, draw a line perpendicular to the projectors.

Step 6. Darken lines AB and CD to show the true size of the inclined surface to complete the partial auxiliary view.

6.2.5 Partial Auxiliary Views

In auxiliary views, it is normal practice *not* to project hidden features or other features that are not part of the inclined surface. When only the details for the inclined surface are projected and drawn in the auxiliary view, the view is called a **partial auxiliary view**. A partial auxiliary view saves time and produces a drawing that is much more readable. Figure 6.11 shows a partial and a full auxiliary view of the same object. The full auxiliary view is harder to draw, read, and visualize. In this example, some of the holes have to be drawn as ellipses in the full auxiliary view. Sometimes a break line is used in a partial auxiliary view. When drawing break lines, do not locate them coincident with a visible or hidden line.

6.2.6 Half Auxiliary Views

Symmetrical objects can be represented as a **half auxiliary view**; that is, only half of the object is drawn. The construction of a half auxiliary view is

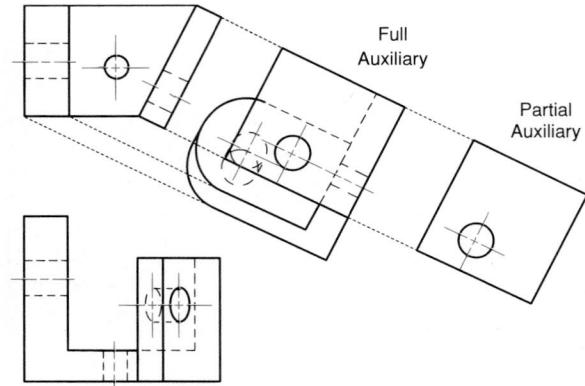

Figure 6.11 A Full Auxiliary View, Including Hidden Lines, and a Partial Auxiliary View with No Hidden Lines

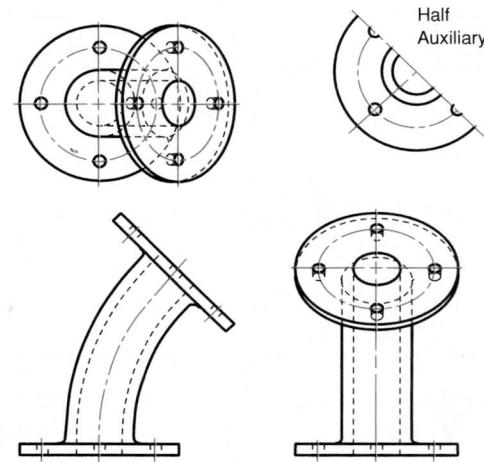

Figure 6.12 A Half Auxiliary View of a Symmetrical Feature

the same as described earlier for full auxiliary views. Figure 6.12 shows an object represented as a half auxiliary view.

6.2.7 Curves

Figure 6.13 shows a cylindrical part that is cut by an inclined plane. The resulting surface is an ellipse that can only be shown true size and shape with an auxiliary view. The process for drawing curves in an auxiliary view is described in the following steps.

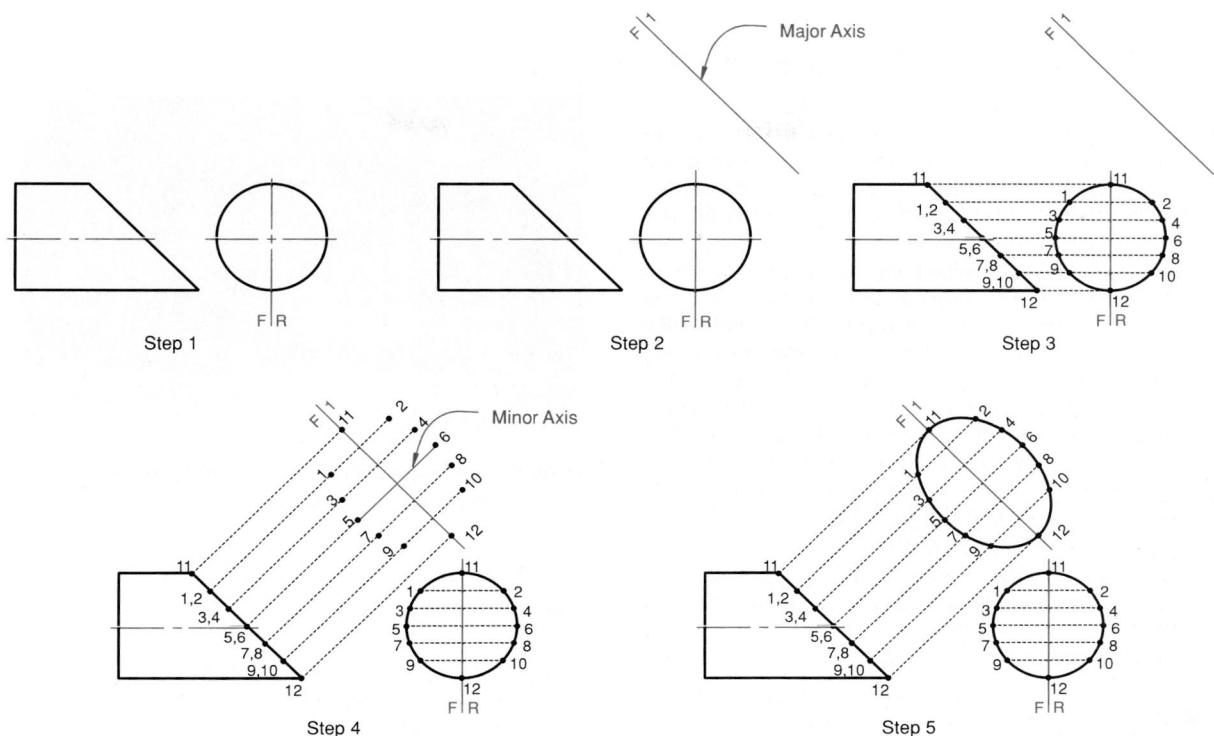

Figure 6.13 Constructing a Curve in an Auxiliary View

Constructing a Curve in an Auxiliary View

Step 1. In the right side view, locate a reference plane at the vertical center of the cylinder. The reference plane will be coincident to the axis of the cylinder and is therefore shown as an edge view in the right side view. The reference plane is located in the center so that all dimensions can be located on either side of the corresponding reference plane in the auxiliary view.

Step 2. Locate the edge view of the reference plane in the auxiliary view by drawing a line parallel to the edge view of the ellipse and at any convenient distance from that edge. The reference plane will coincide with the location of the major axis of the ellipse. The location of the reference plane should leave sufficient room for the auxiliary view to be plotted without running into any of the multiviews.

Step 3. Plot points along the circumference of the circle in the right side view and project these points onto the edge view of the ellipse in the front view. Number the points to assist in plotting the corresponding points in the auxiliary view.

Step 4. Project the points from the ellipse edge view in the front view through the reference plane in the auxiliary view. The projectors should be perpendicular to the edge view and the reference plane. The projector from the point for the center line of the cylinder in the front view coincides with the minor axis of the ellipse in the auxiliary view. Measure and transfer the depth dimensions from the right side view to the projectors in the auxiliary view.

Step 5. Using a French curve, connect the points to create the true size and shape of the curved surface.

6.2.8 Auxiliary Views Using CAD

Auxiliary views can be created with 2-D CAD using the same basic steps outlined in this chapter. Commands such as PARALLEL, PERPENDICULAR, and SNAP are useful in creating auxiliary views. Some 2-D CAD systems can rotate their grids so that they are parallel to the projectors, which makes the

Industry Application Design for the Environment (DFE)

The concern over the environmental health of the earth has prompted government policy-makers to look at pollution prevention. To product designers and engineers, this has meant emphasizing ecology in the design process. This concept is called design for the environment (DFE), or "green design."

DFE is a design process in which a product's environmental attributes are treated as design objectives, rather than constraints. These attributes include: materials recycling, disassembly, maintainability, refurbishability, and reusability. DFE can reduce production cost for such items as hazardous waste disposal and compliance with regulations. DFE establishes a recycling infrastructure, and requires the development of timely and accurate environmental data on the comparative risks of alternative materials, processes, and technologies, all of which measure the "greenness" of a product.

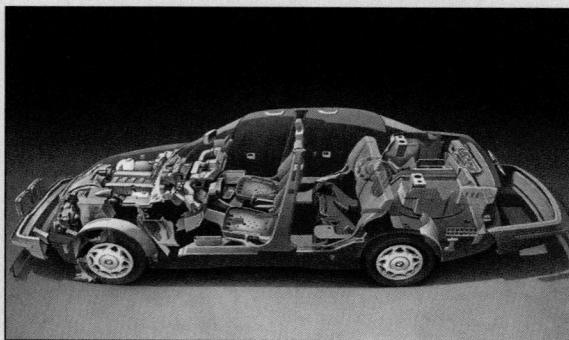

BMW Series 3 automobiles include many recyclable plastic components, shown in blue. (Courtesy of BMW North America.)

Adapted from: S. Ashley, "Designing for the Environment," *Mechanical Engineering*, March 1993, pp. 52-55.

creation of auxiliary views much easier. With 3-D CAD, it is possible to create an auxiliary view by changing the viewing direction to be perpendicular to the inclined or oblique surface of interest. Many 3-D CAD systems allow you to define this view by selecting the surface or edges that lie in the same plane. This view can be saved and then added to the multiview drawing of the part. When an auxiliary view is created from a 3-D model, a full auxiliary view can be created in a much shorter time than using traditional means. © CAD Reference 6.2

6.3 AUXILIARY VIEW APPLICATIONS

Auxiliary views are used to determine the true size and shape of features that would appear foreshortened in any of the principal views. The applications for auxiliary views can be grouped into the following five areas:

- Reverse construction.
- True length of a line.
- Point view of a line.
- Edge view of a plane.
- True size of a plane.

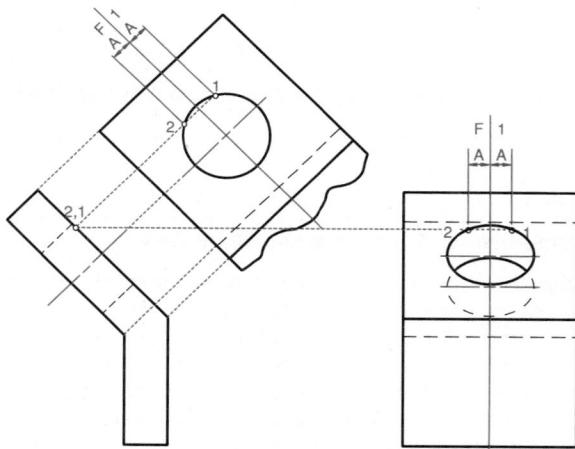

Figure 6.14 Reverse Construction Technique

6.3.1 Reverse Construction

For some objects, an auxiliary view must be created before a principal view can be drawn, using a technique called **reverse construction**. Figure 6.14 shows an example of such a part. The inclined plane cannot be drawn in the right side view unless the auxiliary view is drawn and the measurements are transferred. For example, the hole in the part is drawn first in the auxiliary view, then measurements are taken from it and those measurements are transferred to the right side view, creating the elliptical view of the hole.

6.3.2 View in a Specified Direction: Point View of a Line

Auxiliary views can be used to draw a view in a specified direction. *To create a view of an object in a specified direction, find the point view of the line of sight.* Figure 6.15 shows the top and front views of an object, with arrow AB indicating the desired view. Arrow AB becomes the line of sight for the desired view.

Constructing a View in a Specified Direction

Step 1. For the example in Figure 6.15, the line indicating the specified direction in the front and top views is an oblique line. This means that the true direction of the line must be found before a point view can be created. This is done by creating an auxiliary view that is perpendicular to the line, from either the top or front view. For this example, the line of sight in the top view is chosen. Projection lines are drawn perpendicular to the line of sight. Draw reference plane H-1 perpendicular to these projectors. From each corner of the object in the top view, draw projectors into the auxiliary view, perpendicular to reference plane H-1. Draw projection plane H-F between the front and top views, perpendicular to projectors between those views. Number each corner of the block to assist in the drawing of the auxiliary view.

Step 2. Measure the perpendicular distances from reference plane H-F to each point of the object and line AB in the front view. Transfer these distances along the projectors in auxiliary view 1 from reference plane H-1. Number each point in view 1 and connect them with lines, creating a new view of the object. Line 1-5 is drawn as a dashed line in the auxiliary view, because it is a hidden feature. The line of sight AB is also shown in true length in view 1.

Step 3. Find the point view of line AB by drawing a projector parallel to it in view 1. Project all points in view 1 parallel to the projector for line AB, into a new auxiliary view called view 2. Draw a new fold line perpendicular to the projectors and label it 1-2.

Step 4. In the top view, measure the perpendicular distances from reference plane H-1 to each point. Transfer these distances along the projectors in view 2 from reference plane 1-2. Number each point in the new view and connect them with lines. This creates the desired view in the specified direction, that is, the direction of the arrow AB. The line of sight AB will appear as a point in this view. Lines 1-6, 6-7, and 6-10 are hidden features and are represented as dashed lines.

© CAD Reference 6.3

6.3.3 Dihedral Angles

A **dihedral angle** is the angle between two planes. Determining the true measurement of a dihedral angle is a common application for auxiliary views. *To draw and measure the angle between two planes, create a point view of the line of intersection between the two planes.*

Determining the True Measurement of a Dihedral Angle

The following steps describe how to find the true angle between surfaces A and B in Figure 6.16.

Step 1. Line 1-2 is the line of intersection between surfaces A and B. Line 1-2 is true length in the top view; therefore, a point view of that line can be found by creating an auxiliary view using projectors parallel to that view of the line.

Step 2. Draw the fold line H-1 perpendicular to line 1-2, at any convenient distance from the top view. Draw the fold line H-F between the front and top views such that it is perpendicular to the projectors between the two views, at any convenient distance.

Step 3. Measure the perpendicular distances in the front view from fold line H-F, and transfer those distances to the projectors in the auxiliary view, measuring from fold line H-1. This creates a new view of the object, and the true angle between planes A and B can be measured in this new view.

© CAD Reference 6.4

6.3.4 Successive Auxiliary Views: True Size of Oblique Surfaces

An infinite number of auxiliary views can be created from any given view. In Figure 6.17 the arrows surrounding the primary auxiliary view indicate just some of the lines of sight that can be used to create other auxiliary views, and with each new auxiliary view, others can be created. **Successive auxiliary views** are multiple auxiliary views of an object created by projecting from previous auxiliary views. Figure 6.17 shows the front and top principal views and three successive auxiliary views of an object.

Successive auxiliary views can be used to draw an oblique surface in true size and shape. The first step is to construct a new view from one of the principal views, parallel to a true-length line of the oblique plane. In this new view, the oblique surface will be an edge. A secondary auxiliary view is then created, perpendicular to projectors from the edge view of the oblique surface, and the secondary view shows the true size and shape of the surface.

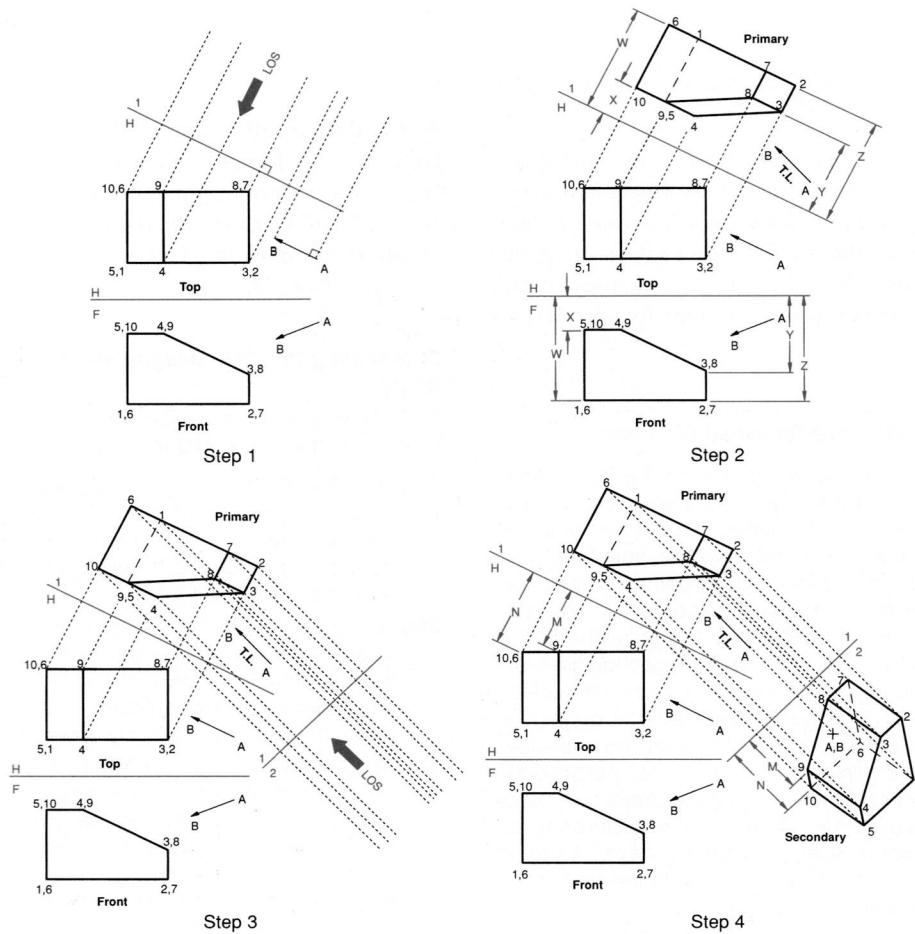

Figure 6.15 Constructing a View in a Specified Direction: Point View of a Line

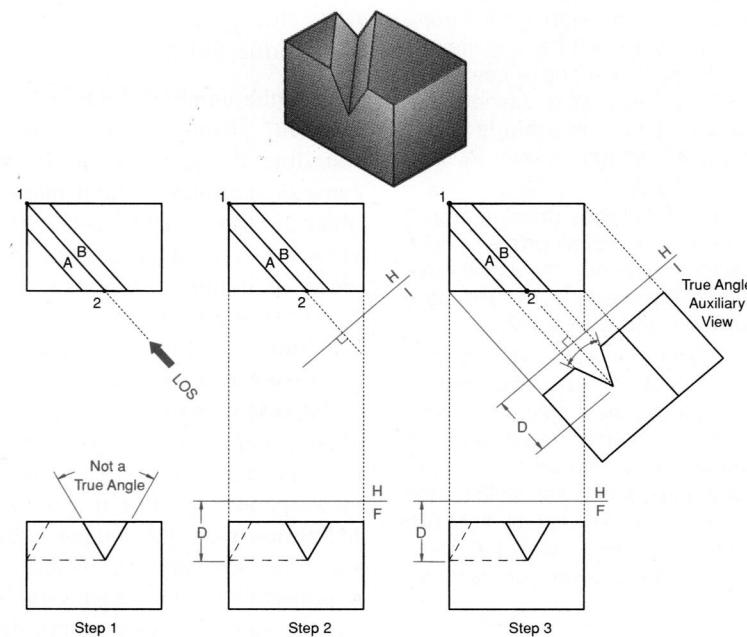

Figure 6.16 Determining the True Measurement of a Dihedral Angle

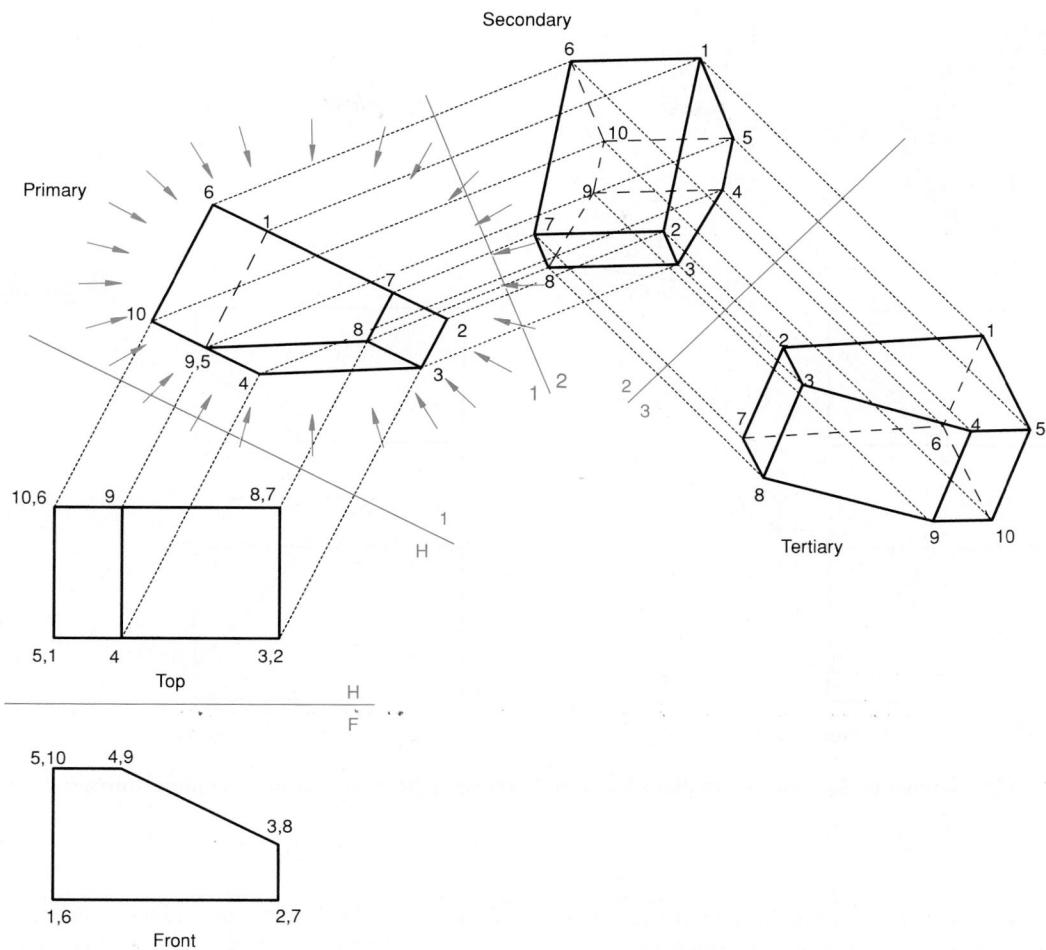

Figure 6.17 Creating Successive Auxiliary Views

The blue arrows surrounding the primary view indicate a few of the possible lines of sight that can be used to generate successive views.

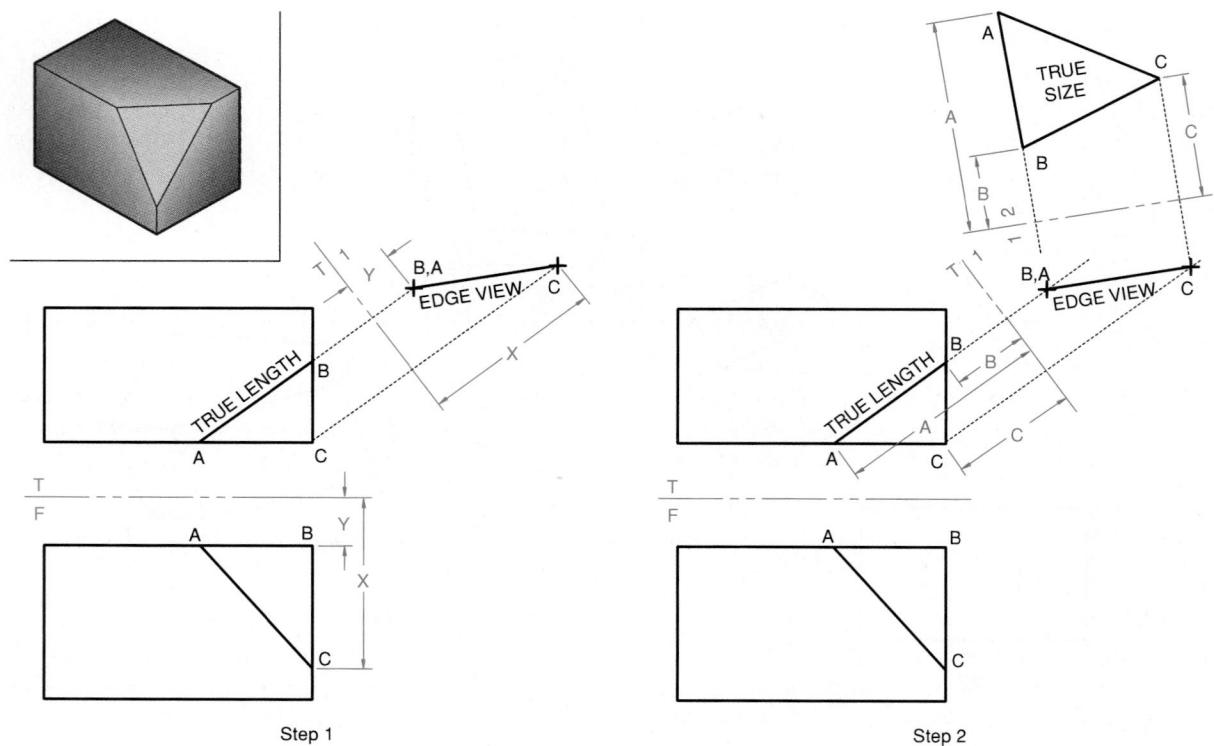

Figure 6.18 Constructing Successive Auxiliary Views to Determine the True Size of an Oblique Surface

The following steps describe how to create a true-size view of the oblique surface in Figure 6.18.

Constructing Successive Auxiliary Views to Determine the True Size of an Oblique Surface

Step 1. For the first auxiliary view, place the line of sight parallel to a true-length line of the oblique surface, in one of the principal views. For this example, side AB of the oblique triangular surface ABC is a true-length line in the top view. Draw a projector from point B, parallel to line AB. Draw a line parallel to this projector, from point C. Draw reference plane T-1 perpendicular to these projectors. Measure the perpendicular distances from reference line T-F to points A and C in the top view. Transfer these measurements to the auxiliary view, measuring along the projectors, from reference line T-1. Darken lines AB, BC, and CA, to produce a true-size view of the oblique surface ABC.

In the front view, measure the perpendicular distances from reference line T-F to points A and C. Transfer these measurements to the auxiliary view, measuring along the projectors, from reference line T-1. This will produce an edge view of the oblique surface, labeled B,A-C.

Step 2. Create a secondary auxiliary view by projecting lines from points A, B, and C, perpendicular to the edge view of the surface. Draw a reference line 1-2, perpendicular to these projectors. Measure the perpendicular distances from reference line T-1 to points B,A and C in the top view. Transfer these measurements to the secondary auxiliary view, measuring along the projectors, from reference line 1-2. Darken lines AB, BC, and CA, to produce a true-size view of the oblique surface ABC.

Practice Exercise 6.2

Using an object with an oblique surface, look at the object from the three principal views. How is the oblique surface seen in the three views? Is it ever seen in true size? Is it ever seen as an edge view? Rotate the object to get an edge view of the oblique surface. Then rotate the object 90 degrees about one of the edges bounding the oblique surface to obtain a true-size view of the surface.

6.4 SUMMARY

Auxiliary views are a type of orthographic projection used to determine the true size and shape of inclined and oblique surfaces of objects. Normally, auxiliary views are projected from existing principal views. However, auxiliary views can also be drawn first and then used to create a principal view. This is done

when a true measurement can only be obtained by an auxiliary view and that measurement is needed in order to create a principal view. This technique is called reverse construction. Any number of auxiliary views of an object can be created. Successive auxiliary views can be created by projecting from an existing auxiliary view.

KEY TERMS

Auxiliary view	Half auxiliary view	Primary auxiliary view	Successive auxiliary view
Depth auxiliary view	Height auxiliary view	Reverse construction	Tertiary auxiliary view
Dihedral angle	Partial auxiliary view	Secondary auxiliary view	Width auxiliary view

QUESTIONS FOR REVIEW

1. Define auxiliary views.
2. Define primary, secondary, and tertiary auxiliary views.
3. Define width, height, and depth auxiliary views.
4. Explain how to find a view in a specified direction.
5. What is a partial auxiliary view?
6. List the five applications for auxiliary views.
7. Describe how to find the true angular measurement for a dihedral angle.

PROBLEMS

6.1 Using instruments or CAD, sketch or draw the two given views and an incomplete auxiliary view of the inclined surfaces in Figure 6.19.

6.2 Using instruments or CAD, sketch or draw the two given views and a complete or incomplete auxiliary view of the inclined surfaces in Figure 6.20.

6.3 Using instruments or CAD, sketch or draw the necessary views, including a complete auxiliary view (Figures 6.21 through 6.40).

(1)

(2)

(3)

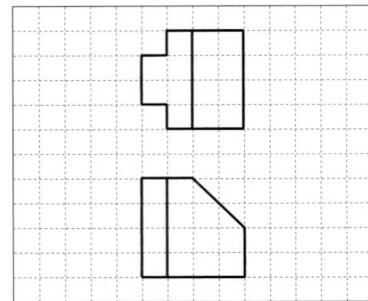

(4)

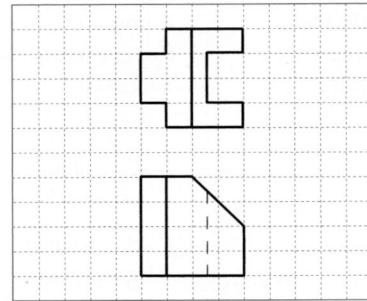

(5)

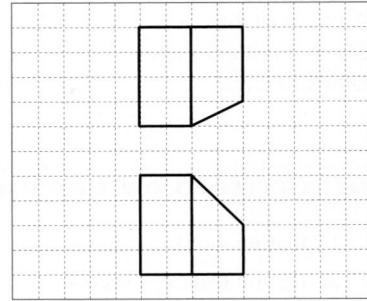

(6)

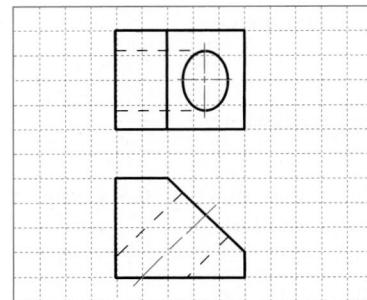

(7)

Figure 6.19 Objects with Inclined Surfaces for Problem 6.1

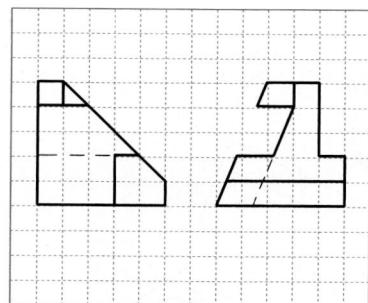

(1)

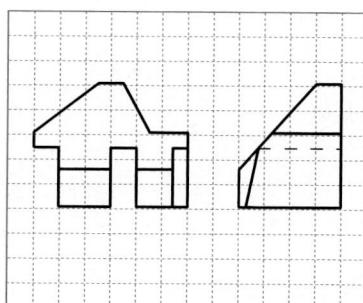

(2)

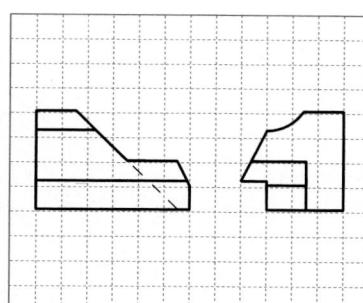

(3)

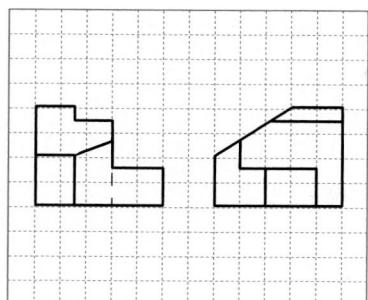

(4)

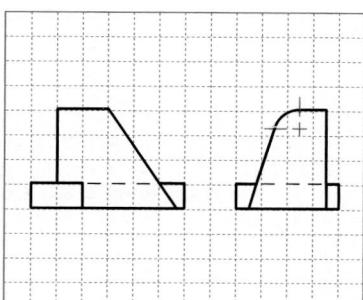

(5)

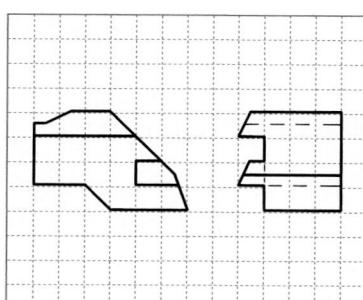

(6)

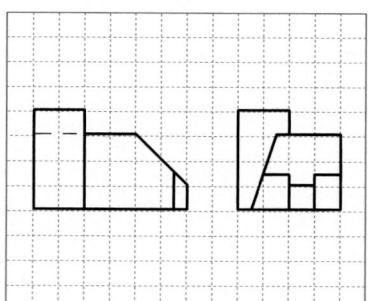

(7)

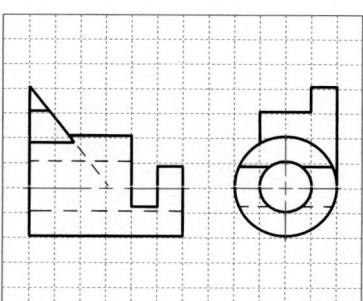

(8)

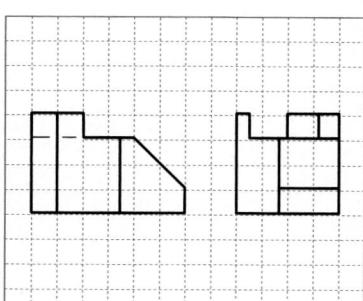

(9)

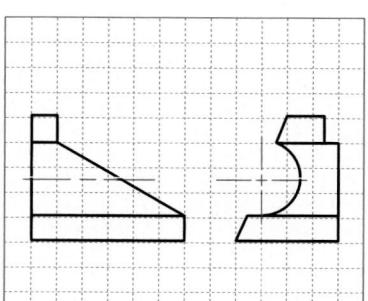

(10)

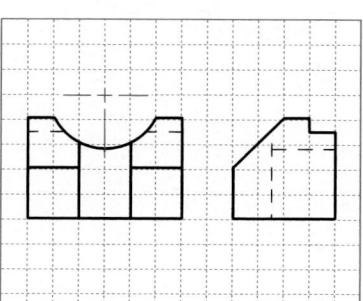

(11)

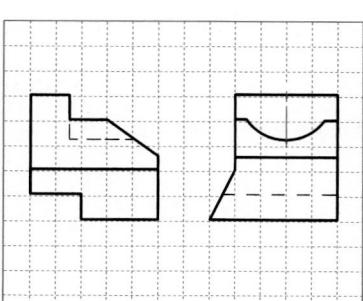

(12)

Figure 6.20 Multiviews for Problem 6.2

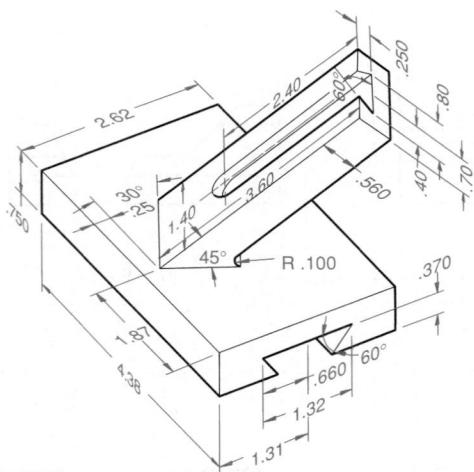

Figure 6.21 Angle Jig

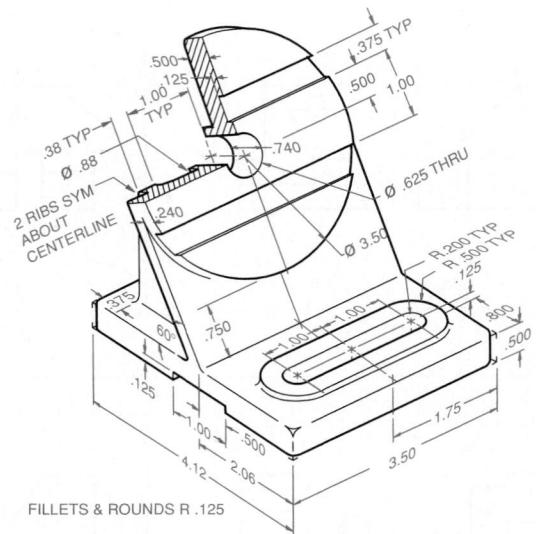

Figure 6.22 Centering Jig

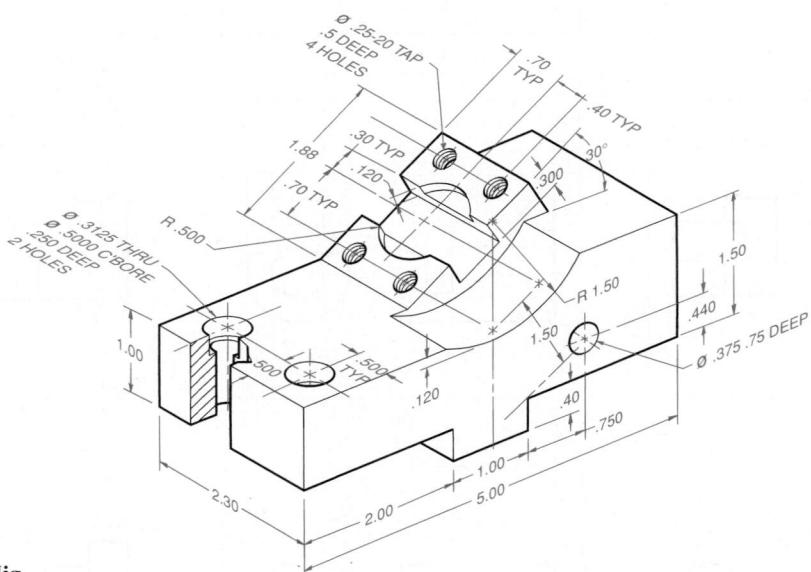

Figure 6.23 Tool Jig

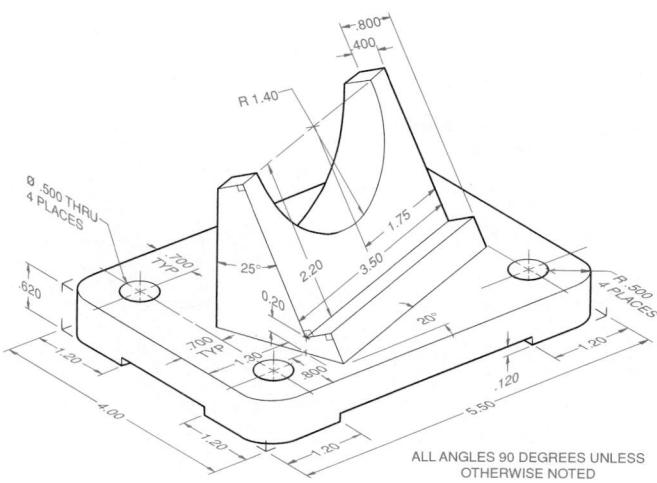

Figure 6.24 Oblique Support

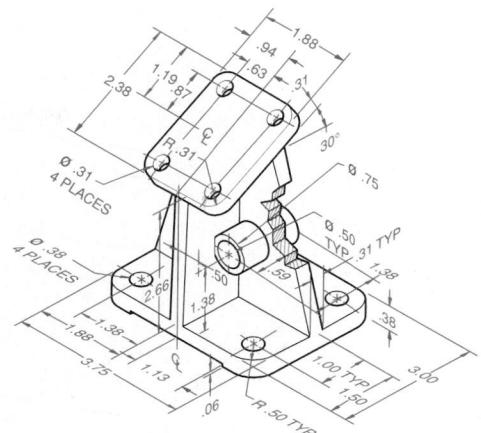

Figure 6.25 Harness Base

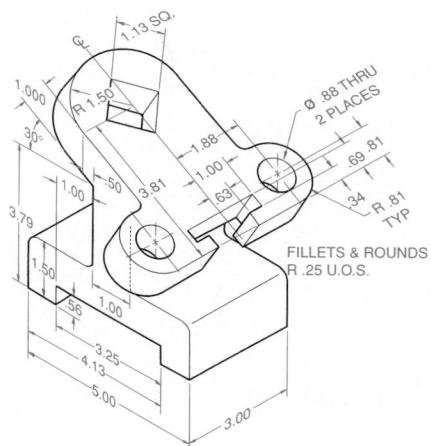

Figure 6.26 Transition Base

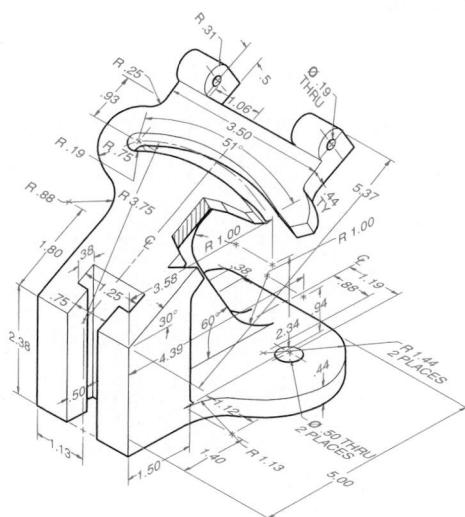

Figure 6.27 Indexing Guide

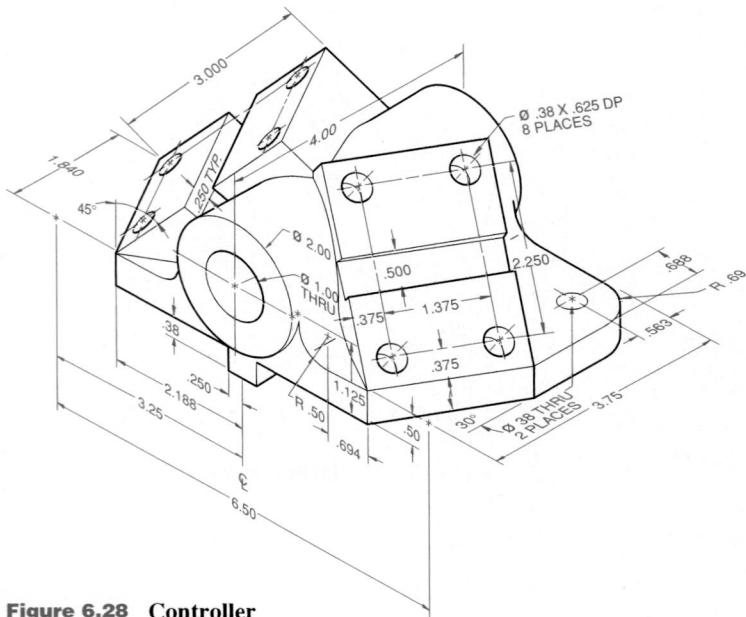

Figure 6.28 Controller

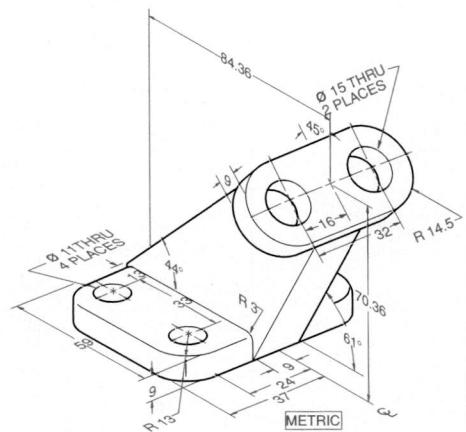

Figure 6.29 Clamp Base

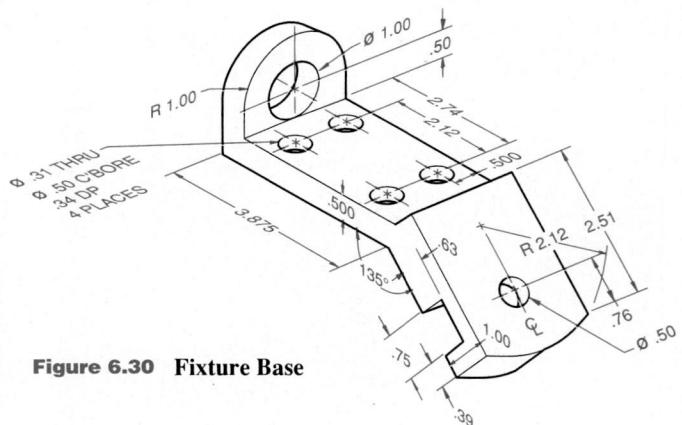

Figure 6.30 Fixture Base

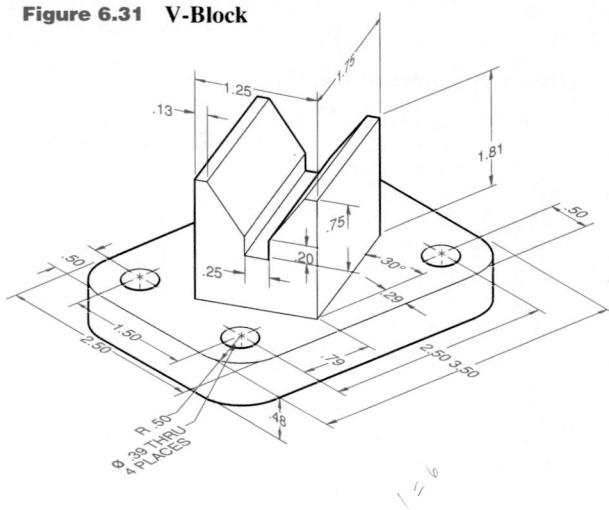

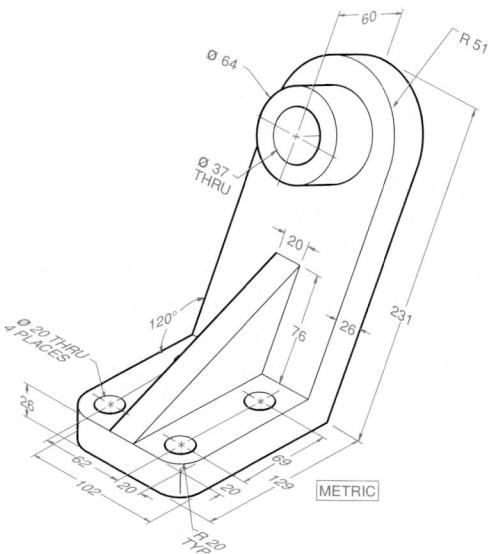

Figure 6.32 Spindle Base

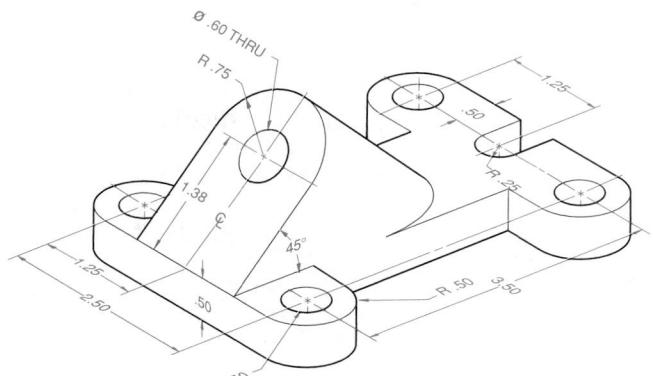

Figure 6.33 Automatic Stop

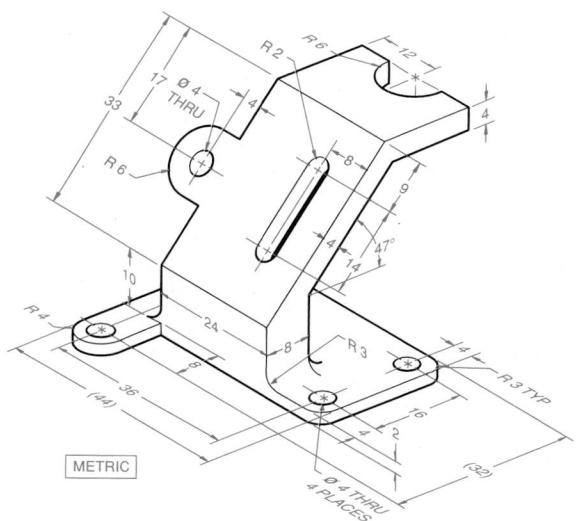

Figure 6.34 Slotted Guide

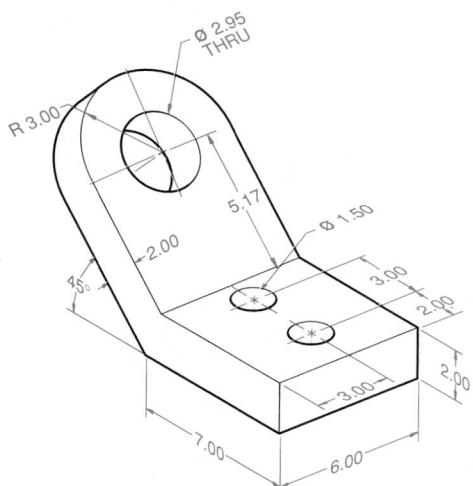

Figure 6.35 Rod Support

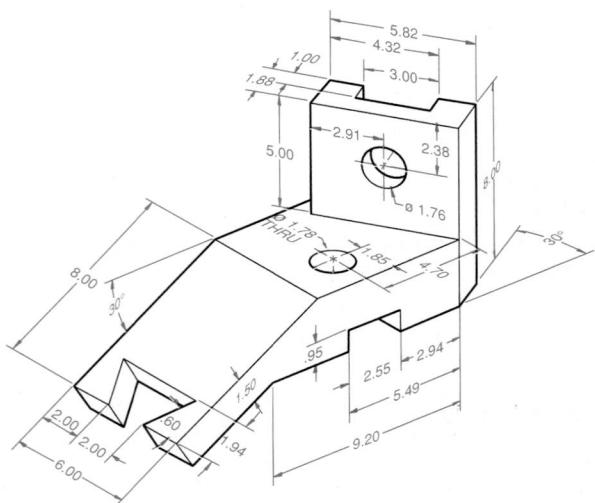

Figure 6.36 Stop Block

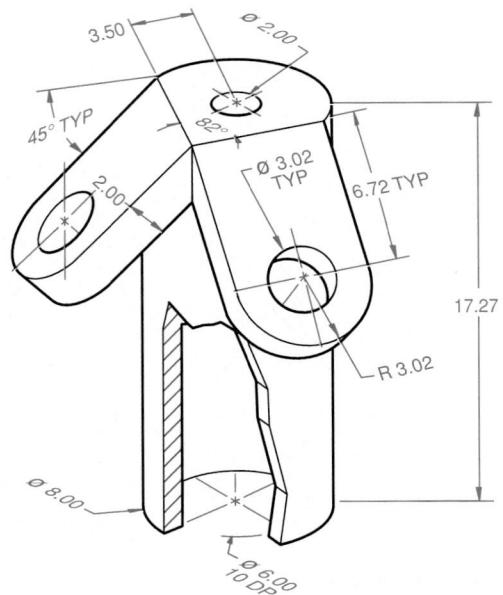

Figure 6.37 Double Angle Support

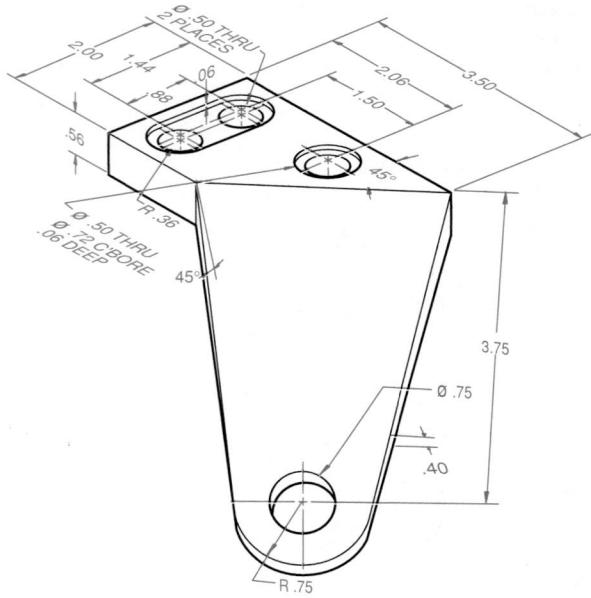

Figure 6.38 Angle Connector

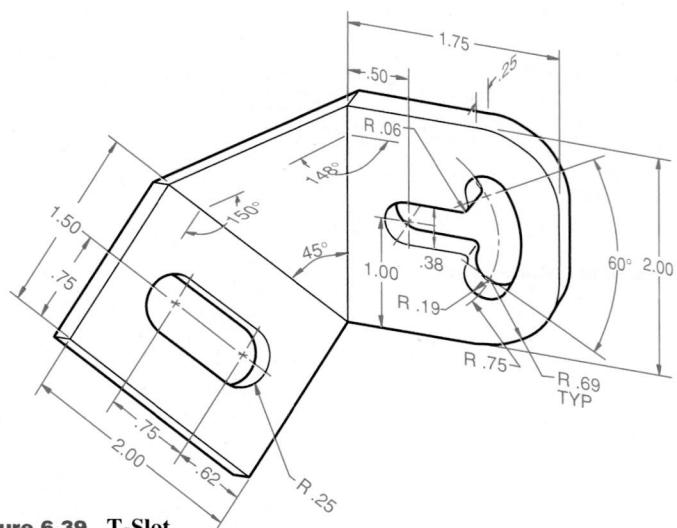

Figure 6.39 T-Slot

CHAPTER 7

Section Views

We graphicists choreograph colored dots on a glass bottle so as to fool the eye and mind into seeing desktops, spacecrafts, molecules, and worlds that are not . . .

Frederick Brooks

OBJECTIVES

After completing this chapter, you will be able to:

1. Apply the concept of cutting planes to create section views.
2. Represent cutting plane lines and section lines, using conventional practices.
3. Create full, half, offset, removed, revolved, broken-out, auxiliary, and assembly section views, using conventional practices.
4. Create conventional breaks for different materials and cross sections.
5. Represent ribs, webs, and thin features in section, using conventional practices.
6. Represent aligned sectioned features, using conventional practices.
7. Apply section theory to computer models when designing.

The technique called section views is used to improve the visualization of new designs, clarify multiview drawings, and facilitate the dimensioning of drawings. For example, orthographic drawings of complicated mechanical parts can be very difficult to visualize and dimension. Section views can be used to reveal interior features of an object that are not easily represented using hidden lines. Architectural drawings use section views to reveal the interior details of walls, ceilings, and floors. Three-dimensional geometric models created with CAD can be sectioned to reveal interior features and assist in the design of complex systems.

- Section views use a technique that is based on passing an imaginary cutting plane through a part to reveal interior features. Creating section views requires visualization skills and adherence to strict standards and conventional practices. This chapter will explain the theory for creating section views, the important conventional practices used for section views, and examples of standard practices.

7.1 SECTIONING BASICS

Section views are an important aspect of design and documentation, and are used to improve clarity and reveal interior features of parts. (Figure 7.1) Section views are also used in the ideation and refinement stages of engineering design to improve the communications and problem-solving processes. **Sectional drawings** are multiview technical drawings that contain special views of a part or parts, views that reveal interior features. A primary reason for creating a section view is the elimination of hidden lines, so that a drawing can be more easily understood or visualized. Figure 7.2 shows a regular multiview drawing and a sectioned multiview drawing of the same part in the front view; the hidden features can be seen after sectioning.

Traditional section views are based on the use of an imaginary cutting plane that cuts through the object to reveal interior features. (Figure 7.3) This imaginary cutting plane is controlled by the designer and can: (a) go completely through the object (full section); (b) go half-way through the object (half section); (c) be bent to go through features that are not aligned (offset section); or (d) go through part of the object (broken-out section).

Section views are used in every engineering discipline. Mechanical assemblies are sectioned to assist in the assembly of components and to aid visualization. (Figure 7.4) Cutaway drawings of roads are used in civil engineering. (Figure 7.5) Sectioned technical illustrations are used to describe interior features of complicated assemblies. (Figure 7.6)

An important reason for using section views is to reduce the number of hidden lines in a drawing. A section view reveals hidden features without the use of hidden lines. (Figure 7.7) Adding hidden lines to a section view complicates the drawing, defeating the purpose of using a section. There are times, however, when a minimum number of hidden lines are needed to represent features other than the primary one shown by the section. (Figure 7.8)

Visible surfaces and edges that represent a change of planes behind the cutting plane are drawn in a section view. For example, Figure 7.9 shows a section view for which the cutting plane passes through the center of a counterbored hole. A line represents the change of planes between the drilled and counterbored holes and is an example of a visible feature that is behind the cutting plane. (Figure 7.9A)

Section lined areas normally are bounded by visible lines, never by hidden lines, because the bounding lines are visible in the section view. (Figure 7.9B)

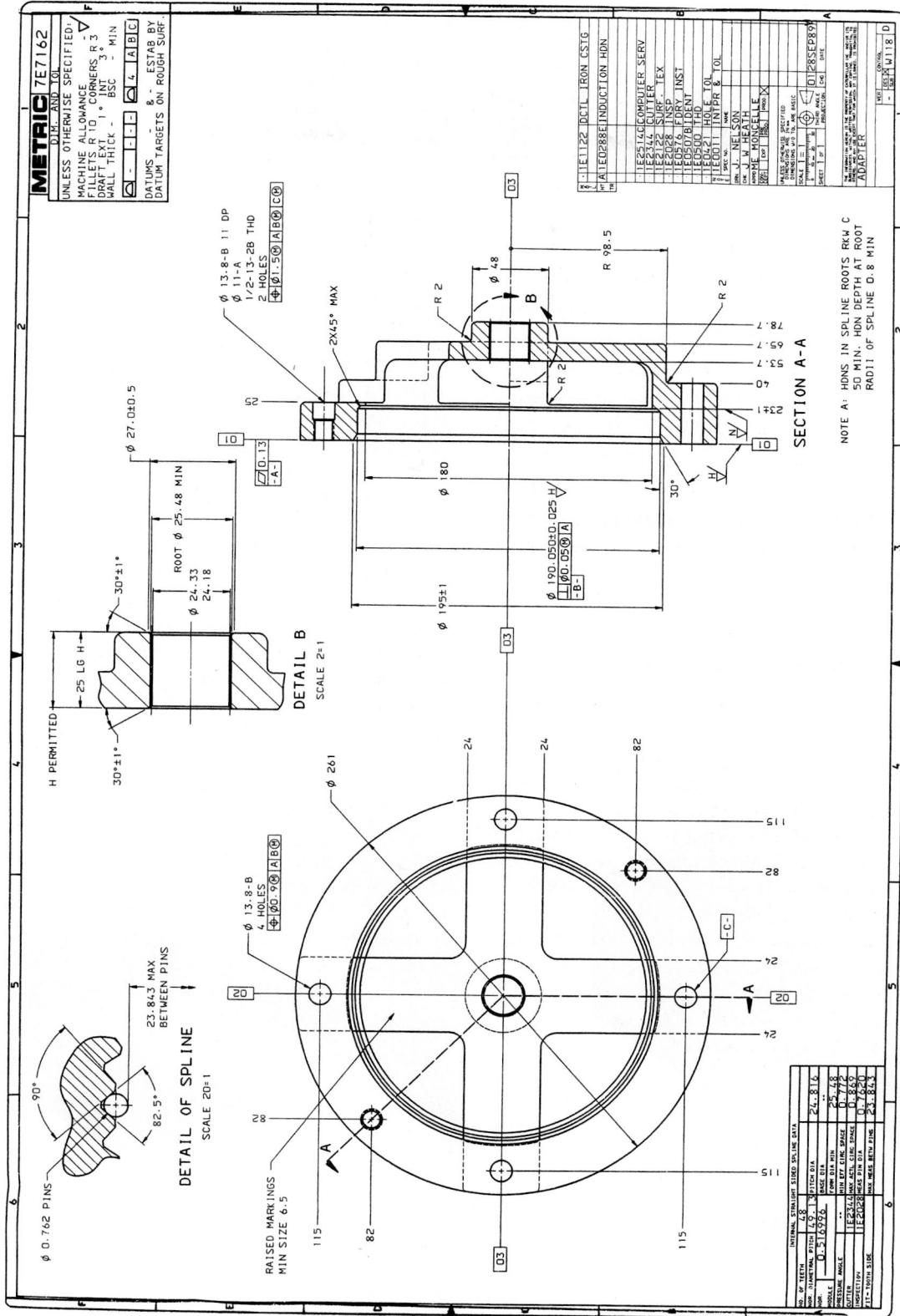

Figure 7.1 A typical multiview technical drawing shows the right side view in full section and removed section details.

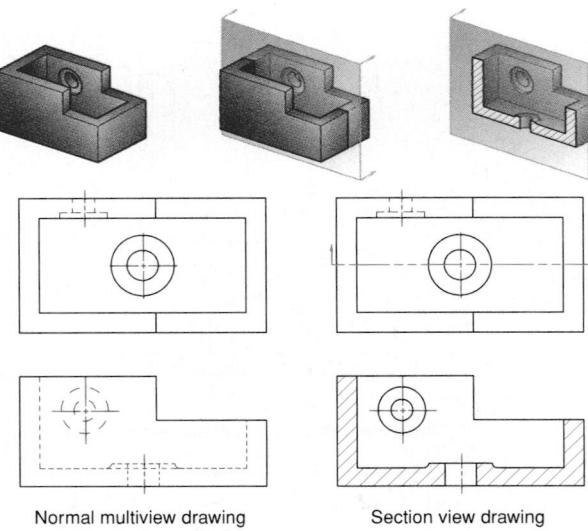

Figure 7.2 Section View Reveals Hidden Features

A section view will typically reveal hidden features, so that the object is more easily visualized.

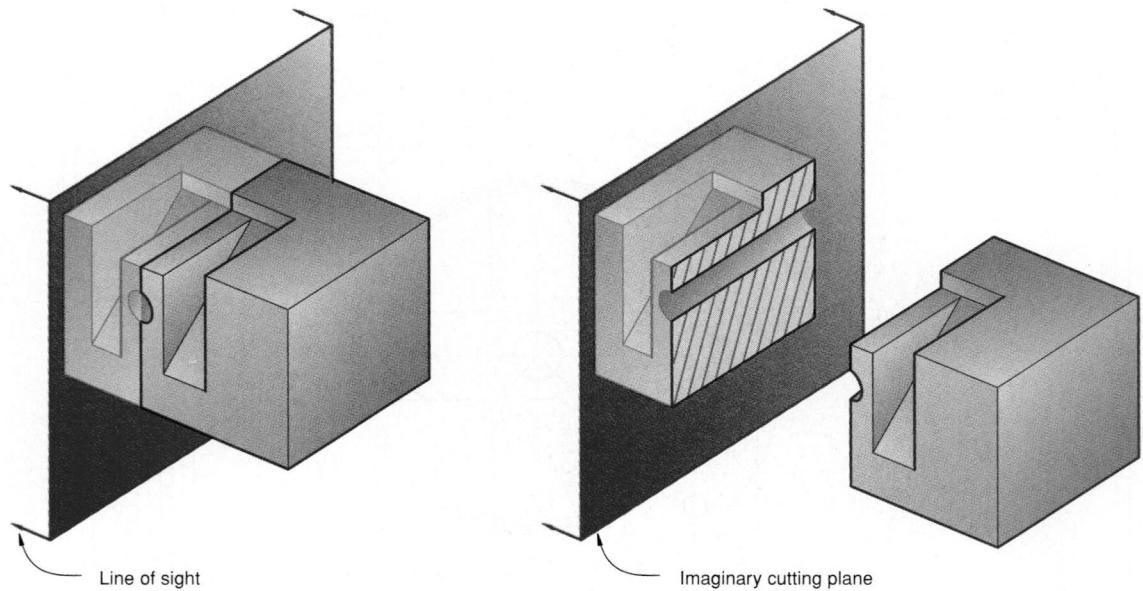

Figure 7.3 Cutting Planes

Imaginary cutting planes used to create section views are passed through the object to reveal interior features.

Figure 7.4 Mechanical Assembly of a Jet Aircraft in Section Showing How Parts Fit and Their Spatial Relationship

(Irwin drawing contest winner, Carl E. Lauter.)

Figure 7.5 Civil Engineering Drawing in Section

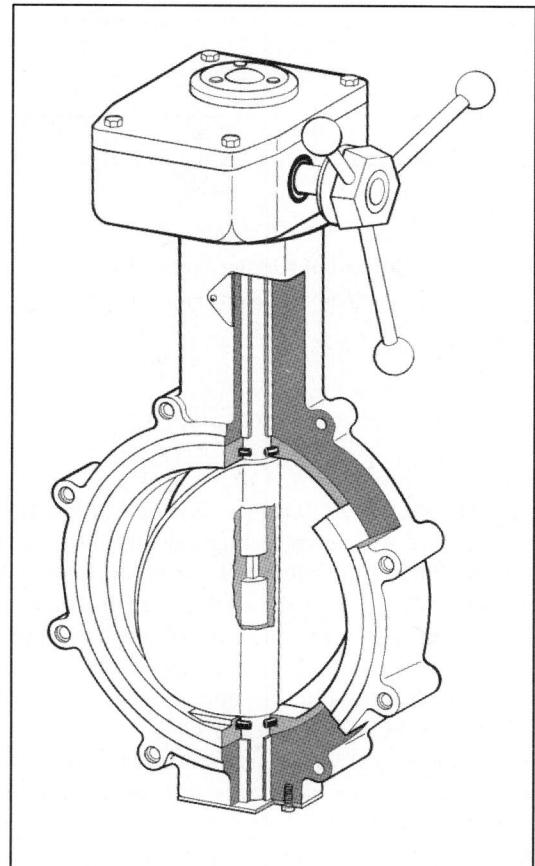

Figure 7.6 Sectioned Technical Illustration of a Valve Assembly

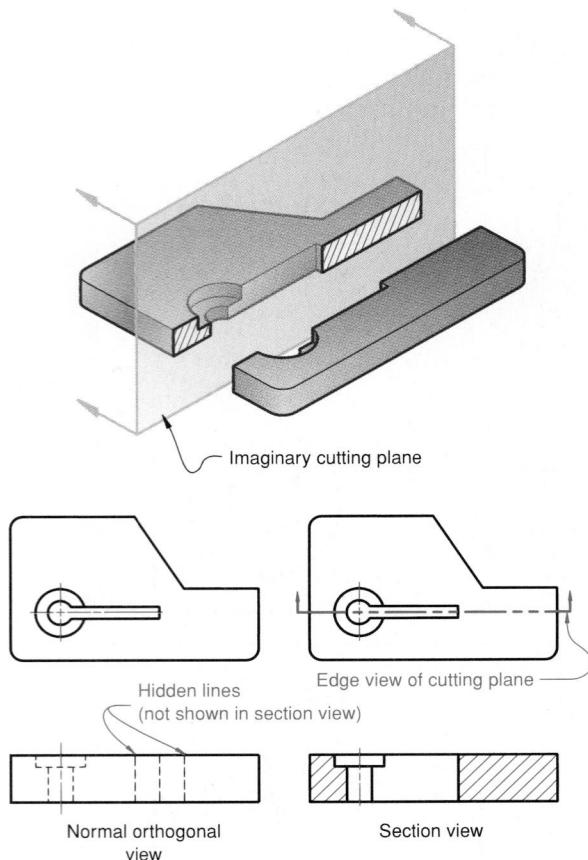

Figure 7.7 Treatment of Hidden Lines

Normally, hidden lines are omitted from section views.

7.1.1 CAD Technique

With 3-D CAD, it is possible to create the section view of a part or assembly automatically by specifying the position of the cutting plane relative to the object (Figure 7.10), and then to select which part of the object to display by picking one side of the cutting plane or the other. Half of the object is removed, using a Boolean subtraction operation, as shown in Figure 7.11. 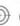

Two-dimensional CAD has automated some of the more time-consuming steps necessary to create orthographic section views. Most CAD programs contain several standard section line patterns (i.e., cross-hatches); section lines are not added one at a time, as they are with traditional tools. The boundary area to be

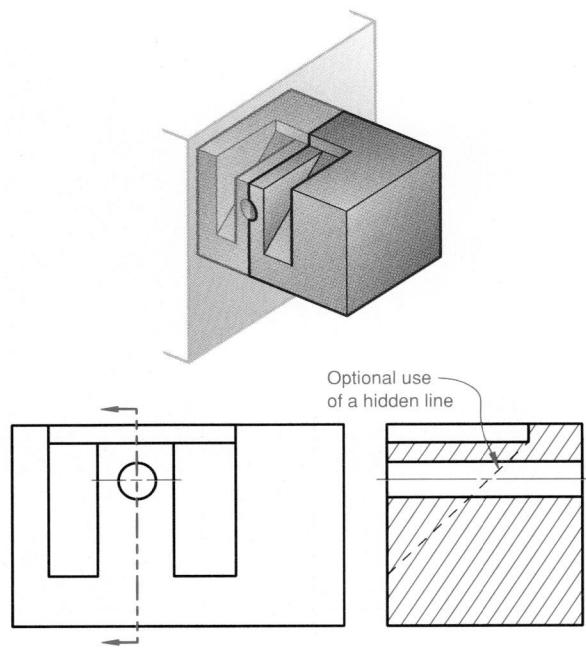

Figure 7.8 Optional Use of Hidden Lines

Hidden lines can be shown in section views usually to eliminate the need for another view.

cross-hatched is selected with the cursor, the user selects the section pattern or creates a custom one by specifying the angle, linetype, and spacing, and the defined boundary is automatically filled in with the selected pattern. 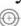

7.1.2 Visualization of Section Views

Figure 7.12 is a multiview drawing of a part that is difficult to visualize in its three-dimensional form because of the many hidden lines. A section view is created by passing an imaginary cutting plane vertically through the center of the part. Figure 7.13 is an isometric representation of the part after it is sectioned. This isometric section view shows the interior features of the part more clearly and is an aid for visualizing the 3-D form. The corners of the isometric section view are numbered so that they can be compared with the orthographic section view.

In Figure 7.12, the cutting plane arrows in the front view point to the left, to represent the direction of sight for producing a right side view in full section. The direction of the arrow can also be thought of as

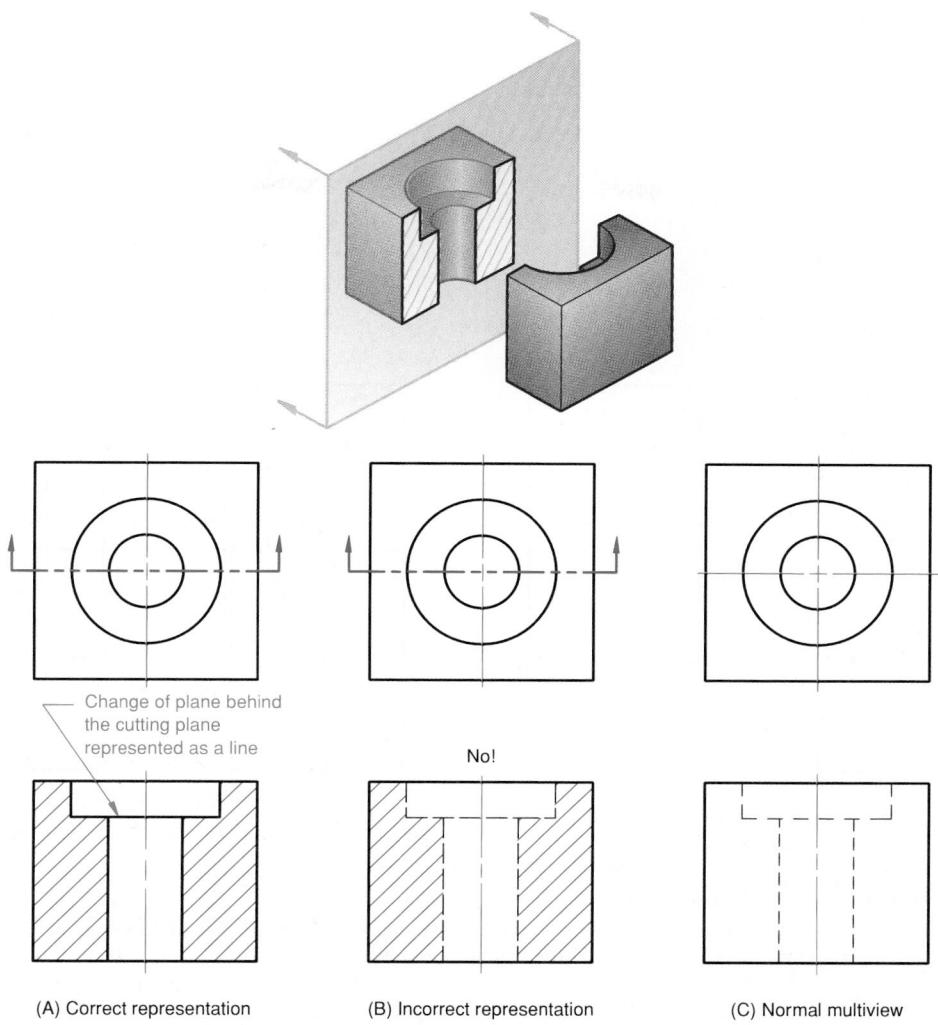

Figure 7.9 Representing Surfaces and Edges in Section Views

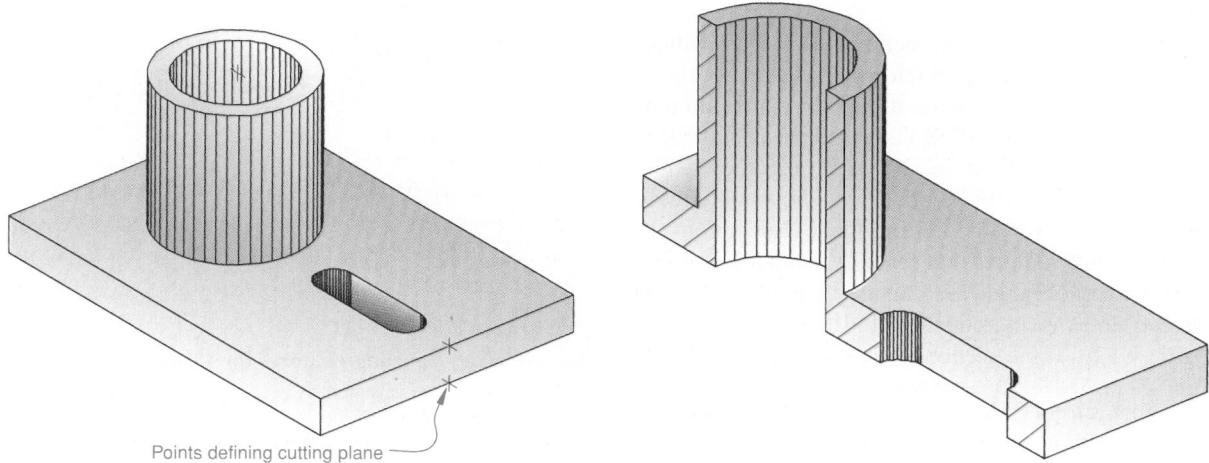

Figure 7.10 Defining a Cutting Plane on a CAD Model
A 3-D CAD solid model can be sectioned by positioning a cutting plane relative to the object.

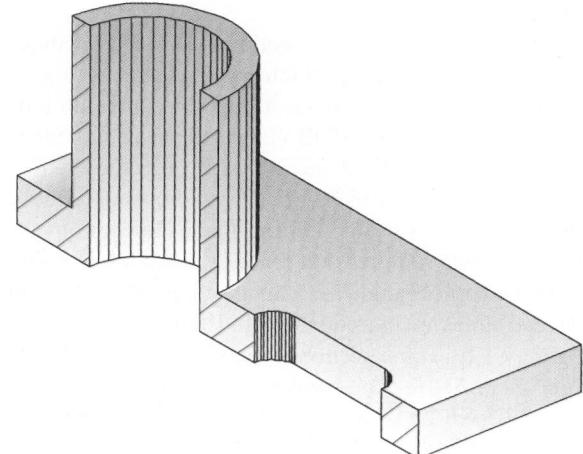

Figure 7.11 Sectioned CAD Model
The object is automatically cut along the cutting plane to produce a section view.

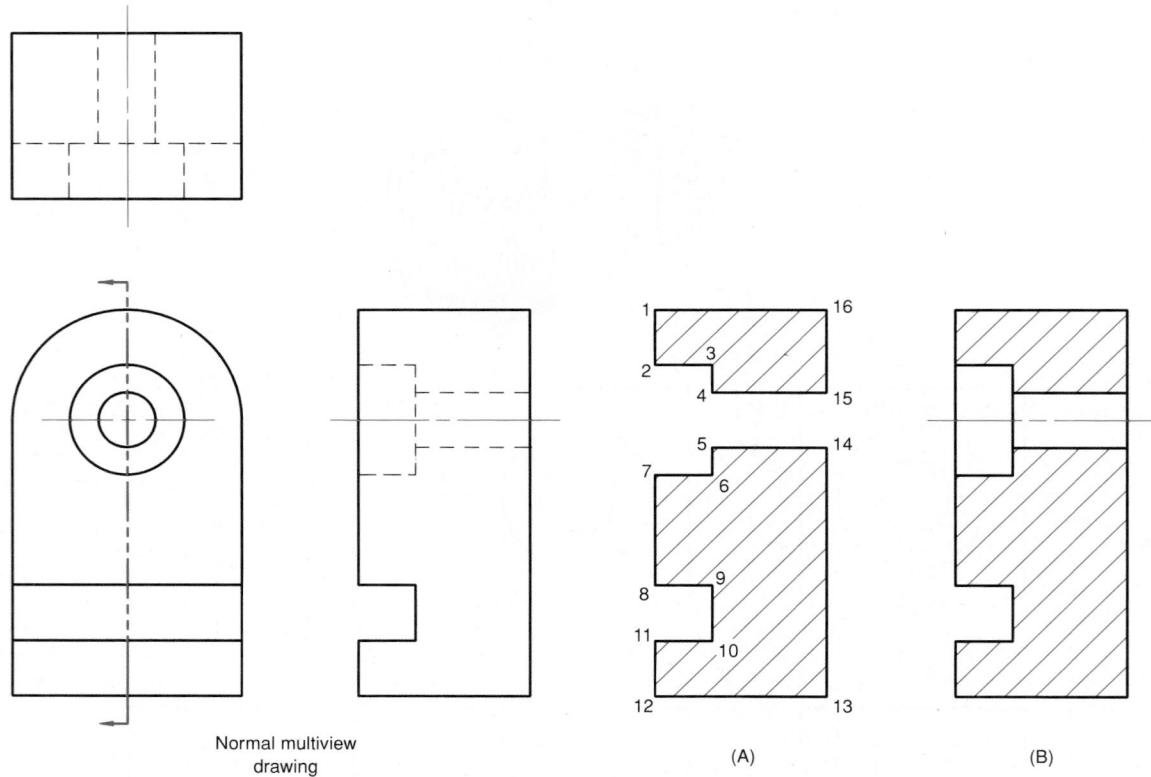

Figure 7.12 Visualization of a Section View

A section view is created by drawing the outline of the surfaces cut by the cutting plane. Details are then added to show surfaces behind the cutting plane, such as the back of the counterbored hole.

pointing toward the half of the object being kept. The right half of the object is “removed” to reveal the interior features of the part.

The line of sight for the section view is perpendicular to the cut surfaces, which means they are drawn true size and shape in the section view. Also, no hidden lines are drawn and all visible surfaces and edges behind the cutting plane are drawn as object lines.

The section view in Figure 7.12A shows only those surfaces touched by the cutting plane. Since conventional practice requires that features behind the cutting plane be represented, the change of planes between the two holes in the counterbored hole are shown in Figure 7.12B. If the section is viewed along the line of sight identified by the arrows in Figure 7.13, arcs A, B, and C will be visible and should be represented as lines. In Figure 7.12B, the lines are 2–7, 4–5, and

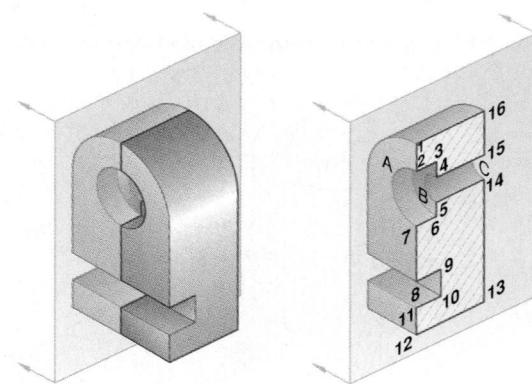

Figure 7.13 Labeling Features for Visualization

The section view is created by passing an imaginary cutting plane vertically through the object. Corners are labeled to assist in the visualization of the orthographic section view.

15–14. The counterbore and through holes are represented as rectangular features 2–7–6–3 and 4–5–14–15.

All the surfaces touched by the cutting plane are marked with section lines. Because all the surfaces are the same part, the section lines are identical and are drawn in the same direction. This practice is explained in more detail in Section 7.3. The center line is added to the counterbored hole to complete the section view.

7.2 CUTTING PLANE LINES

Cutting plane lines, which show where the cutting plane passes through the object, represent the *edge view* of the cutting plane and are drawn in the view(s) adjacent to the section view. In Figure 7.14, the cutting plane line is drawn in the top view, which is adjacent to the sectioned front view. Cutting plane lines are *thick* (0.7 mm or 0.032 inch) dashed lines that extend past the edge of the object $\frac{1}{4}$ " or 6 mm and have line segments at each end drawn at 90 degrees and terminated with arrows. The arrows represent the direction of the line of sight for the section view and they point away from the sectioned view. Two types of lines are acceptable for cutting plane lines in multi-view drawings, as shown in Figure 7.15.

Line B–B is composed by alternating one long and two short dashes. The length of the long dashes varies according to the size of the drawing, and is approximately 20 to 40 mm (1 to $1\frac{3}{4}$ inches). For a very large section view drawing, the long dashes are made very long to save drawing time. The short dashes are approximately 3 mm ($\frac{1}{8}$ inch) long. The open space between the lines is approximately 1.5 mm ($\frac{1}{16}$ inch). Capital letters are placed at each end of the cutting plane line, for clarity or for differentiating between cutting planes when more than one is used on a drawing.

The second method used for cutting plane lines, shown by line C–C in Figure 7.15, is composed of equal-length dashed lines. Each dash is approximately 6 mm ($\frac{1}{4}$ inch) long, with a 1.5 mm ($\frac{1}{16}$ inch) space in between.

7.2.1 Placement of Cutting Plane Lines

Cutting plane lines are only added to a drawing for clarity. If the position of the cutting plane is obvious, as in Figure 7.12, the line need not be drawn. *Also*, if

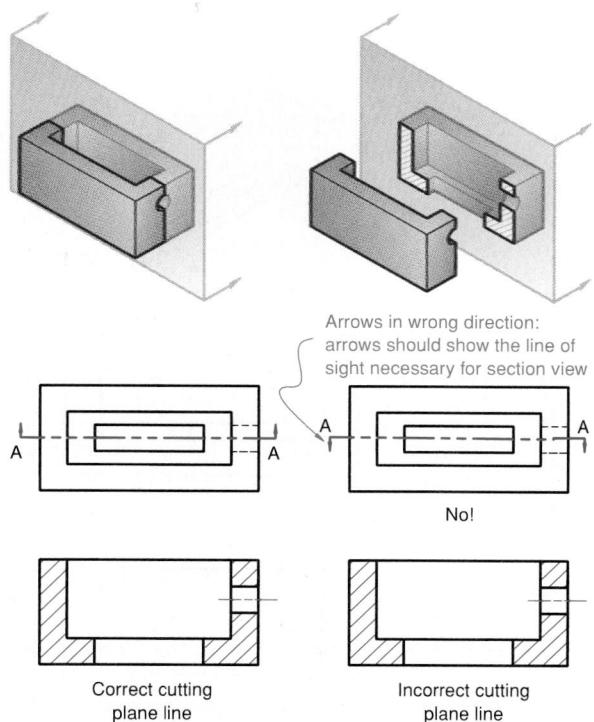

Figure 7.14 Placement of Cutting Plane Lines

The cutting plane line is placed in the view where the cutting plane appears on edge.

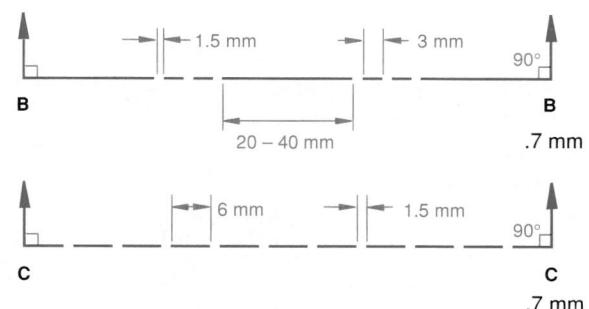

Figure 7.15 Standard Cutting Plane Linestyles

Standard cutting plane linestyles are thick lines terminated with arrows.

the cutting plane line is in the same position as a center line, the cutting plane line has precedence, as demonstrated in Figure 7.12.

In Figure 7.14, the cutting plane appears as an edge in the top view and is normal in the front view; therefore, it is a *frontal cutting plane*. The front half of the object is “removed” and the front view is drawn in section.

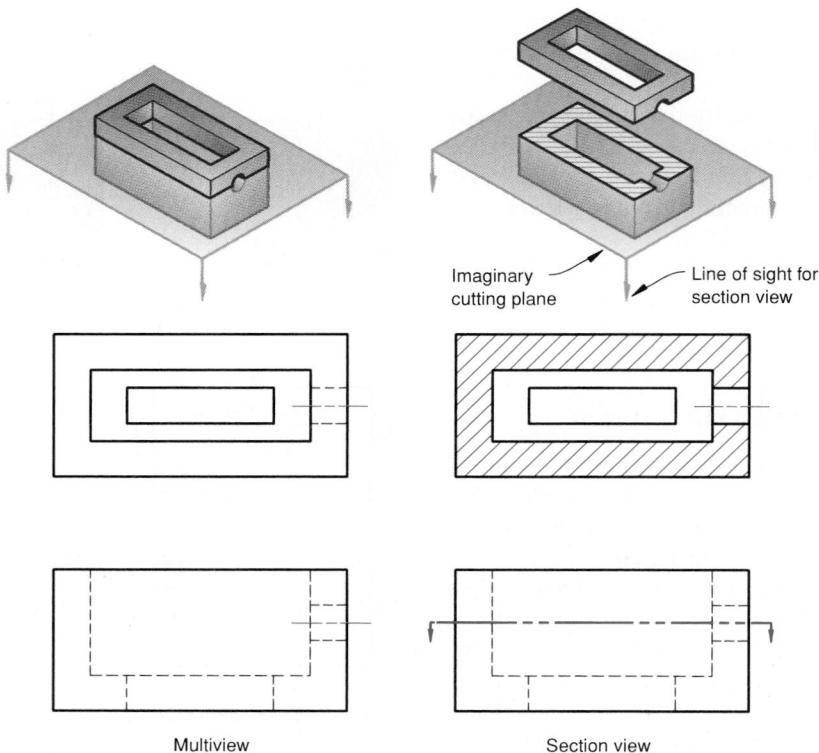

Figure 7.16 Horizontal Section View

A horizontal section view is one where the cutting plane is on edge in the front view and the top view is sectioned.

If the cutting plane appears as an edge in the front view and is normal in the top view, it is a *horizontal cutting plane*. (Figure 7.16) The top half of the object is “removed” and the top view is drawn in section. If the cutting plane appears as an edge in the top and front views and is normal in the profile view, it is a *profile cutting plane*. (Figure 7.17) The left (or right) half of the object is “removed” and the left (or right) side view is drawn in section.

Multiple sections can be done on a single object, as shown in Figure 7.18. In this example, two cutting planes are used: one horizontal and the other profile. Both cutting planes appear on edge in the front view, and are represented by cutting plane lines A–A and B–B, respectively. Each cutting plane creates a section view, and each section view is drawn as if the other cutting plane did not exist.

Most CAD software includes cutting plane lines as a standard linestyle. To create a cutting plane line with CAD:

1. Change the linestyle.
2. Change the pen number for plotting, to create thick lines, and/or change the line thickness.
3. Draw the cutting plane line, using the LINE command.
4. Add arrows to the ends of the cutting plane line.
5. Using the TEXT command, add letters at each end of the cutting plane line, if more than one cutting plane line is on the drawing. 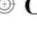

7.3 SECTION LINE PRACTICES

Section lines or **cross-hatch lines** are added to a section view to indicate the surfaces that are cut by the imaginary cutting plane. Different section line symbols can be used to represent various types of materials. However, there are so many different materials used in design that the general symbol (i.e., the one

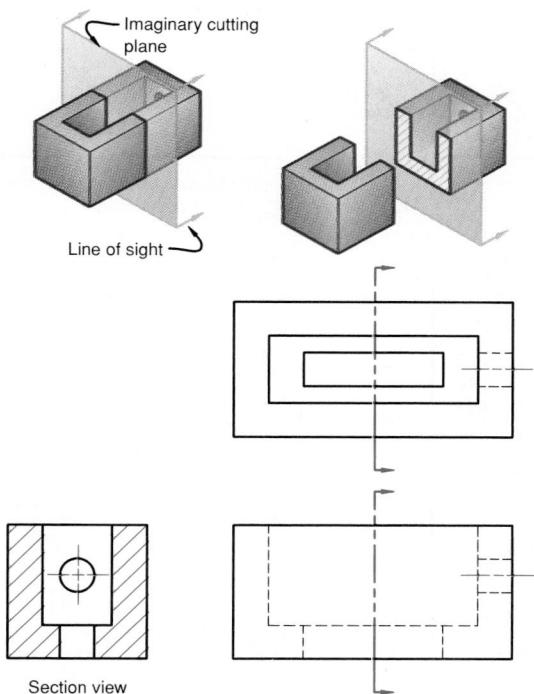

Figure 7.17 Profile Section View

A profile section view is one in which the cutting plane is on edge in the front and top views and the profile view is sectioned.

used for cast iron) may be used for most purposes on technical drawings. The actual type of material required is then noted in the title block or parts list, or entered as a note on the drawing. The angle at which section lines are drawn is usually 45 degrees to the horizontal, but this can be changed for adjacent parts shown in the same section. Also, the spacing between section lines is uniform on a section view.

7.3.1 Material Symbols

The type of section line used to represent a surface varies according to the type of material. However, the **general purpose section line** symbol used in most section view drawings is that of *cast iron*. Figure 7.19 shows some of the ANSI standard section line symbols used for only a few materials; there are literally hundreds of different materials used in design. Occasionally, a general section line symbol is used to represent a group of materials, such as steel. The specific type of steel to be used will be indicated in the title block or parts list. Occasionally, with assembly section views, material symbols are used to identify different parts of the assembly.

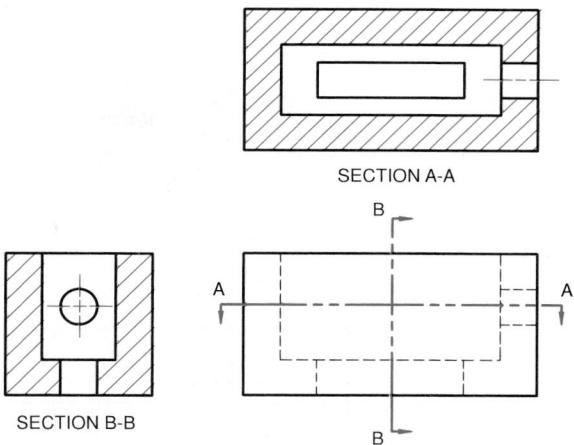

Figure 7.18 Multiple Sectioned Views

Multiple section views can be created on a single multiview drawing. This example shows a horizontal and profile section view. Note that each section view is labeled to correspond to its cutting plane line.

Most CAD software contains a number of ANSI standard materials symbols, which are placed on the CAD drawing automatically, after the area to be sectioned is defined. **© CAD Reference 7.4**

7.3.2 Drawing Techniques

The general purpose cast iron section line is drawn at a 45-degree angle and spaced $\frac{1}{16}$ inch (1.5 mm) to $\frac{1}{8}$ inch (3 mm) or more, depending on the size of the drawing. As a general rule, use $\frac{1}{8}$ -inch spacing. Section lines are drawn as thin (.35 mm or .016 inch) black lines, using an H or 2H pencil.

Figure 7.20 shows examples of good and poor section lines drawn using hand tools. The section lines should be evenly spaced and of equal thickness, and should be thinner than visible lines. Also, do not run section lines beyond the visible outlines or stop them too short.

Section lines should not run parallel or perpendicular to the visible outline. (Figures 7.21A and B) If the visible outline to be sectioned is drawn at a 45-degree angle, the section lines are drawn at a different angle, such as 30 degrees. (Figure 7.21C)

Avoid placing dimensions or notes within the section lined areas. (Figure 7.22) If the dimension or note must be placed within the sectioned area, omit the section lines in the area of the note, as shown in Figures 7.22B and C.

(A) Cast or malleable iron and general use for all materials

(B) Steel

(C) Bronze, brass, copper, and compositions

(D) White metal, zinc, lead, babbitt, and alloys

(E) Magnesium, aluminum, and aluminum alloys

(F) Rubber, plastic, and electrical insulation

(G) Cork, felt, leather and fiber

(H) Sound insulation

(I) Thermal insulation

(J) Titanium and refractory material

(K) Electric windings, electromagnets, resistance, etc.

(L) Concrete

(M) Marble, slate, glass, porcelain, etc.

(N) Earth

(O) Rock

(P) Sand

(Q) Water and other liquids

(R) Across grain > Wood
With grain

Figure 7.19 ANSI Standard Section Lines for Various Materials

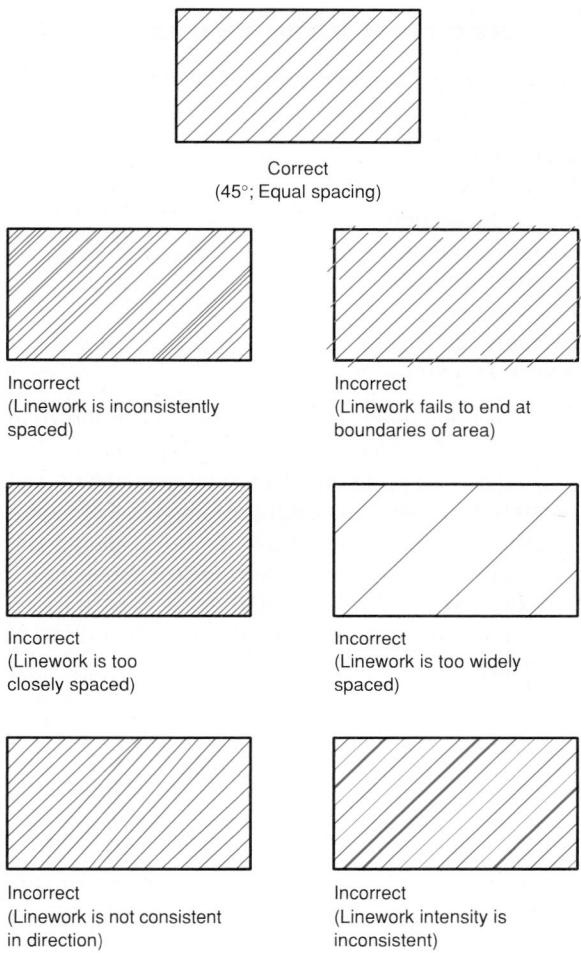

Figure 7.20 Examples of Good and Poor Section Lining Techniques

When using CAD, change to a thin pen or linetype *before* adding the section lines. Most CAD software will automatically space the section lines evenly. Also, some CAD software will automatically omit the section lines if a note is placed within the sectioned area. **CAD Reference 7.5**

7.3.3 Outline Sections

An outline section view is created by drawing partial section lines adjacent to all object lines in the section view. (Figure 7.23) For large parts, outline sections may be used to save time.

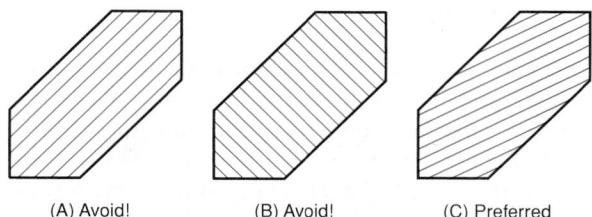

Figure 7.21 Section Lined Placement

Avoid placing section lines parallel or perpendicular to visible lines.

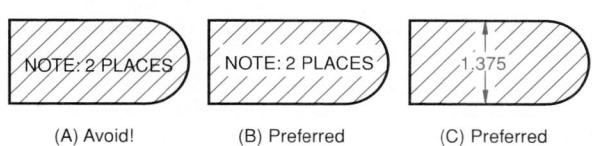

Figure 7.22 Notes in Section Lined Areas

Section lines are omitted around notes and dimensions.

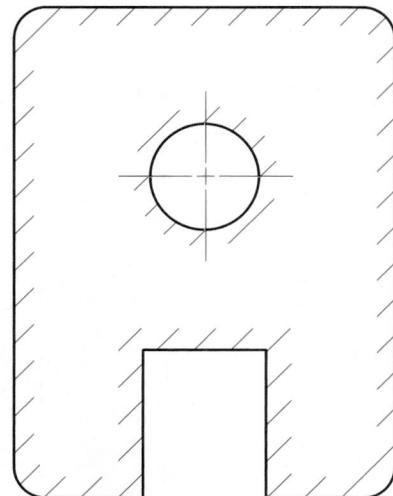

Figure 7.23 Outline Sectioning

Outline sectioning is used on large areas.

7.3.4 Thin Wall Sections

Very thin parts, such as washers and gaskets, are not easily represented with section lines, so conventional practice calls for representing the thin part in solid black. Figure 7.24 shows a section view of two parts separated by a thin gasket. The gasket is drawn solid black to show that it is sectioned. With CAD, a solid black area is produced by making the spacing between section lines very close. © CAD Reference 7.6

Practice Exercise 7.1

Using a foam or clay model of an object, slice the model in half with a knife. With a water-based marker, sketch section lines on the surfaces cut by the knife. Sketch a cutting plane line along the edge created where the model was cut in half. Sketch a three-view drawing of the model as it was before being cut in half. Sketch a three-view drawing with one as a full section view.

Repeat the steps described above to make half, offset, and broken-out sections.

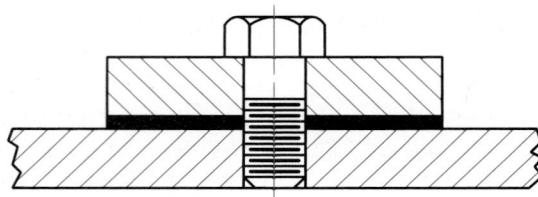

Figure 7.24 Thin Parts in Section

Thin parts in section are represented as solid black.

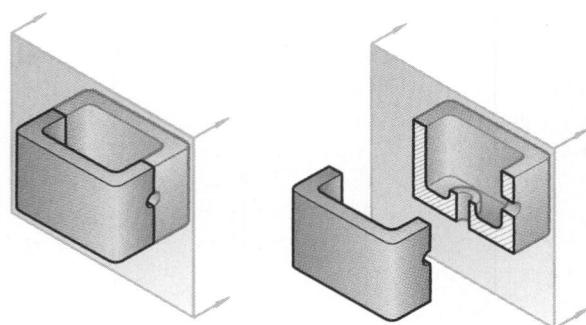

(A) Full section

(B) Standard multiview

(C) Full section view

Figure 7.25 Full Section View

A full section view is created by passing a cutting plane fully through the object.

7.4 SECTION VIEW TYPES

There are many different types of section views used on technical drawings.

- Full section
- Half section
- Broken-out section
- Revolved section
- Removed section
- Offset section
- Assembly section
- Auxiliary section

Up to this point, only full sections have been shown in the figures. The selection of the type of section view to be used is based upon which one most clearly and concisely represents the features of interest. For example, there are times when it may be more appropriate to use a half section view, for symmetrical objects, or a broken-out section, for small areas. The various types of section views are described in the following paragraphs.

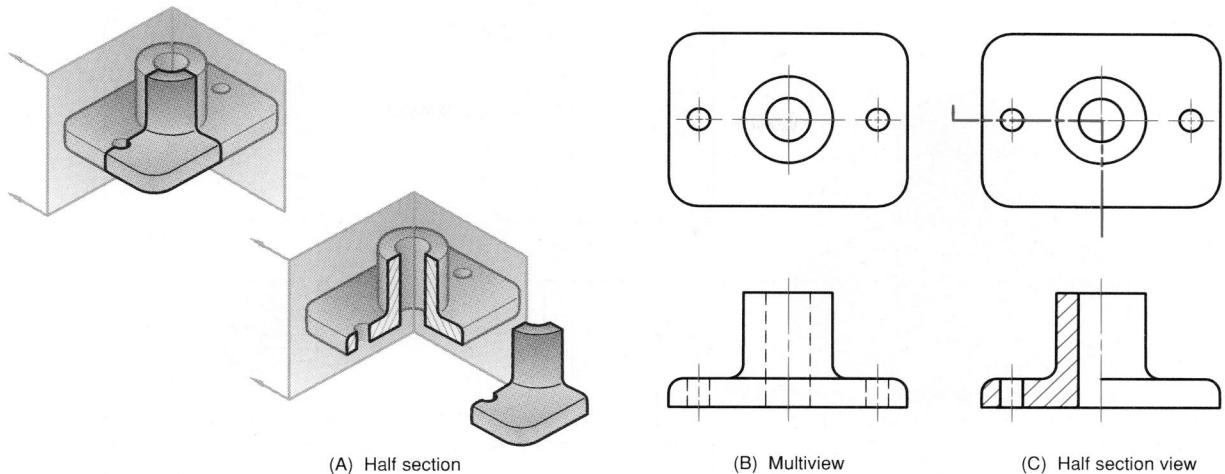

Figure 7.26 Half Section

A half section view is created by passing a cutting plane halfway through the object.

7.4.1 Full Sections

A **full section** view is made by passing the imaginary cutting plane completely through the object, as shown in Figure 7.25A. Figure 7.25B shows the orthographic views of the object, and Figure 7.25C shows the full section view. All the hidden features intersected by the cutting plane are represented by visible lines in the section view. Surfaces touched by the cutting plane have section lines drawn at a 45-degree angle to the horizontal. Hidden lines are omitted in all section views unless they must be used to provide a clear understanding of the object.

The top view of the section drawing shows the cutting plane line, with arrows pointing in the direction of the line of sight necessary to view the sectioned half of the object. In a multiview drawing, a full section view is placed in the same position that an unsectioned view would normally occupy; that is, a front section view would replace the traditional front view.

© CAD Reference 7.7

7.4.2 Half Sections

Half sections are created by passing an imaginary cutting plane only *halfway* through an object. Figure 7.26A shows the cutting plane passing halfway through an object and *one quarter* of the object being removed. Figure 7.26B shows the normal orthographic views before sectioning, and Figure 7.26C shows the orthographic views after sectioning. Hidden lines are omitted on both halves of the section view. Hidden lines may be added to the unsectioned half, for dimensioning or for clarity.

External features of the part are drawn on the unsectioned half of the view. A center line, not an object line, is used to separate the sectioned half from the unsectioned half of the view. The cutting plane line shown in the top view of Figure 7.26C is bent at 90 degrees, and one arrow is drawn to represent the line of sight needed to create the front view in section.

Half section views are used most often on parts that are symmetrical, such as cylinders. Also, half sections are sometimes used in assembly drawings when external features must be shown.

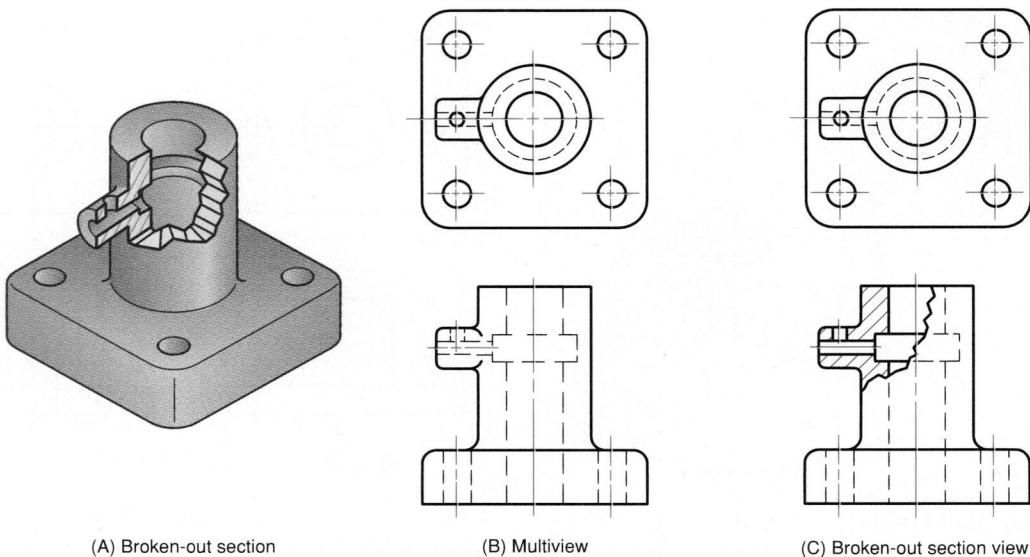

Figure 7.27 Broken-Out Section

A broken-out section view is created by breaking off part of the object to reveal interior features.

7.4.3 Broken-Out Sections

A **broken-out section** is used when only a portion of the object needs to be sectioned. Figure 7.27A shows a part with a portion removed or broken away. A broken-out section is used instead of a half or full section view to save time.

A break line separates the sectioned portion from the unsectioned portion of the view. A break line is drawn freehand to represent the jagged edge of the break. No cutting plane line is drawn. Hidden lines may be omitted from the unsectioned part of the view, unless necessary for clarity, as shown in Figure 7.27C.

Most CAD systems have a freehand drawing command called SKETCH, which can be used to draw a break line.

7.4.4 Revolved Sections

A **revolved section** is made by revolving the cross-section view 90 degrees about an axis of revolution and superimposing the section view on the orthographic view, as shown in Figure 7.28A. Visible lines adjacent to the revolved view can either be drawn or broken out using conventional breaks, as shown in Figure 7.28B. When the revolved view is superimposed on the part, the original lines of the part behind the section are deleted. The cross section is drawn true shape and size, not distorted to fit the view. The axis of revolution is shown on the revolved view as a center line.

A revolved section is used to represent the cross section of a bar, handle, spoke, web, aircraft wing, or other elongated feature. Revolved sections are useful for describing a cross section without having to draw

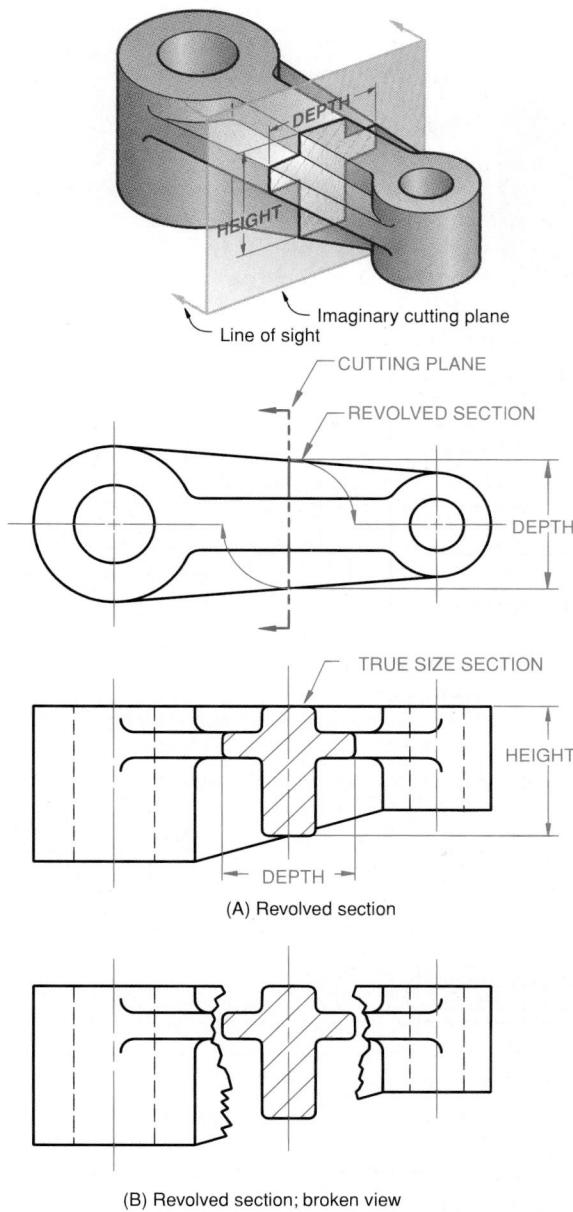

Figure 7.28 Revolved Section

A revolved section view is created by passing a cutting plane through the object, then revolving the cross section 90 degrees.

another view. In addition, these sections are especially helpful when a cross section varies or the shape of the part is not apparent from the given orthographic views.

7.4.5 Removed Sections

Removed section views do not follow standard view alignments as practiced in multiview drawings. Removed sections are made in a manner similar to revolved sections, by passing an imaginary cutting plane perpendicular to a part then revolving the cross section 90 degrees. However, the cross section is then drawn adjacent to the orthographic view, not on it. (Figure 7.29) Removed sections are used when there is not enough room on the orthographic view for a revolved section.

Removed sections are used to show the contours of complicated shapes, such as the wings and fuselage of an airplane, blades for jet engines or power plant turbines, and other parts that have continuously varying shapes. (Figure 7.30)

Normally, the cross section view is drawn adjacent to the orthographic view and close to the position of the cutting plane, which is identified either with a center line or a cutting plane line. If a number of removed sections are done on a part, cutting plane lines may be drawn with labels to clarify the position from which each section is taken. The removed section view is then labeled, such as SECTION A–A as shown in Figure 7.29, to correspond to the labeled cutting plane line.

Removed sections can also be drawn to a larger scale, for better representation of the details of the cross section, and for dimensioning. The scale used for the removed section view is labeled beneath the view. (Figure 7.31) Sometimes removed sections are placed on center lines adjacent to the axis of revolution. (Figure 7.32)

Wherever possible, a removed section should be on the same sheet as the part it represents, and it should be clearly labeled. If the removed section view must be drawn on another sheet, it must be properly labeled, such as SECTION A–A ON SHEET 2.

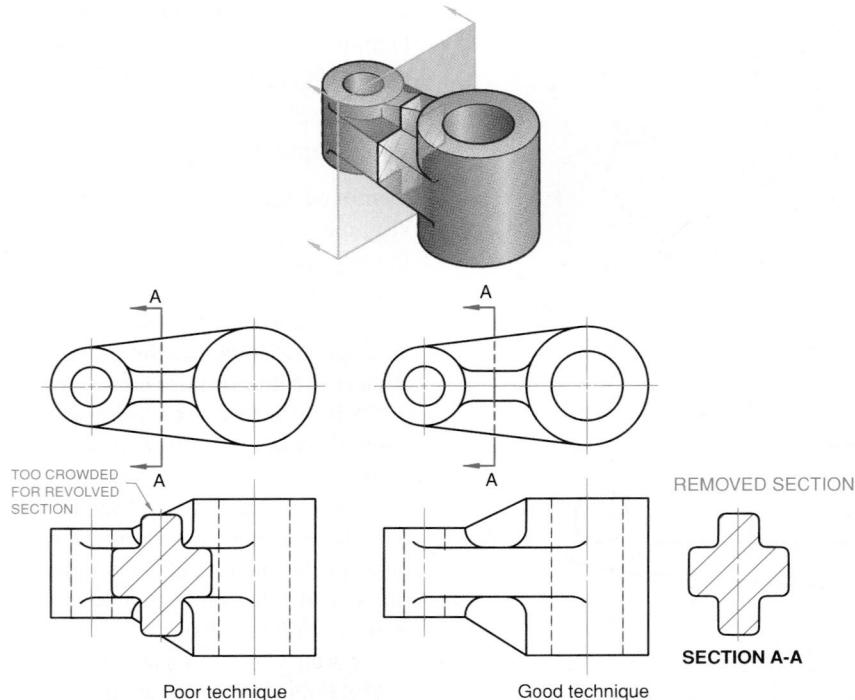

Figure 7.29 Removed Section

A removed section view is created by making a cross section, then moving it to an area adjacent to the view.

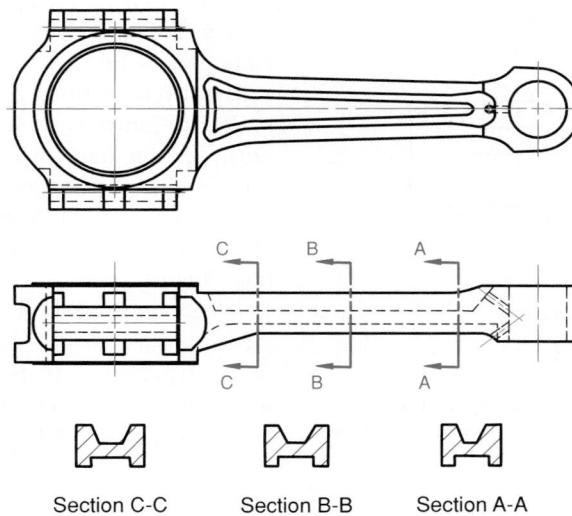

Figure 7.30 Multiple Removed Section Views of a Crankshaft Identified with Labels

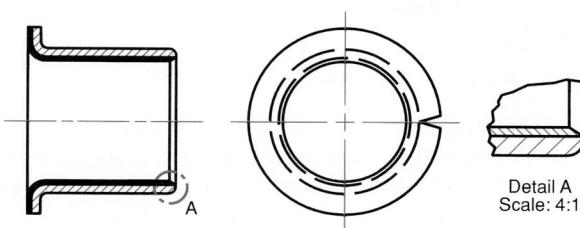

Figure 7.31 Scaled Section View

A scaled removed section view is placed at any convenient location and labeled with the scale.

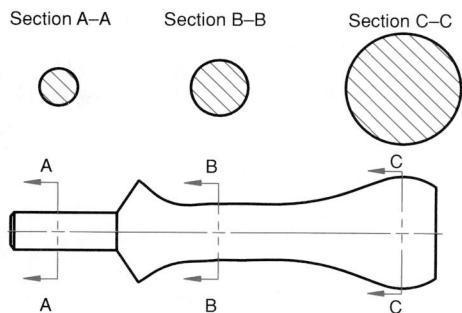

Figure 7.32 Aligning Removed Section Views

In one technique, the removed section view is aligned along center lines adjacent to the regular view.

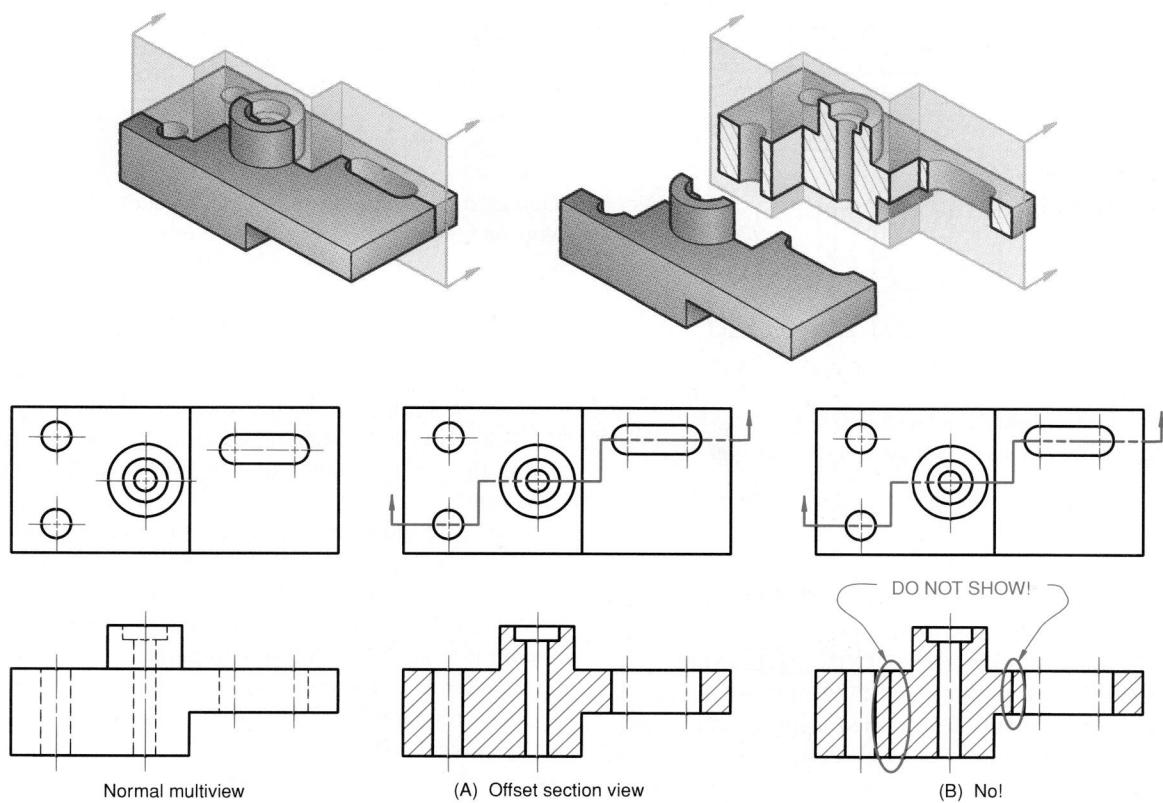

Figure 7.33 Offset Section

An offset section view is created by bending the cutting plane at 90-degree angles to pass through important features.

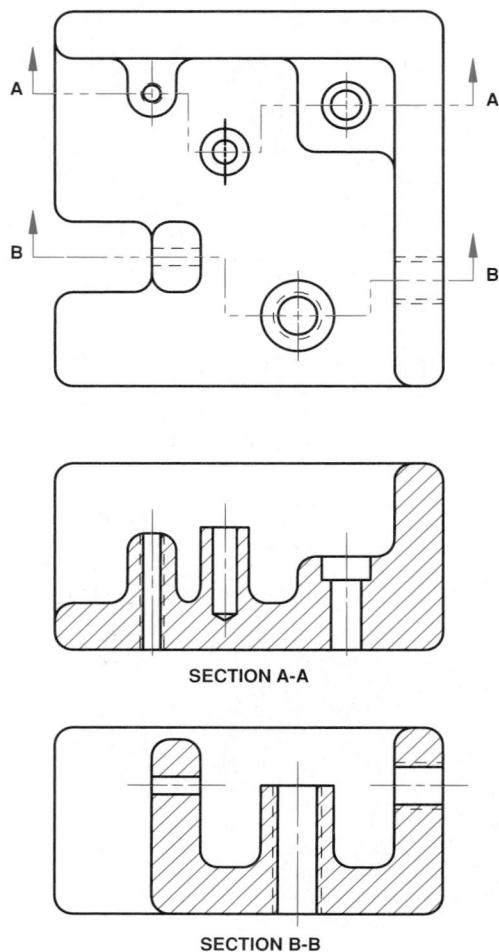

Figure 7.34 Multiple Offset Sections

Multiple offset section views use labels for identification.

7.4.6 Offset Sections

An **offset section** has a cutting plane that is bent at one or more 90-degree angles to pass through important features. (Figure 7.33A) Offset sections are used for complex parts that have a number of important features that cannot be sectioned using a straight cutting plane. In Figure 7.33, the cutting plane is first bent at 90 degrees to pass through the hole, and is then bent at 90 degrees to pass through the slot. The front portion of the object is “removed” to create a full section view of the part. The cutting plane line is drawn with 90-degree offsets, as shown in Figure 7.33A. As shown in Figure 7.33B, the change of plane that occurs when the cutting plane is bent at 90 degrees is not

represented with lines in the section view. Multiple offset sections used on a single view are labeled as shown in Figure 7.34.

7.4.7 Assembly Sections

Assembly sections are typically orthographic, pictorial, full or half section views of parts as assembled. (Figure 7.35) Leonardo da Vinci was one of the first to create assembly sections, using them to illustrate pictorially the complex machine designs he developed.

Section assembly drawings follow special conventions. Standard parts, such as fasteners, dowels, pins, washers, springs, bearings, and gears, and nonstandard parts, such as shafts, are *not* sectioned; instead, they are drawn showing all of their exterior features. For example, in Figure 7.36, fasteners would be cut in half by the cutting plane, yet they are not cross-hatched with section lines.

Typically, the following features are not section lined in an assembly section drawing:

Shafts	Ribs
Bearings, roller or ball	Spokes
Gear teeth	Lugs
Threaded fasteners	Washers
Nuts and bolts	Keys
Rivets	Pins

Adjacent parts in assembly sections are cross-hatched at different angles so that they are more easily identified. (Figure 7.37) Different material symbols can also be used for this purpose. Also, if a part in an assembly section is separated by some distance, the section lines are still drawn in the same direction.

CAD 3-D modeling software can create models of each part, the individual models can be sectioned, and the section views can be placed together, resulting in a 3-D assembly section. An alternative involves using a feature that adds translucency to parts, to reveal interior assemblies. (Figure 7.38) The models can be used to check for interference of parts, or can be analyzed by dynamically showing the parts in action. The models can also be rotated to produce an orthographic assembly section view.

If 2-D CAD is used to create detail drawings, assembly sections can be created by making a pattern or template of the detail views. The assembly section views are then placed together, resulting in an orthographic assembly view. © CAD Reference 7.8

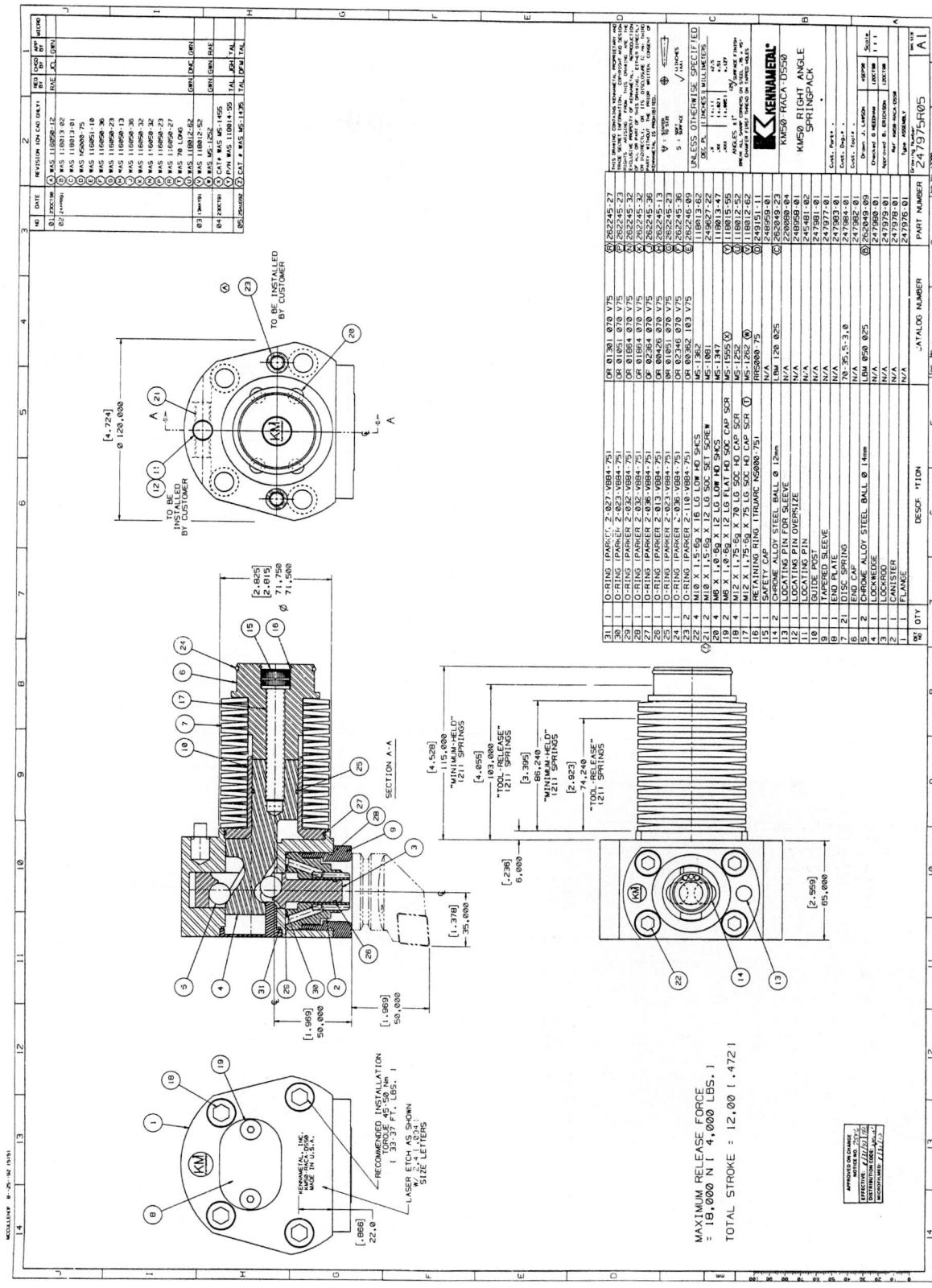

Figure 7-35 Assembly section views are typically full or half sections of multiple assembled parts. (Courtesy of Kennametal Inc.)

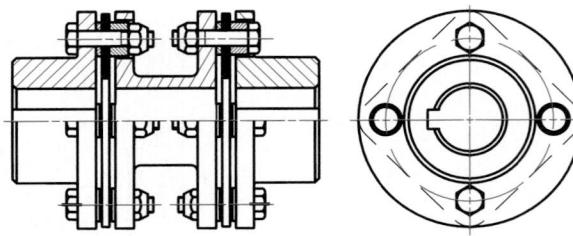

Figure 7.36 Standard Parts Not Section Lined

Standard parts, such as fasteners and shafts, are not section lined in assembly sections, even if they are cut by the cutting plane.

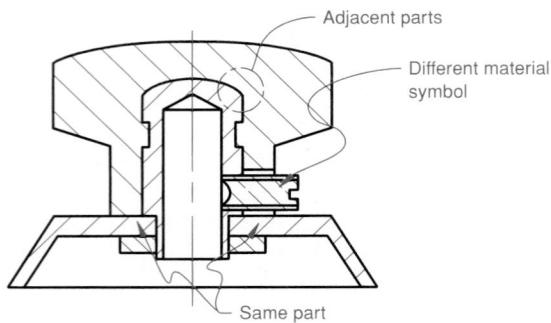

Figure 7.37 Section Lining Adjacent Parts

Adjacent parts in an assembly section are section lined at different angles, so that individual parts can be more easily identified.

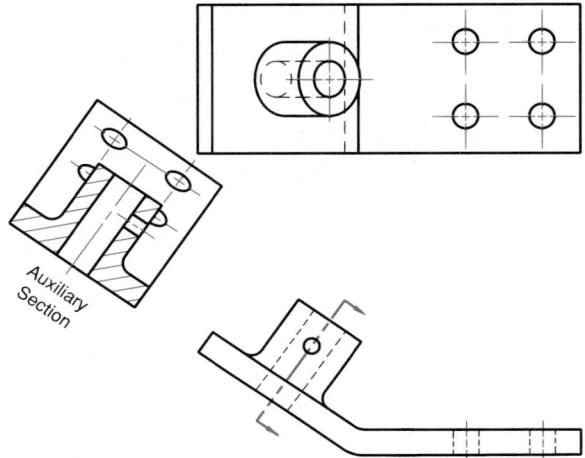

Figure 7.39 A Full Auxiliary Section View

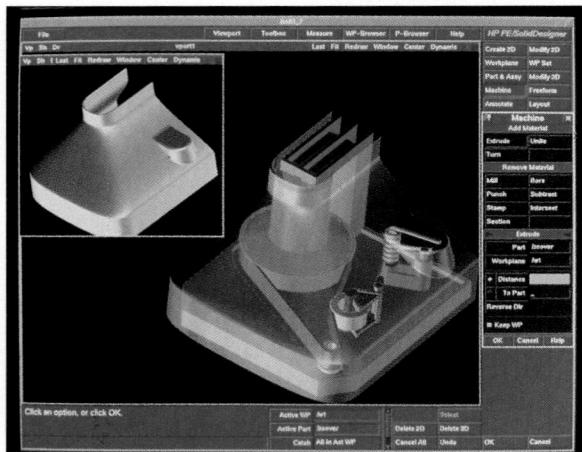

Figure 7.38 Translucency of a CAD Model

With a 3-D CAD model, translucency can be used instead of cutting planes to reveal interior features. (Courtesy of Hewlett-Packard.)

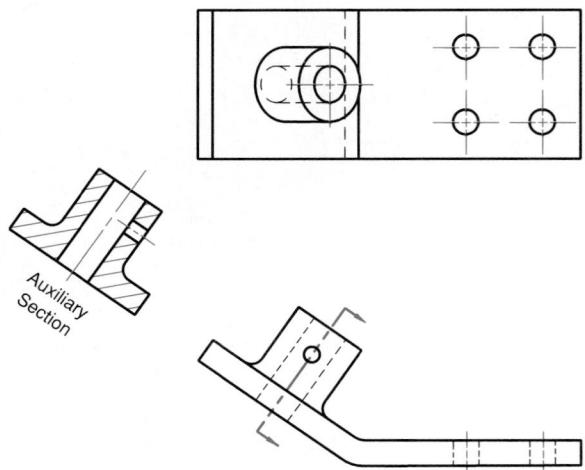

Figure 7.40 A Partial Auxiliary Section View

Parts of the object appearing behind the auxiliary section view are sometimes not drawn, to improve the clarity of the drawing.

Industry Application

Adjustable Mountain Bike Suspension

Front suspensions have become standard equipment on mountain bikes, replacing rigid forks. These suspensions absorb bump impact, protecting the frame and the rider. Elastomer suspensions are commonly found on mountain bikes, but they lack the ability to adjust to varying conditions.

Rock Shox Inc. has introduced a variation to the elastomer suspension: a hydraulically damped suspension system that is adjustable. A knob located at the top of the suspension system allows the rider to make adjustments for varying conditions. An oil-damped air and coil spring mechanism regulates the speed at which its fork compresses and rebounds after impact.

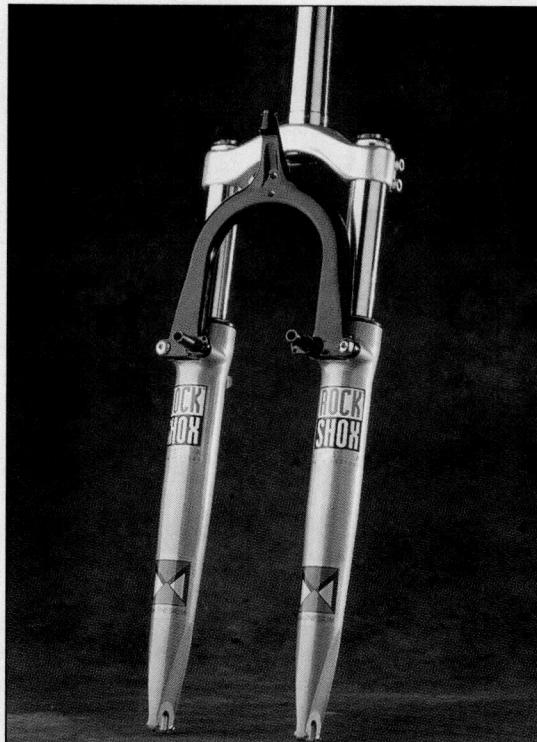

The adjustable bike suspension fork weighs 3.28 pounds and is made mostly of aluminum and magnesium.

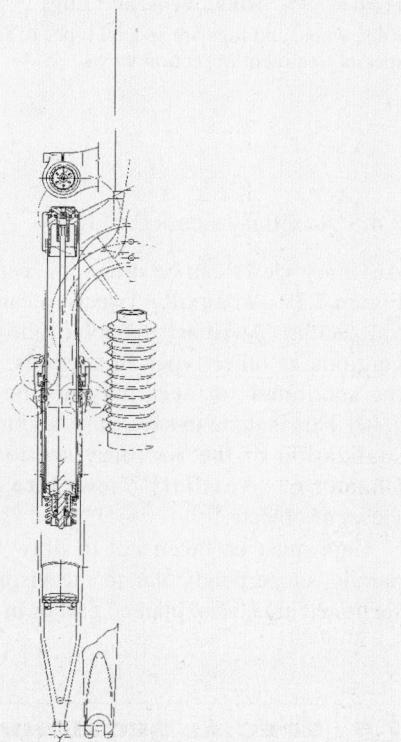

Assembly section view of the adjustable bike suspension, revealing the interior details.

Adapted from W. Leventon, "Mountain Bike Suspension Allows Easy Adjustment," *Design News*, July 19, 1993, pp. 75-77.

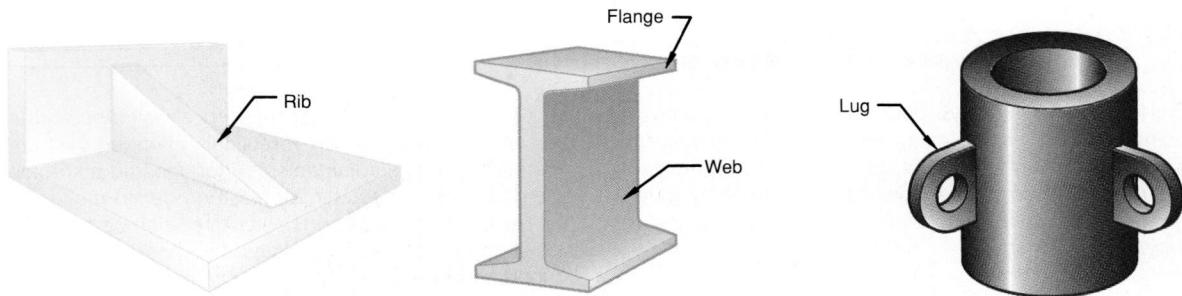

Figure 7.41 Ribs, Webs, and Lugs

Ribs, webs, and lugs are special types of features commonly found in mechanical components. These types of features require special treatment in section views.

7.4.8 Auxiliary Sections

Auxiliary views can be drawn in section, as shown in Figure 7.39. An **auxiliary section** can be a full or partial section. Auxiliary sections follow the same conventions as other types of sections. Features behind the sectioned surfaces may not be drawn. (Figure 7.40) This is done to save time, and to improve the visualization of the auxiliary section view. Review Chapter 6, “Auxiliary Views,” to create auxiliary views of objects.

Care must be taken not to draw the section lines parallel or perpendicular to the visible outline of the sectioned area, as explained earlier in this chapter.

7.5 SPECIAL SECTIONING CONVENTIONS

Conventional practices have been established to handle section views of special situations, such as alignment of holes, ribs, and spokes. These practices are described in the following paragraphs.

7.5.1 Ribs, Webs, and Other Thin Features

Ribs, webs, spokes, lugs, gear teeth, and other thin features are not section lined when the cutting plane passes parallel to the feature. A **rib** or **web** is a thin, flat part that acts as a support. (Figure 7.41) Adding section lines to these features would give the false impression that the part is thicker than it really is.

Figure 7.42 shows a cutting plane that passes parallel to and through a web (SECTION B–B). Figure 7.42B shows the view drawn using conventional practice, which leaves the web unsectioned. Figure 7.42A shows an incorrect representation of the section view, with the web having section lines. This view gives the false impression that the web has substantial thickness.

Leaving thin features unsectioned only applies if the cutting plane passes parallel to the feature. If the cutting plane passes perpendicular or crosswise to the feature (cutting plane A–A), section lines are added as shown in Figure 7.42C.

Occasionally, section lines are added to a thin feature so that it is not mistaken or read as an open area. Figure 7.43A shows a part with webs, which are flush with the rim and the hub. In Figure 7.43B, the part could be interpreted as being round and without webs. To section line a thin feature, use alternate lines, as shown in Figure 7.43C. However, if the feature is not lost, as shown in Figure 7.44, then section lines should not be added.

7.5.2 Aligned Sections

Aligned sections are special types of orthographic drawings used to revolve or align special features of parts, to clarify them or make them easier to represent in section. Aligned sections are used when it is important to include details of a part by “bending” the cutting plane. The cutting plane and the feature are imagined to be aligned or revolved before the section view

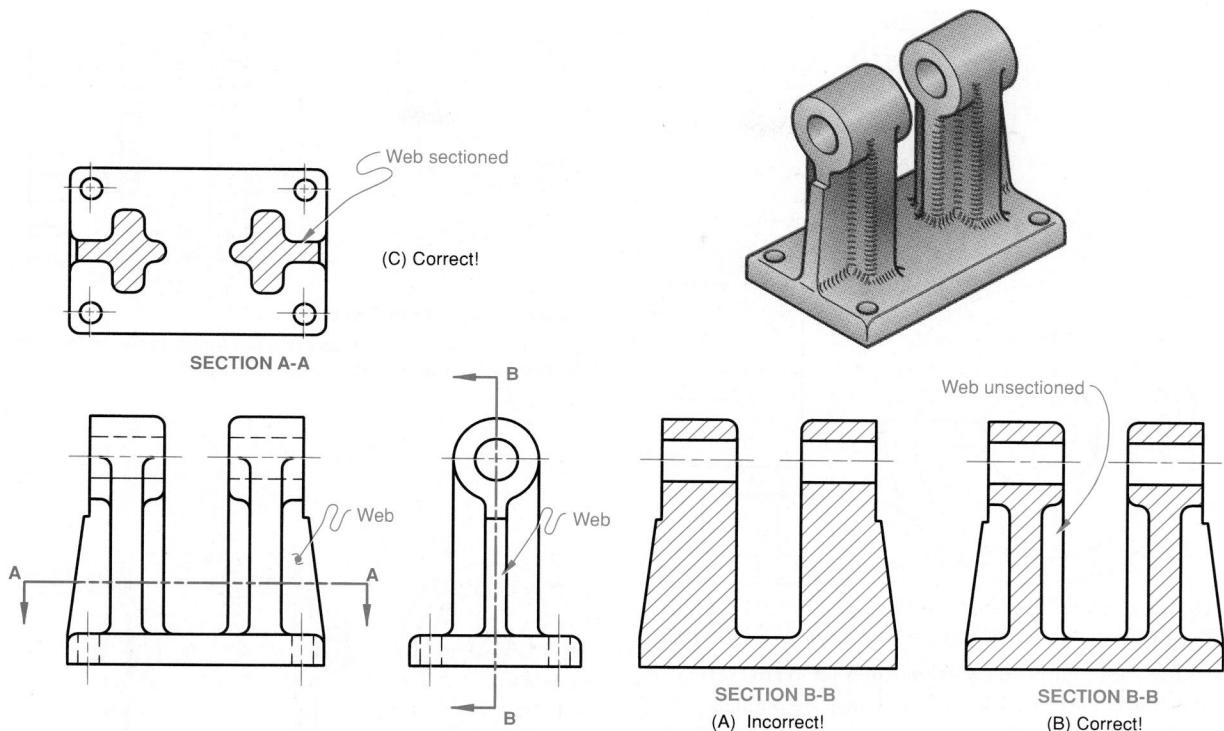

Figure 7.42 Conventional Practices for Webs in Section

Thin features, such as webs, are left unsectioned when cut parallel to the feature by the cutting plane.

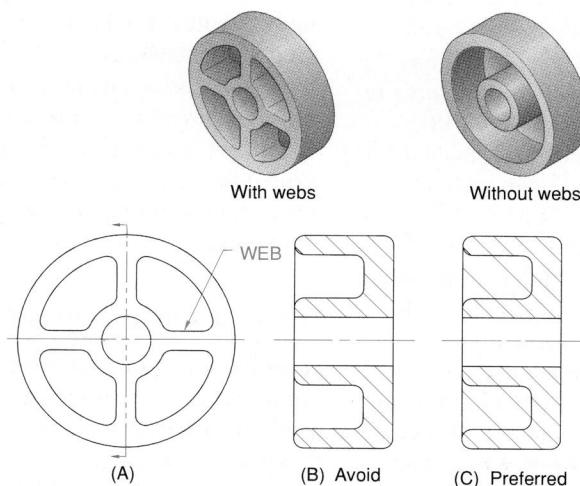

Figure 7.43 Alternate Method of Representing a Web in Section

Thin features are section lined with alternate lines if it clarifies the geometry of the object.

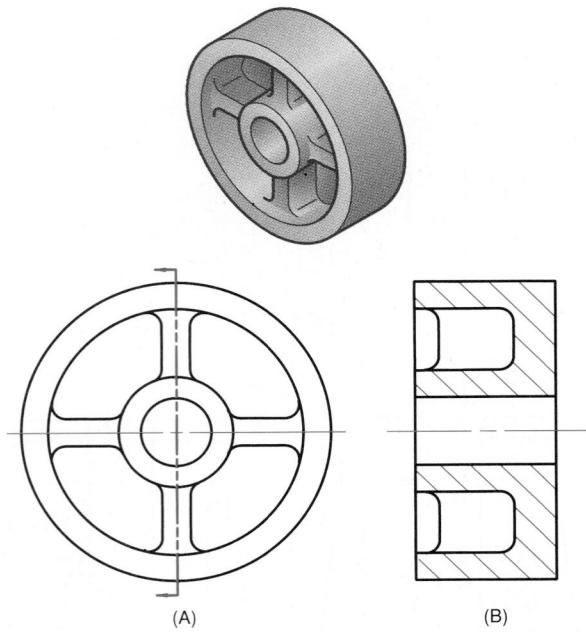

Figure 7.44 Omitting Section Lines on Webs

When the feature is not lost, section lines are omitted.

is created. In other words, the principles of orthographic projection are violated in order to more clearly represent the features of the object.

Normally, the alignment is done along a horizontal or vertical center line, and the realignment is always less than 90 degrees. (Figure 7.45) The aligned section view gives a clearer, more complete description of the geometry of the part. The cutting plane line may be bent to pass through all of the nonaligned features in the unsectioned view. (Figures 7.46 through 7.48)

Conventional practice also dictates the method for representing certain features that are perpendicular to the line of sight. Figure 7.46 shows a part with a feature called a *spoke*, which is bent at a 30-degree angle from the vertical center line. True projection would show the spoke foreshortened in the side view. However, aligning the spoke with the vertical center line in the front view allows the section view to be created more easily, and this is the preferred method for representing the part. Also, even though the spoke has been aligned, standard practice requires that section lines not be placed on the spoke. Also, spoke A is not drawn in the section view, to save time and increase clarity.

Alignment of features is used for many applications. For example, the lug shown in Figure 7.47A is aligned

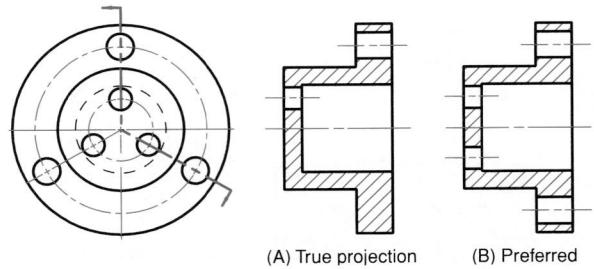

Figure 7.45 Aligned Section

Aligned section conventions are used to rotate the holes into position along the vertical center line.

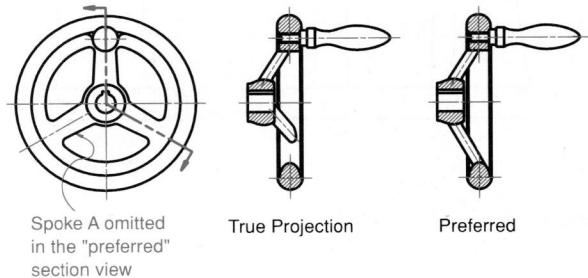

Figure 7.46 Aligning Spokes

Aligning spokes in section views is the conventional method of representation.

in the section view but is not sectioned. A lug is considered a thin feature, so section lines are normally not used when the cutting plane is parallel to the lug's thickness. However, if the lug were positioned as shown in Figure 7.47B, then the lug would be drawn with section lines. Figure 7.48 shows how ribs are aligned before the section view is drawn. The standard practice is to not put section lines on ribs. (Figure 7.48C)

7.5.3 Conventional Breaks

Conventional breaks are used for revolved section views or for shortening the view of an elongated part, such as a shovel handle or vehicle axle. Shortening the length of a part leaves room for the part to be drawn to a larger scale. The printed dimension specifies the true length. (Figure 7.49)

Examples of the conventional breaks used for different materials and cross sections are shown in Figure 7.50. Cylindrical or tubular material is represented as a

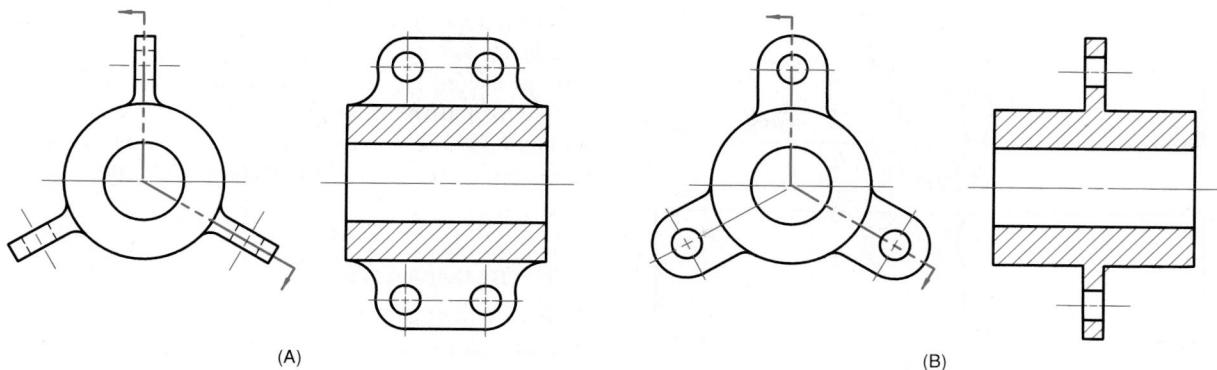

Figure 7.47 Aligning Lugs

Aligning lugs in section views is the conventional method of representation.

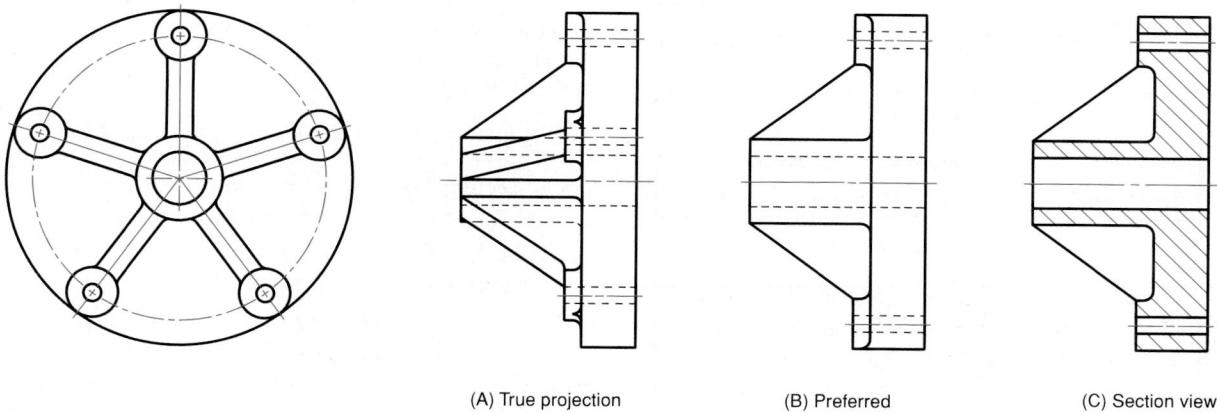

Figure 7.48 Aligning Ribs

Aligning ribs in section views is the conventional method of representation.

Figure 7.49 Conventional Break Symbols Can Shorten the Drawn Length of a Long Object

figure “8” or “S.” For very small parts, the figure “8” can be drawn freehand or using an irregular curve. With CAD, the SPLINE command can be used to create irregular curves. For larger parts, the figure “8” is drawn using a template or compass, following the procedures shown in Figure 7.51. These same procedures are followed with CAD, as well.

Breaks for rectangular metal or wood are drawn freehand, whether using traditional tools or CAD. **CAD Reference 7.9**

7.6 3-D CAD TECHNIQUES

CAD can create section views for 2-D orthographic drawings in a manner similar to that of using hand tools. However, 3-D CAD solid modeling programs can create section views using nontraditional techniques. In using CAD to create a solid model of a part, the user can assign material properties and can view the model from any position. The model can also be assigned surface properties, such as color, reflectivity, and texture. (Figure 7.52)

After the model is defined, section views of the part can be created by defining a cutting plane in 3-D space. The model can be separated along the cutting plane, to reveal interior features, to check for fit of multiple parts, or to create a pictorial assembly section

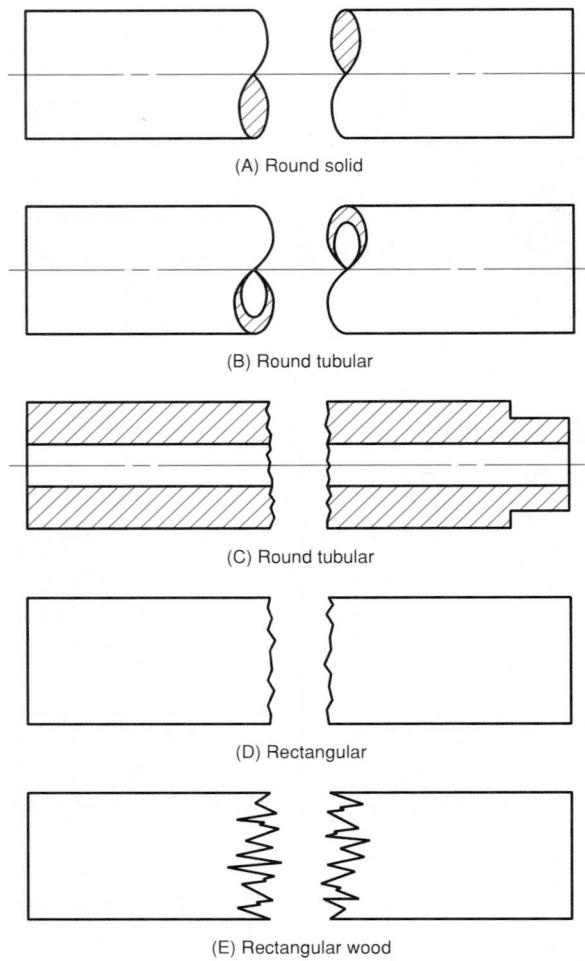

Figure 7.50 Examples of Conventional Break Symbols Used for Various Materials

view. The 3-D model can be rotated so that the line of sight is perpendicular to the sectioned surface, creating an orthographic view for detail drawings.

An alternative to using a cutting plane is changing the surface property from opaque to translucent or transparent, to reveal interior details.

It will soon become common practice to create 3-D solid models that can be manipulated and edited by the user. If a section view is necessary for the design or documentation of a part, a cutting plane will be defined and the section view will be created automatically by the CAD software.

With more advanced systems, cutting planes can be manipulated interactively, creating an animated

sequence of sections of the object being cut away. In scientific and medical applications, it is quite common to use cutting plane techniques to create multiple sections of volumetric data representing the human body, geological features, atmospheric conditions, and so forth. © CAD Reference 7.10

7.7 SUMMARY

Section views are powerful aids in the design, documentation, and construction of products. There are many different types of section views, and there are accepted standards and conventions for creating such views. CAD is particularly useful for automating the creation of section views and adding section lines. In the future, CAD will be used to create both traditional and nontraditional types of section views.

The important practices for creating section views are as follows.

- Section lines (refer to Figures 7.20, 7.21, 7.22)
 1. Section lines are drawn thin (0.35 mm or .016 inch), black, uniform, and uniformly spaced.
 2. Section lines are drawn at 45 degrees to the horizontal when possible.
 3. Section lines are not drawn parallel or perpendicular to the visible outline of the sectioned surface.
 4. Section lines do not extend beyond or stop short of the outline of the sectioned surface.
 5. The cast iron symbol is the general purpose section line symbol.
 6. Very thin parts are not shown with section lines; instead, they are shown in solid black.
- Cutting plane lines (refer to Figure 7.15)
 1. Cutting plane lines are drawn as heavy (0.7 mm or .032 inch) black lines in the view where the cutting plane appears as an edge. One of two conventional methods is used: one long and two short dashes, or a series of short dashes.
 2. The cutting plane line has precedence over center lines.
 3. Cutting plane lines are terminated by bending them at 90 degrees at each end and placing arrows on the ends.
 4. The arrows on the ends of the cutting plane line show the direction of the line of sight necessary to create the section view.

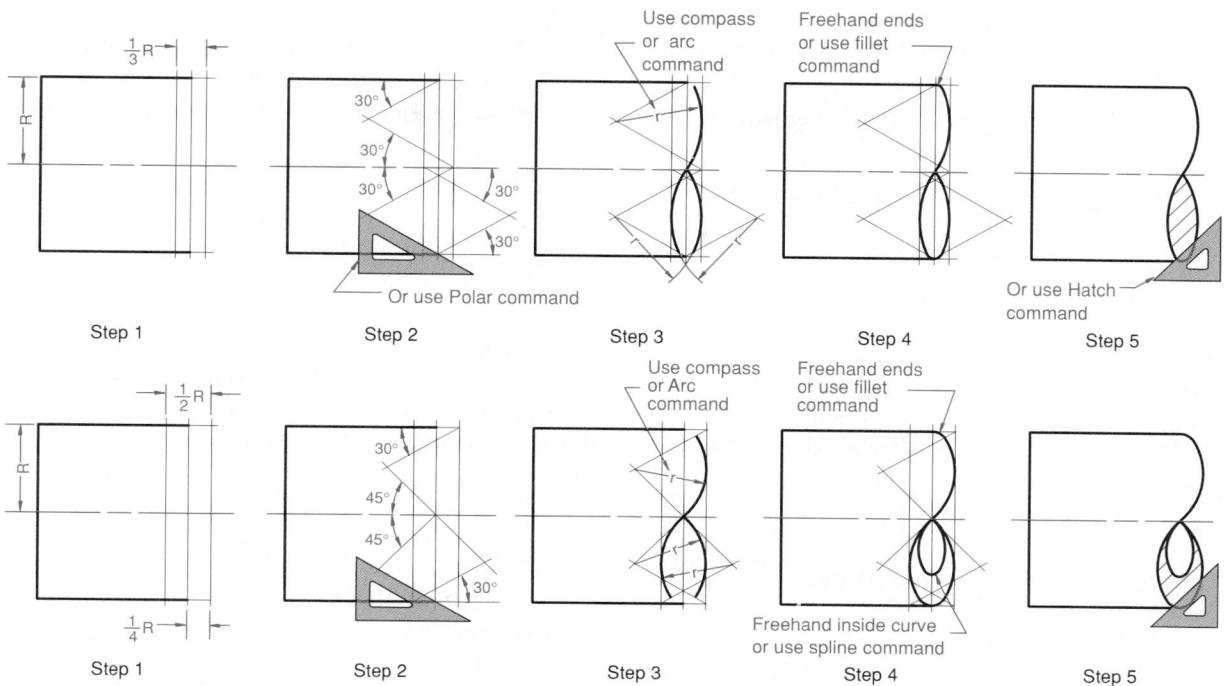

Figure 7.51 Procedures Used to Create a Break for Cylindrical or Tubular Material

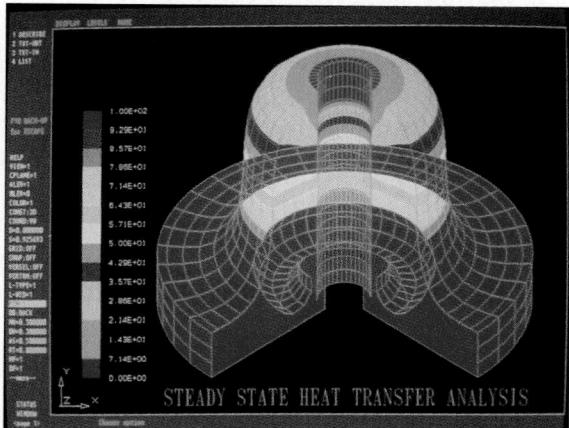

Figure 7.52 A Sectioned Boundary Element Model Used to Analyze the Part

(Courtesy of CADKEY, Inc.)

5. The arrows on the ends of the cutting plane line point away from the section view.
- Full section views (refer to Figures 7.2, 7.7)
 1. The cutting plane passes completely through the object.

2. The cutting plane line need not be drawn if its position is obvious.
3. Hidden features are not represented with dashed lines, unless necessary for clarity or for eliminating the need for additional views.
- Half section views (refer to Figure 7.26)
 1. The cutting plane only goes halfway through the object.
 2. The unsectioned half of the section view does not have hidden lines, unless necessary to clarify details.
 3. External features are drawn on the unsectioned half of the section view.
 4. A center line, not an object line, is used to separate the sectioned half from the unsectioned half in the section view.
- Offset section views (refer to Figure 7.33)
 1. Offsets in the cutting plane line are at 90 degrees.
 2. In the sectioned view, change of plane lines are not drawn where the cutting plane line bends 90 degrees.
- Revolved section views (refer to Figure 7.28)

1. Lines adjacent to the revolved view can be either drawn or broken out using conventional breaks.
2. The axis of revolution is drawn as a center line on the revolved view.

- Removed section views (refer to Figure 7.29)

1. The position of the cutting plane can be identified either by a center line or a cutting plane line.
2. Cutting plane lines may be drawn with labels to clarify the position from which the section is taken.

KEY TERMS

Aligned section	Cross-hatch lines	Half section	Sectional drawings
Assembly section	Cutting plane line	Offset section	Section lines
Auxiliary section	Full section	Removed section	Section views
Broken-out section	General purpose section line	Revolved section	Web
Conventional break		Rib	

QUESTIONS FOR REVIEW

1. Define section drawings.
2. Describe how 3-D CAD is used to create section views.
3. Describe how cutting plane lines are used.
4. Sketch the two standard types of cutting plane lines.
5. List three applications of section views.
6. What convention is used for hidden lines in a section view?
7. What convention is used for hidden lines on the unsectioned half of a half section view?
8. Define section lines.

9. Sketch the material symbol used to represent steel.
10. Describe how thin parts are represented in a section view.
11. Describe the difference between a revolved and a removed section view.
12. List some of the standard parts that are not sectioned in an assembly section. Explain why.
13. What type of line is used to separate the sectioned half from the unsectioned half of a half section view?
14. List some of the future applications of 3-D CAD section views.

PROBLEMS

14.1 Sketch, or draw with instruments or CAD, the views with sections as indicated by the cutting plane lines in Figure 7.53. Each grid square equals $\frac{1}{4}$ " or 6 mm.

14.2 Sketch, or draw with instruments or CAD, the necessary views, including a section view, of the objects shown in Figures 7.54 through 7.69.

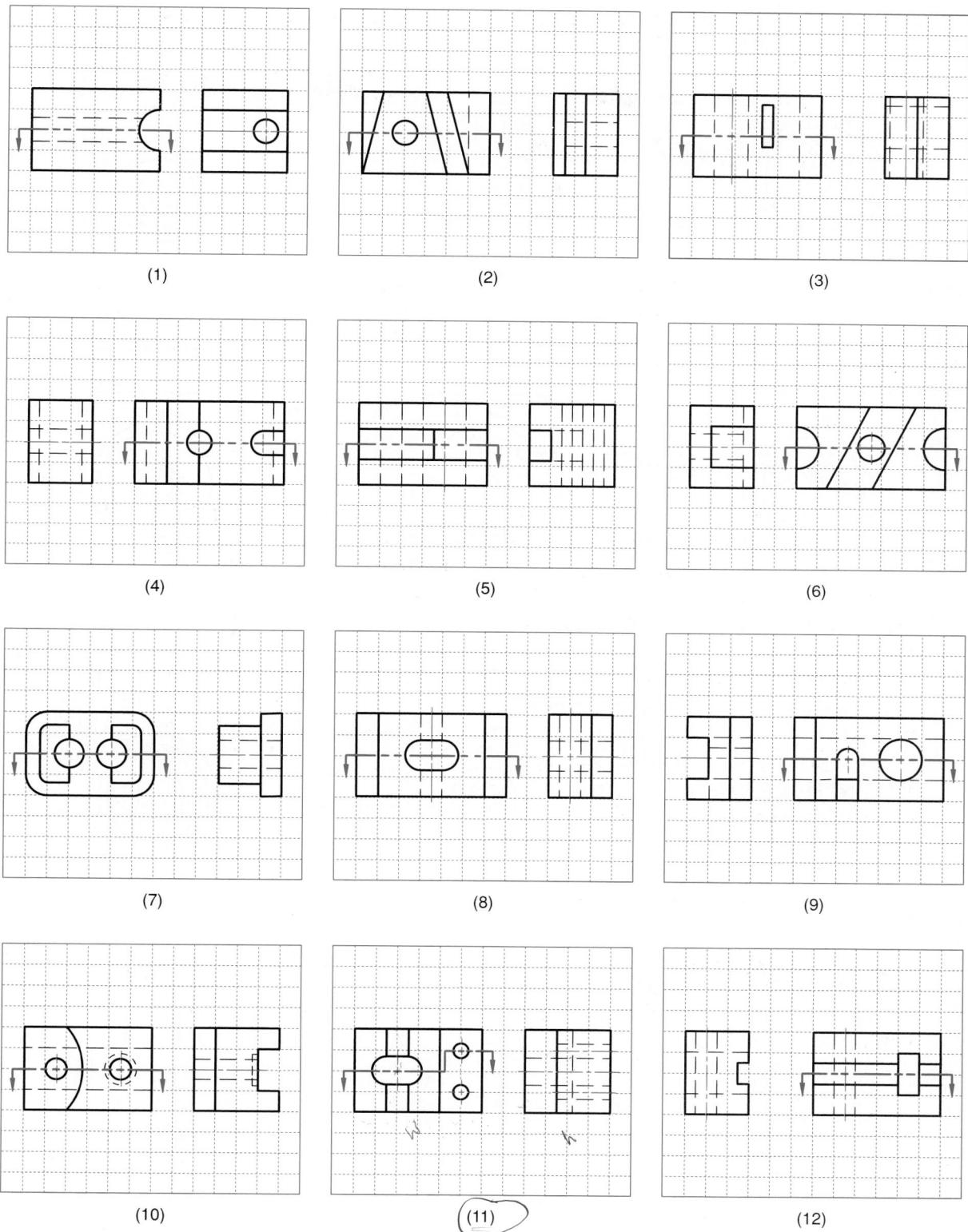

Figure 7.53 Section View Problems

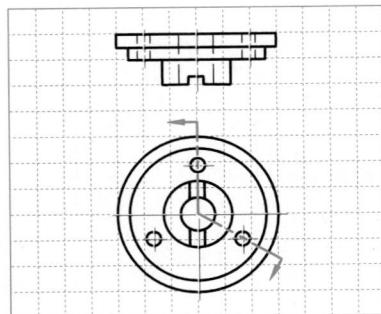

(13)

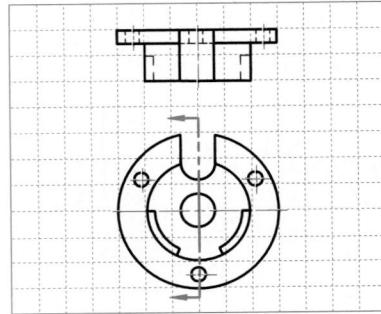

(14)

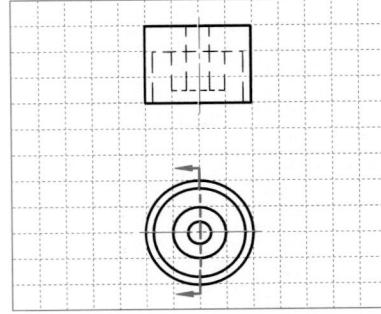

(15)

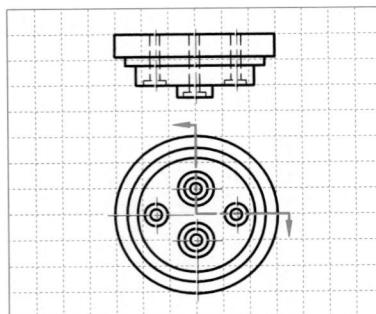

(16)

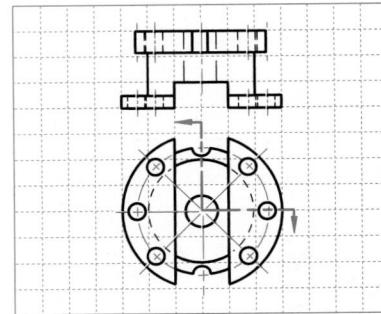

(17)

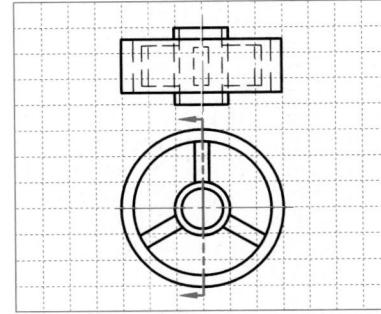

(18)

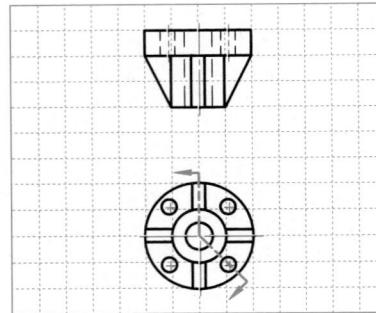

(19)

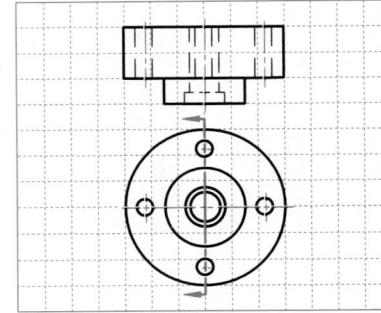

(20)

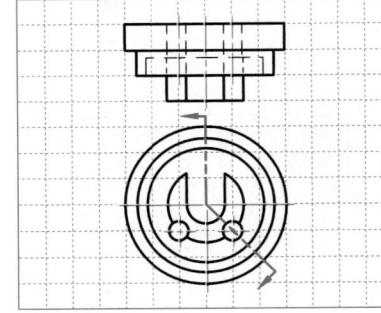

(21)

(22)

(23)

(24)

Figure 7.53 Continued

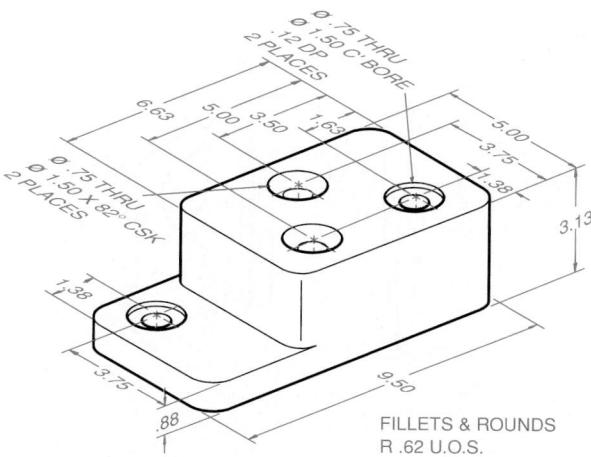

Figure 7.54 Bracket

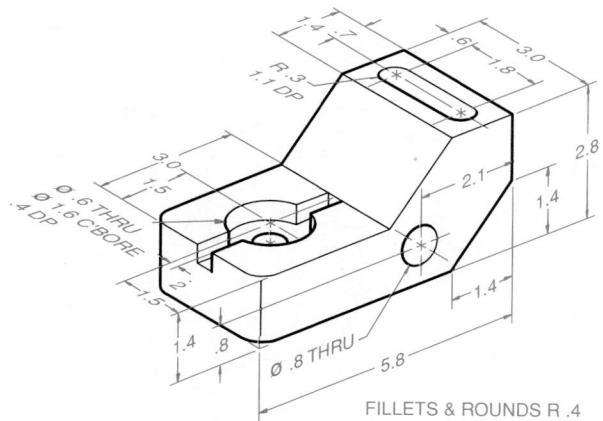

Figure 7.55 Counter Block

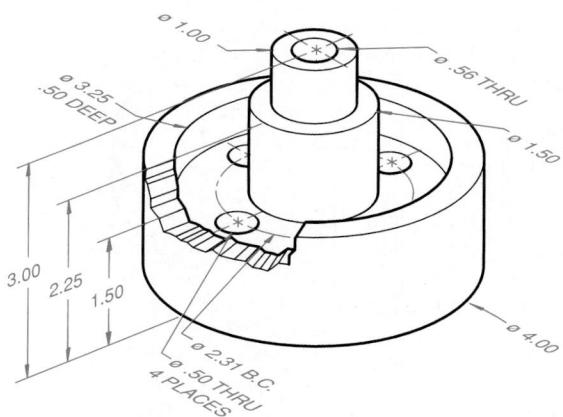

Figure 7.56 Center Support

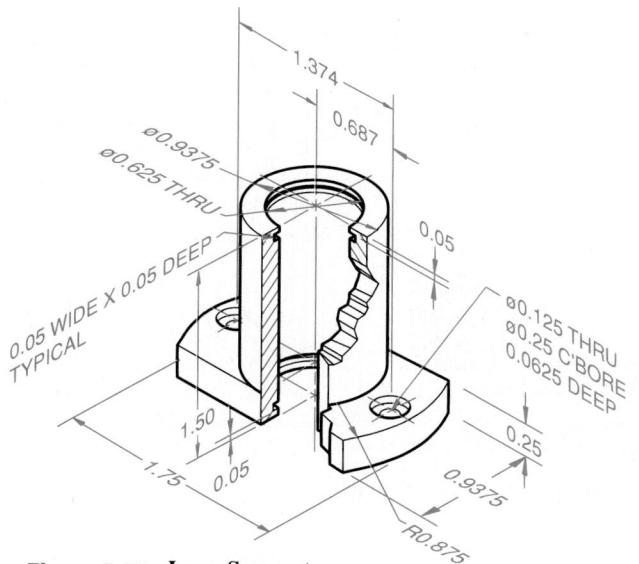

Figure 7.57 Long Support

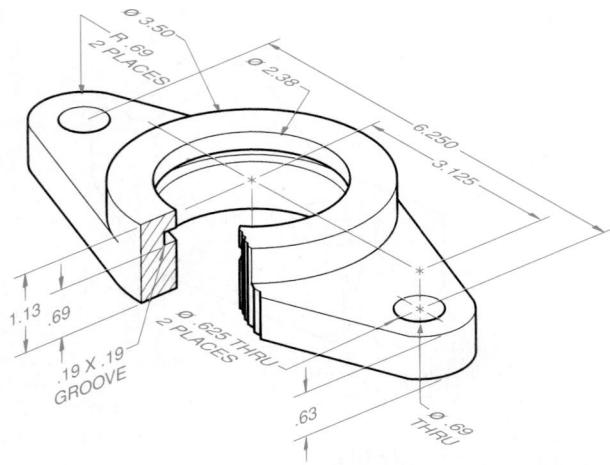

Figure 7.58 Bearing Guide

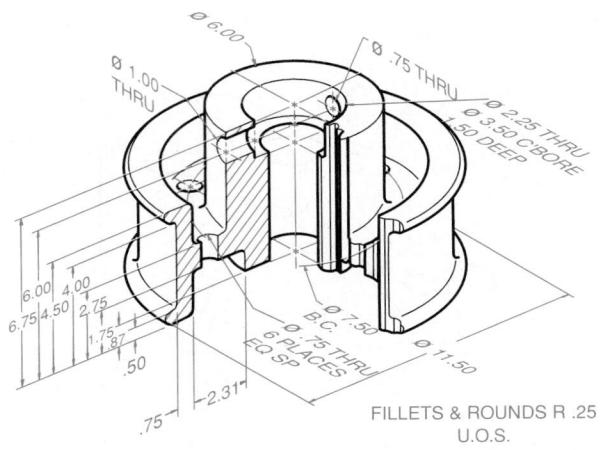

Figure 7.59 Pulley

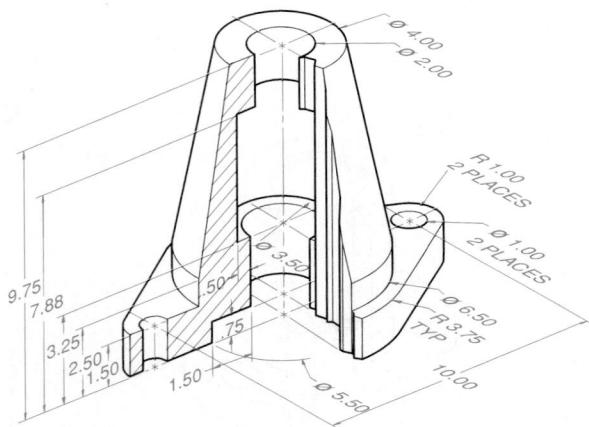

Figure 7.60 Taper Collar

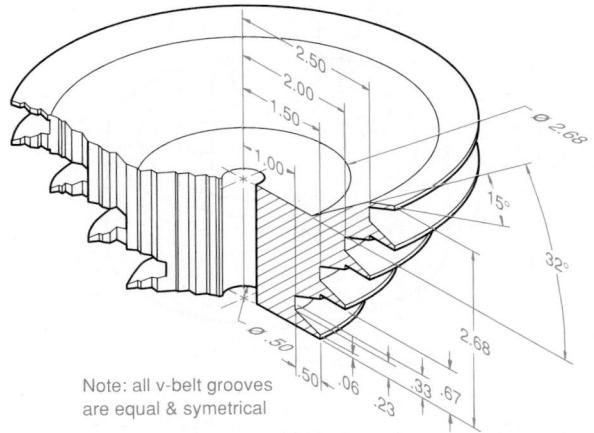

Figure 7.61 Multiple Pulley

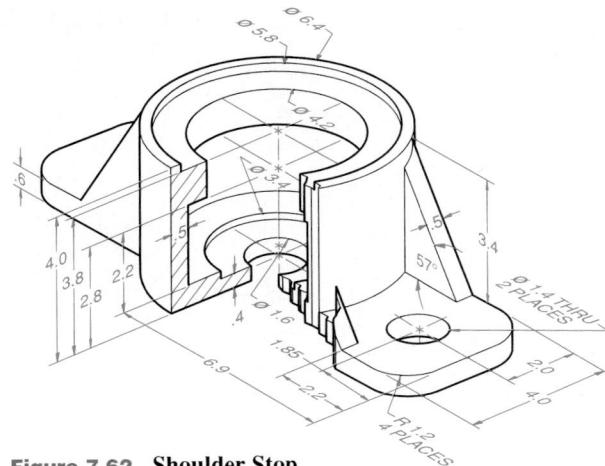

Figure 7.62 Shoulder Stop

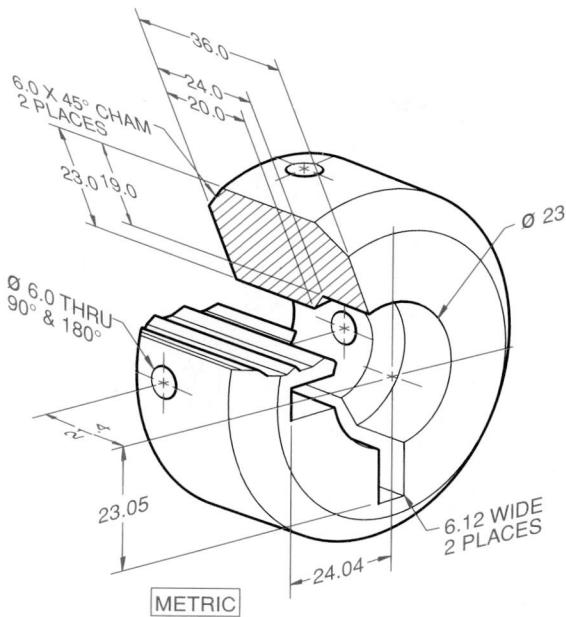

Figure 7.63 Round Adaptor

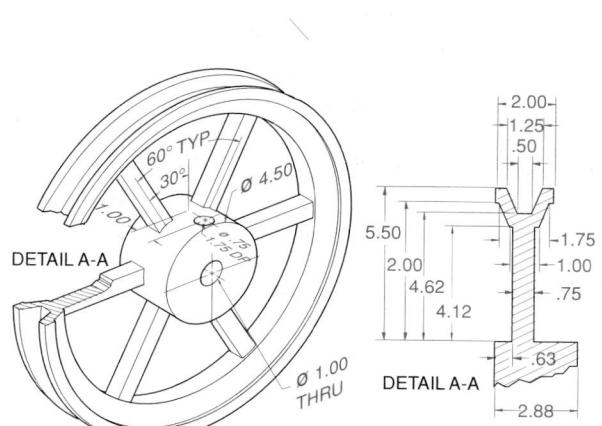

Figure 7.64 V-Pulley

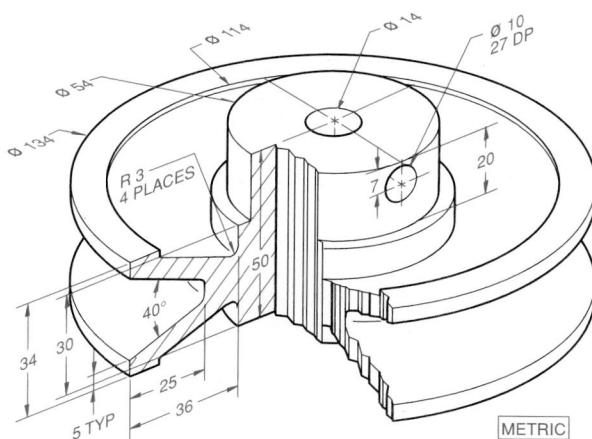

Figure 7.65 Heavy Duty V-Pulley

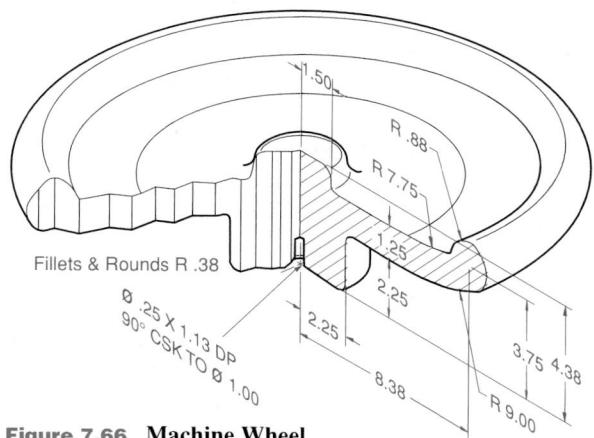

Figure 7.66 Machine Wheel

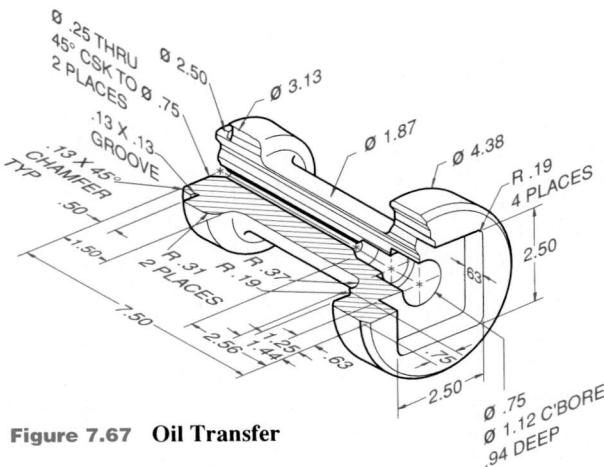

Figure 7.67 Oil Transfer

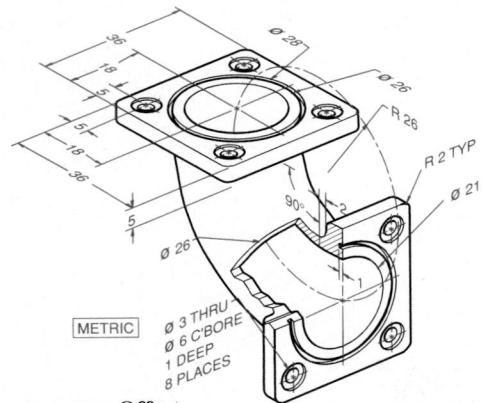

Figure 7.68 Offset

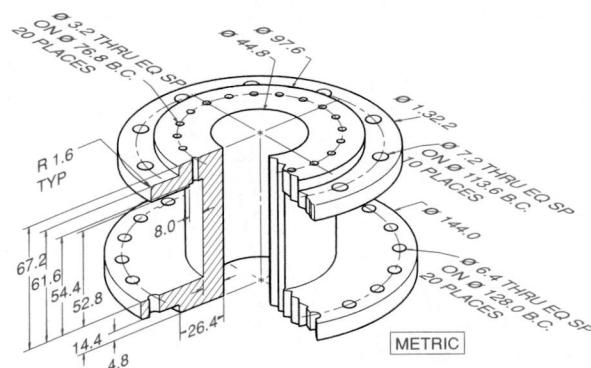

Figure 7.69 Transition

CHAPTER 8

Dimensioning and Tolerancing Practices*

If you can measure that of which you speak, and can express it by a number, you know something about your subject; but if you cannot measure it, your knowledge is meager and unsatisfactory.

Lord Kelvin

OBJECTIVES

After completing this chapter, you will be able to:

1. Apply the standard dimensioning practices for mechanical drawings.
2. Differentiate between current ANSI standards and past practices for dimensioning.
3. Apply English and metric tolerances to dimensions.
4. Calculate standard tolerances for precision fits.
5. Apply tolerances using the basic shaft and basic hole systems.
6. Identify and draw geometric dimensioning and tolerancing symbols.

The process of adding size information to a drawing is known as dimensioning and standard dimensioning practices have been established for this purpose. • There are different standards for different types of drawings, such as architectural drawings, mechanical drawings, highway drawings, steel detail drawings, welding drawings, and so on. In this chapter, the focus will be on mechanical drawings.

- The most common dimensioning standard used in the United States today was developed and is updated by the American National Standards Institute (ANSI) and is published by the American Society of Mechanical Engineers (ASME). The current version of this standard is ANSI Y14.5M-1982. The dimensioning practices described in this text follow this latest ANSI standard.
- Geometric dimensioning and tolerancing (GDT) was developed over the last 40 years as a tool to define parts and features more efficiently. GDT takes the function of the part into consideration, as well as its fit with related parts. This allows the designer to define the part's features more accurately, without increasing the tolerances.

8.1 DIMENSIONING

Geometrics is the science of specifying and tolerancing the shapes and locations of features on objects. In design work, it is essential that the roundness of a shaft be as clearly stated as the size. Once the shape of a part is defined with an orthographic drawing, the size information is added in the form of **dimensions**. Dimensioning a drawing also identifies the tolerance (or accuracy) required for each dimension. If a part is dimensioned properly, then the intent of the designer is clear to both the person making the part and the inspector checking the part. (Figure 8.1) Everyone in this *circle of information* (design, manufacturing, quality control) must be able to speak and understand a common language. A well-dimensioned part is a component of this communications process.

Effective communications between design, manufacturing, and quality control is more essential than ever before. In a modern manufacturing facility, the distinction between design, drafting, prototype building, specification writing, and all of the other functions involved in developing a product are becoming blurred. A product development team

Figure 8.1

Our technological world depends on dimensionally accurate drawings and models for communication of the design and for production.

may be comprised of several types of job classifications, to the point where it is difficult to identify any one “designer.”

In this *concurrent engineering* environment, the ability to convey ideas from one group to another is critical. Consistency is an essential part of effective communication. All drawings should be understood by all users of the drawings, regardless of the user’s role in the design process. For a drafter or designer, communication of the design needs of a part to the others on the team is done by dimensioning.

A fully defined part has three elements: graphics, dimensions, and words (notes). (Figure 8.2) Dimensions are dependent on symbols, which are a specialized set of tools used for communication. Dimensioning provides the vital details that cannot be conveyed by drawing details alone.

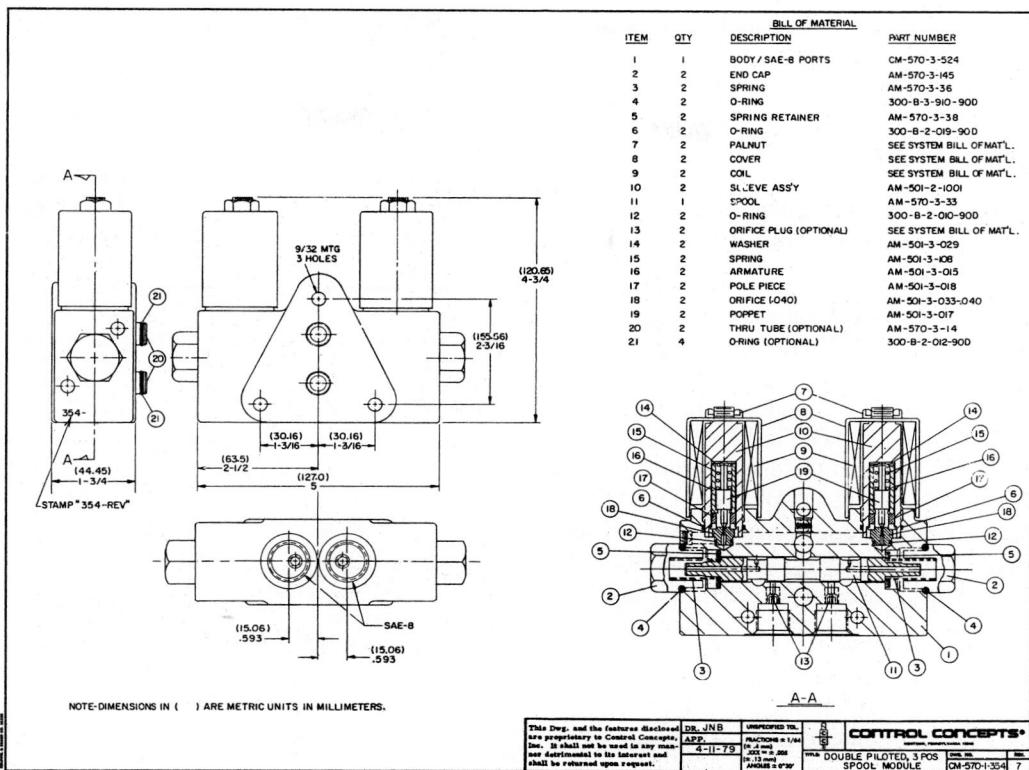

Figure 8.2 Engineering Drawing

An engineering drawing will have graphics, dimensions, and words or notes to fully define the part.

8.2 SIZE AND LOCATION DIMENSIONS

A well-dimensioned part will *communicate* the size and location requirements for each feature. *Communication* is the fundamental purpose of dimensions.

Parts are dimensioned based on two criteria:

1. Basic sizes and locations of the features.
2. Details of construction, for manufacturing.

8.2.1 Units of Measure

On a drawing for use in American industry, all dimensions are in inches, unless otherwise stated. Generally, if parts are more than 72 inches in length, the drawings will switch to feet and inches for the standard unit of measure. Most countries outside of the United States use the metric system of measure, or the international system of units (SI), which is based on the meter.

The SI system is being used more in the United States because of global trade and multinational company affiliations. The common metric unit of measure on engineering drawings is the *millimeter*, abbreviated as *mm*.

Individual identification of linear units is not required if all dimensions on a drawing are either in millimeters or inches. The drawing shall, however, contain a note stating **ALL DIMENSIONS ARE IN MILLIMETERS** (or INCHES, as applicable). If the drawing is in millimeters, an alternative is to use the word **METRIC**, shown in the upper right corner of the drawing.

Occasionally, a company will use dual dimensioning, that is, both metric and English measurements, on a drawing. Although the most recent ANSI standard does not feature dual dimensioning, two methods are found: position and bracket. Position dual dimensioning has the metric value placed above the inch value,

separated by the dimension line. The bracket method, shown in Figure 8.3, shows the decimal inch dimension in brackets. 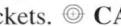

8.2.2 Terminology

There are a number of terms important to dimensioning practices. These terms are illustrated in Figure 8.4 and are defined as follows:

1. **Dimension**—the numerical value that defines the size or geometric characteristic of a feature. Normally, dimension text is 3 mm or 0.125" high, and the space between lines of text is 1.5 mm or 0.0625". (Figure 8.5) With hand tools, guidelines should be used to print the dimension text. A lettering guide is a useful aid for making guidelines. In metric dimensioning, when the value is less than one, a zero precedes the decimal point. In decimal inch dimensioning, when the value is less than one, a zero is not used before the decimal point. (In the text of this book, all values less than one are shown with a zero preceding the decimal point. On the drawings, however, the conventional practices stated here are followed.)

2. **Basic dimension**—a numerical value defining the theoretically exact size of a feature.

3. **Reference dimension**—a numerical value enclosed in parentheses, providing for information only and not directly used in the fabrication of the part. A reference dimension is a calculated size used to show the intended design size of a part. Drawings made to older standards may have placed REF next to a reference dimension, instead of using parentheses.

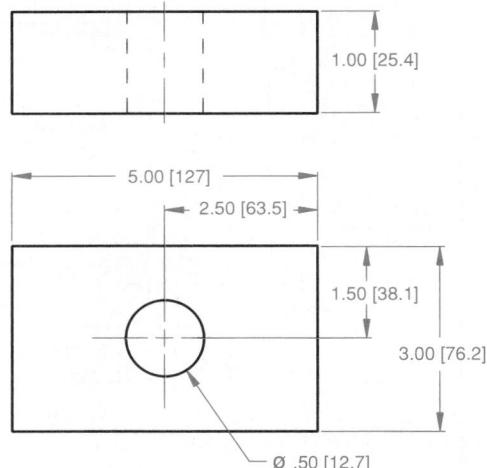

Figure 8.3 A Dual Dimensioned Drawing Shows Both Millimeter and Decimal Inch Measurements

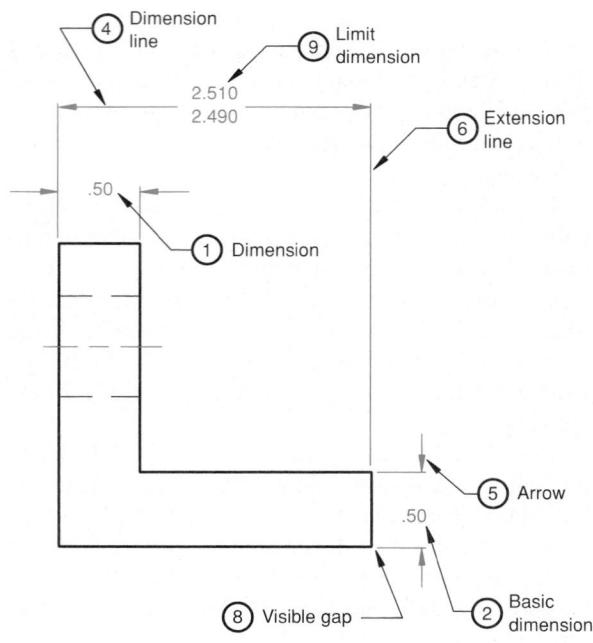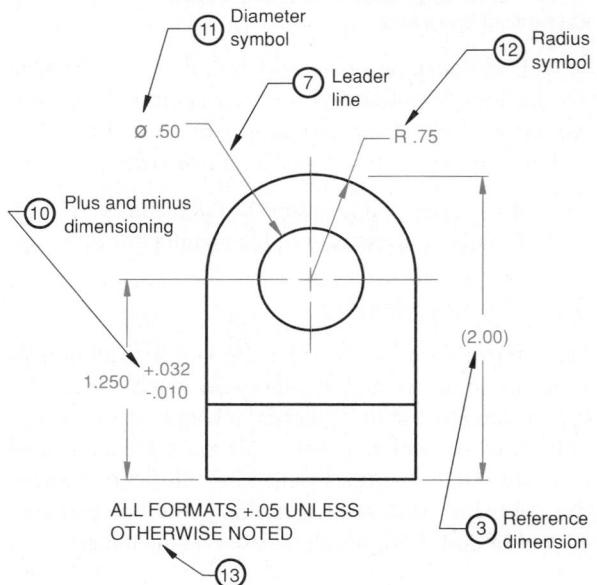

Figure 8.4 Important Elements of a Dimensioned Drawing

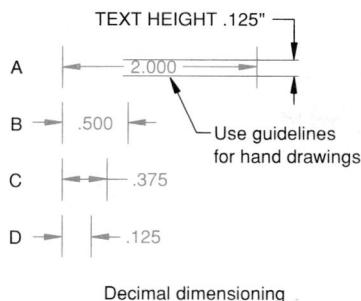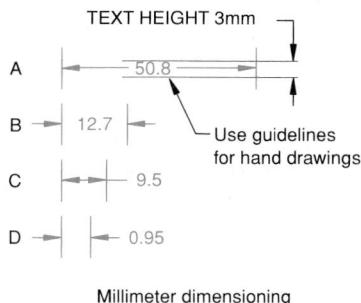

Figure 8.5 Text Height and Standards Used for Decimal and Millimeter Dimensioning

4. **Dimension line**—a thin, solid line that shows the extent and direction of a dimension. Dimension lines are broken for insertion of the dimension numbers.
5. **Arrows**—symbols placed at the ends of dimension lines to show the limits of the dimension. Arrows are uniform in size and style, regardless of the size of the drawing. Arrows are usually about 3 mm ($\frac{1}{8}$ ") long and should be one-third as wide as they are long. Figure 8.6 shows the dimensions used to make an arrow by hand. Arrowheads on engineering drawings are represented by freehand curves, as shown in the figure.
6. **Extension line**—a thin, solid line perpendicular to a dimension line, indicating which feature is associated with the dimension.
7. **Leader line**—a thin, solid line used to indicate the feature with which a dimension, note, or symbol is associated. Leader lines are generally a straight line drawn at an angle that is neither horizontal nor vertical. Leader lines are terminated with an arrow touching the part or detail. On the end opposite the arrow, the

Figure 8.6 Dimensions Used to Draw an Arrowhead
Arrows are three times as long as they are wide.

leader line will have a short, horizontal shoulder. Text is extended from this shoulder such that the text height is centered with the shoulder line.

8. **Visible gap**—there should be a visible gap of 1.5 mm ($\frac{1}{16}$ ") between the feature's corners and the end of the extension line.
9. **Limit dimensioning**—the largest acceptable size and the minimum acceptable size of a feature. The value for the largest acceptable size, expressed as the maximum material condition (MMC), is placed over the value for the minimum acceptable size, expressed as the least material condition (LMC), to denote the limit-dimension-based tolerance for the feature.
10. **Plus and minus dimensioning**—the allowable positive and negative variance from the dimension specified. The plus and minus values may or may not be equal.
11. **Diameter symbol**—a symbol which precedes a numerical value, to indicate that the dimension shows the diameter of a circle. The symbol used is the Greek letter *phi* (ϕ).
12. **Radius symbol**—a symbol which precedes a numerical value, to indicate that the associated dimension shows the radius of an arc. The radius symbol used is the capital letter *R*.
13. **Tolerance**—the amount that a particular dimension is allowed to vary. All dimensions (except reference dimensions) have an associated tolerance. A tolerance may be expressed either through limit dimensioning, plus and minus dimensioning, or a general note.
14. **Datum**—a theoretically exact point used as a reference for tabular dimensioning. (See Figure 8.10)

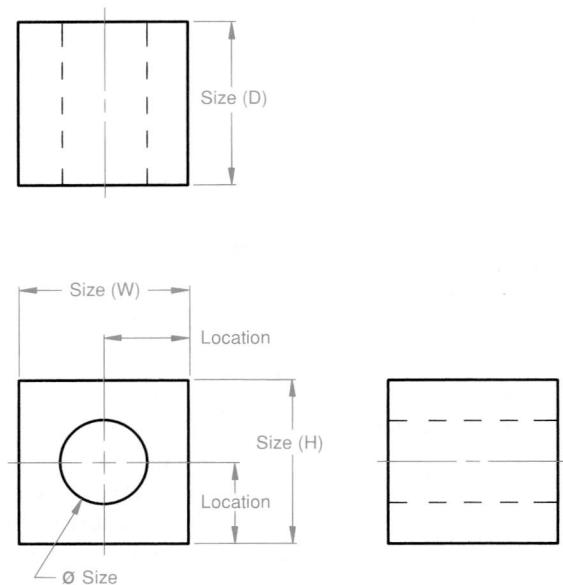**Figure 8.7**

Size and location dimensions are used to describe parts for manufacture.

8.2.3 Basic Concepts

A size dimension might be the overall width of a part, or the diameter of a drilled hole. (Figure 8.7) A location dimension might be the length from the edge of an object to the center of a drilled hole. The basic criterion is, “What information is necessary to make the object?” For example, to drill a hole, the manufacturer would need to know the diameter of the hole, the location of the center of the hole, and the depth to which the hole is to be drilled. These three dimensions describe the hole in sufficient detail for the feature to be made using machine tools.

Dimensions should not be excessive, either through duplication or by dimensioning a feature more than one way. For example, if the diameter of a hole is given in the front view, it should not be given again in the top or profile views. Another excessive dimension would be the radius of the hole in addition to the diameter. The radius information adds nothing to the information about the feature, and can actually be more confusing than helpful.

8.2.4 Size Dimensions

- *Horizontal*—the left-to-right distance relative to the drawing sheet. In Figure 8.8, the *width* is the only horizontal dimension.
- *Vertical*—the up and down distance relative to the drawing sheet. In Figure 8.8, the *height* and the *depth* are both vertical dimensions, even though they are in two different directions on the part.
- *Diameter*—the full distance across a circle, measured through the center. This dimension is usually used only on full circles, or on arcs that are more than half of a full circle.
- *Radius*—the distance from the center of an arc to any point on the arc, usually used on arcs less than half circles. In Figure 8.8, the *RADIUS* points to the outside of the arc, even though the distance measured is to the center, which is inside. The endpoints of the arc are tangent to the horizontal and vertical lines, making a quarter of a circle. This is assumed and there is no need to note it. If the radius is not positioned in this manner, then the actual center of the radius must be located. ☺ **CAD Reference 8.2**

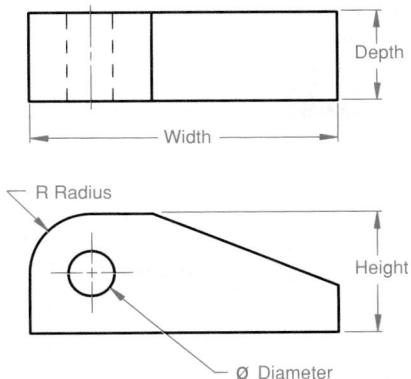

Figure 8.8 Dimensions Showing the Sizes of Features, Such as the Height and Depth of the Part and the Diameter of the Hole

8.2.5 Location and Orientation Dimensions

- **Horizontal Position**—In Figure 8.9, dimensions A and D are horizontal position dimensions which locate the beginnings of the angle. Dimension A measures more than one feature, the sum of the arc's radius and the straight line. The measurement for dimension A is taken parallel to the dimension line. Dimension D is the measurement of a single feature, the sloping line, but it is not the true length of the line. Rather, it is the left-to-right distance that the line displaces. This is called the “delta X value,” or the change in the X direction. The C dimension measures the horizontal location of the center of the hole and arc.
- **Vertical Position**—The B dimension in Figure 8.9 measures the vertical position of the center of the hole. For locating the hole, the dimensions are given to the center, rather than the edges of the hole. All circular features are located from their centers.
- **Angle**—The angle dimension in Figure 8.9 gives the angle between the horizontal plane and the sloping surface. The angle dimension can be taken from several other directions, measuring from any measurable surface. ☺ **CAD Reference 8.3**

8.2.6 Coordinate Dimensions

The advent of computer controlled manufacturing has encouraged dimensioning in terms of rectangular

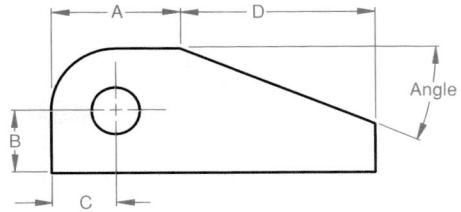

Figure 8.9 Dimensions Showing the Location and Orientations of Features, Such as the Location of the Center of the Hole

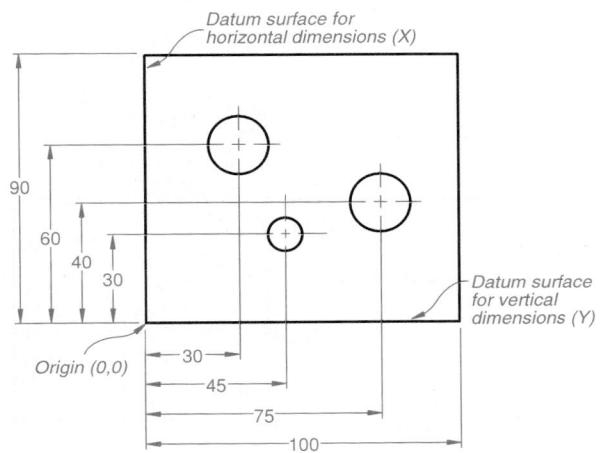

Figure 8.10 A Part Dimensioned Using Coordinate Dimensions, with a Baseline or Datum Surface as a Starting Point

coordinates. In **rectangular coordinate dimensioning**, a baseline (or datum line) is established for each Cartesian coordinate direction, and all dimensions are specified with respect to these baselines. This is also known as **datum dimensioning**, or **baseline dimensioning**. Dimensions may be given either with dimension lines and arrowheads (Figure 8.10), or without dimension lines and arrowheads (Figure 8.11).

All dimensions are specified as X and Y distances from an *origin point*, usually placed at the lower left corner of the part. The origin is identified as *X* and *Y ZERO (0)*.

Datum dimensioning should be used with caution because of the tolerance stack-up that takes place (see discussion on tolerancing in this chapter).

Tabular coordinate dimensioning involves labeling each feature with a letter, and then providing information on size and location in a table, as shown in

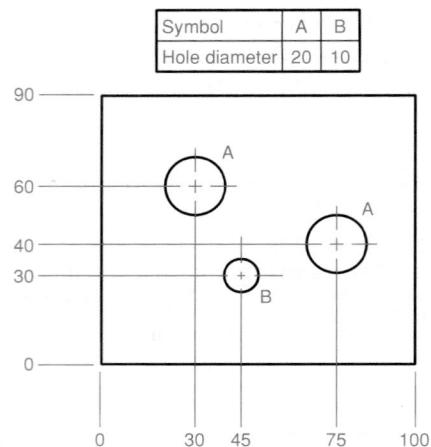

Figure 8.11 Tabular Dimensions Used to Locate the Centers of the Holes

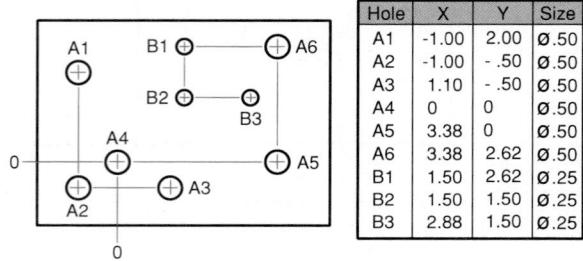

Figure 8.12 Coordinate Dimensioned Part with the Origin at the Center of Hole A4 Instead of the Lower Left Corner of the Part

Figure 8.11. In Figure 8.12, tabular coordinate dimensions are used, with the origin located on an existing feature (the center of hole A4). The dimension values are in a tabulated chart and the holes are labeled. Features, such as hole center A2, that are located to the left of or below the origin have negative values.

© CAD Reference 8.4

8.2.7 Standard Practices

The guiding principle for dimensioning a drawing is *clarity*. To promote clarity, ANSI developed standard practices for showing dimensions on drawings.

Placement Dimension placement depends on the space available between extension lines. When space permits, dimensions and arrows are placed *between* the extension lines, as shown in Figures 8.13A and E.

When there is room for the numerical value but not the arrows as well, the value is placed *between* the

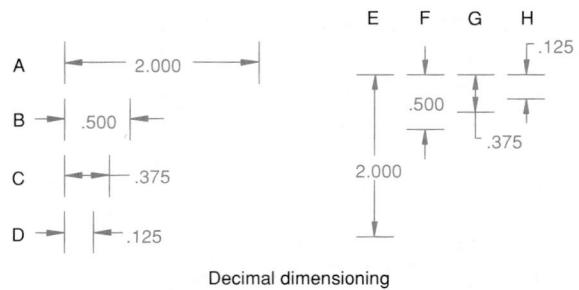

Decimal dimensioning

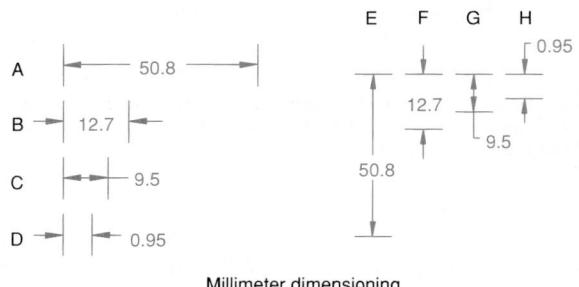

Millimeter dimensioning

Figure 8.13 Dimension Text Placement

Standard practice for the placement of dimensions depends on the space available.

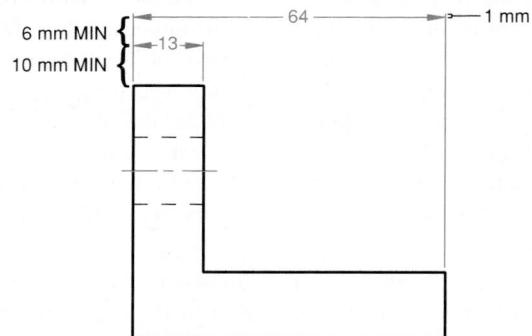

Figure 8.14 Minimum Dimension Line Spacing

Standard practice for the spacing of dimensions is 10 mm from the view and 6 mm between dimension lines.

extension lines and the arrows are placed outside the extension lines, as shown in Figures 8.13B and F.

When there is room for the arrows but not the numerical value, the arrows are placed between the extension lines, and the value is placed outside the extension lines and adjacent to a leader, as shown in Figures 8.13C and G.

When the space is too small for either the arrows or the numerical value, both are placed outside the extension lines, as shown in Figures 8.13D and H.

© CAD Reference 8.5

Spacing The minimum distance from the object to the first dimension is 10 mm ($\frac{3}{8}$ "), as shown in Figure 8.14. The minimum spacing between dimensions is 6 mm ($\frac{1}{4}$ "). These values may be increased where appropriate.

There should be a visible gap between an extension line and the feature to which it refers. Extension lines should extend about 1 mm ($\frac{1}{32}$ ") beyond the last dimension line. **© CAD Reference 8.6**

Grouping and Staggering Dimensions should be grouped, for uniform appearance, as shown in Figure 8.15. As a general rule, do not use object lines as part of your dimension. (Figure 8.15B) Where there are

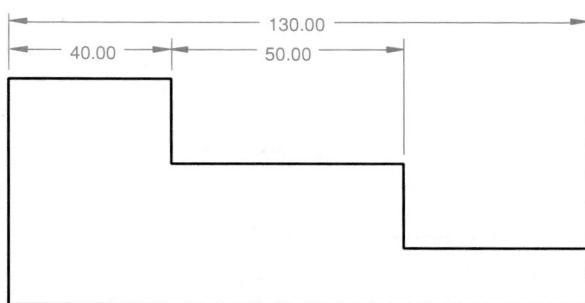

(A) Yes

several parallel dimensions, the values should be staggered, as shown in Figure 8.16. **© CAD Reference 8.7**

Extension Lines **Extension lines** are used to relate a dimension to one or more features and are usually drawn perpendicular to the associated dimension line. Where space is limited, extension lines may be drawn at an angle, as shown in Figure 8.17. Where angled extension lines are used, they must be parallel, and the associated dimension lines must be drawn in the direction to which they apply.

Extension lines should not cross dimension lines, and should avoid crossing other extension lines whenever

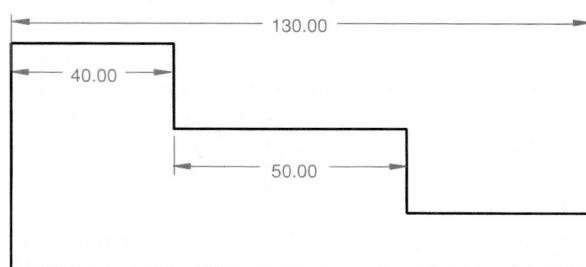

(B) No!

Figure 8.15 Group Dimensions

In standard practice, dimensions are grouped on a drawing. Do not use object lines as extension lines for a dimension.

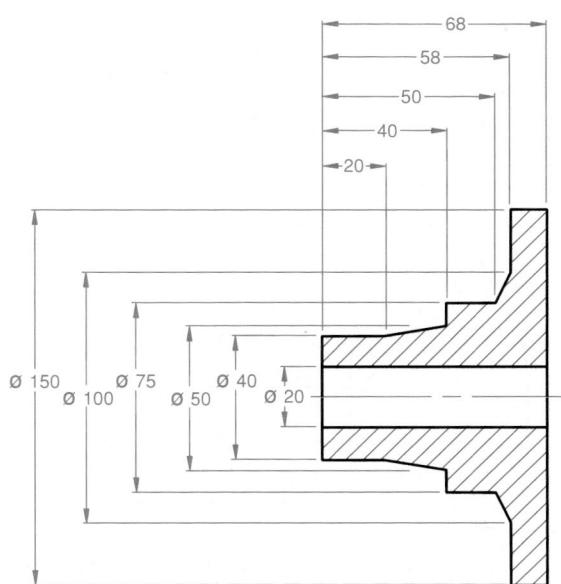**Figure 8.16 Stagger Dimension Text**

The general practice is to stagger the dimension text on parallel dimensions.

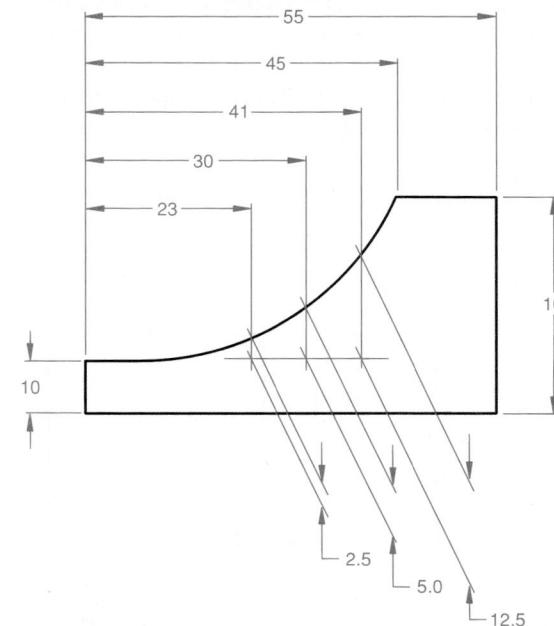**Figure 8.17 Angling Extension Lines**

Angling of extension lines is permissible when space is limited.

possible. When extension lines cross object lines or other extension lines, they should not be broken. When extension lines cross or are close to arrowheads, they should be broken for the arrowhead. (Figure 8.18)

When the center of a feature is being dimensioned, the centerline of the feature is used as an extension line. (Figure 8.19A) When a point is being located by extension lines only, the extension lines must pass through the point. (Figure 8.19B)

Limited Length or Area If a limited length or area (such as the knurled portion of a shaft) will be further detailed, the limits may be defined by a **chain line** (alternating short and long dashes). The chain line is drawn parallel to the surface being defined. If the chain line applies to a surface of revolution, only one side need be shown. (Figure 8.20) When the limited area is being defined in a normal view of the surface, the area within the chain line boundary is section lined. (Figure 8.21) Dimensions are added for length and location, unless the chain line clearly indicates the location and size of the surface.

Reading Direction All dimensions and note text must be oriented to read from the bottom of the drawing (relative to the drawing format). This is called **unidirectional dimensioning**. (Figure 8.22) The *aligned method* of dimensioning may be seen on older drawings, but is not approved by the current ANSI standards. **Aligned dimensions** have text placed parallel to the dimension line, with vertical dimensions read from the right of the drawing sheet.

 CAD Reference 8.9

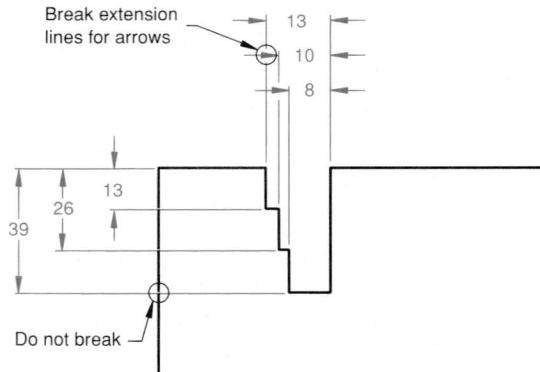

Figure 8.18 Extension Line Practice

Extension lines should not cross dimension lines, are not broken when crossing object or other extension lines, and are broken when crossing arrows.

View Dimensioning Dimensions are to be kept outside the boundaries of views, wherever practical. (Figure 8.23B) Dimensions may be placed within the boundaries where extension or leader lines would be too long, or where clarity would be improved.

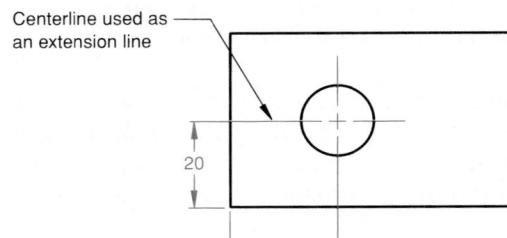

(A)

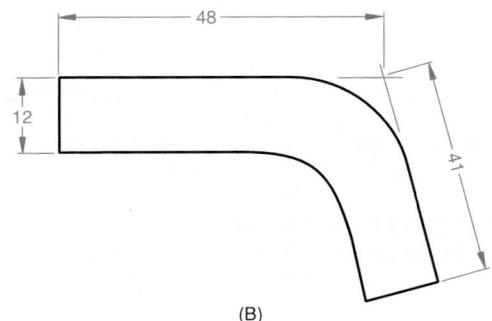

(B)

Figure 8.19

The center of a feature, such as a hole, is located by making the center lines extension lines for the dimension. Extension lines can also cross to mark a theoretical point.

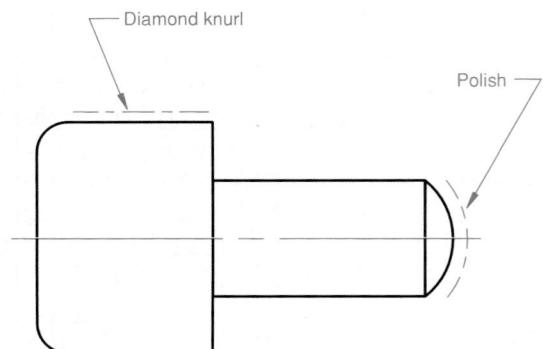

Figure 8.20 Chain Line

Limited area or length is indicated with a dashed chain line.

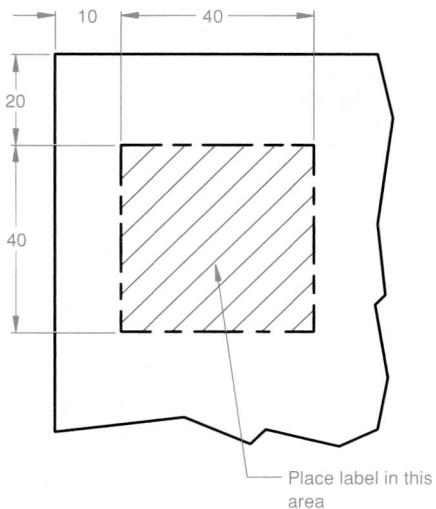

8.21 Chain Line in Normal View

Limited area in the normal view is indicated with a chain line and section lines.

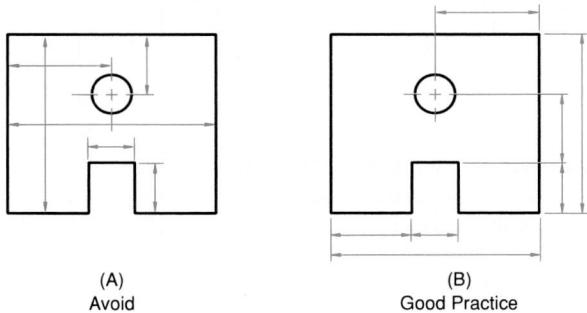

Figure 8.23 Dimension outside of View

Dimensions are kept off the view, unless necessary for clarity.

Out-of-Scale Dimensions Drawings are always made to scale, and the scale is indicated in the title block. If it is necessary to include a dimension that is not in that scale, the out-of-scale dimension text must be underlined with a heavy, straight line placed directly below the dimension text, as shown in Figure 8.24. On older drawings, the letters *NTS*, for *not to scale*, may be found next to the dimension.

Repetitive Features The symbol \times is used to indicate the number of times a feature is to be repeated. The number of repetitions, followed by the symbol \times and a space, precedes the dimension text.

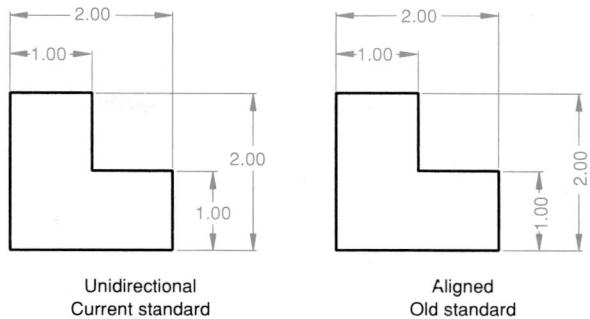

Figure 8.22 Unidirectional and Aligned Methods

The unidirectional method of placing text is the current standard practice.

Figure 8.24 Not-to-Scale Designation

A not-to-scale dimension is indicated by placing a line below the dimension text.

For example, in Figure 8.25, $4 \times \phi .375$ means that there are 4 holes with a diameter of $.375"$. Note that the symbol \times may also be used to indicate "by," such as when a slotted hole is specified as "width by length," as seen in Figure 8.30. Whenever the symbol \times is used for both purposes in the same drawing, care should be taken to avoid confusion.

8.3 DETAIL DIMENSIONING

Holes are typically dimensioned in a view that best describes the shape of the hole. For diameters, the diameter symbol must precede the numerical value. When holes are dimensioned with a leader line, the leader line must be radial. (Figure 8.26) A **radial line** is one that passes through the center of a circle or arc if extended. If it is not clear whether a hole extends completely through a part, the word **THRU** can follow the numerical value.

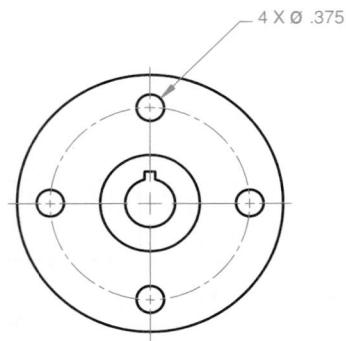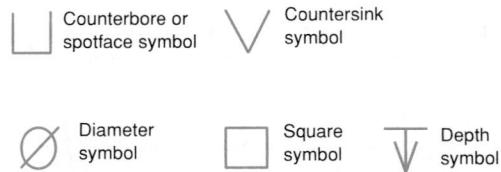

Figure 8.25 Using the Symbol \times to Dimension Repetitive Features

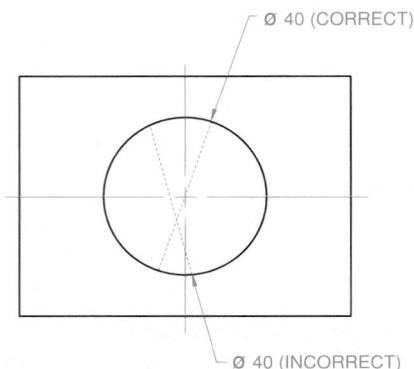

Figure 8.26 Radial Leader Lines

Leader lines used to dimension holes must be radial.

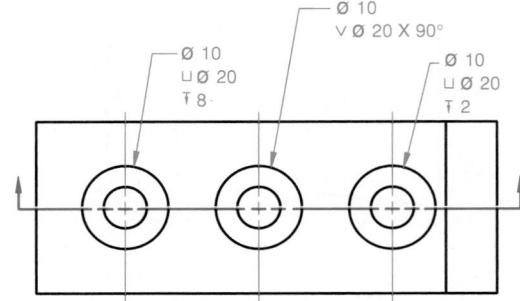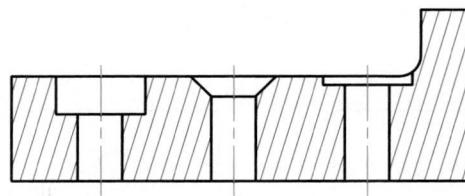

Figure 8.27 Symbols for Drilling Operations

Symbols to represent machine drilling operations always precede the diameter symbol. From left to right, the symbols are for counterbored, countersunk, and spotface holes.

Symbols may be used for spotface, counterbored, and countersunk holes. These symbols must always precede the diameter symbol. (Figure 8.27) The depth symbol may be used to indicate the depth of a hole. The depth symbol precedes the numerical value. When the depth of a blind hole is specified, the depth is to the full diameter of the hole and not to the point. (Figure 8.28) When a chamfer or countersink is placed in a curved surface, the diameter refers to the minimum diameter of the chamfer or countersink. If the depth or remaining thickness of material for a spotface is not given, the spotface depth is the smallest amount required to clean up the material surface to the specified diameter. Chamfers are dimensioned by providing either an angle and a linear dimension, or two linear dimensions. (Figure 8.29) Chamfers of 45 degrees may be specified in a note.

Slotted holes may be dimensioned in any of several ways, depending on which is most appropriate for the application. The various options for dimensioning slotted holes are shown in Figure 8.30.

Keyseats and keyways, which are fastening devices, present some unusual problems. Figure 8.31 shows the proper way to dimension keyseats and keyways. The height of the keyseat itself is not dimensioned because, once the top of the shaft is cut away, there is no feature left to measure. Also, the dimensions are unilateral: for the keyseat, the dimension is a minimum; for the keyway, the dimension is a maximum. This is to ensure a clearance once the key is inserted between the parts.

Figure 8.32 displays some of the dimensioning methods used for various features. On the left side are the ANSI Y14.5-1982 versions. The right side shows

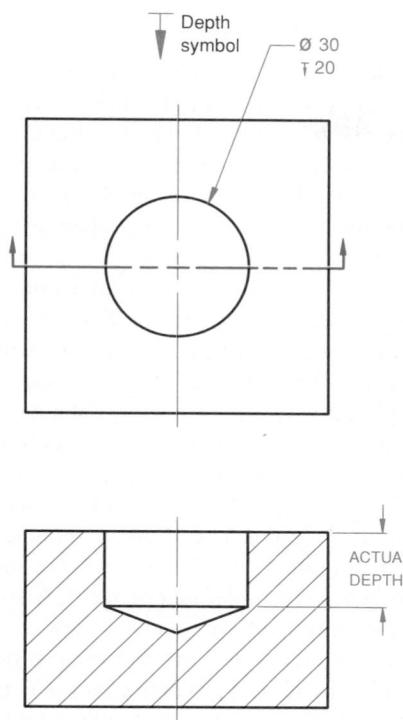

Figure 8.28 Dimensioning a Blind Hole

The depth of a blind hole reflects the depth of the full diameter.

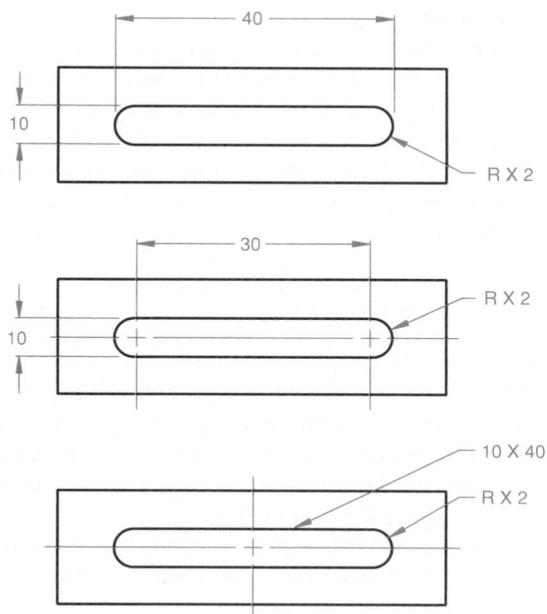

Figure 8.30 Dimensioning Slots

Several methods are appropriate for dimensioning slots.

some of the most common previously used dimensioning versions. The ANSI style relies heavily on symbols, using very few English words. The old style relied heavily on words and descriptions. The problem with such notes is that they are subject to interpretation and may not be easy to translate into other languages.

It is important to be familiar with the older methods of dimensioning because there are still so many drawings in existence that were developed with these methods. ☺ **CAD Reference 8.10**

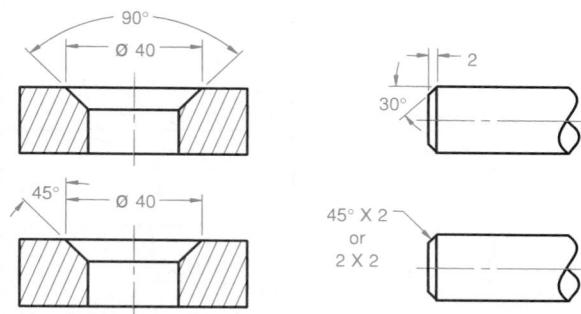

Figure 8.29 Dimensioning Chamfers

Chamfers are dimensioned by providing either an angle and a linear distance, or two linear dimensions.

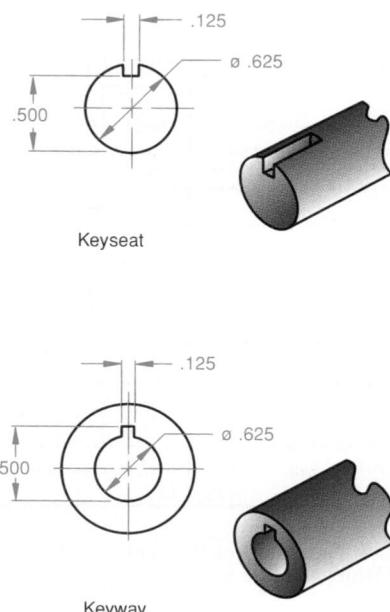

Figure 8.31 Standard Method of Dimensioning Keyways and Keyseats

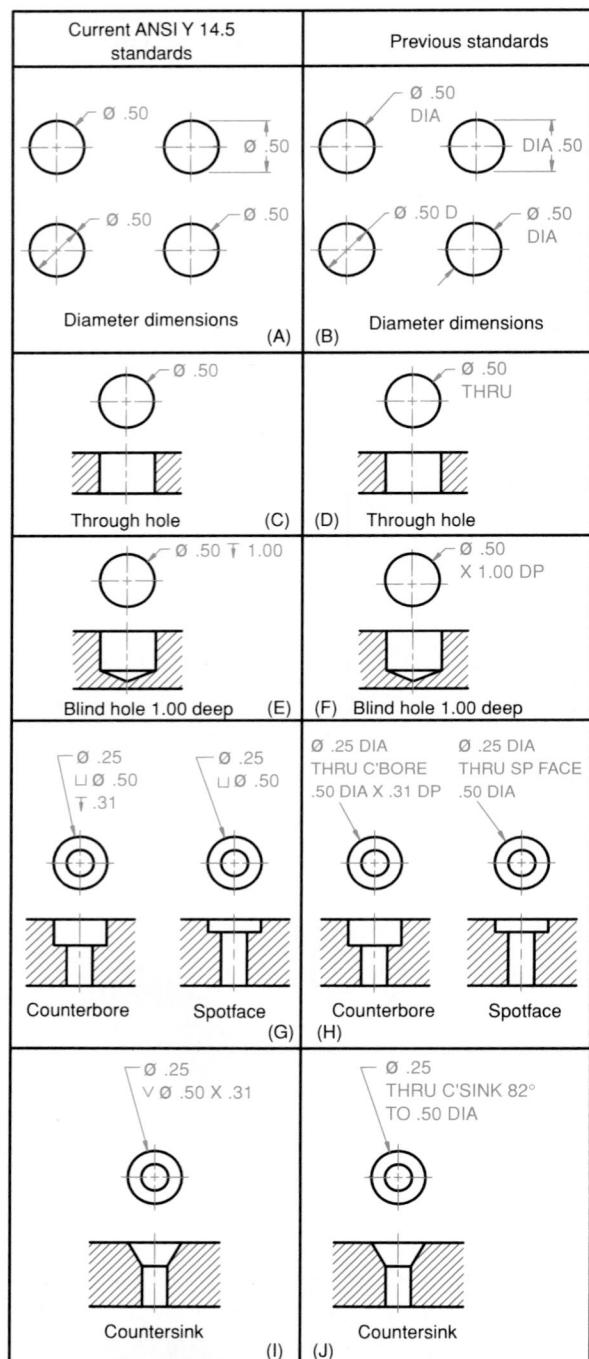

Figure 8.32 Summary of Current and Previous ANSI Standard Dimensioning Symbols

8.3.1 Diameter versus Radius

If a full circle or an arc of more than half a circle is being dimensioned, the diameter is specified, preceded by the diameter symbol, which is the Greek letter *phi*. If the arc is less than half a circle, the radius is specified, preceded by an R. Concentric circles are dimensioned in the longitudinal view, whenever practical. (Figure 8.33)

As previously stated, radii are dimensioned with the radius symbol preceding the numerical value. The dimension line for radii shall have a single arrowhead touching the arc. When there is adequate room, the dimension is placed between the center of the radius and the arrowhead. (Figure 8.34) When space is limited, a radial leader line is used. When an arc is not clearly defined by being tangent to other dimensioned features on the object, the center of the arc is noted with a small cross. (Figure 8.34) The center is not shown if the arc is tangent to other defined surfaces. Also, if the center of an arc interferes with another view, or is outside the drawing area, foreshortened dimension lines may be used. (Figure 8.35) When a radius is dimensioned in a view where it does not appear true shape (such as in Figure 8.36), the word *TRUE* appears preceding the radius symbol.

A spherical radius, such as for the end of a spherical knob, is dimensioned with the symbol *SR* preceding the numerical value.

Earlier methods followed similar requirements, except that the abbreviation *DIA.* (or sometimes simply *D*) was used instead of the diameter symbol. It is not unusual to see the term *DRILL*, or *DRILL & REAM* rather than the *DIA.* callout. However, those terms specify how a part is to be made, and ANSI specifically states that machining methods must be avoided.

8.3.2 Holes and Blind Holes

The diameter is specified for holes and blind holes. *Blind holes* are ones that do not go through the part. If the hole does not go through, the depth is specified, preceded by the depth symbol. (Figures 8.32E and F) Holes with no depth called out are assumed to go through. (Figures 8.32C and D)

Previously, *DEEP* or *DP* was added to the depth dimension. For holes that went all the way through a part, the term *THRU* was used.

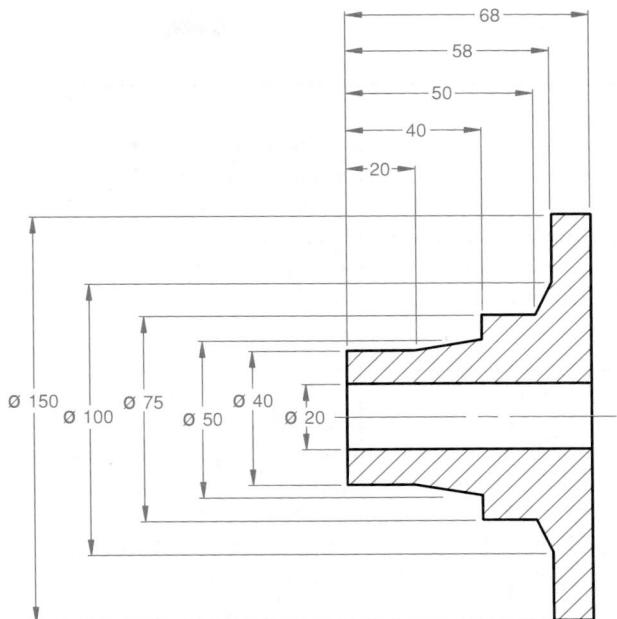

Figure 8.33 Dimensioning Concentric Circles

Concentric circles are dimensioned in the longitudinal view.

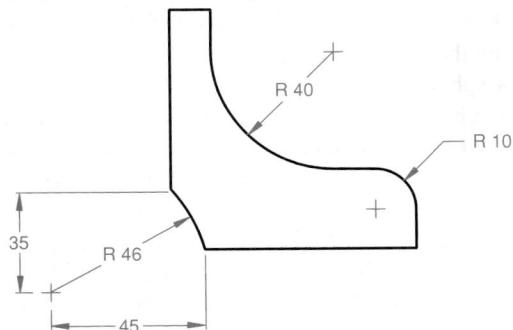

Figure 8.34 Dimensioning Arcs

Arcs of less than half a circle are dimensioned as radii, with the R symbol preceding the dimension value.

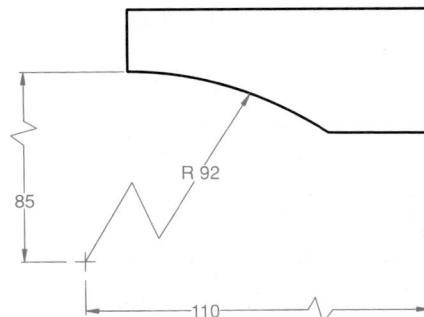

Figure 8.35 Foreshortened Leaders

Foreshortened leader lines are sometimes used on large arcs.

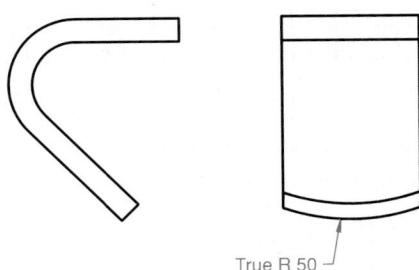

Figure 8.36

Use the word TRUE if the arc is dimensioned in a foreshortened view.

8.3.3 Counterbored Holes

A counterbore symbol is placed before the diameter callout, and the depth of the counterbore is shown with a depth symbol. If a depth is stated, the feature is a counterbore; if not, the feature is a spotface. The full note shows the diameter of the through hole, followed by the diameter of the counterbore, then the depth of the counterbore. (Figures 8.32G and H)

Previously, the term *C'BORE* or *COUNTERBORE* was added to the diameter callout, and the depth was called out with *DEEP* or *DP*.

8.3.4 Spotfaces

Spotfaces use the same specifications as the counterbore, except that the depth can be left out, which means that the machinist is to machine a flat of the given diameter, with the minimum depth necessary to create the flat. (Figures 8.32G and H)

The previous technique also used the same specification as the early counterbore, except that the term *S'FACE* or *SPOTFACE* was used.

8.3.5 Countersinks

A countersink symbol is placed with the diameter of the finished countersink, followed by the angle specification. The depth is not given because the diameter is easier to measure. (Figures 8.32I and J)

Previously, the term *C'SINK* or *COUNTERSINK* was used with the diameter of the finished countersink, and the angle was specified.

8.3.6 Screw Threads

There are standards that apply directly to each size thread. ANSI Y14.6 is a complete definition of all of the inch series threads.

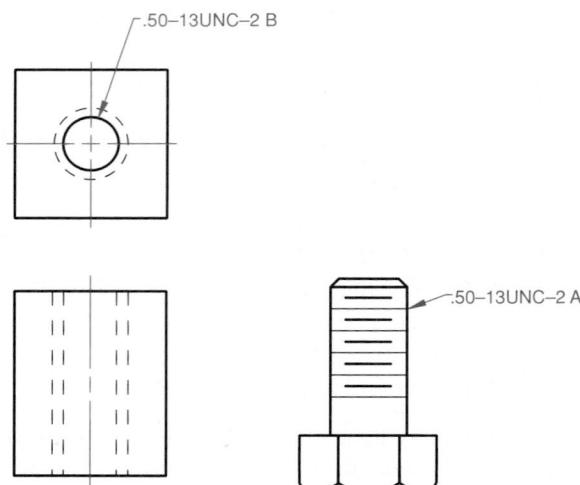

Figure 8.37 Using a Leader and Note to Dimension Screw Threads

Local notes are used to identify thread types and dimensions. (Figure 8.37) For threaded holes, the note should be placed on the circular view. For external threads, the dimension is placed on the longitudinal view of the thread. © CAD Reference 8.11

8.3.7 Grooves

Two dimensions are necessary for a groove, the width and the depth or diameter. Figure 8.38 shows some of the most common ways to dimension a groove in a shaft.

8.3.8 Manufacturers' Gages

Several manufacturers' standards have been devised over the years to define the sizes of certain commodities. For example, the Unified National Screw Thread system is a gage system applying to threads. A few other gages are sheet metal, wire, steel plate, and structural steel shapes. Figure 8.39 shows a gage table for sheet metal. For example, a number 20 gage galvanized sheet would have a thickness of 0.0396, using the table. Standard sheet metal may be dimensioned using a leader and a note.

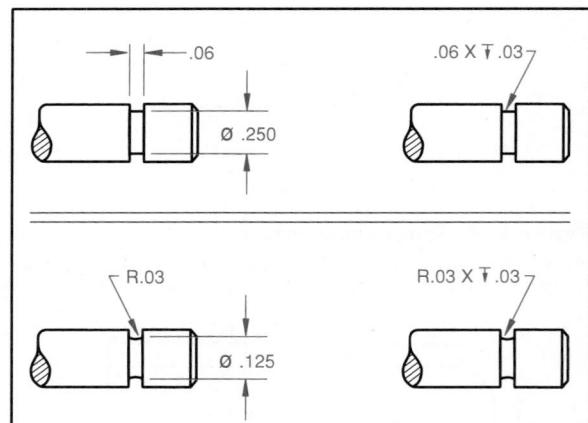

Figure 8.38 Dimensioning Grooves

Dimensioning grooves requires the width and the depth or diameter.

Sheet-Metal Gages in Approximate Decimals of an Inch

No. of Sheet-Metal Gage	Manufacturers' Standard Gage for Steel	Birmingham Gage (B.G.) for Sheets, Hoops	Galvanized Sheet Gage	Zinc Gage	No. of Sheet-Metal Gage	Manufacturers' Standard Gage for Steel	Birmingham Gage (B.G.) for Sheets, Hoops	Galvanized Sheet Gage	Zinc Gage
15/0	...	1.000	20	0.0359	0.0392	0.0396	0.070
14/0	...	0.9583	21	0.0329	0.0349	0.0366	0.080
13/0	...	0.9167	22	0.0299	0.03125	0.0336	0.090
12/0	...	0.8750	23	0.0269	0.02782	0.0306	0.100
11/0	...	0.8333	24	0.0239	0.02476	0.0276	0.125
10/0	...	0.7917	25	0.0209	0.02204	0.0247	...
9/0	...	0.7500	26	0.0179	0.01961	0.0217	...
8/0	...	0.7083	27	0.0164	0.01745	0.0202	...
7/0	...	0.6666	28	0.0149	0.01562	0.0187	...
6/0	...	0.6250	29	0.0135	0.01390	0.0172	...
5/0	...	0.5883	30	0.0120	0.01230	0.0157	...
4/0	...	0.5416	31	0.0105	0.01100	0.0142	...
3/0	...	0.5000	32	0.0097	0.00980	0.0134	...
2/0	...	0.4452	33	0.0090	0.00870
1/0	...	0.3964	34	0.0082	0.00770
1	...	0.3532	35	0.0075	0.00690
2	...	0.3147	36	0.0067	0.00610
3	0.2391	0.2804	...	0.006	37	0.0064	0.00540
4	0.2242	0.2500	...	0.008	38	0.0060	0.00480
5	0.2092	0.2225	...	0.010	39	...	0.00430
6	0.1943	0.1981	...	0.012	40	...	0.00386
7	0.1793	0.1764	...	0.014	41	...	0.00343
8	0.1644	0.1570	0.1681	0.016	42	...	0.00306
9	0.1495	0.1398	0.1532	0.018	43	...	0.00272
10	0.1345	0.1250	0.1382	0.020	44	...	0.00242
11	0.1196	0.1113	0.1233	0.024	45	...	0.00215
12	0.1046	0.0991	0.1084	0.028	46	...	0.00192
13	0.0897	0.0882	0.0934	0.032	47	...	0.00170
14	0.0747	0.0785	0.0785	0.036	48	...	0.00152
15	0.0673	0.0699	0.0710	0.040	49	...	0.00135
16	0.0598	0.0625	0.0635	0.045	50	...	0.00120
17	0.0538	0.0556	0.0575	0.050	51	...	0.00107
18	0.0478	0.0495	0.0516	0.055	52	...	0.00095
19	0.0418	0.0440	0.0456	0.060

Figure 8.39 Standard Sheet Metal Gage Table

Industry Application Global Design Teams Using Computers to Communicate and Exchange Data

Products designed for a global market are using international design teams to take advantage of resources and knowledge from around the world. Computers are the key to sharing data, communicating, and getting designs to market faster. The space station Freedom is an example of global design teams working on a single project. NASA engineers coordinated work with international partners in the design of the space station, which will contain modules from the European and Japanese space agencies, robotic technology from Canada, and possibly a docking berth for Russia's Soyuz.

Computers are used to exchange 2-D and 3-D CAD files through networks. Computer networks also allow engineers to exchange electronic messages (E-mail). Exchanging data electronically is not only faster than sending paper plots through the mail, it is also more accurate. There is much more information in a 3-D computer model than on a paper plot. Tolerances and clearances are much more easily communicated through the exchange of a 3-D computer model.

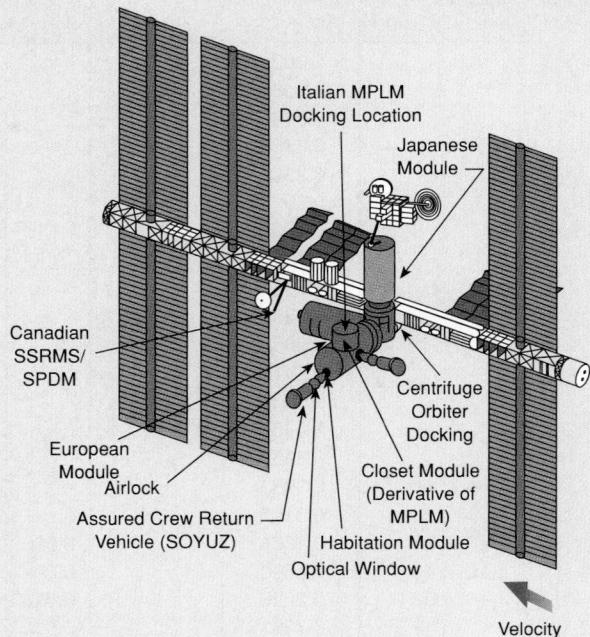

The space station *Freedom* is being designed by an international team.

Adapted from: "Computers Bring Global Design Teams Closer," *Design News*, September 20, 1993, pp. 27–28.

8.4 DIMENSIONING TECHNIQUES

Dimensioning is accomplished by adding size and location information. One dimensioning technique is called **contour dimensioning**, because the contours or shapes of the object are dimensioned in their most descriptive view. (Figure 8.40A) For example, the radius of an arc would be dimensioned where it appears as an arc, not as a hidden line marking its extent. (Figure 8.40B)

A second dimensioning technique involves breaking the part down into its more basic geometric forms. (Figure 8.41) This method is called **geometric breakdown dimensioning** and is used on objects

made of geometric primitives, such as prisms, cylinders, and spheres, or their derivatives, such as half spheres or negative cylinders (holes). This technique is similar to that used for building a solid model using geometric primitives. To create a cylinder with a solid modeler, you would have to define its height and diameter. To dimension a cylinder on an engineering drawing, you would also have to specify the height and diameter. (Figure 8.41)

A common problem in dimensioning is insufficient space for the dimensions. This occurs when the emphasis is placed on identifying and arranging the views, without consideration for the dimensions that

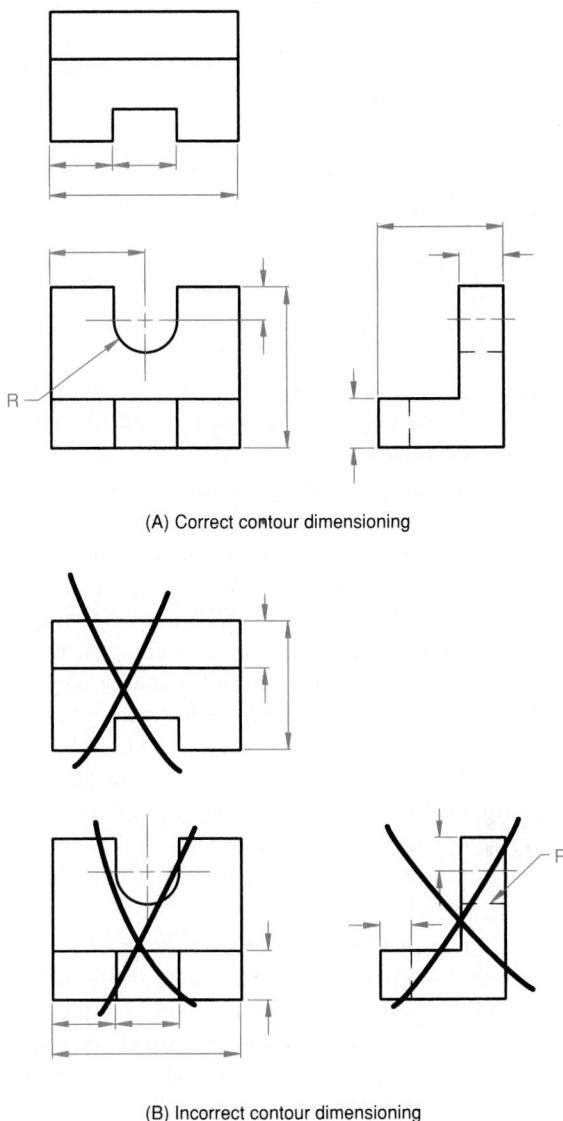

Figure 8.40 Contour Dimensioning

Contour dimensioning technique places dimensions in the most descriptive views of the feature.

will be needed. To avoid this problem, make a free-hand sketch of the part, with all the views *and* all the dimensions in place. Actual dimension values are not required; just the layout of the dimensions, including all radii and diameters. Using the sketch as a guide for the formal drawing should result in sufficient space being left for the dimension.

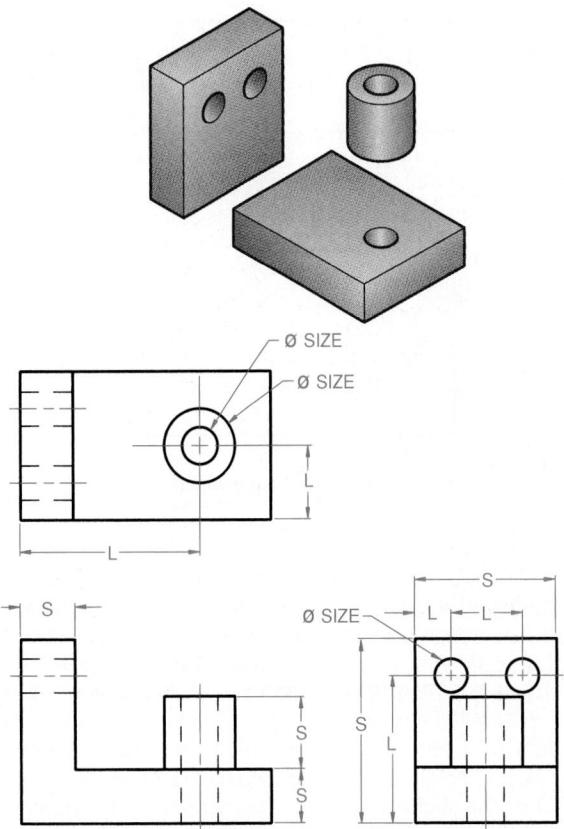

Figure 8.41 Geometric Breakdown Technique

Geometric breakdown dimensioning breaks the object down into its primitive geometric shapes.

8.4.1 The Dimensioning Process

Figure 8.42 is a drawing of a part that is ready for dimensioning. The following steps describe the process for adding the dimensions.

Step 1. In the front view, locate the ends of the angled surface by drawing one dimension line 0.375" or 10 mm from the right edge of the object and another dimension line 0.375" or 10 mm from the top edge of the object. Leave a gap near the centers of the dimension lines for the text. (If using CAD, set a grid to 0.125 or 3 mm spacing.) Draw arrows on the ends of the dimension lines. Leaving a small gap, draw extension lines from the corners of the block. Extend these lines approximately 1 mm past the dimension lines. Measure the distances and place the numerical values in the spaces in the dimension lines. (Figure 8.43)

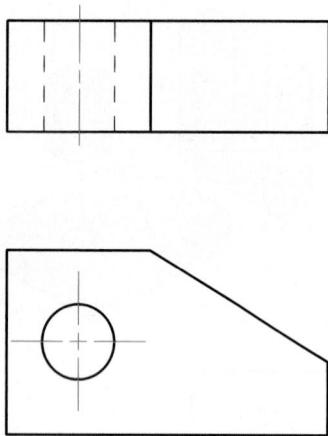

Figure 8.42 Object to Be Dimensioned

Another way to dimension the angled surface is also shown in the figure. In this method, one of the two dimensions in Step 1 is used, and an angle is used to give direction. The other dimension used in Step 1 is no longer necessary, although it could be shown as a reference dimension.

Step 2. Add the dimension lines for the overall dimensions; height, width, and depth. The dimension lines for the width and height dimensions are located 0.625" or 16 mm from the object lines. Locate the ends of the angled line, then add numerical text to each dimension.

Step 3. Next, locate the hole. Locate the center by using horizontal and vertical dimension lines. Extend the center lines and use the lower left corner of the part as a reference point.

Step 4. To dimension the size of the hole, draw a radial leader line from the hole to a convenient location and add a short horizontal extension or shoulder. Since no depth dimension is added to the diameter, the hole goes all the way through the part.

© CAD Reference 8.12

Always check all dimensions for accuracy and completeness. Check the accuracy of numerical values by measuring each dimension with a scale. This should be done even for drawings created with CAD, since most CAD software has a provision for changing dimension text. Underline out-of-scale dimensions.

To ensure that each feature is dimensioned once and only once, pass a straightedge horizontally and vertically across all views, stopping at each feature to determine if an appropriate dimension has been specified and to make sure only one dimension is specified.

8.4.2 Dimensioning Guidelines

The importance of accurate, unambiguous dimensioning cannot be overemphasized. There are many cases where an incorrect or unclear dimension has added considerable expense to the fabrication of a product, caused premature failure, or, in some cases, caused loss of life. *The primary guideline is clarity: Whenever two guidelines appear to conflict, the method which most clearly communicates the size information shall prevail.* Use the following dimensioning guidelines.

1. Every dimension must have an associated tolerance, and that tolerance must be clearly shown on the drawing.
2. Double dimensioning of a feature is not permitted. For example, in Figure 8.44, there are two ways to arrive at the overall length of the object: by adding dimensions A and B, or by directly measuring the dimension C. Since each dimension must have a tolerance, it is not clear which tolerance would apply to the overall length: the tolerance for dimension C, or the sum of the tolerances for dimensions A and B. This ambiguity can be eliminated by removing one of the three dimensions. The dimension that has the least importance to the function of the part should be left out. In this case, dimension C would probably be deleted.
3. Dimensions should be placed in the view that most clearly describes the feature being dimensioned (contour dimensioning). For example, Figure 8.45 illustrates a situation in which the height of a step is being dimensioned. In this case, the front view more clearly describes the step feature.
4. Maintain a minimum spacing between the object and the dimension and between multiple dimensions. This spacing is shown in Figure 8.15. If the spacing is reduced, the drawing will be more difficult to read and a lack of clarity will result.
5. A visible gap shall be placed between the ends of extension lines and the feature to which they refer.
6. Manufacturing methods should not be specified as part of the dimension, unless no other method of manufacturing is acceptable. The old practice of using *drill* or *bore* is discouraged. Because a drawing becomes a legal document for manufacturing, specifying inappropriate manufacturing methods can cause unnecessary expense and may trigger litigation.

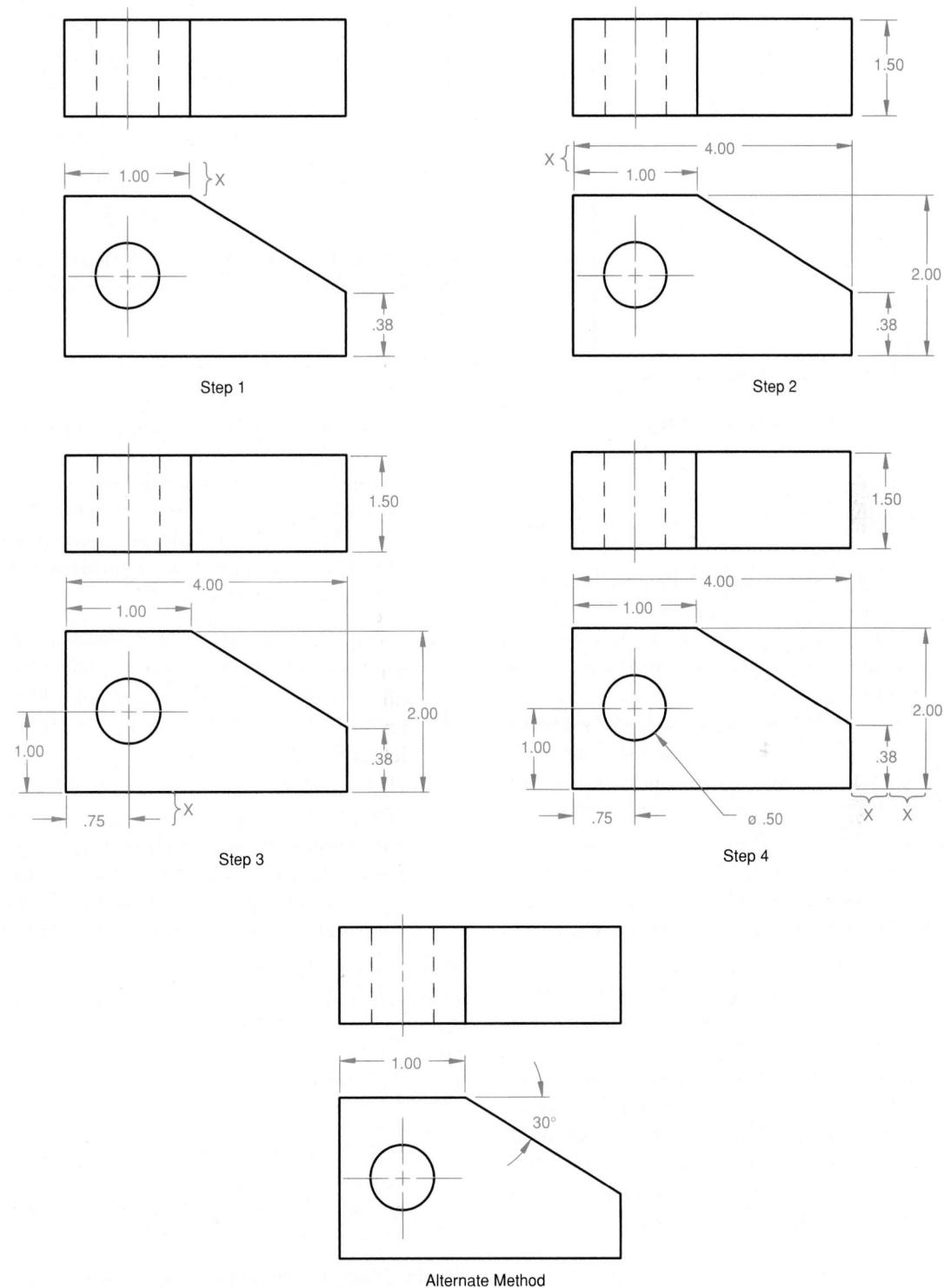

Figure 8.43 Steps to Create a Dimensioned Drawing

Figure 8.44 Avoid Over-Dimensioning

Double dimensioning can cause problems because of tolerancing.

7. Avoid placing dimensions within the boundaries of a view, whenever practicable. If several dimensions are placed in a view, differentiation between the object and the dimensions may become difficult.
8. Dimensions for materials typically manufactured to gages or code numbers shall be specified by numerical values. The gages or code numbers may be shown in parentheses following the numerical values.
9. Unless otherwise specified, angles shown in drawings are assumed to be 90 degrees.
10. Avoid dimensioning hidden lines. Hidden lines are less clear than visible lines.
11. The depth and diameter of blind, counterbored, or countersunk holes may be specified in a note. (Figures 8.27 and 8.28)
12. Diameters, radii, squares, counterbores, spotfaces, countersinks, and depths should be specified with the appropriate symbol preceding the numerical value. (Figure 8.27)
13. Leader lines for diameters and radii should be radial lines. (Figure 8.26)

8.4.3 ANSI Standard Dimensioning Rules

The ANSI Y14.5 standard identifies a series of rules that help to promote good dimensioning practices. The rules, with explanations and examples, are as follows:

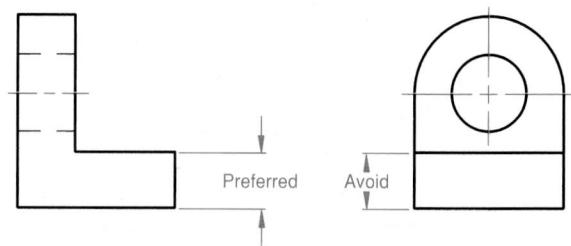

Figure 8.45 Dimension the Most Descriptive View

Dimensions are placed in the most descriptive or contour view.

- a. *Each dimension shall have a tolerance, except for those dimensions specifically identified as reference, maximum, minimum, or stock (commercial stock size). The tolerance may be applied directly to a dimension (or indirectly in the case of basic dimensions), indicated by a general note, or located in a supplementary block of the drawing format.*

Explanation: By definition, a dimension must have a nominal (Latin for *name*) value *and* a tolerance. For example “four and a half inches” does not constitute a dimension; “four and a half inches, plus or minus one-sixteenth inch” does.

- b. *Dimensions for size, form, and location of features shall be complete to the extent that there is full understanding of the characteristics of each feature. Neither scaling (measuring the size of a feature directly from an engineering drawing) nor assumption of a distance or size is permitted.*

Explanation: All features must be dimensioned directly, and a drawing should never have to be scaled. Do not assume that just because a hole is located in the middle of a square, it will be centered. There must be a dimension from an edge to the center of the hole.

- c. *Each necessary dimension of an end product shall be shown. No more dimensions than those necessary for complete definition shall be given. The use of reference dimensions on a drawing should be minimized.*

Explanation: A common mistake is *over-dimensioning*. Only put down everything *necessary* to make the part, but no more. Remember that reference dimensions are only summing information: do not rely on them.

d. Dimensions shall be selected and arranged to suit the function and mating relationship of a part and shall not be subject to more than one interpretation.

Explanation: If a 1" square part is drawn, and then a hole is placed on the centerline of the square, the hole should be $\frac{1}{2}$ " from one side. However, the side must be specified. The tolerance on the centering of the hole is greatly affected by the tolerance on the width of the entire block, and by the side to which it is referenced.

e. The drawing should define a part without specifying manufacturing methods. Thus, only the diameter of a hole is given, without indicating whether it is to be drilled, reamed, punched, or made by any other operation. However, in those instances where manufacturing, processing, quality assurance, or environmental information is essential to the definition of engineering requirements, it shall be specified on the drawing or in a document referenced on the drawing.

Explanation: This rule is in direct response to the common practice of stating how to make a hole. Previously, a hole was specified as follows:

DRILL .500 DIAMETER

or

DRILL .490 DIA., REAM TO .500 DIA.

Under current standards, these callouts are unacceptable. It may seem helpful to place the drill size first, and then the reamed size. However, there are two reasons that this calculation should be done by manufacturing personnel:

- (1) Manufacturing personnel, not design personnel, are the experts at determining how to manufacture parts.
- (2) Even if the designer has the expertise to make these decisions, it is a waste of time to do the work of the manufacturing experts. There is usually more than enough design work to be done.

f. It is permissible to identify as nonmandatory certain processing dimensions that provide for finish allowance, shrink allowance, and other requirements, provided the final dimensions are given on the drawing. Nonmandatory processing dimensions shall be identified by an appropriate note, such as NONMANDATORY (MFG DATA).

Explanation: This rule does not specify how a part is to be manufactured; it simply permits showing dimension information that allows for losses or changes caused by manufacturing.

g. Dimensions should be arranged to provide required information for optimum readability. Dimensions should be shown in the true profile views and refer to visible outlines.

Explanation: This means that dimensions should be laid out carefully, and features should be dimensioned in the view in which they show up best.

h. Wires, cables, sheets, rods, and other materials manufactured to gage or code numbers shall be specified by linear dimensions indicating the diameter or thickness. Gage or code numbers may be shown in parentheses following the dimension.

Explanation: This infers that gages should not be relied on to tolerance materials. Add those tolerances directly, with linear numbers. For example, there is more than one sheet metal gage code, and it is not always clear which one is meant by a callout.

i. A 90° angle is implied where center lines and lines depicting features are shown on a drawing at right angles and where no angle is specified.

Explanation: This rule implies that the tolerance on a square corner is the same as the tolerance on any other angle.

j. A 90° BASIC angle applies where center lines or features in a pattern or surfaces shown at right angles on a drawing are located or defined by basic dimensions and no angle is specified.

Explanation: When setting up a tolerance zone reference frame, all right angles are considered perfectly square.

k. Unless otherwise specified, all dimensions are applicable at $20^\circ C$ ($68^\circ F$). Compensation may be made for measurements made at other temperatures.

Explanation: Materials expand and contract due to changes in temperature. This can affect the measured size of dimensions; therefore, it is important that they be measured at a constant temperature. A similar problem occurs due to high humidity; therefore, for materials that are subject to humidity changes, all measurements should be made between 80 and 100% relative humidity.

8.5 TOLERANCING

Geometric tolerances are controls that affect the shape and/or orientation of features. Some geometric tolerances come from the dimensions that are added to a figure; others come from ANSI Standard Y14.5 M-1982, Rule #1: *The geometry of a part is controlled by its size dimension, whether or not a geometric control is placed on it.* Also, some controls are applied automatically. Examples might include:

The top and bottom of the part are parallel to one another.

All surfaces are flat.

The hole is straight, round, and perpendicular to the front and back surfaces.

The applications and effects of tolerances are discussed in the following sections.

8.5.1 Tolerance Theory

Tolerances are used to control the variation that exists on all manufactured parts. Toleranced dimensions control the amount of variation on each part of an assembly. The amount each part is allowed to vary depends on the function of the part and of the assembly. For example, the tolerances placed on electric hand-drill parts are not as stringent as those placed on jet engine parts. The more accuracy needed in the machined part, the higher the manufacturing cost. Therefore, tolerances must be specified in such a way that a product functions as it should at a cost that is reasonable.

A tolerance of 4.650 ± 0.003 means that the final measurement of the machined part can be anywhere from 4.653 to 4.647 and the part would still be acceptable. The lower and upper allowable sizes are referred to as the *limit dimensions*, and the *tolerance* is the difference between the limits. In the example, the **upper limit** (largest value) for the part is 4.653, the **lower limit** (smallest value) is 4.647, and the tolerance is 0.006.

Tolerances are assigned to mating parts. For example, the slot in the part shown in Figure 8.46 must accommodate another part. A *system* is two or more mating parts.

8.5.2 Interchangeability

One of the great advantages of tolerances is that they allow for **interchangeable parts**, thus permitting the

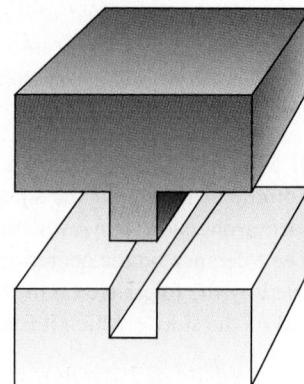

Figure 8.46

A system is two or more mating parts.

replacement of individual parts, rather than having to replace an entire system if only one part goes bad. For example, if a bearing wears out, the replacement bearing of the same specifications will work in the system.

In the 1800s, you could not buy a threaded bolt by itself; you had to buy a matched set of bolt and nut because they were hand fit together. Every bolt and nut were made in a set and not even the machinist who made them could tell you the actual size of the threads! The inability to define the threads, using dimensioning, made interchangeable parts impossible.

Practice Exercise 8.1

Take a ballpoint pen that has a removable cap and remove the cap. The cap is not too difficult to remove, yet it is tight enough to stay on by itself. The cap represents an interchangeable part. Another cap like it will fit just as well. Now imagine you have a small business and you are making these caps by hand. If you had all of the pens on hand, you could polish the inside of each cap until it fit just right. This is exactly how manufacturing was done 100 years ago. Each part was hand fit to its mating part.

The problems with such a "handmade" system today are:

- a. There aren't enough skilled machinists available.
- b. You only get 3¢ each for the caps; they would cost \$5.00 in labor.
- c. No employee would do the work for more than a week: it would be very boring.
- d. The pens may not be available, because another company might make them, in another state.

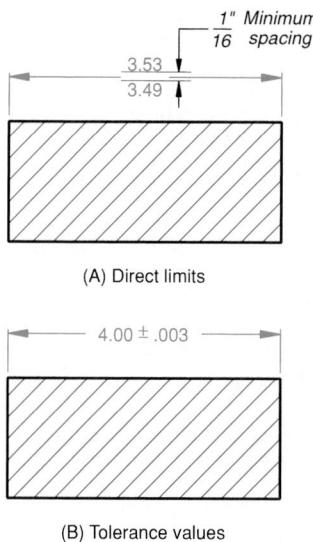

Figure 8.47 Representing Tolerance Values

Tolerances are represented as direct limits or as tolerance values.

In the early days of the Industrial Revolution, all parts were handmade and hand assembled. Each part of an assembly was adjusted, polished, cut, and shaped to fit *perfectly* with its mating part. A wagon wheel is a good example. The spokes, hub, and rim were cut to fit one wheel. The steel hoop was hand fitted to the wheel and then heated and forced onto the rim. After cooling, the hoop would shrink and squeeze the entire assembly together. This was a precision assembly, but it required very little measuring and virtually no communications, because one person made the whole assembly. In fact, the wagon smith made the entire wagon.

In today's manufacturing world, one company would make the hub, another would make the spokes, and another would make the rim. The solution lies in dimensioning and tolerancing to make sure that the parts will fit together, even though they are made by different companies.

8.6 TOLERANCE REPRESENTATION

Tolerance is the total amount a dimension may vary and is the difference between the maximum and minimum limits. Because it is impossible to make everything to an exact size, tolerances are used on production drawings to control the manufacturing process

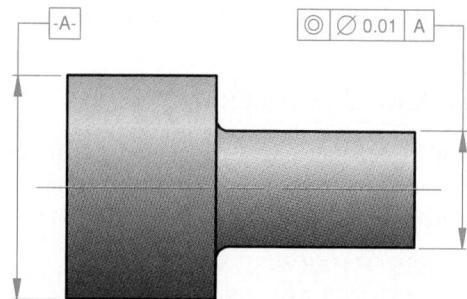

Figure 8.48 Geometric Tolerance System Used to Dimension Parts

more accurately and to control the variation between mating parts. ANSI standards Y14.5M-1982 are commonly used in United States industries to specify tolerances on engineering drawings.

Tolerances can be expressed in several ways:

1. Direct limits, or as tolerance values applied directly to a dimension. (Figure 8.47)
2. Geometric tolerances. (Figure 8.48 and Section 8.8.)
3. Notes referring to specific conditions.
4. A general tolerance note in the title block.

8.6.1 General Tolerances

General tolerances are given in a note or as part of the title block. A general tolerance note would be similar to:

ALL DECIMAL DIMENSIONS TO BE HELD
TO $\pm .002''$

This means that a dimension such as .500 would be assigned a tolerance of $\pm .002$, resulting in an upper limit of .502 and a lower limit of .498.

For metric dimensions, the note would be similar:

ALL METRIC DIMENSIONS TO BE HELD
TO ± 0.05

This means that a dimension such as 65.00 would be assigned a tolerance of ± 0.05 , resulting in an upper limit of 65.05 and a lower limit of 64.95.

If fractional dimensions are used, a general note might be:

ALL FRACTIONAL DIMENSIONS $\pm \frac{1}{64}''$
UNLESS OTHERWISE SPECIFIED

Angular dimensions can be tolerated through a note such as:

ALL ANGULAR TOLERANCES ± 1 DEGREE

Another general tolerance method would specify the tolerances on dimensions in terms of the number of decimal places found in the dimensions, as follows:

UNLESS OTHERWISE SPECIFIED, TOLERANCES ARE AS FOLLOWS:

Decimal inches:

\times = $\pm .020$

$\times\times$ = $\pm .010$

$\times\times\times$ = $\pm .005$

Millimeters:

Whole numbers = ± 0.5

$\times\times$ = ± 0.25

$\times\times\times$ = ± 0.12

In this method, the dimension applied to each feature automatically identifies the required tolerance. Actual tolerances may vary from one company to another, but the ones given here are common tolerances for machined parts.

If a dimension has a tolerance added directly to it, that tolerance supersedes the general tolerance note. A *tolerance added to a dimension always supersedes the general tolerance, even if the added tolerance is larger than the general tolerance.*

8.6.2 Limit Dimensions

Tolerances can be applied directly to dimensioned features, using limit dimensioning. This is the ANSI preferred method; the maximum and minimum sizes are specified as part of the dimension. (See Figure 8.47A.) Either the upper limit is placed above the lower limit, or, when the dimension is written in a single line, the lower limit precedes the upper limit and they are separated by a dash. A minimum spacing of $\frac{1}{16}$ inch is required when the upper limit is placed above the lower limit.

8.6.3 Plus and Minus Dimensions

With this approach, the basic size is given, followed by a plus/minus sign and the tolerance value. (Figure 8.49) Tolerances can be unilateral or bilateral. A **unilateral tolerance** varies in only one direction. A **bilateral tolerance** varies in both directions from the

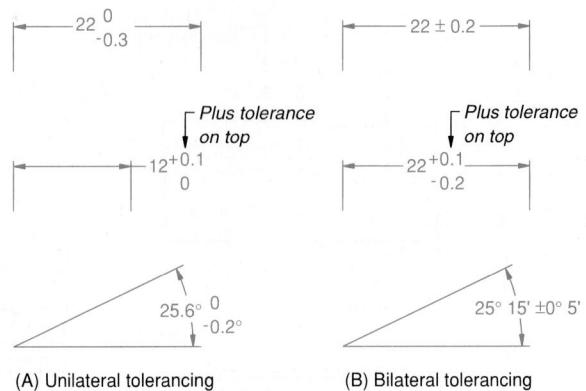

Figure 8.49 Plus and Minus Tolerance System Applied to Various Dimensioning Conditions

basic size. If the variation is equal in both directions, then the variation is preceded by a \pm symbol. *The plus and minus approach can only be used when the two variations are equal.*

8.6.4 Single Limit Dimension

When other elements of a feature will determine one limit dimension, MIN or MAX is placed after the other limit dimension. Items such as depth of holes, length of threads, corner radii, and chamfers can use the single limit dimension technique. **© CAD Reference 8.13**

8.6.5 Important Terms

Figure 8.50 shows a system of two parts with tolerated dimensions. The two parts are an example of ANSI Y14.5M-1982 important terms.

Nominal size—a dimension used to describe the general size, usually expressed in common fractions.

The slot in Figure 8.50 has a nominal size of $\frac{1}{2}$ ".

Basic size—the theoretical size used as a starting point for the application of tolerances. The basic size of the slot in Figure 8.50 is .500".

Actual size—the measured size of the finished part after machining. In Figure 8.50, the actual size is .501".

Limits—the maximum and minimum sizes shown by the tolerated dimension. The slot in Figure 8.50 has limits of .502 and .498, and the mating part has limits of .495 and .497. The larger value for each part is the *upper limit* and the smaller value is the *lower limit*.

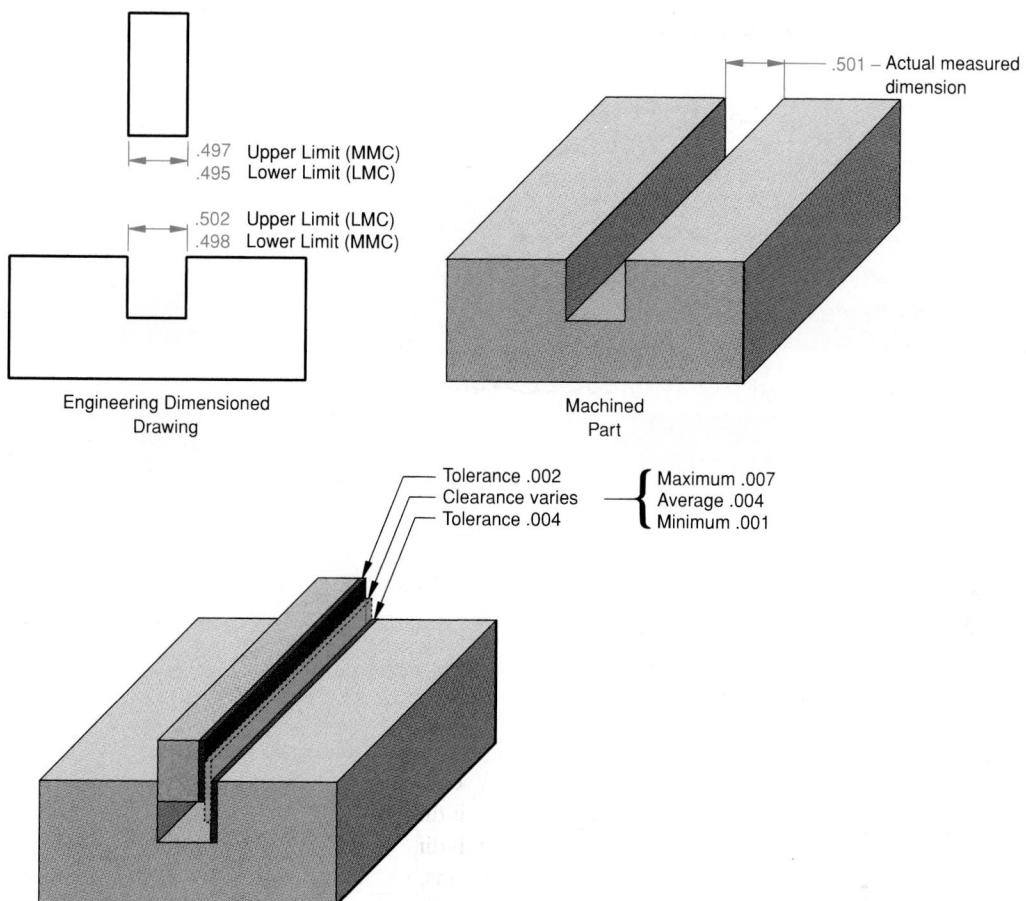

Figure 8.50 Toleranced Parts and the Important Terms

Allowance—the minimum clearance or maximum interference between parts, or the *tightest* fit between two mating parts. In Figure 8.50, the allowance is .001, meaning that the tightest fit occurs when the slot is machined to its smallest allowable size of .498 and the mating part is machined to its largest allowable size of .497. The difference between .498 and .497, or .001, is the allowance.

Tolerance—the total allowable variance in a dimension; the difference between the upper and lower limits. The tolerance of the slot in Figure 8.50 is .004" ($.502 - .498 = .004$) and the tolerance of the mating part is .002" ($.498 - .495 = .002$).

Maximum material condition (MMC)—the condition of a part when it contains the most amount of material. The MMC of an external feature, such as a shaft, is the upper limit. The MMC of an internal feature, such as a hole, is the lower limit.

Least material condition (LMC)—the condition of a part when it contains the least amount of material possible. The LMC of an external feature is the lower limit. The LMC of an internal feature is the upper limit.

Piece tolerance—the difference between the upper and lower limits of a single part.

System tolerance—the sum of all the piece tolerances.

8.6.6 Fit Types

The degree of tightness between mating parts is called the *fit*. The basic hole and shaft system shown in Figures 8.51 and 8.52 is an example of the three most common types of fit found in industry.

Clearance fit occurs when two toleranced mating parts will always leave a space or clearance when assembled. In Figure 8.51, the largest that shaft A can

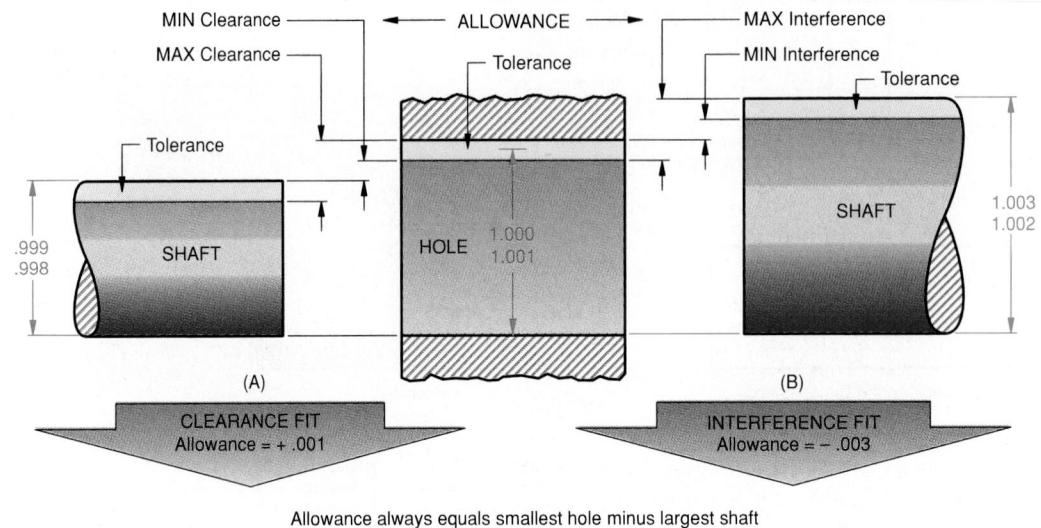

Figure 8.51 Clearance and Interference Fits between Two Shafts and a Hole

Shaft A is a clearance fit and shaft B is an interference fit.

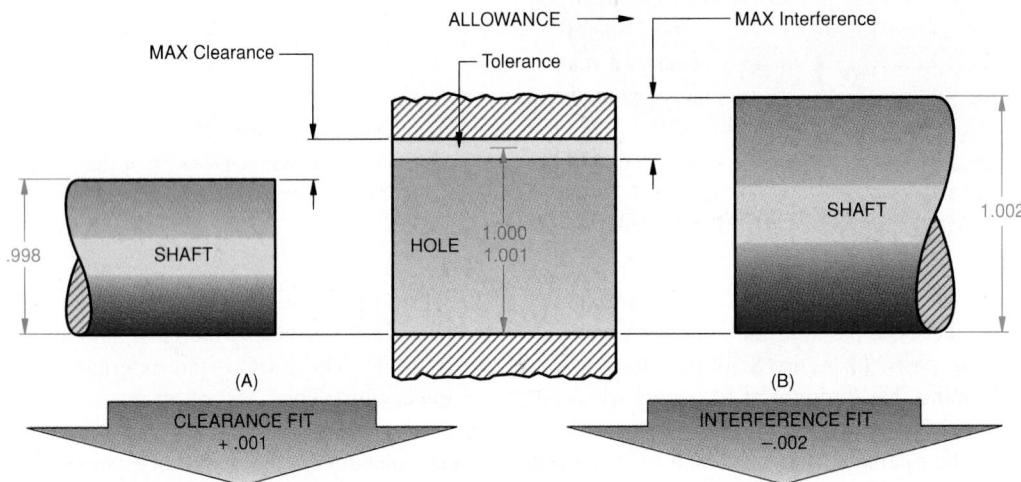

Figure 8.52 Transition Fit between a Shaft and a Hole

When the shaft is machined to its smallest diameter (.998), there is a clearance fit with the hole. When the shaft is machined to its largest diameter (1.002), there is an interference fit with the hole.

be manufactured is .999, and the smallest the hole can be is 1.000. The shaft will always be smaller than the hole, resulting in a minimum clearance of +.001, also called an *allowance*. The maximum clearance occurs when the smallest shaft (.998) is mated with the largest hole (.1001), resulting in a difference of +.003.

Interference fit occurs when two toleranced mating parts will always interfere when assembled. An interference fit *fixes* or *anchors* one part into the other, as though the two parts were one. In Figure 8.51, the smallest shaft B can be manufactured is 1.002, and the largest the hole can be manufactured is 1.001. This means that the shaft will always be larger than the hole, and the minimum interference is -.001. The maximum interference would occur when the smallest hole (1.000) is mated with the largest shaft (1.003), resulting in an interference of -.003. In order to assemble the parts under this condition, it would be necessary to *stretch* the hole or *shrink* the shaft, or to use force to press the shaft into the hole. Having an interference is a desirable situation for some design applications. For example, it can be used to fasten two parts together without the use of mechanical fasteners or adhesive.

Transition fit occurs when two toleranced mating parts are sometimes an interference fit and sometimes a clearance fit when assembled. In Figure 8.52, the smallest the shaft can be manufactured is .998, and the largest the hole can be manufactured is 1.001, resulting in a clearance of +.003. The largest the shaft can be manufactured is 1.002, and the smallest the hole can be is 1.000, resulting in an interference of -.002.

8.6.7 Fit Type Determination

If feature A of one part is to be inserted into or mated with feature B of another part, the type of fit can be determined by the following (Figure 8.53):

- The loosest fit is the difference between the smallest feature A and the largest feature B.
- The tightest fit is the difference between the largest feature A and the smallest feature B.

This technique also works when there are more than two parts in a system. For example, if two parts are to be inserted into a third, then the tightest fit is determined by adding the maximum size of the two parts together, then comparing that value with allowable sizes of the third part. For example, the loosest fit

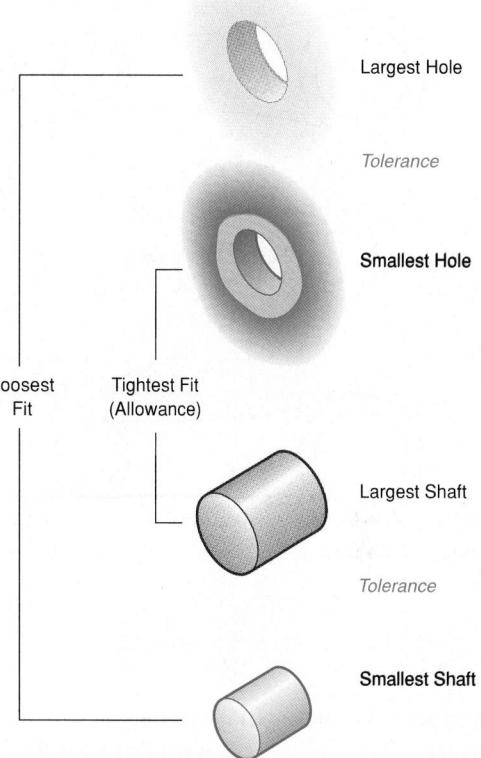

Figure 8.53 Determining Fits

Determining the tightest and loosest fits for a system of parts requires evaluating the extremes in possible dimensions.

is the difference between the minimum size of the two parts together and the maximum size of the third part.

Practice Exercise 8.2

Try writing a general equation that can be used to determine tightest and loosest fits for a system having any number of parts.

8.6.8 Tolerance Costs

Cost is a necessary consideration when determining the tolerances for various parts of an assembly. The cost of a part escalates rapidly as tolerances are tightened. Changing a tolerance from $\pm .010$ to $\pm .005$ can more than double the cost of that feature. The tolerance is twice as accurate, but the reject rate may go up dramatically, or the new tolerance may require a totally different machining operation. In all cases,

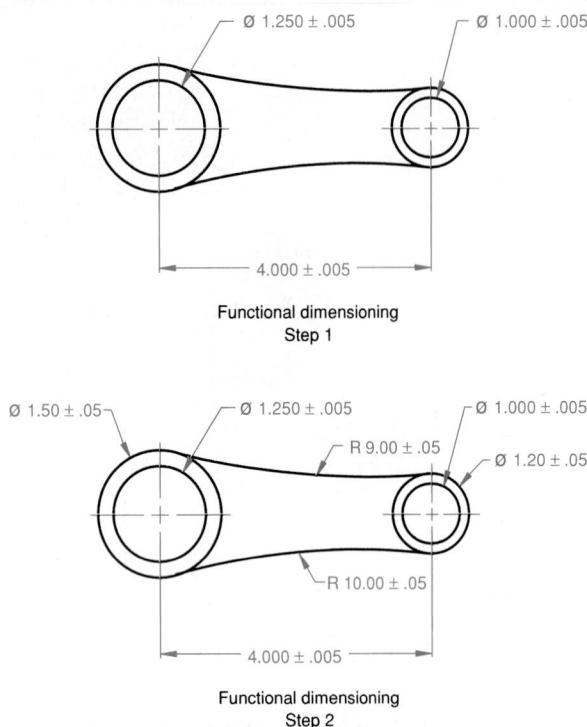

Figure 8.54 Functional Dimensioning

Functional dimensioning begins with tolerancing the most important features.

the specified tolerance and the manufacturing process must be carefully matched to achieve the desired level of quality at minimum cost.

It is important to remember that there may be other ways to enhance the fit of mating parts, such as an alignment pin or some other centering device. These options should be carefully considered before a decision is made to tighten the tolerances.

8.6.9 Functional Dimensioning

When dimensioning a part, identify the *functional features* first. Functional features are those that come in contact with other parts, especially moving parts. Dimension and tolerance these features first, then do all the remaining features. This is called **functional dimensioning**.

As an example, in Figure 8.54, the holes and the distance between them are dimensioned first, with a

tighter tolerance. Then, the dimensions for the material around the holes are added, at a much looser tolerance. Holes are usually functional features. The tolerance on the positions of the two holes is $\pm .005$. In this case, the “pattern of two holes” is located and dimensioned first, since the most important dimension is the distance between the holes, or the dimension *within the pattern*.

8.6.10 Tolerance Stack-Up

The additive rule for tolerances is that tolerances taken in the same direction from one point of reference are additive. The corollary is that tolerances to the same point taken from different directions become additive. The effect is called **tolerance stack-up**.

An example is shown in Figure 8.55 where Part A is manufactured to fit Part B. When assembled, the cylindrical features on Part B are inserted into Part A so that the inclined surface on each part is aligned. The holes in Part A are dimensioned from the left side of the part, and the holes in Part B are dimensioned from the right side of the part. If the distance between the two holes were toleranced on the basis of Part A or Part B alone, the tolerance would be ± 0.010 , which is the sum of the two tolerances taken from the side in each case. However, the two parts are to be fit together, and the tolerance for the distance between the holes must be determined on the basis of *both* Parts A and B. Since the distances to the two holes were taken from different references in the two parts, the tolerances must again be added. This makes the tolerance for the distance between the holes ± 0.020 .

If the reference for Part B had been the same as that for Part A, that is, the left side of the part, the tolerance for the distance between the holes would have remained at ± 0.010 , which would have been more desirable. (Figure 8.56)

The most desirable, and the most recommended, procedure is to relate the two holes directly to each other, not to either side of the part, and not to the overall width of the part. The result will be the best tolerance, ± 0.005 , for the distance between the holes. (Figure 8.57)

Coordinate dimensioning is an alternative way to apply dimension values. The inherent problem with this method is that the distance between two features is never a single toleranced dimension. Each dimension is referenced to the origin, and the additive rule given in the preceding section applies.

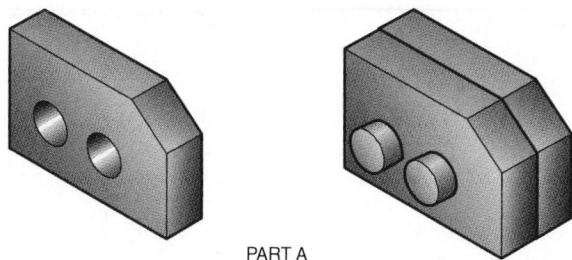

PART A

PARTS A and B
assembled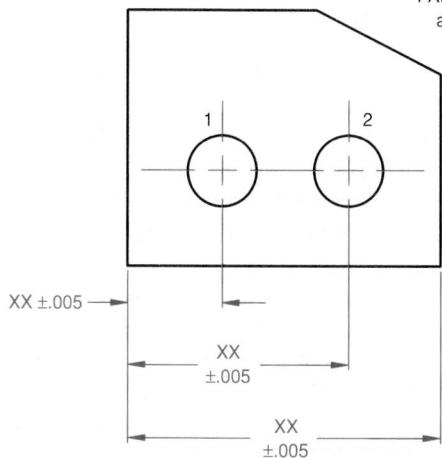

PART A

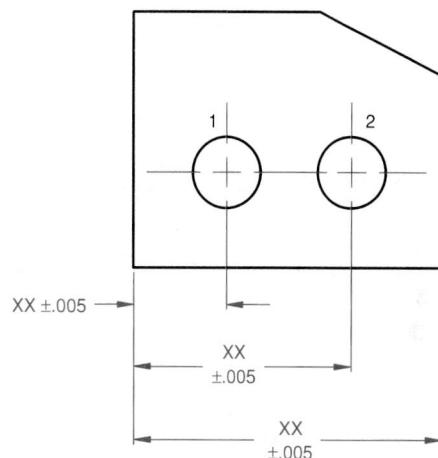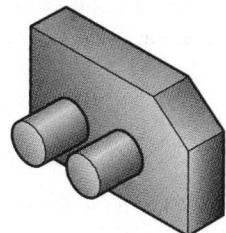

PART B

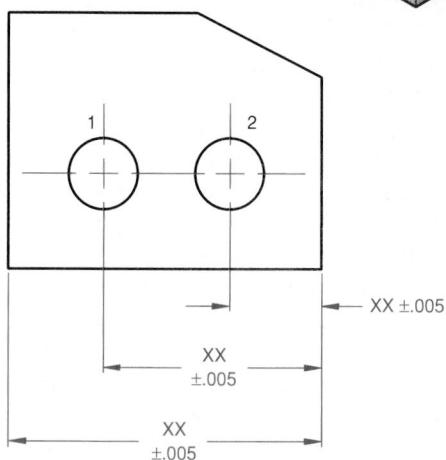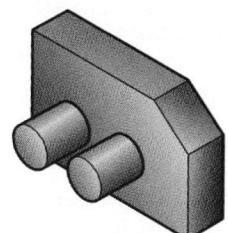

PART B

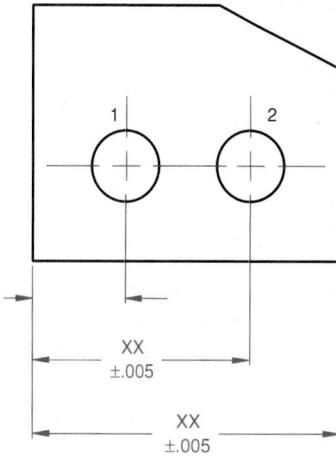**Figure 8.55 Tolerance Stack-Up**

Tolerance stack-up causes assembly problems.

Figure 8.56 Tolerance Stack-Up Reduced

Tolerance stack-up can be reduced by careful selection and placement of dimensions.

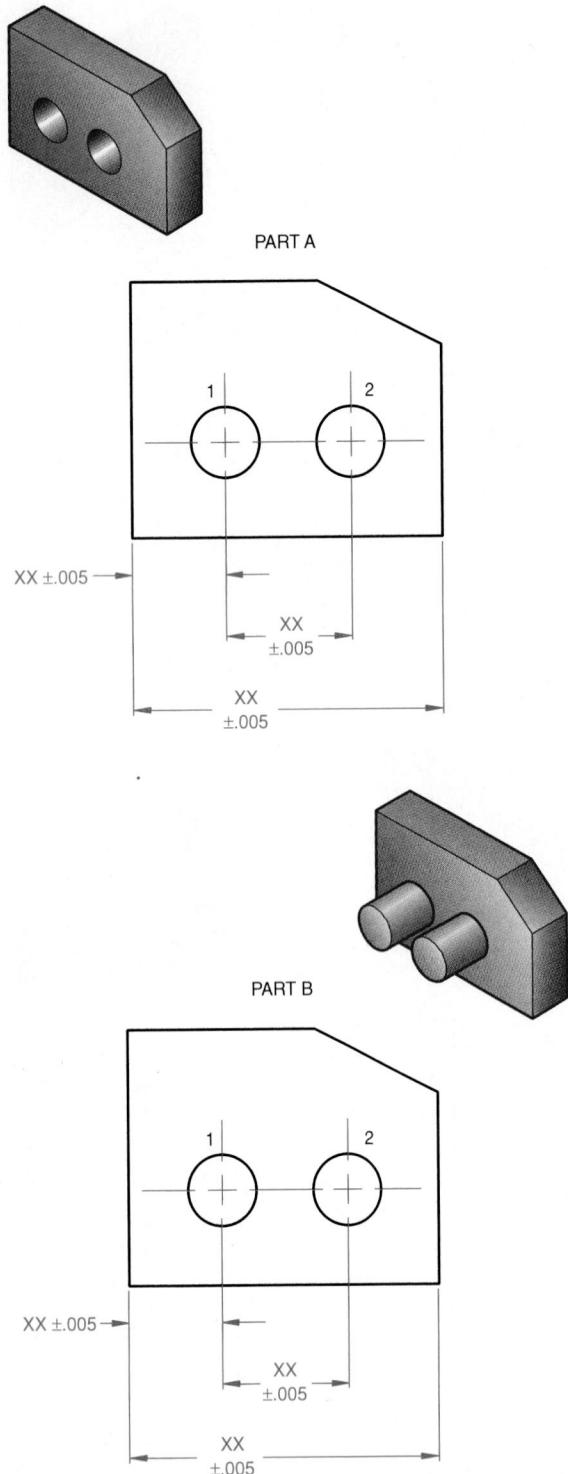

Figure 8.57 Alternate Dimensioning Technique

An alternate method of dimensioning involves locating the pattern, then dimensioning it.

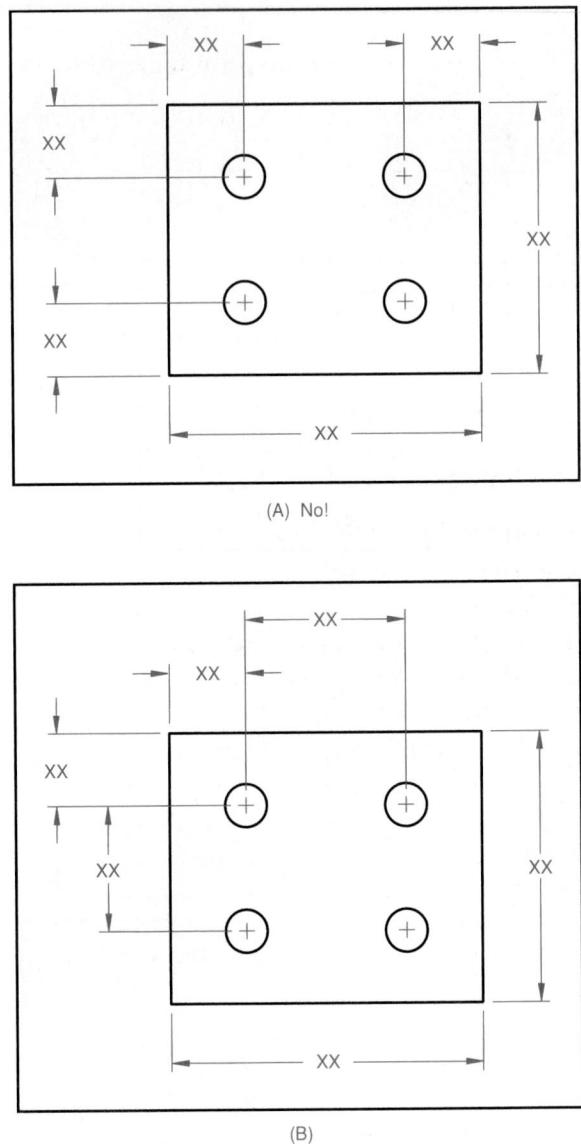

Figure 8.58 Coordinate Dimensioning Stack-Up

Avoid coordinate dimensioning stack-up by using a common reference point and dimensioning the hole spacing directly (B).

Figure 8.58A shows a typical group of holes. As in the previous example, an undesirable tolerance stack-up takes place if the holes are dimensioned as shown. Figure 8.58B shows the same part dimensioned using the *locate, then dimension the pattern* concept. This will greatly increase the probability that the holes will match up with the mating part, assuming that the mating part is dimensioned in the same manner.

Basic Size, mm							
1st Choice	2nd Choice						
1.0	—	—	7.0	25	—	—	90
—	1.1	8.0	—	—	26	100	—
1.2	—	—	9.0	—	28	—	110
—	1.4	10	—	30	—	120	—
1.6	—	—	11	—	32	—	130
—	1.8	12	—	35	—	140	—
2.0	—	—	13	—	38	—	150
—	2.2	14	—	40	—	160	—
2.5	—	—	15	—	42	—	170
—	2.8	16	—	45	—	180	—
3.0	—	—	17	—	48	—	190
—	3.5	18	—	50	—	200	—
4.0	—	—	19	—	55	—	220
—	4.5	20	—	60	—	250	—
5.0	—	—	21	—	65	—	280
—	5.5	22	—	—	70	300	—
6.0	—	—	23	—	75	—	320
—	6.5	—	24	80	—	—	—

Figure 8.59 ANSI Preferred Metric Sizes Used for Metric Tolerancing

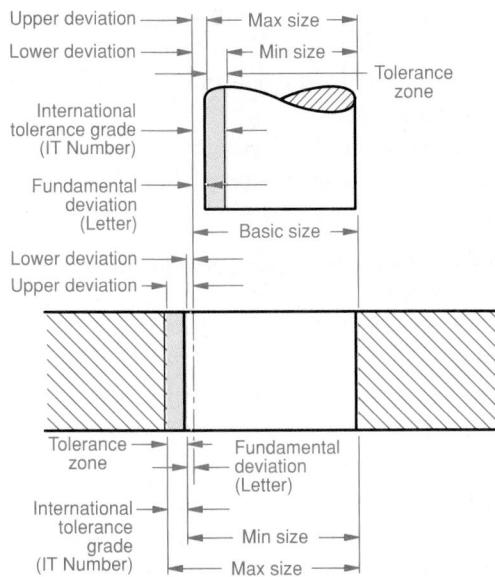

Figure 8.60 Important Definitions Used in Metric Tolerancing

8.6.11 Metric Limits and Fits

The standards used for metric measurements are recommended by the International Standards Organization (ISO) and are given in ANSI B4.2-1978. The terms used in metric tolerancing are as follows:

Basic size—the size to which limits of deviation are assigned. The limits must be the same for both parts. Basic sizes are selected from the chart in Figure 8.59.

Deviation—the difference between the actual size of the part and the basic size.

Upper deviation—the difference between the maximum size limit and the basic size. (Figure 8.60)

Lower deviation—the difference between the minimum size limit and the basic size.

Fundamental deviation—the deviation closest to the basic size. In Figure 8.61, the letter H represents the fundamental deviation for the hole and the letter f indicates the fundamental deviation for the shaft.

Tolerance—the difference between the maximum and minimum size limits on a part.

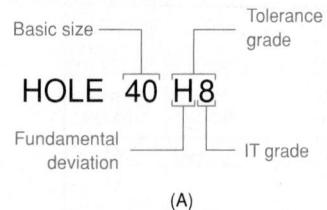

Figure 8.61 Metric Symbols and Their Definitions

Tolerance zone—the tolerance and its position relative to the basic size. (Figure 8.60)

International tolerance grade (IT)—a group of tolerances that vary depending upon the basic size, but have the same level of accuracy within a given grade. The numbers 7 and 8 in Figure 8.61 are IT grades. There are 18 IT grades: IT0, IT1, and IT01 to IT16. The smaller the grade number, the smaller the tolerance zone.

Hole basis—the system of fits where the minimum hole size is the basic size. The fundamental deviation for a hole basis system is indicated by the uppercase letter H. (Figure 8.61A)

Shaft basis—the system of fits where the minimum shaft size is the basic size. The fundamental deviation for a shaft basis system is indicated by the lowercase letter f. (Figure 8.61B)

Metric Tolerance Symbols Combining the IT grade number and the tolerance position letter establishes the tolerance symbol, which identifies the actual upper and lower limits of a part. The toleranced size of the part is defined by the basic size followed by a letter and a number, such as 40H8 or 40f7. The

40H8	$40H8 \left(\begin{array}{c} 40.039 \\ 40.000 \end{array} \right)$	$\left(\begin{array}{c} 40.039 \\ 40.000 \end{array} \right) 40H8$
(A)	(B)	(C)

Figure 8.62 Three Methods of Showing Metric Tolerance Symbols Used for Dimensions

internal part is preceded by the external part in the symbol. The basic callout for a metric fit would appear as 40H8, where:

- 40** The basic size of 40 millimeters.
- H** An internal feature (hole).
- 8** A close running clearance fit.

Figure 8.62 indicates three methods of designating metric tolerances on drawings. The values in parentheses are for reference only and come from ANSI Standard B4.2–1978 tables, as shown in Figure 8.63.

Preferred Fits The *hole basis system* for clearance, interference, and transition fits is shown in Figure 8.64. Hole basis fits have a fundamental deviation of H on the hole, as shown in the figure.

The *shaft basis system* for clearance, interference, and transition fits is shown in Figure 8.65. Shaft basis fits have a fundamental deviation of h on the shaft, as shown in the figure.

A description of the hole basis system and shaft basis system is given in Figure 8.66.

Determining the Tolerance Using the Hole Basis System

Use Appendix 9 and Figures 8.59 and 8.67.

Step 1. Given: A shaft and a hole, the hole basis system, clearance fit, and a basic diameter of 41 mm for the hole.

Step 2. Solution: From Figure 8.59, assign the basic size of 40 mm to the shaft. From Figure 8.66, assign the sliding fit H7/g6. Sliding fit is defined in the figure.

Step 3. Hole: Determine the upper and lower limits of the hole from Appendix 9, using column H7 and row 40 from the hole basis charts. From the table, the limits are 40.025 and 40.000.

Step 4. Shaft: Determine the upper and lower limits of the shaft from Appendix 9, using column g6 and row 40. From the table, the limits are 39.991 and 39.975.

BASIC SIZE	LOOSE RUNNING			FREE RUNNING			CLOSE RUNNING			SLIDING			LOCATIONAL CLEARANCE			
	Hole H11	Shaft c11	Fit	Hole H9	Shaft d9	Fit	Hole H8	Shaft f7	Fit	Hole H7	Shaft g6	Fit	Hole H7	Shaft h6	Fit	
40	MAX	40.160	39.880	0.440	40.062	39.920	0.204	40.039	39.975	0.029	40.025	39.991	0.050	40.025	40.000	0.041
	MIN	40.000	39.720	0.120	40.000	39.858	0.060	40.000	39.950	0.025	40.000	39.975	0.009	40.000	39.984	0.000
50	MAX	50.160	49.870	0.450	50.062	49.920	0.204	50.039	49.975	0.089	50.025	49.991	0.050	50.025	50.000	0.041
	MIN	50.000	49.710	0.130	50.000	49.858	0.080	50.000	49.950	0.025	50.000	49.975	0.009	50.000	49.984	0.000
60	MAX	60.190	59.860	0.520	60.074	59.900	0.248	60.046	59.970	0.106	60.030	59.990	0.059	60.030	60.000	0.049
	MIN	60.000	59.670	0.140	60.000	59.826	0.100	60.000	59.940	0.030	60.000	59.971	0.010	60.000	59.981	0.000
80	MAX	80.190	79.550	0.530	80.074	79.900	0.248	80.046	79.970	0.106	80.030	79.990	0.059	80.030	80.000	0.049
	MIN	80.000	79.660	0.150	80.000	79.826	0.100	80.000	79.940	0.030	80.000	79.971	0.010	80.000	79.981	0.000
100	MAX	100.220	99.830	0.610	100.087	99.880	0.294	100.054	99.964	0.125	100.035	99.988	0.069	100.035	100.000	0.057
	MIN	100.000	99.610	0.170	100.000	99.793	0.120	100.000	99.929	0.036	100.000	99.966	0.012	100.000	99.978	0.000
120	MAX	120.220	119.820	0.620	120.087	119.880	0.294	120.054	119.964	0.125	120.035	119.988	0.069	120.035	120.000	0.057
	MIN	120.000	119.600	0.180	120.000	119.793	0.120	120.000	119.929	0.036	120.000	119.966	0.012	120.000	119.978	0.000
160	MAX	160.250	159.790	0.710	160.100	159.855	0.345	160.063	159.957	0.146	160.040	159.986	0.078	160.040	160.000	0.065
	MIN	160.000	159.540	0.210	160.000	159.755	0.145	160.000	159.917	0.043	160.000	159.961	0.014	160.000	159.975	0.000
200	MAX	200.290	199.760	0.820	200.115	199.830	0.400	200.072	199.950	0.168	200.046	199.985	0.040	200.046	200.000	0.075
	MIN	200.000	199.470	0.240	200.000	199.715	0.170	200.000	199.904	0.050	200.000	199.956	0.015	200.000	199.971	0.000
250	MAX	250.290	249.720	0.860	250.115	249.830	0.400	250.072	249.950	0.168	250.046	249.985	0.090	250.046	250.000	0.075
	MIN	250.000	249.430	0.280	250.000	249.715	0.170	250.000	249.904	0.050	250.000	249.956	0.015	250.000	249.971	0.000
300	MAX	300.320	299.670	0.970	300.130	299.810	0.450	300.081	299.944	0.189	300.052	299.983	0.101	300.052	300.000	0.084
	MIN	300.000	299.350	0.330	300.000	299.680	0.190	300.000	299.892	0.056	300.000	299.951	0.017	300.000	299.968	0.000
400	MAX	400.360	399.600	1.120	400.140	399.790	0.490	400.089	399.938	0.208	400.057	399.982	0.111	400.057	400.000	0.093
	MIN	400.000	399.240	0.400	400.000	399.650	0.210	400.000	399.881	0.062	400.000	399.946	0.018	400.000	399.964	0.000
500	MAX	500.400	499.520	1.280	500.155	499.770	0.540	500.097	499.932	0.228	500.063	499.980	0.123	500.063	500.000	0.103
	MIN	500.000	499.120	0.480	500.000	499.615	0.230	500.000	499.869	0.068	500.000	499.940	0.020	500.000	499.960	0.000

Figure 8.63 A Standard Hole Basis Table for Determining Upper and Lower Limits of a Hole Dimensioned Metrically

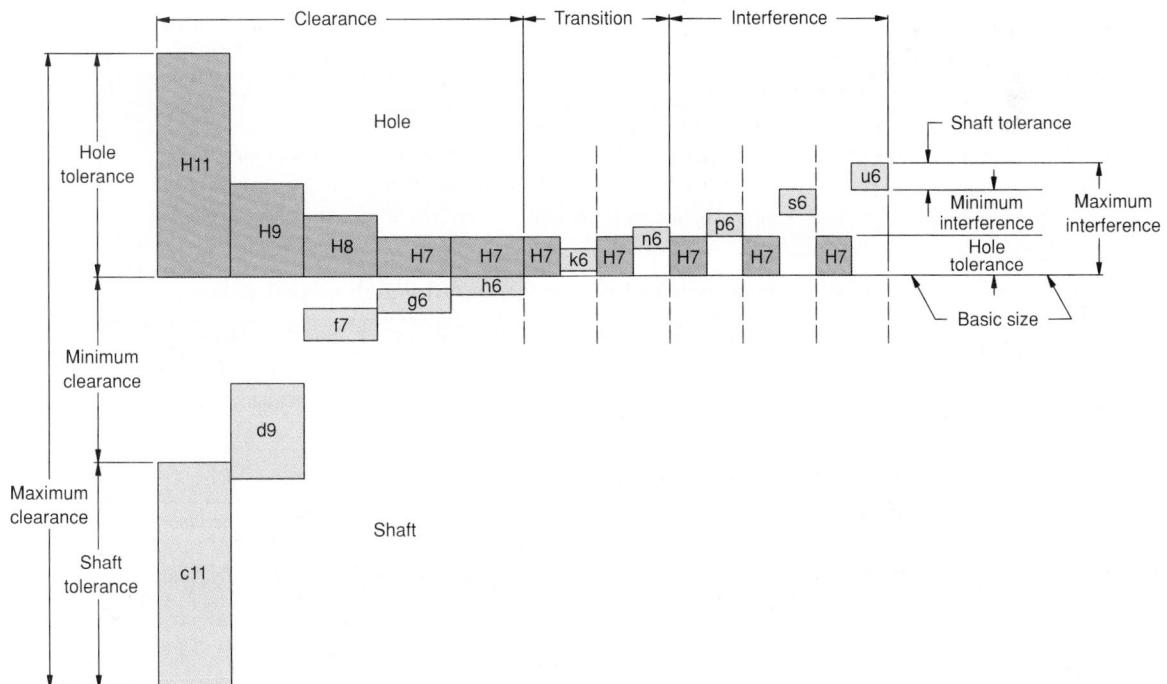

Figure 8.64 The Metric Preferred Hole Basis System of Fits

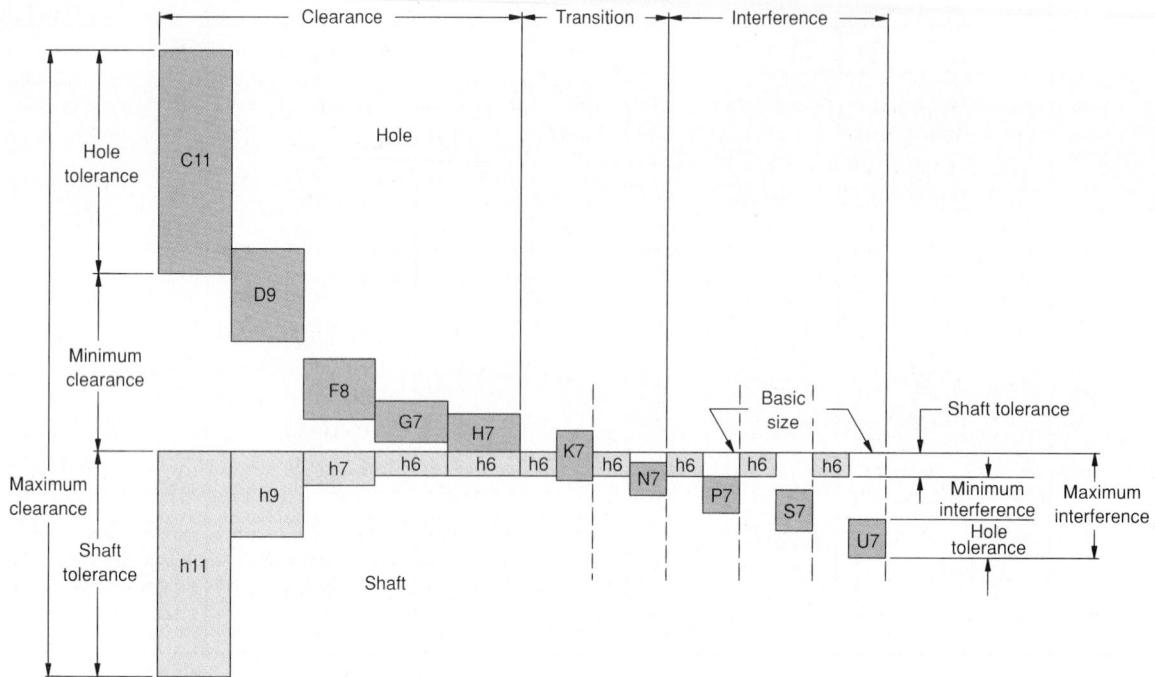

Figure 8.65 The Metric Preferred Shaft Basis System of Fits

ISO Symbol		Description
Hole Basis	Shaft Basis	
H11/c11	C11/h11	Loose running fit for wide commercial tolerances or allowances on external members
H9/d9	D9/h9	
H8/f7	F8/h7	
H7/g6	G7/h6	
H7/h6	H7/h6	Locational clearance fit provides snug fit for locating stationary parts but can be freely assembled and disassembled
	H7/k6	Locational transition fit for accurate location; a compromise between clearance and interference
	H7/n6	Locational transition fit for more accurate location where greater interference is permissible
H7/p6*	P7/h6	Locational interference fit for parts requiring rigidity and alignment with prime accuracy of location but without special bore pressure requirements
H7/s6	S7/h6	Medium drive fit for ordinary steel parts or shrink fits on light sections; the tightest fit usable with cast iron
H7/u6	U7/h6	Force fit suitable for parts that can be highly stressed or for shrink fits where the heavy pressing forces required are impractical

*Transition fit for basic sizes in range from 0 through 3mm

Figure 8.66 Description of Preferred Metric Fits

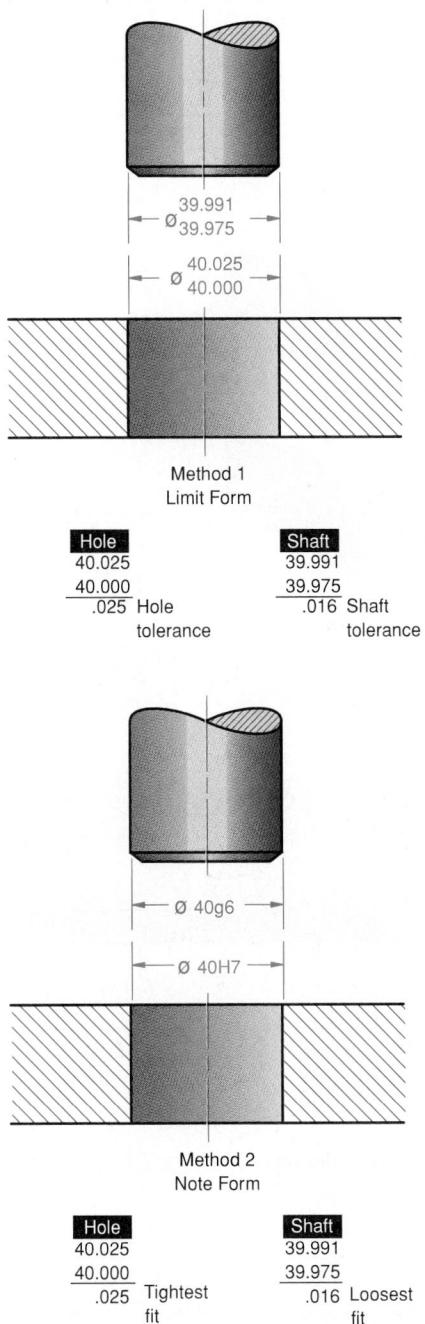

Figure 8.67 The Limit Form and Note Form of Metric Tolerancing

Two methods are acceptable for representing metric tolerances on a drawing. Figure 8.67 shows the *limit form* and the *note form*. The limit form gives the actual tolerance values, and the note form uses the basic size (40) and letters that refer to standard tables to determine the size. Figure 8.68 shows the techniques for applying metric tolerances to a technical drawing.

8.6.12 Standard Precision Fits: English Units

A special group of English unit tolerance relationships, called **preferred precision fits**, have been developed over many years and have a history of working well under certain circumstances. ANSI Standard B4.1 specifies a series of standard fits between cylindrical parts, based on the basic hole system. The tables in Appendixes 3–7 list each type of fit, showing the ANSI recommended sizes, allowances, tolerances, and fits in decimal inches. The different fit classes are as follows:

Running and sliding fits (RC) These are the loosest of the fit classes. These fits would be used when there is a shaft that must move freely inside a bearing or hole, and when the positioning of the shaft is not critical. There is *always* clearance between the shaft and the hole.

Clearance locational fits (LC) These are tighter than the RC class fits, but the shaft and hole *may* be the same size, which is called a **line to line fit**. In an LC fit, the shaft is located more accurately than in the RC fit, but it may still be loose. The shaft does not move as freely inside the hole.

Transition locational fits (LT) These are the *transition* between LC and LN fits. In some cases, these are similar to LC (clearance) fits, and in other cases they will act like LN (interference) fits.

Interference locational fits (LN) In these fits, the shaft can be *line to line* with the hole, but it is almost always larger than the hole. These are used for alignment dowel pins and other devices where a part must be positively located relative to another part.

Force and shrink fits (FN) These are pure *interference* fits, where the shaft is *always* considered larger than the hole. Such fits are used to transmit torque; they will secure a pulley or bearing to a shaft, even if there is a twisting force. These fits are also used to anchor parts that may slide along a shaft.

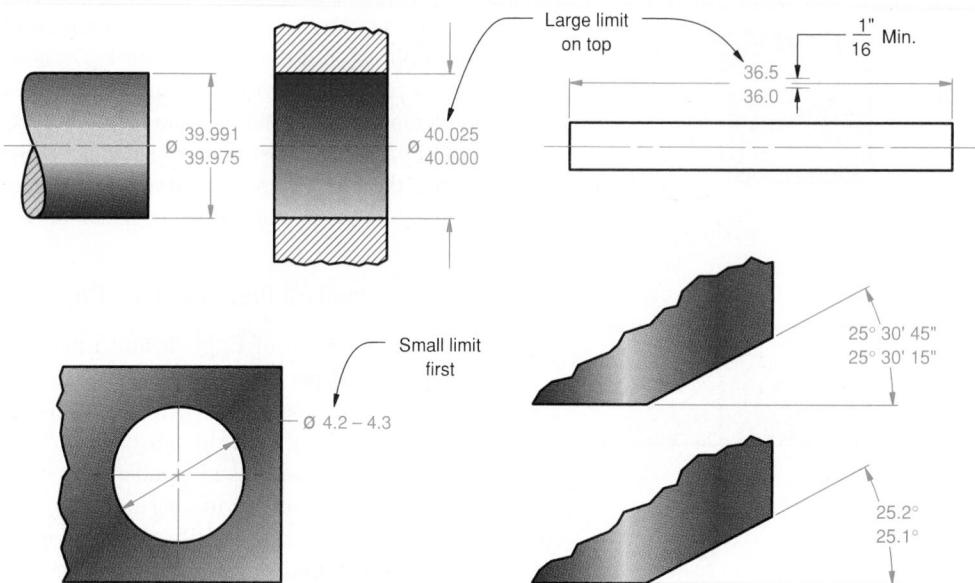

Figure 8.68 Standard Methods of Representing Metric Tolerances on Drawings

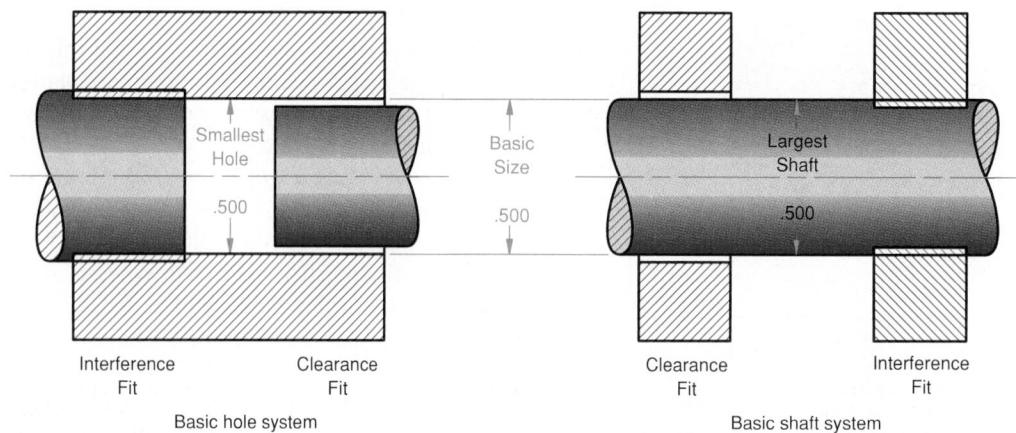

Figure 8.69 The Basic Hole and Shaft Systems for Applying English Unit Tolerances to Parts

The letters plus a number determine the class of fit within each type. For example, LC 4 means a class 4 locational clearance fit.

Basic Size The basic size is the exact theoretical size from which the limits of mating parts are assigned when tolerancing. In Figure 8.69, the nominal size is a $\frac{1}{2}$ "³, and the basic size of 0.500" is assigned to the smallest hole. The other limits of the hole and shaft are then assigned by adding or subtracting the desired allowance and tolerance.

Normally, only two systems are used when determining the basic size: *basic hole* and *basic shaft*.

Basic Hole System In the basic hole system, which is used to apply tolerances to a hole and shaft assembly, the smallest hole is assigned the basic diameter from which the tolerance and allowance are applied. (Figure 8.69) The basic hole system is widely used in industry, because many of the tools used to drill holes, such as drills and reamers, are designed to produce standard-sized holes.

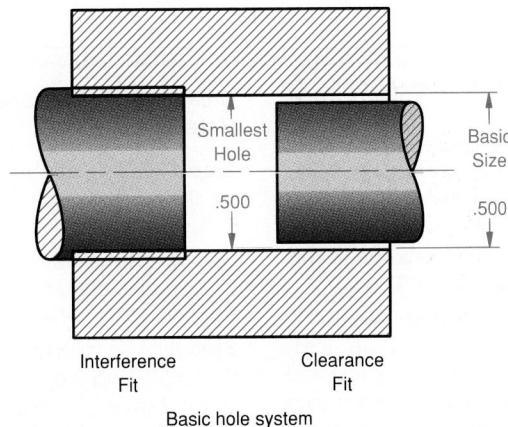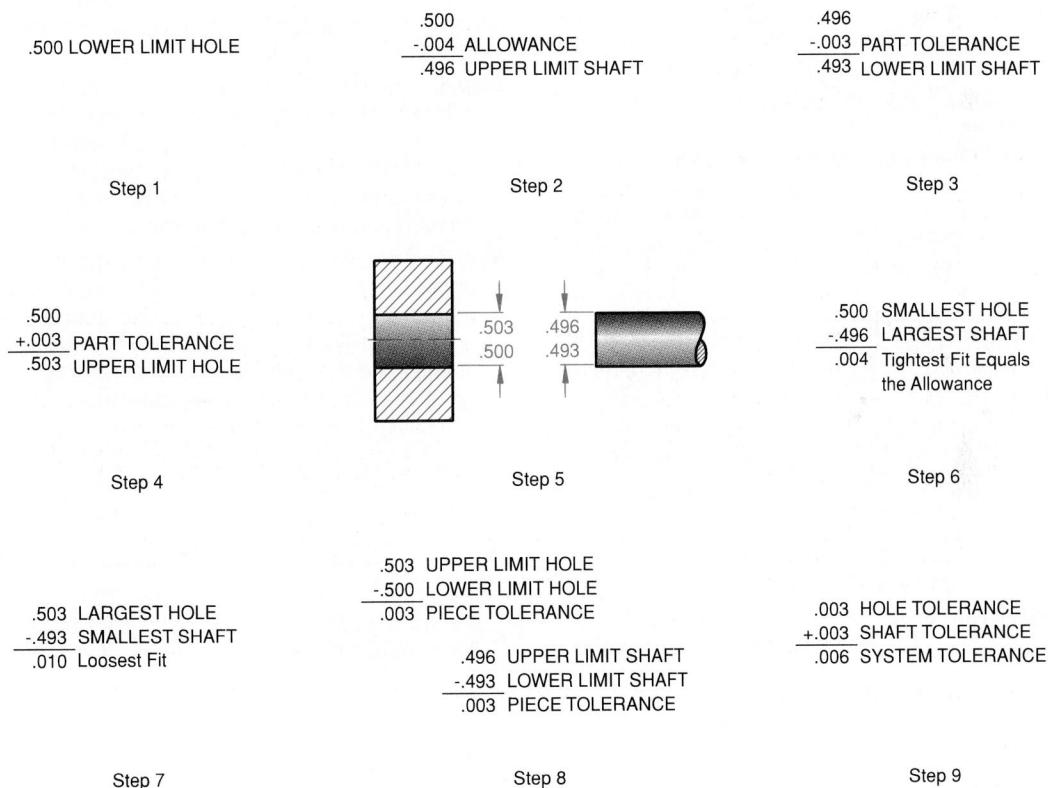

Figure 8.70 Applying Tolerances for a Clearance Fit, Using the Basic Hole System

Creating a Clearance Fit Using the Basic Hole System

Step 1. Using the basic hole system, assign a value of .500" to the smallest diameter of the hole, which is the lower limit. (Figure 8.70)

Step 2. The allowance of .004" is subtracted from the diameter of the smallest hole to determine the diameter of the largest shaft, .496", which is the upper limit.

Step 3. The lower limit for the shaft is determined by subtracting the part tolerance from .496". If the tolerance of the part is .003", the lower limit of the shaft is .493".

Step 4. The upper limit of the hole is determined by adding the tolerance of the part to .500". If the tolerance of the part is .003", the upper limit of the hole is .503".

Step 5. The parts are dimensioned on the drawing, as shown in Figure 8.70.

Step 6. Using the assigned values results in a clearance fit between the shaft and the hole. This is determined by finding the difference between the smallest hole (.500" lower limit) and the largest shaft (.496" upper limit), which is a positive .004". As a check, this value should equal the allowance used in Step 2.

Step 7. The difference between the largest hole (.503" upper limit) and the smallest shaft (.493" lower limit) equals a positive .010". Because both the tightest and loosest fits are positive, there will always be clearance between the shaft and the hole, no matter which manufactured parts are assembled.

Step 8. Check the work by determining the *piece tolerances* for the shaft and the hole. To do so, first find the difference between the upper and lower limits for the hole. Subtract .500" from .503", to get .003" as a piece tolerance. This value matches the tolerance applied in Step 4. For the shaft, subtract .493" from .496", to get .003" as the piece tolerance. This value matches the tolerance applied in Step 3.

Step 9. The *system tolerance* is the sum of all the piece tolerances. To determine the system tolerance for the shaft and the hole, add the piece tolerances of .003" and .003" to get .006".

An interference fit would be possible if an allowance is added to the basic size assigned to the hole. (Figure 8.71)

Creating an Interference Fit Using the Basic Hole System

Step 1. Using the basic hole system, assign a value of .500" to the smallest diameter of the hole, which is the lower limit.

Step 2. The allowance of .007" is added to the smallest hole diameter to determine the diameter of the largest shaft, .507", which is the upper limit.

Step 3. The lower limit for the shaft is determined by subtracting the part tolerance from .507". If the part tolerance is .003", the lower limit of the shaft is .504".

Step 4. The upper limit of the hole is determined by adding the part tolerance to .500". If the part tolerance is .003", the upper limit of the hole is .503".

Step 5. The parts are dimensioned on the drawing, as shown in Figure 8.71.

Step 6. Using the assigned values results in an interference fit between the shaft and the hole. This is determined by finding the difference between the smallest hole (.500" lower limit) and the largest shaft (.507" upper limit), which is a negative .007". This value equals the allowance used in Step 2.

Step 7. The difference between the largest hole (.503" upper limit) and the smallest shaft (.504" lower limit) equals a negative .001". Because both the tightest and loosest fits are negative, there will always be an interference between the shaft and the hole, no matter which manufactured parts are assembled.

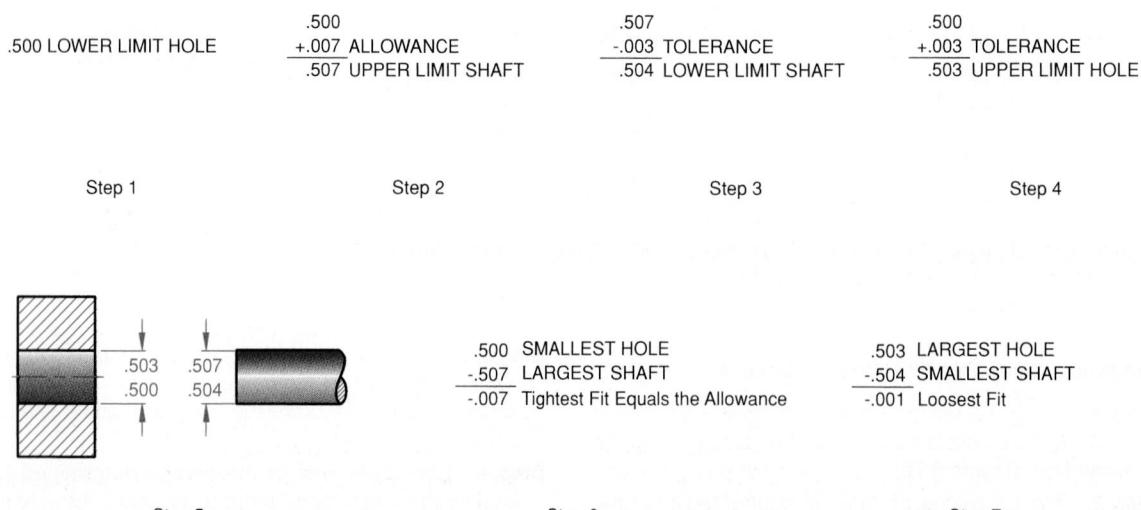

Figure 8.71 Applying Tolerances for an Interference Fit, Using the Basic Hole System

Basic Shaft System The basic shaft system, a less popular method of applying tolerances to a shaft and hole, can be used for shafts that are produced in standard sizes. For this system, the largest diameter of the shaft is assigned the basic diameter from which all tolerances are applied. (Figure 8.72)

Creating a Clearance Fit Using the Basic Shaft System

Step 1. Using the basic shaft system, assign a value of .500" to the largest diameter of the shaft.

Step 2. The allowance of .004" is added to the largest shaft diameter to determine the diameter of the smallest hole, .504".

Step 3. The largest limit for the hole is determined by adding the part tolerance to .504". If the part tolerance is .003", the upper limit of the hole is .507".

Step 4. The smallest limit of the shaft is determined by subtracting the part tolerance from .500". If the part tolerance is .003", the lower limit of the shaft is .497". This results in a clearance fit between the shaft and the hole. An interference fit would be possible by subtracting the allowance from the basic size assigned to the shaft.

Precision Fit Calculation In the following exercise, dimension and tolerance a shaft diameter. A $\frac{1}{2}$ -inch shaft is to be fit into a hole by pressing (an interference fit). In this type of fit, the shaft is *always* larger than the hole and they must be mechanically forced together.

Using Precision Fit Tables

Step 1. Select the precision fit class that is appropriate. In this case, use FN (Force or Shrink class), and select a midrange class, such as FN2.

Step 2. Consider the nominal dimension. In this case, the nominal is .5000. (In precision fits, it is common to use four decimals of accuracy.)

Step 3. Using the fit table shown in Figure 8.73 (from Appendix 7), under the **Nominal Size Range, inches** column, look up the **nominal** shaft range from 0.40 through 0.56. Read across this row and find the shaft column values under the **Class FN2** column. The values +1.6 and +1.2 appear in the box.

Step 4. It is important to remember that the two numbers (1.6 and 1.2) are in **thousandths** (.001) of an inch. To avoid mistakes, write these numbers properly so that their true values are obvious: .0016 and .0012.

Step 5. Add the .0016 to .5000 to create the upper limit value, and add the .0012 to .5000 to create the lower

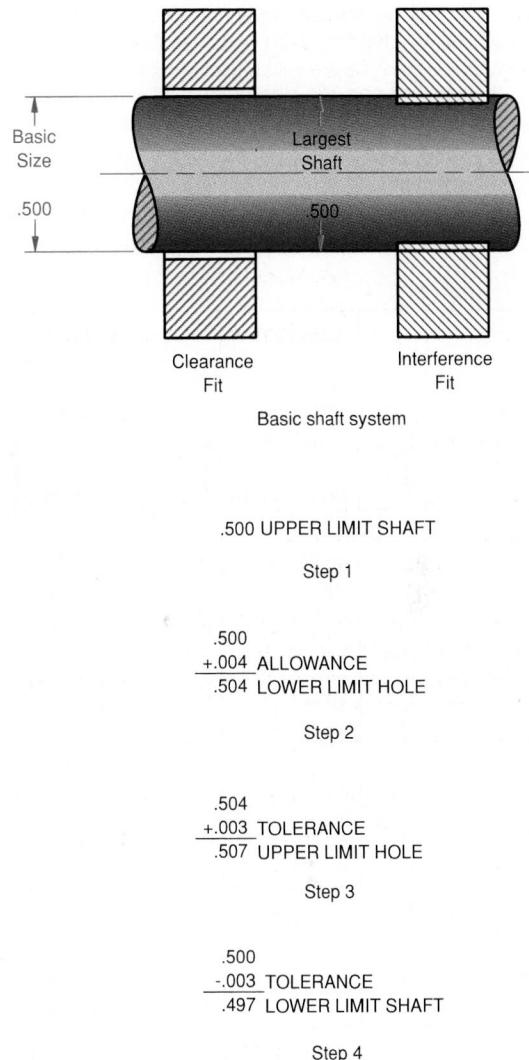

Figure 8.72 Applying Tolerances for a Clearance Fit, Using the Basic Shaft System

limit value. These are the limit tolerances for the shaft. The resulting shaft dimension will look as follows:

.5016
.5012

Step 6. To calculate the limit dimensions for the hole, follow the same procedure, but use the **hole** column values, which are +0.7 and -0.

Step 7. These values are also in thousandths of an inch and are written as .0007 and .0000.

Step 8. Add the .0007 to .5000, to create the upper limit value of the hole, and subtract the .0000 from .5000, to create the lower limit value. These are the

FN1 *Light drive fits* are those requiring light assembly pressures, and produce more or less permanent assemblies. They are suitable for thin sections or long fits, or in cast-iron external members.

FN 2 *Medium drive fits* are suitable for ordinary steel parts, or for shrink fits on light sections. They are about the tightest fits that can be used with high-grade cast-iron external members.

FN3 *Heavy drive fits* are suitable for heavier steel parts or for shrink fits in medium sections.

FN4 *Force fits* are suitable for parts which can be highly stressed, or for shrink fits where the heavy pressing forces required are impractical.

Basic hole system. Limits are in thousandths of an inch.

Limits for hole and shaft are applied algebraically to the basic size to obtain the limits of size for the parts.

Nominal Size Range, inches Over To	Limits of Interference	Class FN 1		Limits of Interference	Class FN 2		Limits of Interference	Class FN 3		Limits of Interference	Class FN 4		Limits of Interference	Class FN 5					
		Standard Limits			Standard Limits			Standard Limits			Standard Limits			Standard Limits					
		Hole H6	Shaft H7		Hole H7	Shaft s6		Hole H7	Shaft t6		Hole H7	Shaft u6		Hole H8	Shaft x7				
0 – 0.12	0.05 0.5	+0.25 –0	+0.5 +0.3	0.2 0.85	+0.4 –0	+0.85 +0.6				0.3 0.95	+0.4 –0	+0.95 +0.7	0.3 1.3	+0.6 –0	+1.3 +0.9				
0.12 – 0.24	0.1 0.6	+0.3 –0	+0.6 +0.4	0.2 1.0	+0.5 –0	+1.0 +0.7				0.4 1.2	+0.5 –0	+1.2 +0.9	0.5 1.7	+0.7 –0	+1.7 +1.2				
0.24 – 0.40	0.1 0.75	+0.4 –0	+0.75 +0.5	0.4 1.4	+0.6 –0	+1.4 +1.0				0.6 1.6	+0.6 –0	+1.6 +1.2	0.5 2.0	+0.9 –0	+2.0 +1.4				
0.40 – 0.56	0.1 0.8	+0.4 –0	+0.8 +0.5	0.5 1.6	+0.7 –0	+1.6 +1.2				0.7 1.8	+0.7 –0	+1.8 +1.4	0.6 2.3	+1.0 –0	+2.3 +1.6				
0.56 – 0.71	0.2 0.9	+0.4 –0	+0.9 +0.6	0.5 1.6	+0.7 –0	+1.6 +1.2				0.7 1.8	+0.7 –0	+1.8 +1.4	0.8 2.5	+1.0 –0	+2.5 +1.8				
0.71 – 0.95	0.2 1.1	+0.5 –0	+1.1 +0.7	0.6 1.9	+0.8 –0	+1.9 +1.4				0.8 2.1	+0.8 –0	+2.1 +1.6	1.0 3.0	+1.2 –0	+3.0 +2.2				
0.95 – 1.19	0.3 1.2	+0.5 –0	+1.2 +0.8	0.6 1.9	+0.8 –0	+1.9 +1.4	0.8 2.1	+0.8 –0	+2.1 +1.6	1.0 2.3	+0.8 –0	+2.3 +1.8	1.3 3.3	+1.2 –0	+3.3 +2.5				
1.19 – 1.58	0.3 1.3	+0.6 –0	+1.3 +0.9	0.8 2.4	+1.0 –0	+2.4 +1.8	1.0 2.6	+1.0 –0	+2.6 +2.0	1.5 3.1	+1.0 –0	+3.1 +2.5	1.4 4.0	+1.6 –0	+4.0 +3.0				

From ANSI B4.1-1967 (R1987).

Figure 8.73 Table Used to Apply Precision Tolerances to Parts

limit tolerances for the hole. The resulting hole dimension will look as follows:

.5007
.5000

Compare the values in Step 5 with those in Step 8, to reveal that this is an interference fit because the hole is always smaller than the shaft.

8.7 TOLERANCES IN CAD

Some tolerancing concepts are unique to CAD. In hand drawing, the graphics are an image of the part and the dimensions add important information to the drawing. In CAD, the graphics can become more descriptive because an accurate mathematical definition of the shape of a part is created, whereas in hand drawing, the graphics are not as accurate.

CAD drawings, then, can be considered *geometry files*, rather than simply drawings. CAD geometry

databases are often translated directly to machining equipment, making them considerably more useful than hand drawings. Rather than having a machinist interpret the dimension shown on the drawing, the machine tool uses the size of the geometric elements encoded in the CAD database.

8.7.1 Geometric Accuracy

When the geometry of a part is created using CAD, that geometry must be completely accurate. Do not use coordinate positions from a readout to locate features, because readouts are accurate only to the number of decimals displayed. For example, a reading of 4.0000 may appear to be 4 inches, but if the readout is changed to five decimals, it may read 4.00004. An angle may appear to be 45 degrees, when in fact it is 45.00035 degrees.

Part geometry should be made so that it can be directly translated to a CAM system for machining. In order for this to occur, lines must:

End exactly at corners.

Never be short (even by .00002 inch).

Never be one on top of another.

Have all lengths and angles that are perfect.

8.7.2 Associative Dimensioning

Most CAD systems have a function that ties a feature directly to its dimension; if the feature changes, the dimension will change automatically. This associative function is an excellent tool for checking geometry as it is being dimensioned. Avoid the temptation to type over a dimension when it is not exactly correct; *change the geometry, not the dimension value*. Uniformly applying a size standard simplifies the later addition of dimensions to a CAD drawing. For example, if the part is drawn using nominal sizes, the dimensioning command can be set up to automatically add and subtract from the nominal size to show the upper and lower limits, respectively. © CAD Reference 8.14

8.8 GEOMETRIC DIMENSIONING AND TOLERANCING

Geometric dimensioning and tolerancing (GDT) is a method of defining parts based on how they function, using standard ANSI symbols. For many years, only a

few companies used GDT to any extent, and even within those companies, there was disagreement on the actual meaning of the symbols and terms. Within the last 15 years, there has been a resurgence of interest and training in GDT, mostly because of the increased use of statistical process control (SPC), and because GDT is a powerful tool in reducing the cost of precision parts.

Statistical process control offers real advantages to companies that manufacture large numbers of parts, because they can reduce or even eliminate the inspection of some features. However, SPC does require that the actual feature be tolerated very efficiently in order to take advantage of the cost reductions. Often, the only way to tolerance such features so that SPC can be used properly is through the use of GDT.

Another reason GDT has become so popular is the widespread acceptance of worldwide quality standards, such as the ISO9000 series. These standards require that a manufacturer specify not only that something is controlled, but also how it is to be controlled. For example, a drawing may say that a feature is round. The questions would be: "How round?" and "how is that roundness inspected?" The standard that controls the dimensioning and tolerancing of parts is ANSI Y14.5 (soon to be ASME Y14.5), and it includes all of the GDT symbols and concepts.

Size tolerances alone are sometimes not enough to meet the design needs of a part. Relationships between features may also need to be controlled. In such cases, notes are added to the drawing defining these relationships.

For example, a table height from the floor to the top is given as 30 inches. (Figure 8.74) Is the top of the table flat? It is, if the tolerance on the 30-inch height is, say, ± 1 inch. The top could never be more than 31 inches, or less than 29 inches. This means that the top must be flat within 2 inches. If the top must be flatter than that, a tighter tolerance would be, say, $\pm 1/4$ inch. Now the top would be flat to within a $1/2$ inch. However, the height tolerance would become too restrictive, causing the rejection of any table that is out of the height tolerance range, even if it is a good table. This is an example of trying to control the form of a part with a size tolerance.

Without GDT, the only way to separate the height tolerance from the flatness tolerance is with notes. The note for the table could read something like this:

NOTE 1. TABLE TOP TO BE FLAT WITHIN A
1/2 INCH TOTAL, WHEN MEA-
SURED WITH A STRAIGHTEDGE.
STRAIGHTEDGE MUST BE AT

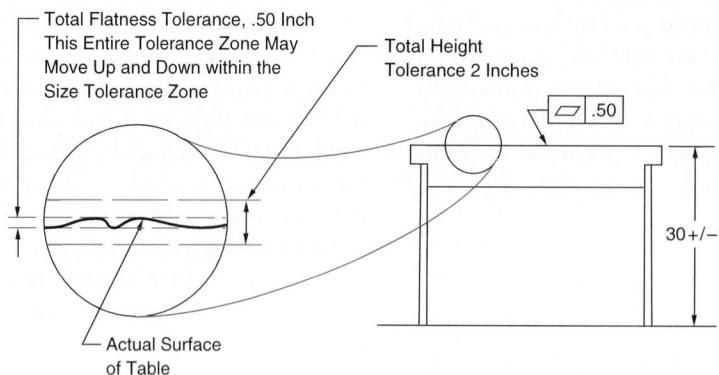

Figure 8.74 Table Height with Flatness

LEAST 10 TIMES AS STRAIGHT AS THE TOLERANCE. ALL STRAIGHTEDGE READINGS MUST BE COMPARED TO EACH OTHER.

Using GDT, we could return to the $+\text{-}1$ inch tolerance and simply place a flatness control (total of .50 inch, in this example) on the top surface. This would solve the problem and would communicate the design needs to the manufacturer and the inspector. The symbols used in GDT create complete manufacturing and inspection definitions with a minimum of confusion and misinterpretation.

The questions that should be asked continuously during the design phase are: What kind of part would be rejected, with these tolerances? Will the rejected parts be unusable? Will we reject all of the parts we cannot use? For our table example, the answers are as follows:

1. Any table that is too high or too low (over 31 inches or under 29 inches), even if the top is perfectly flat. What good is a perfectly flat table if it is only 4 inches off the floor?
2. Any table for which the top is not flat enough, even if the table is within height limits. What good is a 30-inch table if the top is too wavy to set a cup of coffee on it?

8.9 GDT SYMBOLS

The GDT symbols for specifying concise requirements for features are shown in Figure 8.75. The flatness symbol shown is used in Figure 8.74 and is located in a rectangular **feature control frame**, which is divided in half (approximately). On the left side is the

symbol for flatness, which states the actual geometric control for the table top. On the right side is the total size of the tolerance zone. In this case, the tolerance zone is .50 inches total.

This feature control frame specifies strict requirements for the table top, among which are the specifications in the note provided earlier. The requirements include sufficient information for the feature to be manufactured and inspected according to specifications. Examples of feature control frames are shown in Figure 8.76. © CAD Reference 8.15

8.10 GDT RULE #1

Geometrics is the part of tolerancing that has to do with the shapes and positions of features. All dimensions include geometric controls, whether or not geometric tolerancing symbols are used. This results from **Rule #1**, which is as follows.

Rule #1: Individual Feature of Size.

Where only a tolerance of size is specified, the limits of size of an individual feature prescribe the extent to which variations in its geometric form, as well as size, are allowed. (ANSI Y14.5-1982)

For example, if a shaft is dimensioned as 0.500 inch in diameter, this controls the roundness of the shaft, because of Rule #1. (Figure 8.77) The diameter dimension (the “limit of size”) requires that the shaft be within the size tolerance, and that diameter symbol requires the shaft to take on a specific “geometric form.” The total roundness is dependent on the diameter size tolerance. For example, if the 0.500-diameter dimension has a

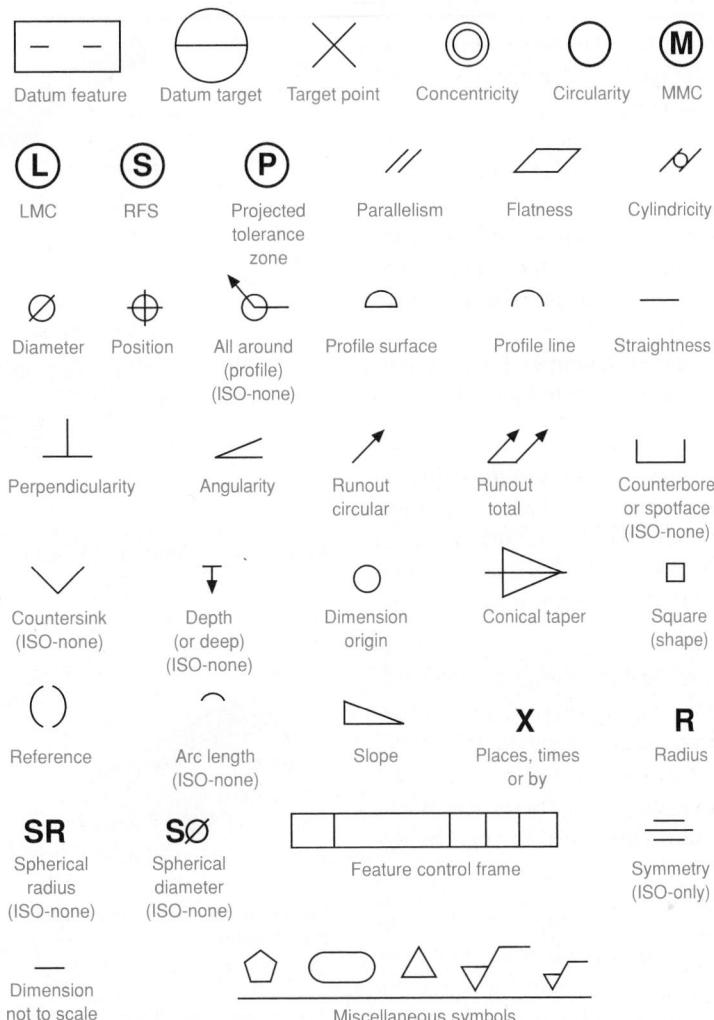

Figure 8.75 Dimensioning and Tolerancing Symbols

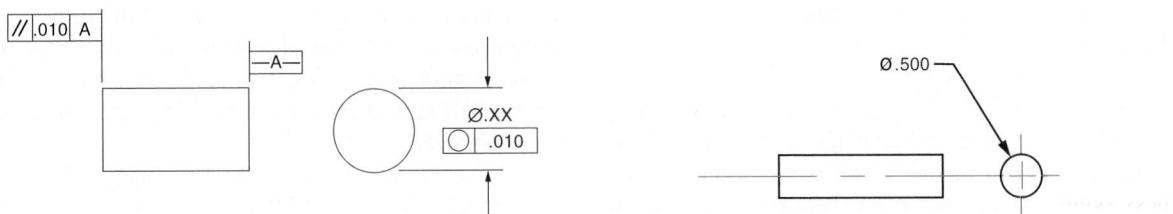

Figure 8.76 Examples of Feature Control Frames

Figure 8.77 Application of Rule #1

tolerance of $+\/-0.005$, then the roundness control is the equivalent of 0.005 (form control tolerance is specified differently than size control tolerance).

To inspect the roundness of a part, measure the diameter and compare the largest reading to the smallest reading at any circular cross section. The shaft can never be larger or smaller than the minimum and maximum diameters. This simple inspection method ensures that the shaft is within both the size tolerance and the roundness tolerance.

In addition, if the shaft drawing is fully dimensioned, the following geometric controls would be required under Rule #1:

1. *Straightness of the line elements of the cylinder.* This condition is built into the diameter size tolerance. The line elements of the cylinder cannot be more “bent” than the total size tolerance, or a portion of them would protrude outside of the maximum size zone.
2. *Flatness of the ends of the shaft, if a length tolerance is included.*
3. *Parallelism between any two opposite line elements.* The line elements of the cylinder must not only be straight, they must also be parallel to one another, within the size tolerance of the cylinder.

The key element is: All dimensions have built-in (natural) geometric controls. Additional symbols should only be used when these natural controls must be refined. In fact, geometric symbols are often used to reduce the accuracy required on a part. For example, consider a shaft used to mount linear positioning bearings (Figure 8.78), which are used for sliding rather than rotating motion. In this case, the shaft must be highly accurate in size and roundness, but that same accuracy is not possible for the straightness. This situation is common in machine controls design. The solution is to tolerance the shaft diameter as accurately as necessary, and then add a larger straightness tolerance to the shaft center axis.

A second example is a keyseat on a driveshaft. (Figure 8.79) In this case, the width of the keyseat is not as critical as the parallelism of the sides of the slot. The keyseat can be wider or narrower, but the key must sit on the shaft as parallel to the centerline as possible. Geometrics are often used to control keyseats and keyways in different ways, depending on how the keys are used.

Shaft in Use

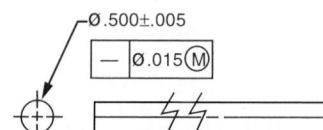

Drawing Callout

Figure 8.78 Shaft and Linear Positioning Bearings

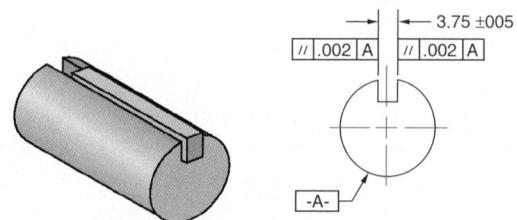

Figure 8.79 Keyseat on a Driveshaft, to Demonstrate Parallelism

8.11 MAXIMUM MATERIAL CONDITION

Maximum material condition (MMC) is the condition in which an external feature (like a shaft) is at its largest allowable size, or an internal feature (like a hole) is at its smallest allowable size. Stated differently, MMC is the condition in which a part will weigh the most.

This should not be confused with the “largest size.” A feature is at its largest size under MMC principles only when it is an external feature, like a shaft. An internal feature, such as a hole, is at MMC when it is at its smallest size; there is more metal in a part with the smallest hole.

8.11.1 Material Condition Symbols

The three symbols used for material conditions are shown in Figure 8.80. The maximum material condition

Figure 8.80 Material Condition Symbols

(MMC) symbol is an M, **least material condition (LMC)**, is an L, and **regardless of feature size (RFS)** is an S.

LMC is the opposite of MMC; it refers to a shaft that is at its smallest, or a hole that is at its largest. RFS requires that the condition of the material *not* be considered. This is used where a tolerance is specified and the actual size of the controlled feature is not considered when applying the tolerance.

8.11.2 Departure from MMC

In GDT, the term *departure from MMC* is often used. To understand this term, remember that in a batch of parts (all of which are within size tolerance limits), there will be many different sizes. In fact, if the inspection equipment were accurate enough, it would reveal that no two parts were exactly the same size.

If a pin is at its largest allowable size, then it is at MMC. The only way it can “depart from MMC” is by becoming smaller (approaching LMC); it cannot get larger. Therefore, if 100 pins are separated by actual size, some would have “departed from MMC” more than others. In other words, some will be smaller than the others (closer to LMC). For a hole, “departure from MMC” means being larger than the minimum allowable.

8.11.3 Perfect Form at MMC

An extension of Rule #1 is the concept of **perfect form at MMC**. If, for example, a shaft is made at its absolute maximum size, it cannot be anything but round. Any eccentric shape would be detectable with a diameter inspection; it would measure oversize at some point.

This is sometimes called the **envelope principle**, which says that if we think of the “perfect part” as an “envelope,” the manufactured parts must never violate the boundaries of the perfect part. For example, as a shaft gets smaller in size, while staying within its size limits, it can get more out of round and still go into the same hole. On the other hand, a hole can be misshaped *only* if it is *larger* than its minimum size (departs from MMC).

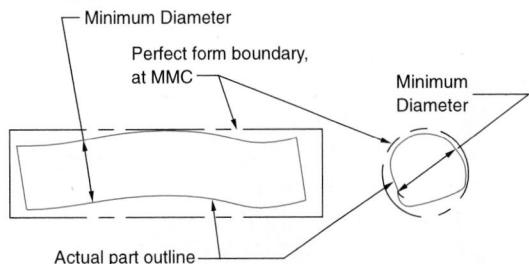

Figure 8.81 Shaft with Perfect Form Boundary at MMC

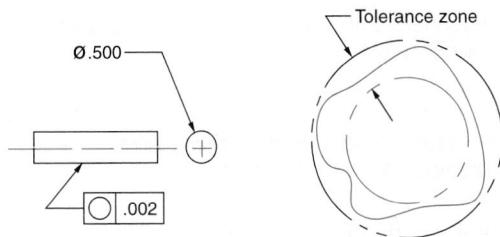

Figure 8.82 Shaft with Roundness Control

In Figure 8.81, notice that the boundary is the perfect shape of a shaft, and the actual part can be any size or shape (within limits) as long as it fits inside the boundary. One caution is that no cross section can measure *under* the minimum size allowed.

Geometric controls are almost always used to *refine* other tolerances, rather than to control features by themselves. For example, in Figure 8.82 the roundness of the shaft is controlled *first* by the diameter tolerance. If the roundness control were removed, the shaft would still have to be round within the limits of the diameter tolerance, per Rule #1.

8.11.4 Separation of Control Types

The roundness control simply says that the shaft must be round to a higher accuracy than that required by the size control. Rule #1 *combines* size and form control into a single tolerance, and a roundness control *separates* size from form. This ability to separate size and form controls makes geometrics extremely valuable. If you rely on size controls alone, ignoring geometrics and using very precise tolerances for every part, you would ensure that the part would fit, but you would have increased costs dramatically. *Tolerancing is the art and science of using the largest tolerance possible that will still allow a part to function.* Ignoring geometrics takes away half of the tools available to accomplish this task.

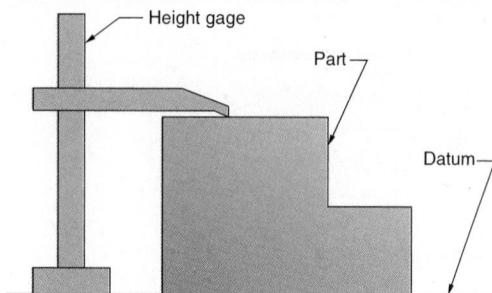

Figure 8.83 Datum and Datum Feature

The bottom surface of the part is the datum feature and the surface plate is the datum.

8.12 DATUMS AND DATUM FEATURES

A **datum** is a starting place for a dimension. A datum may be a perfect plane, a centerline, or a point. Datums are perfect, and they are not real. Examples are the centerline of a shaft, or the point at the center of a sphere. These are theoretical positions that can either be represented with inspection tools or can be derived. For example, a centerline is represented by the center of an inspection pin or gage, or by the center of an inspection spindle. A centerline is derived by measuring to the edge of a gage pin, and then adding half the diameter of the pin to locate the center of the gage pin from an edge or another feature. For a hole, the measurement is *not* to the edge of the feature hole, but to the largest gage pin that will fit into the hole.

A datum that is harder to visualize is the perfect plane. We see surfaces on parts, which are not true unlimited planes but limited planes, and it may be difficult to distinguish between such a surface and the perfect plane it locates. In Figure 8.83, the part has a vertical dimension from the bottom to the top. One way to measure this dimension is to set the part on a surface plate and use a height gage as shown. The bottom surface of the part (a limited plane) is called a **datum feature**, and the surface plate represents the datum (a true unlimited plane). In other words, the datum feature is the one from which measurements are referenced. On many parts, any one of several features could be chosen for this purpose.

8.12.1 Datum Uses

Once a datum has been established, measurements can be taken from the datum rather than from the feature. The importance of doing this is illustrated by

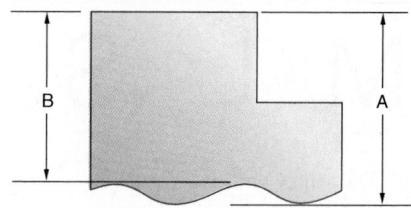

Figure 8.84 Datum and Part Differences

This figure shows the difference in measuring from a surface plate (datum) versus from the part itself.

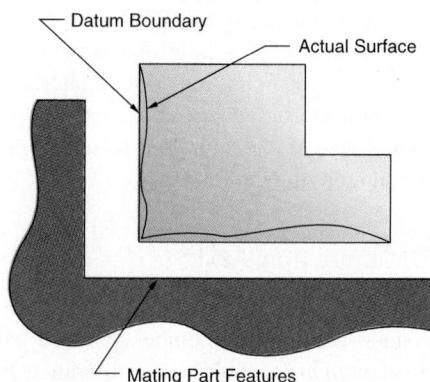

Figure 8.85 Part with Corner Mount and Shaft Hole, Including Mating Parts

Figure 8.84. When measured at location A, the part seems to be within tolerance; however, measuring at location B creates a problem because the measurement is being taken at a high spot of the surface roughness, which may make the part appear to be unacceptably out of tolerance. A better approach is to take a measurement of the largest distance, not a spot location. This distance can be derived by laying the part on a surface plate and measuring from the plate, rather than from the part itself.

8.12.2 Datums and Assembly

Looking at datums from the perspective of assembly function, if one part is mounted on another, as in Figure 8.85, the mating surfaces need not be perfect. The two parts will fit well (i.e., will function) if the mating surfaces (the chosen datum features) have no *protrusions* that extend beyond the design planes (datums). Note that it may be acceptable for the surfaces to have *depressions*, which will not interfere with the mating of the parts.

8.12.3 Datum Feature Control

At times, you may have a choice of features that could be the datum feature. Among the considerations is the fact that a feature chosen as a datum feature is *not* controlled by the associated feature control. This is an important consideration when selecting datum features. As an example, a feature control may require a flat surface to be smooth within certain tolerances, with no protrusions or depressions. As a datum feature, however, the surface may be acceptable with depressions. Other things to consider are size, stability, accessibility, etc., which are covered later in the chapter.

8.12.4 Datum Reference Frame

There are *six degrees of freedom* in space. A part may move up, down, left, right, forward, and backward. When designing a part for manufacturing, you must locate the part in space while it is being made, as well as while it is being inspected and then used. Datums are the locators, and the **datum reference frame** is the six-direction locator of a part in space. For example, if a piece of wood is mounted in a vise for planing, the vise is a six-degree-of-freedom locator for the wood.

In order to reduce waste and scrap material, the design, manufacturing, and inspection functions must all use the same six-degree location in space. In other words, if design selects the left edge of a part from which to dimension a hole, then manufacturing must use that same left edge to determine where to drill the hole. Likewise, the inspectors must inspect the hole location by measuring from the left edge. The left edge is a datum and should be identified as such.

If a hole is located from the left edge and from the bottom of the part, then we have two datums accounted for four degrees of freedom. In a flat part, this may be sufficient. (Figure 8.86)

In those cases where it is important to locate features in all six degrees, a three-plane datum reference frame is needed. The frame is comprised of three perfect planes, all of which are perfectly perpendicular to each other. (Figure 8.87)

8.12.5 Primary Datum

In any case, the critical part of datum selection is identification of the *primary datum*. In many instances, this will be the only datum; in all cases, it is the most important.

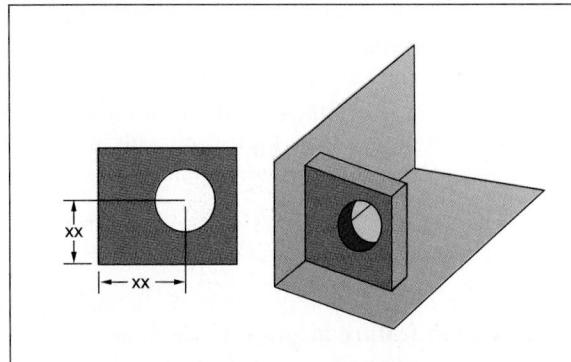

Figure 8.86 Two-Plane Datum Reference Frame in which the Hole Is Dimensioned from the Left and Bottom

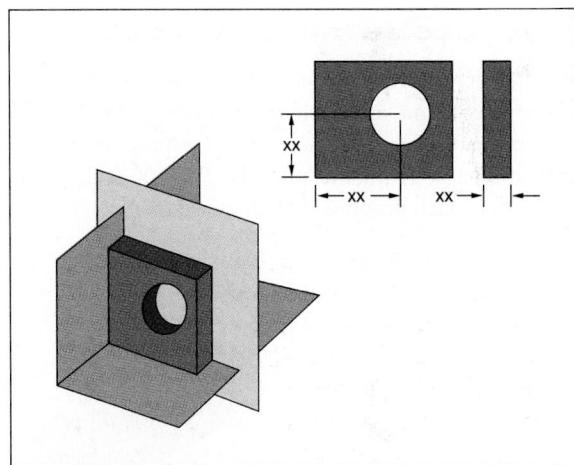

Figure 8.87 Three-Plane Datum Reference Plane

8.12.6 Secondary and Tertiary Datums

Once the primary datum has been established, the secondary datum is created, from which features are located. This should be a functional feature and it must be perpendicular to the primary feature. The tertiary datum must be perpendicular to both the primary and the secondary.

A common error in secondary and tertiary datum selection is illustrated in Figure 8.88. If we used features A, B, and C as the primary, secondary, and tertiary datum features, we would create an illegal datum reference frame because the three features are not mutually perpendicular. Datum feature B is perpendicular to datum feature A but not to datum feature C.

The most useful secondary datum feature can be a hole that is perpendicular to the primary datum. (Figure 8.89) The surface creates the primary datum, and the hole creates two perpendicular planes. This reference frame is probably the most commonly used and is called the plane and cylinder reference frame.

8.12.7 Datum Feature Identifiers

In Figure 8.88, the three symbols A, B, and C are called **datum feature identifiers**. These are not feature control symbols; they identify the features used to create the datums. Such symbols may be attached to the feature with either an extension line or a leader line, as shown.

8.13 GEOMETRIC CONTROLS

Geometric controls fall into three major categories: form, orientation, and position. In this section, we will first present some definitions that are basic to the understanding of geometric controls. Then the individual controls in each group will be discussed.

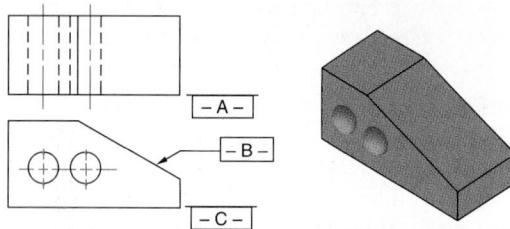

Figure 8.88 Three-Plane Datum Reference Plane, Not Perpendicular

8.13.1 Perfection

Although we use the term “perfect,” it is important to recognize that nothing truly is perfect. Therefore, for our purposes, any inspection instrument will be considered “perfect” if it is at least 10 times more accurate than the part being measured. This accuracy is sometimes referred to as **gaging tolerance**.

8.13.2 Tolerance Zones

The tolerance zone is defined earlier in this chapter. The *shape* of the tolerance zone is directly related to the geometric controls. To make the controls more understandable, you must be able to clearly visualize the tolerance zone that is created.

8.13.3 Virtual Condition

Virtual condition is the combined effect of the largest allowable size (MMC) of a feature, such as a shaft, added to the maximum allowed geometric distortion. For example, if a shaft is allowed to be 0.505" in diameter, and the straightness control allows 0.010" of crookedness, the shaft would no longer *always* go into a 0.505" diameter hole. The minimum size of the hole would have to be 0.515" in diameter in order for the shaft to *always* go into the hole. The *worst condition* of the shaft would be 0.515" in diameter. This is called the virtual condition of the shaft.

8.13.4 Form Controls

Form controls include straightness, roundness, flatness, and cylindricity. All are comparisons of an actual feature to a theoretically perfect feature.

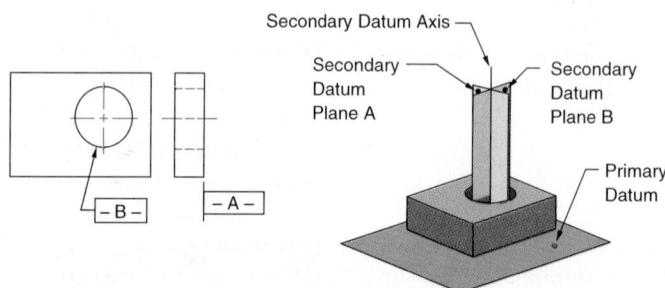

Figure 8.89 Plane and Cylinder Datum Reference Plane

Straightness All geometric form controls are variations and combinations of **straightness**. For example, flatness is straightness applied in all directions at once. Therefore, understanding straightness is important to understanding the entire concept of form controls. Straightness itself is based on line elements. A **line element** is any single line on any surface, in any direction. (Figure 8.90) A **circular line element** is any single line on the surface of a cylinder and perpendicular to the axis (center line) of the cylinder.

Straightness has two distinct variations: line element straightness and axis straightness. These two operate very differently, and they are discernable by the way in which the feature control frame is attached to the feature. For example, if the control frame is part of the diameter callout on a shaft, then the form control is axis straightness; in other words, the control modifies the size of the shaft. However, if the control applies to the edge of the shaft, that is, the surface line elements, then the form control is line element straightness. (Figures 8.91 and 8.92)

If straightness is applied to line elements, then MMC cannot be used because line elements have no size and therefore cannot be features of size. If

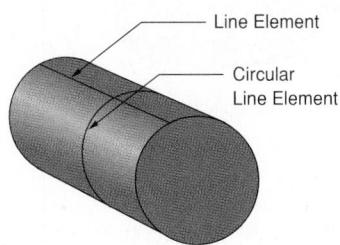

Figure 8.90 Examples of a Line and a Circular Line Element

straightness is applied to the axis of a cylinder, then MMC may be used because the diameter of the shaft is a feature of size.

Line Element Straightness A line element straightness control compares a line on a part to a perfectly straight line. Any type of line element can be evaluated, including those on a flat surface or on the surface of a shaft. If the line is on a flat surface, then a direction must be identified. This is done by the feature control frame. In Figure 8.91, the straightness of the top surface of the rectangular part applies in the long direction only, because the feature control frame is attached to the long view. The MMC modifier cannot be added because the controlled features are not features of size. The tolerance zone for straightness of a line element is: “two perfectly straight lines, parallel, and the tolerance value apart.”

Axis (or Center Plane) Straightness Axis straightness compares the axis (center line) of a cylinder to a perfectly straight line, in three dimensions because shaft center lines can distort in three dimensions. A perfectly straight center line will fit inside a tube that has a zero diameter. Since such a tube is not reliable, the comparison is revised to mean the smallest perfect tube that would still capture the axis.

When the axis straightness control is used for rectangular shapes, both internal and external, the control does not apply to a center line but rather to a center plane. Axis straightness is used only on features of size, which allows the use of the MMC modifier.

Roundness (Circularity) **Roundness** compares a circle (circular element) to a perfect circle. Roundness

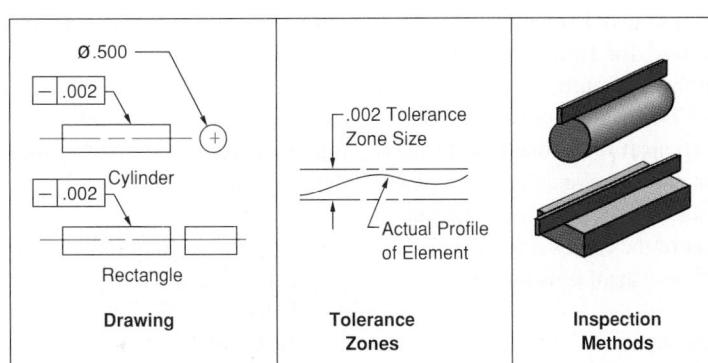

Figure 8.91 Examples of Straightness Line Elements

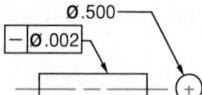	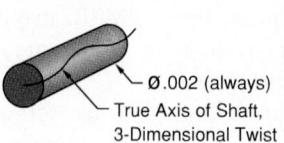	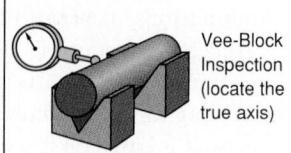 Vee-Block Inspection (locate the true axis)
RFS Basis MMC Modified 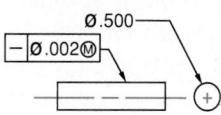	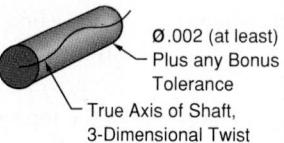	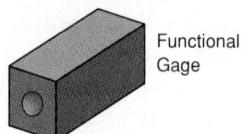 Functional Gage
Drawing	Effect (scale enlarged)	Inspection Methods

Figure 8.92 Straightness of Axis

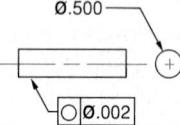	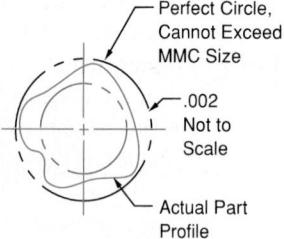	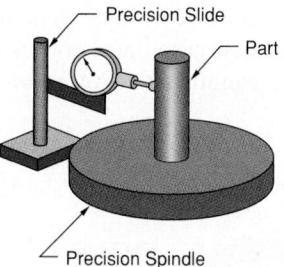 Precision Slide Part Precision Spindle
Drawing	Tolerance Zone	Inspection Method (check only one slice at a time)

Figure 8.93 Roundness

could be considered straightness bent into a circle. Since the circle is measured for form only, not for size, no MMC may be applied. (Figure 8.93)

The tolerance zone is: "Two perfect circles, concentric, and the tolerance value apart." The diameter of the larger circle is: "The diameter of the smaller circle plus two times the tolerance value." Since we are not measuring size, the actual diameter of the circles is irrelevant, as long as the relationship between them is maintained.

Flatness **Flatness** evaluates the largest vertical distance between the highest and lowest points on a surface. Stated differently, flatness compares surface to a perfect plane. (Figure 8.94) Flatness

could be considered straightness on a surface, applied in all directions at once. Flatness may be used on a surface in lieu of straightness when oil-canning or potato-chipping is not acceptable. The tolerance zone is "Two perfect planes, parallel, and the tolerance value apart."

Cylindricity **Cylindricity** compares a cylinder to a perfect cylinder. Three controls are at work: straightness of all line elements, roundness of all circular elements, and taper (comparison of the circular elements to each other). (Figure 8.95) Cylindricity could be considered flatness bent into a perfect barrel. Since this is a form control, no MMC can be applied.

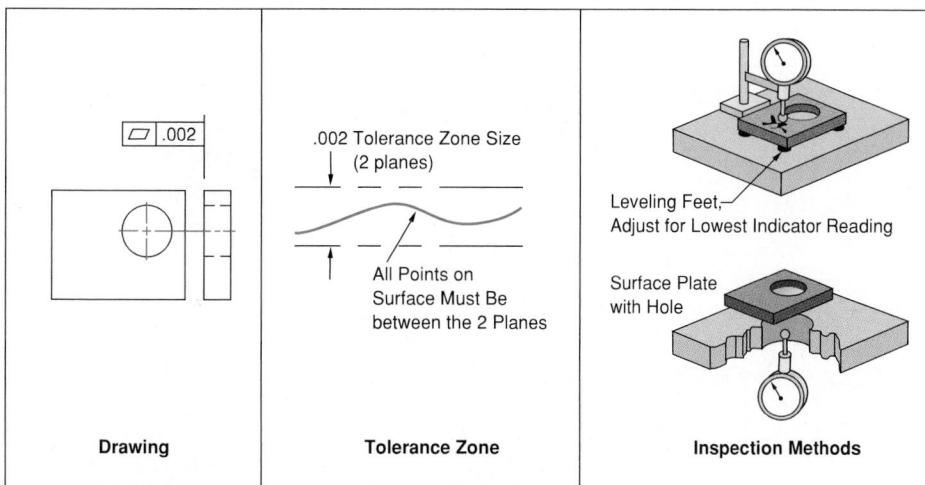

Figure 8.94 Flatness

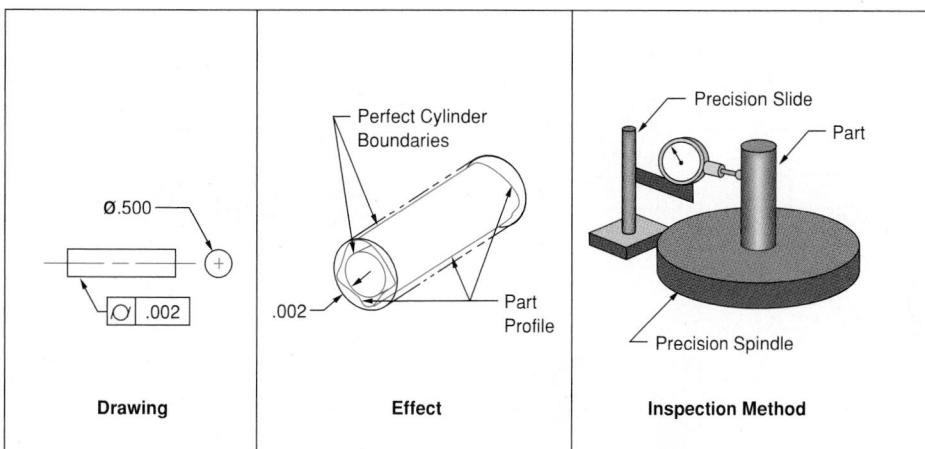

Figure 8.95 Cylindricity

Cylindricity is probably the most expensive control. Under most circumstances, it can be replaced with combinations of other controls, such as roundness and straightness, which are easier to meet and much easier to inspect. The tolerance zone is: "Two perfect cylinders, concentric, and the tolerance value apart."

8.13.5 Orientation Controls

Parallelism **Parallelism** could be considered flatness at a distance, or straightness of an axis, at a distance. (Figure 8.96) Parallelism requires that a feature stay parallel to a datum. If the controlled

feature is a surface, then all points on that surface must stay between two perfect planes that are perfectly parallel to the datum. If the feature is an axis, then all points on the axis must stay between two lines that are perfectly parallel to the datum. The distance between these pairs of planes or pairs of lines is the tolerance value given in the feature control frame. In the case of an axis being controlled relative to a surface, the tolerance zone is two parallel planes.

Perpendicularity **Perpendicularity** is either flatness at 90 degrees to a datum, or straightness of an axis at 90 degrees to a datum. (Figure 8.97) Perpendicularity requires that a feature remain perpendicular to a datum.

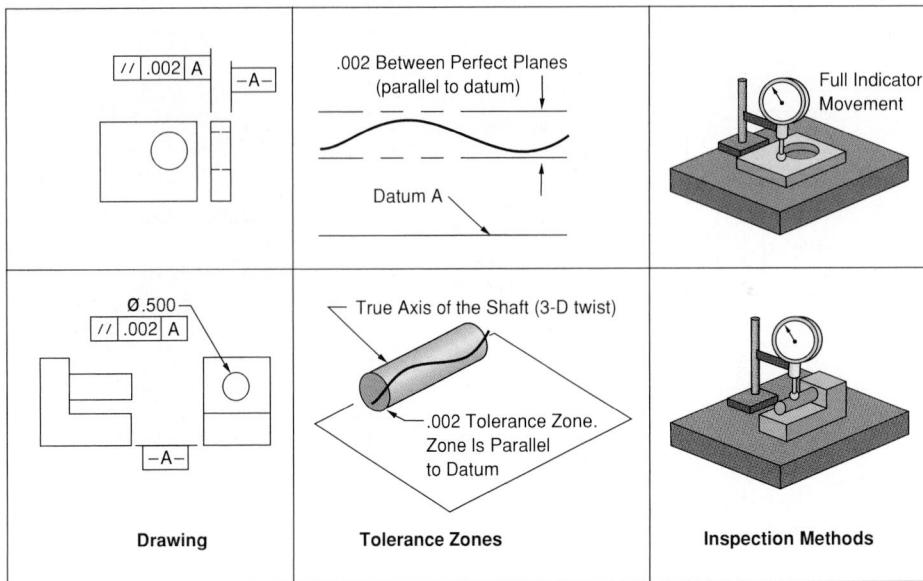

Figure 8.96 Parallelism

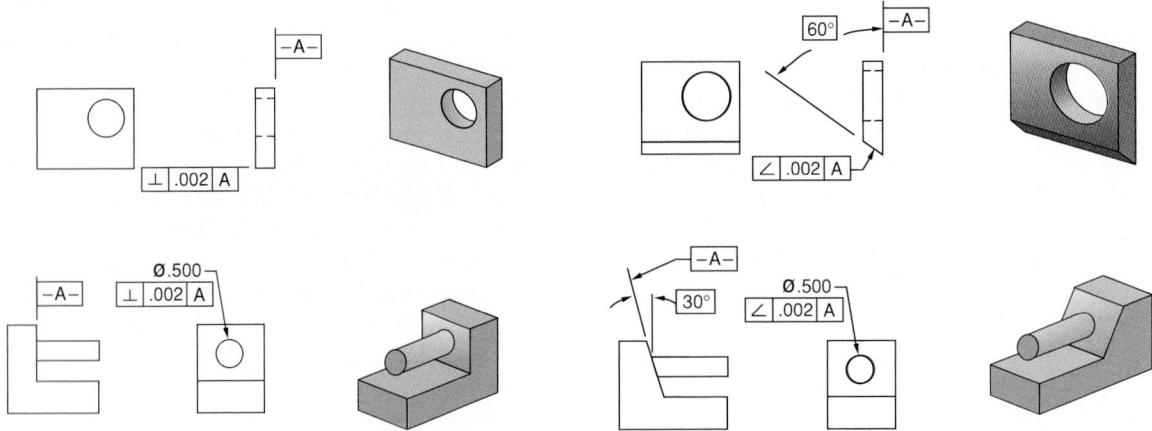

Figure 8.97 Perpendicularity

If the controlled feature is a surface, then all points on that surface must stay between two perfect planes that are perfectly perpendicular to the datum. If the feature is an axis, then all points on the axis must stay between two lines that are perfectly perpendicular to the datum. The distance between the pairs of planes or pairs of lines is the tolerance value given in the feature control frame.

The surface tolerance zone is: "Two planes, parallel, and the tolerance value apart, at exactly 90 degrees from the datum." The axis tolerance zone is: "A cylinder, the tolerance value in diameter, and at 90

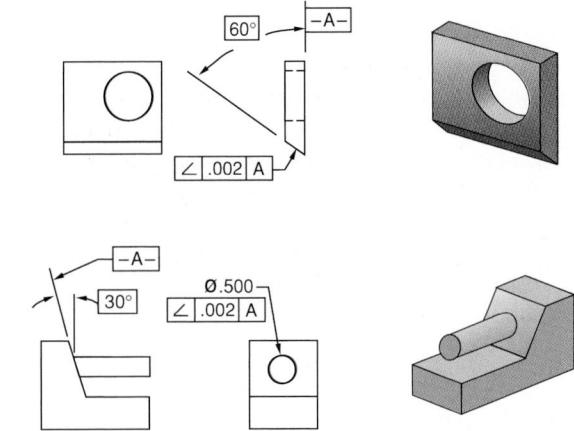

Figure 8.98 Angularity

degrees to the datum." In Figure 8.97, for example, the pin is modified with MMC; therefore, the tolerance value can be larger than 0.002 if the pin is less than its maximum size. The cylindrical tolerance zone is an interesting result of the angle being 90 degrees to the datum.

Angularity **Angularity** is either flatness at some angle to a datum, or straightness of an axis, at an angle to a datum. (Figure 8.98) Angularity requires that a feature remain at a given angle to a datum. If

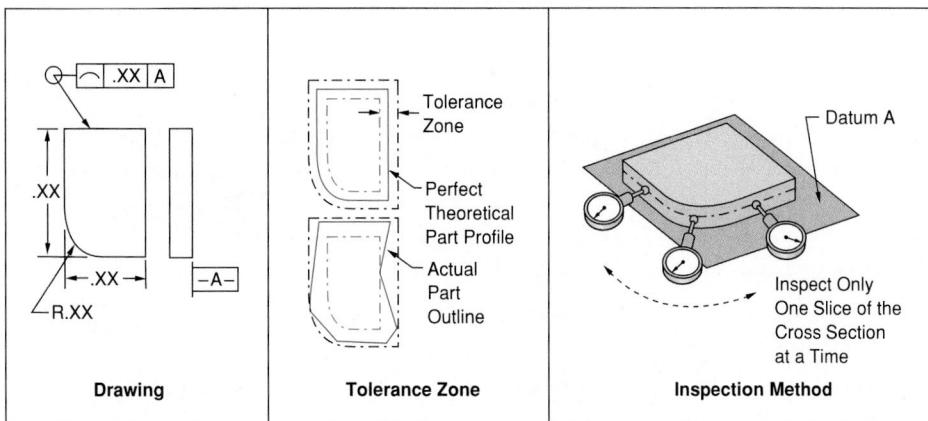

Figure 8.99 Profile of a Line

the controlled feature is a surface, then all points on that surface must stay between two perfect planes that are at a specific perfect angle to the datum. If the feature is an axis, then all points on the axis must stay between two lines that are at a specific perfect angle to the datum. The distance between the pairs of planes or pairs of lines is the tolerance value given in the feature control frame. If the angle is 90 degrees, then perpendicularity applies. MMC may be used when the control is applied to a feature of size, such as the pin in Figure 8.98.

The surface tolerance zone is: "Two planes, parallel, and the tolerance value apart, at exactly the angle stated from the datum." The axis tolerance zone is the same as that for the surface, except that the tolerance value can be larger if MMC is applied.

Line Profile A line profile takes cross-sectional slices of shapes and compares the slices to perfect shapes. (Figure 8.99) Profile is usually used to control shapes that are combinations of contiguous lines, arcs, and other curves. The circle at the bend in the control frame leader line means that the tolerance is to be applied around the entire part.

The tolerance zone is a composite shape made up of two profiles. The first is the perfect profile of the feature minus half the tolerance value. The second profile is the perfect profile plus half the tolerance value. This pair of profiles creates a tolerance zone around the perfect shape. The boundary could

be considered a combination of straightness, roundness, parallelism, perpendicularity, etc., joined contiguously.

Surface Profile A surface profile takes line profile slices and stacks them into three-dimensional surfaces and cylinders (Figure 8.100), which are then compared to perfect shapes. A surface profile is usually used to control shapes that are combinations of contiguous surfaces, cylinders, and other curved shapes. If the profile of a line is used to control the shape of a card in a playing deck, then profile of a surface is used to control the entire deck when it is stacked up. Profile of a surface requires that the stack not be twisted or sloped.

8.13.6 Position Controls

Concentricity **Concentricity** is the condition in which the axes of all cross-sectional elements of a cylinder, cone, or sphere are common to a datum axis, using RFS only. In other words, concentricity compares the position of the real axis of the feature to the position of the datum axis. Concentricity is frequently used on spinning parts, where dynamic balancing is important. The symbol for concentricity is two concentric circles. (Figure 8.101) Although concentricity is a control of the *location* of the center line axis of a feature, it is also concerned with the *shape* of the feature, because changes in the shape can affect the location of that axis.

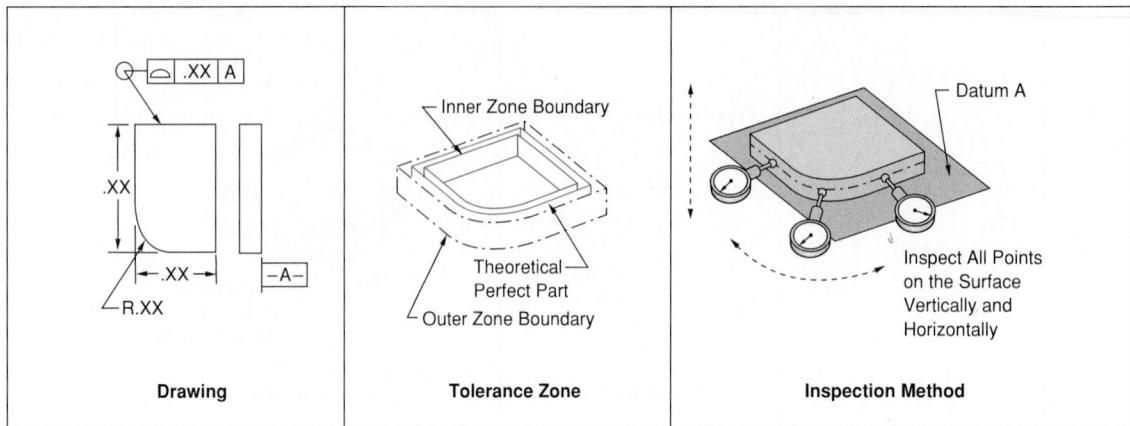

Figure 8.100 Profile of a Surface

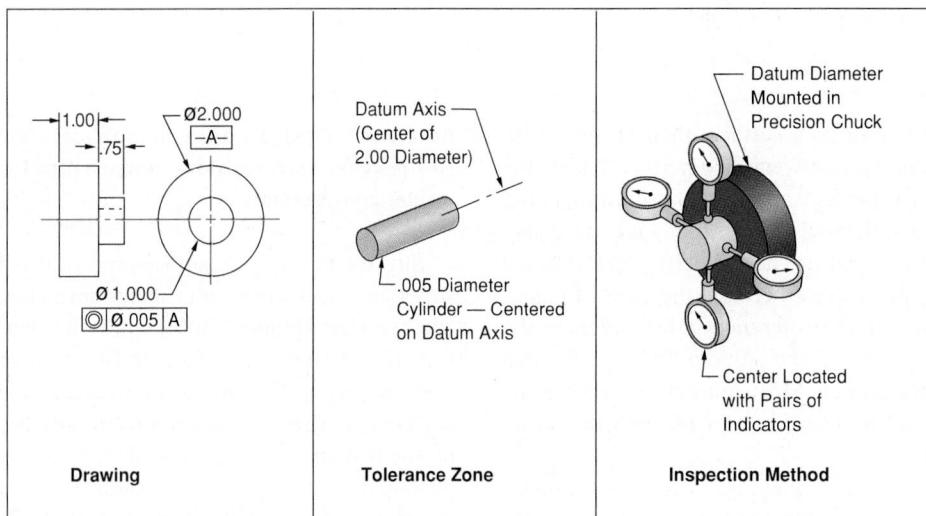

Figure 8.101 Concentricity

Runout There are two types of **runout**: single element and total. Single element runout is denoted by a single arrow in the symbol, and it is similar to roundness in that it only controls one circular element. (Figure 8.102) Total runout is comparable to cylindricity in that it is a control of an entire surface, rather than a single element.

8.14 DESIGN APPLICATIONS

Geometric dimensioning and tolerancing (GDT) is integral to the design process. Therefore, standard problem-solving techniques should be used when applying GDT to the design function.

8.14.1 Five-Step GDT Process

There is a five-step process for applying GDT principles to the design process. These steps are explained in the following, and the next section is an example of the application of this process to the design of a specific part.

Five Steps to Geometric Control

Step 1. Isolate and define the functions of the feature/part. Break the part down to its simplest functions. Be specific; do not generalize. For example, a bracket might use "to maintain a center distance between two shafts," rather than "to hold the shafts."

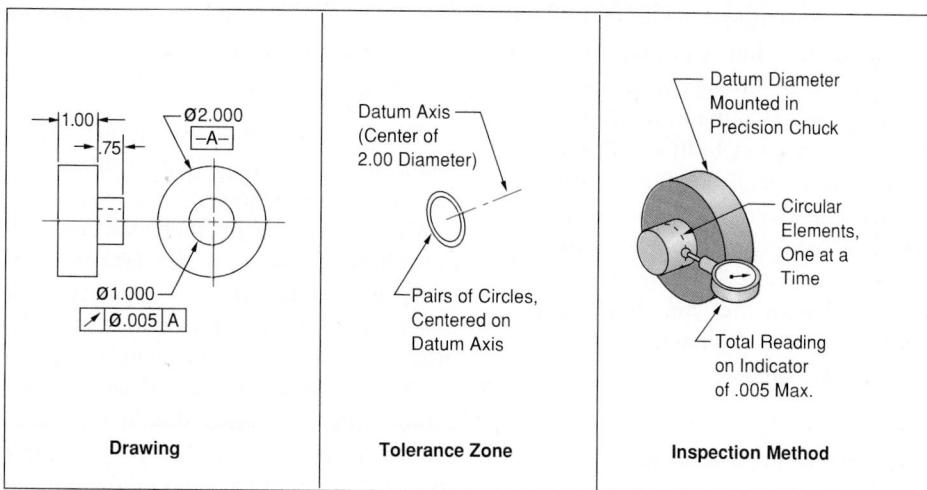

Figure 8.102 Single Element Runout

Step 2. Prioritize the functions. Identify trouble spots. Again, be specific. Ideally, only one function should have top priority. This step can be one of the more difficult, especially if creative design principles are used and the parts are designed to incorporate many functions.

Step 3. Identify the datum reference frame, based on the functional priorities. On a specific part, this step may mean creating several reference frames, each based on a prioritized item. The frame can be either one, two, or three planes.

Step 4. Select the proper control. In those cases, where several controls may be used, such as in the case of coaxial features (i.e., position, runout, or concentricity may apply), start with the simplest and least restrictive control and move up in restrictiveness, as necessary. This is similar to "zero based budgeting" in that you must first prove the need for control, starting with the assumption that no control is needed.

Step 5. Calculate the tolerance values. The tolerance calculations are the last step, even though the tendency is to do them first. They are also the easiest, because they are usually formula based.

8.14.2 Application Example

Figure 8.103 shows a part that mounts on a rail and holds a shaft at a distance above and over from the rail. The part is secured with three bolts which must fit easily into the holes. Therefore, the bolts cannot be used to locate the shaft accurately; instead, the shoulder must be used to locate the part in the X direction. The bolts are used only to clamp the part after positioning. (This is a common situation.)

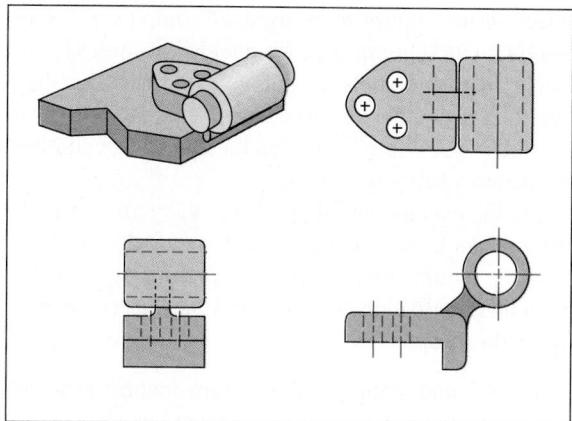

Figure 8.103 Shoulder Bracket for Shaft Positioning

In analyzing this design, remember that only machined surfaces can be held to any kind of accuracy; cast surfaces are unreliable.

Step 1. Isolate and define the functions of the feature/part The most obvious functions are:

- a. Hold a shaft in the large hole.
- b. Provide the three mounting holes in a pattern.
- c. Provide a shoulder to butt up against another part.
- d. Keep the shaft parallel to the shoulder.
- e. Provide a large bearing surface for the shaft.
- f. Keep the shaft level.

Step 2. Prioritize the functions This is probably the most overlooked step, but it is also the most important. All parts can be broken down into their basic functions. In Figure 8.103, it may not be obvious at first, but the bracket must hold the shaft at a specific height and at a certain distance from the shoulder (see dimensions A and B). This positioning seems to be its most important function. A trouble spot on this part is likely to be the long shoulder; it may not stay aligned with the shaft hole center. Another trouble spot is the alignment of the three mounting holes with the shoulder.

PRIORITIES

- Locate the shaft relative to the shoulder.
- Locate the bolt holes relative to the shoulder.

Step 3. Identify the datum reference frame In this step, we create the datum reference frame before selecting the control to be used. A common problem in GDT work is the urge to decide too quickly on which control to apply. In doing so, the designer may overlook a simpler or more direct control, and may mentally “lock into” a particular control, becoming blinded to a better solution.

For the example in Figure 8.103, the vertical shoulder appears to be a critical feature, and it could be a primary datum. Examining that feature against the guidelines on datum feature selection, presented earlier in this chapter, we obtain the following results:

1. Size and stability: The datum feature is to be used to mount the part for manufacture and inspection. However, the vertical shoulder is rather small.
2. Accessibility: The vertical shoulder is exposed.
3. Feature and form controls: The vertical shoulder should probably be controlled and a form control (flatness, roundness, etc.) should probably be used.

4. Functionality: The vertical shoulder relates to the feature being controlled and is therefore very functional.

The conclusion is to use the vertical shoulder as a secondary or tertiary datum feature, but not for the primary datum, because of its relatively small size.

The shaft hole is the most functional feature. But a cylindrical feature usually makes a poor primary datum feature because it is not a feature on which to mount a part. When holes are used as a primary datum, inspectors use expanding mandrels to secure parts.

The next feature that could be used as the primary datum is the horizontal shoulder surface. It is large and stable, easily accessible, controllable with a form control, and very functional in that it locates the shaft hole vertically and will provide a means for holding the shaft. Therefore, the horizontal shoulder surface should be used as the primary datum feature.

Step 4. Select the proper control One requirement is that the shaft hole should be parallel to the shoulder. Therefore, parallelism might be a logical selection as a control. But that selection might be premature, especially since parallelism is not the only control that will keep the two features parallel. It is also important to determine which is the datum feature and which will be the controlled feature. This will directly affect which feature is parallel to which other feature.

Step 5. Calculate the tolerance values For each control selected, calculate the actual value. In the case of holes and fits, the fixed or floating fastener calculations can be used. Apply the MMC modifier where appropriate. Where justified, use RFS or LMC, but there should be adequate reason for this selection. (Figure 8.104)

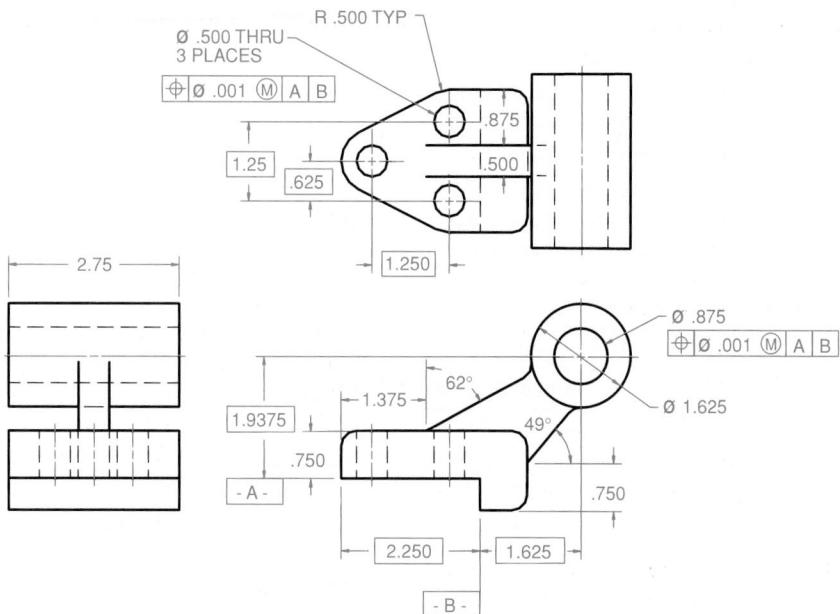

Figure 8.104 Shoulder Bracket with Geometry Tolerancing

8.15 SUMMARY

Dimensioning is a method of accurately communicating size information for objects and structures, so that they can be produced. Dimensioning of mechanical devices follows standards established by ANSI. These standards include the proper use and placement of dimensional information on engineering drawings. Many parts need to be dimensioned using toleranced values. Tolerances allow a dimension to vary within limits. Toleranced dimensions are especially useful in the accurate manufacture of assembled parts.

Just as the clear communication about the shape of an object is accomplished by following the standard principles and conventions of orthographic projection, the clear communication about the size of an object is

accomplished through adherence to standard dimensioning practices. Unless both shape and size information is communicated clearly, it is not possible to move design ideas to reality. Tables 8.1 and 8.2 summarize the basics of dimensioning and tolerancing.

Geometric dimensioning and tolerancing (GDT) is essential in the modern manufacturing environment. The basic elements of geometric controls are as follows:

1. All dimensions include controls of the geometry. Rule #1 states that a size control inherently includes controls of form.
2. Because of Rule #1 the need for GDT callouts on technical drawings is minimized. Such callouts are tools and should be used carefully and accurately.

Table 8.1 Basics of Dimensioning**Parts of a Dimension**

Dimension—A dimension is a numerical value shown on a drawing to define the size of an object, or a part of an object. Dimensions may be expressed in either U.S. or metric units.

Dimension line—A dimension line is a thin solid line used to show the extent and direction of a dimension.

Arrowheads—Arrowheads are placed at the ends of dimension lines to show the limits of the dimension.

Extension line—Extension lines are thin lines drawn perpendicular to dimension lines, and they indicate the feature of the object to which the dimension refers.

Leader line—A leader line is a thin solid line used to direct dimensions or notes to the appropriate feature.

Tolerance—Tolerances are the amount a dimension is allowed to vary. The tolerance is the difference between the maximum and minimum permitted sizes.

Principles of Good Dimensioning

The overriding principle of dimensioning is clarity.

1. Each feature of an object is dimensioned once and only once.
2. Dimensions should be selected to suit the function of the object.
3. Dimensions should be placed in the most descriptive view of the feature being dimensioned.
4. Dimensions should specify only the size of a feature. The manufacturing method should only be specified if it is a mandatory design requirement.
5. Angles shown on drawings as right angles are assumed to be 90 degrees unless otherwise specified, and need not be dimensioned.
6. Dimensions should be located outside the boundaries of the object whenever possible.
7. Dimension lines should be aligned and grouped where possible, to promote clarity and uniform appearance.
8. Crossed dimension lines should be avoided whenever possible. When dimension lines must cross, they should be unbroken.
9. The space between the first dimension line and the object should be at least $\frac{3}{8}$ " (10 mm).
The space between dimension lines should be at least $\frac{1}{4}$ " (6 mm)
10. There should be a visible gap between the object and the origin of an extension line.
11. Extension lines should extend $\frac{1}{8}$ " (3 mm) beyond the last dimension line.
12. Extension lines should be broken if they cross or are close to arrowheads.
13. Leader lines used to dimension circles or arcs should be radial.
14. Dimensions should be oriented to be read from the bottom of the drawing.
15. Diameters are dimensioned with a numerical value preceded by the diameter symbol.
16. Concentric circles should be dimensioned in a longitudinal view whenever possible.
17. Radii are dimensioned with a numerical value preceded by the radius symbol.
18. When a dimension is given to the center of an arc or radius, a small cross is shown at the center.
19. The depth of a blind hole may be specified in a note. The depth is measured from the surface of the object to the deepest point where the hole still measures a full diameter in width.
20. Counterbored, spotfaced, or countersunk holes should be specified in a note.

3. Geometric control callouts should be used to refine the relationship between the size of a feature and its form, not to increase the accuracy of a feature.
4. GDT callouts should be used to open up tolerances, rather than to tighten them up. The MMC concept should reduce part cost; if it does not, reexamine how it is used.

Table 8.3 lists the various geometric controls, their potential application as a datum reference, the use of MMC, and the associated tolerance zone.

GDT is in a state of change. Changes are made to the ANSI Y14.5-1988 standard to keep GDT principles and uses as up-to-date as possible. At the time of publication of this text, there are several major changes currently under consideration. Figure 8.105 is a worksheet used to determine geometric tolerancing. Appendix 55 summarizes the definitions, use, and symbology of GDT.

Table 8.2 Basics of Tolerancing

The basics of tolerancing are explained in terms of a mating shaft and hole.

Limits of Size

- The *upper limit* of the shaft is the diameter of the largest permissible shaft.
- The *upper limit* of the hole is the largest permissible diameter of the hole.
- The *lower limit* of the shaft is the smallest permissible diameter of the shaft.
- The *lower limit* of the hole is the smallest permissible diameter of the hole.

The *piece tolerance* is the difference between the upper and lower limits of one part (hole or shaft).

Limits of Fit

- The *tightest fit* (between hole and shaft) is the difference between the largest shaft and the smallest hole. This creates the minimum clearance.
- The *loosest fit* (between hole and shaft) is the difference between the smallest shaft and the biggest hole. This creates the maximum clearance.

The *system tolerance* is the difference between the tightest and loosest fits. As a check, this value should equal the sum of the piece tolerances.

Types of Fit

- A *clearance fit* means that all the shaft(s) will fit into the hole(s), resulting in a positive clearance.
- An *interference fit* means the shaft(s) will not fit freely into the hole(s), thus resulting in a negative clearance.
- A *transition fit* means that some shafts will fit into some of the holes, but not all of the shafts will fit into all of the holes.

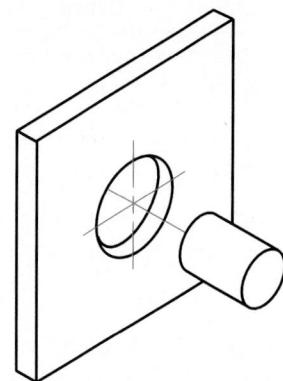

Clearance fit

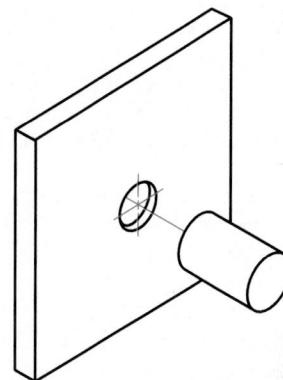

Interference fit

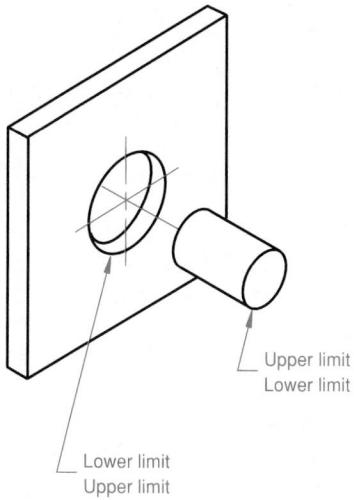

Upper limit
Lower limit

Lower limit
Upper limit

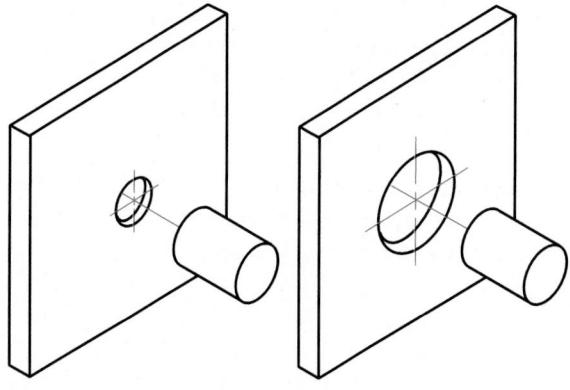

Transition fit

Table 8.3 GDT Quick Reference

Control	Datum	MMC	Tolerance Zone Description	Symbol
Straightness (Line)	No	No	Two lines, parallel	—
Straightness (Axis)	No	Yes	Cylinder	—
Flatness	No	No	Two planes, parallel	
Circularity	No	No	Two circles, concentric	
Cylindricity	No	No	Two cylinders, concentric	
Perpendicularity (Surface)	Yes	No	Two planes, parallel, and 90 degrees to datum	
Perpendicularity (Axis)	Yes	Yes	Cylinder	
Angularity (Surface)	Yes	No	Two planes, parallel, and at angle to datum	
Angularity (Axis)	Yes	Yes	Cylinder	
Parallelism (Surface)	Yes	No	Two planes, parallel, and 180 degrees to datum	
Parallelism	Yes	Yes	Cylinder	
Profile (Line)	Yes	No	Composite, made up of two sets of lines and curves, parallel	
Profile (Surface)	Yes	No	Similar to profile of a line, except it pertains to surfaces	
Runout (Circular)	Yes	No	Two circles, concentric FIM	
Runout (Total)	Yes	No	Two cylinders, concentric FIM	
Concentricity	Yes	No	Cylinder	
Position	Yes	Yes	Cylinder, if feature is a cylinder; two planes, if used for symmetry or if feature is rectangular	

GEOMETRIC TOLERANCING WORKSHEET**PART 1: ISOLATE AND DEFINE THE FUNCTIONS OF THE FEATURE/PART**

Basic Function _____

Additional Functions _____

PART 2: PRIORITIZE THE FUNCTIONS

Feature #1 _____ Feature #2 _____ Feature #3 _____

PARTS 3 & 4: CREATE THE DATUM REFERENCE FRAMES & SELECT CONTROLS

Feature # _____ Function _____

Control _____

Primary Datum Feature Secondary Datum Feature Tertiary Datum Feature

Feature # _____ Function _____

Control _____

Primary Datum Feature Secondary Datum Feature Tertiary Datum Feature

Feature # _____ Function _____

Control _____

Primary Datum Feature Secondary Datum Feature Tertiary Datum Feature

PART 5: CALCULATE THE TOLERANCES

Feature # _____ Feature # _____ Feature # _____

Figure 8.105

KEY TERMS

Actual size	Dimension line	Least material condition (LMC)	Reference dimension
Aligned dimensions	Dimensions	Limit dimensioning	Regardless of feature size (RFS)
Allowance	Envelope principle	Limits	Roundness
Angularity	Extension line	Line element	Rule #1
Arrow	Feature	Line to line fit	Runout
Baseline dimensioning	Feature control frame	Lower deviation	Shaft basis
Basic dimension	Flatness	Lower limit	Statistical process control (SPC)
Basic size	Form controls	Maximum material condition (MMC)	Straightness
Bilateral tolerance	Functional dimensioning	Nominal size	System tolerance
Chain line	Fundamental deviation	Parallelism	Tolerance
Circularity	Gaging tolerance	Perfect form	Tolerance stack-up
Circular line element	Geometric breakdown	Perpendicularity	Tolerance zone
Clearance fit	dimensioning	Piece tolerance	Transition fit
Concentricity	Geometric dimensioning	Plus and minus dimensioning	Unidirectional dimensioning
Contour dimensioning	and tolerancing	Preferred precision fits	Unilateral tolerances
Cylindricity	Geometrics	Profile	Upper deviation
Datum	Hole basis	Radial line	Upper limit
Datum dimensioning	Interchangeable parts	Radius symbol	Virtual condition
Datum feature	Interference fit	Rectangular coordinate dimensioning	
Datum feature identifiers	International tolerance		
Datum reference frame	grade (IT)		
Deviation	Leader line		
Diameter symbol			

QUESTIONS FOR REVIEW

1. How are concentric circles best dimensioned?
2. Sketch the symbols for diameter, radius, depth, counterbore, countersink, and square.
3. Where are these symbols placed with respect to their numerical values?
4. What is the primary difference between counterbore and spotface?
5. When is a small cross required at the center of a radius?
6. Define the depth of a blind hole.
7. When are angled extension lines used? Sketch an example.
8. When should extension lines be broken?
9. How is a reference dimension identified?
10. How can you tell if a dimension is out of scale (without measuring the drawing)?
11. Write a note showing that a .25-inch deep .875-inch diameter hole is to be repeated six times.
12. When is an arc dimensioned with a diameter, and when is one dimensioned with a radius?
13. When should the word “drill” replace the word “diameter” when dimensioning a hole?
14. What is the proper proportion of width to length of arrowheads?
15. What is the difference between limit dimensioning and plus and minus dimensioning?
16. What is MMC?
17. What is the term for the theoretical size of a feature?
18. Compare the thickness of dimension lines to object lines.
19. Compare the thickness of dimension lines to extension lines.
20. If two dimensioning guidelines appear to conflict, which guideline should be followed?

21. Write a definition of what Rule #1 means for a drawing of a flat washer with a 0.500 diameter ID, 1.000 diameter OD, and a thickness of 0.062. Use a tolerance of plus or minus 0.005.
22. Describe the difference between the MMC condition of a shaft and the MMC condition of a hole.
23. How does a shaft depart from MMC? How does a hole depart from MMC?
24. What is the difference between a datum and a datum feature?

PROBLEMS

8.1 (Figures 8.106 and 8.107) Using an A- or B-size layout, sketch or draw the assigned problems, using instruments or CAD. Each grid square equals .25" or 6 mm. Completely dimension the drawing, using one-place millimeter or two-place decimal inches.

8.2 (Figures 8.108 through 8.119) Sketch, or draw with instruments or CAD, a multiview drawing, then add dimensions.

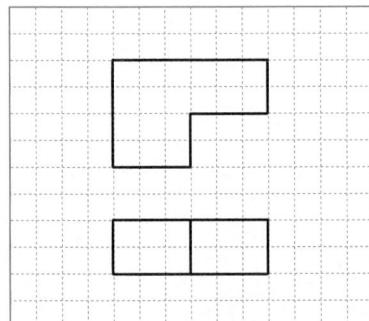

(1)

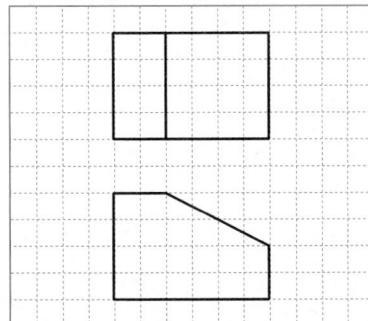

(2)

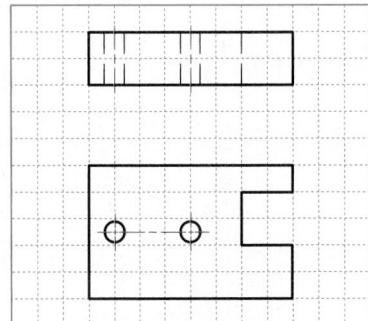

(3)

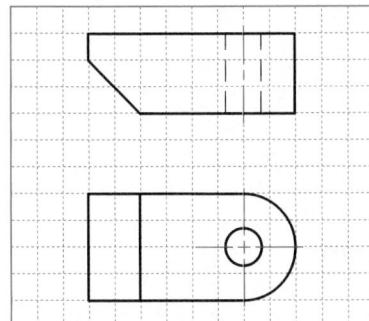

(4)

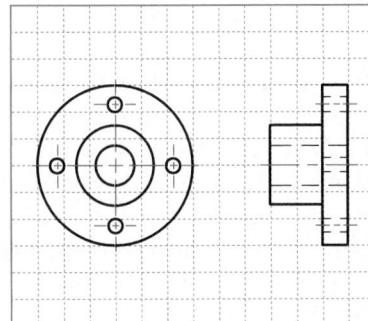

(5)

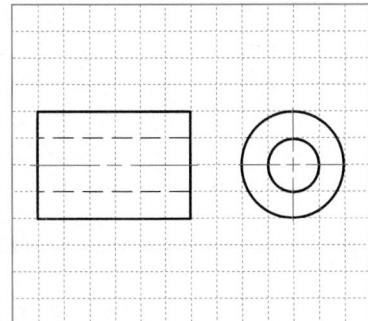

(6)

Figure 8.106 Problem 8.1

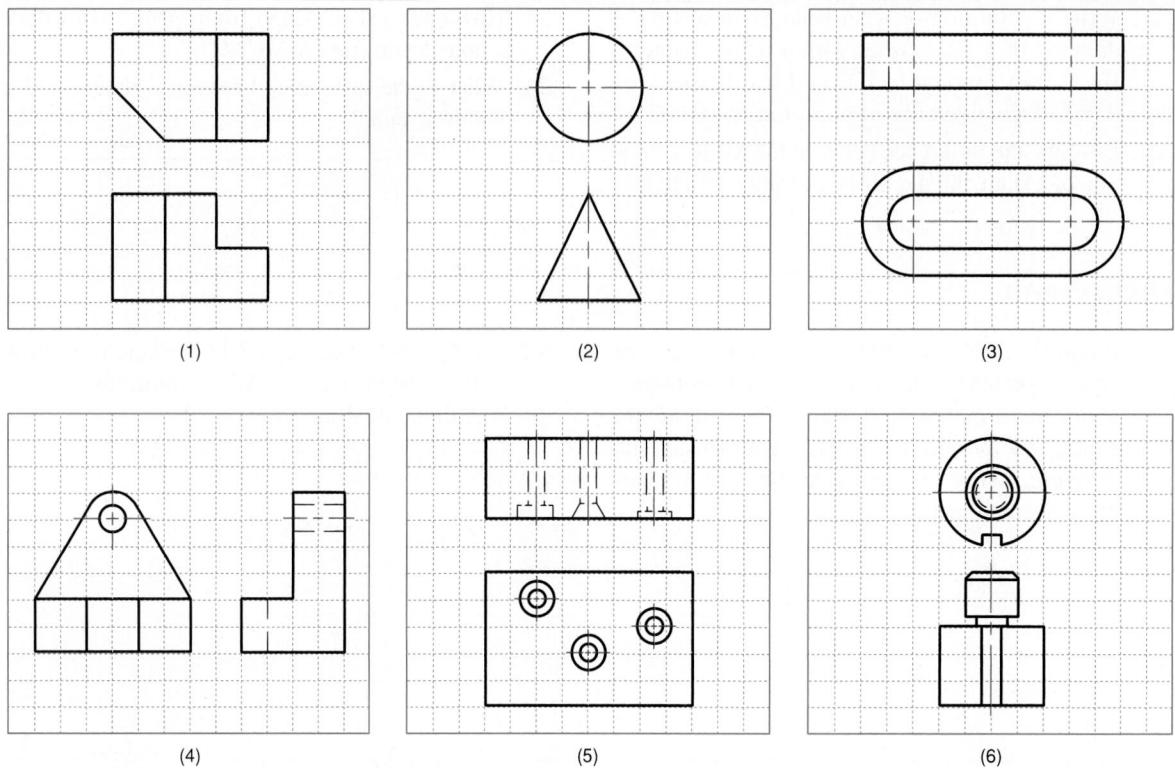

Figure 8.107 Problem 8.1

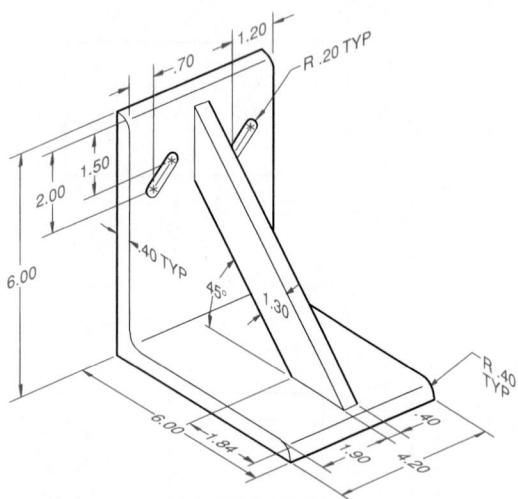

Figure 8.108 Gusseted Angle Bracket

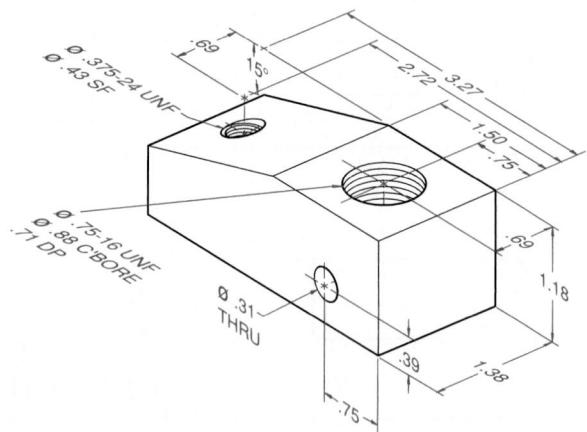

Figure 8.109 Angle Clamp

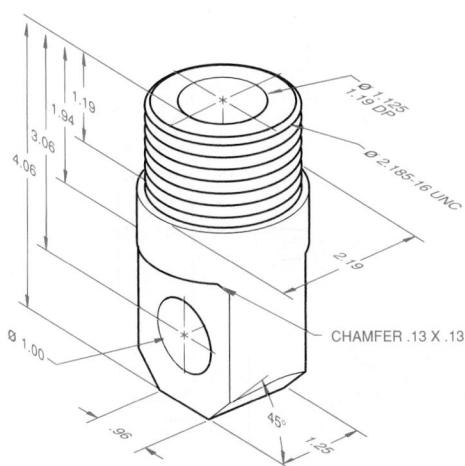

Figure 8.110 Clevis Eye

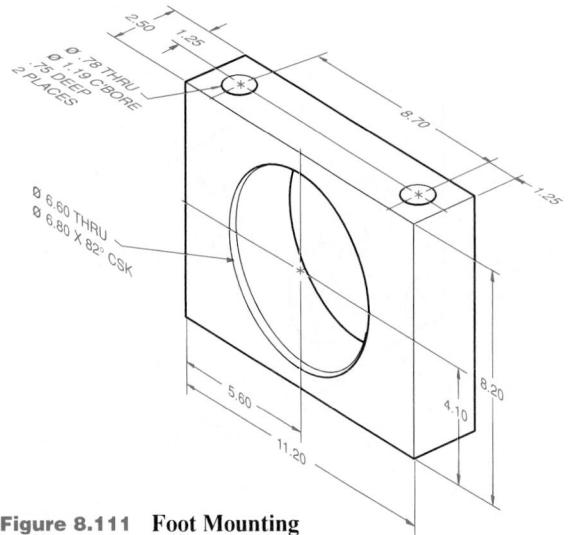

Figure 8.111 Foot Mounting

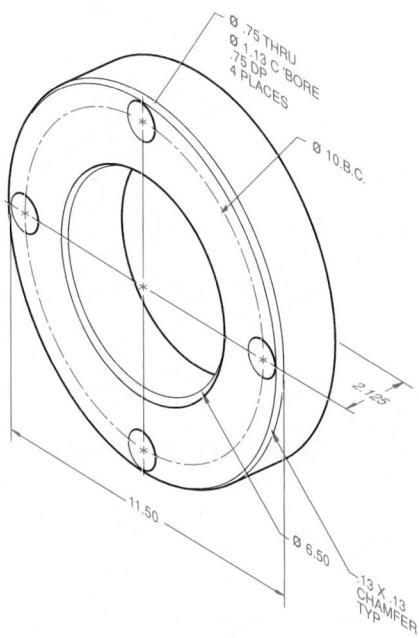

Figure 8.112 Flange Mounting

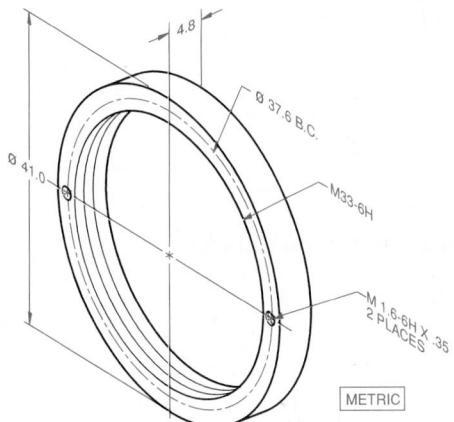

Figure 8.113 Retainer

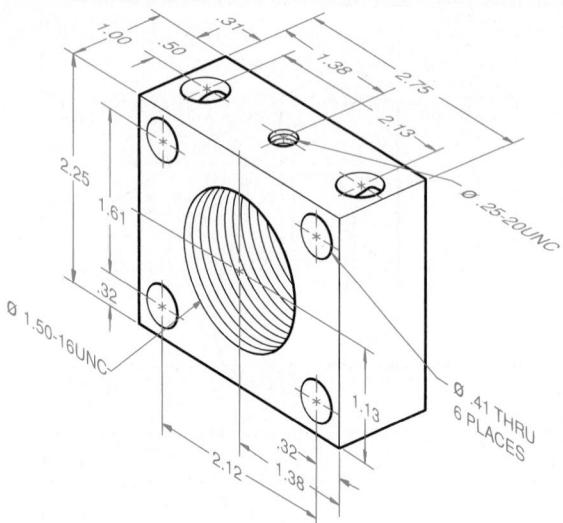

Figure 8.114 Mounting Saddle

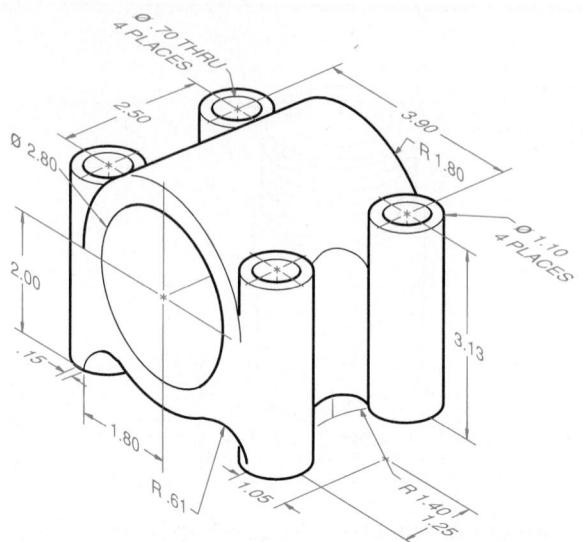

Figure 8.115 Cylinder Bracket

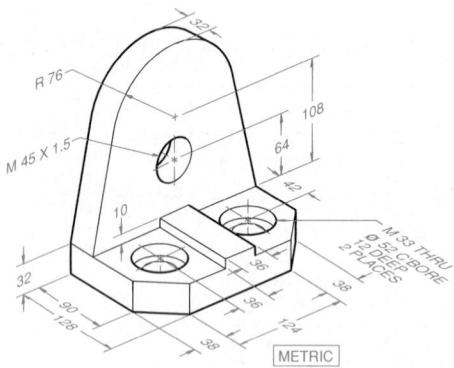

Figure 8.116 Standard Bracket

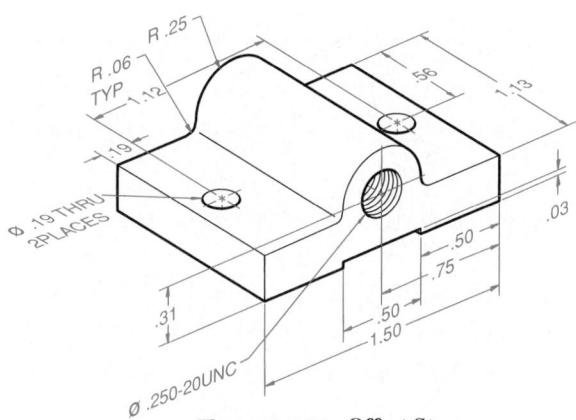

Figure 8.117 Offset Strap

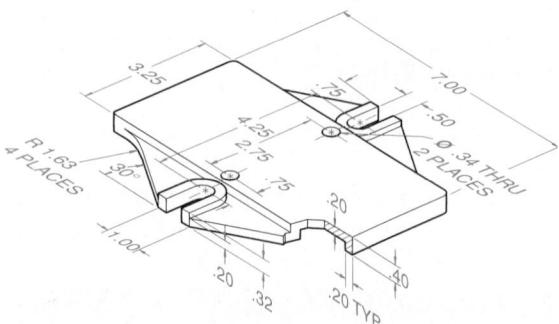

Figure 8.118 Gang Mill Fixture Base

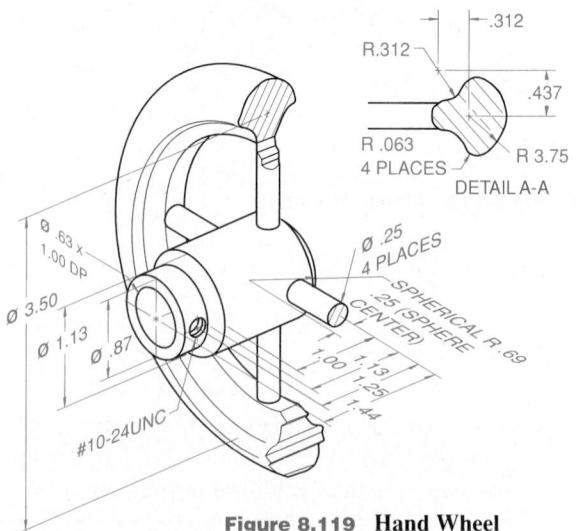

Figure 8.119 Hand Wheel

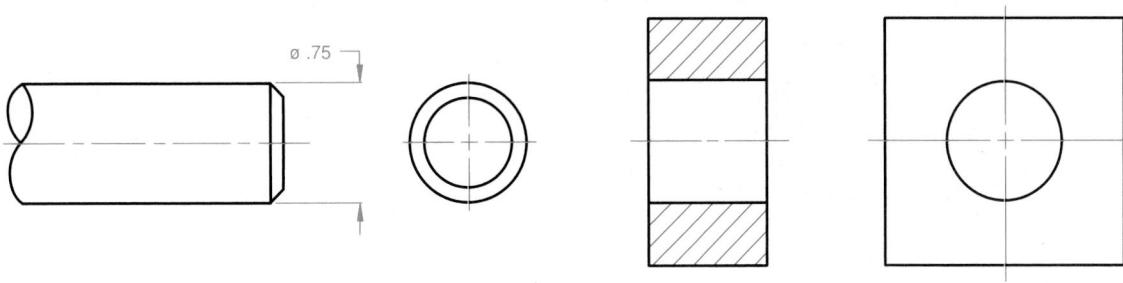

Class of fit			RC 4		LC 6		FN 5	
Hole	Nominal size							
	Limit	±		±			±	
	Upper limit	=		=			=	
	Nominal size							
	Limit	±		±			±	
	Lower limit	=		=			=	
Shaft	Nominal size							
	Limit	±		±			±	
	Upper limit	=		=			=	
	Nominal size							
	Limit	±		±			±	
	Lower limit	=		=			=	
Limits of fit	Smallest hole							
	Largest shaft	-		-			-	
	Tightest fit	=		=			=	
	Largest hole							
	Smallest shaft	-		-			-	
	Loosest fit	=		=			=	

Figure 8.120 Shaft and Hole

8.3 (Figure 8.120) Use the tolerancing tables in Appendices 3–7 to calculate the limit dimensions between the shaft and hole for the given classes of fit.

8.4 (Figure 8.121) Determine the limit dimensions between the shoulder screw and bushing and between the bushing and housing, using the specified fit and the tolerancing tables in Appendix 7.

8.5 Identify an everyday item that would work better if its features were toleranced for geometry, as well as for size. Discuss why.

8.6 Apply geometric tolerances to one of the assemblies found at the end of Chapter 9, “Reading and Constructing Working Drawings.”

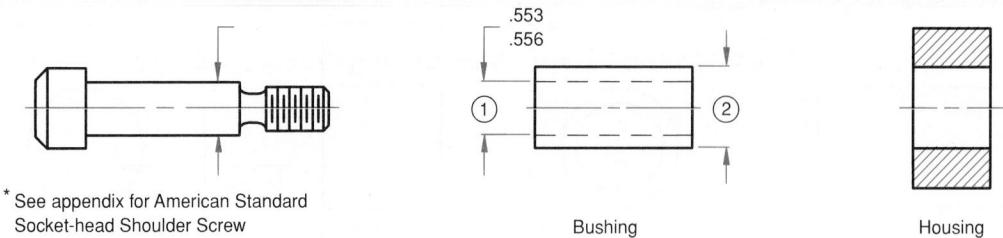

Limits of size			1	2 - FN 4 fit	
Hole	Nominal size		.500		.750
	± Limit	±		±	
	= Upper limit	=		=	
	Nominal size		.500		.750
	± Limit	±		±	
	= Lower limit	=		=	
Shaft	Nominal size		.500		.750
	± Limit	±		±	
	= Upper limit	=		=	
	Nominal size		.500		.750
	± Limit	±		±	
	= Lower limit	=		=	
Limits of fit	Smallest hole				
	- Largest shaft	-		-	
	= Tightest fit	=		=	
	Largest hole				
	- Smallest shaft	-		-	
	= Loosest fit	=		=	

Figure 8.121 Shoulder Screw and Bushing

CHAPTER 9

Reading and Constructing Working Drawings

Civilization expands by extending the number of important operations we can perform without thinking about them.

Alfred North Whitehead

OBJECTIVES

After completing this chapter, you will be able to:

1. Define working drawings.
2. Describe how working drawings are used in industry.
3. List the major components of a complete set of working drawings.
4. Describe the differences between detail and assembly drawings.
5. Describe how part numbers, zoning, and tables are used on working drawings.
6. Understand the function and use of fasteners.
7. Draw standard representations of threads.
8. Specify a metric or English thread in a note.
9. Use the graphic language of mechanisms such as gears, cams, bearings, and linkages.
10. Interpret the specialized graphic language used in piping and welding drawings.
11. Describe how CAD is used to create, store, and retrieve working drawings.
12. List techniques used to create copies of engineering drawings.

Production or working drawings are specialized engineering drawings that provide information required to make the part or assembly of the final design. Working drawings rely on orthographic projection and many other graphical techniques to communicate design information for production. Though there is a common method for representing mechanical parts for production, many industries use specialized production drawings. In addition to standard mechanical drawings, two types of specialized drawings, piping drawings and welding drawings, are described in this chapter.

- An engineered product typically will contain numerous parts. In addition to specialized parts, these products also contain many standard parts such as fasteners (e.g., screws, bolts, and pins) and mechanisms (e.g., gears, cams, and bearings). This chapter will explain the basic functionality of these standard parts and how they are represented in production drawings.
- Reprographics is the storage, retrieval, and copying of engineering drawings. Reprographics techniques such as diazo printing and the digital techniques used with CAD are covered in this chapter.

9.1 BASIC CONCEPTS

Engineering drawings are used to communicate designs to others, document design solutions, and communicate design production information. (Figure 9.1) Preceding chapters discussed the development of engineering drawings for the purpose of communicating the design to others. This chapter will focus on communication of the final design for production purposes. (Figures 9.2 and 9.3) These types of drawings are called **working drawings** or **production drawings**.

Figure 9.4 shows the components of the production cycle. **Documenting** is the process of communicating and archiving design and manufacturing information on a product or structure. The documents created include drawings, models, change orders, memos, and reports.

Part of the documenting process includes storing, retrieving, and copying engineering drawings, a process called *reprographics*. **Archiving** is part of reprographics and involves the storage and retrieval aspects of that process.

CAD has brought significant changes to this area of design documentation. Using 3-D CAD and modern manufacturing techniques, the need for production drawings is minimized. Rather than creating 2-D drawings of the 3-D model, manufacturers extract production

Figure 9.1

Engineering drawings are used as a communications tool.

Figure 9.2

Working drawings are used to produce products, structures, and systems.

Figure 9.3

Working drawings show how complex assemblies are put together.

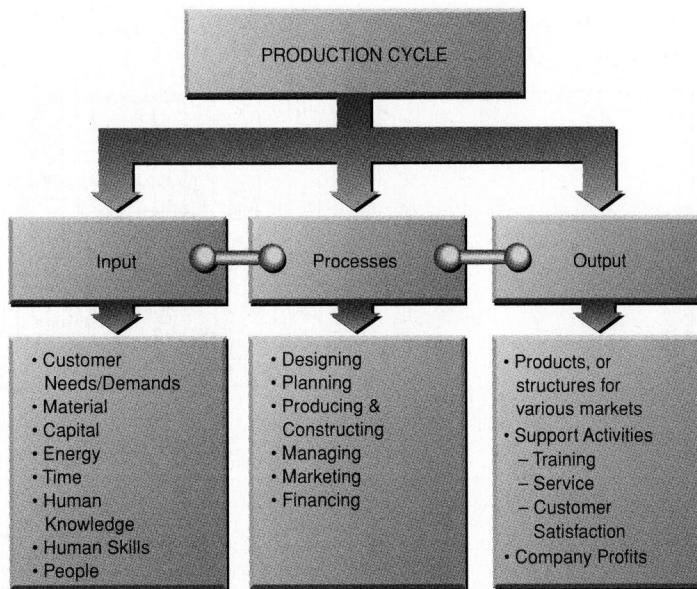

Figure 9.4 Production Cycle

The production cycle includes documenting as a major process.

information and geometry directly from the computer model. With both 2-D and 3-D CAD, electronic file storage and distribution eliminate the need for many traditional reprographics activities. With networked computers, personnel in any phase of manufacturing can access the most current version of the production drawings or models on their computer screens.

9.2 WORKING DRAWINGS

Working drawings are the complete set of standardized drawings specifying the manufacture and assembly of a product based on its design. The complexity of the design determines the number and types of drawings. Working drawings may be on more than one sheet and may contain written instructions called **specifications**.

Working drawings are the *blueprints* used for manufacturing products. Therefore, the set of drawings must: (a) completely describe the parts, both visually and dimensionally; (b) show the parts in assembly; (c) identify all the parts; and (d) specify standard parts. The graphics and text information must be sufficiently complete and accurate to manufacture and assemble the product without error.

Generally, a complete set of working drawings for an assembly includes:

1. Detail drawings of each nonstandard part.
2. An assembly or subassembly drawing showing all the standard and nonstandard parts in a single drawing.
3. A bill of materials (BOM).
4. A title block.

9.2.1 Detail Drawings

A **detail drawing** is a dimensioned, multiview drawing of a single part (Figure 9.5), describing the part's shape, size, material, and finish, in sufficient detail for the part to be manufactured based on the drawing alone. Detail drawings are produced from design sketches or extracted from 3-D computer models. They adhere strictly to ANSI standards, and the standards for the specific company, for lettering, dimensioning, assigning part numbers, notes, tolerances, etc.

In an assembly, standard parts such as threaded fasteners, bushings, and bearings are not drawn as details, but are shown in the assembly view. Standard parts are not drawn as details because they are normally purchased, not manufactured, for the assembly.

For large assemblies or assemblies with large parts, details are drawn on multiple sheets, and a separate sheet is used for the assembly view. If the

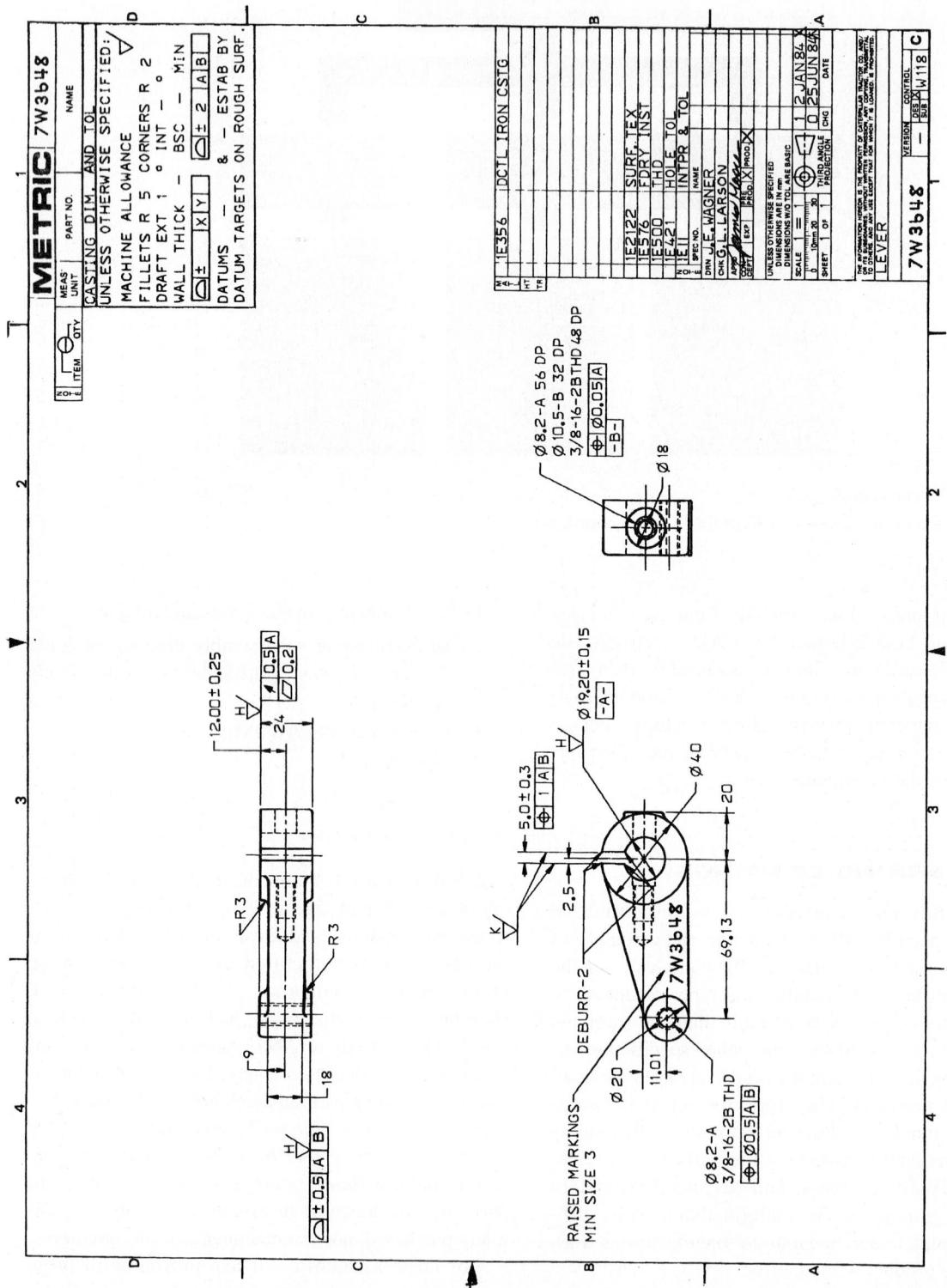

Figure 9.5 A Detail Drawing of a Single Part Called a Lever

This detail drawing includes three orthographic views, metric dimensions, tolerances, finish information, part number in the title block and on the front view, and material type, as well as other information.

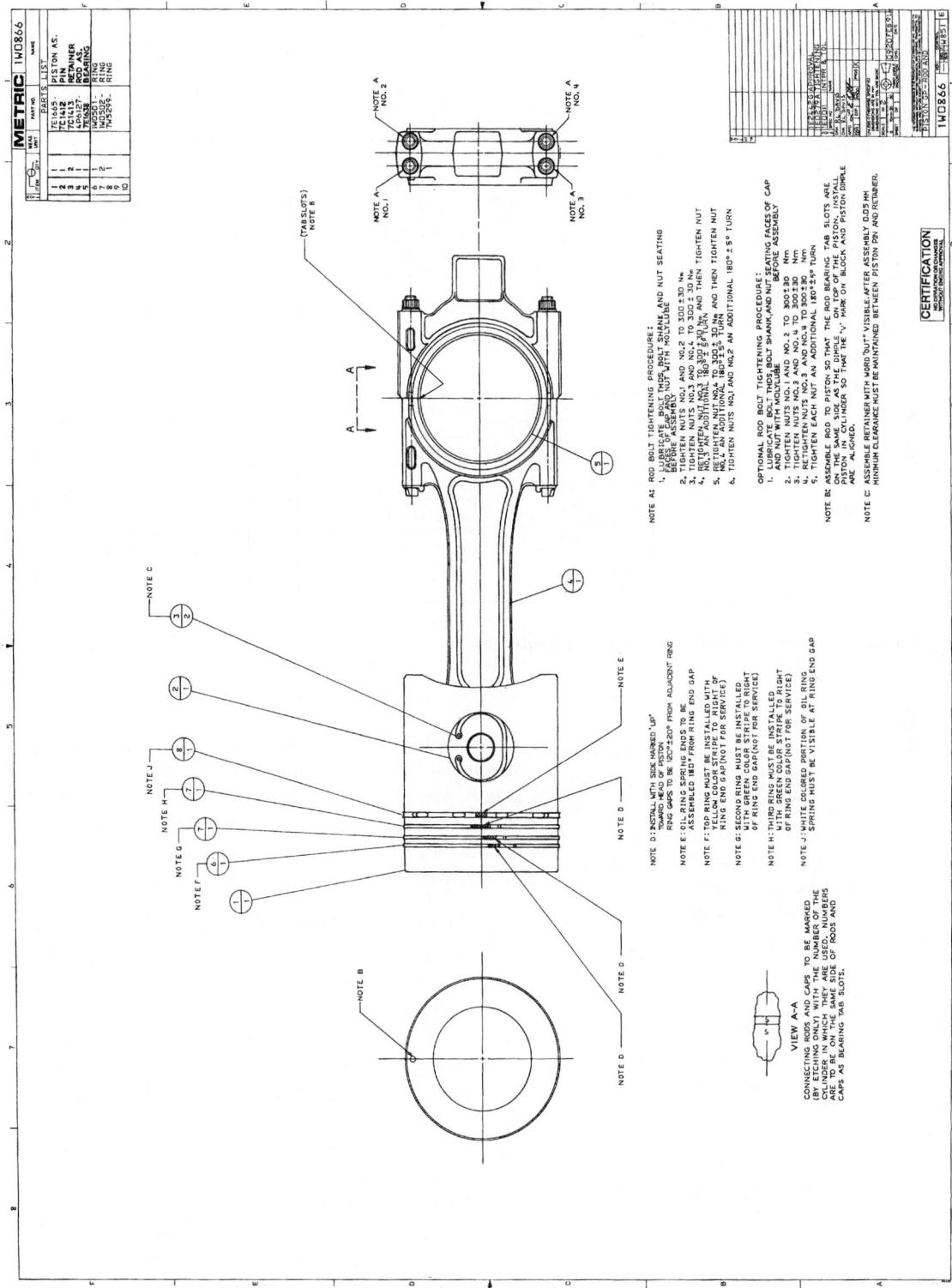

Figure 9.6 Assembly Drawing of a Piston and Rod Containing Eight Parts

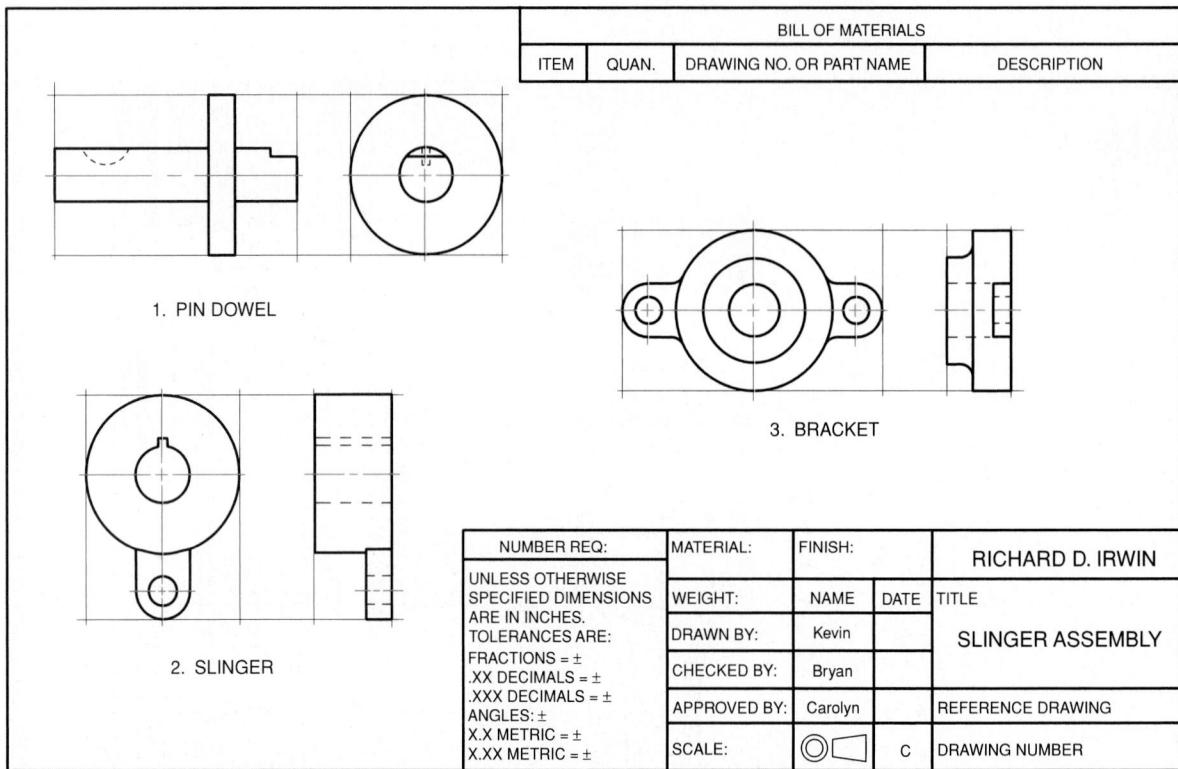

Figure 9.7 Blocking in the Views to Determine Spacing Requirements

assembly is simple or the parts are small, detail drawings for each part of an assembly can be placed on a single sheet. However, many large companies put each part and its part number on a separate drawing sheet, regardless of the size of the part, to facilitate sales and re-use of the part in other assemblies. Figure 9.6 is from a set of working drawings for an engine piston and rod subassembly.

Multiple details on a sheet are usually drawn at the same scale. If different scales are used, they are clearly marked under each detail. Also, when more than one detail is placed on a sheet, the spacing between details is carefully planned, including leaving sufficient room for dimensions and notes. (Figure 9.7) One technique involves lightly blocking in the views for each detail, using construction lines. CAD detail drawings extracted from 3-D models or created in 2-D CAD are more easily manipulated to provide adequate spacing and positioning of multiple details on a single sheet.

9.2.2 Assembly Drawings

An **assembly drawing** shows how each part of a design is put together. (Figure 9.8) If the design depicted is only part of the total assembly, it is referred to as a **subassembly**. For example, Figure 9.6 is a subassembly drawing of a piston used in an engine.

An assembly drawing normally consists of:

1. All the parts, drawn in their operating position.
2. A **parts list** or **bill of materials (BOM)** (shown in Figure 9.8 at the bottom of the drawing sheet, to the left of the title block), showing the detail number for each part, the quantity needed for a single assembly, the description or name of the part, the catalog number if it is a standard part, and the company part number.
3. Leader lines with balloons, assigning each part a **detail number**, in sequential order and keyed to the list of parts in the parts list. For example, the assembly shown in Figure 9.8 has 21 assigned detail numbers, each with a leader and circle, and detail number 5 in the sectioned assembly view is described as an end cap in the parts list.

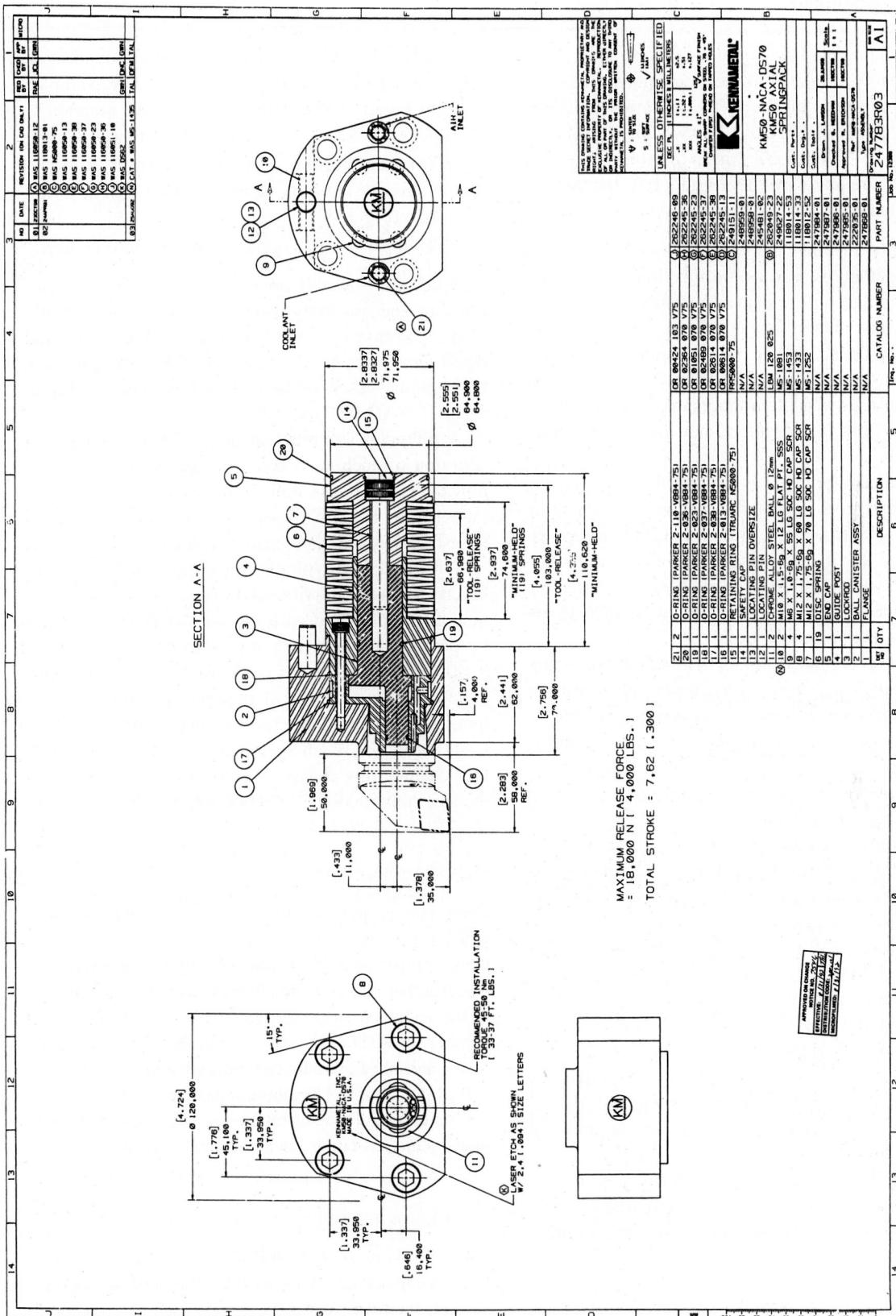

Figure 9.8 Multiview Sectioned Assembly Drawing of a Spring Pack

The front view uses variations of section line symbols to distinguish different parts. (Courtesy of Kennametal.)

4. Machining and assembly operations and critical dimensions related to these functions. In Figure 9.8, the note on the left side view, RECOMMENDED INSTALLATION TORQUE 45–50 Nm (33–37 FT. LBS.), is an assembly operation recommended by the engineer to the person tightening the socket head cap screw.

Assembly drawings are used to describe how parts are put together, as well as the function of the entire unit; therefore, complete shape description is not important. The views chosen should describe the relationships of parts, and the number of views chosen should be the minimum necessary to describe the assembly. It is fairly common to have a single orthographic assembly view, such as the front view, without showing a top and profile view.

An assembly drawing is produced by tracing the needed views from the detail drawings, or by creating the drawing from scratch. With 2-D CAD, it is possible to copy detail views, then place them on the assembly drawing. With 3-D models, simply assemble all the models, then determine the line of sight to extract the needed assembly view.

Dimensions are not shown on assembly drawings, unless necessary to provide overall assembly dimensions, or to assist machining operations necessary for assembly.

Also, hidden lines are omitted in assembly drawings, except when needed for assembly or clarity.

The three basic types of assembly drawings are: outline, sectioned, and pictorial.

An **outline assembly** gives a general graphic description of the exterior shape. (Figure 9.9) Outline assemblies are used for parts catalogs and installation manuals, or for production when the assembly is simple enough to be visualized without the use of other drawings. Hidden lines are omitted, except for clarity.

A **sectioned assembly** gives a general graphic description of the interior shape by passing a cutting plane through all or part of the assembly. (See Figure 9.8) The section assembly is usually a multiview drawing of all the parts, with one view in full section. Other types of sections, such as broken-out and half sections, can also be used.

Chapter 7, “Section Views,” describes the important conventions that must be followed when assemblies are sectioned. These conventions are summarized as follows:

1. Standard parts, such as fasteners, dowels, pins, bearings, and gears, and nonstandard parts, such

as shafts, are not sectioned; they are drawn showing all their exterior features. For example, in Figure 9.8, fasteners, such as part number 7, socket head cap screw, are not sectioned.

2. Adjacent parts in section are lined at different angles, using the cast iron or other type of symbol. (Figure 9.8)
3. Thin parts, such as gaskets, are shown solid black.

Sectioned assembly drawings are used for the manufacture and assembly of complicated devices. With CAD, a sectioned assembly can be created by copying detail views and editing them. A 3-D model can also be sectioned to create a sectioned assembly. (Figure 9.10) © CAD Reference 9.1

A **pictorial assembly** gives a general graphic description of each part, and uses center lines to show how the parts are assembled. (Figure 9.11) The pictorial assembly is normally an isometric view and is used in installation and maintenance manuals.

With 2-D CAD, pictorial assembly drawings can be created using traditional techniques. A 3-D CAD model can also be used to create pictorial assemblies by positioning each part in a pictorial view. (Figure 9.12) Center lines and a parts list are added to complete the drawing. With more sophisticated CAD systems, the part models are referenced from a central CAD database. When specifications on an individual part change, this change is automatically reflected in the assembly model. © CAD Reference 9.2

9.2.3 Part Numbers

Every part in an assembly is assigned a **part number**, which is usually a string of numbers coded in such a way that a company can keep accurate records of its products. For example, in Figure 9.8, the part with detail number 5 in the sectioned assembly drawing has a company part number of 247987-01, as shown in the parts list. Some assemblies are extremely complicated, with thousands of parts. For example, large aircraft have thousands of parts, and considerable documentation is necessary to design, manufacture, assemble, and maintain the aircraft.

9.2.4 Drawing Numbers

Every drawing used in industry is assigned a number. Each company develops its own standard numbering system, based on various criteria, such as sequential numbers, combinations of numbers and letters, sheet

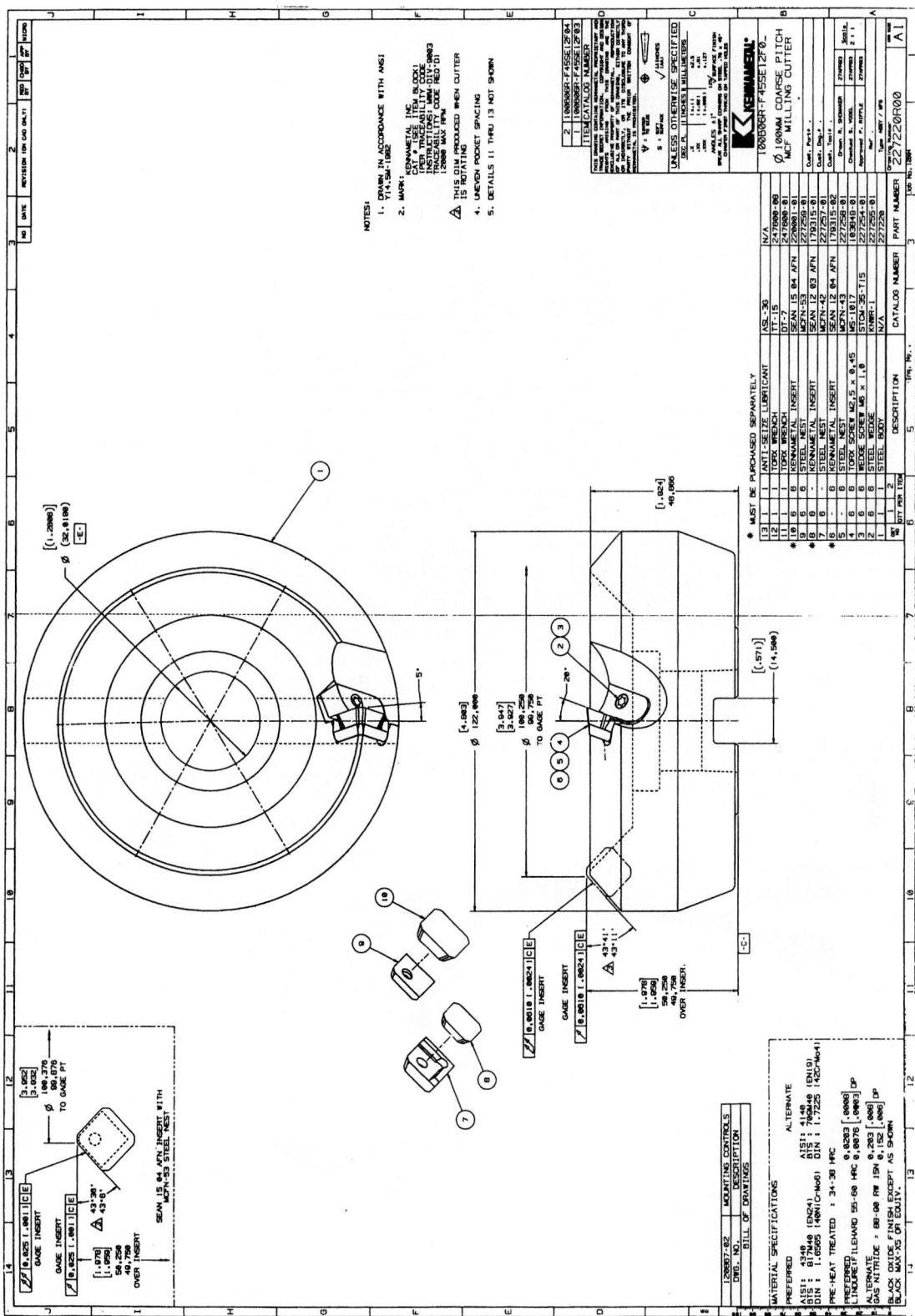

Figure 9.9 Outline Assembly Drawing of a Milling Cutter

(Courtesy of Kennametal.)

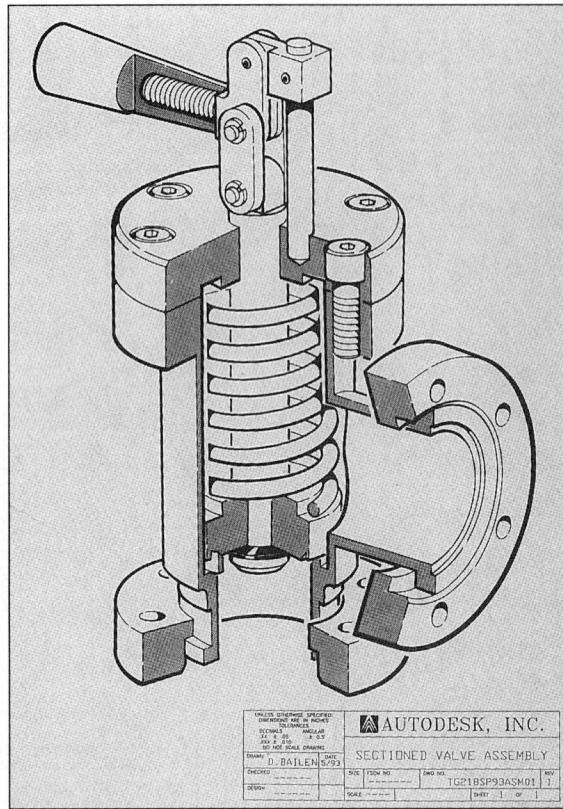

Figure 9.10 Sectioned Assembly Drawing Created with CAD

Sectioned assembly drawings are used by assembly technicians to determine how complicated devices are assembled. (Irwin drawing contest winner, Doug Bailen, Purdue University.)

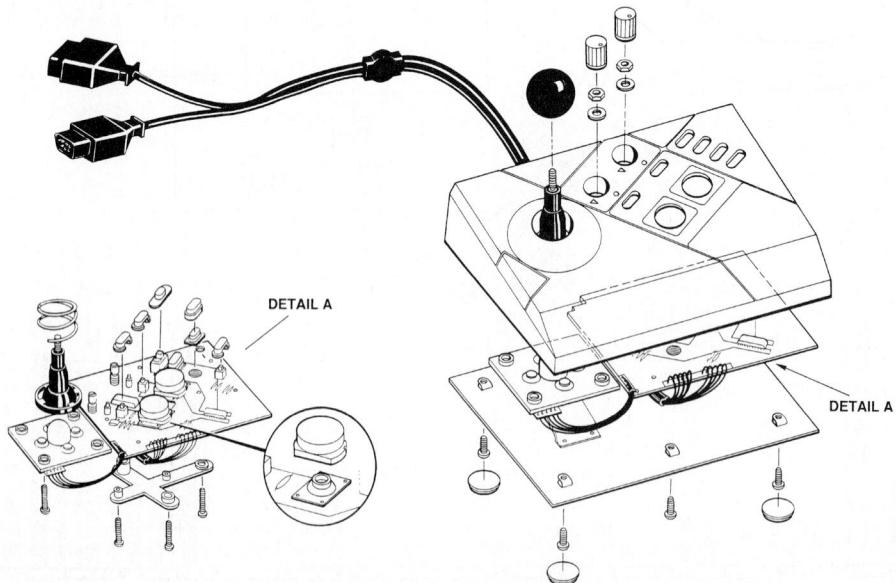

Figure 9.11 Pictorial Assembly Drawing of a Computer Game Joystick

(Courtesy of James Mohler.)

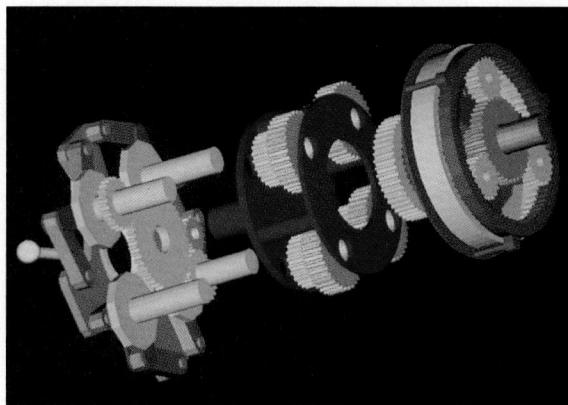

Figure 9.12 Pictorial Shaded Assembly Drawing Made from a 3-D CAD Model

(Courtesy of Rasna, Inc. Infinitely variable transmission design performed by Epilogics Inc., using Rasna Corporation's MECHANICA Applied Motion performance optimization software.)

sizes, number of parts in the assembly, model numbers, function, etc. Going back to Figure 9.8, the **drawing number** assigned is 247783R03, which can be found at the lower right-hand corner of the drawing sheet in the bottom of the title block.

Both part numbers and drawing numbers are commonly used to name CAD files and code information for companywide CIM databases. This coordination between drawings and electronic information simplifies retrieval and updating of design information.

9.2.5 Title Blocks

Title blocks are used to record all the important information necessary for the working drawings. The title block is normally located in the lower right corner of the drawing sheet. Figure 9.13 shows the ANSI standard formats for full and continuation title blocks. A continuation title block is used for multiple-sheet drawings and does not contain as much detail as the title block found on the first sheet. Many industries use their own title block formats.

Title blocks should contain the following:

1. Name and address of the company or design activity. (Figure 9.13A)
2. Title of the drawing. (Figure 9.13B)
3. Drawing number. (Figure 9.13C)
4. Names and dates of the drafters, checker, issue date, contract number, etc. (Figure 9.13D)
5. Design approval, when subcontractors are used. (Figure 9.13E)

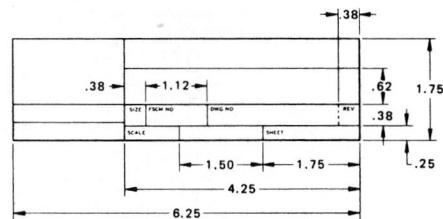

NOTE: All dimensions are in inches. 1 inch = 25.4 mm.
TITLE BLOCK FOR A, B, C, AND G - SIZES

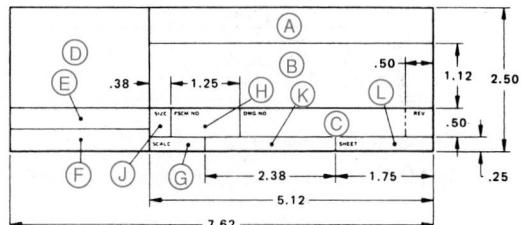

NOTE: All dimensions are in inches. 1 inch = 25.4 mm.
TITLE BLOCK FOR D, E, F, H, J, AND K - SIZES

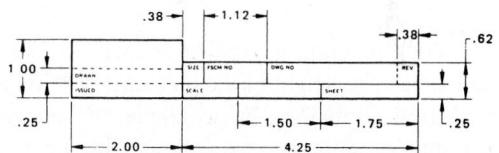

NOTE: All dimensions are in inches. 1 inch = 25.4 mm.
CONTINUATION SHEET TITLE BLOCK FOR A, B, C, and G - SIZES

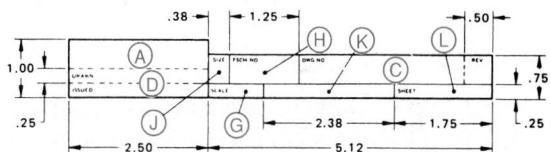

NOTE: All dimensions are in inches. 1 inch = 25.4 mm.
CONTINUATION SHEET TITLE BLOCK FOR D, E, F, H, J, AND K - SIZES

Figure 9.13 ANSI Standard Title Blocks

(ANSI Y14.1-1980.)

6. Additional approval block. (Figure 9.13F)
7. Predominant drawing scale. (Figure 9.13G)
8. Federal supply code for manufacturers (FSCM) number. (Figure 9.13H)
9. Drawing sheet size letter designation. (Figure 9.13J)
10. Actual or estimated weight of the item. (Figure 9.13K)
11. Sheet number, if there are multiple sheets in the set. (Figure 9.13L)

Other information that can be entered in a title block includes surface finish, hardness of material, and heat treatment.

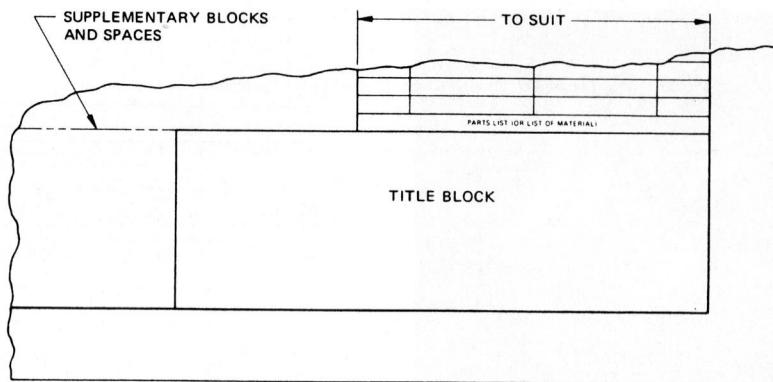

Figure 9.14 Standard Parts List

The parts list runs vertically for as many rows as are needed to list the parts. (ANSI Y14.1-1980.)

Title block lettering is vertical or inclined Gothic capital letters. The height of the text varies by importance of the information. For example, the drawing number should be the largest, followed by the name of the part and the name of the company. **CAD Reference 9.3**

9.2.6 Parts Lists

A complete set of working drawings must include a detailed *parts list* or *bill of material*. Based on ANSI standards, a parts list should be located in the lower right corner above the title block. (Figure 9.14) Additional parts lists may be located at the left of and adjacent to the original block (ANSI Y14.1-1980). As an example, in Figure 9.8, the parts list is located to the left of the title block. A parts list must include a minimum amount of information necessary to manufacture and assemble the part. The information normally included in a parts list is as follows:

1. Name of the part.
2. A detail number for the part in the assembly.
3. The part material, such as cast iron or bronze.
4. The number of times that part is used in the assembly.
5. The company-assigned part number.
6. Other information, such as weight, stock size, etc.

Parts are listed in the general order of size or importance in an assembly. For example, the main body of a part would be assigned detail number 1. If a parts list is started with the labels on the top, then the parts are listed in ascending order from top to bottom. If the parts list is started with the labels on the bottom, then the parts are listed in descending order from top to bottom. (See Figure 9.6, upper-right corner) This technique is used so that new parts added to an assembly can be added to the parts list without affecting the numbering sequence.

Information on standard parts, such as threaded fasteners, includes the part name and size or catalog number. For example, in Figure 9.15, information on the head liner bushing would be obtained from the tabular drawing from an engineering catalog. Such information includes critical dimensions and model number, such as HL-64-22.

Often, parts manufacturers have their parts listed in an electronic format for use with a CAD system. The parts information is available on disk or CD-ROM. Parts information from outside vendors and parts produced in-house can be merged together into a single CAD database. When assembly drawings are produced with 2-D or 3-D CAD, software working with the CAD system can automatically inventory all parts used in the assembly and generate a parts list. **CAD Reference 9.4**

APPLICATIONS:

Similar to an L bushing, but with a head to resist heavy axial loads. Head liners are permanent bushings used to hold renewable drill bushings. The head liner's ID has a precise sliding fit with the renewable bushing's OD. The hardened head liner accurately locates the renewable bushing and protects the jig plate from wear caused by frequent bushing replacement. Note: The "length" listed for a head liner refers to its overall length, not its length under the head. Metric head-liner bushings are the same as metric head-press-fit bushings.

USA

BODY OD	F DIA	G
1/2	5/8	3/32
3/4	7/8	3/32
1	1-1/8	1/8
1-3/8	1-1/2	1/8
1-3/4	1-7/8	3/16
2-1/4	2-3/8	3/16
2-3/4	2-7/8	3/16

For dimensions of larger USA sizes, see page 37 (Extended Range).

METRIC

BODY OD	F DIA	G
12mm	15mm	3mm
15mm	18mm	3mm
18mm	22mm	4mm
22mm	26mm	4mm
26mm	30mm	4mm
30mm	34mm	5mm
35mm	39mm	5mm
42mm	46mm	5mm
48mm	52mm	5mm
55mm	59mm	5mm
62mm	66mm	6mm
70mm	74mm	6mm
78mm	82mm	6mm
85mm	90mm	6mm
95mm	100mm	6mm
105mm	110mm	6mm
115mm	120mm	6mm
125mm	130mm	6mm

ORDERING EXAMPLES:

HL-20-16 Standard USA liner bushing

HL-20-16U Unground OD

HM-18-25-12.00 Standard metric liner bushing (same as metric press-fit type)

Prices shown here apply to standard bushings only, either ground or unground OD, for a standard ID size.

STANDARD LINER ID TOLERANCES:

5/16"	+.0001/.0004	8 to 10mm	+.005/.014mm
1/2"	+.0002/.0005	12 to 18mm	+.006/.017mm
3/4"	+.0003/.0006	22 to 30mm	+.007/.020mm
1"	+.0004/.0007	35 to 48mm	+.009/.025mm
1-3/8"	+.0006/.0010	55 to 78mm	+.010/.029mm
1-3/4"	+.0008/.0012	85 to 105mm	+.012/.034mm
2-1/4"	+.0010/.0015		

ID RANGE	OD	LENGTH	ANSI PART NO.	PRICE 1-5
5/16	1/2 .5017-.5014 (.520-.515 UNG)	5/16	HL-32-5	7.22
		3/8	HL-32-6	7.83
		1/2	HL-32-8	7.83
		3/4	HL-32-12	8.49
		1	HL-32-16	11.07
		1-3/8	HL-32-22	13.61
1/2	3/4 .7518-.7515 (.770-.765 UNG)	5/16	HL-48-5	7.52
		3/8	HL-48-6	7.83
		1/2	HL-48-8	7.83
		3/4	HL-48-12	8.49
		1	HL-48-16	9.75
		1-3/8	HL-48-22	11.36
		1-1/2	HL-48-24	12.33
		1-3/4	HL-48-28	13.24
		2-1/8	HL-48-34	15.41
3/4	1 1.0018-1.0015 (1.020-1.015 UNG)	1/2	HL-64-8	9.45
		3/4	HL-64-12	10.11
		1	HL-64-16	10.71
		1-3/8	HL-64-22	11.36
		1-1/2	HL-64-24	12.64
		1-3/4	HL-64-28	14.26
		2-1/8	HL-64-34	14.87
		2-1/2	HL-64-40	17.70
		3	HL-64-48	27.37
		1/2	HL-88-8	12.81
1	1-3/8 1.3772-1.3768 (1.395-1.390 UNG)	3/4	HL-88-12	11.36
		1	HL-88-16	12.81
		1-3/8	HL-88-22	13.96
		1-1/2	HL-88-24	14.92
		1-3/4	HL-88-28	16.18
		2-1/8	HL-88-34	18.23
		2-1/2	HL-88-40	20.99
		3	HL-88-48	36.71
		3/4	HL-112-12	15.71
		1	HL-112-16	16.50
1-3/8	1-3/4 1.7523-1.7519 (1.770-1.765 UNG)	1-3/8	HL-112-22	18.12
		1-1/2	HL-112-24	19.20
		1-3/4	HL-112-28	20.34
		2-1/8	HL-112-34	23.24
		2-1/2	HL-112-40	26.13
		3	HL-112-48	42.30
		3/4	HL-144-12	22.44
		1	HL-144-16	20.64
		1-3/8	HL-144-22	22.75
		1-1/2	HL-144-24	23.72
1-3/4	2-1/4 2.2525-2.2521 (2.270-2.265 UNG)	1-3/4	HL-144-28	24.98
		2-1/8	HL-144-34	27.56
		2-1/2	HL-144-40	31.05
		3	HL-144-48	45.50
		3/4	HL-176-12	27.20
		1	HL-176-16	24.68
		1-3/8	HL-176-22	27.56
		1-1/2	HL-176-24	29.00
		1-3/4	HL-176-28	30.76
		2-1/8	HL-176-34	33.69
2-1/4	2-3/4 2.7526-2.7522 (2.770-2.765 UNG)	2-1/2	HL-176-40	37.49
		3	HL-176-48	50.96

QUANTITY DISCOUNTS

Quantity	1	6	12	24	50	100	200	500
Discount %	Net	18%	29%	34%	42%	48%	50%	52%
Multipplier	1.00	.82	.71	.66	.58	.52	.50	.48

Figure 9.15 Typical Page from a Parts Catalog

Part numbers for standard parts are listed in parts catalogs. (Courtesy of Vlier Enerpac.)

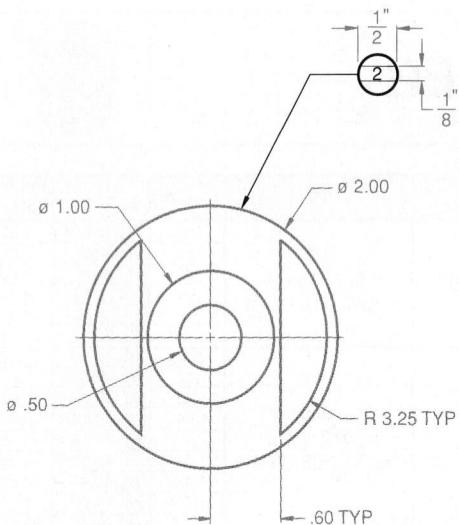**Figure 9.16** Balloons

Balloons are used to identify parts by their assigned number in the assembly.

9.2.7 Part Identification

Parts are identified in assembly drawings by a leader line with an arrow that points to the part. The other end of the leader has a **balloon** showing the part detail number. (Figure 9.16) The balloon is approximately four times the height of the number and placed as close to the part as possible. (Figure 19.17) © CAD Reference 9.5

9.2.8 Revision Block

Drawing revisions occur because of design changes, tooling changes, customer requests, errors, etc. If a drawing is changed, an accurate record of the change must be created and should contain the date, name of the person making the change, description of the change, the change number, and approval. This information is placed in a **revision block** (Figure 9.18), which is normally in the upper right corner of the drawing, with sufficient space reserved for the block to be expanded downward.

A number, letter, or symbol keyed to the revision block identifies the location of the change on the drawing. The most common key is a number placed in a balloon next to the change. For zoned drawings, the change is specified by listing the zone in the revision block.

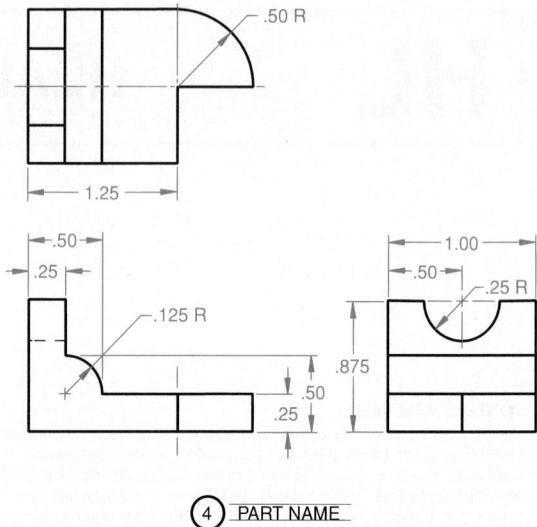**Figure 9.17** Part Name

In detail drawings of an assembly, the part name and detail number are located near one of the views or in the title block.

9.2.9 Scale Specifications

The scale used on a set of working drawings is placed in the title block. (See Figure 9.9) If more than one scale is used, the scale is shown near the detail drawing. Scales are indicated in metric drawings by a colon, such as 1:2; for the English system, an equal sign, such as 1=2, is used.

Common English scales found on engineering drawings are:

1=1	Full
1=2	Half
1=4	Quarter
1=8	Eighth
1=10	Tenth
2=1	Double

Common metric scales include:

1:1	Full
1:2	Half
1:5	Fifth
1:10	Tenth
1:20	Twentieth
1:50	Fiftieth
1:100	Hundredth

The designations **METRIC** or **SI** appear in or near the title block to show that metric dimensions and scale are used on the drawing.

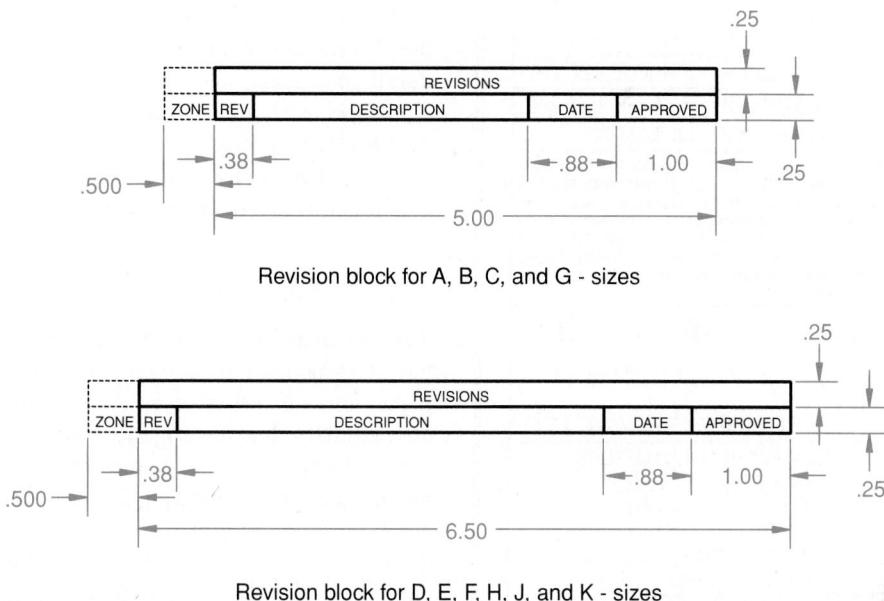

Figure 9.18 Standard Revision Block

(ANSI Y14.1-1980.)

Figure 9.19 Graphics Scale

A graphics scale can also be used, especially on mapping drawings. (Figure 9.19) This graphics scale has calibrations for transferring measurements from the drawing to the scale to determine distances.

CAD drawings are nearly always made full-size so that automatic dimensioning will show the true dimensions. To fit on the paper, CAD drawings are scaled when printed or plotted. The scale number on the CAD plot represents the print/plot scale, not the scale at which the CAD drawing was created. Adjustments must then be made for text size so that the text is not too large or too small when the scaled plot is created.

9.2.10 Tolerance Specifications

Tolerances are specified in a drawing using toleranced dimensions. For those dimensions that are not specifically tolerated, a **general tolerance note** is used. This note is placed in the lower right corner,

near the title block, and usually contains a tolerance and a general statement, such as UNLESS OTHERWISE SPECIFIED.

For example, in Figure 9.20, the general tolerance note specifies the following tolerances for untoleranced dimensions:

One place decimal inches $\pm .1$
 Two place decimal inches $\pm .02$
 Three place decimal inches $\pm .005$
 One place decimal millimeters ± 2.5
 Two place decimal millimeters ± 0.51
 Three place decimal millimeters ± 0.127

The general tolerance note should also contain a general note for angles. In Figure 9.20, the general tolerance note states that unless otherwise specified, all angles are tolerated ± 1 degree.

Refer to Chapter 8, “Dimensioning and Tolerancing Practices,” for a more detailed explanation of tolerances.

9.2.11 Zones

Zones are used on large sheets for reference purposes. Zones in engineering drawings are similar to the zones used on highway maps. Refer back to Figure 9.5 for an example of a standard drawing sheet

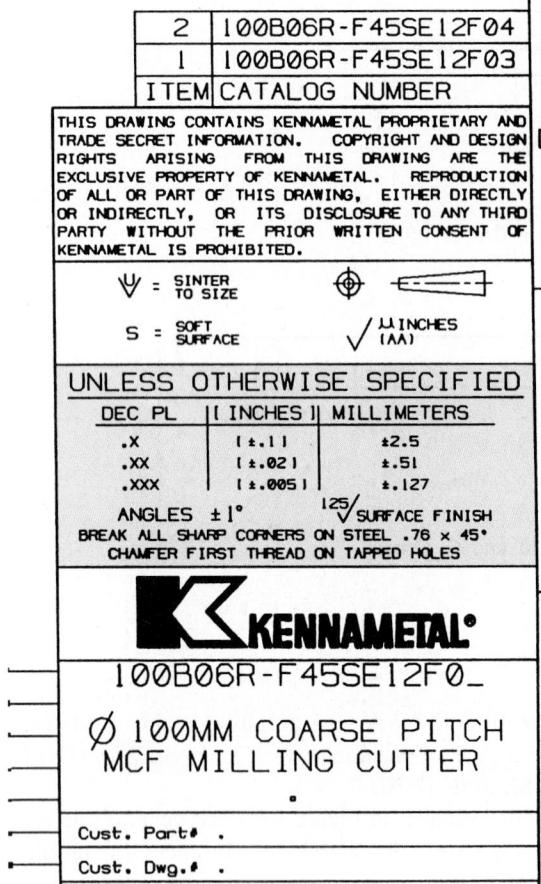

Figure 9.20 General Tolerance Note for Inch and Millimeter Dimensions

(Courtesy of Kennametal.)

with zone markings along the edges. Numerals are used horizontally and letters vertically. To locate a detail in a zone, a letter and number designation would be used, specifying that location. For example, the title block on the E-size ANSI standard drawing sheet is located in zone A-1 and the revision block is located in zone H-1.

9.2.12 Tabular Drawings

Tabular drawings are used when several similar parts have common features. Such parts can be grouped together into a *family of parts*. An example is a series of air cylinders that have many common features, yet vary in length of stroke, diameter of cylinder, etc. Figure 9.21 is a tabular drawing for such air cylinders, and can be used to determine critical dimensions. In the drawing, letters are used for dimensions, instead of numbers. Each letter corresponds to a specific column in the table. For a specific bore size, the table is consulted to determine the actual dimensions for the part. For example, if the cylinder has a $\frac{3}{8}$ " bore, dimension G would be .62, dimension N would be $\frac{1}{4}$, and so on.

The obvious advantage of a tabular drawing is that it saves time. Several parts in a family can be specified in a single engineering drawing, with only those dimensions that vary between parts having to be specified in the table.

Bore	A	B	C	D	E	F	G	H	J	K	L	M	N	P	R	S	T	U	W	Mounting Accessories		
																				Pivot Bkt.	Rod Clevis	Foot Bkt.
$\frac{7}{16}$ "	2.00	.93	.31	.50	.75	.05	.43	.31	10-32	.74	$\frac{7}{16}$ -20	$\frac{3}{16}$ -24	$\frac{3}{16}$	10-32	.15	.25	1.75	0.50	.50	M13S	M14S	M11SS
$\frac{9}{16}$ "	2.00	1.62	.37	.50	.75	.05	.43	.31	10-32	.62	$\frac{7}{16}$ -20	$\frac{7}{16}$ -20	$\frac{3}{16}$	10-32	.15	.25	1.81	1.00	.50	M13S	M14S	M11SO
$\frac{3}{4}$ "	2.56	1.68	.43	.50	.75	.05	.62	.37	1/4NPT	.86	$\frac{5}{16}$ -18	$\frac{1}{2}$ -20	$\frac{1}{4}$	$\frac{1}{4}$ -28	.25	.34	2.28	1.00	.75	M23S	M24S	M21SS
$1\frac{1}{16}$ "	2.81	1.56	.50	.50	.75	.06	.62	.37	1/4NPT	1.12	$\frac{5}{16}$ -18	$\frac{5}{16}$ -24	$\frac{3}{16}$	$\frac{1}{2}$ -24	.25	.34	2.53	1.00	.75	M23S	M24	M21
$1\frac{1}{4}$ "	3.53	1.81	.62	.87	1.12	.09	.71	.50	1/4NPT	1.34	$\frac{3}{16}$ -16	$\frac{3}{16}$ -16	$\frac{7}{16}$	$\frac{7}{16}$ -20	.25	.40	3.12	1.00	.87	M23S	M64S	M61S
$1\frac{1}{2}$ "	3.25	1.68	.62	.87	1.25	.09	.81	.62	1/4NPT	1.56	(-)	$\frac{3}{16}$ -16	$\frac{7}{16}$	$\frac{7}{16}$ -20	.37	.50	2.87	1.00	1.00	M63S	M64S	M61S

*Unthreaded; see Standard Option Section for threaded rear stud mounting.

Note: Spring Forces same as for Model SNHS.

Figure 9.21 Tabular Drawing of an Air Cylinder from a Parts Catalog

(Courtesy of American Cylinders.)

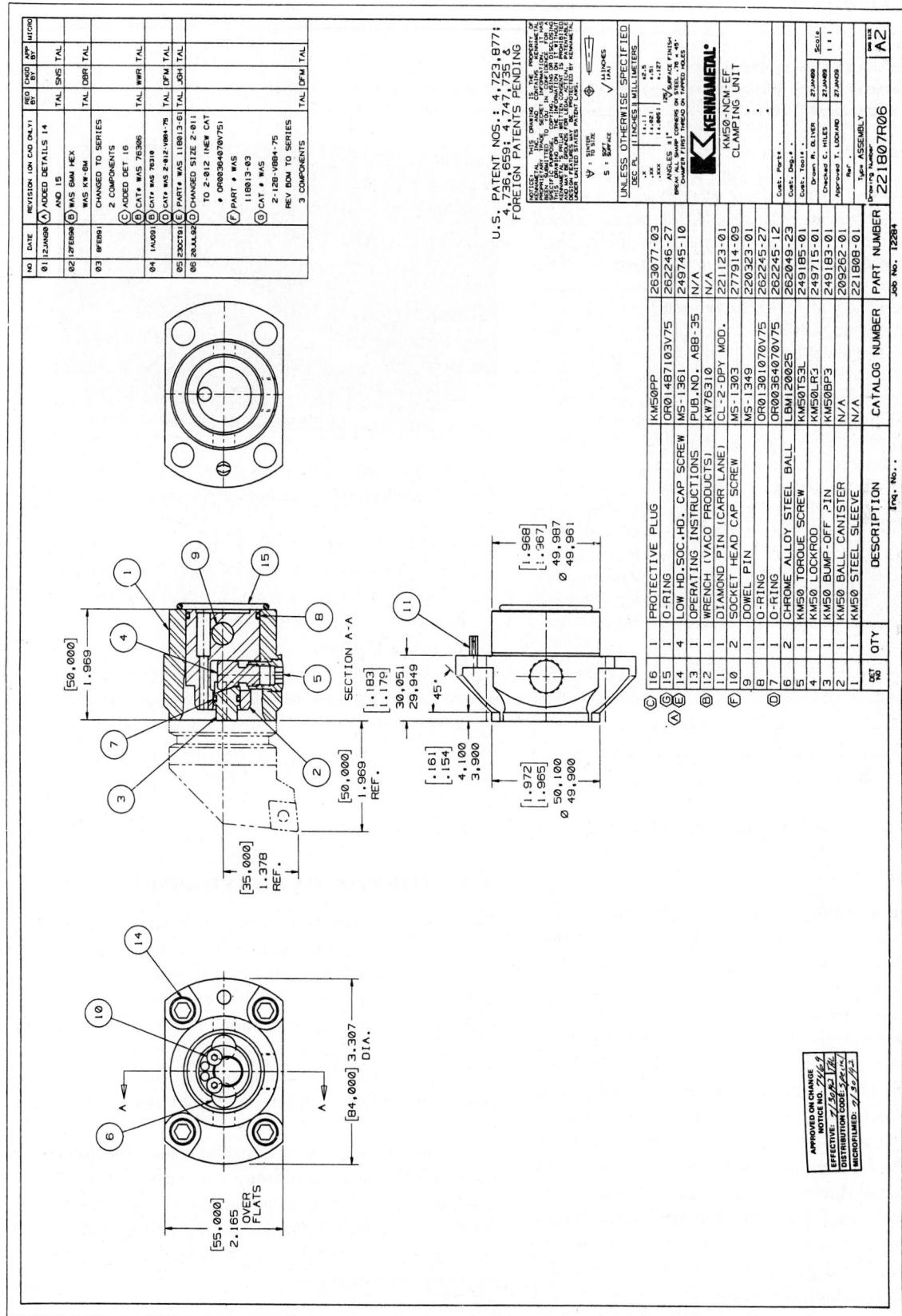

Figure 9.22 A Working Assembly Drawing of a Clamping Unit

(Courtesy of Kennametal.)

Industry Application

Concurrent Engineering and 3-D CAD Produce New Car in Record Time

The Chrysler's Neon is an automobile that was developed in a record time of 31 months, versus the industry standard of four years or more. The car was developed through extensive use of CAD/CAM/CAE tools that were totally integrated. For the first time, designers, engineers, manufacturing personnel, and parts vendors worked off a common data model, which made concurrent engineering a reality for this project.

Designing and building an automobile is a huge task with several distinct stages from concept to finished product. Automobiles have literally thousands of items that need to be designed, manufactured, and assembled. Through the use of CAD, the design and manufacturing was an electronic project from start to finish.

For the first time, no drawings were plotted and used for documentation and specification. Instead, 3-D computer models were sent directly to vendors, either electronically or on tape. The vendors then produced tooling and parts directly from the 3-D database, instead of from parts drawings or prints. Because of the extensive use of CAD models, entire design processes that were previously performed in stages were now handled concurrently.

The Chrysler Neon was designed in only 31 months, using 3-D CAD models and concurrent engineering practices.

Adapted from B. Haase, "The Neon: A Shining Example of Design Efficiency," *Computer Graphics World*, February 1994, pp. 41–44. Photograph courtesy of Chrysler Corporation.

9.2.13 Working Assembly Drawing

A **working assembly drawing**, also known as a **detailed assembly**, combines on a single sheet the detail drawing and the assembly drawing, usually a section view. Such drawings are used for relatively simple assemblies that use some standard parts. Figure 9.22 shows a working assembly drawing of a clamping unit, which has a total of 21 parts, all of which are listed in the QTY (quantity) column of the parts list. Of the 21 parts, only details 1 and 2 are not standard parts. Detail numbers 6 through 16 are all standard parts purchased from other vendors, and therefore do not need detail drawings. Also, parts 3 through 5 are standard in-house parts with their own catalog numbers, so they do not need detail drawings. That leaves only details 1 and 2, which are dimensioned in the front, bottom, and left side views.

9.3 THREADED FASTENERS

Fastening is a method of connecting or joining two or more parts together, using devices or processes. Fasteners are used in nearly every engineered product and structure. (Figure 9.23) For example, structures such as bridges, communications towers, and buildings use many fasteners of several different types in their construction. In addition, products used in medicine, sports, transportation, and piping use fasteners. (Figure 9.24)

One of the most common methods used for fastening is **mechanical fastening**, a process that uses a manufactured device to hold parts of an assembly together. Mechanical fasteners include both threaded and nonthreaded fasteners, such as rivets, keys, pins, snap rings, and clips.

Figure 9.23

The integrity of this bridge depends not only on the quality of its cable and steel, but also on the fasteners which link them.

A **threaded fastener** is a mechanical fastener used to join together two or more parts. Threaded fasteners are formed using a tapping tool for internal threads, a die for external threads, or a machine tool for either internal or external threads.

The first use for a screw thread was probably not as a fastener, but as a means of lifting water. The Archimedes screw was used for this purpose. At first, screw threads were made by hand, from wood or metal. As machine tools such as the lathe developed, screw threads were made to more exacting specifications. However, initially no standards were available, so nuts and bolts from different producers could not be interchanged. When you bought a bolt, you had to buy the matching nut.

Eventually, standards began to emerge. In the 1800s, Joseph Whitworth developed the English standard screw threads. In 1864, the United States adopted its own screw thread standard, based on the thread proposed by William Sellers.

Figure 9.24

Many precision machines require fasteners to hold parts together.

The United States standard thread was different from England's, which later caused problems in World Wars I and II, because spare equipment parts could not be interchanged. In 1948, the *Unified Screw Thread Standard* was established, allowing the United States, England, and Canada to interchange parts. Also, in 1946, the International Organization for Standardization (ISO) began development of the current international system of standard *metric* screw threads.

9.3.1 Applications

The helix is the basic geometric form used for threaded fasteners. A helix is the curve formed by a point moving uniformly at both an angular and a linear rate around a cylinder. The distance that the point moves parallel to the axis during one revolution is called the **lead** or **pitch**, both of which are common terms used in thread technology. A helix has certain mechanical characteristics that make it especially useful for joining, adjusting, and power transmission. Threaded mechanical fasteners are used for these three primary applications.

Joining *Joining* is the process of connecting two or more parts temporarily or permanently. A nut and bolt set is a *temporary fastener*, because it can be removed without being destroyed. This type of fastener is commonly used on devices that need periodic replacement, such as the water pump on a gasoline engine.

Adjusting *Adjusting* is the process of locating or modifying the position of a part. A drafting compass uses a threaded rod to adjust the radial setting.

Power Transmission Screw jacks and certain types of gears use screw threads to transmit power, such as for lifting an automobile. Mechanical *power transmission* is the process of converting or transmitting the force exerted in one direction to a force exerted in the same or a different direction.

9.3.2 Thread Terminology

The terms described in this section are the ones used most for representing threads on technical drawings. (Figure 9.25) For a complete list of terms and definitions related to screw threads, refer to ANSI/ASME Standard B1.7M-1984.

Axis—the longitudinal center line that passes through the screw thread cylinder.

Chamfer—the angular relief at the last thread, to allow easier engagement with the mating part.

Crest—the peak or top surface of a screw thread.

Depth—the distance between the crest and the root of a thread, measured normal to the axis.

Die—a tool used to form external threads.

External thread—the screw thread on the outside of a cylindrical or conical surface.

Internal thread—the screw thread on the inside of a cylindrical or conical surface.

Lead—the distance a screw will travel when turned 360 degrees, or one revolution.

Major diameter—the largest diameter on an internal or external thread.

Minor diameter—the smallest diameter on an internal or external thread.

Pitch—the distance between corresponding points on adjacent thread forms, measured parallel to the axis. The pitch is equal to the number 1 divided by the number of threads per inch. For example, a screw thread with 12 threads per inch would have a pitch of $1/12$.

Pitch diameter—the diameter of an imaginary cylinder that is located equidistant between the major and minor diameters.

Root—the bottom of a screw thread cut into a cylinder.

Screw thread—a continuous and projecting helical ridge on a cylindrical or conical surface.

Side—the screw thread surface that connects the crest and root.

Tap—a tool used to make threads in holes.

Tap drill—a drill bit used to make a hole in metal before tapping an internal thread.

Thread angle—the angle between the surfaces of two adjacent threads.

Thread form—the profile or shape of a thread cut into a cylinder.

Thread series—the number of threads per inch for a given diameter.

Threads per inch—the number of threads in one inch, measured axially (parallel to the axis); the reciprocal of the pitch.

9.3.3 Thread Specifications: English System

To specify a thread, you must provide a minimum of five pieces of information:

1. Thread form
2. Thread series
3. Major diameter
4. Class of fit
5. Threads per inch

Normally, thread specifications are given in the form of a note, using abbreviations and numerical information. The text of the note is done in $1/8$ " or 3 mm sized lettering.

Thread tables are used for specifying thread notes on technical drawings. Thread tables are found in the *Machinery's Handbook*, and a few are included in Appendices 13–40.

Form Thread form is the shape or profile of a screw thread. Many types of thread forms have been developed. (Figure 9.26)

The *sharp-V* thread was originally developed by William Sellers. It is generally used only where increased friction is necessary, such as in set screws or on brass pipes. The *American National* thread

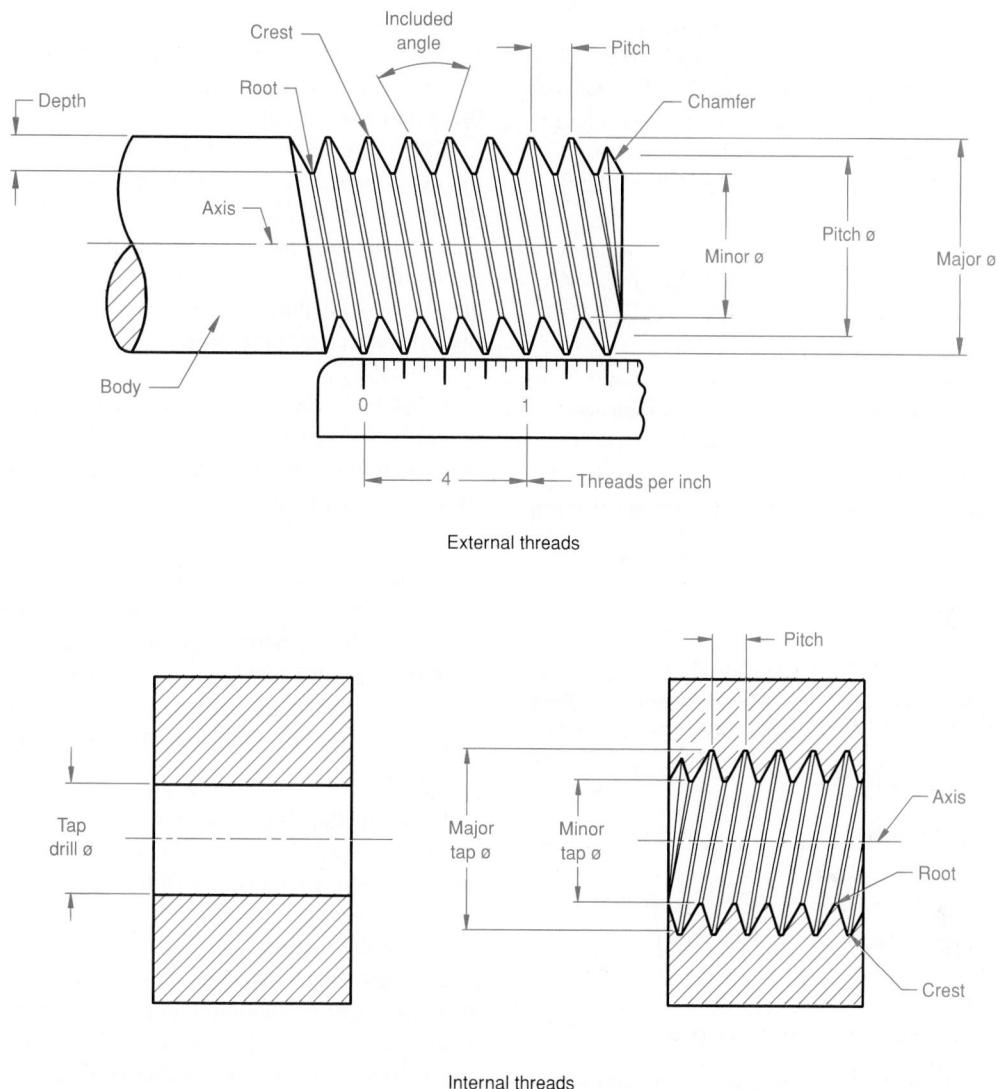

Figure 9.25 Screw Thread Terminology Used with Internal and External Threaded Features

replaced the sharp-V thread and is stronger than the sharp-V thread. This thread form flattens the crest and root of the thread. The *Unified* thread is the current standard used in the United States, Canada, and England. This thread form rounds the root and either rounds or leaves the crest as a sharp V. The symbol for a Unified thread in a thread note is UN. (For a complete listing of screw thread designations, refer to ANSI Y14.6-1978, "Screw Thread Representation.")

A variation on the Unified thread is the *Unified National Round* thread, abbreviated UNR. The UNR has a rounded root and is specified only for external threads.

The *metric* thread is the international standard thread that is similar in shape to the Unified thread. The crests and roots are flat, but the depth is less than that of the Unified thread.

The *Acme*, *square*, and *buttress* threads are used primarily to transmit power in gearing and other types of machines. The *knuckle* thread is usually rolled from sheetmetal or cast, and is used for lightbulb bases, bottle caps, and glass jars.

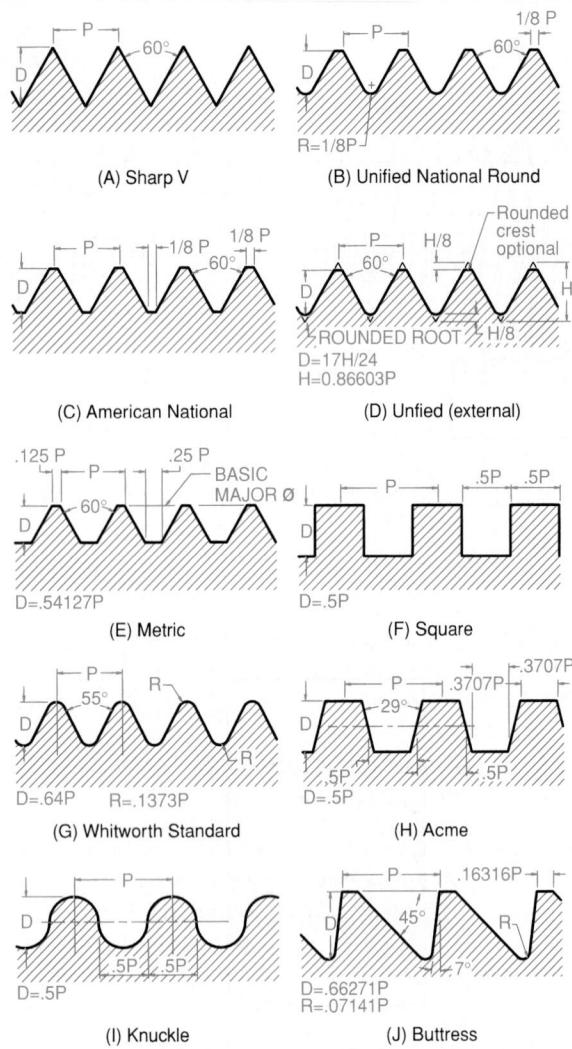

Figure 9.26 Profiles of Standard Screw Thread Forms Used in Industry

Series The thread series refers to the standard number of threads per inch, and there are four classes: coarse (C), fine (F), extra fine (EF), and constant pitch (Appendix 13). When used with the Unified thread, they are abbreviated UNC, UNF, and UNEF. The constant pitch series threads are 4, 6, 8, 12, 16, 20, 28, and 32.

Coarse series fasteners are used for quick assembly or disassembly of cast iron, soft metals, and plastic, and are designated NC or UNC.

Fine series fasteners are used when a great deal of force is necessary for assembly, and are designated NF or UNF. These fasteners are used extensively in the aerospace and automotive industries.

Extra fine series fasteners are used when the length of engagement is short and the application calls for high degrees of stress. They are designated NEF or UNEF.

The **constant pitch series** is specified by writing the number before the form designation. These threads are for special purposes, such as large-diameter or high-pressure environments.

Class of Fit There are three classes of fit established by ANSI for general use. Designated 1, 2, and 3, the classes indicate the tolerance or tightness of fit between mating threaded parts.

Class 1—a loose fit where quick assembly is required and looseness or play between parts is acceptable.

Class 2—a high-quality, general purpose, commercial class of fit for bolts, nuts, and screws widely used in mass production.

Class 3—a very high-quality threaded fastener with a close fit, used for precision tools and for high stress and vibration applications.

Refer to the *Machinery's Handbook*, Table 4, "Screw Thread Systems," for the actual upper and lower limits of each class of fit for a particular thread.

Single and Multiple Threads A *single thread* fastener advances the distance of one pitch (1P) for every 360 degrees of revolution; therefore, the pitch is equal to the lead. The single thread is the nominal type of thread found where considerable pressure or power is needed. (Figure 9.27)

A *multiple thread* fastener has two or more threads that run side by side. For example, a *double thread* fastener has two threads with a lead equal to 2, which results in the threaded part advancing two pitches (2P) in one 360-degree revolution. Multiple threads are used where quick assembly and disassembly are more important than power, such as in valve stems and drafting compasses.

Right- and Left-Hand Threads Most fasteners tighten when turned clockwise and loosen when turned counterclockwise. Such fasteners have *right-hand threads*. A *left-hand thread* fastener is one that

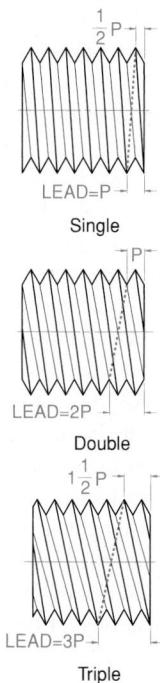

Figure 9.27 Single and Multiple Screw Thread Forms

will assemble when turned counterclockwise. Threaded fasteners are assumed to be right-handed, unless noted with the left-hand designation LH in the thread note.

Thread Pitch Thread pitch is equal to 1 divided by the number of threads per inch. A fastener with 4 threads per inch would have a pitch of $\frac{1}{4}$, and a fastener with 16 threads per inch would have a pitch of $\frac{1}{16}$. Fasteners with a pitch of $\frac{1}{4}$ would have larger threads than those with a pitch of $\frac{1}{16}$. The number of threads per inch is determined by using a thread pitch gage or a scale. (Figure 9.28)

Thread Notes Threads are only symbolically represented on drawings; therefore, thread notes are needed to provide the required information. A thread note must be included on all threaded parts, with a leader line to the external thread or to an internal thread in the circular view. The recommended thread note size is $\frac{1}{8}$ " or 3 mm lettering, whether done by hand or with CAD. The thread note must contain all the information necessary to specify the threads

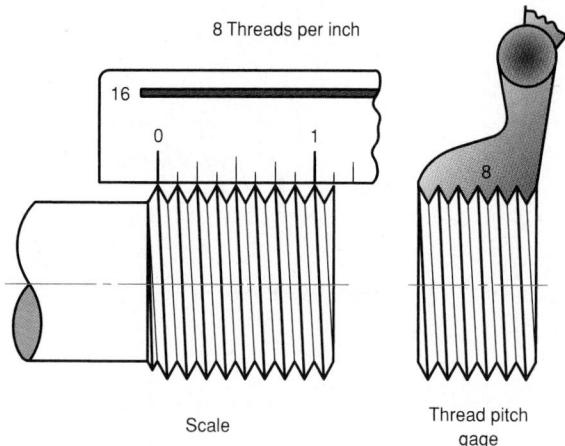

Figure 9.28 Measuring Thread Pitch Using a Scale and a Thread Pitch Gage

completely. (Figure 9.29) External thread notes are given in the longitudinal view. Internal thread notes are given on the end view, with a pointer to the solid circle.

A thread note should contain the following information, in the order given:

1. *Major diameter*, in three-place decimal form, followed by a dash. Fractional sizes are permitted. If a standard number designation is used, the decimal equivalent should be given in parentheses, such as *No. 10 (.190)-32 UNF-2A*.
2. *Number of threads* per inch, followed by a space.
3. *Thread form* designation.
4. *Thread series* designation, followed by a dash.
5. *Thread class* designation (1, 2, or 3).
6. *Internal or external* symbol (A is for external threads, B is for internal threads), followed by a space.
7. *Qualifying information*, such as:
LH for left-hand threads. If the thread is right-hand, RH is omitted.
DOUBLE or TRIPLE for multiple threads.
Thread length.
Material.

Thread notes can also provide information about tap drill depth and size, drill and thread depths,

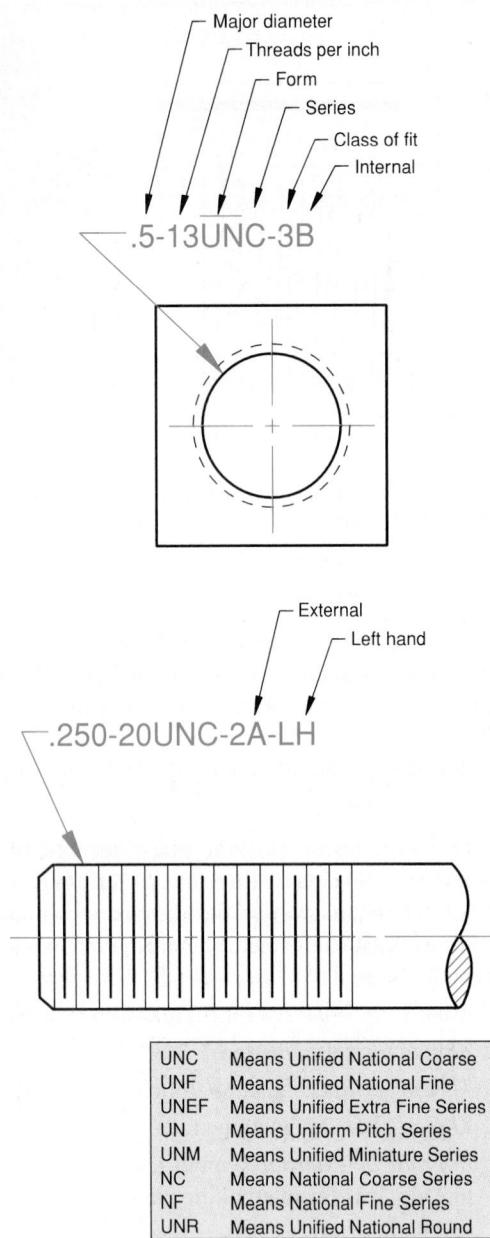

Figure 9.29 Standard Thread Note for English Dimension Fasteners

countersinking, counterboring, and number of holes to be threaded. (Figure 9.30) Tap drill sizes are shown in Appendix 15 and are found in *Machinery's Handbook*, Table 3, in the section "Tapping and Thread Cutting."

Refer to ANSI Y14.6-1978 for more detailed examples of thread notes. © CAD Reference 9.6

Thread Grades Most fasteners used in machine design are made from steel. The composition of the steel determines the fastener's *grade*. Grade numbering follows one of several standards. For example, the Society of Automotive Engineers (SAE) grades fasteners using numbers from 1 through 8. The higher the number, the greater the fastener's strength. Metric bolts and screws use a numerical coding system which ranges from 4.6 to 12.9, with the higher numbers representing higher strengths.

Refer to the *Machinery's Handbook*, "Bolts, Screws, Nuts, and Washers—Working Strengths of Bolts," to determine the specifications for bolt strength.

Practice Exercise 9.1

Get a threaded fastener such as a bolt from your instructor or from a hardware store. Use a scale to determine the number of threads per inch and the pitch of the bolt. Determine the thread form by comparing the threads on the bolt to the thread forms in Figure 9.26. Use a scale to determine the nominal major diameter of the bolt. Look at the head of the bolt and determine its grade by comparing what you see with the appropriate table in the *Machinery's Handbook*.

9.3.4 Thread Specifications: Metric System

Metric thread specifications are based on ISO recommendations and are similar to the Unified standard. ANSI Y14.6aM-1981 can be referenced when specifying metric threads. (See Appendix 14) The basic designation for a metric thread is shown in Figure 9.31. The note specifies that the thread is metric (M), the diameter of the thread is 24 millimeters, followed by the multiplication sign \times , and the pitch is 2 millimeters. Metric threads are either a general-purpose coarse thread or a fine thread.

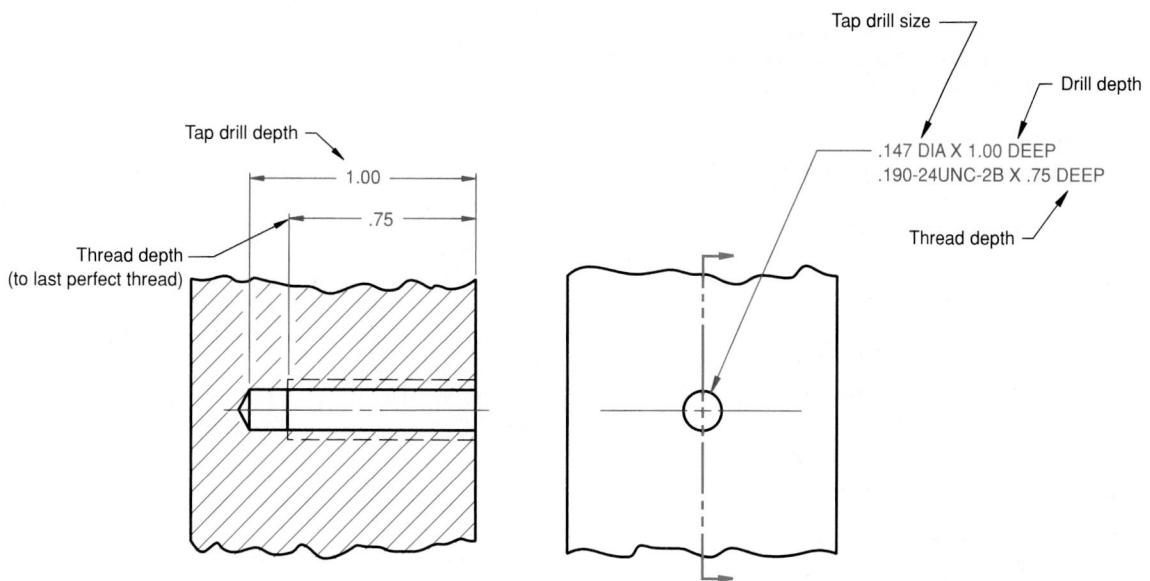

Figure 9.30 Standard Thread Note for Specifying Tap Drill Size

A complete metric thread note, shown in Figure 9.32, should contain the following information, in the order given:

1. *Thread form symbol*. The letter M is used to designate the metric profile. The J profile class is a modified M profile.
2. *Nominal size* (basic major diameter) in millimeters, followed by an x.
3. *Pitch* in millimeters, followed by a dash. The pitch can be eliminated for coarse threads, but it is preferred in the American use of the standards.
4. *General purpose tolerance*, which for external metric threads is 6g, and for internal metric threads is 6H. For closer fits, 6H is used for internal threads and 5g6g is used for external threads. The tolerance class designation then includes:

Pitch diameter tolerance: grade, position
 Minor diameter tolerance: grade, position

For external threads, designate tolerance positions using lowercase letters. For internal threads, designate tolerance positions using uppercase letters. For a left-hand thread, add a dash after the last position tolerance, then the letters LH. Closer fitting threads for mating parts are specified with a slash followed by the closer tolerance designation, such as /5g6g.

9.3.5 Thread Drawings

Most threads are difficult to represent graphically in their true form. The three conventional methods for drawing thread forms are detailed, schematic, and simplified. (Figure 9.33) The *detailed* thread representation is the most realistic, but is more difficult and time consuming to draw and is rarely used on technical drawings. Its use is normally limited to illustrations. The *schematic* and *simplified* representations are easier to draw and are more widely used in technical drawings, with the simplified representation being the most common. Generally, only one of the three methods is used on a single drawing, but they may be mixed if necessary.

Simplified Representation The simplified method of representing threads is the quickest and easiest technique, whether using hand tools or CAD, and can be used for all thread forms, including metric. Simplified external threads are shown in Figure 9.33 for both chamfered and unchamfered ends. The threaded portion is shown using dashed lines that are drawn parallel to the axis at the approximate depth of the minor diameter. When the fastener is drawn in section, the dashed lines are drawn on the section view. (This is one of the few exceptions where hidden lines are drawn on a section view.)

Industry Application Design for Manufacturability (DFM) Reduces Number of Fasteners

DFM AT WORK

Before DFM analysis, the 1993 Camaro/Firebird front corner assembly was to be manufactured on what is called a nonsynchronous palletized-assembly machine. In the assembly process, each bolt would have been driven and the bearing flange rotated by separate, sequential stations. Further complicating matters was that

one bolt was longer than the others and required a nut. After DFM analysis, engineers decided to build the assembly upside down. This permits using four identical bolts and driving them simultaneously. The process also eliminates the nut. And the assembly does not move down a line. Instead, parts come to the assembly, with few transfers and little orienting.

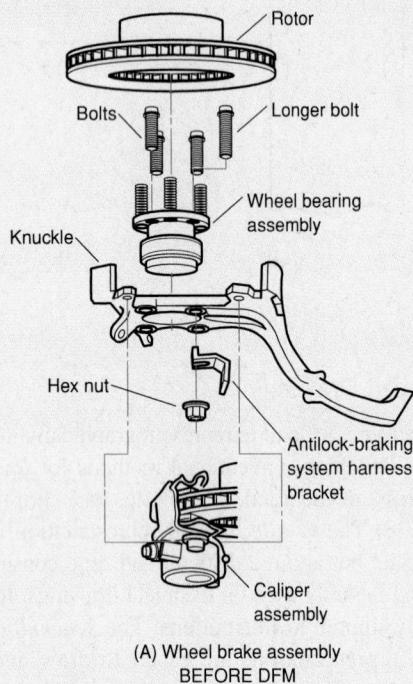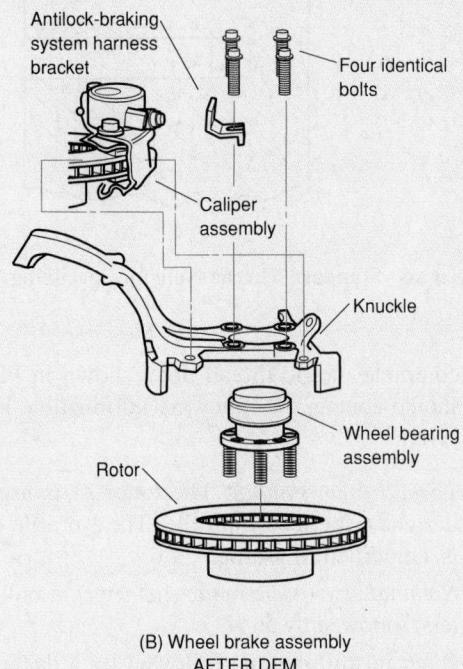

Wheel Brake Assembly before DFM

Wheel Brake Assembly after DFM

From: N. Green and M. Reder, "DFM Boosts U.S. Car Quality," *Machine Design*, May 14, 1993, pp. 61–64.

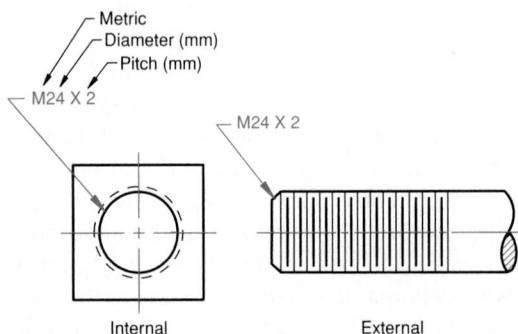

Figure 9.31 Basic Metric Thread Note for Specifying Threads

Schematic Representation The schematic representation approximates the appearance of screw threads with lines drawn approximately equal to the pitch of the thread. When the number of threads per inch is too great to represent clearly, the spacing is slightly enlarged.

Figure 9.34 shows the schematic and simplified representation of internal threads for through, blind, and bottom tapped holes. The major and minor diameters are represented as two equal-length, parallel, hidden lines, for both the schematic and simplified thread representations.

Assembly Sections A threaded fastener in an assembly section is not sectioned. (Figure 9.35) Because they are too small to be shown clearly in section, nuts,

Tolerance specified

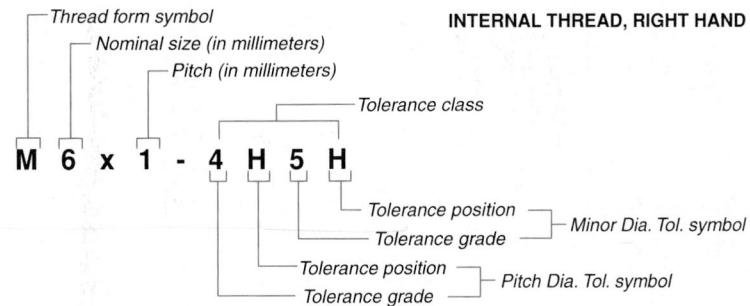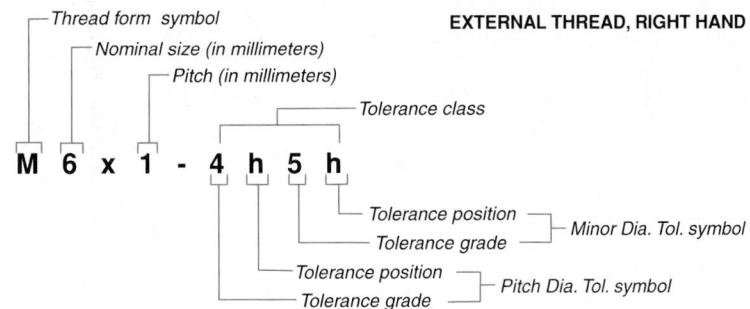

Figure 9.32 Complete Metric Thread Note

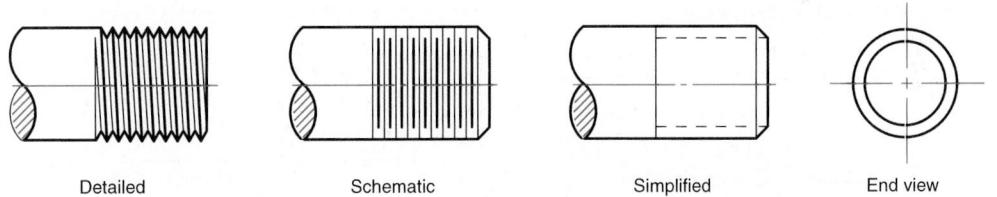

External threads

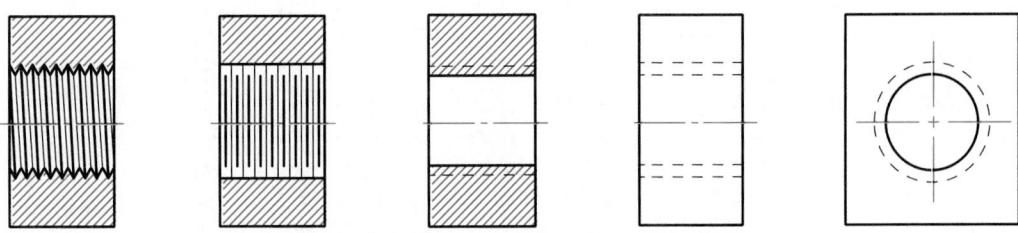

Internal threads

Figure 9.33 Conventional Graphic Thread Form Representation Types: Detailed, Schematic, and Simplified

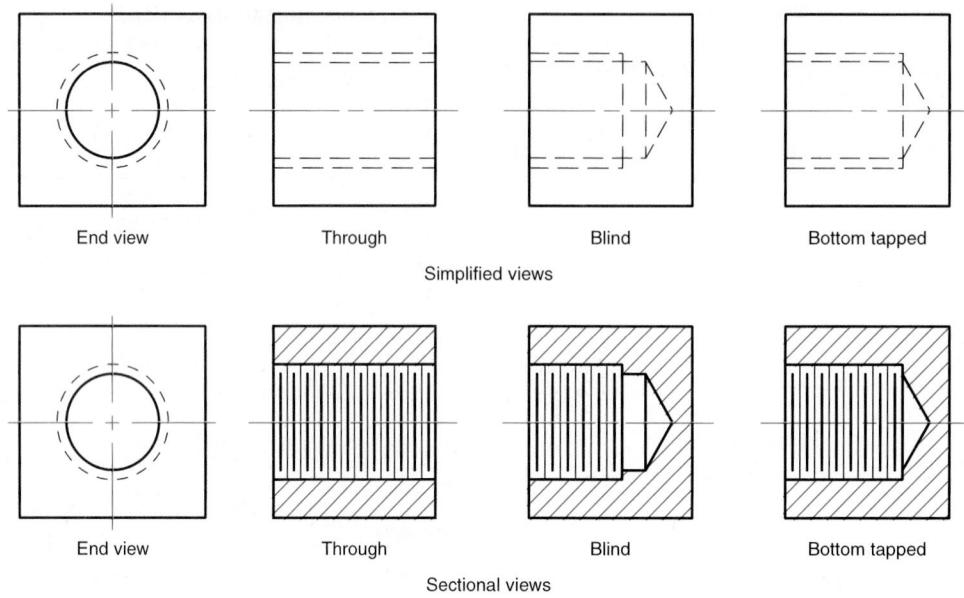

Figure 9.34 Schematic Representation of Internal Threads

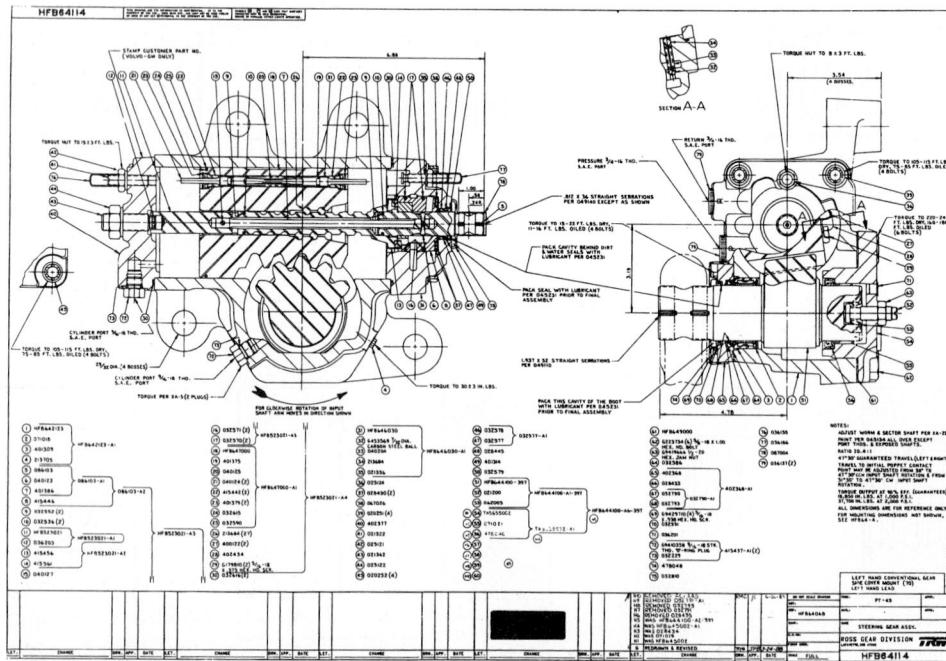

Figure 9.35 Assembly Section with Threaded Fasteners

(Courtesy of TRW Ross Gear Division.)

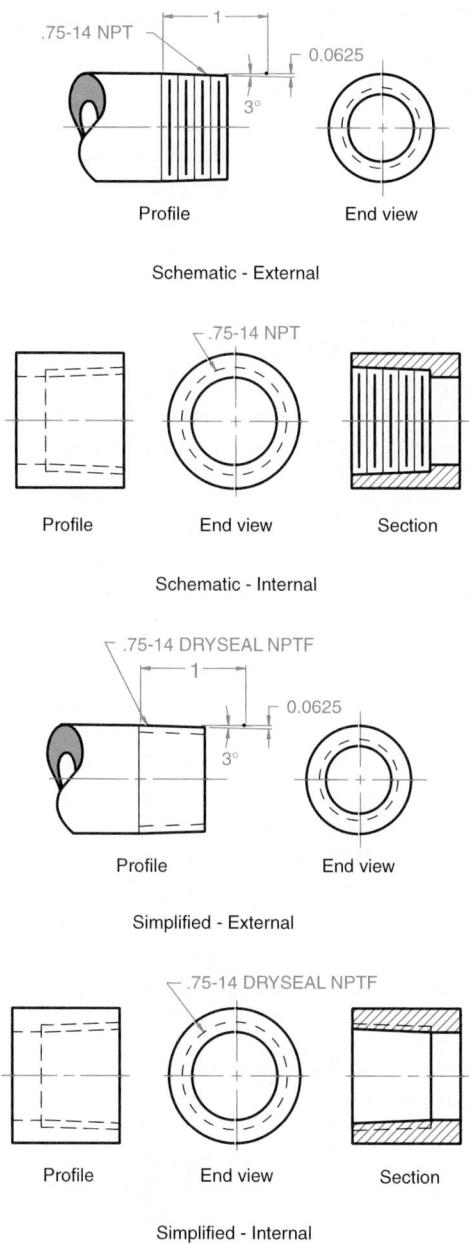

Figure 9.36 Representing Pipe Threads

Graphic representation of tapered pipe threads can include the tapering angle.

bolts, screws, studs, and other fasteners are shown whole, unless a section view is necessary to show some internal feature.

Pipe Threads Pipe threads are used for piping systems that carry liquids and gases, for drilling, and for other applications where pipes must be joined. Two general types of standard pipe threads are used in industry: taper and straight. A taper thread tapers at $\frac{1}{16}$ " per 1" of length, or .75" per foot. Pipe threads with a taper are represented graphically using either the simplified or schematic techniques. The pipe thread note designates the major diameter, the threads per inch, and the symbol for form and series, such as $\frac{1}{2}$ -14 NPT. Symbol designations for common American Standard pipe threads are:

NPT—American Standard taper pipe thread.

NPTR—American Standard taper pipe for railing joints.

NPTF—Dryseal American Standard pipe thread.

NPSF—Dryseal American Standard fuel internal straight pipe thread.

NPSI—Dryseal American Standard fuel intermediate internal straight pipe thread.

Figure 9.36 shows a taper pipe thread drawn schematically and simplified. The taper need not be shown on technical drawings, because the thread note will specify whether the thread is straight or tapered.

For more detailed information on pipe threads, refer to the *Machinery's Handbook* section "American Pipe Threads" and Appendix 40.

CAD Techniques The CAD techniques for representing threads on a technical drawing involve the LINE, CIRCLE, POLYGON, PARALLEL, and COPY commands, as well as several others. The POLYGON command is used to create a hexagon or square of a given size. The PARALLEL or COPY command is used to draw the multiple lines used in schematic and detail thread drawings.

Some CAD software will automatically create simplified thread representations once the type of hole and its position are specified. The software will automatically draw the major and minor diameters, change the linetype, and draw the details for blind tapped holes.

Many 3-D CAD models do not support helical geometry, making it impossible to represent threads accurately. As with 2-D CAD drawings, 3-D models will usually show threads schematically as a series of concentric ridges or not at all, leaving the thread specification for a note.

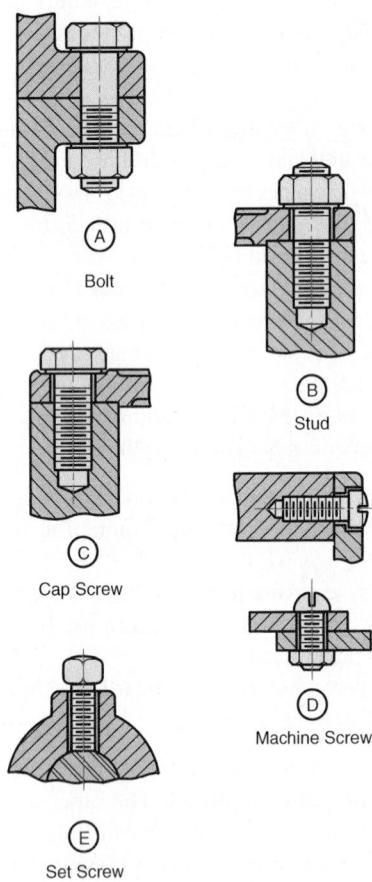

Figure 9.37 General Types of Fasteners

The five general types of fasteners are: bolts, studs, cap screws, machine screws, and set screws.

9.4 STANDARD BOLTS, STUDS, AND SCREWS

The five general types of standard **threaded fasteners** are:

1. **Bolt**—a mechanical threaded device with a head on one end and threads on the other end. Bolts are paired with nuts. (Figure 9.37A) A **nut** is a mechanical threaded device used on the end of a bolt, stud, or machine screw.
2. **Stud**—a rod that is threaded on both ends and joins two mating parts. A nut may be used on one end. (Figure 9.37B)
3. **Cap screw**—a mechanical threaded device with a head on one end and threads on the other end. Cap screws join two mating parts

and have longer threads than bolts. (Figure 9.37C) Also, cap screws can be made with slotted heads.

4. **Machine screw**—a mechanical threaded device with a head on one end and threads on the other end. The threaded end may screw into a mating part, or may be used with a nut. A machine screw is similar to a cap screw, but it is normally smaller. (Figure 9.37D)
5. **Set screw**—a mechanical threaded device with or without a head, used to prevent rotation or movement between parts, such as a shaft and a collar. Set screws have different types of points and heads for different applications. (Figure 9.37E)

The basic difference between a bolt and a screw is that a bolt is normally intended to be tightened or loosened using a nut, while a screw is normally intended to be mated with an internal thread in a part, using the head for tightening or loosening.

9.4.1 Standard Bolts

American National standard bolts have either hexagon or square heads. Square-head bolts are not available in metric. The nuts used on bolts come in several variations, depending on the application or on design considerations. ANSI B18.2.1–1981 is used to specify bolts and ANSI B18.2.2–1972 is used for nuts. Appendices 18–23 contain square and hex bolt and nut tables.

Bolts and screws are specified in the following sequence:

Nominal size (major diameter)
Threads per inch
Length
Name
Material
Protective finish

Examples of thread notes for bolts and nuts are as follows:

.500–13 UNC \times 2 Hex Cap Screw
½–13 UNC \times 2.5 Square Bolt, Steel, Zinc Plated

Hexagon bolts are either *regular*, which are used for general purposes, or *heavy*, which are used for applications that require more strength. The thickness of the head is the major difference between a regular and a heavy bolt. Square bolts are available in the regular form only.

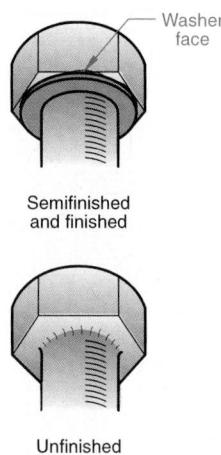

Figure 9.38 Finished and Unfinished Bolts

The difference between a finished and an unfinished hex head bolt is a washer face under the head of the finished bolt.

Bolts are further categorized as either *finished* or *unfinished*. A finished bolt has a finished surface called a *washer face*, which is $\frac{1}{64}$ " thick and provides a smooth bearing surface. (Figure 9.38) An unfinished bolt has a head without a machined surface. Heavy structural bolts are used in many buildings and structures to fasten steel members.

9.4.2 Standard Nuts

A nut is a mechanical threaded device used on the ends of bolts, studs, and machine screws. Various types of nuts are used for different applications. Hex and square nuts, the most common types found in industry (Figure 9.39), come in common and heavy classifications. Other types of nuts are hex jam, hex slotted, hex castle, and crown. Refer to the *Machinery's Handbook* section, "Bolts, Screws, Nuts, and Washers," for standard nut specifications.

9.4.3 Standard Screws

There are many types of heads available for cap and machine screws, and there are specific design reasons for choosing a particular head. Head selection depends on the driving tool to be used, the type of load, and the external appearance desired. Figure 9.40 shows a variety of head styles and their design characteristics.

Cap Screws Cap screws are similar to bolts, except that a cap screw is normally used without a nut. Instead, the cap screw is threaded into one of the mating parts,

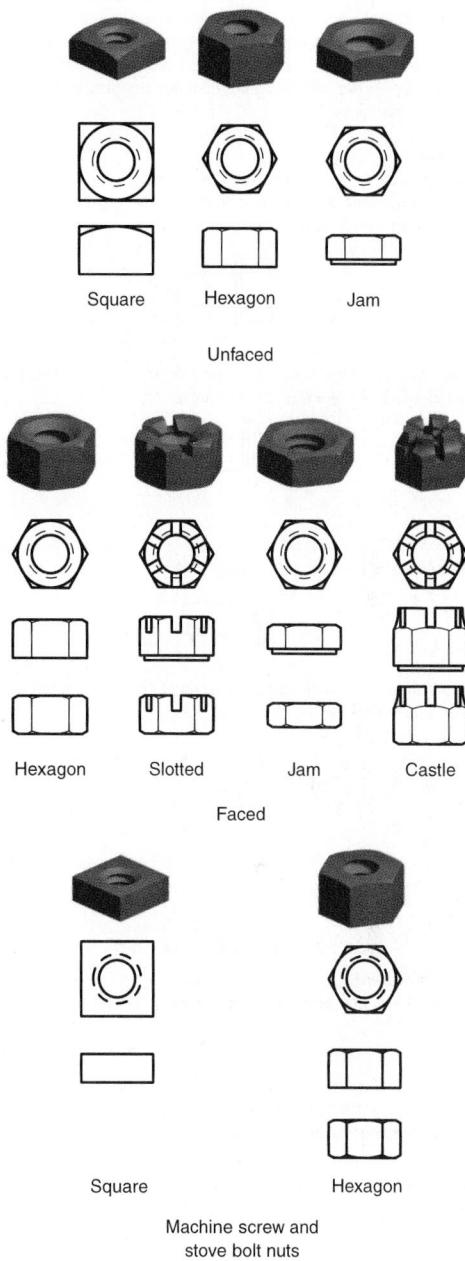

Figure 9.39 Standard Types of Nuts

A variety of hex and square nuts are used for many applications in industry.

clamping one part between the head and the other part. Figure 9.41 shows a hex head cap screw holding the top part between the screw head and the bottom part. The top part normally has a clearance hole, and the bottom part is normally drilled and tapped to match the thread of the cap screw.

Head configurations depend on the driving equipment used (such as a screwdriver or socket wrench), type of joint load, and desired external appearance. Head styles shown can be used for both bolts and screws but are typically identified with the fastener category called "machine screw" or "cap screw."

Washer

Also called a flange head, this configuration eliminates a separate assembly step when a washer is required, increases the bearing areas of the head, and protects the material finish during assembly.

Truss

Head covers a large area. It is used where extra holding power is needed, holes are oversize, or material is soft.

Oval

This head has characteristics similar to a flat head but is sometimes preferred because of its neat appearance.

Binding

This head is commonly used in electrical connections because the undercut prevents fraying of stranded wire.

12-Point

Twelve-sided head is normally used on aircraft-grade fasteners. Its multiple sides allow for a very sure grip and high torque during assembly.

Hex and Square

This has the same advantages as listed for bolts of the same head style.

Pan

Head combines the qualities of truss, binding, and round heads.

Fillister

Deep slot and small head allow a high torque to be applied during assembly.

Flat

Available with various head angles, the fastener centers well and provides a flush surface.

Figure 9.40 Fastener Head Styles and Design Characteristics

(Courtesy of *Machine Design*)

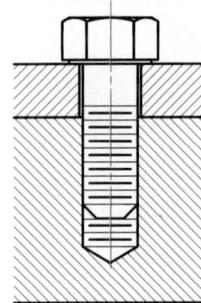

Figure 9.41 Hex Head Cap Screw

Caps screws come in a variety of head styles, and range in diameter from $\frac{1}{4}$ " to $1\frac{1}{4}$ ". The length of the screw thread is equal to either twice the basic screw diameter plus .250" or $2\frac{1}{2}$ times the pitch of the thread, whichever is greater.

The ends of all cap screws are flat, with chamfers that are drawn at 45 degrees. Figure 9.42 gives the basic dimensions used to draw cap screws. Refer to the *Machinery's Handbook* section "Bolts, Screws, Nuts, and Washers," or the ANSI tables of actual dimensions in the appendixes. A cap screw is specified in the same manner as other threaded fasteners, except that head type is appended to the note, as follows:

$\frac{1}{2}$ -13 UNC-2A \times 2- $\frac{1}{4}$ HEX HD CAP SCR.

Machine Screws Machine screws are similar to cap screws, except that they are usually smaller in diameter (.021" to .750"). A machine screw is threaded into one of the mating parts, clamping one part between the head and the other part. The top part normally has a clearance hole, and the bottom part is normally drilled and tapped to match the thread of the cap screw. An alternative would be to use a machine screw and nut in a manner similar to that of using a bolt and nut.

Machine screws are finished with flat bottoms instead of chamfered corners. Machine screws less than 2" long are fully threaded. For actual dimensions, refer to the *Machinery's Handbook* section "Machine Screws," or the ANSI English and metric tables in the appendixes. A machine screw is specified in the same manner as other threaded fasteners, except the head type is appended to the note, as follows:

$\frac{1}{2}$ -13 UNC-2A \times 2- $\frac{1}{4}$ HEX MACH SCR.

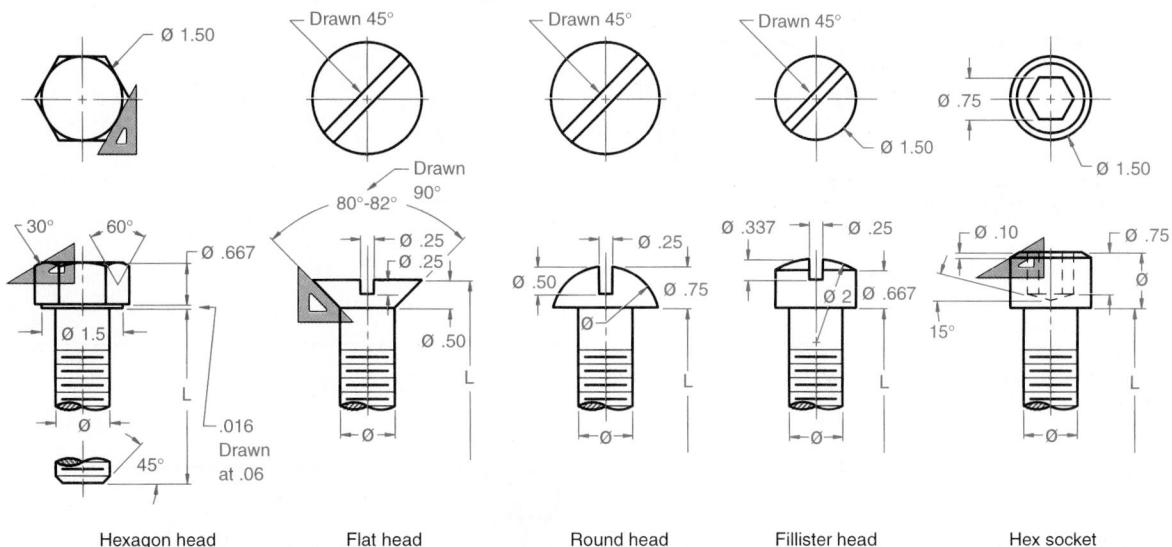

Figure 9.42 Cap Screw Types and Their Dimensions

Set Screws A set screw is used to prevent motion between two parts. The set screw goes through the threaded first part and has a point that presses firmly against the second part, to prevent movement. Set screws come in a variety of head and point types. For actual dimensions, refer to the *Machinery's Handbook* section "Set Screws," or the ANSI English tables in the appendixes. A set screw is specified in the same manner as other threaded fasteners, except that the head type and point are appended to the note, as follows:

½-13 UNC-2A × ¾ HEX HD FLAT PT SS.

9.4.4 Locking Devices

Some locking devices are used to prevent threaded fasteners from coming loose; others are special devices that can be used in place of fasteners. Locking devices such as *retaining rings* and *spring washers* do not use threads. (Figure 9.43) *Slotted* and *castle nuts* are specialized devices with grooves cut into them to accommodate a cotter pin, which prevents slippage after assembly. (See Figure 9.39) *Jam nuts* are thin hex nuts that are fastened on top of regular hex nuts to prevent slippage. (See Figure 9.39) Many of these locking devices and their dimensions are found in manufacturers' catalogs and in the *Machinery's Handbook*.

9.4.5 Templates

Drawing threaded fasteners by hand is both tedious and time consuming. To make this task easier, special templates have been developed for the most common types of fasteners. Figure 9.44 is an example of a template for machine and cap screws.

9.4.6 CAD Techniques

With a CAD system, standard threaded fasteners can be created using symbol (block) libraries with such commands as COPY, BLOCKS, PARALLEL, and others. In addition, several specialized CAD products automatically represent thousands of different types of standard fasteners in both 2-D and 3-D. The user specifies the type of standard fastener needed and the location on the drawing, and the fastener is drawn automatically. (Figure 9.45)

Practice Exercise 9.2

Using the same bolt from Practice Exercise 9.1, sketch the bolt and write a thread note that specifies the fastener. Write the specifications needed for a hex head nut that can be used with the bolt.

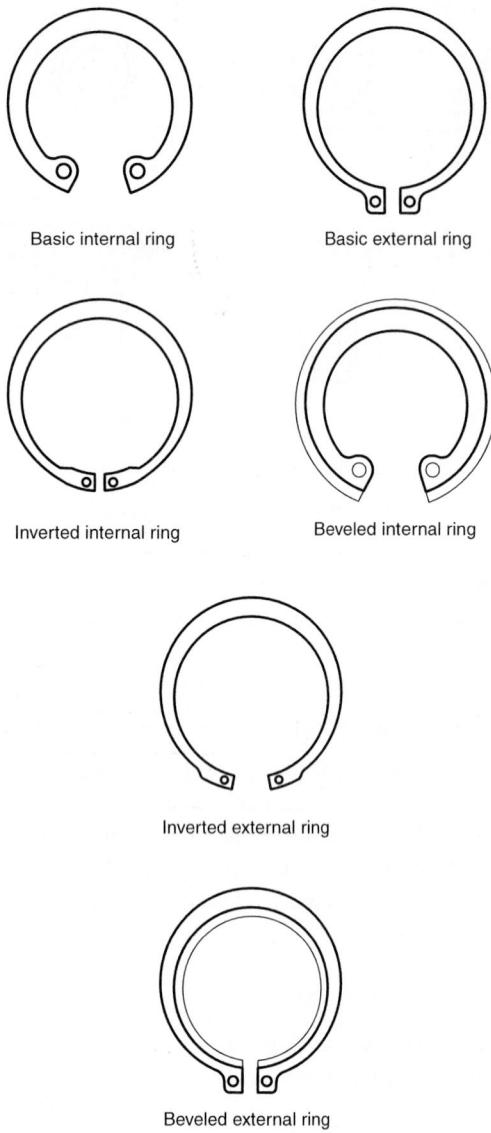

Figure 9.43 Examples of Retaining Rings

Figure 9.44 Fastener Template

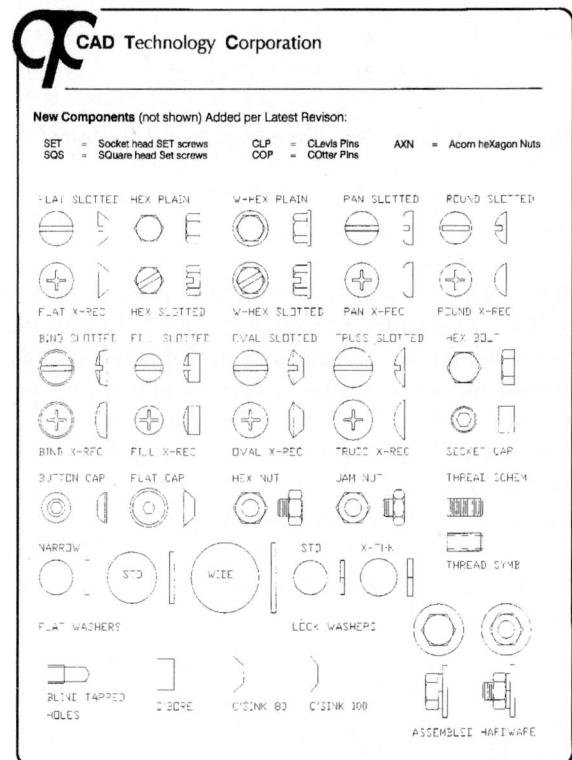

Figure 9.45 Examples of CAD-Generated Standard Fasteners

(Courtesy of CAD Technology Corporation.)

9.5 NONTHEADED FASTENERS

Nonthreaded fasteners are mechanical devices generally used to prevent motion between mating parts. Dowels, pins, keys, rivets, and retaining rings are examples of such fasteners. **Washers**, another type of nonthreaded fastener, are used to lock fasteners or to provide a smooth surface for a fastener.

9.5.1 Standard Washers

Plain washers are used with bolts and nuts to improve the assembling surface and increase the strength. ANSI standard type A plain washers are designated by their inside and outside diameters, and by their thickness. Type B plain washers are only

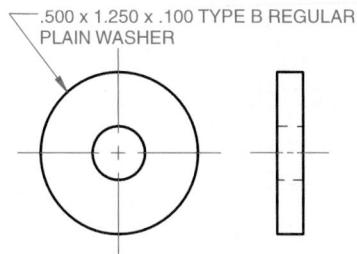

Figure 9.46 Representation and Note for a Plain Washer

available in narrow (N), regular (R), and wide (W) series. Refer to the *Machinery's Handbook* section "Bolts, Screws, Nuts, and Washers," for specifications for American standard plain washers and metric standard washers, and Appendixes 41–44. Figure 9.46 shows how to represent standard washers graphically, using dimensions from the standards table. *Lock washers* are used to prevent a fastener from coming loose due to vibration or movement. (Figure 9.47) *Helical spring* and *tooth* are the most common types of lock washers. Refer to the *Machinery's Handbook* section "Bolts, Screws, Nuts, and Washers," for specifications for American standard lock washers, and Appendixes 45 and 46.

Washers are specified by giving the inside diameter, outside diameter, thickness, type, and name, as follows:

.500 x 1.250 x .100 TYPE B REGULAR
PLAIN WASHER.

9.5.2 Pins

Common types of **pins** are dowel, straight, tapered, groove, and spring. (Figure 9.48) To draw pins, refer to the *Machinery's Handbook* section "Bolts, Screws, Nuts, and Washers," for specifications on American standard pins and metric standard pins, and Appendixes 50–53. *Dowel pins* are used to keep parts in position, or to prevent slippage after assembly. Dowel pins are specified by giving the name, nominal pin diameter, material, and protective finish, as follows:

HARDENED GROUND MACHINE DOWEL—
STANDARD SERIES, $\frac{1}{4} \times 2$, STEEL.

Another type of pin used to keep parts in position is the *cotter pin*, which has a round head and ends that are bent after assembly.

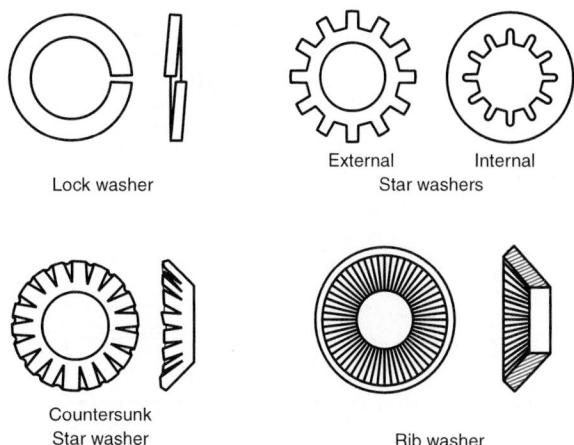

Figure 9.47 Examples of Lock Washers

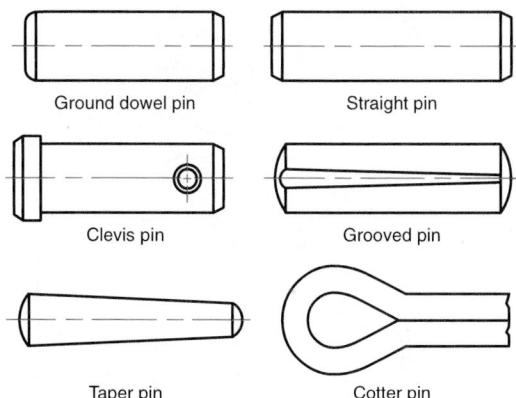

Figure 9.48 Pin Types

9.5.3 Keys

Keys are commonly used to attach two components such as a shaft and hub, to transmit power to gears, pulleys, and other mechanical devices. The key is placed into a *keyseat*, which is a groove cut into the shaft. The shaft and key are inserted into the hub of the mechanical component, such as a gear or wheel, by aligning the key with the *keyway* groove cut into the hub.

Common keys are plain, gib head, Woodruff, and Pratt & Whitney. (Figure 9.49) Gib head keys have parallel sides, with a head added for easy removal from the assembly. The Pratt & Whitney key is rectangular in shape and has rounded ends in the shape of a semicircle. The Woodruff key is not quite a full semicircle, with a full radius or a flat bottom.

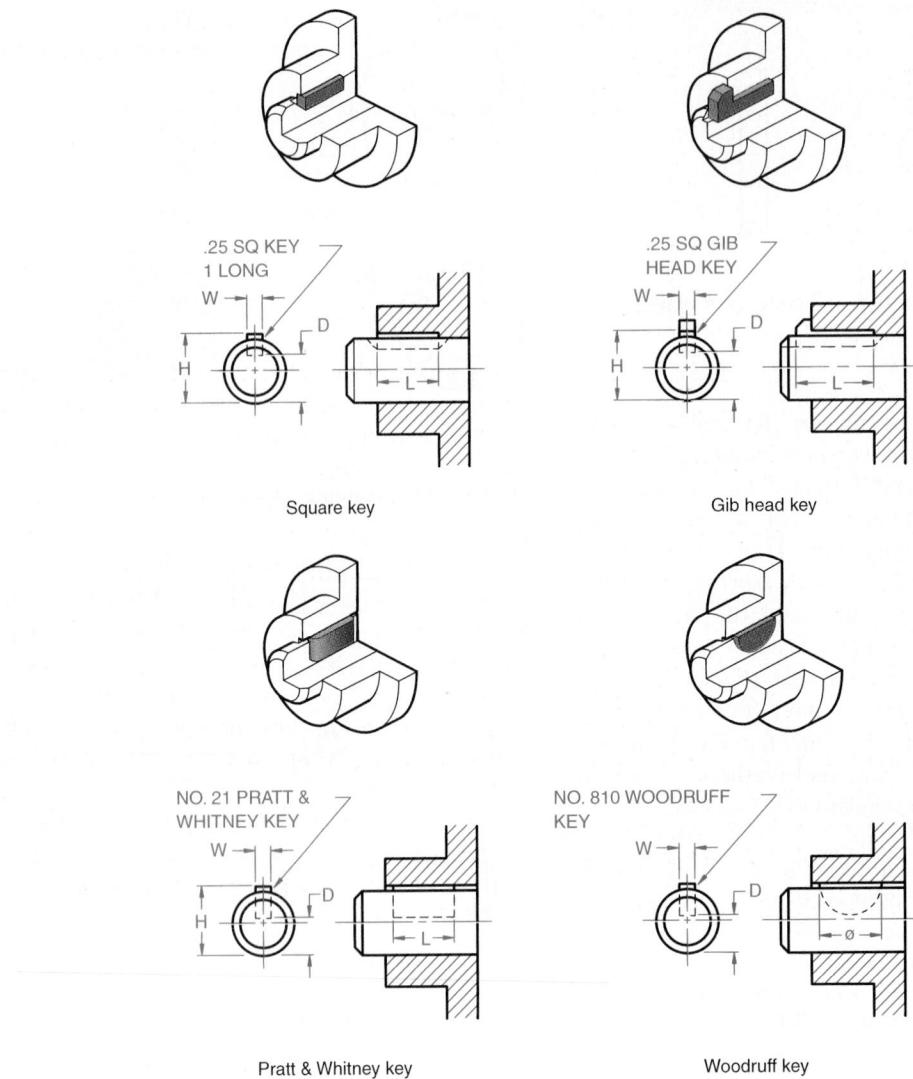

Figure 9.49 Standard Key Types

Standard key sizes have been created by ANSI, based on shaft sizes and tolerances (ANSI B17.1-1989). Standard keys are specified using the size of the shaft. The depth of the keyseat cut into the shaft and the keyway cut into the hub is determined using standard tables. On technical drawings, the key, keyway, and keyseat must be specified in a note. Dimensions are located in standard tables in the *Machinery's Handbook* section "Keys and Keyseats," and in Appendixes 47, 48, and 50.

9.5.4 Rivets

Rivets are metal pins with a head, and are used to attach assembled parts permanently. Rivets are available in a variety of head styles and are generally used for sheetmetal, such as the skin of an aircraft attached to the frame, or ship parts. (Figure 9.50) Larger rivets are used in steel structures, such as bridges, ships, and boilers. The hole for the rivet is drilled or punched, then the rivet is held in place with a tool called a *dolly*, while the other end of the rivet is hammered, pressed, or forged in place. Rivets are defined as *shop*

Figure 9.50 Application for Rivets

Rivets are commonly used to fasten parts of a ship together.

rivets for parts that are assembled in the shop, and *field rivets* for parts that are assembled at the site of construction.

Rivets are classified by head type, body diameter, and length, using ANSI standard tables B18.1.1 and 18.1.2. On technical drawings, rivets are represented using the symbols shown in Figure 9.51.

9.6 SPRINGS

Springs are mechanical devices that expand or contract due to pressure or force. Many types of springs have a helix form. Spring classifications are *compression*, *tension*, *extension*, *flat*, and *constant force*. Springs are further classified by the material, gage, spring index, helix direction, and type of end.

Springs can be represented on technical drawings either in detail or in schematic form. (Figure 9.52) The schematic representation is drawn by laying out the diameter, the free length, and then the diagonals to represent the number of coils. With detailed drawings of springs, phantom lines can be used to save time. Straight lines are used instead of helical curves.

Springs are specified by giving the inside and outside diameters, wire gage, type of ends, material, finish, number of coils, and free and compressed lengths.

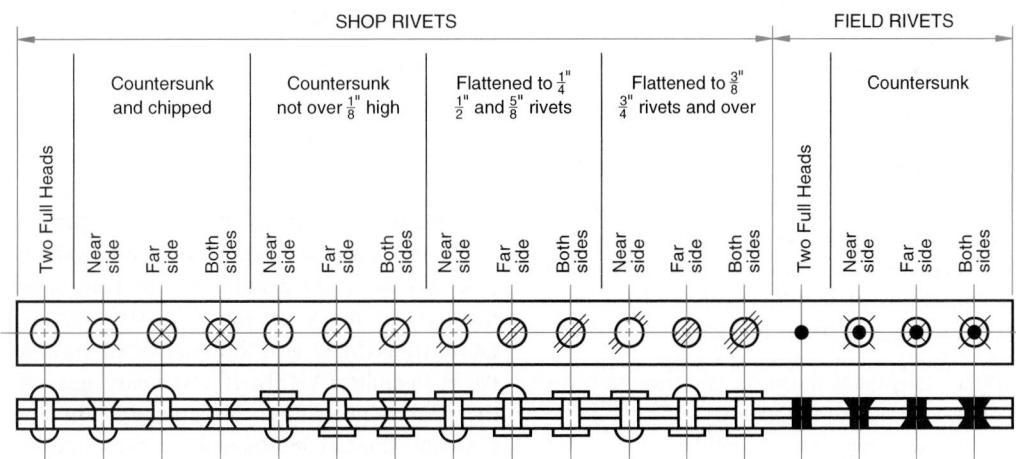

Figure 9.51 Rivet Symbols Used on Engineering Drawings

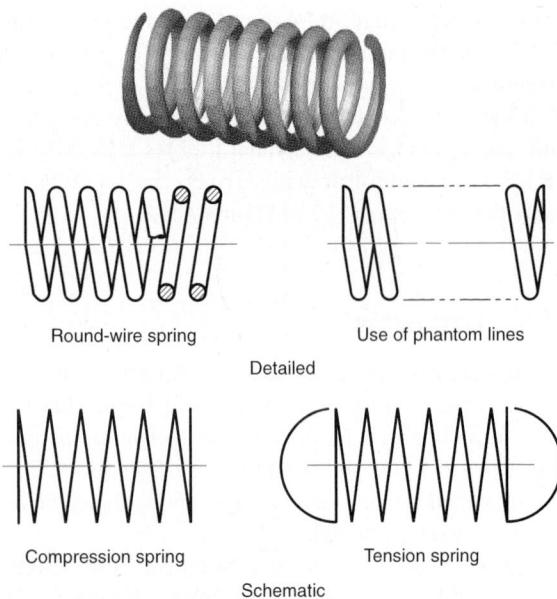**Figure 9.52 Representing Springs**

Springs are represented either in detail or in schematic form.

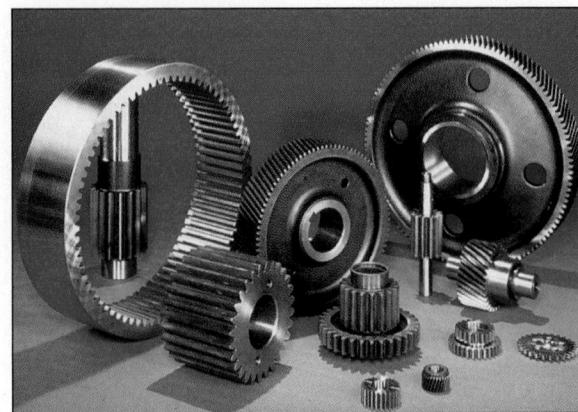**Figure 9.53**

There are many types of gears used for many purposes.
(Courtesy of Fairfield Manufacturing.)

After the analysis is completed, the various mechanical components are specified, and the specifications are used to create the technical drawings or 3-D model.

9.7.1 Gears

A **gear** is a toothed wheel mechanical device used to transmit power and motion between machine parts. Gears are used in many applications, such as automobile engines, household appliances, and computer printers. (Figure 9.53) Gears provide long life-cycles and can transmit power at up to 98 percent efficiency. Vendors' catalogs are used to select standard gears. A **gear train** is the combination of two or more gears. Such combinations are used to:

1. Increase speed.
2. Decrease speed.
3. Change the direction of motion of shafts.

When two gears of different sizes mesh, the larger is called the **gear** and the smaller is the **pinion**. A **gear cluster** is more than one gear on a single shaft.

Gears are selected and specified using standards established by the American Gear Manufacturers Association (AGMA) and the American National Standards Institute (ANSI). If a standard gear is chosen, the gear is not shown in full detail on a technical drawing. Instead, a schematic representation is used and a table of gear cutting values is drawn. Detailed drawings of a gear are made when a special gear is designed, or when gears in assembly must be shown.

9.7 MECHANISMS

A **machine** is a combination of interrelated parts for using or applying energy to do work. A **mechanism** is a mechanical system made of rigid parts or structures (such as housings, pillow blocks, and shafts), connected by various linkages (such as gears, cams, and cranks), and driven by motions or loads. Mechanisms are designed using the laws of physics known as *mechanics*.

A major part of mechanical design deals with the analysis of mechanisms and structures. *Structural analysis* computes deformations and stresses in structures with either no joints or joints of very limited movement. An example of structural analysis is a finite element analysis to measure the stresses on two mating gear teeth. *Mechanism analysis* is concerned with the calculations of motions and forces in mechanical systems. Such analyses include:

Static analysis—calculates the static equilibrium position of the system and components.

Kinematic analysis—detects interferences in the motion of the mechanisms.

Dynamic analysis—calculates the motion of all components due to the forces acting on a system.

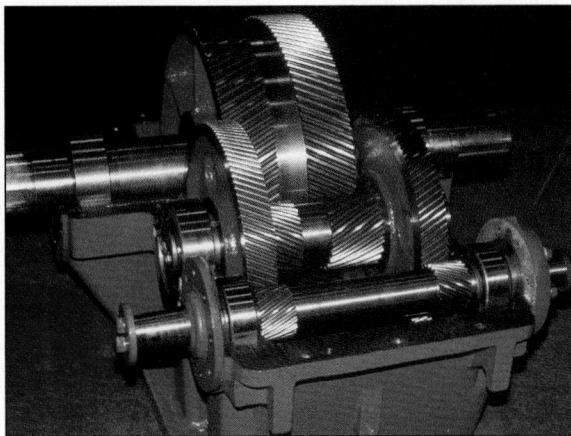

Figure 9.54 Parallel Shafting of Helical Gears

(Courtesy of Fairfield Manufacturing.)

Detailed drawings would also be used for illustration purposes in catalogs, sales brochures, and maintenance and training materials.

Gear Classification Gears are grouped by the positions of the connecting shafts, as follows: parallel, intersecting, and nonintersecting. Gears are classified by the shape of the gear tooth, as follows: spur, helical, bevel, face, crossed helical, hypoid, and worm. The most common type of gear and the easiest to represent graphically is the spur gear. Examples of gears are shown in Figures 9.54 and 9.55.

Gear Teeth Geometry The transmission of power and the quiet operation of a gear depend on using the most effective geometric form available. Most spur gear teeth use the *involute* as the basic geometric form. An **involute** is a curved line formed by the spiral trace of a point on a string unwinding from around a line, circle, or polygon. (See Chapter 3, “Engineering Geometry and Construction.”) The involute of a circle creates the smooth curve necessary in the design of spur gear teeth. (Figure 9.56) The circle is the *base circle* of the gear. Notice that at any point on the curve, a line perpendicular to the curve will be tangent to the base circle. Drawing another base circle along the same center line such that the involutes of both circles are tangent demonstrates that at the point of contact, the two lines tangent to the base circles are coincident. (Figure 9.57)

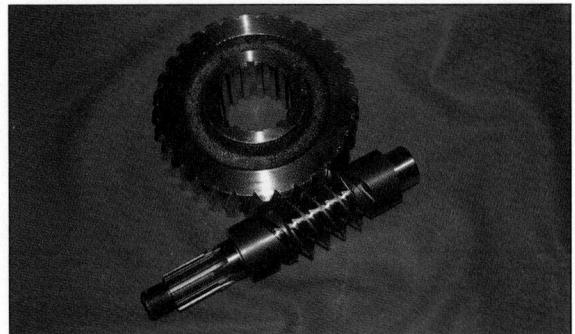

Figure 9.55 Worm Gear

(Courtesy of Fairfield Manufacturing.)

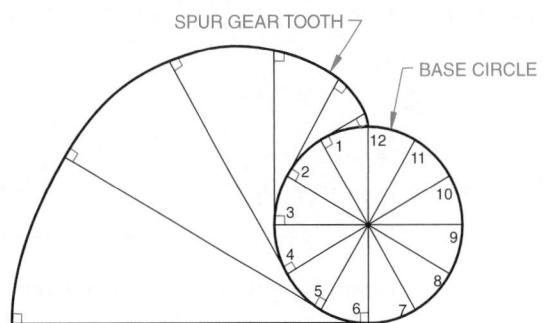

Figure 9.56 Involute Curve

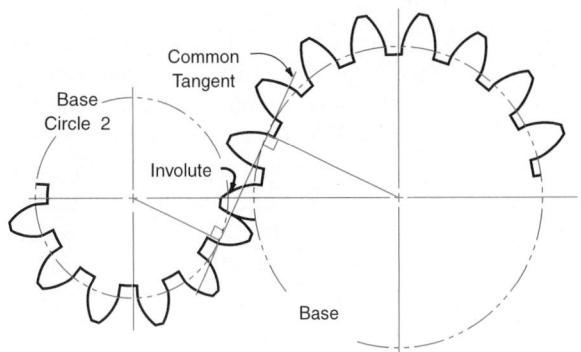

Figure 9.57

Tangent involute curves demonstrate the kinematic principle of gearing.

Only that part of the tooth that comes in contact with the other gear tooth must be an involute. Involutes are rarely used on technical drawings to represent gear teeth; instead, approximations are used.

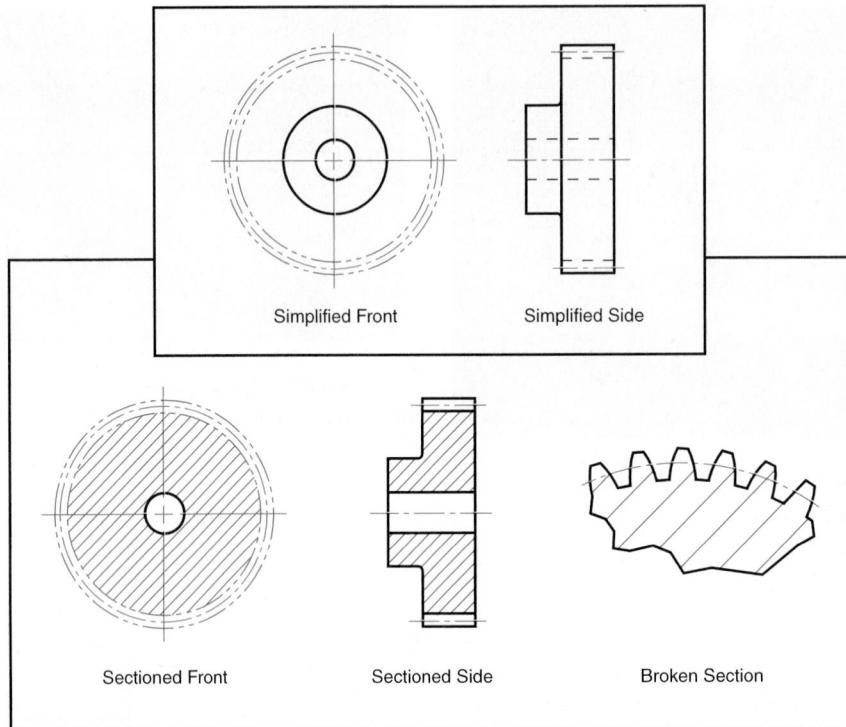

Figure 9.58 Standard Representation of a Spur Gear

Graphical Representation The graphical representation of gears follows ANSI Standards Y14.7.1-1971 and Y14.7.2-1978. The gear drawing should show the front and profile views, as shown in Figure 9.58. This figure shows the simplified method in which, in the front view, the outside and root diameters are represented as phantom lines and the pitch diameter is shown as a center line. The profile view shows the root diameter as a hidden line, the outside diameter as a solid line, and the pitch diameter as a center line. Gear teeth profiles are usually not drawn, unless necessary for the orientation of other features, or for some gear clusters. (Figure 9.59) **CAD Reference 9.7**

Normally, gear drawings include a table of information, called *cutting data*, for manufacturing. (Figure 9.60) A detail drawing of a gear to be manufactured would also include other dimensions not found in the table. The section “Gear Data for Drawings” in the *Machinery’s Handbook* includes tables that list the specifications to be shown on a drawing for helical and spur gears.

9.7.2 Cams

A **cam** is a mechanical device with a surface or groove that controls the motion of a second part, called a *follower*. (Figure 9.61) Cams convert rotary motion to linear motion. The timing and manner of the movement to be created by the cam are the main elements in designing cams. For example, a cam might be used to raise a follower rapidly, keep the follower stationary, then allow the follower to fall slowly to its beginning position. This is all done during the 360-degree revolution of the cam and is called the *displacement*. The *Machinery’s Handbook* has detailed information on cam design and specification.

Cam Types The shape of the cam depends on the motion required and the type of follower used. There are three types of cams (Figure 9.62):

1. Face
2. Groove
3. Cylindrical

Figure 9.59 Standard Representation of Gear Clusters and Other Gear Features

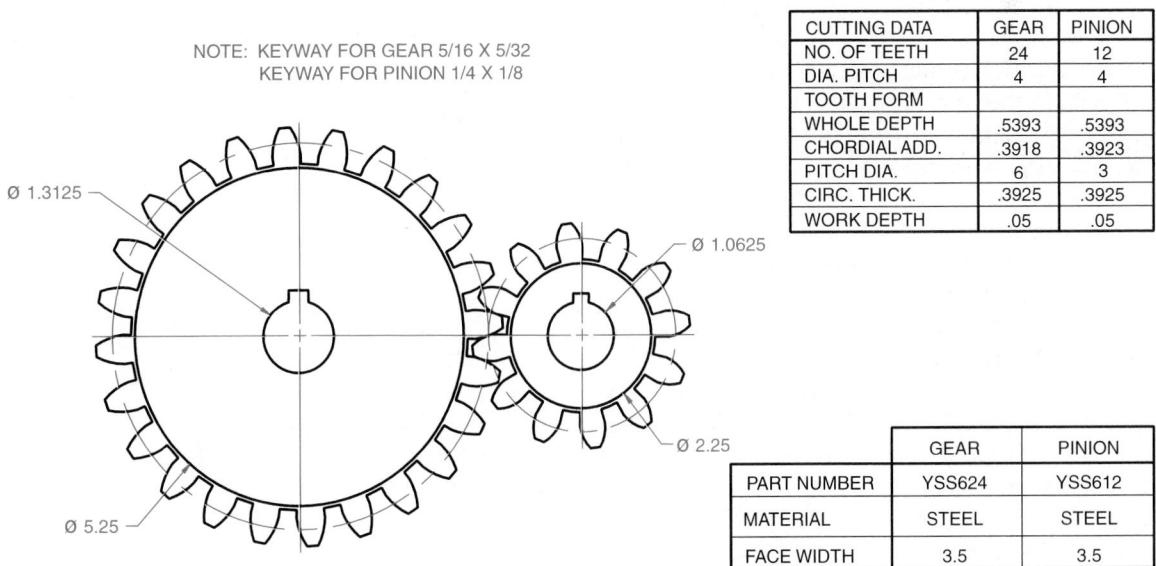

Figure 9.60 Detail Drawing of a Spur Gear

Face cams are flat disks, and the shape controls the movement of the follower. Groove cams are flat disks with grooves cut in them, and the grooves control the movements of the follower. Cylindrical cams are cylinders with grooves cut in them, and the grooves control the movement of the follower.

Follower Types The **cam follower** makes contact with the cam, changing rotary motion to linear motion. There are three major types of followers (Figure 9.63):

1. Knife edge
2. Flat face
3. Roller

The most common type of follower is the roller, which is used for high-speed applications.

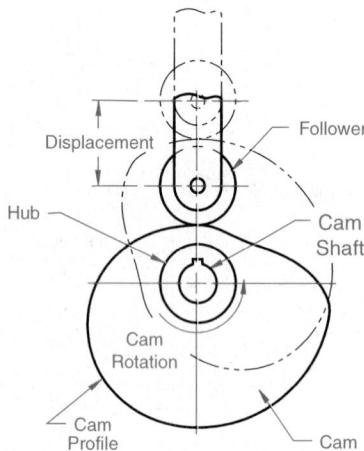

Figure 9.61 Cam and Follower

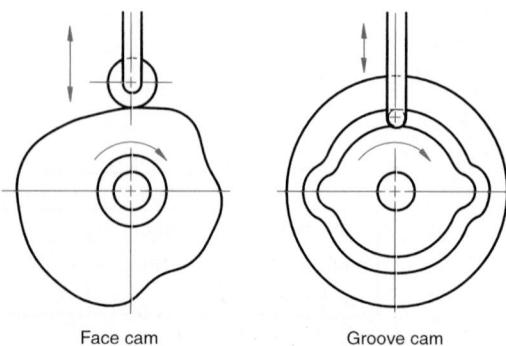

Figure 9.62 Three Types of Cams

Displacement Diagrams **Displacement** is the distance that a follower moves during one complete revolution (or *cycle*) of the cam while the follower is in contact with the cam. A **displacement diagram** is a graph or flat-pattern drawing of the travel (displacement) of the follower on the cam. A **period** is a part of the cam cycle and it includes:

Rise—the upward motion of the follower caused by cam motion.

Fall—the downward motion of the follower caused by cam motion.

Dwell—the stationary position of the follower caused by cam motion.

Figure 9.64 shows a displacement diagram, with important parts labeled. The height (ordinate) is equal to the total displacement of the follower. The base circle (abscissa) is one revolution of the cam

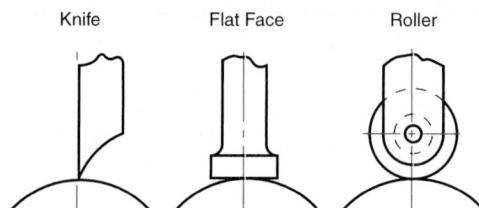

Figure 9.63 Cam Followers

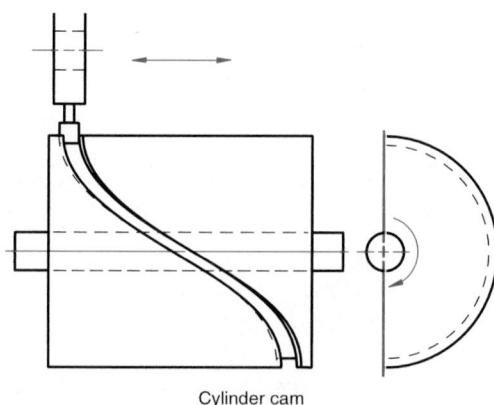

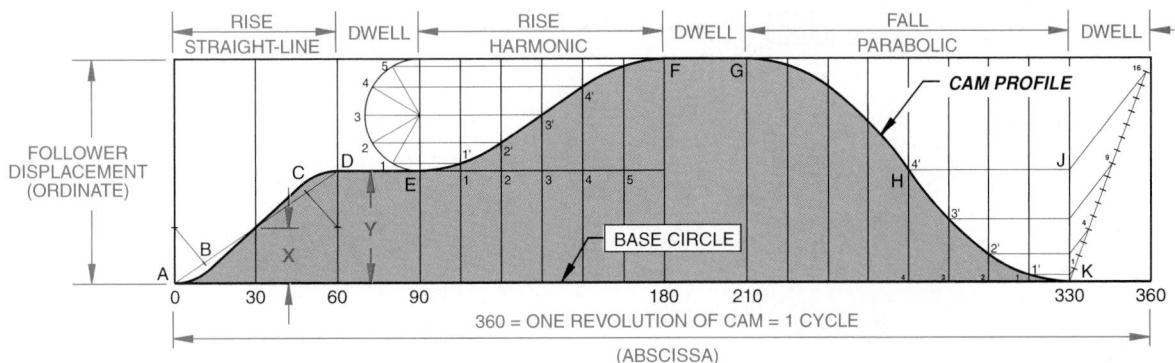

Figure 9.64 Cam Displacement Diagram

and can be drawn at any convenient distance. The horizontal distance is divided into degree increments from 0 to 360.

9.7.3 Linkages

A **link** is a rigid element that transmits force and velocity. Links are the most common type of machine element in use. (Figure 9.65) A **linkage** is a number of links combined to transmit force and velocity.

Symbols Links are drawn in schematic form on technical drawings and for engineering design analysis. Figure 9.66 shows the schematic symbols used for linkage drawings. With CAD, these symbols can be drawn once, placed in a symbols library, then used on many drawings. Third-party software that has link symbols on disk is also available. A linkage *pin joint* is represented with a small circle. A *slider* is represented as a circle surrounded by a rectangle. The linkage crank, lever, or bar is represented as a line. More complex linkages are created by combining these schematic elements.

Linkage Types There are many types of linkages used in engineering design. (Figure 9.66) Some of them are:

Crank—a bar with a fixed joint at one end, where the bar is free to move 360 degrees about the fixed joint.

Lever or rocker—a bar with a fixed joint at one end, where the bar is free to move through a fixed angle about the fixed joint.

Figure 9.65 Example of Linkages Used in an Automobile Engine

(Courtesy of Ford Motor Company.)

Rocker arm—a bar with a fixed joint near the center of a bar, where the bar is free to move through a fixed angle about the fixed joint.

Bell crank—a three or more joints mechanism that has a fixed joint near the center of the bar, which is free to move through a fixed angle about the fixed joint.

Four-bar—a common mechanism made of four pin-connected links.

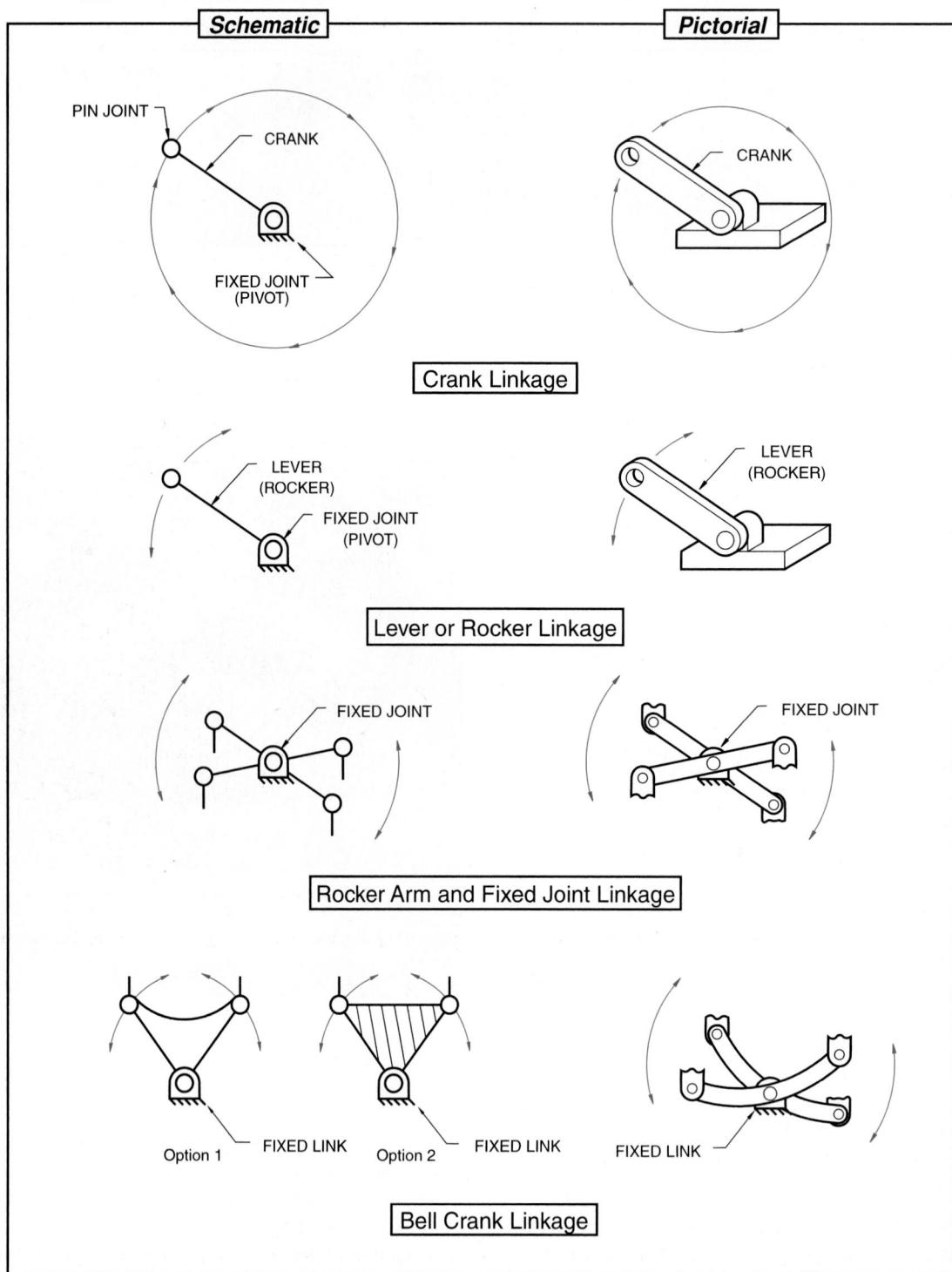

Figure 9.66 Schematic Representations of Linkages

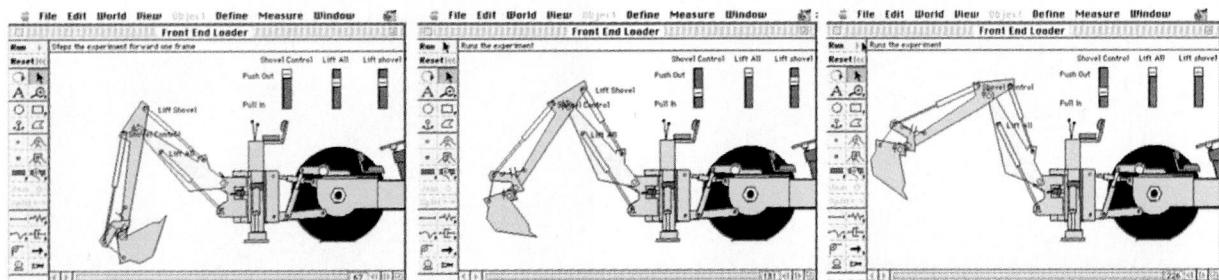

Figure 9.67 CAD Software Used to Analyze Linkages

(Courtesy of Knowledge Revolution.)

Linkage Analysis Linkages can be analyzed mathematically or graphically to determine interference, extreme positions, and angle of oscillation. Geometry and trigonometry are used for mathematical analysis. However, graphics is used to analyze linkages more quickly. There is specialized software that uses CAD drawings of links to analyze linkages. (Figure 9.67)

9.7.4 Bearings

Bearings are mechanical devices used to reduce friction and wear between two parts, and to support a load while permitting motion between two parts. Bearings are used in many different applications, such as automobiles, aircraft, appliances, agricultural equipment, electric motors, pumps, etc. (Figure 9.68) Refer to the *Machinery's Handbook* for designing and specifying bearings.

Plain Bearings Plain bearings provide sliding contact between mating surfaces and are sometimes called *journal bearings*, *sleeves*, or *bushings*. Plain bearings are classed as:

Radial—bearings that support rotating shafts or journals.

Thrust—bearings that support axial loads on rotating mechanisms.

Guide—bearings that guide moving parts in a straight line, sometimes referred to as slipper bearings.

Normally, plain bearings are pressed into a housing using an interference fit. A clearance fit is used between the bearing and the part, such as a shaft. Many plain bearings are made of either bronze or phosphor bronze. Bronze bearings use some form of lubrication; phosphor bronze bearings are impregnated with oil for lubrication.

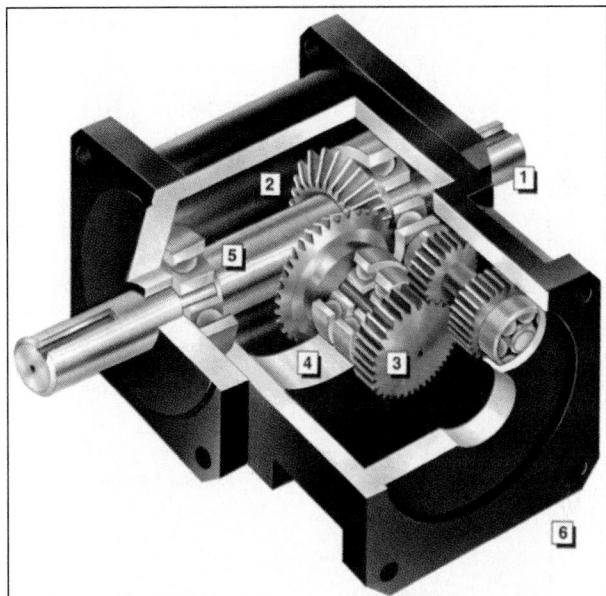

Figure 9.68 A Gearbox Using Bearings to Support the Shafts

(Courtesy of Bayside.)

Rolling Contact Bearings Rolling contact bearings (or rolling bearings) use a rolling element, such as a ball or roller, to reduce friction and wear between mating surfaces. These bearings consist of an inner ring, an outer ring, and the rolling elements. (Figure 9.69) Rolling elements are of two general shapes: balls and rollers. Rollers come in four basic types: cylindrical, needle, tapered, and spherical. When specifying bearings, refer to vendor catalogs for specifications and part numbers.

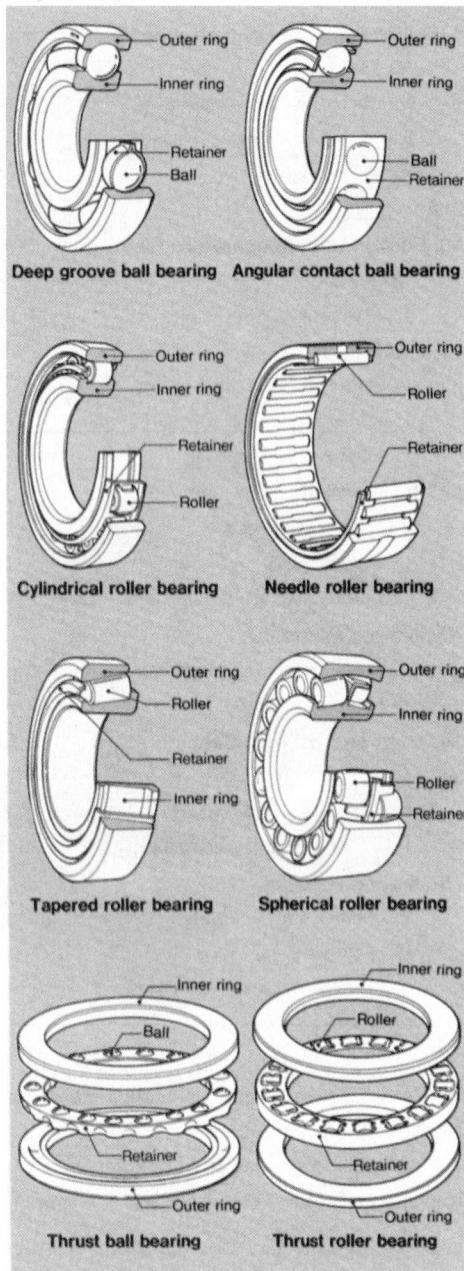

Figure 9.69 Characteristics of Rolling Bearings

(Courtesy of NTN Corporation.)

Graphical Representations Normally, bearings are not shown on technical drawing because they are a standard part. However, bearings are shown on assembly drawings and are listed in a parts list. Also, the bearing is usually shown in section. For a plain bearing, the outline of the bearing is shown with section

Figure 9.70

Piping is used in a variety of industrial applications.

lines, or it is shown in solid black if there is not enough room for section lines. For rolling bearings in an assembly section, the inner and outer rings are shown in section and the ball or roller is unsectioned. A leader line and balloon are used to identify the part number, and the parts list contains the manufacturer and part number of the bearing. **© CAD Reference 9.8**

9.8 PIPING

Piping drawings are used in the design and construction of oil refineries, chemical plants, tank farms, and other applications. (Figure 9.70) Piping drafting is a specialized field that uses graphic symbols and standards to represent process structures that contain pipes, tanks, pumps, boilers, exchangers, valves, and other components. Piping drawings represent a process plant by using symbols for components and single or double lines for the pipes. (Figure 9.71) Standard graphic symbols are very commonly used to represent pipe components, to save time.

Some process plants are so complicated that a model must be made of the design to determine interferences and to visualize the plant. Before CAD, physical models were made for this purpose. With CAD, it is possible to create a **virtual model** of the process plant in the computer. (Figure 9.72) The virtual model can be used to “walk through” the plant to check interferences and clearances, headroom, and other environmental constraints. (See Figure 9.71)

The pipes used in homes to carry water, waste, and gas are called **plumbing**. The pipes used in cities to transport water and waste are called **civil piping**.

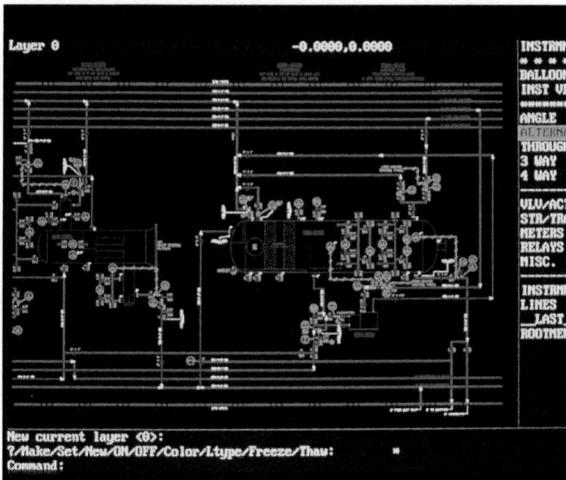

Figure 9.71 Piping Drawing Plan View

(Courtesy of Application Development, Inc.)

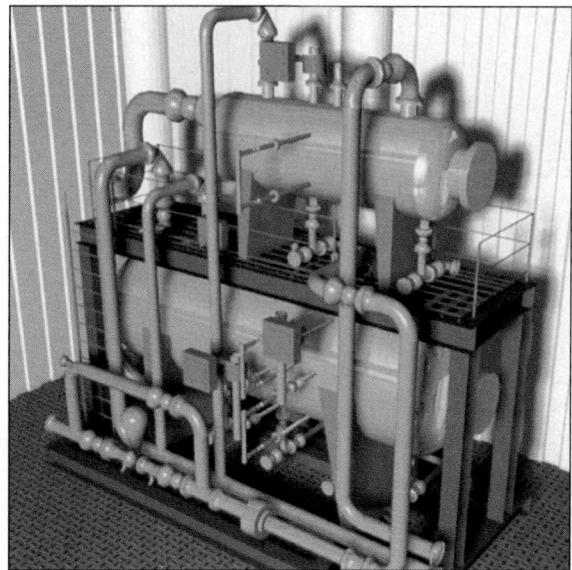

Figure 9.72 Virtual Computer Model

(Courtesy of Application Development, Inc.)

Process piping is used to transport water, air, steam, and raw materials in industrial plants that process the raw materials and convert them into finished products. Pipelines carry materials over long distances. An example is the Alaskan oil pipeline, which carries crude oil from the north shore of Alaska to the south shore. Piping for power plants, gas and oil refineries, transportation systems, refrigeration plants, chemical plants, and gas and air piping systems is controlled through the ANSI Code for Pressure Piping. (ANSI/ASME B31.1-1989)

9.8.1 Piping Components

Pipe Types Pipes used in process plants commonly range from 1" to 24" in diameter and larger. Pipe sizes smaller than 1" are available for instrument and service lines. The nominal pipe size (NPS) is the specification standard for piping and it uses the outside diameter (OD) of the piping. The inside diameter varies according to the wall thickness. Pipe wall thicknesses are specified by ANSI Standard B36.10-1970, using schedule numbers ranging from 10 (thin) to 160 (thick). Pipes are calculated to handle a certain flow of liquid or gas at a certain temperature and pressure. The higher the pressure, the thicker the pipe wall.

Pipes are made of many materials, including:

- steel
- stainless steel
- cast iron

- vitrified clay
- copper
- plastic

Also, the pressures and temperatures of the materials carried by pipes can be very high, so some pipes are welded at the joints.

Pipe Connections Pipes are connected by welding, screwing, gluing, or the use of flanges. The piping material and size determine the joining method. Flared pipe ends require backup flanges for connection. Plastic pipes are fastened by gluing with a solvent.

Pipe Fittings **Pipe fittings** are used to connect lengths of pipe, change direction, create branching, and change pipe size. The 90- and 45-degree elbows and bends are used to change directions. Tees and crosses are used for branching. The return bend is used to make a 180-degree turn.

Screwed fittings are used for screwed connections. Welded fittings are used on welded joints. Flanged fittings are used on flanged joints. (Figure 9.73)

Valves **Valves** are used in piping systems to stop, start, and regulate the flow of fluids. Common types of valves are globe, gate, check, and safety. Globe valves are used for close regulation of flow, which

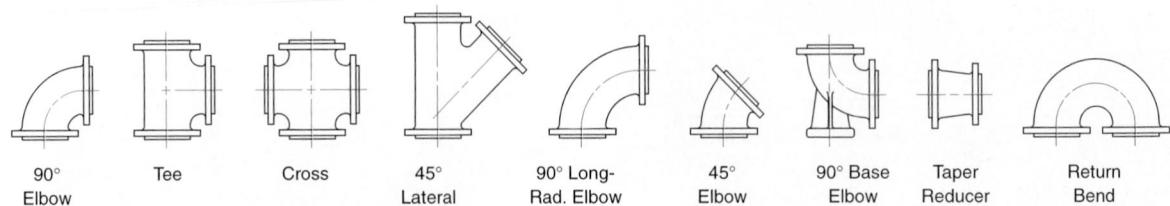

Figure 9.73 Flanged Fittings

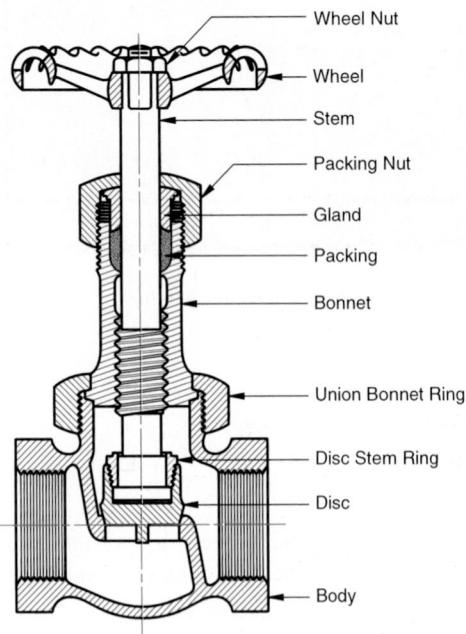

Figure 9.74 Globe Type of Valve

causes some loss of pressure. (Figure 9.74) Check valves are used to control fluid flow in one direction. Gate valves have straight-through openings to control fluid flow with little loss of pressure, and they are usually used for on/off service. Other valve types include by-pass, governor-operated, reducing, diaphragm, float, quick opening, and others.

9.8.2 Pipe Drawings

Pipe drawings are 2-D representations of piping systems. Such drawings use graphic symbols for the design, construction, and maintenance of process systems. Pipe drawings represent pipes in orthographic plan or elevation views, section views, and pictorial

views, especially isometric views. Normally, pipe drawings use symbols to represent pipes, joints, valves, and other piping components. For CAD, schematic piping symbols are available in predrawn symbol libraries, to make the creation of pipe drawings much easier and faster than with hand tools and templates. Process and instrument flow diagrams are also represented in schematic form.

Plan Drawings A **plan drawing** shows the piping layout orthographically from above, as a top view. (See Figure 9.71) A side view is called an **elevation drawing**. The plan or elevation view is the most common type of piping drawing. An elevation drawing includes the building outline and a schematic representation of piping, supports, and equipment. Two types of elevation and plan drawings are used for piping: single-line and double-line.

Single-line drawings simplify the creation of piping drawings by representing the center lines of pipes as thick solid lines. Also, the symbols used to represent various components are drawn as thick lines. (Figure 9.75) For example, a compressed-air line with a screwed 45-degree elbow connected to a gate valve is shown in Figure 9.76. The air line is drawn as a solid line, with the letter A near the center to designate that the pipe is to carry compressed air. The screwed 45-degree elbows are shown as short lines perpendicular to the pipe line. The intersecting circle and triangle on one end is the graphic symbol used to represent a gate valve in the plan view.

Double-line drawings represent pipes as two parallel, solid black lines. Double-line drawings take more time but are much more realistic looking than single-line drawings. (Figure 9.77) Double-line drawings are used for:

Piping system illustrations.
Presentation drawings.

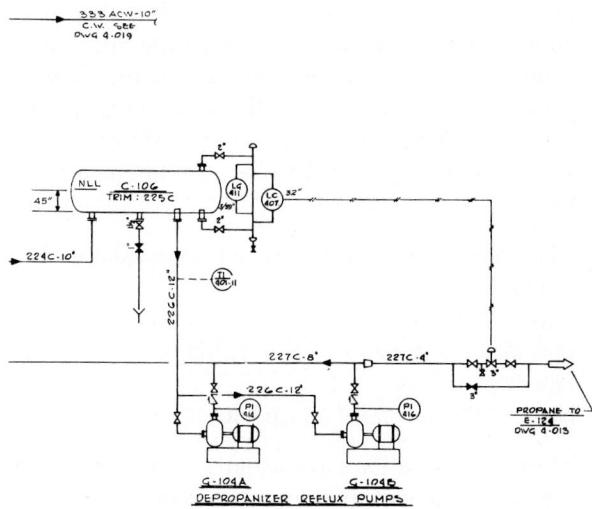

Figure 9.75 Single-Line Elevation Piping Drawing

Figure 9.76 Simple Single-Line Plan Drawing

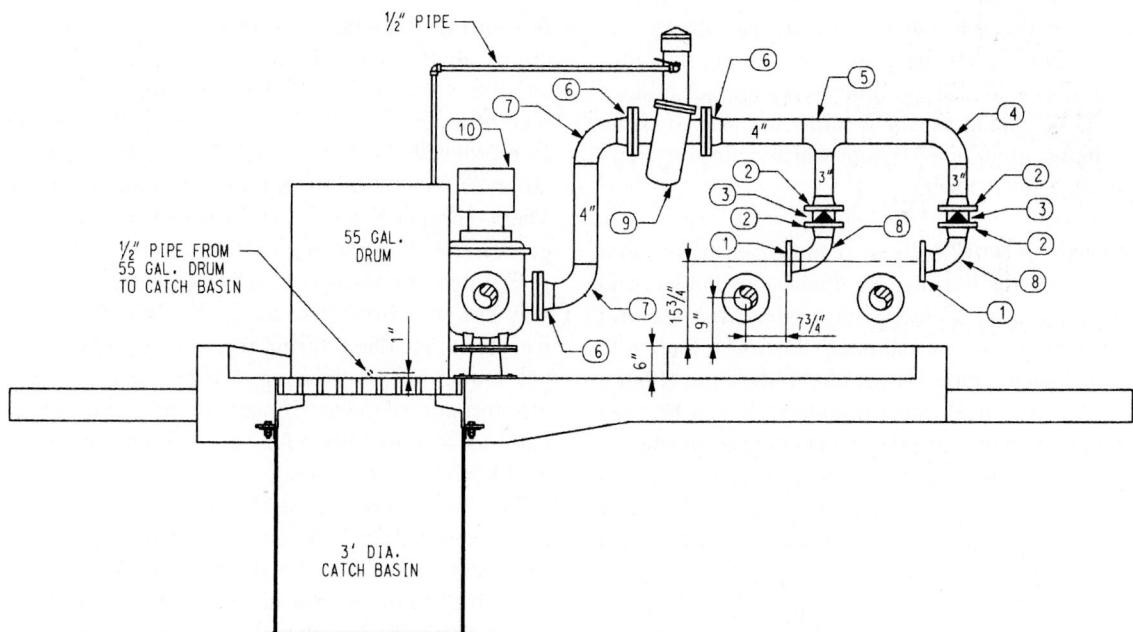

ELEVATION VIEW

SCALE: $1/2" = 1'-0"$

Figure 9.77 Double-Line Drawing of a Process Plant

Visualizations.

Clearance and interference checks for large-diameter pipes.

Begin a double-line drawing by laying out the building and structural members, and then locating the coordinates for the major equipment from the layout plan. Then add the large equipment, such as tanks, filters, and so forth, to the drawing. Equipment vendors will provide the equipment dimensions, which are used to create a scaled drawing. The center lines of the pipes are drawn using construction lines or by employing a construction layer when using CAD. Fittings are then added to the outside diameter of the pipes.

Isometric Drawings Isometric drawings are a pictorial representation of a piping system, and can be a single- or double-line representation, complete with pipes, fittings, valves, equipment, and dimensions. (Figure 9.78) Isometric drawings are an aid in visualizing the piping system. A bill of materials may be included. When using traditional tools, isometric drawings are created after the plan and elevation views are completed. Sometimes isometric piping drawings are not drawn to scale, if dimensions are not critical. Some CAD piping programs allow the user to create the piping system in 3-D, from which isometric views are created automatically.

Dimensions and Notes Plan, elevation, and isometric piping drawings are dimensioned in feet and inches, using an architectural style. Architectural dimensioning uses an unbroken dimension line, with the dimension figure shown above the line. (Figure 9.79) A mechanical dimensioning style can be used for piping drawings, but this is not common practice.

Piping dimensions are given from center to center, end to center, and end to end for the locations of fittings, flange faces, and valves. The lengths of all pipes are dimensioned, and the specifications are written near the pipes using a leader line if necessary, or a line balloon. A **line balloon** is a graphic symbol with square or round ends, used to specify the types of pipe and the pipe lengths. (Figure 9.80)

Dimension lines are unbroken, even if they pass through other lines. Notes are placed after the dimensions and close to where they apply. Figure 9.80 reads as a 1"-diameter condenser water flow pipe with an identification number of 106. At a minimum, a dimensioned piping drawing should contain the following information:

Diameters, lengths, and identification numbers of all pipes.

Location dimensions of all fittings and valves.

Specifications for all valves and fittings.

Pipe flow arrows.

Names and numbers of all equipment.

Piping elevations are usually dimensioned by specifying the elevation from the floor to the center lines of the pipes and to the tops of structures.

9.9 WELDING

A **welding drawing** is a detailed multiview drawing of all the parts assembled, with accompanying welding symbols. A welding drawing is actually a type of assembly drawing showing all the parts fastened together. (Figure 9.81) The graphic representation of welded joints is through welding symbols. The weldment (i.e., the item formed by welding together the various pieces) is not shown, but the joint lines are shown, even though the joint itself may not be visible after the parts are welded. Also, if material is added during the welding process, it is not shown on the drawing. For example, arc welding normally deposits some type of metal onto the parts to be fabricated. This arc welding material is not shown on the drawing.

Welding symbols conform to the American Welding Society (AWS) symbols, which have been adopted by ANSI as ANSI/AWS A2.4-1986. The symbols give all the information necessary for the welder to fasten the parts together using one of the welding techniques. Appendix 54 summarizes the standard welding abbreviations and symbols.

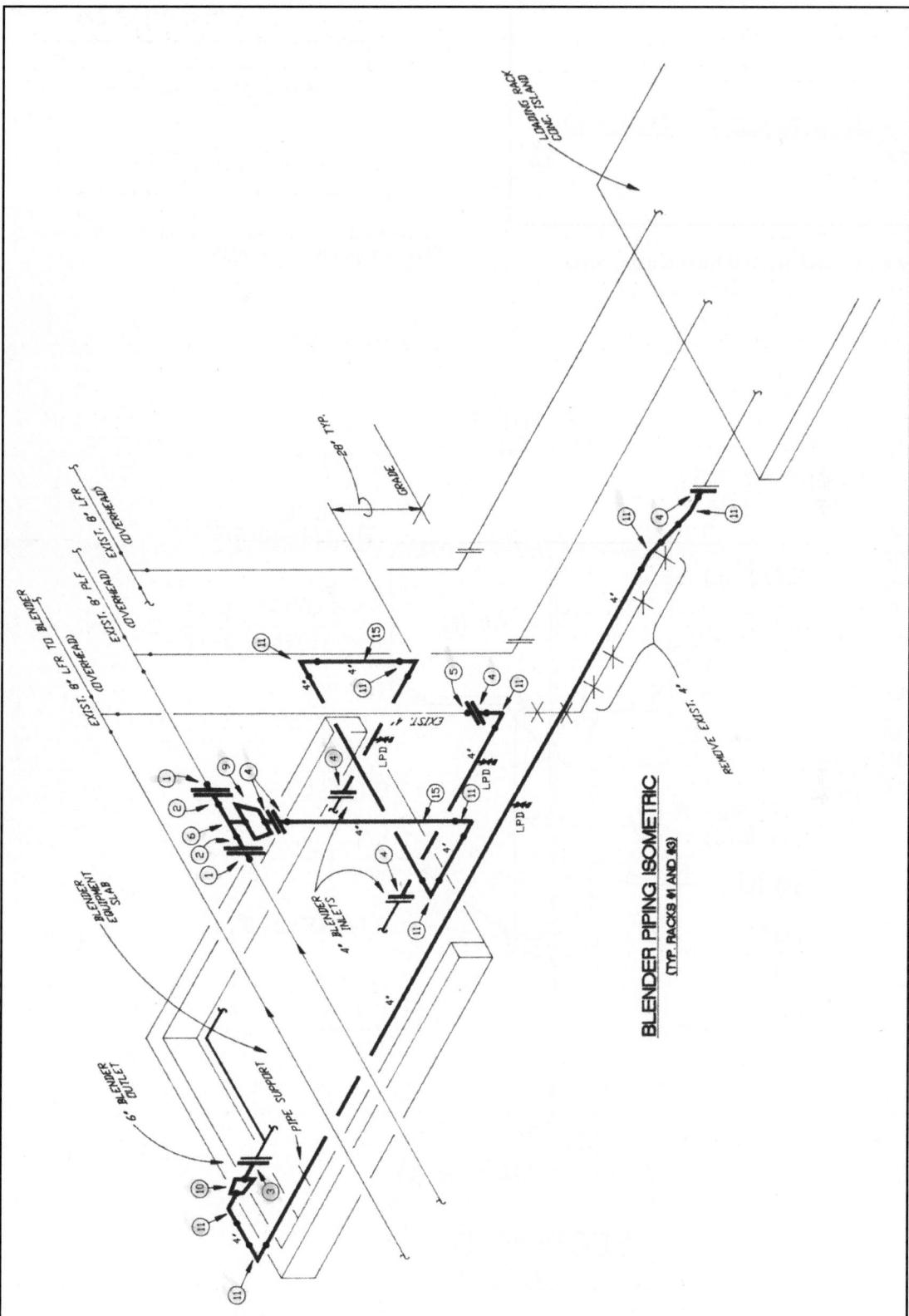

Figure 9.78 Isometric Piping Drawing

Figure 9.79 Architectural Dimensioning Style

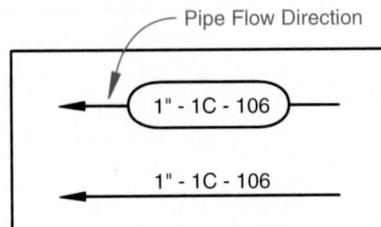

Figure 9.80 A Line Balloon Symbol Used to Specify the Type of Pipe and the Length

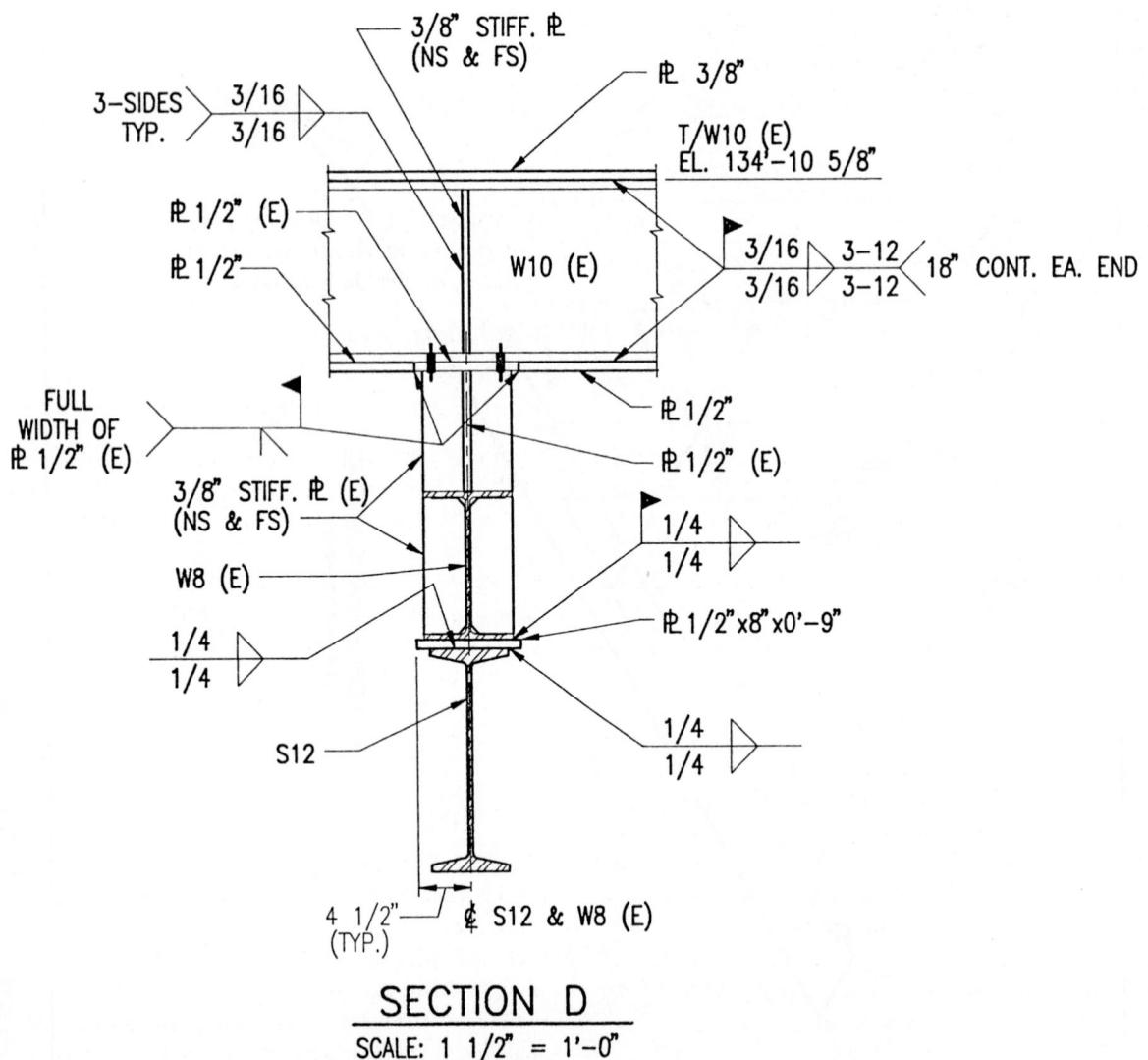

Figure 9.81 A Technical Drawing with Weld Symbols

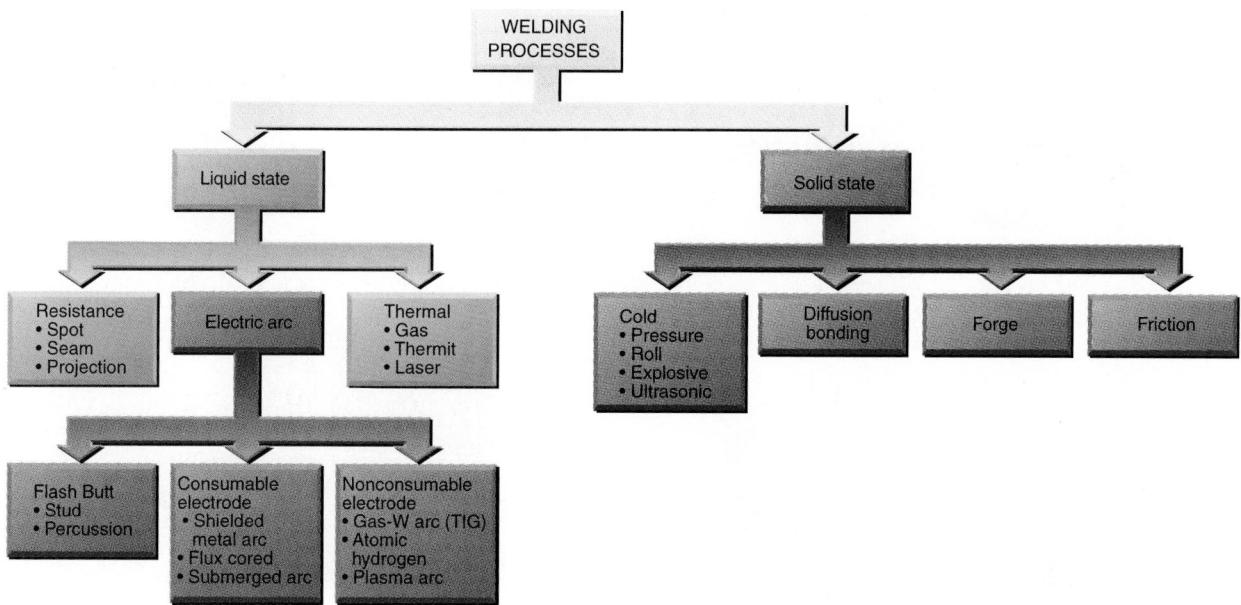

Figure 9.82 Classification of Welding Processes

9.9.1 Welding Processes

Welding is the process of fastening metal together by bringing abutting surfaces to a molten state, with or without the use of filler material. Welding is used to fabricate metals together permanently, in structures and products. Figure 9.82 shows the classification of the welding process into two major categories: liquid state and solid state. Gas or thermal, arc, and resistance welding are the most common processes. Welding can be done by people or machines, such as robots. Robot welders are popular in manufacturing, but still require technical drawings to specify the types and locations of the welds so the technician can program the robots. If the welding is done away from a manufacturing site, such as on a pipeline, it is called **field welding**.

Gas and Arc Welding **Gas welding** is a thermal fastening process that uses a mixture of flammable gas and oxygen, along with a filler material, to melt and fuse abutting surfaces. **Brazing** and **soldering** are related thermal processes that use a mixture of flammable gas and oxygen to deposit a material on abutting surfaces to fasten them. These processes heat the parts to be fastened so that the filler material will melt, but the parts will not. When the filler material hardens after cooling, the parts are permanently fastened.

Arc welding is a fastening process that uses a filler material and an electric arc to melt and fuse abutting surfaces. Arc welding includes:

- Shielded metal arc
- Gas tungsten arc—TIG (tungsten inert gas)
- Gas metal arc—MIG (metal inert gas)

The gas and arc welding processes commonly use the back, fillet, groove, or slot types of welds, which are described in more detail later in this section.

Resistance Welding **Resistance welding** is a fastening process that uses heat and pressure to melt and fuse abutting surfaces. Normally, no filler material is used to fasten the parts. Spot, seam, and flash welding processes are common types of resistance welding techniques.

9.9.2 Welded Joint Types

There are five basic types of welded joints: butt, lap, tee, corner, and edge. (Figure 9.83) Various types of welds are used for each type of joint, depending on the type and thickness of the material and the desired strength. Also, each joint can be fabricated by a number of different welding processes. For example, a butt joint could be joined using a gas or arc welding process.

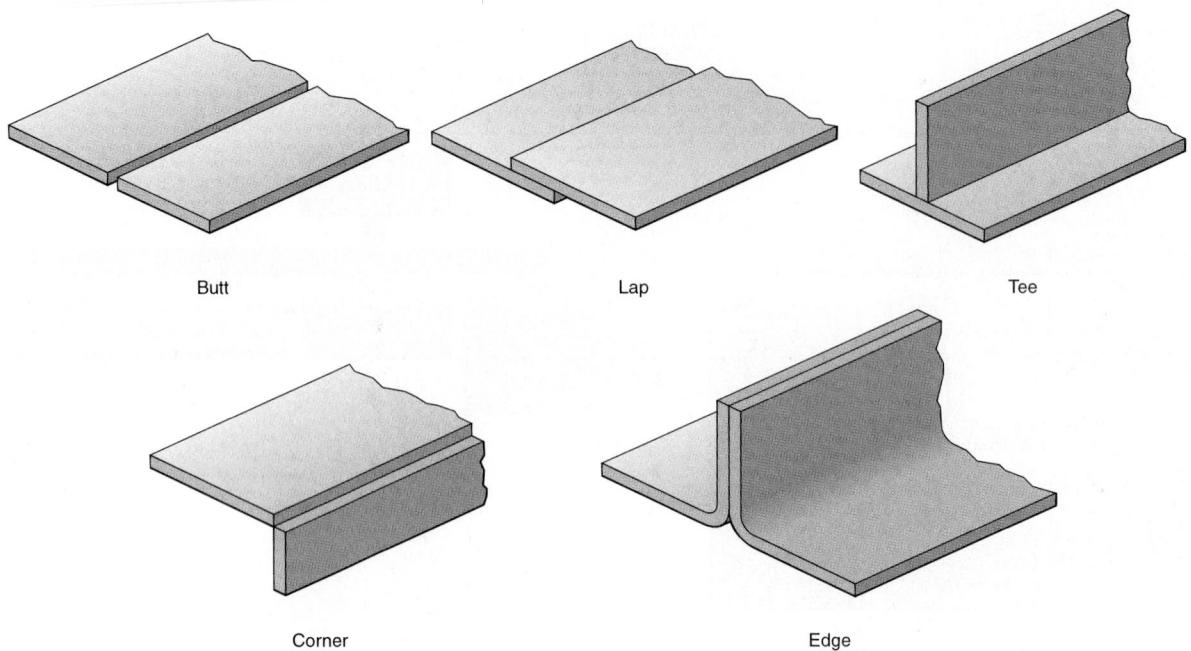

Figure 9.83 Common Types of Welded Joints

9.9.3 Weld Symbols

AWS and ANSI have standardized the weld symbols used to describe welds on technical drawings. (ANSI/AWS A2.4-79) The weld symbol completely describes the specifications for welding a joint, and a bent line with an arrow at the end points at the joint to be welded. The weld symbol is made of the leader, reference line, and tail. (Figure 9.84) A large amount of information can be attached to the leader line. (Figure 9.85) The eight basic parts to a complete weld symbol are:

1. Reference line
2. Leader line and arrow
3. Basic weld symbol (location/depth of weld)
4. Finish symbol
5. Weld symbol (type of weld)
6. Dimensions
7. Supplementary symbols
8. Tail and specifications

Most weld symbols are much simpler than the one shown in Figure 9.85. The weld symbol is attached to the horizontal portion of the leader line, called the reference line. The text height is $1/8''$ or 3 mm. The arrow points at the joint to be welded. The tail is used

Figure 9.84 The Parts of a Weld Symbol

when a specification, process, or other reference is made in the weld symbol; otherwise, it may be omitted. Normally, abbreviations are used to add the specification or process to the tail.

Supplementary weld symbols are shown in Figure 9.86 and are summarized as follows:

- a. A weld symbol is centered and placed below the reference line if the weld will be on the same side as the arrow.
- b. A weld symbol is centered and placed above the reference line if the weld will be on the *opposite* side of the arrow.
- c. If the weld is to be on *both* sides of the joint, then the weld symbol is centered and placed above *and* below the reference line.

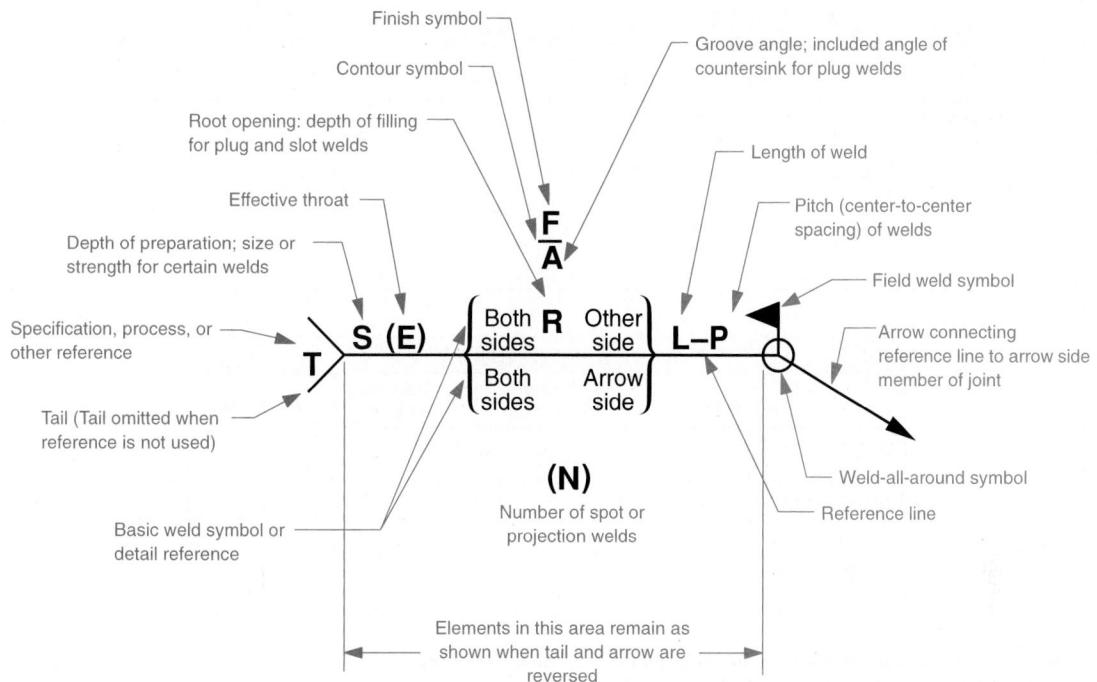

Figure 9.85 AWS Standard Weld Symbol

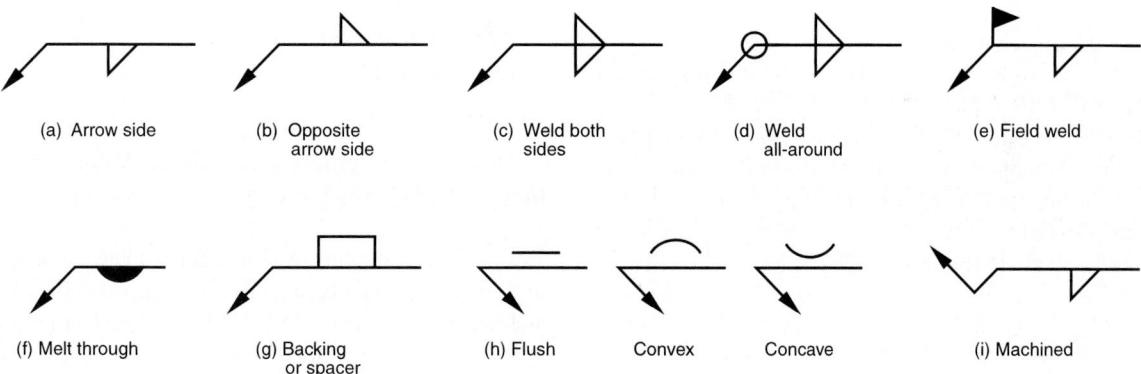

Figure 9.86 Weld Symbol Variations

- d. If the weld is to be *all around* the joint, then the weld-all-around symbol is placed at the intersection of the leader and reference lines.
- e. When the welding process is to take place in the *field* or on the sight of assembly, a special symbol, in the form of a filled-in flag, is used.
- f. The melt through symbol is used when there is to be 100% *penetration* of the weld from one side all the way through the joint.
- g. The backing or spacer material symbol is used when a small *extra piece* is to be added between the two parts to be joined.
- h. Contour symbols are used to represent welds that are *machined* to be either flush, convex, or concave. Contours are represented graphically by a horizontal line for flush contours, and by arcs for convex or concave contours. Methods of finishing are represented by the following letter designations, placed above or below the contour symbol: G–grinding, C–chipping, M–machining, R–rolling, and H–hammering.

GROOVE WELD SYMBOLS					
Square	Scarf	V	Bevel	U	J

OTHER WELD SYMBOLS				
Fillet	Plug or slot	Spot or projection	Back or backing	Surfacing

Figure 9.87 ANSI Standard Weld Symbols Used on Technical Drawings

i. If a joint is to be prepared prior to welding, such as being *machined* to a *bevel*, then the leader line is bent.

Various weld symbols have also been developed for the different types of welds (i.e., weld shapes or grooves). Figure 9.87 shows some of the more common weld symbols. Weld symbols are drawn with hand tools, using the dimensions shown in Figure 9.88, with weld symbol templates, or with CAD, using a symbol library. 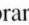 **CAD Reference 9.9**

- Square groove weld
- V-groove weld
- Bevel groove weld
- U-groove weld
- J-groove weld

Other types of groove welds are the V-flare, bevel-flare, and scarf, which is only used for brazing.

Plug Welds A **plug or slot weld** is made on a joint in which one piece of metal is overlapped on another and the weld is used to fill a hole or slot. The graphic symbol is a long rectangle and is used to represent the weld for both the hole and the slot.

Spot Welds A **spot weld** is generally used on sheet metal and is graphically represented as a circle. If the spot weld is on both sides, then the circle straddles the reference line.

Seam Welds A **seam weld** is a weld made between overlapping parts. A seam weld is represented as a circle with two horizontal lines drawn through it.

Surface Welds A **surface weld** is the built-up portion of a part created by welding a single bead or

9.9.4 Weld Types

Weld types are categorized by the weld shape or the type of groove that is filled with welding material. The more common types of welds are groove, fillet, plug and slot, and backing welds. Other types of welds are flange, flare, and seam welds. Each type of weld and its specific weld symbol are described in the following paragraphs. (Figure 9.89)

Fillet Welds A **fillet weld** is located at the internal corner of two parts. The fillet weld symbol is a triangle, with the vertical side *always* to the *left*.

Groove Welds **Groove welds** are grouped by their characteristic appearance. The common types of groove welds are:

Figure 9.88 Size of Weld Symbols, Using 1/8" or 3 mm Grid

FLANGE		FLARE		SEAM
Edge	Corner	Flare V	Flare-bevel	

Figure 9.89 Flange, Flare, and Seam Weld Symbols

multiple beads onto the surface. The symbol is always placed below the reference line because there is no arrow-side significance when welding a surface.

9.10 REPROGRAPHICS

Reprographics refers to the technology and techniques of reproducing documents. After the

engineering drawings have been created, they are copied for others to use, carefully stored, and set up for easy future accessibility. The original drawings are rarely used once they are completed, so copying becomes a very important part of design and production. The techniques for storing and retrieving traditional drawings versus CAD drawings are very different.

Figure 9.90 A Diazo Machine Used to Make Blueline Prints

(Courtesy of Oce-Bruning, Inc.)

Figure 9.91 A Large-Format Xerographic Copying Machine

(Courtesy of Xerox Corporation.)

9.10.1 Reproduction Techniques

Blueprinting *Blueprinting* is a photographic reproduction process in which the copy produced, called a **blueprint**, has white lines on a blue background. Blueprints are made by exposing specially coated paper to light, using the original drawing as the negative, then developing the exposed paper in an ammonia bath. This process requires that the original drawing be created on semitransparent media. Because blueprinting was the first reproduction method in common use, the term *blueprint* is often used as a generic term for any type of copy.

Diazo **Diazo** is a more modern technique similar to the blueprint process. The *diazo print*, also called an ozalid dry print or a blueline print, is a direct-print dry process. Although diazo prints are sometimes referred to as blueprints, they are not considered true blueprints.

The diazo process begins by placing the original drawing face up on the yellow or treated side of the diazo paper. The drawing and diazo paper are fed through the light exposing process. After the paper is exposed, the original drawing is removed and the exposed paper is fed through a chemical fixing process, coming out as a copy with blue, black, or brown lines on white paper. (Figure 9.90)

Xerography **Xerography** is an electrostatic process that transfers images onto ordinary paper. The electrostatic process offers high-quality prints with good archival quality, but it is more expensive than the diazo process. The use of xerography for copying larger engineering drawings is fairly new, even though the process has been used for smaller drawings for some time. Large-format xerographic machines are used to make copies of original drawings. (Figure 9.91) The original is either fed into the machine or placed on a glass surface. The image is transferred to plain paper, producing a black-line copy on white paper.

A distinct advantage of the xerographic process is that multiple reduced or enlarged copies can be produced quickly and easily.

Microfilming Engineering drawings produced on large sheets of paper present a significant storage and retrieval problem for industry. One technique for reducing the size of the originals is **microfilming**, which is a photographic process that produces a small film negative. Either 16 mm or 35 mm film is used. An **aperture card** is a long, rectangular card with a rectangular hole for mounting microfilm. (Figure 9.92) Aperture cards can be easily stored in small, numbered drawers, or can be mailed to other sites. Aperture cards can also be coded or indexed for easy document location.

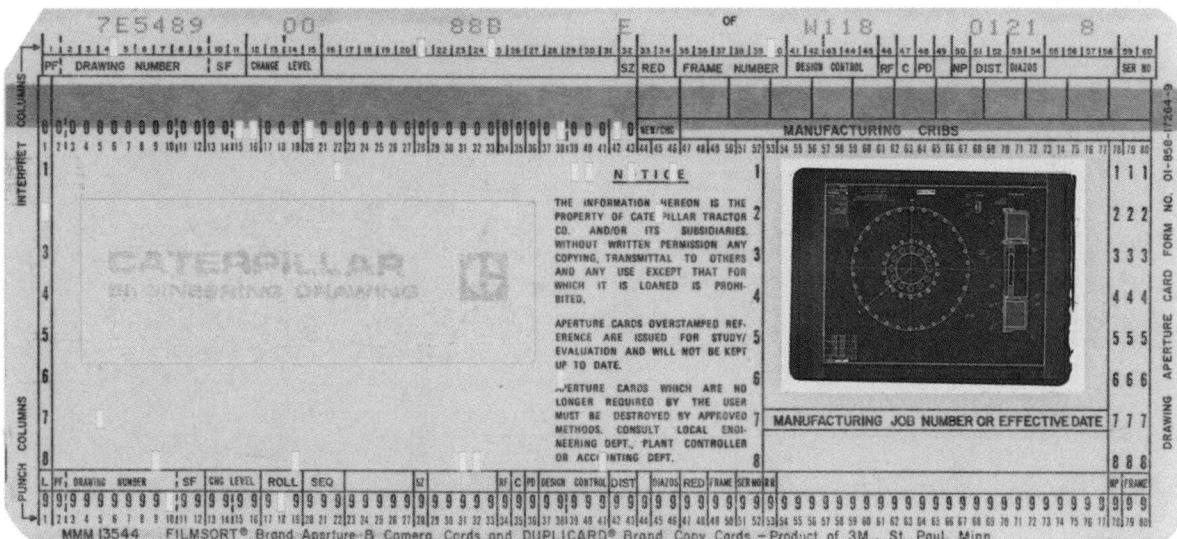

Figure 9.92 An Aperture Card Used to Mount a Microfilm of an Engineering Drawing

9.10.2 Digital Technologies

Just as CAD has revolutionized the engineering design/drafting process, the use of computers for reprographics is revolutionizing the copying, storing, and retrieving of engineering drawings. Plots of CAD-produced drawings can be copied using one of the techniques described earlier in this chapter. However, a more modern approach would be to use the digital data as the basis for storing, copying, and retrieving the engineering drawings.

Scanning Hand-drawings can be converted to digital files using a process called scanning. **Scanning** is an optical electronic process that converts text and graphics into digital data. When a hand-drawing has a change order, many companies scan that drawing into digital data, then edit the drawing using CAD. In this manner, companies are slowly, and on an as-needed basis, beginning to update their older drawings to digital formats.

Storage Techniques CAD-based engineering drawings can be stored as digital files, using large storage media, such as streaming tape, CD-ROM, and removable hard disks. For example, a streaming tape device, such as *digital audio tape (DAT)*, can be used to store upwards of 1 gigabyte of drawing files. This streaming tape technology is slow for retrieval, because it is sequential; however, it offers large data storage capability at a relatively inexpensive cost.

The digital storage of drawing files is accomplished by saving or copying the drawing files to the medium, then storing that medium in a safe place. If working in a computer-networked environment, the system manager would mount the storage media on the network, save or copy the drawing file, then store it in a safe place. Drawings would be saved using a file-naming convention that would conform to the part or drawing numbers.

Engineering digital management systems (EDMS) are database software tools used in some offices to manage digital files. These computer programs, sometimes called drawing managers, are designed to locate and retrieve digitally stored drawing files quickly and easily. EDMS programs provide the ability to navigate quickly through drawing files and view the drawings on screen. EDMS programs assist in the organization of drawing files through the use of long filenames, memos, notes attached to the drawing file, etc. The drawing files can be sorted alphabetically, by date, size, or any other characteristic stored in the database. FIND utilities can then be used to locate a drawing file through the use of a series of search criteria.

Retrieval and Distribution After drawings are digitally stored, they can be retrieved using the EDMS software. Drawings can be viewed on screen, using either the CAD software or special viewing software (Figure 9.93), without resorting to making prints or plots.

Figure 9.93 A Drawing Manager Software Program Used to Manage and View CAD Drawing Files

(Courtesy of ELSA America, Inc.)

Files can be distributed to other sites either on disk or through telecommunications networks, such as phone lines. Telecommunications devices can transmit copies of electronic files (with modems) or paper documents (with fax machines). The use of cellular telecommunications technology has meant that design and production information can be sent directly to mobile units in the field.

KEY TERMS

Aperture card	Detail number	Gear	Nut
Arc welding	Diazo	Gear train	Outline assembly
Assembly drawing	Die	General tolerance note	Part number
Axis	Displacement	Groove weld	Parts list
Balloon	Displacement diagram	Internal thread	Pictorial assembly
Bearings	Documenting	Involute	Pinion
Bill of materials (BOM)	Double-line drawing	Isometric drawings	Pins
Blueprint	Drawing number	Keys	Pipe fittings
Bolt	Elevation drawing	Lead	Piping drawing
Brazing	Engineering digital	Line balloon	Pitch
Cam	management systems	Link	Pitch diameter
Cam follower	(EDMS)	Linkage	Plain bearings
Cap screw	External thread	Machine	Plan drawing
Civil piping	Extra fine series	Machine screw	Plug weld
Coarse series	Fastening	Major diameter	Plumbing
Constant pitch series	Field weld	Mechanical fastening	Process piping
Crest	Fillet weld	Mechanism	Production drawing
Depth	Fine series	Microfilming	Reprographics
Detail drawing	Gas welding	Minor diameter	Resistance welding

9.11 SUMMARY

Working drawings are a fundamental part of any manufacturing or construction business. These drawings document the manufacturing and construction process for simple-to-complex assemblies. Typically, a set of working drawings includes dimensioned detail drawings, assembly drawings, and parts lists normally developed based on ANSI standards.

Most assemblies contain standard parts such as fasteners or mechanisms. These parts all have to be specified on the working drawings using ANSI standards. A basic knowledge of how these standard parts function in a product is critical both to its design and how it is notated on the drawings. Many industries have their own specialized drawings such as piping drawings and welding drawings. These drawings also have standardized methods of representing parts and processes on the drawings.

Traditionally, drawings have been created on paper, which must be stored, retrieved, and copied through a process called reprographics. Increasingly computers are being used to not only generate the original drawings, but also manage their storage, copying, and distribution electronically.

Revision block	Single-line drawing	Tap	Virtual model
Rivets	Slot weld	Tap drill	Washers
Rolling contact bearings	Soldering	Thread angle	Welding
Root	Specifications	Threaded fastener	Welding drawing
Scanning	Spring	Thread form	Working assembly
Screw thread	Stud	Thread series	drawing
Seam weld	Subassembly	Threads per inch	Working drawing
Sectioned assembly	Surface weld	Title blocks	Xerography
Set screw	Tabular drawings	Valves	

QUESTIONS FOR REVIEW

1. Define working drawings.
2. List the types of drawings commonly found in a complete set of working drawings.
3. List the types of assembly drawings.
4. Describe a family of parts.
5. What type of drawing is used for a family of parts?
6. Define a subassembly.
7. What is zoning?
8. List the important items in a parts list.
9. List the important items in a title block.
10. What is a revision block?
11. Describe how CAD is used to create working drawings.
12. Describe how CAD is used for storage and retrieval of drawings.
13. Define reprographics.
14. Describe how CAD drawings are shared with remote sites.
15. Define fastening.
16. List the three applications for screw threads.
17. Identify the different parts of the following thread note: $\frac{1}{2}$ –13UNC–2B.
18. Sketch and identify the three methods of representing threads on engineering drawings.
19. What is a blind hole?
20. What is a bottom tapped hole?
21. What is the major difference between a cap screw and a bolt?
22. Name three types of locking devices.
23. Describe how CAD can be used to represent fasteners on a drawing.
24. Make a list of at least 20 things that you found that use mechanical fasteners, bonding, or forming as a means of fastening.
25. List the classification of gears.
26. List the three types of cams and cam followers.
27. Define link and linkages.
28. List the major types of bearings.
29. List the different types of welding processes.
30. Name the professional society that controls weld symbol standards.
31. Sketch the five basic types of welded joints and name them.
32. There are eight basic parts to a welding symbol. Sketch and name the eight parts.

FURTHER READING

COADE Mechanical Engineering News. COADE Engineering Software, 12777 Jones Rd., Suite 480, Houston, TX 77070, Phone 713-890-4566.

Graves, F. E. "Nuts and Bolts." *Scientific American*, June 1984, pp. 136-144.

Oberg, E.; F. D. Jones; H. L. Horton; H. H. Ryffell. *Machinery Handbook*, 24th ed. New York: Industrial Press, Inc., 1992.

Pancari, A. J. "Pro-Pipe: Fittings, Valves, and Flanges." *CADalyst*, April 1992, pp. 72-74.

Weaver, R. *Process Piping Drafting*. 3rd ed. Houston, TX: Gulf Publishing Company, 1986.

Young, B. "Streamlining the Design Process." *Cadence*, April 1993, pp. 78-80.

PROBLEMS

Integrated Design Communications Problem

The purpose of this problem is to graphically communicate the gear reducer, using newly acquired graphics skills and knowledge, so that it can be manufactured. The gear reducer is a mechanical device used to reduce rotational speed, measured in revolutions per minute (RPM), increase torque, and change directions. This is done by using a worm and gear. The worm and gear are on shafts which must be supported in the cast-iron case by roller bearings and must also be sealed using rubber seals. Figure 10.102, on page 624, is a pictorial exploded assembly drawing of the gear reducer.

Gear reducer assignment

Set up design teams of four to six people. Each design team should assign a group leader and a recorder, then discuss the organization of the team. The team should then evaluate the existing gear reducer assembly and evaluate it using DFM principles. Any recommended changes to the gear reducer should be noted for later use in the project. The group should begin to compile a notebook which will contain information necessary to complete the final report.

The following figures range from simple to complex mechanical and electromechanical assemblies. For each figure, create a complete set of working drawings. Some of the figures require tolerances to be assigned and missing information to be developed. Some of the assemblies may also be redesigned, to improve on the existing design. For each problem, do the following:

1. Sketch orthographic views of each part, with dimensions. If dimensions are missing, determine what they should be by their relationship to other parts.
2. Determine tolerances as noted or assigned.

3. Determine the scale and size of sheet to use if using traditional tools, or the plot scale and sheet size if using CAD.
4. Determine finished surfaces and mark them on the sketch.
5. Determine which parts should be represented as section views on the detail drawings.
6. Determine the specifications for all standard parts in the assembly.
7. Create dimensioned detail drawings of each nonstandard part in the assembly.
8. Create an orthographic or exploded pictorial assembly drawing in section.
9. Label all parts in the assembly drawing, using numbers and balloons.
10. Create an ANSI standard parts list with all relevant information for the parts in the assembly.

Problem Number	Figure Number	Figure Title
9.1	Figure 9.94	Burney Jig
9.2	Figure 9.95	Quick-Acting Hold-Down Clamp
9.3	Figure 9.96	Double Bearing
9.4	Figure 9.97	Dual-Acting Air Cylinder
9.5	Figure 9.98	Machinist's Vise
9.6	Figure 9.99	V-Block
9.7	Figure 9.100	Wheel Support
9.8	Figure 9.101	Butterfly Valve
9.9	Figure 9.102	Surface Gage
9.10	Figure 9.103	Drill Guide
9.11	Figure 9.104	Welder Arm
9.12	Figure 9.105	Pulley Support
9.13	Figure 9.106	Valve Assembly
9.14	Figure 9.107	Water Pump Fixture
9.15	Figure 9.108	Gear Reducer
9.16	Figure 9.109	Fixture Assembly

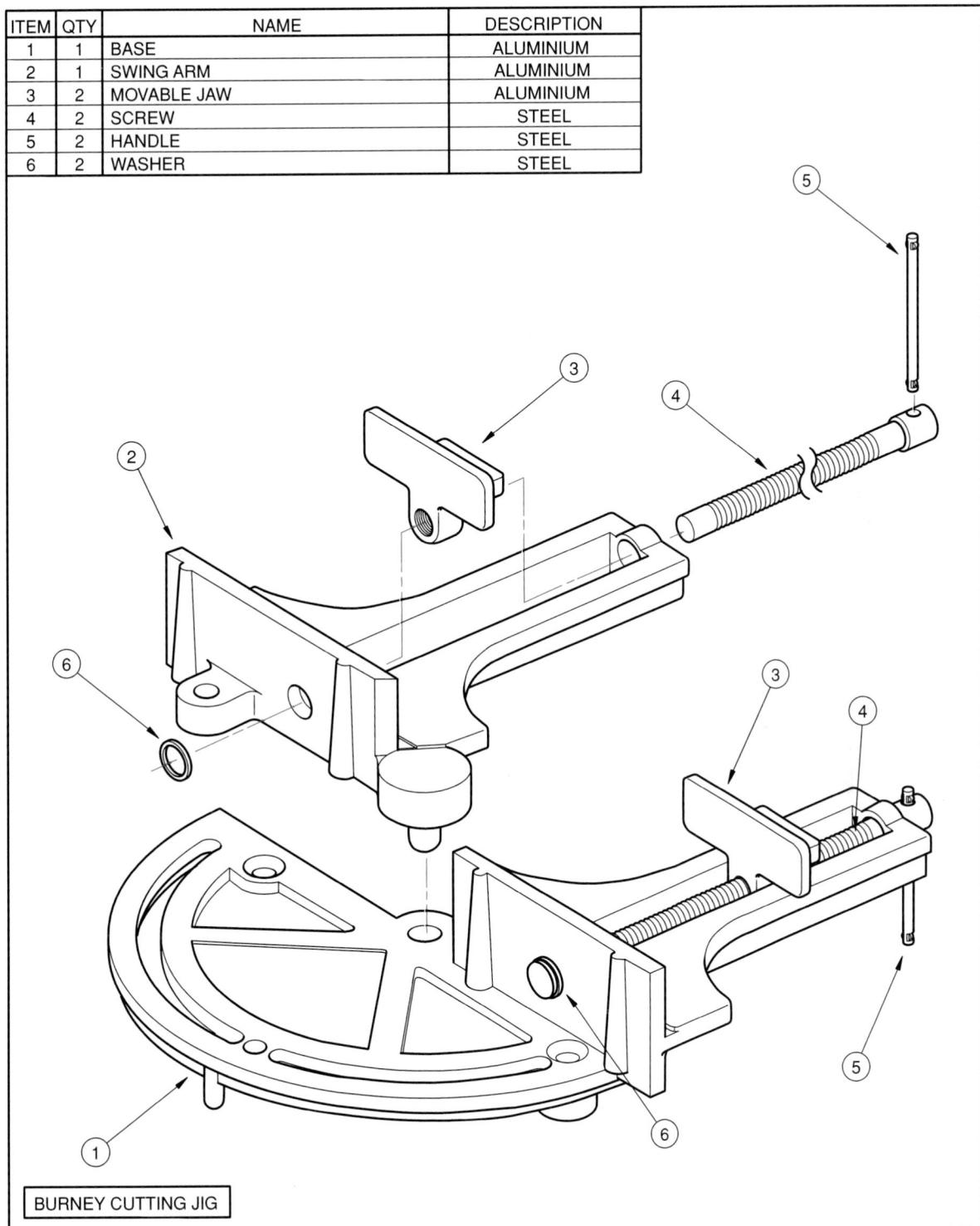

Figure 9.94 Burney Jig

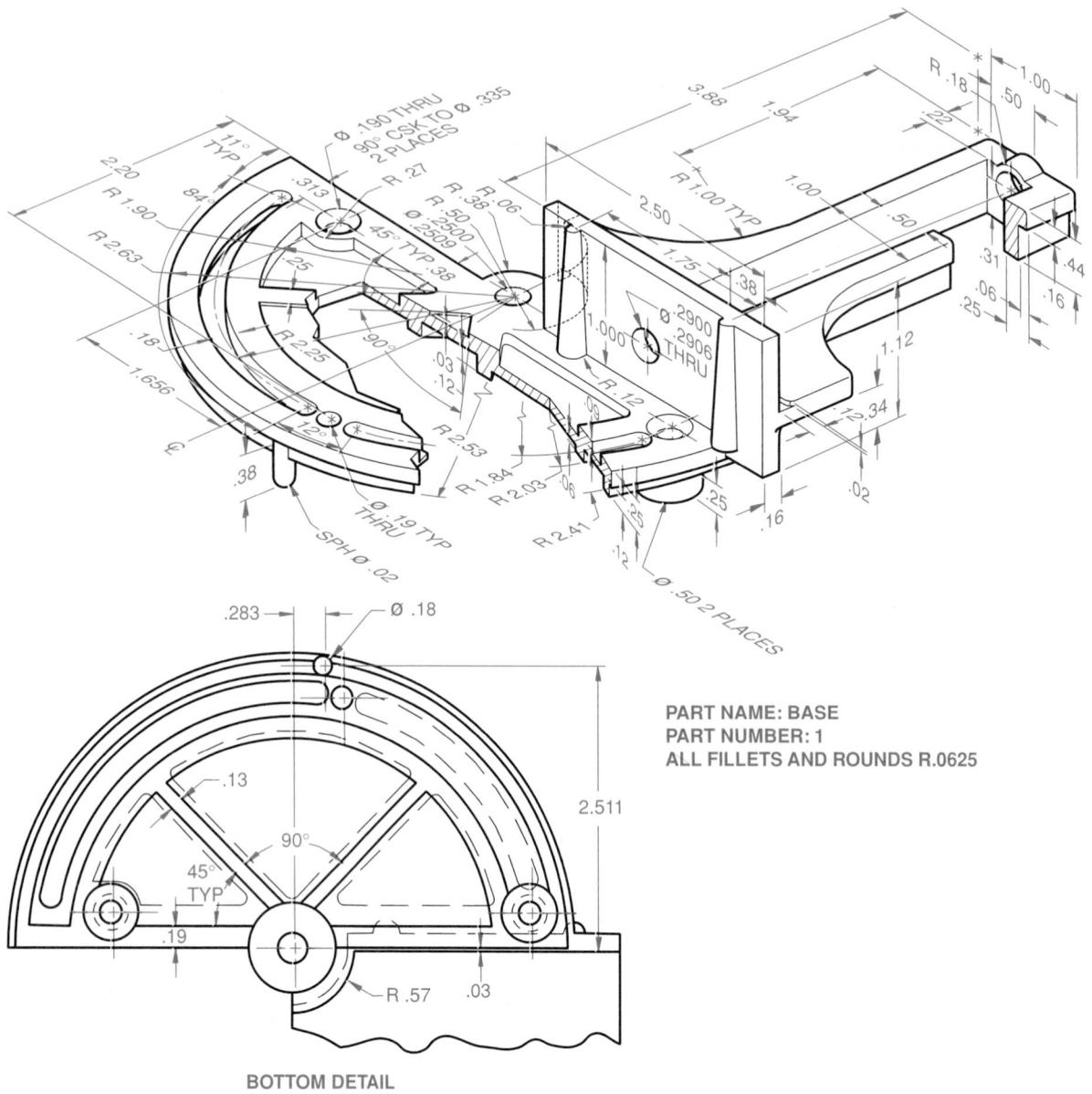

Figure 9.94 Continued

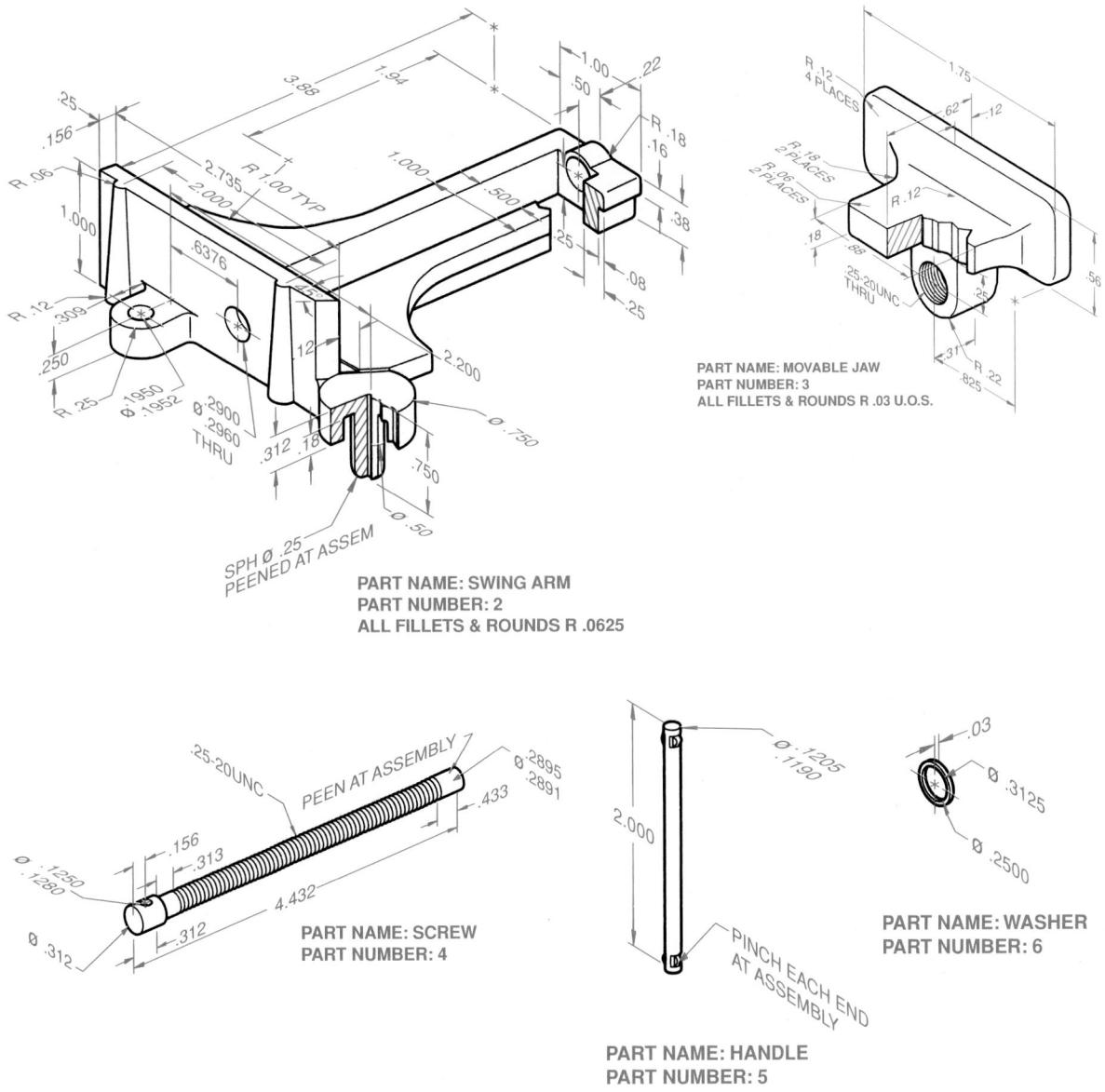

Figure 9.94 Continued

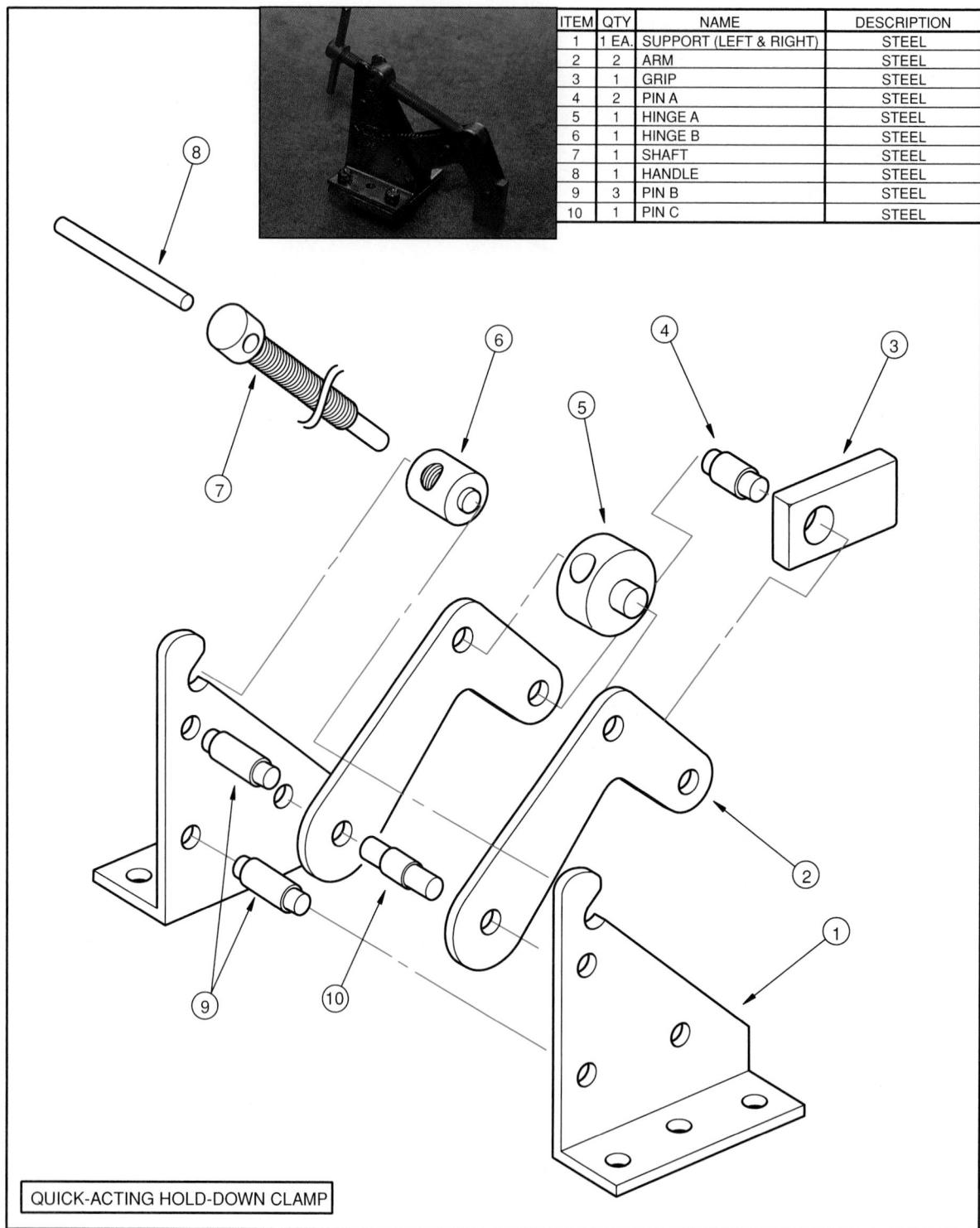

Figure 9.95 Quick-Acting Hold-Down Clamp

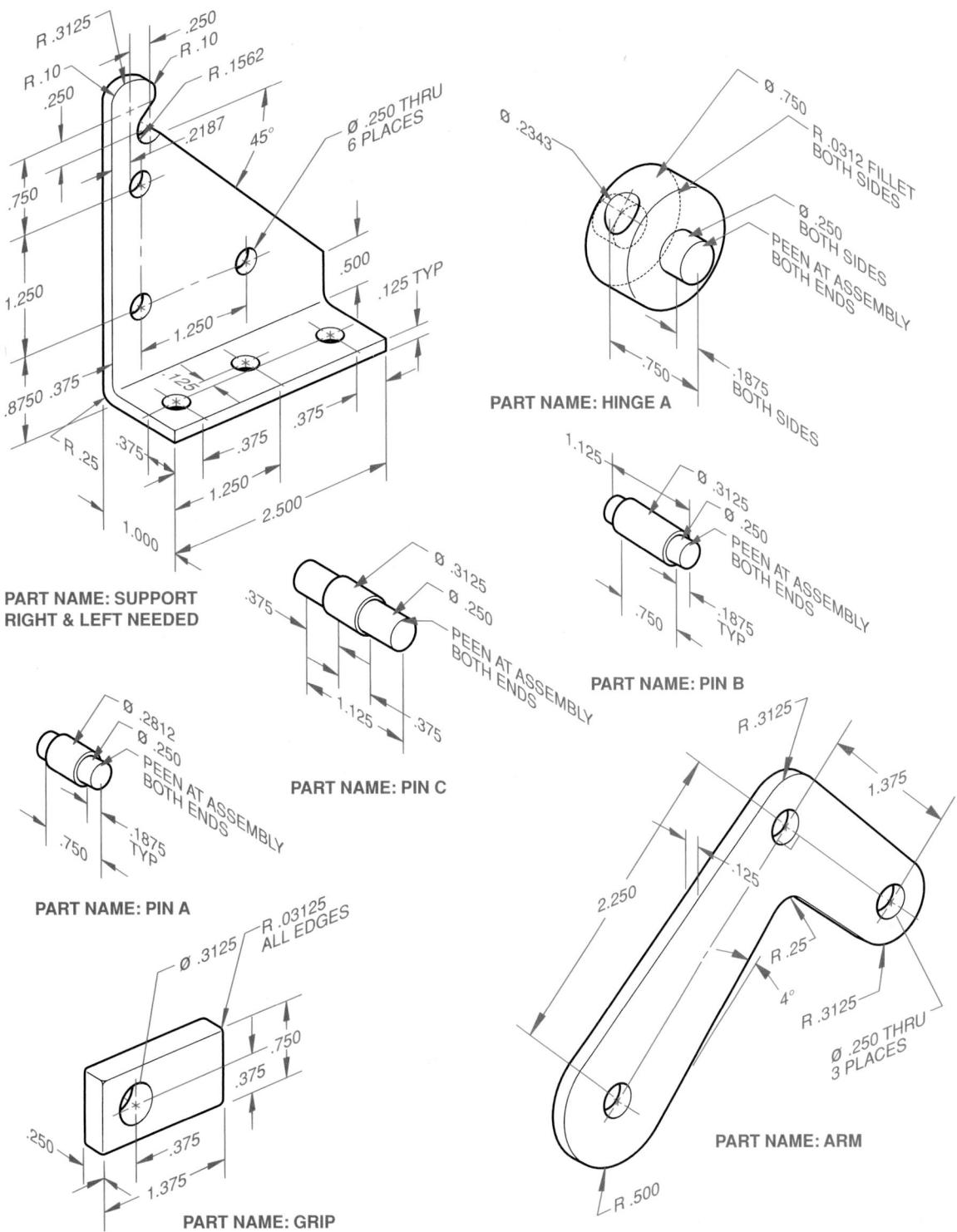

Figure 9.95 Continued

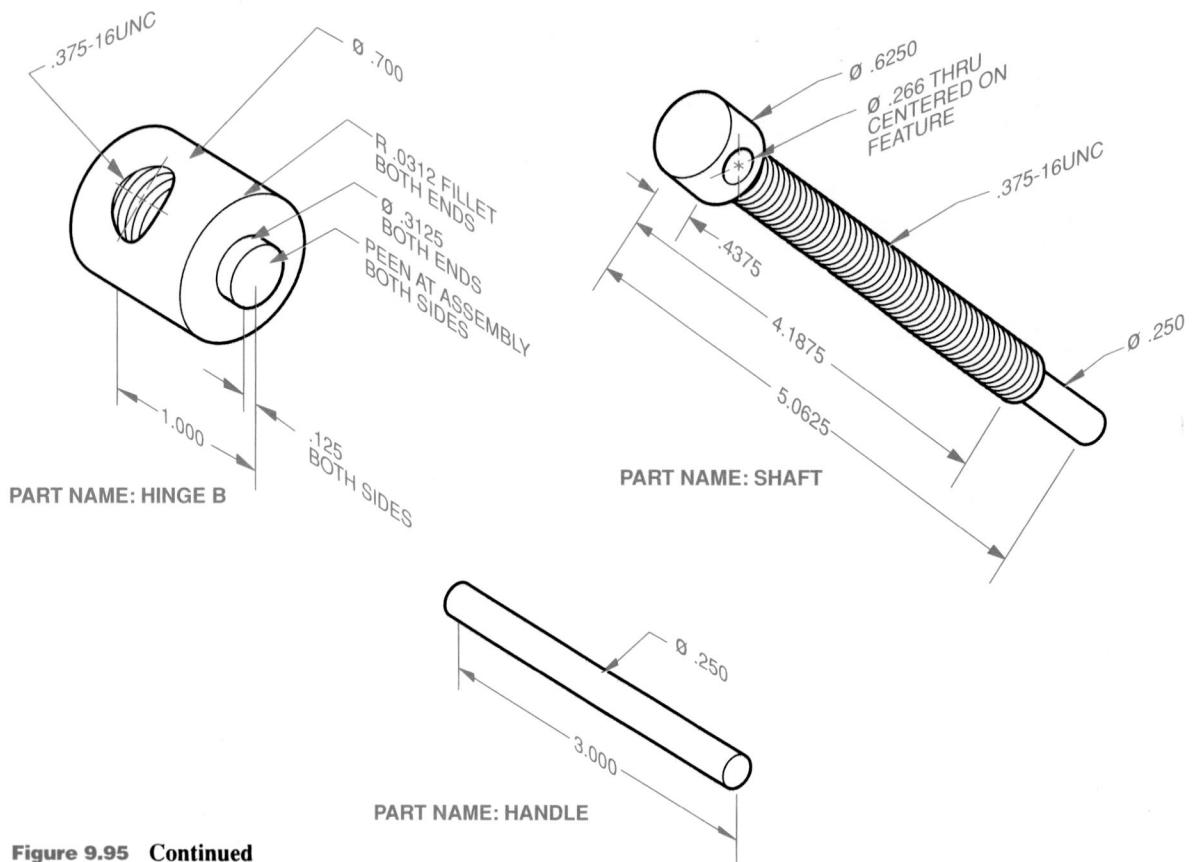

Figure 9.95 Continued

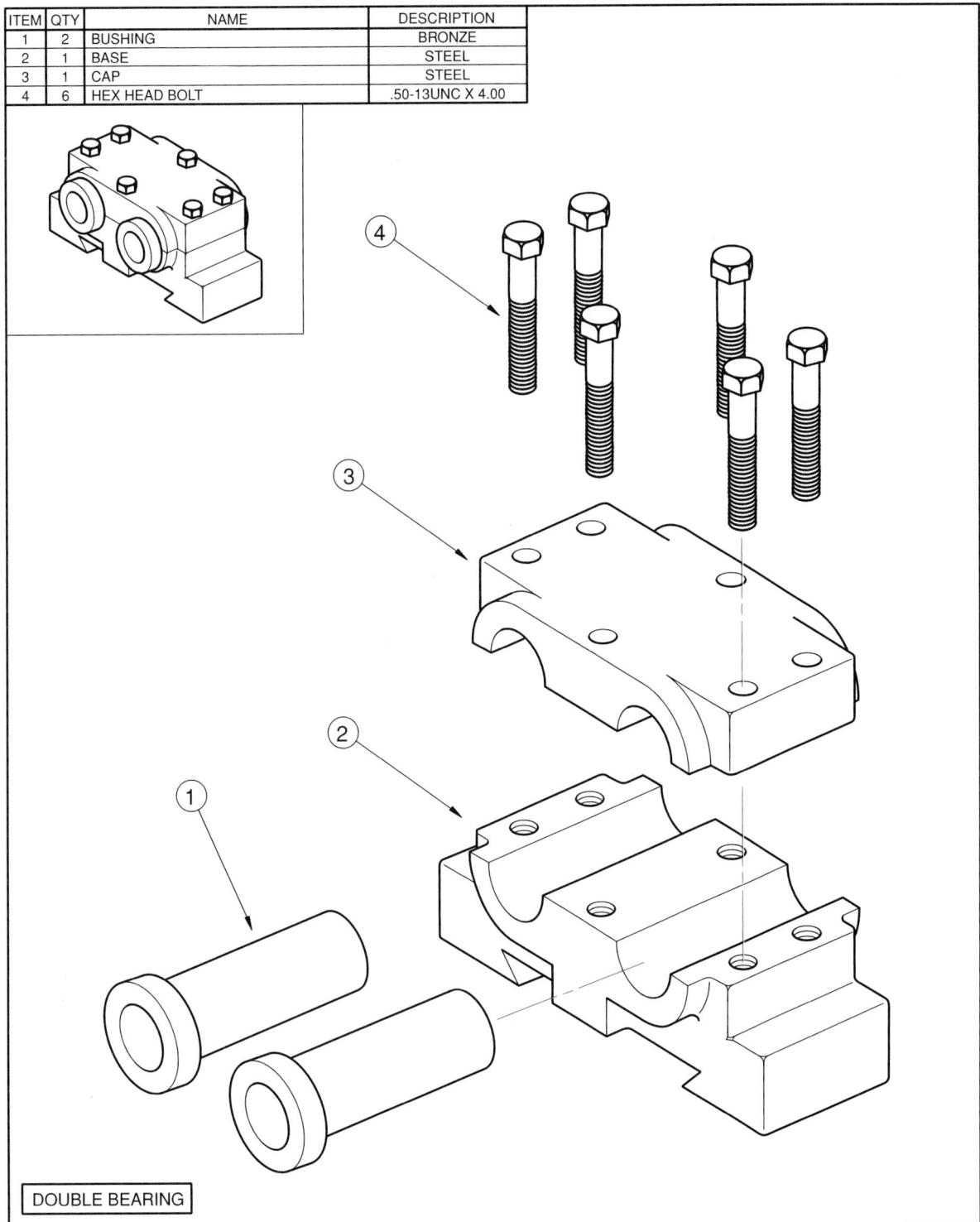

Figure 9.96 Double Bearing

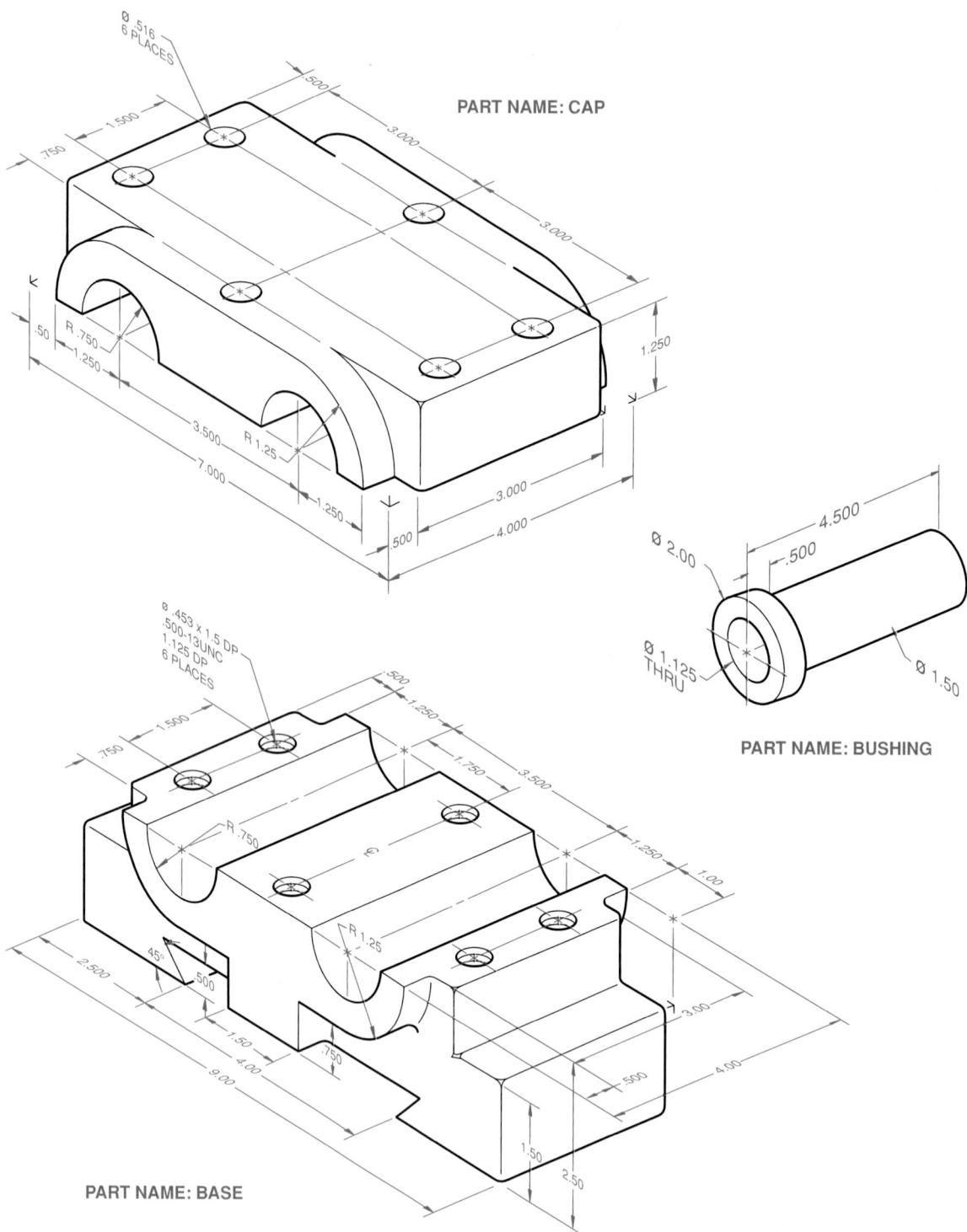

Figure 9.96 **Continued**

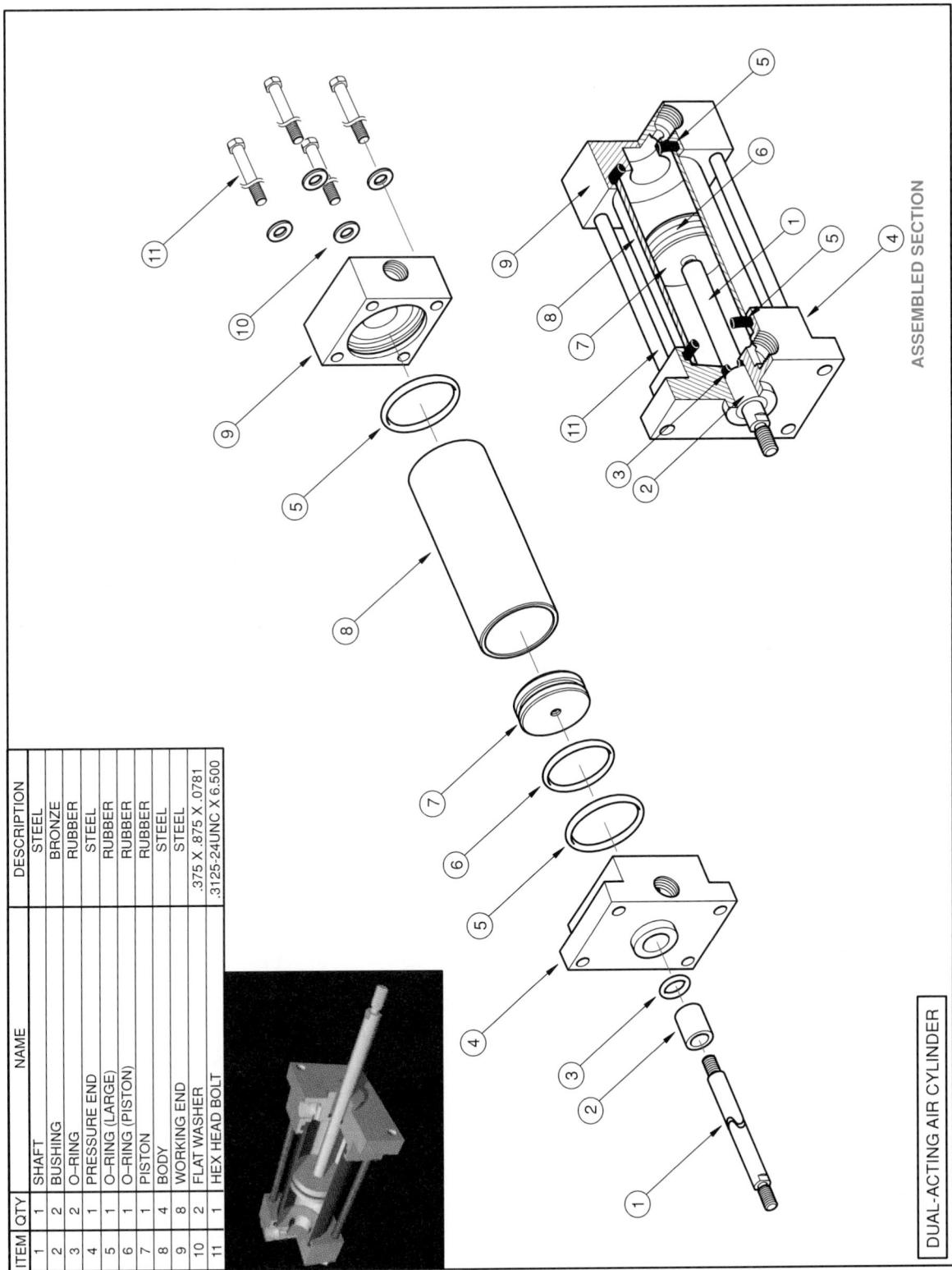

Figure 9.97 Dual-Acting Air Cylinder

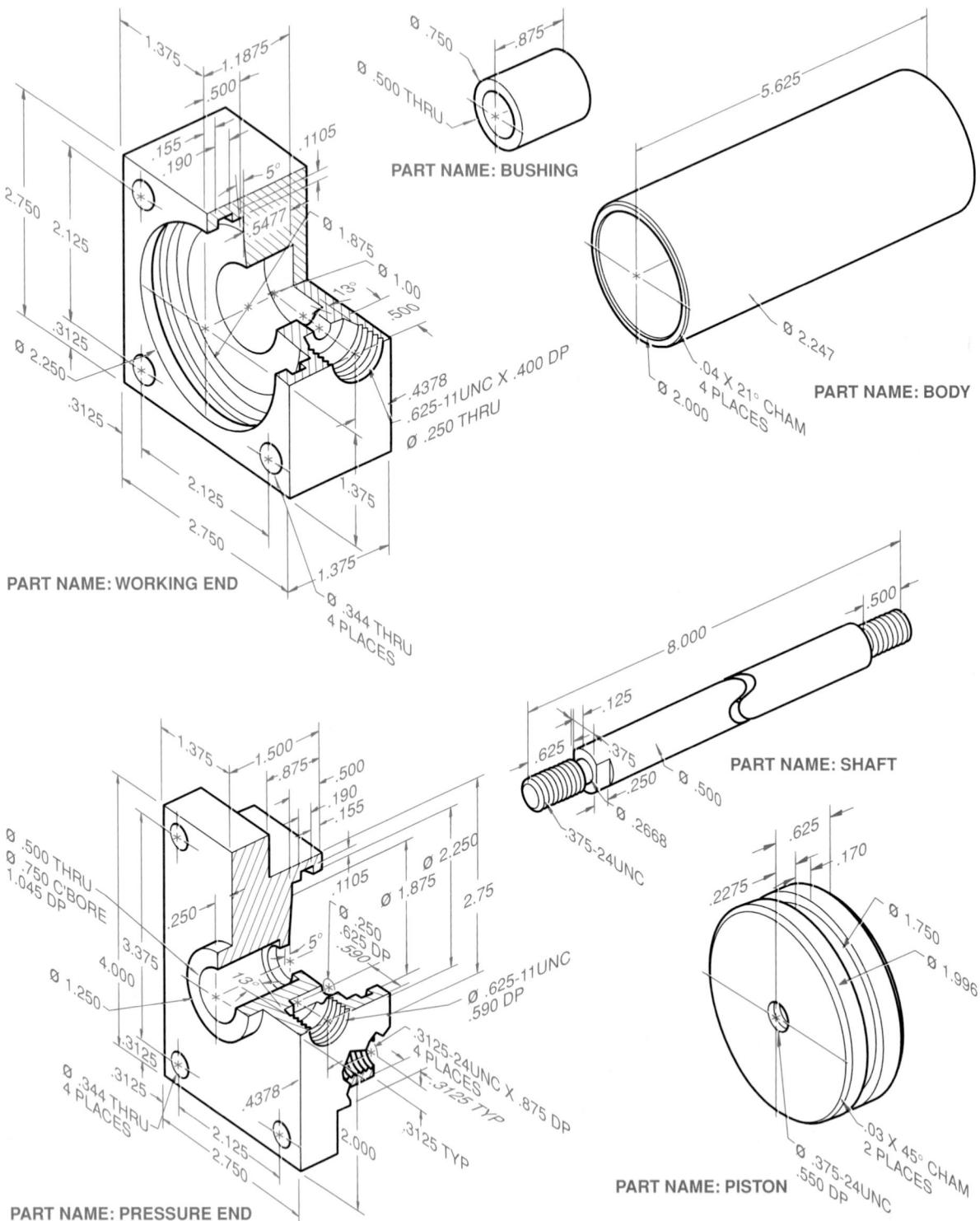

Figure 9.97 **Continued**

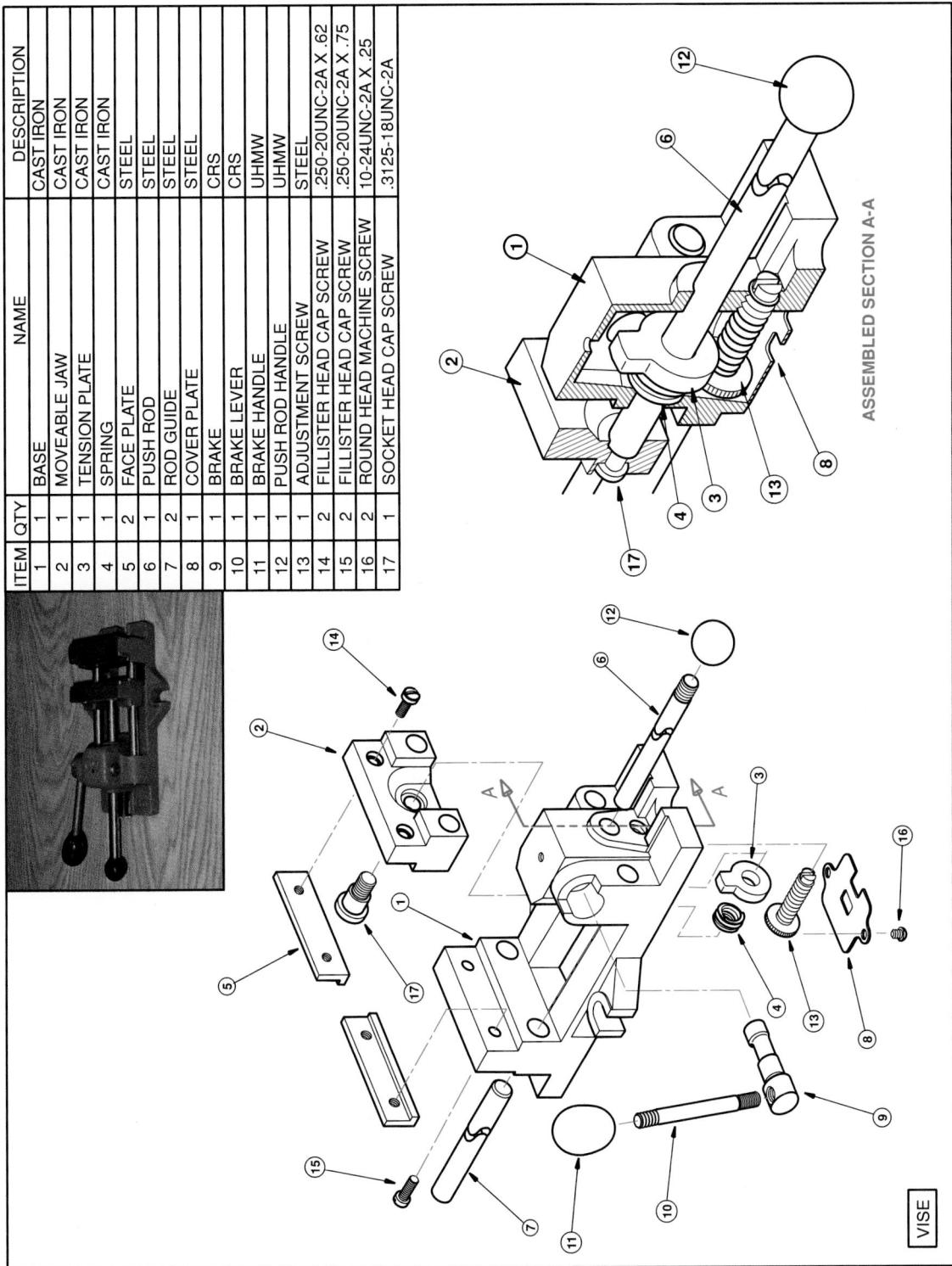

Figure 9.98 Machinist's Vise

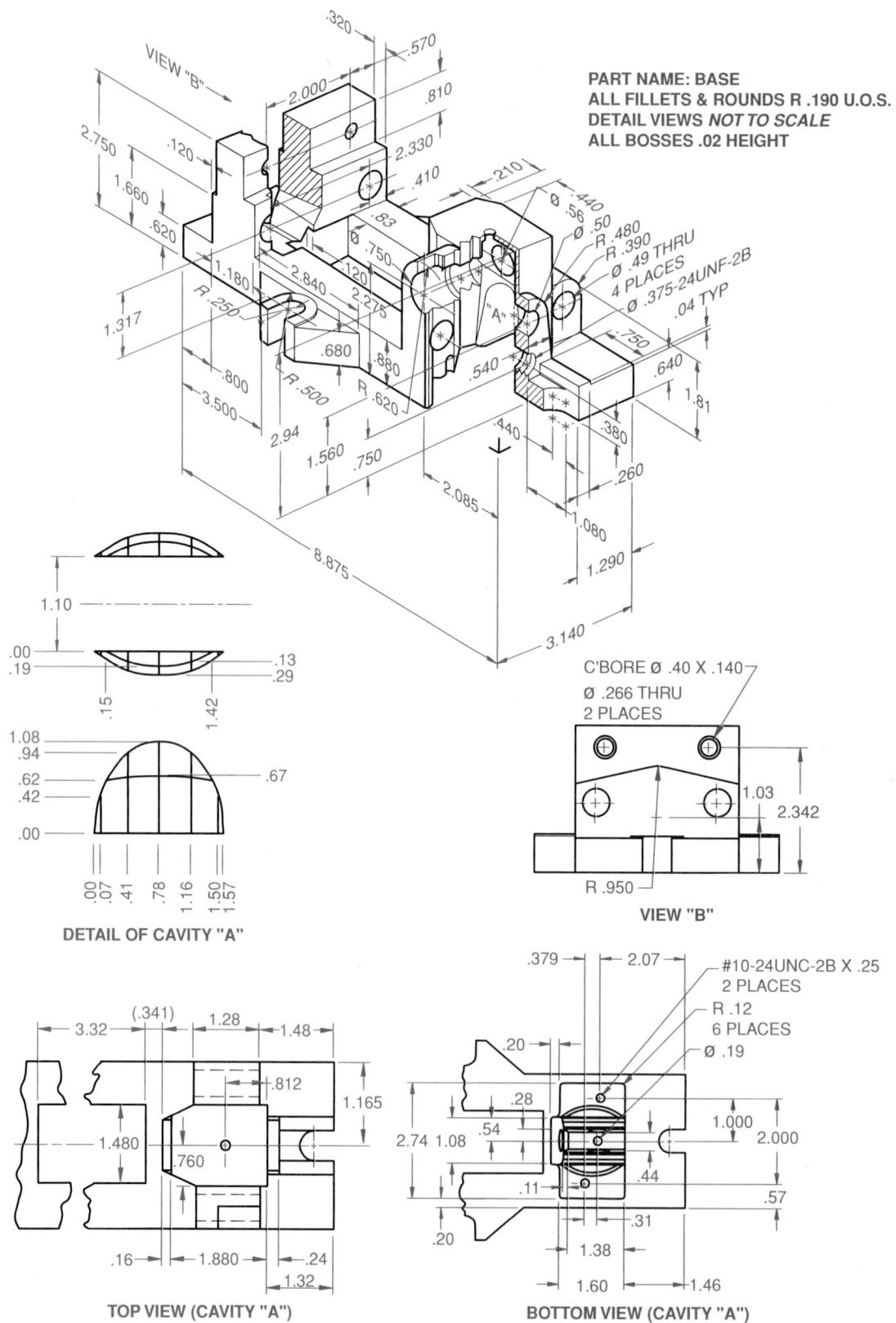

Figure 9.98 Continued

PART NAME: MOVEABLE JAW
ALL FILLETS AND ROUNDS R .190 U.O.S.

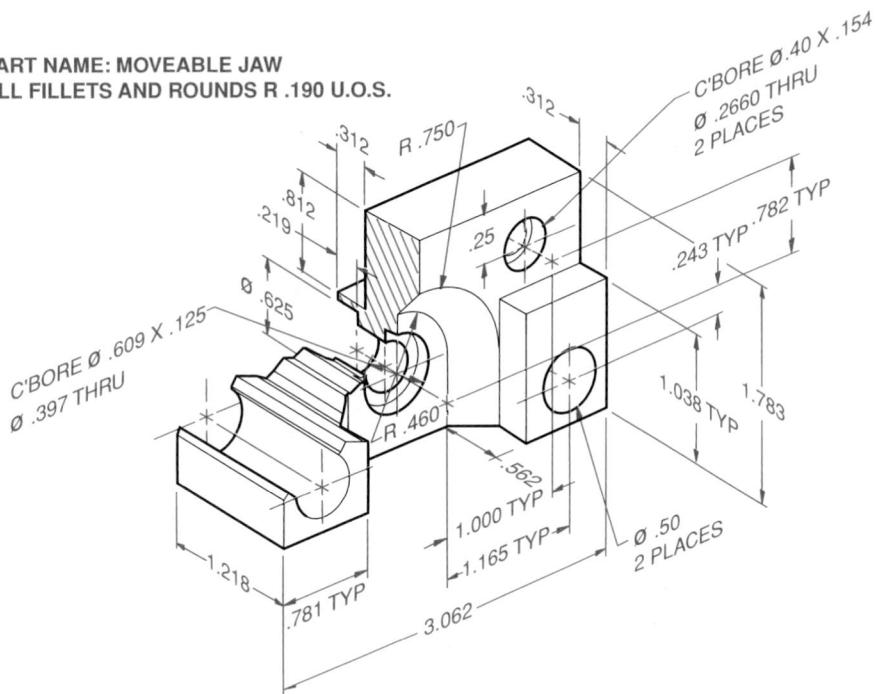

PART NAME: TENSION PLATE
ALL FILLETS AND ROUNDS
R .060 U.O.S.

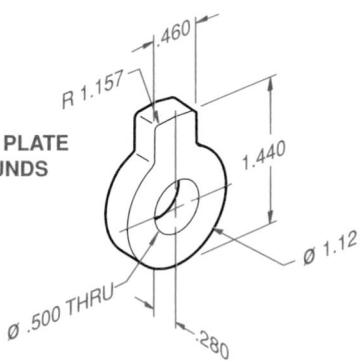

PART NAME: SPRING
NUMBER OF REVOLUTIONS=3
GROUND FLAT BOTH ENDS

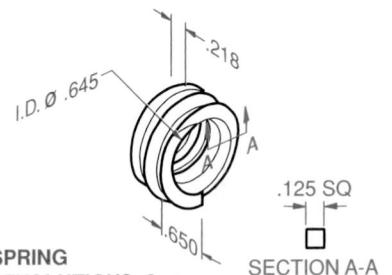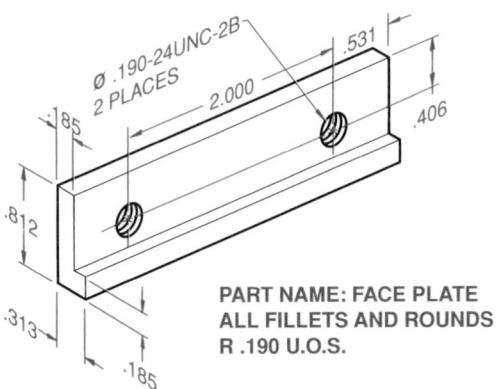

PART NAME: FACE PLATE
ALL FILLETS AND ROUNDS
R .190 U.O.S.

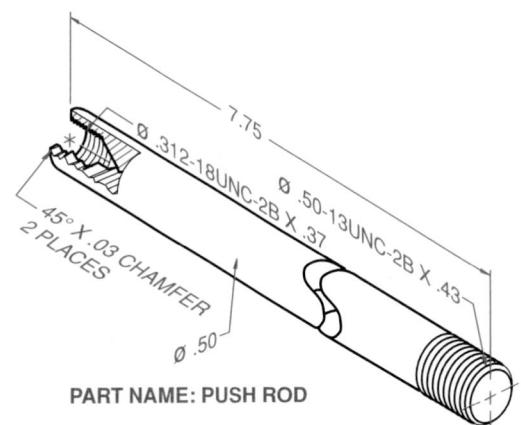

PART NAME: PUSH ROD

Figure 9.98 Continued

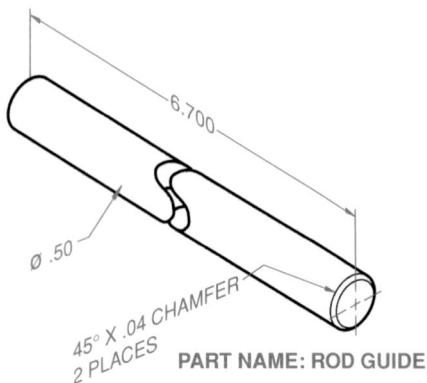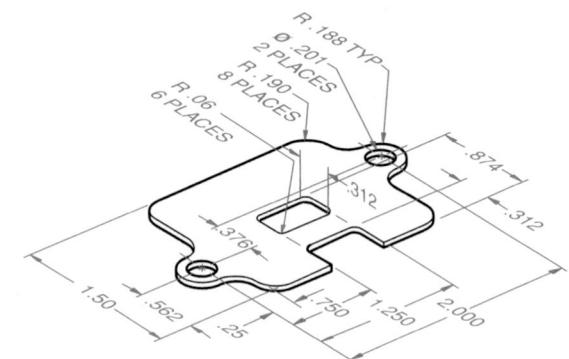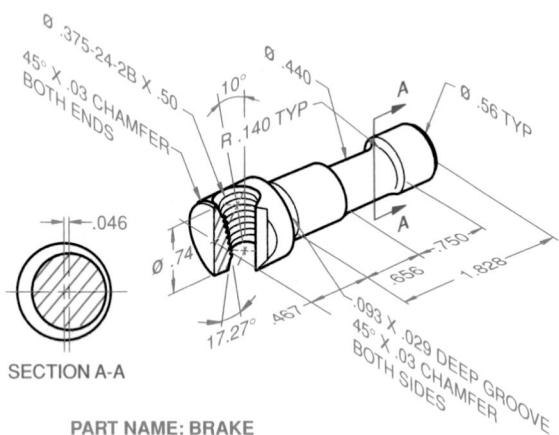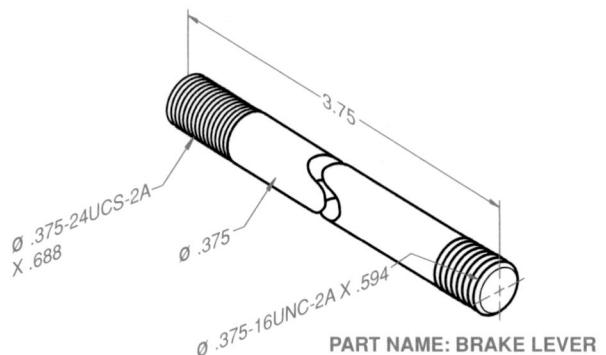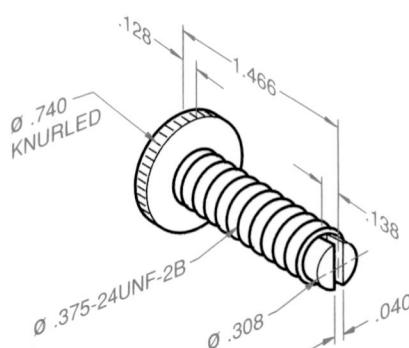

Figure 9.98 Continued

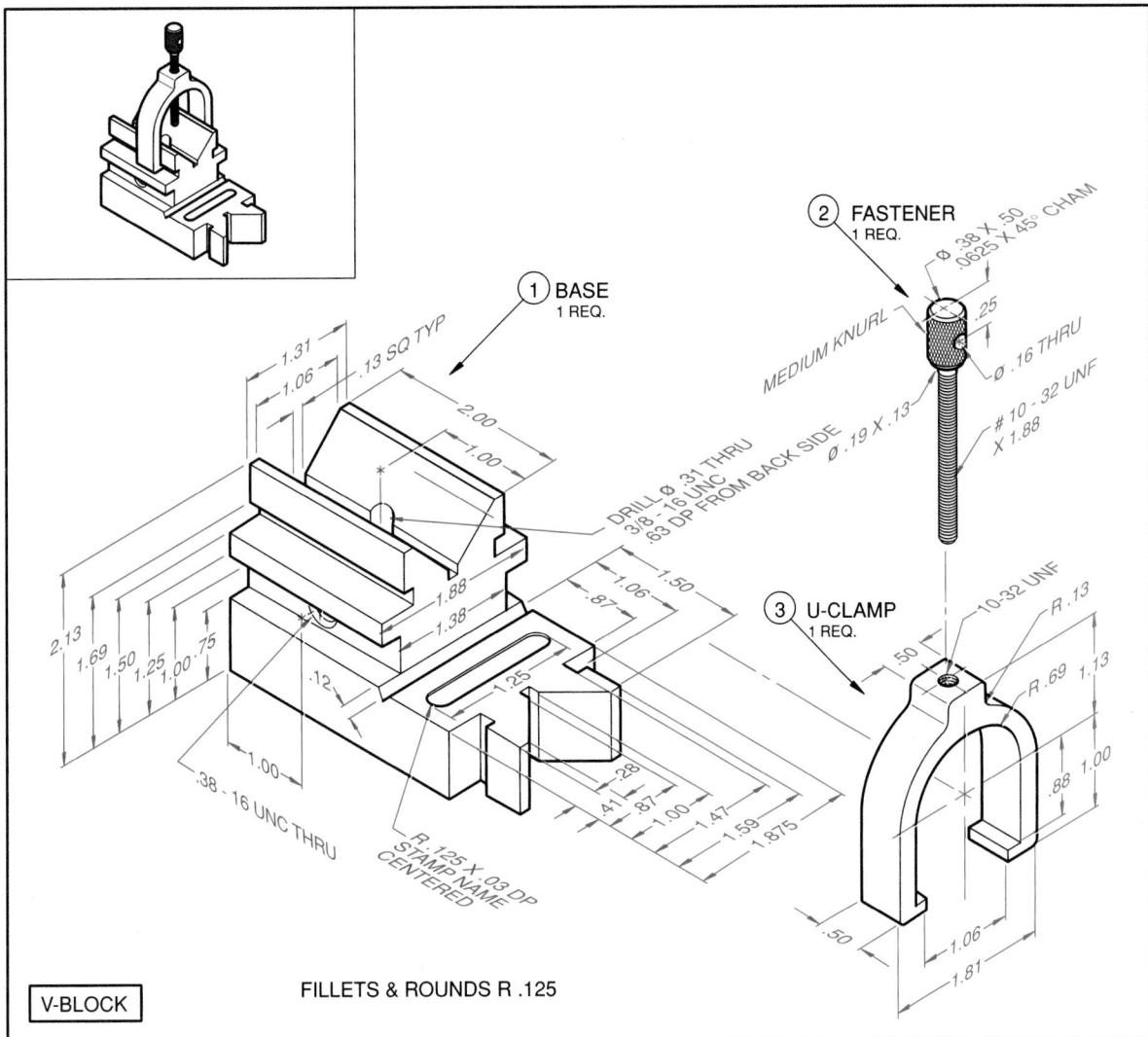

Figure 9.99 V-Block

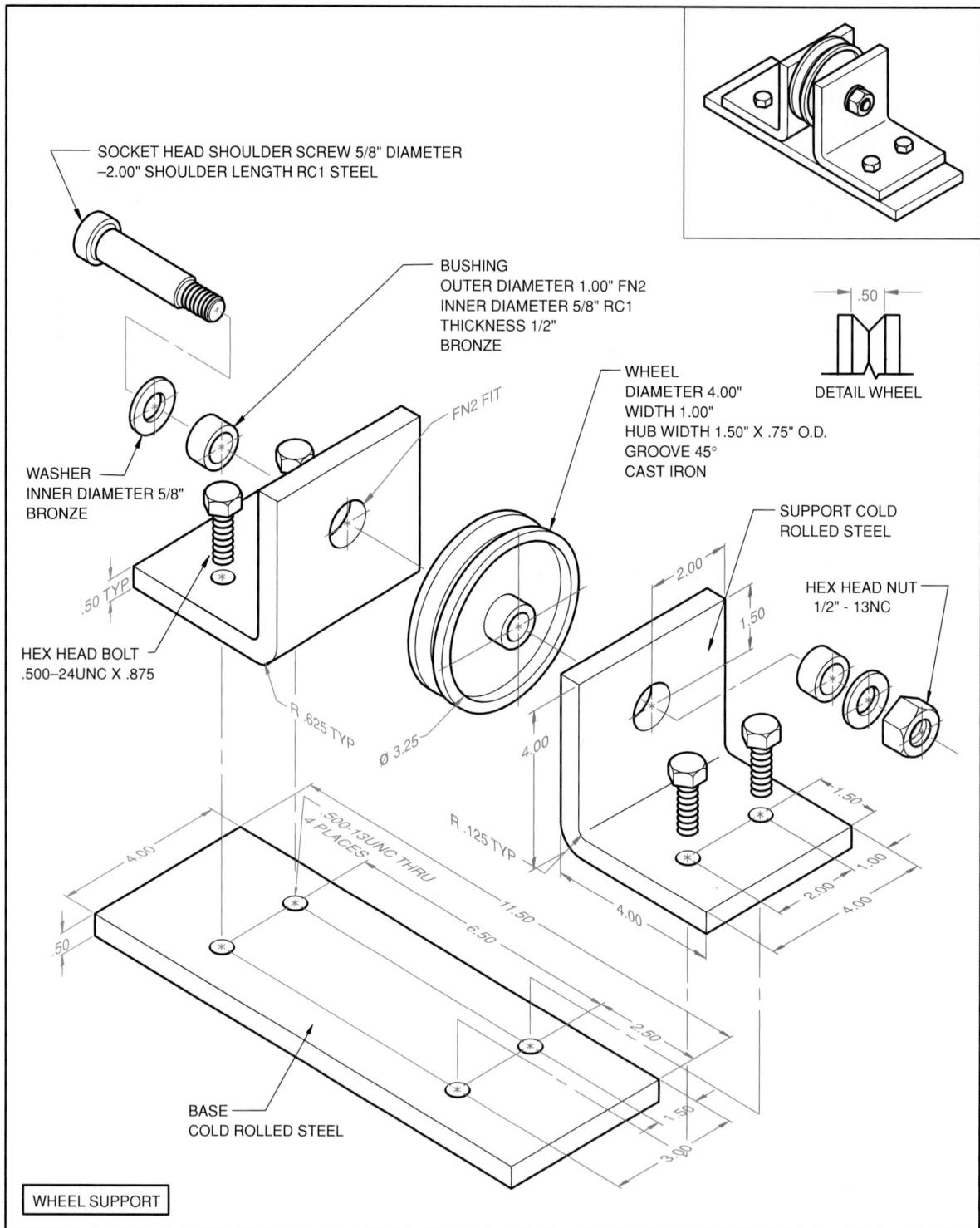

Figure 9.100 Wheel Support

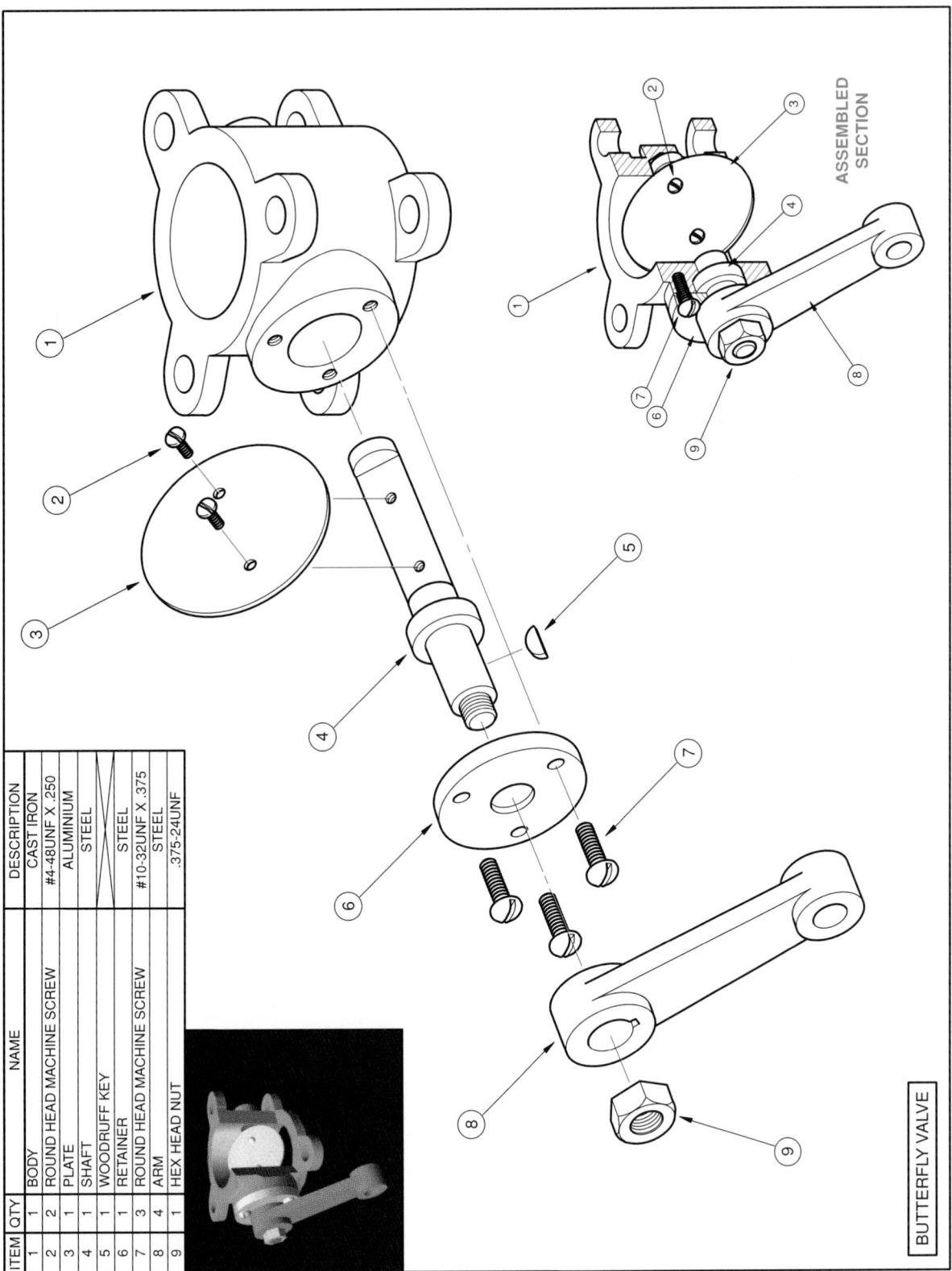

Figure 9.101 Butterfly Valve

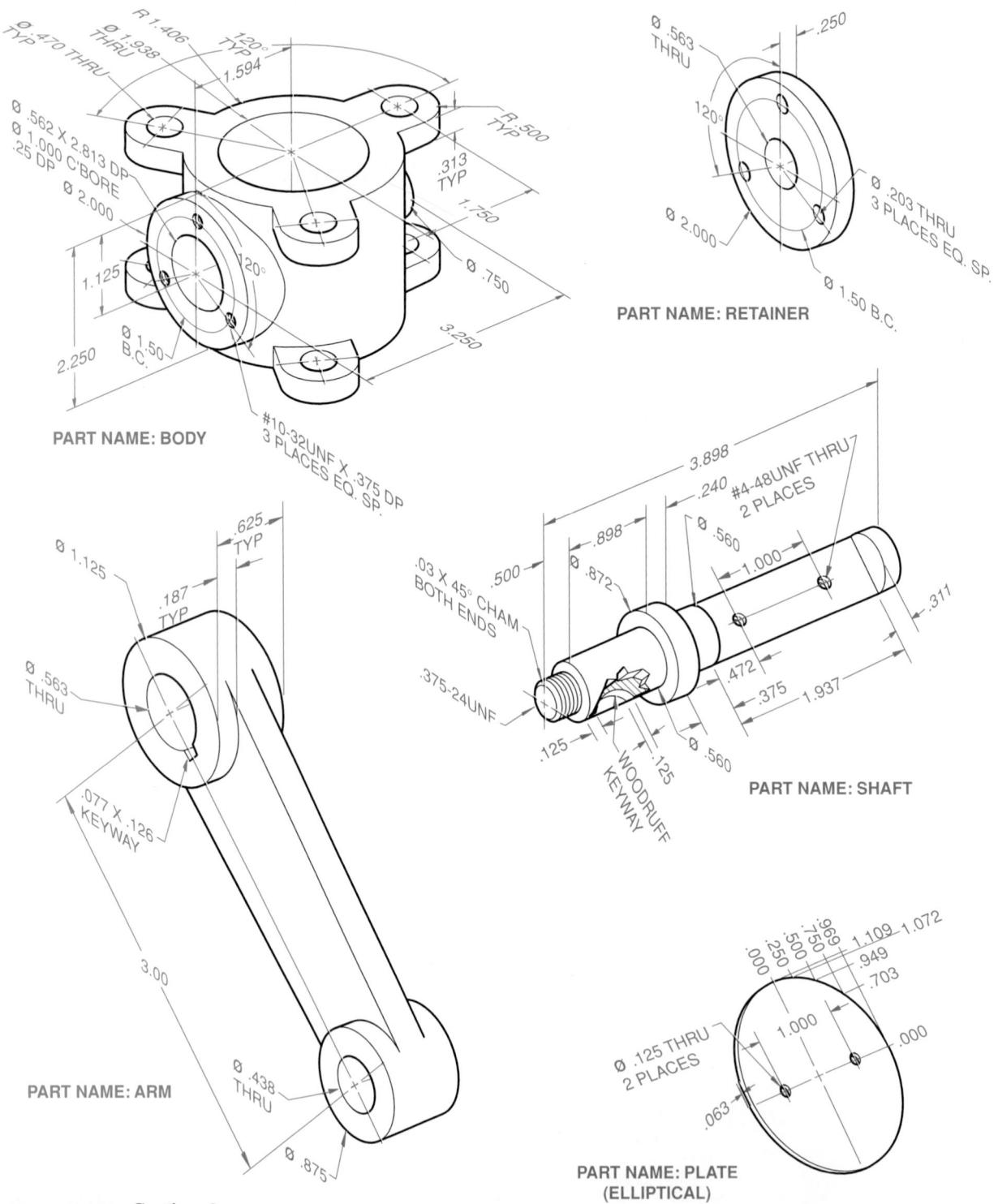

Figure 9.101 **Continued**

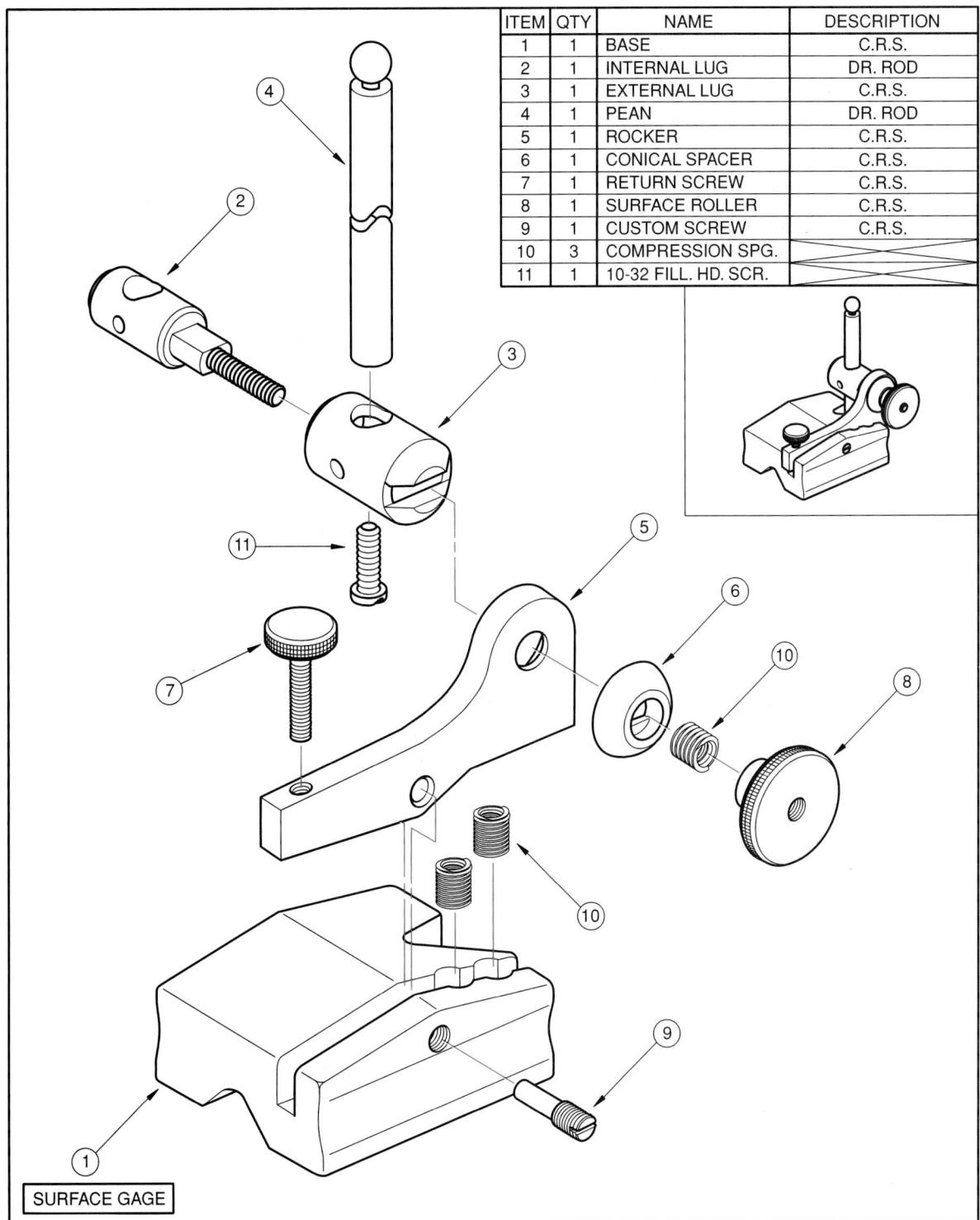

Figure 9.102 Surface Gage

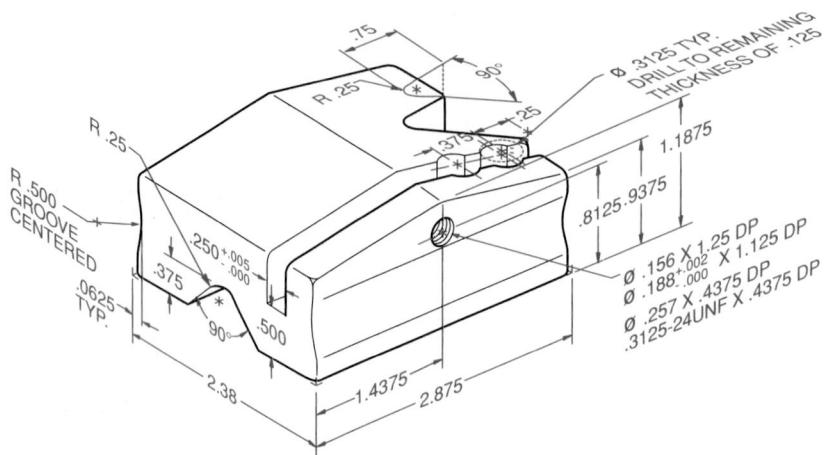

PART NUMBER: 1
FILLETS & ROUNDS R.125
BOTH 90° SLOTS CENTERED

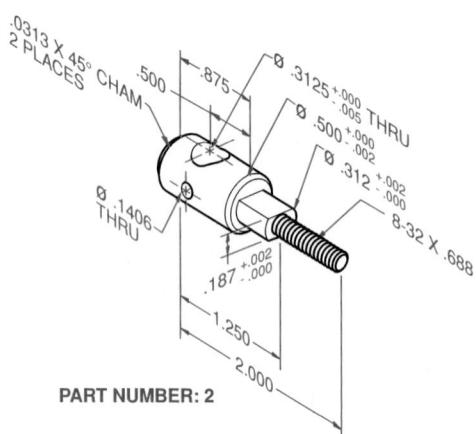

PART NUMBER: 2

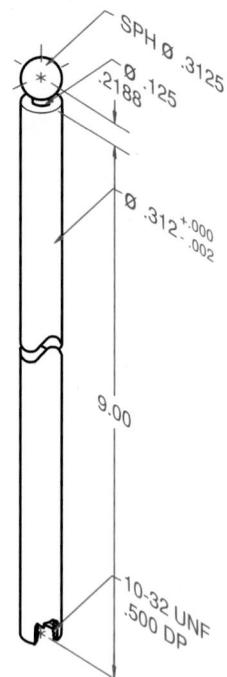

PART NUMBER: 4

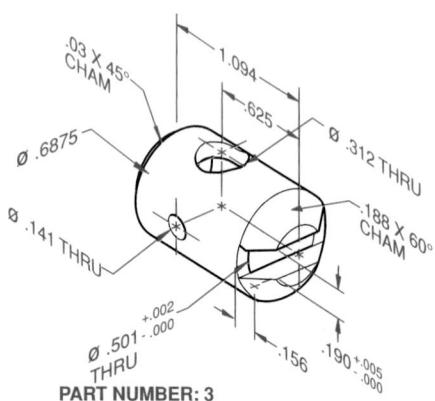

PART NUMBER: 3

Figure 9.102 Continued

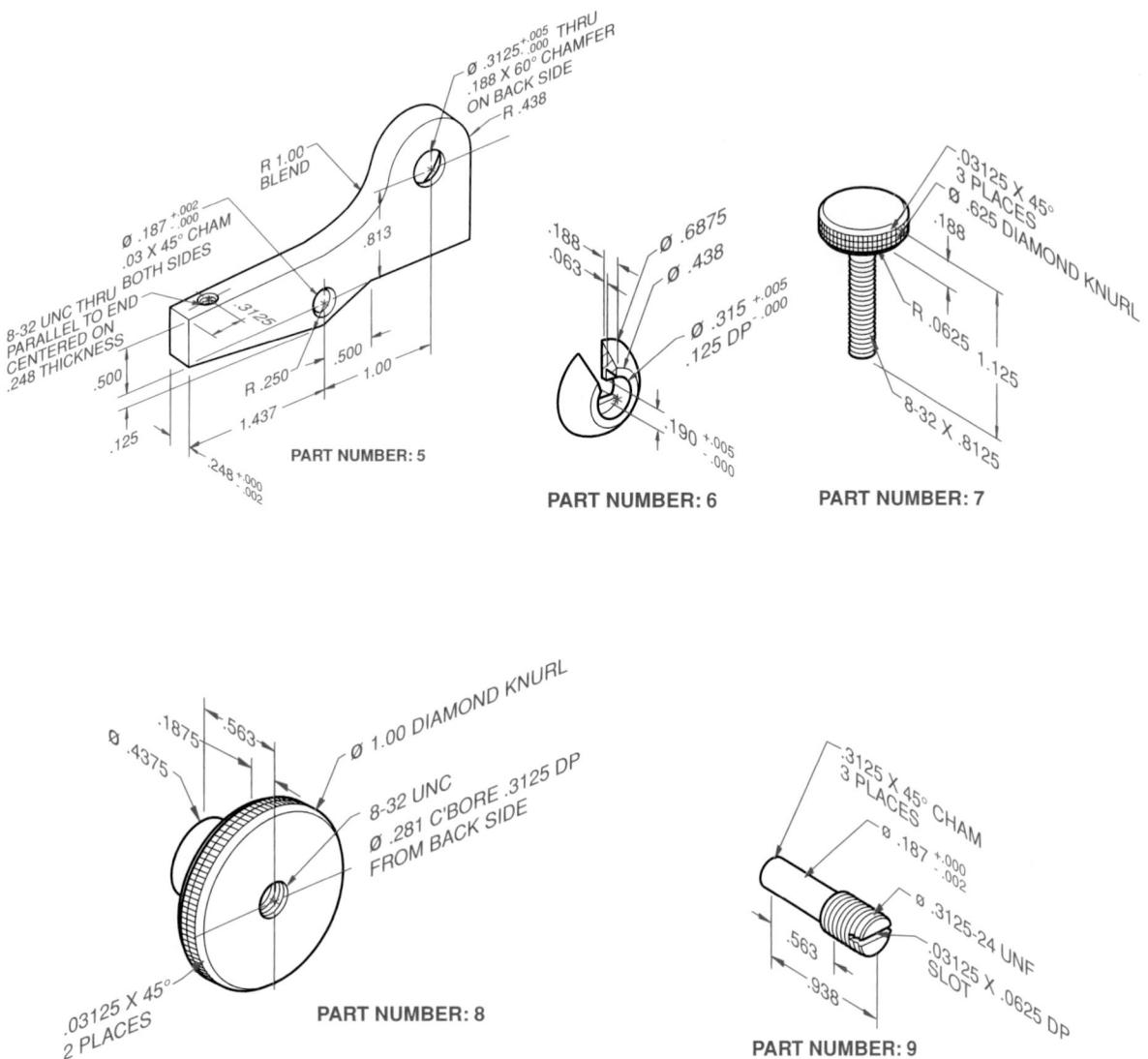

Figure 9.102 Continued

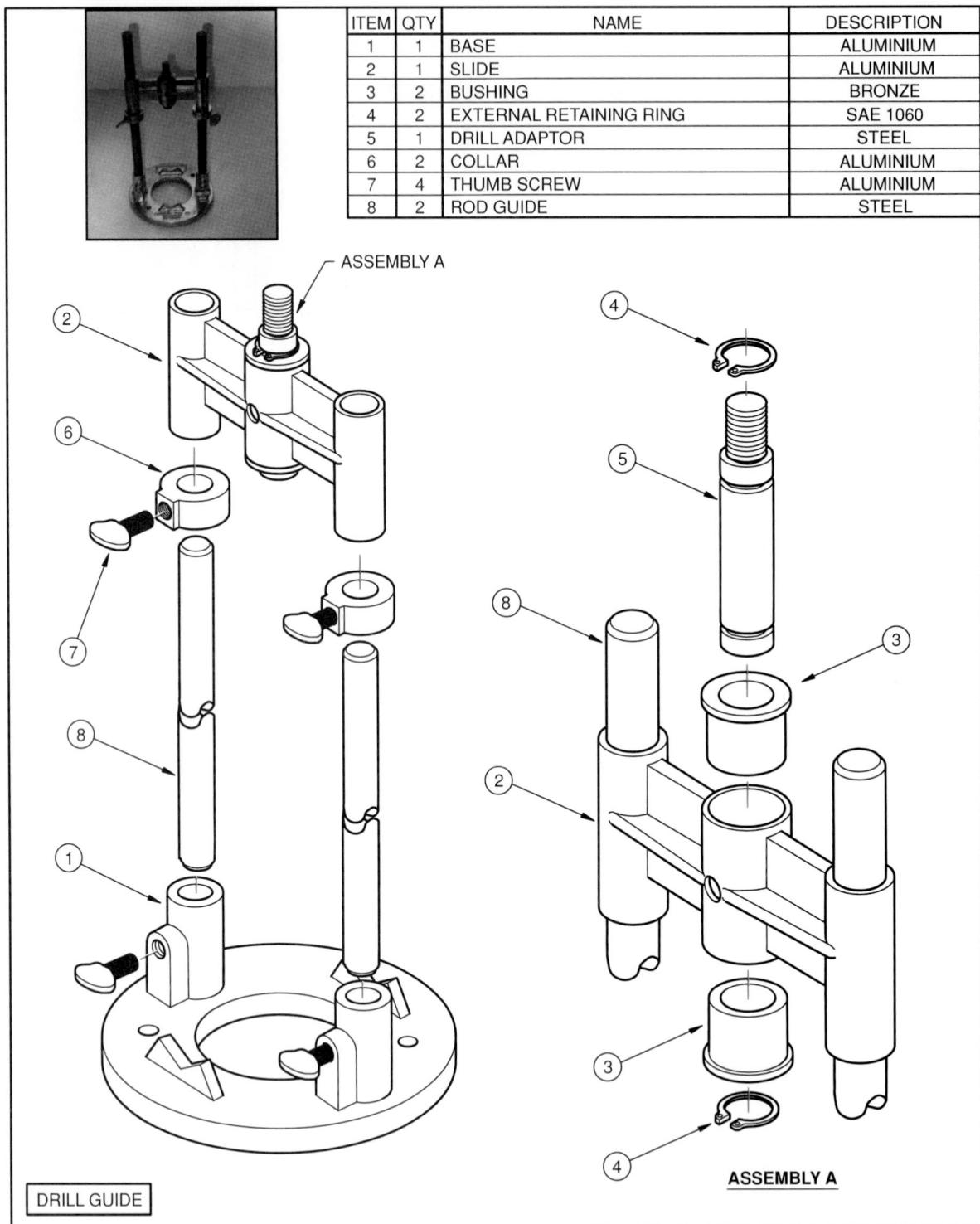

Figure 9.103 Drill Guide

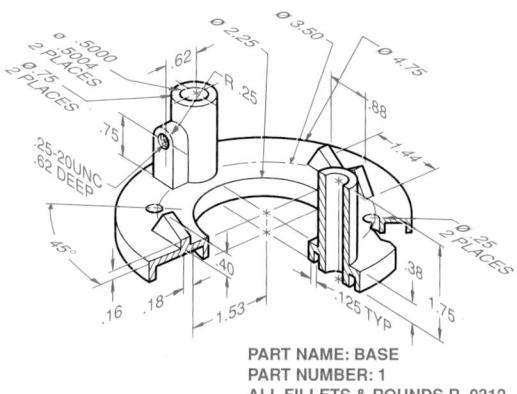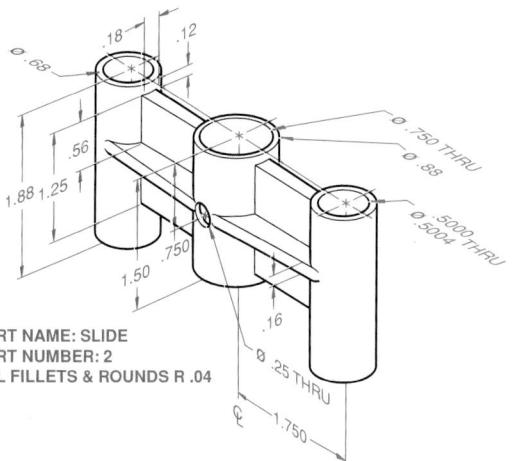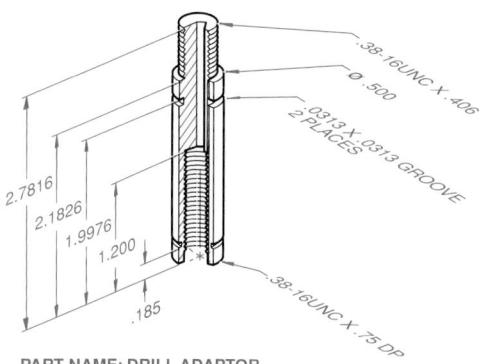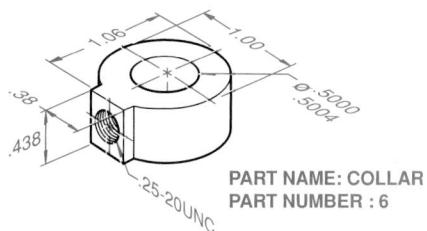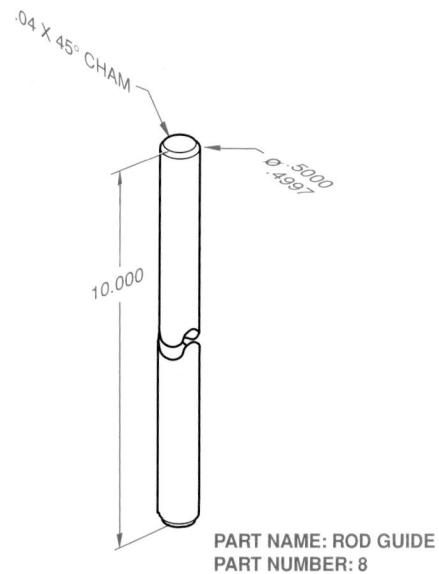

Figure 9.103 Continued

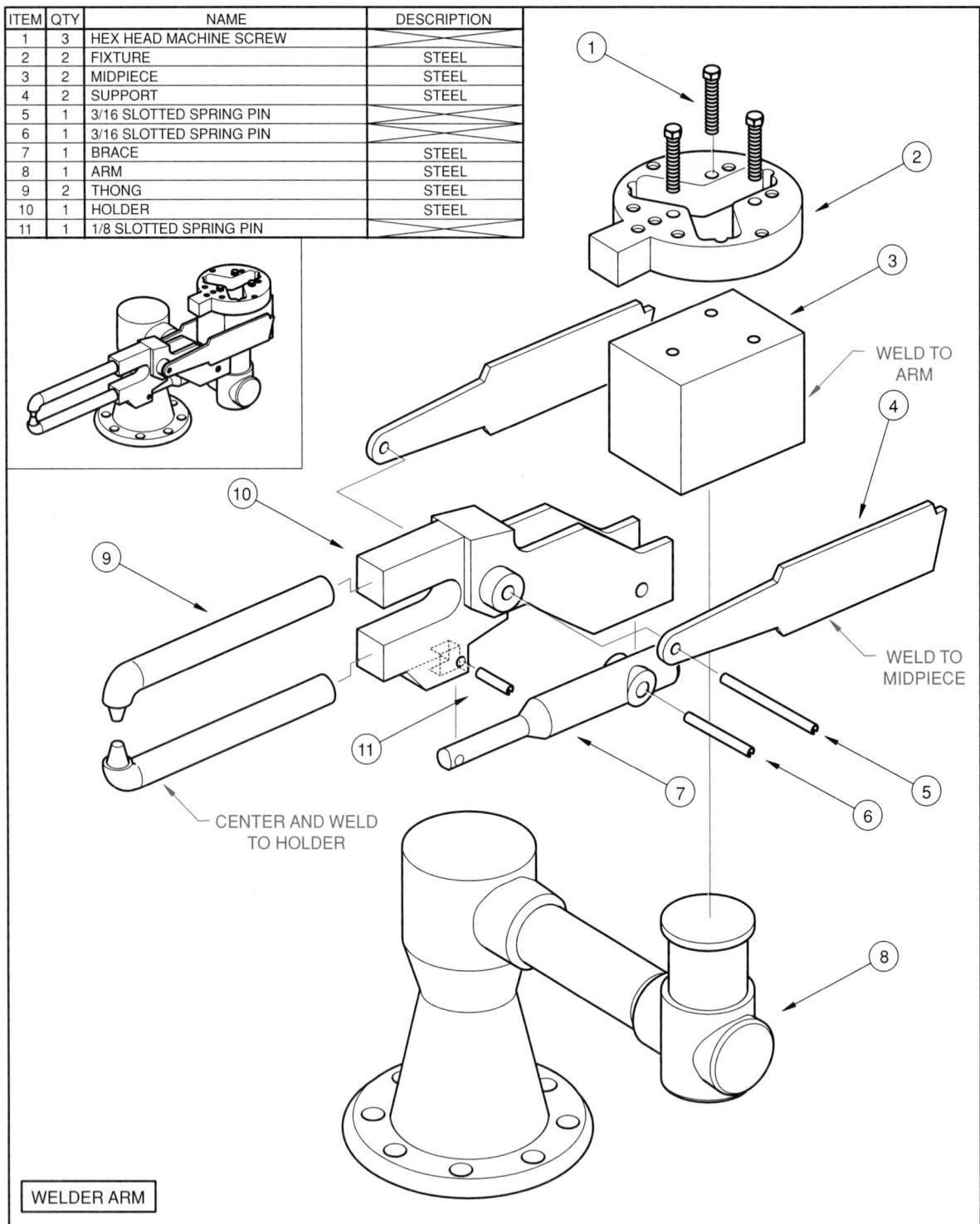

Figure 9.104 Welder Arm

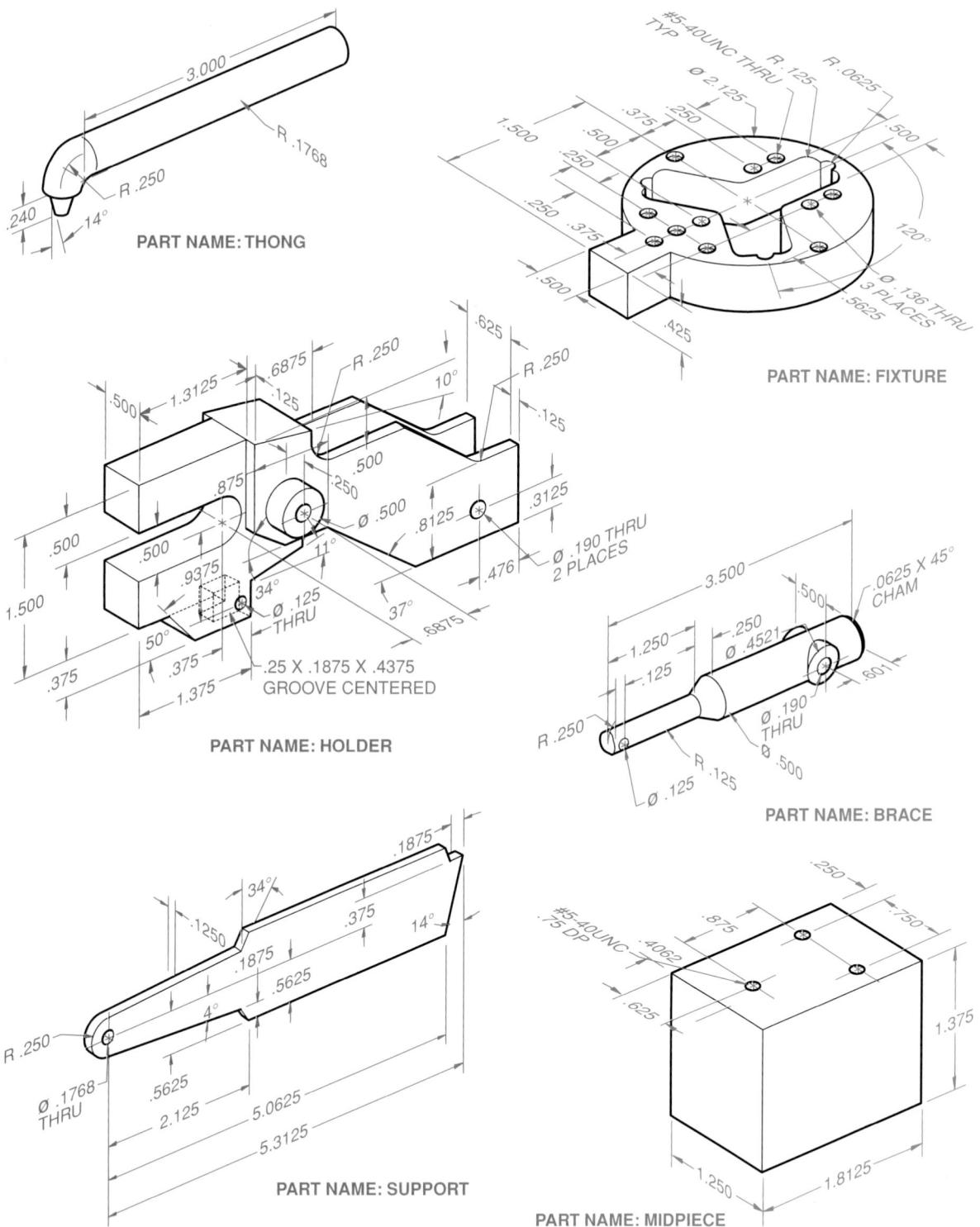

Figure 9.104 **Continued**

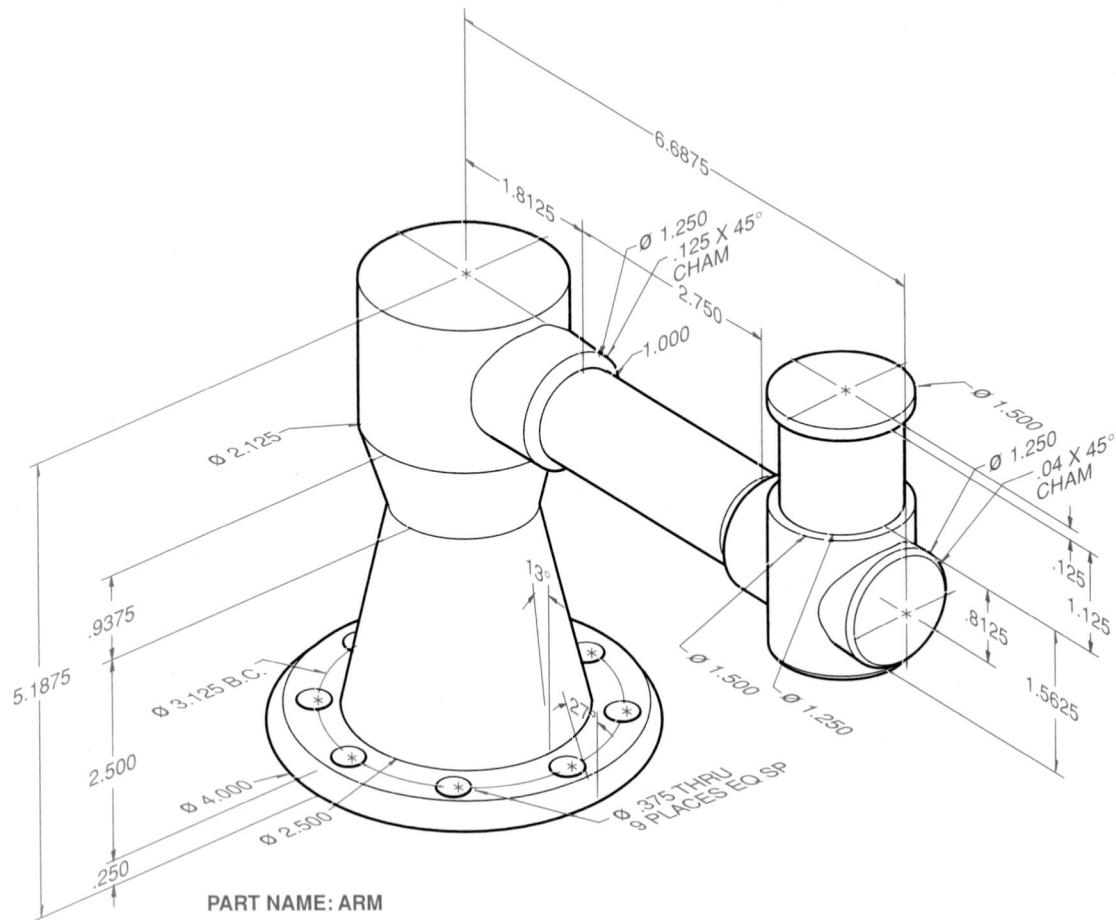

Figure 9.104 Continued

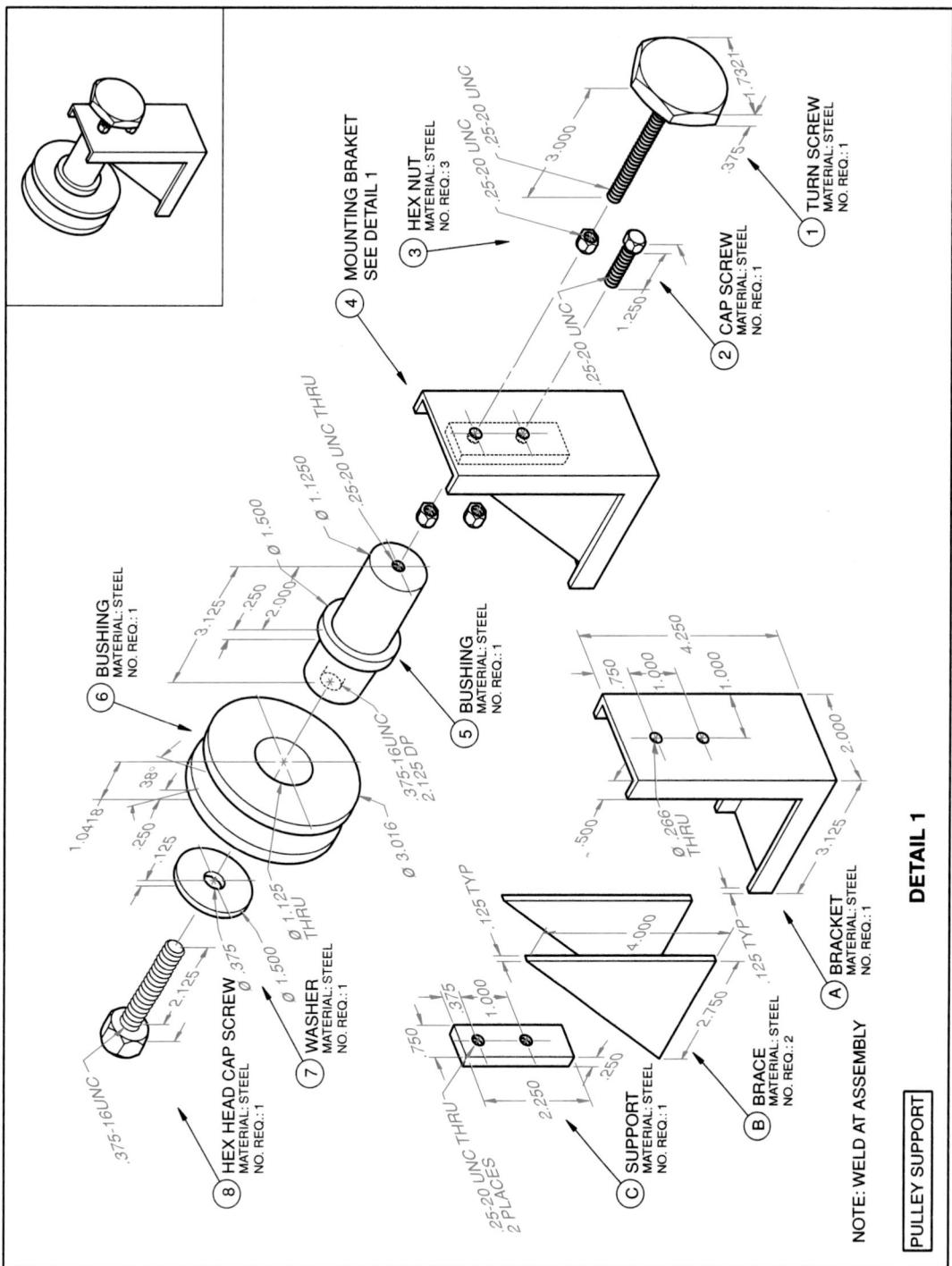

Figure 9.105 Pulley Support

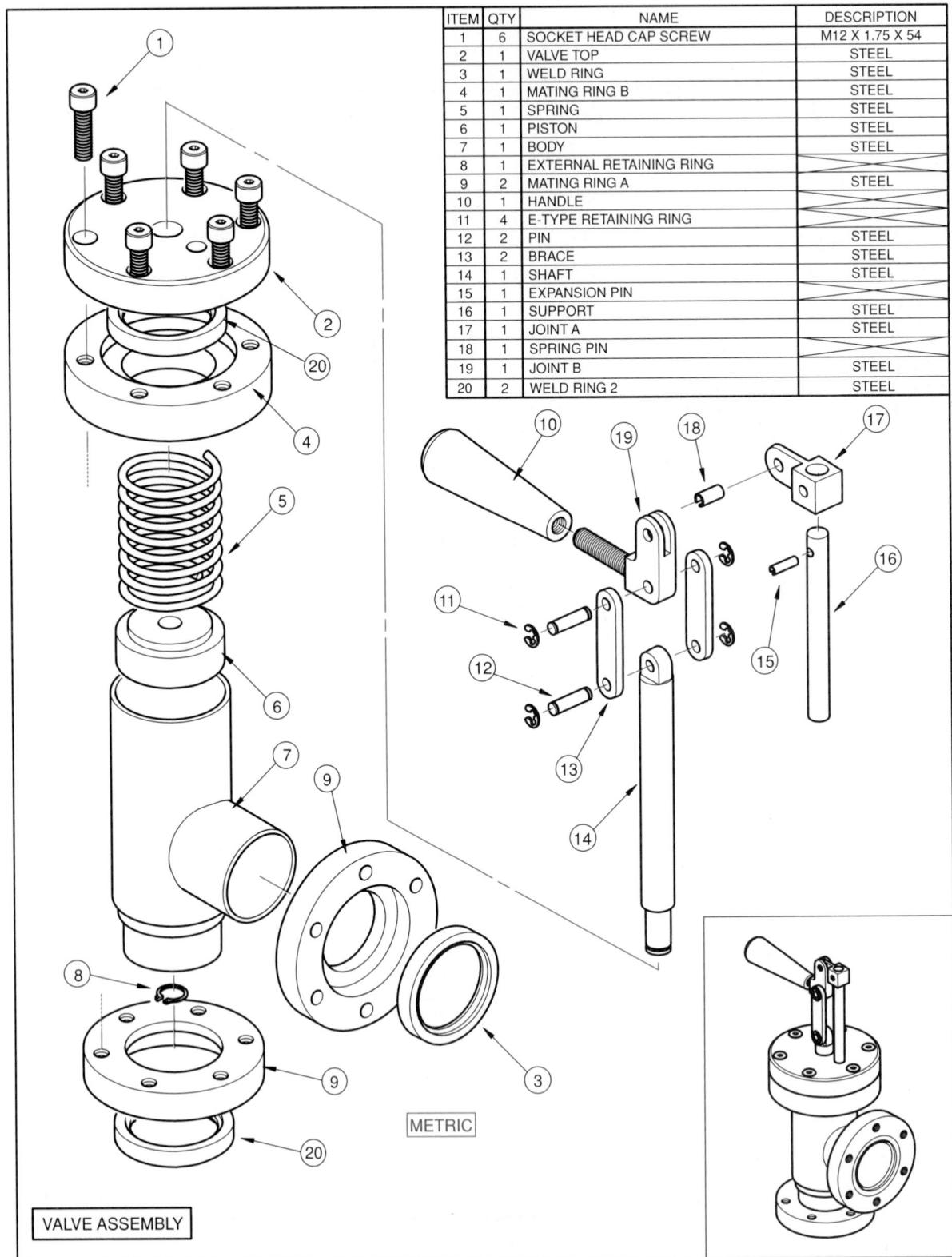

Figure 9.106 Valve Assembly

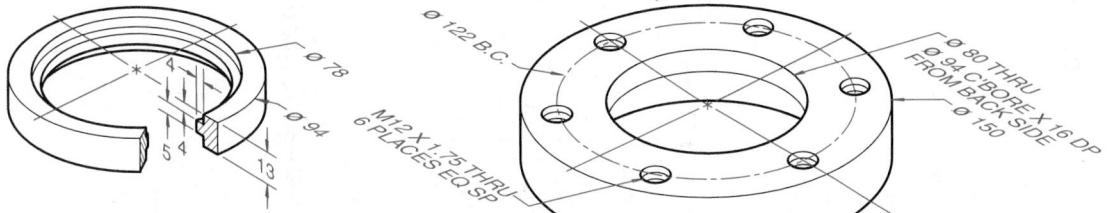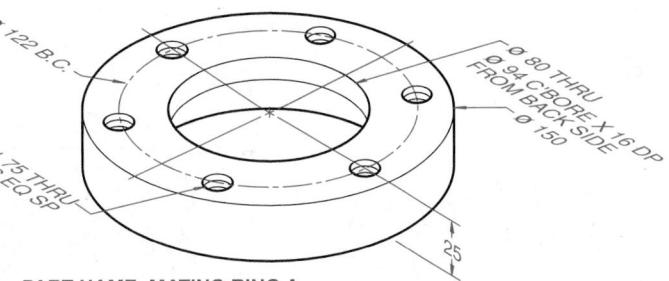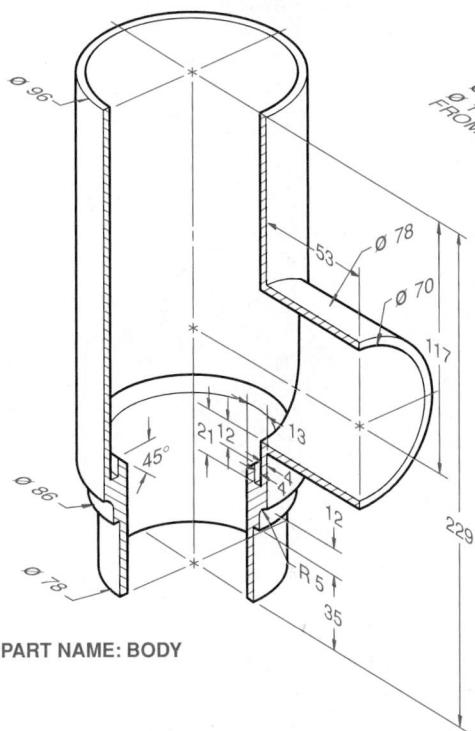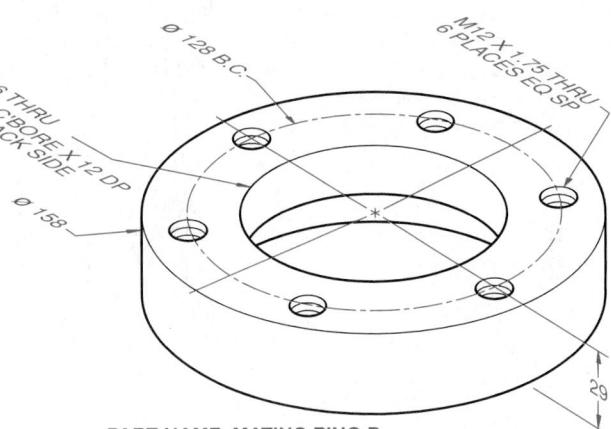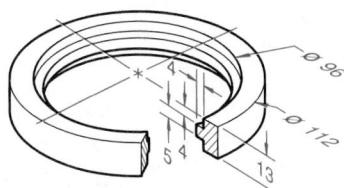

Figure 9.106 Continued

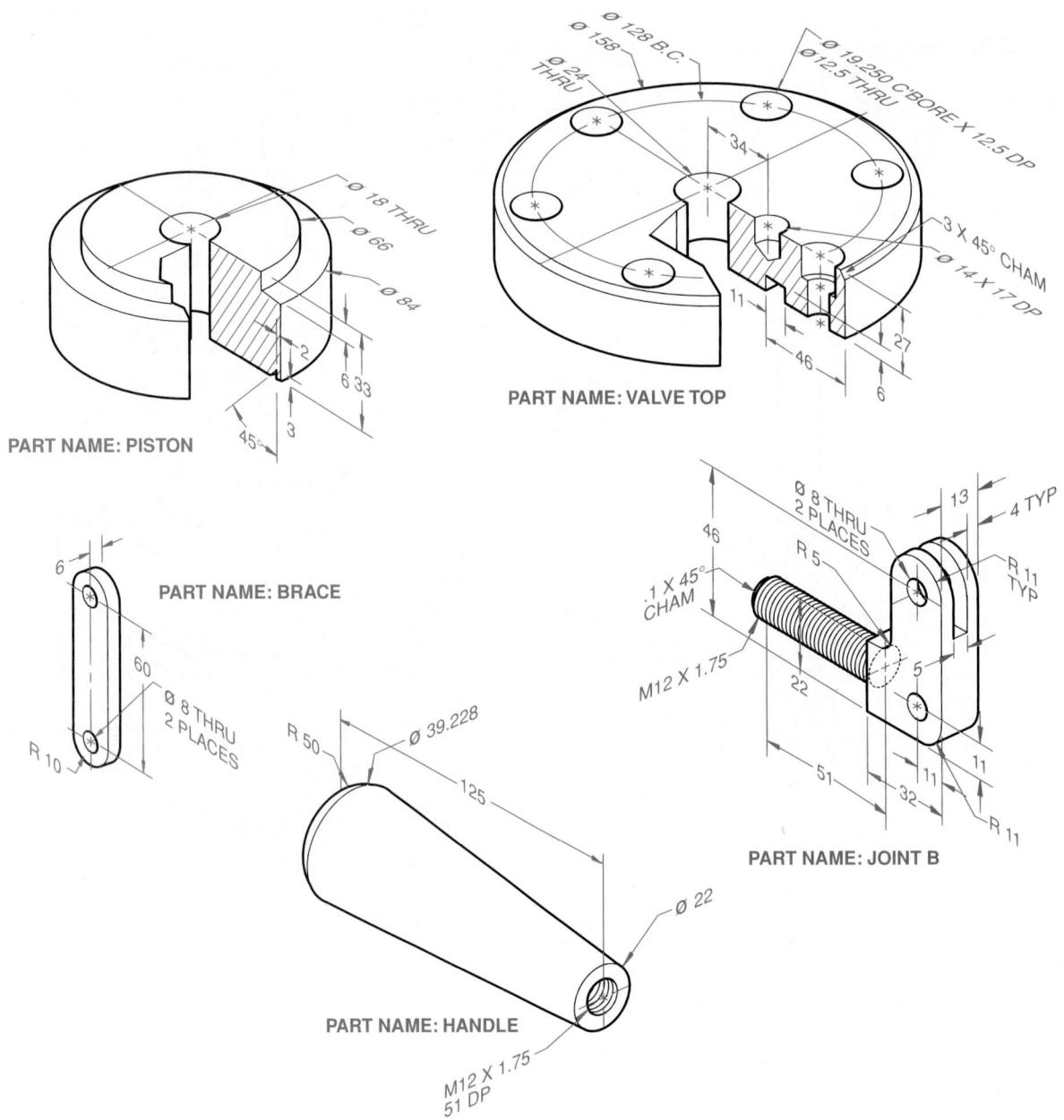

Figure 9.106 Continued

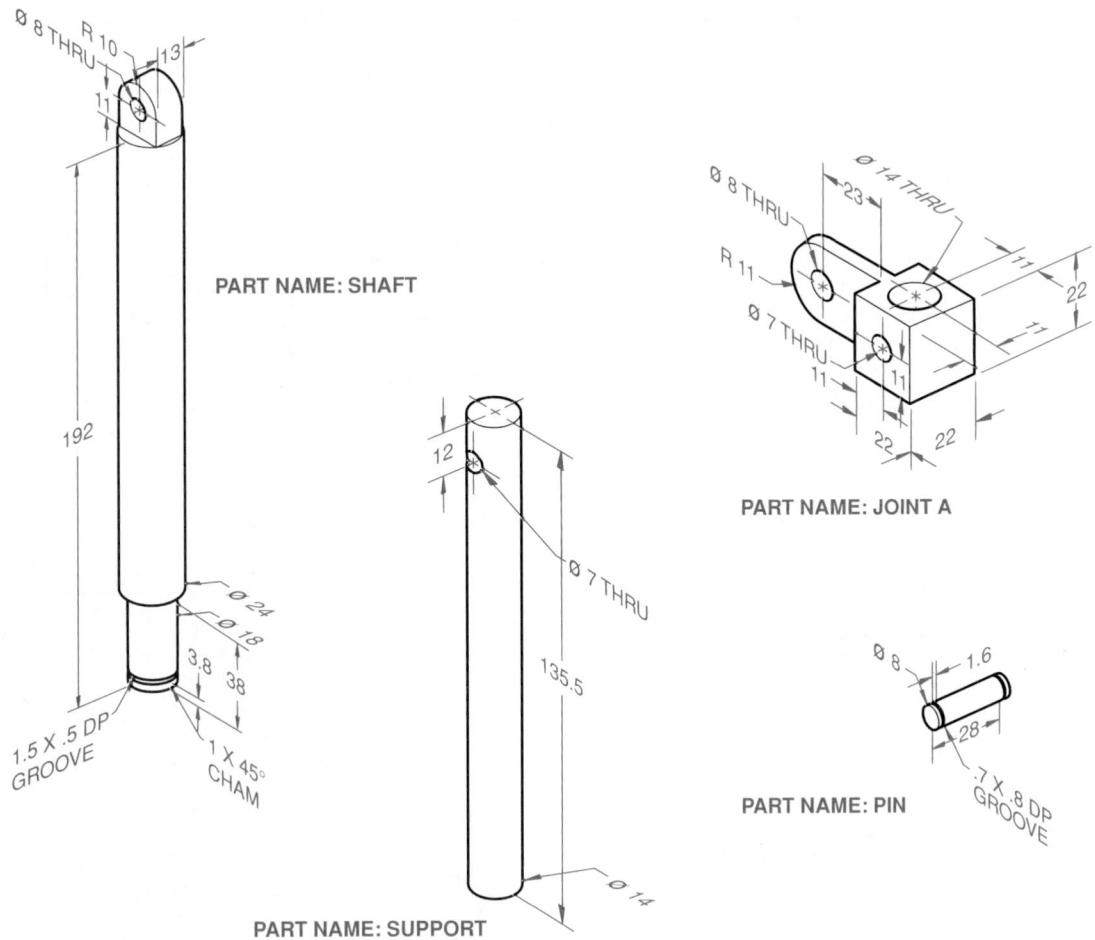

Figure 9.106 Continued

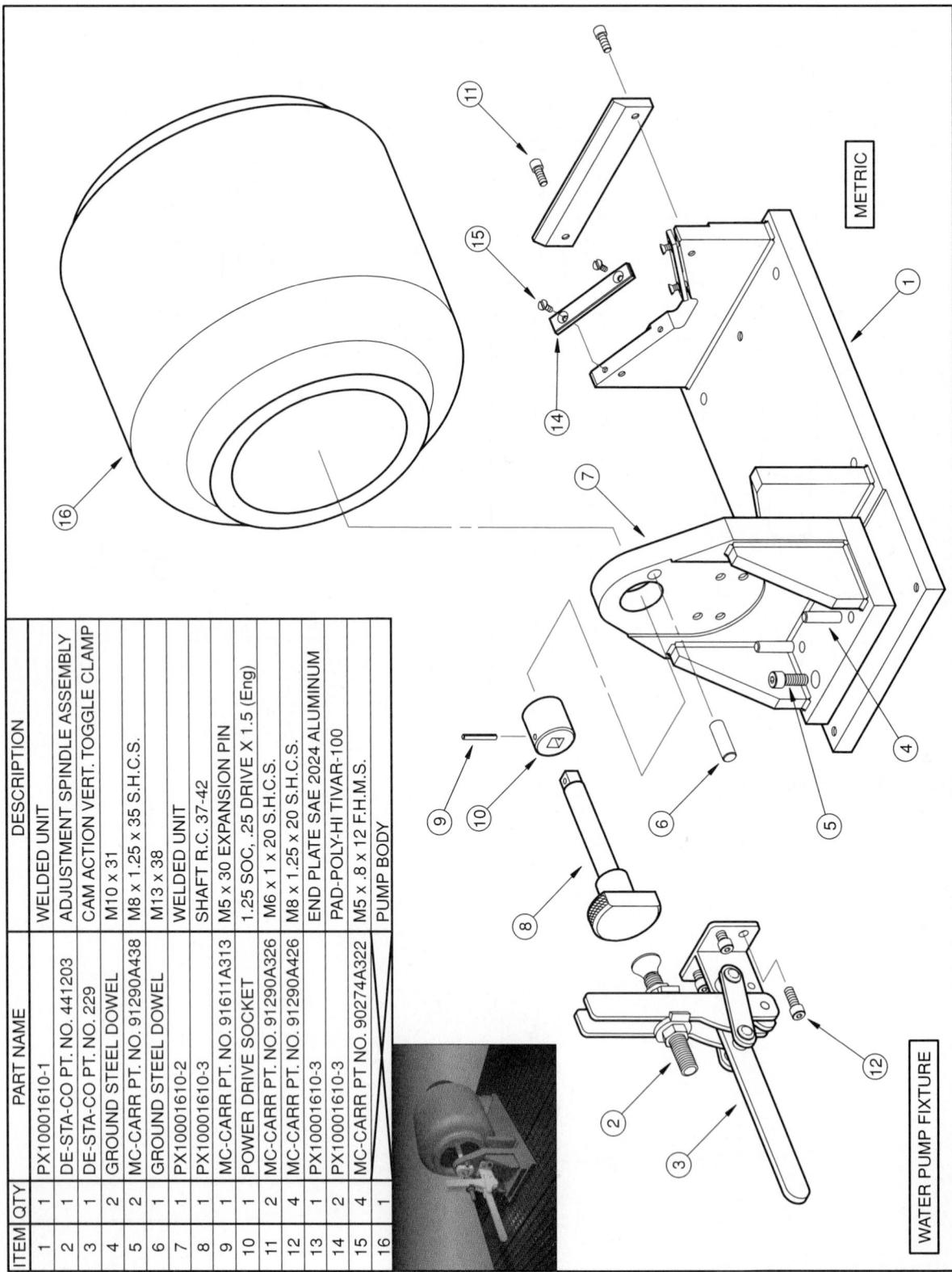

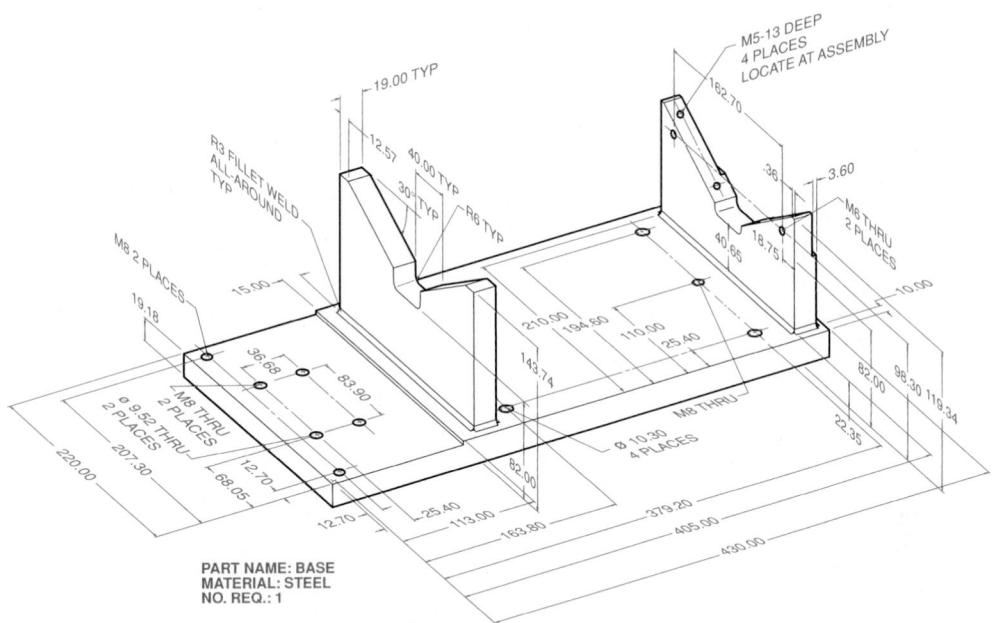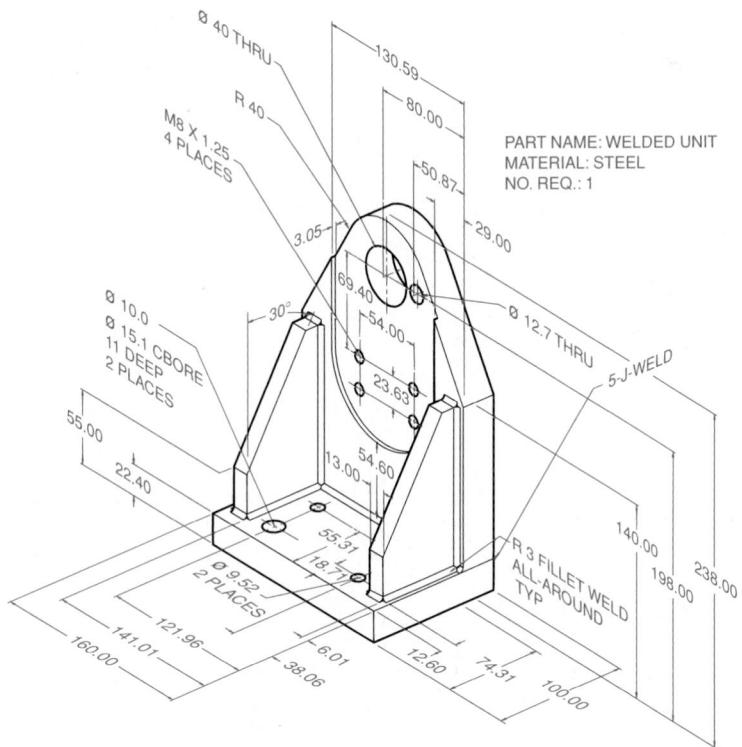

Figure 9.107 Continued

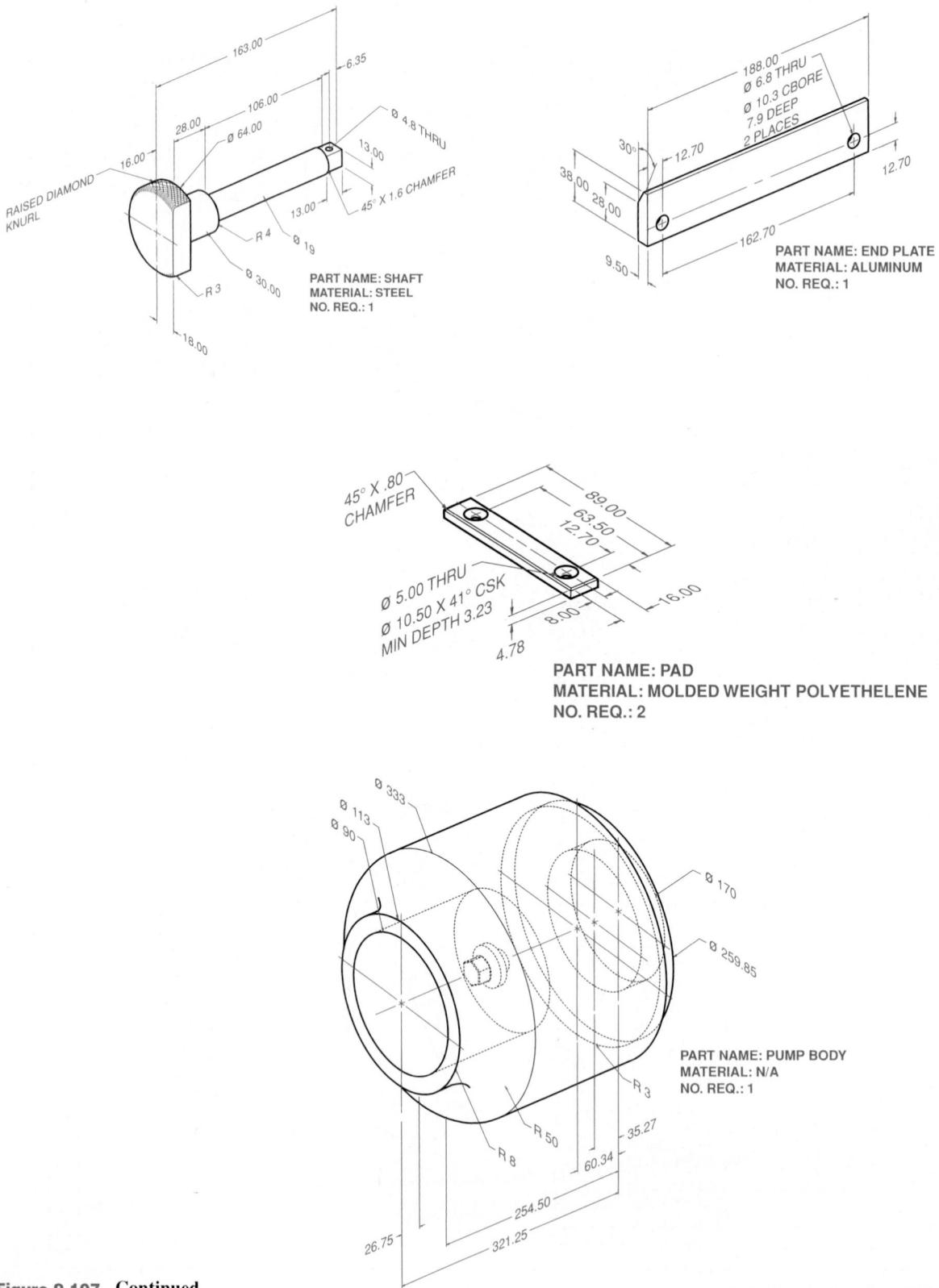

Figure 9.107 Continued

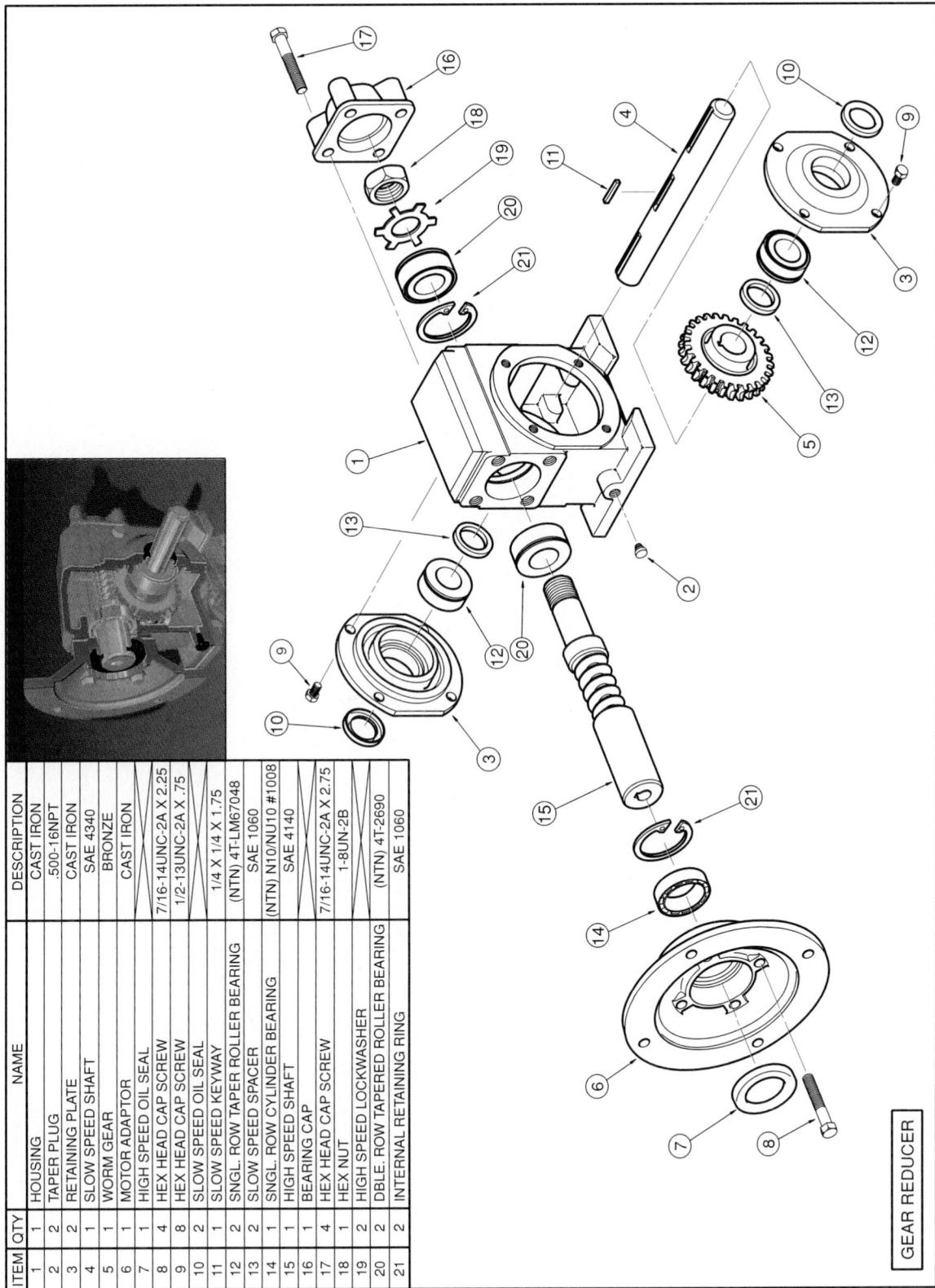

Figure 9.108 Gear Reducer

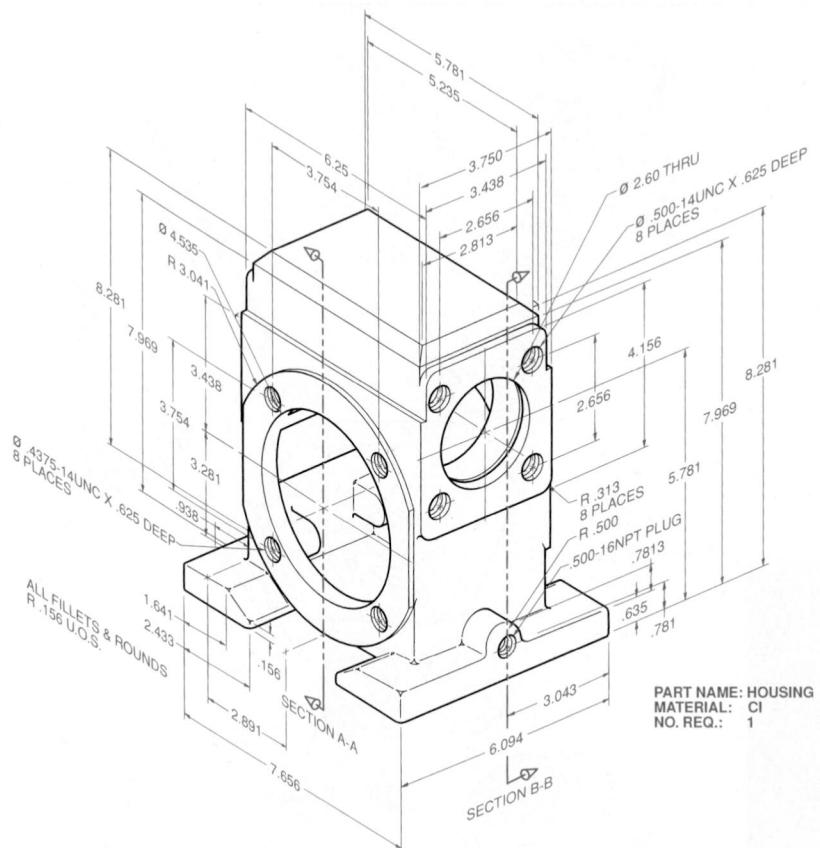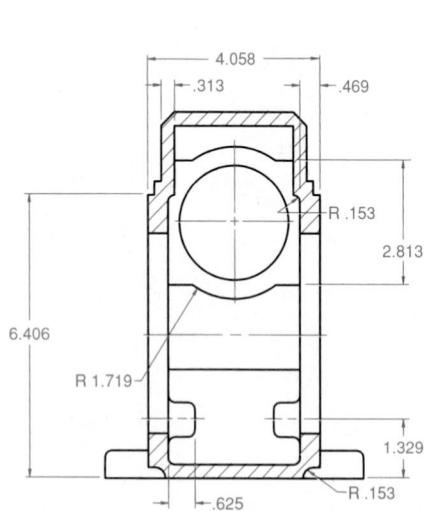

SECTION A-A

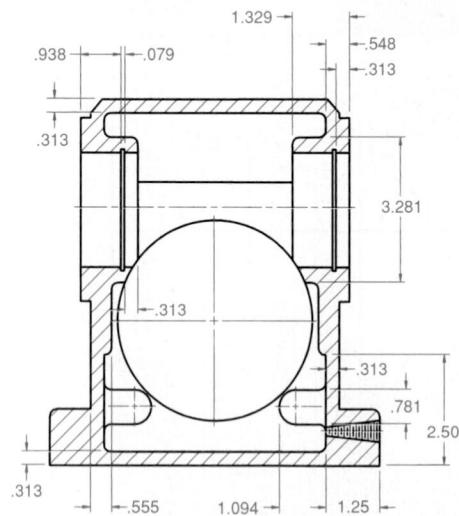

SECTION B-B

Figure 9.108 Continued

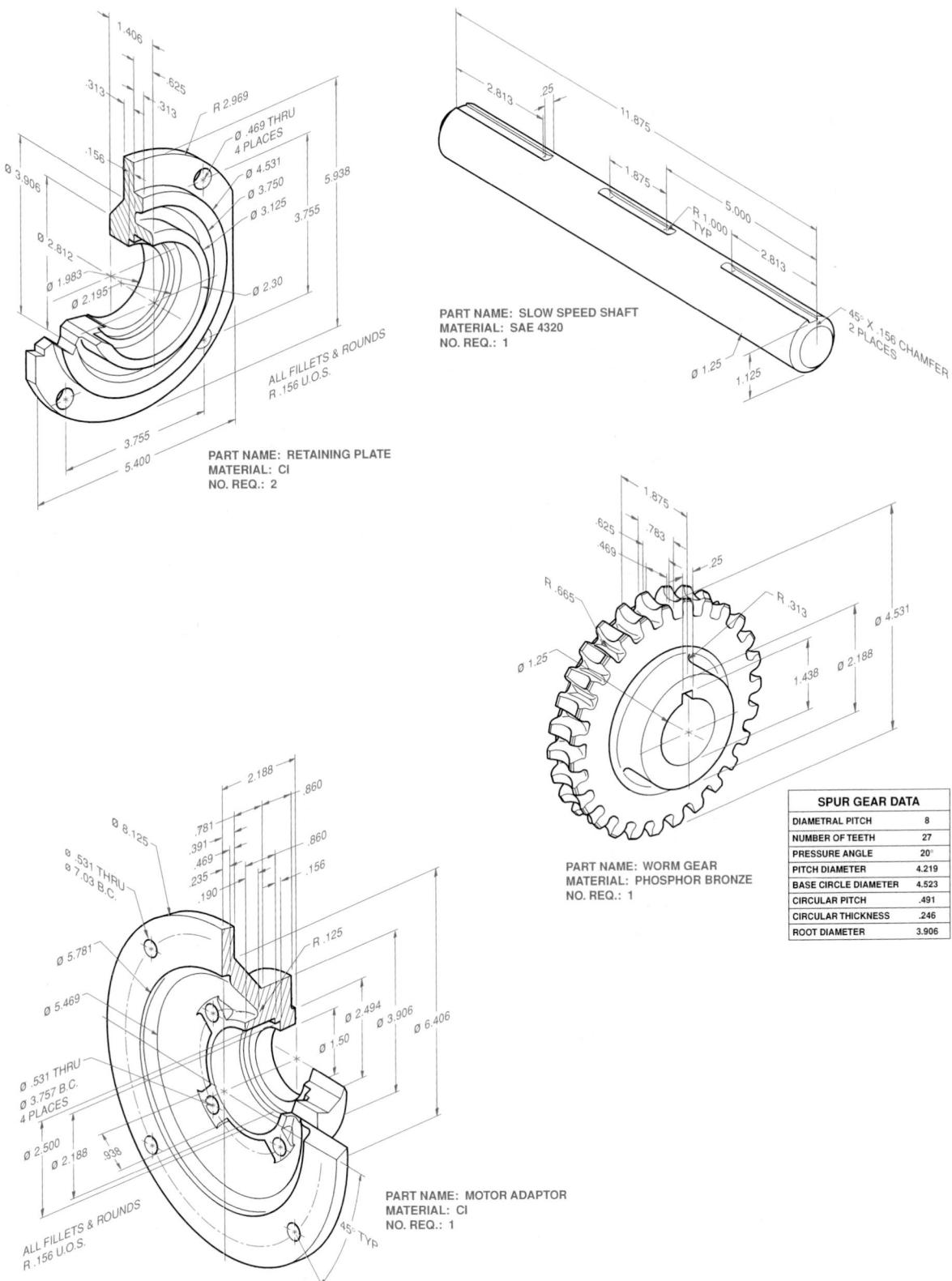

Figure 9.108 Continued

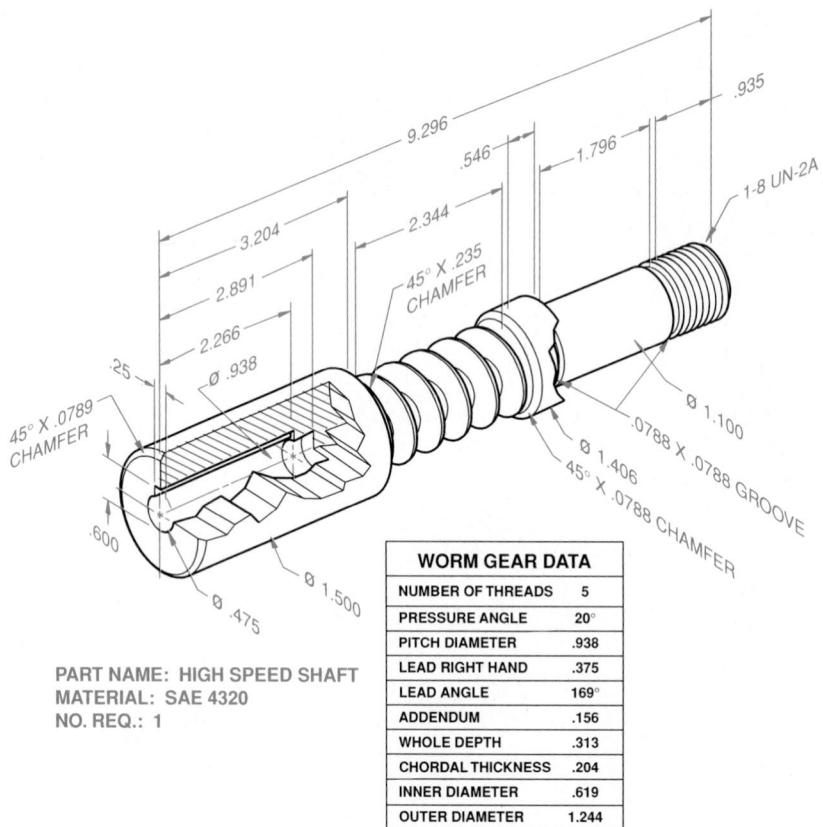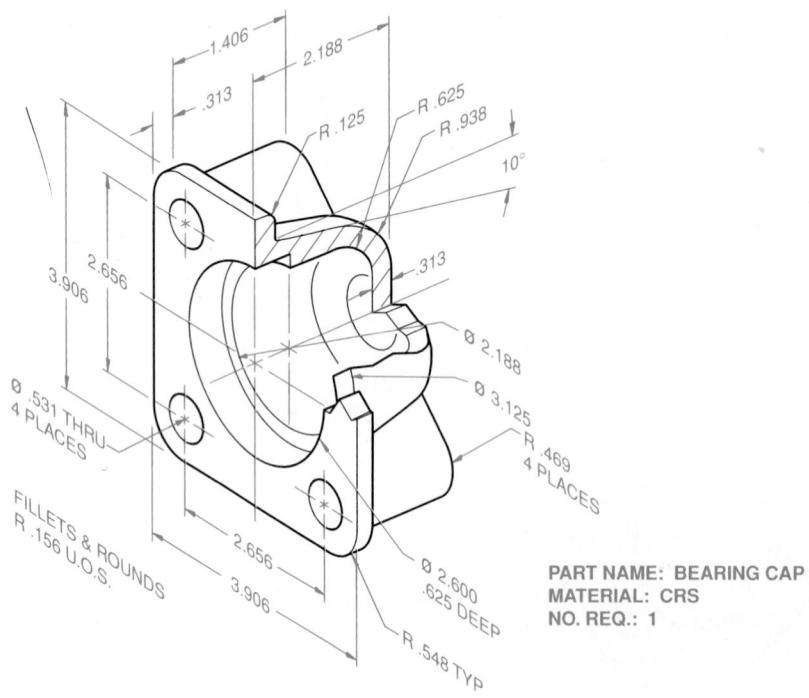

Figure 9.108 **Continued**

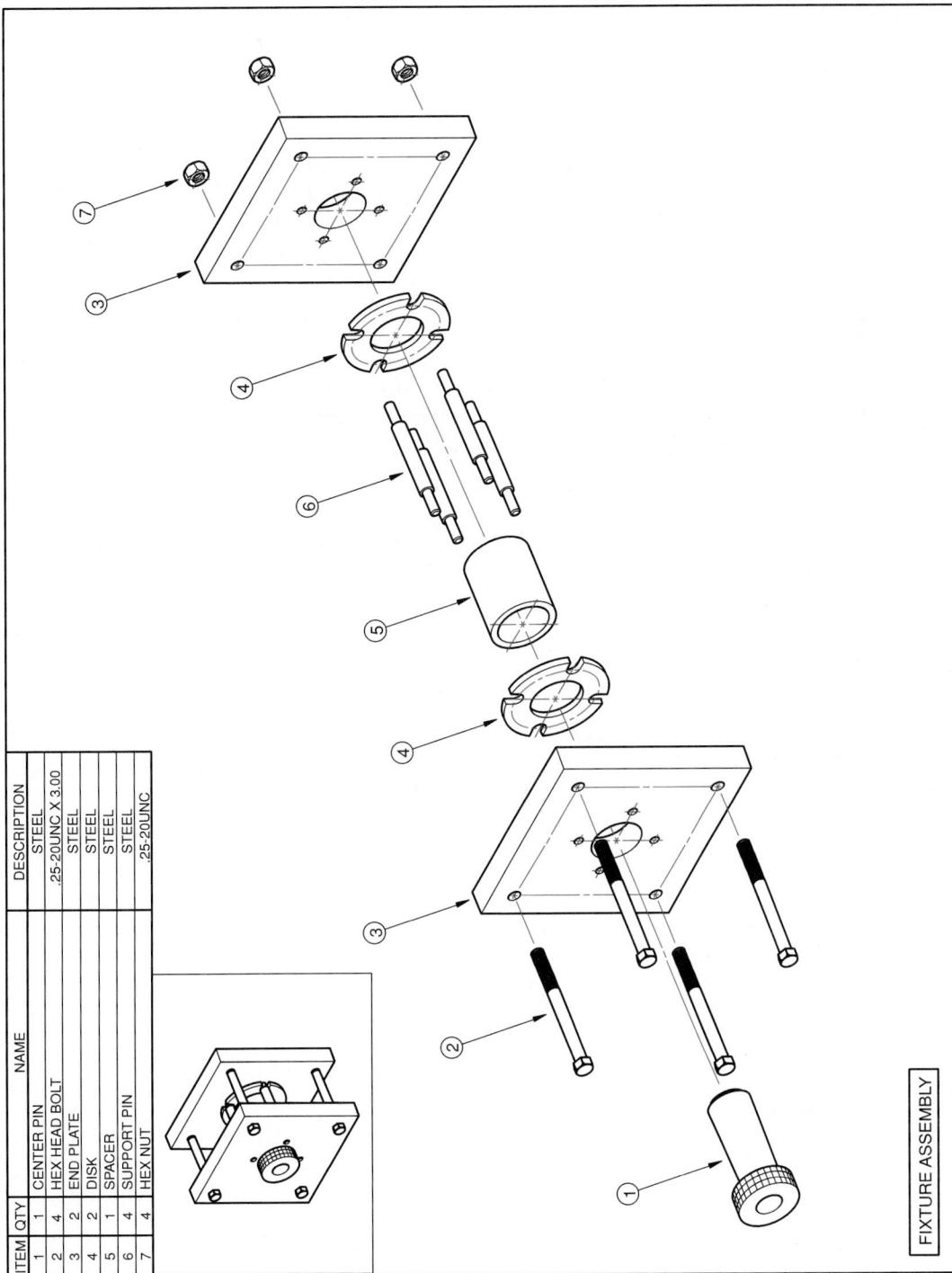

Figure 9.109 Fixture Assembly

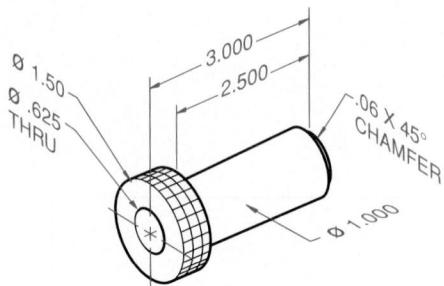

PART NUMBER: 1
MATERIAL: STEEL

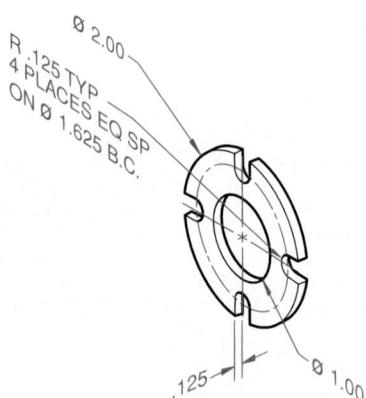

PART NUMBER: 4
MATERIAL: STEEL

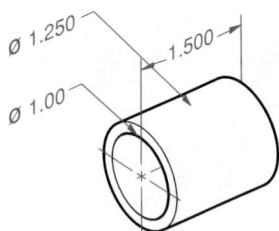

PART NUMBER: 5
MATERIAL: STEEL

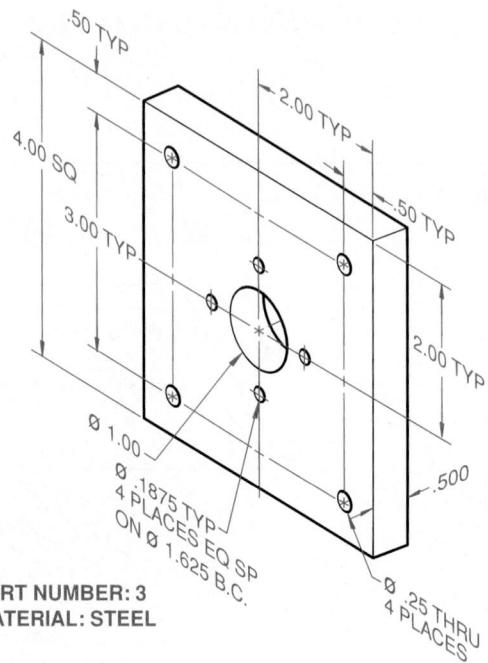

PART NUMBER: 3
MATERIAL: STEEL

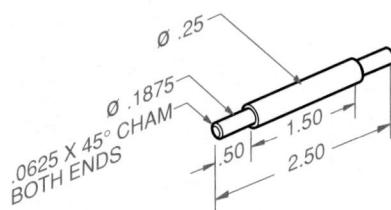

PART NUMBER: 6
MATERIAL: STEEL

Figure 9.109 Continued

CHAPTER 10

Integrated Design and Modeling with CAD

*A scientist can discover a new star but he cannot make one.
He would have to ask an engineer to do it for him.*

Gordon L. Glegg, *The Design of Design*, 1969

OBJECTIVES

After completing this chapter, you will be able to:

1. Describe the engineering design process and the role graphics plays.
2. Describe concurrent engineering and design for manufacturability (DFM).
3. Describe the types of modeling systems used in 3-D modeling.
4. Explain the role 3-D modeling plays in the engineering design process.
5. List and describe the modeling techniques used in design.
6. Describe the rapid prototyping process.
7. List and describe the analysis techniques used in design.
8. Explain how graphing and visualization can be used in the design process.
9. Describe the total quality management (TQM) process.

Technical graphics is an integral part of the engineering design process through which engineers and drafters/designers generate new ideas and solve problems. Traditionally, engineering design consisted of closely related steps documented as paper graphics and text that flowed in a linear/sequential manner through an organization. In the face of increased global competition, many industries in the United States have adopted a team-oriented concurrent approach using 3-D CAD model information as a primary means for communication. • This chapter describes a modern approach to the engineering design process, so that you will have a better understanding of and appreciation for the role of engineering graphics in the design process. Besides describing the design process, the basics of 3-D modeling are described as well as how it integrates into the design process. In addition to CAD tools, other software tools, such as charting and graphing software, are also used for supporting the design process. Basic knowledge of how to create visualizations for graphic analysis is important for its effective use in the design and analysis process.

10.1 DESIGN

Design is the process of conceiving or inventing ideas mentally and communicating those ideas to others in a form that is easily understood. Most often the communications tool is graphics.

Design is used for two primary purposes: personal expression and product or process development. (Figure 10.1) Design for personal expression, usually associated with art, is divided into concrete (realistic) and abstract design and is often a source of beauty and interest. (Figure 10.2) When a design serves some useful purpose, such as the shape of a new automobile wheel, it is classified as a design for product or process development. (Figure 10.3)

Aesthetic design is concerned with the look and feel of a product. *Industrial designers* specialize in the aesthetic qualities of products, as well as other elements related to human-machine functionality.

Functional design is concerned with the function of a product or process. Air flow over an automobile is an example of a functional design element. Most engineers are concerned with functional elements. (Figure 10.4)

Product design is the process used to create new products, such as a new automobile model (Figure 10.5), a new appliance, or a new type of wheelchair. Product design is a complex activity that includes market, production, sales, service, function, and profit analyses. The goal of product design is to produce a product that meets the wants and needs of the consumer, is economically produced, is safe for the consumer and the environment, and is profitable to the company.

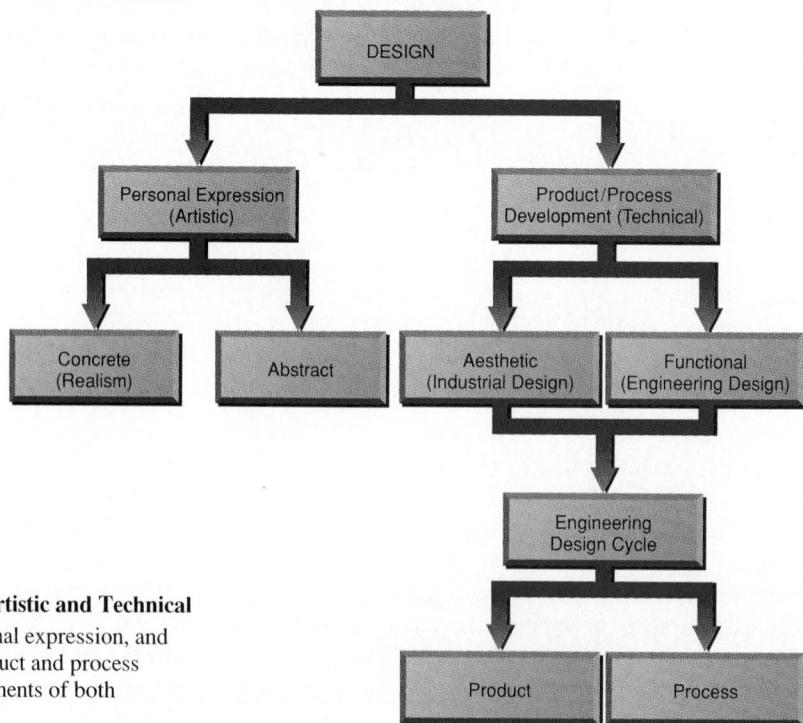

Figure 10.1 Design Is Grouped as Artistic and Technical

Artistic design is concerned with personal expression, and technical design is concerned with product and process development. Technical design has elements of both functional and aesthetic design.

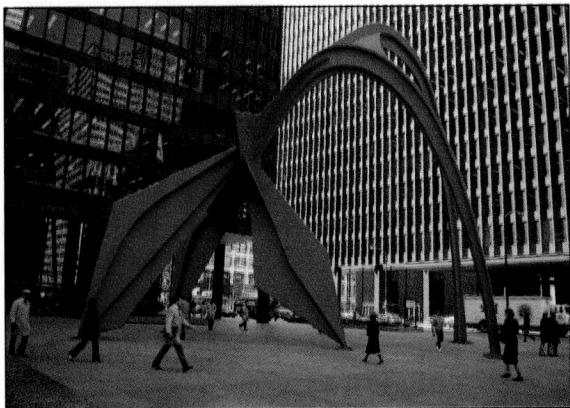

Figure 10.2 Abstract Design

An abstract design, such as this sculpture, is meant to evoke a personal, emotional response in the viewer. Though it does not serve the same functional purpose as the office building behind it, the sculpture enhances the office worker's environment.

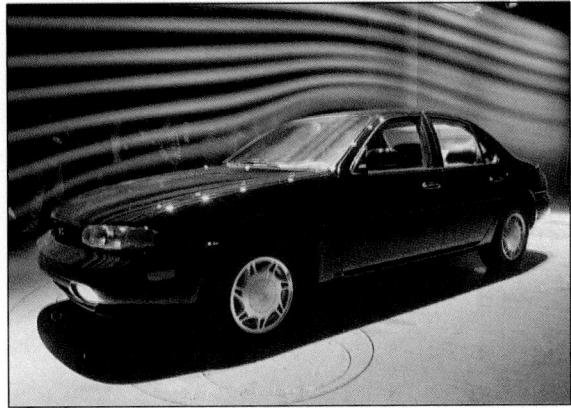

Figure 10.4 Functional Design

The wind tunnel testing of a new automobile determined how the car would function when moving through the air. This is an example of functional design.

Figure 10.3 Aesthetic Design

Aesthetic design is an important part of the engineering design process. Industrial designers have a major role in the engineering design process for consumer products, such as automobiles, appliances, and consumer electronics.

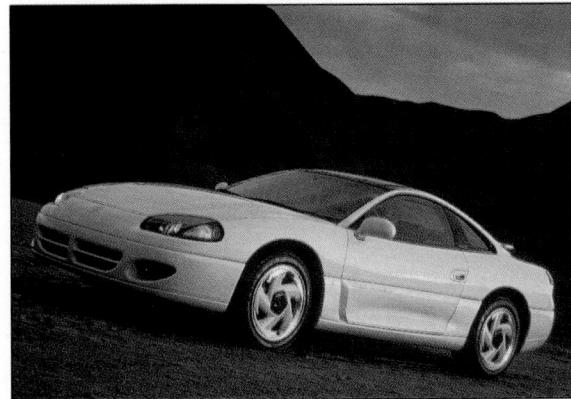

Figure 10.5 Aesthetic and Functional Design

Aesthetic and functional design combine to give this sports car a look of speed and elegance. The car is the result of a product design intended to meet the needs of a specific market.

System design is the process used to create a new system or process. A *systems engineer* or *industrial engineer* is an engineer who specializes in designing systems. A **system** is an orderly arrangement of parts that are combined to serve one general function. Examples of system designs are the arrangement of the assembly process in a factory; the heating, ventilation, and air-conditioning (HVAC) system in a structure; and the electrical system in the automobile in

Figure 10.5. The objective is to produce a system that serves a specific function economically, is safe for the consumer and the environment, and is profitable for the company.

Many products will have both aesthetic and functional design elements, requiring the engineers and designers to work as a team to produce a product or system that is both functional and aesthetically pleasing. (Figure 10.5)

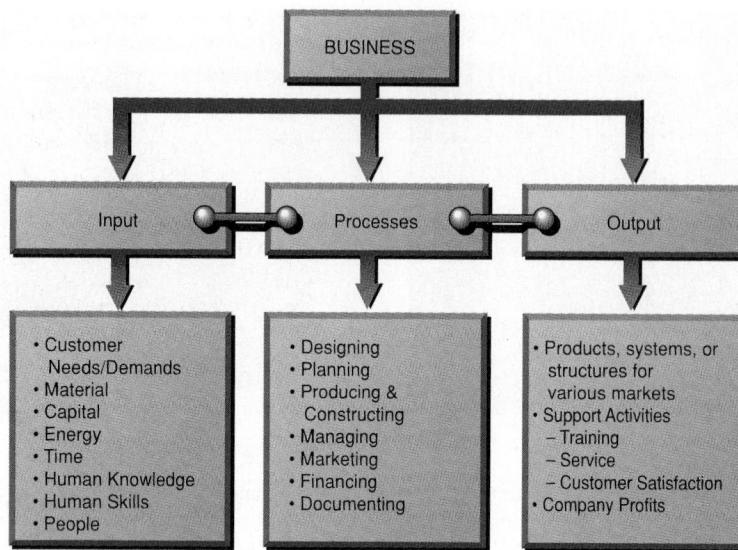

Figure 10.6 The Business Process

A manufacturing business or enterprise includes all the inputs, processes, and outputs necessary to produce a product or construct a structure. Designing is one of the major processes in such a business.

10.2 THE ENGINEERING DESIGN PROCESS

Engineering design is one of the processes normally associated with the entire business or enterprise, from receipt of the order or product idea, to maintenance of the product, and all stages in between. (Figure 10.6) The design process requires input from such areas as customer needs, materials, capital, energy, time requirements, and human knowledge and skills. An example of human knowledge input is an engineer's knowledge of graphics, mathematics, and the sciences. Such knowledge is used by the engineer to analyze and solve problems.

An engineering design involves both a process and a product. A **process** is a series of continuous actions ending in a particular result. A **product** is anything produced as a result of some process. As the design of a product or process is developed, the design team applies engineering principles, follows budgetary constraints, and takes into account legal and social issues. For example, when a building is designed, engineering principles are used to analyze the structure for loads; determine the structure's cost, based on the materials to be used, the size of the structure, and aesthetic considerations; and create a design that adheres to the local laws.

Graphics is an extremely important part of the engineering design process, which uses graphics as a tool to visualize possible solutions and to document the design for communications purposes. Graphics or

geometric modeling using CAD is used to visualize, analyze, document, and produce a product or process. In fact, geometric modeling itself could be considered both a process and a product. As a process, geometric modeling produces final design solutions, as well as inputs to the production process, in the form of computer databases. As a product, geometric modeling is a result of the engineering design process.

10.2.1 Traditional Engineering Design

Traditional engineering design is a linear approach divided into a number of steps. For example, a six-step process might be divided into problem identification, preliminary ideas, refinement, analysis, documentation, and implementation. (See Figure 1.9) The design process moves through each step in a sequential manner; however, if problems are encountered, the process may return to a previous step. This repetitive action is called **iteration** or looping. Many industries use the traditional engineering design process; however, a new process is developing, which combines some features of the traditional process with a team approach that involves all segments of a business.

10.2.2 Concurrent Engineering Design

The **production process** executes the final results of the design process to produce a product or system. In

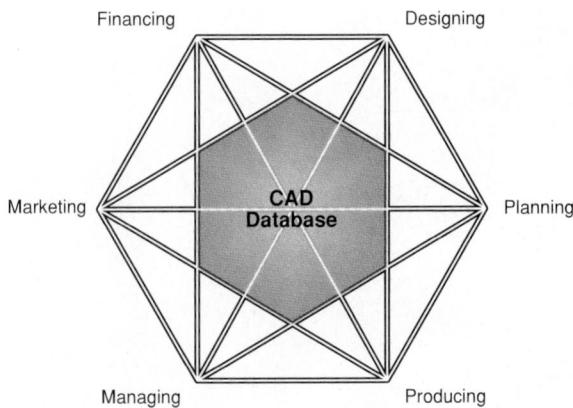

Figure 10.7 Sharing the CAD Database

The concurrent engineering model shows how every area in an enterprise is related, and the CAD database is the common thread of information between areas.

In the past, the creative design process was separated from the production process. With the advent of computer modeling, this separation is no longer necessary, and the modern engineering design approach brings both processes together.

Concurrent engineering is a nonlinear team approach to design that brings together the input, processes, and output elements necessary to produce a product. The people and processes are brought together at the very beginning, which is not normally done in the linear approach. The team consists of design and production engineers, technicians, marketing and finance personnel, planners, and managers, who work together to solve a problem and produce a product. Many companies are finding that concurrent engineering practices result in a better, higher quality product, more satisfied customers, fewer manufacturing problems, and a shorter cycle time between design initiation and final production.

Figure 10.7 represents the concurrent approach to engineering design, based on 3-D modeling. The three intersecting circles represent the concurrent nature of this design approach. For example, in the ideation phase, design engineers interact with service technicians to ensure that the product will be easily serviceable by the consumer or technician. This type of interaction results in a better product for the consumer. The three intersecting circles also represent the three activities that are a major part of the concurrent engineering design process: ideation, refinement, and implementation. These three activities are further divided into smaller segments, as shown by the items surrounding the three circles.

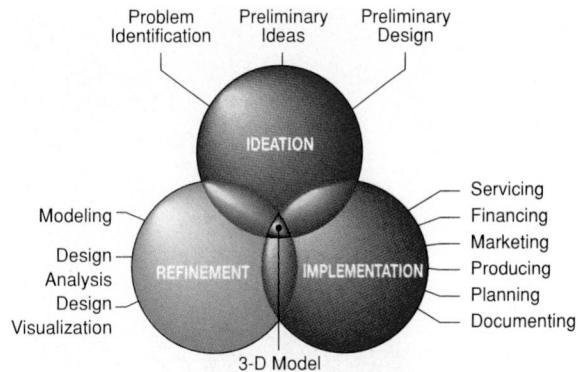

Figure 10.8 Concurrent Engineering Design

The engineering design process consists of three overlapping areas: ideation, refinement, and implementation, which all share the same 3-D CAD database.

The center area in Figure 10.8 represents the 3-D computer model and reflects the central importance of 3-D modeling and graphics knowledge in engineering design and production. With the use of a modeling approach, everyone on the team can have access to the current design through a computer terminal. This data sharing is critically important to the success of the design process.

Through the sharing of information, often in the form of a database, it is possible for all areas of the enterprise to work simultaneously on their particular needs as the product is being developed. For example, a preliminary 3-D model could be created by the design engineers early in the ideation phase. A mechanical engineer could use the same 3-D model to analyze its thermal properties. The information gained from this preliminary analysis could then be given to the design engineers, who could then make any necessary changes early in the ideation phase, minimizing costly changes later in the design process.

 This chapter will use as an example the design process practiced by Motorola, Inc., Schaumburg, Illinois, to design the Motorola MicroTAC Lite cellular telephone. (Figure 10.9) Motorola uses a team approach and a concurrent engineering process to develop new products. A group assigned to a project includes mechanical, industrial, and electrical engineers; technicians; industrial designers; and purchasing, planning, marketing, and other support personnel. Each team member brings his or her unique skills, experience, knowledge, and perspectives to the design problem, and everyone participates in the solution process to get the new product to market as quickly as possible.

Figure 10.9 Concurrent Engineering Design Case Study

The MicroTAC Lite cellular phone was designed and produced using concurrent engineering and total quality management (TQM) principles. (Courtesy of Motorola.)

10.3 3-D MODELING

Traditionally, the means of communication in the engineering design process was through paper drawings done by hand. With the increasing availability of CAD tools, these 2-D technical drawings are being produced on computer. More recently, 3-D modeling software has become available on increasingly powerful PCs (Figure 10.10) and increasingly inexpensive engineering workstations. (Figure 10.11) Because 3-D modeling systems create models of the product being designed, this system offers considerably more possibilities as to how it can be integrated into the design process than a 2-D CAD drawing does.

The following section offers an overview of the most common approaches for generating 3-D computer models. Because working with a 3-D model is so much different than creating a 2-D drawing, the ways in which these models are constructed and viewed are also discussed. As the various stages of the design process are presented, the ways in which 3-D modeling can play an integral role will be outlined.

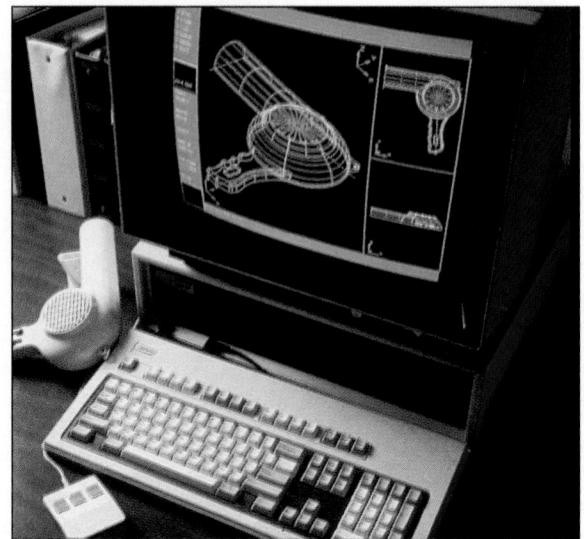

Figure 10.10 PC Workstation

The development of PCs made powerful 3-D CAD software available at an affordable price. (Courtesy of CADKEY, Inc.)

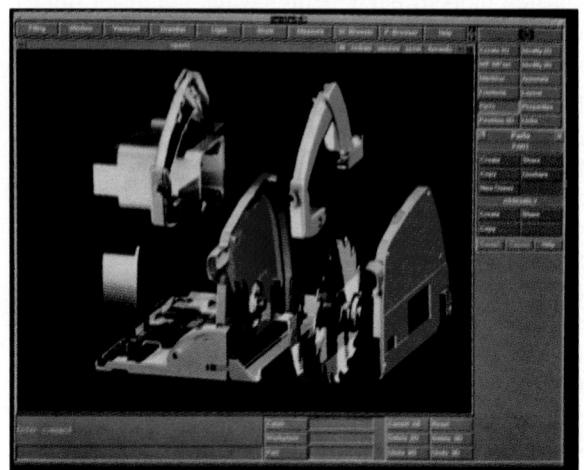

Figure 10.11 UNIX Workstation

UNIX workstations are popular for particularly demanding 3-D modeling work. (Courtesy of Hewlett-Packard.)

10.3.1 Wireframe Modeling

The simplest 3-D modeler is a **wireframe modeler**. In this type of modeler, which is a natural outgrowth of 2-D CAD, two types of elements must be defined in the database: *edges* and *vertices*. (Figure 10.12) For the tetrahedron in the figure, the vertex list contains the geometric information on the model. Each vertex is defined by an (X, Y, Z) coordinate, which anchors the model in space. The topology of the model is represented by the edge

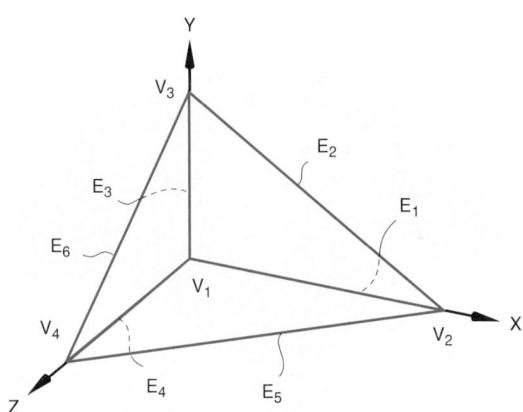

Vertex list

$V_1 (0, 0, 0)$
$V_2 (1, 0, 0)$
$V_3 (0, 1, 0)$
$V_4 (0, 0, 1)$

Edge list

$E_1 < V_1, V_2 >$
$E_2 < V_2, V_3 >$
$E_3 < V_3, V_1 >$
$E_4 < V_1, V_4 >$
$E_5 < V_2, V_4 >$
$E_6 < V_3, V_4 >$

Figure 10.12 The Vertex and Edge List of a Wireframe Model

list. The edge list does not contain coordinate information. The location, orientation, and length of an edge must be derived indirectly, through calculations of the vertices at either end of the edge. For example, edge E1 consists of vertices V1 and V2. The coordinate locations of V1 (0,0,0) and V2 (1,0,0) indicate that E1 has a length of 1 and is oriented along the X axis.

Most wireframe modelers support curved edges, as well as straight edges. Because of the added mathematical complexity, the curved edges are usually only circular curves. An example is a cylinder, as shown in Figure 10.13. The use of curved edges in a wireframe model reveals one of the deficiencies of a wireframe model as a representation of a 3-D object. Take the cylinder as an example. The end faces of the cylinder are represented by single, continuous, circular edges. But a cylinder has no side edges, making it difficult with a wireframe modeler to connect the top and bottom faces of the cylinder. The two linear edges (E5, E6) shown in the figure are artifacts of the wireframe model and are necessary for maintaining integrity of the database and for visualizing the model.

Although wireframe modeling has the advantage of being easy to implement in computer software, it does have some disadvantages. One disadvantage is the problem it has with *uniqueness*. Figure 10.14 shows a wireframe model and some of the possible objects it

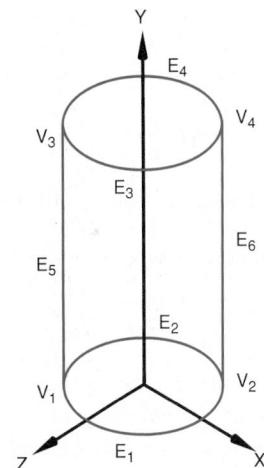

Vertex List

$V_1 (-1, 0, 1)$
$V_2 (1, 0, -1)$
$V_3 (-1, 5, 1)$
$V_4 (1, 5, -1)$

Edge List

$E_1 < V_1, V_2 >$
$E_2 < V_2, V_1 >$
$E_3 < V_3, V_4 >$
$E_4 < V_4, V_3 >$
$E_5 < V_1, V_3 >$
$E_6 < V_2, V_4 >$

Type

Circular
Circular
Circular
Circular
Linear
Linear

Figure 10.13 A Wireframe Model Using Circular and Linear Edges

Full circles are broken into two arcs to allow them to connect to other edges.

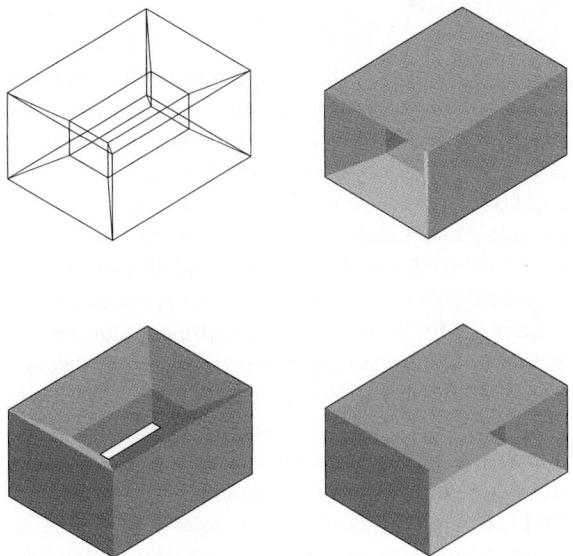

Figure 10.14 Example of a Wireframe Model Lacking Uniqueness

The same edge and vertex list can describe different objects, depending on how the faces are interpreted.

Figure 10.15 A Wireframe Model with an Ambiguous Orientation: The Necker Cube

Which face is in front and which is in back?

could represent. In the model, the lack of information about surfaces gives rise to *ambiguities* concerning the orientation of the object. The Necker cube is a classic example. (Figure 10.15) Because surface information is not available, edges that would normally be hidden are not and the orientation is unclear. Some wireframe modelers have implemented computational routines to calculate and remove hidden edges. Since this involves calculating surface information that is not inherent in a true wireframe modeler, the process is often slow and cumbersome.

10.3.2 Surface Modeling

The pressures of wartime production of ships and aircraft during World War II and the expanding consumer market after the war led to the development of systems using the mathematical descriptions of curved surfaces. *Parametric techniques* popularized by Steven A. Coons were adopted as a way of precisely describing the curvature of a surface in all three dimensions. **Surface models** define the surface features, as well as the edges, of objects. For more information see Chapter 3, “Engineering Geometry and Construction.”

Different types of *spline curves* are used to create surface patches with different modeling characteristics. For example, the advantage of Bezier surface patches is that they are easy-to-sculpt natural surfaces. (Figure 10.16) The control points are an intuitive tool with which the user can work. There are, however, two disadvantages to Bezier patches. First, they do not provide *local control*; a change in one control point affects the shape of the whole patch, and could alter the edge connecting two patches together. Figure 10.17 shows an example of two patches that are connected (there is no gap between them), but without the level of **continuity** necessary to create a smooth surface. The second disadvantage is that it is hard to calculate control points that will allow the patch to pass

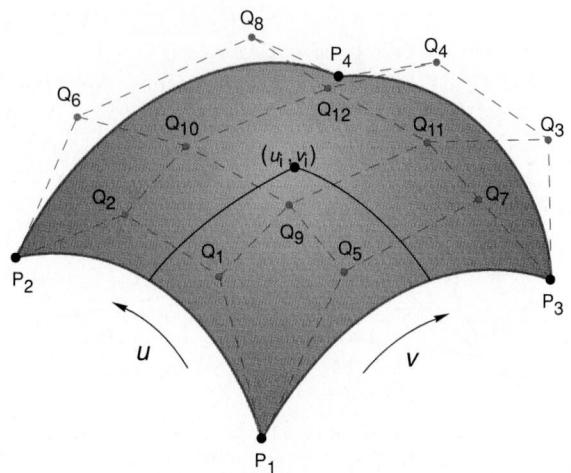

Figure 10.16 A Bezier Surface Patch

The patch consists of four connected Bezier curves and 12 control points.

Figure 10.17 Two Discontinuous Surface Patches

The crease between the surface patches reveals the discontinuity.

through already existing points in a model, which means it is not possible to control the exact location of the patch. This reduces the precision of the model.

In contrast, B-spline patches allow local control; moving one control point does not affect the whole surface. With B-splines, it is much easier to create surfaces through predefined points or curves. NURBS surfaces use *rational B-splines*, which include a *weighting* value at each point on the surface. The weighting value allows some points to have more influence over the shape of the curve than other points. This means that a wider variety of curved surfaces is possible than with regular B-splines. Because NURBS surfaces can also precisely describe conic surfaces, they are gaining popularity in many tasks previously handled by other types of 3-D modelers.

One general weakness of surface modelers is their inability to handle *topology*. For example, if you have a series of patches that form a closed-volume model and you “drill a hole” in the model, you will pass through an infinitely thin surface into a void, for which no information is available. To handle this situation, the user or the system must cover over the inside of the hole. Some surface modelers simply do not have the flexibility to make this sort of topological modification easily.

As mentioned earlier, there are times when surface modeling systems are invaluable. Precise, mathematically defined curved surfaces are a must in the aerospace, automotive, and shipbuilding industries. In many cases, information about the surface of the object is the most critical element in manufacturing the product, and the surface information used in the model can often be used directly by analysis and manufacturing software tools. © CAD Reference 10.1

10.3.3 Solid Modeling

Through the use of parametric description, surface modelers can accurately describe the surface of an object. Often, however, information about the inside of an object, that is, its solidity, is also required. **Solid models** include volumetric information, that is, what is on the inside of the 3-D model, as well as information

about the surface of an object. In this case, the surface of the model represents the boundary between the inside and outside of the object.

Primitive Modeling Many objects, including most mechanical parts, can be described mathematically using basic geometric forms. Modelers are designed to support a set of *geometric primitives*, such as cubes, right rectilinear prisms (i.e., blocks), right triangular prisms (i.e., wedges), spheres, cones, tori, and cylinders. (Figure 10.18) Although most geometric primitives have unique topologies, some differ only in their geometry, like the cube and the right rectilinear prism.

Many modelers allow primitives to be joined together to create more complex objects. The user mentally decomposes the object into a collection of geometric primitives and then constructs the model from these elements. (Figure 10.19)

There are a number of positive aspects to using a limited set of primitives. First, limiting the allowed topologies reduces the risk of an *invalid* model. Typically, the only safeguards needed are limits or rules on parameter input. For example, the diameter of a cylinder could not be specified as zero. Second, the limited number of allowable shapes means a very concise and efficient database. Third, the limited range of primitives means a model that is unique and is easy to validate.

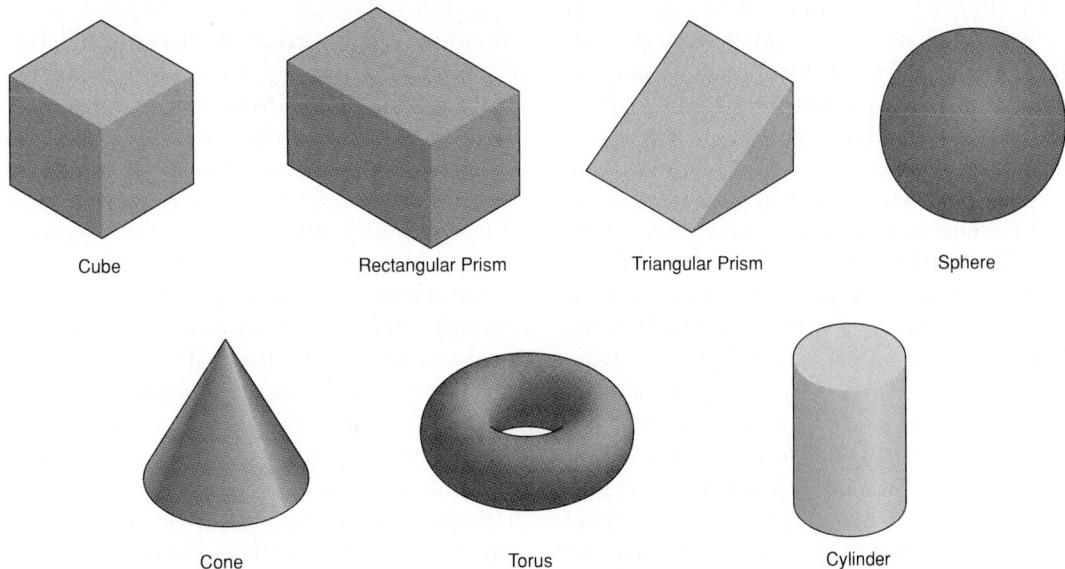

Figure 10.18 Common Geometric Primitives

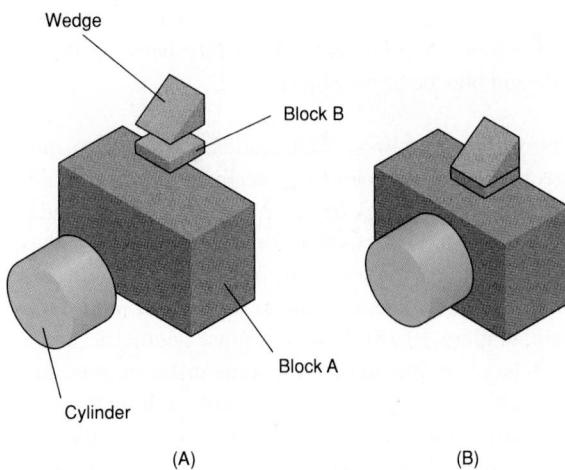

Figure 10.19 A Camera Described with Geometric Primitives

Additive modeling with geometric primitives allows a variety of objects to be represented.

On the other hand, a limited set of primitives limits the ultimate flexibility in the models that can be represented. Even if you have the ability to glue primitives together, this building block style of construction is purely *additive*. There is no way to represent a hole in an object. This *limited domain* means that the correspondence between a model and an actual object can be lacking. © CAD Reference 10.2

Constructive Solid Geometry (CSG) Modeling
Constructive solid geometry (CSG) modeling is a powerful technique that allows flexibility in both the way primitives are defined and the way they are combined. The relationships between the primitives are defined with **Boolean operations**. There are three types of Boolean operations: **union** (\cup), **difference** ($-$), and **intersection** (\cap). Figure 10.20 shows how each of these operations can be used to create different forms. The critical area is the place where two objects overlap. This is where the differences between the Boolean operations are evident. The union operation is essentially additive, with the two primitives being combined. However, in the final form, the volume where the two primitives overlap is only represented once. Otherwise, there would be twice as much material in the area of overlap, which is not possible in a real object. With a difference operation, the area of overlap is not represented at all. The final form resembles one of the original primitives with the area of

overlap removed. With the intersection operation, *only* the area of overlap remains; the rest of the primitive volumes are removed. © CAD Reference 10.3

The final form of a model can be developed in several ways. As with pure primitive instancing, you can begin by defining a number of primitive forms. The primitives can then be located in space such that they are overlapping or adjoining. Boolean operations can then be applied to create the resulting form. The original primitives may be retained in addition to the new form, or they may be replaced by the new form. More primitives can be created and used to modify the form, until the final desired shape is reached. Figure 10.21 shows how the union and difference operations result in a much more realistic camera than the one depicted in Figure 10.19.

As with pure primitive instancing, the person doing the modeling must have a clear idea of what the final form will look like, and must develop a strategy for the sequence of operations needed to create that form. © CAD Reference 10.4

Practice Exercise 10.1

Using clay or foam, create three pairs of primitive shapes, such as cylinders and rectilinear prisms. Sketch a pictorial of two of the primitives overlapping in some way. With the model pairs, create a single object that reflects the three Boolean operations: union, difference, and intersection.

Boundary Representation (B-Rep) Modeling
Boundary representation (B-rep) modeling and CSG modeling are the two most popular forms of solid modeling. With CSG modeling, surfaces are represented indirectly through half-spaces; with B-rep modeling, the surfaces, or *faces*, are themselves the basis for defining the solid. The face of a B-rep model is fundamentally different from a face in a wireframe modeler. Though both include a set of edges connected at vertices, a B-rep face explicitly represents an oriented surface. There are two sides to this surface: one is on the *inside* of the object (the solid side), and the other is on the *outside* of the object (the void side).

© CAD Reference 10.5

Also, like wireframe modelers, B-rep modelers have the capability of containing both linear and curved edges. Supporting curved edges also means supporting curved surfaces, which hinders model

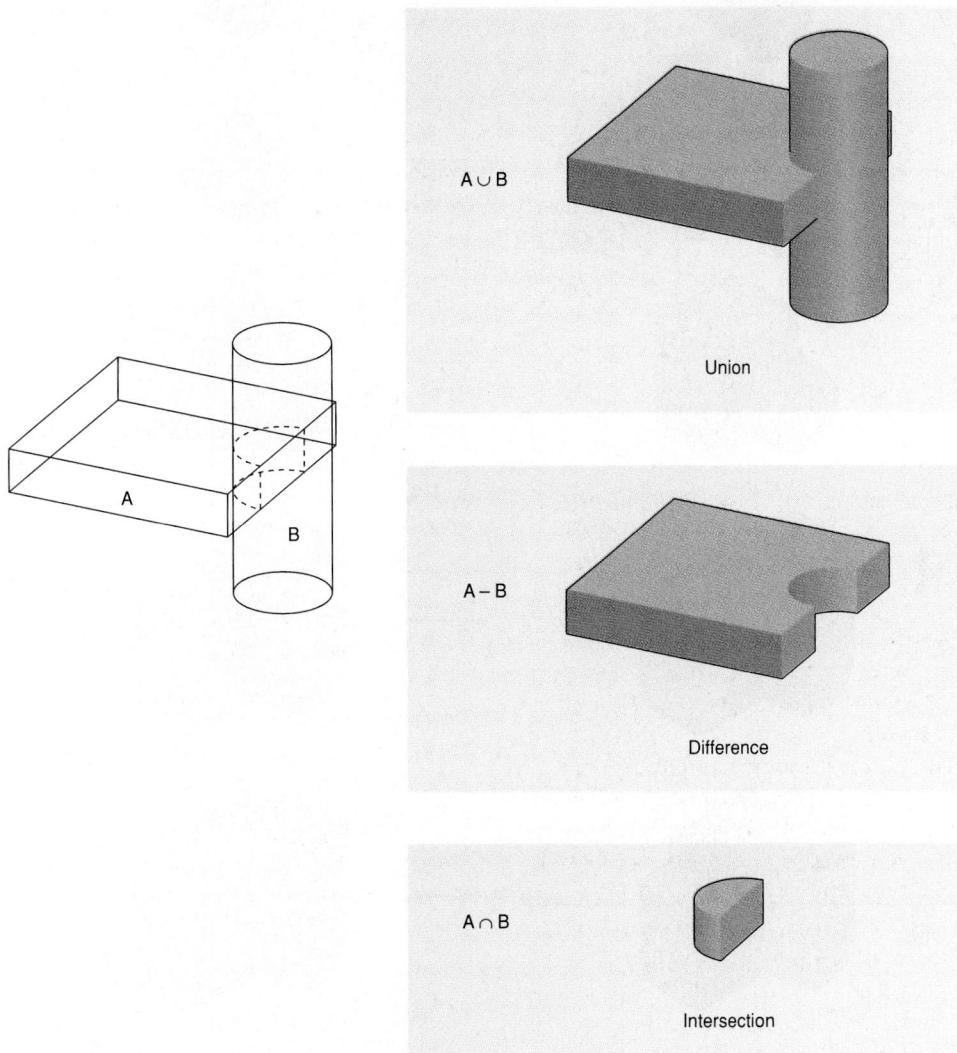

Figure 10.20 The Three Boolean Operations: Union, Difference, and Intersection

The three operations, using the same primitives in the same locations, create very different objects.

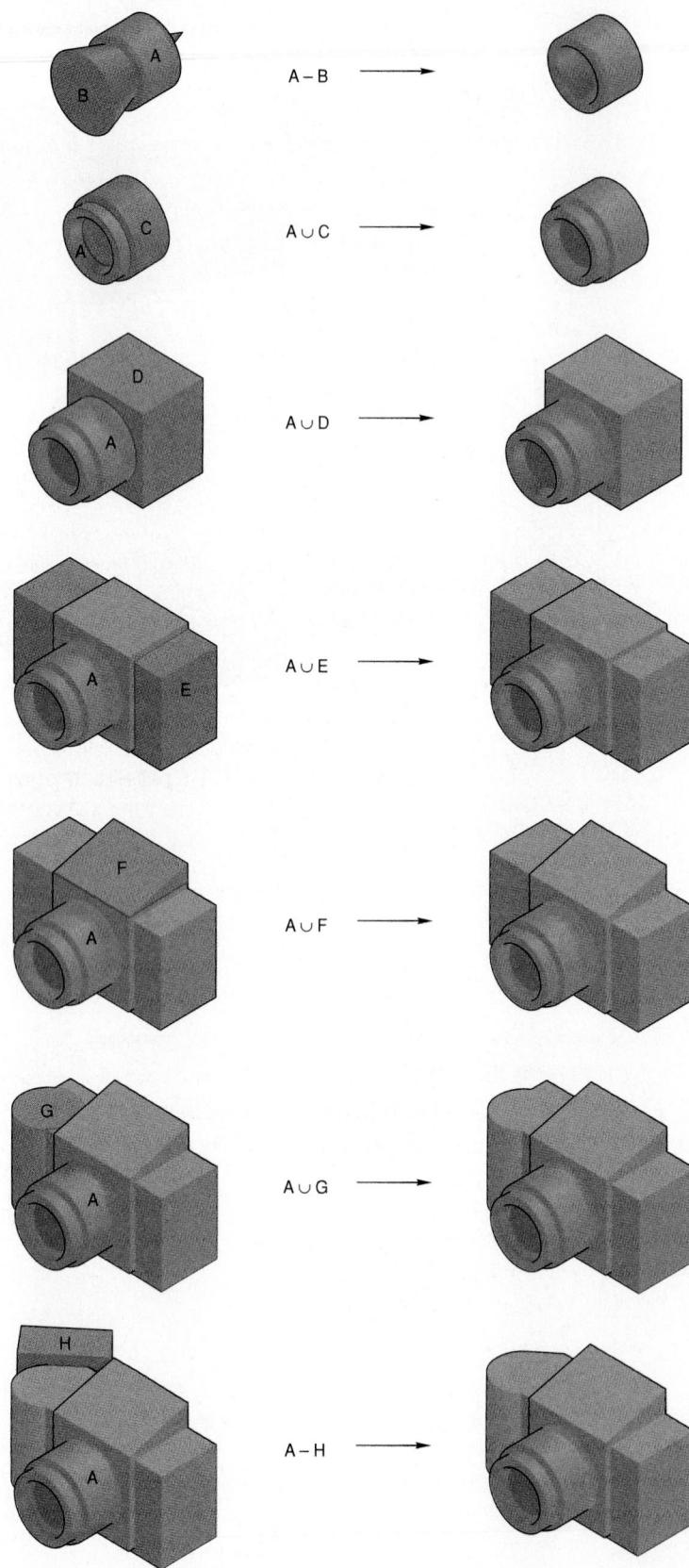

Figure 10.21 A Camera Described Using CSG Modeling

Boolean operations allow much more flexibility than just additive techniques with primitives.

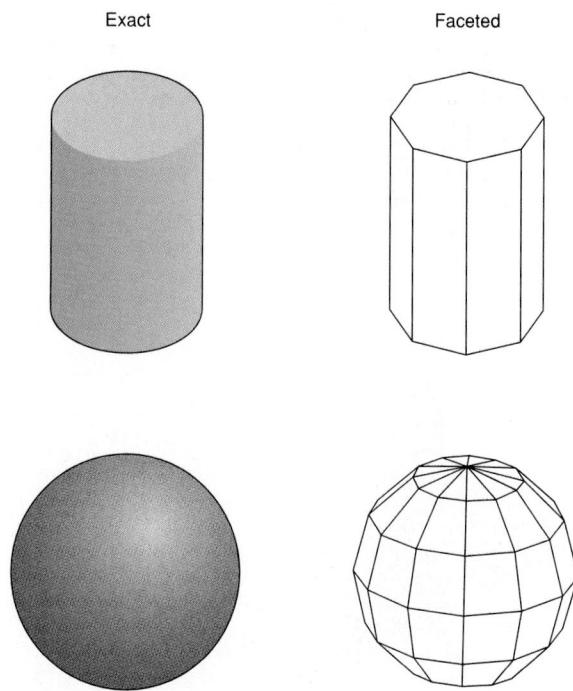

Figure 10.22

Some modelers approximate curved surfaces with a series of planar ones called *facets*.

performance. For that reason, many modelers approximate curved surfaces with a series of planar ones. This is called *faceted* representation. (Figure 10.22) © **CAD Reference 10.6**

10.3.4 3-D Construction Techniques

All modelers require the user to input data or construct the model. Though construction techniques are limited by what the underlying data structure will support, most modelers contain a common suite of tools.

Coordinate Systems With a 2-D CAD system, a Cartesian coordinate system (X,Y) defines the locations of points and lines on the drawing. With a 3-D modeling system, a 3-D coordinate system (X,Y,Z) defines the dimensions of the object. Refer to Section 3.3, “Coordinate Space,” for more information on coordinate systems.

To facilitate model construction, *relative coordinate systems* are used to supplement the basic X,Y,Z coordinate system. The relative, or *local*, coordinate system relates to individual objects or elements. As an example, in Figure 10.23, a local coordinate system was defined at the center of a block to help locate a cone.

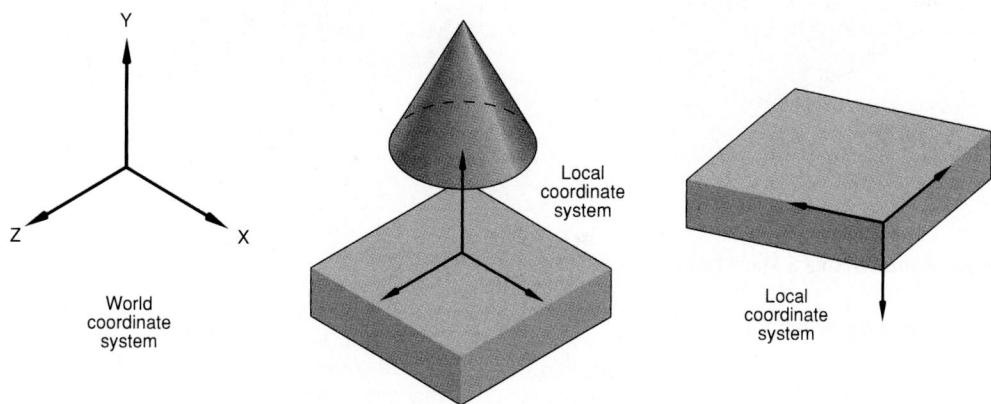

Figure 10.23 Examples of Local Coordinate Systems

Local coordinate systems can be used to locate primitives relative to each other or to features on an object.

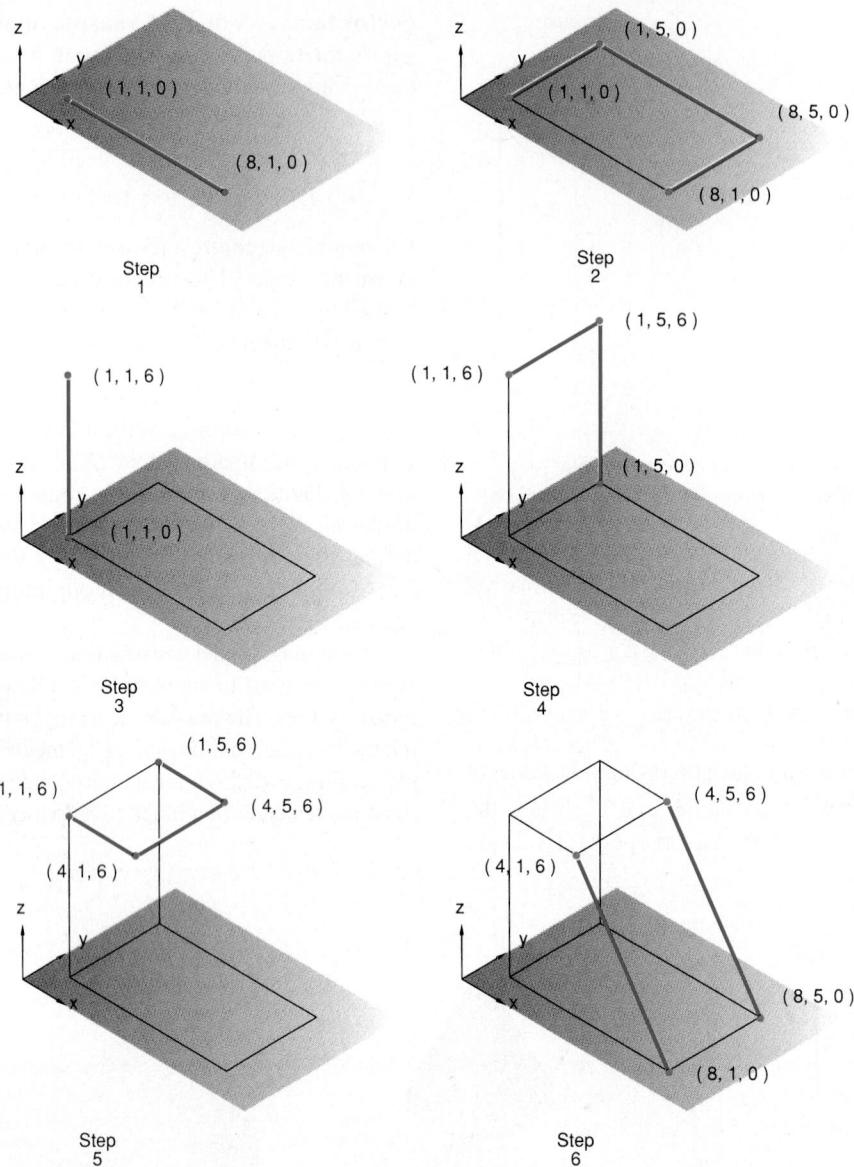

Figure 10.24 Constructing a Wireframe Model

Constructing a Wireframe Model

Euler operations are used to construct this wireframe model. Cartesian coordinates assist in the placement of the vertices during construction. (Figure 10.24)

Step 1. Construct the first orthogonal edge, with vertex coordinates 1,1,0 and 8,1,0, in the X-Y plane.

Step 2. Complete the bottom face of the object with three more orthogonal edges. The two additional vertices are at 8,5,0 and 1,5,0. Each vertex represents the endpoint for two lines, and the face is in the X-Y plane.

Step 3. Connect vertex 1,1,0 with vertex 1,1,6, in the Z direction, introducing the third dimension to the model.

Step 4. Complete the left side face with edges to vertices 1,5,6 and 1,5,0. Two of the vertices, (1,1,0) and (1,5,0), now meet the wireframe model requirement that any vertex have at least three attached edges.

Step 5. Complete the top face, with edges to vertices 4,1,6 and 4,5,6. Notice that the Z value is the same for all vertices on the top face (i.e., Z = 6), and the Z value is the same (i.e., Z = 0) for all vertices on the bottom face. This means the faces are parallel.

Step 6. The vertices at 4,1,6, 4,5,6, 8,1,0, and 8,5,0 all still have only two edges connected to them. Add the last two edges to complete the model. All vertices now have three attached edges. Notice also that the two faces in the X-Z plane are parallel.

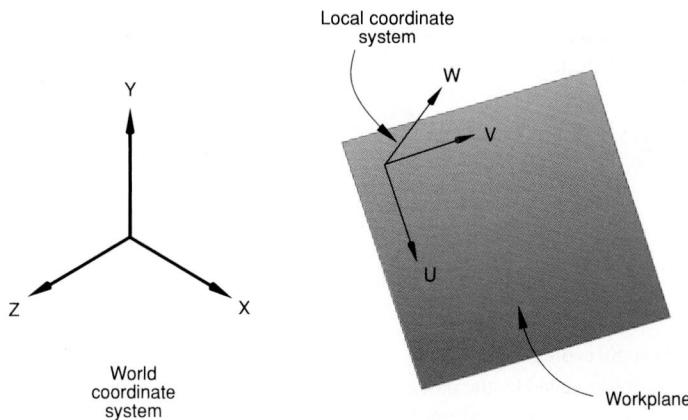

Figure 10.25 A Local Coordinate System Attached to a Workplane

Local coordinate systems are used to locate a workplane relative to the world coordinate system or the model.

Workplanes In 3-D modeling, a local coordinate system can be associated with a **workplane** or *construction* plane, which is an infinitely large 2-D plane that can be oriented anywhere in 3-D space. (Figure 10.25) An alternate coordinate lettering scheme is often used for the associated local coordinate system. For example, U,V,W can be used to indicate the location and orientation of the workplane, with U and V defining the surface of the plane, and W the axis perpendicular to the plane.

A workplane can be used in the same manner as a drawing surface. In a multiview drawing, one view can be oriented along the W axis of the workplane. The effect is that you can draw on the workplane as though you were looking directly down on a piece of paper.

The workplane is not fixed in one location; it can be moved freely in 3-D space. Workplanes are often oriented using features of the model being built. Since the process of model building usually entails modifying or adding onto what already exists, the location of a workplane can be defined with respect to an existing face or vertices. (Figure 10.26)

© CAD Reference 10.7

Sweeping Operations Defining an object by specifying every geometric element it contains is a cumbersome process. Most CAD systems use methods of automating object generation. In a **sweeping operation**, a closed polygon, called a *profile*, is drawn on the workplane (the U–V plane) and is moved or swept along a defined path, for a defined length. In the wireframe modeling example earlier in this chapter, a *declarative* method was used; that is, each individual vertex in the model was explicitly defined. The sweeping

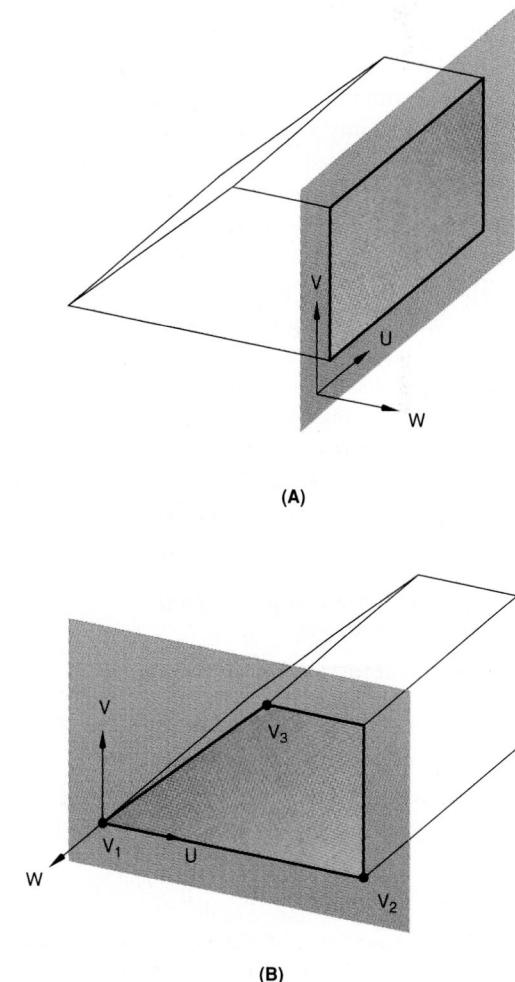

Figure 10.26 Locating a Workplane by the Features of the Model

Both faces and individual vertices can be used to orient and locate workplanes.

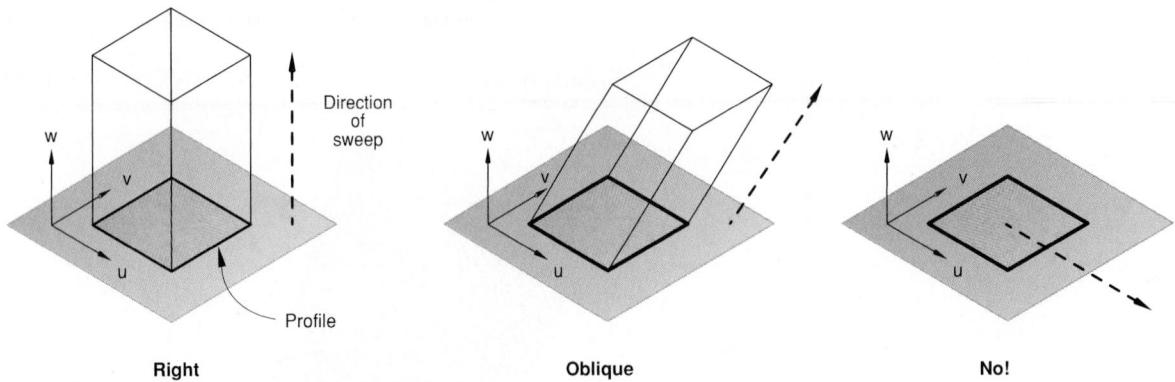

Figure 10.27 Types of Linear Sweeping Operations

In some systems, linear sweeps (represented by the dashed line) are limited to being perpendicular to the workplane; in others, any angle other than parallel to the workplane is allowed.

technique is *procedural*; instructions are given, defining the profile and the path, to transform a single polygon into a 3-D solid.

In the simplest case, the path is *linear* and a prismatic solid is created. (Figure 10.27) If the linear path is coincident with the W axis, a right prism is created. If the path is at any other angle to the W axis, an oblique prism is created. An angle of 90 degrees is not allowed because it creates a form that is not three-dimensional; the path is parallel to the U-V plane.

Another path a sweep could follow is *circular* (revolute). The specifications for a revolute path are more demanding than those for a linear path. With a revolute path, an axis of rotation must be defined in terms of both orientation and location. Figures 10.28A and 10.28B show two different revolute sweeps, each with a different placement for the axis of rotation. In addition, angular displacements of other than 360 degrees can be specified. (Figure 10.28C) © CAD Reference 10.8

Creating a 3-D Model Using Sweeping and Boolean Operations

Sweeping operations can be used to speed the model construction process. Combined with Boolean operations, swept objects can represent both positive and negative geometry. (Figure 10.29)

Step 1. With a 2-D rectangular polygon defined on the workplane, determine the direction and distance for the sweep, to produce the first solid.

Step 2. Using the top face of the initial solid as a guide, relocate the workplane, create a semicircle, then sweep it to create the half cylinder. These two objects are joined by using a Boolean union operation.

Step 3. Rather than using an existing face on the solid for orientation, rotate the workplane 90 degrees so that it is vertical and create a triangle. Sweep the triangle to create a wedge and unite it with the model.

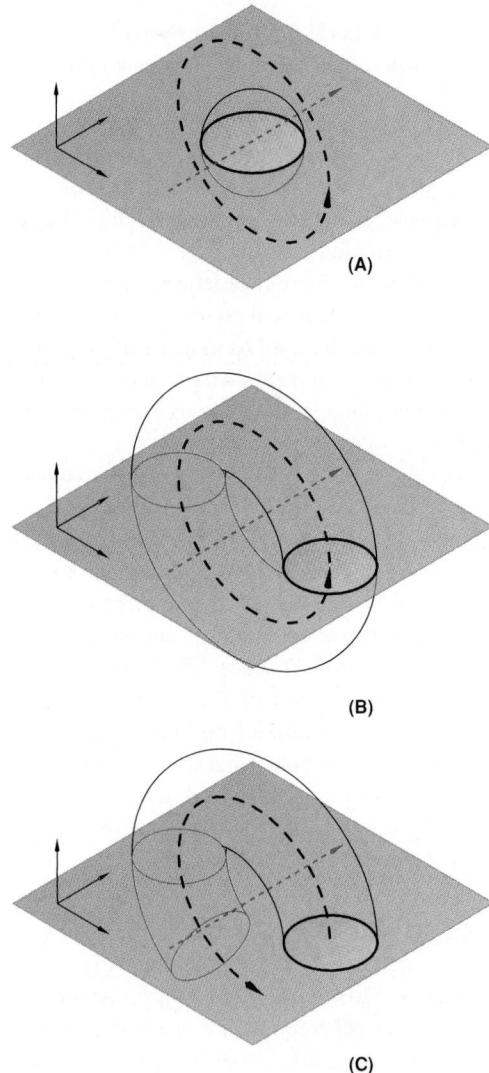

Figure 10.28 Examples of Circular Sweeping Operations

The resulting object is dependent on the location of the sweep axis relative to the profile, and to the angular displacement.

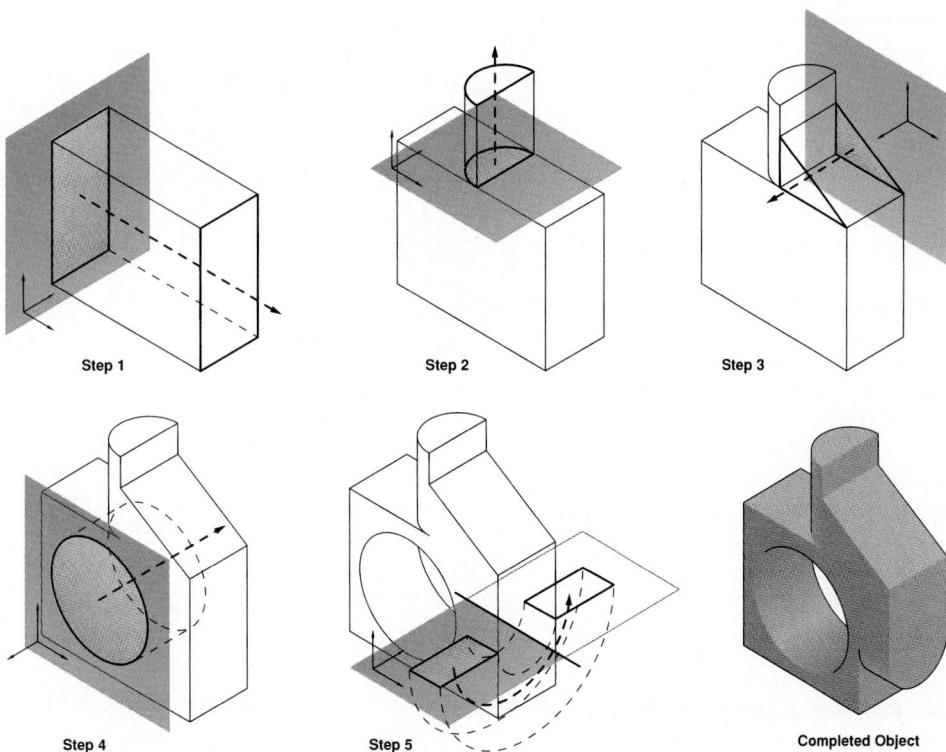

Figure 10.29 Creating a Solid Model Using Sweeping and Boolean Operations

Step 4. Translate the workplane so that it is on the front face of the object. Create a circle on the front face and sweep it to the rear face of the object, to form a cylinder. Using the Boolean difference operation, subtract the cylinder from the object to make a hole through the model.

Step 5. Do a final sweep with a rectangle following a circular path for 180 degrees. Use the Boolean difference operation to remove a portion of the bottom of the model.

The world and any associated local coordinate systems define the model. The viewing coordinate system also has three axes, which are defined by the viewer's orientation in space: vertical, horizontal, and depth. Even though it would be convenient to associate the computer screen with the image plane coordinate system, that could lead to incorrect assumptions. Therefore, it is best at this time to imagine a 2-D plane in 3-D space, similar to a workplane.

10.3.5 3-D Viewing Techniques

The techniques used for viewing 3-D models are based on the principles of projection theory described earlier in this text. (See Chapter 4, “Sketching, Text, and Visualization.”) The computer screen, like a sheet of paper, is two-dimensional. Therefore, 3-D forms must be projected into 2-D. For review, the primary elements in creating a projection are the *model* (object), the *viewer*, and an *image (view plane)*. (Figure 10.30) A coordinate system is attached to each of these elements and is used to define the spatial relationship between the elements.

The View Camera The **view camera** is a metaphor used to describe the viewing process with respect to 3-D models in various CAD systems. Most systems support more than one view of the model at a time. For each view, there is a camera, and there is an image plane onto which the model is projected. (Figure 10.31) The camera records the image on the plane and broadcasts that image to the computer screen. The broadcasted image is contained within a **viewport** on the screen, and viewports may be resizable and relocatable, or fixed, depending on the system. In addition, the limit to the number of active viewports, and therefore the number of cameras, active at one time also varies.

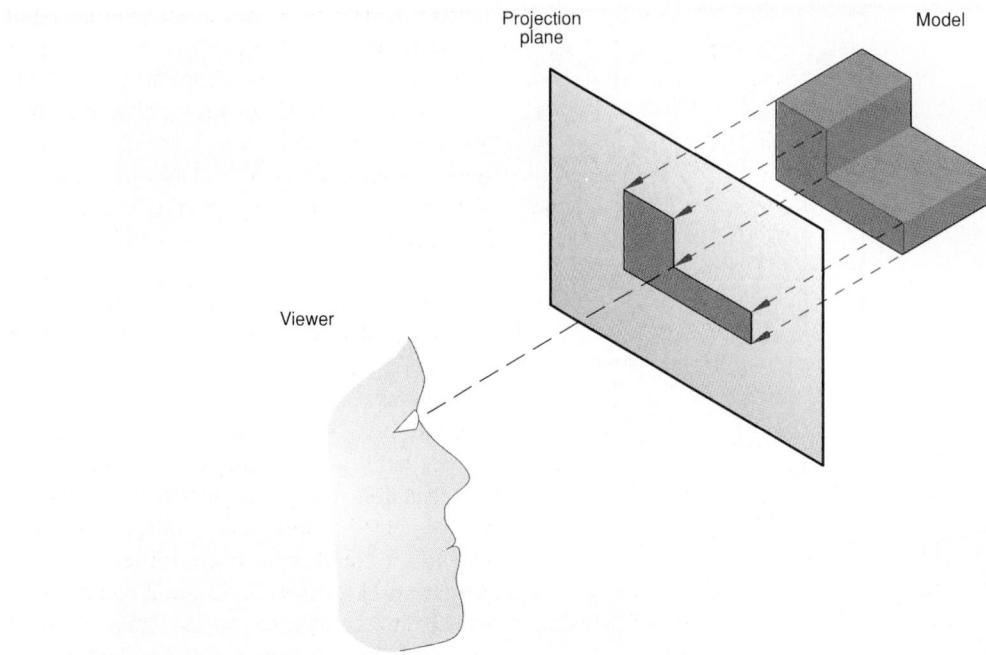

Figure 10.30 Elements of a Projection System

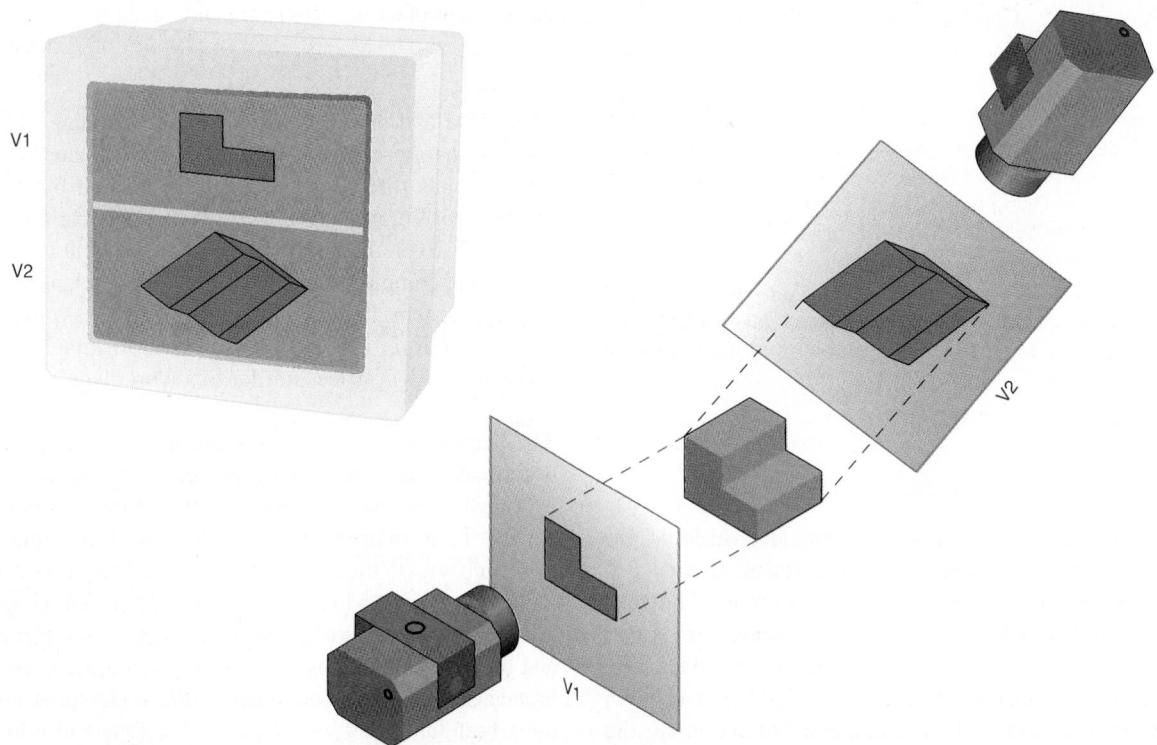

Figure 10.31 The View Cameras Capturing Projections Seen on the Display

The metaphor of the view camera can be used to understand how the computer monitor can display multiple views of the 3-D model.

Figure 10.32 View Commands that Do Not Involve Changing the Viewpoint

View commands used extensively in 2-D CAD systems are also useful when viewing 3-D models.

View cameras are used during model construction, as well as after the model is built. Active workplanes can be attached to the view plane of the camera, so that what you draw is seen on the screen port without distortion. With this arrangement, the U and V axes of the workplane correspond to the horizontal and vertical axes of the screen viewport, respectively. This is an intuitive alignment that eases the difficult job of maneuvering in 3-D space.

View Camera Operation Once a view camera has been oriented and a projection calculated, a number of auxiliary commands can be used to manipulate the view of the model. (Figure 10.32) When a view is calculated, the projection of the model is stored in a buffer, and any change in the view that does not change the viewing direction can be done quickly and efficiently. Such commands include zoom in, zoom out, and pan, which can be done faster than, say, rotating the view about the object.

Projection calculations are not sensitive to the point of view; a traditional front view of the object is as easy to calculate as an isometric pictorial view. This is not the case with 2-D CAD or mechanical drafting. The implication is that, except for the occasional need to conform to a standard view, there is no reason to stick solely to the traditional views when working with 3-D modelers. **© CAD Reference 10.9**

View Camera Strategy Viewpoints should be chosen on the basis of the task to be performed. With multiple view ports, the views are often distributed between those used strictly for viewing and those used for constructing the model. A pictorial view of the model is useful for observing the progress of the overall construction. The pictorial is often an axonometric view oriented such that the features currently being worked on are seen with a minimum amount of foreshortening. Pictorial views are a compromise that allow all three major dimensions of the model to be seen. With 3-D modelers, dimetric and trimetric pictorials are as much an option as isometric pictorials. Rather than being limited to a certain pictorial view, the user can interactively orient the model to depict the features to the best advantage.

During model construction, traditional multiviews are typically used. The workplane is aligned to an existing face on the model, or along a global axis, and the resulting view matches a traditional front, side, or top view. For those systems that have fixed view cameras, the standard arrangement is three traditional views and an isometric pictorial. (Figure 10.33)

Practice Exercise 10.2

Select a small object with features on at least three faces. Use a small sheet of clear plastic as an image (view) plane. Use your eyes as the camera behind the image plane. Move the image plane about the object to find three orthographic views that capture most of the important features of the object. Move the view plane to one of the views and use a water-based marker to sketch the projection of the object on the plastic. On sheets of tracing paper, sketch the arrangement of view ports shown in Figure 10.33. Each view port should be the size of the plastic view plane. Place the plastic under one sheet of tracing paper and transfer the projection drawn into the view port. Repeat this process until the other two orthographic views and a pictorial view are transferred to the view ports on the tracing paper. This process mimics the process of creating views in view ports using a 3-D modeling system.

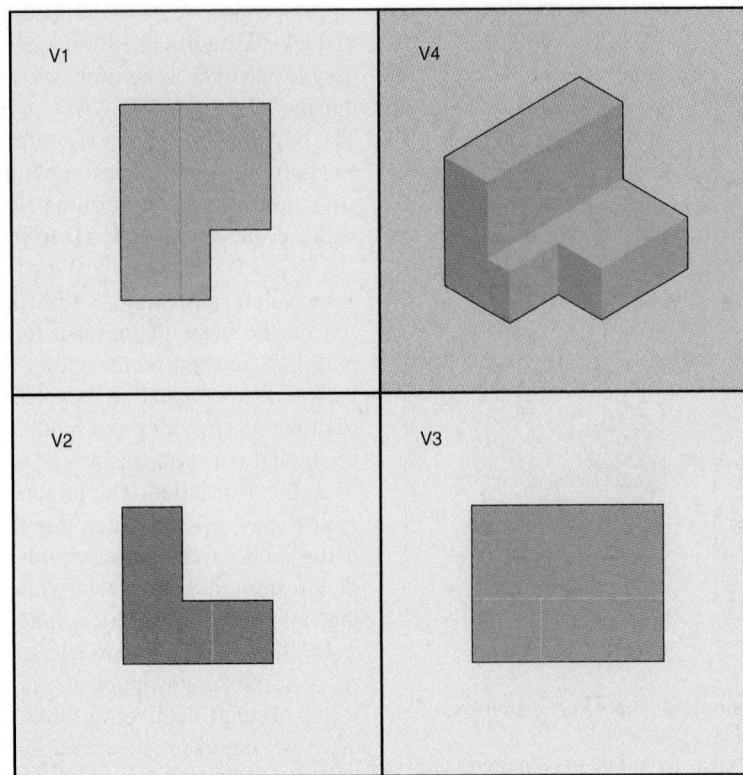

Figure 10.33 Standard Four-View Arrangement for a 3-D Modeling System

Many modeling systems have a default view setup depicting the three standard multiviews and a pictorial view.

10.3.6 Object Modification

During the modeling process, changes can be made to the model without having to delete and start over. For example, after the model is built, you might decide to make a drilled hole larger. Various object modification processes can be used to edit or change an existing model. This section describes many of these modification processes.

Geometric Transformations Solids can be modified in several ways. **Geometric transformations** include (Figure 10.34):

Translation—moving the solid linearly from one location to another along an axis.

Scaling—reducing or enlarging the object.

Shearing—moving selected vertices linearly along an axis.

Rotation—rotating the solid about an axis.

Reflection—transforming the solid into a mirror image across an axis.

Reflection, translation, and rotation are **rigid-body transformations**; they do not distort the shape of the solid. Scaling can be applied uniformly or nonuniformly to the three dimensions of the solid. If applied nonuniformly, face distortion will occur, but the edges will remain parallel. With shearing, distortion of some faces occurs, but parallelism is still preserved.

Of all the transformations, translation and rotation are the most important. Both play a central role in the creation and modification of solids. They are used for the two most common sweeping functions, linear and revolute, and for changing the viewpoint of a view camera.

All of the transformations can be specified through declarative statements indicating specific coordinates in space, features on the solid, or construction geometry. For example, for a translation, the *from* coordinate can be an existing vertex on the solid and the *to* coordinate can be either a feature on a solid or a construction point in space. Indirect, procedural commands can also be used in some situations, depending in part on the flexibility of the system and the sensitivity of

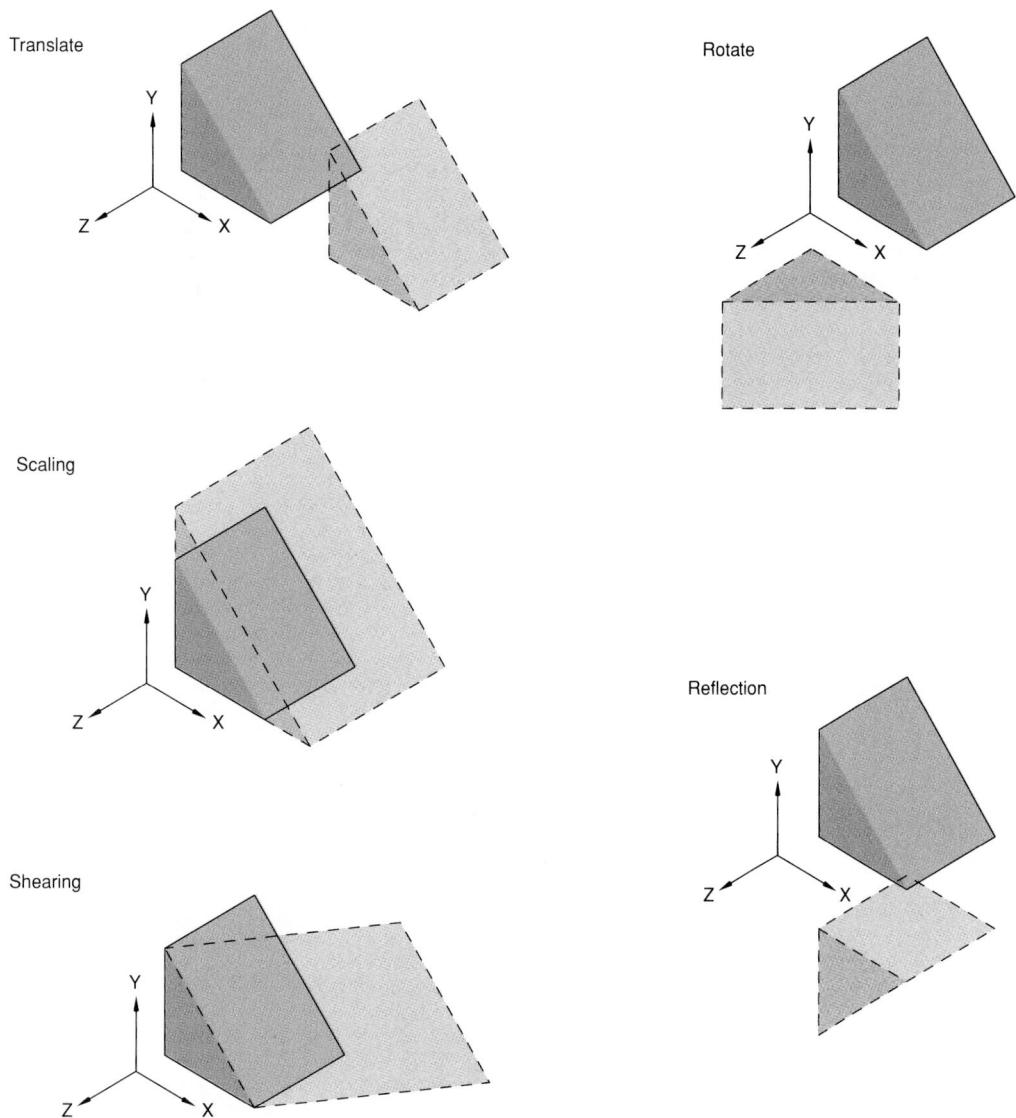

Figure 10.34 Common Geometric Transformations

Transformations can modify the location, orientation, or shape of an object.

the transformation to absolute position specifications. For example, a command such as, “Have face F1 of solid S1 adjoin face F2 of solid S2,” may be possible, and may involve a combination of translational and rotational transformations.

Other Operations Another approach for transforming the geometry of a single-object solid is **tweaking**. This technique encompasses a variety of operations

that involve changing the geometry but not the topology of a solid. (Figure 10.35) For example, the radius of a sphere can be changed without adding or deleting any new faces, and the size of a hole can be changed as long as the enlargement does not cross the edges of any other face. Depending on the sophistication of the modeler, *stretching* of individual or groups of points may be allowed. Because stretching may change the surface geometry of the face, limitations may be placed on the uniformity of the stretch.

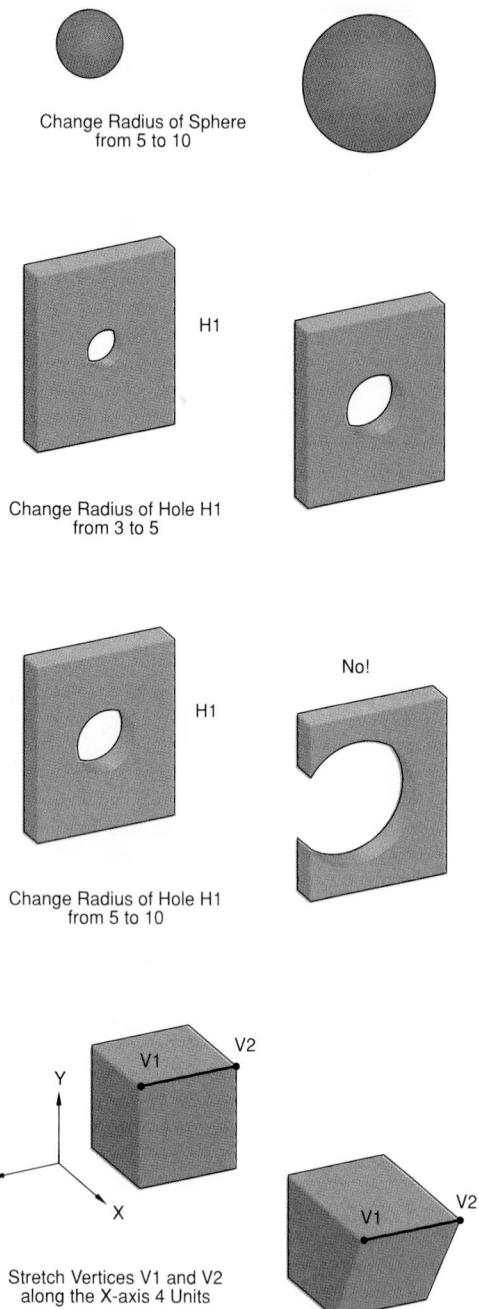

Figure 10.35 Examples of Tweaking Operations

Tweaking changes the geometry but not the topology of the object.

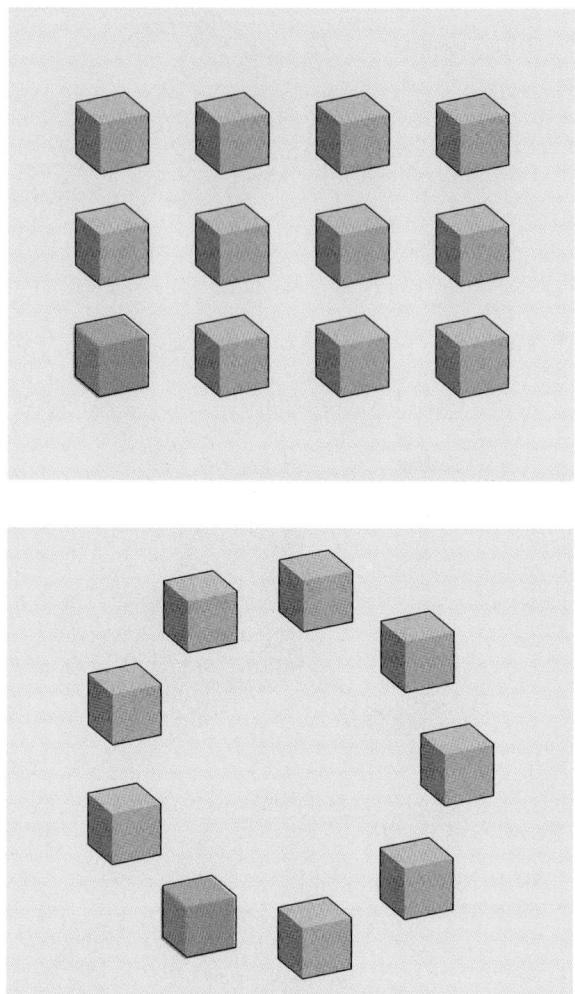

Figure 10.36 Linear and Radial Copies

Automating multiple duplications speeds the process of building models and assemblies.

Solids can also be copied, using options that rely on translation, rotation, or other transformations. For example, with a single copy, the operation might specify a translation to place the copy at the new location. For multiple copies, procedural instructions are given, specifying how the duplicates are to be distributed. (Figure 10.36) The distribution may be linear, in one, two, or three dimensions, or rotational (radial) about a specified axis. **CAD Reference 10.10**

A typical two-solid model modification involves the following steps:

1. Two solids are created.
2. The solids are oriented relative to each other such that there is some overlap or contact.
3. A Boolean operation is specified.
4. The resulting solid is inspected for validity.
5. Another operation is executed, if desired.

The two solids used in a Boolean operation play different roles: One solid is the *operand*, the solid that is acted on, and the other is the *operator*, the solid that does the action. In 3-D solid modeling, the model is the operand and is modified by a series of operator solids. The operator solids are typically easily specified primitives, while the model grows increasingly more complex with each operation. The operator solids can be thought of as *tools*, transient forms created specifically for the purpose of modifying the model. In a CSG modeler, all of the operator primitives are stored in a binary tree.

10.4 3-D MODELING AND THE DESIGN PROCESS

CAD was introduced into most businesses as an automated drafting tool, and was then defined as computer-aided drafting. The introduction of 3-D modeling systems has transformed CAD into computer-aided *design*.

CAD 3-D modeling plays an important role in many newly emerging manufacturing techniques, including computer-aided manufacturing (CAM), computer-integrated manufacturing (CIM), concurrent engineering, and design for manufacturability (DFM). All of these manufacturing techniques are aimed at shortening the design cycle, minimizing material and labor expenditures, raising product quality, and lowering the cost of the final product. Central to these goals is better communications within a company. By sharing the 3-D database of the proposed product, more people can be working simultaneously on various aspects of the design problem. The graphics nature of the database has convinced many that 3-D modeling is a superior method of communicating many of the design intents.

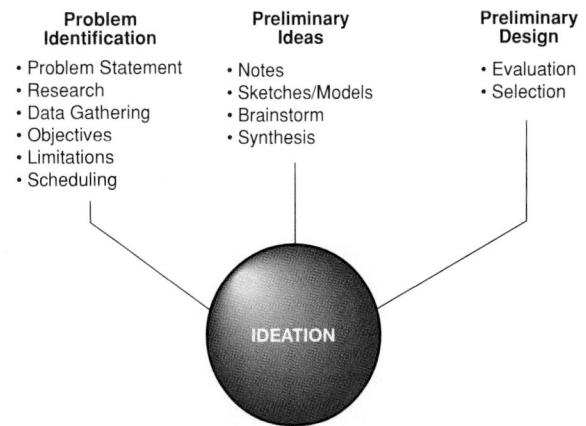

Figure 10.37 Ideation Process

The ideation process includes problem identification, preliminary ideas development, and preliminary design. Ideation is the start of the design process.

10.5 IDEATION

Ideation is a structured approach to thinking for the purpose of solving a problem. Ideation is that phase of the design process in which the basic design is conceived (conceptual phase). Feasibility studies are often performed to define the problem, identify important factors that limit the scope of the design, evaluate anticipated difficulties, and consider the consequences of the design. The ideation process consists of three important steps: problem identification, preliminary ideas, and preliminary design. Each of these areas can be further subdivided, as shown in Figure 10.37.

10.5.1 Problem Identification

Problem identification is an ideation process in which the parameters of the design project are set before an attempt is made to find a solution to the design. Problem identification includes the following elements:

Problem statement, which summarizes the problem to be solved.

Research, which gathers relevant information useful to the design team.

Data gathering, sometimes called *feasibility study*, which determines market needs, benchmarking with the competition, and rough physical measurements, such as weight and size.

Objectives, which list the things to be accomplished by the team.

Limitations, which list the factors in the design specifications.

Scheduling, which organizes activities into a sequence.

Engineering design problems must be clearly defined before the design process can begin. The problem definition requires input from customers, marketing, management, and engineering. Data to determine consumer needs is gathered through surveys, such as personal or telephone interviews, mail questionnaires, and focus groups. As an example, Motorola gathered data on the actual and projected numbers of cellular phone users. Marketing determined the average income, demographics, typical jobs, and other information on cellular phone users, as well as the opinions of the customers regarding the proposed design.

The competition is surveyed to “benchmark” a product line. A **benchmark** in this context is the study of a product similar to the one being considered for design.

In our example, cellular phones marketed by the competition were analyzed for size, weight, material, features, power, price, and many other features. The research and development (R&D) department was also consulted to determine if there were any new developments that would help in the design of a new ultralight cellular phone. For instance, the R&D department may have developed a miniaturized version of the transmission component that could be used in the new design.

Journal and trade magazines are reviewed for reports on developments in related technologies. A patent search may be done, and consultants specializing in areas where the design team is weak may be hired. This process of researching similar products and technologies and applying the results to the new design is called **synthesis**.

After all the data are gathered, the information is shared with the team before preliminary ideas are developed. (Figure 10.38) Presentation graphics are a tool used to display the data in the form of charts and graphs, and are thus an important element in the information-sharing process.

After the problem statement is created and the research and data gathering are completed, objectives are developed by the team. Objectives specifically state what is to be accomplished during the design process, and may include factors related to manufacturing, materials, marketing, and other areas. Included

Figure 10.38 Sharing the Data Gathered

Many times, preliminary data are shared with the team in the form of charts and graphs. The team then uses the data to finalize the goals of the project.

in this process are limitations or constraints on the project, such as time, material, size, weight, environmental factors, and cost.

Scheduling of the design activities is one of the last stages in problem identification. To plan and schedule simple projects, a **Gantt chart** may be used. In a Gantt chart, horizontal bars are used to represent resources or activities, and time is represented by the length of the bars. A method of scheduling large projects is the **project evaluation and review technique (PERT)**, with which activities are scheduled in such a way as to optimize progress toward completion. The **critical path method (CPM)**, used with PERT, defines those activities that must be completed in sequential order while other activities are taking place.

Figure 10.39 is an example of a simple CPM chart. The circles represent events which are the start or completion of a mental or physical task. The lines between the circles represent the actual performance of a task and indicate an increment of time. The numbers along the lines show the amount of time allotted to complete each task. The critical path is the thicker line, which may also be in a different color.

The MicroTAC Lite cellular phone was developed to distance Motorola's cellular phone from the competition. A team was assembled and project leaders assigned. The team included representatives from manufacturing, mechanical and electrical engineering, industrial design, service, assembly, marketing, finance, and the consumer sector. The team was given

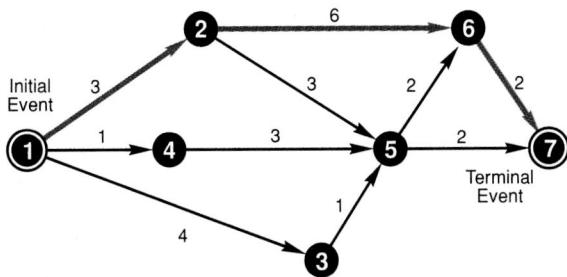

Figure 10.39 CPM Chart Created for a Simple Project

The thick line represents the critical path, for those activities that must be completed in sequential order while progressing through the project.

the assignment of creating a technological leap forward by drastically reducing the weight and size of the cellular phone. The team was to accomplish this task using concurrent engineering strategies. The problem statement was: Design and produce the world's lightest cellular phone that would weigh less than 8 ounces and fit in a shirt pocket when not in use.

A few of the objectives and limitations for the Micro-TAC Lite phone were:

- Integrate total quality management (TQM) into the process.
- Integrate design for manufacturability (DFM) into the process.
- Use outside vendors for the circuit boards and other components not normally produced by Motorola.
- Keep the retail cost of the phone below that of the competition.
- Make the weight with the battery pack at or below 8 ounces.
- Make the product palm-sized, and aesthetically pleasing.
- Include a dot matrix alphanumeric color LED display.
- Design for 45 minutes of continuous talk time from a fully charged battery.
- Include call placement features, such as automatic redial, speed dialing, and a memory program.
- Make it sturdy enough to withstand durability testing, including temperature, humidity, shock, dust, vibration, and the 4-foot drop test.
- Design for compliance with all Federal Communications Commission (FCC) rules and regulations.

10.5.2 Preliminary Ideas Statement

After the problem identification is complete, the team begins to develop preliminary ideas for solving

Figure 10.40 Brainstorming

Brainstorming by the team will result in a list of possible solutions, as well as rough sketches or computer models. During brainstorming, members of the design team will generate as many ideas as possible, without criticism or discussion of feasibility.

the problem. This stage of the process is sometimes referred to as brainstorming. **Brainstorming** is the process of identifying as many solutions to a problem as possible. This synthesizing process is used as a catalyst to generate as many ideas as possible by giving the group a starting point for the design solution. Ideas are suggested freely, without criticism or discussion of feasibility. The length of the session varies but ends when the free flow of ideas begins to slow down.

Brainstorming results in a list of ideas, along with some preliminary sketches or computer models. (Figure 10.40) The computer models would not be dimensionally accurate, but would approximate the preliminary idea. All ideas are sketched or modeled, listed, and shared with the whole team. Eventually, two to six ideas are selected for further analysis. The number of ideas chosen depends on the complexity of the design and the amount of time and resources available.

At Motorola the design team met to begin the brainstorming process. Data gathered in the problem identification stage was brought to the meetings. An agenda was set by each group leader, to keep the session on track. The various ideas were discussed, using the objectives, limitations, and problem statement as the criteria. The open exchange of ideas generated many possible solutions, which were sketched with detailed notes. The major problems in developing an 8-ounce cellular phone were discussed, and some

team members were assigned the task of determining the feasibility of miniaturizing electronic circuitry to that level.

Every group in the design team had a major role in the development of ideas. Mechanical and electrical engineers concentrated on the design of the case, electronic circuitry, and features, using input from the consumer, as well as data gathered from other sources. Industrial designers interacted with the engineers to create rough sketches and computer models of some of the initial ideas. Industrial engineers and technicians examined the feasibility of assembling some of the proposed designs. Marketing kept the group focused on the wants and needs of the consumer. Finance kept the group focused on cost factors.

The team met several times in smaller groups to discuss the feasibility of some design ideas before four or five were chosen to move on to the refinement stage. Integrated throughout the process was an emphasis on quality, which directed the design team always to keep quality concepts and practices part of its discussions.

10.5.3 Preliminary Design

After brainstorming, the ideas are evaluated, using as the criteria the problem statements, project goals, and limitations. Industrial designers may create preliminary models out of foam or other material, or may use the computer models created in the preliminary ideas phase to control machines which generate physical models.

The choice for the final design may be easy if only one design meets the criteria. However, there is frequently more than one viable design solution. When this happens, an evaluation table may be used to “score” each design idea relative to the goals of the project.

Ideation Graphics and Visualization In the ideation phase, rough sketches and conceptual computer models, called ideation drawings or models, are produced. (Figure 10.41) **Ideation drawings** communicate new ideas through the use of rough sketches and computer models. These drawings are a synthesis of the information gathered in the preliminary stages of the design process, and may combine what was visualized in the mind with what has been put on paper or in the computer. Copying drawings or modifying computer models encourages new ideas to evolve from existing concepts.

At Motorola the cellular phone ideas were checked for:

- Adherence to the specifications of size, weight, appearance, durability, and so forth.
- Manufacturability.

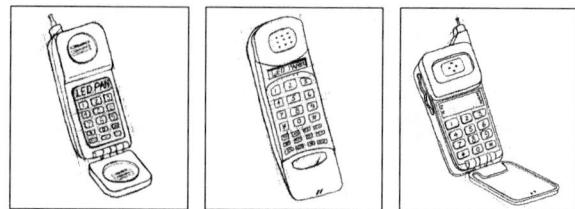

Figure 10.41 Preliminary Design Sketches of Proposed Cellular Phones, as Generated in the Brainstorming Sessions

These design sketches will be further refined, then one or a combination of two or more will be chosen as the final design.

- Quality.
- Cost.
- Limits of the available technology, such as micro-miniaturization of circuits and components.
- Environmental and safety concerns.
- Comparison against the competition and known solutions to the problem.

The team may have decided that some research was needed because of concerns generated by the preliminary ideas. The evaluation process helped the team determine which designs to continue examining.

Presentation Graphics Presentation graphics are used to present data in more easily understood form, such as charts or graphs. Preliminary engineering and cost analyses may also be graphed. Ideation requires skills in sketching, visualization, and presentation graphics. **© CAD Reference 10.11**

Sketch Modeling Early in the design process, during the idea generation phase, models must be constructed quickly so that the design ideas can be tested. Because speed is more important than accuracy at this stage, modelers designed for this purpose are called **sketch modelers**.

The initial computer models are often developed using simple primitives. (Figure 10.42) The more promising designs are refined to provide a better idea of how the final product may look. In these early stages, many designs may be developed simultaneously and then compared.

10.6 REFINEMENT

Refinement is a repetitive (iterative or cyclical) process used to test the preliminary design, make changes if

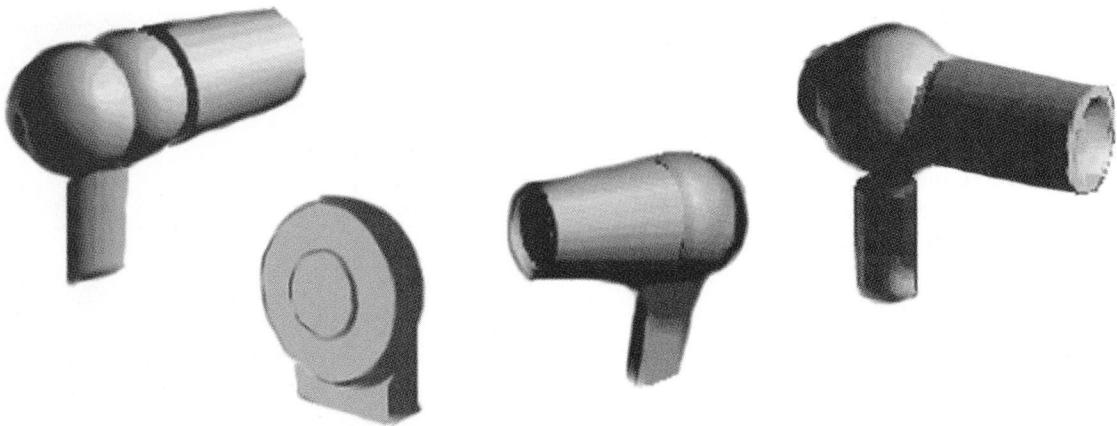

Figure 10.42 Form Refinement of a Hair Dryer

3-D modeling tools can be used for designs at all stages of development.

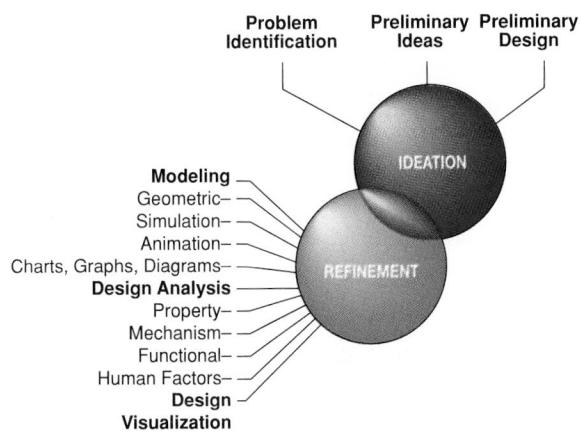

Figure 10.43 Refinement Process

The refinement process includes modeling, design analysis, and visualization. These elements are used to determine if the design meets the goals set earlier in the design process. Refinement is an iterative process, which means that changes made to the design may cause elements in the refinement stage to be repeated.

necessary, and determine if the design meets the goals of the project. (Figure 10.43) Refinement is the second major stage in the concurrent engineering design process and consists of three main areas: modeling, design analysis, and design visualization. These areas are further subdivided into activities that ultimately result in the selection of a single design solution.

The refinement stage normally begins with technicians using the rough sketches and computer models to create dimensionally accurate drawings and models. (Figure 10.44) At this point, the engineers begin

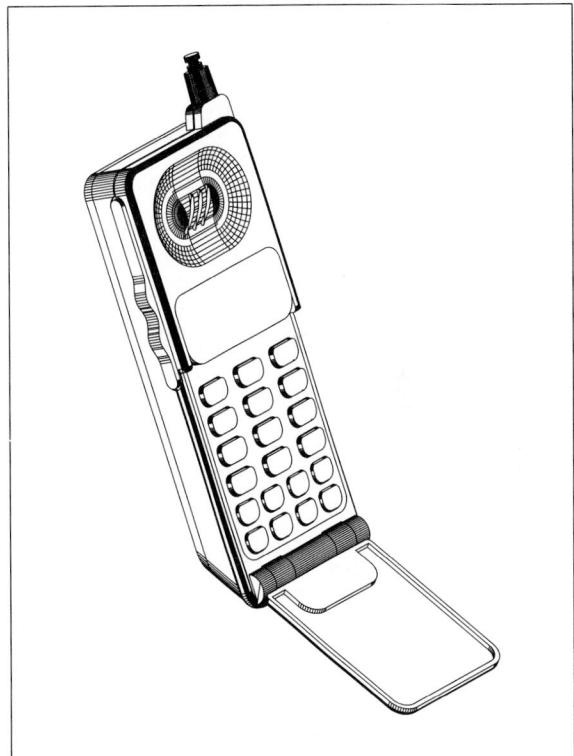

10.44 Refined 3-D Computer Model

Engineering drawings and models that are more dimensionally accurate are produced in the refinement stage.

to select the materials for the component parts, considering such factors as heat, light, noise, vibration, humidity, strength, weight, size, loads, cost, and many others. The engineers work closely with the industrial designer so that the materials selected will work well with the proposed form.

The preliminary design is tested physically, using finite element analysis, kinematic tests, animation, and spatial analysis. The design is analyzed relative to the project objectives and problem statement, and manufacturing begins to determine the processes needed to produce the product. The preliminary design is also market tested to a small group. At this stage changes may be recommended in the initial design. The final step in the refinement stage is selection of the final design for the product.

The refinement stage is heavily dependent on graphics to document, visualize, analyze, and communicate the design idea. These drawings and computer models are called refinement drawings or design drawings. **Refinement drawings** are technical drawings and models used to analyze preliminary design ideas. (See Figure 10.44)

10.6.1 Modeling

Modeling is the process of representing abstract ideas, words, and forms, through the orderly use of simplified text and images. Engineers use models for thinking, visualizing, communicating, predicting, controlling, and training. Models are classified as either descriptive or predictive.

A **descriptive model** presents abstract ideas, products, or processes in a recognizable form. An example of a descriptive model is an engineering drawing or 3-D computer model of a mechanical part. (Figure 10.45) The drawing or model serves as a means of communication but cannot be used to predict behavior or performance. A **predictive model** is one that can be used to understand and predict the behavior/performance of ideas, products, or processes. An example of a predictive model is a finite element model of a bridge support, which is used to predict mechanical behavior of the bridge under applied loads. (See Section 10.6.3, "Design Analysis," for a discussion of finite element models.)

During the refinement process, two types of models are useful: mathematical models and scale models.

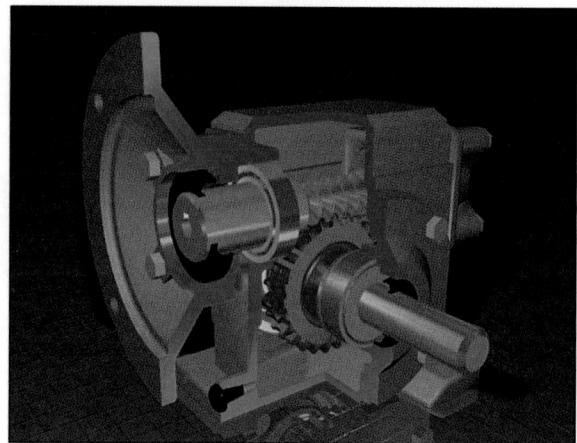

Figure 10.45 Descriptive Model

This cutaway section view of an assembly is an example of a descriptive model.

A **mathematical model** uses mathematical equations to represent system components. This technique is useful for understanding and predicting the performance of large, complex systems. Normally, a large system is broken into its simpler components before being modeled. Figure 10.46 is an example of a mathematical model used to predict the power loss of thrust bearings when velocity is increased. By reading the graph, you can predict how much loss there will be, without having to test the bearing physically at every operating speed. This results in a tremendous savings in time and cost during the refinement stage of the design process.

A **scale model** is a physical model created to represent system components. This is one of the most useful and easily understandable of all the modeling processes. The model can be full size or a replica made to scale. Before the advent of 3-D geometric modeling using computers, physical models were made by skilled craftsmen, from clay, wood, foam, or other materials. (Figure 10.47) Physical models are extremely useful for conducting spatial, aesthetic, human factors, and property analyses. For example, the cellular phone could be modeled in foam or wood and given to the human factors engineers and the consumers group on the design team to get their feedback on the interaction between the model and the human test subjects. In addition, the circuitry of the cellular

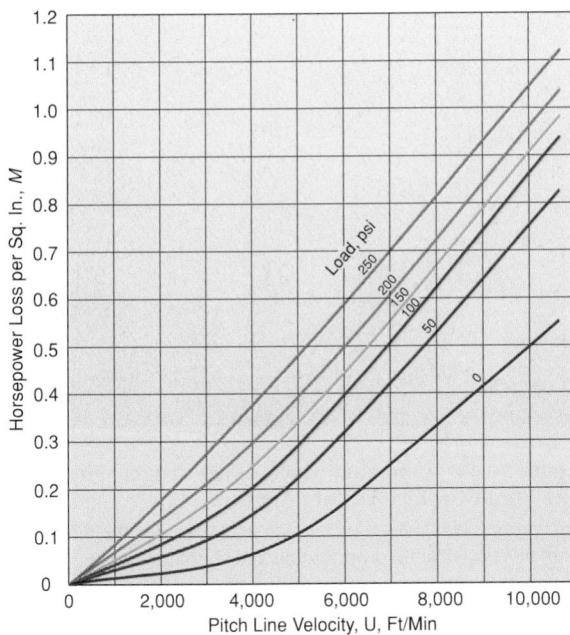

Figure 10.46 Predictive Model

A mathematical model is used to predict power loss of a thrust bearing at various speeds. (From *Machinery's Handbook*, 24th ed.)

Figure 10.47 Real Model

Real models created from clay are used for spatial, aesthetic, and property analyses. (Courtesy of 3D Systems, Inc.)

Figure 10.48 Rapid Prototyping

Real models are produced on a rapid prototyping system. (Courtesy of 3D Systems, Inc.)

phone could be created as a working model using breadboarding, which is a technique used by electrical engineers and technicians to test new circuits.

For some products, recent advances in computer modeling and rapid prototyping have reduced the need for creating physical models using traditional techniques. **Rapid prototyping** is a broad term used to describe several related processes that create real models directly from a 3-D CAD database. (Figure 10.48) This can dramatically reduce the time between modeling and manufacturing.

In some cases, it is not practical to make a prototype, due to size or cost. In other cases, the prototype would not respond the way the actual product would. For these situations, as well as others, **virtual reality (VR)** systems offer a viable analysis approach. (Figure 10.49) VR systems use the principles of perception to develop completely *immersive* environments in which the user can interact with the object through some or all of the senses. In such an environment, the user has the feeling of actually interacting with the virtual model.

VR technology requires models that correspond closely to the real object. Also, the system must be able to monitor all actions taken by the user. This includes

Figure 10.49 Virtual Reality Technology

This technology allows a more complete use of the senses to explore and evaluate design concepts. (NASA.)

changing the point of view when the user's head position changes, or depicting a virtual hand when the user is reaching out and grasping the virtual object. In addition, the user needs to receive feedback that closely mimics the environment's responses to the user's actions. The visual and auditory fields must be completely controlled by the system, and this is often done with headsets. State-of-the-art technology that would provide kinesthetic feedback is being developed. The virtual model would feel like it has weight when it is being moved around by the user.

At Motorola, the cellular phone's components were modeled on a CAD system early in the design stage. Mechanical engineers and technicians created a 3-D solid model of the phone case from the design sketches, and the industrial designers edited that computer model. (Figure 10.50) Electrical engineers and technicians computer modeled the circuitry and other components. Industrial engineers used the computer models to begin designing the assembly line, and to provide feedback to the design team on the phone's manufacturability (DFM). The geometric database was shared by all members of the team in analyzing the final design.

Figure 10.50 Computer Model of the Cellular Phone with Plastic Surface Texture Applied

This model adds a level of realism necessary for the design team to visualize the proposed design so that it can be evaluated before going into production.

10.6.2 Computer Simulation and Animation

Computer simulation is the *precise* modeling of complex situations that involve a time element. The 3-D computer model can be used instead of a physical model for property analyses. Material properties can be assigned to a computer model so that it behaves and looks like the real product. For example, instead of a scale model of a new aircraft being made and tested in a wind tunnel, a computer model can be used to simulate the aircraft in the wind tunnel test. (Figure 10.51)

Computer animation is the *imprecise* modeling of complex situations that involve a time element. The major difference between simulation and animation is the degree of precision. An animation only approximately replicates a real situation; a simulation accurately replicates a real situation. For example, to determine the aerodynamic characteristics of an airplane using computer simulation, the aircraft and the fluid properties of air must be precisely represented or inaccurate information will be obtained. On the other hand, if all that is needed is a visual representation of the aircraft in flight, then the computer model need not be precise and an animation of the vehicle is sufficient. © CAD Reference 10.12

Figure 10.51 Computer Model Simulating an Aircraft in a Wind Tunnel

The computer model supplements or replaces the need for physical models in engineering analysis.

At Motorola, the assembly line used to produce the cellular phone could be either simulated or animated using computer models. The simulation would dynamically show the phone being assembled and would assist the industrial engineers and technicians in determining where bottlenecks or trouble spots might occur during assembly. The information thus obtained would be used to further refine the design to make it more easily manufacturable, following DFM principles.

10.6.3 Design Analysis

Design analysis is the evaluation of a proposed design, based on the criteria established in the ideation phase. It is the second major area within the refinement process, and the whole design team is involved. Typical analyses performed on designs include:

Property analysis, which evaluates a design based on its physical properties, such as strength, size, volume, center of gravity, weight, and center of rotation, as well as on its thermal, fluid, and mechanical properties.

Mechanism analysis, which determines the motions and loads associated with mechanical systems made of rigid bodies connected by joints.

Functional analysis, which determines if the design does what it is intended to do; in other words, if the design performs the tasks and meets the requirements specified in the ideation phase.

Human factors analysis, which evaluates a design to determine if the product serves the physical, emotional, quality, mental, and safety needs of the consumer.

Aesthetic analysis, which evaluates a design based on its aesthetic qualities.

Market analysis, which determines if the design meets the needs of the consumer, based on the results of surveys or focus groups.

Financial analysis, which determines if the price of the proposed design will be in the projected price range set during the ideation phase.

Property Analysis **Property analysis** is normally associated with the engineering profession and includes finite element modeling. Property analysis determines if the product is safe and can stand up to the rigors of everyday use. Models are tested under extraordinary conditions, and the information gained can determine if changes must be made to the design. For example, a component might fail under extreme operating conditions. The design team would then recommend changes in the component itself, or in related parts of the product, to correct the deficiency, and the model would then be reanalyzed. This **iterative process** is a major part of the design analysis phase.

Finite element modeling (FEM) is an analytical tool used in solid mechanics to determine the static and dynamic responses of components under various conditions, such as different temperatures. (Figure 10.52) The fluid mechanics of designs can also be determined using FEM. The interaction of a part with a fluid flow, such as water or air, is simulated through the use of color bands. (Figure 10.53) For example, Figure 10.54 shows how a jet engine turbine blade reacts to various loads. The stresses are shown using a color scale, with the highest stress represented in red.

The FEM process uses the 3-D computer model as input. Through a process called **discretization** or meshing (Figure 10.55), the continuous 3-D solid model is changed into a model comprised of multiple polygonal shapes, such as rectangles and triangles, which are called “elements.” Each corner of each element is

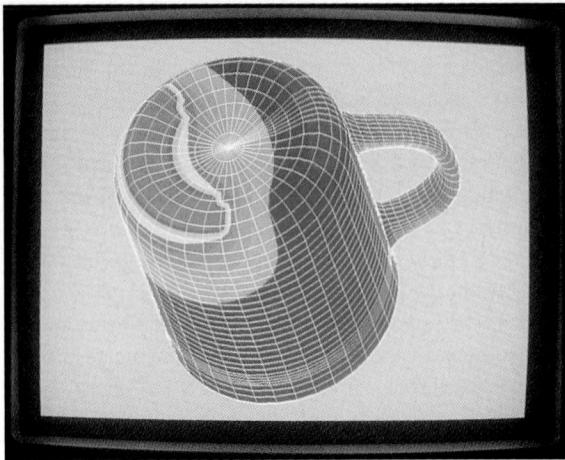

Figure 10.52 Thermal Analysis

The effect of a hot liquid in a cup is determined using finite element analysis. The use of color assists the user in visually determining the areas of high temperature. Blue is the coolest and red is the hottest area on this cup. (Photo courtesy of Algor, Inc.)

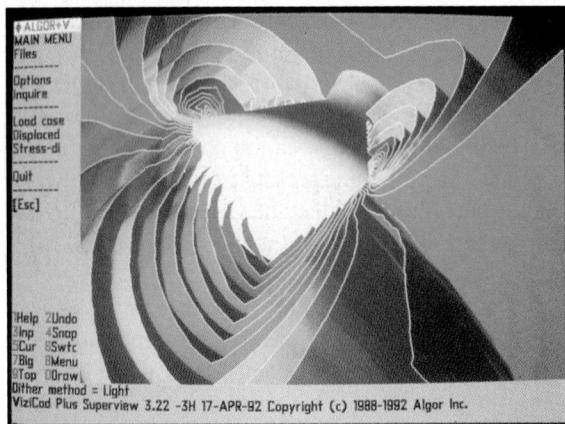

Figure 10.53 Fluid Analysis

The fluid flow around a part is represented with color bands. (Photo courtesy of Algor, Inc.)

called a “node.” After discretization, the **boundary condition** is defined. This condition describes how an object is tied down. For example, an object bolted down to a surface is called fully constrained; in contrast, an object allowed to spin on a shaft is partially constrained. Once the boundary condition is defined, properties, such as material, temperature, and forces, are assigned to the model.

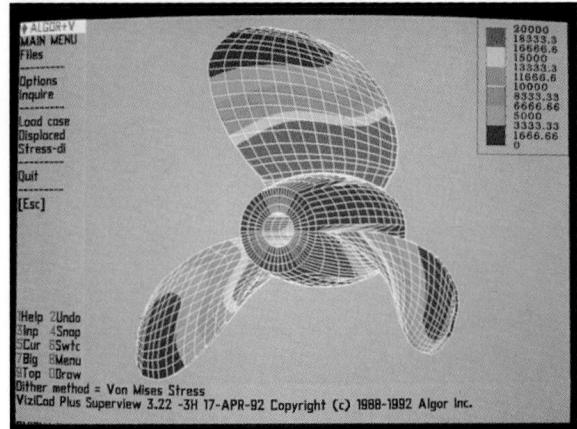

Figure 10.54 Stress Analysis

A stress analysis of jet engine turbine blades is determined using FEM. Areas of high stress are represented in red and low stress in blue. (Photo courtesy of Algor, Inc.)

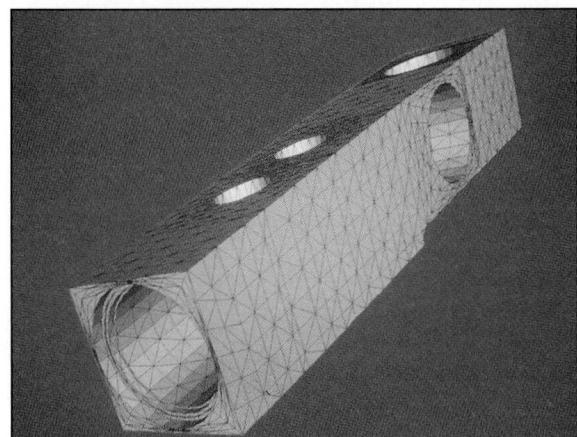

Figure 10.55 Discretization

Before a finite element analysis can be performed, the solid CAD model must be broken into smaller, discrete parts, using a process called discretization. Lines are added to the model after discretization, to represent the boundaries of each discrete part of the model. (Photo courtesy of Algor, Inc.)

The model is then evaluated under varying conditions. For example, stress forces are applied fully to a constrained model and the results are shown on screen in multiple colors. (Figure 10.56) The colors represent various levels of stress. The model might also deform to illustrate the effect of the forces being applied. The model could even be animated to show the deformation taking place and to show the incremental increases

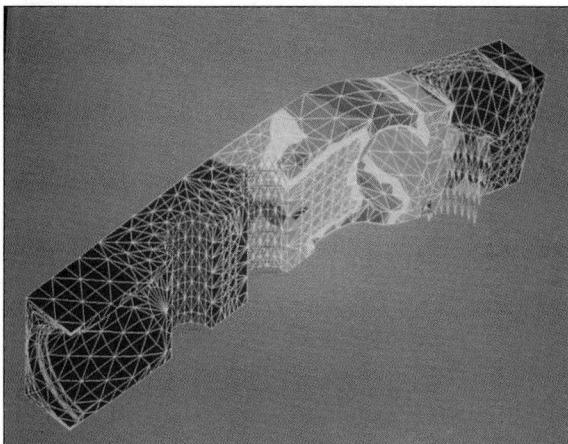

Figure 10.56 Boundary Conditions Applied

After the finite element model is created, the boundary conditions, such as temperature or load, are defined. The model is then analyzed by the computer. The results are shown using color, or by deforming the model if a load is applied. (Photo courtesy of Algor, Inc.)

in the levels of stress. This process allows the designer to determine if the model will perform safely under extreme operating conditions.

The results of the property analysis are used to recommend changes in the design. This analysis is a critical step in the refinement process. © CAD Reference 10.13

Mechanism Analysis **Mechanism analysis** is concerned with the calculation of motions and loads in mechanical systems comprised of rigid bodies connected by joints. A clamping device is an example of such a system. Mechanism analysis includes assembly, kinematic, and dynamic analyses.

Assembly analysis is used to define the individual rigid bodies of the mechanism and to assemble them correctly, considering both geometry and velocities. (Figure 10.57) When the computer model is used to make the assembly and assign the velocities, the computer uses the engineers' input to determine complex geometric and trigonometric relationships.

Kinematic analysis determines the motion of assemblies without regard to the loads. For example, kinematic analysis is used to find the position of any point on the mechanism at any time during movement of the assembly, to determine clearances and range of motion. Computer modeling can be used to trace motion paths in 3-D models. (Figure 10.58)

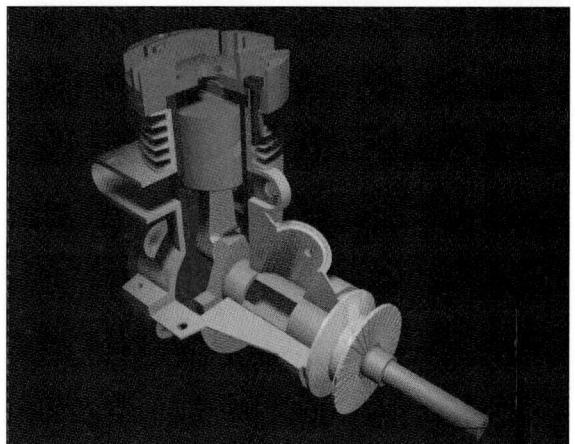

Figure 10.57 Assembly Analysis

Assembly analysis is performed on an engine to determine proper clearances between mating parts. (Courtesy of Autodesk, Inc.)

Figure 10.58 Kinematic Analysis

The kinematic analysis of a mechanism is used to evaluate the range of motion during operation.

Dynamic analysis determines the loads that drive or create the motion of a mechanism. This type of analysis can be in the form of a computer simulation, as described in the preceding section. (Figure 10.59) © CAD Reference 10.14

Functional Analysis **Functional analysis** is a judgment process in which factors, such as cost, appearance, profitability, marketability, safety, and others, are used to determine the worth of a design. Some factors are based on empirical evidence, such as product testing to see if it performs or functions as it was intended. For example, the design of a new computer

Figure 10.59 Dynamic Analysis

This dynamic analysis of a clamp evaluates the forces involved with the movement of the mechanism.

printer could be tested to determine consistent print quality, frequency of failure, or cost relative to the intended market. In this example, the new printer would not be functional if it failed too often, cost too much, or produced poor print quality. The whole project might have to be modified by returning to the ideation phase.

Human Factors Analysis **Human factors analysis** determines how a design interacts with the dimensions, range of motion, senses, and mental capabilities of the population that will use the product. For example, the human dimensions of the hand and the distance from the ear to the mouth are important attributes which must be taken into account in the design of a cellular phone and its dialing keypad. Human dimensions can be found in *The Measure of Man*, by Henry Dreyfuss. There is also computer software that can be used to define a human model, using such criteria as age, gender, build, race, and other factors. The human model thus created is then merged with the computer model of the product, and static and dynamic simulations are conducted. (Figure 10.60)

The design of a product must also match human capabilities, as well as human dimensions. For example, can the controls of the cellular phone keypad be seen in a dimly lit room? Are they confusing to the novice user?

Quite often, the results of this human factors analysis are used to guide the development of graphics and text in the technical and users manuals.

Figure 10.60 Using a Computer Model of a Human to Evaluate a Workstation Design

Both reach and cone of vision of an operator can be modeled to evaluate a workstation design.

Aesthetic Analysis **Aesthetic analysis** is a process that evaluates a design based on aesthetic qualities. The look and feel of the product are analyzed by industrial designers, marketing personnel, environmental and human factors engineers, and the customer. This is the design process stage that is difficult to measure and quantify. However, it is important because this is where products are given the human touch that is so necessary in the design of most products and structures. Aesthetics are more important in some industries than in others. For example, the design of Motorola's MicroTAC Lite cellular phone used aesthetic analysis to create a "good" look and feel. (Figure 10.61) Also, in the design of automobile bodies, extensive aesthetic analyses are done to create a body style that is both pleasing and desirable. Aesthetic qualities are hard to quantify, yet they often make the difference in the product's success or failure in the marketplace. © CAD Reference 10.15

Market and Financial Analyses A market analysis is performed before a product is sold or even produced. This **market analysis** determines the needs and wants of the customer so that the product produced is the product wanted by the consumer. A market analysis determines the demographic characteristics such as age, gender, education, salary, geographic location, and so forth, of a typical consumer.

Financial analysis determines the capital available for a project, as well as the projected expenses to design, manufacture, assemble, market, and service a product. Financial analysis also determines the **return**

Figure 10.61 Aesthetic Analysis

In the design of the MicroTAC Lite, aesthetic analyses are done to create a good look and feel. (Courtesy of Motorola.)

on investment (ROI) that can be anticipated for a new product. The ROI is the ratio of annual profit to investment expected from a product.

10.7 DESIGN VISUALIZATION

Design visualization is a process used throughout the refinement stage to improve the communication, analysis, and understanding of a product or structure. The fundamental capability of the human visual system to perceive 3-D form, color, and pattern is exploited to convey information about a product. Design visualization is an analysis method that has recently been added to the engineer's toolbox, due to advancements in computer graphics. Visualization techniques are used by everyone on the design team to refine the preliminary design. Engineering uses visualization techniques to determine interferences between parts;

Figure 10.62 Visualization of an Aircraft Carrier Control Room

You enter the primary flight control compartment, which shows the position of the flight controller or airboss. (Courtesy of Newport News Shipbuilding.)

FEM uses colors, deformation, and animation to show the results of forces; marketing uses rendered images to get customer feedback; and production uses animation to analyze production procedures.

There are many visualization techniques available to the design team. Surface shading of computer models is used to depict what the design will look like after production. Technical illustrations are produced using traditional hand drawings or computers. System parts are shown in motion using computer animation to determine interferences. Structures are analyzed using the technique of walkthroughs, to evaluate aesthetic and functional design parameters. Figure 10.62 is an example of how a computer-generated walkthrough is used as a visualization tool.

Graphics is an extremely important part of the refinement stage. Sketches are made to communicate design changes. Design drawings and models are created and updated throughout the refinement process. **Graphical analysis** is a process used in engineering analysis to display empirical data in the form of graphics. For example, computer models that are generated using empirical data can be analyzed and the results can be displayed graphically, using color to differentiate important information. Graphical analysis is used to check clearances, operating limits of moving parts, and many other physical properties. Technical data, market surveys, and other information can also be displayed in graphs to aid in visually analyzing the information.

For the cellular phone, the refinement stage began with the computer modeling of the final design. Dimensions were not critical at this stage, but were getting closer to being final. Technicians created a solid model using the design sketches and preliminary models from the ideation phase.

Electrical, manufacturing, and mechanical engineers worked closely together in the design of the circuitry and outside case. The size of the circuitry necessary to create an 8-ounce phone that would fit in the palm of the hand determined the basic size and shape of the outside case. The manufacturing engineers provided input regarding the consequences of using a particular shape and material for the assembly of the phone. The industrial designer began to finalize the aesthetic design of the outside case, given the parameters from the engineers.

This team worked together to produce a refined computer model, which was then shared with the rest of the design team members to gather their input and recommendations. The results of the aesthetic analysis were shared by the whole group, including the consumers, who found that the product did not look appealing: the lines were not thin and the earpiece looked awkward.

The case and circuitry were further refined, then reanalyzed by the engineers. The electrical engineer developed the circuitry to fit in the case, and tested it for power, sound quality, and so forth. The circuitry was first breadboarded, then tested to determine if it worked within the parameters set forth in the design. The mechanical engineer analyzed the strength of the case with respect to dropping, hinge use and misuse, and environmental factors. Much of this testing was accomplished with the computer model.

The stress placed on the case, circuit board, and fasteners from a 4-foot fall was determined using FEM. The 3-D computer model of the design was meshed, then a load was applied to represent the force of impacting the ground after falling 4 feet. The stresses were displayed in varying colors. Areas of the phone that could fail were seen on the model and design changes were made.

Drawings and models were changed as necessary during the analysis stage. The drawings and models were then further refined. Standard parts were used whenever possible, to save cost and time. For example, the fasteners used to hold the circuit board to the case, as well as many of the resistors, are standard parts in the cellular phone.

A mechanism analysis was conducted to determine the clearances of the circuit board/components/case assembly. A kinematic analysis was used to determine the ranges of motion for the mouthpiece, from its closed to open positions, and the telescoping antenna.

The manufacturing engineers and related technicians began to design and lay out the factory floor. Sketches and computer models of the assembly line were created.

A 3-D Computer Model Used to Determine the Clearance between the Case and the Circuitry of the Phone

Marketing began to gather information about the product. As the design was further refined, the assembly line computer model was used to begin testing the assembly process. This provided valuable input into DFM strategies. Assembly problems were corrected earlier in the refinement stage. The engineering team viewed the product model as it was being assembled and made changes to the final design to improve the DFM of the cellular phone.

10.7.1 Data Visualization Elements

The analysis data must be evaluated to determine the most appropriate graphical presentation format. Depending on the type of analysis performed, there may be considerable differences in the amounts and types of data available before and after the analysis. Common graphical techniques for representing different types of data are discussed in the following sections.

Data Types The data analyzed by engineers and technicians are divided into two basic categories: qualitative and quantitative. (Figure 10.63) **Qualitative data** are symbolic, have no inherent magnitude, and are used for labeling and identifying. Qualitative data with no inherent order (for example, New York, Boston, Houston) are considered **nominal**; qualitative data with an inherent order, such as the months of the year, are called **ordinal**.

The bulk of the data evaluated is **quantitative**, which has an inherent magnitude. Quantitative data are further classified by the number of components and the scales of values. **Scalar** quantitative data have only one component and can only express a magnitude. (Figure

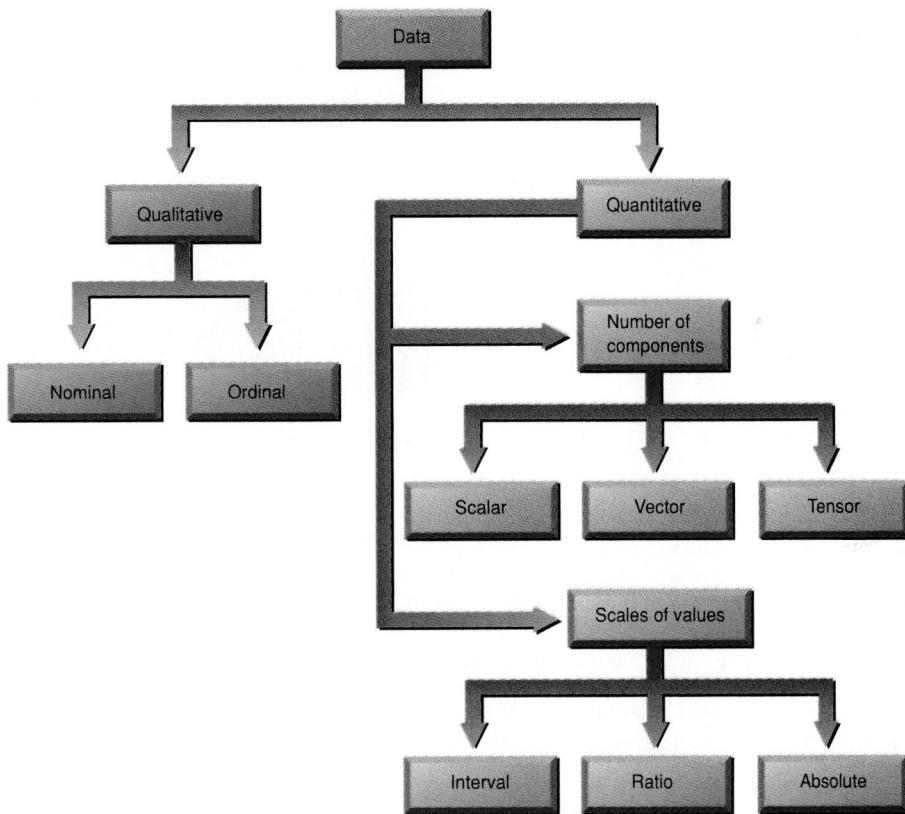

Figure 10.63 Organization of Data Types

Selecting an appropriate method of analyzing data requires a knowledge of the data's characteristics.

10.64A) **Vector** data can express both magnitude and direction. (Figure 10.64B) The number of scalar components in the vector depends on the number of dimensions (i.e., dimensionality) of the coordinate system being used. Though in principle any number of dimensions is possible, 2-D and 3-D coordinate systems are the most common and are the ones used in this text.

Marks **Marks** are the fundamental graphic elements used to encode data in a visualization. Marks can be thought of as graphic primitives and are typically classified as either simple or compound. *Simple marks* include points, lines, areas, and volumes, all of which interrelate closely with the dimension of the data type. Points indicate a location in 2-D or 3-D space; lines indicate length and/or connection; areas indicate a region in 2-D space; and volumes do the same in 3-D space.

Complex marks are collections of simple marks, perceptually forming a unit. (Figure 10.65) This loose

definition covers several possibilities, including arrows, meshes, contour lines, and glyphs. A **glyph** is a compound mark that cannot be defined by other commonly recognized names. Glyphs are usually custom designed to encode multiple data elements into a single mark. The guiding objective for designing glyphs, or any other mark, is to tap into the innate perceptual abilities of the viewers. This is accomplished through careful design.

Data are encoded into an image by varying the qualities of the marks. The qualities manipulated are rooted in human perception. Manipulating such qualities as location, orientation, size, color, and shape, reveals differences in data values. Equally important to data visualization are similarities that group marks together. In Figure 10.66, similar colors and symbols result in data grouped together, while changes of location differentiate between individual data points within each group.

An element that does not fit easily into any of the mark categories is *text*. Text should be used to support

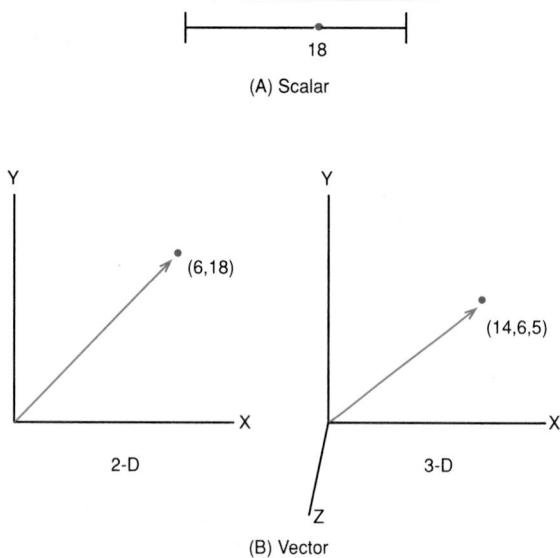

Figure 10.64 Scalar and Vector Data Types

graphic elements, not as a replacement for them. Text is typically used to label individual qualitative data points, scales, or units of measure. Text is also used for supplementary information. Often a small amount of text can simplify a visualization considerably. However, text should be integrated into the visualization as much as possible, rather than being set apart in a separate legend.

Encoding Data Variables Usually, an analysis is designed to examine data relationships. The functional relationships between variables are described as either independent or dependent. For example, in the earlier discussion of probes applied to a model to create a response, the probes, which are controlled by the experimenter, are *independent* of the model; therefore, they are an **independent variable**. However, the response data are *dependent* on the model's reactions to the probe, so the data are **dependent variables**.

Suppose that heat is the probe, the model is for a reactor vessel, and the response being analyzed is the pressure inside the vessel. (Figure 10.67A) The heat is an independent variable because it is controlled by the researcher. As the heat is varied, the pressure inside the vessel is monitored. The researcher knows ahead of time what temperatures to use, but doesn't know what the resulting pressure will be at the different temperatures. The pressure is dependent on the appli-

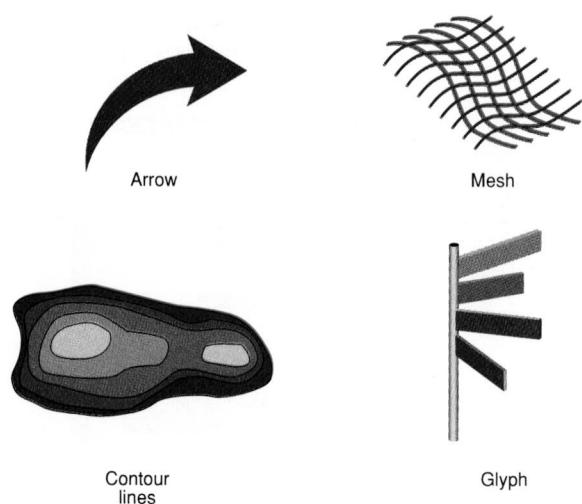

Figure 10.65 Examples of Complex Marker Types

Complex marks are a synthesis of simple marker types and appropriate use of perceptual cues such as color and size.

Figure 10.66 Using Perceptual Cues to Encode Data

Effective visualizations exploit our natural ability to discriminate between visual elements such as color, size, shape, and orientation.

cation of the laws of physics to this particular vessel design, and the object of the experiment is to explore this relationship.

The resulting data are encoded, via marks, into a visualization. For every heat value, a corresponding pressure value is recorded. A simple line graph is used to display the data, with the independent variable (temperature) mapped on the horizontal scale and the dependent variable (pressure) shown on the vertical scale. (Figure 10.67B)

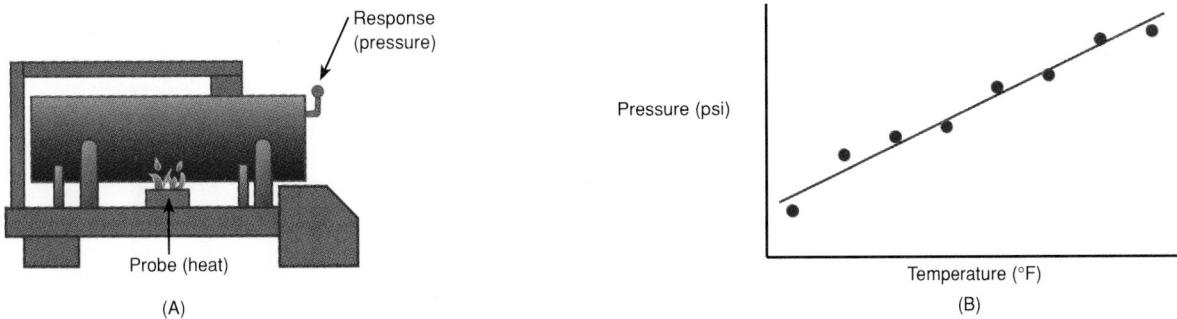

Figure 10.67 Independent and Dependent Variables

The first task in designing a visualization is identifying the types of variables to be displayed in the visualization.

10.7.2 Visualizations for One Independent Variable

The most common type of visualization is the 2-D graph or plot (Figure 10.68), which is defined by two primary axes (scales). The area within the vertical and horizontal **scale lines** is the region where the data are presented. Text is used to indicate the range and units on the scales. The data are shown with marks in the **data region**, where **reference lines** are used to relate scale values to data marks. Text is used to label marks either directly or indirectly through the use of a key or **legend**. The legend should be isolated from the graph and enclosed by a border. The legend will indicate the variables associated with the point marks or line types on a visualization.

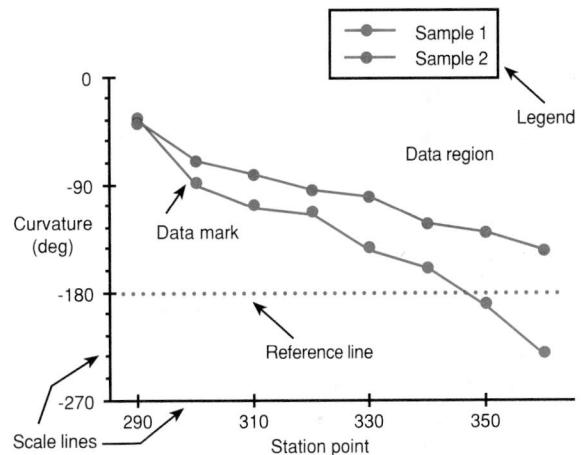

Figure 10.68 Elements of a 2-D Graph

Line Graphs Variations in experimental data mean that points represented on the graph may show a trend, yet may not align perfectly with a straight line. The point marks can still be connected together to form a **line graph**. The line mark would connect the points by following a progression of independent values, rather than vice-versa. (Figure 10.69) Using a technique called *regression*, a “best-fit” line, representing the *trend* of the data, is drawn on the graph. (Figure 10.70) This **regression line** could be linear, or a second- or third-order curve. Higher order curves are not common, since they are unlikely to represent well understood phenomena.

Line graphs allow the viewer to perceive *orientation* and *direction*. Absolute values of individual data points are secondary to the trend revealed by the line. The direction of the line reveals information about the relationship between the dependent and independent

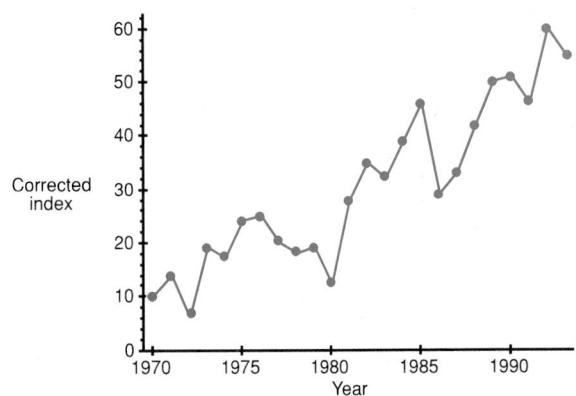

Figure 10.69 Connected Line Graph

Connected line graphs encode scalar data with line marks. The graph depicts the trend in the data relationship between the independent and dependent variables.

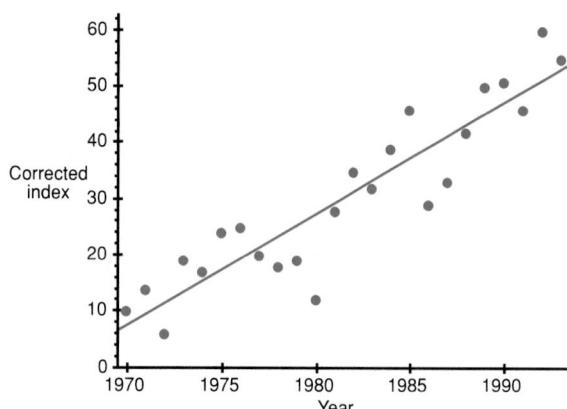

Figure 10.70 Regression Line Graph

Regression line graphs depict statistical or estimated trends in the data relationship, rather than connecting the individual data points.

variables. For example, in Figure 10.70, the line angling down indicates that as distance increases, intensity level goes down. This depicts a negative relationship between the two variables.

Bar Graphs Another common type of 2-D graph is the **bar graph**. (Figure 10.71) A bar graph uses either line or area marks to allow a closer focus on individual data values. However, in a bar graph, the line mark is used to show *length*, rather than orientation. Though area marks are commonly used in bar graphs, one dimension of the bar is held constant, reducing the variability in the mark to the length of the other dimension. Bar graphs are most often used when there are only a few independent variable values, and they are usually qualitative. Also, unlike line graphs, bar graphs sometimes show the independent variable on the vertical axis. (Figure 10.72)

Data with a well-defined zero point are best shown by having one end of all of the bars aligned on a common baseline, thus making it easier to compare their absolute values, or to estimate ratios. When the data are depicting an interval or range along a scale, with no natural zero point, the bars can float. (Figure 10.73) Though more difficult for making comparisons of length, **range bars** are a useful tool for depicting the location of an interval. Mentally or physically drawing a reference line through the range bars at a specific dependent value permits comparisons of the

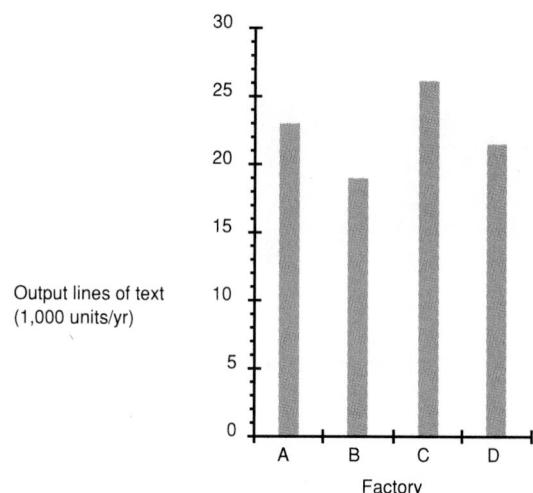

Figure 10.71 Bar Graph

Bar graphs are often used when the independent variable is qualitative rather than quantitative. The bar mark represents the distance from some common origin value to the dependent variable.

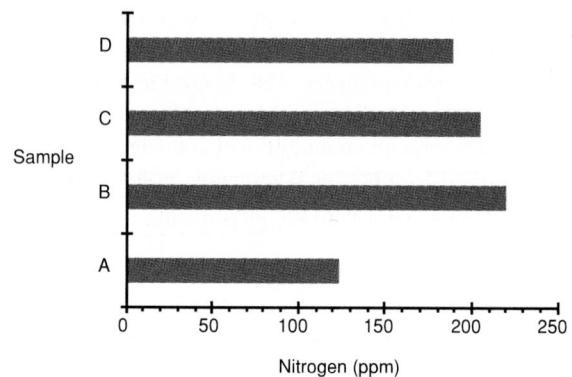

Figure 10.72 Horizontal Bar Graph

Horizontal bar graphs are sometimes used as an alternative to standard bar graphs. Here, the independent and dependent variable axes are switched.

locations of various range bars. For example, using time as the dependent variable, the points at which various independent values turn “on” or “off” can be identified and compared.

A number of techniques are used with bar graphs to group similar data together. If the independent variable has logical subgroups, spacing can be used to depict these groups. In Figure 10.74, separate data points represent each of three years within each category. Three

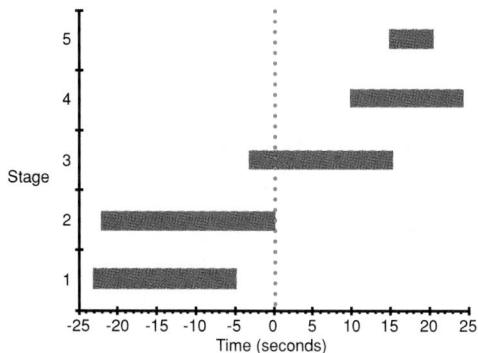

Figure 10.73 Range Bar Graph

Range bar graphs do not have bars that are anchored at a common origin. These bar markers are used to encode interval (or range) data.

grouped bars, each depicting one year, are used with a space between categories. Assuming the categories and subcategories of the independent variable are kept to a minimum, comparisons can be made both between years in a single category and between categories in a single year.

Sometimes, data values are a *composite* of a common group of subvalues. For example, in Figure 10.75, the overall weights of a series of models are divided into metal, plastic, and liquid components. Within a single prototype, comparisons are made of the relative weights of steel, plastic, and aluminum. In addition, comparisons of each of these subcategories are made between models. With this approach, the composite values (i.e., overall weights) of each group are easy to discern, but the lack of a common baseline for the subcategories makes absolute-value judgments difficult.

With both grouped and composite bars, the use of color or pattern coding to distinguish between the subcategories is recommended.

10.7.3 Visualizations for Two Independent Variables

It is common to have two independent variables that must be examined. The same techniques used to display one independent variable can be used to display two, if various encoding marks are employed. Another option is to increase the number of geometric dimensions used to display the data. In both cases, perceptual abilities, such as color discrimination or depth perception, are important for visualizing the second independent variable.

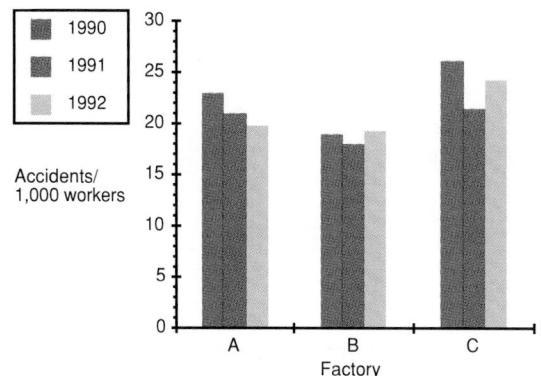

Figure 10.74 Group Bar Graphs

Group bar graphs can be used to depict subcategories of a data variable.

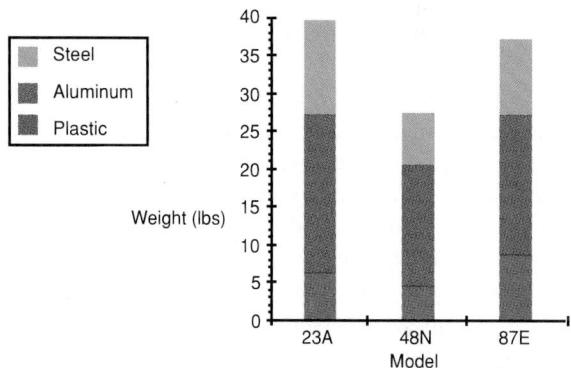

Figure 10.75 Composite Bar Graphs

Composite bar graphs allow both individual subcategory values and an overall value to be represented by the length of a bar mark.

Multiple Line Graphs If the second independent variable has only a few discrete values, a **multiple line graph** can be used. The horizontal and vertical scales of the graph are used the same way as for only one independent variable. Each value of the second independent variable is represented as a separate line on the graph and each line must be coded, typically with either a *color* or a *shape* and a legend to indicate the code-to-value mapping. (Figure 10.76A) If there is sufficient room, text labels pointing to the individual lines can be used instead of the legend. The use of color versus shapes to code the second variable depends on how the graph is going to be

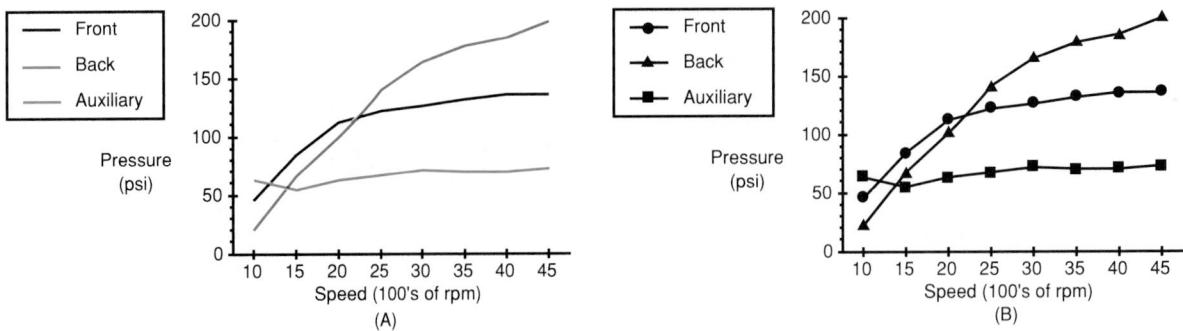

Figure 10.76 Multiple Line Graphs, with Color and Shape Coding

Multiple line graphs allow more than one independent variable level on a single graph. Each line mark represents a different level (value) of the independent variable.

displayed. Color reduces clutter and is less affected by being reduced or displayed at lower resolution. However, if the graph is to be photocopied in black and white, shape or line style coding is preferable. (Figure 10.76B)

3-D Graphs and Plots Two independent and one dependent variable can be combined in a 3-D graph or plot. Two of the dimensional axes represent the independent variables, and the third axis (usually Z) represents the dependent variable. (Figure 10.77) For every X,Y value representing an independent variable, a Z value maps a dependent variable.

Connecting point marks in a 2-D graph results in a line graph. With a 3-D plot, connecting the points results in a **surface plot**, which can be depicted in a number of ways. The simplest depiction is a mesh covering the surface. (Figure 10.77A) Removing hidden lines helps in perceiving the 3-D form, but may hide data points that are occluded. (Figure 10.77B) Alternatively, the surface can be shaded. For example, the plot could simulate a light source falling on the object. (Figure 10.77C) The shading value gradient over the surface would assist in perceiving the 3-D form, but may cause confusion; shading values could be mistaken for the coding of a data variable. A fourth approach is to shade the surface by varying the color according to the dependent variable value. (Figure 10.77D)

A 2-D option for a 3-D surface plot is a **contour plot**. A surface plot is sliced with a plane. (Figure 10.78A) This XY plane represents a constant dependent variable value over all possible independent variable combinations. Next, a line is traced at the intersection between the plane and the surface. This **contour line**, or **isoline**, (i.e., a line of constant value) represents the independent variable combinations that result in the dependent variable value. (Figure 10.78B)

Typically, multiple contour lines are drawn on a contour plot to represent a uniform sampling of dependent variable values. (Figure 10.78C) The horizontal and vertical scales represent independent variable values, and the contour lines show the mapping of constant dependent variable values. If the surface is thought of as a piece of terrain, the lines are like elevation contours on a terrain map.

Rarely will collected data points fall exactly on one of the contour lines, since the surface itself is the product of *interpolating* between the data points. The contour line represents an intersection with this interpolated surface, not actual collected data points. The denser and more regular the sampled data, the better will be the interpolation. Both contour and surface plots are most successful when data are sampled at regular intervals of both independent variables.

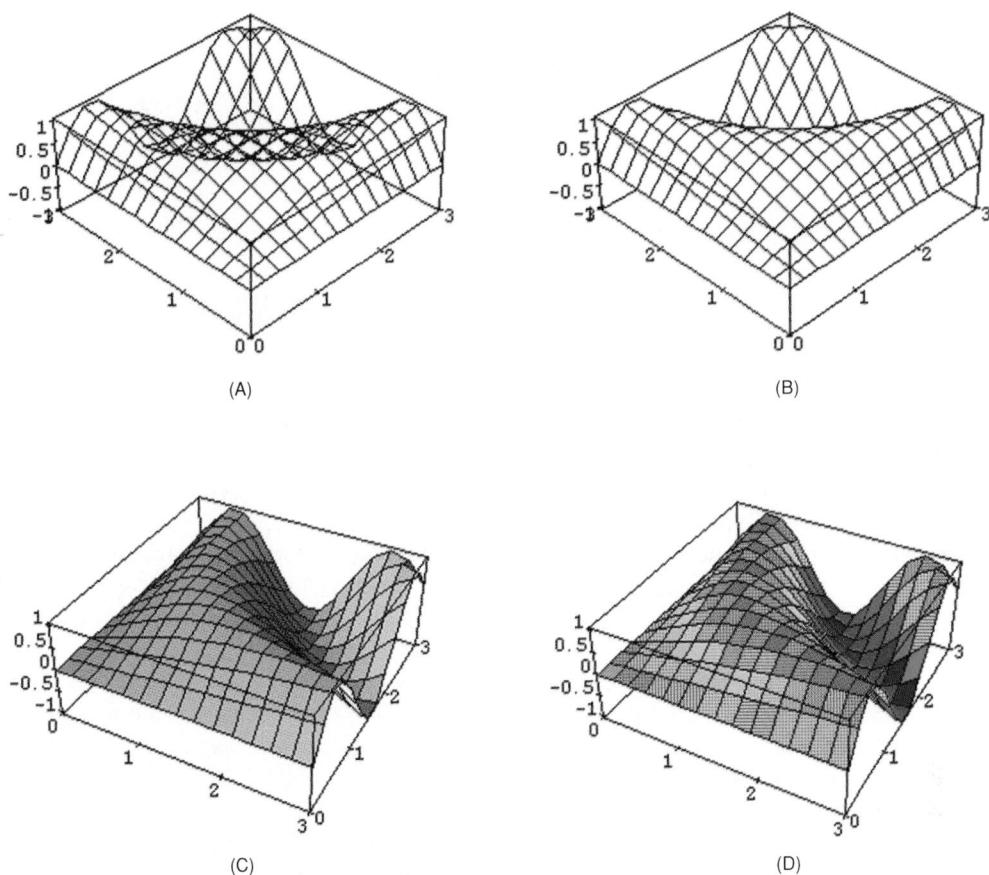

Figure 10.77 Examples of Surface Plots

Surface plots use a variety of visualization techniques to connect data points in 3-D space with a surface mesh. (Mathematica, Wolfram Research, Inc.)

10.8 IMPLEMENTATION

Implementation is the third and final phase in concurrent engineering design and is the process used to change the final design from an idea into a product, process, or structure. At this point the design is finalized and any changes become very expensive. The implementation process includes nearly every phase of the business, such as planning, production, financing,

marketing, service, and documentation. (Figure 10.79) The goal of this phase is to make the design solution a reality for the enterprise and the consumer.

10.8.1 Planning

The **planning** process determines the most effective method of moving a product through the production cycle. Manufacturing engineers and technologists are

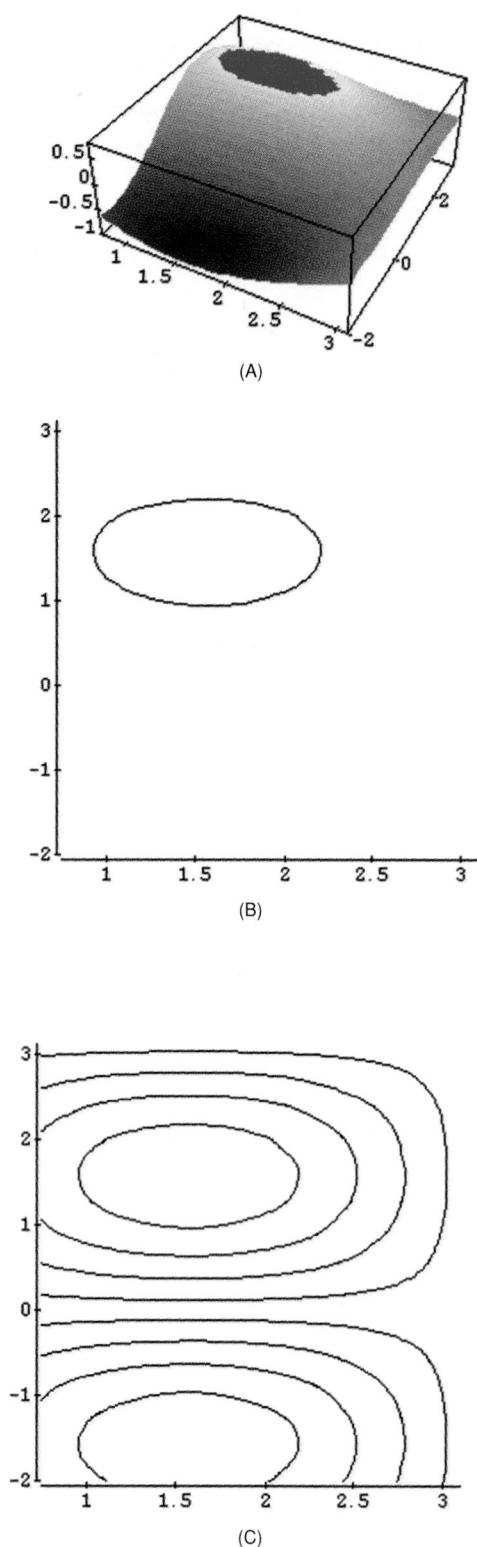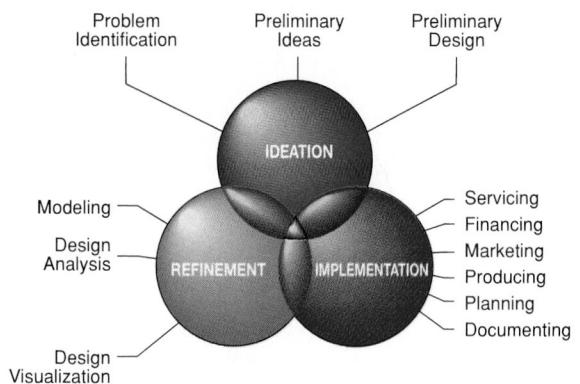

Figure 10.79 Implementation Process

In this phase of the design process, the final design moves from idea to final product.

the leaders in the planning process, as they schedule the machines and jobs necessary to create the product. Planning requires process sheets, data and material flow diagrams, project modeling and work organization charts, bills of material, and other documents. (Figure 10.80) Modern planning techniques include computer-aided process planning (CAPP), material requirement planning (MRP), and just-in-time (JIT) scheduling.

CAPP uses the computer model of the design to determine which machines and processes should be used. *MRP* calculates the raw materials needed to produce the product, and uses solid models to assist in these calculations. For example, the solid model of a part can be analyzed to determine the volumes of various parts, and the results can then be used to calculate the amounts of different materials needed to make the parts.

Just-in-time (JIT) is an operational philosophy that tries to reduce cycle time while eliminating waste. Anything related to the manufacture of a product that does not add value to the product is considered waste. For example, inventory sitting idle in a warehouse for a long period of time does not add value to a product. A JIT system prevents waste by taking deliveries on orders only as they are needed.

Figure 10.78 Contour Plot

Contour plots are a method of visualizing data with two independent variable values in a 2-D plot. Each contour line (isoline) represents combinations of the two independent variables which give rise to a certain dependent variable value. (Mathematica, Wolfram Research, Inc.)

Industry Application

Using AutoCAD Solid Modeling for New Product Development

In a competitive world, rapid product development is a necessary ingredient for success. As a result, most projects are driven by time-to-market concerns. This is especially true in the case of a design firm such as GVO in Palo Alto, California, which specializes in creating product designs. GVO takes ideas from clients and works with them to make a product functional for the target market. Firms like GVO add value to a client's core technology by adding artistic flair to the design and incorporating the user's needs with appropriate material selection and economical manufacturing processes. GVO uses AutoCAD during part of a five-phase approach to design.

Phase 1 Initiation

Every product has a beginning. It may be a sketch on a napkin or a rough prototype. This idea is the beginning of the product development cycle. Information is gathered from the client about the product desired and notes are made.

Phase 2 The Concepts

During this phase, ideas are developed with the client. Hand sketches, AutoCAD sketches, Styrofoam models, and cardboard mock-ups are used to present ideas. AutoCAD's advanced modeling extension (AME) can be used to quickly model features that may otherwise be hard to describe. At this stage, the AME model is preliminary and generally does not contain accurate dimensions. It is used more as a visualization tool because of the speed with which it can develop rough representations of the design.

Once the preliminary concept is modeled in AME, the model can be used for a variety of other purposes not normally associated with solid modeling. Perspectives of the model can be generated and rendered. Wireframe representations can be plotted to assist the industrial designer in doing presentation artwork for visualizing a client's ideas. Animations can be generated using shaded models. AME can really speed up information transfer during this phase.

This model shows how the garden sprayer fits into a tester.

Phase 3 The Layout

By the time Phase 3 begins, product concept and general direction are frozen. This is where AME can play a big role in the mechanical design. In contrast to Phase 2, the AME models and AutoCAD drawings must now be very accurate. GVO designers are using AME to do many of their mechanical layouts. The layout phase is critical since the resulting layout becomes a dimensional reference from which the product's spatial relationships are evaluated. Engineering data, such as centers of gravity, mass moments of inertia, weights, and volumes, are easily extracted from the AME models. Such data can be used in calculations to study other aspects of a part or assembly.

Phase 4 The Prototype

After a layout is near completion, GVO begins making detailed part drawings. AME includes two time-saving routines, called SOLVIEW and SOLDRAW, for generating 2-D views on an AME model. These routines provide the user with the ability to create orthographic, auxiliary, and cut-section views of the AME model. The final detail drawing includes a parts draft, variable radii, color descriptions, logo information, artwork placements, and manufacturing instructions. Prototypes are generated from the final detail drawings, as a final drawing check prior to developing the tooling used to produce the parts.

Phase 5 Manufacturing

The next step is the development of tooling for manufacturing. This is done by specialists who work closely with companies that do plastic injection modeling and metal die casting. When fabrication of the tooling is completed and checked for accuracy, mass production of the new product begins.

One of the main advantages of using AME is the ability to visualize designs much more easily and quickly, and at an earlier stage in the design process. The more information that can be communicated to the rest of the design team and to the client, the easier it is to see what parts of the design might cause problems.

This new Ortho Lock'n Spray garden sprayer was modeled and assembled using solid modeling.

Material Specs.		Part Name	Plug Housing	Part No.	TA 1274	
Purchased Stock Size		Usage	Plug Assembly	Date Issued		
Pcs. Per Pur. Size		Assy. No.	TA 1279	Date Sup'd.		
Weight		Sub. Assy. No.		Issued By		
Oper. No.	Operation Description	Dept.	Machine	Set Up Hr	Rate Pc/Hr.	Tools
20	Drill 1 hole $.32 \pm .005$	Drill	Mach 513 Deko 4	1.5	254	Drill Fixture L-76. Jig #10393
30	Deburr .312 $\pm .005$ Dia. Hole	Drill	Mach 510 Drill	.1	424	Multi-Tooth burring Tool
40	Chamfer .900/.875, Bore .828/.875 dia. (2 Passes), Bore .7600/.7625 (1 Pass)	Lathe	Mach D109 Lathe	1.0	44	Rasst-1, TPG 221. Chamfer Tool
50	Tap Holes as designated - 1/4 Min. Full Thread	Tap	Mach 514 Drill Tap	2.0	180	Fixture #CR-353. Tap. 4 Flute Sp.
60	Bore Hole 1.133 to 1.138 Dia.	Lathe	H & H E107	3.0	158	L44 Turret Fixture. Hartford
						Superspacer, pl. #45. Holder #L46.
						PDTW-100, Inser #21. Chk. Fixture
70	Deburr .005 to .010, Both Sides, Hand Feed To Hard Stop	Lathe	E162 Lathe	.5	176	Collect #CR179, 1327 RPM
80	Broach Keyway To Remove Thread Burrs	Drill	Mach. 507 Drill	.4	91	B87 Fixture, L59 Broach. Tap. .875120 G-H6
90	Hone Thread I.D. .822/.828	Grind	Grinder		120	
95	Hone .7600/.7625	Grind	Grinder		120	

Figure 10.80 Process Plan

This process plan shows the machining operations, the tools used, setup time, and rate per hour. This level of planning is necessary to estimate cost and to assure the smooth movement of parts during production.

10.8.2 Production

Production is the process used to transform raw materials into finished products and structures, using labor, equipment, capital, and facilities. The production process requires engineering drawings, change orders, technical specifications, bills of material, and many other documents. Drawings or 3-D models are used to lay out the factory floor, and computer models can be used to run machine tools that make the parts, and simulate the assembly process and the movement of materials in the factory. (Figure 10.81)

Increasingly, the machinery used for fabrication is programmed using the computer models of each part. The information related to the model is translated into manufacturing operations by specialized programs. These programs control the machine tools through a process called **numeric control (NC)**. Originally, information was provided to NC machines by punched tapes. Improvements in technology have led to the full-scale integration of computers with machine tools, and the development of **computer numeric control (CNC)**. The use of CNC means less translation and less chance for error. In the current generation of CNC technology, simulations of the tool cutting action are created

Figure 10.81 Factory Floor Simulation

The production process is enhanced by using a computer model of the factory floor to simulate activities. This surface model could even be animated to test manufacturing operations, such as the range of motion for the robots.

and tested on virtual models before actual materials and equipment are used. (Figure 10.82) This cuts down on material waste and reduces troubleshooting time, freeing up the equipment for greater use in production.

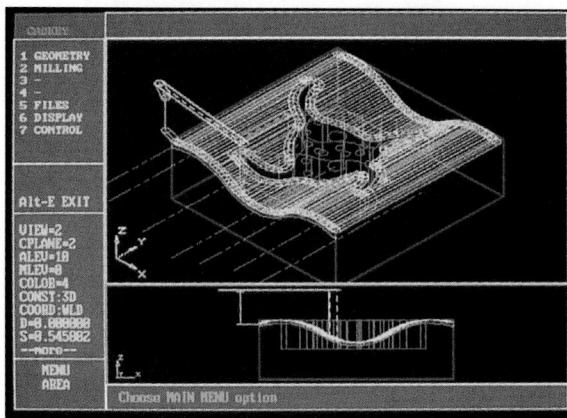

Figure 10.82 Planning Tool Paths Using a Virtual 3-D Model

Tool paths can be troubleshooted on virtual models without risk of damaging expensive tooling. (Courtesy of CADKEY, Inc.)

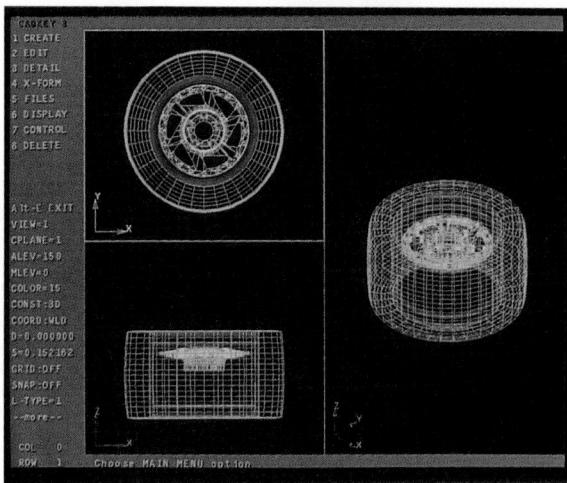

Figure 10.84 CAD Database Used to Create an Illustration

A CAD model of a tire and wheel is used by the illustrator to create technical illustrations. (Courtesy of CADKEY, Inc.)

Figure 10.83 Marketing Process

The marketing process is an integral part of the engineering design process. The marketing concept means that an organization aims its efforts at satisfying the customer, but at a profit. (From *Essentials of Marketing*, 5th ed., E. J. McCarthy and W. E. Perreault, Jr., Richard D. Irwin.)

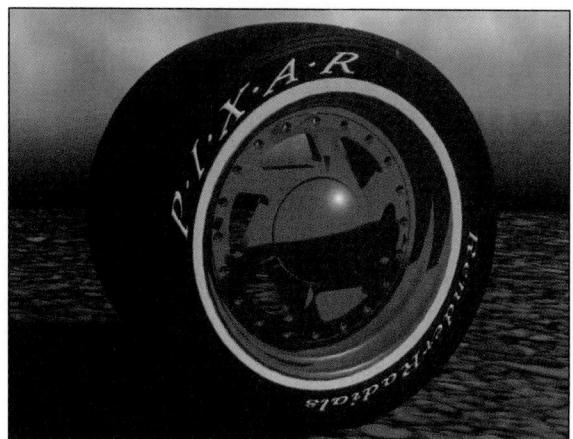

Figure 10.85 A Computer Rendered Image Created by the Technical Illustrator Using the CAD Model

The technical illustrator can import the 3-D CAD model into a rendering program, where surface textures and light sources are applied. (Courtesy of CADKEY, Inc.)

10.8.3 Marketing

The **marketing** process anticipates customer needs and directs the flow of goods from the producer to the consumer. (Figure 10.83) Marketing plays a very important role in the ideation, refinement, and implementation stages, and is much more than just selling

or advertising: Marketing makes sure that the right products are produced and find their way to the consumer. To successfully sell a new product, marketing requires product illustrations and presentation graphics. Computer models and technical drawings can be used as the basis for creating the illustrations needed. (Figures 10.84 and 10.85)

The Motorola marketing team:

- Analyzed the needs of the people who use cellular phones.
- Predicted what type of cellular phone users would want and decided who the company would try to satisfy.
- Estimated how many people would be using cellular phones in the next few years and who would buy them.
- Determined where these cellular phone users would be and how to get the phone to them.
- Estimated what price they would want to pay for a cellular phone.
- Decided which types of promotions should be used.
- Gathered information about the competition relative to types and prices of cellular phones produced.

The brochure produced for the MicroTAC Lite by the marketing department was developed around the theme of a feather, focusing on the fact that the phone was the lightest cellular phone in the world. (Figure 10.86)

10.8.4 Finance

The **finance** process analyzes the feasibility of producing a product, relative to capital requirements and return on investment (ROI). In any enterprise, finance is the management of cash flow such that the means are always available to achieve the firm's objectives as quickly as possible. (Figure 10.87) Financial administration includes:

Estimating and planning the flow of cash receipts and expenditures.

Raising from outside sources the needed funds for day-to-day operations.

Controlling the operations to ensure cash flow through the business.

Dividing the earnings between payments to the owners and investment in the future development of the business.

The basic activities in finance, regardless of the type of organization, are financial planning; the actual financing of proposed operations; financial analysis and control; and the disposition of net earnings. Financial planning estimates a firm's dollar volume of sales, which is used by management to determine inventory, labor, and training requirements, as well as facility usage. Budgets are used to estimate and plan the financing necessary for a new design,

Figure 10.86 A Page from the Product Brochure Developed by the Marketing Department

The marketing theme chosen was a feather, to focus the consumer on the lightweight design. (Courtesy of Motorola.)

Figure 10.87 Activities Involved in Financing to Analyze the Feasibility of Producing a Product

and the design team must work within budgetary constraints. As the design is finalized, the finance people working on the team determine the costs and projected earnings. They use information obtained from other members of the team on such items as sales, pricing, inventory, production, and personnel.

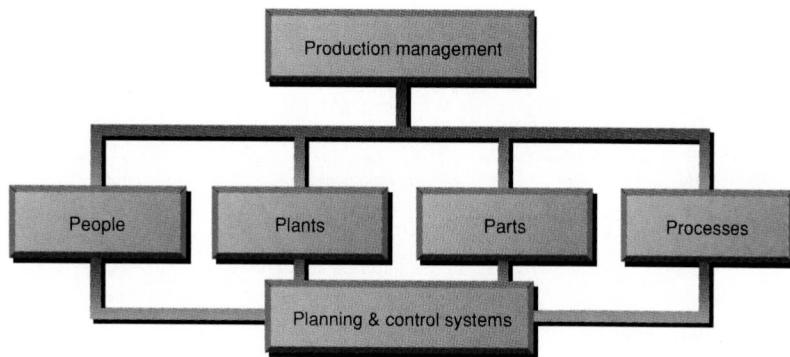

Figure 10.88 Production Manager's Responsibilities

Production management activities in a manufacturing firm include directing people, plants, parts, and processes. (From *Production and Operations Management*, 6th ed., R. B. Chase and N. J. Aquilano, Richard D. Irwin, Inc.)

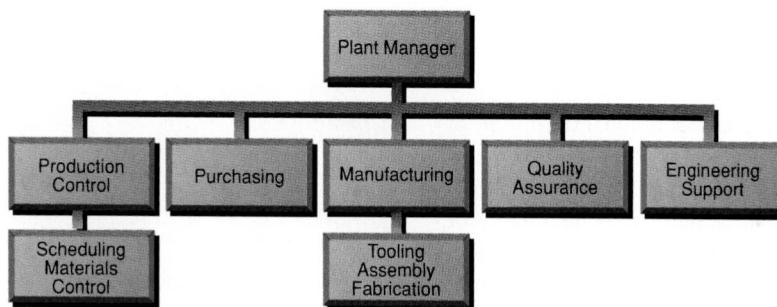

Figure 10.89 Organization of a Manufacturing Plant

The typical management organization of a manufacturing plant includes production control, purchasing, manufacturing, quality control, and engineering support. (From *Production and Operations Management*, 6th ed., R. B. Chase and N. J. Aquilano, Richard D. Irwin.)

10.8.5 Management

Management is the logical organization of people, materials, energy, equipment, and procedures into work activities designed to produce a specified end result, such as a product. Managers control or guide the everyday operations of an enterprise. *Production managers* direct the resources required to produce the goods and services of an organization. Figure 10.88 shows that production managers direct people, plants, parts, and processes, as well as the planning and control systems. Figure 10.89 shows what a plant manager controls in a manufacturing firm. Typically, each group listed under the plant manager has its own manager to run the day-to-day operations. For example, a managing engineer is responsible for engineering support. The managing

engineer organizes and executes around the priorities of the project and the company, and is guided by the plant engineer.

Global competition has forced industry in the United States to become much more quality conscious. Many industries are using a management process called **total quality management (TQM)**. TQM is the process of managing the organization as a whole such that it excels in all areas of production and service that are important to the customer. The key concepts are: (1) quality is applicable throughout the organization in everything it does; and (2) quality is defined by the customer. To translate customer quality demands into specifications, marketing or product development must accurately determine what the customer wants, and product designers must develop a product or service that consistently achieves that level of quality.

Dimension	Meaning
Performance	Primary product or service characteristics
Features	Added touches, bells and whistles, secondary characteristics
Reliability	Consistency of performance over time
Durability	Useful life
Serviceability	Resolution of problems and complaints
Response	Characteristics of the human-to-human interface (timeliness, courtesy, professionalism, etc.)
Aesthetics	Sensory characteristics (sound, feel, look, etc.)
Reputation	Past performance and other intangibles

Figure 10.90 Dimensions of Design Quality

Design quality includes many aspects of a product, such as reliability, durability, features, and others. (From *Production and Operations Management*, 6th ed., R. B. Chase and N. J. Aquilano, Richard D. Irwin.)

TQM practices require an operational definition of quality, an understanding of its dimensions, and methods for including customer opinions in the specifications. Product quality can be defined as the quality of the product's design and the quality of its conformance to that design. **Design quality** is the inherent value of the product in the marketplace. The common dimensions of design quality are listed in Figure 10.90. As an example, these dimensions have been adapted to the cellular phone design. (Figure 10.91) Conformance quality is the degree to which the product or service design specifications are met. Conformance quality is primarily concerned with the operational functions and the quality of the organizations within a firm.

10.8.6 Service

Service is an activity which supports the installation, training, maintenance, and repair of a product or structure for the consumer. Service uses technical illustrations and reports to support its activities. Technical illustrations are included in installation, maintenance, and repair manuals. (Figure 10.92) The technical illustrations are typically assembly drawings, which show how multiple parts fit together, pictorial drawings, rendered illustrations, and graphics showing the order of assembly, as well as the functionality, of the components of the product. Using a variety of techniques, parts normally hidden from view are shown in their operating positions.

Measures	Dimension	Cellular Phone
Performance	Strength of signal	
Features	Weighs less than 8 ounces	
Reliability	Mean time to failure	
Durability	Useful life	
Serviceability	Ease of repair	
Response	Turn-around time for service call	
Aesthetics	Look and feel of phone	
Reputation	Independent evaluation of product	

Figure 10.91

The dimensions of design quality are applied to the cellular telephone.

10.8.7 Documentation

Once the design is finalized in the refinement process, the design moves into the last phase of development, called documentation. **Documentation** is a process used to formally record and communicate the final design solution. Before concurrent engineering, most graphics documentation was in the form of 2-D engineering drawings and illustrations. With CAD and 3-D modeling, much of the graphics produced in the refinement stage is in the form of 3-D models. These models are used as input to the documentation stage to create engineering drawings, technical illustrations, animations,

Figure 10.92 Merging Text and Graphics

Technical illustrations are used in maintenance manuals produced with computers by merging text and graphics. (Courtesy of Intergraph Corporation.)

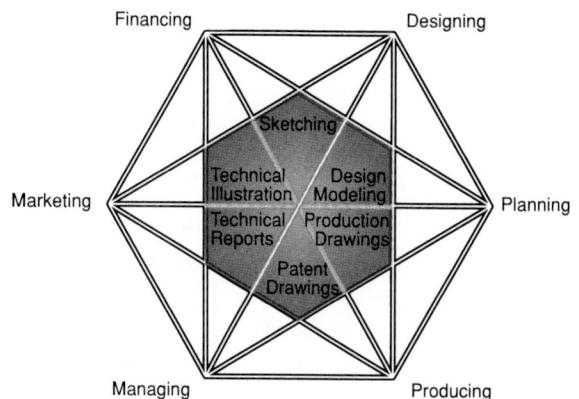

Figure 10.93 Concurrent Documentation

The concurrent documentation process integrates all types of graphics, to facilitate communications between all areas in a business.

and patent drawings. Documentation thus becomes a concurrent activity throughout the design process, instead of something that occurs only at the end.

Concurrent documentation is a process that creates documents at the same time that the product design is being developed. If concurrent engineering is being employed, it makes sense to use concurrent documentation to facilitate the communication process. Figure 10.93 shows the major documentation processes integrated with the concurrent engineering model.

The more effectively a company can communicate information about its products, both internally and to its customers, the more successful the company will be. Documentation is the common thread that runs throughout the entire design process. The documentation becomes the corporate memory for a project. Concurrent documentation practices maximize creative time and minimize documentation time; therefore, concurrent engineering and documentation must be one integral system. All information generated is communicated electronically, using computer hardware and software and the 3-D design model.

Design Drawings and Models **Design drawings** and models are all the sketches, rough design layout drawings, and initial 3-D computer models created during the ideation and refinement phases. (Figure 10.94) When concurrent documentation is employed, these drawings and models are refined along with the design.

Design drawings and models are used as input to the other documentation processes. For example, the 3-D model created for engineering analysis is used to extract multiview production drawings.

Production Drawings and Models Multiview dimensioned drawings and assembly drawings with a parts list are used for production purposes. These multiview drawings are called **production drawings** because they are used as the communications medium between design and production or manufacturing. (Figure 10.95) (See Chapter 9, “Reading and Constructing Working Drawings.”)

If the design is modeled in 3-D by CAD, then multiview drawings can automatically be extracted from the model. (Figure 10.96) Dimensions are added to the drawings, then assembly drawings with a parts list are produced, to create the production drawings. Production drawings contain sufficient detail for the product to be produced. The production drawings are copied or blueprinted, then used by manufacturing engineers and technicians in the fabrication and assembly of the process. Another purpose for engineering drawings is **archiving**, which is a process used to create a permanent graphics record of the design in the form of drawings saved on vellum, microfiche, computer tape, or some other medium. The archival drawings are placed in a secure environment, such as a vault, to ensure their safety.

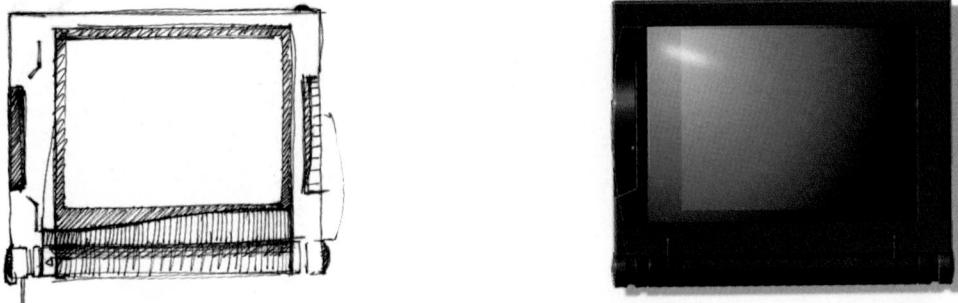

Figure 10.94 A Design Drawing Used in the Ideation Phase

A laptop computer screen shown as an early ideation sketch (left) and as the final manufactured product (right). (Courtesy of Design Edge.)

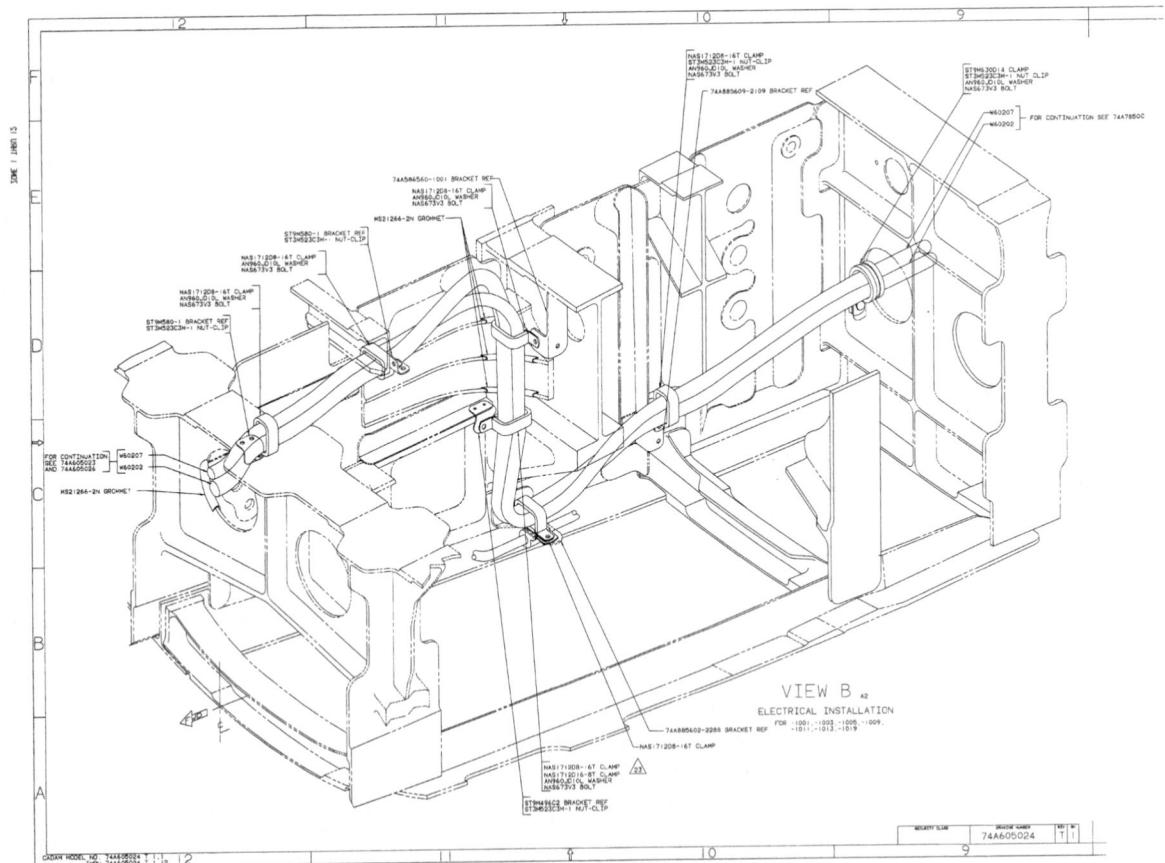

Figure 10.95 Production Drawing

A production drawing showing the installation of the electrical harness system in a jet aircraft. (Courtesy of Northrop.)

Figure 10.96 Multiview Drawing

This drawing shows the front, top, and right side views of one piece of the case. The drawings for this cellular phone were generated directly from a 3-D model.

It is possible to create a product without the use of paper drawings by linking the entire business to computers. The product would be designed and modeled in CAD. The CAD model would be used as input for computer numerical control (CNC) machines, where the tool path would be created. (Figure 10.82) Machinists, engineers, and technicians would use a computer terminal to access a central database, which would contain the engineering drawings and 3-D model. The drawings or 3-D model would be displayed on the computer terminal, serving as the communications medium instead of paper. Although the total elimination of paper in industry may not be possible, some companies are nearly paperless today, with the product and processes controlled by computers. **© CAD Reference 10.16**

Technical Illustrations **Technical illustrations** are developed and used throughout the concurrent engineering and documentation cycle, starting with the design database. For example, using computer

Figure 10.97 Technical Illustration

This technical illustration of a building was created by rendering the CAD model created earlier in the design process. (Courtesy of CADKEY, Inc.)

software, the 3-D model could be viewed from any direction and illustrations could be rendered. Hand- or computer-rendered illustrations are used by industrial designers to convey their ideas to others on the team early in the design process. (Figure 10.97) Rendered illustrations are used by marketing, to create advertising and sales information, as well as by service, to create technical documents such as installation and maintenance manuals. **© CAD Reference 10.17**

Animations **Animations** are used in the documentation phase to support the marketing, training, production, and service activities. In marketing, animations are used to produce advertisements; in service, they are used to create training videos for service technicians; and, in production, they are used to show how the assembly line operates. In the concurrent documentation process, animations are created by the computer animation software, using the design computer model as the input database. **© CAD Reference 10.18**

Technical Reports **Technical reports** are in-depth accounts that chronicle the design process. For example, progress reports are created in the early stages of the design process to document the decisions made by the design team. Similar reports are done periodically to review the status of a project.

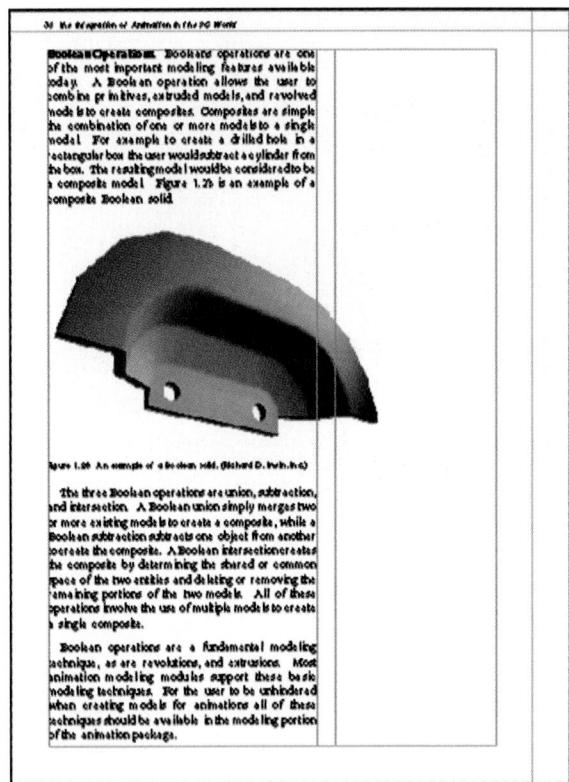

Figure 10.98 Technical Report

A page from a technical report with graphics and text merged is created with a page layout computer program.

Final reports, which include both text and graphics, are written at the end of the design cycle and are much more detailed in content. The final report typically contains the following:

- Title Page
- Table of Contents
- Abstract
- Problem Identification
- Procedures
- Problem Solution
- Results
- Conclusions
- Bibliography
- Appendixes

A letter of transmittal normally accompanies the final report. This letter briefly describes the contents of the report and the reasons for the project.

The text and graphics in the reports are created using computer-based word processing, page layout, spreadsheet, database, and graphics programs. The engineering drawings and models created in the design

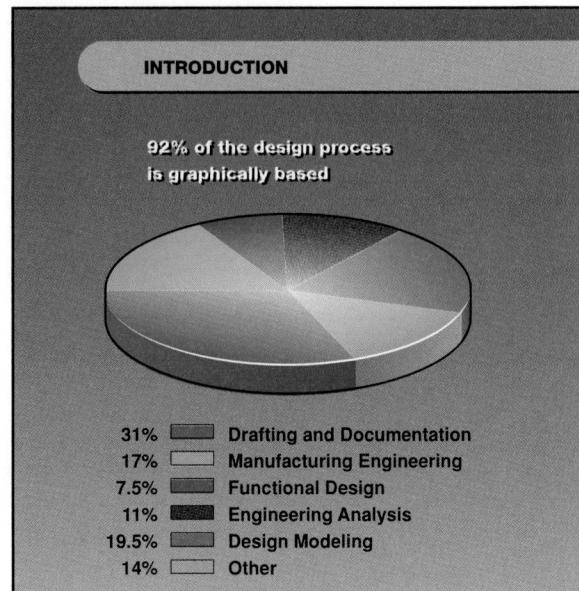

Figure 10.99 Presentation Graphics

A slide created for a presentation includes text and graphics merged together by a computer presentation software program.

process are used to illustrate the text. The technical illustrator uses the CAD database to create other types of illustrations, such as exploded assemblies. Spreadsheet and database programs are used to present numerical data in the form of tables, graphs, and charts. The page layout program assembles the text and graphics to create finished documents. (Figure 10.98)

© CAD Reference 10.19

Presentation Graphics **Presentation graphics** are text, illustrations, and other visual aids used when making an oral report to a group. (Figure 10.99) Progress and final reports are often presented to managers at various levels in a company. Oral reports are supplemented with visual aids, which help the listener understand the information being presented. Presentation graphics include:

- Charts
- Graphs
- Tables
- Flip charts
- Overhead transparencies
- Videos
- Slides
- Photographs
- Real models
- Computer models

The implementation of the Motorola MicroTAC Lite cellular phone was a team effort. Marketing developed an advertising strategy that focused on the fact that the phone was the smallest and lightest cellular phone on the market. Graphics documents were created for archiving the final design, communicating the design to production, marketing, and service, and those giving presentations. These graphics documents were in the form of drawings, models, plots, electrical schematics, plant layouts, exploded assemblies, technical illustrations, and sketches.

Concurrent engineering practices and TQM principles were used successfully to create the MicroTAC Lite in a very short time. The design team members combined their abilities and knowledge to produce a product that has been widely accepted by the consumer. The MicroTAC Lite was the first cellular phone to break the 8-ounce barrier and set the standard for the cellular phone industry throughout the world.

A concept technical illustration sketch used by the design team to visualize the final product.

The graphics database created in the design process is a source for much of the graphics used in a presentation. The design computer models can be captured on slides and photographs, or as plots. Animations and simulations can be captured on videotape. Multimedia presentations can be created by using authoring software to combine several graphics media into a single, computer-assisted presentation. Multimedia presentations contain text, charts, graphs, scanned slides and drawings, animations, and sound. The authoring software is used to *script* or organize the various computer-based presentation materials. © CAD Reference 10.20

Patent Drawings* A **patent** is the “right to exclude others from making, using, or selling” and is issued by the federal government. The patenting process was developed to encourage the prompt disclosure of technical advances by granting a limited period of protection for the exclusive use of that advance. A patent is granted for a period of 17 years.

An application consists of three components: the claims, the description, and the drawings. The claims define those elements that distinguish the invention from known technology of a similar nature; that is, the elements that are “adding to the pool of knowledge.”

The description should “enable a workman ordinarily skilled in the arts to practice or replicate the invention.” The drawings should detail and clarify all elements of the claimed invention.

The patent drawing is a highly regulated piece of graphics. One of the best sources for the applicable regulations is the *Guide for Patent Draftsmen*, from the Patent and Trademark Office. It features selected rules of practice relating to patent drawings and covers such diverse matters as the medium and the style requirements for patent office acceptance.

Patent drawings can be flow block diagrams (Figure 10.100), schematics, or other labeled representations. The views used in a patent drawing may be plan, elevation, section, or perspective (pictorial). Exploded views are also permitted, to indicate order of assembly. (Figure 10.101)

10.9 SUMMARY

This chapter introduces you to modern design practices. Graphics have been and will continue to be an important part of engineering design. Graphics, in all forms, are the communications medium of choice in the design process. The use of computers to create 3-D models is a critical part of the modern design process. These models are used to generate a database of information that can be shared with all

* Written by Professor Charles W. White, Assistant Professor of Technical Graphics, Purdue University, West Lafayette, IN., with assistance from R. Godlewski, Patent Attorney.

Industry Application Design for Manufacturability (DFM)

By redesigning the Seville's rear bumper, Cadillac cut the number of parts in half, reduced assembly time by 57 percent, and saved an estimated \$462,000 in labor

costs. The new design also led to higher quality, as there were fewer parts and steps that could lead to defects.

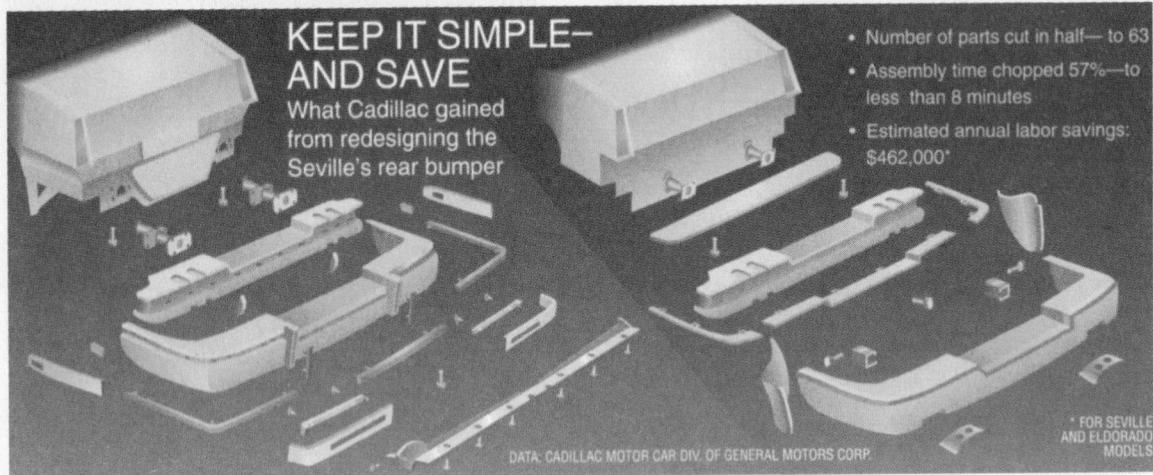

Art reprinted from October 25, 1991, issue of *Business Week* by special permission, copyright 1991, McGraw-Hill, Inc.

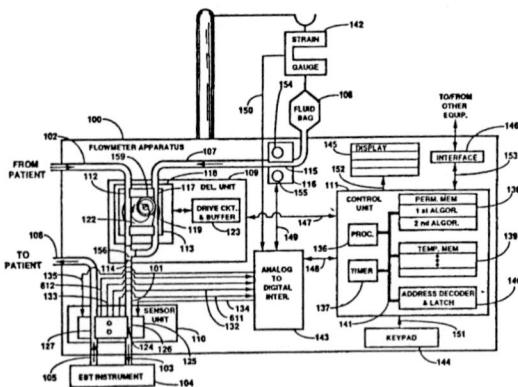

Figure 10.100 Diagram Patent Drawing

This is a patent drawing of a medical device in the form of a diagram.

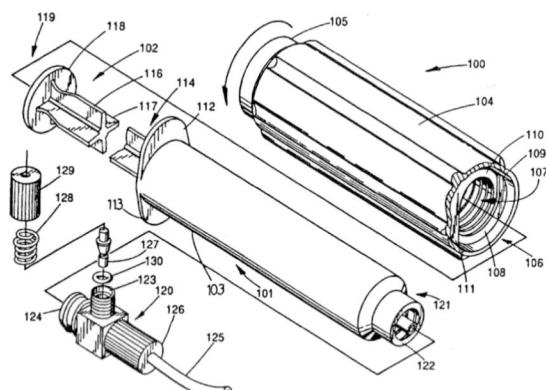

KEY TERMS

Aesthetic analysis	Design for manufacturability (DFM)	Line graph	Refinement
Aesthetic design	Design quality	Management	Refinement drawings
Animations	Design visualization	Market analysis	Regression line
Archiving	Difference (–)	Marketing	Return on investment (ROI)
Assembly analysis	Discretization	Mathematical model	Reverse engineering
Bar graph	Documentation	Mechanism analysis	Rigid-body transformations
Benchmark	Dynamic analysis	Modeling	Scale lines
Boolean operations	Engineering design	Multiple line graph	Scale model
Boundary condition	Finance	Nominal	Service
Boundary representation (B-rep)	Financial analysis	Ordinal	Sketch modelers
Brainstorming	Finite element modeling (FEM)	Patent	Solid model
Computer animation	Form	Planning	Surface model
Computer numeric control (CNC)	Function	Predictive model	Surface plot
Computer simulation	Functional analysis	Presentation graphics	Sweeping operation
Concurrent documentation	Functional design	Primitive instancing	Synthesis
Concurrent engineering	Gantt chart	Problem identification	System
Constructive solid geometry (CSG)	Geometric transformations	Process	System design
Contour line	Glyph	Product	Technical illustrations
Contour plot	Graphical analysis	Product design	Technical reports
Critical path method (CPM)	Human factors analysis	Production	Total quality management (TQM)
Data region	Ideation drawings	Production drawings	Tweaking
Dependent variable	Implementation	Production process	Union (\cup)
Descriptive model	Independent variable	Project evaluation and review technique (PERT)	Vector
Design	Intersection (\cap)	Property analysis	View camera
Design analysis	Iteration	Qualitative data	View port
Design drawings	Iterative process	Quantitative data	Virtual reality (VR)
	Kinematic analysis	Rapid prototyping	Wireframe model
	Legend	Reference lines	Workplane

QUESTIONS FOR REVIEW

1. Describe the design process.
2. Describe the engineering design process.
3. Describe engineering analysis.
4. Describe aesthetic analysis.
5. Define documentation.
6. Define a production drawing.
7. Describe how CAD is used in the design process.
8. Describe the role of graphics in the design process.
9. Describe presentation graphics.
10. Highlight the important ways that graphics are used throughout the design process.
11. Describe TQM.
12. Describe and sketch the concurrent engineering model.
13. Describe and sketch the concurrent documentation model.
14. Describe DFM.
15. List and describe the modeling techniques used in design.
16. Describe real or physical modeling.
17. Describe the difference between simulation and animation.
18. Describe the reverse engineering process.
19. Define and describe knowledge-based engineering (KBE).
20. Describe the rapid prototyping process and why it is useful in engineering design.
21. What is a fundamental difference between 2-D and 3-D CAD systems? Is there any overlap between the two types of CAD systems?
22. What is the minimum information needed to define a true wireframe model? Is there enough information in a wireframe model to determine which edges are hidden?
23. What are the advantages and disadvantages of the three types of curves used to make surface patches?
24. Define the three types of Boolean operations and sketch examples of each one. Can you derive the same final object using different Boolean operations and/or primitives?
25. Describe the differences and similarities of B-rep models and CSG models; do the same for wireframe models and B-rep models.
26. Describe different ways a profile could be swept about an axis to form a solid. Will all such profiles be valid objects in all modelers?
27. Which geometric transformations are rigid body transformations? Which ones are not?
28. Does a tweaking operation alter the topology of an object?
29. Explain the advantages and disadvantages of using a virtual model over a real model when designing a product.
30. Describe the areas of technical design in which data visualization is important. How does data visualization differ from traditional engineering graphics?
31. Give examples of nominal, ordinal, and scalar variables. Are these variables qualitative or quantitative?
32. Give examples of independent and dependent variables. Can a dependent variable sometimes be an independent variable, and vice versa?
33. Give examples of three different visualizations in which a line mark can be used. What are some of the different ways of coding multiple independent variables in a line graph?
34. Give examples of at least three different types of bar graphs. Can the independent variable be depicted on both the vertical and horizontal axes? What are two ways multiple independent variables can be depicted in a bar graph?

FURTHER READING

Beakley, G. C., and H. W. Leach. *Introduction to Engineering Design Graphics*. New York: Macmillan Publishing Company, 1973.

Chase, R. B., and N. J. Aquilano. *Production and Operations Management*. Homewood, IL: Richard D. Irwin, Inc., 1992.

Dieter, G. E. *Engineering Design: A Materials and Process Approach*. New York: McGraw-Hill, Inc., 1983.

Dreyfuss, H. *The Measure of Man, Human Factors in Design*. New York: Whitney Library of Design, 1967.

Friedhoff, R. M., and W. Benzon. *Visualization: The Second Computer Revolution*. New York: Harry N. Abrams Inc., 1989.

Guide for Patent Draftsmen (Selected Rules of Practice Relating to Patent Drawings). Washington, D.C.: U.S. Department of Commerce, Patent and Trademark Office, 1989.

Hunt, V. D. *Quality in America*. Homewood, IL: Business One Irwin, 1992.

McCarthy, E. J., and W. E. Perreault, Jr. *Essentials of Marketing*. 5th ed. Homewood, IL: Richard D. Irwin, Inc., 1991.

Oberg, E.; F. D. Jones; H. L. Horton; and H. H. Ryffell, *Machinery's Handbook*. 24th ed. New York: Industrial Press, Inc., 1992.

Pillers, M. "Using AME for New Product Development." *CADENCE*, May 1993, pp. 45–48.

Taylor, D. L. *Computer-Aided Design*. Reading, Mass.: Addison-Wesley, 1992.

Tufte, E. R. *Envisioning Information*. Cheshire, CT: Graphics Press, 1990.

Zeid, I. *CAD/CAM Theory and Practice*. New York: McGraw-Hill, 1991.

PROBLEMS

Integrated Design Communications Problem

Gear reducer assignment

The members of the team will work together to create a complete set of working drawings of the gear reducer. The set of drawings will include dimensioned details, exploded isometric or orthographic assembly drawings, a parts list, and specifications for standard parts. The working drawings will be turned in, along with sketches, calculations, and a short report describing the project and how problems were solved. Figure 10.102 is a pictorial exploded assembly drawing of the gear reducer.

General Instructions

The following design problems are intended to challenge you to be creative, individually or in a group. Those problems designed specifically for a group are so labeled. The design problems are not meant to teach the design process, as much as how to represent ideas graphically, using drawings and computer models. Any design problem labeled a **concept** means that all details of the solution are not necessary. For example, Problem number 2 is a concept automobile highway bridge. Obviously, a highway bridge cannot be completely designed in 10, or even 16, weeks by students. However, the basic concept for a highway bridge can be developed and graphically represented in that timeframe.

For each project, you must create the engineering drawings and models necessary to communicate your solution to others. The engineering drawings should include:

1. Initial design sketches.
2. Multiview drawings, with dimensions. (Concept designs only need critical dimensions and details, where necessary.)
3. Sectioned assembly drawings, with parts list.
4. Pictorial drawings of the final design, with parts list where appropriate.

Group projects use a team approach to solve the design problems. The team should consist of four to eight students, randomly selected. Each team should have a group leader to schedule meetings, assign tasks and deadlines, and make sure the team works together as a group to solve the problem.

1. **Concept solar-powered vehicle. (Group)** Design a solar-powered concept vehicle, for one passenger, that can travel up to 20 MPH.
2. **Concept automobile highway bridge. (Group)** Design a bridge structure that will carry four lanes of traffic and cross a river. The bridge should be 125 feet across, and 78 feet above the water in the center.

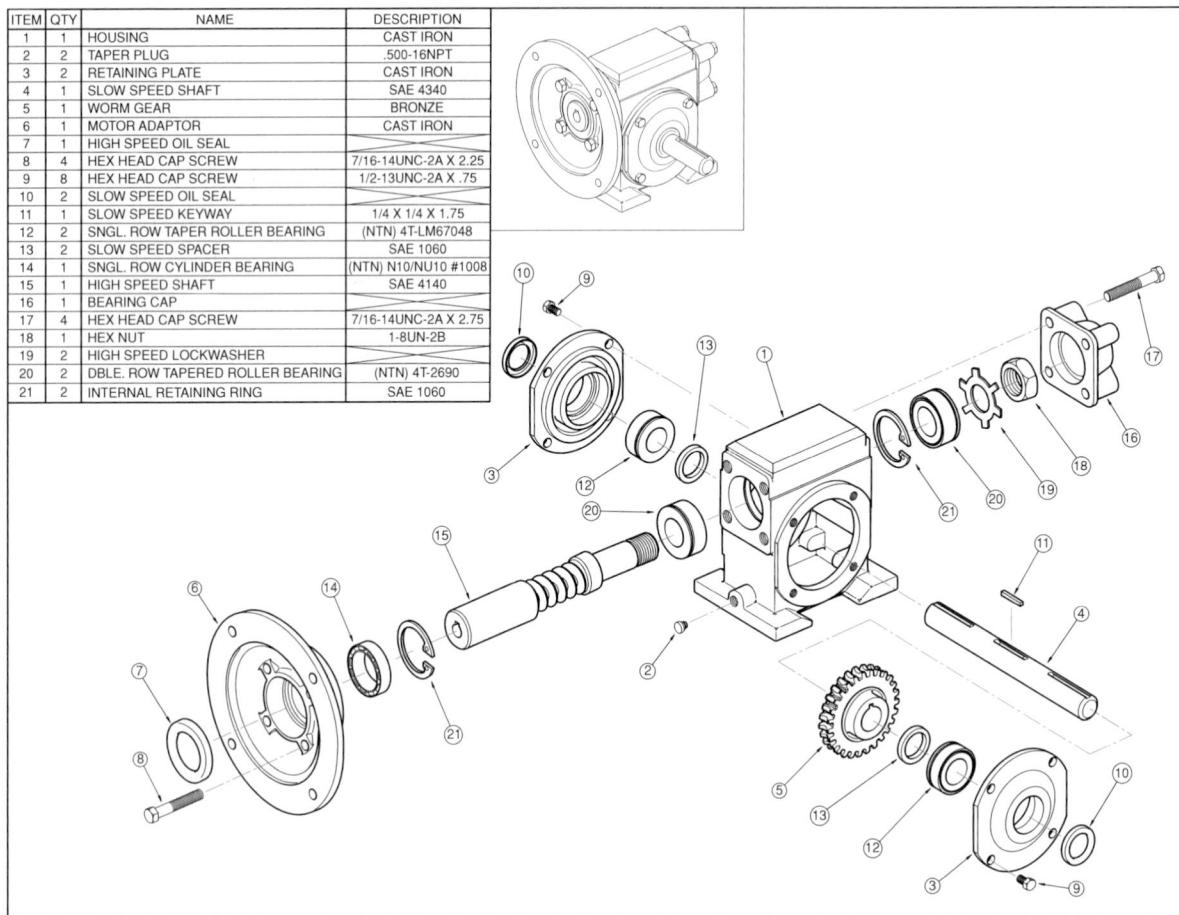

Figure 10.102 An Exploded Assembly Drawing of the Gear Reducer

3. **Concept multipurpose outdoor stadium.** **(Group)** Design a multipurpose outdoor stadium for football, baseball, and soccer, that will have seating for 54,000 people.
4. **Concept multipurpose indoor stadium.** **(Group)** Design a multipurpose indoor stadium for basketball, hockey, and volleyball, that will have seating for 18,000 people.
5. **Ergonomic three-button mouse.** Design an ergonomic computer mouse, with three buttons, that can be used by left- and right-handed people.
6. **Laptop computer case.** Design a hard-plastic carrying case, for a notebook computer and mouse, that weighs 7 pounds and is 2.25" by 8" by 11".
7. **Computer disk storage unit.** Design a storage box to hold and organize 100 3-1/2" computer disks.
8. **Concept airport facility. (Group)** Design an airport facility for a small city, to accommodate two airlines and jets no larger than a Boeing 727.
9. **Portable stadium seat.** Design a portable stadium seat, with a backrest that can be folded flat and with storage for a rain poncho.
10. **Snow ski carrier.** Design a device that holds four pairs of downhill or cross-country skis and poles and attaches to an automobile.
11. **Children's playground. (Group)** Design a neighborhood playground with tennis courts, a basketball court, and playground equipment.
12. **Concept spacecraft. (Group)** Design a three-person space vehicle to be used by a space station for in-space satellite repair missions.

13. **Remote control.** Design a hand-held infrared remote control for an entertainment center that has cable TV, a videocassette player/recorder, and a stereo with cassette tape, tuner, and audio CD player.
14. **Concept mountain bike. (Group)** Design a lightweight frame for a 26" mountain bike with a shock absorbing front fork.
15. **Stair-stepper exerciser.** Design an exercise stair-stepper with dual hydraulic cylinders that can be adjusted for variable resistance. The unit must have a height adjustment for the handlebar and must fold flat for storage.
16. **Portable basketball hoop.** Design a portable basketball system with a water-filled base that provides 250 pounds of weight for stability. The pole should be adjustable every 6" between 7' and 10' and the unit must have wheels for easy movement.
17. **Communications device.** Design a communications device that uses pictures, for use by a disabled child. For example, a drawing of a cup with the word "drink" could be used to communicate that the child is thirsty. The communications device must have a minimum of 25 words for basic living functions, such as eat, sleep, open, close, help, etc.
18. **Propane gas grill.** Design an outdoor propane gas grill with approximately 600 square inches of cooking area.
19. **Logs splitter.** Design a device to split hardwood logs for home fireplaces. The device should use hydraulics to split the logs.
20. **Aluminum can crusher.** Design a device that will automatically crush aluminum beverage cans for recycling. The device should have a feature that automatically loads, crushes, and discharges the cans.
21. **Toothpaste dispenser.** Design a device that will automatically dispense toothpaste from a standard toothpaste tube. This device should be able to mount on a wall.
22. **Door latch/lock.** Design a door latching/locking system. Define the environment (office, home, industrial, etc.) and the kind of door with which it will be used. Take into consideration the characteristics and abilities of a wide range of people who might be using the door. Include such factors as height, strength, and physical handicap.
23. **Garden hose sprayer.** Design a hand-held garden hose sprayer. The sprayer must have an on/off control and be able to spray a variety of patterns. Consider how the handle will fit on the sprayer and work the controls. Specify how the sprayer will connect to the hose (standard threaded connection, or a quick-release design).
24. **Workpiece hold-down device.** Design a quick-release hold-down device used for holding down a workpiece in a wood or metal shop. The device must be able to hold material up to 3" thick and have at least an 8" reach. It should have the ability to release the workpiece quickly, and should be easy to position and move to other work surfaces. The holding strength of the device should also be considered.
25. **Wood pellet feeder.** Formed pellets from waste wood are an increasingly popular way of heating both industrial and residential spaces. Design a system that feeds pellets from a hopper into a furnace. Consider the feedback mechanism needed to decide how fast to feed the pellets to generate the required heat. Also consider the high temperatures under which portions of the feeder will have to operate.
26. **Portable clothesline.** Design a portable clothesline/clothes holder for drying a full load of clothes, including full-length dresses. One person must be able to set up the device quickly, and it must be collapsible to a size no bigger than a large suitcase. Consider out-of-balance situations, that is, when the clothes are not evenly distributed.
27. **Portable bed.** Design a portable bed or cot for camping use. Define the group of people (population) that would be using the cot, and research the range of body dimensions and range of weight in this population. Also consider the space needed to store the bed when not in use, and how easy it is to set up.
28. **Paintbrush dryer/cleaner.** Design a device that can be used for both cleaning and hastening the drying of paintbrushes. The device should be usable with both water- and oil-based paints and brushes of all sizes. Consider a method of containing the volatile solvents used to clean oil-based paint from brushes.

29. **Cellular telephone mount.** Design a system for mounting cellular telephones in cars. The mount should not be permanent and should be adaptable to most makes and models of cars. The design should not compromise the safety of the vehicle operator by impeding the use of controls.

30. **Home office workstation.** Design a home office workstation with the following items integrated into it:

- Computer with 16" monitor.
- Phone.
- Fax machine.
- Personal size photocopy machine.

The workstation should also have at least two file drawers, a drawer for office supplies, and clear counter space for paperwork.

31. **Outdoor table.** Design an outdoor table for use on a patio or deck. The table should be a knock-down (KD) design that can be easily assembled and disassembled by the homeowner. The table should also be weatherproof. Consider the seating comfort for both adults and children by researching the range of body dimensions in this population.

32. **Pallet moving system.** Design a system for moving standard warehouse pallets. Define whether the system will load and unload pallets from trucks or just move within the warehouse. Also decide how high the system will lift the pallets.

33. **Hazardous environment rescue vehicle. (Group)** Design a vehicle for use in search and rescue operations in hazardous environments, such as a chemical or nuclear plant. Consider how many people the vehicle will hold, what level of medical care will be provided, and what terrain the vehicle will be able to travel over. Once the initial concept is developed by the group, divide the design into smaller components to be worked on by individual team members.

34. **Space shuttle robot arm. (Group)** Design a robot arm for the space shuttle cargo bay, to be used for launching and retrieving satellites. The arm must have considerable reach and maneuverability, but must still be able to stow away inside the cargo bay. Consider whether the arm will only be controlled from within the shuttle, or by astronauts riding on the arm, as well. Once the initial concept is developed by the group, divide the design into smaller components to be worked on by individual team members.

35. **Wheelchair vehicle lift.** Design a device that will lift a child or adult in a wheelchair to a van. The device should be permanently attached to the vehicle.

36. **Pet feeding device.** Design a device that will automatically dispense food for a household pet, such as a dog or cat.

37. **Photographer's blind.** Design a portable, nature photographer's blind. The blind should be lightweight, easy to assemble and disassemble, and small enough to be carried easily when disassembled.

38. **Drillpress.** Design a device that can be used to convert a $\frac{3}{8}$ " electric hand drill into a drillpress. You must be able to attach and remove the drill easily from the device.

39. **Portable scoreboard. (Group)** Design a portable sports scoreboard that can be used for high school soccer, baseball, football, basketball, and volleyball.

40. **Mass transit passenger car.** Design a mass transit passenger car for a high-speed commuter rail system, to be used in major metropolitan areas in the United States.

41. **Gear reducer.** Design a gear reduction box that will reduce the speed of an input shaft turning at 1000 RPM to an output shaft turning at 100 RPM.

42. **TV support.** Design a 25" TV monitor support that can be mounted on a classroom wall. The support needs to allow the TV to be easily repositioned to different viewing angles.

Reverse Engineering Problems

Reverse engineering is a process of taking existing products, evaluating and measuring them, and then creating the CAD database to reproduce them. The following problems can be used as reverse engineering projects. Use a micrometer, scale, and calipers to make measurements. Use manufacturer's catalogs to specify standard parts, such as bearings and fasteners. For each project, the following is required:

1. Disassemble, measure, and sketch each part.
2. Create 3-D models or engineering drawings of each nonstandard part, with dimensions.
3. Specify standard parts, using engineering catalogs.
4. Create an assembly drawing with parts list.
5. Create a written report that summarizes your project, lists the strengths and weaknesses of the product you reverse engineered, comments on the serviceability of the product, and recommend changes to the design, especially as it relates to DFM principles.

The products to be reverse engineered are as follows:

1. $\frac{3}{8}$ " reversible electric hand drill.
2. Staple gun.
3. Electric kitchen hand mixer.
4. Electric can opener.
5. Electric hair dryer.
6. Electric glue gun.
7. Electric hand jigsaw.
8. Dustbuster.
9. Kant-twist clamp.
10. Hold-down clamp.
11. Drillpress vise.
12. Telephone.
13. Computer mouse.
14. Paper stapler.
15. Paper feeder tray for a laser printer.
16. Multiple pen holder for a plotter.
17. Computer game joystick.
18. Piston and connecting rod for an automobile engine.

APPENDIXES

- 1.** Metric Equivalents
- 2.** Trigonometry Functions
- 3.** ANSI Running and Sliding Fits (RC)
- 4.** ANSI Clearance Locational Fits (LC)
- 5.** ANSI Transition Locational Fits (LT)
- 6.** ANSI Interference Locational Fits (LN)
- 7.** ANSI Force and Shrink Fits (FN)
- 8.** Description of Preferred Metric Fits
- 9.** ANSI Preferred Hole Basis Metric Clearance Fits
- 10.** ANSI Preferred Hole Basis Transition and Interference Fits
- 11.** ANSI Preferred Shaft Basis Metric Clearance Fits
- 12.** ANSI Preferred Shaft Basis Metric Transition and Interference Fits
- 13.** Unified Standard Screw Thread Series
- 14.** Thread Sizes and Dimensions
- 15.** Tap Drill Sizes for American National Thread Forms
- 16.** Hex Cap Screws (Finished Hex Bolts)
- 17.** Socket Head Cap Screws (1960 Series)
- 18.** Square Head Bolts
- 19.** Hex Nuts and Hex Jam Nuts
- 20.** Square Nuts
- 21.** ANSI Metric Hex Jam Nuts and Heavy Hex Nuts
- 22.** ANSI Metric Hex Nuts, Styles 1 and 2
- 23.** ANSI Metric Slotted Hex Nuts and Hex Flange Nuts
- 24.** ANSI Square and Hexagon Machine Screw Nuts and Flat Head Machine Screws
- 25.** ANSI Slotted Flat Countersunk Head Cap Screws
- 26.** ANSI Slotted Round and Fillester Head Cap Screws
- 27.** Drill and Counterbore Sizes for Socket Head Cap Screws
- 28.** ANSI Hexagon and Spline Socket Head Cap Screws

- 29.** ANSI Hexagon Socket Head Shoulder Screws
- 30.** Drill and Counterbore Sizes for Metric Socket Head Cap Screws
- 31.** ANSI Socket Head Cap Screws—Metric Series
- 32.** ANSI Metric Hex Bolts
- 33.** ANSI Metric Hex Cap Screws
- 34.** ANSI Hex and Hex Flange Head Metric Machine Screws
- 35.** ANSI Slotted Flat Head Metric Machine Screws
- 36.** ANSI Slotted Headless Set Screws
- 37.** ANSI Hexagon and Spline Socket Set Screws
- 38.** ANSI Hexagon and Spline Socket Set Screw Optional Cup Points
- 39.** ANSI Square Head Set Screws
- 40.** ANSI Taper Pipe Threads (NPT)
- 41.** ANSI Metric Plain Washers
- 42.** ANSI Type A Plain Washers—Preferred Sizes
- 43.** ANSI Type A Plain Washers—Additional Selected Sizes
- 44.** ANSI Type B Plain Washers
- 45.** ANSI Helical Spring Lock Washers
- 46.** ANSI Internal and External Tooth Lock Washers
- 47.** ANSI Keyseat Dimensions for Woodruff Keys
- 48.** ANSI Standard Woodruff Keys
- 49.** Key Size versus Shaft Diameter—Key Size and Keyway Depth
- 50.** ANSI Standard Plain and Gib Head Keys
- 51.** ANSI Chamfered, Square End, and Taper Pins
- 52.** British Standard Parallel Steel Dowel Pins—Metric Series
- 53.** ANSI Cotter and Clevis Pins
- 54.** Welding Symbols
- 55.** Geometric Symbols, Definitions, and Characteristics
- 56.** CAD References for *AutoCAD 13 Companion*, Leach
- 57.** CAD References for *AutoCAD 12 Companion*, Leach
- 58.** CAD References for *CADKEY Companion*, Cherng

Appendix 1 Metric Equivalents

Length	
U.S. to Metric	Metric to U.S.
1 inch = 2.540 centimeters	1 millimeter = 0.039 inch
1 foot = 0.305 meter	1 centimeter = 0.394 inch
1 yard = 0.914 meter	1 meter = 3.281 feet, or 1.094 yards
1 mile = 1.609 kilometers	1 kilometer = 0.621 mile
Area	
1 inch ² = 6.451 centimeter ²	1 millimeter ² = 0.00155 inch ²
1 foot ² = 0.093 meter ²	1 centimeter ² = 0.155 inch ²
1 yard ² = 0.836 meter ²	1 meter ² = 10.764 foot ² , or 1.196 yard ²
1 acre ² = 4,046.873 meter ²	1 kilometer ² = 0.386 mile ² , or 247.04 acre ²
Volume	
1 inch ³ = 16.387 centimeter ³	1 centimeter ³ = 0.061 inch ³
1 foot ³ = 0.28 meter ³	1 meter ³ = 35.314 foot ³ , or 1.308 yard ³
1 yard ³ = 0.764 meter ³	1 liter = 0.2642 gallons
1 quart = 0.946 liter	1 liter = 1.057 quarts
1 gallon = 0.003785 meter ³	1 meter ³ = 264.02 gallons
Weight	
1 ounce = 28.349 grams	1 gram = 0.035 ounce
1 pound = 0.454 kilogram	1 kilogram = 2.205 pounds
1 ton = 0.907 metric ton	1 metric ton = 1.102 tons
Velocity	
1 foot/second = 0.305 meter/second	1 meter/second = 3.281 feet/second
1 mile/hour = 0.447 meter/second	1 kilometer/hour = 0.621 mile/second
Acceleration	
1 inch/second ² = 0.0254 meter/second ²	1 meter/second ² = 3.278 feet/second ²
1 foot/second ² = 0.305 meter/second ²	
Force	
N (Newton) = basic unit of force, kg·m/s ² . A mass of one kilogram (1kg) exerts a gravitational force of 9.8 N (theoretically, 9.80665 N) at mean sea level.	
Density	
1 pound/inch ³ = 27.68 grams/centimeter ³	1 gram/centimeter ³ = 0.591 ounce/inch ³

Prefix	Symbol	Multiplier
tera	T	1,000,000,000,000
giga	G	1,000,000,000
mega	M	1,000,000
kilo	k	1,000
hecto	h	100
deka	da	10
—	—	1
deci	d	0.1
centi	c	0.01
milli	m	0.001
micro	μ	0.000001
nano	n	0.000000001
pico	p	0.000000000001

Appendix 2 Trigonometry Functions

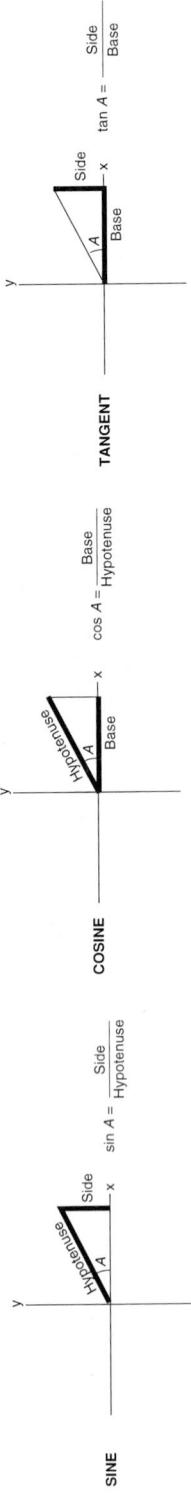

Right Triangles

Oblique Triangles

Known Sides and Angles		Unknown Sides and Angles		Area
a, b	$c = \sqrt{a^2+b^2}$	$A = \arctan \frac{a}{b}$	$B = \arctan \frac{b}{a}$	$C = \frac{ab}{2}$
a, c	$b = \sqrt{c^2-a^2}$	$A = \arcsin \frac{a}{c}$	$B = \arccos \frac{a}{c}$	$B = \frac{a\sqrt{c^2-a^2}}{2c}$
b, c	$a = \sqrt{c^2-b^2}$	$A = \arccos \frac{b}{c}$	$c = \sqrt{a^2+b^2}$	$A = \frac{b\sqrt{c^2-b^2}}{2c}$
a, $\angle A$	$b = \frac{a}{\tan A}$	$B = 90^\circ - A$	$c = \sqrt{a^2+b^2}$	$B = \frac{a\sqrt{a^2+b^2}}{b}$
a, $\angle B$	$b = a \tan B$	$A = 90^\circ - B$	$a = \sqrt{b^2 \tan^2 B + b^2}$	$A = \frac{a\sqrt{b^2 \tan^2 B + b^2}}{b}$
b, $\angle A$	$a = b \tan A$	$B = 90^\circ - A$	$c = \frac{b^2 \tan A}{2}$	$C = \frac{b^2 \tan A}{2a}$
b, $\angle B$	$a = \frac{b}{\tan B}$	$A = 90^\circ - B$	$c = \frac{b^2}{2 \tan B}$	$B = \frac{b^2}{2a}$
c, $\angle A$	$a = c \sin A$	$B = 90^\circ - A$	$a = c \sin A \cos A$	$C = \frac{c \sin A}{2a}$
c, $\angle B$	$a = c \cos B$	$A = 90^\circ - B$	$b = c \sin B \cos A$	$B = \frac{c \sin B}{2a}$

Appendix 3 ANSI Running and Sliding Fits (RC)
American National Standard Running and Sliding Fits (ANSI B4.1-1967, R1979)

Tolerance limits given in body of table are added or subtracted to basic size (as indicated by + or - sign) to obtain maximum and minimum sizes of mating parts.

Nominal Size Range, Inches Over To	Class RC 1				Class RC 2				Class RC 3				Class RC 4			
	Clear- ance*	Standard Tolerance Limits		Clear- ance*	Standard Tolerance Limits		Clear- ance*	Standard Tolerance Limits		Clear- ance*	Standard Tolerance Limits		Clear- ance*	Standard Tolerance Limits		Clear- ance*
		Hole H5	Shaft g4		Hole H6	Shaft g5		Hole H7	Shaft f6		Hole H8	Shaft f7		Hole H8	Shaft f7	
Values shown below are in thousandths of an inch																
0- 0.12	0.1 0.45	+ 0.2 0	- 0.1 - 0.25	0.1 0.55	+ 0.25 0	- 0.1 - 0.3	0.3 0.95	+ 0.4 0	- 0.3 - 0.55	0.3 1.3	+ 0.6 0	- 0.3 - 0.7	0.3 1.3	+ 0.6 0	- 0.3 - 0.7	0.3 1.3
0.12- 0.24	0.15 0.5	+ 0.2 0	- 0.15 - 0.3	0.15 0.65	+ 0.3 0	- 0.15 - 0.35	0.4 1.12	+ 0.5 0	- 0.4 - 0.7	0.4 1.6	+ 0.7 0	- 0.4 - 0.9	0.4 1.6	+ 0.7 0	- 0.4 - 0.9	0.4 1.6
0.24- 0.40	0.2 0.6	+ 0.25 0	- 0.2 - 0.35	0.2 0.85	+ 0.4 0	- 0.2 - 0.45	0.5 1.5	+ 0.6 0	- 0.5 - 0.9	0.5 2.0	+ 0.9 0	- 0.5 - 1.1	0.5 2.0	+ 0.9 0	- 0.5 - 1.1	0.5 2.0
0.40- 0.71	0.25 0.75	+ 0.3 0	- 0.25 - 0.45	0.25 0.95	+ 0.4 0	- 0.25 - 0.55	0.6 1.7	+ 0.7 0	- 0.6 - 1.0	0.6 2.3	+ 1.0 0	- 0.6 - 1.3	0.6 2.3	+ 1.0 0	- 0.6 - 1.3	0.6 2.3
0.71- 1.19	0.3 0.95	+ 0.4 0	- 0.3 - 0.55	0.3 1.2	+ 0.5 0	- 0.3 - 0.7	0.8 2.1	+ 0.8 0	- 0.8 - 1.3	0.8 2.8	+ 1.2 0	- 0.8 - 1.6	0.8 2.8	+ 1.2 0	- 0.8 - 1.6	0.8 2.8
1.19- 1.97	0.4 1.1	+ 0.4 0	- 0.4 - 0.7	0.4 1.4	+ 0.6 0	- 0.4 - 0.8	1.0 2.6	+ 1.0 0	- 1.0 - 1.6	1.0 3.6	+ 1.6 0	- 1.0 - 2.0	1.0 3.6	+ 1.6 0	- 1.0 - 2.0	1.0 3.6
1.97- 3.15	0.4 1.2	+ 0.5 0	- 0.4 - 0.7	0.4 1.6	+ 0.7 0	- 0.4 - 0.9	1.2 3.1	+ 1.2 0	- 1.2 - 1.9	1.2 4.2	+ 1.8 0	- 1.2 - 2.4	1.2 4.2	+ 1.8 0	- 1.2 - 2.4	1.2 4.2
3.15- 4.73	0.5 1.5	+ 0.6 0	- 0.5 - 0.9	0.5 2.0	+ 0.9 0	- 0.5 - 1.1	1.4 3.7	+ 1.4 0	- 1.4 - 2.3	1.4 5.0	+ 2.2 0	- 1.4 - 2.8	1.4 5.0	+ 2.2 0	- 1.4 - 2.8	1.4 5.0
4.73- 7.09	0.6 1.8	+ 0.7 0	- 0.6 - 1.1	0.6 2.3	+ 1.0 0	- 0.6 - 1.3	1.6 4.2	+ 1.6 0	- 1.6 - 2.6	1.6 5.7	+ 2.5 0	- 1.6 - 3.2	1.6 5.7	+ 2.5 0	- 1.6 - 3.2	1.6 5.7
7.09- 9.85	0.6 2.0	+ 0.8 0	- 0.6 - 1.2	0.6 2.6	+ 1.2 0	- 0.6 - 1.4	2.0 5.0	+ 1.8 0	- 2.0 - 3.2	2.0 6.6	+ 2.8 0	- 2.0 - 3.8	2.0 6.6	+ 2.8 0	- 2.0 - 3.8	2.0 6.6
9.85-12.41	0.8 2.3	+ 0.9 0	- 0.8 - 1.4	0.8 2.9	+ 1.2 0	- 0.8 - 1.7	2.5 5.7	+ 2.0 0	- 2.5 - 3.7	2.5 7.5	+ 3.0 0	- 2.5 - 4.5	2.5 7.5	+ 3.0 0	- 2.5 - 4.5	2.5 7.5
12.41-15.75	1.0 2.7	+ 1.0 0	- 1.0 - 1.7	1.0 3.4	+ 1.4 0	- 1.0 - 2.0	3.0 6.6	+ 2.2 0	- 3.0 - 4.4	3.0 8.7	+ 3.5 0	- 3.0 - 5.2	3.0 8.7	+ 3.5 0	- 3.0 - 5.2	3.0 8.7
15.75-19.69	1.2 3.0	+ 1.0 0	- 1.2 - 2.0	1.2 3.8	+ 1.6 0	- 1.2 - 2.2	4.0 8.1	+ 2.5 0	- 4.0 - 5.6	4.0 10.5	+ 4.0 0	- 4.0 - 6.5	4.0 10.5	+ 4.0 0	- 4.0 - 6.5	4.0 10.5

See footnotes at end of table.

Nominal Size Range, Inches Over To	Class RC 5				Class RC 6				Class RC 7				Class RC 8				Class RC 9	
	Clear- ance*	Standard Tolerance Limits		Clear- ance*	Standard Tolerance Limits		Clear- ance*	Standard Tolerance Limits		Clear- ance*	Standard Tolerance Limits		Clear- ance*	Standard Tolerance Limits		Clear- ance*	Standard Tolerance Limits	
		Hole H8	Shaft e7		Hole H9	Shaft e8		Hole H9	Shaft d8		Hole H10	Shaft c9		Hole H11	Shaft		Hole H11	Shaft
Values shown below are in thousandths of an inch																		
0- 0.12	0.6 1.6	+ 0.6 0	- 0.6 - 1.0	0.6 2.2	+ 1.0 0	- 0.6 - 1.2	1.0 2.6	+ 1.0 0	- 1.0 - 1.6	2.5 5.1	+ 1.6 0	- 2.5 - 3.5	4.0 8.1	+ 2.5 0	- 4.0 - 5.6	4.0 8.1	+ 2.5 0	- 4.0 - 5.6
0.12- 0.24	0.8 2.0	+ 0.7 0	- 0.8 - 1.3	0.8 2.7	+ 1.2 0	- 0.8 - 1.5	1.2 3.1	+ 1.2 0	- 1.2 - 1.9	2.8 5.8	+ 1.8 0	- 2.8 - 4.0	4.5 9.0	+ 3.0 0	- 4.5 - 6.0	4.5 9.0	+ 3.0 0	- 4.5 - 6.0
0.24- 0.40	1.0 2.5	+ 0.9 0	- 1.0 - 1.6	1.0 3.3	+ 1.4 0	- 1.0 - 1.9	1.6 3.9	+ 1.4 0	- 1.6 - 2.5	3.0 6.6	+ 2.2 0	- 3.0 - 4.4	5.0 10.7	+ 3.5 0	- 5.0 - 7.2	5.0 10.7	+ 3.5 0	- 5.0 - 7.2
0.40- 0.71	1.2 2.9	+ 1.0 0	- 1.2 - 1.9	1.2 3.8	+ 1.6 0	- 1.2 - 2.2	2.0 4.6	+ 1.6 0	- 2.0 - 3.0	3.5 7.9	+ 2.8 0	- 3.5 - 5.1	6.0 12.8	+ 4.0 0	- 6.0 - 8.8	6.0 12.8	+ 4.0 0	- 6.0 - 8.8
0.71- 1.19	1.6 3.6	+ 1.2 0	- 1.6 - 2.4	1.6 4.8	+ 2.0 0	- 1.6 - 2.8	2.5 5.7	+ 2.0 0	- 2.5 - 3.7	4.5 10.0	+ 3.5 0	- 4.5 - 6.5	7.0 15.5	+ 5.0 0	- 7.0 - 10.5	7.0 15.5	+ 5.0 0	- 7.0 - 10.5
1.19- 1.97	2.0 4.6	+ 1.6 0	- 2.0 - 3.0	2.0 6.1	+ 2.5 0	- 2.0 - 3.6	3.0 7.1	+ 2.5 0	- 3.0 - 4.6	5.0 11.5	+ 4.0 0	- 5.0 - 7.5	8.0 18.0	+ 6.0 0	- 8.0 - 12.0	8.0 18.0	+ 6.0 0	- 8.0 - 12.0
1.97- 3.15	2.5 5.5	+ 1.8 0	- 2.5 - 3.7	2.5 7.3	+ 3.0 0	- 2.5 - 4.3	4.0 8.8	+ 3.0 0	- 4.0 - 5.8	6.0 13.5	+ 4.5 0	- 6.0 - 9.0	9.0 20.5	+ 7.0 0	- 9.0 - 13.5	9.0 20.5	+ 7.0 0	- 9.0 - 13.5
3.15- 4.73	3.0 6.6	+ 2.2 0	- 3.0 - 4.4	3.0 8.7	+ 3.5 0	- 3.0 - 5.2	5.0 10.7	+ 3.5 0	- 5.0 - 7.2	7.0 15.5	+ 5.0 0	- 7.0 - 10.5	10.0 24.0	+ 9.0 0	- 10.0 - 15.0	10.0 24.0	+ 9.0 0	- 10.0 - 15.0
4.73- 7.09	3.5 7.6	+ 2.5 0	- 3.5 - 5.1	3.5 10.0	+ 4.0 0	- 3.5 - 6.0	6.0 12.5	+ 4.0 0	- 6.0 - 8.5	8.0 18.0	+ 6.0 0	- 8.0 - 12.0	12.0 28.0	+ 10.0 0	- 12.0 - 18.0	12.0 28.0	+ 10.0 0	- 12.0 - 18.0
7.09- 9.85	4.0 8.6	+ 2.8 0	- 4.0 - 5.8	4.0 11.3	+ 4.5 0	- 4.0 - 6.8	7.0 14.3	+ 4.5 0	- 7.0 - 9.8	10.0 21.5	+ 7.0 0	- 10.0 - 14.5	15.0 34.0	+ 12.0 0	- 15.0 - 22.0	15.0 34.0	+ 12.0 0	- 15.0 - 22.0
9.85-12.41	5.0 10.0	+ 3.0 0	- 5.0 - 7.0	5.0 13.0	+ 5.0 0	- 5.0 - 8.0	8.0 16.0	+ 5.0 0	- 8.0 - 11.0	12.0 25.0	+ 8.0 0	- 12.0 - 17.0	18.0 38.0	+ 12.0 0	- 18.0 - 38.0	18.0 38.0	+ 12.0 0	- 18.0 - 38.0
12.41-15.75	6.0 11.7	+ 3.5 0	- 6.0 - 8.2	6.0 15.5	+ 6.0 0	- 6.0 - 9.5	10.0 19.5	+ 6.0 0	- 10.0 - 13.5	14.0 29.0	+ 9.0 0	- 14.0 - 20.0	22.0 45.0	+ 14.0 0	- 22.0 - 31.0	22.0 45.0	+ 14.0 0	- 22.0 - 31.0
15.75-19.69	8.0 14.5	+ 4.0 0	- 8.0 - 10.5	8.0 18.0	+ 6.0 0	- 8.0 - 12.0	12.0 22.0	+ 6.0 0	- 12.0 - 16.0	16.0 32.0	+ 10.0 0	- 16.0 - 22.0	25.0 51.0	+ 16.0 0	- 25.0 - 35.0	25.0 51.0	+ 16.0 0	- 25.0 - 35.0

All data above heavy lines are in accord with ABC agreements. Symbols H5, g4, etc. are hole and shaft designations in ABC system. Limits for sizes above 19.69 inches are also given in the ANSI Standard.

* Pairs of values shown represent minimum and maximum amounts of clearance resulting from application of standard tolerance limits.

SOURCE: Reprinted courtesy of The American Society of Mechanical Engineers.

Appendix 4 ANSI Clearance Locational Fits (LC)
American National Standard Clearance Locational Fits (ANSI B4.1-1967, R1979)

Tolerance limits given in body of table are added or subtracted to basic size (as indicated by + or - sign) to obtain maximum and minimum sizes of mating parts.

Nominal Size Range, Inches Over To	Class LC 1				Class LC 2				Class LC 3				Class LC 4				Class LC 5				
	Clear- ance*	Standard Tolerance Limits		Clear- ance*	Standard Tolerance Limits		Clear- ance*	Standard Tolerance Limits		Clear- ance*	Standard Tolerance Limits		Clear- ance*	Standard Tolerance Limits		Clear- ance*	Standard Tolerance Limits		Clear- ance*	Standard Tolerance Limits	
		Hole H6	Shaft h5		Hole H7	Shaft h6		Hole H8	Shaft h7		Hole H10	Shaft h9		Hole H7	Shaft g6		Hole H7	Shaft h9		Hole H7	Shaft g6
Values shown below are in thousandths of an inch																					
0 - 0.12	0.45	+ 0.25 0	- 0.2 0.65	0	+ 0.4 0	- 0.25 1	0	+ 0.6 0	- 0.4 2.6	0	+ 1.6 0	- 1.0 - 1.0	0.1 0.75	+ 0.4 0	- 0.1 - 0.35	0	+ 0.4 0	- 0.1 - 0.35	0	+ 0.4 0	- 0.1 - 0.35
0.12 - 0.24	0.5	+ 0.3 0	- 0.2 0.8	0	+ 0.5 0	- 0.3 1.2	0	+ 0.7 0	- 0.5 3.0	0	+ 1.8 0	- 1.2 - 1.2	0.15 0.95	+ 0.5 0	- 0.15 - 0.45	0	+ 0.5 0	- 0.15 - 0.45	0	+ 0.5 0	- 0.15 - 0.45
0.24 - 0.40	0.65	+ 0.4 0	- 0.25 0.25	0	+ 0.6 0	- 0.4 1.5	0	+ 0.9 0	- 0.6 3.6	0	+ 2.2 0	- 1.4 1.2	0.2 1.2	+ 0.6 0	- 0.2 - 0.6	0	+ 0.6 0	- 0.2 - 0.6	0	+ 0.6 0	- 0.2 - 0.6
0.40 - 0.71	0.7	+ 0.4 0	- 0.3 1.1	0	+ 0.7 0	- 0.4 1.7	0	+ 1.0 0	- 0.7 4.4	0	+ 2.8 0	- 1.6 - 1.6	0.25 1.35	+ 0.7 0	- 0.25 - 0.65	0	+ 0.7 0	- 0.25 - 0.65	0	+ 0.7 0	- 0.25 - 0.65
0.71 - 1.19	0.9	+ 0.5 0	- 0.4 1.3	0	+ 0.8 0	- 0.5 2	0	+ 1.2 0	- 0.8 5.5	0	+ 3.5 0	- 2.0 - 2.0	0.3 1.6	+ 0.8 0	- 0.3 - 0.8	0	+ 0.8 0	- 0.3 - 0.8	0	+ 0.8 0	- 0.3 - 0.8
1.19 - 1.97	1.0	+ 0.6 0	- 0.4 1.6	0	+ 1.0 0	- 0.6 2.6	0	+ 1.6 0	- 1 6.5	0	+ 4.0 0	- 2.5 - 2.5	0.4 2.0	+ 1.0 0	- 0.4 - 1.0	0	+ 1.0 0	- 0.4 - 1.0	0	+ 1.0 0	- 0.4 - 1.0
1.97 - 3.15	1.2	+ 0.7 0	- 0.5 1.9	0	+ 1.2 0	- 0.7 3	0	+ 1.8 0	- 1.2 7.5	0	+ 4.5 0	- 3 2.3	0.4 0	+ 1.2 0	- 0.4 - 1.1	0	+ 1.2 0	- 0.4 - 1.1	0	+ 1.2 0	- 0.4 - 1.1
3.15 - 4.73	1.5	+ 0.9 0	- 0.6 2.3	0	+ 1.4 0	- 0.9 3.6	0	+ 2.2 0	- 1.4 8.5	0	+ 5.0 0	- 3.5 - 3.5	0.5 2.8	+ 1.4 0	- 0.5 - 1.4	0	+ 1.4 0	- 0.5 - 1.4	0	+ 1.4 0	- 0.5 - 1.4
4.73 - 7.09	1.7	+ 1.0 0	- 0.7 2.6	0	+ 1.6 0	- 1.0 4.1	0	+ 2.5 0	- 1.6 10.0	0	+ 6.0 0	- 4 3.2	0.6 0	+ 1.6 0	- 0.6 - 1.6	0	+ 1.6 0	- 0.6 - 1.6	0	+ 1.6 0	- 0.6 - 1.6
7.09 - 9.85	2.0	+ 1.2 0	- 0.8 3.0	0	+ 1.8 0	- 1.2 4.6	0	+ 2.8 0	- 1.8 11.5	0	+ 7.0 0	- 4.5 - 4.5	0.6 3.6	+ 1.8 0	- 0.6 - 1.8	0	+ 1.8 0	- 0.6 - 1.8	0	+ 1.8 0	- 0.6 - 1.8
9.85-12.41	2.1	+ 1.2 0	- 0.9 3.2	0	+ 2.0 0	- 1.2 5	0	+ 3.0 0	- 2.0 13.0	0	+ 8.0 0	- 5 - 5	0.7 3.9	+ 2.0 0	- 0.7 - 1.9	0	+ 2.0 0	- 0.7 - 1.9	0	+ 2.0 0	- 0.7 - 1.9
12.41-15.75	2.4	+ 1.4 0	- 1.0 3.6	0	+ 2.2 0	- 1.4 5.7	0	+ 3.5 0	- 2.2 15.0	0	+ 9.0 0	- 6 - 6	0.7 4.3	+ 2.2 0	- 0.7 - 2.1	0	+ 2.2 0	- 0.7 - 2.1	0	+ 2.2 0	- 0.7 - 2.1
15.75-19.69	2.6	+ 1.6 0	- 1.0 4.1	0	+ 2.5 0	- 1.6 6.5	0	+ 4 0	- 2.5 16.0	0	+ 10.0 0	- 6 - 6	0.8 4.9	+ 2.5 0	- 0.8 - 2.4	0	+ 2.5 0	- 0.8 - 2.4	0	+ 2.5 0	- 0.8 - 2.4

See footnotes at end of table.

Nominal Size Range, Inches Over To	Class LC 6				Class LC 7				Class LC 8				Class LC 9				Class LC 10				Class LC 11			
	Clear- ance*	Std. Tolerance Limits		Clear- ance*	Std. Tolerance Limits		Clear- ance*	Std. Tolerance Limits		Clear- ance*	Std. Tolerance Limits		Clear- ance*	Std. Tolerance Limits		Clear- ance*	Std. Tolerance Limits		Clear- ance*	Std. Tolerance Limits				
		Hole H9	Shaft f8		Hole H8	Shaft e9		Hole H10	Shaft e9		Hole H10	Shaft d9		Hole H11	Shaft c10		Hole H12	Shaft c10		Hole H13	Shaft b11			
Values shown below are in thousandths of an inch																								
0 - 0.12	0.3	+ 1.0 0	- 0.3 3.2	0.6	+ 1.6 0	- 0.6 1.6	1.0	+ 1.6 0	- 1.0 6.6	2.5	+ 2.5 0	- 2.5 4.1	4	+ 4 0	- 4 8	5	+ 6 0	- 5 11	0	+ 6 0	- 5 11			
0.12 - 0.24	0.4	+ 1.2 2.3	- 0.4 0	0.8	+ 1.8 4.6	- 0.8 2.4	1.2	+ 1.8 0	- 1.2 7.6	2.8	+ 3.0 0	- 2.8 4.6	4.5	+ 5 0	- 4.5 9.5	6	+ 7 0	- 6 13	0	+ 7 0	- 6 13			
0.24 - 0.40	0.5	+ 1.4 2.8	- 0.5 1.4	1.0	+ 2.2 4.6	- 1.0 2.4	1.6	+ 2.2 0	- 1.6 8.7	3.0	+ 3.5 0	- 3.0 5.2	5	+ 6 0	- 5 11	7	+ 9 0	- 7 16	0	+ 9 0	- 7 16			
0.40 - 0.71	0.6	+ 1.6 3.2	- 0.6 1.6	1.2	+ 2.8 5.6	- 1.2 2.8	2.0	+ 2.8 0	- 2.0 13.0	3.5	+ 4.0 0	- 3.5 6.3	6	+ 7 0	- 6 13	8	+ 10 0	- 8 18	0	+ 10 0	- 8 18			
0.71 - 1.19	0.8	+ 2.0 4.0	- 0.8 2.0	1.6	+ 3.5 3.5	- 1.6 3.6	2.5	+ 3.5 0	- 2.5 13.0	4.5	+ 5.0 0	- 4.5 8.0	7	+ 8 0	- 7 15	10	+ 12 0	- 10 22	0	+ 12 0	- 10 22			
1.19 - 1.97	1.0	+ 2.5 5.1	- 1.0 2.6	2.0	+ 4.0 4.5	- 2.0 4.5	3.6	+ 4.0 0	- 3.0 15.0	5.0	+ 6 0	- 5.0 9.0	8	+ 10 0	- 8 18	12	+ 16 0	- 12 28	0	+ 16 0	- 12 28			
1.97 - 3.15	1.2	+ 3.0 6.0	- 1.0 3.0	2.5	+ 4.5 5.5	- 2.5 11.5	4.0	+ 4.5 0	- 4.0 17.5	6.0	+ 7 0	- 6.0 10.5	10	+ 12 0	- 10 22	14	+ 18 0	- 14 32	0	+ 18 0	- 14 32			
3.15 - 4.73	1.4	+ 3.5 7.1	- 1.4 3.6	3.0	+ 5.0 10.0	- 3.0 11.5	5.0	+ 5.0 0	- 5.0 21	7	+ 9 0	- 7 12	11	+ 14 0	- 11 25	16	+ 22 0	- 25 38	0	+ 22 0	- 25 38			
4.73 - 7.09	1.6	+ 4.0 8.1	- 1.6 4.1	3.5	+ 6.0 13.5	- 3.5 7.5	6	+ 6 0	- 6 16	8	+ 10 0	- 8 14	12	+ 16 0	- 12 24	18	+ 25 0	- 28 44	0	+ 25 0	- 28 44			
7.09 - 9.85	2.0	+ 4.5 9.3	- 2.0 4.8	4.0	+ 7.0 15.5	- 4.0 8.5	7	+ 7 0	- 7 11.5	7	+ 12 0	- 10 17	10	+ 12 0	- 10 17	16	+ 18 0	- 16 34	22	+ 28 0	- 34 78			
9.85-12.41	2.2	+ 5.0 10.2	- 2.2 0	4.5	+ 8.0 20.0	- 4.5 11	7	+ 8 0	- 8 23	12	+ 12 0	- 14 37	12	+ 12 0	- 14 23	16	+ 18 0	- 16 44	22	+ 28 0	- 34 100			
12.41-15.75	2.5	+ 6.0 12.0	- 2.5 0	5.0	+ 10.0 20.0	- 5 11	9	+ 10 0	- 9 23	16	+ 16 0	- 14 42	16	+ 16 0	- 14 42	22	+ 22 0	- 22 46	30	+ 35 0	- 35 65			
15.75-19.69	2.8	+ 6.0 12.8	- 2.8 0	5.0	+ 10.0 21.0	- 5 11	9	+ 10 0	- 9 25	16	+ 16 0	- 14 42	16	+ 16 0	- 14 42	22	+ 25 0	- 25 50	35	+ 40 0	- 35 75			

All data above heavy lines are in accordance with American-British-Canadian (ABC) agreements. Symbols H6, H7, s6, etc. are hole and shaft designations in ABC system. Limits for sizes above 19.69 inches are not covered by ABC agreements but are given in the ANSI Standard.

* Pairs of values shown represent minimum and maximum amounts of interference resulting from application of standard tolerance limits.

SOURCE: Reprinted courtesy of The American Society of Mechanical Engineers.

Appendix 5 ANSI Transition Locational Fits (LT)

ANSI Standard Transition Locational Fits (ANSI B4.1-1967, R1979)

Nominal Size Range, Inches	Class LT 1			Class LT 2			Class LT 3			Class LT 4			Class LT 5			Class LT 6		
	Std. Tolerance Limits		Fit*	Std. Tolerance Limits		Fit*	Std. Tolerance Limits		Fit*	Std. Tolerance Limits		Fit*	Std. Tolerance Limits		Fit*	Std. Tolerance Limits		
	Hole H7	Shaft js6		Hole H8	Shaft js7		Hole H7	Shaft k6		Hole H8	Shaft k7		Hole H7	Shaft n6		Hole H7	Shaft n7	
Values shown below are in thousandths of an inch																		
0- 0.12	-0.12 +0.52	+0.4 0	+0.12 -0.12	-0.2 +0.8	+0.6 0	+0.2 -0.2							-0.5 +0.15	+0.4 0	+0.5 +0.25	-0.65 +0.15	+0.4 0	+0.65 +0.25
0.12- 0.24	-0.15 +0.65	+0.5 0	+0.15 -0.15	-0.25 +0.95	+0.7 0	+0.25 -0.25							-0.6 +0.2	+0.5 0	+0.6 +0.3	-0.8 +0.2	+0.5 0	+0.8 +0.3
0.24- 0.40	-0.2 +0.8	+0.6 0	+0.2 -0.2	-0.3 +1.2	+0.9 0	+0.3 -0.3	-0.5 +0.5	+0.6 0	+0.5 +0.1	-0.7 +0.8	+0.9 0	+0.7 +0.1	-0.8 +0.2	+0.6 0	+0.8 +0.4	-1.0 +0.2	+0.6 0	+1.0 +0.4
0.40- 0.71	-0.2 +0.9	+0.7 0	+0.2 -0.2	-0.35 +1.35	+1.0 0	+0.35 -0.35	-0.5 +0.6	+0.7 0	+0.5 +0.1	-0.8 +0.9	+1.0 0	+0.8 +0.1	-0.9 +0.2	+0.7 0	+0.9 +0.5	-1.2 +0.2	+0.7 0	+1.2 +0.5
0.71- 1.19	-0.25 +1.05	+0.8 0	+0.25 -0.25	-0.4 +1.6	+1.2 0	+0.4 -0.4	-0.6 +0.7	+0.8 0	+0.6 +0.1	-0.9 +1.1	+1.2 0	+0.9 +0.1	-1.1 +0.2	+0.8 0	+1.1 +0.6	-1.4 +0.2	+0.8 0	+1.4 +0.6
1.19- 1.97	-0.3 +1.3	+1.0 0	+0.3 -0.3	-0.5 +2.1	+1.6 0	+1.6 -0.5	-0.7 +0.9	+1.0 0	+0.7 +0.1	-1.1 +1.1	+1.6 0	+1.1 +0.1	-1.3 +0.2	+1.0 0	+1.3 +0.7	-1.7 +0.3	+1.0 0	+1.7 +0.7
1.97- 3.15	-0.3 +1.5	+1.2 0	+0.3 -0.3	-0.6 +2.4	+1.8 0	+0.6 -0.6	-0.8 +1.1	+1.2 0	+0.8 +0.1	-1.3 +1.7	+1.8 0	+1.3 +0.1	-1.5 +0.4	+1.2 0	+1.5 +0.8	-2.0 +0.4	+1.2 0	+2.0 +0.8
3.15- 4.73	-0.4 +1.8	+1.4 0	+0.4 -0.4	-0.7 +2.9	+2.2 0	+0.7 -0.7	-1.0 +1.3	+1.4 0	+1.0 +0.1	-1.5 +2.1	+2.2 0	+1.5 +0.1	-1.9 +0.4	+1.4 0	+1.9 +1.0	-2.4 +0.4	+1.4 0	+2.4 +1.0
4.73- 7.09	-0.5 +2.1	+1.6 0	+0.5 -0.5	-0.8 +3.3	+2.5 0	+0.8 -0.8	-1.1 +1.5	+1.6 0	+1.1 +0.1	-1.7 +2.4	+2.5 0	+1.7 +0.1	-2.2 +0.4	+1.6 0	+2.2 +1.2	-2.8 +0.4	+1.6 0	+2.8 +1.2
7.09- 9.85	-0.6 +2.4	+1.8 0	+0.6 -0.6	-0.9 +3.7	+2.8 0	+0.9 -0.9	-1.4 +1.6	+1.8 0	+1.4 +0.2	-2.0 +2.6	+2.8 0	+2.0 +0.2	-2.6 +0.4	+1.8 0	+2.6 +1.4	-3.2 +0.4	+1.8 0	+3.2 +1.4
9.85-12.41	-0.6 +2.6	+2.0 0	+0.6 -0.6	-1.0 +4.0	+3.0 0	+1.0 -1.0	-1.4 +1.8	+2.0 0	+1.4 +0.2	-2.2 +2.8	+3.0 0	+2.2 +0.2	-2.6 +0.6	+2.0 0	+2.6 +1.4	-3.4 +0.6	+2.0 0	+3.4 +1.6
12.41-15.75	-0.7 +2.9	+2.2 0	+0.7 -0.7	-1.0 +4.5	+3.5 0	+1.0 -1.0	-1.6 +2.0	+2.2 0	+1.6 +0.2	-2.4 +3.3	+3.5 0	+2.4 +0.2	-3.0 +0.6	+2.2 0	+3.0 +1.6	-3.8 +0.6	+2.2 0	+3.8 +1.6
15.75-19.69	-0.8 +3.3	+2.5 0	+0.8 -0.8	-1.2 +5.2	+4.0 0	+1.2 -1.2	-1.8 +2.3	+2.5 0	+1.8 +0.2	-2.7 +3.8	+4.0 0	+2.7 +0.2	-3.4 +0.7	+2.5 0	+3.4 +1.8	-4.3 +0.7	+2.5 0	+4.3 +1.8

All data above heavy lines are in accord with ABC agreements. Symbols H7, js6, etc. are hole and shaft designations in ABC system.

* Pairs of values shown represent maximum amount of interference (-) and maximum amount of clearance (+) resulting from application of standard tolerance limits.

SOURCE: Reprinted courtesy of The American Society of Mechanical Engineers.

Appendix 6 ANSI Interference Locational Fits (LN)
ANSI Standard Interference Locational Fits (ANSI B4.1-1967, R1979)

Tolerance limits given in body of table are added or subtracted to basic size (as indicated by + or - sign) to obtain maximum and minimum sizes of mating parts.

Nominal Size Range, Inches	Over	To	Class LN 1		Class LN 2		Class LN 3	
			Standard Limits		Standard Limits		Standard Limits	
			Limits of Inter- ference	Hole H6	Shaft n5	Limits of Inter- ference	Hole H7	Shaft p6
Values shown below are given in thousandths of an inch								
0- 0.12	0 0.45		+ 0.25 0	+ 0.45 + 0.25	0 0.65	+ 0.4 0	+ 0.65 + 0.4	0.1 0.75
0.12- 0.24	0 0.5		+ 0.3 0	+ 0.5 + 0.3	0 0.8	+ 0.5 0	+ 0.8 + 0.5	0.1 0.9
0.24- 0.40	0 0.65		+ 0.4 0	+ 0.65 + 0.4	0 1.0	+ 0.6 0	+ 1.0 + 0.6	0.2 1.2
0.40- 0.71	0 0.8		+ 0.4 0	+ 0.8 + 0.4	0 1.1	+ 0.7 0	+ 1.1 + 0.7	0.3 1.4
0.71- 1.19	0 1.0		+ 0.5 0	+ 1.0 + 0.5	0 1.3	+ 0.8 0	+ 1.3 + 0.8	0.4 1.7
1.19- 1.97	0 1.1		+ 0.6 0	+ 1.1 + 0.6	0 1.6	+ 1.0 0	+ 1.6 + 1.0	0.4 2.0
1.97- 3.15	0.1 1.3		+ 0.7 0	+ 1.3 + 0.8	0.2 2.1	+ 1.2 0	+ 2.1 + 1.4	0.4 2.3
3.15- 4.73	0.1 1.6		+ 0.9 0	+ 1.6 + 1.0	0.2 2.5	+ 1.4 0	+ 2.5 + 1.6	0.6 2.9
4.73- 7.09	0.2 1.9		+ 1.0 0	+ 1.9 + 1.2	0.2 2.8	+ 1.6 0	+ 2.8 + 1.8	0.9 3.5
7.09- 9.85	0.2 2.2		+ 1.2 0	+ 2.2 + 1.4	0.2 3.2	+ 1.8 0	+ 3.2 + 2.0	1.2 4.2
9.85-12.41	0.2 2.3		+ 1.2 0	+ 2.3 + 1.4	0.2 3.4	+ 2.0 0	+ 3.4 + 2.2	1.5 4.7
12.41-15.75	0.2 2.6		+ 1.4 0	+ 2.6 + 1.6	0.3 3.9	+ 2.2 0	+ 3.9 + 2.5	2.3 5.9
15.75-19.69	0.2 2.8		+ 1.6 0	+ 2.8 + 1.8	0.3 4.4	+ 2.5 0	+ 4.4 + 2.8	2.5 6.6

All data in this table are in accordance with American-British-Canadian (ABC) agreements.
Limits for sizes above 19.69 inches are not covered by ABC agreements but are given in the ANSI Standard.

Symbols H7, p6, etc. are hole and shaft designations in ABC system.

* Pairs of values shown represent minimum and maximum amounts of interference resulting from application of standard tolerance limits.

SOURCE: Reprinted courtesy of The American Society of Mechanical Engineers.

Appendix 7 ANSI Force and Shrink Fits (FN)
ANSI Standard Force and Shrink Fits (ANSI B4.1-1967, R1979)

Nominal Size Range, Inches Over To	Class FN 1			Class FN 2			Class FN 3			Class FN 4			Class FN 5		
	Interference*	Standard Tolerance Limits		Interference*	Standard Tolerance Limits		Interference*	Standard Tolerance Limits		Interference*	Standard Tolerance Limits		Interference*	Standard Tolerance Limits	
		Hole H6	Shaft		Hole H7	Shaft s6		Hole H7	Shaft t6		Hole H7	Shaft u6		Hole H8	Shaft x7
Values shown below are in thousandths of an inch															
0-0.12	0.05 0.5	+ 0.25 0	+ 0.5 + 0.3	0.2 0.85	+ 0.4 0	+ 0.85 + 0.6				0.3 0.95	+ 0.4 0	+ 0.95 + 0.7	0.3 1.3	+ 0.6 0	+ 1.3 + 0.9
0.12-0.24	0.1 0.6	+ 0.3 0	+ 0.6 + 0.4	0.2 1.0	+ 0.5 0	+ 1.0 + 0.7				0.4 1.2	+ 0.5 0	+ 1.2 + 0.9	0.5 1.7	+ 0.7 0	+ 1.7 + 1.2
0.24-0.40	0.1 0.75	+ 0.4 0	+ 0.75 + 0.5	0.4 1.4	+ 0.6 0	+ 1.4 + 1.0				0.6 1.6	+ 0.6 0	+ 1.6 + 1.2	0.5 2.0	+ 0.9 0	+ 2.0 + 1.4
0.40-0.56	0.1 0.8	+ 0.4 0	+ 0.8 + 0.5	0.5 1.6	+ 0.7 0	+ 1.6 + 1.2				0.7 1.8	+ 0.7 0	+ 1.8 + 1.4	0.6 2.3	+ 1.0 0	+ 2.3 + 1.6
0.56-0.71	0.2 0.9	+ 0.4 0	+ 0.9 + 0.6	0.5 1.6	+ 0.7 0	+ 1.6 + 1.2				0.7 1.8	+ 0.7 0	+ 1.8 + 1.4	0.8 2.5	+ 1.0 0	+ 2.5 + 1.8
0.71-0.95	0.2 1.1	+ 0.5 0	+ 1.1 + 0.7	0.6 1.9	+ 0.8 0	+ 1.9 + 1.4				0.8 2.1	+ 0.8 0	+ 2.1 + 1.6	1.0 3.0	+ 1.2 0	+ 3.0 + 2.2
0.95-1.19	0.3 1.2	+ 0.5 0	+ 1.2 + 0.8	0.6 1.9	+ 0.8 0	+ 1.9 + 1.4				1.0 2.1	+ 0.8 0	+ 2.3 + 1.8	1.3 3.3	+ 1.2 0	+ 3.3 + 2.5
1.19-1.58	0.3 1.3	+ 0.6 0	+ 1.3 + 0.9	0.8 2.4	+ 1.0 0	+ 2.4 + 1.8	1.0 2.6	+ 1.0 0	+ 2.6 + 2.0	1.5 3.1	+ 1.0 0	+ 3.1 + 2.5	1.4 4.0	+ 1.6 0	+ 4.0 + 3.0
1.58-1.97	0.4 1.4	+ 0.6 0	+ 1.4 + 1.0	0.8 2.4	+ 1.0 0	+ 2.4 + 1.8	1.2 2.8	+ 1.0 0	+ 2.8 + 2.2	1.8 3.4	+ 1.0 0	+ 3.4 + 2.8	2.4 5.0	+ 1.6 0	+ 5.0 + 4.0
1.97-2.56	0.6 1.8	+ 0.7 0	+ 1.8 + 1.3	0.8 2.7	+ 1.2 0	+ 2.7 + 2.0	1.3 3.2	+ 1.2 0	+ 3.2 + 2.5	2.3 4.2	+ 1.2 0	+ 4.2 + 3.5	3.2 6.2	+ 1.8 0	+ 6.2 + 5.0
2.56-3.15	0.7 1.9	+ 0.7 0	+ 1.9 + 1.4	1.0 2.9	+ 1.2 0	+ 2.9 + 2.2	1.8 3.7	+ 1.2 0	+ 3.7 + 3.0	2.8 4.7	+ 1.2 0	+ 4.7 + 4.0	4.2 7.2	+ 1.8 0	+ 7.2 + 6.0
3.15-3.94	0.9 2.4	+ 0.9 0	+ 2.4 + 1.8	1.4 3.7	+ 1.4 0	+ 3.7 + 2.8	2.1 4.4	+ 1.4 0	+ 4.4 + 3.5	3.6 5.9	+ 1.4 0	+ 5.9 + 5.0	4.8 8.4	+ 2.2 0	+ 8.4 + 7.0
3.94-4.73	1.1 2.6	+ 0.9 0	+ 2.6 + 2.0	1.6 3.9	+ 1.4 0	+ 3.9 + 3.0	2.6 4.9	+ 1.4 0	+ 4.9 + 4.0	4.6 6.9	+ 1.4 0	+ 6.9 + 6.0	5.8 9.4	+ 2.2 0	+ 9.4 + 8.0

See footnotes at end of table.

Nominal Size Range, Inches Over To	Class FN 1			Class FN 2			Class FN 3			Class FN 4			Class FN 5		
	Interference*	Standard Tolerance Limits		Interference*	Standard Tolerance Limits		Interference*	Standard Tolerance Limits		Interference*	Standard Tolerance Limits		Interference*	Standard Tolerance Limits	
		Hole H6	Shaft		Hole H7	Shaft s6		Hole H7	Shaft t6		Hole H7	Shaft u6		Hole H8	Shaft x7
Values shown below are in thousandths of an inch															
4.73- 5.52	1.2 2.9	+ 1.0 0	+ 2.9 + 2.2	1.9 4.5	+ 1.6 0	+ 4.5 + 3.5	3.4 6.0	+ 1.6 0	+ 6.0 + 5.0	5.4 8.0	+ 1.6 0	+ 8.0 + 7.0	7.5 11.6	+ 2.5 0	+ 11.6 + 10.0
5.52- 6.30	1.5 3.2	+ 1.0 0	+ 3.2 + 2.5	2.4 5.0	+ 1.6 0	+ 5.0 + 4.0	3.4 6.0	+ 1.6 0	+ 6.0 + 5.0	5.4 8.0	+ 1.6 0	+ 8.0 + 7.0	9.5 13.6	+ 2.5 0	+ 13.6 + 12.0
6.30- 7.09	1.8 3.5	+ 1.0 0	+ 3.5 + 2.8	2.9 5.5	+ 1.6 0	+ 5.5 + 4.5	4.4 7.0	+ 1.6 0	+ 7.0 + 6.0	6.4 9.0	+ 1.6 0	+ 9.0 + 8.0	9.5 13.6	+ 2.5 0	+ 13.6 + 12.0
7.09- 7.88	1.8 3.8	+ 1.2 0	+ 3.8 + 3.0	3.2 6.2	+ 1.8 0	+ 6.2 + 5.0	5.2 8.2	+ 1.8 0	+ 8.2 + 7.0	7.2 10.2	+ 1.8 0	+ 10.2 + 9.0	11.2 15.8	+ 2.8 0	+ 15.8 + 14.0
7.88- 8.86	2.3 4.3	+ 1.2 0	+ 4.3 + 3.5	3.2 6.2	+ 1.8 0	+ 6.2 + 5.0	5.2 8.2	+ 1.8 0	+ 8.2 + 7.0	8.2 11.2	+ 1.8 0	+ 11.2 + 10.0	13.2 17.8	+ 2.8 0	+ 17.8 + 16.0
8.86- 9.85	2.3 4.3	+ 1.2 0	+ 4.3 + 3.5	4.2 7.2	+ 1.8 0	+ 7.2 + 6.0	6.2 9.2	+ 1.8 0	+ 9.2 + 8.0	10.2 13.2	+ 1.8 0	+ 13.2 + 12.0	13.2 17.8	+ 2.8 0	+ 17.8 + 16.0
9.85-11.03	2.8 4.9	+ 1.2 0	+ 4.9 + 4.0	4.0 7.2	+ 2.0 0	+ 7.2 + 6.0	7.0 10.2	+ 2.0 0	+ 10.2 + 9.0	10.0 13.2	+ 2.0 0	+ 13.2 + 12.0	15.0 20.0	+ 3.0 0	+ 20.0 + 18.0
11.03-12.41	2.8 4.9	+ 1.2 0	+ 4.9 + 4.0	5.0 8.2	+ 2.0 0	+ 8.2 + 7.0	7.0 10.2	+ 2.0 0	+ 10.2 + 9.0	12.0 15.2	+ 2.0 0	+ 15.2 + 14.0	17.0 22.0	+ 3.0 0	+ 22.0 + 20.0
12.41-13.98	3.1 5.5	+ 1.4 0	+ 5.5 + 4.5	5.8 9.4	+ 2.2 0	+ 9.4 + 8.0	7.8 11.4	+ 2.2 0	+ 11.4 + 10.0	13.8 17.4	+ 2.2 0	+ 17.4 + 16.0	18.5 24.2	+ 3.5 0	+ 24.2 + 22.0
13.98-15.75	3.6 6.1	+ 1.4 0	+ 6.1 + 5.0	5.8 9.4	+ 2.2 0	+ 9.4 + 8.0	9.8 13.4	+ 2.2 0	+ 13.4 + 12.0	15.8 19.4	+ 2.2 0	+ 19.4 + 18.0	21.5 27.2	+ 3.5 0	+ 27.2 + 25.0
15.75-17.72	4.4 7.0	+ 1.6 0	+ 7.0 + 6.0	6.5 10.6	+ 2.5 0	+ 10.6 + 9.0	9.5 13.6	+ 2.5 0	+ 13.6 + 12.0	17.5 21.6	+ 2.5 0	+ 21.6 + 20.0	24.0 30.5	+ 4.0 0	+ 30.5 + 28.0
17.72-19.69	4.4 7.0	+ 1.6 0	+ 7.0 + 6.0	7.5 11.6	+ 2.5 0	+ 11.6 + 10.0	11.5 15.6	+ 2.5 0	+ 15.6 + 14.0	19.5 23.6	+ 2.5 0	+ 23.6 + 22.0	26.0 32.5	+ 4.0 0	+ 32.5 + 30.0

All data above heavy lines are in accordance with American-British-Canadian (ABC) agreements. Symbols H6, H7, s6, etc. are hole and shaft designations in ABC system. Limits for sizes above 19.69 inches are not covered by ABC agreements but are given in the ANSI standard.

* Pairs of values shown represent minimum and maximum amounts of interference resulting from application of standard tolerance limits.

SOURCE: Reprinted courtesy of The American Society of Mechanical Engineers.

Appendix 8 Description of Preferred Metric Fits

ISO SYMBOL		DESCRIPTION
Hole Basis	Shaft Basis	
H11/c11	C11/h11	<i>Loose running</i> fit for wide commercial tolerances or allowances on external members.
H9/d9	D9/h9	<i>Free running</i> fit not for use where accuracy is essential, but good for large temperature variations, high running speeds, or heavy journal pressures.
H8/f7	F8/h7	<i>Close running</i> fit for running on accurate machines and for accurate location at moderate speeds and journal pressures.
H7/g6	G7/h6	<i>Sliding</i> fit not intended to run freely, but to move and turn freely and locate accurately.
H7/h6	H7/h6	<i>Locational clearance</i> fit provides snug fit for locating stationary parts; but can be freely assembled and disassembled.
H7/k6	K7/h6	<i>Locational transition</i> fit for accurate location, a compromise between clearance and interference.
H7/n6	N7/h6	<i>Locational transition</i> fit for more accurate location where greater interference is permissible.
H7/p6 ¹	P7/h6	<i>Locational interference</i> fit for parts requiring rigidity and alignment with prime accuracy of location but without special bore pressure requirements.
H7/s6	S7/h6	<i>Medium drive</i> fit for ordinary steel parts or shrink fits on light sections, the tightest fit usable with cast iron.
H7/u6	U7/h6	<i>Force</i> fit suitable for parts which can be highly stressed or for shrink fits where the heavy pressing forces required are impractical.

¹ Transition fit for basic sizes in range from 0 through 3 mm.

SOURCE: Reprinted courtesy of The American Society of Mechanical Engineers.

Appendix 9 ANSI Preferred Hole Basis Metric Clearance Fits
American National Standard Preferred Hole Basis Metric Clearance Fits (ANSI B4.2-1978, R1984)

Basic Size*	Loose Running			Free Running			Close Running			Sliding			Locational Clearance		
	Hole H11	Shaft c11	Fit [†]	Hole H9	Shaft dg	Fit [†]	Hole H8	Shaft f7	Fit [†]	Hole H7	Shaft g6	Fit [†]	Hole H7	Shaft h6	Fit [†]
1 Max	1.060	0.940	0.180	1.025	0.980	0.070	1.014	0.994	0.030	1.010	0.998	0.018	1.010	1.000	0.016
1 Min	1.000	0.880	0.060	1.000	0.955	0.020	1.000	0.984	0.006	1.000	0.992	0.002	1.000	0.994	0.000
1.2 Max	1.260	1.140	0.180	1.225	1.180	0.070	1.214	1.194	0.030	1.210	1.198	0.018	1.210	1.200	0.016
1.2 Min	1.200	1.080	0.060	1.200	1.155	0.020	1.200	1.184	0.006	1.200	1.192	0.002	1.200	1.194	0.000
1.6 Max	1.660	1.540	0.180	1.625	1.580	0.070	1.614	1.594	0.030	1.610	1.598	0.018	1.610	1.600	0.016
1.6 Min	1.600	1.480	0.060	1.600	1.555	0.020	1.600	1.584	0.006	1.600	1.592	0.002	1.600	1.594	0.000
2 Max	2.060	1.940	0.180	2.025	1.980	0.070	2.014	1.994	0.030	2.010	1.998	0.018	2.010	2.000	0.016
2 Min	2.000	1.880	0.060	2.000	1.955	0.020	2.000	1.984	0.006	2.000	1.992	0.002	2.000	1.994	0.000
2.5 Max	2.560	2.440	0.180	2.525	2.480	0.070	2.514	2.494	0.030	2.510	2.498	0.018	2.510	2.500	0.016
2.5 Min	2.500	2.380	0.060	2.500	2.455	0.020	2.500	2.484	0.006	2.500	2.492	0.002	2.500	2.494	0.000
3 Max	3.060	2.940	0.180	3.025	2.980	0.070	3.014	2.994	0.030	3.010	2.998	0.018	3.010	3.000	0.016
3 Min	3.000	2.880	0.060	3.000	2.955	0.020	3.000	2.984	0.006	3.000	2.992	0.002	3.000	2.994	0.000
4 Max	4.075	3.930	0.220	4.030	3.970	0.090	4.018	3.990	0.040	4.012	3.996	0.024	4.012	4.000	0.020
4 Min	4.000	3.855	0.070	4.000	3.940	0.030	4.000	3.978	0.010	4.000	3.988	0.004	4.000	3.992	0.000
5 Max	5.075	4.930	0.220	5.030	4.970	0.090	5.018	4.990	0.040	5.012	4.996	0.024	5.012	5.000	0.020
5 Min	5.000	4.855	0.070	5.000	4.940	0.030	5.000	4.978	0.010	5.000	4.988	0.004	5.000	4.992	0.000
6 Max	6.075	5.930	0.220	6.030	5.970	0.090	6.018	5.990	0.040	6.012	5.996	0.024	6.012	6.000	0.020
6 Min	6.000	5.855	0.070	6.000	5.940	0.030	6.000	5.978	0.010	6.000	5.988	0.004	6.000	5.992	0.000
8 Max	8.090	7.920	0.260	8.036	7.960	0.112	8.022	7.987	0.050	8.015	7.995	0.029	8.015	8.000	0.024
8 Min	8.000	7.830	0.080	8.000	7.924	0.040	8.000	7.972	0.013	8.000	7.986	0.005	8.000	7.991	0.000
10 Max	10.090	9.920	0.260	10.036	9.960	0.112	10.022	9.987	0.050	10.015	9.995	0.029	10.015	10.000	0.024
10 Min	10.000	9.830	0.080	10.000	9.924	0.040	10.000	9.972	0.013	10.000	9.986	0.005	10.000	9.991	0.000
12 Max	12.110	11.905	0.315	12.043	11.956	0.136	12.027	11.984	0.061	12.018	11.994	0.035	12.018	12.000	0.029
12 Min	12.000	11.795	0.095	12.000	11.907	0.050	12.000	11.966	0.016	12.000	11.983	0.006	12.000	11.989	0.000
16 Max	16.110	15.905	0.315	16.043	15.950	0.136	16.027	15.984	0.061	16.018	15.994	0.035	16.018	16.000	0.029
16 Min	16.000	15.795	0.095	16.000	15.907	0.050	16.000	15.966	0.016	16.000	15.983	0.006	16.000	15.989	0.000
20 Max	20.130	19.890	0.370	20.052	19.935	0.169	20.033	19.980	0.074	20.021	19.993	0.041	20.021	20.000	0.034
20 Min	20.000	19.760	0.110	20.000	19.883	0.065	20.000	19.959	0.020	20.000	19.980	0.007	20.000	19.987	0.000

Basic Size*	Loose Running			Free Running			Close Running			Sliding			Locational Clearance		
	Hole H11	Shaft c11	Fit [†]	Hole H9	Shaft dg	Fit [†]	Hole H8	Shaft f7	Fit [†]	Hole H7	Shaft g6	Fit [†]	Hole H7	Shaft h6	Fit [†]
25 Max	25.130	24.890	0.370	25.052	24.935	0.169	25.033	24.980	0.074	25.021	24.993	0.041	25.021	25.000	0.034
25 Min	25.000	24.760	0.110	25.000	24.883	0.065	25.000	24.959	0.020	25.000	24.980	0.007	25.000	24.987	0.000
30 Max	30.130	29.890	0.370	30.052	29.935	0.169	30.033	29.980	0.074	30.021	29.993	0.041	30.021	30.000	0.034
30 Min	30.000	29.760	0.110	30.000	29.883	0.065	30.000	29.959	0.020	30.000	29.980	0.007	30.000	29.987	0.000
40 Max	40.160	39.880	0.440	40.062	39.920	0.204	40.039	39.975	0.089	40.025	39.991	0.050	40.025	40.000	0.041
40 Min	40.000	39.720	0.120	40.000	39.858	0.080	40.000	39.950	0.025	40.000	39.975	0.009	40.000	39.984	0.000
50 Max	50.160	49.870	0.450	50.062	49.920	0.204	50.039	49.975	0.089	50.025	49.991	0.050	50.025	50.000	0.041
50 Min	50.000	49.710	0.130	50.000	49.858	0.080	50.000	49.950	0.025	50.000	49.975	0.009	50.000	49.984	0.000
60 Max	60.190	59.860	0.520	60.074	59.900	0.248	60.046	59.970	0.106	60.030	59.990	0.059	60.030	60.000	0.049
60 Min	60.000	59.670	0.140	60.000	59.826	0.100	60.000	59.940	0.030	60.000	59.971	0.010	60.000	59.981	0.000
80 Max	80.190	79.850	0.530	80.074	79.900	0.248	80.046	79.970	0.106	80.030	79.990	0.059	80.030	80.000	0.049
80 Min	80.000	79.660	0.150	80.000	79.826	0.100	80.000	79.940	0.030	80.000	79.971	0.010	80.000	79.981	0.000
100 Max	100.220	99.830	0.610	100.087	99.880	0.294	100.054	99.964	0.125	100.035	99.988	0.069	100.035	100.000	0.057
100 Min	100.000	99.610	0.170	100.000	99.793	0.120	100.000	99.929	0.036	100.000	99.966	0.012	100.000	99.978	0.000
120 Max	120.220	119.820	0.620	120.087	119.880	0.294	120.054	119.964	0.125	120.035	119.988	0.069	120.035	120.000	0.057
120 Min	120.000	119.600	0.180	120.000	119.793	0.120	120.000	119.929	0.036	120.000	119.966	0.012	120.000	119.978	0.000
160 Max	160.250	159.790	0.710	160.100	159.855	0.345	160.063	159.957	0.146	160.040	159.986	0.079	160.040	160.000	0.065
160 Min	160.000	159.540	0.210	160.000	159.755	0.145	160.000	159.917	0.043	160.000	159.961	0.014	160.000	159.975	0.000
200 Max	200.190	199.760	0.820	200.115	199.830	0.400	200.072	199.950	0.168	200.046	199.985	0.090	200.046	200.000	0.075
200 Min	200.000	199.470	0.240	200.000	199.715	0.170	200.000	199.904	0.050	200.000	199.956	0.015	200.000	199.971	0.000
250 Max	250.290	249.720	0.860	250.115	249.830	0.400	250.072	249.950	0.168	250.046	249.985	0.090	250.046	250.000	0.075
250 Min	250.000	249.430	0.280	250.000	249.715	0.170	250.000	249.904	0.050	250.000	249.956	0.015	250.000	249.971	0.000
300 Max	300.320	299.670	0.970	300.130	299.810	0.450	300.081	299.944	0.189	300.052	299.983	0.101	300.052	300.000	0.084
300 Min	300.000	299.350	0.330	300.000	299.680	0.190	300.000	299.892	0.056	300.000	299.951	0.017	300.000	299.968	0.000
400 Max	400.360	399.600	1.120	400.140	399.790	0.490	400.089	399.938	0.208	400.057	399.982	0.111	400.057	400.000	0.093
400 Min	400.000	399.240	0.400	400.000	399.650	0.210	400.000	399.881	0.062	400.000	399.946	0.018	400.000	399.964	0.000
500 Max	500.400	499.520	1.280	500.155	499.770	0.540	500.097	499.932	0.228	500.063	499.980	0.123	500.063	500.000	0.103
500 Min	500.000	499.120	0.480	500.000	499.615	0.230	500.000	499.869	0.068	500.000	499.940	0.020	500.000	499.960	0.000

All dimensions are in millimeters.

* The sizes shown are first choice basic sizes (see Table 1). Preferred fits for other sizes can be calculated from data given in ANSI B4.2-1978 (R1984).

† All fits shown in this table have clearance.

SOURCE: Reprinted courtesy of The American Society of Mechanical Engineers.

Appendix 10 ANSI Preferred Hole Basis Transition and Interference Fits (ANSI B4.2-1978, R1984)

Basic Size*	Locational Transition			Locational Transition			Locational Interference			Medium Drive			Force		
	Hole H ₇	Shaft k ₆	Fit [†]	Hole H ₇	Shaft n ₆	Fit [†]	Hole H ₇	Shaft p ₆	Fit [†]	Hole H ₇	Shaft s ₆	Fit [†]	Hole H ₇	Shaft u ₆	Fit [†]
1 Max	1.010	1.006	+0.010	1.010	1.010	+0.006	1.010	1.012	+0.004	1.010	1.020	-0.004	1.010	1.024	-0.008
1 Min	1.000	1.000	-0.006	1.000	1.004	-0.010	1.000	1.006	-0.012	1.000	1.014	-0.020	1.000	1.018	-0.024
1.2 Max	1.210	1.206	+0.010	1.210	1.210	+0.006	1.210	1.212	+0.004	1.210	1.220	-0.004	1.210	1.224	-0.008
1.2 Min	1.200	1.200	-0.006	1.200	1.204	-0.010	1.200	1.206	-0.012	1.200	1.214	-0.020	1.200	1.218	-0.024
1.6 Max	1.610	1.606	+0.010	1.610	1.610	+0.006	1.610	1.612	+0.004	1.610	1.620	-0.004	1.610	1.624	-0.008
1.6 Min	1.600	1.600	-0.006	1.600	1.604	-0.010	1.600	1.606	-0.012	1.600	1.614	-0.020	1.600	1.618	-0.024
2 Max	2.010	2.006	+0.010	2.010	2.010	+0.006	2.010	2.012	+0.004	2.010	2.020	-0.004	2.010	2.024	-0.008
2 Min	2.000	2.000	-0.006	2.000	2.004	-0.010	2.000	2.006	-0.012	2.000	2.014	-0.020	2.000	2.018	-0.024
2.5 Max	2.510	2.506	+0.010	2.510	2.510	+0.006	2.510	2.512	+0.004	2.510	2.520	-0.004	2.510	2.524	-0.008
2.5 Min	2.500	2.500	-0.006	2.500	2.504	-0.010	2.500	2.506	-0.012	2.500	2.514	-0.020	2.500	2.518	-0.024
3 Max	3.010	3.006	+0.010	3.010	3.010	+0.006	3.010	3.012	+0.004	3.010	3.020	-0.004	3.010	3.024	-0.008
3 Min	3.000	3.000	-0.006	3.000	3.004	-0.010	3.000	3.006	-0.012	3.000	3.014	-0.020	3.000	3.018	-0.024
4 Max	4.012	4.009	+0.011	4.012	4.016	+0.004	4.012	4.020	0.000	4.012	4.027	-0.007	4.012	4.031	-0.011
4 Min	4.000	4.001	-0.009	4.000	4.008	-0.016	4.000	4.012	-0.020	4.000	4.019	-0.027	4.000	4.023	-0.031
5 Max	5.012	5.009	+0.011	5.012	5.016	+0.004	5.012	5.020	0.000	5.012	5.027	-0.007	5.012	5.031	-0.011
5 Min	5.000	5.001	-0.009	5.000	5.008	-0.016	5.000	5.012	-0.020	5.000	5.019	-0.027	5.000	5.023	-0.031
6 Max	6.012	6.009	+0.011	6.012	6.016	+0.004	6.012	6.020	0.000	6.012	6.027	-0.007	6.012	6.031	-0.011
6 Min	6.000	6.001	-0.009	6.000	6.008	-0.016	6.000	6.012	-0.020	6.000	6.019	-0.027	6.000	6.023	-0.031
8 Max	8.015	8.010	+0.014	8.015	8.019	+0.005	8.015	8.024	0.000	8.015	8.032	-0.008	8.015	8.037	-0.013
8 Min	8.000	8.001	-0.010	8.000	8.010	-0.019	8.000	8.015	-0.024	8.000	8.023	-0.032	8.000	8.028	-0.037
10 Max	10.015	10.010	+0.014	10.015	10.019	+0.005	10.015	10.024	0.000	10.015	10.032	-0.008	10.015	10.037	-0.013
10 Min	10.000	10.001	-0.010	10.000	10.010	-0.019	10.000	10.015	-0.024	10.000	10.023	-0.032	10.000	10.028	-0.037
12 Max	12.018	12.012	+0.017	12.018	12.023	+0.006	12.018	12.029	0.000	12.018	12.039	-0.010	12.018	12.044	-0.015
12 Min	12.000	12.001	-0.012	12.000	12.012	-0.023	12.000	12.018	-0.029	12.000	12.028	-0.039	12.000	12.033	-0.044
16 Max	16.018	16.012	+0.017	16.018	16.023	+0.006	16.018	16.029	0.000	16.018	16.039	-0.010	16.018	16.044	-0.015
16 Min	16.000	16.001	-0.012	16.000	16.012	-0.023	16.000	16.018	-0.029	16.000	16.028	-0.039	16.000	16.033	-0.044
20 Max	20.021	20.015	+0.019	20.021	20.028	+0.006	20.021	20.035	-0.001	20.021	20.048	-0.014	20.021	20.054	-0.020
20 Min	20.000	20.002	-0.015	20.000	20.015	-0.028	20.000	20.022	-0.035	20.000	20.035	-0.048	20.000	20.041	-0.054

Basic Size*	Locational Transition			Locational Transition			Locational Interference			Medium Drive			Force		
	Hole H ₇	Shaft k ₆	Fit [†]	Hole H ₇	Shaft n ₆	Fit [†]	Hole H ₇	Shaft p ₆	Fit [†]	Hole H ₇	Shaft s ₆	Fit [†]	Hole H ₇	Shaft u ₆	Fit [†]
25 Max	25.021	25.015	+0.019	25.021	25.028	+0.006	25.021	25.035	-0.001	25.021	25.048	-0.014	25.021	25.061	-0.027
25 Min	25.000	25.002	-0.015	25.000	25.015	-0.028	25.000	25.022	-0.035	25.000	25.035	-0.048	25.000	25.048	-0.061
30 Max	30.021	30.015	+0.019	30.021	30.028	+0.006	30.021	30.035	-0.001	30.021	30.048	-0.014	30.021	30.061	-0.027
30 Min	30.000	30.002	-0.015	30.000	30.015	-0.028	30.000	30.022	-0.035	30.000	30.035	-0.048	30.000	30.048	-0.061
40 Max	40.025	40.018	+0.023	40.025	40.033	+0.008	40.025	40.042	-0.001	40.025	40.059	-0.018	40.025	40.076	-0.035
40 Min	40.000	40.002	-0.018	40.000	40.017	-0.033	40.000	40.026	-0.042	40.000	40.043	-0.059	40.000	40.060	-0.076
50 Max	50.025	50.018	+0.023	50.025	50.033	+0.008	50.025	50.042	-0.001	50.025	50.059	-0.018	50.025	50.086	-0.045
50 Min	50.000	50.002	-0.018	50.000	50.017	-0.033	50.000	50.026	-0.042	50.000	50.043	-0.059	50.000	50.070	-0.086
60 Max	60.030	60.021	+0.028	60.030	60.039	+0.010	60.030	60.051	-0.002	60.030	60.072	-0.023	60.030	60.106	-0.057
60 Min	60.000	60.002	-0.021	60.000	60.020	-0.039	60.000	60.032	-0.051	60.000	60.053	-0.072	60.000	60.087	-0.106
80 Max	80.030	80.021	+0.028	80.030	80.039	+0.010	80.030	80.051	-0.002	80.030	80.078	-0.029	80.030	80.121	-0.072
80 Min	80.000	80.002	-0.021	80.000	80.020	-0.039	80.000	80.032	-0.051	80.000	80.059	-0.078	80.000	80.102	-0.121
100 Max	100.035	100.025	+0.032	100.035	100.045	+0.012	100.035	100.059	-0.002	100.035	100.093	-0.036	100.035	100.146	-0.089
100 Min	100.000	100.003	-0.025	100.000	100.023	-0.045	100.000	100.037	-0.059	100.000	100.071	-0.093	100.000	100.124	-0.146
120 Max	120.035	120.025	+0.032	120.035	120.045	+0.012	120.035	120.059	-0.002	120.035	120.101	-0.044	120.035	120.166	-0.109
120 Min	120.000	120.003	-0.025	120.000	120.023	-0.045	120.000	120.037	-0.059	120.000	120.079	-0.101	120.000	120.144	-0.166
160 Max	160.040	160.028	+0.037	160.040	160.052	+0.013	160.040	160.068	-0.003	160.040	160.125	-0.060	160.040	160.215	-0.150
160 Min	160.000	160.003	-0.028	160.000	160.027	-0.052	160.000	160.043	-0.068	160.000	160.100	-0.125	160.000	160.190	-0.215
200 Max	200.046	200.033	+0.042	200.046	200.060	+0.015	200.046	200.079	-0.004	200.046	200.151	-0.076	200.046	200.265	-0.190
200 Min	200.000	200.004	-0.033	200.000	200.031	-0.060	200.000	200.050	-0.079	200.000	200.122	-0.151	200.000	200.236	-0.265
250 Max	250.046	250.033	+0.042	250.046	250.060	+0.015	250.046	250.079	-0.004	250.046	250.169	-0.094	250.046	250.313	-0.238
250 Min	250.000	250.004	-0.033	250.000	250.031	-0.060	250.000	250.050	-0.079	250.000	250.140	-0.169	250.000	250.284	-0.313
300 Max	300.052	300.036	+0.048	300.052	300.066	+0.018	300.052	300.088	-0.004	300.052	300.202	-0.118	300.052	300.382	-0.298
300 Min	300.000	300.004	-0.036	300.000	300.034	-0.066	300.000	300.056	-0.088	300.000	300.170	-0.202	300.000	300.350	-0.382
400 Max	400.057	400.040	+0.053	400.057	400.073	+0.020	400.057	400.098	-0.005	400.057	400.244	-0.151	400.057	400.471	-0.378
400 Min	400.000	400.004	-0.040	400.000	400.037	-0.073	400.000	400.062	-0.098	400.000	400.208	-0.244	400.000	400.435	-0.471
500 Max	500.063	500.045	+0.058	500.063	500.080	+0.023	500.063	500.108	-0.005	500.063	500.292	-0.189	500.063	500.580	-0.477
500 Min	500.000	500.005	-0.045	500.000	500.040	-0.080	500.000	500.068	-0.108	500.000	500.252	-0.292	500.000	500.540	-0.580

All dimensions are in millimeters.

* The sizes shown are first choice basic sizes (see Table 1). Preferred fits for other sizes can be calculated from data given in ANSI B4.2-1978 (R1984).

† A plus sign indicates clearance; a minus sign indicates interference.

SOURCE: Reprinted courtesy of The American Society of Mechanical Engineers.

Appendix 11 ANSI Preferred Shaft Basis Metric Clearance Fits
American National Standard Preferred Shaft Basis Metric Clearance Fits (ANSI B4.2-1978, R1984)

Basic Size*	Loose Running			Free Running			Close Running			Sliding			Locational Clearance			
	Hole C ₁₁	Shaft h ₁₁	Fit [†]	Hole D ₉	Shaft h ₉	Fit [†]	Hole F ₈	Shaft h ₇	Fit [†]	Hole G ₇	Shaft h ₆	Fit [†]	Hole H ₇	Shaft h ₆	Fit [†]	
1	Max	1.120	1.000	0.180	1.045	1.000	0.070	1.020	1.000	0.030	1.012	1.000	0.018	1.010	1.000	0.016
	Min	1.060	0.940	0.060	1.020	0.975	0.020	1.006	0.990	0.006	1.002	0.994	0.002	1.000	0.994	0.000
1.2	Max	1.320	1.200	0.180	1.245	1.200	0.070	1.220	1.200	0.030	1.212	1.200	0.018	1.210	1.200	0.016
	Min	1.260	1.140	0.060	1.220	1.175	0.020	1.206	1.190	0.006	1.202	1.194	0.002	1.200	1.194	0.000
1.6	Max	1.720	1.600	0.180	1.645	1.600	0.070	1.620	1.600	0.030	1.612	1.600	0.018	1.610	1.600	0.016
	Min	1.660	1.540	0.060	1.620	1.575	0.020	1.606	1.590	0.006	1.602	1.594	0.002	1.600	1.594	0.000
2	Max	2.120	2.000	0.180	2.045	2.000	0.070	2.020	2.000	0.030	2.012	2.000	0.018	2.010	2.000	0.016
	Min	2.060	1.940	0.060	2.020	1.975	0.020	2.006	1.990	0.006	2.002	1.994	0.002	2.000	1.994	0.000
2.5	Max	2.620	2.500	0.180	2.545	2.500	0.070	2.520	2.500	0.030	2.512	2.500	0.018	2.510	2.500	0.016
	Min	2.560	2.440	0.060	2.520	2.475	0.020	2.506	2.490	0.006	2.502	2.494	0.002	2.500	2.494	0.000
3	Max	3.120	3.000	0.180	3.045	3.000	0.070	3.020	3.000	0.030	3.012	3.000	0.018	3.010	3.000	0.016
	Min	3.060	2.940	0.060	3.020	2.975	0.020	3.006	2.990	0.006	3.002	2.994	0.002	3.000	2.994	0.000
4	Max	4.145	4.000	0.220	4.060	4.000	0.090	4.028	4.000	0.040	4.016	4.000	0.024	4.012	4.000	0.020
	Min	4.070	3.925	0.070	4.030	3.970	0.030	4.010	3.988	0.010	4.004	3.992	0.004	4.000	3.992	0.000
5	Max	5.145	5.000	0.220	5.060	5.000	0.090	5.028	5.000	0.040	5.016	5.000	0.024	5.012	5.000	0.020
	Min	5.070	4.925	0.070	5.030	4.970	0.030	5.010	4.988	0.010	5.004	4.992	0.004	5.000	4.992	0.000
6	Max	6.145	6.000	0.220	6.060	6.000	0.090	6.028	6.000	0.040	6.016	6.000	0.024	6.012	6.000	0.020
	Min	6.070	5.925	0.070	6.030	5.970	0.030	6.010	5.988	0.010	6.004	5.992	0.004	6.000	5.992	0.000
8	Max	8.170	8.000	0.260	8.076	8.000	0.112	8.035	8.000	0.050	8.020	8.000	0.029	8.015	8.000	0.024
	Min	8.080	7.910	0.080	8.040	7.964	0.040	8.013	7.985	0.013	8.005	7.991	0.005	8.000	7.991	0.000
10	Max	10.170	10.000	0.260	10.076	10.000	0.112	10.035	10.000	0.050	10.020	10.000	0.029	10.015	10.000	0.024
	Min	10.080	9.910	0.080	10.040	9.964	0.040	10.013	9.985	0.013	10.005	9.991	0.005	10.000	9.991	0.000
12	Max	12.205	12.000	0.315	12.093	12.000	0.136	12.043	12.000	0.061	12.024	12.000	0.035	12.018	12.000	0.029
	Min	12.095	11.890	0.095	12.050	11.957	0.050	12.016	11.982	0.016	12.006	11.989	0.006	12.000	11.989	0.000
16	Max	16.205	16.000	0.315	16.093	16.000	0.136	16.043	16.000	0.061	16.024	16.000	0.035	16.018	16.000	0.029
	Min	16.095	15.890	0.095	16.050	15.957	0.050	16.016	15.982	0.016	16.006	15.989	0.006	16.000	15.989	0.000
20	Max	20.240	20.000	0.370	20.117	20.000	0.169	20.053	20.000	0.074	20.028	20.000	0.041	20.021	20.000	0.034
	Min	20.110	19.870	0.110	20.065	19.948	0.065	20.020	19.979	0.020	20.007	19.987	0.007	20.000	19.987	0.000

Basic Size*	Loose Running			Free Running			Close Running			Sliding			Locational Clearance			
	Hole C ₁₁	Shaft h ₁₁	Fit [†]	Hole D ₉	Shaft h ₉	Fit [†]	Hole F ₈	Shaft h ₇	Fit [†]	Hole G ₇	Shaft h ₆	Fit [†]	Hole H ₇	Shaft h ₆	Fit [†]	
25	Max	25.240	25.000	0.370	25.117	25.000	0.169	25.053	25.000	0.074	25.028	25.000	0.041	25.021	25.000	0.034
	Min	25.110	24.870	0.110	25.065	24.948	0.065	25.020	24.979	0.020	25.007	24.987	0.007	25.000	24.987	0.000
30	Max	30.240	30.000	0.370	30.117	30.000	0.169	30.053	30.000	0.074	30.028	30.000	0.041	30.021	30.000	0.034
	Min	30.110	29.870	0.110	30.065	29.948	0.065	30.020	29.979	0.020	30.007	29.987	0.007	30.000	29.987	0.000
40	Max	40.280	40.000	0.440	40.142	40.000	0.204	40.064	40.000	0.089	40.034	40.000	0.050	40.025	40.000	0.041
	Min	40.120	39.840	0.120	40.080	39.938	0.080	40.025	39.975	0.025	40.009	39.984	0.009	40.000	39.984	0.000
50	Max	50.290	50.000	0.450	50.142	50.000	0.204	50.064	50.000	0.089	50.034	50.000	0.050	50.025	50.000	0.041
	Min	50.130	49.840	0.130	50.080	49.938	0.080	50.025	49.975	0.025	50.009	49.984	0.009	50.000	49.984	0.000
60	Max	60.330	60.000	0.520	60.174	60.000	0.248	60.076	60.000	0.106	60.040	60.000	0.059	60.030	60.000	0.049
	Min	60.140	59.810	0.140	60.100	59.926	0.100	60.030	59.970	0.030	60.010	59.981	0.010	60.000	59.981	0.000
80	Max	80.340	80.000	0.530	80.174	80.000	0.248	80.076	80.000	0.106	80.040	80.000	0.059	80.030	80.000	0.049
	Min	80.150	79.810	0.150	80.100	79.926	0.100	80.030	79.970	0.030	80.010	79.981	0.010	80.000	79.981	0.000
100	Max	100.390	100.000	0.610	100.207	100.000	0.294	100.090	100.000	0.125	100.047	100.000	0.069	100.035	100.000	0.057
	Min	100.170	99.780	0.170	100.120	99.913	0.120	100.036	99.965	0.036	100.012	99.978	0.012	100.000	99.978	0.000
120	Max	120.400	120.000	0.620	120.207	120.000	0.294	120.090	120.000	0.125	120.047	120.000	0.069	120.035	120.000	0.057
	Min	120.180	119.780	0.180	120.120	119.913	0.120	120.036	119.965	0.036	120.012	119.978	0.012	120.000	119.978	0.000
160	Max	160.460	160.000	0.710	160.245	160.000	0.345	160.106	160.000	0.146	160.054	160.000	0.079	160.040	160.000	0.065
	Min	160.210	159.750	0.210	160.145	159.900	0.145	160.043	159.960	0.043	160.014	159.975	0.014	160.000	159.975	0.000
200	Max	200.530	200.000	0.820	200.285	200.000	0.400	200.122	200.000	0.168	200.061	200.000	0.090	200.046	200.000	0.075
	Min	200.240	199.710	0.240	200.170	199.885	0.170	200.050	199.954	0.050	200.015	199.971	0.015	200.000	199.971	0.000
250	Max	250.570	250.000	0.860	250.285	250.000	0.400	250.122	250.000	0.168	250.061	250.000	0.090	250.046	250.000	0.075
	Min	250.280	249.710	0.280	250.170	249.885	0.170	250.050	249.954	0.050	250.015	249.971	0.015	250.000	249.971	0.000
300	Max	300.650	300.000	0.970	300.320	300.000	0.450	300.137	300.000	0.189	300.069	300.000	0.101	300.052	300.000	0.084
	Min	300.330	299.680	0.330	300.190	299.870	0.190	300.056	299.948	0.056	300.017	299.968	0.017	300.000	299.968	0.000
400	Max	400.760	400.000	1.120	400.350	400.000	0.490	400.151	400.000	0.208	400.075	400.000	0.111	400.057	400.000	0.093
	Min	400.400	399.640	0.400	400.210	399.860	0.210	400.062	399.943	0.062	400.018	399.964	0.018	400.000	399.964	0.000
500	Max	500.880	500.000	1.280	500.385	500.000	0.540	500.165	500.000	0.228	500.083	500.000	0.123	500.063	500.000	0.103
	Min	500.480	499.600	0.480	500.230	499.845	0.230	500.068	499.937	0.068	500.020	499.960	0.020	500.000	499.960	0.000

All dimensions are in millimeters.

* The sizes shown are first choice basic sizes (see Table 1). Preferred fits for other sizes can be calculated from data given in ANSI B4.2-1978 (R1984).

Appendix 12 ANSI Preferred Shaft Basis Metric Transition and Interference Fits
American National Standard Preferred Shaft Basis Metric Transition and Interference Fits (ANSI B4.2-1978, R1984)

Basic Size*	Locational Transition			Locational Transition			Locational Interference			Medium Drive			Force		
	Hole K ₇	Shaft h ₆	Fit [†]	Hole N ₇	Shaft h ₆	Fit [†]	Hole P ₇	Shaft h ₆	Fit [†]	Hole S ₇	Shaft h ₆	Fit [†]	Hole U ₇	Shaft h ₆	Fit [†]
1 Max	1.000	1.000	+0.006	0.996	1.000	+0.002	0.994	1.000	0.000	0.986	1.000	-0.008	0.982	1.000	-0.012
1 Min	0.990	0.994	-0.010	0.986	0.994	-0.014	0.984	0.994	-0.016	0.976	0.994	-0.024	0.972	0.994	-0.028
1.2 Max	1.200	1.200	+0.006	1.196	1.200	+0.002	1.194	1.200	0.000	1.186	1.200	-0.008	1.182	1.200	-0.012
1.2 Min	1.190	1.194	-0.010	1.186	1.194	-0.014	1.184	1.194	-0.016	1.176	1.194	-0.024	1.172	1.194	-0.028
1.6 Max	1.600	1.600	+0.006	1.596	1.600	+0.002	1.594	1.600	0.000	1.586	1.600	-0.008	1.582	1.600	-0.012
1.6 Min	1.590	1.594	-0.010	1.586	1.594	-0.014	1.584	1.594	-0.016	1.576	1.594	-0.024	1.572	1.594	-0.028
2 Max	2.000	2.000	+0.006	1.996	2.000	+0.002	1.994	2.000	0.000	1.986	2.000	-0.008	1.982	2.000	-0.012
2 Min	1.990	1.994	-0.010	1.986	1.994	-0.014	1.984	1.994	-0.016	1.976	1.994	-0.024	1.972	1.994	-0.028
2.5 Max	2.500	2.500	+0.006	2.496	2.500	+0.002	2.494	2.500	0.000	2.486	2.500	-0.008	2.482	2.500	-0.012
2.5 Min	2.490	2.494	-0.010	2.486	2.494	-0.014	2.484	2.494	-0.016	2.476	2.494	-0.024	2.472	2.494	-0.028
3 Max	3.000	3.000	+0.006	2.996	3.000	+0.002	2.994	3.000	0.000	2.986	3.000	-0.008	2.982	3.000	-0.012
3 Min	2.990	2.994	-0.010	2.986	2.994	-0.014	2.984	2.994	-0.016	2.976	2.994	-0.024	2.972	2.994	-0.028
4 Max	4.003	4.000	+0.011	3.996	4.000	+0.004	3.992	4.000	0.000	3.985	4.000	-0.007	3.981	4.000	-0.011
4 Min	3.991	3.992	-0.009	3.984	3.992	-0.016	3.980	3.992	-0.020	3.973	3.992	-0.027	3.969	3.992	-0.031
5 Max	5.003	5.000	+0.011	4.996	5.000	+0.004	4.992	5.000	0.000	4.985	5.000	-0.007	4.981	5.000	-0.011
5 Min	4.991	4.992	-0.009	4.984	4.992	-0.016	4.980	4.992	-0.020	4.973	4.992	-0.027	4.969	4.992	-0.031
6 Max	6.003	6.000	+0.011	5.996	6.000	+0.004	5.992	6.000	0.000	5.985	6.000	-0.007	5.981	6.000	-0.011
6 Min	5.991	5.992	-0.009	5.984	5.992	-0.016	5.980	5.992	-0.020	5.973	5.992	-0.027	5.969	5.992	-0.031
8 Max	8.005	8.000	+0.014	7.996	8.000	+0.005	7.991	8.000	0.000	7.983	8.000	-0.008	7.978	8.000	-0.013
8 Min	7.990	7.991	-0.010	7.981	7.991	-0.019	7.976	7.991	-0.024	7.968	7.991	-0.032	7.963	7.991	-0.037
10 Max	10.005	10.000	+0.014	9.996	10.000	+0.005	9.991	10.000	0.000	9.983	10.000	-0.008	9.978	10.000	-0.013
10 Min	9.990	9.991	-0.010	9.981	9.991	-0.019	9.976	9.991	-0.024	9.968	9.991	-0.032	9.963	9.991	-0.037
12 Max	12.006	12.000	+0.017	11.995	12.000	+0.006	11.989	12.000	0.000	11.979	12.000	-0.010	11.974	12.000	-0.015
12 Min	11.988	11.989	-0.012	11.977	11.989	-0.023	11.971	11.989	-0.029	11.961	11.989	-0.039	11.956	11.989	-0.044
16 Max	16.006	16.000	+0.017	15.995	16.000	+0.006	15.989	16.000	0.000	15.979	16.000	-0.010	15.974	16.000	-0.015
16 Min	15.988	15.989	-0.012	15.977	15.989	-0.023	15.971	15.989	-0.029	15.961	15.989	-0.039	15.956	15.989	-0.044
20 Max	20.006	20.000	+0.019	19.993	20.000	+0.006	19.986	20.000	-0.001	19.973	20.000	-0.014	19.967	20.000	-0.020
20 Min	19.985	19.987	-0.015	19.972	19.987	-0.028	19.965	19.987	-0.035	19.952	19.987	-0.048	19.946	19.987	-0.054

Basic Size*	Locational Transition			Locational Transition			Locational Interference			Medium Drive			Force		
	Hole K ₇	Shaft h ₆	Fit [†]	Hole N ₇	Shaft h ₆	Fit [†]	Hole P ₇	Shaft h ₆	Fit [†]	Hole S ₇	Shaft h ₆	Fit [†]	Hole U ₇	Shaft h ₆	Fit [†]
25 Max	25.006	25.000	+0.019	24.993	25.000	+0.006	24.986	25.000	-0.001	24.973	25.000	-0.014	24.960	25.000	-0.027
25 Min	24.985	24.987	-0.015	24.972	24.987	-0.028	24.965	24.987	-0.035	24.952	24.987	-0.048	24.939	24.987	-0.061
30 Max	30.006	30.000	+0.019	29.993	30.000	+0.006	29.986	30.000	-0.001	29.973	30.000	-0.014	29.960	30.000	-0.027
30 Min	29.985	29.987	-0.015	29.972	29.987	-0.028	29.965	29.987	-0.035	29.952	29.987	-0.048	29.939	29.987	-0.061
40 Max	40.007	40.000	+0.023	39.992	40.000	+0.008	39.983	40.000	-0.001	39.966	40.000	-0.018	39.949	40.000	-0.035
40 Min	39.982	39.984	-0.018	39.967	39.984	-0.033	39.958	39.984	-0.042	39.941	39.984	-0.059	39.924	39.984	-0.076
50 Max	50.007	50.000	+0.023	49.992	50.000	+0.008	49.983	50.000	-0.001	49.966	50.000	-0.018	49.939	50.000	-0.045
50 Min	49.982	49.984	-0.018	49.967	49.984	-0.033	49.958	49.984	-0.042	49.941	49.984	-0.059	49.914	49.984	-0.086
60 Max	60.009	60.000	+0.028	59.991	60.000	+0.010	59.979	60.000	-0.002	59.958	60.000	-0.023	59.924	60.000	-0.087
60 Min	59.979	59.981	-0.021	59.961	59.981	-0.039	59.949	59.981	-0.051	59.928	59.981	-0.072	59.894	59.981	-0.106
80 Max	80.009	80.000	+0.028	79.991	80.000	+0.010	79.979	80.000	-0.002	79.952	80.000	-0.029	79.909	80.000	-0.072
80 Min	79.979	79.981	-0.021	79.961	79.981	-0.039	79.949	79.981	-0.051	79.922	79.981	-0.078	79.879	79.981	-0.121
100 Max	100.010	100.000	+0.032	99.990	100.000	+0.012	99.976	100.000	-0.002	99.942	100.000	-0.036	99.889	100.000	-0.089
100 Min	99.975	99.978	-0.025	99.955	99.978	-0.045	99.941	99.978	-0.059	99.907	99.978	-0.093	99.854	99.978	-0.146
120 Max	120.010	120.000	+0.032	119.990	120.000	+0.012	119.976	120.000	-0.002	119.934	120.000	-0.044	119.869	120.000	-0.109
120 Min	119.975	119.978	-0.025	119.955	119.978	-0.045	119.941	119.978	-0.059	119.899	119.978	-0.101	119.834	119.978	-0.166
160 Max	160.012	160.000	+0.037	159.988	160.000	+0.013	159.972	160.000	-0.003	159.915	160.000	-0.060	159.825	160.000	-0.150
160 Min	159.972	159.975	-0.028	159.948	159.975	-0.052	159.932	159.975	-0.068	159.875	159.975	-0.125	159.785	159.975	-0.215
200 Max	200.013	200.000	+0.042	199.986	200.000	+0.015	199.967	200.000	-0.004	199.895	200.000	-0.076	199.781	200.000	-0.190
200 Min	199.967	199.971	-0.033	199.940	199.971	-0.060	199.921	199.971	-0.079	199.849	199.971	-0.151	199.735	199.971	-0.265
250 Max	250.013	250.000	+0.042	249.986	250.000	+0.015	249.967	250.000	-0.004	249.877	250.000	-0.094	249.733	250.000	-0.238
250 Min	249.967	249.971	-0.033	249.940	249.971	-0.060	249.921	249.971	-0.079	249.831	249.971	-0.169	249.687	249.971	-0.313
300 Max	300.016	300.000	+0.048	299.986	300.000	+0.018	299.964	300.000	-0.004	299.850	300.000	-0.118	299.670	300.000	-0.298
300 Min	299.964	299.968	-0.036	299.934	299.968	-0.066	299.912	299.968	-0.088	299.798	299.968	-0.202	299.618	299.968	-0.382
400 Max	400.017	400.000	+0.053	399.984	400.000	+0.020	399.959	400.000	-0.005	399.813	400.000	-0.151	399.586	400.000	-0.378
400 Min	399.960	399.964	-0.040	399.927	399.964	-0.073	399.902	399.964	-0.098	399.750	399.964	-0.244	399.529	399.964	-0.471
500 Max	500.018	500.000	+0.058	499.983	500.000	+0.023	499.955	500.000	-0.005	499.771	500.000	-0.189	499.483	500.000	-0.477
500 Min	499.955	499.960	-0.045	499.920	499.960	-0.080	499.892	499.960	-0.108	499.708	499.960	-0.292	499.420	499.960	-0.580

All dimensions are in millimeters.

* The sizes shown are first choice basic sizes (see Table 1). Preferred fits for other sizes can be calculated from data given in ANSI B4.2-1978 (R1984).

† A plus sign indicates clearance; a minus sign indicates interference.

SOURCE: Reprinted courtesy of The American Society of Mechanical Engineers.

Appendix 13 Unified Standard Screw Thread Series

Sizes		Basic Major Diameter	Threads Per Inch												Sizes
			Series with graded pitches			Series with constant pitches									
Primary	Secondary		Coarse UNC	Fine UNF	Extra fine UNEF	4UN	6UN	8UN	12UN	16UN	20UN	28UN	32UN		
0	1	0.060	—	80	—	—	—	—	—	—	—	—	—	—	0
2		0.073	64	72	—	—	—	—	—	—	—	—	—	—	1
4		0.086	56	64	—	—	—	—	—	—	—	—	—	—	2
5		0.099	48	56	—	—	—	—	—	—	—	—	—	—	3
6		0.112	40	48	—	—	—	—	—	—	—	—	—	—	4
8		0.125	40	44	—	—	—	—	—	—	—	—	—	—	5
10		0.138	32	40	—	—	—	—	—	—	—	—	—	UNC	6
		0.164	32	36	—	—	—	—	—	—	—	—	—	UNC	8
		0.190	24	32	—	—	—	—	—	—	—	—	—	UNF	10
		0.216	24	28	32	—	—	—	—	—	—	—	—	UNF	12
1/4		0.250	20	28	32	—	—	—	—	—	—	UNC	UNF	UNEF	1/4
5/16		0.3125	18	24	32	—	—	—	—	—	—	20	28	UNEF	5/16
3/8	12	0.375	16	24	32	—	—	—	—	—	UNC	20	28	UNEF	3/8
7/16		0.4375	14	20	28	—	—	—	—	—	16	UNF	UNEF	32	7/16
1/2		0.500	13	20	28	—	—	—	—	—	16	UNF	UNEF	32	1/2
9/16		0.5265	12	18	24	—	—	—	—	UNC	16	20	28	32	9/16
5/8		0.625	11	18	24	—	—	—	—	12	16	20	28	32	5/8
11/16		0.6875	—	—	24	—	—	—	—	12	16	20	28	32	11/16
3/4		0.750	10	16	20	—	—	—	—	12	UNF	UNEF	28	32	3/4
13/16		0.8125	—	—	20	—	—	—	—	12	16	UNEF	28	32	13/16
7/8		0.875	9	14	20	—	—	—	—	12	16	UNEF	28	32	7/8
		0.9375	—	—	20	—	—	—	—	12	16	UNEF	28	32	15/16
1	1	1.000	8	12	20	—	—	UNC	UNF	16	UNEF	28	32	1	1
1-1/16		1.0625	—	—	18	—	—	8	12	16	20	28	—	—	1-1/16
1-1/8		1.125	7	12	18	—	—	8	UNF	16	20	28	—	—	1-1/8
1-3/16		1.1875	—	—	18	—	—	8	12	16	20	28	—	—	1-3/16
1-1/4		1.250	7	12	18	—	—	8	UNF	16	20	28	—	—	1-1/4
1-5/16		1.3125	—	—	18	—	—	8	12	16	20	28	—	—	1-5/16
1-3/8		1.375	6	12	18	—	UNC	8	UNF	16	20	28	—	—	1-3/8
1-7/16		1.4375	—	—	18	—	6	8	12	16	20	28	—	—	1-7/16
1-1/2		1.500	6	12	18	—	UNC	8	UNF	16	20	28	—	—	1-1/2
1-9/16		1.5625	—	—	18	—	6	8	12	16	20	—	—	—	1-9/16
1-5/8		1.625	—	—	18	—	6	8	12	16	20	—	—	—	1-5/8
1-11/16		1.6875	—	—	18	—	6	8	12	16	20	—	—	—	1-11/16
1-3/4		1.750	5	—	—	—	6	8	12	16	20	—	—	—	1-3/4
1-13/16		1.8125	—	—	—	—	6	8	12	16	20	—	—	—	1-13/16
1-7/8		1.875	—	—	—	—	6	8	12	16	20	—	—	—	1-7/8
1-15/16		1.9375	—	—	—	—	6	8	12	16	20	—	—	—	1-15/16
2	2	2.000	4-1/2	—	—	—	6	8	12	16	20	—	—	—	2
2-1/8		2.215	—	—	—	—	6	8	12	16	20	—	—	—	2-1/8
2-1/4		2.250	4-1/2	—	—	—	6	8	12	16	20	—	—	—	2-1/4
2-3/8		2.375	—	—	—	—	6	8	12	16	20	—	—	—	2-3/8
2-1/2		2.500	4	—	—	UNC	6	8	12	16	20	—	—	—	2-1/2
2-5/8		2.625	—	—	—	4	6	8	12	16	20	—	—	—	2-5/8
2-3/4		2.750	4	—	—	UNC	6	8	12	16	20	—	—	—	2-3/4
2-7/8	3	2.875	—	—	—	4	6	8	12	16	20	—	—	—	2-7/8
3		3.000	4	—	—	UNC	6	8	12	16	20	—	—	—	3
3-1/8		3.125	—	—	—	4	6	8	12	16	—	—	—	—	3-1/8
3-3/8		3.250	4	—	—	UNC	6	8	12	16	—	—	—	—	3-3/8
3-1/2		3.375	—	—	—	4	6	8	12	16	—	—	—	—	3-1/2
3-5/8		3.500	4	—	—	UNC	6	8	12	16	—	—	—	—	3-5/8
3-3/4		3.625	—	—	—	4	6	8	12	16	—	—	—	—	3-3/4
3-7/8		3.750	4	—	—	UNC	6	8	12	16	—	—	—	—	3-7/8
		3.875	—	—	—	4	6	8	12	16	—	—	—	—	3-7/8
4	4	4.000	4	—	—	UNC	6	8	12	16	20	—	—	—	4
4-1/8		4.125	—	—	—	4	6	8	12	16	—	—	—	—	4-1/8
4-1/4		4.250	—	—	—	4	6	8	12	16	—	—	—	—	4-1/4
4-3/8		4.375	—	—	—	4	6	8	12	16	—	—	—	—	4-3/8
4-1/2		4.500	—	—	—	4	6	8	12	16	—	—	—	—	4-1/2
4-5/8		4.625	—	—	—	4	6	8	12	16	—	—	—	—	4-5/8
4-3/4		4.750	—	—	—	4	6	8	12	16	—	—	—	—	4-3/4
4-7/8		4.875	—	—	—	4	6	8	12	16	—	—	—	—	4-7/8
5	5	5.000	—	—	—	4	6	8	12	16	—	—	—	—	5
5-1/8		5.125	—	—	—	4	6	8	12	16	—	—	—	—	5-1/8
5-1/4		5.250	—	—	—	4	6	8	12	16	—	—	—	—	5-1/4
5-3/8		5.375	—	—	—	4	6	8	12	16	—	—	—	—	5-3/8
5-1/2		5.500	—	—	—	4	6	8	12	16	—	—	—	—	5-1/2
5-5/8	6	5.625	—	—	—	4	6	8	12	16	—	—	—	—	5-5/8
5-7/8		5.750	—	—	—	4	6	8	12	16	—	—	—	—	5-7/8
		5.875	—	—	—	4	6	8	12	16	—	—	—	—	5-7/8
6	6	6.000	—	—	—	4	6	8	12	16	—	—	—	—	6

SOURCE: Reprinted courtesy of The American Society of Mechanical Engineers.

Appendix 14 Thread Sizes and Dimensions

Nominal Size		Diameter				Tap Drill (for 75% thread)			Threads per Inch		Pitch (mm)		Threads per Inch (Approx.)	
		Major		Minor										
Inch	mm	Inch	mm	Inch	mm	Drill	Inch	mm	UNC	UNF	Coarse	Fine	Coarse	Fine
—	M1.4	0.055	1.397	—	—	—	—	—	—	—	0.3	0.2	85	127
0	—	0.060	1.524	0.0438	1.092	3/64	0.0469	1.168	—	80	—	—	—	—
—	M1.6	0.063	1.600	—	—	—	—	1.25	—	—	0.35	0.2	74	127
1	—	0.073	1.854	0.0527	1.320	53	0.0595	1.1499	64	—	—	—	—	—
1	—	0.073	1.854	0.0550	1.397	53	0.0595	1.499	—	72	—	—	—	—
—	M2	0.079	2.006	—	—	—	—	1.6	—	—	0.4	0.25	64	101
2	—	0.086	2.184	0.0628	1.587	50	0.0700	1.778	56	—	—	—	—	—
2	—	0.086	2.184	0.0657	1.651	50	0.0700	1.778	—	64	—	—	—	—
—	M2.5	0.098	2.489	—	—	—	—	2.05	—	—	0.45	0.35	56	74
3	—	0.099	2.515	0.0719	1.828	47	0.0785	1.981	48	—	—	—	—	—
3	—	0.099	2.515	0.0758	1.905	46	0.0810	2.057	—	58	—	—	—	—
4	—	0.112	2.845	0.0795	2.006	43	0.0890	2.261	40	—	—	—	—	—
4	—	0.112	2.845	0.0849	2.134	42	0.0935	2.380	—	48	—	—	—	—
—	M3	0.118	2.997	—	—	—	—	2.5	—	—	0.5	0.35	51	74
5	—	0.125	3.175	0.0925	2.336	38	0.1015	2.565	40	—	—	—	—	—
5	—	0.125	3.175	0.0955	2.413	37	0.1040	2.641	—	44	—	—	—	—
6	—	0.138	3.505	0.0975	2.464	36	0.1065	2.692	32	—	—	—	—	—
6	—	0.138	3.505	0.1055	2.667	33	0.1130	2.870	—	40	—	—	—	—
—	M4	0.157	3.988	—	—	—	—	3.3	—	—	0.7	0.35	36	51
8	—	0.164	4.166	0.1234	3.124	29	0.1360	3.454	32	—	—	—	—	—
8	—	0.164	4.166	0.1279	3.225	29	0.1360	3.454	—	36	—	—	—	—
10	—	0.190	4.826	0.1359	3.429	26	0.1470	3.733	24	—	—	—	—	—
10	—	0.190	4.826	0.1494	3.785	21	0.1590	4.038	—	32	—	—	—	—
—	M5	0.196	4.978	—	—	—	—	4.2	—	—	0.8	0.5	32	51
12	—	0.216	5.486	0.1619	4.089	16	0.1770	4.496	24	—	—	—	—	—
12	—	0.216	5.486	0.1696	4.293	15	0.1800	4.572	—	28	—	—	—	—
—	M6	0.236	5.994	—	—	—	—	5.0	—	—	1.0	0.75	25	34
1/4	—	0.250	6.350	0.1850	4.699	7	0.2010	5.105	20	—	—	—	—	—
1/4	—	0.250	6.350	0.2036	5.156	3	0.2130	5.410	—	28	—	—	—	—
5/16	—	0.312	7.938	0.2403	6.096	F	0.2570	6.527	18	—	—	—	—	—
5/16	—	0.312	7.938	0.2584	6.553	I	0.2720	6.908	—	24	—	—	—	—
—	M8	0.315	8.001	—	—	—	—	6.8	—	—	1.25	1.0	20	25
3/8	—	0.375	9.525	0.2938	7.442	5/16	0.3125	7.937	16	—	—	—	—	—
3/8	—	0.375	9.525	0.3209	8.153	Q	0.3320	8.432	—	24	—	—	—	—
—	M10	0.393	9.982	—	—	—	—	8.5	—	—	1.5	1.25	17	20
7/16	—	0.437	11.113	0.3447	8.738	U	0.3680	9.347	14	—	—	—	—	—
7/16	—	0.437	11.113	0.3726	9.448	25/64	0.3906	9.921	—	20	—	—	—	—
—	M12	0.471	11.963	—	—	—	—	10.30	—	—	1.75	1.25	14.5	20
1/2	—	0.500	12.700	0.4001	10.162	27/64	0.4219	10.715	13	—	—	—	—	—
1/2	—	0.500	12.700	0.4351	11.049	29/64	0.4531	11.509	—	20	—	—	—	—
—	M14	0.551	13.995	—	—	—	—	12.00	—	—	2	1.5	12.5	17
9/16	—	0.562	14.288	0.4542	11.531	31/64	0.4844	12.3031	12	—	—	—	—	—
9/16	—	0.562	14.288	0.4903	12.446	33/64	0.5156	13.096	—	18	—	—	—	—
5/8	—	0.625	15.875	0.5069	12.852	17/32	0.5312	13.493	11	—	—	—	—	—
5/8	—	0.625	15.875	0.5528	14.020	37/64	0.5781	14.684	—	18	—	—	—	—
—	M16	0.630	16.002	—	—	—	—	14.00	—	—	2	1.5	12.5	17
—	M18	0.709	18.008	—	—	—	—	15.50	—	—	2.5	1.5	10	17
3/4	—	0.750	19.050	0.6201	15.748	21/32	0.6562	16.668	10	—	—	—	—	—
3/4	—	0.750	19.050	0.6688	16.967	11/16	0.6875	17.462	—	16	—	—	—	—
—	M20	0.787	19.990	—	—	—	—	17.50	—	—	2.5	1.5	10	17
—	M22	0.866	21.996	—	—	—	—	19.50	—	—	2.5	1.5	10	17
7/8	—	0.875	22.225	0.7307	18.542	49/64	0.7656	19.446	9	—	—	—	—	—
7/8	—	0.875	22.225	0.7822	19.863	13/16	0.8125	20.637	—	14	—	—	—	—
—	M24	0.945	24.003	—	—	—	—	21.00	—	—	3	2	8.5	12.5
1	—	1.000	25.400	0.8376	21.2598	7/8	0.8750	22.225	8	—	—	—	—	—
1	—	1.000	25.400	0.8917	22.632	59/64	0.9219	23.415	—	12	—	—	—	—
—	M27	1.063	27.000	—	—	—	—	24.00	—	—	3	2	8.5	12.5

SOURCE: Reprinted courtesy of The American Society of Mechanical Engineers.

Appendix 15 Tap Drill Sizes for American National Thread Forms

Appendix 16 Hex Cap Screws (Finished Hex Bolts)

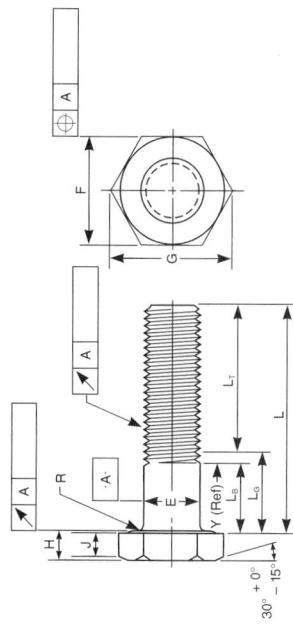

Screw Thread	Commercial Tap Drills*		Screw Thread		Commercial Tap Drills*		Commercial Tap Drills*	
	Outside Diam.	Root Diam.	Outside Diam.	Root Diam.	Size or Number	Decimal Equiv.	Size or Number	Decimal Equiv.
1/16-64	0.0422	9/64	0.0469	27	0.4519	19/64	0.4687	19/64
7/32	0.0445	35/64	0.0469	9/16-12	0.4542	31/64	0.4844	31/64
9/32-60	0.0563	1/2	0.0625	18	0.4903	33/64	0.5156	33/64
7/16	0.0601	52	0.0635	27	0.5144	17/32	0.5312	17/32
3/8-48	0.0667	49	0.0730	9/8-11	0.5069	17/32	0.5312	17/32
5/8	0.0678	49	0.0730	12	0.5168	33/64	0.5469	33/64
7/16-48	0.0833	43	0.0890	18	0.5528	19/64	0.5701	19/64
1/8-32	0.0844	39/64	0.0937	27	0.5769	19/64	0.5937	19/64
40	0.0925	38	0.1015	11/16-11	0.5694	19/32	0.5937	19/32
9/16-40	0.1081	32	0.1160	16	0.6063	55/64	0.6230	55/64
5/8-32	0.1157	34	0.1250	9/4-10	0.6201	21/32	0.6502	21/32
36	0.1202	30	0.1285	12	0.6418	43/64	0.6719	43/64
11/16-32	0.1313	9/4	0.1406	16	0.6638	11/16	0.6875	11/16
9/16-24	0.1334	26	0.1470	27	0.7019	23/32	0.7187	23/32
32	0.1469	22	0.1570	13/16-10	0.6826	23/32	0.7187	23/32
13/16-24	0.1499	20	0.1610	7/8-9	0.7397	49/64	0.7666	49/64
7/8-24	0.1646	16	0.1770	12	0.7668	53/64	0.7969	53/64
15/16-24	0.1806	10	0.1935	14	0.7822	131/64	0.8125	131/64
14-20	0.1850	7	0.2010	27	0.8269	27/32	0.8377	27/32
24	0.1939	4	0.2090	15/16-9	0.7932	53/64	0.8281	53/64
27	0.2019	3	0.2130	1 - 8	0.8376	7/8	0.8701	7/8
28	0.2036	3	0.2130	12	0.8918	89/64	0.9219	89/64
32	0.2094	7/8	0.2187	14	0.9072	91/64	0.9375	91/64
5/16-18	0.2493	F	0.2570	27	0.9519	91/64	0.9587	91/64
20	0.2476	13/16	0.2556	13/16 - 7	0.9394	63/64	0.9834	63/64
24	0.2584	I	0.2720	12	1.0168	138/64	1.0469	138/64
27	0.2644	J	0.2770	11/4 - 7	1.0644	17/64	1.1094	17/64
32	0.2719	9/8	0.2912	12	1.1418	111/64	1.1719	111/64
3/8-16	0.2938	5/8	0.3125	13/8 - 6	1.1585	17/8	1.2187	17/8
20	0.3100	21/16	0.3281	12	1.2668	1.1964	1.2669	1.1964
24	0.3229	Q	0.3320	13/16 - 6	1.2835	111/64	1.3437	111/64
27	0.3269	R	0.3390	12	1.3918	12/64	1.4219	12/64
7/16-14	0.3447	U	0.3580	15/16 - 5 1/2	1.3888	12/64	1.4531	12/64
20	0.3726	25/64	0.3906	13/8 - 5	1.4902	19/16	1.5635	19/16
24	0.3824	X	0.3970	17/8 - 5	1.6152	111/64	1.6875	111/64
27	0.3894	Y	0.4040	2 - 4 1/2	1.7113	12/16	1.7812	12/16
14-12	0.3918	Z	0.4219	2 1/2 - 4 1/2	1.8363	12/16	1.9062	12/16
13	0.4001	27/64	0.4219	2 1/4 - 4 1/4	1.9613	21/32	2.0312	21/32
20	0.4351	29/64	0.4531	2 3/8 - 4	2.0502	21/32	0.4531	21/32
24	0.4459	29/64	0.4531	2 1/2 - 4	2.1752	21/32	0.4531	21/32

* These tap drill diameters allow approximately 75 per cent of a full thread to be produced. For small thread sizes in the first column, the use of drills to produce the larger hole sizes shown in Table 2 will reduce defects caused by tap problems and breakage.

SOURCE: Reprinted courtesy of The American Society of Mechanical Engineers.

Appendix 17 Socket Head Cap Screws (1960 Series)

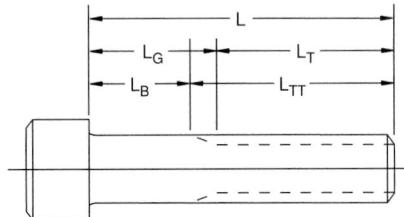

Nominal Size or Basic Screw Diameter	L_T		L_{TT}		Nominal Size or Basic Screw Diameter	L_T		L_{TT}		
	Thread Length	Total Thread Length	Min	Max		Thread Length	Total Thread Length	Min	Max	
0	0.0600	0.50	0.62		7/8	0.8750	2.25	3.69		
1	0.0730	0.62	0.77		1	1.0000	2.50	4.12		
2	0.0860	0.62	0.80		1 1/8	1.1250	2.81	4.65		
3	0.0990	0.62	0.83		1 1/4	1.2500	3.12	5.09		
4	0.1120	0.75	0.99		1 3/8	1.3750	3.44	5.65		
5	0.1250	0.75	1.00		1 1/2	1.5000	3.75	6.08		
6	0.1380	0.75	1.05		1 3/4	1.7500	4.38	7.13		
8	0.1640	0.88	1.19		2	2.0000	5.00	8.11		
10	0.1900	0.88	1.27		2 1/4	2.2500	5.62	8.99		
1/4	0.2500	1.00	1.50		2 1/2	2.5000	6.25	10.00		
5/16	0.3125	1.12	1.71		2 3/4	2.7500	6.88	10.87		
3/8	0.3750	1.25	1.94		3	3.0000	7.50	11.75		
7/16	0.4375	1.38	2.17		3 1/4	3.2500	8.12	12.63		
1/2	0.5000	1.50	2.38		3 1/2	3.5000	8.75	13.50		
5/8	0.6250	1.75	2.82		3 3/4	3.7500	9.38	14.37		
3/4	0.7500	2.00	3.25		4	4.0000	10.00	15.25		

SOURCE: Reprinted courtesy of The American Society of Mechanical Engineers.

Appendix 18 Square Head Bolts

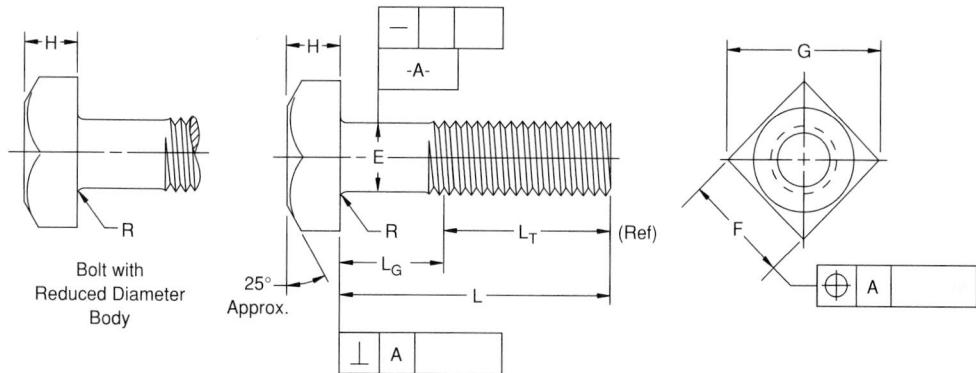

Nominal Size or Basic Product Diameter		E		F		G		H			R		LT	
		Body Diameter	Width Across Flats			Width Across Corners		Height			Radius of Fillet		Thread Length for Bolt Lengths	
			Max	Basic	Max	Min	Max	Min	Basic	Max	Min	Max	Min	Basic
1/4	0.2500	0.260	3/8	0.375	0.362	0.530	0.498	11/64	0.188	0.156	0.03	0.01	0.750	1.000
5/16	0.3125	0.324	1/2	0.500	0.484	0.707	0.665	13/64	0.220	0.186	0.03	0.01	0.875	1.125
3/8	0.3750	0.388	9/16	0.562	0.544	0.795	0.747	1/4	0.268	0.232	0.03	0.01	1.000	1.250
7/16	0.4375	0.452	5/8	0.625	0.603	0.884	0.828	19/64	0.316	0.278	0.03	0.01	1.125	1.375
1/2	0.5000	0.515	3/4	0.750	0.725	1.061	0.995	21/64	0.348	0.308	0.03	0.01	1.250	1.500
5/8	0.6250	0.642	15/16	0.938	0.906	1.326	1.244	27/64	0.444	0.400	0.06	0.02	1.500	1.750
3/4	0.7500	0.768	1-1/8	1.125	1.088	1.591	1.494	1/2	0.524	0.476	0.06	0.02	1.750	2.000
7/8	0.8750	0.895	1-5/16	1.312	1.269	1.856	1.742	19/32	0.620	0.568	0.06	0.02	2.000	2.250
1	1.0000	1.022	1-1/2	1.500	1.450	2.121	1.991	21/32	0.684	0.628	0.09	0.03	2.250	2.500
1-1/8	1.1250	1.149	1-11/16	1.688	1.631	2.386	2.239	3/4	0.780	0.720	0.09	0.03	2.500	2.750
1-1/4	1.2500	1.277	1-7/8	1.875	1.812	2.652	2.489	27/32	0.876	0.812	0.09	0.03	2.750	3.000
1-3/8	1.3750	1.404	2-1/16	2.062	1.994	2.917	2.738	29/32	0.940	0.872	0.09	0.03	3.000	3.250
1-1/2	1.5000	1.531	2-1/4	2.250	2.175	3.182	2.986	1	1.036	0.964	0.09	0.03	3.250	3.500

SOURCE: Reprinted courtesy of The American Society of Mechanical Engineers.

Appendix 19 Hex Nuts and Hex Jam Nuts
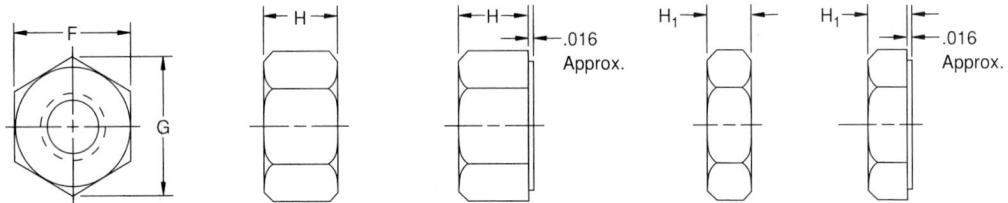

Nominal Size or Basic Major Diameter of Thread		F			G		H			H ₁			Runout of Bearing Face, FIM		
		Width Across Flats			Width Across Corners		Thickness Hex Nuts			Thickness Hex Jam Nuts			Hex Nuts		Hex Jam Nuts
		Basic	Max	Min	Max	Min	Basic	Max	Min	Basic	Max	Min	Up to 150,000 psi and Greater	150,000 psi	All Strength Levels
1/4	0.2500	7/16	0.438	0.428	0.505	0.488	7/32	0.226	0.212	5/32	0.163	0.150	0.015	0.010	0.015
5/16	0.3125	1/2	0.500	0.489	0.577	0.557	17/64	0.273	0.258	3/16	0.195	0.180	0.016	0.011	0.016
3/8	0.3750	9/16	0.562	0.551	0.650	0.628	21/64	0.337	0.320	7/32	0.227	0.210	0.017	0.012	0.017
7/16	0.4375	11/16	0.688	0.675	0.794	0.768	3/8	0.385	0.365	1/4	0.260	0.240	0.018	0.013	0.018
1/2	0.5000	3/4	0.750	0.736	0.866	0.840	7/16	0.448	0.427	5/16	0.323	0.302	0.019	0.014	0.019
9/16	0.5625	7/8	0.875	0.861	1.010	0.982	31/64	0.496	0.473	5/16	0.324	0.301	0.020	0.015	0.020
5/8	0.6250	1-5/16	0.938	0.922	1.083	1.051	35/64	0.559	0.535	3/8	0.387	0.363	0.021	0.016	0.021
3/4	0.7500	1 1/8	1.125	1.088	1.299	1.240	41/64	0.665	0.617	27/64	0.446	0.398	0.023	0.018	0.023
7/8	0.8750	1-5/16	1.312	1.269	1.516	1.447	3/4	0.776	0.724	31/64	0.510	0.458	0.025	0.020	0.025
1	1.0000	1-1/2	1.500	1.450	1.732	1.653	55/64	0.887	0.831	35/64	0.575	0.519	0.027	0.022	0.027
1-1/8	1.1250	1-11/16	1.688	1.631	1.949	1.859	31/32	0.999	0.939	39/64	0.639	0.579	0.030	0.025	0.030
1-1/4	1.2500	1-7/8	1.875	1.812	2.165	2.066	1-1/16	1.094	1.030	23/32	0.751	0.687	0.033	0.028	0.033
1-3/8	1.3750	2-1/16	2.062	1.994	2.382	2.273	1-11/64	1.206	1.138	25/32	0.815	0.747	0.036	0.031	0.036
1-1/2	1.5000	2-1/4	2.250	2.175	2.598	2.480	1-9/32	1.317	1.245	27/32	0.880	0.808	0.039	0.034	0.039

SOURCE: Reprinted courtesy of The American Society of Mechanical Engineers.

Appendix 20 Square Nuts

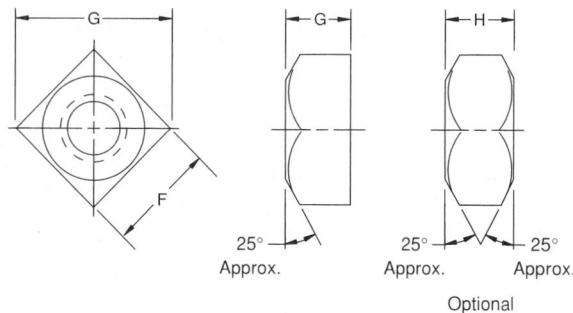

Nominal Size or Basic Major Diameter of Thread		F			G		H		
		Width Across Flats			Width Across Corners		Thickness		
		Basic	Max	Min	Max	Min	Basic	Max	Min
1/4	0.2500	7/16	0.438	0.425	0.619	0.554	7/32	0.235	0.203
5/16	0.3125	9/16	0.562	0.547	0.795	0.721	17/64	0.283	0.249
3/8	0.3750	5/8	0.625	0.606	0.884	0.802	21/64	0.346	0.310
7/16	0.4375	3/4	0.750	0.728	1.061	0.970	3/8	0.394	0.356
1/2	0.5000	13/16	0.812	0.788	1.149	1.052	7/16	0.458	0.418
5/8	0.6250	1	1.000	0.969	1.414	1.300	35/64	0.569	0.525
3/4	0.7500	1-1/8	1.125	1.088	1.591	1.464	21/32	0.680	0.632
7/8	0.8750	1-5/16	1.312	1.269	1.856	1.712	49/64	0.792	0.740
1	1.0000	1-1/2	1.500	1.450	2.121	1.961	7/8	0.903	0.847
1-1/8	1.1250	1-11/16	1.688	1.631	2.386	2.209	1	1.030	0.970
1-1/4	1.2500	1-7/8	1.875	1.812	2.652	2.458	1-3/32	1.126	1.062
1-3/8	1.3750	2-1/16	2.062	1.994	2.917	2.708	1-13/64	1.237	1.169
1-1/2	1.5000	2-1/4	2.250	2.175	3.182	2.956	1-5/16	1.348	1.276

SOURCE: Reprinted courtesy of The American Society of Mechanical Engineers.

Appendix 21 ANSI Metric Hex Jam Nuts and Heavy Hex Nuts

American National Standard Metric Hex Jam Nuts and Heavy Hex Nuts
(ANSI B18.2.4.5M and B18.2.4.6M-1979, R1990)

HEX JAM NUTS						
Nominal Nut Diam. and Thread Pitch	Width Across Flats, <i>S</i>		Width Across Corners, <i>E</i>		Thickness, <i>M</i>	
	Max	Min	Max	Min	Max	Min
M10 x 1.5						
M10 x 0.8	8.00	7.78	9.24	8.79	2.70	2.45
M6 x 1	10.00	9.78	11.55	11.05	3.20	2.90
M8 x 1.25	13.00	12.73	15.01	14.38	4.00	3.70
M12 x 1.75						
M10 x 1.5	15.00	14.73	17.32	16.64	5.00	4.70
M12 x 2	18.00	17.73	20.78	19.48	7.77	7.00
M14 x 2	21.00	20.67	24.25	23.35	9.00	8.00
M16 x 2	24.00	23.67	27.71	26.75	8.00	7.42
M20 x 2.5	30.00	29.16	34.64	32.95	10.00	9.10
M24 x 3	36.00	35.00	41.57	39.55	12.00	10.90
M30 x 3.5	46.00	45.00	53.12	50.85	15.00	13.90
M36 x 4	55.00	53.80	63.51	60.79	18.00	16.90
Metric Heavy Hex Nuts						
M12 x 1.75	21.00	20.16	24.25	22.78	12.3	11.9
M14 x 2	24.00	23.16	27.71	26.17	14.3	13.6
M16 x 2	27.00	26.16	31.18	29.56	17.1	16.2
M20 x 2.5	34.00	33.00	39.26	37.29	20.7	19.4
M22 x 2.5	36.00	35.00	41.57	39.55	23.6	22.3
M24 x 3	41.00	40.00	47.34	45.20	24.2	22.9
M27 x 3	46.00	45.00	53.12	50.85	27.6	26.3
M30 x 3.5	50.00	49.00	57.74	55.37	30.7	29.1
M36 x 4	60.00	58.80	69.28	66.44	36.6	35.0
M42 x 4.5	70.00	67.90	80.83	77.41	42.0	40.4
M48 x 5	80.00	77.60	92.38	88.46	48.0	46.4
M56 x 5.5	90.00	87.20	103.92	99.41	56.0	54.1
M64 x 6	100.00	96.80	115.47	110.35	64.0	62.1
M72 x 6	110.00	106.40	127.02	121.30	72.0	70.1
M80 x 6	120.00	116.00	138.56	132.24	80.0	78.1
M90 x 6	135.00	130.50	155.88	148.77	90.0	87.8
M100 x 6	150.00	145.00	173.21	165.30	100.0	97.8

All dimensions are in millimeters.

* This size with width across flats of 15 mm is not standard. Unless specifically ordered, M10 hex jam nuts will with across flats will be furnished.

SOURCE: Reprinted courtesy of The American Society of Mechanical Engineers.

Appendix 22 ANSI Metric Hex Nuts, Styles 1 and 2

American National Standard Metric Hex Nuts, Styles 1 and 2
(ANSI B18.2.4.1M and B18.2.4.2M-1979, R1989)

Nominal Nut Diam. and Thread Pitch	Metric Hex Nuts — Style 1		Metric Hex Nuts — Style 2	
	Width Across Flats, <i>S</i>	Width Across Corners, <i>E</i>	Width Across Flats, <i>S</i>	Width Across Corners, <i>E</i>
M1.6 x 0.35	3.20	3.02	3.70	3.41
M2 x 0.4	4.00	3.82	4.62	4.32
M2 x 0.45	5.00	4.82	5.77	5.45
M3 x 0.5	5.50	5.32	6.35	6.01
M3.5 x 0.6	6.00	5.82	6.93	6.58
M4 x 0.7	7.00	6.78	8.08	7.66
M5 x 0.8	8.00	7.78	9.24	8.79
M6 x 1	10.00	9.78	11.55	11.05
M8 x 1.25	13.00	12.73	15.01	14.38
*M10 x 1.5				
M10 x 1.5	15.00	14.73	17.32	16.64
M10 x 1.5	16.00	15.73	18.48	17.77
M12 x 1.75	18.00	17.73	20.78	20.03
M14 x 2	21.00	20.67	24.25	23.36
M16 x 2	24.00	23.67	27.71	26.75
M20 x 2.5	30.00	29.16	34.64	32.95
M24 x 3	36.00	35.00	41.57	39.55
M30 x 3.5	46.00	45.00	53.12	50.85
M36 x 4	55.00	53.80	63.51	60.79
Metric Heavy Hex Nuts — Style 2				
M3 x 0.5	5.50	5.32	6.35	6.01
M3.5 x 0.6	6.00	5.82	6.93	6.58
M4 x 0.7	7.00	6.78	8.08	7.66
M5 x 0.8	8.00	7.78	9.24	8.79
M6 x 1	10.00	9.78	11.55	11.05
M8 x 1.25	13.00	12.73	15.01	14.38
*M10 x 1.5				
M10 x 1.5	15.00	14.73	17.32	16.64
M12 x 1.75	18.00	17.73	20.78	20.03
M14 x 2	21.00	20.67	24.25	23.36
M16 x 2	24.00	23.67	27.71	26.75
M20 x 2.5	30.00	29.16	34.64	32.95
M24 x 3	36.00	35.00	41.57	39.55
M30 x 3.5	46.00	45.00	53.12	50.85
M36 x 4	55.00	53.80	63.51	60.79

All dimensions are in millimeters.
* This size with width across flats of 15 mm is not standard. Unless specifically ordered, M10 hex nuts will with across flats will be furnished.

SOURCE: Reprinted courtesy of The American Society of Mechanical Engineers.

Appendix 23 ANSI Metric Slotted Hex Nuts and Hex Flange Nuts
American National Standard Metric Slotted Hex Nuts
 (ANSI B18.2.4.3M-1979, R1989)

Nominal Nut Diam. and Thread Pitch	Width Across Flats, <i>S</i>		Width Across Corners, <i>E</i>		Thickness, <i>M</i>		Bearing Face Diam., <i>D_w</i>	Unslotted Thickness, <i>F</i>	Width of Slot, <i>N</i>		Washer Face Thickness <i>C</i>	
	Max	Min	Max	Min	Max	Min			Max	Min	Max	Min
M5 × 0.8	8.00	7.78	9.24	8.79	5.10	4.80	6.9	3.2	2.9	2.0	1.4	...
M6 × 1	10.00	9.78	11.55	11.05	5.70	5.40	8.9	3.5	3.2	2.4	1.8	...
M8 × 1.25	13.00	12.73	15.01	14.38	7.50	7.14	11.6	4.4	4.1	2.9	2.3	...
*M10 × 1.5	15.00	14.73	17.32	16.64	10.0	9.6	13.6	5.7	5.4	3.4	2.8	0.6
M10 × 1.5	16.00	15.73	18.48	17.77	9.30	8.94	14.6	5.2	4.9	3.4	2.8	...
M12 × 1.75	18.00	17.73	20.78	20.03	12.00	11.57	16.6	7.3	6.9	4.0	3.2	...
M14 × 2	21.00	20.67	24.25	23.35	14.10	13.40	19.6	8.6	8.0	4.3	3.5	...
M16 × 2	24.00	23.67	27.71	26.75	16.40	15.70	22.5	9.9	9.3	5.3	4.5	...
M20 × 2.5	30.00	29.16	34.64	32.95	20.30	19.00	27.7	13.3	12.2	5.7	4.5	0.8
M24 × 3	36.00	35.00	41.57	39.55	23.90	22.60	33.2	15.4	14.3	6.7	5.5	0.8
M30 × 3.5	46.00	45.00	53.12	50.85	28.60	27.30	42.7	18.1	16.8	8.5	7.0	0.8
M36 × 4	55.00	53.80	63.51	60.79	34.70	33.10	51.1	23.7	22.4	8.5	7.0	0.4

All dimensions are in millimeters.

* This size with width across flats of 15 mm is not standard. Unless specifically ordered, M10 slotted hex nuts with 16 mm width across flats will be furnished.

American National Standard Metric Hex Flange Nuts
 (ANSI B18.2.4.4M-1982)

Nominal Nut Diam. and Thread Pitch	Width Across Flats, <i>S</i>		Width Across Corners, <i>E</i>		Flange Diam., <i>D_c</i>	Bearing Circle Diam., <i>D_w</i>	Flange Edge Thickness, <i>C</i>	Thickness, <i>M</i>		Flange Top Fillet Radius, <i>R</i>	
	Max	Min	Max	Min				Max	Min	Max	Min
M5 × 0.8	8.00	7.78	9.24	8.79	11.8	9.8	1.0	5.00	4.70	0.3	
M6 × 1	10.00	9.78	11.55	11.05	14.2	12.2	1.1	6.00	5.70	0.4	
M8 × 1.25	13.00	12.73	15.01	14.38	17.9	15.8	1.2	8.00	7.60	0.5	
M10 × 1.5	15.00	14.73	17.32	16.64	21.8	19.6	1.5	10.00	9.60	0.6	
M12 × 1.75	18.00	17.73	20.78	20.03	26.0	23.8	1.8	12.00	11.60	0.7	
M14 × 2	21.00	20.67	24.25	23.35	29.9	27.6	2.1	14.00	13.30	0.9	
M16 × 2	24.00	23.67	27.71	26.75	34.5	31.9	2.4	16.00	15.30	1.0	
M20 × 2.5	30.00	29.16	34.64	32.95	42.8	39.9	3.0	20.00	18.90	1.2	

All dimensions are in millimeters.

SOURCE: Reprinted courtesy of The American Society of Mechanical Engineers.

Appendix 24 ANSI Square and Hexagon Machine Screw Nuts and Flat Head Machine Screws
**American National Standard Square and Hexagon Machine Screw Nuts
(ANSI B18.6.3-1972, R1991)**
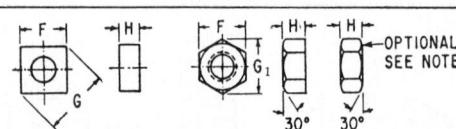

Nom. Size	Basic Diam.	Basic F	Max. F	Min. F	Max. G	Min. G	Max. G1	Min. G1	Max. H	Min. H
0	.0600	$\frac{5}{64}$.156	.150	.221	.206	.180	.171	.050	.043
1	.0730	$\frac{5}{64}$.156	.150	.221	.206	.180	.171	.050	.043
2	.0860	$\frac{3}{16}$.188	.180	.265	.247	.217	.205	.066	.057
3	.0990	$\frac{3}{16}$.188	.180	.265	.247	.217	.205	.066	.057
4	.1120	$\frac{1}{4}$.250	.241	.354	.331	.289	.275	.098	.087
5	.1250	$\frac{5}{16}$.312	.302	.442	.415	.361	.344	.114	.102
6	.1380	$\frac{5}{16}$.312	.302	.442	.415	.361	.344	.114	.102
8	.1640	$\frac{11}{32}$.344	.332	.486	.450	.397	.378	.130	.117
10	.1900	$\frac{3}{8}$.375	.362	.530	.497	.433	.413	.130	.117
12	.2160	$\frac{7}{16}$.438	.423	.619	.581	.505	.482	.161	.148
$\frac{1}{4}$.2500	$\frac{7}{16}$.438	.423	.619	.581	.505	.482	.193	.178
$\frac{5}{16}$.3125	$\frac{9}{16}$.562	.545	.795	.748	.650	.621	.225	.208
$\frac{3}{8}$.3750	$\frac{9}{16}$.625	.607	.884	.833	.722	.692	.257	.239

All dimensions in inches. Hexagon machine screw nuts have tops flat and chamfered. Diameter of top circle should be the maximum width across flats within a tolerance of minus 15 per cent. Bottoms are flat but may be chamfered if so specified. Square machine screw nuts have tops and bottoms flat without chamfer.

American National Standard Slotted 100-Degree Flat Countersunk Head Machine Screws (ANSI B18.6.3-1972, R1991)
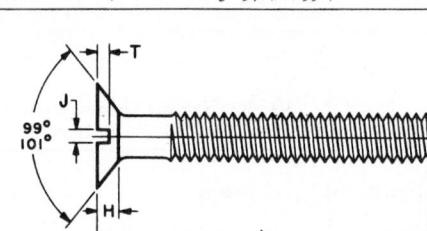

Nominal Size ¹ or Basic Screw Diam.	Head Diam., A		Head Height, H	Slot Width, J	Slot Depth, T
	Max., Edge Sharp	Min., Edge Rounded or Flat			
0000	0.0210	.043	.037	.009	.008 .004
000	0.0340	.064	.058	.014	.012 .008
00	0.0470	.093	.085	.020	.017 .010
0	0.0600	.119	.096	.026	.023 .016
1	0.0730	.146	.120	.031	.026 .019
2	0.0860	.172	.143	.037	.031 .023
3	0.0990	.199	.167	.043	.035 .027
4	0.1120	.225	.191	.049	.039 .031
6	0.1380	.279	.238	.060	.048 .039
8	0.1640	.332	.285	.072	.054 .045
10	0.1900	.385	.333	.083	.060 .050
$\frac{1}{4}$.2500	.507	.442	.110	.075 .064
$\frac{5}{16}$.3125	.635	.556	.138	.084 .072
$\frac{3}{8}$.3750	.762	.670	.165	.094 .081

All dimensions are in inches.

¹ When specifying nominal size in decimals, zeros preceding the decimal point and in the fourth decimal place are omitted.

SOURCE: Reprinted courtesy of The American Society of Mechanical Engineers.

Appendix 25 ANSI Slotted Flat Countersunk Head Cap Screws

American National Standard Slotted Flat Countersunk Head Cap Screws (ANSI B8.6.2-1972, R1977)

Nominal Size* or Basic Screw Diam.	Head Dia., A		Slot Depth, T	Fillet Rad., U	Ref.
	Body Diam., E	Edge Rnd. or Flat	Head Hgt., H	Slot Width, J	
1/4 0.2500	.2500	.2450	.068	.045	.100
5/16 0.3125	.3125	.3125	.094	.081	.150
3/8 0.3750	.3750	.3750	.104	.081	.175
1/2 0.5000	.5000	.4930	.118	.102	.220
9/16 0.6250	.6250	.6250	.133	.116	.200
5/8 0.6875	.6875	.6875	.149	.131	.250
1 1.0000	1.0000	1.020	.281	.232	.300
1 1.1250	1.1250	1.125	.352	.300	.350
1 1.2500	1.2500	1.250	.423	.367	.400
1 1.3750	1.3750	1.375	.494	.440	.460
1 1.5000	1.5000	1.500	.565	.514	.530

SOURCE: Reprinted courtesy of The American Society of Mechanical Engineers.

Appendix 26 ANSI Slotted Round and Fillester Head Cap Screws

American National Standard Slotted Round Head Cap Screws (ANSI B18.6.2-1972, R1983)

Nom. Size* or Basic Screw Diam.	Body Diam., E		Head Diam., A	Head Height, H	Slot Width, J	Slot Depth, T
	Max.	Min.				
1/4 0.2500	.2500	.2450	.418	.191	.175	.094
5/16 0.3125	.3125	.3125	.540	.245	.226	.072
3/8 0.3750	.3750	.3750	.603	.273	.252	.138
7/16 0.4375	.4375	.4375	.750	.328	.302	.167
1/2 0.5000	.5000	.4930	.812	.386	.354	.178
9/16 0.6250	.6250	.6250	.937	.409	.378	.252
5/8 0.6875	.6875	.6875	.970	.437	.405	.270
1 1.0000	1.0000	1.020	1.000	.507	.456	.220
1 1.0625	1.0625	1.080	1.000	.546	.507	.270
1 1.1250	1.1250	1.140	1.000	.575	.536	.270
1 1.1875	1.1875	1.200	1.000	.604	.563	.270
1 1.2500	1.2500	1.260	1.000	.633	.592	.270
1 1.3125	1.3125	1.320	1.000	.662	.621	.270
1 1.3750	1.3750	1.380	1.000	.691	.650	.270
1 1.4375	1.4375	1.440	1.000	.720	.679	.270
1 1.5000	1.5000	1.500	1.000	.749	.708	.270

All dimensions are in inches.
Fillet Radius, U: For fillet radius see table below.
Threads: Threads are Unified Standard Class 2A; UNC, UNF and 8 UN Series or UNRC.

* When specifying a nominal size in decimals, the zero preceding the decimal point is omitted as is any zero in the fourth decimal place.

American National Standard Slotted Fillister Head Cap Screws (ANSI B18.6.2-1972, R1983)

Nom. Size* or Basic Screw Diam.	Body Diam., E		Head Diam., A	Head Height, H	Total Head Height, O	Slot Width, J	Slot Depth, T
	Max.	Min.					
1/4 0.2500	.2500	.2450	.375	.363	.172	.157	.075
5/16 0.3125	.3125	.3125	.437	.424	.203	.230	.084
3/8 0.3750	.3750	.3690	.562	.547	.250	.229	.112
7/16 0.4375	.4375	.4310	.625	.608	.297	.274	.133
1/2 0.5000	.5000	.4930	.750	.731	.328	.301	.153
9/16 0.6250	.6250	.6250	.812	.792	.375	.346	.188
5/8 0.6875	.6875	.6875	.875	.853	.422	.391	.213
1 1.0000	1.0000	1.020	.970	.950	.466	.432	.220
1 1.0625	1.0625	1.080	.970	.950	.496	.466	.220
1 1.1250	1.1250	1.140	.970	.950	.521	.488	.220
1 1.1875	1.1875	1.200	.970	.950	.549	.516	.220
1 1.2500	1.2500	1.260	.970	.950	.577	.544	.220
1 1.3125	1.3125	1.320	.970	.950	.605	.571	.220
1 1.3750	1.3750	1.380	.970	.950	.633	.600	.220
1 1.4375	1.4375	1.440	.970	.950	.661	.628	.220
1 1.5000	1.5000	1.500	.970	.950	.689	.656	.220

All dimensions are in inches.
Fillet Radius, U: For fillet radius see table below.
Threads: Threads are Unified Standard Class 2A; UNC, UNF and 8 UN Series or UNRC.

* When specifying a nominal size in decimals, the zero preceding the decimal point is omitted as is any zero in the fourth decimal place.

SOURCE: Reprinted courtesy of The American Society of Mechanical Engineers.

Appendix 27 Drill and Counterbore Sizes for Socket Head Cap Screws

A-26

Appendix 28 ANSI Hexagon and Spline Socket Head Cap Screws

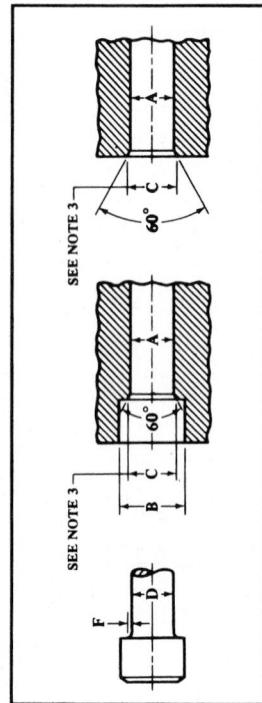

Nominal Size or Basic Screw Diameter	Nominal Drill Size			Counterbore Diameter	Countersink Diameter ³
	Close Fit ¹		Normal Fit ²		
	Number or Fractional Size	Decimal Size	Number or Fractional Size		
0 0.0600	5/16	0.067	49	0.073	1/8
1 0.0730	46 3/32	0.081	43	0.089	5/32
2 0.0860	36	0.094	36	0.106	3/16
3 0.0990	36	0.106	31	0.120	7/32
4 0.1120	1/8	0.125	29	0.136	7/32
5 0.1250	9/64	0.141	23	0.154	1/4
6 0.1380	23	0.154	18	0.170	9/32
8 0.1640	15	0.180	10	0.194	5/16
10 0.1900	5	0.206	2	0.221	3/8
1/4 0.2500	17/64	0.266	9/32	0.281	7/16
5/16 0.3125	21/64	0.328	11/32	0.344	17/32
3/8 0.3750	25/64	0.391	13/32	0.406	5/8
7/16 0.4375	29/64	0.453	15/32	0.469	23/32
1/2 0.5000	33/64	0.516	17/32	0.531	13/16
5/8 0.6250	41/64	0.641	21/32	0.656	1
3/4 0.7500	49/64	0.766	27/32	0.781	13/16
7/8 0.8750	57/64	0.891	29/32	0.906	13/16
1 1.0000	1 1/64	1.016	1 1/32	1.031	1 1/8
1 1/4 1.2500	1 9/32	1.281	1 5/16	1.312	1 3/8
1 1/2 1.5000	1 17/32	1.531	1 9/16	1.562	1 6/8
1 3/4 1.7500	1 25/32	1.781	1 13/16	1.812	2 3/8
2 2.0000	2 1/32	2.031	2 9/16	2.062	3 1/8

All dimensions in inches.

¹ Close Fit: The close fit is normally limited to holes for those lengths of screws which are threaded to the head in assemblies where only one screw is to be used or where two or more screws are to be used and the mating holes are to be produced either at assembly or by matched and coordinated tooling.

² Normal Fit: The normal fit is intended for screws of relatively long length or for assemblies involving two or more screws where the mating holes are to be produced by conventional tooling methods. It provides for the maximum allowable eccentricity of the longest standard screws and for certain variations in the parts to be fastened, such as: deviations in hole straightness, angularity between the axis of the tapped hole and that of the hole for the shank, differences in center distances of the mating holes, etc.

³ Countersink: It is considered good practice to countersink or break the edges of holes which are smaller than (D Max + 2F Max) in parts having a hardness which approaches, equals or exceeds the screw hardness. If such holes are not countersunk, the heads of screws may not seat properly on the sharp edges on holes may deform the fillets on screws thereby making them susceptible to fatigue in applications involving dynamic loading. The countersink or corner relief, however, should not be larger than is necessary to insure that the fillet on the screw is cleared.

Source: Appendix to American National Standard ANSI B18.3-1986.

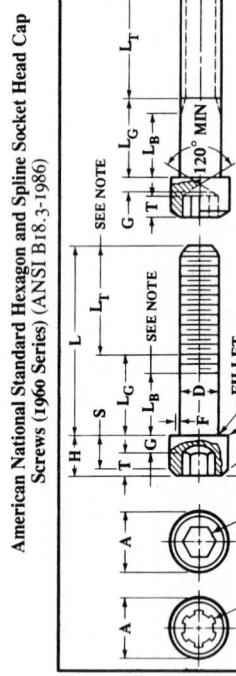

American National Standard Hexagon and Spline Socket Head Cap Screws
Screws (1960 Series) (ANSI B18.3-1986)

Nominal Size	Body Diameter	Head Diameter		Head Height	Spine Socket Size	Hex Socket Size	Fillet Ext.	Key Engage- ment*
		Max	Min					
0	0.0600	0.0568	0.056	0.091	0.060	0.057	0.060	0.025
1	0.0730	0.0730	0.0695	0.118	0.073	0.070	0.067	0.031
2	0.0860	0.0860	0.0822	0.140	0.134	0.086	0.086	0.038
3	0.0990	0.0990	0.0949	0.161	0.154	0.099	0.096	0.044
4	0.1120	0.1120	0.1075	0.183	0.176	0.112	0.168	0.051
5	0.1250	0.1250	0.205	0.188	0.125	0.121	0.111	0.057
6	0.1380	0.1380	0.226	0.188	0.138	0.133	0.134	0.064
7	0.1640	0.1640	0.270	0.262	0.164	0.168	0.141	0.077
8	0.1840	0.1840	0.312	0.303	0.190	0.183	0.156	0.090
10	0.1900	0.1900	0.350	0.345	0.250	0.244	0.216	0.120
1/4	0.2500	0.2435	0.375	0.365	0.247	0.244	0.216	0.151
5/16	0.3125	0.3055	0.469	0.457	0.312	0.306	0.291	0.250
7/16	0.3750	0.3978	0.562	0.559	0.378	0.368	0.350	0.312
11/16	0.4375	0.4294	0.645	0.642	0.438	0.430	0.454	0.375
15/16	0.5000	0.4919	0.750	0.753	0.500	0.492	0.454	0.375
19/16	0.5625	0.6163	0.938	0.921	0.625	0.616	0.595	0.500
23/16	0.6250	0.6740	1.125	1.107	0.750	0.740	0.620	0.539
27/16	0.78750	0.7406	1.312	1.293	0.875	0.864	0.698	0.625
1	1.0000	0.9886	1.500	1.479	1.000	0.988	0.790	0.750
1 1/8	1.1250	1.1086	1.688	1.665	1.125	1.111	1.000	0.957
1 1/4	1.2500	1.2336	1.875	1.852	1.250	1.236	1.111	1.045
1 3/8	1.3750	1.3568	2.062	2.038	1.375	1.360	1.224	1.145
1 5/8	1.5000	1.4818	2.250	2.224	1.500	1.485	1.370	1.290
1 7/8	1.7500	1.7295	2.625	2.597	1.750	1.734	1.520	1.444
2	1.7500	1.9780	3.000	2.995	2.000	1.985	1.750	1.632
2 1/4	2.2500	2.2280	3.375	3.344	2.250	2.232	1.750	1.600
2 1/2	2.5000	2.4763	3.750	3.717	2.500	2.483	2.000	1.845
2 3/4	2.7500	2.7265	4.115	4.090	2.750	2.730	2.000	1.870
3	3.0000	2.9762	4.500	4.464	3.000	2.979	2.500	2.250
3 1/4	3.2500	3.2285	4.875	4.825	3.250	3.228	2.750	2.500
3 1/2	3.5000	3.4762	5.250	5.211	3.500	3.478	3.000	2.750
3 3/4	3.7500	3.6265	5.625	5.584	3.750	3.727	3.250	2.900
4	4.0000	3.9762	6.000	5.938	4.000	3.976	3.750	3.400

* Key engagement depths are minimum. All dimensions in inches. The body length L_B of the screw is the length of the unthreaded cylindrical portion of the shank. The length of thread L_T is the distance from the extreme point to the last complete (full form) thread. Standard length increments for screw diameters up to 1 inch are $1/16$ inch for lengths $1/4$ inch through $1/2$ inch; $1/8$ inch for lengths $1/2$ through 1 inch; $1/4$ inch for lengths 1 through $3/4$ inches; $1/2$ inch for lengths $3/4$ through $7/8$ inches; 1 inch for lengths $7/8$ through 1 inches and for diameters over 1 inch; $1/2$ inch for lengths 1 through 7 inches; 1 inch for lengths 7 through 10 inches and for diameters over 1 inch; $1/2$ inch for lengths 10 through 12 inches; 1 inch for lengths 12 through 14 inches and for diameters over 1 inch; 1 inch for lengths 14 through 16 inches and for diameters over 1 inch; 1 inch for lengths 16 through 18 inches and for diameters over 1 inch; 1 inch for lengths 18 through 20 inches and for diameters over 1 inch; 1 inch for lengths 20 through 22 inches and for diameters over 1 inch; 1 inch for lengths 22 through 24 inches and for diameters over 1 inch; 1 inch for lengths 24 through 26 inches and for diameters over 1 inch; 1 inch for lengths 26 through 28 inches and for diameters over 1 inch; 1 inch for lengths 28 through 30 inches and for diameters over 1 inch; 1 inch for lengths 30 through 32 inches and for diameters over 1 inch; 1 inch for lengths 32 through 34 inches and for diameters over 1 inch; 1 inch for lengths 34 through 36 inches and for diameters over 1 inch; 1 inch for lengths 36 through 38 inches and for diameters over 1 inch; 1 inch for lengths 38 through 40 inches and for diameters over 1 inch; 1 inch for lengths 40 through 42 inches and for diameters over 1 inch; 1 inch for lengths 42 through 44 inches and for diameters over 1 inch; 1 inch for lengths 44 through 46 inches and for diameters over 1 inch; 1 inch for lengths 46 through 48 inches and for diameters over 1 inch; 1 inch for lengths 48 through 50 inches and for diameters over 1 inch; 1 inch for lengths 50 through 52 inches and for diameters over 1 inch; 1 inch for lengths 52 through 54 inches and for diameters over 1 inch; 1 inch for lengths 54 through 56 inches and for diameters over 1 inch; 1 inch for lengths 56 through 58 inches and for diameters over 1 inch; 1 inch for lengths 58 through 60 inches and for diameters over 1 inch; 1 inch for lengths 60 through 62 inches and for diameters over 1 inch; 1 inch for lengths 62 through 64 inches and for diameters over 1 inch; 1 inch for lengths 64 through 66 inches and for diameters over 1 inch; 1 inch for lengths 66 through 68 inches and for diameters over 1 inch; 1 inch for lengths 68 through 70 inches and for diameters over 1 inch; 1 inch for lengths 70 through 72 inches and for diameters over 1 inch; 1 inch for lengths 72 through 74 inches and for diameters over 1 inch; 1 inch for lengths 74 through 76 inches and for diameters over 1 inch; 1 inch for lengths 76 through 78 inches and for diameters over 1 inch; 1 inch for lengths 78 through 80 inches and for diameters over 1 inch; 1 inch for lengths 80 through 82 inches and for diameters over 1 inch; 1 inch for lengths 82 through 84 inches and for diameters over 1 inch; 1 inch for lengths 84 through 86 inches and for diameters over 1 inch; 1 inch for lengths 86 through 88 inches and for diameters over 1 inch; 1 inch for lengths 88 through 90 inches and for diameters over 1 inch; 1 inch for lengths 90 through 92 inches and for diameters over 1 inch; 1 inch for lengths 92 through 94 inches and for diameters over 1 inch; 1 inch for lengths 94 through 96 inches and for diameters over 1 inch; 1 inch for lengths 96 through 98 inches and for diameters over 1 inch; 1 inch for lengths 98 through 100 inches and for diameters over 1 inch; 1 inch for lengths 100 through 102 inches and for diameters over 1 inch; 1 inch for lengths 102 through 104 inches and for diameters over 1 inch; 1 inch for lengths 104 through 106 inches and for diameters over 1 inch; 1 inch for lengths 106 through 108 inches and for diameters over 1 inch; 1 inch for lengths 108 through 110 inches and for diameters over 1 inch; 1 inch for lengths 110 through 112 inches and for diameters over 1 inch; 1 inch for lengths 112 through 114 inches and for diameters over 1 inch; 1 inch for lengths 114 through 116 inches and for diameters over 1 inch; 1 inch for lengths 116 through 118 inches and for diameters over 1 inch; 1 inch for lengths 118 through 120 inches and for diameters over 1 inch; 1 inch for lengths 120 through 122 inches and for diameters over 1 inch; 1 inch for lengths 122 through 124 inches and for diameters over 1 inch; 1 inch for lengths 124 through 126 inches and for diameters over 1 inch; 1 inch for lengths 126 through 128 inches and for diameters over 1 inch; 1 inch for lengths 128 through 130 inches and for diameters over 1 inch; 1 inch for lengths 130 through 132 inches and for diameters over 1 inch; 1 inch for lengths 132 through 134 inches and for diameters over 1 inch; 1 inch for lengths 134 through 136 inches and for diameters over 1 inch; 1 inch for lengths 136 through 138 inches and for diameters over 1 inch; 1 inch for lengths 138 through 140 inches and for diameters over 1 inch; 1 inch for lengths 140 through 142 inches and for diameters over 1 inch; 1 inch for lengths 142 through 144 inches and for diameters over 1 inch; 1 inch for lengths 144 through 146 inches and for diameters over 1 inch; 1 inch for lengths 146 through 148 inches and for diameters over 1 inch; 1 inch for lengths 148 through 150 inches and for diameters over 1 inch; 1 inch for lengths 150 through 152 inches and for diameters over 1 inch; 1 inch for lengths 152 through 154 inches and for diameters over 1 inch; 1 inch for lengths 154 through 156 inches and for diameters over 1 inch; 1 inch for lengths 156 through 158 inches and for diameters over 1 inch; 1 inch for lengths 158 through 160 inches and for diameters over 1 inch; 1 inch for lengths 160 through 162 inches and for diameters over 1 inch; 1 inch for lengths 162 through 164 inches and for diameters over 1 inch; 1 inch for lengths 164 through 166 inches and for diameters over 1 inch; 1 inch for lengths 166 through 168 inches and for diameters over 1 inch; 1 inch for lengths 168 through 170 inches and for diameters over 1 inch; 1 inch for lengths 170 through 172 inches and for diameters over 1 inch; 1 inch for lengths 172 through 174 inches and for diameters over 1 inch; 1 inch for lengths 174 through 176 inches and for diameters over 1 inch; 1 inch for lengths 176 through 178 inches and for diameters over 1 inch; 1 inch for lengths 178 through 180 inches and for diameters over 1 inch; 1 inch for lengths 180 through 182 inches and for diameters over 1 inch; 1 inch for lengths 182 through 184 inches and for diameters over 1 inch; 1 inch for lengths 184 through 186 inches and for diameters over 1 inch; 1 inch for lengths 186 through 188 inches and for diameters over 1 inch; 1 inch for lengths 188 through 190 inches and for diameters over 1 inch; 1 inch for lengths 190 through 192 inches and for diameters over 1 inch; 1 inch for lengths 192 through 194 inches and for diameters over 1 inch; 1 inch for lengths 194 through 196 inches and for diameters over 1 inch; 1 inch for lengths 196 through 198 inches and for diameters over 1 inch; 1 inch for lengths 198 through 200 inches and for diameters over 1 inch; 1 inch for lengths 200 through 202 inches and for diameters over 1 inch; 1 inch for lengths 202 through 204 inches and for diameters over 1 inch; 1 inch for lengths 204 through 206 inches and for diameters over 1 inch; 1 inch for lengths 206 through 208 inches and for diameters over 1 inch; 1 inch for lengths 208 through 210 inches and for diameters over 1 inch; 1 inch for lengths 210 through 212 inches and for diameters over 1 inch; 1 inch for lengths 212 through 214 inches and for diameters over 1 inch; 1 inch for lengths 214 through 216 inches and for diameters over 1 inch; 1 inch for lengths 216 through 218 inches and for diameters over 1 inch; 1 inch for lengths 218 through 220 inches and for diameters over 1 inch; 1 inch for lengths 220 through 222 inches and for diameters over 1 inch; 1 inch for lengths 222 through 224 inches and for diameters over 1 inch; 1 inch for lengths 224 through 226 inches and for diameters over 1 inch; 1 inch for lengths 226 through 228 inches and for diameters over 1 inch; 1 inch for lengths 228 through 230 inches and for diameters over 1 inch; 1 inch for lengths 230 through 232 inches and for diameters over 1 inch; 1 inch for lengths 232 through 234 inches and for diameters over 1 inch; 1 inch for lengths 234 through 236 inches and for diameters over 1 inch; 1 inch for lengths 236 through 238 inches and for diameters over 1 inch; 1 inch for lengths 238 through 240 inches and for diameters over 1 inch; 1 inch for lengths 240 through 242 inches and for diameters over 1 inch; 1 inch for lengths 242 through 244 inches and for diameters over 1 inch; 1 inch for lengths 244 through 246 inches and for diameters over 1 inch; 1 inch for lengths 246 through 248 inches and for diameters over 1 inch; 1 inch for lengths 248 through 250 inches and for diameters over 1 inch; 1 inch for lengths 250 through 252 inches and for diameters over 1 inch; 1 inch for lengths 252 through 254 inches and for diameters over 1 inch; 1 inch for lengths 254 through 256 inches and for diameters over 1 inch; 1 inch for lengths 256 through 258 inches and for diameters over 1 inch; 1 inch for lengths 258 through 260 inches and for diameters over 1 inch; 1 inch for lengths 260 through 262 inches and for diameters over 1 inch; 1 inch for lengths 262 through 264 inches and for diameters over 1 inch; 1 inch for lengths 264 through 266 inches and for diameters over 1 inch; 1 inch for lengths 266 through 268 inches and for diameters over 1 inch; 1 inch for lengths 268 through 270 inches and for diameters over 1 inch; 1 inch for lengths 270 through 272 inches and for diameters over 1 inch; 1 inch for lengths 272 through 274 inches and for diameters over 1 inch; 1 inch for lengths 274 through 276 inches and for diameters over 1 inch; 1 inch for lengths 276 through 278 inches and for diameters over 1 inch; 1 inch for lengths 278 through 280 inches and for diameters over 1 inch; 1 inch for lengths 280 through 282 inches and for diameters over 1 inch; 1 inch for lengths 282 through 284 inches and for diameters over 1 inch; 1 inch for lengths 284 through 286 inches and

Appendix 29 ANSI Hexagon Socket Head Shoulder Screws

American National Standard Hexagon Socket Head Shoulder Screws (ANSI B18.3-1986)

Standard Hexagon S
ANSI B18.3-1986)

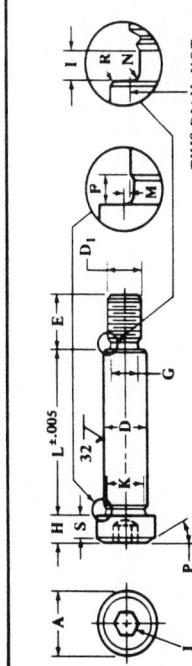

THIS DIAM. NOT TO EXCEED MAJOR DIAM. OF THREAD									
Nominal Size	Shoulder Diameter		Head Diameter		Head Height		Head Side Height		Nominal Thread Length
	Max.	Min.	Max.	Min.	Max.	Min.	Min.	Max.	
	<i>D</i>		<i>A</i>		<i>H</i>		<i>S</i>	<i>D</i> ₁	<i>E</i>
1/4	0.2480	0.2460	0.375	0.357	0.188	0.177	0.157	10-24	0.375
5/16	0.3105	0.3085	0.438	0.419	0.219	0.209	0.183	10-20	0.438
3/8	0.3739	0.3710	0.562	0.543	0.250	0.240	0.209	5/16-18	0.590
1/2	0.4980	0.4960	0.750	0.729	0.312	0.302	0.262	3/8-16	0.625
63/32	0.6210	0.6180	0.875	0.853	0.375	0.365	0.315	1/2-13	0.750
3/4	0.7480	0.7460	1.000	0.977	0.500	0.490	0.421	3/8-11	0.875
1	0.9980	0.9960	1.312	1.287	0.625	0.610	0.527	3/8-10	1.000
1 1/4	1.2480	1.2460	1.750	1.723	0.750	0.735	0.633	7/8-9	1.125
1 1/2	1.4980	1.4960	2.125	2.095	1.000	0.980	0.842	1 1/8-7	1.500
1 3/4	1.7480	1.7460	2.375	2.345	1.125	1.105	0.948	1 1/8-7	1.750
2	1.9980	1.9960	2.750	2.720	1.250	1.230	1.054	1 1/2-6	2.000
Nominal Size	Thread Neck Diameter		Thread Neck Width		Shoulder Neck Diam.		Thread Neck Width		Head Fillet Extension Above <i>D</i>
	Max.	Min.	Max.	Min.	Max.	Min.	Max.	Min.	
	<i>G</i>	<i>I</i>	<i>K</i>	<i>F</i>	<i>N</i>	<i>M</i>	<i>M</i>	<i>M</i>	<i>J</i>
1/4	0.142	0.133	0.083	0.227	0.093	0.023	0.017	0.014	1/8
5/16	0.193	0.182	0.100	0.289	0.093	0.028	0.022	0.017	5/32
3/8	0.249	0.237	0.111	0.352	0.093	0.031	0.025	0.020	3/16
1/2	0.304	0.291	0.125	0.477	0.093	0.035	0.039	0.026	1/4
5/8	0.414	0.397	0.154	0.602	0.093	0.042	0.036	0.032	5/16
3/4	0.521	0.502	0.182	0.727	0.093	0.051	0.045	0.039	3/8
1	0.638	0.616	0.200	0.977	0.125	0.055	0.049	0.050	1/2
1 1/4	0.750	0.726	0.222	1.227	0.125	0.062	0.056	0.060	5/8
1 1/2	0.904	0.934	0.286	1.478	0.125	0.072	0.066	0.070	7/8
1 3/4	1.089	1.059	0.286	1.728	0.125	0.072	0.066	0.080	1
2	1.307	1.277	0.333	1.978	0.125	0.102	0.096	0.090	1 1/4

All dimensions are in inches. The shoulder is the enlarged unthreaded portion of the screw. Standard lengths for shoulder screws are $\frac{1}{8}$ inch for nominal screw lengths of $\frac{1}{4}$ inches through $\frac{3}{4}$ inch, $\frac{1}{2}$ inch for lengths above $\frac{1}{4}$ through 5 inches, and $\frac{1}{2}$ inch for lengths over 5 inches. The standard conform to the Unified Standard Class 3A, UNC. Hexagon socket sizes for the respective sizes are the same as for set screws of the same nominal size (see Table 7) except that shoulder screw sizes are $\frac{1}{8}$ inch for screw sizes $\frac{1}{4}$ through $\frac{3}{4}$ inches, $\frac{1}{4}$ inch for shoulder screw size $\frac{1}{2}$ inch, socket size is $\frac{1}{4}$ inch for screw size $\frac{1}{2}$ through 1 $\frac{1}{2}$ inches, and $\frac{1}{2}$ inch for screw size 2 inches. Socket size is $\frac{1}{4}$ inches for shoulder screw size 2 $\frac{1}{2}$ inches. For manufacturing details not shown refer to Standard ASME B18.1-1966.

SOURCE: Reprinted courtesy of The American Society of Mechanical Engineers

Appendix 30 Drill and Counterbore Sizes for Metric Socket Head Cap Screws

Nominal Size or Basic Screw Diameter	Nominal Drill Size, A		Counterbore Diameter, X	Countersink Diameter, Y
	Nominal Fit*	Normal Fit†		
M1.6	1.80	1.95	3.50	2.0
M2	2.20	2.40	4.40	2.6
M2.5	2.70	3.00	5.40	3.1
M3	3.40	3.70	6.50	3.6
M4	4.40	4.80	8.25	4.7
M5	5.40	5.80	9.75	5.7
M6	6.40	6.80	11.25	6.8
M8	8.40	8.80	14.25	9.2
M10	10.50	10.80	17.25	11.2
M12	12.50	12.80	19.25	14.2
M14	14.50	14.75	22.25	16.2
M16	16.50	16.75	25.50	18.2
M20	20.50	20.75	31.50	22.4
M24	24.50	24.75	37.50	26.4
M30	30.75	31.75	47.50	33.4
M36	37.00	37.50	56.50	39.4
M42	43.00	44.00	66.00	45.6
M48	49.00	50.00	75.00	52.6

All dimensions are in millimetres.
*** Close Fit.** The close fit is normally limited to holes for those lengths of screws which are threaded to the head in assemblies where only one screw is to be used or where two or more screws are to be used and the mating holes are to be matched at assembly or by matched and coordinated tooling.

Normal fit. It is intended that the mating holes are to be produced by conventional tolerancing methods. It provides for the maximum allowable eccentricity of the longest standard screws and for certain variations in the parts to be fastened, such as: deviations in hole straightness, angularity between the axis of the tapped hole and that of the hole for shank, differences in center distances of the mating holes, etc.

Countersink. It is considered good practice to countersink or break the edges of holes which are smaller than B Max. (See Table 20) in parts having a hardness which approaches, equals, or exceeds the screw hardness. If such holes are not countersunk, the heads of screw may not seat properly or the sharp edges on holes may deform the fillets on screws, thereby making them susceptible to fatigue in applications involving dynamic loading. The countersink or corner fillet, however, should not be larger than is necessary to ensure that the fillet on the screw is cleared. Normally, the diameter of countersink does not have to exceed B Max. Countersinks or corner

SOURCE: Reprinted courtesy of The American Society of Mechanical Engineers.

All dimensions are in inches. The shoulder is the enlarged unthreaded portion of the screw. Standard lengths for shoulder screws are $\frac{1}{8}$ inch for nominal screw lengths of $\frac{1}{4}$ inches through $\frac{3}{4}$ inch; $\frac{1}{2}$ inch for lengths above $\frac{1}{4}$ through 5 inches; and $\frac{1}{2}$ inch for lengths over 5 inches. The standard conform to the Unified Standard Class 3A, UNC. Hexagon socket sizes for the respective sizes are the same as for set screws of the same nominal size (see Table 7) except that shoulder screw sizes are $\frac{1}{8}$ inch for screw size $\frac{1}{4}$ inches, $\frac{1}{4}$ inch for screw size $\frac{5}{16}$ inches, $\frac{5}{16}$ inch for screw size $\frac{3}{8}$ inches, $\frac{3}{8}$ inch for screw size $\frac{1}{2}$ inches, $\frac{1}{2}$ inch for screw size $\frac{5}{8}$ inches, $\frac{5}{8}$ inch for screw size $\frac{3}{4}$ inches, and $\frac{3}{4}$ inch for screw size 1 inches. Socket size is $\frac{1}{4}$ inches. For manufacturing details not shown refer to Standard ASME B18.1.

A-27

Appendix 31 ANSI Socket Head Cap Screws—Metric Series

American National Standard Socket Head Cap Screws—Metric Series
(ANSI B18.3;1M-1986)

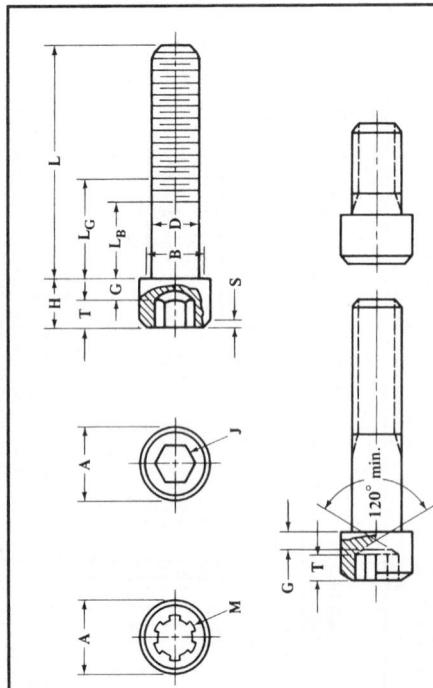

Nom. Size and Thread Pitch	Body Diameter, <i>D</i>	Head Diameter, <i>A</i>	Head Height, <i>H</i>	Chamfer Radius, <i>S</i>	Hexagon Socket Spline Size, <i>J</i>	Key Engagement Size, <i>M</i>	Transition Diam. <i>T</i>	Dimensions				Nom. Min	Nom. Max	Max. Min	Nom. Min	Max. Max	Nom. Min	Max. Max	Nom. Min	Max. Max	
								Max.	Min.	Max.	Min.										
M1.6 × 0.35	1.60	1.46	3.00	2.87	1.60	1.52	0.16	1.5	1.839	0.80	2.0										
M2.00	1.86	3.80	3.65	2.00	1.91	2.00	1.20	1.5	1.839	1.00	2.6										
M2.50 × 0.45	2.50	2.36	4.50	4.33	2.50	2.40	0.25	2.0	2.438	1.25	3.1										
M3.00	2.86	5.50	5.32	3.00	2.89	0.30	2.5	2.819	1.50	3.6											
M4.00	3.82	7.00	6.80	4.00	3.88	0.40	3.0	3.378	2.00	4.7											
M5.00	4.82	8.50	8.27	5.00	4.86	0.50	4.0	4.648	2.50	5.7											
M6.00	5.82	10.00	9.74	6.00	5.85	0.60	5.0	5.486	3.00	6.8											
M8.00 × 1.25	8.00	7.78	13.00	12.70	8.00	7.83	0.80	6.0	7.391	3.00	9.2										
M10.00	9.78	16.00	15.67	10.00	9.81	1.00	8.0	...	5.00	11.2											
M12.00 × 1.75	12.00	11.73	18.00	17.63	12.00	11.79	1.20	10.0	...	6.00	14.2										
M14.00 × 2*	14.00	13.73	21.00	20.60	14.00	13.77	1.40	12.0	...	7.00	16.2										
M16.00	15.73	24.00	23.58	16.00	15.76	1.60	14.0	...	8.00	18.2											
M20.00 × 2.5	20.00	19.67	30.00	29.53	20.00	19.73	2.00	17.0	...	10.00	22.4										
M24.00 × 3	24.00	23.67	36.00	35.48	24.00	23.70	2.40	19.0	...	12.00	26.4										
M30.00 × 3.5	30.00	29.67	45.00	44.42	30.00	29.67	3.00	22.0	...	15.00	33.4										
M36.00 × 4	36.00	35.61	54.00	53.37	36.00	35.64	3.60	27.0	...	18.00	39.4										
M42.00 × 4.5	42.00	41.61	63.00	62.31	42.00	41.61	4.20	32.0	...	21.00	45.6										
M48.00 × 5	48.00	47.61	72.00	71.27	48.00	47.58	4.80	36.0	...	24.00	52.6										

All dimensions are in millimeters.

* The M14.2 size is not recommended for use in new designs.

† See Countersink footnote in Table 25.‡ See also Table 23.

‡ L_G is grip length and L_B is body length (see Table 21).

For lengths of complete threads, see Table 21.

For additional manufacturing and acceptance specifications, see Standard.

SOURCE: Reprinted courtesy of The American Society of Mechanical Engineers.

Appendix 32 ANSI Metric Hex Bolts

American National Standard Metric Hex Bolts
(ANSI B18.2.3;5M-1979, R1989)

Thread Diameter, <i>D</i> and Bolt Length, <i>L</i>	For Bolt Lengths									
	Head Height, <i>K</i>		Width Across Corners, <i>E</i>		Width Across Flats, <i>S</i>		Body Diameter, <i>D</i> , <i>s</i>		For Bolt Lengths	
M6 × 0.8	5.48	4.52	8.00	7.64	9.24	8.63	3.58	2.4	16	22
M6 × 1	6.19	5.52	10.00	9.04	11.55	10.89	4.35	2.8	18	24
M8 × 1.25	8.58	7.42	13.00	12.57	15.01	14.20	5.68	5.10	3.7	22
M10 × 1.5	10.58	9.42	15.00	14.57	17.32	16.46	6.85	6.17	4.5	26
M10 × 1.75	10.58	9.42	16.00	15.57	18.48	17.59	6.85	6.17	4.5	32
M12 × 2	12.70	11.30	18.00	17.57	20.16	19.78	7.95	7.24	5.2	30
M14 × 2	14.70	13.30	20.00	19.50	21.16	20.25	8.51	7.95	5.3	34
M16 × 2	16.70	15.30	24.00	23.16	27.71	26.17	9.68	8.70	5.7	38
M20 × 2.5	20.84	19.16	30.00	29.16	34.64	32.95	13.40	12.12	8.8	46
M24 × 3	24.84	23.16	36.00	35.00	41.57	39.55	15.90	14.56	10.5	54
M30 × 3.5	30.84	29.16	46.00	45.00	53.12	50.55	19.75	17.92	13.1	66
M36 × 4	37.00	35.00	55.00	53.80	63.51	60.79	23.55	21.72	15.8	74
M42 × 4.5	43.00	41.00	65.00	62.90	75.06	71.71	27.05	25.03	18.2	90
M48 × 5	49.00	47.00	75.00	72.90	86.60	82.76	31.70	28.93	21.0	102
M56 × 5.5	57.20	54.80	85.00	82.20	98.15	93.71	36.20	33.80	24.5	137
M64 × 6	65.52	62.86	95.00	91.86	109.70	104.65	41.32	38.68	28.0	153
M72 × 6	73.84	70.80	105.00	101.40	121.24	115.60	46.45	43.55	31.5	169
M80 × 6	82.16	78.80	115.00	111.00	132.79	126.54	51.58	48.42	35.0	172
M90 × 6	92.48	88.60	130.00	125.50	143.07	137.74	54.26	39.2	32	192
M100 × 6	102.80	98.60	145.00	140.00	167.43	159.80	65.90	60.10	43.4	212

All dimensions are in millimeters.
* This size with switch across flats of 15 mm is not standard. Unless specifically ordered, M10 hex bolts with 16 mm width across flats will be furnished.

† Basic thread length, *B*, is a reference dimension.

‡ For additional manufacturing and acceptance specifications, see Standard.

Standard.

SOURCE: Reprinted courtesy of The American Society of Mechanical Engineers.

Appendix 33 ANSI Metric Hex Cap Screws

American National Standard Metric Hex Cap Screws
(ANSI B18.2.3.1M-1979, R1989)

Nominal Screw Diam., D , and Thread Pitch	Body Diam., D_s		Width Across Flats, S		Width Across Corners, E		Head Height, K		Wrenching Height, K_1	Washer Face Thick., C	Washer Face Diam., D_w
	Max	Min	Max	Min	Max	Min	Max	Min			
M5 × 0.8	5.00	4.82	8.00	7.78	9.24	8.79	3.65	3.35	2.4	0.5	0.2
M6 × 1	6.00	5.82	10.00	9.78	11.55	11.05	4.15	3.85	2.8	0.5	0.2
M8 × 1.25	8.00	7.78	13.00	12.73	15.01	14.38	5.50	5.10	3.7	0.6	0.3
*M10 × 1.5	10.00	9.78	15.00	14.73	17.32	16.64	6.63	6.17	4.5	0.6	0.3
M10 × 1.5	10.00	9.78	16.00	15.73	18.48	17.77	6.63	6.17	4.5	0.6	0.3
M12 × 1.75	12.00	11.73	18.00	17.73	20.78	20.03	7.76	7.24	5.2	0.6	0.3
M14 × 2	14.00	13.73	21.00	20.67	24.25	23.35	9.09	8.51	6.2	0.6	0.3
M16 × 2	16.00	15.73	24.00	23.67	27.71	26.75	10.32	9.68	7.0	0.8	0.4
M20 × 2.5	20.00	19.67	30.00	29.16	34.64	32.95	12.88	12.12	8.8	0.8	0.4
M24 × 3	24.00	23.67	36.00	35.00	41.57	39.55	15.44	14.56	10.5	0.8	0.4
M30 × 3.5	30.00	29.67	46.00	45.00	53.12	50.85	19.48	17.92	13.1	0.8	0.4
M36 × 4	36.00	35.61	55.00	53.80	63.51	60.79	23.38	21.62	15.8	0.8	0.4
M42 × 4.5	42.00	41.38	65.00	62.90	75.06	71.71	26.97	25.03	18.2	1.0	0.5
M48 × 5	48.00	47.38	75.00	72.60	86.60	82.76	31.07	28.93	21.0	1.0	0.5
M56 × 5.5	56.00	55.26	85.00	82.20	98.15	93.71	36.20	33.80	24.5	1.0	0.5
M64 × 6	64.00	63.26	95.00	91.80	109.70	104.65	41.32	38.68	28.0	1.0	0.5
M72 × 6	72.00	71.26	105.00	101.40	121.24	115.64	46.45	43.55	31.5	1.2	0.6
M80 × 6	80.00	79.26	115.00	111.00	132.72	126.54	51.58	48.42	35.0	1.2	0.6
M90 × 6	90.00	89.13	130.00	125.50	150.11	143.07	57.74	54.26	39.2	1.2	0.6
M100 × 6	100.00	99.13	145.00	140.00	167.43	159.60	63.90	60.10	43.4	1.2	0.6

All dimensions are in millimeters.

* This size with width across flats of 15 mm is not standard. Unless specifically ordered, M10 hex cap screws with 16 mm width across flats will be furnished.

† Basic thread lengths, B , are the same as given in Table 6.‡ Transition thread length, X , includes the length of incomplete threads and tolerances on grip gaging length and body length. It is intended for calculation purposes.

For additional manufacturing and acceptance specifications, reference should be made to the Standard.

SOURCE: Reprinted courtesy of The American Society of Mechanical Engineers.

Appendix 34 ANSI Hex and Hex Flange Head Metric Machine Screws

American National Standard Hex and Hex Flange Head Metric Machine Screws (ANSI B18.6.7M-1985)

Hex Head										
Nominal Screw Size and Thread Pitch	D _S		S ²		E ²		K		D _A	R
	Body Diameter		Hex Width Across Flats		Hex Width Across Corners		Head Height		Underhead Fillet	
	Max	Min	Max	Min	Min	Max	Max	Min	Max	Min
M2 × 0.4	2.00	1.65	3.20	3.02	3.38	1.6	1.3	2.6	0.1	
M2.5 × 0.45	2.50	2.12	4.00	3.82	4.28	2.1	1.8	3.1	0.1	
M3 × 0.5	3.00	2.58	5.00	4.82	5.40	2.3	2.0	3.6	0.1	
M3.5 × 0.6	3.50	3.00	5.50	5.32	5.96	2.6	2.3	4.1	0.1	
M4 × 0.7	4.00	3.43	7.00	6.78	7.59	3.0	2.6	4.7	0.2	
M5 × 0.8	5.00	4.36	8.00	7.78	8.71	3.8	3.3	5.7	0.2	
M6 × 1	6.00	5.21	10.00	9.78	10.95	4.7	4.1	6.8	0.3	
M8 × 1.25	8.00	7.04	13.00	12.73	14.26	6.0	5.2	9.2	0.4	
M10 × 1.5	10.00	8.86	16.00	15.73	17.62	7.5	6.5	11.2	0.4	
M12 × 1.75	12.00	10.68	18.00	17.73	19.86	9.0	7.8	13.2	0.4	
M10 × 1.5 ⁵	10.00	8.86	15.00	14.73	16.50	7.5	6.5	11.2	0.4	

See footnotes at end of table.

Hex Flange Head											
Nominal Screw Size and Thread Pitch	D _S		S ²		E ²		D _C		K	K ₁	C ⁵
	Body Diameter		Hex Width Across Flats		Hex Width Across Corners		Flange Diameter		Overall Head Height	Hex Height	Flange Edge Thickness
	Max	Min	Max	Min	Min	Max	Max	Min	Min	Max	Max
M2 × 0.4	2.00	1.65	3.00	2.84	3.16	4.5	4.1	2.2	1.3	0.3	0.1
M2.5 × 0.45	2.50	2.12	3.20	3.04	3.39	5.4	5.0	2.7	1.6	0.3	0.2
M3 × 0.5	3.00	2.58	4.00	3.84	4.27	6.4	5.9	3.2	1.9	0.4	0.2
M3.5 × 0.6	3.50	3.00	5.00	4.82	5.36	7.5	6.9	3.8	2.4	0.5	0.2
M4 × 0.7	4.00	3.43	5.50	5.32	5.92	8.5	7.8	4.3	2.8	0.6	0.2
M5 × 0.8	5.00	4.36	7.00	6.78	7.55	10.6	9.8	5.4	3.5	0.7	0.3
M6 × 1	6.00	5.21	8.00	7.78	8.66	12.8	11.8	6.7	4.2	1.0	0.4
M8 × 1.25	8.00	7.04	10.00	9.78	10.89	16.8	15.5	8.6	5.6	1.2	0.5
M10 × 1.5	10.00	8.86	13.00	12.72	14.16	21.0	19.3	10.7	7.0	1.4	0.6
M12 × 1.75	12.00	10.68	15.00	14.72	16.38	24.8	23.3	13.7	8.4	1.8	0.7

All dimensions in millimeters. ¹ A slight rounding of all edges of the hexagon surfaces of indented hex heads is permissible provided the diameter of the bearing circle is not less than the equivalent of 90 per cent of the specified minimum width across flats dimension. ² Dimensions across flats and across corners of the head are measured at the point of maximum metal. Taper of sides of head (angle between one side and the axis) shall not exceed 2° or 0.10 mm, whichever is greater, the specified width across flats being the large dimension. ³ Heads may be indented, trimmed, or fully upset at the option of the manufacturer. ⁴ The M10 size screws having heads with 15 mm width across flats are not ISO Standard. Unless M10 size screws with 15 mm width across flats are specifically ordered, M10 size screws with 16 mm width across flats shall be furnished. ⁵ The contour of the edge at periphery of flange is optional provided the minimum flange thickness is maintained at the minimum flange diameter. The top surface of flange may be straight or slightly rounded (convex) upward.

SOURCE: Reprinted courtesy of The American Society of Mechanical Engineers.

Appendix 35 ANSI Slotted Flat Head Metric Machine Screws
American National Standard Slotted and Cross and Square Recessed Flat Countersunk Head Metric Machine Screws (ANSI B18.6.7M-1985)

Slotted and Style A¹ for Cross and Square Recessed Heads
Style B¹ for Cross and Square Recessed Heads

Nominal Screw Size and Thread Pitch	Slotted and Style A		Style B				D _K				K	R	N		T			
	D _S		D _{SH} ¹		D _S	L _{SH} ¹		Head Diameter		Head Height	Underhead Fillet Radius	Slot Width		Slot Depth				
	Body Diameter		Body and Shoulder Diameter	Shoulder Diameter	Body Diameter	Shoulder Length		Theoretical Sharp					Max	Min	Max	Min		
	Max	Min				Max	Min	Max	Min			Max	Min	Max	Min			
M2 x 0.4 ²	2.00	1.65	2.00	1.86	1.65	0.50	0.30	4.4	4.1	3.5	1.2	0.8	0.4	0.7	0.5	0.6	0.4	
M2.5 x 0.45	2.50	2.12	2.50	2.36	2.12	0.55	0.35	5.5	5.1	4.4	1.5	1.0	0.5	0.8	0.6	0.7	0.5	
M3 x 0.5	3.00	2.58	3.00	2.86	2.58	0.60	0.40	6.3	5.9	5.2	1.7	1.2	0.6	1.0	0.8	0.9	0.6	
M3.5 x 0.6	3.50	3.00	3.50	3.32	3.00	0.70	0.50	8.2	7.7	6.9	2.3	1.4	0.7	1.2	1.0	1.2	0.9	
M4 x 0.7	4.00	3.43	4.00	3.82	3.43	0.80	0.60	9.4	8.9	8.0	2.7	1.6	0.8	1.5	1.2	1.3	1.0	
M5 x 0.8	5.00	4.36	5.00	4.82	4.36	0.90	0.70	10.4	9.8	8.9	2.7	2.0	1.0	1.5	1.2	1.4	1.1	
M6 x 1	6.00	5.21	6.00	5.82	5.21	1.10	0.90	12.6	11.9	10.9	3.3	2.4	1.2	1.9	1.6	1.6	1.2	
M8 x 1.25	8.00	7.04	8.00	7.78	7.04	1.40	1.10	17.3	16.5	15.4	4.6	3.2	1.6	2.3	2.0	2.3	1.8	
M10 x 1.5	10.00	8.86	10.00	9.78	8.86	1.70	1.30	20.0	19.2	17.8	5.0	4.0	2.0	2.8	2.5	2.6	2.0	

All dimensions in millimeters. ¹ All recessed head heat-treated steel screws of property class 9.8 or higher strength have the Style B head form. Recessed head screws other than those specifically designated to be Style B have the Style A head form. The underhead shoulder on the Style B head form is mandatory and all other head dimensions are common to both the Style A and Style B head forms. ² This size is not specified for Type III square recessed flat countersunk heads; Type II cross recess is not specified for any size.

SOURCE: Reprinted courtesy of The American Society of Mechanical Engineers.

Appendix 36 ANSI Slotted Headless Set Screws

American National Standard Slotted Headless Set Screws
(ANSI B18.6.2-1972, R1983)

Nominal Size* or Basic Screw Diameter	Slot Width, <i>J</i>	Slot Depth, <i>T</i>	Point Length						
			Dog Point Diam., <i>P</i>	Dog Point Diam., <i>Q</i>	Cup and Flat Point Diams., <i>C</i>	Dog Point Diam., <i>P</i>	Dog Point Diam., <i>Q</i>	Half Dog, <i>Q</i>	
Max.	Min.	Max.	Min.	Max.	Min.	Max.	Min.	Max.	
0	0.0600	.014	.020	.016	.033	.027	.040	.037	.032
1	0.0730	.016	.020	.016	.033	.049	.045	.040	.046
2	0.0860	.018	.025	.019	.047	.059	.053	.046	.057
3	0.0990	.020	.028	.022	.054	.066	.062	.052	.064
4	0.1120	.024	.031	.025	.061	.075	.065	.054	.074
5	0.1250	.026	.036	.026	.067	.083	.078	.063	.082
6	0.1380	.028	.040	.022	.073	.092	.087	.067	.091
8	0.1640	.032	.053	.030	.094	.109	.096	.076	.109
10	0.1900	.035	.062	.043	.102	.127	.103	.093	.127
12	0.2160	.042	.073	.051	.115	.137	.115	.105	.137
14	0.2500	.049	.081	.041	.126	.156	.149	.130	.156
16	0.3120	.055	.097	.073	.132	.166	.151	.131	.166
18	0.3750	.068	.106	.099	.142	.172	.136	.116	.172
20	0.4375	.076	.114	.104	.154	.194	.141	.114	.194
21	0.5000	.086	.126	.112	.170	.212	.164	.130	.212
22	0.5625	.096	.146	.136	.201	.245	.193	.150	.245
24	0.6250	.107	.157	.151	.231	.287	.214	.174	.287
26	0.7500	.134	.188	.176	.270	.344	.234	.194	.344
28	0.9375	.162	.224	.201	.332	.409	.321	.250	.409
30	1.1250	.197	.266	.231	.379	.486	.375	.305	.486
32	1.3125	.237	.316	.271	.469	.562	.448	.364	.562
34	1.7500	.344	.450	.344	.562	.738	.582	.450	.738
36	2.0000	1	1	1	1	1	1	1	1

All dimensions are in inches. The crown radius *I* has the same value as the basic screw diameter to three decimal places.

Oval Point Radius, *R*: Values of the oval point radius according to nominal screw size are: For a screw size of *o*, a radius of *o*.051; *1*, *055*; *2*, *064*; *3*, *074*; *4*, *084*; *5*, *094*; *6*, *104*; *8*, *123*; *10*, *142*; *12*, *162*; *14*, *188*; *16*, *224*; *18*, *281*; *20*, *328*; *24*, *375*; *30*, *422*; *36*, *460*; and for *3/8*, *5/16*, *1/2*, *11/16*, *13/16*, *15/16*, *17/16*, *19/16*, *21/16*, *23/16*, *25/16*, *27/16*, *29/16*, *31/16*, *33/16*, *35/16*, *37/16*, *39/16*, *41/16*, *43/16*, *45/16*, *47/16*, *49/16*, *51/16*, *53/16*, *55/16*, *57/16*, *59/16*, *61/16*, *63/16*, *65/16*, *67/16*, *69/16*, *71/16*, *73/16*, *75/16*, *77/16*, *79/16*, *81/16*, *83/16*, *85/16*, *87/16*, *89/16*, *91/16*, *93/16*, *95/16*, *97/16*, *99/16*, *101/16*, *103/16*, *105/16*, *107/16*, *109/16*, *111/16*, *113/16*, *115/16*, *117/16*, *119/16*, *121/16*, *123/16*, *125/16*, *127/16*, *129/16*, *131/16*, *133/16*, *135/16*, *137/16*, *139/16*, *141/16*, *143/16*, *145/16*, *147/16*, *149/16*, *151/16*, *153/16*, *155/16*, *157/16*, *159/16*, *161/16*, *163/16*, *165/16*, *167/16*, *169/16*, *171/16*, *173/16*, *175/16*, *177/16*, *179/16*, *181/16*, *183/16*, *185/16*, *187/16*, *189/16*, *191/16*, *193/16*, *195/16*, *197/16*, *199/16*, *201/16*, *203/16*, *205/16*, *207/16*, *209/16*, *211/16*, *213/16*, *215/16*, *217/16*, *219/16*, *221/16*, *223/16*, *225/16*, *227/16*, *229/16*, *231/16*, *233/16*, *235/16*, *237/16*, *239/16*, *241/16*, *243/16*, *245/16*, *247/16*, *249/16*, *251/16*, *253/16*, *255/16*, *257/16*, *259/16*, *261/16*, *263/16*, *265/16*, *267/16*, *269/16*, *271/16*, *273/16*, *275/16*, *277/16*, *279/16*, *281/16*, *283/16*, *285/16*, *287/16*, *289/16*, *291/16*, *293/16*, *295/16*, *297/16*, *299/16*, *301/16*, *303/16*, *305/16*, *307/16*, *309/16*, *311/16*, *313/16*, *315/16*, *317/16*, *319/16*, *321/16*, *323/16*, *325/16*, *327/16*, *329/16*, *331/16*, *333/16*, *335/16*, *337/16*, *339/16*, *341/16*, *343/16*, *345/16*, *347/16*, *349/16*, *351/16*, *353/16*, *355/16*, *357/16*, *359/16*, *361/16*, *363/16*, *365/16*, *367/16*, *369/16*, *371/16*, *373/16*, *375/16*, *377/16*, *379/16*, *381/16*, *383/16*, *385/16*, *387/16*, *389/16*, *391/16*, *393/16*, *395/16*, *397/16*, *399/16*, *401/16*, *403/16*, *405/16*, *407/16*, *409/16*, *411/16*, *413/16*, *415/16*, *417/16*, *419/16*, *421/16*, *423/16*, *425/16*, *427/16*, *429/16*, *431/16*, *433/16*, *435/16*, *437/16*, *439/16*, *441/16*, *443/16*, *445/16*, *447/16*, *449/16*, *451/16*, *453/16*, *455/16*, *457/16*, *459/16*, *461/16*, *463/16*, *465/16*, *467/16*, *469/16*, *471/16*, *473/16*, *475/16*, *477/16*, *479/16*, *481/16*, *483/16*, *485/16*, *487/16*, *489/16*, *491/16*, *493/16*, *495/16*, *497/16*, *499/16*, *501/16*, *503/16*, *505/16*, *507/16*, *509/16*, *511/16*, *513/16*, *515/16*, *517/16*, *519/16*, *521/16*, *523/16*, *525/16*, *527/16*, *529/16*, *531/16*, *533/16*, *535/16*, *537/16*, *539/16*, *541/16*, *543/16*, *545/16*, *547/16*, *549/16*, *551/16*, *553/16*, *555/16*, *557/16*, *559/16*, *561/16*, *563/16*, *565/16*, *567/16*, *569/16*, *571/16*, *573/16*, *575/16*, *577/16*, *579/16*, *581/16*, *583/16*, *585/16*, *587/16*, *589/16*, *591/16*, *593/16*, *595/16*, *597/16*, *599/16*, *601/16*, *603/16*, *605/16*, *607/16*, *609/16*, *611/16*, *613/16*, *615/16*, *617/16*, *619/16*, *621/16*, *623/16*, *625/16*, *627/16*, *629/16*, *631/16*, *633/16*, *635/16*, *637/16*, *639/16*, *641/16*, *643/16*, *645/16*, *647/16*, *649/16*, *651/16*, *653/16*, *655/16*, *657/16*, *659/16*, *661/16*, *663/16*, *665/16*, *667/16*, *669/16*, *671/16*, *673/16*, *675/16*, *677/16*, *679/16*, *681/16*, *683/16*, *685/16*, *687/16*, *689/16*, *691/16*, *693/16*, *695/16*, *697/16*, *699/16*, *701/16*, *703/16*, *705/16*, *707/16*, *709/16*, *711/16*, *713/16*, *715/16*, *717/16*, *719/16*, *721/16*, *723/16*, *725/16*, *727/16*, *729/16*, *731/16*, *733/16*, *735/16*, *737/16*, *739/16*, *741/16*, *743/16*, *745/16*, *747/16*, *749/16*, *751/16*, *753/16*, *755/16*, *757/16*, *759/16*, *761/16*, *763/16*, *765/16*, *767/16*, *769/16*, *771/16*, *773/16*, *775/16*, *777/16*, *779/16*, *781/16*, *783/16*, *785/16*, *787/16*, *789/16*, *791/16*, *793/16*, *795/16*, *797/16*, *799/16*, *801/16*, *803/16*, *805/16*, *807/16*, *809/16*, *811/16*, *813/16*, *815/16*, *817/16*, *819/16*, *821/16*, *823/16*, *825/16*, *827/16*, *829/16*, *831/16*, *833/16*, *835/16*, *837/16*, *839/16*, *841/16*, *843/16*, *845/16*, *847/16*, *849/16*, *851/16*, *853/16*, *855/16*, *857/16*, *859/16*, *861/16*, *863/16*, *865/16*, *867/16*, *869/16*, *871/16*, *873/16*, *875/16*, *877/16*, *879/16*, *881/16*, *883/16*, *885/16*, *887/16*, *889/16*, *891/16*, *893/16*, *895/16*, *897/16*, *899/16*, *901/16*, *903/16*, *905/16*, *907/16*, *909/16*, *911/16*, *913/16*, *915/16*, *917/16*, *919/16*, *921/16*, *923/16*, *925/16*, *927/16*, *929/16*, *931/16*, *933/16*, *935/16*, *937/16*, *939/16*, *941/16*, *943/16*, *945/16*, *947/16*, *949/16*, *951/16*, *953/16*, *955/16*, *957/16*, *959/16*, *961/16*, *963/16*, *965/16*, *967/16*, *969/16*, *971/16*, *973/16*, *975/16*, *977/16*, *979/16*, *981/16*, *983/16*, *985/16*, *987/16*, *989/16*, *991/16*, *993/16*, *995/16*, *997/16*, *999/16*, *1001/16*, *1003/16*, *1005/16*, *1007/16*, *1009/16*, *1011/16*, *1013/16*, *1015/16*, *1017/16*, *1019/16*, *1021/16*, *1023/16*, *1025/16*, *1027/16*, *1029/16*, *1031/16*, *1033/16*, *1035/16*, *1037/16*, *1039/16*, *1041/16*, *1043/16*, *1045/16*, *1047/16*, *1049/16*, *1051/16*, *1053/16*, *1055/16*, *1057/16*, *1059/16*, *1061/16*, *1063/16*, *1065/16*, *1067/16*, *1069/16*, *1071/16*, *1073/16*, *1075/16*, *1077/16*, *1079/16*, *1081/16*, *1083/16*, *1085/16*, *1087/16*, *1089/16*, *1091/16*, *1093/16*, *1095/16*, *1097/16*, *1099/16*, *1101/16*, *1103/16*, *1105/16*, *1107/16*, *1109/16*, *1111/16*, *1113/16*, *1115/16*, *1117/16*, *1119/16*, *1121/16*, *1123/16*, *1125/16*, *1127/16*, *1129/16*, *1131/16*, *1133/16*, *1135/16*, *1137/16*, *1139/16*, *1141/16*, *1143/16*, *1145/16*, *1147/16*, *1149/16*, *1151/16*, *1153/16*, *1155/16*, *1157/16*, *1159/16*, *1161/16*, *1163/16*, *1165/16*, *1167/16*, *1169/16*, *1171/16*, *1173/16*, *1175/16*, *1177/16*, *1179/16*, *1181/16*, *1183/16*, *1185/16*, *1187/16*, *1189/16*, *1191/16*, *1193/16*, *1195/16*, *1197/16*, *1199/16*, *1201/16*, *1203/16*, *1205/16*, *1207/16*, *1209/16*, *1211/16*, *1213/16*, *1215/16*, *1217/16*, *1219/16*, *1221/16*, *1223/16*, *1225/16*, *1227/16*, *1229/16*, *1231/16*, *1233/16*, *1235/16*, *1237/16*, *1239/16*, *1241/16*, *1243/16*, *1245/16*, *1247/16*, *1249/16*, *1251/16*, *1253/16*, *1255/16*, *1257/16*, *1259/16*, *1261/16*, *1263/16*, *1265/16*, *1267/16*, *1269/16*, *1271/16*, *1273/16*, *1275/16*, *1277/16*, *1279/16*, *1281/16*, *1283/16*, *1285/16*, *1287/16*, *1289/16*, *1291/16*, *1293/16*, *1295/16*, *1297/16*, *1299/16*, *1301/16*, *1303/16*, *1305/16*, *1307/16*, *1309/16*, *1311/16*, *1313/16*, *1315/16*, *1317/16*, *1319/16*, *1321/16*, *1323/16*, *1325/16*, *1327/16*, *1329/16*, *1331/16*, *1333/16*, *1335/16*, *1337/16*, *1339/16*, *1341/16*, *1343/16*, *1345/16*, *1347/16*, *1349/16*, *1351/16*, *1353/16*, *1355/16*, *1357/16*, *1359/16*, *1361/16*, *1363/16*, *1365/16*, *1367/16*, *1369/16*, *1371/16*, *1373/16*, *1375/16*, *1377/16*, *1379/16*, *1381/16*, *1383/16*, *1385/16*, *1387/16*, *1389/16*, *1391/16*, *1393/16*, *1395/16*, *1397/16*, *1399/16*, *1401/16*, *1403/16*, *1405/16*, *1407/16*, *1409/16*, *1411/16*, *1413/16*, *1415/16*, *1417/16*, *1419/16*, *1421/16*, *1423/16*, *1425/16*, *1427/16*, *1429/16*, *1431/16*, *1433/16*, *1435/16*, *1437/16*, *1439/16*, *1441/16*, *1443/16*, *1445/16*, *1447/16*, *1449/16*, *1451/16*, *1453/16*, *1455/16*, *1457/16*, *1459/16*, <i

Appendix 38 ANSI Hexagon and Spline Socket Set Screw Optional Cup Points
**American National Standard Hexagon and Spline Socket Set Screw
Optional Cup Points (ANSI B18.3-1986)**
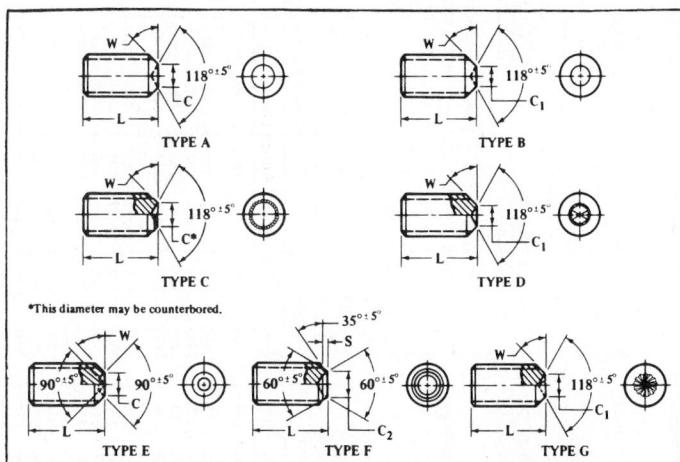

Nom. Size	Point Diam.		Point Diam.		Point Diam.		Point Length	
	Max.		Max.		Max.		Max.	
	<i>C</i>	<i>C</i> ₁	<i>C</i> ₁	<i>C</i> ₂	<i>C</i> ₂	<i>S</i>	<i>S</i>	
0	0.033	0.027	0.032	0.027	0.027	0.022	0.007	0.004
1	0.040	0.033	0.038	0.033	0.035	0.030	0.008	0.005
2	0.047	0.039	0.043	0.038	0.043	0.038	0.010	0.007
3	0.054	0.045	0.050	0.045	0.051	0.046	0.011	0.007
4	0.061	0.051	0.056	0.051	0.059	0.054	0.013	0.008
5	0.067	0.057	0.062	0.056	0.068	0.063	0.014	0.009
6	0.074	0.064	0.069	0.062	0.074	0.068	0.017	0.012
8	0.087	0.076	0.082	0.074	0.090	0.084	0.021	0.016
10	0.102	0.088	0.095	0.086	0.101	0.095	0.024	0.019
1/4	0.132	0.118	0.125	0.114	0.156	0.150	0.027	0.022
5/16	0.172	0.156	0.156	0.144	0.190	0.185	0.038	0.033
3/8	0.212	0.194	0.187	0.174	0.241	0.236	0.041	0.036
7/16	0.252	0.232	0.218	0.204	0.286	0.281	0.047	0.042
1/2	0.291	0.270	0.250	0.235	0.333	0.328	0.054	0.049
5/8	0.371	0.347	0.312	0.295	0.425	0.420	0.067	0.062
3/4	0.450	0.425	0.375	0.357	0.523	0.518	0.081	0.076
7/8	0.530	0.502	0.437	0.418
1	0.609	0.579	0.500	0.480
1 1/16	0.689	0.655	0.562	0.542
1 1/4	0.767	0.733	0.625	0.605
1 3/16	0.848	0.808	0.687	0.667
1 1/2	0.926	0.886	0.750	0.730
1 3/4	1.086	1.039	0.875	0.855
2	1.244	1.193	1.000	0.980

All dimensions are in inches.

The cup point types shown are those available from various manufacturers.

SOURCE: Reprinted courtesy of The American Society of Mechanical Engineers.

Appendix 39 ANSI Square Head Set Screws

American National Standard Square Head Set Screws
(ANSI B18.6.2-1972, R1983)

OPTIONAL HEAD CONSTRUCTIONS

Nominal Size* or Basic Screw Diameter	Width Across Corners, <i>G</i>		Head Height, <i>H</i>		Neck Relief Diameter, <i>K</i>		Neck Relief Fillet Rad., <i>S</i>		Head Relief Rad., <i>W</i>	
	Max.	Min.	Max.	Min.	Max.	Min.	Max.	Min.	Max.	Min.
10	.188	.180	.205	.247	.148	.134	.145	.140	.087	.48
14	.250	.230	.324	.354	.331	.196	.178	.185	.032	.62
16	.3125	.292	.392	.442	.415	.245	.224	.225	.036	.78
18	.3750	.352	.462	.530	.497	.293	.270	.294	.041	.94
21	.4375	.417	.548	.623	.581	.341	.335	.345	.046	1.09
24	.5000	.480	.648	.727	.665	.389	.361	.380	.050	1.25
26	.5625	.542	.705	.745	.647	.437	.407	.454	.054	1.41
30	.6250	.602	.784	.833	.685	.507	.492	.550	.059	1.59
34	.7500	.725	.879	.928	.822	.655	.620	.692	.065	1.83
38	.8750	.850	.951	.974	.842	.731	.716	.792	.072	2.19
41	1.0000	1.000	1.060	1.094	1.037	1.070	1.052	1.120	.076	2.50
42	1.1250	1.125	1.196	1.237	1.179	1.078	1.052	1.126	.081	2.81
44	1.2500	1.250	1.291	1.327	1.237	1.174	1.137	1.206	.086	3.12
48	1.3750	1.375	1.442	1.495	1.381	1.309	1.270	1.343	.092	3.48
50	1.5000	1.500	1.562	1.642	1.492	1.415	1.374	1.447	.099	3.83
52	1.6250	1.625	1.684	1.751	1.613	1.539	1.499	1.570	.109	4.19
56	1.7500	1.750	1.812	1.879	1.743	1.664	1.624	1.693	.119	4.54
60	1.8750	1.875	1.937	2.000	1.863	1.783	1.743	1.813	.129	4.90
64	2.0000	2.000	2.062	2.121	1.991	1.912	1.871	1.940	.139	5.25
70	2.1250	2.125	2.187	2.246	2.116	2.036	1.995	2.064	.149	5.60
76	2.2500	2.250	2.312	2.371	2.241	2.161	2.120	2.189	.159	5.95
84	2.3750	2.375	2.437	2.495	2.363	2.283	2.242	2.311	.169	6.30
96	2.5000	2.500	2.562	2.621	2.491	2.411	2.370	2.439	.179	6.65
112	2.6250	2.625	2.684	2.743	2.613	2.532	2.491	2.560	.189	7.00
136	2.7500	2.750	2.812	2.871	2.741	2.660	2.619	2.688	.199	7.35
160	2.8750	2.875	2.937	3.000	2.863	2.782	2.731	2.800	.209	7.70
192	3.0000	3.000	3.062	3.121	2.991	2.910	2.859	2.928	.219	8.05
224	3.1250	3.125	3.187	3.246	3.116	3.036	2.985	3.054	.229	8.40
256	3.2500	3.250	3.312	3.371	3.241	3.160	3.109	3.178	.239	8.75
288	3.3750	3.375	3.437	3.500	3.363	3.282	3.231	3.300	.249	9.10
320	3.5000	3.500	3.562	3.621	3.491	3.410	3.359	3.428	.259	9.45
352	3.6250	3.625	3.684	3.743	3.613	3.532	3.471	3.540	.269	9.80
384	3.7500	3.750	3.812	3.871	3.741	3.660	3.599	3.668	.279	10.15
416	3.8750	3.875	3.937	4.000	3.863	3.782	3.711	3.780	.289	10.50
448	4.0000	4.000	4.062	4.121	3.991	3.910	3.849	3.918	.299	10.85
480	4.1250	4.125	4.187	4.246	4.116	4.036	3.975	4.044	.309	11.20
512	4.2500	4.250	4.312	4.371	4.181	4.100	4.039	4.108	.319	11.55
544	4.3750	4.375	4.437	4.500	4.303	4.222	4.161	4.230	.329	11.90
576	4.5000	4.500	4.562	4.621	4.411	4.330	4.269	4.338	.339	12.25
608	4.6250	4.625	4.684	4.743	4.533	4.452	4.391	4.460	.349	12.60
640	4.7500	4.750	4.812	4.871	4.661	4.580	4.519	4.588	.359	12.95
672	4.8750	4.875	4.937	5.000	4.781	4.700	4.639	4.708	.369	13.30
704	5.0000	5.000	5.062	5.121	4.911	4.830	4.769	4.838	.379	13.65
736	5.1250	5.125	5.187	5.246	4.961	4.880	4.819	4.888	.389	14.00
768	5.2500	5.250	5.312	5.371	5.051	4.970	4.909	5.078	.399	14.35
800	5.3750	5.375	5.437	5.500	5.191	5.110	5.049	5.118	.409	14.70
832	5.5000	5.500	5.562	5.621	5.341	5.260	5.199	5.268	.419	15.05
864	5.6250	5.625	5.684	5.743	5.463	5.382	5.321	5.390	.429	15.40
904	5.7500	5.750	5.812	5.871	5.591	5.510	5.449	5.518	.439	15.75
936	5.8750	5.875	5.937	6.000	5.711	5.630	5.569	5.638	.449	16.10
968	6.0000	6.000	6.062	6.121	5.881	5.800	5.739	5.808	.459	16.45
1000	6.1250	6.125	6.187	6.246	5.961	5.880	5.819	5.888	.469	16.80
1032	6.2500	6.250	6.312	6.371	6.051	5.970	5.909	6.078	.479	17.15
1064	6.3750	6.375	6.437	6.500	6.241	6.160	6.099	6.168	.489	17.50
1104	6.5000	6.500	6.562	6.621	6.341	6.260	6.199	6.268	.499	17.85
1136	6.6250	6.625	6.684	6.743	6.461	6.380	6.319	6.388	.509	18.20
1168	6.7500	6.750	6.812	6.871	6.591	6.510	6.449	6.518	.519	18.55
1200	6.8750	6.875	6.937	7.000	6.761	6.680	6.619	6.688	.529	18.90
1232	7.0000	7.000	7.062	7.121	6.881	6.800	6.739	6.808	.539	19.25
1264	7.1250	7.125	7.187	7.246	6.961	6.880	6.819	6.888	.549	19.60
1296	7.2500	7.250	7.312	7.371	7.051	6.970	6.909	7.078	.559	19.95
1328	7.3750	7.375	7.437	7.500	7.141	7.060	6.999	7.168	.569	20.30
1360	7.5000	7.500	7.562	7.621	7.321	7.240	7.179	7.348	.579	20.65
1392	7.6250	7.625	7.684	7.743	7.401	7.320	7.259	7.428	.589	21.00
1424	7.7500	7.750	7.812	7.871	7.521	7.440	7.379	7.548	.599	21.35
1456	7.8750	7.875	7.937	8.000	7.641	7.560	7.499	7.668	.609	21.70
1488	8.0000	8.000	8.062	8.121	7.761	7.680	7.619	7.788	.619	22.05
1520	8.1250	8.125	8.187	8.246	7.881	7.800	7.739	7.908	.629	22.40
1552	8.2500	8.250	8.312	8.371	7.961	7.880	7.819	8.088	.639	22.75
1584	8.3750	8.375	8.437	8.500	8.041	7.960	7.899	8.168	.649	23.10
1616	8.5000	8.500	8.562	8.621	8.161	8.080	7.919	8.288	.659	23.45
1648	8.6250	8.625	8.684	8.743	8.281	8.200	8.139	8.418	.669	23.80
1680	8.7500	8.750	8.812	8.871	8.381	8.300	8.239	8.518	.679	24.15
1712	8.8750	8.875	8.937	9.000	8.461	8.380	8.319	8.698	.689	24.50
1744	9.0000	9.000	9.062	9.121	8.541	8.460	8.399	8.778	.699	24.85
1776	9.1250	9.125	9.187	9.246	8.621	8.540	8.479	8.858	.709	25.20
1808	9.2500	9.250	9.312	9.371	8.701	8.620	8.559	8.938	.719	25.55
1840	9.3750	9.375	9.437	9.500	8.781	8.700	8.639	9.018	.729	25.90
1872	9.5000	9.500	9.562	9.621	8.861	8.780	8.719	9.198	.739	26.25
1904	9.6250	9.625	9.684	9.743	8.941	8.860	8.799	9.278	.749	26.60
1936	9.7500	9.750	9.812	9.871	9.021	8.940	8.879	9.358	.759	26.95
1968	9.8750	9.875	9.937	10.000	9.101	9.020	8.959	9.438	.769	27.30
2000	10.0000	10.000	10.062	10.121	9.181	9.100	9.039	9.518	.779	27.65
2032	10.1250	10.125	10.187	10.246	9.261	9.180	9.119	9.598	.789	28.00
2064	10.2500	10.250	10.312	10.371	9.341	9.260	9.199	9.678	.799	28.35
2096	10.3750	10.375	10.437	10.500	9.421	9.340	9.279	9.758	.809	28.70
2128	10.5000	10.500	10.562	10.621	9.501	9.420	9.359	9.838	.819	29.05
2160	10.6250	10.625	10.684	10.743	9.581	9.500	9.439	9.918	.829	29.40
2192	10.7500	10.750	10.812	10.871	9.661	9.580	9.519	10.098	.839	29.75
2224	10.8750	10.875	10.937	11.000	9.741	9.660	9.599	10.178	.849	30.10
2256	11.0000	11.000	11.062	11.121	9.821	9.740	9.679	10.258	.859	30.45
2288	11.1250	11.125	11.187	11.246	9.901	9.820	9.759	10.338	.869	30.80
2320	11.2500	11.250	11.312	11.371	9.981	9.900	9.839	10.418	.879	31.15
2352	11.3750	11.375	11.437	11.500	1.061	1.080	1.019	10.498	.889	31.50
2384	11.5000	11.500	11.562	11.621	1.141	1.160	1.099	10.578	.899	31.85
2416	11.6250	11.625	11.684	11.743	1.221	1.240	1.179	10.658	.909	32.20
2448	11.7500	11.750	11.812	11.871	1.301	1.320	1.259	10.738	.919	32.55
2480	11.8750	11.875	11.937	12.000	1.381	1.400	1.339	10.818	.929	32.90
2512	12.0000	12.000	12.062	12.121	1.461	1.480	1.419	10.898	.939	33.25
2544	12.1250	12.125	12.187	12.246	1.541	1.560	1.499	10.978	.949	33.60
2576	12.2500	12.250	12.312	12.371	1.621	1.640	1.569	11.058	.959	33.95
2608	12.3750	12.375	12.437	12.500	1.701	1.720	1.649	11.138	.969	34.30
2640	12.5000	12.500	12.562	12.621	1.781	1.800	1.729	11.218	.979	34.65
2672	12.									

Appendix 40 ANSI Taper Pipe Threads (NPT)
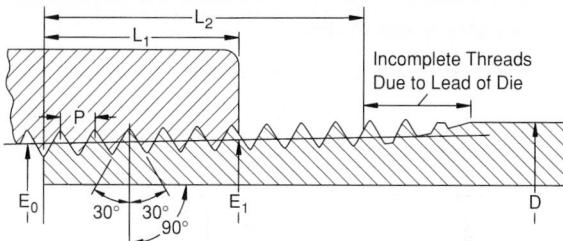

$$E_0 = D - (0.050D + 1.1)p$$

$$E_1 = E_0 + 0.0625 L_1$$

$$L_2 = (0.80D + 6.8)p$$

p = Pitch

Depth of thread = $0.80p$

Total Taper 3/4-inch per Foot

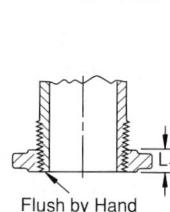
Tolerance on Product

One turn large or small from notch on plug gage or face of ring gage.

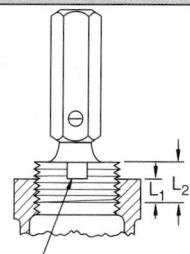

Notch flush with face of fitting. If chamfered, notch flush with bottom of chamfer

Nominal Pipe Size	D		p	E_0	$E_1\ddagger$	$L_1\bullet$	$L_2\$$	
Outside Diameter of Pipe	Number of Threads per Inch	Pitch of Thread	Pitch Diameter at End of External Thread	Pitch Diameter at End of Internal Thread	Normal Engagement by Hand between External and Internal Threads	Length of Effective External Thread	Height of Thread	
1/16	0.3125	27	0.03704	0.27118	0.28118	0.160	0.2611	0.02963
1/8	0.405	27	0.03704	0.36351	0.37360	0.1615	0.2639	0.02963
1/4	0.540	18	0.05556	0.47739	0.49163	0.2278	0.4018	0.04444
3/8	0.675	18	0.05556	0.61201	0.62701	0.240	0.4078	0.04444
1/2	0.840	14	0.07143	0.75843	0.77843	0.320	0.5337	0.05714
3/4	1.050	14	0.07143	0.96768	0.98887	0.339	0.5457	0.05714
1	1.315	11.5	0.08696	1.21363	1.23863	0.400	0.6828	0.06957
1 1/4	1.660	11.5	0.08696	1.55713	1.58338	0.420	0.7068	0.06957
1 1/2	1.900	11.5	0.08696	1.79609	1.82234	0.420	0.7235	0.06957
2	2.375	11.5	0.08696	2.26902	2.29627	0.436	0.7565	0.06957
2 1/2	2.875	8	0.12500	2.71953	2.76216	0.682	1.1375	0.10000
3	3.500	8	0.12500	3.34062	3.38850	0.766	1.2000	0.10000
3 1/2	4.000	8	0.12500	3.83750	3.88881	0.821	1.2500	0.10000
4	4.500	8	0.12500	4.33438	4.38712	0.844	1.3000	0.10000
5	5.563	8	0.12500	5.39073	5.44929	0.937	1.4063	0.10000
6	6.625	8	0.12500	6.44609	6.50597	0.958	1.5125	0.10000
8	8.625	8	0.12500	8.43359	8.50003	1.063	1.7125	0.10000
10	10.750	8	0.12500	10.54531	10.62094	1.210	1.9250	0.10000
12	12.750	8	0.12500	12.53281	12.61781	1.360	2.1250	0.10000
14 O.D.	14.000	8	0.12500	13.77500	13.87262	1.562	2.2500	0.10000
16 O.D.	16.000	8	0.12500	15.76250	15.87575	1.812	2.4500	0.10000
18 O.D.	18.000	8	0.12500	17.75000	17.87500	2.000	2.6500	0.10000
20 O.D.	20.000	8	0.12500	19.73750	19.87031	2.125	2.8500	0.10000
24 O.D.	24.000	8	0.12500	23.71250	23.86094	2.375	3.2500	0.10000

Dimensions in inches.

†Also pitch diameter at gaging notch.

‡Also length of plug gage.

¶Also length of ring gage, and length from gaging notch to small end of plug gage.

*For the 1/8-27 and 1/4-18 sizes... E_1 approx. = $D - (0.05D + 0.827)p$

Above information extracted from American National Standard for Pipe Threads, ANSI B2.1.

Reprinted courtesy of ITT-Grinnell.

SOURCE: Reprinted courtesy of The American Society of Mechanical Engineers.

Appendix 41 ANSI Metric Plain Washers**American National Standard Metric Plain Washers**
(ANSI B18.22M-1981, R1990)
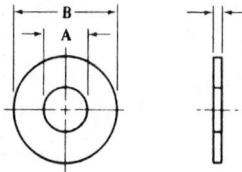

Nominal Washer Size*	Washer Series	Inside Diameter, A		Outside Diameter, B		Thickness, C	
		Max	Min	Max	Min	Max	Min
1.6	Narrow	2.09	1.95	4.00	3.70	0.70	0.50
	Regular	2.09	1.95	5.00	4.70	0.70	0.50
	Wide	2.09	1.95	6.00	5.70	0.90	0.60
2	Narrow	2.64	2.50	5.00	4.70	0.90	0.60
	Regular	2.64	2.50	6.00	5.70	0.90	0.60
	Wide	2.64	2.50	8.00	7.64	0.90	0.60
2.5	Narrow	3.14	3.00	6.00	5.70	0.90	0.60
	Regular	3.14	3.00	8.00	7.64	0.90	0.60
	Wide	3.14	3.00	10.00	9.64	1.20	0.80
3	Narrow	3.68	3.50	7.00	6.64	0.90	0.60
	Regular	3.68	3.50	10.00	9.64	1.20	0.80
	Wide	3.68	3.50	12.00	11.57	1.40	1.00
3.5	Narrow	4.18	4.00	9.00	8.64	1.20	0.80
	Regular	4.18	4.00	10.00	9.64	1.40	1.00
	Wide	4.18	4.00	15.00	14.57	1.75	1.20
4	Narrow	4.88	4.70	10.00	9.64	1.20	0.80
	Regular	4.88	4.70	12.00	11.57	1.40	1.00
	Wide	4.88	4.70	16.00	15.57	2.30	1.60
5	Narrow	5.78	5.50	11.00	10.57	1.40	1.00
	Regular	5.78	5.50	15.00	14.57	1.75	1.20
	Wide	5.78	5.50	20.00	19.48	2.30	1.60
6	Narrow	6.87	6.65	13.00	12.57	1.75	1.20
	Regular	6.87	6.65	18.80	18.37	1.75	1.20
	Wide	6.87	6.65	25.40	24.88	2.30	1.60
8	Narrow	9.12	8.90	18.80†	18.37†	2.30	1.60
	Regular	9.12	8.90	25.40†	24.48†	2.30	1.60
	Wide	9.12	8.90	32.00	31.38	2.80	2.00
10	Narrow	11.12	10.85	20.00	19.48	2.30	1.60
	Regular	11.12	10.85	28.00	27.48	2.80	2.00
	Wide	11.12	10.85	39.00	38.38	3.50	2.50
12	Narrow	13.57	13.30	25.40	24.88	2.80	2.00
	Regular	13.57	13.30	34.00	33.38	3.50	2.50
	Wide	13.57	13.30	44.00	43.38	3.50	2.50
14	Narrow	15.52	15.25	28.00	27.48	2.80	2.00
	Regular	15.52	15.25	39.00	38.38	3.50	2.50
	Wide	15.52	15.25	50.00	49.38	4.00	3.00
16	Narrow	17.52	17.25	32.00	31.38	3.50	2.50
	Regular	17.52	17.25	44.00	43.38	4.00	3.00
	Wide	17.52	17.25	56.00	54.80	4.60	3.50
20	Narrow	22.32	21.80	39.00	38.38	4.00	3.00
	Regular	22.32	21.80	50.00	49.38	4.60	3.50
	Wide	22.32	21.80	66.00	64.80	5.10	4.00
24	Narrow	26.12	25.60	44.00	43.38	4.60	3.50
	Regular	26.12	25.60	56.00	54.80	5.10	4.00
	Wide	26.12	25.60	72.00	70.80	5.60	4.50
30	Narrow	33.02	32.40	56.00	54.80	5.10	4.00
	Regular	33.02	32.40	72.00	70.80	5.60	4.50
	Wide	33.02	32.40	90.00	88.60	6.40	5.00
36	Narrow	38.92	38.30	66.00	64.80	5.60	4.50
	Regular	38.92	38.30	90.00	88.60	6.40	5.00
	Wide	38.92	38.30	110.00	108.60	8.50	7.00

All dimensions are in millimeters.

* Nominal washer sizes are intended for use with comparable screw and bolt sizes.

† The 18.80/18.37 and 25.40/24.48 mm outside diameters avoid washers which could be used in coin-operated devices.

SOURCE: Reprinted courtesy of The American Society of Mechanical Engineers.

Appendix 42 ANSI Type A Plain Washers—Preferred Sizes

American National Standard Type A Plain Washers—
Preferred Sizes** (ANSI B18.22.1-1965, R1990)

Nominal Washer Size**	Series	Inside Diameter				Outside Diameter				Thickness			
		Basic		Tolerance		Basic		Tolerance		Basic		Tolerance	
		Plus	Minus	Plus	Minus	Plus	Minus	Plus	Minus	Basic	Max.	Min.	Max.
—	—	0.078	0.000	0.005	0.188	0.000	0.005	0.020	0.025	0.016	0.020	0.016	0.016
—	—	0.094	0.000	0.005	0.250	0.000	0.005	0.020	0.025	0.016	0.240	0.005	0.028
—	—	0.125	0.008	0.005	0.312	0.068	0.005	0.032	0.040	0.025	0.312	0.008	0.048
No. 6	—	0.138	0.008	0.005	0.312	0.015	0.005	0.032	0.040	0.025	0.312	0.005	0.035
No. 8	0.164	0.156	0.008	0.005	0.375	0.049	0.005	0.049	0.065	0.036	0.406	0.015	0.049
No. 10	0.190	0.188	0.008	0.005	0.438	0.015	0.005	0.049	0.065	0.036	0.4375	0.015	0.065
3/16	0.168	0.219	0.008	0.005	0.500	0.015	0.005	0.049	0.065	0.036	0.469	0.015	0.065
No. 12	0.216	0.250	0.015	0.005	0.562	0.015	0.005	0.049	0.065	0.036	0.438	0.015	0.065
1/4	0.281	0.312	0.015	0.005	0.625	0.015	0.005	0.065	0.080	0.051	0.531	0.015	0.065
1/4	0.250	0.281	0.015	0.005	0.734*	0.015	0.007	0.065	0.080	0.051	0.500	0.015	0.065
5/16	0.312	0.344	0.015	0.005	0.688	0.015	0.007	0.065	0.080	0.051	0.312	0.015	0.065
5/16	0.312	0.375	0.015	0.005	0.875	0.030	0.007	0.083	0.104	0.064	0.754*	0.015	0.065
3/8	0.406	0.466	0.015	0.005	0.812	0.015	0.007	0.065	0.080	0.051	0.375	0.015	0.065
3/8	0.375	0.438	0.015	0.005	1.000	0.030	0.007	0.065	0.080	0.051	0.438	0.015	0.065
7/16	0.438	0.499	0.015	0.005	0.922	0.015	0.007	0.065	0.080	0.051	0.438	0.015	0.064
7/16	0.438	0.500	0.015	0.005	1.250	0.030	0.007	0.083	0.104	0.064	0.500	0.015	0.064
1/2	0.500	0.531	0.015	0.005	1.662	0.030	0.007	0.095	0.121	0.074	0.562	0.015	0.064
1/2	0.500	0.562	0.015	0.005	1.375	0.030	0.007	0.109	0.132	0.086	0.562	0.015	0.065
9/16	0.562	0.594	0.015	0.005	1.156*	0.030	0.007	0.095	0.121	0.074	0.625	0.015	0.065
9/16	0.562	0.625	0.015	0.005	1.499*	0.030	0.007	0.109	0.132	0.086	0.625	0.015	0.065
5/8	0.625	0.656	0.030	0.007	1.312	0.030	0.007	0.121	0.140	0.074	0.625	0.015	0.108
5/8	0.625	0.688	0.030	0.007	1.750	0.030	0.007	0.134	0.160	0.108	0.688	0.030	0.108
3/4	0.750	0.812	0.030	0.007	1.469	0.030	0.007	0.134	0.160	0.108	0.688	0.030	0.136
3/4	0.750	0.812	0.030	0.007	2.000	0.030	0.007	0.148	0.177	0.122	0.812	0.030	0.177
7/8	0.875	0.938	0.030	0.007	1.750	0.030	0.007	0.134	0.160	0.108	0.812	0.030	0.192
7/8	0.875	0.938	0.030	0.007	2.250	0.030	0.007	0.165	0.192	0.136	0.938	0.030	0.192
1	1.000	1.062	0.030	0.007	2.000	0.030	0.007	0.134	0.160	0.108	0.938	0.030	0.192
1	1.000	1.062	0.030	0.007	2.500	0.030	0.007	0.165	0.192	0.136	1.062	0.030	0.192
1 1/8	1.125	1.250	0.030	0.007	2.250	0.030	0.007	0.134	0.160	0.108	1.062	0.045	0.192
1 1/8	1.125	1.250	0.030	0.007	2.750	0.030	0.007	0.165	0.192	0.136	1.250	0.030	0.192
1 1/4	1.250	1.375	0.030	0.007	2.500	0.030	0.007	0.165	0.192	0.136	1.375	0.030	0.192
1 1/4	1.250	1.375	0.030	0.007	3.000	0.030	0.007	0.165	0.192	0.136	1.500	0.045	0.192
1 3/8	1.375	1.500	0.045	0.010	3.250	0.045	0.010	0.180	0.213	0.153	1.625	0.045	0.213
1 3/8	1.375	1.500	0.045	0.010	4.500	0.045	0.010	0.180	0.213	0.153	1.688	0.045	0.213
1 1/2	1.625	1.625	0.045	0.010	4.750	0.045	0.010	0.180	0.220	0.153	1.812	0.045	0.213
1 1/2	1.500	1.625	0.045	0.010	3.000	0.045	0.010	0.180	0.213	0.153	1.938	0.045	0.213
1 5/8	1.750	1.750	0.045	0.010	3.750	0.045	0.010	0.180	0.213	0.153	2.062	0.045	0.213
1 3/4	1.750	1.875	0.045	0.010	4.000	0.045	0.010	0.180	0.213	0.153	2.125	0.045	0.213
1 3/4	1.750	2.000	0.045	0.010	4.250	0.045	0.010	0.180	0.213	0.153	2.125	0.045	0.213
2	2.000	2.125	0.045	0.010	4.500	0.045	0.010	0.180	0.213	0.153	2.125	0.045	0.213
2 1/4	2.250	2.375	0.045	0.010	4.750	0.045	0.010	0.180	0.220	0.153	2.375	0.045	0.213
2 1/2	2.500	2.625	0.045	0.010	5.000	0.045	0.010	0.180	0.220	0.153	2.625	0.045	0.213
2 3/4	2.750	2.875	0.065	0.010	5.250	0.065	0.010	0.259	0.310	0.228	2.875	0.065	0.213
3	3.000	3.125	0.065	0.010	5.500	0.065	0.010	0.284	0.327	0.249	3.125	0.065	0.213

All dimensions are in inches.

* The 0.734-inch, 1.156-inch, and 1.469-inch outside diameters avoid washers which could be used in coin operated devices.

** Preferred sizes are for the most part from series previously designated "Standard Plate" and "SAE." Where common sizes exist in the two series, the SAE size is designated "N" (narrow) and the Standard Plate "W" (wide). These sizes, as well as all other sizes of Type A Plain Washers are to be ordered by ID, OD, and thickness dimensions.

*** Nominal washer sizes are intended for use with comparable nominal screw or bolt sizes.

Additional selected sizes of Type A Plain Washers are shown in Table 1B.

Appendix 43 ANSI Type A Plain Washers—Additional Selected Sizes

American National Standard Type A Plain Washers—
Additional Selected Sizes (ANSI B18.22.1-1965, R1990)

Nominal Washer Size**	Series	Inside Diameter				Outside Diameter				Thickness			
		Basic		Tolerance		Basic		Tolerance		Basic		Tolerance	
		Plus	Minus	Plus	Minus	Plus	Minus	Plus	Minus	Basic	Max.	Min.	Max.
—	—	0.078	0.000	0.005	0.188	0.000	0.005	0.020	0.025	0.016	0.219	0.000	0.025
—	—	0.094	0.000	0.005	0.250	0.000	0.005	0.020	0.025	0.016	0.250	0.000	0.028
—	—	0.125	0.008	0.005	0.312	0.068	0.005	0.032	0.040	0.025	0.312	0.008	0.048
No. 6	0.138	0.156	0.008	0.005	0.312	0.015	0.005	0.049	0.065	0.025	0.312	0.015	0.048
No. 8	0.164	0.188	0.008	0.005	0.438	0.015	0.005	0.049	0.065	0.036	0.438	0.015	0.048
No. 10	0.190	0.219	0.008	0.005	0.500	0.015	0.005	0.049	0.065	0.036	0.500	0.015	0.048
3/16	0.168	0.200	0.015	0.005	0.562	0.015	0.005	0.049	0.065	0.036	0.562	0.015	0.048
No. 12	0.216	0.250	0.015	0.005	0.625	0.015	0.005	0.049	0.065	0.036	0.625	0.015	0.048
1/4	0.250	0.281	0.015	0.005	0.625	0.015	0.005	0.049	0.065	0.036	0.625	0.015	0.048
1/4	0.250	0.312	0.015	0.005	0.734*	0.015	0.007	0.065	0.080	0.051	0.734*	0.015	0.051
5/16	0.312	0.375	0.015	0.005	0.688	0.015	0.007	0.065	0.080	0.051	0.688	0.015	0.051
5/16	0.312	0.375	0.015	0.005	0.875	0.030	0.007	0.104	0.124	0.064	0.875	0.030	0.064
3/8	0.406	0.466	0.015	0.005	0.812	0.015	0.007	0.065	0.080	0.051	0.812	0.015	0.064
3/8	0.375	0.438	0.015	0.005	1.000	0.030	0.007	0.083	0.104	0.051	1.000	0.030	0.064
7/16	0.438	0.499	0.015	0.005	0.922	0.015	0.007	0.065	0.080	0.051	0.922	0.015	0.064
7/16	0.438	0.500	0.015	0.005	1.250	0.030	0.007	0.083	0.104	0.051	1.250	0.030	0.064
1/2	0.500	0.531	0.015	0.005	1.662	0.030	0.007	0.095	0.121	0.074	1.662	0.030	0.064
1/2	0.500	0.562	0.015	0.005	1.375	0.030	0.007	0.109	0.132	0.086	1.375	0.030	0.064
9/16	0.562	0.594	0.015	0.005	1.156*	0.030	0.007	0.124	0.140	0.074	1.156*	0.030	0.064
9/16	0.562	0.625	0.015	0.005	1.499*	0.030	0.007	0.109	0.132	0.086	1.499*	0.030	0.064
5/8	0.625	0.656	0.030	0.007	1.312	0.030	0.007	0.121	0.140	0.074	1.312	0.030	0.108
5/8	0.625	0.688	0.030	0.007	1.750	0.030	0.007	0.134	0.160	0.108	1.750	0.030	0.108
3/4	0.750	0.812	0.030	0.007	1.469	0.030	0.007	0.134	0.160	0.108	1.469	0.030	0.136
3/4	0.750	0.812	0.030	0.007	2.000	0.030	0.007	0.148	0.177	0.122	2.000	0.030	0.177
7/8	0.875	0.938	0.030	0.007	1.750	0.030	0.007	0.134	0.160	0.108	1.750	0.030	0.192
7/8	0.875	0.938	0.030	0.007	2.250	0.030	0.007	0.165	0.192	0.136	2.250	0.030	0.192
1	1.000	1.062	0.030	0.007	2.5								

Appendix 44 ANSI Type B Plain Washers

American National Standard Type B Plain Washers
(ANSI B18.22-1-1965; R1990)

Nominal Washer Size**	Series†	Inside Diameter				Outside Diameter				Thickness			
		Basic		Plus	Minus	Basic		Plus	Minus	Basic		Plus	Minus
		Basic	Tolerance	Plus	Minus	Basic	Tolerance	Plus	Minus	Basic	Tolerance	Plus	Minus
No. 0	0.060	N	0.068	0.000	0.005	0.125	0.000	0.005	0.028	0.028	0.022	0.015	0.005
		R	0.068	0.000	0.005	0.188	0.000	0.005	0.028	0.028	0.022	0.015	0.005
		W	0.068	0.000	0.005	0.250	0.000	0.005	0.025	0.028	0.022	0.015	0.005
No. 1	0.073	N	0.084	0.000	0.005	0.156	0.000	0.005	0.028	0.028	0.022	0.015	0.005
		R	0.084	0.000	0.005	0.219	0.000	0.005	0.025	0.028	0.022	0.015	0.005
		W	0.084	0.000	0.005	0.281	0.000	0.005	0.026	0.028	0.022	0.015	0.005
No. 2	0.086	N	0.094	0.000	0.005	0.188	0.000	0.005	0.025	0.028	0.022	0.015	0.005
		R	0.094	0.000	0.005	0.250	0.000	0.005	0.025	0.028	0.022	0.015	0.005
		W	0.094	0.000	0.005	0.344	0.000	0.005	0.032	0.036	0.028	0.015	0.005
No. 3	0.099	N	0.109	0.000	0.005	0.219	0.000	0.005	0.025	0.028	0.022	0.015	0.005
		R	0.109	0.000	0.005	0.312	0.000	0.005	0.032	0.036	0.028	0.015	0.005
		W	0.109	0.000	0.005	0.406	0.000	0.005	0.040	0.045	0.036	0.015	0.005
No. 4	0.112	N	0.125	0.000	0.005	0.257	0.000	0.005	0.032	0.036	0.028	0.015	0.005
		R	0.125	0.000	0.005	0.438	0.000	0.005	0.040	0.045	0.036	0.015	0.005
		W	0.125	0.000	0.005	0.608	0.000	0.005	0.040	0.045	0.036	0.015	0.005
No. 5	0.125	N	0.141	0.000	0.005	0.281	0.000	0.005	0.032	0.036	0.028	0.015	0.005
		R	0.141	0.000	0.005	0.466	0.000	0.005	0.040	0.045	0.036	0.015	0.005
		W	0.141	0.000	0.005	0.500	0.000	0.005	0.040	0.045	0.036	0.015	0.005
No. 6	0.138	N	0.156	0.000	0.005	0.312	0.000	0.005	0.032	0.036	0.028	0.015	0.005
		R	0.156	0.000	0.005	0.488	0.000	0.005	0.040	0.045	0.036	0.015	0.005
		W	0.156	0.000	0.005	0.562	0.000	0.005	0.040	0.045	0.036	0.015	0.005
No. 7	0.164	N	0.188	0.000	0.005	0.375	0.000	0.005	0.040	0.045	0.036	0.015	0.005
		R	0.188	0.000	0.005	0.500	0.000	0.005	0.040	0.045	0.036	0.015	0.005
		W	0.188	0.000	0.005	0.562	0.000	0.005	0.040	0.045	0.036	0.015	0.005
No. 8	0.190	N	0.203	0.000	0.005	0.406	0.000	0.005	0.040	0.045	0.036	0.015	0.005
		R	0.203	0.000	0.005	0.438	0.000	0.005	0.040	0.045	0.036	0.015	0.005
		W	0.203	0.000	0.005	0.562	0.000	0.005	0.040	0.045	0.036	0.015	0.005
No. 9	0.216	N	0.234	0.000	0.005	0.438	0.000	0.005	0.040	0.045	0.036	0.015	0.005
		R	0.234	0.000	0.005	0.500	0.000	0.005	0.040	0.045	0.036	0.015	0.005
		W	0.234	0.000	0.005	0.625	0.000	0.005	0.040	0.045	0.036	0.015	0.005
No. 10	0.250	N	0.281	0.015	0.005	0.500	0.015	0.005	0.063	0.071	0.056	0.025	0.015
		R	0.281	0.015	0.005	0.734*	0.015	0.005	0.063	0.071	0.056	0.025	0.015
		W	0.281	0.015	0.005	1.015	0.015	0.005	0.063	0.071	0.056	0.025	0.015
No. 11	0.312	N	0.344	0.015	0.005	0.625	0.015	0.005	0.063	0.071	0.056	0.025	0.015
		R	0.344	0.015	0.005	0.875	0.015	0.005	0.063	0.071	0.056	0.025	0.015
		W	0.344	0.015	0.005	1.125	0.015	0.005	0.063	0.071	0.056	0.025	0.015
No. 12	0.375	N	0.406	0.015	0.005	0.734*	0.015	0.005	0.063	0.071	0.056	0.025	0.015
		R	0.406	0.015	0.005	1.000	0.015	0.005	0.063	0.071	0.056	0.025	0.015
		W	0.406	0.015	0.005	1.250	0.030	0.007	0.100	0.112	0.090	0.025	0.015
No. 13	0.438	N	0.469	0.015	0.005	0.875	0.015	0.005	0.063	0.071	0.056	0.025	0.015
		R	0.469	0.015	0.005	1.125	0.015	0.005	0.063	0.071	0.056	0.025	0.015
		W	0.469	0.015	0.005	1.469*	0.030	0.007	0.100	0.112	0.090	0.025	0.015

All dimensions are in inches.

* The 0.734-inch and 1.469-inch outside diameters avoid washers which could be used in coin operated devices.

** Nominal washer sizes are intended for use with comparable nominal screw or bolt sizes.

* N indicates Narrow; R, Regular; and W, Wide Series.

Inside and outside diameters shall be concentric within at least the inside diameter tolerance. Washers shall be flat within 0.005 inch for basic outside diameters up through 0.875 inch and within 0.010 inch for larger outside diameters.

For 2 1/4-, 2 1/2-, 2 3/4-, and 3-inch sizes see ANSI B18.22-1-1965 (R1990).

SOURCE: Reprinted courtesy of The American Society of Mechanical Engineers.

Nominal Washer Size**	Series†	Inside Diameter				Outside Diameter				Thickness			
		Basic		Plus	Minus	Basic		Plus	Minus	Basic		Plus	Minus
		Basic	Tolerance	Plus	Minus	Basic	Tolerance	Plus	Minus	Basic	Tolerance	Plus	Minus
No. 0	0.060	N	0.068	0.000	0.005	0.125	0.000	0.005	0.028	0.028	0.022	0.015	0.005
		R	0.068	0.000	0.005	0.188	0.000	0.005	0.025	0.028	0.022	0.015	0.005
		W	0.068	0.000	0.005	0.250	0.000	0.005	0.025	0.028	0.022	0.015	0.005
No. 1	0.073	N	0.084	0.000	0.005	0.156	0.000	0.005	0.028	0.028	0.022	0.015	0.005
		R	0.084	0.000	0.005	0.219	0.000	0.005	0.025	0.028	0.022	0.015	0.005
		W	0.084	0.000	0.005	0.281	0.000	0.005	0.026	0.028	0.022	0.015	0.005
No. 2	0.086	N	0.094	0.000	0.005	0.188	0.000	0.005	0.025	0.028	0.022	0.015	0.005
		R	0.094	0.000	0.005	0.250	0.000	0.005	0.025	0.028	0.022	0.015	0.005
		W	0.094	0.000	0.005	0.344	0.000	0.005	0.032	0.036	0.028	0.015	0.005
No. 3	0.099	N	0.109	0.000	0.005	0.219	0.000	0.005	0.025	0.028	0.022	0.015	0.005
		R	0.109	0.000	0.005	0.312	0.000	0.005	0.032	0.036	0.028	0.015	0.005
		W	0.109	0.000	0.005	0.406	0.000	0.005	0.040	0.045	0.036	0.015	0.005
No. 4	0.112	N	0.125	0.000	0.005	0.257	0.000	0.005	0.032	0.036	0.028	0.015	0.005
		R	0.125	0.000	0.005	0.438	0.000	0.005	0.040	0.045	0.036	0.015	0.005
		W	0.125	0.000	0.005	0.608	0.000	0.005	0.040	0.045	0.036	0.015	0.005
No. 5	0.125	N	0.141	0.000	0.005	0.281	0.000	0.005	0.032	0.036	0.028	0.015	0.005
		R	0.141	0.000	0.005	0.466	0.000	0.005	0.040	0.045	0.036	0.015	0.005
		W	0.141	0.000	0.005	0.500	0.000	0.005	0.040	0.045	0.036	0.015	0.005
No. 6	0.138	N	0.156	0.000	0.005	0.312	0.000	0.005	0.032	0.036	0.028	0.015	0.005
		R	0.156	0.000	0.005	0.488	0.000	0.005	0.040	0.045	0.036	0.015	0.005
		W	0.156	0.000	0.005	0.562	0.000	0.005	0.040	0.045	0.036	0.015	0.005
No. 7	0.164	N	0.188	0.000	0.005	0.375	0.000	0.005	0.040	0.045	0.036	0.015	0.005
		R	0.188	0.000	0.005	0.500	0.000	0.005	0.040	0.045	0.036	0.015	0.005
		W	0.188	0.000	0.005	0.625	0.000	0.005	0.040	0.045	0.036	0.015	0.005
No. 8	0.190	N	0.203	0.000	0.005	0.406	0.000	0.005	0.040	0.045	0.036	0.015	0.005
		R	0.203	0.000	0.005	0.438	0.000	0.005	0.040	0.045	0.036	0.015	0.005
		W	0.203	0.000	0.005	0.562	0.000	0.005	0.040	0.045	0.036	0.015	0.005
No. 9	0.216	N	0.234	0.000	0.005	0.438	0.000	0.005	0.040	0.045	0.036	0.015	0.005
		R	0.234	0.000	0.005	0.500	0.000	0.005	0.040	0.045	0.036	0.015	0.005
		W	0.234	0.000	0.005	0.875	0.000	0.005	0.040	0.045	0.036	0.015	0.005
No. 10	0.250	N	0.281	0.015	0.005	0.500	0.015	0.005	0.063	0.071	0.056	0.025	0.015
		R	0.281	0.015	0.005	0.734*	0.015	0.005	0.063	0.071	0.056	0.025	0.015
		W	0.281	0.015	0.005	1.000	0.015	0.005	0.063	0.071	0.056	0.025	0.015
No. 11	0.216	N	0.234	0.015	0.005	0.625	0.015	0.005	0.063	0.071	0.056	0.025	0.015
		R	0.234	0.015	0.005	0.875	0.015	0.005	0.063	0.071	0.056	0.025	

Appendix 45 ANSI Helical Spring Lock Washers
American National Standard Helical Spring Lock Washers (ANSI-ASME B18.21.1-1990)

Nominal Washer Size	Inside Diameter, <i>A</i>		Regular			Heavy			Extra Duty			
	Max.	Min.	O.D., <i>B</i> Max.	Section Width, <i>W</i>	Section Thickness, <i>T</i> §	O.D., <i>B</i> Max.	Section Width, <i>W</i>	Section Thickness, <i>T</i> §	O.D., <i>B</i> Max.	Section Width, <i>W</i>	Section Thickness, <i>T</i> §	
No. 2	0.086	0.094	0.088	0.172	0.035	0.020	0.182	0.040	0.025	0.208	0.053	0.027
No. 3	0.099	0.107	0.101	0.195	0.040	0.025	0.209	0.047	0.031	0.239	0.062	0.034
No. 4	0.112	0.120	0.114	0.209	0.040	0.025	0.223	0.047	0.031	0.253	0.062	0.034
No. 5	0.125	0.133	0.127	0.236	0.047	0.031	0.252	0.055	0.040	0.300	0.079	0.045
No. 6	0.138	0.148	0.141	0.250	0.047	0.031	0.266	0.055	0.040	0.314	0.079	0.045
No. 8	0.164	0.174	0.167	0.293	0.055	0.040	0.307	0.062	0.047	0.375	0.096	0.057
No. 10	0.190	0.200	0.193	0.334	0.062	0.047	0.350	0.070	0.056	0.434	0.112	0.068
No. 12	0.216	0.227	0.220	0.377	0.070	0.056	0.391	0.077	0.063	0.497	0.130	0.080
1/4	0.250	0.260	0.252	0.487	0.109	0.062	0.489	0.110	0.077	0.533	0.132	0.084
5/16	0.3125	0.322	0.314	0.583	0.125	0.078	0.593	0.130	0.097	0.619	0.143	0.108
3/8	0.375	0.385	0.377	0.680	0.141	0.094	0.688	0.145	0.115	0.738	0.170	0.123
7/16	0.4375	0.450	0.440	0.776	0.156	0.109	0.784	0.160	0.133	0.836	0.186	0.143
1/2	0.500	0.512	0.502	0.869	0.171	0.125	0.879	0.176	0.151	0.935	0.204	0.162
9/16	0.5625	0.574	0.564	0.965	0.188	0.141	0.975	0.193	0.170	1.035	0.223	0.182
5/8	0.625	0.640	0.628	1.072	0.203	0.156	1.086	0.210	0.189	1.150	0.242	0.202
11/16	0.6875	0.703	0.691	1.169	0.219	0.172	1.185	0.227	0.207	1.251	0.260	0.221
3/4	0.750	0.765	0.753	1.264	0.234	0.188	1.284	0.244	0.226	1.354	0.279	0.241
13/16	0.8125	0.828	0.816	1.359	0.250	0.203	1.383	0.262	0.246	1.454	0.298	0.261
7/8	0.875	0.890	0.878	1.455	0.266	0.219	1.485	0.281	0.266	1.557	0.322	0.285
15/16	0.9375	0.953	0.941	1.551	0.281	0.234	1.585	0.298	0.284	1.679	0.345	0.308
I	1.000	1.015	1.003	1.647	0.297	0.250	1.691	0.319	0.306	1.785	0.366	0.330
1 1/16	1.0625	1.080	1.066	1.742	0.312	0.266	1.794	0.338	0.326	1.896	0.389	0.352
1 1/8	1.125	1.144	1.129	1.838	0.328	0.281	1.894	0.356	0.345	2.004	0.411	0.375
1 3/16	1.1875	1.208	1.192	1.934	0.344	0.297	1.992	0.373	0.364	2.108	0.431	0.396
1 1/4	1.250	1.272	1.254	2.028	0.359	0.312	2.096	0.393	0.384	2.214	0.452	0.417
1 5/16	1.3125	1.335	1.317	2.124	0.375	0.328	2.194	0.410	0.403	2.318	0.472	0.438
1 3/8	1.375	1.399	1.379	2.210	0.391	0.344	2.292	0.427	0.422	2.420	0.491	0.458
1 7/16	1.4375	1.462	1.442	2.314	0.406	0.359	2.386	0.442	0.440	2.520	0.509	0.478
1 1/2	1.500	1.524	1.504	2.409	0.422	0.375	2.481	0.458	0.458	2.617	0.526	0.496

All dimensions are given in inches. * See Standard for sizes over 1 1/2 to 3, inclusive, for regular and heavy helical spring lock washers and over 1 1/2 to 2, inclusive, for extra-duty helical spring lock washers. § *T* = mean section thickness = $(t_i + t_o) / 2$.

SOURCE: Reprinted courtesy of The American Society of Mechanical Engineers.

Appendix 46 ANSI Internal and External Tooth Lock Washers

American National Standard Internal and External Tooth Lock Washers (ANSI/ASME B18.21.1-1990)

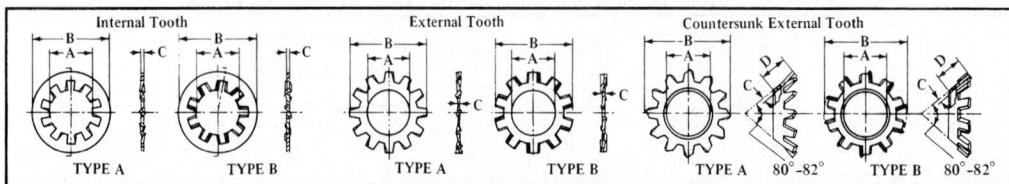

Internal Tooth		External Tooth		Countersunk External Tooth	
	TYPE A	TYPE B	TYPE A	TYPE B	TYPE A
	B	A	B	A	B
	C		C		C

Internal Tooth Lock Washers																							
Size	#2	#3	#4	#5	#6	#8	#10	#12	1/4	5/16	3/8	7/16	1/2	9/16	5/8	11/16	3/4	13/16	7/8	1	1 1/8	1 1/4	
A	Max	0.095	0.109	0.123	0.136	0.150	0.176	0.204	0.231	0.267	0.332	0.398	0.464	0.530	0.596	0.663	0.728	0.795	0.861	0.927	1.060	1.192	1.325
	Min	0.089	0.102	0.115	0.129	0.141	0.168	0.195	0.221	0.256	0.320	0.384	0.448	0.512	0.576	0.640	0.704	0.769	0.832	0.894	1.019	1.144	1.275
B	Max	0.200	0.232	0.270	0.280	0.295	0.340	0.381	0.410	0.478	0.610	0.692	0.789	0.900	0.985	1.071	1.166	1.245	1.315	1.410	1.637	1.830	1.975
	Min	0.175	0.215	0.245	0.255	0.275	0.325	0.365	0.394	0.460	0.594	0.670	0.740	0.867	0.957	1.045	1.130	1.220	1.290	1.364	1.590	1.799	1.921
C	Max	0.015	0.019	0.019	0.021	0.021	0.023	0.025	0.025	0.028	0.034	0.040	0.040	0.045	0.045	0.050	0.050	0.055	0.055	0.060	0.067	0.067	0.067
	Min	0.010	0.012	0.015	0.017	0.017	0.018	0.020	0.020	0.023	0.028	0.032	0.032	0.037	0.042	0.042	0.047	0.047	0.052	0.059	0.059	0.059	0.059

External Tooth Lock Washers																							
A	Max	...	0.109	0.123	0.136	0.150	0.176	0.204	0.231	0.267	0.332	0.398	0.464	0.530	0.596	0.663	0.728	0.795	0.861	0.927	1.060
A	Max	...	0.102	0.115	0.129	0.141	0.168	0.195	0.221	0.256	0.320	0.384	0.448	0.513	0.576	0.641	0.704	0.768	0.833	0.897	1.025
B	Max	...	0.220	0.245	0.270	0.305	0.365	0.395	0.460	0.494	0.588	0.670	0.740	0.886	0.960	1.045	1.130	1.220	1.290	1.380	1.590
C	Max	...	0.015	0.019	0.019	0.022	0.023	0.025	0.028	0.028	0.034	0.040	0.040	0.045	0.045	0.050	0.050	0.055	0.055	0.060	0.067	0.067	0.067
	Min	...	0.012	0.014	0.015	0.016	0.018	0.020	0.023	0.023	0.028	0.032	0.032	0.037	0.042	0.042	0.047	0.047	0.052	0.059	0.059	0.059	0.059

Heavy Internal Tooth Lock Washers											
A	Size	1/4	5/16	3/8	7/16	1/2	9/16	5/8	3/4	7/8	1
A	Max	0.267	0.332	0.398	0.464	0.530	0.596	0.663	0.795	0.927	...
	Min	0.256	0.320	0.384	0.448	0.512	0.576	0.640	0.768	0.894	...
B	Max	0.536	0.607	0.748	0.858	0.924	1.034	1.135	1.265	1.447	...
	Min	0.500	0.590	0.700	0.800	0.880	0.990	1.100	1.240	1.400	...
C	Max	0.045	0.050	0.050	0.067	0.067	0.067	0.084	0.084	0.128	...
	Min	0.035	0.040	0.042	0.050	0.055	0.055	0.059	0.070	0.075	...

Countersunk External Tooth Lock Washers*												
A	Size	#4	#6	#8	#10	#12	1/4	#16	5/16	3/8	7/16	1/2
A	Max	0.123	0.150	0.177	0.205	0.231	0.267	0.287	0.333	0.398	0.463	0.529
	Min	0.113	0.140	0.167	0.195	0.220	0.255	0.273	0.318	0.383	0.448	0.512
C	Max	0.019	0.021	0.021	0.025	0.025	0.025	0.028	0.028	0.034	0.045	0.045
	Min	0.015	0.017	0.017	0.020	0.020	0.020	0.023	0.023	0.028	0.037	0.037
D	Max	0.065	0.092	0.105	0.099	0.128	0.128	0.147	0.192	0.255	0.270	0.304
	Min	0.050	0.082	0.088	0.083	0.118	0.113	0.137	0.165	0.242	0.260	0.294

All dimensions are given in inches. * Starting with #4, approx. O.D.'s are: 0.213, 0.289, 0.322, 0.354, 0.421, 0.454, 0.505, 0.599, 0.765, 0.867, and 0.976.

SOURCE: Reprinted courtesy of The American Society of Mechanical Engineers.

ANSI Keyseat Dimensions for Woodruff Keys (ANSI B17.2-1967, R1990)

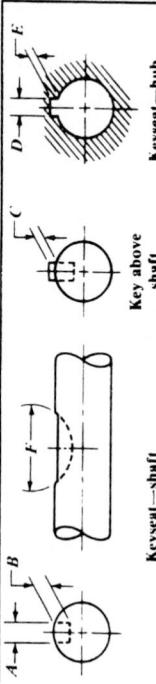

- These Width A values were set with ~~such~~ which will

key which will receive a key with the greatest amount of looseness consistent with assuring the key's sticking in the keyseat (shaft). Minimum keyseat width is that figure permitting the largest shaft distortion acceptable when assembling maximum key in minimum keyseat.

卷之三

All dimensions are given in inches.

² See footnote at end of table.

SOURCE: Reprinted courtesy of The American Society of Mechanical Engineers.

Appendix 48 ANSI Standard Woodruff Keys

ANSI Standard Woodruff Keys (ANSI B17.2-1967, R1990)

Key No.	Nominal Key Size $W \times B$	Height of Key				Distance Below Center E
		Actual Length F + 0.000 - 0.010 - $p.010$	Max.	Min.	C	
202	1 $\frac{1}{8}$ \times 1 $\frac{1}{16}$	0.248	0.109	0.104	0.109	0.104
202.5	1 $\frac{1}{8}$ \times 1 $\frac{3}{16}$	0.311	0.140	0.135	0.140	0.135
302.5	1 $\frac{1}{8}$ \times 1 $\frac{1}{8}$	0.311	0.140	0.135	0.140	0.135
203	1 $\frac{1}{8}$ \times 1 $\frac{3}{8}$	0.374	0.172	0.167	0.172	0.167
303	1 $\frac{1}{8}$ \times 1 $\frac{7}{16}$	0.374	0.172	0.167	0.172	0.167
403	1 $\frac{1}{8}$ \times 1 $\frac{1}{2}$	0.374	0.172	0.167	0.172	0.167
204	1 $\frac{1}{8}$ \times 1 $\frac{1}{2}$	0.491	0.203	0.198	0.194	0.194
304	1 $\frac{1}{8}$ \times 1 $\frac{1}{2}$	0.491	0.203	0.198	0.194	0.194
404	1 $\frac{1}{8}$ \times 1 $\frac{1}{2}$	0.491	0.203	0.198	0.194	0.194
305	1 $\frac{1}{8}$ \times 1 $\frac{5}{8}$	0.612	0.350	0.245	0.240	0.240
405	1 $\frac{1}{8}$ \times 1 $\frac{5}{8}$	0.612	0.350	0.245	0.240	0.240
505	1 $\frac{1}{8}$ \times 1 $\frac{5}{8}$	0.612	0.350	0.245	0.240	0.240
605	1 $\frac{1}{8}$ \times 1 $\frac{5}{8}$	0.612	0.350	0.245	0.240	0.240
707	1 $\frac{1}{8}$ \times 1 $\frac{5}{8}$	0.866	0.375	0.365	0.359	0.359
807	1 $\frac{1}{8}$ \times 1 $\frac{5}{8}$	0.866	0.375	0.365	0.359	0.359
506	1 $\frac{1}{8}$ \times 1 $\frac{3}{4}$	0.740	0.313	0.308	0.303	0.303
606	1 $\frac{1}{8}$ \times 1 $\frac{3}{4}$	0.740	0.313	0.308	0.303	0.303
806	1 $\frac{1}{8}$ \times 1 $\frac{3}{4}$	0.740	0.313	0.308	0.303	0.303
507	1 $\frac{1}{8}$ \times 1 $\frac{7}{8}$	0.866	0.375	0.370	0.365	0.359
607	1 $\frac{1}{8}$ \times 1 $\frac{7}{8}$	0.866	0.375	0.370	0.365	0.359
707	1 $\frac{1}{8}$ \times 1 $\frac{7}{8}$	0.866	0.375	0.370	0.365	0.359
807	1 $\frac{1}{8}$ \times 1 $\frac{7}{8}$	0.866	0.375	0.370	0.365	0.359
608	1 $\frac{1}{8}$ \times 1 $\frac{1}{2}$	0.992	0.438	0.433	0.428	0.428
708	1 $\frac{1}{8}$ \times 1 $\frac{1}{2}$	0.992	0.438	0.433	0.428	0.428
808	1 $\frac{1}{8}$ \times 1 $\frac{1}{2}$	0.992	0.438	0.433	0.428	0.428
1008	1 $\frac{1}{8}$ \times 1 $\frac{1}{2}$	0.992	0.438	0.433	0.428	0.428
1208	1 $\frac{1}{8}$ \times 1 $\frac{1}{2}$	0.992	0.438	0.433	0.428	0.428
1010	1 $\frac{1}{8}$ \times 1 $\frac{1}{2}$	1.114	0.484	0.479	0.475	0.469
1210	1 $\frac{1}{8}$ \times 1 $\frac{1}{2}$	1.114	0.484	0.479	0.475	0.469
811	1 $\frac{1}{8}$ \times 1 $\frac{1}{2}$	1.114	0.484	0.479	0.475	0.469
1011	1 $\frac{1}{8}$ \times 1 $\frac{1}{2}$	1.114	0.484	0.479	0.475	0.469
1211	1 $\frac{1}{8}$ \times 1 $\frac{1}{2}$	1.114	0.484	0.479	0.475	0.469
812	1 $\frac{1}{8}$ \times 1 $\frac{1}{2}$	1.484	0.641	0.636	0.631	0.625
1012	1 $\frac{1}{8}$ \times 1 $\frac{1}{2}$	1.484	0.641	0.636	0.631	0.625
1212	1 $\frac{1}{8}$ \times 1 $\frac{1}{2}$	1.484	0.641	0.636	0.631	0.625

All dimensions are given in inches.

The key numbers indicate nominal key dimensions. The last two digits give the nominal diameter B in eighths of an inch and the digits preceding the last two give the nominal width W in thirty-seconds of an inch.

SOURCE: Reprinted courtesy of The American Society of Mechanical Engineers.

Key No.	Nominal Key Size $W \times B$	Height of Key				Distance Below Center E
		Actual Length F + 0.000 - 0.010 - $p.010$	Max.	Min.	C	
617-1	3 $\frac{1}{16}$ \times 2 $\frac{1}{8}$	1.380	1.380	1.380	0.406	0.396
817-1	5 $\frac{1}{16}$ \times 2 $\frac{1}{8}$	1.380	1.380	1.380	0.406	0.396
1017-1	5 $\frac{1}{8}$ \times 2 $\frac{1}{8}$	1.380	1.380	1.380	0.406	0.396
1217-1	5 $\frac{1}{8}$ \times 2 $\frac{1}{8}$	1.380	1.380	1.380	0.406	0.396
617	3 $\frac{1}{16}$ \times 2 $\frac{1}{8}$	1.723	0.531	0.526	0.521	0.515
817	5 $\frac{1}{16}$ \times 2 $\frac{1}{8}$	1.723	0.531	0.526	0.521	0.515
1017	5 $\frac{1}{8}$ \times 2 $\frac{1}{8}$	1.723	0.531	0.526	0.521	0.515
1217	5 $\frac{1}{8}$ \times 2 $\frac{1}{8}$	1.723	0.531	0.526	0.521	0.515
822-1	3 $\frac{1}{16}$ \times 2 $\frac{3}{8}$	2.000	0.594	0.589	0.584	0.578
1022-1	5 $\frac{1}{16}$ \times 2 $\frac{3}{8}$	2.000	0.594	0.589	0.584	0.578
1222-1	5 $\frac{1}{8}$ \times 2 $\frac{3}{8}$	2.000	0.594	0.589	0.584	0.578
1422-1	7 $\frac{1}{16}$ \times 2 $\frac{3}{8}$	2.000	0.594	0.589	0.584	0.578
1622-1	7 $\frac{1}{8}$ \times 2 $\frac{3}{8}$	2.000	0.594	0.589	0.584	0.578
822	3 $\frac{1}{16}$ \times 2 $\frac{3}{8}$	2.317	0.750	0.745	0.740	0.734
1022	5 $\frac{1}{16}$ \times 2 $\frac{3}{8}$	2.317	0.750	0.745	0.740	0.734
1222	5 $\frac{1}{8}$ \times 2 $\frac{3}{8}$	2.317	0.750	0.745	0.740	0.734
1422	7 $\frac{1}{16}$ \times 2 $\frac{3}{8}$	2.317	0.750	0.745	0.740	0.734
1622	7 $\frac{1}{8}$ \times 2 $\frac{3}{8}$	2.317	0.750	0.745	0.740	0.734
822.5	3 $\frac{1}{16}$ \times 3 $\frac{1}{2}$	2.880	0.938	0.933	0.928	0.922
1022.5	5 $\frac{1}{16}$ \times 3 $\frac{1}{2}$	2.880	0.938	0.933	0.928	0.922
1222.5	5 $\frac{1}{8}$ \times 3 $\frac{1}{2}$	2.880	0.938	0.933	0.928	0.922
1422.5	7 $\frac{1}{16}$ \times 3 $\frac{1}{2}$	2.880	0.938	0.933	0.928	0.922
1622.5	7 $\frac{1}{8}$ \times 3 $\frac{1}{2}$	2.880	0.938	0.933	0.928	0.922
822.5	1 $\frac{1}{16}$ \times 3 $\frac{1}{2}$	2.880	0.938	0.933	0.928	0.922
1022.5	1 $\frac{1}{8}$ \times 3 $\frac{1}{2}$	2.880	0.938	0.933	0.928	0.922
1222.5	1 $\frac{1}{16}$ \times 3 $\frac{1}{2}$	2.880	0.938	0.933	0.928	0.922
1422.5	1 $\frac{1}{8}$ \times 3 $\frac{1}{2}$	2.880	0.938	0.933	0.928	0.922
1622.5	1 $\frac{1}{16}$ \times 3 $\frac{1}{2}$	2.880	0.938	0.933	0.928	0.922

All dimensions are given in inches.
The key numbers indicate nominal key dimensions. The last two digits give the nominal diameter B in eighths of an inch and the digits preceding the last two give the nominal width W in thirty-seconds of an inch.

The key numbers with the -1 designation, while representing the nominal key size have a shorter length F and due to a greater distance below center E are less in height than the keys of the same number without the -1 designation.

Appendix 49 Key Size versus Shaft Diameter—Key Size and Keyway Depth

Key Size Versus Shaft Diameter (ANSI B17.1-1967, R1989)

Nominal Shaft Diameter	T ₀ (Incl.)	Nominal Key Size				Nominal Keyseat Depth	
		Width, W	Height, H		Rectangular		
			Square	Rectangular			
5/16	7/16	3/32	3/32	3/32	3/32	3/16	
7/16	9/16	1/8	1/8	1/8	1/8	3/32	
6/16	8/16	3/16	3/16	3/16	3/16	3/32	
7/8	1 1/4	1/4	1/4	1/4	1/4	1/4	
1 1/4	1 3/8	5/16	5/16	5/16	5/16	1/8	
1 3/8	1 3/8	3/8	3/8	3/8	3/8	1/8	
1 3/4	2 1/4	1/2	1/2	1/2	1/2	1/8	
2 1/4	2 1/4	5/8	5/8	5/8	5/8	1/8	
2 3/4	3 1/4	3/4	3/4	3/4	3/4	3/8	
3 3/4	3 3/4	7/8	7/8	7/8	7/8	5/16	
4 1/2	4 1/2	1	1	1	1	3/8	
5 1/2	6 1/2	1 1/4	1 1/4	1 1/4	1 1/4	7/16	
6 1/2	7 1/2	1 3/4	1 3/4	1 3/4	1 3/4	1 1/8	
7 1/2	9	2	2	2	2	1 1/4	
9		2 1/2	2 1/2	2 1/2	2 1/2	2 1/2	

All dimensions are given in inches. For larger shaft sizes, see ANSI Standard.

Square keys preferred for shaft diameters above heavy line; rectangular keys, below.

Some key standards show $1\frac{1}{4}$ inches; preferred height is $1\frac{1}{2}$ inches.

Depth Control Values S and T for Shaft and Hub (ANSI B17.1-1967, RI989)

Nominal Shaft Diameter	Parallel and Taper				Taper			
	Square		Rectangular		Square		Rectangular	
	S	T	S	T	S	T	S	T
1 $\frac{1}{16}$	0.430	0.445	0.560	0.544	0.545	0.535	0.519	0.582
9 $\frac{7}{16}$	0.493	0.509	0.623	0.607	0.598	0.588	0.562	0.653
5 $\frac{15}{16}$	0.548	0.564	0.709	0.678	0.684	0.664	0.634	0.717
1 $\frac{1}{2}$	0.581	0.612	0.773	0.742	0.748	0.718	0.781	0.871
1 $\frac{1}{16}$	0.634	0.676	0.837	0.806	0.812	0.781	0.844	0.907
1 $\frac{3}{16}$	0.678	0.739	0.900	0.869	0.875	0.839	0.904	0.971
7 $\frac{1}{16}$	0.711	0.802	0.964	0.932	0.939	0.907	0.994	1.058
7 $\frac{5}{16}$	0.796	0.827	1.051	1.019	1.026	0.994	1.062	1.121
1 $\frac{1}{16}$	0.859	0.890	1.114	1.083	1.089	1.058	1.121	1.185
1 $\frac{1}{16}$	0.923	0.954	1.178	1.146	1.153	1.121	1.188	1.248
1 $\frac{3}{16}$	0.986	1.017	1.241	1.210	1.216	1.185	1.251	1.311
1 $\frac{3}{16}$	1.049	1.080	1.304	1.273	1.279	1.248	1.314	1.399
1 $\frac{1}{2}$	1.102	1.112	1.144	1.136	1.136	1.132	1.197	1.261
1 $\frac{1}{16}$	1.137	1.160	1.155	1.142	1.143	1.139	1.202	1.266
1 $\frac{3}{16}$	1.201	1.232	1.188	1.148	1.149	1.142	1.216	1.279
1 $\frac{7}{16}$	1.225	1.288	1.605	1.543	1.580	1.518	1.644	1.581
1 $\frac{1}{2}$	1.289	1.351	1.669	1.666	1.644	1.607	1.707	1.645
1 $\frac{9}{16}$	1.325	1.415	1.732	1.670	1.707	1.645	1.771	1.708
1 $\frac{5}{16}$	1.446	1.478	1.796	1.733	1.771	1.711	1.834	1.771
1 $\frac{11}{16}$	1.479	1.541	1.859	1.796	1.834	1.771	1.897	1.833
1 $\frac{3}{4}$	1.542	1.605	1.922	1.860	1.897	1.835	2.007	1.945
1 $\frac{1}{16}$	1.527	1.590	2.032	2.032	2.071	2.071	2.034	2.009
1 $\frac{7}{16}$	1.591	1.654	2.096	2.096	2.135	2.135	2.097	2.072
1 $\frac{5}{16}$	1.655	1.717	2.160	2.160	2.198	2.198	2.161	2.136
2	1.718	1.781	2.223	2.223	2.261	2.261	2.223	2.195

All dimensions are given in inches.

All dimensions are given in inches.

Appendix 50 ANSI Standard Plain and Gib Head Keys

ANSI Standard Plain and Gib Head Keys (ANSI B17.1-1967, R1989)

All dimensions are given in inches.

All dimensions are given in inches.

* For locating position of dimension H , Tolerance does not apply. For larger sizes the following relationships are suggested as guides for establishing A and R.

Following relationships are suggested as guides for $\text{E}_{\text{ad}}^{\text{max}}$:

Appendix 51 ANSI Chamfered, Square End, and Taper Pins

American National Standard Chamfered and Square End Straight Pins
(ANSI B18.8.2-1978)

CHAMFERED STRAIGHT PIN				SQUARE END STRAIGHT PIN					
Nominal Size ¹ or Basic Pin Diameter	Pin Diameter, A		Chamfer Length, C	Nominal Size ¹ or Basic Pin Diameter	Pin Diameter, A		Chamfer Length, C		
	Max	Min	Max		Max	Min	Max	Min	
1/16 0.062	0.0625	0.0605	0.025	0.005	5/16 0.312	0.3125	0.3105	0.040	0.020
3/32 0.094	0.0937	0.0917	0.025	0.005	3/8 0.375	0.3750	0.3730	0.040	0.020
7/64 0.109	0.1094	0.1074	0.025	0.005	7/16 0.438	0.4375	0.4355	0.040	0.020
1/8 0.125	0.1250	0.1230	0.025	0.005	1/2 0.500	0.5000	0.4980	0.040	0.020
5/32 0.156	0.1562	0.1542	0.025	0.005	5/8 0.625	0.6250	0.6230	0.055	0.035
3/16 0.188	0.1875	0.1855	0.025	0.005	7/4 0.750	0.7500	0.7480	0.055	0.035
7/32 0.219	0.2187	0.2167	0.025	0.005	7/8 0.875	0.8750	0.8730	0.055	0.035
1/4 0.250	0.2500	0.2480	0.025	0.005	1 1.000	1.0000	0.9980	0.055	0.035

All dimensions are in inches.

¹ Where specifying nominal size in decimals, zeros preceding decimal point are omitted.

American National Standard Taper Pins (ANSI B18.8.2-1978, R1989)

Pin Size Number and Basic Pin Diameter ¹	Major Diameter (Large End), A				End Crown Radius, R		Range of Lengths, ² L	
	Commercial Class		Precision Class		Max	Min	Stand. Reamer Avail. ³	Other
	Max	Min	Max	Min				
7/0 0.0625	0.0638	0.0618	0.0635	0.0625	0.072	0.052	...	1/4-1
6/0 0.0780	0.0793	0.0773	0.0790	0.0780	0.088	0.068	...	1/4-1 1/2
5/0 0.0940	0.0953	0.0933	0.0950	0.0940	0.104	0.084	1/4-1	1 1/4, 1 1/2
4/0 0.1090	0.1103	0.1083	0.1100	0.1090	0.119	0.099	1/4-1	1 1/4-2
3/0 0.1250	0.1263	0.1243	0.1260	0.1250	0.135	0.115	1/4-1	1 1/4-2
2/0 0.1410	0.1423	0.1403	0.1420	0.1410	0.151	0.131	1/2-1 1/4	1 1/2-2 1/2
0 0.1560	0.1573	0.1553	0.1570	0.1560	0.166	0.146	1/2-1 1/4	1 1/2-3
1 0.1720	0.1733	0.1713	0.1730	0.1720	0.182	0.162	3/4-1 1/4	1 1/2-3
2 0.1930	0.1943	0.1923	0.1940	0.1930	0.203	0.183	3/4-1 1/2	1 3/4-3
3 0.2190	0.2203	0.2183	0.2200	0.2190	0.229	0.209	3/4-1 3/4	2-4
4 0.2500	0.2513	0.2493	0.2510	0.2500	0.260	0.240	3/4-2	2 1/4-4
5 0.2890	0.2903	0.2883	0.2900	0.2890	0.299	0.279	1-2 1/2	2 3/4-6
6 0.3410	0.3423	0.3403	0.3420	0.3410	0.351	0.331	1 1/4-3	3 1/4-6
7 0.4090	0.4103	0.4083	0.4100	0.4090	0.419	0.399	1 1/4-3 1/4	4-8
8 0.4920	0.4933	0.4913	0.4930	0.4920	0.502	0.482	1 1/4-4 1/2	4 3/4-8
9 0.5910	0.5923	0.5903	0.5920	0.5910	0.601	0.581	1 1/4-5 1/4	5 1/2-8
10 0.7060	0.7073	0.7053	0.7070	0.7060	0.716	0.696	1 1/2-6	6 1/4-8
11 0.8600	0.8613	0.8593	0.870	0.850	...	2-8
12 1.0320	1.0333	1.0313	1.042	1.022	...	2-9
13 1.2410	1.2423	1.2403	1.251	1.231	...	3-11
14 1.5210	1.5223	1.5203	1.531	1.511	...	3-13

All dimensions are in inches.

For nominal diameters, B, see Table 6.

¹ When specifying nominal pin size in decimals, zeros preceding the decimal and in the fourth decimal place are omitted.² Lengths increase in 1/8-inch steps up to 1 inch and in 1/4-inch steps above 1 inch.³ Standard reamers are available for pin lengths in this column.

SOURCE: Reprinted courtesy of The American Society of Mechanical Engineers.

Appendix 52 British Standard Parallel Steel Dowel Pins—Metric Series
British Standard Parallel Steel Dowel Pins — Metric Series (BS 1804: Part 2: 1968)

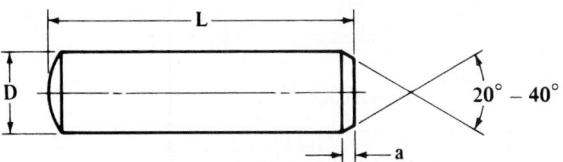

Nominal Diameter D , mm														
	1	1.5	2	2.5	3	4	5	6	8	10	12	16	20	25
Nom. Length L , mm	0.3	0.3	0.3	0.4	0.45	0.6	0.75	0.9	1.2	1.5	1.8	2.5	3	4
4	0	0	0	0	0									
6	0	0	0	0	0									
8	0	0	0	0	0									
10	0	0	0	0	0	0								
12	0	0	0	0	0	0	0							
16	0	0	0	0	0	0	0	0						
20		0	0	0	0	0	0	0	0					
25			0	0	0	0	0	0	0	0				
30				0	0	0	0	0	0	0	0			
35					0	0	0	0	0	0	0	0		
40						0	0	0	0	0	0	0	0	
45							0	0	0	0	0	0	0	0
50								0	0	0	0	0	0	0
60									0	0	0	0	0	0
70										0	0	0	0	0
80										0	0	0	0	0
90											0	0	0	0
100											0	0	0	0
110												0	0	0
120												0	0	0

Limits of Tolerance on Diameter

Nom. Diam., mm	Grade*						
	1	2	3				
	Tolerance Zone						
m5	h7	h11					
Over	To & Incl.	Limits of Tolerance, 0.001 mm					
3	3	+ 7	+ 2	0	- 12†	0	- 60
6	6	+ 9	+ 4	0	- 12	0	- 75
10	10	+ 12	+ 6	0	- 15	0	- 90
14	14	+ 15	+ 7	0	- 18	0	- 110
18	18	+ 15	+ 7	0	- 18	0	- 110
24	24	+ 17	+ 8	0	- 21	0	- 130
	30	+ 17	+ 8	0	- 21	0	- 130

* The limits of tolerance for grades 1 and 2 dowel pins have been chosen to provide satisfactory assembly when used in standard reamed holes (H7 and H8 tolerance zones). If the assembly is not satisfactory, BS 1916: Part 1, Limits and Fits for Engineering should be consulted, and a different class of fit chosen.

† This tolerance is larger than that given in BS 1916, and has been included because the use of a closer tolerance would involve precision grinding by the manufacturer, which is uneconomic for a grade 2 dowel pin.

The tolerance limits on the overall length of all grades of dowel pin up to and including 50 mm long are $+0.5$, -0.0 mm, and for pins over 50 mm long, are $+0.8$, -0.0 mm. The Standard specifies that the roughness of the cylindrical surface of grades 1 and 2 dowel pins, when assessed in accordance with BS 1134, shall not be greater than $0.4 \mu\text{m}$ CLA (16 CLA).

SOURCE: Reprinted courtesy of The American Society of Mechanical Engineers.

Appendix 53 ANSI Cotter and Clevis Pins

American National Standard Cotter Pins (ANSI B18.8.1-1972, R1983)

EXTENDED PRONG SQUARE CUT TYPE						HAMMER LOCK TYPE					
Nom. Size	Diam. A* & Width B Max.	Wire Width B Min.	Head Diam. C Min.	Prong L'gth D Min.	Hole Size	Nom. Size	Diam. A* & Width B Max.	Wire Width B Min.	Head Diam. C Min.	Prong L'gth D Min.	Hole Size
1/32	.032	.022	.06	.01	.047	3/16	.176	.137	.38	.09	.203
3/64	.048	.035	.09	.02	.062	7/32	.207	.161	.44	.10	.234
1/16	.060	.044	.12	.03	.078	5/32	.225	.176	.50	.11	.266
5/64	.076	.057	.16	.04	.094	3/8	.280	.220	.62	.14	.312
3/32	.090	.069	.19	.04	.109	7/16	.335	.263	.75	.16	.375
7/64	.104	.080	.22	.05	.125	1/2	.406	.320	.88	.20	.438
1/8	.120	.093	.25	.06	.141	5/8	.473	.373	1.00	.23	.500
9/64	.134	.104	.28	.06	.156	3/4	.598	.472	1.25	.30	.625
5/32	.150	.116	.31	.07	.172	7/8	.723	.572	1.50	.36	.750

All dimensions are given in inches. * Tolerances are: $-.004$ inch for the $1/32$ - to $3/16$ -inch sizes, incl.; $-.005$ inch for the $5/32$ - to $7/16$ -inch sizes, incl.; $-.006$ inch for the $3/8$ - to $1/2$ -inch sizes, incl.; and $-.008$ inch for the $9/64$ - and $1/8$ -inch sizes.

American National Standard Clevis Pins (ANSI B18.8.1-1972, R1983)

Nom. Size (Basic Pin Diam.)	Shank Diam. A Max. ¹	Head Diam. B Max. ²	Head Hgt. C Max. ³	Head Chamfer D Nom. ⁴	Hole Diam. E Max. ⁵	Point Diam. F Max. ⁶	Pin Lgth. G Basic ⁷	Head to Hole Center H Max. ⁸	Point Length L Max. Min.	Cotter Pin Size for Hole
3/16	.186	0.32	.07	.02	.088	.15	.058	.0504	.055 .035	1/16
1/4	.248	0.38	.10	.03	.088	.21	.077	.0692	.055 .035	1/16
5/16	.311	0.44	.10	.03	.119	.26	.094	.0832	.071 .049	3/32
3/8	.373	0.51	.13	.03	.119	.33	.106	.0958	.071 .049	3/32
7/16	.436	0.57	.16	.04	.119	.39	.119	.1.082	.071 .049	3/32
1/2	.496	0.63	.16	.04	.151	.44	.1.36	.1.223	.089 .063	1/8
5/8	.621	0.82	.21	.06	.151	.56	.1.61	.1.473	.089 .063	1/8
3/4	.746	0.94	.26	.07	.182	.68	.1.91	.1.739	.110 .076	5/32
7/8	.871	1.04	.32	.09	.182	.80	.2.16	.1.989	.110 .076	5/32
1	.996	1.19	.35	.10	.182	.93	.2.41	.2.239	.110 .076	5/32

All dimensions are given in inches. ¹ Tolerance is $-.005$ inch. ² Tolerance is $-.02$ inch. ³ Tolerance is $-.015$ inch. ⁴ Tolerance is $\pm .01$ inch. ⁵ Tolerance is $-.01$ inch.

⁷ Lengths tabulated are intended for use with standard clevises, without spacers. When required, it is recommended that other pin lengths be limited wherever possible to nominal lengths in .06-inch increments. ⁸ Tolerance is $-.020$ inch.

SOURCE: Reprinted courtesy of The American Society of Mechanical Engineers.

Appendix 54 Welding Symbols***Designation of Welding and Allied Processes by Letters**

Welding and Allied Processes	Letter Designation	Welding and Allied Processes	Letter Designation
Adhesive bonding	ABD	Projection welding	RPW
Arc welding	AW	Resistance seam welding	RSEW
Atomic hydrogen welding	AHW	Resistance spot welding	RSW
Bare metal arc welding	BMAW	Upset welding	UW
Carbon arc welding	CAW	Soldering	S
Electrogas welding	EGW	Dip soldering	DS
Flux cored arc welding	FCAW	Furnace soldering	FS
Gas metal arc welding	GMAW	Induction soldering	IS
Gas tungsten arc welding	GTAW	Infrared soldering	IRS
Plasma arc welding	PAW	Iron soldering	INS
Shielded metal arc welding	SMAW	Resistance soldering	RS
Stud arc welding	SW	Torch soldering	TS
Submerged arc welding	SAW	Wave soldering	WS
Arc welding process variations		Solid state welding	SSW
Gas carbon arc welding	CAW-G	Cold welding	CW
Gas metal arc welding-pulsed arc	GMAW-P	Diffusion welding	DFW
Gas metal arc welding-short circuiting arc	GMAW-S	Explosion welding	EXW
Gas tungsten arc welding-pulsed arc	GTAW-P	Forge welding	FOW
Series submerged arc welding	SAW-S	Friction welding	FRW
Shielded carbon arc welding	CAW-S	Hot pressure welding	HPW
Twin carbon arc welding	CAW-T	Roll welding	ROW
Brazing	B	Ultrasonic welding	USW
Arc brazing	AB	Thermal cutting	TC
Block brazing	BB	Arc cutting	AC
Diffusion brazing	DFB	Air carbon arc cutting	AAC
Dip brazing	DB	Carbon arc cutting	CAC
Flow brazing	FLB	Gas metal arc cutting	GMAC
Furnace brazing	FB	Gas tungsten arc cutting	GTAC
Induction brazing	IB	Metal arc cutting	MAC
Infrared brazing	IRB	Plasma arc cutting	PAC
Resistance brazing	RB	Shielded metal arc cutting	SMAC
Torch brazing	TBN	Electron beam cutting	EBC
Twin carbon arc brazing	TCAB	Laser beam cutting	LBC
Other welding processes		Oxygen cutting	OC
Electron beam welding	EBW	Chemical flux cutting	FOC
Electroslag welding	ESW	Metal powder cutting	POC
Flow welding	FLOW	Oxyfuel gas cutting	OFC
Induction welding	IW	Oxyacetylene cutting	OFC-A
Laser beam welding	LBW	Oxyhydrogen cutting	OFC-OH
Thermit welding	TW	Oxynatural gas cutting	OFC-N
Oxyfuel gas welding	OFW	Oxypropane cutting	OFC-P
Air acetylene welding	AAW	Oxygen arc cutting	AOC
Oxyacetylene welding	OAW	Oxygen lance cutting	LOC
Oxyhydrogen welding	OHW	Thermal spraying	THSP
Pressure gas welding	PGW	Electric arc spraying	EASP
Resistance welding	RW	Flame spraying	FLSP
Flash welding	FW	Plasma spraying	PSP
High frequency resistance welding	HFRW		
Percussion welding	PEW		

*Courtesy of the American Welding Society.

WELDING SYMBOLS 1

SUPPLEMENTARY SYMBOLS USED WITH WELDING SYMBOLS

LOCATION OF ELEMENTS OF A WELDING SYMBOL

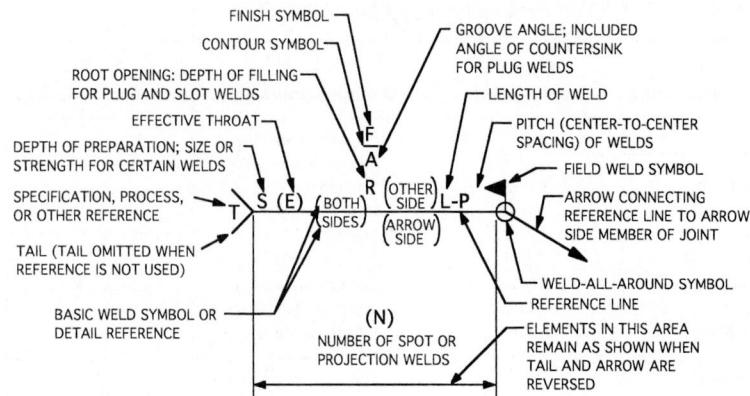

FIELD WELD SYMBOL

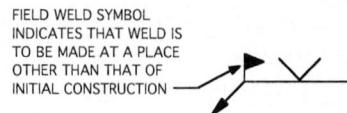

COMPLETE PENETRATION

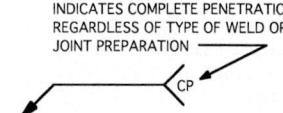

SUPPLEMENTARY SYMBOLS

WELD-ALL-AROUND	FIELD WELD	MELT-THRU	BACKING, SPACER	CONTOUR		
				FLUSH	CONVEX	CONCAVE

BASIC WELDING SYMBOLS AND THEIR LOCATION SIGNIFICANCE

LOCATION SIGNIFICANCE	ARROW SIDE	OTHER SIDE	BOTH SIDES	NO ARROW SIDE OR OTHER SIDE SIGNIFICANCE
FILLET				NOT USED
PLUG OR SLOT			NOT USED	NOT USED
SPOT OR PROJECTION			NOT USED	
SEAM			NOT USED	
BACK OR BACKING			NOT USED	NOT USED
SURFACING		NOT USED	NOT USED	NOT USED
SCARF FOR BRAZED JOINT				NOT USED
FLANGE EDGE			NOT USED	NOT USED
FLANGE CORNER			NOT USED	NOT USED
SQUARE				
V				NOT USED
BEVEL				NOT USED
U				NOT USED
J				NOT USED
FLARE-V				NOT USED
FLARE-BEVEL				NOT USED

DESIGN OF STANDARD SYMBOLS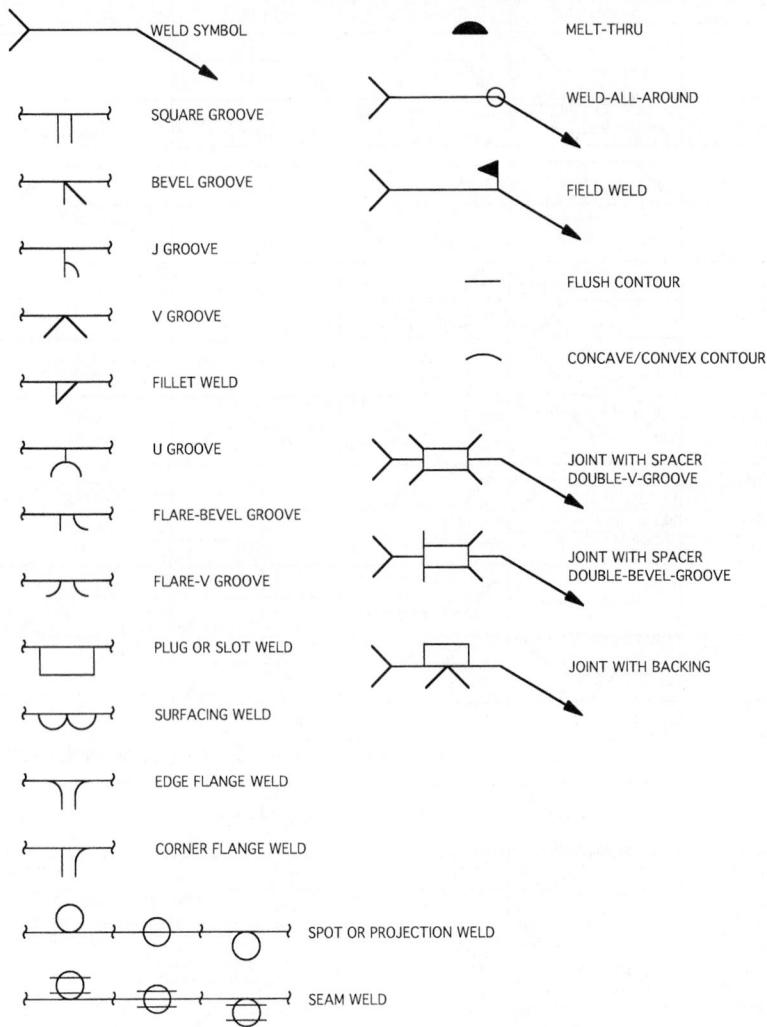

Appendix 55 Geometric Symbols, Definitions, and Characteristics

GEOMETRIC SYMBOLS AND DEFINITIONS

Individual Features Related Features	
Feature-Control Frame	
A specification box that shows a particular geometric characteristic (flatness, straightness, etc.) applied to a part feature and states the allowable tolerance. The feature's tolerance may be individual, or related to one or more datums. Any datum references and tolerance modifiers are also shown.	
Datum Feature	Datum Targets
A flag which designates a physical feature of the part to be used as a reference to measure geometric characteristics of other part features.	Callouts occasionally needed to designate specific points, lines, or areas on an actual part to be used to establish a theoretical datum feature.
Basic Dimension	Cylindrical Tolerance Zone
A box around any drawing dimension makes it a "basic" dimension, a theoretically exact value used as a reference for measuring geometric characteristics and tolerances of other part features.	This symbol, commonly used to indicate a diameter dimension, also specifies a cylindrically shaped tolerance zone in a feature-control frame.
Maximum Material Condition	Least Material Condition
Abbreviation: MMC. A tolerance modifier that applies the stated tight tolerance zone only while the part theoretically contains the maximum amount of material permitted within its dimensional limits (e.g. minimum hole diameters and maximum shaft diameters), allowing more variation under normal conditions.	Abbreviation: LMC. A tolerance modifier that applies the stated tight tolerance zone only while the part theoretically contains the minimum amount of material permitted within its dimensional limits (e.g. maximum hole diameters and minimum shaft diameters), allowing more variation under normal conditions.
Regardless of Feature Size	Projected Tolerance Zone
Abbreviation: RFS. A tolerance modifier that applies the stated tight tolerance zone under all size conditions. RFS is generally assumed if neither MMC nor LMC are stated.	An additional specification box attached underneath a feature-control frame. It extends the feature's tolerance zone beyond the part's surface by the stated distance, ensuring perpendicularity for proper alignment of mating parts.

GEOMETRIC CHARACTERISTICS

	Flatness
	All points on the indicated surface must lie in a single plane, within the specified tolerance zone.
	Straightness
	All points on the indicated surface or axis must lie in a straight line in the direction shown, within the specified tolerance zone.
	Circularity (Roundness)
	If the indicated surface were sliced by any plane perpendicular to its axis, the resulting outline must be a perfect circle, within the specified tolerance zone.
	Cylindricity
	All points on the indicated surface must lie in a perfect cylinder around a center axis, within the specified tolerance zone.

Linear Profile

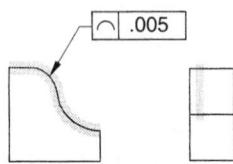

All points on any full slice of the indicated surface must lie on its theoretical two-dimensional profile, as defined by basic dimensions, within the specified tolerance zone. The profile may or may not be oriented with respect to datums.

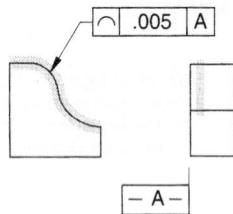

Surface Profile

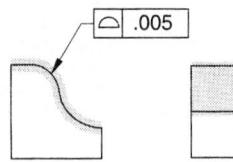

All points on the indicated surface must lie on its theoretical three-dimensional profile, as defined by basic dimensions, within the specified tolerance zone. The profile may or may not be oriented with respect to datums.

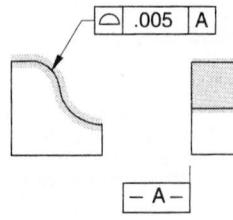

Perpendicularity (Squareness)

$\perp .002 A$

All points on the indicated surface, axis, or line must lie in a single plane exactly 90° from the designated datum plane or axis, within the specified tolerance zone.

Angularity

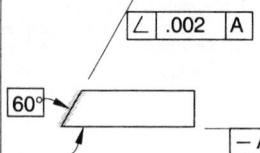

All points on the indicated surface or axis must lie in a single plane at exactly the specified angle from the designated datum plane or axis, within the specified tolerance zone.

// Parallelism

$/ / .002 A$

All points on the indicated surface or axis must lie in a single plane parallel to the designated datum plane or axis, within the specified tolerance zone.

Circular Runout

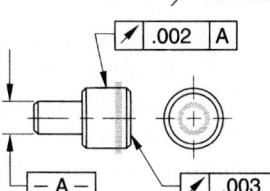

Each circular element of the indicated surface is allowed to deviate only the specified amount from its theoretical form and orientation during 360° rotation about the designated datum axis.

Total Runout

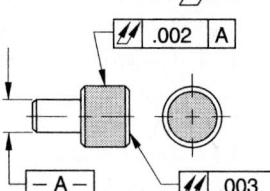

The entire indicated surface is allowed to deviate only the specified amount from its theoretical form and orientation during 360° rotation about the designated datum axis.

Concentricity

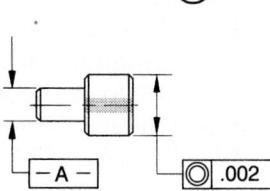

If the indicated surface were sliced by any plane perpendicular to the designated datum axis, every slice's center of area must lie on the datum axis, within the specified cylindrical tolerance zone (controls rotational balance).

Position (Replaces \equiv Symmetry)

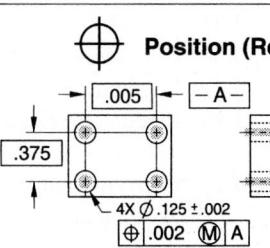

The indicated feature's axis must be located within the specified tolerance zone from its true theoretical position, correctly oriented relative to the designated datum plane or axis.

Appendix 56 CAD References for AutoCAD 13 Companion, Leach

1.1 Mouse, drawing a line 12, 30
1.2 Drawing horizontal lines 30
1.3 Drawing vertical lines 33
1.4 Drawing inclined lines 33
1.5 Erasing 43, 50, 85
1.6 Object snap 61
1.7 Drawing parallel lines 186, 158
1.8 Drawing perpendicular lines 66
1.9 Drawing lines relative, at angles 30, 33
1.10 Drawing irregular curves 161, 172
1.11 Scales 3, 5, 133, 143
1.12 Circles, arcs 33, 73, 76
1.13 Divide, measure 187, 188
1.14 Templates, symbols (*Blocks*) 217

2.1 Sketching 160
2.2 Projections 241
2.3 Isometric pictorial (2-D) 256
2.4 Isometric ellipse 258
2.5 Lettering 201
2.6 Text styles 210
2.7 Text height 203, 210, 335
2.8 Text alignment 203
2.9 Text variables 212, 297, 391
2.10 Vertex, edge, and face listing 195
2.11 Cutting planes in 3-D 278
2.12 Symmetry NA
2.13 Surface developments NA
2.14 Rotating objects in 3-D 350, 352
2.15 Auxiliary views 283, 284, 290

3.1 Coordinates, 3-D coordinates 2, 10, 30, 342
3.2 Polar coordinates 30
3.3 Cylindrical coordinates 342
3.4 Spherical coordinates 342
3.5 Absolute and relative coordinates 30
3.6 World coordinate system, user coordinate systems 343, 370
3.7 Point or node 80
3.8 Dividing a line into equal parts 187
3.9 Dividing a line into proportional parts 187
3.10 Bisecting a line 65
3.11 Locating the point of tangency between a circle or arc and a line 66
3.12 Locating the point of tangency between two circles 66

3.13 Drawing an arc tangent to a given point on that line 65
3.14 Drawing an arc tangent to two lines 75
3.15 Drawing an arc tangent to a line and an arc 75
3.16 Drawing an arc tangent to two arcs 75
3.17 Drawing lines tangent to two circles 66
3.18 Drawing a circle through three points 75
3.19 Locating the center of a circle 64, 195
3.20 Ogee curve NA
3.21 Rectified arcs (use *Ddmodify ...*, *PICK Arc*) 169
3.22 Constructing a parabola (*Spline*) 161
3.23 Constructing a hyperbola (*Spline*) 161
3.24 Constructing an ellipse 155
3.25 Spiral NA
3.26 Cycloid NA
3.27 Helix NA
3.28 Bisecting an angle (*polar coordinates*, *object snaps*, *Xline*) 30, 65, 158
3.29 Transferring an angle (*Copy*) 101
3.30 Surfaces NA
3.31 Circumscribe a square (*Polygon*) 154
3.32 Constructing an equilateral triangle (*Polygon*) 154
3.33 Pentagon 154
3.34 Hexagon 154
3.35 Rules surfaces NA
3.36 Cone 384
3.37 Cylinder 385
3.38 Convolute NA
3.39 Polyhedron NA
3.40 Fractal curves and surfaces NA

4.1 Conventional view placement 342, 343, 352, 382
4.2 Alignment of views 240
4.3 Line conventions 245, 125
4.4 Hidden lines 245
4.5 Center lines 245, 303
4.6 One-view drawings 81, 105, 225
4.7 Two-view drawings 280
4.8 Three-view drawings 249, 252
4.9 Multiviews from 3-D models NA
4.10 Fillets and rounds 182, 247, 404
4.11 Chamfers 184, 403
4.12 Runouts 247

5.1 Isometric viewpoints (*3-D model*) 354, 355
5.2 Isometric drawings, dimensions 257, 313
5.3 Creating isometric drawings 259
5.4 Oblique planes in isometric NA
5.5 Isometric ellipses 258
5.6 Assembly drawings (*3-D*) NA
5.7 Isometric grids 257
5.8 Oblique drawings 324
5.9 Perspective drawing 350

6.1 Auxiliary views 283
6.2 Auxiliary views using CAD 283
6.3 Point view of a line (*UCS Zaxis, Plan*) 372, 358
6.4 Dihedral angles (*UCS 3point, Plan*) 372, 358

7.1 Section views (*Section, Slice*) 419, 420
7.2 Section lines (*Bhatch*) 268
7.3 Cutting plane lines 278
7.4 Material symbols 271
7.5 Hatch style 275
7.6 Thin wall sections 272
7.7 Full sections 268
7.8 Assembly sections NA
7.9 Conventional breaks (*Spline, Sketch*) 160, 161
7.10 3-D models and section views 419, 420

8.1 Units of measure 328
8.2 Size dimensions (*linear, aligned, angular diameter, radius, etc.*) 295–305
8.3 Angular dimensions 295–305
8.4 Coordinate dimensions (*ordinate*) 307
8.5 Dimension text placement 294, 296, 326, 327
8.6 Spacing 294, 325
8.7 Grouping and staggering 298, 300
8.8 Extension lines 294–297, 325
8.9 Reading direction 297, 311, 327
8.10 Detail dimensions (*text*) 297, 301, 303

8.11 Screw threads, notes 306
8.12 Dimensioning process 333
8.13 Limit dimensions, tolerances 330
8.14 Associative dimensions 308
8.15 Geometric dimensioning and tolerancing 308

9.1 Sectioned assembly NA
9.2 Pictorial assembly NA
9.3 Title block 216
9.4 Parts list 190, 215
9.5 Parts identification NA
9.6 Thread notes 297, 306
9.7 Gears NA
9.8 Bearings NA
9.9 Welding symbols NA

10.1 Surface modeling 340
10.2 Solid modeling, primitives 341, 380
10.3 CSG modeling 341, 380
10.4 Boolean operations 381
10.5 B-rep modeling 341, 380
10.6 Faceted models 361, 364
10.7 Workplanes 343, 370
10.8 Sweeping operations 388, 390
10.9 Parallel and perspective projection 110, 352, 354
10.10 Geometric transformation 101, 396, 397
10.11 Ideation drawings *Preface*
10.12 Computer animation NA
10.13 Finite element analysis NA
10.14 Mechanism analysis NA
10.15 Aesthetic analysis NA
10.16 Production drawings 239, 267, 283
10.17 Technical illustrations 351
10.18 Animations NA
10.19 Technical reports NA
10.20 Presentation graphics NA

NA = Not Applicable—capabilities not provided in AutoCAD or not discussed.

Appendix 57 CAD References for AutoCAD 12 Companion, Leach

1.1 Mouse, drawing a line 10, 23
1.2 Drawing horizontal lines 23
1.3 Drawing vertical lines 26
1.4 Drawing inclined lines 26
1.5 Erasing 34, 39, 70
1.6 Object snap 50
1.7 Drawing parallel lines 154
1.8 Drawing perpendicular lines 52
1.9 Drawing lines relative, at angles 23, 26, 45
1.10 Drawing irregular curves 142
1.11 Scales 3, 5, 106, 117
1.12 Circles, arcs 59, 61
1.13 Divide, measure 155, 156
1.14 Templates, symbols (*Blocks*) 181

2.1 Sketching 132
2.2 Projections 219
2.3 Isometric pictorial (2-D) 235
2.4 Isometric ellipse 236
2.5 Lettering 167
2.6 Text styles 172
2.7 Text height 169, 174, 305
2.8 Text alignment 170
2.9 Text variables 174, 278
2.10 Vertex, edge, and face listing 160
2.11 Cutting planes in 3-D 388
2.12 Symmetry NA
2.13 Surface developments NA
2.14 Rotating objects in 3-D space 324, 326
2.15 Auxiliary views 257

3.1 Coordinates, 3-D coordinates 2, 6, 23, 312
3.2 Polar coordinates 23
3.3 Cylindrical coordinates 312
3.4 Spherical coordinates 312
3.5 Absolute and relative coordinates 23
3.6 World coordinate system, user coordinate systems 313
3.7 Point or node 65
3.8 Dividing a line into equal parts 155
3.9 Dividing a line into proportional parts 155
3.10 Bisecting a line (*MIDpoint*) 51
3.11 Locating the point of tangency between a circle or arc and a line 52
3.12 Locating the point of tangency between two circles 52

3.13 Drawing an arc tangent to a given point on that line 52
3.14 Drawing an arc tangent to two lines 60
3.15 Drawing an arc tangent to a line and an arc 52, 61
3.16 Drawing an arc tangent to two arcs 52, 60
3.17 Drawing lines tangent to two circles 52, 60
3.18 Drawing a circle through three points 60
3.19 Locating the center of a circle 50
3.20 Ogee curve NA
3.21 Rectified arcs (use *Modify ...*, *PICK Arc*) 141
3.22 Constructing a parabola (*Spline*) 127, 142
3.23 Constructing a hyperbola (*Spline*) 127, 142
3.24 Constructing an ellipse 129
3.25 Spiral NA
3.26 Cycloid NA
3.27 Helix NA
3.28 Bisecting an angle (*polar coordinates, object snaps*) 23, 50
3.29 Transferring an angle (*Copy*) 82
3.30 Surfaces NA
3.31 Circumscribe a square (*Polygon*) 128
3.32 Constructing an equilateral triangle (*Polygon*) 128
3.33 Pentagon 128
3.34 Hexagon 128
3.35 Ruled surfaces NA
3.36 Cone NA
3.37 Cylinder NA
3.38 Convolute NA
3.39 Polyhedron NA
3.40 Fractal curves and surfaces NA

4.1 Conventional view placement 314, 328, 330, 344
4.2 Alignment of views 220
4.3 Line conventions 223
4.4 Hidden lines 224
4.5 Center lines 224, 274
4.6 One-view drawings 68, 180, 207
4.7 Two-view drawings 255
4.8 Three-view drawings 227
4.9 Multiviews from 3-D models NA
4.10 Fillets and rounds 152, 225, 355
4.11 Chamfers 153, 354
4.12 Runouts 227

5.1 Isometric viewpoints (3-D model) 326
5.2 Isometric drawings, dimensions 234, 284
5.3 Creating isometric drawings 235
5.4 Oblique planes in isometric NA
5.5 Isometric ellipses 236
5.6 Assembly drawings (3-D) NA
5.7 Isometric grids 235
5.8 Oblique drawings 239
5.9 Perspective drawings 324

6.1 Auxiliary views 258
6.2 Auxiliary views using CAD 258
6.3 Point view of a line NA
6.4 Dihedral angles NA

7.1 Section views (*Solselect, Solcut*) 388, 389
7.2 Section lines (*Bhatch*) 247
7.3 Cutting plane lines 254
7.4 Material symbols 248
7.5 Hatch style 250
7.6 Thin wall sections 249
7.7 Full sections 247
7.8 Assembly sections NA
7.9 Conventional breaks 135
7.10 3-D models and section views 388, 389

8.1 Units of measure 42
8.2 Size dimensions (*Horiz, Vert, Diameter, Radius*) 267–270
8.3 Angular dimensions 267, 275
8.4 Coordinate dimensions (*Ordinate*) 277
8.5 Dimension placement 267–275, 289
8.6 Spacing 267–275, 290
8.7 Grouping and staggering 271
8.8 Extension lines 290
8.9 Reading direction 291, 293
8.10 Detail dimensions (*Leader*) 277

8.11 Screw threads, notes 277, 293
8.12 Dimensioning process 304
8.13 Limit dimensions, tolerances 293
8.14 Associative dimensions 279
8.15 Geometric dimensions and tolerancing NA

9.1 Sectioned assembly NA
9.2 Pictorial assembly NA
9.3 Title block 205
9.4 Parts lists NA
9.5 Part identification, balloons NA
9.6 Thread notes 167, 277, 278
9.7 Gears NA
9.8 Bearings NA
9.9 Welding symbols NA

10.1 Surface modeling 310
10.2 Geometric primitives 311, 338
10.3 CSG modeling 338
10.4 Boolean operations 339
10.5 B-rep modeling 338
10.6 Faceted models 334
10.7 Workplanes 313, 341
10.8 Sweeping operations (*Solext, Solrev*) 349, 350
10.9 Parallel and perspective projection 324
10.10 Geometric transformation 380
10.11 Ideation drawings *Preface*
10.12 Computer animation NA
10.13 Finite element analysis NA
10.14 Mechanism analysis NA
10.15 Aesthetic analysis NA
10.16 Production drawings 219
10.17 Technical illustrations 324
10.18 Animations NA
10.19 Technical reports NA
10.20 Presentation graphics NA

NA = Not Applicable—capabilities not provided in AutoCAD or not discussed.

Appendix 58 CAD References for *CADKEY Companion, Cherno*

1.1	Drawing a line	48	3.14	Arc tangent to two lines	207
1.2	Drawing horizontal lines	49	3.15	Arc tangent to a line and an arc	207
1.3	Drawing vertical lines	52	3.16	Arc tangent to two arcs	207
1.4	Drawing inclined lines	54	3.17	Line tangent to two circles	185
1.5	Erasing	55	3.18	A circle through three points	203
1.6	Object snap	81	3.19	Locating the center of a circle	203
1.7	Drawing parallel lines	63	3.20	Ogee curve	192
1.8	Drawing perpendicular lines	65	3.21	Constructing rectified arcs	207
1.9	Drawing lines relative, at angles	66	3.22	Drawing a parabola	322
1.10	Drawing irregular curves	68	3.23	Drawing a hyperbola	325
1.11	Scales	77	3.24	Drawing ellipses	325
1.12	Circles, arcs	70	3.25	Drawing spirals	NA
1.13	Divide, measure	60, 209	3.26	Drawing a cycloid	NA
1.14	Template symbols	42	3.27	Drawing a helix	283
2.1	Sketching	91	3.28	Bisecting an angle	202
2.2	Projections	96	3.29	Transferring an angle	NA
2.3	Isometric pictorial	97	3.30	Sweeping surfaces	609
2.4	Isometric ellipse	97	3.31	Drawing a square	190
2.5	Lettering	102, 107	3.32	Constructing an equilateral triangle	192
2.6	Text styles	104, 107	3.33	Constructing pentagons	192
2.7	Text height	104, 108	3.34	Constructing hexagons	192
2.8	Text alignment	104, 108	3.35	Constructing ruled surfaces	604
2.9	Special text characters	107	3.36	Cone surfaces	606, 608
2.10	Vertex, edge, and face listing	125	3.37	Cylinder surfaces	603
2.11	Cutting planes in 3-D	422	3.38	Convolute surfaces	608
2.12	Symmetry	148, 162	3.39	Polyhedron surfaces	606
2.13	3-D surfaces	603	3.40	Fractal curves and surfaces	606
2.14	Rotating objects in 3-D space	133	4.1	Conventional view placement	265
2.15	Auxiliary views	138, 265	4.2	Alignment of views	267
3.1	Coordinate, 3-D coordinates	171	4.3	Line convention	267
3.2	Polar coordinates	174	4.4	Hidden lines	267
3.3	Cylindrical coordinates	NA	4.5	Center Lines	267
3.4	Spherical coordinates	NA	4.6	One-view drawing	272, 277
3.5	Absolute and relative coordinates	171, 347	4.7	Two-view drawing	272, 277
3.6	World and local coordinates	171	4.8	Three-view drawing	272, 277
3.7	Points	175	4.9	Multiviews from 3-D drawing	272, 277
3.8	Dividing a line into equal parts	330	4.10	Fillets and rounds	296
3.9	Divide a line into proportional parts	330	4.11	Chamfer	298
3.10	Bisecting a line (triangle method)	60, 330	4.12	Runouts	296
3.11	Points of tangency between a circle or arc and a line	185	5.1	Creating isometric view	242
3.12	Point of tangency between two circles	185	5.2	Isometric drawings, dimensions	242
3.13	Arc tangent to a given point on that line	207	5.3	Box-in method creating isometric view	NA
			5.4	Constructing oblique drawing	148

5.5	Creating isometric ellipse	225	8.14	Associative dimensions	466
5.6	Creating assembly isometric drawing	568	8.15	Geometric dimensioning and tolerancing	491
5.7	Using isometric grids	NA	9.1	Sectioned assembly	569
5.8	Constructing an oblique drawing	148	9.2	Pictorial assembly	572
5.9	Creating a perspective drawing	157	9.3	Title block	574
6.1	Depth auxiliary view	347, 348	9.4	Parts list	574
6.2	Auxiliary drawing using CAD	350	9.5	Parts identifications, balloons	521
6.3	Point view of a line	352	9.6	Threads notes	538
6.4	Dihedral angles	354	9.7	Gears	NA
7.1	Section views	421, 422	9.8	Bearings	NA
7.2	Section lines	426	9.9	Welding symbols	513
7.3	Cutting plane lines	426	10.1	Surface modeling	598
7.4	Material symbols	427	10.2	Geometric primitives	242
7.5	Hatch style	421	10.3	CSG modeling	NA
7.6	Thin wall sections	435	10.4	Boolean operation	614, 647
7.7	Full sections	430	10.5	B-rep modeling	NA
7.8	Assembly sections	569	10.6	Faceted representation	NA
7.9	Conventional breaks	443	10.7	Construction plane	227
7.10	3-D models and section views	432	10.8	Sweeping operations	NA
8.1	Units of measure	453, 454	10.9	Parallel and perspective projection	247, 157
8.2	Size dimensions	466	10.10	Geometric transformation	235
8.3	Angular dimensions	468	10.11	Ideation drawings	14
8.4	Coordinate dimensions	468	10.12	Computer animation	NA
8.5	Dimension placement	457	10.13	Finite element analysis	15
8.6	Spacing	458	10.14	Dynamic analysis	NA
8.7	Grouping and staggering	466	10.15	Aesthetic analysis	NA
8.8	Extension lines	466, 474	10.16	Production control	NA
8.9	Reading direction	466	10.17	Technical illustrations	15
8.10	Detail dimensions	466	10.18	Animations	18
8.11	Screws, threads, notes	473	10.19	Technical report	18
8.12	Dimensioning process	466	10.20	Presentation graphics	18
8.13	Limit dimensions, tolerances	464			

NA = Not Applicable—capabilities not provided in CADKEY or not discussed.

A

Absolute coordinates, 145
Actual size, 418
Additive technique, 100
Adjacent areas, 253–254
Adjacent views, 220
Aesthetic analysis, 595
Aesthetic design, 566
Aligned dimensions, 402
Aligned sections, 380, 382
Allowance, 419
Alphabet of lines, 20–22, 220
American National Standards Institute (ANSI), 6, 9, 259–261
American Welding Society (AWS), 512
Analysis
 aesthetic, 595
 assembly, 597
 design, 595
 dynamic, 597
 financial, 595, 598
 functional, 595, 597–598
 graphical, 599
 human factors, 595, 598
 kinematic, 597
 market, 595, 598
 mechanism, 595, 597
 property, 595–597
 by solids, 256–257
 by surfaces, 258–259
Angles, 181–182, 241, 293, 312
Angularity, 446–447
Animation, 594, 617
ANSI standards, 9–10, 259–261, 414–416
Aperture card, 520
Applications, 11
Approximations, 179, 180
Arc, 165, 300–301
Architect's scale, 29
Archiving, 615
Arrows, 397
Assembly analysis, 597
Assembly drawing, 305, 467
Assembly sections, 376
Auxiliary section, 380
Auxiliary views, 445, 349
 applications, 344–348
 CAD, 343–344
 classifications, 337–344
 curves, 342–343
 depth, 338
 dihedral angle, 345
 fold-line, 334–335
 fold-line labeling conventions, 338
 half, 342
 height, 338–340

Auxiliary views—*cont.*

 partial, 342
 point view of a line, 345
 primary, 337
 reference plane, 335–337
 reverse construction, 344
 secondary, 337
 sections, 380
 in a specified direction, 345
 successive, 345, 348
 tertiary, 337
 width, 341–342
Axis, 482
Axonometric axes, 282
Axonometric projection, 282

B

Balloon, 305, 476
Bar graphs, 604
Baseline dimensioning, 399
Basic dimension, 396
Basic size, 418, 425
Bearings, 507–508
Benchmark, 588
Bezier, P. E., 180
Bezier curve, 180
Bilateral tolerance, 418
Bill of material (BOM), 93, 467, 474
Bird's eye view, 317
Bisecting an angle, 181
Bisector, 152
Blind hole, 243, 406
Blueprint, 520
Bolts, 492–493
Boolean operations, 574
Bottom view, 217
Boundary condition, 596
Boundary representation (B-rep) modeling, 574, 577
Bounding box, 65–66
Brainstorming, 589
Brazing, 515
Break lines, 22
Broken-out section, 372
B-spline curve, 180

C

Cabinet oblique, 77, 308
CAD (computer-aided design/drafting) systems, 4, 11, 12
Cam, 502–505
Cam follower, 504
CAPP (computer-aided process planning), 608
Cap screw, 492, 493–494

Cartesian coordinate system, 140

Cavalier oblique, 77, 308
Center line, 22, 224, 287
Central view, 220
Chain line, 402
Chamfer, 246, 482
Change of planes, 240
Circles, 161–163, 310
Circular line element, 443
Civil engineer's scale, 30–31
Civil piping, 508
Clearance fit, 419, 421
Coarse series fasteners, 484
Combination scale, 28
Communications, defining graphics, 2
Compass, 36–37
Computer-aided design/drafting (CAD) systems, 4, 11, 12
Computer-aided process planning (CAPP), 608
Computer animation, 594
Computer numerical control (CNC), 8, 610
Computer simulation, 594
Concentricity, 447
Concurrent documentation, 615
Concurrent engineering, 8, 569
Cones, 193–194
Conical helix, 178
Conics, 166
Construction lines, 64–68
Constructive solid geometry (CSG) modeling, 574
Contour dimensioning, 410
Contour line, 606
Contour plot, 606
Conventional breaks, 382–383
Conventions, 9, 11
Convolute, 194
Coordinate measuring machine (CMM), 8
Coordinates, 140
 absolute, 145
 cylindrical, 144–145
 dimensions, 399–400
 local, 146
 polar, 143
 relative, 145–146
 spherical, 145
 world, 146
Coordinate space, 140–146
Coordinate systems, 146
Corner, 240
Counterbored hole, 243, 407
Countersunk hole, 243
Crest, 482
Critical path method (CPM), 588
Cross-hatch lines, 366

Curved intersection, 301
 Curved line, 152–154
 Cutting plane, 101
 Cutting plane lines, 22, 365–366
 Cycloids, 177–178
 Cylinders, 194, 249–250
 Cylindrical coordinates, 144–145
 Cylindrical helix, 178
 Cylindricity, 444–445

D

Data region, 603
 Data types, 600
 Datum, 397, 440
 assembly, 440
 dimensioning, 399
 feature, 440
 feature control, 441
 feature identifiers, 442
 primary, 441
 reference frame, 441
 secondary and tertiary, 441–442
 uses, 440
 da Vinci, Leonardo, 314
 Delta coordinates, 145
 Dependent variables, 602
 Depth, 482
 Depth auxiliary view, 338
 Descriptive model, 592
 Design, 566–567
 aesthetic, 566
 analysis, See Analysis
 applications, 448–450
 CAD, 587
 concurrent, 568–569
 drawings, 615
 functional, 566
 ideation, 587–590
 implementation, 607–619
 process, 2, 6–8, 568–569, 587
 product, 566, 568
 quality, 614
 refinement, 590–599
 summary of, 619–620
 system, 567
 3-D modeling, See 3-D modeling
 traditional, 568
 visualization, See Design visualization
 Design visualization, 94–97, 599
 data visualization elements, 600–601
 encoding data variables, 602
 marks, 601–602
 for one independent variable, 603–605
 for two independent variables, 605–606
 Detail drawing, 465–467
 Detail number, 467
 Developable surface, 185
 Development, 104
 Deviation, 425
 Diameter symbol, 397
 Diazo, 520
 Die, 482
 Difference, 574
 Dihedral angle, 345
 Dimensioning, 394, 451. See also Dimensions
 ANSI standards, 414–416

Dimensioning—*cont.*
 baseline, 399
 blind holes, 406
 contour, 410
 counterbored holes, 407
 countersinks, 408
 datum, 399
 detail, 403–408
 diameter versus radius, 406
 gages, 408
 geometric breakdown, 410
 grooves, 408
 guidelines, 412, 414
 holes, 406, 407
 interchangeability, 416–417
 process, 411–412
 rectangular coordinate, 399
 screw threads, 408
 spotfaces, 408
 standard practices, 400–403
 unidirectional, 402
 view, 402
 Dimensions, 287, 313, 394, 396. See also
 Dimensioning
 aligned, 402
 arrows, 397
 basic, 396
 basic concepts, 398
 chain line, 402
 coordinate, 399–400
 datum, 397
 diameter symbol, 397
 dimension line, 22, 397
 extension line, 22, 397, 401–402
 grouping and staggering, 401
 leader line, 397
 limit, 397, 418
 limited length or area, 402
 lines, 22, 397
 location, 395, 399
 orientation, 399
 out-of-scale, 403
 placement, 400
 plus and minus, 397, 418
 radial line, 403
 radius symbol, 397
 reading direction, 402
 reference, 396
 repetitive features, 403
 single limit, 418
 size, 395, 398
 spacing, 401
 terminology, 396–397
 tolerance, 397
 units of measure, 395–396
 visible gap, 397
 Dimetric projection, 282
 Directrix, 166, 183
 Discretization, 595
 Displacement, 504
 Displacement diagram, 504
 Display device, 12
 Divider, 37–38
 Documentation, 614–615
 Documenting, 464
 Double-curved line, 152, 178
 Double-curved surface, 106, 183

Double-line drawings, 510–512
 Drafting machines, 16
 Drawing, 5. See also Design; Perspective;
 Projection; Sketching; Tools; View;
 Visualization; and under specific type
 of drawing

lines, See Lines
 Drawing instrument set, 36–38
 Drawing number, 470, 473
 Drawing paper, 18
 Dynamic analysis, 597

E

Edges, 97, 150, 234
 Edge view, 238
 Einstein, Albert, 94–95
 Elevation drawing, 510
 Ellipse, 102, 171–175, 294, 297–301
 Engineer, 4
 Engineering design, 2
 Engineering digital management systems
 (EDMS), 521–522
 Engineering geometry, 140, 198
 Envelope principle, 439
 Epicycloid, 177
 Eraser, 60
 Erasing shield, 23
 Extension lines, 22, 397, 401–402
 External thread, 482

F

Faces, 97, 194
 Fastening, 480
 Fasteners. See Nonthreaded fasteners;
 Threaded fasteners
 Feature control frame, 436
 Features, solid object, 97–98
 Fillet, 243, 305
 Fillet weld, 518
 Finance, 612
 Financial analysis, 595, 598
 Finish mark, 246
 Finite element modeling (FEM), 595
 Finite plane, 182
 Flatness, 444
 Focus, 166, 167
 Fold lines, 217, 334–335, 338
 Foreshortened plane, 240
 Form controls, 442
 Fractals, 197
 Freeform curves, 179
 Freeform surface, 185
 Frontal plane, 210, 236
 Front view, 215
 Full section, 371
 Functional analysis, 595, 597–598
 Functional design, 566
 Functional dimensioning, 422
 Fundamental deviation, 425

G

Gaging tolerance, 442
 Gantt chart, 588
 Gas welding, 515
 Gears, 500–502
 Gear train, 500

General oblique, 308
 General purpose section line, 367
 Generating point, 175
 Generatrix, 183
 Geometric breakdown dimensioning, 410
 Geometric controls
 angularity, 446–447
 axis straightness, 443
 concentricity, 447
 cylindricity, 444–445
 flatness, 444
 form controls, 442
 line element straightness, 443
 line profile, 447
 orientation controls, 445
 parallelism, 445
 perfection, 442
 perpendicularity, 445–446
 roundness, 443–444
 runout, 448
 straightness, 443
 surface profile, 447
 tolerance zones, 442
 virtual condition, 442
 Geometric dimensioning and tolerancing (GDT), 451
 geometric controls. See Geometric Controls
 rule #1, 436, 438
 statistical process control, 435
 symbols, 436
 Geometric elements, 147
 Geometric modeling, 8
 Geometric primitives, 147
 Geometrics, 394
 Geometric transformations, 584–585
 Glyph, 601
 Graphical analysis, 599
 Graphics, 2, 140
 Graphics theory, 10
 Grid paper, 60
 Groove weld, 518
 Ground line, 317
 Ground's eye view, 317
 Guide lines, 87

H

Half auxiliary view, 342
 Half section, 371
 Hardware, 12
 Height auxiliary view, 338–340
 Helix, 178
 Helix angle, 178
 Hexagons, 190–191
 Hidden lines, 22, 223, 286–287
 Hole basis, 426
 Holes
 blind, 243, 406
 counterbored, 243, 407
 countersunk, 243
 cylinders intersecting prisms and, 250
 spotfaced, 243
 through, 243
 Horizon line, 315
 Horizontal plane, 210, 236

Human factors analysis, 595, 598
 Human's eye view, 317
 Hyperbola, 169–171
 Hypocycloid, 177

I

Ideation, 6
 preliminary design, 590
 preliminary ideas statement, 589–590
 problem identification, 587–589
 Ideation drawings, 590
 Image plane, 107
 Implementation, 607
 Inclined face, 102
 Inclined line, 234
 Inclined plane, 236, 238, 299–300
 Independent variable, 602
 Infinite plane, 182
 Inkjet printers, 15–16
 Input device, 12, 15
 Interchangeable parts, 416–417
 Interference fit, 421
 Internal thread, 482
 International Standards Organization (ISO), 35
 International System of Units (système internationale [SI]), 35
 International tolerance grade (IT), 426
 Interpolation, 179
 Intersecting cylinders, 249–250
 Intersecting line, 149–150
 Intersection, 574
 Involute, 178, 501
 Irregular curves, 154, 249
 Isoline, 606
 Isometric axes, 284
 Isometric axis, 70
 Isometric drawings, 284, 512
 Isometric grid, 305–306
 Isometric grid paper, 60
 Isometric line, 284
 Isometric planes, 284
 Isometric projections, 282
 Iteration, 568
 Iterative process, 595

J

Just-in-time (JIT) scheduling, 608

K

Keyboard, 12
 Keys, 497–498
 Kinematic analysis, 597

L

Lead, 178, 481, 482
 Leader line, 397
 Least material condition (LMC), 397, 419
 Left side view, 215
 Lettering
 computer, 90–93
 guides, 87–88
 hand, 87–90
 standards, 87
 template, 86

Limit dimension, 397, 418
 Limiting element, 97
 Limits, 418
 Line balloon, 512
 Line element, 443
 Line graph, 603
 Line profile, 447
 Line of sight (LOS), 206
 Lines, 149
 alphabet of, 20–22, 220
 bisecting a, 152
 break, 22
 center, 22, 224, 287
 chain, 402
 contour, 606
 cross-hatch, 366
 curved, 152–154
 cutting plane, 22, 365–366
 dimension, 22, 397
 dividing, 151–152
 double-curved, 152, 178
 drawing techniques, 22–27
 extension, 22, 397, 401–402
 fold, 217
 general purpose section, 367
 ground, 317
 guide, 87
 hidden, 22, 223, 286–287
 horizon, 315
 inclined, 234
 intersecting, 149–150
 isometric, 284
 leader, 397
 missing line problems, 255–256
 miter, 86
 nonisometric, 72, 286, 289–291
 nonparallel, 149
 normal, 234
 oblique, 234
 parallel, 149
 perpendicular, 149
 phantom, 22
 projection, 107
 radial, 403
 reference, 603
 regression, 603
 scale, 603
 section, 22, 366–367
 single-curved, 152
 straight, 149–152
 tangent, 150
 true-length, 234
 visible, 22
 Linestyles, 20
 Line to line fit, 429
 Line weight, 17–18
 Link, 505
 Linkages, 505–507
 Local coordinate system, 146
 Locking devices, 495
 Locus, 149
 Long axis isometric, 286
 Lower deviation, 425
 Lower limit, 416

M

Machine, 500
 Machine screws, 492, 494
 Major axis, 72
 Major diameter, 171, 482
 Management, 613–614
 Mandelbrot, Benoit, 197
 Market analysis, 595, 598
 Marketing, 611
 Marks, 601–602
 Material requirement planning (MRP), 608
 Mathematical model, 592
 Maximum material condition (MMC), 397, 410, 438
 departure from, 439
 perfect form at, 439
 separation of control types, 439
 symbols, 438–439

Mechanical engineer's scale, 31–33
 Mechanical fastening, 480
 Mechanical pencils, 17
 Mechanism analysis, 595, 597
 Mechanisms, 500
 cams, 502–505
 bearings, 507–508
 gears, 500–502
 linkages, 505–507

Media, 18
 Metric scale, 35–36
 Microfilming, 520
 Midpoint, 152
 Minor axis, 72
 Minor diameter, 173, 482
 Missing lines, 255–256
 Miter line, 86
 Modeling, 592
 Mouse, 15
 Multiple image planes, 109–110
 Multiple line graph, 605
 Multiview drawings, 77–81, 210. See also Multiview sketches; Views; Visualization

advantages of, 213–214
 ANSI standards for, 259–261
 representations of, 238–250
 summary of, 261
 from 3-D CAD models, 227–231
 three-view, 224, 227
 Multiview projection planes, 210–212
 Multiview sketches, 69. See also Sketching; Views; Visualization
 circles and arcs, 83
 one-view sketches, 83
 precedence of lines, 82
 three-view sketches, 85–86
 two-view sketches, 83–84

N

Negative solid, 99
 Node, 147
 Nominal, 600
 Nominal size, 418

Nonisometric lines, 72, 286, 289–291
 Nonisometric planes, 286
 Nonparallel lines, 149
 Nonthreaded fasteners
 keys, 497–498
 pins, 497
 rivets, 498–499
 standard washers, 496–497
 Normal face, 102
 Normal line, 234
 Normal plane, 234
 Numeric control (NC), 610
 Nuts, 493

O

Oblique face, 102
 Oblique line, 234
 Oblique pictorials, 76–77
 Oblique plane, 238, 291–293
 Oblique projection, 306
 Octagon, 192
 Offset coordinate method, 311
 Offset measurement, 289
 Offset sections, 376
 Ogee curve, 164–165
 Ordinal, 600
 Origin, 140
 Orthographic projection, 206
 Outline assembly, 470
 Outline sections, 369–370
 Output devices, 15–16

P

Paper
 drawing, 18
 grid, 60
 isometric grid, 60
 square grid, 60
 tracing, 60
 Parabola, 166–169
 Paraboloid, 169
 Parallel edge, 16
 Parallelepiped, 196
 Parallelism, 445
 Parallel line, 149
 Parallelogram, 186
 Parallel projection, 107
 Parameter, 179
 Parametric equations, 179
 Partial auxiliary views, 342
 Partial views, 259–260
 Part identification, 476
 Part number, 470
 Parts list, 467, 474
 Patent, 619
 Patch, 185
 Pencils, 17–18, 58–59
 Pen plotters, 15
 Pentagons, 190
 Perpendicularity, 445–446
 Perpendicular line, 149

Perspective. See also Projection; Views; Visualization
 background, 313–314
 CAD drawings, 323
 drawing classifications, 317
 one-point, 319–323
 projection, 69, 206
 terminology, 315, 317
 variables selection, 319
 PERT (project evaluation and review technique), 588

Phantom lines, 22
 Physical model construction, 251
 Pictorial assembly, 470

Pictorial drawing
 axonometric drawings, 282
 background, 313–314
 CAD, 323
 classifications, 317–319
 isometric axonometric projections, 282, 284–306
 oblique, 306–313
 one-point perspectives, 319–323
 terminology, 315, 317
 summary, 323
 variables selection, 319

Picture plane, 315

Piece tolerance, 419

Pinion, 500

Pins, 497

Pipe fittings, 509

Piping, 508–512

Piping drawings, 508, 510

Pitch, 178, 481, 484

Pitch diameter, 482

Plain bearings, 507

Planar surface, 182, 183

Plan drawing, 510, 512

Plane of projection, 206

Planes, 182, 238

change of, 240

finite, 182

foreshortened, 240

frontal, 210, 236

horizontal, 210, 236

inclined, 236, 238, 299–300

infinite, 182

isometric, 284

nonisometric, 286

normal, 234

oblique, 238, 291–293

picture, 315

principal, 234

profile, 212, 236

workplane (construction), 579

Planning, 607–608

Plug (slot) weld, 518

Plumbing, 508

Plus and minus dimension, 397, 418

Points, 90, 147, 149, 238

Point view of a line, 345

Polar coordinates, 143

Pole, 176

Polygon, 187
 Polygonal prism, 196
 Polyhedron, 194
 Precedence of lines, 82
 Predictive model, 592
 Preferred precision fits, 429
 Presentation graphics, 618–619
 Picture plane, 315
 Primary auxiliary view, 337
 Primary axes, 107–108
 Primitive modeling, 573–574
 Principal plane, 234
 Principal view, 214
 Prisms, 250
 Problem identification, 587–588
 Process, 568
 Process piping, 509
 Product, 568
 Product design, 566
 Production, 610
 Production drawings, 615. *See also* Working drawings
 Profile plane, 212, 236
 Project evaluation and review technique (PERT), 588
 Projection, 68. *See also* Perspective axonometric, 282
 dimetric, 282
 first-angle, 217–219
 frontal plane of, 210
 horizontal plane of, 210
 isometric, 282
 isometric axonometric, 282–306
 isometric ellipses, 72–75
 on isometric grid paper, 75
 isometric pictorials, 70–72
 lines, 107
 multiview, 77–81, 210
 oblique, 306
 oblique pictorials, 76–77
 orientation of views, 212
 orthographic, 206
 parallel, 69, 206
 perspective, 69, 206
 plane of, 206
 profile plane of, 212
 studies, 251
 third-angle, 217–219
 trimetric, 282
 Projection lines, 107
 Projection theory, 206, 306
 Property analysis, 595–597
 Proportions, 64–68
 Protractor, 17
 Pyramid, 196

Q
 Quadrilaterals, 186
 Qualitative data, 600
 Quantitative, 600

R
 Radial line, 403
 Radius symbol, 397
 Range bars, 604

Rapid prototyping, 593
 Rectangular coordinate dimensioning, 399
 Reference dimension, 396
 Reference lines, 603
 Reference plane, 335–337
 Reference point, 140
 Refinement, 590–592
 computer animation, 594
 computer simulation, 594
 drawings, 592
 design analysis, 595–599
 modeling, 592–594
 Refinement drawings, 592
 Regression line, 603
 Regular curve, 153–154
 Regular isometric, 286
 Regular polygon, 187
 Regular polyhedra, 194
 Related views, 220
 Relative coordinates, 145–146
 Removed section, 373
 Removed views, 261
 Reprographics, 519–522
 Resistance welding, 515
 Return on investment (ROI), 598–599
 Reversed axis isometric, 286
 Revision block, 93, 476
 Revolution conventions, 260
 Revolved section, 372–373
 Rib, 380
 Right-hand rule, 143
 Right side view, 215
 Rigid-body transformations, 584
 Rivets, 498–499
 Rolling contact bearings, 507–508
 Root, 482
 Roulettes, 175
 Round, 243, 305
 Roundness, 443–444
 Ruled surface, 185, 192–197
 Runout, 246, 448

S
 Scalar, 600
 Scale
 architect's, 29
 civil engineer's, 30–31
 combination, 28
 mechanical engineer's, 31–33
 metric, 35–36
 overview of, 28–29
 Scale lines, 603
 Scale model, 592
 Scale specifications, 476–477
 Scanning, 521
 Screw threads, 304, 313, 482
 Seam weld, 518
 Secondary auxiliary views, 337
 Sectional drawing, 358
 Sectioned assembly, 470
 Section lines, 22, 366–367
 Section views, 303–304, 358
 aligned, 380, 382
 assembly, 376
 auxiliary, 380

Section views—*cont.*
 broken-out, 372
 CAD, 362, 383–384
 conventional breaks, 382–383
 cutting plane lines, 365–366
 full, 371
 half, 371
 line practices, 366–370
 offset, 376
 outline, 369–370
 removed section, 373
 revolved section, 372–373
 ribs, webs, and other thin features, 380
 summary of, 384–386
 types, 370–380
 visualization, 362, 364–365

Service, 614
 Set screws, 492, 495
 Shaft basis, 426
 Shape, 98
 Shape description, 140
 Side, 482
 Similar shapes, 254–255
 Single-curved line, 152
 Single-curved surface, 104
 Single-line drawings, 510
 Size and location dimensions, 395, 398
 Sketching. *See also* Drawing
 an arc, 63–64
 with a CAD system, 60–61
 a circle, 63–64
 construction lines, 64–68
 curved lines, 63–64
 document, 68
 ellipses for multiview drawings, 64
 freehand, 58–60
 ideation, 68
 identically proportioned squares, 66–68
 the isometric axis, 70–72
 an isometric cylinder, 74
 an isometric ellipse, 72–74
 on isometric grid paper, 75
 lettering in. *See* Lettering
 multiview, *See* Multiview sketches;
 View(s)
 objects, 68
 oblique pictorials, 76–77
 pictorial, 69
 proportions in, 64–68
 semi-ellipses, 74–75
 straight lines, 61–63
 summary of, 113
 technical, 56–61
 visualization in, *See* Visualization

Sketch modelers, 590
 Soldering, 515
 Solid modeling, 573–577
 Solids
 analysis by, 256–257
 object combinations and negative, 98–100
 Space curves, 249
 Specifications, 465
 Sphere, 301, 303
 Spherical coordinates, 145
 Spiral (of Archimedes), 176–177
 Spline, 26, 179

Spline curve, 179
 Spotfaced hole, 243
 Spot weld, 518
 Springs, 499
 Square, 186
 Square grid paper, 60
 Standards, 9, 10, 259
 Station point, 315
 Statistical process control, 435
 Stereoscopic displays, 112
 Straightedge, 16
 Straight lines, 149–152
 Studs, 492
 Subassembly drawing, 467
 Subtractive technique, 100
 Successive auxiliary views, 345, 348
Surface
 analysis by, 258–259
 curved, 241–242, 311
 developable, 185
 double-curved, 106, 183
 elliptical, 247
 fractal curves and, 197
 freeform, 185
 oblique, 301
 planar, 182, 183
 polyhedra, 194, 196
 of revolution, 185
 ruled, 185, 192–197
 single-curved, 183, 192–194
 swept, 185
 summary of, 198
 two-dimensional, 185–192
 undevelopable, 185
 warped, 185, 197
 Surface labeling, 255
 Surface modeling, 572–573
 Surface models (developments), 104–106
 Surface plot, 606
 Surface weld, 518–519
 Sweeping operation, 579–581
 Swept surface, 185
 Symmetry, 103–104
 Synthesis, 588
 System design, 567
 System tolerance, 419

T

Tablet, 12
 Tabular drawings, 478
 Tangencies
 arcs and, 155, 156–158
 circles and, 155, 159–161
 curves and, 154
 Tangent, 150
 Tap, 482
 Tap drill, 482
 Technical drawing, 6
 Technical graphics, 3–4, 5, 40
 Technical illustrations, 617

Technical reports, 617–618
 Technical sketching, See Sketching
 Technologists, 4
 Template(s), 38, 86, 162, 299, 495
 Tertiary auxiliary views, 337
 Tesla, Nikola, 94, 95
Text
 alignment, 91
 on drawings, 93
 height, 91
 Thin-lead pencils, 17
 Third-angle projection, 217–219
 Thread angle, 482
 Threaded fasteners
 applications, 481–482
 CAD, 497
 locking devices, 495
 templates, 495
 thread specifications
 English, 482–486
 metric, 486–491
 types of standard, 492–495

Threads
 acme, 483
 bolts, 492–493
 buttress, 483
 CAD, 491, 495
 cap screw, 492, 493–494
 drawings, 487–491
 fit, 484
 form, 482–484
 grades, 486
 knuckle, 483
 left-hand, 484–485
 machine screws, 492, 494
 metric, 483
 multiple, 484
 notes, 485–486
 nuts, 493
 pipe, 491
 pitch, 485
 right-hand, 484
 series, 482
 constant pitch, 484
 extra fine, 484
 fine, 484
 set screws, 492, 495
 single, 484
 specifications
 English, 482–486
 metric, 486–491
 square, 483
 studs, 492
 templates, 495
 terminology, 482
 3-D graphs and plots, 606

3-D modeling—*cont.*
 solid modeling, 573–577
 surface modeling, 572–573
 viewing techniques, 581–583
 wireframe modeling, 570–572

Through hole, 243
 Title blocks, 93, 473–474
Tolerances, 397, 419, 425, 451. See also
 Tolerancing
 associative dimensioning, 435
 basic hole system, 430–433
 basic shaft system, 433
 basic size, 430
 CAD, 434–436
 costs, 421–422
 fits, 419–421
 functional dimensioning, 422
 general, 417–418
 geometric accuracy, 435
 limit dimensions, 418
 metric limits and fits, 425–429
 plus and minus dimensions, 418
 precision fit calculation, 433–434
 representation, 417–434
 single limit dimension, 418
 stack-up, 422–424
 standard precision fits, 429–434
 terminology, 418–419

Tolerance specifications, 477
 Tolerance stack-up, 422
 Tolerance zone, 426
 Tolerancing. See also Dimensions;
 Tolerance
 interchangeability, 416–417
 theory, 416

Tools
 computer-aided drawing, 12, 15–16
 sketching
 freehand, 58–60
 CAD, 60–61
 technical drawing, 11–12
 traditional, 16–19, 39

Total quality management (TQM), 613
 Tracing paper, 60
 Trammel, 64
 Transition fit, 421
 Triangle, 19, 187–189
 Trimetric projection, 282
 Trochoid, 177
 True-length line, 234
 Tweaking, 585

U

Undevelopable surface, 185
 Unidirectional dimensioning, 402
 Unilateral tolerance, 418
 Union, 574
 Upper deviation, 425
 Upper limit, 416

V

Valves, 509–510
Vanishing point, 315
Vector data, 601
Vertex, 187
Vertex labeling, 256
Vertices, 98
Views. *See also* Perspective; Projection; Visualization
adjacent, 220
auxiliary, *See* Auxiliary views
bird's eye, 317
bottom, 217
central, 220
conventional, placement, 217
first- and third-angle projection, 217–219
fold lines, 217
front, 215
fundamental, of edges and planes, 233–238
ground's eye, 317
human's eye, 317
left side, 215
line conventions, 220, 223–224
multiview drawings, *See* Multiview drawings
oblique section, 313
partial, 259–260
principal, 214
rear, 217
related, 220
removed, 261
right side, 215

Views—*cont.*

section, *See* Section views
selecting, 231–233
3-D viewing techniques, 581–583
top, 215
worm's eye, 317
View camera, 581–583
Viewport, 581
Virtual condition, 442
Virtual model, 508
Virtual reality (VR), 593–594
Visible gap, 397
Visible lines, 22
Visualization, 10. *See also* Views
advanced techniques in, 112
design, *See* Design visualization
general, 98–106
of multiview drawings, 250–259
planar surfaces, 101–106
of section views, *See* Section views
solid object combinations and negative solids, 98–100
solid object features, 97–98
techniques for engineering drawings, 107–111

W

Warped surface, 185, 197
Washers, 496–497
Web, 380
Welding, 512
processes, 515
joints, 515

Welding—*cont.*

symbols, 516–518
types, 518–519
Welding drawing, 512
Width auxiliary views, 341–342
Wireframe modeling, 570–572
Working drawings, 464, 465
assembly drawing, 467, 470
detail drawing, 465–467
drawing numbers, 470, 473
part identification, 476
part numbers, 470
parts list, 474
revision block, 476
scale specification, 476–477
summary of, 522
tabular drawings, 478
title blocks, 473–474
tolerance specifications, 477
working assembly drawing, 480
zones, 477–478

Working assembly drawing, 480

Workplane, 579

World coordinate system, 146

Worm's eye view, 317

X

Xerography, 520

Z

Zones, 477–478